ENCYCLOPEDIA OF AFRICAN-AMERICAN CULTURE AND HISTORY

EDITORIAL BOARD

ENCYCLOPEDIA OF AFRICAN-AMERICAN CULTURE AND HISTORY

Edited by

JACK SALZMAN
DAVID LIONEL SMITH
CORNEL WEST

Volume 5

MACMILLAN LIBRARY REFERENCE USA
SIMON & SCHUSTER MACMILLAN
NEW YORK

SIMON & SCHUSTER AND PRENTICE HALL INTERNATIONAL
LONDON MEXICO CITY NEW DELHI SINGAPORE SYDNEY TORONTO

Simon & Schuster Macmillan
1633 Broadway, New York, NY 10022

PRINTED IN THE UNITED STATES OF AMERICA

printing number

 2 3 4 5 6 7 8 9 10

LIBRARY OF CONGRESS CATALOGING–IN–PUBLICATION DATA
Encyclopedia of African-American culture and history /
 edited by Jack Salzman, David Lionel Smith, Cornel West.
 p. cm.
 Includes bibliographical references and index.
 ISBN 0-02-897345-3 (set)
 1. Afro-Americans—Encyclopedias. 2.
 Afro-Americans—History—Encyclopedias. I. Salzman,
 Jack. II. Smith, David L., 1954– III. West, Cornel.
 E185E54 1995
 973′.0496073′003—dc20 95-33607
 CIP

This paper meets the requirements of ANSI / NISO Z39.48-1992
(Permanence of Paper)

S

Saar, Betye Irene (July 30, 1926–), artist. Betye Brown was born in Los Angeles and moved to Pasadena, Calif., at age six following the death of her father. While her mother worked as a seamstress and receptionist to support her family, Brown attended public school in Pasadena and enrolled at Pasadena City College. She earned a B.A. degree in design from the University of California at Los Angeles in 1949 and married artist Richard Saar (pronounced "Say-er") shortly thereafter.

During her early career, Saar worked as a costume designer in theater and film in Los Angeles. In the late 1950s and early '60s, she resumed formal art training at California State University in Long Beach, at the University of Southern California, and at California State University in Northridge. In graduate school, Saar mastered the techniques of graphics, printmaking, and design, but after seeing a Joseph Cornell exhibition at the Pasadena Art Museum in 1967, she turned to what would become her signature work: three-dimensional assemblage boxes. Saar's encounter with Cornell's surrealist boxes led her away from her early, two-dimensional work in prints to her first landmark piece, *Black Girl's Window* (mixed media, 1969). Here Saar used Cornell-inspired elements like a segmented window and a surrealist combination of objects to explore issues of personal identity. The piece presents a black girl, possibly Saar, pressing her face and hands against a glass pane, surrounded by images of the occult.

During the late 1960s and '70s, Saar's boxes reflected her political engagement with the CIVIL RIGHTS MOVEMENT by satirizing persistent derogatory images of African Americans. In *The Liberation of Aunt Jemima* (1972), Saar appropriated the racist stereotype of Aunt Jemima (*see* STEREOTYPES) by transforming her from a passive black female into a militant revolutionary. Her later work took on a more personal, autobiographical dimension, exploring her own mixed heritage of Native American, Irish, and African descent, and her spiritual beliefs. The death of Saar's Aunt Hattie in particular pushed her work inward and inspired such nostalgic collages as *Keep for Old Memoirs* (1976), made from old family photographs and personal remnants such as gloves and handkerchiefs.

In 1974, Saar traveled to Haiti and Mexico under a National Endowment for the Arts grant, then to Nigeria for the second World Black and African Festival of Arts and Culture (1977). These trips, together with Saar's visits to the Egyptian, Oceanic, and African collections at the Field Museum of Natural History in Chicago, resulted in a series of altarpieces (1975–1977) which combined personal emblems with totems from African, Caribbean, and Asian cultures. *Dambella* (1975) contains obvious references to Haitian voodoo with its ritualistic animal parts and snakeskin, while *Spiritcatcher* (1976–1977), with its spiral structure and found objects, recalls Simon Rodia's Watts Towers in Los Angeles, which Saar had visited as a child.

In the 1980s and 1990s, Saar continued to create assemblage boxes and collages while also experimenting with room-sized installations. As always,

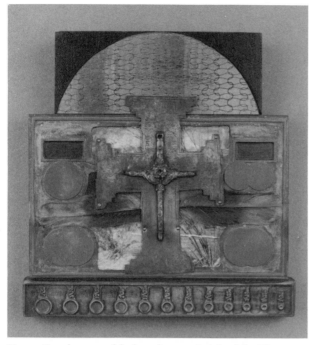

Betye Saar's assembled sculpture *Spirit of the Elements*, 1979, in metal, feather, woven thread, and paint on wood, acknowledges Saar's African and Christian heritage. (The Studio Museum in Harlem)

she works in materials culled and recycled from foreign markets, thrift shops, or her own personal history; she intends these "found treasures" to stir emotion and personal or collective memories in the viewer. Her *Mojotech* installation at the Massachusetts Institute of Technology (1988) explored the relationship between technology and magic, creating hybrid altars out of high-tech elements like computer-system circuit boards as well as traditional religious objects.

Saar's work has been shown at numerous solo exhibitions, including the Studio Museum in Harlem in New York (1980); the Museum of Contemporary Art, Los Angeles (1984); and the Pennsylvania Academy of the Arts, Philadelphia (1987). Since 1983, she has been awarded several commissions to create installations for public sites in Los Angeles, New Jersey, and Miami. Saar won a John Simon Guggenheim Memorial Foundation Award in 1991, and she was one of the two artists chosen to represent the United States in the 1994 São Paulo Biennial in Brazil.

REFERENCES

Albright-Knox Art Gallery. *The Appropriate Object.* Buffalo, N.Y., 1989.

Studio Museum in Harlem. *Rituals: Betye Saar.* New York, 1980.

TAMARA L. FELTON

St. Louis, Missouri. St. Louis, Mo., was founded in 1764 by French trader Pierre Laclade as a settlement and fur trading post in the Louisiana territory, then owned by Spain. African Americans, both slave and free, were present in the city virtually from the date of its creation. Few population figures are available for blacks during the colonial period. In 1772, a Spanish pastor, Father Valentine, arrived in the settlement, and in three years baptized twenty-four blacks into the Roman Catholic faith. By 1776, blacks formed about 30 percent of the rapidly growing settlement. Slaves and free blacks were employed as domestics, agricultural laborers, ship pilots, hunters, dockworkers, and craftspeople. Some free blacks, such as Jeannette Fourchet, became successful farmers.

In 1803, following the Louisana Purchase, the district of St. Louis, with its 667 slaves and 70 free black residents, became part of the United States. The number of slaves grew to 740 in St. Louis County by 1810, about 20 percent of the area's growing population. This large slave force frightened the district authorities, who passed several ordinances between 1808 and 1818 to prevent slaves from gathering in public, drinking, or associating with free blacks or whites. An 1818 ordinance prescribed jail or whipping for slaves found in public between 9:00 P.M. and daylight. The development of the steamboat and the increase in river traffic sparked sustained expansion of the settlement. In 1823, three years after Missouri became a state, and six years after the first steamboat docked at St. Louis, the city was incorporated with a population of 5,000.

Slavery continued in St. Louis throughout the antebellum period, but its rate of growth was soon checked by labor competition from white northern and European immigrants. Furthermore, some slaves—the most famous was future abolitionist William Wells BROWN—escaped to free states across the Mississippi, or purchased their freedom by "hiring out" their time. In 1830, slaves still made up a fourth of the city's residents, but their numbers remained virtually static from then on, and slaves fell from 9 percent to 1 percent of the population during those years, mainly personal servants of wealthy whites in the city's third and fourth wards. The city remained solidly proslavery in its politics, and abolitionists stayed out of the area. When St. Louis slave Dred Scott tried to buy his freedom in 1846, his owner, who was part of a committee to defend slave-owner interests, refused. Forced to seek his freedom in court, with the help of white lawyers he won his freedom in 1850, before the case was overturned in the notorious 1857 U.S. Supreme Court decision, *Dred Scott* v. *Sanford* (*see* DRED SCOTT DECISION). (Soon after the case was decided, Scott was manu-

mitted by a subsequent owner.) Even as slavery declined in St. Louis, the city remained a major slave market and was a major depot for slaves shipped to the deep South, home to such important slavetrading firms as Blakey and McAfee, and Bolton, Dickens and Company. Although the city enjoyed an unwarranted reputation, even among some abolitionists, for mild slavemasters, treatment and punishment of slaves was as cruel in St. Louis as elsewhere. Slaves were often whipped in public and sometimes beaten to death.

As economic opportunity grew during the antebellum years, a local free black class sprang up in St. Louis, whose numbers surpassed those of slaves by 1860. Free blacks occupied an uncertain place in society between slaves and whites. Life for St. Louis free blacks was better than for plantation slaves, though the free black Henry Clay Bruce (older brother of Blanche K. BRUCE, St. Louis school teacher and later U.S. senator) claimed that while elite free blacks looked down on slaves, they faced so many legal restrictions that their status was hardly better. Most whites despised them and made their presence difficult in numerous ways. After 1835, all free blacks had to register with county courts and have white guarantors or pay large sums as bonds of good behavior. In 1847, laws were passed prohibiting free blacks from entering Missouri and forbidding the teaching of blacks to read or write. City ordinances and state laws prohibited blacks from assembling publicly, traveling without permits, or testifying against whites in court. Their precarious position was underlined by white violence. In 1836, a white mob lynched Francis McIntosh, a free black cook accused of the fatal stabbing of a constable. McIntosh's trial judge refused to intervene, saying that the lynching was justified by "a higher law." In 1846, Charles Lyons was summarily expelled from the state for not having a license. When he protested that his constitutional rights had been violated, Circuit Judge James Krum ruled that blacks were not citizens and had no right to trial by jury. Even sympathetic white leaders such as Francis Blair favored African colonization as the best solution to racial problems.

Within the free black community, there were marked social differences. Most were poor laborers, who lived on the waterfront and attended Baptist churches with slaves, with whom they often retained family ties. At the top was "the Colored Aristocracy," as Cyprian Clamorgan termed it in an 1858 pamphlet. Largely made up of light-skinned mulattos, educated merchants, and professionals, many owning substantial property (up to $500,000 worth in one case). The "aristocrats" attended their own churches, usually either Roman Catholic or Methodist Episcopal, and sent their children to be educated in exclusive northern schools. They largely refused to socialize with the other members of the community.

Large numbers of African Americans in St. Louis, whatever their social disdain for slaves, were involved in abolitionist and racial uplift efforts. The Rev. Moses DICKSON founded a secret abolitionist fraternity, the TWELVE KNIGHTS OF TABOR, in 1846. Several black churches and schools opened during the antebellum era. In 1845, the Roman Catholic Sisters of St. Joseph of Carandolet opened a Sunday school for one hundred black girls, but it soon closed following attacks by a white mob. In 1856, other nuns established a clandestine school. In 1858, the Jesuit priest Father Peter Loning opened a chapel and school for blacks in the upper gallery of St. Francis Xavier Church. Blacks such as Elizabeth KECKLEY, a mulatto seamstress and later an employee and confidante of First Lady Mary Todd Lincoln, began schools, at times using the label "sewing schools" as a front. Hiram REVELS and Blanche K. Bruce, the two Reconstruction-era black U.S. senators, both taught school in St. Louis during the 1860s.

The city's most outstanding leader was John Berry MEACHUM, a free black from Virginia. Meachum assisted John Mason Peck, a white missionary, in establishing religious services for blacks. In 1825, following his ordination by Peck, Meachum founded and became minister of the First African Baptist (later First Baptist) Church on Third and Almond streets, probably the first independent black religious congregation west of the Mississippi River. He also established a church school in defiance of the state's ban on black literacy. In the meantime, he prospered as a carpenter and barrelmaker, and set up his shop as a training ground for enslaved blacks, whom he would buy and instruct and who would purchase their freedom from him out of their wages. After 1847, Meachum evaded the laws banning black assembly and literacy by establishing a "school for freedom" on his steamboat moored on the Mississippi River, beyond Missouri jurisdiction.

The coming of the CIVIL WAR polarized opinion on slavery. By 1860, REPUBLICAN PARTY and pro-Union sentiment, nurtured by economic as well as ideological ties, was ascendant. A small abolitionist movement (see ABOLITION) set up in the city. On January 1, 1861, a slave auction was interrupted by a crowd of 2,000 men who forced the end of public sales, though newspaper advertisements for slaves continued to appear. When war broke out, St. Louis became a Union outpost. Refugees poured in, swelling the black population. They found employment in building levees and other laboring activities. In May 1863, blacks were recruited into the Army, and a Bureau of Colored Troops was set up in St. Louis.

Blacks eventually volunteered in large numbers for the war effort. The AMERICAN MISSIONARY ASSOCIATION established a freedom school in the Missouri Hotel and in 1864 set up a Colored Board of Education to raise money for black schools.

An important partner in education was the Western Sanitary Commission (WSC), established during the war by liberal whites. Originally intended to care for wounded Union soldiers, the WSC soon devoted itself to relief efforts and the uplift of the black community. The WSC set up five tuition-supported schools, including a high school, and established a Freedmen's Orphan Home. Its members were mostly paternalistic in spirit and were unwilling to allow much black involvement in leadership. The WSC ceased operation in 1865.

The same year, following the end of the Civil War, slavery was outlawed and the ban on education was ended. St. Louis's population ballooned to 311,000 by 1870, making it the third largest city in the United States. The black population, however, grew even faster, rising from 2 percent of the 1860 population to 6 percent by 1870. Most had fled the oppressive atmosphere of the deep South and agreed with the popular adage, "Better a lamppost on Targee Street [the main street of the heavily black Near South Side] than the mayor of Dixie." They welcomed the jobs and educational opportunity available in St. Louis. In 1868, local officials successfully lobbied for the creation of a branch of the ill-fated FREEDMAN'S BANK in St. Louis to encourage black business. The black WSC schools, taken over by the St. Louis Board of Education, were funded by the city. By 1875, there were twelve black schools, although they were dilapidated, irregularly spaced in districts, and staffed by poorly paid teachers. The city did not hire its first black teacher, the Rev. Richard Cole, until 1877.

Although racial segregation was widespread, there were exceptions. Libraries and streetcars remained open to blacks throughout the century. There were even occasional incidences of interracial action. After the depression of 1873 brought widespread unemployment, an unsuccessful general strike was called to restore jobs and end wage cuts. Black levee workers marched and participated equally. The end of the RECONSTRUCTION era limited black opportunity. Outside of a few post office positions, blacks received few government jobs. When thousands of EXODUSTERS fleeing to Kansas from the South were stranded in St. Louis in spring 1879, city authorities refused to provide relief or aid for passage beyond the city. The African-American community raised three thousand dollars to support travel expenses. In response to the prejudice, blacks united politically, although they remained divided along class and occupational lines, with old-time free black St. Louisans

scorning newcomers. In 1880, the *St. Louis Advance,* the city's first black newspaper, was started by publisher P. H. Murray. John W. Wheeler's successful *St. Louis Palladium* followed in 1884.

By the turn of the century, the outline of the black community in St. Louis had been clearly established. A few successful businessmen grew up, many blacks, such as future entertainer Josephine BAKER, lived in great poverty in Mill Creek Valley in the Near South Side. Others lived in "Chestnut Valley," the entertainment and vice district surrounding Chestnut, Market, and 20th streets.

There, in such establishments as Honest John Turpin's Silver Dollar Saloon, and the Hurrah Sporting Club, RAGTIME music was popularized by musicians led by Scott JOPLIN, "the King of Ragtime." In 1900, the year after he wrote the bestselling "Maple Leaf Rag," Joplin and his white publisher, John Stark, moved to St. Louis. Ragtime soon became a nationwide craze, with St. Louis its mecca. Joplin's house at 2658A Morgan Street (later Delmar Boulevard) is today a ragtime museum and center. Other ragtime artists included Tom Turpin, composer of the "St. Louis Rag" and proprietor of the Rosebud Café, and Louis Chauvin.

In the early twentieth century, blacks organized politically into the Negro Civic League, led by attorney Homer G. Phillips, which leaned toward the Republicans, and the Democratic Negro Jefferson League. The two combined to elect black candidates such as Constable Charles Turpin in 1902 and delivered black votes in exchange for patronage and protection from legal discrimination.

Even so, the political influence blacks exercised on white elites did not change their essential powerlessness in the city. In 1916 white voters easily passed a residential segregation initiative, despite a heavy campaign against it by blacks and white officials. Although the measure was annulled following legal action by the fledgling St. Louis NAACP, restrictive covenants in much of the city kept blacks from moving into white areas until the U.S. Supreme Court's 1948 *Shelley* v. *Kraemer* decision.

The city soon improved its tattered reputation for racial harmony. After 1915, during the beginning months of the Great Migration, large numbers of southern blacks arrived in the area. Many were lured by false promises of high wages to the industrial suburb of East St. Louis, Ill., an oppressive company-dominated town whose businesses were shielded from taxes and regulation. Racial tensions grew following a failed labor strike and race baiting by Democrats fearful that the new blacks would swell the Republican vote. In July 1917, East St. Louis exploded in an enormous and bloody race riot. St. Louis, in contrast, seemed a haven for blacks; as the

city's newspapers denounced the rioting, city residents organized relief efforts, and St. Louis police protected African Americans fleeing from East St. Louis.

The Great Migration transformed and revitalized St. Louis. In 1920, new voters helped elect the city's (and state's) first black legislator, Walthall Moore, and soon there were a handful of black municipal officials. Business expanded also. In 1919, the Douglass Life Insurance Company was founded. It was soon the largest insurer of Missouri blacks. Annie Malone, a beautician, established a very successful beauty business, and may have been the richest black woman in the United States during the 1920s. She founded the Poro Beauty College to teach her system and set up the Poro Music College and a black orphans' home on the proceeds of her business. The *St. Louis Argus* and the *St. Louis American* were the major African-American newspapers. While blacks continued to be excluded from white areas, two new black neighborhoods, the "Ville" and "Grove" sections, sprang up. Black commercial activity was concentrated near the shopping district of Chouteau, Franklin, and Vanderventer avenues.

Although St. Louis, musically immortalized in W. C. HANDY's 1914 "St. Louis Blues," was never to regain the central place in American music it had held in the ragtime era, the city remained enormously important to African-American music. Along with Chicago and Memphis, the greater St. Louis area, including East St. Louis, Ill., was a major midwestern center for BLUES and JAZZ before World War II. Some of its leading blues musicians were Lonnie JOHNSON, "St. Louis Jimmy" Oden, Roosevelt Sykes, and "Peetie Wheatstraw." Big band jazz also became quite popular after the turn of the century, especially the riverboat bands led by Fate Marable, Charlie Creath, and Dewey Jackson. Later, NIGHTCLUBS such as the Jazzland, the Plantation, and the Hummingbird were the places to find big bands, such as the Jeters-Pillars Orchestra and Cab Calloway's band. Two of the most important jazz trumpeters of all time, Clark TERRY and Miles DAVIS, came from the St. Louis area.

The mass of blacks remained poor during the 1920s and were made even poorer by the GREAT DEPRESSION. Works Project Administration contractors in St. Louis routinely discriminated against unemployed blacks until a formal appeal was made to Washington. Still, when city leaders authorized the use of federal funds to construct Homer Phillips Hospital, a $1.3 million black hospital, black labor was excluded from the project. The hospital filled a glaring need both for health care and for graduate medical and nursing training for blacks, but it long remained underfunded, overcrowded, and unsafe.

After World War II, blacks made the first successful challenges to discrimination in St. Louis. By 1949, city swimming pools and parks were opened to blacks, and Washington University integrated, although courts refused to order city schools to desegregate. The same year, students began a nine-year campaign of sit-ins that desegregated downtown stores and lunch counters.

In the 1950s, the CIVIL RIGHTS MOVEMENT, led by students and labor activists mobilized by the CONGRESS OF RACIAL EQUALITY (CORE), hit St. Louis in force. In the late 1950s, St. Louis CORE also joined with the NAACP Youth Council, led by William CLAY (who would become Missouri's first black congressman in 1969) to form the Job Opportunities Council, which inaugurated strikes and sit-ins against discriminatory hiring practices.

During the early 1960s, CORE activists expanded the use of civil disobedience to obtain jobs for blacks and made dramatic peaceful takeovers of buildings to gain attention. They also protested to improve schooling for blacks. Even after the U.S. Supreme Court's 1954 BROWN V. BOARD OF EDUCATION OF TOPEKA, KANSAS ended legal school segregation, integration lagged due to almost total residential segregation. CORE activists lay in front of school buses to end the segregation of black students bused into white schools. Despite attempted busing, in 1965 91 percent of black children were still in mostly black schools.

After civil rights protest declined, NAACP and CORE members, such as Ivory Perry, shifted toward a concentration on tenants' rights and ward electoral politics as successful strategies for change. Urban renewal projects in St. Louis not only had failed to change residential segregation patterns, but had created new problems. The Pruitt-Igoe houses, a federal housing project for blacks opened in 1954, was badly planned, with few jobs available nearby and limited transportation, play, and shopping facilities. The project (home during the 1960s to future champion boxers Leon and Michael SPINKS) eventually deteriorated so badly that in 1971 officials ordered it torn down, a national symbol of the failure of urban renewal.

Since the 1960s, blacks have made many gains in St. Louis. Educational opportunities have opened up, businessmen such as David B. Price, Jr., and Wayman F. Smith III have risen to prominence, and African Americans have entered the government. In 1993, St. Louis narrowly elected its first black mayor, former circuit court clerk Freeman Bosley, Jr.

Still, black St. Louisans face enormous difficulties. As a result of continued deindustrialization, by 1990 the city had less than half its 1950 residents, and its population had become almost half African Ameri-

can, despite a 25 percent drop in the black population over the previous twenty years. A school desegregation plan adopted in 1976 was still not complete fifteen years later. In 1991, Project HOPE estimated black unemployment in the city at 34 percent, and black youth unemployment at 96 percent.

Despite its troubles, St. Louis has remained an important incubator of musical talent. In the 1950s many significant blues and ROCK AND ROLL musicians were based in St. Louis, including Ike Turner, Tina TURNER, Chuck BERRY, Albert KING, and J. B. Hutto. The St. Louis–based Black Artists Group, formed in 1968 and disbanded in 1972, produced a number of extraordinary talents in avant-garde jazz, including Hamiett Bluiett, Joseph and Lester Bowie, Julius Hemphill, and Oliver LAKE. The city has also been the home of such varied talents as entertainer Redd FOXX, comedian/activist Dick GREGORY, and opera singers Grace BUMBRY and Felicia Weathers.

REFERENCES

CHRISTENSEN, LAWRENCE O. "Race Relations in St. Louis, 1865–1916." *Missouri Historical Review* (January 1984).

CLAMORGAN, CYPRIAN. *The Colored Aristocracy of St. Louis.* St. Louis, 1858.

DAY, JUDY, and M. JAMES KEDRO. "Free Blacks in St. Louis: Antebellum Conditions, Emancipation and the Post War Era." *Missouri Historical Society Bulletin* (January 1974): 117–135.

FOLEY, WILLIAM E. *The Genesis of Missouri: From Frontier Outpost to Statehood.* Columbia, Mo., 1989.

GREENE, LORENZO J., GARY R. KREMER, and ANTONIO F. HOLLAND. *Missouri's Black Heritage.* Rev. ed. Columbia, Mo., 1992.

GREGORY, DICK, and ROBERT LIPSYTE. *Nigger: An Autobiography.* New York, 1964.

LIPSITZ, GEORGE. *A Life in the Struggle: Ivory Perry and the Culture of Opposition.* Philadelphia, 1988.

PRIMM, JAMES NEAL. *St. Louis: Lion of the Valley.* Boulder, Colo., 1981.

RAINWATER, LEE. *Behind Ghetto Walls: Black Families in a Federal Slum.* Chicago, 1970.

TREXLER, HARRISON. *Slavery in Missouri, 1804–1865.* 1914. Reprint. New York, 1986.

GREG ROBINSON

Salaam, Kalamu Ya (March 24, 1947–), playwright and journalist. Born Vallery Ferdinand III in New Orleans in 1947, Kalamu Ya Salaam, like many other black writers of his generation, built a career on the twin bases of activism and art. After serving in the U.S. Army during 1967–1968, Salaam attended Southern University in New Orleans, from which he was expelled in 1969 for participating in student demonstrations. He was allied with the Free Southern Theatre, 1968–1971, which in a span of two years produced seven of his one-act plays. His early works, such as *The Picket* (1968), *Mama* (1969), and *Happy Birthday, Jesus* (1969), were influenced by the BLACK ARTS MOVEMENT. Later plays, such as *The Quest* (1972) and *Somewhere in the World* (1973), employed a combination of poetic ritual and social analysis to examine societal issues of the 1970s and '80s.

Salaam has been active in many fields besides theater. In 1970 he helped found *Black Collegian*, a national magazine for black college students. In 1973 he cofounded Ahidiana, a Pan-African nationalist organization (*see* PAN AFRICANISM). As a journalist, he has written and published widely on a variety of subjects, including literary, music, and social criticism. In 1981, for his frequent music reviews and critiques, he was awarded an American Society of Composers and Publishers (ASCAP) Award for excellence in writing about music. Salaam considers himself an "Afrikan" writer and disowns any Western sensibility. He argues that a proper black aesthetic is one that concerns itself with society and its problems. Through the early 1990s Salaam has lived and written in New Orleans. His work has appeared regularly in the *African American Review*.

REFERENCES

DAVIS, THADIOUS M., and TRUDIER HARRIS, eds. *Dictionary of Literary Biography*, Vol. 38, *Afro-American Writers After 1955: Dramatists and Prose Writers.* Detroit, 1985.

PETERSON, BERNARD L., JR. *Contemporary Black American Playwrights and Their Plays.* New York, 1988.

MICHAEL PALLER

Salem, Peter (1750?–August 16, 1816), American Revolutionary War soldier. Peter Salem was born a slave in Framingham, Mass. He was originally owned by New England historian Jeremy Belknap, and took his last name from Belknap's previous residence, Salem, Mass. Salem was subsequently sold to Major Lawson Buckminster.

At the outbreak of the War for Independence, Salem was temporarily released by his owners so that he could serve with the Continental Army. He enlisted in Captain Thomas Drury's company, Col. John Nixon's Fifth Massachusetts Regiment, and served at the Battle of Bunker Hill on June 17, 1775. Salem was identified by a number of participants in the battle as the soldier who fired the shot that killed British Maj. John Pitcairn at Bunker Hill. In 1787 Belknap recorded in his diary that a person present at

the battle informed him that "A negro man . . . took aim at Major Pitcairn, as he was rallying the dispersed British troops and shot him thro' the head." Samuel Swett, whose chronicle of the battle was published in 1818, specifically identifies Salem as Pitcairn's assassin: "Among the foremost of the leaders was the gallant Maj. Pitcairn, who exultingly cried 'the day is ours,' when Salem, a black soldier, and a number of others, shot him through and he fell. . . ." Since no conclusive evidence exists and other black soldiers were present at the battle, historians differ on whether these accounts are accurate and actually refer to Salem, but there is general agreement that he was at least present at the Battle of Bunker Hill.

Shortly after the battle Salem was nearly discharged from the Army because of General George Washington's decree that no more slaves were to be recruited for the militia. But Salem was granted full freedom by his owners so that he could continue fighting and served at Saratoga and Stony Point.

The legend of Salem's exploits at Bunker Hill was given popular currency by John Trumbull's 1786 painting *The Battle of Bunker's Hill,* which depicts a black soldier, commonly thought to be Salem, standing with musket in hand while Pitcairn lies mortally wounded.

After the war Salem built a cabin in Leicester, Mass., and wove cane for a living. He died in a poorhouse in Framingham in 1816. As a soldier of the AMERICAN REVOLUTION, Salem was paid respects at his death by the citizens of Framingham. They erected a monument to his memory, with the inscription: "Peter Salem / A Soldier of the Revolution / Concord / Bunker Hill / Saratoga / Died, August 16th, 1816."

A U.S. postage stamp bearing a reproduction of Trumbull's painting was issued in 1968.

REFERENCES

KAPLAN, SIDNEY. *The Black Presence in the Era of the American Revolution, 1770–1800.* Greenwich, Conn., 1973.
QUARLES, BENJAMIN. *The Negro in the American Revolution.* Chapel Hill, N.C., 1961.

THADDEUS RUSSELL

Sam and Dave. This soul vocal duo, consisting of Samuel Moore, who was born in Miami, Fla., on Oct. 12, 1935, and Dave Prater, who was born in Ocilla, Ga., on May 9, 1937, was formed in 1958 and during the next decade it helped define the rugged RHYTHM AND BLUES sound at Stax Records. The duo made their first recordings with the Roulette label, but it was not until 1965, when they switched to the Memphis-based Stax label, which was affiliated with Atlantic Records, that they had their first hit, "You Don't Know Like I Know." The duo continued to work with Stax, backed by the legendary Stax house band, on songs written and produced by Isaac Hayes and David Porter, until 1968, when Atlantic's agreement with Stax expired.

During this period, Sam and Dave exemplified what became known as the "Memphis sound." Both had begun their careers on the GOSPEL circuit, and their hit songs, such as "Hold On, I'm Coming" (1966), "Soul Man" (1967), and "I Thank You" (1968), combined the aggressive vocal techniques and emotional lyrics of gospel with the refined harmonizing style of 1950s black vocal rhythm-and-blues groups. Although Stax Records intended Sam and Dave to appeal largely to African-American listeners, the duo had tremendous crossover success and became popular among both white and black audiences. Sam and Dave split up in 1970. They both pursued unsuccessful solo careers but reunited several times during the 1970s. The duo briefly regained the spotlight in 1979, when their song "Soul Man" was used in the film *The Blues Brothers.* Dave Prater died on April 9, 1988, in a car crash near Syracuse, Ga.

REFERENCES

HIRSHEY, GERRY. *Nowhere to Run: The Story of Soul Music.* New York, 1984.
SALVO, BARBARA, and PATRICK SALVO. "The Memphis Sound of Music." *Sepia* 23, no. 12 (1974): 64–78.

GENETTE MCLAURIN

Sanchez, Sonia (September 19, 1934–), poet. Sonia Sanchez was born Wilsonia Benita Driver, the daughter of Wilson L. and Lena Jones Driver, in Birmingham, Ala. During her childhood in the South as well as in HARLEM, she was outraged by the way American society systematically mistreated black people. This sense of racial injustice transformed her from a shy, stuttering girl into one of the most vocal writer-activists in contemporary literature. In the early 1960s she began publishing poems under her married name, Sonia Sanchez, which she continued to use professionally after a divorce. Although best known for verse urging black unity and action, verse reflecting the cadences of African-American speech and music, she also became an accomplished dramatist, essayist, and editor, as well as an enduring proponent of black studies.

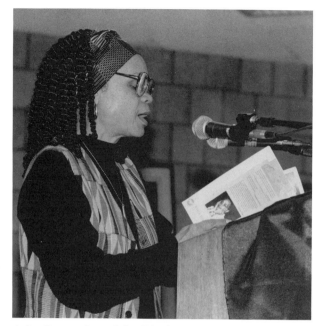

A leading voice of the Blacks Arts movement, Sonia Sanchez uses her biting and militant poetry to challenge the structures of white dominance. She is pictured here speaking at a rally for Kwame Toure (the former Stokely Carmichael) in 1993. (C. Fournier)

Sanchez studied at Hunter College in New York (B.A., 1955) and at New York University and has taught at many institutions, including Rutgers, the University of Pittsburgh, and Amherst College. She worked during the CIVIL RIGHTS MOVEMENT as a supporter of the CONGRESS OF RACIAL EQUALITY but in 1972 joined the NATION OF ISLAM because she thought that it was doing more to instill cultural pride and morality in young people. In a 1983 interview, Sanchez said that her political and cultural affiliations, harassment by the FBI, and her insistence that black writers be included in curricula explained why she didn't gain a permanent academic position until 1978, when she became a professor at Temple University.

Homecoming (1969), her first collection of poetry, addressed racial oppression in angry voices derived from street talk. Sanchez soon became sought-after for her passionate, confrontational readings. Although her use of profanity was shocking to some, she has never regretted her artistic approach: "There is vulgar stuff out there. One has got to talk about it in order for it not to be."

While the plight of African Americans in a white society is her major subject, Sanchez has also critiqued struggles within the black community. *Sister Son/ji,* a play produced off-Broadway in 1972, is about a militant young woman fighting the sexism of the black revolutionary movement. Sanchez herself left the Nation of Islam in 1975 because the organi-

zation would not change the subservient role it assigned to women.

Books by Sanchez include poetry collections: *We a BaddDDD People* (1970), *A Blues Book for Blue Black Magical Women* (1973), *homegirls & handgrenades* (1984); juvenile fiction: *A Sound Investment and Other Stories* (1979); plays: *Uh, Huh: But How Do It Free Us?* (1975), *Malcolm Man/Don't Live Here No More* (1979); as well as numerous contributions to journals, recordings, and anthologies as a poet, essayist, and editor.

Sanchez has received major awards from PEN (1969), the National Institute of Arts and Letters (1970), and the National Endowment for the Arts (1978–1979). Other honors include the Lucretia Mott Award (1984), the Smith College Tribute to Black Women Award (1982), a doctorate from WILBERFORCE UNIVERSITY (1972), and the American Book Award from the Before Columbus Foundation (1985).

REFERENCES

BARKSDALE, RICHARD, and KENETH KINNAMON, eds. *Black Writers of America: A Comprehensive Anthology.* New York, 1972.
BASEL, MARILYN K. *Contemporary Authors: New Revision Series.* Vol. 24. Detroit, 1989, pp. 410–414.
BROWN-GUILLORY, ELIZABETH. *Black Women in America.* New York, 1972, pp. 1003–1005.
METZGER, LINDA, ed. *Black Writers: A Selection of Sketches from Contemporary Authors.* Detroit, 1989.
SALAAM, KALAMU YA. *Dictionary of Literary Biography: Afro-American Poets Since 1955.* Detroit, 1985, pp. 295–306.
TATE, CLAUDIA, ed. *Black Women Writers at Work.* New York, 1983, pp. 132–148.

DEREK SCHEIPS

Sanders, Farrell Pharoah (October 13, 1940–), jazz composer and performer. Pharoah Sanders was born in Little Rock, Ark. In addition to performing on the tenor saxophone, flute, and piccolo, he also writes music. After completing high school in 1959, he went to Oakland, Calif. on an arts scholarship to Oakland Junior College. During high school in Little Rock he had performed with RHYTHM AND BLUES BANDS, and at that time his interests were evenly divided between music and the visual arts. In California he met and played with Dewey Redman, Billy Higgins, Sonny Simmons, Vi Redd, and Philly Joe JONES. He also met John Coltrane in San Francisco for the first time. In 1962 he moved to New York City where he worked with SUN RA, Wilbur Ware, Don CHERRY, Archie SHEPP, and Sonny Murray. He

also took part in some rehearsals with George Russell. Sanders joined John Coltrane in 1966 and worked with him until the latter's death in 1967. He continued to work with Alice Coltrane and then formed his own band in 1969.

Pharoah Sanders, stylistically, is a very strong saxophonist with a very large sound: he was originally influenced by both Coltrane and Albert Ayler. In addition to being a very moving and conventionally melodic player, he possesses a thorough understanding of and ability to execute multiphonics and upper harmonics with astonishing facility and clarity. Though best known as an exponent of free jazz, he is equally conversant in bebop and modal styles.

REFERENCES

CARR, IAN, DIGBY FAIRWEATHER, and BRIAN PRIESTLY. *Jazz, the Essential Companion.* New York, 1987.
EKKEHARD, JOST. *Free Jazz.* Graz, Austria, 1974.
FOX, CHARLES. *The Jazz Scene.* London, 1972.
LITWEILER, JOHN. *The Freedom Principle: Jazz After 1958.* New York, 1984.
RIVELLI, PAULINE, and ROBERT LEVIN, eds. *The Black Giants.* New York, 1970.
WILLIAMS, MARTIN. *The Jazz Masters in Transition, 1957–1969.* New York, 1970.
WILMER, VALERIE. *As Serious As Your Life.* Westport, Conn., 1981.

BILL DIXON

Sanderson, Jeremiah Burke (August 10, 1821–August 19, 1875), clergyman and educator. Jeremiah Burke Sanderson was born in New Bedford, Mass. He received basic education at a public school and afterward worked as a barber. In the early 1840s, Sanderson participated in the antislavery movement as secretary of the New Bedford Anti-Slavery Society and as an agent for the abolitionist LIBERATOR. His antislavery lecture tours in New England enhanced his reputation among reform leaders, who honored him with an invitation to address the anniversary meeting of the AMERICAN ANTI-SLAVERY SOCIETY (AASS) in 1845.

Sanderson resettled in California in 1854, hoping to find temporary employment and to return eventually to his family in New England. Instead, he remained in the San Francisco area and by 1860 had brought his wife and children to the West Coast. Once in California, Sanderson became active in several community concerns. He organized the Franchise League and the Young Men's Union Beneficial Society in San Francisco. As a delegate to the black state conventions in 1855 and 1856, he participated in the campaigns against the state's black laws (*see* BLACK CODES).

Sanderson made his most impressive social contributions as an educator. Over a twenty-year period, he nurtured the fledgling school system for the black communities in California. He worked as a teacher and administrator for schools in Sacramento, Stockton, San Francisco, and Oakland. Sanderson also took on responsibilities for organizing the AFRICAN METHODIST EPISCOPAL (AME) Church in California. His ministry included congregations in San Francisco and Oakland, and in 1875 he received an appointment as secretary of the AME California Conference. His life ended that same year in a railroad accident.

REFERENCES

LAPP, RUDOLPH M. "Jeremiah B. Sanderson: Early California Negro Leader." *Journal of Negro History* 53 (1968): 321–333.
RIPLEY, C. PETER, ET AL., eds. *The Black Abolitionist Papers,* Vol. 3, *The United States, 1830–1846.* Chapel Hill, N.C., 1991.

MICHAEL F. HEMBREE

Sanford, John Elroy. *See* Foxx, Redd.

San Francisco and Oakland, California. The history of African Americans in the San Francisco Bay Area, specifically San Francisco and Oakland, is one of both success and failure. Present from its first settlement, blacks at first found San Francisco a land of opportunity and riches. The dream soon evaporated, however, and the area became hostile to black achievement. The black population, frozen out of industrial labor, remained small. During and after WORLD WAR II, the area's black population growth reached enormous levels, bringing racial tensions and conflict in its wake. At the end of the twentieth century, African Americans represented a large fraction of the Bay Area's inhabitants. Economic and social discrimination persists, despite numerous black success stories.

The Spanish settlement in San Francisco began in 1776, and it soon grew into a small town. Mexican blacks were among the settlers, and they remained after the area was turned over to Mexican control in 1821. During the Mexican period, two men of African descent served as mayors. During the 1840s, William LEIDESDORFF, a black man from the Danish West Indies, became a prosperous merchant and city

official under the Mexicans, though he also played an important role in the American takeover. San Francisco's Leidesdorff Street was named in his honor.

In 1848, two years after the establishment of American control over California and San Francisco, gold was discovered at Sutter's Mill, in northern California. The Gold Rush of 1849 sparked massive immigration, which turned San Francisco into a city almost overnight. Black immigrants settled near the waterfront and on the "Chili Hill" slope of Telegraph Hill. The city soon acquired a somewhat exaggerated reputation as a land of hope for African Americans. Frederick DOUGLASS and others spread the newspaper reports of "black luck" on the West Coast and catalyzed further immigration. The suburb of Oakland, across the bay, also expanded during the period, first after the inauguration of ferry service in 1852, then after the city's selection as terminus of the Western Pacific and related railroads in 1869.

Slavery became an issue in local politics as white southern Forty-Niners brought their slaves to the area as gold miners, and fugitive slaves migrated West. Even after the state of California entered the Union in 1850 and officially abolished slavery, masters used subterfuges to continue holding African Americans in bondage. For example, George Washington Dennis was brought to San Francisco by his master to work in a gambling parlor. As it happens, Dennis saved $1,000 for his freedom from the nickels and dimes he swept off the parlor's floor. He later became a wealthy livery stable owner and real estate speculator, and his son Edward Dennis became the city's first black police officer in the 1880s.

Most of San Francisco's early black settlers were free. They included Rev. John Jamison Moore, pastor of the Stockton Street African Methodist Episcopal Church, the city's first black church; William NEWBY, who founded the newspaper MIRROR OF THE TIMES (1856); William Yates, a former porter for the U.S. Supreme Court who chaired the first of three California Colored State Conventions during the 1850s to organize civil rights efforts; writer/abolitionist James Madison BELL; artist/lithographer Grafton T. Brown; and merchants Peter Lester and Mifflin W. Gibbs. Isaac Flood, an ex-slave from South Carolina and one of the first black settlers in Oakland, ultimately became a wealthy landowner and community leader.

Mary Ellen "Mammy" PLEASANT, an ex-slave who arrived in the city from Boston in 1847 and opened a thriving restaurant and boardinghouse (and later a bordello), rapidly became the leader of the black community. She was one of thirty-seven blacks who organized the Mutual Benefit and Relief Society (see MUTUAL AID SOCIETIES) in 1850 to aid new arrivals. Profiting from a chronic labor shortage, she

found jobs for 300 African Americans, employing sixty herself in her restaurant and laundry. Soon thereafter, she helped the Rev. Jeremiah SANDERSON set up a black school in the basement of the St. Cyprian African Methodist Episcopal Church. Pleasant also became active in civil rights efforts. A participant in the Colored Conventions, she organized the San Francisco Franchise League in 1852 to petition the legislature to grant blacks suffrage. She later became a fund-raiser for radical abolitionist John Brown (see JOHN BROWN'S RAID).

Despite the efforts of Pleasant and her associates, legal discrimination and disfranchisement remained in San Francisco. An 1850 law, which forbade non-whites to testify against whites in court, led to theft by unscrupulous whites and large-scale abuse of blacks and members of the growing Chinese-American community. In 1858, the state legislature passed a bill forbidding black immigration, prompting an exodus of the city's blacks to Victoria, British Columbia.

In 1866, following the end of the CIVIL WAR, blacks renewed efforts at winning equal status. At the Fourth Convention of the Colored Citizens of California that year, San Francisco's William Henry Hall moved for a concerted campaign to gain suffrage rights. The Executive Committee of San Francisco was created as a lobbying group, and it established the weekly journal *Elevator* as its organ. However, a bill to grant suffrage died in the state legislature in 1868, and blacks were not enfranchised until 1869. In 1868 Mary Ann Pleasant sued the local streetcar company after being ejected from a car and won a judgment of $500. In 1872, after black schools in San Francisco and Oakland were closed by local authorities who opposed black education, Mary Frances Ward enrolled at a white school and was rejected. She sued, and the case went to the California Supreme Court, which ruled in her favor. In 1875 the San Francisco Board of Education banned educational segregation. In 1878 David W. Ruggles became the first black to sit on a grand jury in the city.

By the last decades of the nineteenth century, San Francisco's African-American community had stabilized. The black population remained small but was extremely diverse, as black immigrants arrived from the Caribbean, Canada, Cape Verde, and other places. By 1900 San Francisco had a higher percentage of foreign-born blacks than any other American city except New York. Prejudice was widespread, although there was little overt antiblack violence. Blacks were sometimes barred or restricted in restaurants and saloons. As white labor unions such as the Building Trades Council, which mostly excluded blacks, gained unusual power in the city, African Americans found it increasingly difficult to obtain

work. Most became sailors or were forced either into service trades such as barbers or into domestic service. However, several blacks were prosperous, and the literacy rate in the black community was high. While the community institutions became clustered in a black enclave in the city's Western Addition area after 1900, housing was relatively open during the period, and blacks lived in all but the most exclusive white areas. Black patients were admitted at city hospitals and health care facilities. Before police closed the Barbary Coast entertainment district in 1917, many black performers worked on its streets and in clubs such as Purcell's Elite Café and the Olympia. The most notable were vaudevillian Bert WILLIAMS and his partner George WALKER. During the late 1910s, early New Orleans JAZZ musicians such as Kid ORY and Jelly Roll MORTON settled for a time in the area. Morton opened an interracial club which was quickly closed down by police.

A few African-American leaders achieved limited fame and wealth, such as Stuart T. Davison, a physician who in the early 1880s was one of the first black graduates of the University of California at Berkeley, and attorney Edward D. Mabson (later head of the activist Negro Equity League). Elite blacks formed clubs and lodges, and in 1901 they organized the Afro-American League of San Francisco under Theophilus B. Morton. Morton also founded the Afro-American Cooperative and Investment Association to spur economic unity. The Afro-American League soon became inactive, and in 1915 the Northern California branch of the NATIONAL ASSOCIATION FOR THE ADVANCEMENT OF COLORED PEOPLE (NAACP) was formed.

Throughout the period, Oakland was more welcoming to blacks than San Francisco. The railroads employed many black residents. Oakland's port, where unions were weak, accepted black workers. Oakland also provided a large number of blacks the opportunity of becoming homeowners. Community leadership was provided by various organizations, including churches such as the Beth Eden Baptist Church, founded in 1890; the California Association of Colored Women's Clubs, based in Oakland; and the Oakland Sunshine newspaper (1906). In 1906, after the great San Francisco earthquake and fire, over 100,000 people, some of them black, sought temporary refuge in Oakland. Many stayed, and from 1900 to 1910 the city's black population tripled, surpassing that of San Francisco.

Blacks continued to migrate to the Bay Area during the Great Migration of the mid-1910s and early '20s, although not in the massive numbers that moved to eastern cities. The great distance and the lack of established family and job contacts in the West limited the flow of new arrivals. During this period,

West Oakland became established as the center of the city's evolving black community. In 1915, journalist Delilah BEASLEY started a twenty-year tenure as a columnist for the white-owned Oakland Tribune. An active crusader for civil rights, she also wrote the landmark historical study, Negro Trail Blazers of California (1919). E. L. Daly used real estate profits to buy and consolidate several black newspapers into the powerful and successful California Voice.

During the 1920s, economic opportunities for San Francisco blacks expanded somewhat. At the same time, prejudice became more marked. Increasingly, blacks were forced to settle in the Western Addition (also known as the Fillmore district), often in dilapidated homes. Even there, blacks faced exclusion. In 1924 black leaders organized the Booker T. Washington Community Center on Geary Street. When the center attempted to lease property on Divisidero Street, local whites attempted to oppose the move. Soon after the center relocated, a white group bought the building and foreclosed on the center's lease. The black community saved the center through a determined campaign of fund-raising.

Blacks organized protests against the rising tide of discrimination. The San Francisco NAACP (which was born following a split in the Bay Area branch in the early 1920s) became noted for its lawsuits and lobbying efforts. In 1921 the NAACP won an important, if temporary, victory when it persuaded Mayor Eugene Rolphe to ban a showing of the film BIRTH OF A NATION (1915), which blacks considered offensive (Oakland's mayor refused to ban the film). Black political influence remained limited, though, and when the film was again shown in San Francisco in 1930, Rolphe refused to act.

The GREAT DEPRESSION hit blacks in the Bay Area extremely hard. By 1937 an estimated 13.7 percent of San Francisco's black laborers were unemployed, and in Oakland the figure was 15.3 percent. Large numbers of African Americans were forced to rely on public relief. Job competition with white workers led to racial tension, accompanied by police harassment.

The depression experience radicalized many Bay Area blacks, who became active in union and other left-wing activities. John Pittman's newspaper, the San Francisco Spokesman, criticized the NAACP for its moderation and called for such measures as cooperative health care. Pittman and lawyer William L. PATTERSON became active in the COMMUNIST PARTY OF THE U.S.A. The communists were the first active interracial group in San Francisco. In 1934 the radical International Longshoreman's Union, led by Harry Bridges, became the first large union in the area to admit blacks.

Through the efforts of such leaders as labor leader C. L. Dellums (uncle of future U.S. Rep. Ronald

DELLUMS) and administrator Vivian Marsh of the BROTHERHOOD OF SLEEPING CAR PORTERS, a disproportionate number of African Americans—860 in Oakland alone by 1937—found employment in the federal jobs programs of the New Deal during the late 1930s, notably in the WORKS PROJECT ADMINISTRATION (which also employed artist Sargent JOHNSON to make large sculptures for the Golden Gate exhibition) and the Negro Division of the National Youth Administration. These jobs not only allowed African Americans to earn money but offered them training for jobs from which they would ordinarily have been excluded by unions. Many of them, particularly women, were actually able to upgrade their job status in public relief employment.

The coming of WORLD WAR II largely transformed the condition of blacks in the Bay Area. Bay Area shipyards and industry rapidly expanded. Black jobseekers, as well as military personnel and their spouses, poured into the Bay Area, many from the southern states. San Francisco's black population increased more than sixfold in five years, and Oakland's rose by 341 percent. Many white employers and unions at first refused to admit blacks, and recruited migrant white workers to relieve the tremendous labor shortage. However, little by little, under the twin pressures of demand for workers and pressure from the local office of the federal FAIR EMPLOYMENT PRACTICES COMMITTEE (FEPC), industries began to hire black workers for well-paying jobs. In 1944 the California Supreme Court declared union segregation unconstitutional, further eroding barriers to black advancement.

Despite the black economic surge, the mass migration led to difficulties. Landlords in white neighborhoods refused to rent to large numbers of migrants, and many were unable to secure proper housing. San Francisco's Fillmore district, already a heavily black area, expanded as blacks moved into housing vacated by Japanese sent to internment camps. A new ghetto grew up in the Bayview–Hunter's Point district. Oakland's black population spilled over from West Oakland to North and East Oakland and to Richmond. Racial discrimination and exclusion from public accommodations became more frequent. Several groups, notably the Bay Area Council Against Discrimination (led by Walter Gordon, later governor of the Virgin Islands), and the white-led Council for Civic Unity, were set up by blacks and white liberals to promote equality.

A notorious episode of racial discrimination was the Port Chicago incident (see PORT CHICAGO MUTINY). In 1944 an ammunition ship explosion rocked Port Chicago, a Bay Area shipyard, killing 320 people, including 202 black sailors. When 328 black sailors were ordered to return, they refused; 258 were arrested, and 50 of them were court-martialed. Convicted of mutiny, they were sentenced to long prison terms. NAACP Legal Defense Fund director THURGOOD MARSHALL appealed the case before the Judge Advocate General of the Navy in 1945, but the convictions were upheld.

After the end of the war, migration to the Bay Area continued at a reduced pace. In 1946 the NATIONAL URBAN LEAGUE opened its first local chapter. Many blacks were released from the well-paying jobs they had occupied during the war, though black professionals, skilled laborers, and government officials found employment in increasing numbers. San Francisco hired its first black teachers, and the number of black doctors and lawyers in the city increased several times. Bay Area blacks also made their first major political gains. In 1946 physician William McKinley Thomas became Commissioner of the San Francisco Housing Authority, the city's first black high government official. In 1948 Oakland's William Byron Rumsford became the first black from Northern California to be elected to the state legislature. With the aid of white sympathizers, several interracial antidiscrimination groups were founded. The short-lived Fellowship Church, with the Rev. Howard Thurman as its pastor, was one of the first completely integrated churches in America. In 1952 the NAACP represented Mattie Banks, an African American, in her attempt to move into public housing in North Beach. Despite the Housing Authority's warning (soon borne out) that whites would leave if blacks were admitted to public housing in white areas, the state Superior Court banned segregated public housing. Nevertheless, private housing remained largely segregated during the period. When baseball star Willie MAYS moved to San Francisco with his team, the Giants, in 1958, his difficulty in finding a house was well publicized. Despite the formation of a local FEPC in 1958, job discrimination remained a chronic problem.

By the 1960s, the majority of Bay Area blacks was stuck in inner-city areas with poor housing, and faced disproportionately high unemployment rates. Ironically, the ghettoization of San Francisco blacks increased black political influence, and in 1964 Terry Francois, an African American, was named to the city's board of supervisors. The same year, Willie BROWN was elected to the state legislature from San Francisco. He would remain there for thirty years and became one of the most powerful figures in California politics as Speaker of the California House. While San Francisco's black population remained static, Oakland's larger population continued to expand. As Oakland's whites began to move to nearby suburbs, African Americans became a significant proportion of the city's residents.

In the early 1960s, civil rights forces, notably the CONGRESS OF RACIAL EQUALITY (CORE), began demonstrating for employment opportunities and protesting de facto school segregation and police brutality. In 1963 a march against police brutality at San Francisco's city hall attracted two hundred people. The next year, the success of the interracial Free Speech Movement at the University of California–Berkeley, led by veterans of the Mississippi Freedom Summer, resulted in mass civil rights demonstrations. However, nonviolent protesters failed to make sufficient headway against discrimination. In 1966, following the shooting of a black teenager by police in Hunter's Point, African Americans throughout the city rioted. The rioting lasted for five days and devastated large sections of the Fillmore district.

The most notable radical black group to emerge from the Bay Area was the BLACK PANTHER PARTY, formed by Huey NEWTON and Bobby SEALE in Oakland in 1966. The Panthers' revolutionary Marxist ideology and militant image quickly made them heroes to blacks and white leftists throughout the United States. They were particularly well regarded in Oakland for their efforts to combat police brutality and for their establishment of a free breakfast program for schoolchildren. Despite police repression and internecine conflict—which destroyed the Panther movement by the late 1970s—the Panthers helped create such institutions as the Oakland Community School and the Oakland Community Housing Center, which funded housing for homeless African Americans.

Since the 1960s, blacks in the Bay Area have benefited from increased educational and social opportunities and have become politically powerful. In 1968 the Oakland Black Caucus was formed as an umbrella community group. Three years later, Ronald Dellums became the Bay Area's first African American in Congress. In 1977, with support from the Panthers, Lionel Wilson was elected Oakland's first black mayor. (In 1991 Oakland would again elect an African American, Elihu Harris, as mayor.) In 1983 Robert MAYNARD bought the *Oakland Tribune,* becoming the first African-American editor of a major metropolitan daily, and in 1993 Pearl Stewart, his successor, became the first African-American woman editor. Oakland has also become a showplace of black culture, with such institutions as the Ebony Museum of Art and the Northern California Center for Afro-American History and Life. Meanwhile, San Francisco became the home of noted black artists and intellectuals such as beat poet Bob KAUFMAN and authors Alice WALKER and Terry MCMILLAN. The Bayview Opera House, San Francisco's oldest theater, has been transformed into a black community cultural center.

Other prominent black Bay Area figures include such clergy/community activists as United Methodist Bishop Leontine KELLY, who became the first black woman bishop of a major denomination in 1984, and the Rev. Cecil Williams, who distinguished himself by leading relief efforts after the 1989 earthquake. Natives such as singers Johnny MATHIS, the POINTER SISTERS, and Sly STONE, athletes Bill RUSSELL, K. C. JONES, Frank ROBINSON, and O. J. SIMPSON, and actor Danny GLOVER have gone on to fame elsewhere.

San Francisco's development as a lesbian and gay mecca has had a mixed effect on local African Americans. Gay leaders have generally supported liberal coalitions, and the gay community has offered a home to many gay and lesbian blacks, including the popular singer and cult icon Sylvester and filmmaker Marlon RIGGS. However, tensions have arisen between the two communities over such issues as use of civil rights rhetoric, gentrification of black areas, and allocation of resources for people with AIDS. In 1993 African-American minister Eugene Lumpkin was forced to resign from the city's Human Rights Commission after referring to homosexuality as an "abomination." In an effort to defuse tensions, gay community leaders called for a black advisory panel to the commission.

Despite the city's liberal reputation, San Francisco remains a difficult place for African Americans. The black population there has dropped significantly since 1970, while Oakland's has remained largely static. Most blacks remain trapped in East Oakland and in San Francisco's Fillmore and Bayview districts. Black unemployment and underemployment in both cities has remained high, and affirmative-action policies have failed to eliminate disparities. Blacks have been forced into labor competition with both white and nonwhite immigrants. Schools have remained inadequate. Private housing and schools remain out of financial reach for most black residents, while drug abuse and gang warfare are particular problems. In 1989 a community antidrug demonstration drew 1,000 people. The shattered state of the two communities was perhaps best symbolized by the murder of former BLACK PANTHER leader Huey NEWTON outside a crack house in Oakland in 1988 and by the difficult rebuilding efforts following the earthquake of 1989 and drought-induced fires in the early 1990s.

REFERENCES

BEASLEY, DELILAH L. *The Negro Trailblazers of California.* Los Angeles, 1919.

BROUSSARD, ALBERT S. *Black San Francisco: The Struggle for Racial Equality in the West, 1900–1954.* Lawrence, Kans., 1993.

BROWN, ELAINE. *A Taste of Power: A Black Woman's Story.* New York, 1993.

CROUCHETT, LAWRENCE P., LONNIE G. BUNCH, III and MARTHA KENDALL WINNACKER. *Visions Toward Tomorrow: The History of the East Bay Afro-American Community.* Oakland, Calif., 1989.

DANIELS, DOUGLAS HENRY. *Pioneer Urbanites: A Social and Cultural History of Black San Francisco.* Philadelphia, 1980.

HIPPLER, ARTHUR E. *Hunter's Point: A Black Ghetto.* New York, 1974.

LAPP, RUDOLPH M. *Blacks in Gold Rush California.* New Haven, Conn., 1977.

SMITH, JAY ALFRED. *Thus Far by Faith: A Study of Historical Backgrounds and the First Fifty Years of the Allen Temple Baptist Church.* Oakland, Calif., 1973.

WHEELER, B. GORDON. *Black California: A History of African Americans in the Golden State.* New York, 1993.

GREG ROBINSON

Santamaria, Mongo Ramon (April 7, 1922–), percussionist, and composer. Born in Havana, Cuba, Santamaria studied violin as a child. Influenced by his African-born grandfather, Santamaria began to play drums, absorbing Yoruba ritual music as well as the rhythms of jazz and popular Cuban music. During his teens he began concentrating on conga and bongo drums, and started playing professionally. In 1950 he moved to the United States. Santamaria worked for Perez Prado for three years, then played in bands led by Tito Puente and Cal Tjader. Since 1961 Santamaria has led his own bands, often in collaboration with arranger Marty Sheller, playing a distinctive blend of Afro-Cuban popular and ritual music, jazz, and soul. Although these ensembles are largely composed of Cuban and Puerto Rican musicians, they have also featured players from the jazz tradition, such as pianists Chick Corea and Herbie HANCOCK, flutist Hubert Laws, and saxophonist Sonny Fortune.

In the 1960s, Santamaria's rendition of Herbie Hancock's "Watermelon Man" was enormously popular with mainstream audiences. During this time he recorded versions of rock songs, and shared bills with popular rock acts such as the Jefferson Airplane and the Grateful Dead. He also appeared in the 1966 film *Made in Paris.* In the 1970s Santamaria returned to his Latin jazz roots, recording *Mongo at Montreux* (1971) and *Fuego* (1973). In addition to his work as a percussionist, Santamaria has composed several songs that helped popularize and introduce Latin rhythms into African-American music, including "Afro-Blue," which was recorded by John COLTRANE. Santamaria, who continues to record (*Summertime* with Dizzy GILLESPIE, 1980; *Soy Yo,* 1987; *Afro Roots,* 1990) and perform internationally, has for many years lived in New York.

REFERENCES

ROBERTS, J. S. *The Latin Tinge: The Impact of Latin American Music on the United States.* New York, 1979.

SMITH, A. J. "Mongo Santamaria: Cuban King of Congas." *Downbeat* 44, no. 8 (1977): 19.

ERNEST BROWN

Santeria. Santeria, or "saint worship," is a religion that has its roots in both the spiritual practices of the Yoruba people of Western Africa and in Roman Catholicism. The Yoruba people believed in the supreme God Olodumare and in lesser deities known as orishas. As slaves brought to work on sugar plantations in Cuba, they were baptized and catechized in the Roman Catholic Church in accordance with the Slave Code of 1789. The synthesis of these two religious practices occurred as slaves began to recognize Catholic saints as spiritual beings similar to their *orishas.* Eventually each *orisha* was matched with a Catholic saint and came to be known by both the African and Christian name (for instance, *Orula* and St. Francis of Assisi describe the same being). Under Spanish rule, the followers of this religion, *santeros,* continued to honor their spiritual ancestors and sought power through them. They communicated to the *orishas* through the *ashe,* the blood and power, of animal sacrifice and other offerings, such as food or clothing; today, community service is also a method of communication. The *orishas,* in turn, spoke to *santeros* through divination, performed by *babalawos,* who could read the future in sea- or coconut shells or in cards immersed in clear water.

Santeria became a presence in the United States largely as a result of the exodus of Cubans after the revolution of 1959. There is little public display of the religion. *Botanicas,* which sell candles, beads, oils, herbs, plants, and plaster statues of Catholic saints, are found in Latino sections of New York, Miami, and Los Angeles. The number of followers is not easily determined. In southern Florida, which has had a large Caribbean immigration, roughly 70,000 people practice Santeria.

The Society for the Prevention of Cruelty to Animals has protested the ritual slaughter of animals on several occasions. One 1980 raid on an apartment in the Bronx where Santeria was reportedly being practiced yielded three goats and eighteen chickens. A larger case arose when Ernesto Pichardo opened a public church for Santeria followers—the first in the United States—in Hialeah, Fla., in 1987. After a two-year struggle, the town passed an ordinance banning animal sacrifice. Pichardo and others claimed such

rulings to be hypocritical in a society where meat is slain daily for consumption, especially since in Santeria the animal sacrificed is often eaten afterward. In June 1993, the Supreme Court removed the ban on religious animal sacrifices as discrimination against religious practice.

REFERENCES

GONZALEZ-WIPPLER, MIGENE. *Santeria, the Religion: A Legacy of Faith, Rites, and Magic.* New York, 1989.
MURPHY, JOSEPH M. *Santeria: An African Religion in America.* Boston, 1988.

WALTER FRIEDMAN
GRISSEL BORDONI-SEIJO

Satchmo. *See* Armstrong, Louis "Satchmo."

Saunders, Prince (c. 1775–February 1839), educator and colonizationist. The exact date and location of Prince Saunders's birth are uncertain, but he probably was born in 1775 at Lebanon, Conn. In 1784, he was baptized at Thetford, Vt., where he attended school and lived in the home of a prominent lawyer, George Oramel Hinckley. At age twenty-one, Saunders was teaching at the African School in Colchester, Conn. In 1807 and 1808, under Hinckley's sponsorship, he attended Moor's Charity School at Dartmouth College in Dartmouth, N.H. In 1808, Saunders moved to Boston to accept a position at Boston's African School. Three years later, he founded and ran the Belle Lettres Society, a literary group composed primarily of young white men, and was elected secretary of the African Masonic Lodge. Saunders also was instrumental in procuring funds to establish and support three African primary and one African grammar school in Boston.

After meeting the prominent colonizationist Paul CUFFE and the English abolitionist William Wilberforce in 1815, Saunders became interested in colonization in Haiti. Wilberforce also persuaded Saunders to accept a position as adviser to the Haitian emperor, Henri Christophe, and in February 1816, Saunders established himself in Haiti as Christophe's official courier. Saunders returned to England a few months later where he published *Haytian Papers,* a commentary on Haitian government under Christophe. In the autumn of 1816, Saunders returned to Haiti and established the Lancastrian system of teaching, by which a single teacher is able to control the work of hundreds of students, in the capital. Saunders

also introduced smallpox vaccination into Haiti that same year.

Saunders fell into disfavor with Christophe after returning to England, and instead of returning to Haiti, he sailed for Philadelphia in 1818 where he became a lay reader at St. Thomas Episcopal Church and joined the Pennsylvania Society for Abolition. Despite strong opposition from Philadelphia's black leaders, Saunders remained a vocal supporter of the colonization movement, traveling to Boston later that year to promote colonization in Haiti.

In 1820, Saunders returned to Haiti, hoping to restore his relationship with Christophe by reviving his efforts to establish a colony of African Americans in Haiti; but, shortly thereafter, Christophe was overthrown by a rival political leader, Jean Pierre Boyer. Saunders sailed for Philadelphia in 1821 but returned to Haiti on several occasions during the next two years in an unsuccessful effort to reach an agreement with Boyer.

Little is known about Saunders's career after 1823, and there is some controversy surrounding Saunders's relationship with Boyer after this date. Some accounts state that Saunders served as Boyer's attorney-general, while others mention no reconciliation or cabinet appointment. It is clear, however, that Saunders remained in Haiti until his death in Port-au-Prince in 1839.

REFERENCES

GRIGGS, EARL LESLIE, and CLIFFORD H. PRATOR, eds. *Henri Christophe and Thomas Clarkson: A Correspondence.* New York, 1968.
"Saunders, Prince—Statesmen." *Negro History Bulletin* (May 1940):127.
WHITE, ARTHUR O. "Prince Saunders: An Instance of Social Mobility Among Antebellum New England Blacks." *Journal of Negro History* 60 (October 1975): 526–535.

LOUISE P. MAXWELL

Saunders, Raymond (October 28, 1934–), painter. Raymond Saunders was born and raised in Pittsburgh. At sixteen, he enrolled at the Carnegie Institute of Technology in Pittsburgh, where he studied for three years as part of a program for youth talented in the arts. In 1953, Saunders moved to Philadelphia to commence his formal art education, splitting his training between the Pennsylvania Academy of the Fine Arts (1953–1957), the University of Pennsylvania (1954–1957), and the Barnes Foundation (1953–1955). At the academy, Saunders won first prizes in oil painting and figure drawing as well as a

Cresson European Traveling Scholarship. Saunders served in the U.S. Army from 1957 to 1959 and then returned to the Carnegie Institute for his B.F.A. in 1960. He moved to California and earned an M.F.A. from the California College of Arts and Crafts in Oakland in 1961. Saunders has held several teaching positions; he was professor of art at California State University in Hayward from 1969 to 1987; since 1987 he has been professor of fine arts at the California College of Arts and Crafts.

Saunders creates densely layered paintings and collages that juxtapose found objects and symbolic fragments against deep-hued, painted backgrounds. His work incorporates and reworks elements of Abstract Expressionism, Pop Art, and the urban collage of artist Robert Rauschenberg. While Saunders is not a political artist, in his essay "Black Is a Color" (c. 1968) he has championed the use of black as a positive presence rather than a symbol of absence. Many of Saunders's collages, like *China Parts* (1987), *Celeste Age 5 Invited Me to Tea* (1986), and *Cala* (1984), use a thick, black compositional field to give order and substance to the myriad of playful, symbolic fragments Saunders has assembled within. Black gestural scrawls and paint splatters punctuate the flat surfaces and mark the artist's emotional presence. Saunders was an early admirer of urban graffiti. His painting *Red Star* (1970) combines graffiti and seemingly random scrawls and splatters of paint with neatly stenciled letters and numbers against a swirl of bright colors. A crisp red star in the middle provides a sense of order and formal contrast to the chaotic background.

Though Saunders's work does not lend itself to narrative interpretation, his fragments constitute an inventory of personal and collective meanings. *Jacob Lawrence, Romare Bearden, American Painting* (1987–1988) pays tribute to the two great African-American painters in a highly personal, oblique fashion. Only the collage's title, the handwritten names of the two painters, and the inclusion of paint palettes and swatches provide clues as to meaning. Otherwise the viewer is left to contemplate enigmatic scribbling, mounds of thickly applied paint, and domestic symbols like pots and pans, fruit and flowers. Yet in a style characteristic of Saunders's work, these widely diverse images combine to produce formal pictorial order.

Saunders's numerous awards and achivements include a Guggenheim Fellowship (1976), a Ford Foundation Purchase Award (1962), and the Prix de Rome (1964), which brought him to the American Academy in Rome for two years. Saunders was the first African-American artist to win this prize, and he used it to travel throughout Western Europe and North Africa. Solo exhibitions of his work have been held at the Seattle Art Museum (1981), the Los Angeles Municipal Art Gallery (1984), and the Pennsylvania Academy of the Fine Arts (1990). In New York the Metropolitan Museum of Art, the Whitney Museum, and the Museum of Modern Art, among others, have purchased his work.

REFERENCES

FEINBERG, JOY. *Raymond Saunders: Recent Work, January 6 to February 22, 1976.* Exhibition catalogue. Berkeley, Calif., 1976.
PATTON, SHARON F. "The Search for Identity, 1950–1987." In *African-American Artists, 1880–1987: Selections from the Evans-Tibbs Collection.* Exhibition catalogue. Washington, D.C., 1989.

SHIRLEY SOLOMON

Savage, Augusta Christine Fells (February 29, 1892–March 26, 1962), portrait sculptor and educator. The seventh of fourteen children, Augusta Savage was born in Green Cove Springs, Fla., to Cornelia and Edward Fells. Fells, a Methodist minister, initially punished his young daughter for making figurines in the local red clay, then came to accept her talent. Augusta attended public schools and the state normal school in Tallahassee (now Florida A&M) briefly. At sixteen, she married John T. Moore, who died within a few years of the birth of their only child. In the mid-1910s, she married James Savage, a laborer and carpenter; the two divorced in the early 1920s. In 1915, Savage moved to West Palm Beach, where one of her clay pieces won twenty-five dollars at a county fair. Public support encouraged Savage to move north in the Great Migration to New York, where she arrived in 1921 with just $4.60 and a letter of recommendation from the superintendent of the county fair to sculptor Solon Borglum, director of the School of American Sculpture.

Through Borglum's influence, Savage was admitted to the tuition-free college Cooper Union ahead of 142 women on the waiting list. She completed the four-year program in three years, specializing in portraiture. In the early 1920s, she sculpted realistic busts of W. E. B. DU BOIS, Frederick DOUGLASS, W. C. HANDY, and Marcus GARVEY. In 1923, Savage married Robert L. Poston, a Garveyite journalist who died five months later. The same year, Savage was one of a hundred American women who received a $500 scholarship from the French government for summer study at the palace of Fontainebleau. However, when the American committee of seven white men discovered her racial identity, they withdrew

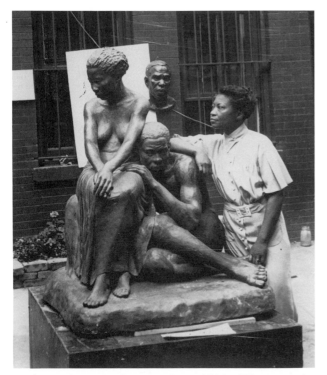

Sculptor Augusta Savage, June 1936. (Photographs and Prints Division, Schomburg Center for Research in Black Culture, The New York Public Library, Astor, Lenox and Tilden Foundations)

the offer. One committee member, Hermon A. Mac-Neil, gave her private instruction instead. Two years later, Countess Irene Di Robilant of the Italian-American Society gave Savage a scholarship for study at the Royal Academy of Fine Arts in Rome, but Savage was unable to raise money for expenses abroad as she struggled to support her parents while working at a laundry.

In 1926, Savage exhibited her work in three locations—at the New York Public Library, at the Frederick Douglass High School in Baltimore, and at the sesquicentennial exhibition in Philadelphia. The following year, she studied privately with sculptor Onorio Ruotolo, former dean of the Leonardo da Vinci Art School. She also worked with sculptor Antonio Salemme and taught soap sculpture classes to children at Procter & Gamble.

In 1928, recognition from the Harmon Foundation, which exhibited her *Evening* and *Head of a Negro,* brought Savage sales. Eugene Kinckle Jones, executive secretary of the NATIONAL URBAN LEAGUE, was so impressed with his purchase of a baby's bust that Savage had sculpted that he asked the Carnegie Corporation to sponsor her training. Through the Carnegie, Savage began study with sculptor Victor Salvatore, who urged her to continue her studies in France.

In fall 1929, Savage went to Paris with funds from both Carnegie and the Julius Rosenwald Fund. There, she studied privately with Felix Benneteau and created realistic portrait busts in plaster and clay. The most notable works Savage created abroad are of black female nudes, such as *Amazon* (a female warrior holding a spear) and *Mourning Victory* (a standing nude who gazes at a decapitated head on the ground) and works that celebrate her African heritage, such as *The Call* (in response to Alain Locke's call for racially representative art) and *Divinité nègre* (a female figurine with four faces, arms, and legs). In 1930, *La dépêche africaine,* a French journal, ran a cover story on Savage, and three of her figurative works were exhibited at the Salon d'Automne. Savage also sent works to the United States for display; the Harmon Foundation exhibited *Gamin* in 1930 and *Bust* and *The Chase* (in palm wood) in 1931. In 1931 Savage won a gold medal for a piece at the Colonial Exposition and exhibited two female nudes (*Nu* in bronze, and *Martiniquaise* in plaster) at the Société des Artistes Français.

After her return to New York, Savage exhibited three works (*Gamin, Envy,* and *Woman of Martinique*) at the American Art–Anderson Galleries in 1932. That same year, she opened the Savage School of Arts and Crafts. Some of her students, who included Jacob LAWRENCE, Norman LEWIS, William ARTIS, and Ernest CRICHLOW, participated in Vanguard, a group Savage founded in 1933 to discuss art and progressive causes. She disbanded the group the following year when membership became communist-controlled.

In 1934, Argent Galleries and the Architectural League exhibited Savage's work, and she became the first African American elected to the National Association of Women Painters and Sculptors. Two years later, Savage supervised artists in the WPA's FEDERAL ARTS PROJECT and organized classes and exhibitions at the Uptown Art Laboratory. In 1937, she became the first director of the Harlem Community Art Center. After receiving a commission from the New York World's Fair Board of Design, she left that position in 1938 to sculpt a sixteen-foot plaster harp, the strings of which were the folds of choir robes on singing black youths. Named after James Weldon JOHNSON's poem/song (also called the NEGRO NATIONAL ANTHEM), *Lift Every Voice and Sing* was exhibited at the New York World's Fair of 1939 but was bulldozed afterward. (Savage could not afford to have it cast in bronze.)

In June 1939, Savage opened the Salon of Contemporary Art, the first gallery devoted to the exhibition and sale of works by African-American artists. It folded within a few months for lack of funds. The same year, Savage exhibited fifteen works in a solo

show at Argent Galleries; among them were *Green Apples, Sisters in the Rain, Creation, Envy, Martyr, The Cat,* and a bust of James Weldon Johnson. She also exhibited at the American Negro Exposition and at Perrin Hall in Chicago in 1940.

About 1945, Savage retired to Saugerties, N.Y., where she taught children in nearby summer camps, occasionally sold her work, and wrote children's stories and murder mysteries. She died of cancer in New York City.

REFERENCES

BEARDEN, ROMARE, and HARRY HENDERSON. *A History of African-American Artists: From 1792 to the Present.* New York, 1993.

BIBBY, DEIRDRE. *Augusta Savage and the Art Schools of Harlem.* New York, 1988.

POSTON, T. R. "Augusta Savage." *Metropolitan Magazine* (January 1935): 28–31, 55, 66–67.

THERESA LEININGER-MILLER

Savoy Ballroom. Dubbed the "Home of Happy Feet," the Savoy Ballroom was HARLEM's first and greatest Swing Era dance palace, and for more than three decades was the premiere showcase for the greatest of the swing big bands and dancers.

At the time of the Savoy's opening on March 12, 1926, at 596 Lenox Avenue, between 140th and 141st streets, Harlem boasted no dance halls to match the opulence of Roseland and the Arcadia ballrooms in midtown Manhattan, but offered primarily cramped, rundown, and often illegal clubs. None of the Harlem ballrooms that opened after the Savoy ever approached the Savoy's opulence. Two mirrored flights of marble stairs led from street level up to a chandeliered lobby, and to the orange-and-blue room itself, which measured two hundred by five hundred feet and could hold up to 7,000 people. There were two bandstands, a disappearing stage under multicolored spotlights, and a vast dance floor, which was worn down and replaced every three years. Despite the elegance of the setting, the ballroom attracted a working class audience who paid low-priced entrance fees for an evening of swing dancing.

Every black big band of note, and many white ones as well, eventually performed at the Savoy. Opening night featured Fletcher HENDERSON's Orchestra, and in the late 1920s Duke ELLINGTON, King OLIVER, and Louis ARMSTRONG brought their orchestras to the Savoy. In 1932 Kansas City swing made its New York debut at the Savoy, as Bennie MOTEN brought a band including pianist Count BASIE, trumpeter Oran "Hot Lips" Page, and saxophonist Ben WEBSTER. Although Al Cooper's Savoy Sultans served as the house band, Chick WEBB's orchestra, featuring vocalist Ella FITZGERALD, became identified with the Savoy during its 1932–1939 stay. An arranger and saxophonist with Webb, Edgar Sampson, composed the ballroom's anthem, "Stompin' at the Savoy," in 1934.

Often more than one band was booked into the Savoy for an evening. As the bands alternated tunes and sets, a "battle of the bands," in which the two ensembles would vie for the acclamation of the audience, would ensue. Among the most memorable confrontations was Chick Webb's 1938 victory over an orchestra led by Count Basie.

In the 1940s the Savoy encountered competition from the Golden Gate, the Apollo, the Alhambra, Rockland Palace, and the Audubon Ballroom. Nonetheless, in the early years of the decade Coleman HAWKINS, Erskine Hawkins, Benny Carter, and Louis Armstrong all led big bands there. In 1942 Jay McShann's appearance at the Savoy and on radio broadcasts from the ballroom introduced saxophonist Charlie PARKER to a wider audience. In the summer of 1943 the temporary closing of the Savoy was a precipitating factor in the Harlem riots that August. More than 250 bands eventually performed at the Savoy, including those of Earl "Fatha" HINES, Don Redman, Jimmie LUNCEFORD, Teddy Hill, and Andy Kirk. Unlike the COTTON CLUB and Connie's Inn, which enforced strict racial boundaries, the Savoy welcomed both black and white patrons and performers.

The dancing at the Savoy was as remarkable as the music. The ballroom was the center for the development of Lindyhopping, the energetic and acrobatic style of swing dancing that in the 1930s made a dramatic break with the previous conventions of popular dance. In the 1920s and '30s dancers such as Leon James, Leroy Jones, Shirley "Snowball" Jordan, "Killer Joe" Piro, and couples George "Shorty" Snowden and "Big Bea" and Sketch Jones with "Little Bea" created and perfected patterns such as "The Itch" and "The Big Apple." The extraordinary inventiveness and agility of the Savoy dancers was credited not only to a cross-fertilization with the bands on the stage but also to the unwritten rule against Savoy dancers copying each others' steps. In the mid-1930s a new generation of Lindyhoppers, including Frankie Manning, Norma Miller, Al Minns, Joe Daniels, Russell Williams, and Pepsi Bethel, favored leaping "air steps," such as the "Hip to Hip," "Side Flip," "Over the Back," "Over the Head," and "the Scratch," which came to dominate the older, more earthbound "floor steps."

During its thirty-two-year existence the Savoy represented a remarkably successful example of an

interracial cultural meeting place, an embodiment of the widescale acceptance of black urban culture by whites during the 1930s and '40s. But unlike the earlier settings of the HARLEM RENAISSANCE, the Savoy's music and dance were presented without racial exoticism. The Savoy flourished as long as white audiences saw Harlem as an attractive and safe spot for nightlife. Unfortunately, the heyday of the Savoy lasted only until the postwar economic decline of Harlem. Also, with the rise of bebop and ROCK AND ROLL, big band JAZZ ceased to be America's dominant form of popular music. The owners of the Savoy found it harder to continue to book new big bands each week. The Savoy's doors closed in the late 1950s, and the building was torn down in 1958 to make way for a housing project.

REFERENCES

CHARTERS, SAMUEL BARCLAY, and LEONARD KUNSTADT. *Jazz: A History of the New York Scene.* 1962. Reprint. New York, 1984.

ENGELBRECHT, BARBARA. "Swinging at the Savoy." *Dance Research Journal* 15, no. 2 (Spring 1983): 3–10.

STEARNS, MARSHALL, and JEAN STEARNS. *Jazz Dance: The Story of American Vernacular Dance.* 1964. Reprint. New York, 1979.

JONATHAN GILL

Sayers, Gale Eugene (May 30, 1943–), professional football player. Born in Wichita, Kans., Gale Sayers was raised in the poor northside district of Omaha, Neb. A highly touted high-school track and FOOTBALL star, he enrolled at the University of Kansas at Lawrence in 1962. At Kansas, Sayers was a two-time football All-American at halfback (1963–1964). He also gained attention off the field when he was arrested for joining a SIT-IN protest against housing discrimination. In 1965, Sayers left school to sign with the Chicago Bears of the National Football League (NFL). He began his football career by winning Rookie of the Year honors and capturing the league scoring title. A five-time all-pro, he twice led the NFL in rushing (1966 and 1969). Over his career he averaged a record 30.6 yards per kickoff return. In 1969, Sayers received the George S. Halas Award, given to the NFL's most courageous player, for his recovery from a severe knee injury that cut short his promising 1968 season. He dedicated the award to his teammate and friend Brian Piccolo, who was dying of cancer. Recurring knee problems finally slowed the "Kansas Cyclone," and Sayers retired from football before the 1972 season.

One of the greatest broken-field runners in the history of the NFL was Chicago Bears halfback Gale Sayers (foreground), whose slashing, shifting style can be seen in this 1966 photograph. (AP/Wide World Photos)

After retirement, Sayers returned to the University of Kansas, completing his undergraduate degree in 1974 and receiving a master's degree in education in 1977. He served as assistant athletic director at the University of Kansas and as athletic director at Southern Illinois University in Carbondale (1976–1981). Upon leaving Southern Illinois, Sayers hoped to obtain a job in the business office of an NFL franchise, but after contacting all twenty-eight teams, he received no offers. Three years later, in 1984, Sayers founded Crest Computer Supplies. By 1994, the Skokie, Ill.–based company ranked thirty-second on *Black Enterprise*'s Top 100 Industrial/Service Companies and registered $43 million in annual sales.

Sayers has served as cochairman of the NAACP Legal and Educational Defense Fund's sports committee and has remained active in the American Cancer Society. He was inducted into the Pro Football Hall of Fame in 1977. His autobiography, *I Am Third,* was published in 1970.

REFERENCES

ASHE, ARTHUR R., JR. *A Hard Road to Glory: A History of the African-American Athlete.* New York, 1986.

"Black Enterprise Top 100s." *Black Enterprise* (June 1994): 88.

PORTER, DAVID L., ed. *Biographical Dictionary of American Sports: Football*. New York, 1987.
SAYERS, GALE, with Al Silverman. *I Am Third*. New York, 1970.

BENJAMIN K. SCOTT

Scalawags.

Scalawags. A term of abuse invented by opponents of RECONSTRUCTION, *scalawag* was used to describe white members of the REPUBLICAN PARTY who had been born in the South, as opposed to the CARPETBAGGERS, who came from the North. Denounced as "white Negroes," traitors to their race and region, scalawags were drawn from across the spectrum of white southern society. Some were men of stature and wealth, such as James L. Alcorn, a former Whig party leader and one of the largest planters in the Yazoo-Mississippi Delta, who became Mississippi's first Republican governor. Alcorn attracted a number of "Old Whigs" to the Republican party by promising to direct a "harnessed revolution" in which blacks' rights would be respected, but political power would remain in white hands. As governor, he opposed civil rights legislation and appointed Democrats (*see* DEMOCRATIC PARTY) to office, policies that alienated black Republicans. Other scalawags were business entrepreneurs such as Rufus Bullock, Georgia's first Reconstruction governor, who believed a "new era" had dawned in the South and that the Republicans were more likely to promote economic development than the Democrats. Republicans also attracted a number of partisans to whom Reconstruction offered opportunities denied under the prewar regime. South Carolina congressman Simeon Corley, for example, had been "hated and despised" before the war as a Unionist and social reformer.

The largest number of scalawags, however, were nonslaveholding white farmers from the southern up-country. Many had been wartime Unionists who had suffered reprisals for their opposition to the Confederacy, and they cooperated with the Republicans in order to prevent "rebels" from returning to power. Unionists, declared a North Carolina Republican newspaper, must choose "between salvation at the hand of the Negro or destruction at the hand of the rebel." Many of these up-country scalawags also hoped Reconstruction governments would help them recover from wartime economic losses by suspending the collection of debts and by enacting laws protecting small property holders from losing their homes to creditors.

Nowhere in the South during Reconstruction did the Republican party receive a majority of the white vote, but in North Carolina, Tennessee, Alabama, and Arkansas it initially commanded a significant minority. Generally, scalawags favored debtor relief, low taxes, and measures to restrict the voting rights of former confederates. Many were skeptical of Republican programs for state-aided economic growth. While willing to recognize blacks' newly gained political and civil rights, they strongly opposed legislation mandating the racial integration of schools and public facilities.

As Reconstruction progressed, economic progress failed to materialize, blacks became more assertive politically, and Democrats effectively directed both violence and appeals to racial unity against white Republicans. Consequently, the number of scalawags diminished. In strongholds of southern Unionism such as eastern Tennessee and western North Carolina, the Republican party remained a political force long after the end of Reconstruction. But in general, the failure to attract the support of more white Southerners, and to retain the backing of enough scalawags, was a major cause of Reconstruction's overthrow.

REFERENCES

ELLEM, WARREN A. "Who Were the Mississippi Scalawags?" *Journal of Southern History* 38 (1972): 217–240.
WIGGINS, SARAH M. *The Scalawag in Alabama Politics, 1865–1881*. University, Ala., 1971.

ERIC FONER

Scales, Jeffrey Henson

Scales, Jeffrey Henson (1954–), photographer. Born in San Francisco, Jeffrey Henson Scales is a freelance photographer working in New York City. His first assignments were for the BLACK PANTHER PARTY in Oakland, Calif., in 1968. Scales studied at the San Francisco Art Institute and at the University of Southern California in Los Angeles.

His work has focused primarily on men, with documentary projects that explore the nature of what are traditionally known as men's places. They include a study, "Blues People," of musicians in Chicago's blues bars; work on gangs in South Central Los Angeles; a project, "House's Barber Shop," done in Harlem; and a series on college fraternities around the country. Scales is also known for his portraiture and for his images of Harlem, where he currently resides. In 1991 he was the recipient of a Mid-Atlantic Arts Award in photography and a W. Eugene Smith Award in humanistic photography.

MEG HENSON SCALES

"Man Smoking, 147th Street, Harlem" by Jeffrey Scales, c. 1986. See entry on p. 2396. (Photographs and Prints Division, Schomburg Center for Research in Black Culture, The New York Public Library, Astor, Lenox and Tilden Foundations)

Arthur Alfonso Schomburg. (Photographs and Prints Division, Schomburg Center for Research in Black Culture, The New York Public Library, Astor, Lenox and Tilden Foundations)

Schomburg, Arthur Alfonso (January 24, 1874–June 10, 1938), bibliophile. Arthur Schomburg was born in San Juan, Puerto Rico, to a German merchant and an unmarried black laundress who was a native of St. Thomas, Virgin Islands. He received some formal education, but was largely self-taught. He emigrated to the United States in 1891, moving to New York City. Schomburg worked in a law office, was active in the "Porto [sic] Rican Revolutionary Party," and began his lifelong quest to amass a collection of African-American books and other materials in order to demonstrate the existence and significance of black history. In 1906 he went to work at Bankers Trust Company, where he eventually became head of the mail room, staying with the company for twenty-three years.

With his broad knowledge and passion for African-American history, Schomburg became a leading spirit in the HARLEM RENAISSANCE and an inspiration to a generation of historians. He was an active Prince Hall Mason, he cofounded with John Edward Bruce in 1911 the Negro Society for Historical Research, and in 1922 he became president of the soon-to-be moribund American Negro Academy. Schomburg wrote numerous pamphlets and bibliographical studies. His best-known essay is "The Negro Digs Up His Past," in Alain LOCKE's *The New Negro* (1925), a call to the important task of careful schol-

arly research into African and African-American history.

In 1925 the New York Public Library established a special Negro Division at the 135th Street Branch, and the next year the Carnegie Corporation purchased for $10,000 Schomburg's vast and unequalled collection of books, manuscripts, and art works, and donated it to the library. Schomburg, who was a librarian at Fisk University from 1930 to 1932, became curator of his own collection with another Carnegie grant, which he received in 1932. His collection forms the core of the present Schomburg Center for Research in Black Culture, the largest collection of materials by and about people of African descent. Schomburg died in New York City on June 10, 1938.

REFERENCE

SINNETTE, ELINOR DES VERNEY. *Arthur Alfonso Schomburg: Black Bibliophile and Collector*. Detroit, 1989.

RICHARD NEWMAN

Schultz, Michael (November 10, 1938–), theater and film director. Michael Schultz was born in Milwaukee, Wis. He attended the University of Wisconsin at Madison from 1957 to 1961 but received his bachelor's degree from Marquette University in 1964. Leaving Wisconsin for New York City, Schultz joined the Negro Ensemble Company. In 1968 he directed the Company's *Song of the Lusitanian Bogey* and *Kongi's Harvest*. In 1969 he made his Broadway debut with *The Reckoning*. After directing additional plays in New York during the early 1970s, Schultz moved to the West Coast to concentrate more on television and film.

In 1971 his version of the 1969 play *To Be Young, Gifted, and Black* (a work based on Lorraine Hansberry's unpublished writings) appeared on television. Schultz's first film, *Honeybaby, Honeybaby* (1974), was quickly forgotten, though his *Cooley High,* which came out the following year, was a commercial and critical success. In 1975 Schultz also directed a television production of Lonne Elder's *Ceremonies in Dark Old Men.* The following year he directed *Car Wash,* and in 1977 Richard PRYOR starred in two of his films, *Greased Lightning* and *Which Way Is Up?* Schultz's 1978 tribute to the Beatles, *Sgt. Pepper's Lonely Hearts Club Band,* failed and marked the beginning of what some in the industry saw as his creative decline, although he continued to direct films, including *Krush Groove* (1985).

In 1991 Schultz returned to the New York stage to direct Langston HUGHES and Zora Neal HURSTON's *Mule Bone.* He also directed the film *Livin' Large* (1991), which some critics saw as a return to his comedic successes of the mid-1970s. Schultz received the Black Filmmakers Hall of Fame's 1991 Oscar Micheaux Award.

REFERENCE

BOGLE, DONALD M. *Blacks in American Films and Television.* New York, 1988.

SHIPHERD REED
PETER SCHILLING

Schuyler, George S. (1895–1977), journalist. George S. Schuyler, often considered a political gadfly because of his move from young radical socialist to arch conservative later in life, was born in Providence, R.I., in 1895. Raised in Syracuse, N.Y., he attended school until he was seventeen, when he dropped out to enter the U.S. Army. He spent seven years in the service and saw action in France during World War I as a first lieutenant.

After the service, Schuyler was active in the labor movement, sometimes moving between Syracuse and New York City. He finally settled in New York as the HARLEM RENAISSANCE began. Although never a star of the Renaissance, he served as its goad. It was Schuyler's essay, "The Negro-Art Hokum," for example, that spurred Langston HUGHES's now classic 1926 response, "The Negro Artist and the Racial Mountain." Both essays appeared in the *Nation.* In 1923 Schuyler joined A. Philip RANDOLPH's *Messenger* as a columnist and assistant editor and later became its managing editor. The publication was considered so fiery that several southern members of Congress brought it under House investigation.

Schuyler moved on to do publicity for the NAACP, whose publication the *Crisis,* under the editorship of W. E. B. DU BOIS, had opposed the radicalism of Randolph, Schuyler, and others. Schuyler's first book, *Racial Intermarriage in the United States,* was published in 1929.

In 1931 Schuyler published two novels—*Black No More* and *Slaves Today: A Story of Liberia.* The first was a scathing satire of black people enabled to become white by taking a chemical and so to vanish from Harlem and reappear elsewhere as whites. The second described the slavelike labor conditions in Liberia. A third novel, *Black Empire,* assembled from fiction serialized from 1936 through mid-1937 in the *Pittsburgh Courier,* a black weekly newspaper, was posthumously published in book form in 1991. The novel told of a black elite, headed by a fascistlike black genius, which revenges wrongs done by whites in the United States, gathers an army and air force, and heads to Africa, where the genius of black scientists carves out a black empire. It defeats all incursions by European whites. Schuyler wrote this work under the pen name of Samuel I. Brooks. (He also used Brooks and other pseudonyms while publishing fiction in the *Courier* until 1939.)

From 1927 to 1933 Schuyler published nine essays in H. L. Mencken's *American Mercury.* Eugene Gordon, a black communist of the period, wrote in 1934 in Nancy Cunard's *Negro* that Schuyler was "an opportunist of the most odious sort," which indicated that to some he had already distanced himself from socialism. Shortly thereafter, Schuyler began a forty-year sojourn with the *Courier.* While he published furiously, he noted that his primary interest was in "having enough money to live on properly." He supplemented his $60 weekly *Courier* salary by publishing in several white journals, including the *Nation, Plain Talk,* and *Common Ground.*

Schuyler during his prime was considered to be one of the best journalists working. His satire was called Rabelaisian, and he frequently played devil's

advocate. He and his wife Josephine had a daughter, Philippa, in 1931. A prodigy who had grown to become a noted concert pianist, she was killed at age 35 in a helicopter crash while on tour in Vietnam in 1967 (*see* Philippa Duke SCHUYLER). Schuyler himself died in 1977.

REFERENCE

SCHUYLER, GEORGE S. *Black and Conservative: The Autobiography of George S. Schuyler.* New Rochelle, N.Y., 1966.

JOHN A. WILLIAMS

Schuyler, Philippa Duke (August 2, 1931–May 9, 1967), concert pianist. Philippa Duke Schuyler was born in Harlem during the Great Depression. Her father, George S. SCHUYLER, was a black journalist from Syracuse, N. Y.; her mother, Josephine Cogdell, a white artist from Texas. A troubled genius who was proficient in music, languages, and writing, Schuyler was both celebrated and victimized as a result of her parents' grand experiment: They believed that products of mixed marriages (through "hybrid vigor") would be genetically superior, thus becoming the "final solution" to America's race problems.

Schuyler, who had an I.Q. of 185, could read and write by age two and a half. At four she was composing, by five performing Mozart, and at twelve she became the youngest member of ASCAP, having written over one hundred compositions. New York mayor Fiorello La Guardia declared June 19, 1940, "Philippa Duke Schuyler Day" at the New York World's Fair. At fourteen, she performed Camille Saint-Saëns's Concerto in G Minor with the New York Philharmonic. To many young African Americans, she was a role model.

Schuyler sought her career overseas, performing in over eighty countries. She wrote five books about her life and travels, which were published between 1960 and 1969. Her articles were syndicated and tended to be politically conservative, a trait she shared with her journalist father in his later years. Never able to find a home, she traveled constantly and toward the end of her life began to pass for white in hopes of reclaiming her identity in America. Schuyler died in a helicopter crash while on a mission of mercy in Vietnam, at the age of thirty-five. Her best known works are orchestral: *Manhattan Nocturne* (1943), *Sleepy Hollow Sketches* (1945–1946), and *Nile Fantasy* (1965); her later works show the influence of African music and idioms.

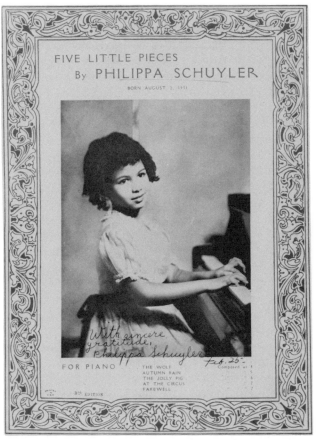

Philippa Schuyler, a piano prodigy and composer. Her orchestral work *Manhattan Nocturne* was performed by the New York Philharmonic when she was thirteen. She had a second career as a journalist and author on African and international affairs. (Photographs and Prints Division, Schomburg Center for Research in Black Culture, The New York Public Library, Astor, Lenox and Tilden Foundations)

REFERENCE

TALALAY, KATHRYN. "Philippa Duke Schuyler, Pianist/Composer/Writer." *The Black Perspective in Music* 10, no. 1 (1982): 43–68.

KATHRYN TALALAY

Science. As a race, people of African origin have been the object of scientific scrutiny and analysis in America since the colonial period. The practice of science—and the perspectives of its practitioners—were shaped to a large extent by prevailing social and theological notions of racial hierarchy. Science operated on the assumption that the Negro race was inferior; it helped define race and was subsequently abused in the promotion of racism in America.

Racial Concepts

Models of racial classification had roots in the work of the eighteenth-century Swedish naturalist Carl Linnaeus. Linnaeus's framework was adopted by nineteenth-century naturalists and broadened by Georges Cuvier, Charles Lyell, Charles Darwin, and others to include analysis of hair, skull, and facial features. Lyell and Darwin thought of the Negro as an intermediate step on the ladder of evolution, somewhere between monkey and Caucasian. Cuvier held that blacks were "the most degraded of human races, whose form approaches that of the beast." Louis Agassiz, the Swiss-born American naturalist and professor at Harvard University, considered the Negro almost a separate species. It was difficult, he said, in observing "their black faces with their thick lips and grimacing teeth . . . to repress the feeling that they are not of the same blood as us."

The racially charged views of these and other scientists became part of the legacy passed on to succeeding generations. Nineteenth-century America, for example, saw the rise of craniometry (measurement of the brain) and anthropometry (the taking of anatomical measurements in general) as methods of exploring and comparing the physical, mental, and moral condition of the races. This work was carried out, during the Civil War and afterward, largely by white physicians in the service of governmental bodies such as the U.S. Sanitary Commission, a predecessor of the U.S. Public Health Service.

Physicians played a vital role in developing a science-based analysis of the Negro. The condition of the American Negro (often referred to as "the other race") was a common topic of discussion in professional journals, at conferences, and in articles on health topics for popular newspapers and magazines during the nineteenth century. White physicians portrayed African Americans as constitutionally weak—more prone to disease than whites, with a higher mortality rate, and exhibiting signs that pointed toward eventual extinction. Data and statistics, generally void of appropriate context, were used to buttress this thesis. The low rate of suicide among blacks, for example, was interpreted as a reflection of limited intellectual capacity—an indication that blacks lived only for the moment and, unlike whites, lacked the conceptual skills necessary to plan and shape the future.

Nineteenth-century black physicians remained more or less silent about the racial dogmas advanced by their white counterparts for several reasons. First, since white organizations generally refused to admit them to membership, black physicians were kept busy developing alternative forums—their own professional societies, discussion groups, journals—to provide opportunities for shared learning and expe-

rience. The National Medical Association, the black counterpart of the American Medical Association, was founded in 1895 through the efforts of prominent physicians such as Miles Vandahurst LYNK and Robert Fulton BOYD. Second, black physicians recognized that generating racial or political controversy risked a backlash that could undermine efforts to place their own professional role and community on a solid foundation. And third, some black professionals accepted the truth of racial stereotypes and distanced themselves from the perceived taint of their race by thinking of themselves as unique, as somehow different from the "typical" African American.

Eugenics and Other Movements

In the early twentieth century, activities pursued under the guise of science continued to point to the alleged inferiority of African Americans. The eugenics movement is a good example. While it had always been present in some form (in spirit if not in name), eugenics assumed formal standing as a science with the rediscovery of Mendel's seminal paper on genetics in 1900 and the establishment in 1910 of the Eugenics Records Office at Cold Spring Harbor, Long Island. Defined as the science of improving the hereditary qualities of particular races or breeds, eugenics found devotees among geneticists and reputable practitioners in other branches of the biological sciences. It captured the public imagination, bringing issues of racial inferiority into focus not only in the realm of natural science, but in the social arena as well. Eugenics, with its growing stock of data on what were termed "weak races," fed into regressive social policies such as the anti-immigration movement and programs of coercive sterilization aimed at "purifying" the nation's population stocks. Its ideas permeated American society, promoting racial fear among whites and self-antipathy among some blacks. Although eugenics slipped out of the mainstream of American science in the 1930s following its adoption by the Germans as a social-engineering tool, its assumptions remained firmly embedded in the American social fabric.

The racial thrust underlying the work of the craniometrists, anthropometrists, physician-scientists, and eugenicists persisted past the middle of the twentieth century—in spite of the rise of the civil rights movement. In some respects, it persists down to the present day. Examples are numerous. From 1932 to 1972, the United States Public Health Service carried out the Tuskegee Study of Untreated Syphilis in the Negro Male (popularly known as the TUSKEGEE SYPHILIS EXPERIMENT). This project gathered together four hundred African-American "guinea pigs"; misled them about the nature of their illness by reinforcing the subjects' belief that they were suf-

fering from vague ailments related to "bad blood"; and withheld treatment from them in order to observe the progress of the disease. One rationale underlying the project was the need to assess racial differences in the impact of the disease. Then there was the segregation of blood in the armed services during World War II. Still later, during the 1960s and '70s, Arthur Jensen, Richard Herrnstein, and William Shockley applied IQ and other data in studies of racial differences. These scientists drew broad conclusions, for example, about the genetic inferiority—and, in particular, the inherently lower intelligence—of blacks as compared to whites. Since the 1980s, some work in sociobiology and genetic engineering has attempted to identify genes with behavioral traits. In 1992, the National Institutes of Health awarded funds for a conference on heredity and criminal behavior but later withdrew support to placate critics who felt that linking genetics and crime in this way could add renewed authority to theories that blacks (represented disproportionately in U.S. crime statistics) were biologically inferior.

African Americans in Science

Science may have been used and abused in racially motivated ways, but this did not stop African Americans from being drawn to careers in the field. The history of blacks in American science is as old as the history of science in America. In colonial America, free blacks were known for their inventive, scientific, and technical skills. The first to achieve a national reputation in science was Benjamin BANNEKER (1731–1806), known in the latter part of the eighteenth century as a mathematician, astronomer, and compiler and publisher of almanacs (see MATHEMATICIANS). In 1791, Banneker served as part of a team of surveyors and engineers who contributed to planning the city of Washington, D.C. Other free blacks, including Thomas L. Jennings (1791–1859) and Norbert RILLIEUX, developed and patented technical devices in the years leading up to the Civil War. Some slaves were known for their inventive abilities, but their legal status prevented them from holding patents and from receiving widespread public recognition of their achievement.

After the Civil War, the number of blacks undertaking scientific work increased slowly. The establishment of black institutions of higher learning—necessary because white institutions did not routinely admit African-American students—provided an essential start. Nevertheless, black colleges and universities tended to focus on curricula in theology, education, medicine, and other fields that were more practical (or technical) than scientific, geared primarily toward creating a niche or foothold for African-American professionals in the social and economic

mainstream. Science, in the sense of an activity devoted to pure or basic research, did not fit readily into this framework. As a result, African Americans wanting specialized science education or training were obliged to seek out programs at white institutions. It was a difficult proposition that only a few tackled successfully before the end of the nineteenth century. One of the earliest was Edward Alexander BOUCHET (1852–1918), who earned a Ph.D. in physics from Yale University in 1876. Bouchet was said to have been the first African American to earn a Ph.D. from an American university. His subsequent career did not, however, include research in the sciences. He became a high-school science teacher at the Institute for Colored Youth, Philadelphia. Because of his race, professional opportunities in science were essentially closed to him. Bouchet's was nonetheless an important accomplishment, a counterexample to the widespread mythology about the mental inferiority of blacks.

The number of blacks entering scientific fields increased markedly after the turn of the twentieth century. Among these were Charles Henry TURNER, zoologist; George Washington CARVER, agricultural botanist; Ernest Everett JUST, embryologist; St. Elmo BRADY, chemist; Elmer Samuel IMES, physicist; William Augustus HINTON, bacteriologist; and Julian Herman LEWIS, pathologist. Percy Lavon JULIAN, chemist, and Charles Richard DREW, a surgeon and pioneer of the blood banking system, followed a couple of decades later. This cohort represents the first group of black scientists to receive graduate degrees from major white universities, pursue science at the research level, and publish in leading scientific journals.

World War II brought African-American scientists, as a distinct group, to public attention for the first time. Prior to this, they had worked primarily as teachers at black colleges and universities, and had not—with the notable exception, perhaps, of Ernest Just—exerted their influence widely or made their presence felt in the larger scientific community. As part of the war mobilization effort at Los Alamos and in the various branches of the Manhattan Project attached to laboratories at the University of Chicago, Columbia University, and other universities, some white scientists witnessed for the first time a sizable number of black physicists and chemists entering their world. African Americans who worked on the atom bomb project included Edwin Roberts Russell (b. 1913), Benjamin Franklin Scott (b. 1922), J. Ernest WILKINS, Jr., Jasper Brown Jeffries (b. 1912), George Warren Reed, Jr. (b. 1920), Moddie Daniel Taylor (1912–1976), and the brothers Lawrence Howland Knox (b. 1907) and William Jacob Knox, Jr. (b. 1904). At a postwar conference in 1946, one

eminent white scientist, Arthur Holly Compton, remarked on how the bomb project had brought races and religions together for a common purpose.

After the war, even though a few white universities began to open up faculty appointments and graduate fellowships to blacks, racial discrimination continued to operate at many levels within the professional world of science. It was common for major associations, including the American Association for the Advancement of Science, to hold conventions in cities where segregation was both customary and legally enforced, and where hotels serving as convention sites denied accommodation to anyone of African-American origin. Blacks often relied on their own scientific associations, such as the National Institute of Science (founded in 1942) and Beta Kappa Chi Scientific Society (incorporated in 1929), to share ideas and foster collegial ties. Furthermore, most science education for African Americans—certainly at the undergraduate level—continued to take place within the confines of historically black colleges and universities.

Following passage of the 1964 U.S. Civil Rights Bill, new educational opportunities gradually opened up for blacks, and scientific careers—in both academia and industry—became more of a tangible, realistic goal. Rosters of noteworthy scientists from the 1960s to the 1990s mention a number of African Americans, including Harold AMOS, bacteriologist; Shirley Ann JACKSON, physicist; Edward William Hawthorne (1921–1986), physiologist; Marie Maynard Daly (b. 1921), biochemist; and Ronald Erwin MCNAIR, astronautical physicist. Scientific organizations, learned societies, and educational institutions grew more inclusive during this period. David Harold BLACKWELL, a mathematician, was elected to the National Academy of Sciences in 1965. The physicist Walter Eugene MASSEY became the first African-American president of the American Association for the Advancement of Science in 1988 and the first African-American director of the National Science Foundation in 1990. Nevertheless, statistics indicate that African Americans continue to be underrepresented in science. Only 2 to 3 percent of American scientists are black, while African Americans constitute around 12 percent of the total U.S. population.

REFERENCES

BRANSON, HERMAN. "The Negro and Scientific Research." *Negro History Bulletin* 15 (April 1952): 131–136, 151.

DREW, CHARLES RICHARD. "Negro Scholars in Scientific Research." *Journal of Negro History* 35 (April 1950): 135–149.

HABER, LOUIS. *Black Pioneers of Science and Invention.* New York, 1970.

KLEIN, AARON E. *The Hidden Contributors: Black Scientists and Inventors in America.* Garden City, N.Y., 1971.

MANNING, KENNETH R. "The Complexion of Science." *Technology Review* 94 (November/December 1991): 60–69.

———. "Race, Science, and Identity." In Gerald Early, ed. *Lure and Loathing: Essays on Race, Identity, and the Ambivalence of Assimilation.* New York, 1993, pp. 317–336.

"Minorities in Science: The Pipeline Problem." *Science* 258 (November 13, 1992): 1175–1237.

PEARSON, WILLIE, JR. *Black Scientists, White Society, and Colorless Science: A Study of Universalism in American Science.* Millwood, N.Y., 1985.

WRIGHT, CLARENCE. "The Negro in the Natural Sciences." In Jessie P. Guzman, ed. *Negro Year Book: A Review of Events Affecting Negro Life, 1941–1946.* Tuskegee, Ala., 1947, pp. 34–47.

KENNETH R. MANNING

Science Education. Following emancipation, African Americans recognized education as a key element in their struggle to enter the American mainstream. While some studied at white institutions, the vast majority who attended college enrolled in those institutions intended specifically for blacks. By 1912, over sixty such colleges had been established. Few blacks, however, devoted themselves to the study of science.

The widely held view that blacks lacked intellectual ability was in part responsible for hindering the development of rigorous science curricula at black colleges. Another factor was the emphasis placed by black leaders on nonscientific pursuits. Booker T. WASHINGTON's advocacy of industrial or vocational education as the most rewarding path for blacks carried the momentum away from scientific and other intellectually oriented goals. Even those black leaders—W. E. B. DU BOIS and others—who opposed Washington's philosophy tended to stress law, theology, and the humanities over science as disciplines essential to the fulfillment of blacks' social and political interests.

Nevertheless, the first Ph.D. awarded to an African American was in a scientific field. Edward A. BOUCHET earned his degree in physics at Yale in 1876. In the period 1876–1943, ninety-one blacks earned doctorates in the physical and biological sciences. Over 90 percent of these degrees were awarded after 1930, a period when black educational institutions such as HOWARD UNIVERSITY hoped to invigorate their academic programs by recruiting faculty with advanced qualifications.

At black colleges, the study of science was ordinarily viewed not as an end in itself but as a means to acquire essential background for the pursuit of medicine (*see* MEDICAL EDUCATION), PHARMACY, agriculture, and other clinical or practical disciplines. After 1930, black Ph.D.s such as Herman Russell BRANSON (physics), Samuel Milton Nabrit (biology), and Henry C. MCBAY (chemistry) taught a high proportion of premedical students. Yet they also served as pioneer mentors and role models for students who sought careers in scientific research. McBay, a professor at Morehouse College, stimulated over forty blacks to earn doctorates and to embark on research careers in academia, government, and industry.

Such individual efforts did not directly challenge the disfranchisement of blacks within the American educational system. The racial integration of schools, prompted by the civil rights acts of the 1960s, was intended to open up new opportunities. The door to science education, however, remained just slightly ajar. In 1985, blacks earned only 5 percent of all baccalaureates in science, 3.4 percent of master's degrees, and 2 percent of doctorates. Moreover, a high proportion of these degrees were awarded not in the physical or biological sciences but in less rigorous programs, such as psychology. This circumstance is attributable in part to the emergence of a disguised form of segregation known as tracking, in which a typical black student is counseled away from demanding courses and into a curriculum without high-level mathematics and science. The Quality Education for Minorities Network and similar programs were established to make headway on such problems before the turn of the twenty-first century.

REFERENCES

National Science Foundation. *Women and Minorities in Science and Engineering*. Washington, D.C., 1988.

PEARSON, WILLIE, JR., and H. KENNETH BECHTEL, eds. *Blacks, Science, and American Education*. New Brunswick, N.J., 1989.

PHILIP N. ALEXANDER

Science Fiction. Although the term *science fiction* originated in the 1920s, the genealogy of the form continues to be the subject of debate. British author/critic Brian W. Aldiss makes a well-argued case for Mary Shelley's *Frankenstein* (1818) as science fiction's authentic ancestor, thereby tracing the birth of the genre to the Gothic mode and the Romantic movement of which it was a part. Samuel R. DELANY, the first African-American writer consciously dedicated to the science fiction enterprise, strongly demurs, arguing that science fiction has its true beginnings in pulp magazines such as *Amazing Stories,* which began publication in 1926. These two disparate views are perhaps reconciled by one quite reasonable position of current scholarship: that although what "we now call science fiction was written in earlier centuries . . . the emergence of SF as a special field, with its own subculture of writers, editors, and fans, is a phenomenon of the twentieth century" (Bainbridge 1986, p. 9). One aspect of the problem of precise definition or of pinpointing origins is that there are so many overlappings between science fiction and fantasy, a much older but still vigorous form. Indeed, the very notion of *genre* must be approached as something quite porous and impure; thus, the use of the term here will imply very soft, unstable borders.

Novelist and essayist Ishmael REED has called George SCHUYLER's *Black No More* (1931) the first science fiction novel by an African American. Although the subtitle of Schuyler's book, "Being an Account of the Strange and Wonderful Workings of Science in the Land of the Free, A.D. 1933–1940," might seem to support Reed's contention, *Black No More* is in fact no more science fiction than is, for example, Jonathan Swift's *Gulliver's Travels* (1726). Both are works of satire, in which science is one of the projects being satirized. Race, as a marker of "difference," is Schuyler's actual subject; science is a target to the extent that it lends its authority to theories of race that impact invidiously on non-Europeans. If *Black No More* were to be categorized as science fiction, then works like Reed's own "Cab Calloway Stands In for the Moon" (1970), or Amiri BARAKA's stories "God and Machine" (1971) or "Answers in Progress" (1967), or "Jazz and Palmwine" (1970) by the Congolese writer Emmanuel Boundzéki Dongala might also qualify for this designation. Despite the admittedly complex and varied nature of the science fiction genre, however, the presence of elements of science fiction or fantasy in a given work is not sufficient to impress it into service as "science fiction." The aforementioned works are most appropriately situated within the context of African-American literature, the imaginative scope of which often traverses the borders of other literary territories.

A historian of science fiction's readership has claimed that there were "thousands" of black science fiction fans in the 1930s. Yet as recently as 1988–1989, an exchange of letters in the journal *Science Fiction Studies* raised these questions: Where are the black science fiction readers? Where, indeed (apart from Delany, Octavia BUTLER, and Steven Barnes), are the black science fiction writers? One might also ask: why have a number of African-American science

fiction writers appeared since the early 1960s and not before? To the extent that the genre has been identified as "utopian," "apocalyptic," a literature of "cognitive estrangement," a mapping of alternative possibilities, it seems to have much in common, broadly speaking, with certain characteristics of African-American literature, and contemporary African-American science fiction writers have indeed exploited these points of similarity between the two literatures.

But it is also important to remember that for a long time, science fiction was considered to be a sort of para-literature—popularly read but uncanonized by the academy, a poor but ubiquitous cousin to "serious" literature. This situation has altered dramatically with the rise of critical interest in science fiction and the inclusion of science fiction courses in university curricula. So-called minority literatures, among which African-American literature is a senior partner, have been similarly stigmatized, although the civil rights and Black Power movements, and the more recent emphasis on multiculturalism in the United States, have done much to overcome this condescension and lack of understanding. Given the struggle African-American authors waged to be taken seriously outside their own communities (and sometimes even within them), it is perhaps not surprising that they did not take on the added burden of adopting a genre that was itself marginalized in terms of respectability.

The decade of the 1960s, when Delany began publishing, was the period in which science fiction began to command attention beyond its prior constituency, gaining recognition for its frequently bold experimentalism and heightened sophistication. Some of its focus shifted from outer space to inner space, from futurological hardware to the "software" of a more human emphasis. Simultaneously, science fiction writers began to become more conscious of, and desirous of critically examining, the nature and the history of their enterprise.

Samuel Delany was a significant figure in both of these events. This "evolutionary leap" of science fiction took place, of course, during the far more general release of transformational energies that characterized the 1960s, one of the most crucial examples of which was the black cultural revolution. Though a very active participant in the "invention" of the counterculture of that era, Delany was not directly involved in the black revolution, yet he was surely among its beneficiaries to the extent that he felt free to transgress barriers to black participation in all things American, and, indeed, to refuse self-imposed limits to what one could do and be. No doubt his great success in the field was an encouragement to other black writers contemplating a career in science

fiction. Still, the time was ripe for an expansion of the possible within the realm of African-American culture itself, and this, one concludes, is what made the difference. The black artist would no longer be bound by others' expectations as to what constituted his or her "proper" role. Just as the restive and yet restorative consciousness of the present has been employed by a number of African-American authors to interrogate the past, so, too, has that same consciousness been used by African-American science fiction writers to critically explore the future.

Samuel R. Delany is not only the first African-American writer committed to the field of science fiction; he is also the best known, most critically acclaimed, and most prolific, having written more than two dozen books since his first publication in 1962. Delany is, at the same time, one of the most challenging critics of the science fiction genre and its history. He is also a figure of some controversy, especially with regard to his concern with the nature and politics of sexuality, first broached explicitly in his longest and best-selling novel, *Dhalgren* (1975), and in the little-known pornographic/philosophic work *The Tides of Lust* (1973). Much of Delany's creative work could be characterized very broadly as employing archaeologies of the past and the future in order to both understand and transcend the complexities of the present.

Following Delany in importance and productivity is Octavia E. Butler, the first black woman science fiction writer. She is best known for her novel *Kindred* (1979), which, although it deals with time travel, has been celebrated as an important work of both black and feminist literature. *Kindred* is a perfect example of what could be called the de-ghettoization of science fiction, analogous to the crossover phenomenon in other cultural spheres. Butler's other works include *Patternmaster* (1976), *Mind of My Mind* (1977), *Survivor* (1978), *Wild Seed* (1980), *Clay's Ark* (1984), *Dawn* (1987), *Adulthood Rites* (1988), and *Imago* (1989), and deal imaginatively and critically with questions of race, gender, and power.

Two other writers demand mention. First is Steven Barnes, author of novels including *Streetlethal* (1983) and *Gorgon Child* (1989), as well as a number of collaborations with veteran science fiction author Larry Niven. Much of Barnes's work extrapolates dilemmas of the present into the not-so-distant future, where questions of race, gender, and sexual orientation confront increasingly blatant forms of repression. Second is Charles R. Saunders, born in the United States but living in Canada since 1969. He is a writer primarily of heroic fantasy, best exemplified by his first novel, *Imaro* (1981), which takes place in a mythical Africa. Saunders has attempted to counter Eurocentric fantasies about Africa—typified by the

writings of H. Rider Haggard and Edgar Rice Burroughs—through the depiction of what could be termed Afrocentric fantasies.

It can be expected that more African-American and, indeed, other "minority" science fiction writers will emerge in the future, to join the handful of present practitioners who have already had a significant impact on a vibrant and varied genre. (See also Anthony DAVIS, who has composed a science fiction opera, *Under the Double Moon.*)

REFERENCES

ALDISS, BRIAN W. *Trillion Year Spree: The History of Science Fiction.* New York, 1986.
BAINBRIDGE, WILLIAM SIMS. *Dimensions of Science Fiction.* Cambridge, Mass., 1986.
Black American Literature Forum 18, no. 2 (Summer 1984). Special issue on science fiction by black writers.
Callaloo 14, no. 2 (Spring 1991). Contains section on science fiction and fantasy by black authors.
DELANY, SAMUEL R. *Starboard Wine: More Notes on the Language of Science Fiction.* Pleasantville, N.Y., 1984.

ROBERT ELLIOT FOX

Scientific Associations. When scientific associations began to flourish in the United States around the middle of the nineteenth century, and for decades thereafter, the typical member was an educated white male with the connections, position, or financial means to carry on research. Entire groups—African Americans, women, and others—were either kept out or denied meaningful participation.

The exclusion of blacks reflected the scientific community's compliance with segregationist politics prevalent in society at large. Furthermore, blacks emerging from slavery focused on educational, economic, and professional priorities in which science seldom played an integral role. They established schools and colleges, churches, fraternal societies, and business and health organizations—but no associations devoted exclusively to science. While they were active in patenting inventions, their essential aim was economic rather than scientific. Some black professional associations, especially those relating to health, had a scientific component, although by and large this was restricted to applied or clinical subjects, not to pure research. Almost from the time of its founding in 1895, the National Medical Association provided a scientific forum for its members at annual meetings.

Through the middle of the twentieth century, few blacks joined predominantly white scientific associations. *Who's Who in Colored America* (1941–1944), for example, identifies only twenty-six. Most of these belonged to the American Chemical Society and the American Association for the Advancement of Science (AAAS). Of twenty-seven associations cited in this sample, only four included more than one black member. One of these—the Virginia Academy of Science—included three black members in a state where segregation was the law. Blacks did not routinely attend meetings of such associations; as de facto "corresponding" members, they benefited primarily from studying the publications and proceedings. An exception was the zoologist Ernest Everett JUST, who gave papers regularly at meetings of the American Society of Zoologists and the AAAS (at the latter, often with his students from HOWARD UNIVERSITY). It was a momentous occasion in May 1939 when Amanda E. Peele became the first black woman to deliver a paper at a meeting of the Virginia Academy of Science.

Just was the first African American to hold office in a national scientific association, becoming vice-president of the American Society of Zoologists in 1930. This achievement did not, however, establish a pattern or precedent. Twenty years later, although black scientists were attending meetings of major associations in increasing numbers, they felt discouraged because their participation was restricted in certain respects. Black mathematicians, for example, complained in 1951 about a decision by the Mathematical Association of America not to protest the exclusion of blacks from social events at Vanderbilt University, the association's host for a regional conference that year. This complaint, and others that followed, prompted some associations to codify a policy of nondiscrimination, following the lead of the American Psychological Association in 1950.

Because their needs and concerns were never adequately addressed by these groups, black scientists formed associations of their own. One of the earliest, the National Institute of Science, was founded in 1942 to provide an alternative forum for college and university science teachers, students, and scientists in industry and government. In 1990, the institute had over 800 members. Other black scientific associations, most of them founded since 1970, include the National Organization of Black Chemists and Chemical Engineers, the National Association of Black Consulting Engineers, the National Society of Black Engineers, and the National Society of Black Physicists.

Some predominantly white associations created programs to promote scientific opportunity for underrepresented groups—for example, the AAAS' National Network of Minority Women in Science. Even though African Americans still constitute a small pro-

portion of the membership of these associations, a few have gained prominence within them. Henry Hill became the first black president of the American Chemical Society in 1976, and Walter MASSEY the first black president of the AAAS in 1988.

REFERENCES

"Discriminatory Practices." *Science* 114 (August 10, 1951): 161–162.

PHILIP N. ALEXANDER

Scientific Institutions. The rise of the modern scientific institution paralleled the increasing demands (in scale and expense) of research in the twentieth century. Scientific institutions are often directly connected to agencies of government, industry, commerce, or nonprofit philanthropy. Otherwise, they operate with the backing of such agencies.

Until WORLD WAR II, few African-American scientists had access to the facilities of scientific institutions. The biologist Charles Henry TURNER, a Ph.D. from the University of Chicago (1907), was a high school teacher who carried out research in his spare time and without affiliation. An early exception to this pattern was the biologist Ernest Everett JUST, who worked each summer for twenty years (beginning in 1909) at the Marine Biological Laboratory, Woods Hole, Mass. Until the 1920s, Just was the only black at Woods Hole. Although he suffered frequent isolation and racial ostracism, he established a precedent whereby other black biologists—Samuel Milton Nabrit and Roger Arliner YOUNG, among others—were ultimately able to take advantage of research opportunities there.

The mobilization effort during World War II brought more blacks into the scientific mainstream. Black physicists and chemists participated in classified research projects in radar, ballistics, atomic energy, and chemical warfare—all under federal sponsorship. Lloyd A. Quarterman, a nuclear physicist and student of Enrico Fermi, worked on the Manhattan Project (the atom bomb) at Argonne National Laboratory. Other black scientists—for example, the chemists Moddie D. Taylor and William J. Knox—were attached to atomic research laboratories within educational institutions. Taylor worked at the University of Chicago, Knox at Columbia University. At the conclusion of the war, one eminent American scientist remarked how the bomb project had brought together "colored and white, Christian and Jew" for a common purpose.

The poignant irony of juxtaposing concepts of racial harmony and weapons of mass destruction escaped many people at the time. Besides, this "harmony" was not so much a spiritual revolution as an artificial response to a national crisis. Once the crisis passed, the status quo remained essentially intact. Nevertheless, institutions run by the federal government continued to hire black scientists. On the staff of Argonne National Laboratory, for example, were George W. Reed (nuclear chemist and geochemist), Virgil G. Trice (chemical engineer), and Erskine G. Roberts (power systems engineer). Walter E. MASSEY (theoretical physicist) later served as director and vice president for research at Argonne prior to his appointment as director of the National Science Foundation.

The picture was not so bright, however, in the private sector. While the George Washington Carver Research Foundation, established at Tuskegee Institute in 1940, provided a temporary base for the work of some black scientists "dedicated to the advancement of knowledge through research in agriculture, the natural sciences, and related areas," a void of opportunity existed elsewhere until the 1960s (*see* TUSKEGEE UNIVERSITY). Some black scientists started their own institutions. The chemist Percy L. JULIAN, for example, founded Julian Laboratories in the 1950s. It was an unusual circumstance when Marie Maynard DALY, the first black female Ph.D. in chemistry (New York University, 1948), began working as a research assistant at the Rockefeller Institute for Medical Research in 1951. E. E. Just had been rejected by the Rockefeller three decades earlier.

REFERENCES

BRANSON, HERMAN. "The Negro and Scientific Research." *Negro History Bulletin* 15 (1952): 131–137.
SAMMONS, VIVIAN OVELTON. *Blacks in Science and Medicine*. New York, 1990.

PHILIP N. ALEXANDER

Scientific Theories of Race. *See* Race, Scientific Theories of.

SCLC. *See* Southern Christian Leadership Conference.

Scott, Dred. *See* Dred Scott v. Sandford.

Scott, Emmett J. (February 13, 1873–December 12, 1957), author and administrator. Born in Houston, Tex., Emmett Scott briefly attended Wiley College in Marshall, Tex., before beginning to work as a journalist at the *Houston Post* in 1881. (He was awarded an honorary M.A. from Wiley College in 1901.) In 1894 Scott founded and edited his own weekly African-American newspaper, the *Houston Freeman*. Because his views were generally in close agreement with those of Booker T. WASHINGTON, Scott was asked by Washington to become his personal secretary. From this position, which Scott held until Washington's death in 1915, he was elected secretary of the Tuskegee Institute in 1912. Scott became widely recognized as a leader in what later became known as the "Tuskegee Machine," the group of people close to Booker T. Washington who wielded great influence over African-American presses, churches, and schools in order to promote Washington's views.

After Washington's death, Scott became special assistant to the U.S. secretary of war in charge of Negro affairs at the start of World War I. At a time when race relations in the military were an issue of debate, Scott became the liaison between black soldiers and the War Department. From 1919 until 1939, Scott held positions as secretary, treasurer, or business manager at HOWARD UNIVERSITY, in Washington, D.C. There he helped create procedures for electing the first alumni trustees. In the business community, Scott became the principal organizer of the National Negro Business League. Like Washington, Scott believed that African Americans who achieved business success and property ownership would be given political and civil rights. His views are set forth in such works as *Tuskegee and Its People* (1910), *The American Negro in the World War* (1919), and a biography of his mentor, Booker T. Washington, *Builder of a Civilization* (1916).

REFERENCES

LOGAN, RAYFORD, ed. *Dictionary of American Negro Biography*. New York, 1982.
LOW, W. AUGUSTUS, ed. *Encyclopedia of Black America*. New York, 1981.

SASHA THOMAS

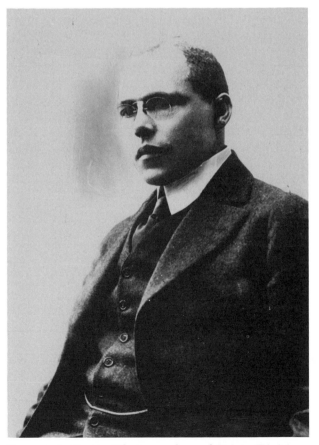

Emmett J. Scott. (Photographs and Prints Division, Schomburg Center for Research in Black Culture, The New York Public Library, Astor, Lenox and Tilden Foundations)

Scott, Hazel (June 11, 1920–October 2, 1981), pianist, singer. Hazel Dorothy Scott was born in Port of Spain, Trinidad, to Alma Long Scott, a musician, and Thomas Scott, a college professor. In 1924, her father obtained a teaching position in the United States, and the family moved to New York City.

Scott began playing the piano at age two and made her performance debut at age three in Trinidad. At the initiative of her mother, she began formal musical training when the family moved to New York; she made her U.S. debut as a five-year-old at New York's Town Hall. Three years later, Scott auditioned for a scholarship at Juilliard School of Music. Although it was decided that she was too young to enter the school, Juilliard Professor Paul Wagner, who presided over the audition, was so impressed with her rendition of Rachmaninoff's Prelude in C-Sharp Minor that he offered to take her on as a private student.

In 1934, Scott's father died, and her mother took a job as a saxophonist in Lil Hardin ARMSTRONG's all-female band. A few months later, Scott's mother decided to organize her own band—Alma Long Scott's All-Woman Orchestra—with Hazel playing both piano and trumpet. In 1936, at age sixteen, Scott played with the Count Basie Orchestra at the Roseland Ballroom and on a radio program broadcast on the Mutual Broadcasting System. By age eighteen, already a veteran of the road, Scott appeared on Broadway in

the musical *Sing Out the News*. She then became a film actress in the 1940s and played herself in such films as *Something to Shout About* (1943), *Broadway Rhythm* (1944), and *Rhapsody in Blue* (1945). In 1945, in a high-profile marriage, Scott married New York Rep. Adam Clayton POWELL, JR. Although the marriage quickly faltered, beginning with a separation of several years and finally ending in divorce in 1956, the couple produced one child, Adam Clayton Powell III, in 1946.

In 1950, Scott hosted a summer television program, *Hazel Scott,* on which she performed show tunes and café favorites, becoming the first black woman to host her own television program. However, Scott, a political activist who had refused to appear before segregated audiences and was a vocal critic of McCarthyism, was listed in the notorious *Red Channels,* a publication of names of entertainers who were thought to be involved in COMMUNIST PARTY activity. On September 14, 1950, Scott testified before the House Un-American Activities Committee in defense of her right to appear at rallies and events for political causes. Her show was canceled shortly thereafter.

In 1961 Scott moved to Europe after remarrying; when her marriage ended in divorce five years later, she returned to the United States. Upon her return, she made guest appearances on such television shows as *Julia* and *The Bold Ones*. Scott continued to perform in New York–area clubs until a few months before her death from cancer in 1981.

REFERENCES

BOGLE, DONALD. *Blacks in American Films and Television.* New York, 1988.

HINE, DARLENE CLARK, ed. *Black Women in America: An Historical Encyclopedia.* Brooklyn, N.Y., 1993.

KENYA DILDAY

Scott, James Sylvester (February 12, 1885–August 30, 1938), ragtime composer. James Scott was born in Neosho, Mo., and as a child taught himself to play piano. After his family moved to Carthage, Mo., around the turn of the century, Scott worked as a shoe-shine boy. He also began to play music professionally, often performing on piano and steam calliope at local fairs and amusement parks. From 1902 to 1914 he worked as a window washer and picture framer, as well as a clerk and song plugger at Dumar's Music Store. It was during this time that he also began composing and publishing ragtime songs. Among his earliest successes were "A Summer Breeze" (1903) and "The Fascinator" (1903). In 1906 Scott visited Scott JOPLIN in St. Louis, and though the two never worked together, Joplin did introduce Scott to John Stark, who became Scott's publisher. Stark also gave titles to most of Scott's compositions.

In his prime Scott was considered, along with Scott Joplin and the white composer Joseph Lamb, to form the "big three" of RAGTIME. Scott's compositions, with their manic leaps, buoyant rhythms and rich, moody tonalities, helped define the classic ragtime sound. His most important ragtime compositions from this time include "Frog Legs Rag" (1906), "Great Scott Rag" (1909), "The Ragtime Betty" (1909), "Sunburst Rag" (1909), "Grace and Beauty" (1909), and "Hilarity Rag" (1910). Although Scott made no piano rolls, there is evidence to suggest that in addition to writing many of the classics of ragtime, he was a fine pianist as well.

In 1914 Scott moved to Kansas City, Kans., where he taught, arranged, and worked as piano accompanist at the Paramount, Eblon, and Lincoln Theaters. Scott continued to compose and published "Climax Rag" (1914), "Evergreen Rag" (1915), "Prosperity Rag" (1916), "Paramount Rag" (1916), "Peace and Plenty Rag" (1919), and "Modesty Rag" (1920). He also wrote waltzes, including "Suffragette" (1914) and "Springtime of Love" (1919).

In the 1920s and 1930s Scott led a band in Kansas City, but he never regained his previous success and popularity. During his last years Scott lived in relative anonymity. The rise of JAZZ eclipsed the popularity of ragtime, and the introduction of sound into movies prevented him from earning a living as an accompanist to silent films. Scott suffered from dropsy and died of kidney failure in Kansas City, Mo., in 1938. His grave was unmarked until 1981, during a resurgence of interest in his music.

REFERENCES

DEVEAUX, SCOTT, and WILLIAM H. KENNEY. *The Music of James Scott.* Washington, D.C., 1992.

HAASE, JOHN EDWARD, ed. *Ragtime: Its History, Composers, and Music.* New York, 1985.

JONATHAN GILL

Scott, Rosalie Virginia. See McClendon, Rose.

Scott, Wendell Oliver (August 29, 1921–December 23, 1990), automobile race driver. Wendell Scott was born and raised in Danville, Va. He got his first chance in stock car racing in 1949, when Danville po-

lice gave his name to a local racetrack owner who asked for information on African Americans with speeding records.

Over the next twelve years Scott won eighty Sportsman and forty Modified stock car races, as well as the 1959 Virginia State Championships. Prejudice kept him from the prestigious Grand National (GN) tour until 1961, when he made his GN debut at the Spartanburg Fairgrounds in South Carolina. In that year he finished in the top ten five times and earned $3,240. In 1962 he earned $7,000 for eleven top ten finishes.

Scott's biggest victory came in 1963, when he won the Jake 200, a race sponsored by the National Association of Stock Car Auto Racing (NASCAR) in Jacksonville, Fla. This was Scott's only GN win, but it was marred by the racism he endured throughout his career. Unwilling to allow a white beauty queen to kiss a black driver, the race promoters gave the winner's trophy to Buck Baker, who had come in second. After the victory ceremony a NASCAR official apologized to Scott and gave him the winner's check of $1,150, but Scott never received the trophy.

Race officials often harassed Scott by requiring him to make trivial repairs on his car before they would allow him to race, and he said that some drivers deliberately tried to make him crash because he was black.

Scott's best year was 1969, when he won $27,542 and gained the notice of the mainstream racing fans. He retired in 1973 with a career record of more than 500 GN races, 20 top five finishes, 128 victories in the lower Sportsman division, and $180,000 in total earnings.

After his retirement Scott lived in Danville and occasionally drove in races. Scott's racing career was the basis for the 1977 film *Greased Lightning,* in which Scott was portrayed by Richard Pryor. He died in 1990 in Danville.

REFERENCES

ASHE, ARTHUR R., JR. *A Hard Road to Glory: A History of the African-American Athlete Since 1946.* New York, 1988.
Obituary. *New York Times,* December 25, 1990, p. 36.

THADDEUS RUSSELL

Scott, William Edouard (March 11, 1884–May 15, 1964), painter. William Edouard Scott was born in Indianapolis and studied drawing as a child with a local painter, Otto Stark. Scott graduated from Manual Training High School in Indianapolis in 1903 and attended the Art Institute of Chicago from 1904–1909, working as a janitor and waiter to pay tuition.

From 1910 to 1918, Scott alternately resided in France and the United States. He went to Paris in 1910 and studied with the African-American artist Henry O. TANNER. He returned to the United States after fifteen months, exhibiting work at the Art Institute of Chicago in 1911 (*The Seine, Paris, France,* 1911). Scott relocated to Paris a year later to study at the Julien Academy where he created *La Pauvre Voisine* (The Poor Neighbor), which was executed in a sentimental, representational, and academic style with a flattened sense of perspective. The painting was exhibited at the salon in 1912 and was purchased by the Argentinian government.

Scott returned to the United States in 1912 and painted murals for schools in Chicago and Indianapolis, including his representation of the children's story *The Old Woman Who Lived in a Shoe* (1914), which portrayed black characters in the Mother Goose nursery rhyme. He went back to Paris in 1913 to study at the Colarossi Academy and exhibit in Paris and London; the following year he returned to the United States where he continued his mural work in Chicago and Indianapolis. During this time he also completed his well-known portrait, *Booker T. Washington* (1916). In 1918, Scott returned to Europe with a commission from W. E. B. DU BOIS to sketch African-American soldiers for the cover of the NAACP's magazine, the CRISIS, in honor of African-American troops serving in France (*Crisis,* November 1918).

In the 1920s, Scott continued to create murals, and in 1927 his achievements as a painter were recognized when he received the gold medal for fine arts from the Harmon Foundation. In 1931 he was awarded a Julius Rosenwald Fellowship to travel to Haiti, where he worked primarily as a painter, creating works that were influenced by the neoclassical painter Jacques David, such as *Calabash for Market* (1931), *Haitian Market* (1931), and his best-known work, a portrait of two street peasants, *Blind Sister Mary* (1933).

In 1933, Scott returned to the United States and completed murals for the Harlem Branch of the New York YMCA He worked for the Federal Arts Project's Mural and Easel Division from 1935 to 1939. Scott painted the mural *Frederick Douglass Appealing to President Lincoln and his Cabinet to Enlist Negroes* (1943) for the Records and Deeds Building in Washington, D.C.

In 1955, Scott relocated to Mexico City and learned that he had diabetes. His leg was amputated in 1958, and the loss of eyesight made it difficult for him to paint toward the end of his life. He died in a nursing home in Chicago.

REFERENCES

FINE, ELSA HONIG. *The Afro-American Artist: A Search for Identity*. New York, 1973.

ROBERTS, PETER J. William Edouard Scott: Some Aspects of His Life and Work. Master's thesis, Emory University, 1980.

RENEE NEWMAN

Scott-Heron, Gil (April 1, 1949–), composer and writer. Gil Scott-Heron spent his childhood in Jackson, Tenn., until the age of thirteen, when he moved to New York City. He attended Lincoln University in Pennsylvania because two men he greatly admired, Langston HUGHES and African leader Kwame Nkrumah, had gone to Lincoln. After his freshman year he took a leave of absence to write a novel, *The Vulture,* and a book of poetry, *Small Talk at 125th and Lenox,* both published in 1970. He returned to Lincoln to complete his sophomore year and then applied to the graduate program at Johns Hopkins University. In 1972 he received an M.A. and published a second novel, *The Nigger Factory.*

Although he published a second book of poetry, *So Far, So Good,* in 1988, Scott-Heron has concentrated on composing, performing, and recording music. From 1974 on, he was accompanied by the Midnight Band, led by Brian Jackson. With Jackson, a pianist, generally concentrating on musical arrangements and Scott-Heron collaborating on lyrics, the group has produced more than fifteen recordings, including *Winter in America, Sun City,* and *From South Africa to South Carolina.* Combining Latin, blues, and jazz rhythms with a distinct vocal style, Scott-Heron uses music to interpret the political and social experience of black people throughout the world.

REFERENCES

"BBB Interviews Gil Scott-Heron." *Black Books Bulletin* 6, no. 3 (1979): 36–41.

CHATMAN, PRISCILLA. "Gil Scott-Heron and His Music." *Black Stars* 5, no. 2 (1975): 14–18.

SALAAM, KALAMU YA. "Where He's Coming From: Gil Scott-Heron." *Black Collegian* 35 (1980): 182–190.

GENETTE MCLAURIN

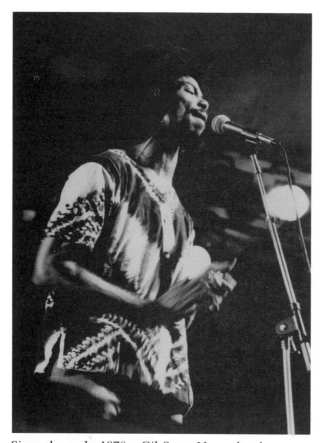

Since the early 1970s, Gil Scott-Heron has been one of the foremost exponents of a revolutionary transformation of African-American life. His scalding political commentaries, delivered to the accompaniment of a jazz ensemble, memorably dissect the dilemmas of black life in American society. (Photographs and Prints Division, Schomburg Center for Research in Black Culture, The New York Public Library, Astor, Lenox and Tilden Foundations)

Scottsboro Case. On April 9, 1931, an Alabama judge sentenced eight black teenagers to death: Haywood Patterson, Olen Montgomery, Clarence Norris, Willie Roberson, Andrew Wright, Ozie Powell, Eugene Williams and Charley Weems. After perfunctory trials in the mountain town of Scottsboro, all-white juries convicted the youths of raping two white women (Victoria Price and Ruby Bates) aboard a freight train as it moved across northern Alabama on March 25. The case of the ninth defendant—thirteen-year-old Leroy Wright—ended in a mistrial after a majority of the jury refused to accept the prosecution's recommendation for life imprisonment because of his extreme youth.

The repercussions of the Scottsboro case were felt throughout the 1930s; by the end of the decade, it had become one of the great civil rights cases of the twentieth century.

After the quick conviction and draconian verdict, the Communist party's legal affiliate, the International Labor Defense (ILD), took over the case from the National Association for the Advancement of Colored People. Using both propaganda and aggres-

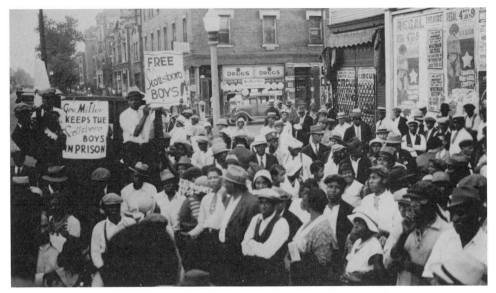

Demonstration to free the Scottsboro Boys. (Photographs and Prints Division, Schomburg Center for Research in Black Culture, The New York Public Library, Astor, Lenox and Tilden Foundations)

sive legal action, the ILD succeeded in obtaining a new trial for the eight defendants. In a landmark case, *Powell* v. *Alabama* (1932), the U.S. Supreme Court ruled that defendants in capital cases had to receive more than a pro forma defense. (One Scottsboro attorney had been drunk at the original trial; the other was elderly and incompetent.)

The April 1933 retrial of Haywood Patterson was moved to Decatur, Ala. Defense attorney Samuel Leibowitz introduced extensive evidence that the two women had concocted the charge of rape in order to avoid prosecution for prostitution and vagrancy. The highlight of the trial came when Ruby Bates—who had disappeared in 1932—dramatically renounced her earlier accusations and testified on behalf of Patterson and the other Scottsboro defendants.

But the jurors—reflecting the belief of the local white community that Bates was bribed by communist agitators ("Jew money from New York" in the words of one prosecutor)—ignored her testimony. They were particularly incensed by the willingness of Alabama's African-American population to join the defense in attacking the state's all-white jury system. (In pretrial hearings before Judge James E. Horton, Jr., ten members of Decatur's black community defied Klan cross burnings and threats to insist that they were qualified to serve as jurors but had never been called.) The jury convicted Patterson and mandated the judge to order the death penalty.

To the surprise of almost everyone, Judge Horton—convinced that Patterson and the other defendants were innocent—set aside the verdict, pointing out that the evidence "overwhelmingly preponder-

ated" in favor of the Scottsboro defendants. He ordered a new trial and announced that the nine defendants would never be convicted in his court. In the next election, however, voters defeated Horton and elected a judge more amenable to the prosecution's case to preside over the trial of Patterson and Clarence Norris.

Many in Alabama had come to see the Scottsboro Case as a test of white Southerners' resolve against the forces of "communism" and "racial amalgamation." The guilt or innocence of the defendants thus seemed irrelevant.

The trials that followed were travesties of justice. Horton's replacement, Judge William Washington Callahan, barred critical defense evidence, bullied and belittled defense attorneys and witnesses, effectively acted as coprosecutor. In the fall of 1933, all-white juries convicted both Patterson and Clarence Norris.

ILD attorneys once again successfully appealed to the Supreme Court, this time on the grounds that African Americans had been systematically excluded from Alabama juries. In *Norris* v. *Alabama* (1935), the court accepted the defense argument, overturned the Norris and Patterson verdicts, and returned the case to Alabama for retrial. The decision, though not ending all-white juries, marked another step in the Supreme Court's willingness to chip away at the legal system of the South.

In 1936, oversight of the case passed from the Communist party to a coalition of mainline civil rights organizations. This shift gave Alabama officials—by now embarrassed over the continuing judicial rebukes—an opportunity to compromise. The

state dropped the charges against the four youngest defendants, and the other five received prison sentences from twenty years to life with the understanding that once publicity in the case had subsided, they would be quietly released. Despite the intense lobbying of national civil rights leaders (and the secret intervention of President Franklin Roosevelt), Alabama officials blocked their release. It was 1950 before the last of the Scottsboro defendants, Andrew Wright, received his parole.

For a generation of African Americans who came of age in the 1930s, the Scottsboro Case was a vivid reminder of white legal oppression, and it helped further their resolve to mobilize against JIM CROW.

REFERENCES

CARTER, DAN T. *Scottsboro: A Tragedy of the American South.* 2nd ed. Baton Rouge, La., 1976.

NORRIS, CLARENCE, and SYBIL WASHINGTON. *The Last of the Scottsboro Boys: An Autobiography.* New York, 1979.

PATTERSON, HAYWOOD, with Earl Conrade. *Scottsboro Boy.* New York, 1950.

DAN T. CARTER

Scruggs, Mary Elfrieda. *See* Williams, Mary Lou.

Scurlock, Addison (June 19, 1883–1964), photographer. Addison Scurlock was the patriarch of a family of photographers who documented the cultural, social, and political history of Washington, D.C., and adjacent communities from the early 1900s to the present. Born in Fayetteville, N.C., Scurlock was the son of George Clay Scurlock, a local politician. The family moved to Washington in 1900, shortly after Addison's graduation from high school. George Clay Scurlock worked for the U.S. Treasury Department as a messenger while he studied law. On passing the bar examination, he opened a law office on U Street.

In 1900 young Addison Scurlock became an apprentice to Moses P. Rice, a local photographer of some prominence who had a studio on Pennsylvania Avenue. By 1904, Scurlock was sufficiently confident of his newly acquired skills to strike out on his own. His first photographic studio was located in the home of his parents, in the 500 block of Florida Avenue, N.W.

In 1911, he opened the Scurlock Studio of 900 U Street. He had garnered a reputation for his portrai-

ture among the vibrant African-American intelligentsia and burgeoning middle-class communities in the District and counted many of Washington's most celebrated citizens, both black and white, as his customers. He was the official photographer for HOWARD UNIVERSITY, and was frequently called on to document the visits of prominent black Americans to the nation's capital. His mastery of the panorama camera made him the photographer of choice for large socially and historically significant community gatherings—such as weddings, cotillions, and banquets—throughout the District of Columbia. His clients included schools, churches, and social and civic organizations. According to historian Michael Winston, "The agencies of the Federal Government, though riddled with discrimination, offered [him] stable employment."

Scurlock was respected as a businessman, and was often described by those who knew him as a man who "didn't need a calling card." He made his clients feel comfortable with their own images: according to his son Robert Scurlock, "He wanted it to look like the person in their Sunday best, their best face forward." He was astute at lighting his subjects, and often touched up photographs so that he might achieve an image he could take pride in and his clients would value. *Washington Post* reporter Peter Perl stated that "for decade after decade, thousands of Washingtonians have wanted the Scurlock face."

Scurlock's accomplishments as a still photographer were well recognized and appreciated during his lifetime. Carter G. WOODSON, the black historian and founder of the ASSOCIATION FOR THE STUDY OF AFRO-AMERICAN LIFE AND HISTORY (first known as the Association for the Study of Negro Life and History), distributed a series of Scurlock portraits of black leaders to schools throughout the nation. In the 1930s, Scurlock was able to reach a broad audience through the publication of his work in books and newspapers. He also produced a weekly newsreel of Washington events, which was shown in local movie theaters.

From the beginning, the Scurlock photographic business was a family endeavor. His wife, Mamie, managed his studios; by 1940 his sons Robert and George, both graduates of Howard University, had joined the business. The Scurlock brothers worked as photojournalists, supplying photographs to the black press, and George handled the studio's nonportrait work. In 1948 the brothers opened the Capital School of Photography, where they trained many aspiring photographers.

In 1952, the school closed and Robert Scurlock opened Custom Craft Studios, introducing color photography to the Scurlock customers. Addison Scurlock died at the age of eighty-one in 1964. The

Scurlock Studios on Connecticut Avenue closed in the early 1970s; the Ninth Street studio was demolished in 1983. Robert Scurlock continues to operate the Custom Craft Studio in the tradition of his father. His clients include local and national politicians, scholars, artists, and social activists. While the family goal of creating photographs that communicate the dignity of their subjects persists today, the historical significance of their work continues to be of importance.

REFERENCES

CORCORAN GALLERY OF ART. *The Historic Photographs of Addison N. Scurlock.* Washington, D.C., 1976.
PERL, PETER. "The Scurlock Look." *Washington Post Magazine* (December 2, 1990).

CLAUDINE BROWN

Seale, Robert George "Bobby" (October 22, 1936–), activist. Bobby Seale was born to George and Thelma Seale in Dallas. Before he had reached the age of ten, his family moved to California, where his father continued in his profession as a building carpenter. At the age of eighteen, Bobby Seale was accepted into the Air Force and sent to Amarillo, Tex., for training as an aircraft sheet-metal mechanic. After training for six months, he graduated as an honor student from the Technical School Class of Air Force Training. He was then sent to Ellsworth Air Force Base in Rapid City, S. Dak., where he served for three and a half years and was discharged as a corporal. He attended Merrit College in Oakland, Calif., after his discharge.

When he enrolled in college in 1961, Seale intended to study engineering. He joined the Afro-American Association, an organization formed by young militant African Americans in Oakland to explore the various problems confronting the black community. Influenced by the association's regular book-discussion sessions, Seale became interested in the works of Mao Zedong and Kwame Nkrumah, and he also began to read W. E. B. DU BOIS and Booker T. WASHINGTON. His awareness of and involvement in the Afro-American Association were shaped by a fellow student, Huey NEWTON, whose articulation of the social problems victimizing the black community attracted his interest.

With Newton, Seale formed the Soul Students Advisory Council; which was concerned with ending the drafting of black men into the service to fight in the VIETNAM WAR. Fired by nationalist zeal, especially after he heard MALCOLM X speak, Seale invited three friends, Kenny, Isaac, and Ernie, to create the REVOLUTIONARY ACTION MOVEMENT to organize African Americans on the West Coast for black liberation. In October of 1966, he and Huey Newton formed the BLACK PANTHER PARTY in Oakland. The party's objectives were reflected in its ten-point platform and program, which emphasized freedom, full employment, and equality of opportunity for African Americans. It called for an end to white racism and police brutality against black people. Although the FBI under J. Edgar Hoover's directorship declared Seale's party to be the greatest threat to the internal security of the United States, the party's programs for the poor won it broad support from the community as well as praise from civic groups. The Black Panther party also recognized the need for political participation by African Americans. To this end, it frequently organized voter-registration drives.

Three years after the formation of the party, Seale shifted his philosophical and ideological stance from race to class struggle, stressing the unity of the people and arguing that the Panthers would not "fight racism with more racism." In 1973 he ran for mayor of Oakland, forcing a runoff with John Reading, the incumbent, who defeated him. In 1974, he resigned as the chairman of the Black Panther party, perhaps in an effort to work within the mainstream political system. Since the late 1980s, Seale has been involved in an organization called Youth Employment Strategies, of which he was founder, and in encouraging black youth to enroll in doctoral programs. He is based in Philadelphia.

REFERENCES

FONER, PHILIP, ed. *The Black Panthers Speak.* New York, 1976.
PINCKNEY, ALPHONSO. *Red, Black and Green: Black Nationalism in the United States.* New York, 1976.
SEALE, BOBBY. *Seize the Time.* New York, 1970.
———. *A Lonely Rage: The Autobiography of Bobby Seale.* New York, 1978.

LEVI A. NWACHUKU

Seattle, Washington. Soon after its founding in 1852, Seattle, Wash., attracted a small group of African-American laborers, artisans, and domestic servants. However, a black community did not emerge until the 1890s, when William Gross, the city's second African-American settler, subdivided his farm among arriving families and created the nucleus of one section of black Seattle. About the same time, another neighborhood evolved thirty blocks south, around the waterfront at Jackson Street. By 1910 the two communities had joined, forming an

L-shaped pattern in the east-central section of the city known as the Central District.

Early twentieth-century black Seattle grew slowly; fewer than 4,000 of the city's 368,000 residents in 1940 were African American. Employment discrimination relegated the majority of Seattle's pre–World War II blacks to the economic periphery, where they worked as janitors, maids, railroad porters, ship stewards, and longshoremen—and persuaded other blacks to avoid the city. Nonetheless, the small community supported a number of churches, social clubs, and fraternal organizations, as well as chapters of the NATIONAL ASSOCIATION FOR THE ADVANCEMENT OF COLORED PEOPLE (NAACP), the NATIONAL URBAN LEAGUE, and, in the early 1920s, a division of the UNIVERSAL NEGRO IMPROVEMENT ASSOCIATION. This separate sphere for Seattle's blacks emerged partly from the exclusion practiced by white organizations, but also from the desire by local African Americans to control their own community-based organizations and institutions.

During World War II, black Seattle was transformed by the influx of thousands of defense workers. Between 1940 and 1950 the city's black population rose 313 percent, from 3,789 to 15,666. The beginning of this wartime influx came with the 1942 decision of the War Manpower Commission to recruit black workers for Boeing Aircraft and the numerous shipyards in and around the city. By 1945, blacks constituted 1,200 of the 42,008 aircraft construction workers in the Seattle area and 4,000 of the 60,000 shipyard workers.

The employment outlook for Seattle-area blacks after World War II was equally encouraging. Unlike most West Coast cities, Seattle retained most of its wartime jobs in the postwar era, and the black population continued to grow. Moreover, the black community registered important political gains—particularly in 1949, when a statewide Fair Practices Law was enacted, and Charles Stokes, an African American, was elected to the state legislature to represent the Thirty-seventh District, which contained a majority of Seattle's African Americans.

Black migration to the city continued into the 1950s. However, the growth of the black community prompted greater segregation and discrimination by whites. In 1950, 69 percent of Seattle's blacks lived in 10 of the city's 118 census tracts. By 1960, 78 percent lived within the same tracts, although the total black population had increased by 11,000 residents. De facto school segregation was a direct outgrowth of the increasing residential segregation of black Seattle. In the early 1950s, no Seattle public schools were predominantly black; by 1962, six of the city's eighty-six elementary schools and one of its eight high schools had black majorities.

The growing isolation of Seattle's blacks implicit in these developments prompted them in the early 1960s to challenge segregation and discrimination, both in the courts and by the direct-action tactics made famous in Montgomery, Birmingham, and other southern cities (see CIVIL RIGHTS MOVEMENT). Led by local ministers such as the Rev. Samuel McKinney and the Rev. Mance Jackson, blacks, beginning in 1961, boycotted and picketed stores that refused to hire African-American workers and staged marches and sit-ins to demand open housing and an end to school segregation. Like the national campaign, the local efforts failed to ameliorate all of the grievances of the African-American community, prompting growing frustration and anger, particularly among younger black Seattleites, by the mid-1960s. While the city avoided civil disorder on the scale of the Watts riot in 1965 or the Newark and Detroit uprisings in 1967, there were numerous small conflicts during the summers of 1967 and 1968. Partially as a consequence of these racial confrontations, the Central Area Motivation Program (CAMP) and the Seattle Opportunities Industrialization Center were founded to provide technical assistance and training to unemployed black Seattleites. Moreover, by 1968, in the wake of the Rev. Dr. Martin Luther King's assassination, the city finally adopted an open-housing ordinance, which allowed African Americans to move outside the four-square-mile Central District.

The continued prosperity of Boeing in the late 1960s, the expansion of financial services in the 1970s, and the emergence of a local computer industry in the 1980s continued to attract African-American migrants. Consequently, the black population increased from 37,868 in 1970 to 51,948 in 1990. During the 1960s, a growing number of blacks were elected to public office, often with white support. In 1967 Sam Smith, a former state legislator, was the first African American elected to the Seattle City Council. By 1970 three blacks—state senator George Flemming and state representatives Peggy Maxie and Michael Ross—represented Seattle's Thirty-seventh District in the legislature. However, black Seattle registered its most important political accomplishment to date in 1989 when Norman Rice was elected as the city's first black mayor.

REFERENCES

SALE, RODGER. *Seattle: Past to Present*. Seattle, 1976.
TAYLOR, QUINTARD. A History of Blacks in the Pacific Northwest: 1788–1970. Ph.D. diss., University of Minnesota, 1977.
———. "The Emergence of Afro-American Communities in the Pacific Northwest, 1865–1910." *Journal of Negro History* 64 (1979): 342–351.

_____. "Black Urban Development—Another View: Seattle's Central District, 1910–1940." *Pacific Historical Quarterly* 58 (1989): 429–448.

QUINTARD TAYLOR

Seaway National Bank. Seaway National Bank was opened on January 2, 1965, in a storefront at 8555 South Cottage Grove Avenue. A group of African Americans, including businessman Moses J. Proffit, who became chairman of the board of directors, and entrepreneur Ernest T. Collins, who became vice chairman, sold stock door to door and in grocery stores to raise the necessary $1 million and to ensure that local blacks would own the bank. By 1993, Seaway was the third largest black-owned commercial bank, with $211 million in assets and four branches on Chicago's South Side.

But despite its grassroots origin, Seaway has generated its profits not primarily by making loans within the black community but rather by investing in securities and making commercial loans to large companies. Seaway did not have a branch in an inner-city neighborhood until 1983, when the Federal Deposit Insurance Corporation gave it the failed Union National Bank, after having insured its accounts. Consequently, it has been criticized for making insufficient mortgage loans to low- and moderate-income families. And in 1993, after its first examination for compliance with the 1977 Community Reinvestment Act (CRA), which mandated lending in underserved areas, the Office of the Comptroller of the Currency, the chief bank regulator, gave Seaway National a "needs to improve" rating and barred it from buying other banks until it had done so.

In the early 1990s, Seaway began to face competition from larger banks, whom the federal government also pressured to comply with the CRA. In the early 1990s, Seaway entered the municipal-bond trustee business on a large scale as well as the pension fund management business, the latter of which was facilitated by a federal mandate to increase the amount of pension funds managed by minority organizations. And in 1993, in response to federal and local demands, Seaway planned to increase its mortgage lending from $2 million annually to $25 million over four years.

REFERENCE

"A New Day for Black Financial Institutions." *Black Enterprise* (June 1993): 143.

SIRAJ AHMED

Sebree, Charles (August 1914–September 27, 1985), painter, set designer, director, and playwright. Charles Sebree was born and raised in Madisonville, Ky. In 1924, he moved with his family to Chicago, where he attended the Art Institute for three years and soon became active in the flourishing black art scene on Chicago's South Side. From 1936 to 1938, Sebree painted murals in the Easel Division of the Illinois Federal Art Project. He moved to New York City in 1940, where he illustrated *The Lost Zoo* (1940), a book of poems by poet Countee CULLEN. His work to this point prompted critic Alain LOCKE to call Sebree "one of the most talented of the younger contemporary modernists." In 1941, Sebree worked as an assistant to the French expatriate painter Fernand Léger. During WORLD WAR II, he served in the U.S. Navy. His illustrations appeared in *Theater Arts* and *Mademoiselle* magazines. In 1944, he won a fellowship from the Julius Rosenwald Foundation.

Sebree's interest in European modernism and African sculpture is revealed in such early paintings as *Boy in a Blue Jacket* (1938) and *The New York Hat* (1938), which also display a uniquely personal form of somber, even mystical, expressionism. Sebree's thickly textured, Picasso-like figures possess sad, rounded eyes and solid, boldly outlined forms. His subjects also included fantasy animals and clowns. Some of Sebree's best-known work consists of small-

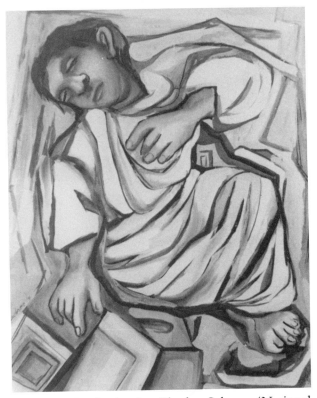

Ethiopia's Awakening by Charles Sebree. (National Archives)

scale figure paintings like *Woman with Head Scarf* (c. 1950), a watercolor on board that captures in calm, green shades the sorrowful face of a hooded woman with closed eyes. The painting invokes Byzantine icons and medieval images of female saints.

During the 1940s and '50s in New York, Sebree expanded the range of his artistic interests and became involved in the theater as a set designer, director, and playwright. Among his many theatrical projects, Sebree danced and designed sets and costumes for the Afro-Caribbean–inspired Katherine DUNHAM Dance Company. He worked for the AMERICAN NEGRO THEATRE as both the director and set designer for the 1945–1946 production of Sean O'Casey's *Juno and the Paycock* starring Harry BELAFONTE. Sebree also wrote a number of plays, including *Dry August* (1949), and, with Greer Johnson, the Broadway musical *Mrs. Patterson,* which opened in 1954 with Eartha KITT.

Sebree's early paintings were shown in numerous group exhibits of African-American art including the Renaissance Society between 1935 and 1946, the American Negro Exposition (1940), and the Chicago Art Institute (1951). In New York, Sebree exhibited at the Museum of Modern Art and at City College of New York (CCNY) (1967). From 1961 until his death in 1985, Sebree lived in Washington, D.C., where he continued to paint while teaching summer art courses at Howard University and designing sets for the Howard University Players. Interest in Sebree's paintings has increased in recent years; a small retrospective of his work was held in 1984 at the Evans-Tibb Gallery in Washington, D.C.

REFERENCES

LEWIS, JO ANN. "Solid Sebree." *Washington Post,* December 13, 1984, p. C7.
LOCKE, ALAIN. *The Negro in Art: A Pictorial Record of the Negro Artist and of the Negro Theme in Art.* Washington, D.C., 1940.
PORTER, JAMES. *Modern Negro Art.* New York, 1943.

SHIRLEY SOLOMON

Secession. The secession of eleven slaveholding states occurred in response to the election of Abraham Lincoln to the presidency in 1860. As Alexander H. Stephens, the vice president of the Confederacy, stated, the "cornerstone" of the new government rested "upon the great truth that the negro is not equal to the white man."

The idea of secession has a long history among disaffected Americans. The Constitution does not directly address the issue, so proponents could argue that secession was legal rather than revolutionary. New England Federalists during the WAR OF 1812 openly threatened secession, and, ironically, Garrisonian abolitionists (*see* ABOLITION) recommended the same course in the 1840s as a protest against SLAVERY. But proslavery Southerners supported the idea of secession as being consistent with the dominant Jeffersonian-Jacksonian belief in "states' rights."

Most southern whites viewed secession as inexpedient as long as slavery was relatively safe in the Union; but the escalating sectional tension after the MEXICAN WAR undermined that confidence. The growing northern determination that the new western territories should be "free soil" appeared ominous, and the attempt to admit California as a free state provoked serious discussion of secession. The COMPROMISE OF 1850 briefly quieted the threat, but the rise of the REPUBLICAN PARTY later in the decade added impetus to the movement. The Republican party's triumph in 1860 allowed outright secessionists to argue that the federal government now threatened slavery. Lincoln had pledged that he would not attack the institution of slavery in the southern states, but he also hoped for its "ultimate extinction."

South Carolina forced the issue, electing a secession convention that voted to dissolve the state's relation to the Union on December 20, 1860. Over the next two months, the other Deep South states voted to secede, first Mississippi, then Alabama, Florida, Georgia, Louisiana, and, finally, Texas. There was substantial resistance to immediate secession, with opponents generally campaigning under the title of "Cooperationists" or "Cooperative Secessionists." Resistance to immediate secession tended to be strongest in the areas outside the plantation belt, particularly in the mountain areas populated by white small farmers. There was also a tendency for some of the wealthiest plantation counties to vote against immediate secession.

In the eight states of the upper South, the larger concentration of nonslaveholders prevented immediate action. Most whites hoped reconciliation was possible. Only the Confederate attack on Fort Sumter in April 1861, commencing the CIVIL WAR, and President Lincoln's subsequent call for troops forced these states to choose sides. Four states—Virginia, Tennessee, Arkansas, and North Carolina—seceded, but opposition remained strong in the mountain enclaves. The northwestern part of Virginia remained in the Union, becoming West Virginia. Four other slave states, termed "border states"—Kentucky, Delaware, Missouri, and Maryland—stayed with the Union or declared neutrality.

After Fort Sumter, a wave of enthusiasm swept through the white South, and many initially dubious Southerners reconciled themselves to the breakup of

the Union. The limited support for immediate secession, however, points to the later social divisions that weakened the Confederacy.

REFERENCES

BARNEY, WILLIAM L. *The Secessionist Impulse: Alabama and Mississippi in 1860*. Princeton, N. J., 1974.

CROFTS, DANIEL W. *Reluctant Confederates: Upper South Unionists in the Secession Crisis*. Chapel Hill, N.C., 1989.

JOHNSON, MICHAEL P. *Toward a Patriarchal Republic: The Secession of Georgia*. Baton Rouge, La., 1977.

POTTER, DAVID M. *The Impending Crisis, 1848–1861*. New York, 1976.

MICHAEL W. FITZGERALD

Second Amenia Conference. *See* Amenia Conference of 1933.

Second World War. *See* World War II.

Seminole Wars. From the beginning of the eighteenth century and continuing for over a century, American Indians from various groups streamed into Spanish Florida, establishing a new identity as Seminoles. They fled there for many reasons: white expansion; violent rivalries with other Indian nations such as the Creeks; and international conflict between England, Spain, and eventually the United States. In time, these Indians became identified as *Seminoles,* a Muskogee term that means "runaways." The various groups of Seminoles cemented relationships with each other, eventually establishing loose military and political alliances.

African Americans figured prominently in this alliance in the nineteenth century, both as slaves of the Indians (who had started keeping slaves at the end of the eighteenth century) and as Maroons, African Americans who had escaped slavery in Georgia and the Carolinas and made their way to Florida (*see* MAROONAGE). As military allies and increasingly as members of the Seminole community, blacks participated in the First Seminole War (1817–1818), the Second Seminole War (1835–1842), and the Third Seminole War (1855–1858), fighting with Seminole Indians against the U.S. Army.

The number of blacks held in bondage by the Indians was small, and they usually enjoyed better treatment than from white masters. Slaves lived in their own homes, were often encouraged to marry Indians, and participated in village governance. Any offspring of slave marriages were considered free. Many Indian leaders took African wives, and by the outbreak of the Seminole Wars several Seminole leaders were of African-Indian background.

Most blacks in Florida, however, were Maroons who resided in autonomous villages where Indians were a minority. Their population received a small but steady influx of runaway slaves from southern plantations. While Florida was still under Spanish control, Spanish offers of asylum, established in the late seventeenth century, for runaway slaves willing to desert their British, and later American, masters also offered a powerful incentive for maroonage. These villages practiced communal agriculture and a religion formulated from African, European, and native American traditions. The Maroon community selected its own leaders, who were in turn recognized by the Seminoles, sitting in counsel and having an equal voice in Seminole affairs.

In early 1818, Gen. Andrew Jackson led troops into Spanish Florida, destroying several Seminole settlements in the Florida panhandle in the opening battles of the First Seminole War. After being driven out of settlements near the Appalachicola River, blacks and Indians were driven back to the Suwannee River area. Intent on both gaining territory for potential annexation and in setting a precedent for the destruction of runaway-slave communities as a deterrent for further defection, the U.S. Army burned villages, destroyed crops, and captured Seminole Indians and Maroons. Defending their livelihoods and potentially their freedom, Seminole blacks joined in the Indians' attempts at resistance. Jackson's actions drove the local population, Indian and black, to the east and south; some sought refuge as far south as the Florida Everglades.

Seminole blacks played an important role in ongoing negotiations between the U.S. government and the various Seminole chiefs. Acting as interpreters, blacks were instrumental in first facilitating and later resisting the Indian Removal Act of 1830. The act required all Native Americans in the southeastern United States to be relocated on land west of the Mississippi. Another treaty, signed by several Seminole representatives in 1833, agreed to the removal of the Seminole community from Florida to land in the Indian Territory (now Oklahoma). While initially acquiescing, the Seminoles later argued that the agreement had been coerced and that the government had acted in bad faith. They worried that the government might try to reenslave blacks aligned with them.

Sentiment against the Removal Act increased, and by 1835, Seminole raids on white settlements had

2418 SENGSTACKE, ROBERT ABBOTT

grown measurably. By the end of that year, hostilities escalated into a full-scale war that eventually resulted in the death of almost fifteen hundred American soldiers and the decimation and removal of Florida Seminoles, both Indian and black. During the first days of the Second Seminole War, the Seminoles took the offensive. On December 26 and 27, 1835, Native Americans and black forces under the Seminole King Philip raided several plantations; Seminoles under Osceola killed Wiley Thompson, the federal government's Indian agent, on December 28. At the same time, another Seminole party ambushed a U.S. Army column, possibly with the aid of the column's African-American guide, and killed almost one hundred soldiers. Throughout the war, which would eventually encompass Florida from St. Augustine to Lake Okeechobee, Seminole blacks ably served as strategists, interpreters, spies, and warriors.

By the end of 1836, Seminole black involvement was sufficient to prompt Gen. Thomas Jesup, who commanded the Army forces, to comment that the war "is a Negro and not an Indian war. . . ." He believed that if the renegade African Americans were not subdued, slavery throughout the entire South would be adversely affected. Seminole resistance, despite brave efforts, had largely faltered by 1838; much of the nation was removed to Oklahoma, taking their slaves with them. Under an agreement with Gen. Jesup, both Seminole blacks and black slaves of Seminole Indians were to be permitted to make the journey unmolested. While several slaveholders challenged this edict, they never succeeded in recovering the majority of black slaves from the Seminoles via legal measures. While token Seminole resistance would continue, fewer than five hundred Seminoles remained in Florida by 1842, when the war was officially concluded.

Despite government assurances of noninterference with Seminole slaves and Seminole blacks, life during and after emigration to Oklahoma was precarious for African Americans. During the initial emigration process after 1838, over nine hundred Seminole blacks and slaves were scheduled for removal to the Indian Territory; fewer than five hundred arrived. Some of those unaccounted for may have died, and others were probably sold into slavery again. Once in their new home west of the Mississippi, blacks were no more secure. While military officials intervened on occasion to protect the rights granted to Seminoles under the truce after the Second Seminole War, slave hunters and slave traders embarked upon numerous expeditions to kidnap groups of African Americans from their Seminole communities. Some African Americans took an opportunity offered by Wild Cat, a Seminole Indian leader, to flee to Mexico in 1850, where they eluded further pursuit.

Public and private efforts to displace the remaining Seminoles in Florida also occurred. In 1855, small groups of Seminole warriors began attacking small, isolated settlements and ambushing small groups of soldiers on patrol. After striking, the Seminole would retreat back into swampy hummocks, especially in the Everglades, which provided excellent cover. Given their dwindling supply of land and the growing public pressure to remove them, many Seminoles must have felt that fighting was the only alternative to capitulation and emigration. By the time the Third Seminole War was officially concluded in 1858, almost all of the remaining Seminoles, both Indian and black, had been killed or had departed for Oklahoma. When the last group of about 150 Seminole emigrants left Florida in 1858, only two blacks accompanied them. They joined the remnants of the Seminole community in Oklahoma. The Florida Seminoles had not been completely eradicated; descendants of those who refused to come out of hiding and emigrate remained in small numbers.

REFERENCES

LITTLEFIELD, DANIEL F. *Africans and Seminoles: From Removal to Emancipation.* Westport, Conn., 1977.

MULROY, KEVIN. *Freedom on the Border: The Seminole Maroons in Florida, the Indian Territory, Coahuila, and Texas.* Lubbock, Tex., 1993.

WATTS, JILL M. " 'We Live Not for Ourselves Only': Seminole Black Perceptions and the Second Seminole War." *UCLA Historical Journal* 7 (1986): 5–28.

JILL M. WATTS

Sengstacke, Robert Abbott (May 29, 1943–), photographer, newspaper editor, and publisher. By the time he was two years old, Robert Sengstacke was interested in drawing. Sengstacke concentrated on painting until he turned fourteen, when his father, John Sengstacke, who was publisher of the CHICAGO DEFENDER and president of Sengstacke Newspaper Enterprise, gave him a box camera, and his aunt gave him a developing set. In 1959, Sengstacke purchased another camera and an enlarger and organized a photography studio in his parents' basement. He took pictures of local high school students and worked as a freelance photographer for the *Defender*.

In 1962, Sengstacke moved to Los Angeles to attend Los Angles City College, where he studed business administration and art. He left school in 1964 and returned to Chicago to work as staff photographer for the *Defender*. Sengstacke was the first non-Muslim appointed as a staff photographer for *Muhammad Speaks* (1966–1968), the newspaper of the

NATION OF ISLAM, where he recorded significant public events and private encounters within the Nation of Islam. He also worked with the Visual Arts Workshop and the Organization of Black American Culture (OBAC) to create the *Wall of Respect* (1967), an outdoor mural located on Chicago's South Side that commemorated significant figures in African-American history.

During the 1960s, Sengstacke began to view photography as an art and as a powerful tool that African Americans could use to document their own history. The CIVIL RIGHTS MOVEMENT became the central subject of Sengstacke's photographs, and he became known for his images of such civil rights leaders as the Rev. Dr. Martin Luther KING, Jr., Jessie JACKSON, and Ralph ABERNATHY. Sengstacke also photographed demonstrators at various civil rights marches, most notably in his series on the march from Selma to Montgomery in 1965. Sengstacke was known for his ability to record intimate moments within large-scale political events.

In the summer of 1969, Sengstacke returned to school at the University of Southern California to study filmmaking. He was artist-in-residence at Fisk University from 1969 to 1971, and in 1971 he became vice president of Sengstacke Newspaper Enterprise. During that year he also worked as a photographer on assignment in Mississippi for EBONY MAGAZINE. In the mid- to late 1970s, he photographed in Syria, Egypt, Lebanon, Jordan, and Israel for the Black Press and in Jamaica for the Jamaican Board of Tourism (1974). Sengstacke received the National Newspaper Association Best News Photography Award in 1974. He became general manager of the *Tri-State Defender* in Memphis, Tenn., in 1975, and four years later was appointed editor and publisher.

During the 1980s, Sengstacke began working commercially for Eastman Kodak and the *Phil Donahue Show;* he also took on assignments for *Essence,* JET MAGAZINE, *Negro Digest, Life Magazine,* the *Washington Post,* and the *New York Times.* Sengstacke became the president of Sengstacke Newspaper Enterprise in 1988.

Since the mid-1960s, Sengstacke has exhibited in colleges throughout the United States, as well as in small public exhibits in Chicago and New York. He was the first African-American photographer from Chicago to exhibit work at the main branch of the Chicago Public Library (1969). His work also has been shown at Morehouse College in Atlanta (1970), the Chicago City Hall (1973), the University of Minnesota (1977), the William Grant Still Community Arts Center in Los Angeles (1979), the Kenkeleba House in New York (1986), and the Studio Museum in Harlem (1986). He was appointed executive editor of the *Chicago Daily Defender* in 1993.

REFERENCES

DRISKELL, DAVID. *Robert Sengstacke: Photographer.* Exhibition brochure. New York, 1974.

WILLIS-THOMAS, DEBORAH. *An Illustrated Bio-Bibliography of Black Photographers, 1940–1988.* New York, 1989.

MELISSA RACHLEFF

Sexuality. There are numerous stereotypes and at least as many myths about so-called black sexuality that have been generated in an American society permeated to a great degree by white racist beliefs. In his classic study *The Nature of Prejudice,* Gordon Allport writes:

> There is a subtle psychological reason why Negroid characteristics favor an association of ideas with sex. The Negro seems dark, mysterious, distant—yet at the same time warm and potentially accessible. Sex is forbidden; colored people are forbidden; the ideas begin to fuse. (Allport 1958, p. 351)

This ambiguous national environment has had a significant social and psychological impact on African-American sexual behavior and has profoundly distorted sexual relationships between blacks and whites. Its effects have even been seen to hamper efforts to create a functioning community of interests between the races.

Current issues in black sexuality can be traced to slavery and its aftermath. Blacks who were first brought to America's shores were stripped almost completely of their cultural heritage. Slaves were torn from their families and communities in Africa and deposited in this country without consideration for kinship ties or social relationships. No respect or understanding of African concepts of what was normal and acceptable in sex was shown by the slaveholders. Instead, the white masters, from their often hypocritical Puritan perspective, construed black sexual behavior as savage, bestial, and immoral. They were unable or unwilling to recognize the fact that while African sexual practices naturally differed from those of Western nations, a social system for sexual function was very much in evidence.

In the New World, without the structure of their own societies, black people had to find new avenues for sexual expression. Plantation life as well as the haphazard sale of slaves often prevented the formation of new family institutions, which would then influence the sexual styles of these unwilling new inhabitants. According to historical reports, sexual relations on the slave plantations were very casual and could be ended when a partner was sold or when the

white master decided to break up a slave liaison that displeased him.

However, Herbert Gutman reports in his well-documented study of the black family during slavery that although premarital intercourse was common among the slaves, it was not an indication of indiscriminate mating. Most women, he reports, had all of their children by a single father. He argues that sexual activity among slaves was not "casual," as other historians have suggested. Sexual fidelity was an expected standard among married slaves. He concludes that "no aspect of slave behavior has been more greatly misunderstood than sexual mores and practices" (Gutman 1976, p. 61).

Be that as it may, today the black community is coping with value conflicts and the legacies of slavery. Some social-science observers in low-income black communities report a strong sexual awareness among black children of elementary-school age that is not typical of middle-class youngsters, black or white. The following observation was made of black female teenagers in Harlem:

> Many ghetto daughters and mothers regard a pregnancy outside marriage as a mistake that is regrettable, but the baby is usually accepted as a member of the girl's family without stigma. Black teenage girls generally regard having a baby as a symbol of womanhood. (Silverstein and Krate 1976, p. 116)

Although the out-of-wedlock birthrate among white teenagers is on a steep rise, the attention paid to black illegitimacy rates gives the widespread impression, originating from slave times, of black sexual promiscuity. Many whites saw blacks as having not *different* morals but instead what they labeled "loose morals," an accusation that generated other black sexual stereotypes, which were passed down and today still have a significant impact on the black experience. White preoccupation with fantasies of animalistic black sexual prowess have come to profoundly influence sexual-racial politics in America.

The actual sexual behavior of blacks has been so misrepresented that it is difficult to obtain an objective scientific impression. Alfred Kinsey's classic surveys of sexual behavior in the human male and female scarcely mention the black population (*Sexual Behavior in the Human Male,* 1948; . . . *in the Human Female,* 1953). The pioneering work of Masters and Johnson (1966) in *Human Sexual Response* does not report on the small number of black subjects in their study. Scientific neglect of black sexual behavior is particularly surprising when one considers the widespread popular attention that has been focused on sexual themes in black stereotypes and black-white relationships.

It is difficult (and perhaps impossible) to categorize the sexual behavior of a whole race. In addition, statistical differences between races or groups tend to blur the extent to which races and groups behave similarly. The sexual behavior of a particular black individual will depend on many variables, primary among which are religious and class factors. Reports indicate that blacks suffer from the same type and range of sexual problems, such as impotence and orgasmic dysfunction, as whites. Rates of homosexuality (*see* GAY MEN; LESBIANS) and other alternative forms of sexual release are felt to be similar among the white and black populations. However, it is clear that sexual exploitation and sexual stereotypes remain serious issues in the behavior and psychology of black Americans.

During slavery and thereafter, many whites viewed blacks as genetically inferior and frantically condemned interracial marriage, or the "mongrelization" of the white race. At the same time, white men considered illicit and abusive sexual contact with black women as appropriate to their position of power. Many white men arranged to have both black and white women available to them, while denying the black male access to white women. Additionally, black men often could not protect their women from white men. Not surprisingly, it followed that black males were emasculated, not only sexually but economically and politically. The theme of powerlessness is central to the black experience in America and intrudes significantly in black sexual activity.

Whenever an entire racial group is degraded and oppressed, compensatory attitudes and behavior usually develop in its members. For example, some have observed that because of societal images of blacks as sexually animalistic, many blacks, particularly those in the middle class, have reacted by adopting strongly Victorian attitudes about sex. Young middle-class black females especially have been taught to follow strict moral codes in order to project an image contrary to the prevailing stereotypes.

The black woman, like the black man, evokes a lurid sexual image in the unconscious of many whites, even today. But the black woman, sought after by white men for sexual gratification, is otherwise degraded as ugly and socially undesirable. Blackness itself is still viewed as dirty. The prevailing, idealized standard of beauty continues to be the northern European blue-eyed blond. So-called Negroid features and hair are often not seen as attractive. Thus, an additional effect of racism was to cause many blacks (particularly those of darker complexion) to feel sexually unwanted.

Black women, in a society where men are still the primary aggressors in courting, not only experience the pain of being rejected by whites but, more poi-

gnantly, have often been denied approval from black men. Within the black community, there has been a color hierarchy that incorporates racist feelings and contributes to group self-hatred. Lighter-skinned black women with straight hair were frequently preferred by black men.

In addition, the black woman has had to endure the burden of the "superwoman" myth—the notion of her strength and self-sufficiency. Because she has never had the historical privilege of being "just a housewife" but has instead had to share in outside employment as well as managing a marriage and a household, she was often labeled a "matriarch" and a "mammy." These images usually connoted an overweight, loud-talking, aggressive woman who, by American standards, is sexually unattractive.

Historically, the presumed hypersexuality of blacks was seen as evidence of their bestiality. Since white men first began to explore Africa, they have returned with wild tales about the large size of black male genitalia. Currently, there are few scientific data on the size of the black penis versus the white penis. However, Laurence R. Tenzer (1990), in his review of the available literature, concludes that although there is evidence that the black penis appears slightly larger in the flaccid state, there is little difference in the erect state. He suggests that ignorance about sexuality leads white men to associate a larger flaccid penis with superior virility. In any case, it is widely accepted among sex researchers that the size of the penis per se has little to do with the sexual satisfaction of one's partner. Yet the imagined enormous dimensions of the black penis remains a preoccupation of many whites.

Since sexual prowess has a close association with aggressive behavior in any form, white control of potential black male aggression has been profound. Black male violence, particularly against whites, has been met swiftly, harshly, and often with a disregard for law and due process. Many black males through history have been summarily lynched, executed, or given overly severe prison penalties. As a result, many black males adopted a manner of docility and compliance in order to survive and be accepted in the white world. "Racial etiquette" required that black males bow, shuffle, and act like "boys." Today, there remains undue fear of black male aggression, and often that fear has obvious sexual connotations.

Black men have felt rejection both in and outside the group, but most severely in the taboo against social and sexual relations with white women. The white man's fantasy of such possible contact led to a rape complex—a paranoid fear of black male aggression. Historically, black men have been lynched for rape when they merely looked at a white woman. One report notes that in colonial times, even when black males were not actually killed, "in several colonies, the laws prescribed castration for blacks who attempted to rape white women" (D'Emilio and Freedman 1988, p. 31). Clearly, black men have had to live in a state of fear and apprehension in their contact with white women. In fact, the rape issue became such a profound symbol of the oppression of the black male that in the late 1960s, some black militants elevated the rape of a white woman by a black male to an "insurrectionary act" (Eldridge Cleaver, *Soul on Ice,* 1968). Such twisted thinking can pervade relations between blacks and whites even in the sanctity of the bedroom.

Black males have also resented the generalized notion in white society that they are all yearning to sleep with or marry a white woman. With the removal of many social barriers since the civil rights movement of the 1960s, however, there has been no rush to intermarry. As of 1990, there were approximately 211,000 black-white marriages, of which about 150,000 were made up of black men and white women (U.S. Bureau of the Census 1990, p. 143). This figure represents only about 4 percent of black married men. Nevertheless, the bottom-line appeal of ardent racists to their liberal white counterparts remains: "Would you want your daughter to marry one?"

There remains today some element of the "forbidden-fruit syndrome" in the interactions of black men and white women, and also to some extent in those of white men and black women. Abram Kardiner and Lionel Ovesey, in their 1951 psychoanalytic study of a small sample of black patients, note that "sex relations with white women have a high demonstrative value in terms of pride and prestige" (Kardiner and Ovesey 1955, p. 9). It was only in 1967 that antimiscegenation statutes were struck down by the courts; this attests to the widespread and profound fear of black-white copulation. Many social commentators point to the intense paranoia that underlies whites' fear of interracial sex. These issues have become so complex that professionals have wondered whether most interracial liaisons are pathological. The speculation itself places a stigma and an additional burden on the interracial couple.

Although black-white psychological dynamics have certainly been modified since the legal demise of segregation and the "black is beautiful" movement of the 1960s, it is certain that black-white sex relationships continue to suffer from the intrusion of psychological issues generated by racism.

In recent years, there has been an increased interest in and analysis of the effects of racism on the romantic interactions between black men and black women. Several areas of strain, particularly white beauty standards, have already been alluded to. However, some

investigators believe that the black experience has differed so significantly from white norms that black men and women sometimes have difficulty relating to each other free of the taint of defensiveness and ambivalence. Kardiner and Ovesey (1955) bluntly state that the black male uniformly has bad relations with black females on an emotional level. They attribute this difficulty to the frustrated dependency and hostility that many black males develop in female-dominated households. In 1990, about 44 percent of black families were female-headed (U.S. Bureau of the Census 1990, p. 6). Many authors suggest that black males cannot feel securely masculine because of their powerlessness in society and frequent socioeconomic failure. William H. Grier and Price M. Cobbs (*Black Rage,* 1968) express similar views about the emasculation of the black male but add that a significant problem in black male-female interactions is that the man devalues the woman because of her low caste status. Mutual respect, so crucial for a romantic partnership, may be lacking.

On the other hand, social scientists such as Andrew Billingsley (1992) and Robert B. Hill (1971) argue that these explanations are biased and stereotypical and belie the essential strength of the black family. Hill, for example, suggests that one such strength lies in the ability of family members to adapt comfortably to unusual and changing family roles. Billingsley also reports that black men and women have evolved relationships that demonstrate shared responsibility and egalitarian family roles quite different from the basic patriarchal structure of the normative white family.

Black Americans have been deeply affected in their sexual behaviors in a variety of ways that can be traced to the legacies of slavery and racism. As a result, distortions often appear in black erotic encounters with each other as well as with whites. Human sexual behavior is heavily influenced by class and socioeconomic factors; this makes it impossible to scientifically distinguish "black sexuality" or "white sexuality."

People must be cognizant of their own prejudices and of the dynamics that may be unique in the sexual activities and values of black individuals. At the same time, they must avoid any well-meaning attitudes and interpretations that are based on myth and stereotypes. Racial issues are only one factor among a host of others that must be taken into consideration when seeking to understand any individual's sexual behavior.

REFERENCES

ALLPORT, GORDON W. *The Nature of Prejudice.* Garden City, N.Y., 1958.

BILLINGSLEY, ANDREW. *Climbing Jacob's Ladder: The Enduring Legacy of African-American Families.* New York, 1992.

D'EMILIO, JOHN, and ESTELLE B. FREEDMAN. *Intimate Matters: A History of Sexuality in America.* New York, 1988.

GUTMAN, HERBERT C. *The Black Family in Slavery and Freedom, 1750–1925.* New York, 1976.

HILL, ROBERT B. *The Strengths of Black Families.* New York, 1971.

KARDINER, ABRAM, and LIONEL OVESEY. *The Mark of Oppression: Explorations in the Personality of the American Negro.* Cleveland, 1955.

SILVERSTEIN, B., and R. KRATE. *Children of the Dark Ghetto: A Developmental Psychology.* New York, 1976.

TENZER, LAWRENCE F. *A Completely New Look at Interracial Sexuality.* Manahawkin, N.J., 1990.

U.S. Bureau of the Census. *Household and Family Characteristics: March 1990 and 1989.* Washington, D.C., 1990.

ALVIN F. POUSSAINT

Seymour, William Joseph (May 2, 1870–September 28, 1922), Pentecostal minister. The son of former slaves, William J. Seymour was born in Centerville, La. Little is known about his early life, other than his Baptist upbringing. In 1895 he moved to Indianapolis and joined a black congregation of the Methodist Episcopal Church. In 1900 he went to Cincinnati, where he separated from the Methodists and joined the "Evening Light Saints" or the Church of God Reformation movement, one of a group of loosely organized, multidenominational churches that followed Holiness doctrine. The HOLINESS MOVEMENT, which began in the nineteenth century, maintained that sanctification was a necessary act of grace after conversion. While in Cincinnati, Seymour caught smallpox and lost the use of his left eye. Convinced that his survival was a sign from God, he entered the ministry and became a traveling evangelist.

In 1903 Seymour moved to Houston. He received his first pastorship in 1905 when Lucy Farrow, the pastor of the black Holiness church there, went north to work as a governess for the children of Charles F. Parham. Parham, a white man, was teaching in Kansas that baptism in the Holy Spirit consisted of speaking in tongues (glossolalia). Parham moved his Bible school to Houston later that year. Seymour tried to enroll, even though the state's segregation laws would not permit blacks and whites in the same classroom. He instead sat in the hall outside the classroom, where he could hear the lessons. Seymour brought the doctrine of speaking in tongues to Cal-

ifornia in 1906 when members of a Holiness church in Los Angeles offered him their pastorship. Seymour's insistence that glossolalia was the true sign of the Holy Spirit offended his congregation, who locked him out of the church.

Seymour continued to preach and hold meetings at the home of friends before settling into a church abandoned by an African Methodist Episcopal congregation, then being used as a stable and warehouse, at 312 Azusa Street, which became the birthplace of modern PENTECOSTALISM. A revival began there in April 1906, and by May at least a thousand people had been to the Azusa Street Mission. The revival was strengthened by the reactions to the San Francisco earthquake of April 18, giving the services a millennial urgency. The mission at Azusa Street attracted worshipers of all races from across the country. Pilgrims included Charles Harrison MASON, who took belief in glossolalia to the Church of God in Christ. Others spread the revival to Scandinavia, Canada, India, and England.

Seymour soon formalized the revival by incorporating the Pacific Apostolic Faith movement. He also published a newspaper, *The Apostolic Faith,* in which he wrestled with profound theological issues raised by the Pentecostal movement. The journal soon had an international circulation. Missions to India and Hong Kong in 1907 maintained the global influence of Pentecostalism. Between 1906 and 1915 there were reports of revivals in Jerusalem, China, Europe, Latin America, and the Pacific Islands. Women were participants at every level of the revival. The early Azusa Street movement showed a remarkable interracialism, prompting one observer to say, "The color line has been washed away by the blood." But, as with many other American religious movements, multiracial unity could not be sustained beyond the first few years, once spiritual vivacity began to wane. By 1914 the congregation at Azusa Street was all black.

Soon Seymour's leadership of the rapidly expanding and fissuring Pentecostal movement was challenged. Seymour married in 1908, causing some dissent in the church. Two important church leaders defected to Portland, Ore., taking with them the mailing list of *Apostolic Faith.* In 1914 one of Seymour's disciples from Chicago, William H. Durham, organized the Assemblies of God. In 1915 Seymour reorganized his church, and published *The Doctrine and Discipline of the Azusa Street Apostolic Faith Mission of Los Angeles.* He also formalized his leadership position in the Pacific Apostolic Faith movement with the title bishop, also providing that his successor be "a man of color." He continued as pastor of the Azusa Street Mission until his death in Los Angeles in 1922.

REFERENCES

BURGESS, STANLEY M., and GARY B. MCGEE, eds. *Dictionary of Pentecostal and Charismatic Movements.* Grand Rapids, Mich., 1988.
DUPREE, SHERRY SHERROD. *Biographical Dictionary of African-American Holiness-Pentecostals, 1880–1990.* Washington, D.C., 1989.
SYNAN, VINSON. *Holiness-Pentecostal Movement in the United States.* Grand Rapids, Mich., 1981.

LYDIA MCNEILL
ALLISON X. MILLER

Shadd, Abraham Doras (March 2, 1801–February 11, 1882), abolitionist. Abraham Shadd was born a free black in the greater Philadelphia area, where he spent his childhood. In 1819, Shadd inherited $1,000 from his father's estate and continued in his father's occupation as a shoemaker. He subsequently acquired some property in Wilmington, Del., where he lived during the 1820s. In 1833, dissatisfied with the educational opportunities available to African Americans in Delaware, Shadd moved his family to West Chester, Pa.

By 1830, Abraham Shadd had become an active abolitionist. He represented Delaware at the National Convention for the Improvement of Free People of Color in Philadelphia from 1830 to 1832. As president of the convention in 1833, he condemned the AMERICAN COLONIZATION SOCIETY for its plan to relocate free northern blacks to Africa. He emphasized instead the need for temperance societies, increased education, and the formation of manual labor schools for blacks. In the mid-1830s he offered his homes in Wilmington and West Chester to the UNDERGROUND RAILROAD to house escaped slaves.

Shadd was one of five blacks appointed to the board of managers of the AMERICAN ANTI-SLAVERY SOCIETY at its founding meeting in Philadelphia in 1833, and from the mid-1830s to the mid-1840s he was a local subscription agent for such antislavery papers as the LIBERATOR, *Emancipator, National Reformer,* and *Colored American.* Shadd, a militant advocate of African-American civil rights, helped lead an extensive protest against Pennsylvania's disfranchisement of African-American voters in the late 1830s. He also served as a leading delegate to Pennsylvania's African-American state conventions in 1841 and 1848.

The deteriorating situation for African Americans in the late 1840s and the passage of the FUGITIVE SLAVE ACT in 1850 led Shadd to endorse Canadian immigration. In 1851 he resettled his family in Ra-

leigh, Canada West (now Ontario). Shadd also served on the general board of commissioners of the National Emigration Convention, which gave support to Martin R. DELANY's Niger Valley Exploring Party in 1855.

In 1859, Shadd, an active participant in local politics, gained a seat on the Raleigh Town Council, becoming the first black to hold elected office in British North America. He remained in Canada after the Civil War. Shadd was active in politics and worked to establish Masonic lodges throughout Ontario until his death in 1882. His daughter, Mary Ann Shadd, became an educator and journalist and was the first African-American woman editor of a newspaper in North America (*see* Mary Ann Shadd CARY). A grandson, Alfred Schmitz Shadd (1870–1915), became a physician and Canadian politician.

REFERENCES

APTHEKER, HERBERT. *A Documentary History of the Negro People in the United States.* New York, 1951.

BEARDEN, JIM, and LINDA JEAN BUTLER. *Shadd: The Life and Times of Mary Shadd Cary.* Toronto, 1977.

RIPLEY, C. P. *The Black Abolitionist Papers,* Vol. 3, *The United States, 1830–1846.* Chapel Hill, N.C., 1991.

MARGARET D. JACOBS

Assata Shakur (center) escorted by police after being indicted in the May 2, 1973, slaying of State Trooper Werner Forrester in a shoot-out on the New Jersey Turnpike. (AP/Wide World Photos)

Shakur, Assata (Chesimard, Joanne Deborah Bryon) (1947–), nationalist, activist. Born in Queens, N.Y., Joanne Deborah Bryon spent her early childhood alternately with her grandparents in Wilmington, N.C., and with her mother in New York. She dropped out of high school at seventeen, but returned to college during her early twenties—attending Manhattan Community College and City College of New York. She was married for a year while in school and continued to use her married name. She became a student activist and participated in rent strikes, antiwar demonstrations, and SIT-INS, protesting racial injustices. As a reflection of her new political consciousness and her commitment to her African heritage, she changed her name to Assata ("she who struggles") Shakur ("the thankful"). The assassination of the Rev. Dr. Martin Luther KING, Jr., in 1968 precipitated Assata Shakur's embrace of the militant Black Power movement and her rejection of nonviolence.

Assata Shakur moved to Oakland, Calif., where she joined the BLACK PANTHER PARTY (BPP) in Oakland and helped organize community education programs, demonstrations, and political rallies. When she returned to New York, she became a key member of the BPP's Harlem chapter. She helped orga-

nize and staff the Free Breakfast Program for community children, oversaw the planning of a free clinic, and coordinated member health care, first aid, and community outreach.

Assata Shakur, as well as many other members of the Harlem chapter, believed that politically motivated armed actions were a viable tactic in the struggle for black liberation. It is unclear what specific actions she participated in, but she became a prime target of the FEDERAL BUREAU OF INVESTIGATION's Counterintelligence Program (COINTELPRO). Partially because of this surveillance and harassment, Assata Shakur went into hiding and became a member of the Black Liberation Army (BLA)—a clandestine nationwide network largely composed of former BPP members who had gone underground to escape criminal charges or police and FBI repression and who believed that structural change could be precipitated by armed struggle.

While underground, Assata Shakur was placed on the FBI's Most Wanted List and indicted for three bank robberies (April 5, 1971, August 23, 1971, and September 1, 1972), the kidnapping and murder of two drug dealers (December 28, 1972 and January 2, 1973) and the attempted murder of policemen on January 23, 1973. On May 2, 1973, Assata Shakur and two other BLA members were stopped on the New

Jersey turnpike by New Jersey State Troopers. After the officers discovered guns in their cars, a confrontation ensued, and Assata Shakur was shot, one state trooper suffered minor injuries, and another—Werner Forrester—was killed. Assata Shakur's companions escaped. Accounts of this incident conflict and it is unclear if Assata Shakur discharged any weapon that night. She was hospitalized and charged with Forrester's murder.

During the next four years, Assata Shakur was held in detention. The trials for the indictments brought while she was underground either ended in acquittal or were dropped due to lack of evidence. During her imprisonment, she was confined to a men's prison, placed in solitary confinement for a year, given inadequate medical attention, and faced physical abuse. While in prison she became pregnant by Kamau, her codefendant during her New York bank robbery trial, and gave birth to a girl in 1974. Assata Shakur's imprisonment and what many of her supporters believed was a false arrest brought international attention to her plight as a political prisoner.

In March 1977, Assata Shakur was convicted of murdering state trooper Werner Forrester, although medical experts testified that her injuries would have rendered her incapable of firing the fatal shot. She was imprisoned at the maximum security prison for women in Alderson, W. Va., and then moved to New Jersey's Clinton Correctional Facility for Women. Two years after her conviction, she escaped from prison and was given political asylum in Cuba. The circumstances behind the escape are unknown.

In 1987, Assata Shakur's autobiography, which chronicles her life and ideological development, was published. Although many of her activities in Cuba have been shrouded in secrecy, Assata Shakur has continued to be a vocal revolutionary nationalist in the 1980s and 1990s.

REFERENCES

SHAKUR, ASSATA. *Assata: An Autobiography*. Westport, Conn., 1987.

VAN DEBURG, WILLIAM. *New Day in Babylon: The Black Power Movement and American Culture*. Chicago, 1992.

ROBYN SPENCER

Shange, Ntozake (October 18, 1948–), playwright and performer. Ntozake Shange was born Paulette Williams in Trenton, N.J. She took the Zulu name Ntozake ("she who comes with her own things") Shange ("she who walks like a lion") in 1971. Shange grew up in an upper-middle-class family, very

involved in political and cultural activities. She earned degrees in American studies from Barnard (1970) and the University of Southern California (1973). She lives in Philadelphia with her daughter.

Shange's writing is marked by unique spelling and punctuation, partly to establish a recognizable style, like that of a musician, but also as a reaction against Western culture. Much of her work is in the form of a "choreopoem," blending music, drama, and dance. Her work is brutally honest, reflective, and intense. She writes for those whose voices have often been ignored, especially young African-American women.

Her best-known work is the play *for colored girls who have considered suicide/when the rainbow is enuf* (1976). Despite many harrowing scenes the work is essentially optimistic, showing the "infinite beauty" of black women. The play's conception took place over many years; it opened on Broadway in September 1976, and played there for almost two years before going on national and international tour.

Shange is a highly prolific author whose other published plays include *a photograph: lovers in motion, boogie woogie landscapes,* and *spell #7*, which were collected in *three pieces* (1981). Many other plays have not been published as yet, including a powerful adaptation of Bertolt Brecht's *Mother Courage* (1980).

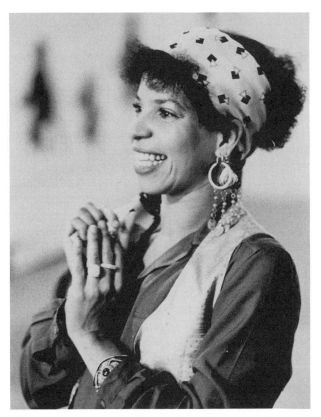

Playwright, poet, and novelist Ntozake Shange's best-known work is *for colored girls who have considered suicide/when the rainbow is enuf*. (Shawn Walker)

Her volumes of poetry include *Nappy Edges* (1978), *A Daughter's Geography* (1983), *from okra to greens* (1984), *Ridin' the Moon in Texas: Word Paintings* (1987), and *The Love Space Demands: A Continuing Saga* (1991). She has written two novels, *Sassafrass, Cypress & Indigo* (1982), and *Betsey Brown* (1985). Many of these works have also been adapted into theatrical form. Her prose is collected in *See No Evil: Prefaces, Essays, and Accounts, 1976–1983* (1984).

Shange has received many awards, including the Obie and the Outer Critics Circle awards.

REFERENCES

BROWN-GILLORY, ELIZABETH. *Their Place on the Stage: Black Women Playwrights in America*. New York, 1988.

RICHARDS, SANDRA L. "Ntozake Shange." In Valerie Smith, ed. *African American Writers*. New York, 1991, pp. 379–393.

LOUIS J. PARASCANDOLA

Sharpton, Alfred, Jr. (October 3, 1954–), political activist. Born in Brooklyn, N.Y., Al Sharpton began preaching as a Pentecostal minister at age four, and soon began touring the preaching circuit as the "wonder boy preacher." In 1964, the year his father died, Sharpton was ordained as a minister and preached at the New York World's Fair and on tour with gospel singer Mahalia JACKSON. In the late 1960s, Sharpton was attracted to Congressman Adam Clayton POWELL, JR., who became his political mentor. In 1969 he was appointed youth director of the Rev. Jesse JACKSON's Operation Breadbasket, where he arranged boycotts and led demonstrations to force employers to hire blacks.

In 1971, Sharpton formed the National Youth Movement, an outgrowth of his Operation Breadbasket activities. The next year he was the youngest delegate to attend the National Black Political Convention in Gary, Ind. In 1973, Sharpton met soul singer James BROWN and became involved in promoting him. During the next eight years Sharpton split his time among managing Brown's singing tours, trying to manage the growth and boycott activity of the National Youth Movement, and making political connections in New York's African-American community. In 1978 he ran unsuccessfully for the New York State Senate.

During the early 1980s Sharpton became a leading community activist and led marches for black political and economic empowerment. He first became widely known in 1987, when he led protests after the murder of blacks in Howard Beach, N.Y., and served as an "adviser" to Tawana Brawley, whose claim that she had been raped by white police sparked a major controversy. Sharpton was discredited by the discovery that Brawley had invented her story and by accusations that he had acted as an informant for the FEDERAL BUREAU OF INVESTIGATION. Sharpton was also indicted on charges of financial improprieties in the National Youth Movement. (In 1990 he was acquitted on the fraud charges, and in 1993 pleaded guilty to a misdemeanor charge of refusing to file a 1986 federal tax return.) He regained the spotlight when he led marches in Bensonhurst, N.Y., after the 1989 murder of a young African American, Yusef Hawkins.

During the early 1990s, Sharpton, still a controversial figure, continued his protest activity on behalf of African Americans and other causes. In January 1992 he was stabbed in the chest in a bias incident but quickly recovered. He also turned to mainstream electoral politics. In 1992 he ran in the Democratic primary for the U.S. Senate from New York. While he finished third in a bitter, four-way race, he earned praise for his refusal to attack opponents personally. In 1993 he served a well-publicized forty-five-day jail sentence that grew out of a 1988 protest march. In 1994 he ran for the state's other U.S. Senate seat. While badly beaten by the popular incumbent, Sharpton realized his own goal by attracting 25 percent of the primary vote.

REFERENCE

KLEIN, MICHAEL. *The Man Behind the Soundbite: The Real Story of Reverend Al Sharpton*. New York, 1991.

GREG ROBINSON

Shell, Arthur "Art" (November 26, 1946–), professional football player, coach. Born in Charleston, S.C., Art Shell grew up in Charleston's Daniel Jenkins Housing Project. When he was fifteen, his mother died of a heart attack, and Shell, the eldest of five children, helped manage the household while his father was at work in a papermill. In his senior year at Bonds-Wilson High School, Shell received all-state honors in football and basketball. Upon graduation, he accepted a football scholarship at Maryland State, where he played both offense and defense, and was named a Little All-American offensive tackle in his senior year (1967). At Maryland State, Shell also started three seasons at center for the school's basketball team.

Shell graduated in 1968 with a B.S. in industrial arts education. That same year, he was made a third-

round draft pick by the Oakland Raiders of the American Football League. In a professional career that would span fifteen seasons, Shell played in eight Pro Bowl games and participated in Oakland victories in Super Bowls XI and XV. An observant and thoughtful player, he began a coaching career after his retirement following the 1982 season. In 1983 he began a six-year tenure as offensive line coach of the Los Angeles Raiders after their move from Oakland. In 1989, the same year he was inducted into the Professional Football Hall of Fame for his achievements as a player, Shell was named head coach of the Raiders, thereby becoming the first African-American head coach in modern National Football League history.

REFERENCES

LIEBER, JILL. "Dreams Do Come True." *Sports Illustrated* (October 23, 1989): 74–78.
PORTER, DAVID L., ed. *The Biographical Dictionary of American Sport: Football.* Westport, Conn., 1987.

BENJAMIN K. SCOTT

Shepp, Archibald Vernon "Archie" (May 24, 1937–), tenor and soprano saxophonist and composer. Born in Fort Lauderdale, Fla., Shepp grew up in Philadelphia and began performing as a saxophonist and clarinetist while a teenager. He studied drama at Goddard College in Vermont and, after graduating, moved to New York City. Unable to support himself as an actor, he taught junior high school (1961–1963) and became active in the burgeoning avant-garde jazz and drama scenes. His raucous early style on tenor saxophone combined the stylings of hardbopper Sonny ROLLINS and swing era giant Ben Webster while pushing the harmonic and melodic limitations of improvisation. His uniquely rugged solos demonstrate his debt to the pantheon of traditional tenor players. Shepp also helped introduce a militant political activism to avant-garde jazz in the 1960s, advocating black nationalism in poems and essays, both in print ("An Artist Speaks Bluntly," *Downbeat* 32, 1965; "A View from the Inside," *Downbeat Yearbook,* 1966) and in performances during which he delivered impromptu lectures.

Shepp made his first recordings with Cecil Taylor in 1960 (*The World of Cecil Taylor;* reissued as *Air*) and in 1961 (*Into the Hot,* also with Gil Evans). That year he also performed onstage with Taylor's quartet in Jack Gelber's play *The Connection* at the Living Theater. He recorded with trumpeter Bill Dixon in 1962 and with saxophonist John Tchicai in 1963 on a series of albums as the New York Contemporary Five, including a composition dedicated to Medgar

EVERS. In 1964 he played second tenor on a now-lost recording for John COLTRANE's *A Love Supreme* and in that year recorded *Four for Trane,* an album produced by Coltrane. The next year Shepp led a sextet and a trio on *Fire Music,* which included "Malcolm, Malcolm, Semper Malcolm," dedicated to MALCOLM X. In 1967 Shepp wrote and produced a play, *Junebug Graduates Tonight!* In 1969 a group he led on a French and Algerian tour resulted in a series of controversial recordings for the Actuel series of BYG Records; with Rhasaan Roland Kirk and others he interrupted the taping of the Merv Griffin television show to demand that networks hire more black musicians. In the early 1970s, Shepp began teaching at the State University of New York at Buffalo, and in 1974 he became a member of the Afro-American Studies Department at the University of Massachusetts at Amherst.

Starting in the mid-1970s, Shepp's style became more overtly refined by his reverence for the jazz tradition. Always a lover of Ellingtonia, he also has recorded several tributes to traditional musicians and historical periods, including *Bird Fire: Tribute to Charlie Parker* (1979) and a series of spirituals in duet with pianist Horace Parlan. Shepp played piano on *Doodling* (1976) and *Maple Leaf Rag* (1978). In addition to teaching, Shepp continues to perform and record, as a leader of his own group on *Little Red Moon* (1986) as well as with vocalist Jeanne Lee on *African Moods* (1984) and duets with Dutch pianist Jasper van't Hof (1987) and bassist Richard Davis (*Body and Soul,* 1991).

REFERENCES

FREEDMAN, S. "Archie Shepp: Embracing the Jazz Ritual." *Downbeat* 49, no. 4 (1982): 22.
LITWEILER, JOHN. *The Freedom Principle: Jazz After 1958.* New York, 1984.
SMITH, B. "Archie Shepp: Four for Trane." *Coda* 204 (1985): 20.

RON WELBURN

Sherrod, Charles (January 2, 1937–), civil rights activist. The eldest of six children, Charles Sherrod was born in St. Petersburg, Va. His mother was only fourteen years old when he was born, and the family struggled to make ends meet. Sherrod worked his way through Virginia Union University in Richmond, receiving a B.A. in 1958 and a B.D. in 1961. Ordained as a Baptist minister, he later also studied at the Union Theological Seminary in New York City and the University of Georgia.

An early leader of the STUDENT NONVIOLENT CO-ORDINATING COMMITTEE (SNCC), Sherrod served as its field secretary from 1961 to 1966. In February 1961 he went to Rock Hill, Ga., with several other SNCC activists who volunteered to be arrested for sitting at a segregated lunch counter. In this first-ever "jail-in," SNCC affirmed the principle of noncooperation with evil laws. Its expression of solidarity with nine local students who had already been incarcerated also helped forge alliances of broader regional scope. Sherrod and the others set an example of dedication to the civil rights cause by refusing to post bail and serving out terms of thirty days at hard labor.

In October 1961 SNCC sent Sherrod and Cordell Reagon to Albany, Ga., to lead a drive to register voters and attack segregation. Albany had no local tradition of protest, and the two organizers first had to overcome the fear and apathy of the black population. They succeeded in doing so by reaching out to a broad constituency in the "churches, social meetings, on the streets, in the pool halls, lunchrooms, and nightclubs." On November 1, Sherrod and others were arrested at the bus terminal while testing new Interstate Commerce Commission regulations against segregation. Over the next several months, the Albany Movement, a coalition of civil rights groups, continued to hold mass rallies and demonstrations. Rev. Dr. Martin Luther KING, Jr., came twice to Albany to help draw public attention to the struggle. But by the end of the summer of 1962, the movement dissipated without achieving its goals, outmaneuvered by the local police chief plagued by several outbursts of violence, and racked by internal dissension between SNCC and King's SOUTHERN CHRISTIAN LEADERSHIP CONFERENCE (SCLC). King considered it one of his worst defeats.

Sherrod, however, continued to work in and around Albany, learning several important lessons from the 1961 campaign. The experience strengthened SNCC's commitment to making alliances with local leaders in its community-organizing efforts. Sherrod, himself a singer and songwriter, also came away with an appreciation of the role of music and freedom songs in maintaining morale and building élan in the movement. He brought a sense of religious enthusiasm and idealism to his work and recognized the central importance of efforts to promote black self-respect and freedom from fear of whites. Toward this end and also to demonstrate the feasibility of interracial cooperation, Sherrod recruited white students to assist in his voter registration drives. By 1963, however, both Sherrod's commitment to interracialism and his emphasis on the psychological dimension of the struggle were losing favor with much of SNCC. He left the organization in 1966, largely over these issues.

After leaving SNCC, Sherrod formed the Southwest Georgia Independent Voters Project, which he directed until 1987, and sought to create agricultural cooperatives in the area. Ultimately successful in desegregating Albany's downtown and in registering black voters, Sherrod was elected city commissioner in 1976. Married to Shirley M. Sherrod, he has two children, Russia and Kenyatta.

REFERENCES

CARSON, CLAYBORNE. *In Struggle: SNCC and the Black Awakening of the 1960s.* Cambridge, Mass., 1981.
GARROW, DAVID J. *Bearing the Cross.* New York, 1986.

JEANNE THEOHARIS

Shine, Ted (April 26, 1931–), playwright. Born in Baton Rouge, La., and raised in Dallas, Tex., Ted Shine received a B.A. from Howard University in 1953, and an M.A. in writing from Iowa State University in 1958. In 1960 he began his teaching career as an instructor in English and drama at Dillard University. From 1961 to 1967 he taught drama at Howard University, and in 1967 he joined the faculty at Prairie View A & M University in Texas, as chair of the drama department, where he continued to teach through the early 1990s. While at Prairie View, Shine also earned a Ph.D. in the history of criticism from the University of California at Santa Barbara in 1973.

From 1969 to 1973, Shine wrote approximately sixty scripts for Maryland Public Broadcasting's television series *Our Street*. The program was initially conceived as a means of using drama to inform citizens of community services available to them. In time, however, *Our Street* became a soap opera depicting the problems besetting the urban family. Since the 1960s Shine's plays, most of which are set in the South, have been performed in off-Broadway theaters in New York City and frequently by colleges and universities, especially in the South. His plays include *Morning, Noon and Night* (1964), *Contribution* (1969), *Flora's Kisses* (1969), *Shoes* (1969), *The Night of Baker's End* (1974), *Herbert III* (1975), *Good Old Soul* (1983), *Going Berserk* (1984), and *Deep Ellum Blues* (1986). These works have contributed to Shine's reputation for aggressive examinations of the politics of racism.

In 1977 Shine was a member of the Kennedy Center for the Performing Arts Task Force on Playwrights and Black Producing Theatres, which, in association with the American Theatre Association, supported and promoted African-American theater. He also served as adjudicator for the Lorraine Hans-

berry Playwriting Award, given by the American Theatre Association.

REFERENCES

BRASMER, WILLIAM, and DOMINICK CONSOLO eds. *Black Drama: An Anthology.* Columbus, Ohio, 1970, pp. 367–389.

HATCH, JAMES V., ed. *Black Theater, U.S.A.: Forty-five Plays by Black Americans: 1847–1974.* New York, 1974, pp. 854–863.

PETER SCHILLING

Shirley, George Irving (April 18, 1934–), opera singer. Born in Indianapolis, George Shirley grew up in Detroit and went on to become a crucial figure in the integration of numerous institutions—from the Detroit public school system to the U.S. Army chorus and, finally, to the Metropolitan Opera. Shirley learned to sing in his youth, and he received a degree in music education in 1955 from Wayne State University in Detroit. After graduation, he taught in Detroit's public schools and served from 1956 to 1959 in the Army, where he was the first African American to join the chorus. After his discharge, the young tenor made his operatic debut in the role of Eisenstein with the Turnau Opera Players in their 1959 production of Johann Strauss's *Die Fledermaus* at Woodstock, N.Y. The next year, Shirley won the American Opera auditions and he made his European debut in Milan and Florence as Rodolfo in Puccini's *La Bohème.* In 1960, he became the first African American to join the American Opera Company.

In 1961, his competition performance of "Nessun dorma" from Puccini's *Turandot* at the Metropolitan Opera auditions earned him first prize and a contract with the Metropolitan—the first African-American tenor to do so. Shirley made his Metropolitan debut singing Ferrando in Mozart's *Così Fan Tutte,* and he sang there regularly for the next eleven years. In the 1960s, Shirley appeared in the role of Alwa in Berg's *Lulu* at Santa Fe. He made his British debut in 1966 as Tamino in Mozart's *Magic Flute* at Glyndebourne and returned to Britain the next year to play Don Ottavio in Mozart's *Don Giovanni* at Covent Garden.

By the 1970s, Shirley was considered one of the most prominent tenors in opera. In addition to his work at the Metropolitan, in 1977 he created the role of Romilayu in American composer Leon Kirchner's *Lily*—based on Saul Bellow's *Henderson the Rain King*—in its New York City Opera premiere. He also appeared as Loge in Wagner's *Das Rheingold* in Berlin in 1984. Shirley has also held a number of teaching appointments at institutions including Staten Island Community College in the early 1970s, the University of Maryland from 1980 to 1987, and the University of Michigan since 1987.

REFERENCE

CHEATHAM, WALLACE. "Conversation with George Shirley: A Renowned Divo Speaks." *Black Perspective in Music* 18 (1990): 141.

A. LOUISE TOPPIN

Short, Robert Waltrip "Bobby" (September 15, 1924–), cabaret pianist and singer. Bobby Short was born in Danville, Ill., and learned to sing and play piano as a child. Before adolescence he was already well known for performing at local nightclubs and cabarets. As a young teenager, he moved to Chicago to attend school, and he also sang on the radio and in nightclubs. In 1937 he traveled to New York, where, during an engagement at the Frolic, playing songs like "Gone with the Wind" and "It's a Sin to Tell a Lie," he earned a reputation for a precocious sense of elegance and sophistication as well as a light, fresh touch on piano. Short toured throughout the United States for a decade, performing versions of jazz and pop standards by Duke ELLINGTON, the Gershwins, Cole Porter, Rodgers and Hart, and others before settling in New York in the early 1950s, where he worked in Broadway pit orchestras and appeared in such cabarets as the Blue Angel, the Living Room, and the Red Carpet. His smooth singing and stylish stage presence made him the most prominent exponent of the cabaret style of jazz-influenced pop singing. Short performed at the White House in 1970 and published a memoir, *Black and White Baby,* the following year.

Since the early 1970s Short has served as a one-man revival of the cabaret song tradition. He has also championed the songs and lyrics of lesser-known black musicians, including Andy Razaf. Short's recordings include *Songs by Bobby Short* (1956), *The Mad Twenties* (1958), *My Personal Property* (1963), *At the Café Carlyle* (1974), *Town Hall Concert* (with Mabel MERCER, 1968), and *Guess Who's in Town* (1987). Short has also appeared in such television productions as *Pins and Needles* (1966) and *Roots: the Next Generation* (1979) and in the film *Splash* (1984). In 1968 Short began to perform regularly for four months a year at New York's Café Carlyle. He lives in France for much of the rest of the year.

REFERENCES

GAVIN, JAMES. *Intimate Nights: The Golden Age of New York Cabaret.* New York, 1991.

MERKIN, RICHARD. " 'S Wonderful." *Gentlemen's Quarterly* 60 (October 1990): 94.

JONATHAN GILL

Shorter, Wayne (August 25, 1933–) jazz saxophonist and composer. Born in Newark, N.J., Wayne Shorter aspired to be a painter and sculptor before taking up the clarinet at the age of sixteen. He switched to the tenor saxophone and graduated from New York University in 1956 with a degree in music, having played in New Jersey big bands as well as sitting in with Sonny Stitt's ensemble. He worked briefly in 1956 for pianist Horace SILVER before being drafted into the army, where he served for two years. In 1958 he studied informally with saxophonist John COLTRANE and worked for trumpeter Maynard Ferguson, and in 1959 he was hired as saxophonist for Art BLAKEY's Jazz Messengers, then a unique training course for hard-bop musicians. Blakey was so impressed with Shorter's skills as a writer of compact yet creative compositions that he made him music director. It was during his four years with Blakey that Shorter developed the frank, economical style of improvisation on display on *The Big Beat* (1960), *The Witch Doctor* (1961), *The Freedom Rider* (1961), and *Free for All* (1964).

In 1964 Shorter, who had moved from Newark to New York City, joined trumpeter Miles DAVIS's quintet, a six-year stint that saw him further develop his composing style ("Footprints," "Pinocchio," "Dolores," "Nefertiti"), assume a more speechlike, agitated tone on tenor, take up the soprano saxophone, and experiment with an electrified fusion of jazz and rock music. In addition to performing on Davis albums considered central to the avant-garde movements of the 1960s (*E.S.P.*, 1965; *Miles Smiles*, 1966; *Nefertiti*, 1967; *Filles de Kilimanjaro*, 1968; *In a Silent Way*, 1969; *Bitches' Brew*, 1969), Shorter recorded numerous albums as a leader, stretching the accepted forms of hard bop (*Night Dreamer*, 1963; *Speak No Evil*, 1964; *Ju Ju*, 1964; *Adam's Apple*, 1966; *Schizophrenia*, 1967).

In 1970 Shorter, along with pianist Joe Zawinul, whom he had met working with Maynard Ferguson, broke away from Davis to form Weather Report, which helped pioneer the fusion of jazz and rock music on such albums as *Heavy Weather* (1976). During the 1970s Shorter also recorded with his own groups (*Native Dancer*, 1974) and toured and recorded (1976–1977) with V.S.O.P., a group made up of Davis's rhythm section from the early 1960s: pianist Herbie HANCOCK, bassist Ron CARTER, and drummer Tony Williams. In the 1980s and 1990s Shorter has contin-

ued to perform and record both under his own name (*Atlantis*, 1985; *Etcetera*, 1986; *Phantom Navigator*, 1987), with rock guitarist Carlos Santana (1988), and in reunion concerts with V.S.O.P. In 1986 he appeared in the film *'Round Midnight*.

REFERENCES

MEADOWS, EDDIE. "The Miles Davis/Wayne Shorter Connection: Continuity and Change." *Jazz Forschung* 20 (1988): 55–63.
WITHERDEN, B. "Wayne Shorter: The Phantom Speaks." *Wire* 38 (1987): 14.

EDDIE S. MEADOWS

Shuttlesworth, Fred L. (March 18, 1922–), minister and civil rights leader. Born in Mugler, Ala., Shuttlesworth received a B.A. from Selma University in Alabama and a B.S. from Alabama State Teachers College. He became pastor of several Baptist churches, including the First Baptist Church in Birmingham, Ala., and the Revelation Baptist Church in Cincinnati, Ohio. He involved himself with civil rights causes, including participating in an unsuccessful attempt in 1955 to secure positions for African Americans on the local police force. When the NATIONAL ASSOCIATION FOR THE ADVANCEMENT OF COLORED PEOPLE (NAACP) was banned in Alabama, he joined the ALABAMA CHRISTIAN MOVEMENT FOR HUMAN RIGHTS (ACMHR) and was elected its first president. As head of both the ACMHR and the integration movement in Birmingham, Shuttlesworth focused his attention on ending discrimination in public transportation. Although his home was destroyed by dynamite, in 1961 Shuttlesworth succeeded in overturning Birmingham's segregation law.

A believer in the Rev. Dr. Martin Luther KING, Jr.'s philosophy of nonviolent direct action, Shuttlesworth helped organize and in 1957 became a secretary of the SOUTHERN CHRISTIAN LEADERSHIP CONFERENCE (SCLC). During the spring of 1960, he aided student civil rights SIT-INS in Birmingham and was arrested for his participation. In the spring of 1963, Shuttlesworth led a major antisegregation campaign in Birmingham, which influenced passage of the 1964 Civil Rights Act. Also in 1963, Shuttlesworth received the Rosa Parks Award from SCLC. Remaining a key adviser to King in the 1960s, he was also active in the CONGRESS OF RACIAL EQUALITY (CORE) and the NAACP.

REFERENCES

LICHTENSTEIN, NELSON, ed. *Political Profiles*. New York, 1980.

PLOSKI, HARRY A. *The Negro Almanac.* New York, 1982.

NEIL GOLDSTEIN

Sickle-Cell Disease.

Sickle-cell disease is a genetically acquired disorder of the red blood cells. A person who inherits the sickle-cell gene from both parents is born with the disease; a person inheriting the gene from only one parent is a sickle-cell carrier. Sickling disorders in the United States are concentrated in areas where there are large groups of African Americans, such as the Northeast, Midwest, and rural South. Sickle-cell disease (a term preferred to the older "sickle-cell anemia") can also be found among the populations of West Africa, the Caribbean, Guyana, Panama, Brazil, Italy, Greece, and India. Eight percent of African Americans are heterozygous for the sickling gene or trait. These carriers may become ill at high altitudes, and some unexpected deaths have occurred to soldiers during extreme maneuvers. The gene for sickle-cell hemoglobin was first introduced to the Americas through the slave trade. Carriers of the disease have some immunity to the fatal form of malaria, something that proved useful to African slaves in swampy tidal regions, as in the Chesapeake and South Carolina.

The sickle cell, so called because of its bent shape, was not named until 1910, when J. B. Herrick described the blood cells of an anemic patient. In 1949 Linus Pauling discovered the chemical abnormality that causes red blood cells to become misshapen and also found the link between the sickle cell and malaria. Although the attention given the disease has increased substantially since World War II, misinformation about the illness persists and often causes discrimination against sickle-cell carriers in the insurance industry and the job market. In the 1970s the prevalence and consequences of sickle-cell disease became widely publicized in both the African-American and mainstream media.

Several organizations have been established for education and research about the disease, including the National Association for Sickle-Cell Disease, founded in 1971 in Los Angeles. Numerous hospitals have centers for the study of sickle-cell disease, including the Columbia University Comprehensive Sickle-Cell Center at Harlem Hospital in New York City, founded in 1972, and the Center for Sickle-Cell Disease at Howard University, founded by Ronald B. Scott in 1972. These organizations have undertaken extensive fund-raising campaigns for research and treatment of the illness. Government funding for research has risen since the early 1970s. Attempts to cut federal research support in the 1980s drew vehement opposition from many black organizations. In 1993 thirty-eight states and the District of Columbia required testing of newborns for sickle-cell traits.

In persons with sickle-cell disease, deoxygenated hemoglobin S causes the red blood cells in the body to assume the sickle shape. These cells cannot carry oxygen as normal red blood cells do, and they lodge in small blood vessels, causing ischemia (oxygen deficiency) and necrosis. This blockage of vessels is called vaso-occlusive crisis and gives rise to intense pain.

Symptoms of sickle-cell disease usually appear after six months of age when the last of the fetal hemoglobin, which increases oxygen supply in the blood, leaves the infant's body. Untreated, a patient may develop circulatory collapse. Such a patient is given large amounts of intravenous fluids to support circulation and prevent shock. Older patients may have pain in the larger bones, chest, back, joints, and abdomen and can develop hemorrhages into the eye and brain.

Treatment for sickle-cell patients commonly calls for pain medication ranging from oral analgesics to the injectable narcotics for pain management. Intravenous fluids are prescribed to prevent dehydration and flood the vasculature with the intention of floating the sickling cells from occluded vessels. Antibiotics are ordered for infections, and prophylactic penicillin is suggested for infants to prevent infections. Blood transfusions are not routinely recommended for short-term crises but may be indicated during prolonged episodes and when lung and central nervous system involvement is evident.

Experimental treatment for sickle-cell patients includes the use of hydroxyurea, which can increase the level of fetal hemoglobin circulating in the body. Bone-marrow transplants have been performed on some children. This remains a risky procedure, however, carrying a 5 to 10 percent mortality rate. Though no cure exists, methods of treating chronic sickle-cell patients have improved in the past twenty years. Conservative treatment methods offer a prudent course of disease management. People with sickle-cell disease, once expected to live only to their forties, now live longer and healthier lives.

REFERENCES

EDELSTEIN, STUART J. *The Sickled Cell: From Myth to Molecules.* Cambridge, Mass., 1986.

KIPLE, KENNETH F., and VIRGINIA HIMMELSTEIM KING. *Another Dimension to the Black Diaspora: Diet, Disease, and Racism.* New York, 1981.

OSKI, FRANK. *Principles and Practice to Pediatrics.* Philadelphia, 1994.

JANE M. DELUCA

Sifford, Charles L. (June 2, 1922–), golfer. Charles Sifford was born in Charlotte, N.C. Like many African Americans who were restricted from both public and private courses, he began his career in GOLF as a caddie. At thirteen, he won a ten-dollar tournament in his hometown with a score of 70. He later moved to Philadelphia, where he worked as a chauffeur and taught golf (one of his students was singer Billy ECKSTINE). He also began to compete in the UNITED GOLFERS ASSOCIATION (UGA) tournaments. The UGA was a professional association formed by African Americans in 1928, as the larger Professional Golfers Association (PGA) barred black membership. Sifford won an unprecedented number of UGA championships, including five consecutive titles between 1952 and 1956 and another in 1960. In 1957 he rose to prominence winning a predominantly white tournament, the Long Beach Open, in California. In 1961, the PGA formally dropped its restriction against black members, and Sifford began to compete frequently in PGA events. In 1964 he won the Puerto Rican Open and, three years later, the Hartford Open.

In 1969, Sifford became the first African American to win a major PGA tournament, the nationally televised Los Angeles Open. Despite his proven abilities on the course, he faced discrimination throughout his career. In the 1969 Greater Greensboro Open, in North Carolina, he was taunted by a group of spectators who threw cans of beer, shouted racial slurs, and otherwise harassed him. While these offenders were arrested, Sifford was distracted and finished out of the prize money.

Sifford later went on to be a founding member of the PGA Seniors tour. In 1975 he won the PGA Seniors Open and in 1980 the Suntree Seniors Open. Over the years he earned $339,000 on the PGA tour and $251,000 on the PGA Senior tour. He also helped to pave the way for other black professionals to enter the sport.

REFERENCES

EDWARDS, DICK. "19 Years Is a Long Time to Be in the Rough." *Black Sports* (August 1973): 32.
"Top Negro Golfer." *Ebony* (June 1956): 81.

LAWRENCE LONDINO

Charlie Sifford, 1986. (AP/Wide World Photos)

Silver, Horace (Tavares, Ward Martin) (September 28, 1928–), pianist and composer. Born in Norwalk, Conn., Horace Silver began playing tenor saxophone and piano in high school. He was influenced in his early years by bebop pianists Bud POWELL and Thelonious MONK, blues pianist Memphis Slim, and the folk music of the Cape Verde Islands, off the coast of Africa, where his father was raised.

In 1950, Silver was hired by white saxophonist Stan Getz after Getz heard him performing in a Hartford, Conn., nightclub. He worked with Getz for two years, recording his own compositions "Penny," "Potter's Luck," and "Split Kick." Starting in 1951 Silver began playing with many of New York's top soloists, including saxophonists Coleman HAWKINS, Lou Donaldson, and Lester YOUNG, drummer Art BLAKEY, and bassist Oscar PETTIFORD. In 1954 he played piano on Miles DAVIS's landmark recording of "Walkin'," a session that ushered in the earthy, swaggering descendant of bebop that came to be known as hard bop.

From 1954 to 1956 Silver, along with Blakey, co-led the Jazz Messengers, which included saxophonist Hank Mobley and trumpeter Kenny Dorham (*A Night at Birdland,* 1954). In 1956 he left the Jazz Messengers and began leading his own small groups, which became, along with Blakey's Messengers, the ultimate training ground for hard-bop musicians in the 1950s and 1960s. Instrumentalists who worked for Silver on now-classic albums (*Horace-Scope* in 1960, *The Tokyo Blues* in 1962, *Song for My Father* in 1964, *The Cape Verdean Blues* in 1965, and *Serenade to*

a Soul Sister in 1968) include tenor saxophonists Junior Cook, Joe Henderson, Stanley Turrentine, and Hank Mobley; trumpeters Donald Byrd, Art Farmer, Blue Mitchell, and Woody Shaw; and drummers Roy Brooks, Louis Hayes, and Roger Humphries.

Silver's playing and composing ("Opus de Funk," 1953; "Doodlin'," 1954; "The Preacher," 1955; "Nica's Dream," 1956; and "Filthy McNasty," 1961) exemplifies not only the energetic, driving aspects of hard bop, but also a lyrical, humorous side, using blues and gospel voicings over a strong backbeat, a style that became known as soul-jazz. Although his influence waned after the 1960s, Silver, who lives in New York, has continued to perform and record frequently (*Total Response,* 1970; *Silver 'n Voices,* 1976; *Spiritualizing the Senses,* 1983; *The Continuity of Spirit,* with the Los Angeles Modern String Orchestra, 1985; and *Music to Ease Your Disease,* 1988).

REFERENCES

MEADOWS, EDDIE. "Prolegomenon to the Music of Horace Silver." *Jazz Forschung* 18 (1986): 123–131.

WILLIAMS, MARTIN. "Horace Silver: The Meaning of Craftsmanship." In *The Jazz Tradition,* New York, 1970, pp. 148–155.

EDDIE S. MEADOWS

Simkins, Mary Modjeska Monteith

Simkins, Mary Modjeska Monteith (December 5, 1899–May 15, 1992), civil rights activist. Born in Columbia, S.C., Modjeska Monteith was the eldest child of a prominent black family who taught her independence of spirit, racial pride, and commitment to community service. A lifelong resident of Columbia, Simkins received a B.A. in 1921 from Benedict College in Columbia and taught in an elementary school until her marriage in 1929 to Andrew Whitfield Simkins, a successful black entrepreneur. The marriage gave her the financial independence to pursue her political activism.

In 1931, Simkins became director of Negro work for the South Carolina Tuberculosis Association, setting up disease-testing clinics and improving health education among blacks. She held this position until 1942, when she was forced to leave because she refused to give up her ties with the NATIONAL ASSOCIATION FOR THE ADVANCEMENT OF COLORED PEOPLE, which her employers considered subversive. In an interview conducted in 1975, she recalled, "My answer was I'd rather see a person die and go to hell with tuberculosis than to be treated how some of my people were treated."

In 1942, Simkins was elected state secretary of the South Carolina Conference of the NAACP. She was a driving force behind the landmark equal rights lawsuits the organization undertook, writing letters and publishing articles to raise funds and awareness. She was secretary of the Teachers Defense Fund in 1945, when the NAACP sued for equal pay on behalf of black teachers in the Columbia public schools. In 1951 the NAACP filed *Briggs* v. *Elliot* as a direct attack on segregation in the Columbia public schools. *Briggs* was one of several cases collectively decided by the Supreme Court in 1954, as BROWN V. BOARD OF EDUCATION OF TOPEKA, KANSAS. When the plaintiffs in *Briggs* became victims of economic reprisal, losing jobs and homes, Simkins spoke at rallies across the country, collecting goods to distribute to the needy. In 1956 she became public relations director of the black-owned Victory Savings Bank in Columbia. She subsequently served on the bank's board of directors and was one of its senior stockholders.

In 1957, Simkins left the NAACP but continued her work on the local level with such organizations as the Richland County Citizens Committee, which helped to desegregate the schools in Columbia County and improve the conditions for black patients in local mental health institutions. Her social activism continued throughout her life and covered a wide range of interests. A self-styled "independent thinker" who was frustrated with traditionally white-dominated politics, Simkins worked with alternative black-dominated third parties such as the Progressive Democratic party in the 1940s and the United Citizens party in the 1970s. She was active in the antinuclear movement, and she served as vice president of the South Carolina Coalition against the Death Penalty. On May 10, 1987, the Rev. Jesse JACKSON honored her during a speech at a benefit dinner for the AMERICAN CIVIL LIBERTIES UNION and the Carolina Resource Center. Simkins campaigned for him during his 1988 presidential bid.

After her death in May 1992, Benedict College named its research archives after her, and the Columbia branch of the NAACP established the Modjeska Simkins Scholarship Award.

REFERENCES

SALEM, DOROTHY C., ed. *African American Women: A Biographical Dictionary.* New York, 1993.

SMITH, JESSIE CARNEY, ed. *Notable Black Women.* Detroit, 1992.

WOODS, BARBARA A. "Modjeska Simkins and the South Carolina Conference of the NAACP, 1939–1957." In *Black Women in United States History,* Vol. 16. Brooklyn, N.Y., 1990, pp. 99–120.

LYDIA MCNEILL

Simmons, Jake, Jr. (January 17, 1901–March 25, 1981), businessman and civil rights leader. Jake Simmons's background was as unusual as his career: His great-grandfather, Cow Tom, was brought to Indian Territory as a slave to the Creek tribe in 1837; he rose to become one of the few black chiefs of a Native American tribe. Born near Muskogee, Okla., Simmons was raised on the fertile ground of the former Creek nation. In 1914, his father sent him to Tuskegee Institute to study under Booker T. WASHINGTON (see TUSKEGEE UNIVERSITY). Simmons emulated the great educator's entrepreneurial drive and flair for oratory, soon parlaying these skills into a career as an oil broker. Operating in the racially hostile environs of Oklahoma and East Texas, he established himself as one of the few courageous enough to defend the economic rights of African-American and Native American landowners.

As he built his dynasty, Simmons gained political power and used it to further civil rights. In 1938, he and his wife, Eva Simmons, initiated one of the earliest school desegregation cases to reach the Supreme Court. As taxpayers, the couple sued the Muskogee Board of Education in federal court to bar the sale of $500,000 in bonds on the grounds that the money raised would go solely to white schools and that "no provisions have been made for the expenditure of so much as one dollar for the direct or indirect educational benefits of any Negro child, although it is proposed for Negroes to pay taxes to discharge such bonds." Appearing before a specially convened three-judge federal circuit court, the Simmonses' attorney, Charles Chandler, presented compelling statistics to show that far more money was being spent on white schools and teachers than on black schools. The court gave the county a conditional go-ahead, and the Simmonses appealed their case to the Supreme Court.

The lawsuit tied up the bond issue for months, and powerful forces attempted to force Simmons to withdraw the lawsuit. Economic pressure and death threats were met with defiance and news that his Muskogee home was well stocked with firearms. But the Court was unwilling to tread on the ground of segregation. Ignoring the fact that the Simmons case tore apart the legal pretense of "separate but equal," in March 1939 the Supreme Court dismissed the appeal, noting that the Simmons case was "so unsubstantial as not to need further argument."

Jake Simmons became a force to be reckoned with in the Southwest; in his words, he became "a crusader for human dignity." While serving as head of the state's NAACP during the 1960s, his opinion was said to hold sway over ten thousand voters. He used his power like a regional godfather, providing jobs and guidance for countless Oklahomans.

During the 1960s Simmons became the first African-American businessman to look for oil in postcolonial Nigeria and Ghana. As a committed nationalist, he won the goodwill of African leaders (see BLACK NATIONALISM). He won important concessions for American multinationals like Phillips Petroleum, all the while helping African officials develop their investment codes. In 1978, Ghana awarded him its Grand Medal for his role in creating and sustaining the country's oil industry. His millionaire's fortune was built upon the percentages he received on oil deals in Africa and across the Southwest United States. He often told his sons, "How the hell can a black man stay in bed in the morning when white men rule the world?" and he lived by those words until his death, in 1981, in Muskogee, Okla.

REFERENCE

GREENBERG, JONATHAN D. *Staking a Claim: Jake Simmons and the Making of an African-American Oil Dynasty.* New York, 1990.

JONATHAN D. GREENBERG

Simmons, William J. (June 26, 1849–October 30, 1890), clergyman and writer. William J. Simmons was born in Charleston, S.C., the son of slaves, Edward and Esther Simmons. Early in his childhood, his mother fled north with her three children, and they lived successively in Philadelphia; Roxbury, Mass.; and Chester, Pa. The family finally settled in Bordentown, N.J., and at the age of twelve, William Simmons became the assistant to a white dentist. After unsuccessfully attempting to enroll in a dental school, he enlisted in the Union Army at the age of fifteen and fought in several engagements in Virginia.

Returning to Bordentown from the war, Simmons joined a white Baptist church and decided to study for the ministry. He earned a B.A. from Howard University in 1873 and, in 1881, an M.A. During this time, he taught at two local schools, as well as becoming an ordained minister. In 1874, he married Josephine A. Silence of Washington, D.C., and they were the parents of seven children.

In 1879, Simmons left with his family for Lexington, Ky., to become pastor of the First Baptist Church. There he quickly rose to prominence in both educational and religious circles, editing the *American Baptist* and restructuring the Normal and Theological Institution into the State University of Kentucky, Louisville. He advocated both industrial and academic education for African-American youth in the South and remained throughout his life a sharp critic of Jim Crow practices and racial exclusion from state

jobs. In 1887, Simmons wrote *Men of Mark: Eminent, Progressive, and Rising,* a biographical encyclopedia that he hoped would encourage black youth. A second volume on distinguished African-American women never came to fruition because of his death at age forty-one on October 30, 1890.

REFERENCES

ADAMS, RUSSELL. *Great Negroes Past and Present.* Chicago, 1969.

SIMMONS, WILLIAM J. *Men of Mark.* 1887. Reprint. New York, 1968.

DAVID B. IGLER

Simone, Nina (Waymon, Eunice Kathleen)

(February 21, 1933–), singer. Born in Tryon, N.C., Simone was encouraged to study piano and organ starting at age three by her mother, an ordained black Methodist minister. She was soon able to play hymns on the organ by ear, and at age six she became the regular pianist at her family's church. She studied privately, as well as at Asheville (N.C.) High School, to become a classical pianist. She also studied at the Curtis Institute of Music in Philadelphia (1950–1953) and the Juilliard School in New York (1954–1956). Simone's career as a vocalist, which spans more than three decades and more than forty albums, came almost by accident, when during a 1954 nightclub engagement in Atlantic City, N.J., she was informed that in addition to playing piano she would have to sing. She adopted the stage name Nina Simone for this occasion, which marked the beginning of her career as a jazz singer.

From the very start, Simone chafed under the restrictions of the label "jazz singer," and indeed, her mature style integrates classical piano techniques with a repertory drawn from sources as varied as the blues and folk music (*Jazz as Played,* 1958). Early in her career, Simone also began addressing racial problems in the United States. In 1963, angered by the death of Medgar EVERS, and the bombing of an African-American church in Birmingham, Ala., she composed her first civil rights anthem, "Mississippi Goddam," and during the next decade much of her work was explicitly dedicated to the civil rights movement, sung in her forceful and clear alto voice. In 1963 she composed "Four Women" with Langston HUGHES. Her other popular songs from this time include "Young, Gifted, and Black," "Old Jim Crow," and "Don't Let Me Be Misunderstood." In the 1970s Simone continued to perform internationally and record (*Baltimore,* 1978). Starting in the late 1970s she divided her time between Los Angeles and Switzer-land. In more recent years she has lived in Paris, but she continues to appear regularly in New York. In 1987 she released *Let It Be Me.* Her autobiography, *I Put a Spell on You,* was published in 1991.

REFERENCE

SIMONE, NINA. *I Put a Spell on You.* New York, 1991.

ROSITA M. SANDS

Simpson, Coreen

(February 18, 1942–), photographer. Coreen Simpson was born in New York City and was raised with her brother in a foster home after her mother, who was Jewish, and her father, who was black, were divorced. Simpson became interested in photography as an adult when she was writing magazine articles and was dissatisfied with her editors' selection of images. From Walter Johnson, a local neighborhood photographer, and Frank Stewart, who taught at the Studio Museum in Harlem, Simpson learned how to use a camera, print her work, and recognize the styles of well-known photographers.

Simpson started her career as a photographer by covering fashion and cultural events for the *Village Voice* and the AMSTERDAM NEWS in the early 1980s. She has provided extensive coverage of fashion shows in New York and Paris, and has photographed a diverse selection of cultural events in black communities including the Black Muslim convention at the Felt Forum in New York in 1985, the Rev. Jesse JACKSON's Rainbow Coalition eight-nation African tour in 1986, and the funeral of writer James BALDWIN in 1988.

In the early 1980s, Simpson became interested in documenting Harlem at night, particularly the patrons and performers in the neighborhood's nightclubs. Her portrait series *B-Boys* (or *Break-Boys*) features large-scale prints (three by five feet) documenting the hairstyles and fashions worn by fans of hip-hop and RAP music at night spots such as New York's Roxy Club during the 1980s (*Portrait of Vic,* 1986). Simpson has been compared to photographers Diane Arbus and Weegee for her ability to present uncommon individuals with depth of character and dignity in her portraits of punk rockers, transvestites, and cooks in Harlem's restaurants (*Portrait of Velma Jones,* 1978). Simpson also became an active jewelry maker in the early 1980s, selling her pieces outdoors on Fifty-seventh Street and in New York City department stores.

In the late 1980s, Simpson began recombining the *B-Boy* portraits, creating collages, several of which were exhibited at the Studio Museum in Harlem in

In the 1970s and '80s Coreen Simpson provided one of the more vivid photographic accounts of black life in New York City. She has since gone on to acclaim as a maker of collages. Her photograph of Richard Mayhew dates from 1978. (The Studio Museum in Harlem)

1989. Simpson continued to draw upon the *B-Boys* series, as well as upon African traditions in the construction of headdresses and masks, in her project *Aboutface*, which was exhibited at the Jamaica Arts Center in New York in 1992. *Aboutface* looks at the relationship between identity and stylized self-presentation through the artist's symbolic use of masking. Simpson superimposes an individual's facial parts, as well as objects or patterns, onto the visage of someone else to show how the body is a site for adornment and performance.

Simpson's work has been shown in solo and group exhibitions at the Smithsonian Institution (1978–80), the Studio Museum in Harlem (1979, 1989), the Brooklyn Museum (1982), the Schomburg Center for Research in Black Culture (1982), the Tompkins Square Gallery in New York City (1988), and the Jamaica Arts Center in Queens, New York (1992).

She was photographer-in-residence at the Studio Museum in Harlem (1978), Atlanta University (1981), and the Jamaica Arts Center (1991). Her photographs have been featured in such publications as *Vogue, Black Enterprise, American Art, Art News, Glamour, Ms.,* and *Essence.*

REFERENCES

Aboutface: New Works by Coreen Simpson. New York, 1992.
BILLOPS, CAMILLE. "Coreen Simpson." *Artists and Influence* 4 (1986): 103–114.
BIRT, ROGER. "Coreen Simpson: An Interpretation." *Black American Literature Forum* 21, no. 3 (Fall, 1987): 27–29, 292–304.

MELISSA RACHLEFF

Simpson, Lorna (1960–), photographer. Born in Brooklyn, N.Y., Lorna Simpson enrolled as an undergraduate at the School of Visual Arts in New York City to study painting. She soon turned to documentary photography and received a B.F.A. in photography from the school in 1982. In 1985 Simpson earned an M.F.A. degree in visual arts from the University of California–San Diego (UCSD), where she also studied and taught film and became involved in performance art. Her first large-scale series of photographs, *Gestures and Reenactments* (1985), launched her ongoing project of rethinking the relationships among photographic images, textual description, and the representation of African Americans, particularly women.

Simpson's work reflects an awareness of the ways in which photography has been traditionally used by the social sciences and the media to classify, study, objectify, and ultimately control black men and women. In large multipaneled or sequential works such as *You're Fine* (1988), *Stereo Styles* (1988), and *Guarded Conditions* (1989), Simpson typically presents a black Everywoman with her back turned to the viewer or her face deliberately obscured by cropping; the viewer is thus effectively denied access to the woman's identity and inner psychological state. Instead, Simpson provides clues as to subjective meaning in the accompanying captions, which usually refer to issues of gender and racial oppression. In contrast to the neutral, carefully controlled tone of her photographs, Simpson's captions can be emotionally charged, thereby creating an interpretive tension between word and image. In *You're Fine* Simpson presents an anonymous black woman lying on her side in a simple white shift, her back turned away from the viewer in a pose that recalls the reclining

Lorna Simpson. (Allford/Trotman Associates)

pose of the nineteenth-century female nude. The ominous text comments on the invasive and objectifying qualities of public surveillance.

Social commentary also informs Simpson's *Stereo Styles,* which consists of ten Polaroid prints in two tiers; each print shows the back of the same black woman's head done in a different hairstyle. Simpson here comments on the popular idea expressed in cosmetics advertisements that hairstyles can communicate personality traits. Since 1988 Simpson has abstracted the female body even further and combined its parts with such symbolic objects as African masks, black hair, and articles of women's clothing (*Flipside* 1991; *1978–1988,* 1990; *Bio,* 1992).

In 1991 Simpson created *Five Rooms* with composer Alva Rogers, a site-specific, multimedia installation for the 1991 Spoleto Festival U.S. exhibition in Charleston, S.C., which presented a narrative of black slavery in America. She created another installation, *Standing in the Water,* for the Whitney Museum of American Art in New York City in 1994. Simpson's work has been shown in more than ninety major exhibitions throughout the United States and Europe; sites of solo exhibits include the Museum of Modern Art (1990) and the Museum of Contemporary Art, Chicago (1992–1993), both of which have also acquired her work. Simpson was the first African-American woman ever chosen to exhibit in the Venice Biennale (1990).

REFERENCES

WILLIS, DEBORAH. *Lorna Simpson: Untitled 54.* San Francisco, 1992.

WRIGHT, BERYL J. *Lorna Simpson: For the Sake of the Viewer.* Chicago, 1992.

DEIRDRE A. SCOTT

Simpson, Merton Daniel (September 20, 1928–), African art dealer and painter. Merton Simpson was born in Charleston, S.C. As a child, he painted and played saxophone. He took art classes with William Halsey at the University of Charleston in the late 1940s. He moved to New York in 1949, and from 1949 to 1951, he attended Cooper Union, where he studied with Robert Motherwell and Robert Gwathmey. He also attended New York University, studying with William Baziotes from 1949 to 1951 while working as a frame carver in a frame shop.

Simpson became acquainted with the world of galleries while living in Charleston when he asked William Halsey, a local artist and gallery owner, for criticism and instruction on some of his paintings. He learned about African art by spending time in Julius Carlebach's gallery in New York and began trading African art as a way to support his family. In 1949, while a student in New York, Simpson purchased his first African carving, a Bakongo fetish, for $150, paying for it over a three-month period. Because Simpson had no money and no collateral, he had to work with dealers who were willing to wait at least four weeks for payment, giving Simpson enough time to find a buyer for each valuable piece.

From 1951 to 1954, Simpson concentrated on his own art work when he served as an artist in the Special Services division of the U.S. Air Force. His best-known painting from this period was a portrait of President Dwight D. Eisenhower (1952). Simpson also played saxophone in the Air Force Band. During the 1950s, Simpson's paintings were featured in several solo exhibitions at the Gibbes Gallery from 1952 to 1956, but his primary occupation, when he returned to civilian life, was collecting and selling African art.

Simpson opened his first gallery, on Madison Avenue and Seventy-ninth Street, in the early 1960s and became one of the most trusted and respected dealers in art from African, Oceanic, and American Indian cultures. In 1967, Simpson's gallery relocated to an inauspicious third-floor walk-up at Eightieth Street and Madison Avenue. Here, visitors have been able to view Simpson's latest purchases, many of which were created in the third and fourth centuries, some as recently as the 1940s. Simpson personally owns less than a dozen pieces and avoids competing with clients to obtain rare items. In 1978, at a Sothe-

by's auction in London, Simpson bid $333,000 for a thirteen-and-a-half inch Oceanic work, a Pentecost Island mask made of wood, which he continues to hold in his sparse but valuable personal collection. With a serious clientele of approximately twenty buyers, Simpson's pieces cost between $500 and $50,000.

Simpson's own paintings have been exhibited throughout his career as an art dealer. His work has been shown in solo exhibitions at the Krasner Gallery, New York (1960); Edward Merrin Gallery, New York (1978); Allan Stone Gallery, New York (1983); and the Noir d'Ivoire Gallery, Paris (1992).

REFERENCES

DUDAR, HELEN. "No. 1 in Primitive Art." *Connoisseur* (March 1982): 20–22.
HOLLINGSWORTH, A. C. "Merton Simpson/Artist." *Black Art: An International Quarterly* 3, no. 2 (1979): 21–29.

TAMARA L. FELTON

Simpson, Orenthal James "O. J."

Simpson, Orenthal James "O. J." (July 9, 1947–), football player. O. J. Simpson was born in San Francisco and starred in football, baseball, and track at Galileo High School. After graduating in 1965, Simpson enrolled at City College of San Francisco, where he set several junior-college football rushing records in two seasons. In 1967 the highly recruited halfback transferred to the University of Southern California (USC).

At USC, Simpson emerged as a national star, displaying tremendous speed and open-field running abilities. In two seasons he carried the ball 649 times for 3,295 yards and 34 touchdowns, led USC to a national championship in 1967, and won the Heisman Memorial Trophy in 1968.

Simpson was selected first overall by the American Football League's Buffalo Bills in the 1969 professional football draft. He failed to live up to expectations in his first three years with Buffalo, but in 1972 he rushed for 1,251 yards and established himself as one of the National Football League's best running backs. The following season Simpson rushed for 2,003 yards, becoming the first player to rush for more than 2,000 yards in one season. He rushed for more than 1,000 yards in each of his next four seasons with Buffalo, and in 1976 he set a single-game rushing record with 273 yards gained against the Detroit Lions. After that year, Simpson's statistics declined, and following the 1977 season he was traded to the San Francisco Forty-niners, where he spent the final two years of his football career. Simpson retired in 1979 with a professional rushing record of 2,404 carries for 11,236 yards and 61 touchdowns. He was inducted into the NFL Hall of Fame in 1985.

Following his retirement from football, Simpson lived in Los Angeles and capitalized on his good looks and polished public persona by launching a successful career in television, film, and advertising. He appeared in several made-for-television and feature films, including *Roots* (1977) and three *Naked Gun* films (1988, 1991, 1993), served as a network sports commentator, and was featured in commercials.

Simpson became the center of a sensational murder case when his former wife, Nicole Brown, and a male friend of hers were stabbed to death in Los Angeles on June 12, 1994. Suspicion focused on Simpson, who led the police on a nationally televised car chase before surrendering at his home in a Los Angeles suburb. He was subsequently indicted and pleaded not guilty to both counts of murder. In the avalanche of publicity surrounding the case, some disquieting information about Simpson was revealed, including a pattern of wife abuse that included a little-publicized 1989 conviction for spousal battery. Information also surfaced later about possible police misconduct in the investigation of the case. After a lengthy pretrial hearing, a protracted jury selection process, and an eight-month trial, he was acquitted of all charges on October 3, 1995.

REFERENCES

ASHE, ARTHUR R., JR. *A Hard Road to Glory: A History of the African-American Athlete Since 1946.* New York, 1988.
HAMILTON, WILLIAM. "O. J. Simpson Surrenders After Freeway Drama." *Washington Post,* June 18, 1994, p. A1.
PORTER, DAVID L., ed. *Biographical Dictionary of American Sports: Football.* Westport, Conn., 1988.

THADDEUS RUSSELL

Simpson, William H.

Simpson, William H. (c. 1830–1872), painter. Little is known today of the life of the portrait painter William H. Simpson, although he was an active and successful artist in the northeastern United States between 1858 and 1872. According to his colleague, author and abolitionist William Wells BROWN, Simpson was born and educated in Buffalo, N.Y. Simpson's talent surfaced early, and as a boy, he was often punished for pursuing his art rather than his homework. After an elementary education, Simpson worked as an errand boy for the white artist Mathew Wilson.

Wilson soon discovered Simpson's talent and made him an apprentice in his studio. This apprenticeship was apparently the sum total of Simpson's formal artistic education. By 1855 both Wilson and Simpson had moved from Buffalo to Boston, Mass., and in

1858 Simpson listed himself in the city directory as an artist.

Simpson was an active member of Boston's African-American community. Along with fellow artist Edward Mitchell BANNISTER and community leaders William Cooper NELL and George Ruffin, Simpson was a member of both the Histrionic Club and the Crispus Attucks Choir, performing at social and political functions in the black community. Like Bannister, Simpson, and framer Jacob Andrews, he lived for several years at the boardinghouse of Lewis Hayden, which was an active stop on the UNDERGROUND RAILROAD. Brown also noted that Simpson contributed to his community's efforts to end slavery and win citizenship for black Americans.

In 1859 Simpson opened his own studio at 42-44 Court Street. By the 1860s his fame as a portraitist had grown, and he won commissions throughout the eastern United States and in Canada. In 1864 Simpson executed a portrait of Massachusetts Governor John Albion Andrew, who helped organize the first black Civil War regiment in the North. The abolitionist newspaper the *Liberator* described how the portrait was presented to the governor in a ceremony organized by Boston's black abolitionists. A year later, Boston's African-American Masonic Lodge commissioned him to paint a portrait of the recently deceased leader John T. Hilton. Abolitionist Senator Charles Sumner also sat for his portrait in the studio of the young artist.

Although most of Simpson's works have been lost, a pair of paintings, portraying Bishop Jermain Wesley LOGUEN and his wife, Caroline Loguen, exist in the collection of the Howard University Gallery of Art in Washington, D.C. Loguen, a fugitive slave, became the New York Bishop of the African Methodist Episcopal Church, and an ardent fighter against slavery.

Sometime between 1863 and 1872, Simpson painted another pair of portraits—of Burwell and Charity Banks, prominent Baltimore citizens—which are on exhibit at the Banneker Museum in Annapolis, Maryland.

George Forbes, a turn-of-the-century African-American author who wrote about Simpson's career, remarked on the many Simpson portraits owned by prominent families in the Northeast. Forbes also noted that Simpson moved to Chicago at the beginning of the 1870s. He died there in 1872.

REFERENCES

BROWN, WILLIAM WELLS. "William H. Simpson." In *The Rising Sun; or, Antecedents and Advancement of the Colored Race*. Boston, 1874, pp. 478–481.

FORBES, GEORGE. *E.M. Bannister with Sketch of Earlier Artists*. Boston Public Library. Boston.

JUANITA MARIE HOLLAND

Sims, Howard "Sandman" (c. 1925–), tap dancer. Born Howard Bernard in Los Angeles, raised in a family of tap dancers, and having neither the money nor the inclination for dancing school, Sims learned to dance on the streets of Los Angeles under the tutelage of his older brother. He went to New York City in 1946 to become a boxer; while warming his feet, he used to delight his spectators by dancing in a rosin box. After breaking his hand in a bout, Sims turned to dance. He started performing in a specially constructed, slightly concave box that he designed. By developing this technique, Sims turned a boxing tool into a dance arena.

Sims used the gritty sounds of sand grating against the wood to enhance the rhythm of his movements. He became a well-known sand dancer, admired by audiences for his athletic, virtuosic style and for the clarity and odd syncopations of his percussions. For seventeen years he performed at Harlem's APOLLO THEATER as a comedian, playing Pepe, the rambunctious character who hooks performers offstage with a long cane when they are booed off the boards during the theater's famous Amateur Night. As a dancer, he toured with the big bands of Duke ELLINGTON, Count BASIE, and Lionel HAMPTON. Sims is featured in George Nierenberg's 1979 documentary film *No Maps on My Taps* and appeared in the 1989 film *Taps*. In 1990 he was featured at an evening of tap dancing at the Apollo Theater.

REFERENCE

SINCLAIR, ABIOLA. "Looking at Greg's Mentor, Sandman." *Amsterdam News,* February 25, 1989.

CONSTANCE VALIS HILL

Singleton, Arthur James "Zutty" (May 14, 1898–July 14, 1975), drummer, bandleader. Born in Bunkie, La., Singleton moved to New Orleans around age ten and was playing drums and percussion accompaniment for silent movies by age fifteen. After serving in the Navy during World War I, he returned to New Orleans, where he performed with Papa Celestin, Luis Russell, Louis "Big Eye" Nelson, and John Robichaux. From 1921 to 1923 he performed with Fate Marable's riverboat bands and made his first recording with Marble in 1924 ("Frankie and Johnny"). The next year Singleton recorded with Charlie Creath in St. Louis, then he moved to Chicago, where he worked with Doc Cooke, Jimmie Noone, Dave Peyton, and Clarence Jones.

Singleton's recordings with Louis Armstrong's Hot Seven ("Muggles") in 1928 and as part of a trio with "Jelly Roll" MORTON and Barney BIGARD ("My

Little Dixie Home") in 1929 established his professional reputation; his style was grounded in both the jazz and marching band traditions of New Orleans, as well as in his early experiences as a silent movie accompanist. Along with Warren "Baby" Dodds, Singleton brought New Orleans dance drumming north, helping to spawn the jazz style known as the Chicago school. His distinctive use of the full array of percussive timbres on his early recordings includes some of the first recorded performances with wire brushes and the sock cymbal. Singleton is also credited with being among the first drummers to play extended solos.

While touring with Carroll Dickerson in the late 1920s, Singleton resettled in New York, where he worked with Fats WALLER, Bubber MILEY, and Otto Hardwick and led his own groups. During the 1930s and early 1940s, while he lived in Los Angeles, Singleton's drumming began to incorporate swing elements, and he worked in a variety of groups, including those led by Fats Waller ("Moppin' and Boppin'," 1944), and Sidney BECHET, Roy ELDRIDGE, Slim Gaillard, Dizzy GILLESPIE, and Charlie PARKER. He also led his own groups and worked in television and films, including *Stormy Weather* (1943), *New Orleans*, and *Love That Brute* (1950). From 1951 to 1953 he toured Europe and North Africa and then returned New York, where he continued to perform and record (*Zutty and the Clarinet Kings*, 1967) until 1970, when he suffered a stroke that led to his retirement. He died in New York in 1976.

REFERENCES

JONES, M. "Satchmo's Master Drummer." *Melody Maker* 1, no. 26 (July 26, 1975): 29.
WILLIAMS, MARTIN. "Zutty Singleton: The Pioneer Jazz Forgot." *Downbeat* 30, no. 30 (1963): 18.

ANTHONY BROWN

Singleton, Benjamin "Pap" (c. 1809–1892), migrationist. Little is known about Benjamin "Pap" Singleton's life before the 1870s. He was born and raised a slave in Nashville but escaped to Canada as a young adult, stayed there briefly, and then settled in Detroit, where he worked as a scavenger and ran a boarding house that was often used by fugitive slaves.

After the end of the CIVIL WAR, Singleton returned to the Nashville area, worked as a carpenter and coffin maker, and began what he saw as his mission to deliver black people from the former slave states. During the late 1860s and '70s, many of the coffins Singleton made were for victims of the racist violence prevalent during RECONSTRUCTION. He later

cited this as the reason for his urgent desire to see former slaves leave what he considered the irredeemable South. Throughout his career Singleton considered himself a messianic leader created by God to lead his people to an all-black promised land on earth.

In the late 1860s Singleton, along with W. A. Sizemore and Columbus Johnson, urged black Tennesseans to acquire land in rural parts of the state and establish independent farms. Faced with white landowners who refused to sell to African Americans at affordable prices, Singleton and his allies looked to westward migration as the only hope for freedom. They conducted a scouting tour of Kansas, returned to Nashville, and touted the western state as the best location for African-American settlement. Several black families from Nashville took up Singleton's call and moved to Kansas in the early 1870s.

In 1874 Singleton and Johnson issued fliers throughout the Nashville area urging African Americans to emigrate to Kansas. Between 1877 and 1879 Singleton and his associates settled hundreds of black families in Kansas colonies. In 1879, when the largely spontaneous, mass migration to Kansas by former slaves from Mississippi, Louisiana, and Texas began,

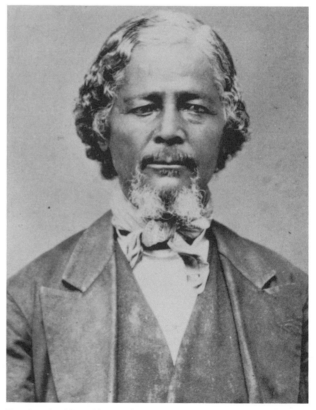

Benjamin "Pap" Singleton. (Photographs and Prints Division, Schomburg Center for Research in Black Culture, The New York Public Library, Astor, Lenox and Tilden Foundations)

the EXODUSTERS filled Singleton's colonies and overwhelmed his movement.

In 1880, while living in one of his own colonies, Singleton was vaulted to fame when he was called to testify before a Senate committee investigating the exodus. Countering charges made by Democratic committee members that the entire migration was merely a plot by Republicans to win political control in western states, Singleton exclaimed, "I am the whole cause of the migration. Nobody but me. I am the Moses of the colored exodus!" In fact, the mass settlement of approximately twenty thousand former slaves in Kansas lacked any one leader or central organization and originated in states Singleton had not attempted to organize. It is likely, however, that Singleton's work in bringing the first families to Kansas may have partly inspired the 1879 exodus.

In 1881 Singleton led a short-lived movement in Topeka to establish a racially integrated, cooperative economy. The organization Singleton founded to achieve this purpose, the United Colored Links, attempted to form a coalition with the white Greenback party but folded in less than a year.

In 1883 Singleton moved his focus to international migration and selected Cyprus as the next destination of the black exodus. His new organization for settlement in Cyprus, the Chief League, failed to accomplish its original goal and in 1885 was reorganized by Singleton into the Trans-Atlantic Society. Reflecting Singleton's turn toward a more pronounced black nationalism, the Trans-Atlantic Society declared its commitment to returning former slaves to Africa in order to establish "a separate national existence." There are no records of the Trans-Atlantic Society after 1887, when Singleton fell into obscurity. He died in St. Louis in 1892 after a long spell of ill health.

REFERENCES

BONTEMPS, ARNA, and JACK CONROY. *Anyplace but Here*. 1945. Reprint. New York, 1966.

PAINTER, NELL IRVIN. *Exodusters: Black Migration to Kansas After Reconstruction*. New York, 1977.

THADDEUS RUSSELL

Sissle, Noble (July 10, 1889–December 17, 1975), musician. Noble Sissle was born in Indianapolis, Ind. He began singing soprano as a boy in his father's Methodist church and became a tenor soloist in the Central High School Glee Club of Cleveland. His first singing job was with Edward Thomas's Male Quartet, which performed throughout the Midwest. Sissle entered DePaul University for a short term (1913) and transferred to Butler University in India-

napolis (1914–1915). He later became a vocalist for Joe Porter's Serenaders at River View Park in Baltimore.

Sissle went to New York to join James Reese EUROPE's Society Dance Orchestra in 1916. They both enlisted in the Army during WORLD WAR I, and Europe organized the 369th Infantry Regimental Band with Sissle as drum major. Sissle went overseas with the band.

After Europe's death in May 1919, Sissle joined "Eubie" BLAKE and toured the vaudeville circuit with the Dixie Duo—one of the first black acts to play without burnt cork. Sissle and Blake later teamed with Flournoy Miller and Aubrey Lyles to produce the highly successful comedy *Shuffle Along,* which opened in New York in 1921 and ran for 504 performances. Its cast included Josephine BAKER, Florence MILLS, and Paul ROBESON. Sissle and Blake's best-known songs from this show were "I'm Just Wild About Harry" and "Love Will Find a Way." They collaborated in the production of other musicals such as *Runnin' Wild* (1924), *Chocolate Dandies* (1924), and *Shuffle Along of 1933.*

In 1925 Sissle and Blake returned to vaudeville and toured abroad. The partnership later dissolved, and Sissle performed as a soloist in Europe.

In 1928 Sissle formed an orchestra that performed in Europe and the United States well into the mid-1950s. He was also active in professional organizations and was a founder of the Negro Actors' Guild in 1937 and its first president. During WORLD WAR II, Sissle toured Europe with a USO show, doing a restaged version of *Shuffle Along* (1945–1946). He helped influence a generation of musical comedy. *Shuffle Along* was probably the most successful, influential, and widely disseminated work of musical theater written and performed by American blacks (*see* MUSIC; MUSICAL THEATER).

REFERENCE

KIMBALL, ROBERT, and WILLIAM BOLCOM. *Reminiscing with Sissle and Blake*. New York, 1973.

MARVA GRIFFIN CARTER

Sisters of the Holy Family. Sisters of the Holy Family, one of the earliest religious orders of black women in America, was founded in 1842 by Henriette Delille in New Orleans, La. Delille was an educated free woman of African descent who had worked with Sister Ste. Marthe Fontier and Marie Jeanne Aliquot, two Catholic women from France who went to New Orleans in the 1820s to serve the black community. Their efforts to form an integrated

religious community were unsuccessful because of state segregation laws. In the late 1820s, Delille and Juliette Gaudin, a Cuban-born woman of African descent, continued their service to the black community by teaching religion to slaves. Delille and Gaudin tried to form a community of black nuns but confronted entrenched racism among Catholics and widespread discrimination. In the late 1820s the Ursuline Sisters refused to allow them to become a black branch. When they tried to found an independent order, they faced institutional barriers for recognition under civil law and had to challenge prevalent notions about the inability of black women to become nuns. In 1842, with the support of Abbé Rousselon, the pastor of St. Augustine parish, the diocese finally allowed them to begin a new order in St. Augustine's Church. Only in 1872 did they gain the right to wear the habit publicly and not until 1949 were they officially recognized by the Vatican as an independent religious congregation.

Although the Holy Family Sisters was a small order—there were only six members in 1960—they provided many important services for the African-American community. They encouraged slave couples to have their unions blessed in the church and discouraged concubinage between white men and women of color in Louisiana. They nursed the ill during a yellow fever epidemic in 1853. After the CIVIL WAR and RECONSTRUCTION, they supervised an asylum for African-American girls and organized a home for orphaned African-American boys in 1896. In 1920 the boys' home was converted into a home for the aged. Their most important work, however, was in the field of education. They opened schools in Texas and Belize in addition to six schools in New Orleans. The schools served both the middle class and the poor. By 1970 the Sisters were also offering day care services. In the 1990s the Sisters of the Holy Family continue to provide crucial social services and religious and academic training for the African-American community.

REFERENCES

DAVIS, CYPRIAN. *The History of Black Catholics in the United States.* New York, 1990.
DETIEGE, SISTER AUDREY MARIE. *Henriette Delille: Free Woman of Color.* New Orleans, 1976.
HART, SISTER MARY FRANCIS. *Violets in the King's Garden: A History of the Sisters of the Holy Family of New Orleans.* New Orleans, 1976.

PAM NADASEN

Sit-Ins. Sit-ins are a form of nonviolent direct action that are credited with initiating the modern CIVIL RIGHTS MOVEMENT. A lunch counter sit-in on February 1, 1960, by four African-American students from Greensboro Agricultural and Technical College in North Carolina is generally regarded as marking a new, more activist phase in the struggle to achieve racial justice.

The use of the sit-in as a confrontational political strategy actually began much earlier. During labor unrest in the 1930s, strikers used what was referred to as the "sit-down" as a technique for gaining leverage with employers. Since a number of the early civil rights activists of the 1940s had previously been engaged in economic struggles on behalf of workers, they were familiar with the use of the sit-down as a useful weapon. The sit-down was also one in a series of increasingly confrontational strategies employed by the Indian emancipator Mohandas K. Gandhi.

Gandhi's campaign to free India of British rule, a struggle against colonialism that many Americans believed had a parallel in African-American efforts to break free from the consequences of white discrimination, was reported with increasing frequency in American activist circles in the 1930s and later. Those who founded the CONGRESS OF RACIAL EQUALITY (CORE) in the United States in 1942—creating the first modern civil rights organization—were in fact significantly influenced by Gandhi and his concept of satyagraha, or soul force. A complex spiritual and political ideology that was revealed in techniques of nonviolent direct action, satyagraha, including the sit-down, was adapted to American purposes in the 1940s by the pioneering leaders in the civil rights struggle.

College students doing homework during a sit-in. (Photographs and Prints Division, Schomburg Center for Research in Black Culture, The New York Public Library, Astor, Lenox and Tilden Foundations)

Although the Howard University NAACP held the first successful sit-in of the twentieth-century civil rights campaign, in the spring of 1943 at a Washington, D.C., restaurant, it was CORE that perfected the tactic as a principal weapon in the fight for racial equality. Several weeks after the encounter by the Howard group, CORE members began a sit-in, in May 1943, at Jack Spratt's restaurant in Chicago. In line with Gandhian ideals and satyagraha, the sit-in had been preceded by weeks of less confrontational strategies designed to persuade Jack Spratt's owners to serve black and white customers on an equal basis. When the sit-in was finally implemented, white CORE members seated in the restaurant refused to eat their meal until their black colleagues were also seated and served. After sitting in, nonviolently, for several hours, the interracial group was finally served. A few weeks later, a similar protest occurred at Stoner's restaurant in the city, with similarly successful results.

CORE quickly recognized the value of using the sit-in as a means for achieving integration of public accommodations. The sit-in became an effective symbol of the challenge to the "separate but equal" notion of the *Plessy* v. *Ferguson* Supreme Court decision. Consequently, CORE leaders began holding workshops and training institutes around the country to prepare potential sit-in participants for the kinds of abuse and harassment they might experience as they attempted to raze the wall of segregation in public facilities.

CORE, however, was a small and limited operation in the civil rights campaign during the 1940s and '50s. When the four college students in Greensboro sat in at the department-store lunch counter reserved for whites in 1960, they revealed the usefulness of the strategy and launched a new phase in the modern civil rights movement. The sit-in, in a variety of forms—as a swim-in in public pools, or a pray-in in segregated religious facilities—became a vital part of the struggle. Because they were challenging local laws and customs upholding segregation, the participants were often arrested for their actions. Their strategy was to sit quietly and ignore all forms of verbal and physical abuse directed toward them until they were removed, arrested, or served.

As the civil rights campaign moved into its more assertive phase of black power activism after 1963, the nonviolent sit-in was employed less frequently. Over the course of the previous two decades, it had been an effective strategy in achieving the integration of local facilities.

REFERENCES

CHAFE, WILLIAM. *Civilities and Civil Rights: Greensboro, North Carolina, and the Black Struggle for Equality*. New York, 1980.

MEIER, AUGUST, and ELLIOTT RUDWICK. *CORE: A Study in the Civil Rights Movement*. Urbana, Ill., 1973.

CAROL V. R. GEORGE

Sixteenth Street Baptist Church (Birmingham, Alabama).

Serving as an organizing center for civil rights rallies and marches during the 1960s campaigns for desegregation in Birmingham, Ala., the Sixteenth Street Baptist Church became famous as the site at which a bombing killed four young black girls and injured twenty others in September 1963. Together with civil rights activists Fred L. SHUTTLESWORTH, Andrew YOUNG, James BEVEL, Dick GREGORY, and Ralph ABERNATHY, the Rev. Dr. Martin Luther KING, Jr., used Sixteenth Street Baptist as his "church command post."

On September 15, 1963, 400 African Americans gathered to worship at the Sixteenth Street Baptist Church. Four girls—Cynthia Wesley, Carole Robertson, Addie Mae Collins, each of them age four-

Lawrence Guyot (in overalls) outside the bombed Sixteenth Street Baptist Church. (© Declaun Haun/Black Star)

teen, and Denise McNair, age eleven—were in the basement of the church, preparing to lead the service, when a bomb exploded, killing them instantly. That same day, two white Eagle Scouts shot at two black boys on a bicycle, killing the thirteen-year-old riding on the handlebars. Worried about black reprisals for the bombing, Gov. George C. Wallace ordered three hundred state troopers to patrol Birmingham. That evening one officer shot and killed a fleeing black man in the back of the head.

Martin Luther King, Jr., gave the eulogy at a joint funeral for three of the girls, urging African Americans to keep up their struggle despite the murders. Although eight thousand people gathered for the funeral, including eight hundred pastors, some of whom were white, no city officials attended.

The bombing of the Sixteenth Street Baptist Church was one of twenty-eight other unsolved bombings in Birmingham in the early 1960s. Shortly after, police arrested Robert Edward Chambliss, a local Klansman, in the bombing of Sixteenth Street Baptist, but soon let him go. In 1977, Chambliss was finally tried and convicted for first-degree murder in the bombing.

REFERENCE

BRANCH, TAYLOR. *Parting the Waters: America in the King Years, 1954–1963*. New York, 1988.

MARGARET D. JACOBS

Skin Color. Color symbolism has been a potent force in various cultures throughout the world. It has figured prominently in religion, literature, art, and a wide range of human relationships. The emotional or connotative significance of color has translated into attitudes toward the various shades of pigmentation evident in the world's population. While white-dominated Western culture has long exhibited a preference for light or pale-skin peoples, such a preference has by no means been absent among societies in Asia, the Middle East, and even Africa. Various theories, based on sociological, anthropological, and psychological analyses, as well as historical experience, have been advanced to explain the existence of pigmentocracies that reward peoples of light complexion and penalize those of dark skin color. For many of these theories, the point of reference has been the significance of skin color in defining the status of African Americans, both within the larger white-dominated society and the black community. (*See also* RACE, SCIENTIFIC THEORIES OF.)

In the centuries following the initial contact between sub-Saharan Africans and Europeans, differ-ences in skin color helped shape the relations between the two peoples and also significantly influenced intraracial behavior and attitudes. In time, visible complexional differences, as well as their causes and implications, spawned a vast literature and a host of popular conceptions drawn from a hodgepodge of observations, scripture, pseudoscientific pronouncements, and self-congratulatory speculation. For northern Europeans, especially the English, the most striking characteristic of Africans initially was their "blackness." Conditioned to associate black with baseness and white with purity, Europeans ultimately invented the idea of race based on their perception of skin color, cultural, and other differences between themselves and Africans. The ideology of race that gradually emerged classified whites as superior and blacks as inferior. Although the skin color of Africans may not explain their enslavement by Europeans, it did serve as a convenient rationale for a system of bondage.

By the time black SLAVERY had been firmly established in the British colonies of North America, whites had transformed the Africans' color from a matter of intense curiosity into a serious social issue, one complicated by the offspring of black/white and black/Indian unions, who were neither black nor white. The progeny of the black/white unions, commonly called mulattoes, appeared early and multiplied at varying rates throughout the colonial era and the early history of the new republic. Denounced in colonial statutes as an "abominable mixture and spurious issue," mulattoes of numerous shades of dark and light complexion came to occupy an anomalous position in a white-dominated society inclined to associate whites with freedom and blacks with slavery.

In the slave South, the status of mulattoes, quadroons, octoroons, and other "mixed-blood" people varied from section to section. The upper South, which contained the majority of the mulatto population, early embraced the "one-drop rule," whereby anyone with any known Negro ancestor, regardless of how fair his or her complexion, was classified as black. But even in the upper South, such a code neither entirely eliminated the privileges accorded mulattoes nor destroyed the belief that mulattoes were superior to blacks. Travelers' accounts and various other sources clearly indicate that whites exhibited a promulatto bias, especially in employing light-skin slaves as house servants rather than field hands. Although a majority of the mulattoes in the upper South were slaves, the large number of free families of color in the region were also characterized by fair complexions. Although the white ancestry of mixed-blood slaves was of varied social origins, well-to-do white fathers of fair-complexioned mulatto children sometimes granted them freedom and provided them with

education, property, and opportunities unavailable to other blacks. Through this and other means, especially the purchase of freedom, there came into existence throughout the South free mulatto families whose members tended to marry other light-skinned individuals.

During most of the pre–Civil War era, the lower South, where mulattoes were less numerous, refused to adhere rigidly to the "one-drop rule." In certain lower southern cities, especially along the Gulf and Atlantic coasts, there developed a color-caste system similar to one in the Caribbean, in which mixed-blood people occupied a middle tier between free whites and enslaved blacks. Color assumed symbolic significance in these cities. In no other city did the reputation for colorphobia and snobbery equal that of the free-mulatto elite of CHARLESTON, S.C., a reputation that persisted well into the twentieth century. Viewed with favor and leniency by the white establishment, Charleston's slaveholding mulatto elite, intricately related to one another by blood and marriage, was sometimes so fair in complexion that it was impossible to discern any African ancestry. Nothing underscored the color consciousness of this mulatto elite more dramatically than the long-lived BROWN FELLOWSHIP SOCIETY, which was organized in 1790 and limited to light-skinned "free brown men." This prompted the later formation of the Society of Free Dark Men (see FREE BLACKS, 1619–1860), made up of descendants of Charleston's privileged blacks.

The significance of color was only slightly less evident in New Orleans, where three-quarters of the slaves were dark-skinned and about the same proportion of the *gens de couleur libres* was fair complexioned. The presence of CREOLES of color—those claiming French or Spanish as well as African ancestry—in NEW ORLEANS; Pensacola, Fla.; Mobile, Ala.; and other Gulf Coast cities involved an interplay of color and ethnocultural distinctions that created a more complex situation than that existing in Charleston. New Orleans's reputation as a "modern Golgotha" owed much to its alleged sexual permissiveness across the color line. Often cited by critics were the "quadroon balls" involving white men and mulatto women and especially the institution of formalized mistress-keeping known as *plaçage,* in which white males established liaisons with fair-complexioned mulatto girls, who became their "second wives" and the mothers of their "second families." Though less formalized than *plaçage,* the "shadow family" was a phenomenon that existed throughout the South. Both practices contributed to the lightening of the skin color of mixed-blood people, who usually chose fair-skinned mates, further expanding the light-complexioned black population.

By 1850, when the United States census began distinguishing between blacks and mulattoes, a more complex and specific sliding scale of color was already well established in common usage (and would be refined even further in the future), especially by African Americans. So pervasive was color consciousness that the word *color* became virtually synonymous with *race.* For example, petitions and resolutions issued by gatherings of northern free blacks often spoke of equal rights "without distinction of color." Skin color also figured significantly in antebellum "mulatto fiction." Novels and stories about light-skinned blacks, especially works produced by antislavery advocates, described with great specificity the complexion of their almost-white characters, who were also usually of extraordinary intelligence, talent, and grace. For such writers, the presence of the "tragic mulattos" stood as indisputable evidence of the immorality of slaveholding white Southerners, which was considered all the more gross because they often enslaved their own blood kin—"the white children of slavery."

One by-product of the siege mentality that gripped the white South in the wake of the abolitionist crusade (see ABOLITION) was the hardening of the opposition to miscegenation and the acceptance of the "one-drop rule" throughout the region as the means of distinguishing between whites and blacks—no matter how fair the complexion of the latter. The results were momentous. Sizable numbers of light-skinned free blacks migrated out of the South, while free mulattoes who had once identified with the white elite and had stood aloof from dark-skinned blacks, free as well as slave, gradually shifted their allegiance. The CIVIL WAR and EMANCIPATION, followed by RECONSTRUCTION, accelerated the engagement of light-complexioned mulattoes with the black masses in matters of public concern. In fact, light-complexioned blacks occupied a disproportionately large share of leadership positions in the post–Civil War South. Despite the blending of peoples of widely different skin color in the public life of black America and the existence of the "one-drop rule," color differences among African Americans continued to have meaning for both whites and blacks. Even though whites embraced a two-category (black/white) system of race relations, preached race purity, subscribed to contradictory theories about the "hybrid" nature of mulattoes, and subjected African Americans of all hues to legal and extralegal discrimination, they nonetheless accorded preferential treatment to light-complexioned blacks, especially in employment. At the same time, skin color in the Negro world exercised an influence that was as pervasive as it was mischievous.

Color, according to one observer, "appeared mysteriously in everything" in the black community at

the beginning of the twentieth century. An elaborate sliding scale of color among blacks existed and figured in varying degrees in considerations regarding prestige, status, selection of marriage partners, education, church affiliation—virtually every aspect of social life. An accumulation of distortions and unfounded allegations, perpetrated in particular by color-conscious "mulatto baiters," could easily lead to the conclusion that complexion alone determined one's place in the class structure in the African-American community—a conclusion that obscures the fact that the majority of fair-skinned blacks constituted what has been referred to as "nameless mulatto nobodies." Nevertheless, color gradation among African Americans was often an indicator of a range of interrelated variables such as opportunity, education, acculturation, and even wealth. Such variables focused on the minuscule light-skinned aristocracy of color that did, in fact, occupy the highest stratum of the black class structure from the nineteenth century until well into the twentieth century.

Viewing themselves as cultural brokers, these aristocrats of color spoke to blacks and for blacks to whites. The alleged colorphobia of this elite became the target of bitter criticism that was aired in black newspapers and magazines. Such criticism became increasingly shrill in the early twentieth century with the triumph of JIM CROW on the grounds that the "white fever" among certain light-skinned blacks disrupted racial solidarity at the moment it was most needed. The concern over color gradations even surfaced in the late nineteenth-century debate among blacks over the proper terminology to be applied to people of African descent. Arguing that whites and blacks had "mixed so thoroughly" that there were few "full-blooded Negroes left" in the United States, some advocated *Afro-American* or *colored* as more accurate terms. Others who preferred to be called Negroes claimed that all other terms were merely subterfuges invoked by fair-complexioned hybrids intent upon distancing themselves from people of darker hue.

Of all the charges leveled against the fair-complexioned upper class, none circulated more widely or persisted longer than those related to "blue veinism," a reference to skin fair enough to reveal one's blue veins. Rumors abounded, from the late nineteenth to the mid-twentieth centuries, that a blue-vein society or club consisting exclusively of fair-skinned blacks had been or was being established in one city or another. Churches that attracted such people were likely to be known as blue vein, or B.V., churches. Opposition to the dominant position occupied by the light-complexioned elite promoted a succession of well-publicized struggles, involving especially the control of schools, churches, and various

other organizations. The controversy that erupted in the 1906 convention of the NATIONAL ASSOCIATION OF COLORED WOMEN focused on the light complexion of Josephine Wilson Bruce, the wife of the former senator from Mississippi, who was a candidate for president of the organization. Dark-skinned delegates defeated Bruce because they desired a president who was visibly "altogether a Negro" rather than one whose complexion would allow whites to link her ability to her "white blood." Shocked to discover the existence of color lines within black society, white reporters believed that they had witnessed a "new phase of color discrimination."

Obviously such whites were unacquainted with the verbal assaults leveled against the fair-complexioned black aristocrats, called "accidental puny colored exquisites," that appeared regularly in African-American newspapers, magazines, and even novels throughout the opening decades of the twentieth century. Voicing a common sentiment among dark-complexioned blacks, Nannie H. BURROUGHS declared in 1904 that "many Negroes have colorphobia as bad as the white folks have Negrophobia." Among other African Americans who denounced the color consciousness of blacks as a serious impediment to racial progress were three well-known clergymen: Henry Highland GARNET, Alexander CRUMMELL, and Francis J. GRIMKÉ. Critics intent upon combating the white notion that mulattoes were intellectually superior to blacks pointed to the achievements of poet Paul Laurence DUNBAR, scholar Kelly MILLER, and other dark-skinned individuals. But no African American waged a more relentless battle against those blacks who allegedly placed a premium on their light skin color, hair quality, and other European features, than John E. BRUCE, a prominent journalist who wrote under the pen name Bruce Grit. From 1877 until his death in 1924, he delighted in referring to mixed-blood blacks as "the illegitimate progeny of vicious white men of the South." The linking of a light skin with bastardy lent support to the exclusiveness practiced by at least some dark-complexioned families who, boasting of "pure African blood," forbade their offspring to associate in any romantic way with persons of light skin.

It scarcely seems surprising that some fair-skinned mulattoes keenly experienced the uncertainties and ambiguities of the "marginal man" described by Everett V. Stonequist in 1937. Proscribed by the white-imposed "one-drop rule," light mulattoes also confronted contradictory perceptions and expectations in the black community. In expressing this sense of marginality, the young, fair-complexioned Charles W. CHESNUTT, who became a famous novelist, confided in his journal: "I am neither fish nor fowl, neither 'nigger,' white, nor 'buckrah.' Too 'stuck up' for

the colored folks, and of course, not recognized by the whites." Cyrus Field Adams, a well-known black editor who was regularly accused of trying to "pass" for white, stoutly denied the charge, declaring that he had spent most of his life "trying to pass for colored." Light-skinned individuals coped with the problems of marginality in various ways, from embracing a black identity and assuming leadership roles in movements combating antiblack discrimination, to disappearing from the black world and assuming a white identity. The phenomenon of PASSING for white assumed an extraordinarily fair complexion and physical features identified with whites. Passing could be either permanent or temporary, yet both involved risks and sacrifices.

Even though critics of the African-American preoccupation with the color scale may well have exaggerated the extent to which a light skin shaped one's self-image, behavior, and attitude, especially toward those of darker complexion, the historical evidence clearly suggests that the color preferences of blacks mirrored those of whites. "The whites," a black observer noted in 1901, "regulate all our tastes." As a result, concoctions claiming to change the skin color of African Americans from dark to light or almost-white found a lucrative market in the black community and constituted a staple source of advertising revenue for the black press. From the late nineteenth century on, such products—along with those guaranteed to "de-kink" hair—appeared in profusion under such labels as Dr. Read's Magic Face Bleach, Imperial Whitener, Black Skin Remover, Mme. Turner's Mystic Face Bleach, Dr. Fred Palmer's Skin Whitener, Shure White, and numerous others. Of all such mail-order preparations, none surpassed Black-No-More for extravagant claims. Produced in Chillicothe, Ohio, by Dr. James H. Herlihy, a self-proclaimed famous chemist, Black-No-More promised to solve the nation's race problem by turning blacks white. "Colored people," one advertisement asserted, "your salvation is at hand. The Negro need no longer be different in color from the white man." This "greatest discovery of the age" guaranteed to transform "the blackest skin into the purest white without pain, inconvenience or danger." Complaints that Black-No-More and several similar concoctions made fraudulent claims and did, in fact, cause severe pain and skin damage prompted the U.S. Post Office to bar them from the mails in 1905. But the crackdown by the post office by no means halted the sale of skin lighteners, which continued in the ensuing decades to proliferate, although they made slightly more guarded claims. As late as the 1960s, skin-bleaching preparations, including Dr. Fred Palmer's Skin Whitener, still found ready markets among African Americans. By 1920, however, those concerned about the

implications of the widespread popularity of skin bleaches became more strident in their criticism of people who used them. African-American cosmetic specialists were more forthright in warning about the dangers of "strong" bleaches and the inappropriateness of applying white powder to dark complexions. One such specialist assured black women in 1917 that a light skin was "no prettier than a dark one" and that the beauty of any skin, light or dark, was found in "the clarity and evenness of color." The wording of skin-lightener advertisements increasingly referred to skin tone rather than skin color.

This shift occurred within the context of two important developments: the accelerated engagement of light- and dark-skinned blacks in the public arena; and the "browning" of black America. The former was especially evident in the emergence of the "New Negro" associated with the cultural phenomenon known as the HARLEM RENAISSANCE in the 1920s, in which the mulatto elite led the way in articulating and popularizing the nation's black heritage and in condemning blacks' obsession with skin-color gradations. At the same time, the majority of Negro Americans had become neither visibly white nor black; rather the skin color of most consisted of various shades of brown. Although the mixing of blacks and whites declined in the decades after Reconstruction, the widespread mixing of light- and dark-skinned blacks generally had the effect of lightening the complexion of African Americans. Social scientists began to refer to "brown," rather than "black," America. By 1957, EBONY could report that "the old definition of 'the true Negro,' one with black skin, woolly hair, a flat nose and thick lips, no longer obtains."

Notwithstanding the emergence of "brown America," the impact of the Harlem Renaissance, and repeated claims that "blue vein societies" and color snobbery were rapidly disappearing, the color question remained an emotion-laden issue among African Americans. In the 1920s and later, black writers commented on the irony involved in the African-American concern with skin color, noting that while whites drew a single color line between themselves and people with "one drop" of Negro blood, blacks who condemned such a practice drew multiple color lines among themselves. The wide variety of complexional shades among African Americans ultimately gave rise to a skin-color lexicon in which minutely defined classifications ranged from peaches-and-cream and high yellow to brown and blue-black. For some African Americans, embarrassed by the obvious color consciousness present in the black community and troubled by its implications, the less said about "the nasty business of color," the better. Yet, as a black journalist noted early in the twentieth century: "The

question of tints is one of the racial follies that die hard."

Among those who refused to remain silent regarding the issue was Marcus GARVEY, a flamboyant native of Jamaica whose Harlem-based back-to-Africa movement used the emotive power of blackness to win wide appeal among the urban black masses during the 1920s (*see also* UNIVERSAL NEGRO IMPROVEMENT ASSOCIATION). Whatever else Garvey may have accomplished, his bellicose discussions of skin color served to keep alive and exacerbate the "question of tints." Deeply distrustful of light-complexioned blacks, he preached race pride and purity, castigated mulattoes, especially those involved in the NATIONAL ASSOCIATION FOR THE ADVANCEMENT OF COLORED PEOPLE and the NATIONAL URBAN LEAGUE, and stood the prevailing eschatology of color on its head by equating black with good and white with evil. His newspaper, *The Negro World,* refused to accept advertisements for skin lighteners and hair straighteners. Garvey's emphasis on skin color figured prominently in the controversy that developed between him and W. E. B. DU BOIS of the NAACP. Du Bois responded to Garvey's description of him as a "hater of dark people" and "a white man Negro" by describing the Jamaican as a fat, black, and ugly charlatan who "aroused more bitter color enmity inside the race" than ever previously existed. Du Bois denied that a black/mulatto schism had ever possessed "any substantial footing" in the United States and maintained that by the 1920s such a schism had been rejected by "every thinking Negro." Clearly, Garvey had struck a nerve, and Du Bois responded with assertions that, at best, obscured the influence of color gradations among African Americans.

If color consciousness among African Americans received less notice in the popular media in the decades following Garvey's imprisonment and deportation in the mid-1920s, the topic increasingly attracted the attention of scientists and social scientists. By the mid-twentieth century, scientific inquiry regarding human skin pigmentation had evolved into the field of pigment-cell biology. Much of the research in this field focused on the pigment melanin, a term derived from the Greek word for "black." Although scientists generally agree that human skin color is based predominantly on melanin and have discovered much about its origins and pathology, questions about the evolution and distribution of skin pigmentation in the world's population, as an authority noted in 1991, are likely to remain "an ongoing conundrum for a long time." Perhaps even more pertinent to African Americans than biological investigations of pigmentation were the findings of social scientists, both black and white, whose works shed light on the role of skin color in determining everything from status, self-image, and personality development to educational and employment opportunities, the selection of marriage partners, and wealth in the black community. While the results of tests and surveys designed to measure the influence of color gradations upon virtually every aspect of African-American life were by no means identical, they did agree that blacks, to an extraordinary degree, had accepted the skin-color preferences of the dominant white society and that a light skin in all social strata of the Negro community had definite advantages. But Gunnar Myrdal's classic study, *An American Dilemma,* published in 1944, noted that as the black community became increasingly "race conscious," it was no longer considered proper for African Americans to reveal their color preferences publicly. Ten years later, *Ebony* admitted that some fair-complexioned blacks were still "cashing in on color" but that most African Americans of all complexional shades were embracing a common cause and identity.

Such an embrace became even closer as the CIVIL RIGHTS MOVEMENT gained momentum and the "black is beautiful" slogan achieved popularity in the 1950s and '60s. Rejecting skin bleaches and hair straighteners, young blacks of all skin colors donned dashikis and Afro hairstyles and insisted upon being called "black Americans" or "Afro-Americans," often over the objections of their elders. Although *Ebony* continued to accept advertisements for bleaches, its editorials nonetheless reflected the change in color preference by noting that the "old black magic that made Sheba Queen" was again "sending red corpuscles racing up and down male veins." For a time, dark skin was in vogue and many fair-complexioned blacks found themselves on the defensive. Their skin color meant that they had to work harder at proving loyalty to their African heritage and to the larger black community. Some even complained of discrimination and ostracism by dark-skinned persons. Studies conducted during the 1970s suggested that the "black is beautiful" movement was without effect: One demonstrated that black children exhibited a clear preference for "light brown" skin color over that of either "black" or a "very light shade"; another suggested that a light skin retarded rather than facilitated upward mobility in the black class structure; still another indicated that blacks no longer preferred those whose complexions were lighter than their own as mates.

Even while "black is beautiful" was in vogue and African Americans were encouraged to "be proud of the Negro Look," old methods of lightening dark skin continued to flourish and new ones gained in popularity. Skin bleaches, both for the face and entire

body, appeared in various forms—liquid, powder, and cream—and constituted a $14 million business in 1968. In adjusting to the times, some bleaching products referred to themselves as skin toners. All the while, techniques of lightening skin color other than the use of bleaches had made their appearance. The 1940s and '50s witnessed the introduction of various new methods of lightening skin, ranging from depigmentation processes to the use of monobenzyl ether of hydroquinone. Later, dermatologists and plastic surgeons developed procedures for lightening dark skin and converting "broad features into aquiline ones." The most widely used dermatological procedures were chemical peel and dermabrasion, which proved to be painful, risky, and expensive. Tinted contact lenses, however, made possible a change of eye color without risk or pain.

Sociological studies of the color question as related to blacks clearly suggested that in the early 1990s skin color remained one of the mechanisms that determined "who gets what" in black America. Light-skinned blacks still enjoyed a more advantageous economic position and higher standing in the black community. One well-known study in 1990 concluded that there was "little evidence that the association between skin color and socioeconomic status [had] changed during the 30-year period from 1950 to 1980." Despite pressure on blacks "to keep quiet" about their color prejudices, antagonism resulting from such prejudices occasionally erupted into public controversies. For example, some cases arising under AFFIRMATIVE ACTION involved charges of intraracial color discimination. When the fair-complexioned, green-eyed Vanessa Williams, an African American, was chosen Miss America in 1983, some blacks angrily complained that she was "half white" and not "in essence black." Later claims that Michael JACKSON, an African-American superstar in the entertainment world, had altered both his skin color and facial features, occasioned much comment, including allegations that he was attempting to "get away from his race." In June 1994, a controversy over skin color erupted in response to the portrait of African-American athlete O. J. SIMPSON that appeared on the cover of *Time* magazine following his arrest on suspicion of murdering his former wife and her friend. That *Time* substantially darkened Simpson's complexion in transforming a mug shot into a "photo-illustration" prompted charges that the magazine "had darkened Simpson's face in a racist and prejudicial attempt to make him look more sinister and guilty."

Beginning in the 1980s, the significance of skin-color preference among African Americans has been explored at length on television talk shows and in films, novels, social science studies, and even autobiographies. African Americans may still consider the issue a bit of dirty linen, but they are less reluctant to discuss it publicly. By candidly confronting the color consciousness and prejudices of African Americans, films such as Kathe Sandler's television documentary "A Question of Color" (1992), as well as scholarly treatises and other works, contributed to a greater understanding of a phenomenon that has persistently helped to shape the experiences, attitudes, and life chances of African Americans.

REFERENCES

BERZON, JUDITH R. *Neither Black nor White: The Mulatto Character in American Fiction.* New York, 1978.

DAVIS, FLOYD JAMES. *Who Is Black? One Nation's Definition.* University Park, Pa., 1991.

DOMINGUEZ, VIRGINIA R. *White by Definition: Social Classification in Creole Louisiana.* New Brunswick, N.J., 1986.

EMBREE, EDWIN E. *Brown America: The Story of a New Race.* New York, 1931.

EVANS, WILLIAM M. "From the Land of Canaan to the Land of Guinea: The Strange Odyssey of the Sons of Ham." *American Historical Review* 85 (February 1980): 15–43.

GATEWOOD, WILLARD B. *Aristocrats of Color: The Black Elite, 1880–1920.* Bloomington, Ind., 1990.

GERGEN, KENNETH J. "The Significance of Skin Color in Human Relations." *Daedalus* 96 (September 1967): 390–406.

HIRSCH, ARNOLD, and JOSEPH LOGSDON, eds. *Creole New Orleans: Race and Americanization.* Baton Rouge, La., 1992.

HUGHES, MICHAEL, and BRADLEY R. HERTEL. "The Significance of Color Remains: A Study of Life Chances, Mate Selection, and Ethnic Consciousness Among Black Americans." *Social Forces* 69 (June 1990): 1105–1119.

JORDAN, WINTHROP D. *White over Black: American Attitudes Toward the Negro, 1550–1812.* Chapel Hill, N.C., 1969.

MENCKE, JOHN G. *Mulattoes and Race Mixture: American Attitudes and Images.* Ann Arbor, Mich., 1979.

REUTER, EDWARD B. *The Mulatto in the United States.* New York, 1970.

ROBINS, ASHLEY H. *Biological Perspectives on Human Pigmentation.* Cambridge, U.K., 1991.

RUSSELL, KATHY, MIDGE WILSON, and RONALD HALL. *The Color Complex: The Politics of Skin Color Among African Americans.* New York, 1992.

TOPLIN, ROBERT BRENT. "Between Black and White: Attitudes Toward Southern Mulattoes, 1830–1861." *Journal of Southern History* (May 1979): 185–200.

WILLIAMSON, JOEL. *New People, Miscegenation, and Mulattoes in the United States.* New York, 1980.

WILLARD B. GATEWOOD

Slater Fund. John Fox Slater, a Connecticut industrialist, created the Slater Fund in 1882, when he donated one million dollars for the schooling of former slaves and their children in the South. He was motivated by a belief that education was vital if African Americans were to become responsible participants in the American economy and political process. Slater chose a distinguished board, chaired by former President Rutherford B. Hayes, to administer the endowment. Board members soon determined to support black industrial education, believing that manual training would provide blacks with useful skills, instruct them in moral discipline and social conformity, and prepare them for a subservient role in the post–Civil War South. They used their appropriations to pressure black schools and colleges to adopt the industrial education curriculum during the 1880s. They particularly applauded and assisted the work of black educators such as Booker T. WASHINGTON, who accepted the racial status quo in the South. Between 1891 and 1911, the New York–based fund supported a few model industrial schools such as HAMPTON INSTITUTE (in Virginia) and Washington's Tuskegee Institute (in Alabama) (*see* TUSKEGEE UNIVERSITY), eventually giving these two schools one-half of its annual appropriations. After 1911, the fund pursued its interest in manual training by preparing black teachers in county training schools; it helped build 384 such schools in the South over the next two decades. The Slater Fund joined with the Jeanes Fund, the Peabody Education Fund, and the Virginia Randolph Fund in 1937 to form the Atlanta-based Southern Education Fund, which still exists.

REFERENCE

FINKENBINE, ROY E. " 'Our Little Circle': Benevolent Reformers, the Slater Fund, and the Argument for Black Industrial Education, 1882–1908." *Hayes Historical Journal* 6 (1986): 6–22.

ROY E. FINKENBINE

Slave Narratives. The autobiographical narratives of former slaves comprise one of the most extensive and influential traditions in African-American literature and culture. The best-known slave narratives were authored by fugitives from slavery who used their personal histories to illustrate the horrors of America's "peculiar institution." But a large number of former slaves who either purchased their freedom or endured their bondage until emancipation also recounted their experiences under slavery. Most of the major authors of African-American literature before 1900, including Frederick DOUGLASS, William Wells BROWN, Harriet JACOBS, and Booker T. WASHINGTON, launched their writing careers via the slave narrative.

During the formative era of African-American autobiography, from 1760 to the end of the Civil War in the United States, approximately seventy narratives of fugitive or former slaves were published as discrete entities, some in formats as brief as the broadside, others in bulky, sometimes multivolume texts. Slave narratives dominated the literary landscape of antebellum black America, far outnumbering the autobiographies of free people of color, not to mention the handful of novels published by American blacks during this time. After slavery was abolished in North America, ex-slaves continued to produce narratives of their bondage and freedom in substantial numbers. From 1865 to 1930, during which time at least fifty former slaves wrote or dictated book-length accounts of their lives, the ex-slave narrative remained the preponderant subgenre of African-American autobiography. During the GREAT DEPRESSION of the 1930s, the FEDERAL WRITERS' PROJECT gathered oral personal histories and testimony about slavery from 2,500 former slaves in seventeen states, generating roughly 10,000 pages of interviews that were eventually published in a "composite autobiography" of eighteen volumes. One of the slave narratives' most reliable historians has estimated that a grand total of all contributions to this genre, including separately published texts, materials that appeared in periodicals, and oral histories and interviews, numbers approximately six thousand.

The earliest slave narratives have strong affinities with popular white American accounts of Indian captivity and Christian conversion in the New World. But with the rise of the antislavery movement in the early nineteenth century came a new demand for slave narratives that would highlight the harsh realities of slavery itself. White abolitionists (*see* ABOLITION) were convinced that the eyewitness testimony of former slaves against slavery would touch the hearts and change the minds of many in the northern population of the United States who were either ignorant of or indifferent to the plight of African Americans in the South. In the late 1830s and early 1840s, the first of this new brand of outspokenly antislavery slave narratives found their way into print. These set the mold for what would become by mid-century a standardized form of autobiography and abolitionist propaganda.

Typically, the antebellum slave narrative carries a black message inside a white envelope. Prefatory (and sometimes appended) matter by whites attests to the reliability and good character of the narrator, and calls attention to what the narrative will reveal about the moral abominations of slavery. The former

slave's contribution to the text centers on his or her rite of passage from slavery in the South to freedom in the North. Usually the antebellum slave narrator portrays slavery as a condition of extreme physical, intellectual, emotional, and spiritual deprivation, a kind of hell on earth. Precipitating the narrator's decision to escape is some sort of personal crisis, such as the sale of a loved one or a dark night of the soul in which hope contends with despair for the spirit of the slave. Impelled by faith in God and a commitment to liberty and human dignity comparable (the slave narrative often stresses) to that of America's Founding Fathers, the slave undertakes an arduous quest for freedom that climaxes in his or her arrival in the North. In many antebellum narratives, the attainment of freedom is signaled not simply by reaching the free states but by renaming oneself and dedicating one's future to antislavery activism.

Advertised in the abolitionist press and sold at antislavery meetings throughout the English-speaking world, a significant number of antebellum slave narratives went through multiple editions and sold in the tens of thousands. This popularity was not solely attributable to the publicity the narratives received from antislavery movement. Readers could see that, as one reviewer put it, "the slave who endeavours to recover his freedom is associating with himself no small part of the romance of the time." To the noted transcendentalist clergyman Theodore Parker, slave narratives qualified as America's only indigenous literary form, for "all the original romance of Americans is in them, not in the white man's novel." The most widely read and hotly debated American novel of the nineteenth century, Harriet Beecher Stowe's UNCLE TOM'S CABIN (1852), was profoundly influenced by its author's reading of a number of slave narratives, to which she owed many graphic incidents and the models for some of her most memorable characters.

In 1845 the slave narrative reached its epitome with the publication of the Narrative of the Life of Frederick Douglass, an American Slave, Written by Himself. Selling more then 30,000 copies in the first five years of its existence, Douglass's Narrative became an international bestseller, its contemporary readership far outstripping that of such classic white autobiographies as Henry David Thoreau's Walden (1854). The abolitionist leader William Lloyd Garrison introduced Douglass's Narrative by stressing how representative Douglass's experience of slavery had been. But Garrison could not help but note the extraordinary individuality of the black author's manner of rendering that experience. It is Douglass's style of self-presentation, through which he recreated the slave as an evolving self bound for mental as well as physical freedom, that makes his autobiography so

important. After Douglass's Narrative, the presence of the subtitle, Written by Himself, on a slave narrative bore increasing political and literary significance as an indicator of a narrator's self-determination independent of external expectations and conventions. In the late 1840s well-known fugitive slaves such as William Wells Brown, Henry W. BIBB, and James W. C. PENNINGTON reinforced the rhetorical self-consciousness of the slave narrative by incorporating into their stories trickster motifs from African-American folk culture, extensive literary and biblical allusion, and a picaresque perspective on the meaning of the slave's flight from bondage to freedom.

As the slave narrative evolved in the crisis years of the 1850s and early 1860s, it addressed the problem of slavery with unprecedented candor, unmasking as never before the moral and social complexities of the American caste and class system in the North as well as the South. In My Bondage and My Freedom (1855), Douglass revealed that his search for freedom had not reached its fulfillment among the abolitionists, although this had been the implication of his Narrative's conclusion. Having discovered in Garrison and his cohorts some of the same paternalistic attitudes that had characterized his former masters in the South, Douglass could see in 1855 that the struggle for full liberation would be much more difficult and uncertain than he had previously imagined. Harriet Jacobs, the first African-American female slave to author her own narrative, also challenged conventional ideas about slavery and freedom in her strikingly original Incidents in the Life of a Slave Girl (1861). Jacobs's autobiography shows how sexual exploitation made slavery especially oppressive for black women. But in demonstrating how she fought back and ultimately gained both her own freedom and that of her two children, Jacobs proved the inadequacy of the image of victim that had been pervasively applied to female slaves in the male-authored slave narrative.

In most post-emancipation slave narratives, slavery is depicted as a kind of crucible in which the resilience, industry, and ingenuity of the slave was tested and ultimately validated. Thus the slave narrative argued that readiness of the freedman and freedwoman for full participation in the post–Civil War social and economic order. The biggest-selling of the late nineteenth- and early twentieth-century slave narratives was Booker T. Washington's Up from Slavery (1901), a classic American success story. Because Up from Slavery extolled black progress and interracial cooperation since emancipation, it won a much greater hearing from whites than was accorded those former slaves whose autobiographies detailed the legacy of injustices burdening blacks in the postwar South. Washington could not dictate the agenda of the slave narrative indefinitely, however. Modern

black autobiographies, such as Richard WRIGHT's *Black Boy* (1945), and contemporary African-American novels, such as Ernest J. GAINES's *The Autobiography of Miss Jane Pittman* (1971) and Toni MORRISON's *Beloved* (1989), display unmistakable formal and thematic allegiances to the antebellum slave narrative, particularly in their determination to probe the origins of psychological as well as social oppression and in their searching critique of the meaning of freedom for twentieth-century blacks and whites alike.

REFERENCES

ANDREWS, WILLIAM L. *To Tell a Free Story: The First Century of Afro-American Autobiography, 1760–1865.* Urbana, Ill., 1986.

DAVIS, CHARLES T., and HENRY LOUIS GATES, JR., eds. *The Slave's Narrative.* New York, 1985.

FOSTER, FRANCES SMITH. *Witnessing Slavery: The Development of Ante-bellum Slave Narratives.* Westport, Conn., 1979.

JACKSON, BLYDEN. *A History of Afro-American Literature.* Volume I, *The Long Beginning, 1746–1895.* Baton Rouge, La., 1989.

SEKORA, JOHN, and DARWIN T. TURNER, eds. *The Art of Slave Narrative.* Macomb, Ill., 1982.

STARLING, MARION WILSON. *The Slave Narrative: Its Place in American History.* Washington, D.C., 1988.

WILLIAM L. ANDREWS

Slave Religion. Slave religion refers to the religious faith, beliefs, and practices of Africans brought by force to the New World beginning in 1619 and African Americans held in bondage until EMANCIPATION. Despite the brutality of slavery, Africans in America retained fragments of their traditional religious worldview. In West African indigenous beliefs, a high god ruled a pantheon of intermediate lesser gods and spirits. The high god created all things and showed compassion to the weak and injured parties in society, often displaying maternal qualities.

The intermediate lesser gods activated various wishes of the high god. Africans, therefore, prayed to intermediate divinities for specific purposes, such as rain, crops, or fertility. The spirits of the ancestors occupied an intermediate status with the lesser gods. Africans viewed the ancestors as the living dead, with immense power because they were close to the living as well as in the realm of the divine. Veneration of the ancestors through the pouring of libations marked most religious occasions.

The purpose of humanity (i.e., the living) was to honor the ancestors, recognize the lesser gods, and attribute all power and respect to the high or supreme god. Fundamentally, the living served to maintain correct relationships among the divinities, the spirits, and humanity. In fact, the value of an individual derived from connection to a larger community. Evil was an active presence, signifying a disruption of God's created order of right relationships and goodness. Slaves eventually combined their African religious retentions with their reinterpreted Christianity to produce slave religion.

Between 1619 and the early eighteenth century, plantation slave owners did not pursue systematic attempts at making their black bondsmen and women Christians. White slave owners generally refused to introduce the gospel to their "property." Some owners viewed slaves as less than human and therefore without souls needing Christian redemption. Others believed that too much unnecessary time would be lost on preaching to black chattel. Some suspected a converted slave would become lazy or impudent or, worse, resistant. They feared that Christianity would make the slaves believe they were equal to whites and, thus, give them an argument for freedom.

Not until the formation in London of the Society for the Propagation of the Gospel in Foreign Parts (SPG) in 1701 did white missionaries and slave masters begin an organized effort to convert slaves to Christianity. Though the SPG did establish some schools for Africans, the scope of their missionary work was limited by the number and quality of ministers that were sent to North America, as well as opposition by many slave owners to the Christianization of their slaves. Also, as an arm of the Church of England, the SPG primarily focused on converting slaves by appealing to their intellect while demanding control of the body, in contrast to African religious traditions' emphasis on physical movement caused by spirit possession. Consequently the society's requirements of reciting catechisms, the Apostles' Creed, the Lord's Prayer, and the Ten Commandments failed to spread Christianity significantly among black chattel in the thirteen British colonies. Not until the Great Awakenings (1740 and the early 1800s) did black slaves embrace the Christian religion in large numbers. Unlike the SPG missionaries, the Great Awakening preachers emphasized conversion of the heart, encouraged ecstatic expressions of the body, and required a simple confession of Jesus Christ's lordship.

Though slaves converted throughout the South, they resisted some of the theology and religious practices of the Great Awakenings. For instance, ministers often taught that baptism did not free black chattel. And white preachers delivered homilies exhorting slaves to obey their masters as signs of faithfulness to God. In practice, white churches segregated religious services and controlled free worship

by slaves. Plantation owners established segregated seating with slaves partitioned in the rear, placed in the balcony, or relegated outside church windows. When allowed their own black congregations, slaves heard the gospel from hired white preachers or black preachers scrutinized by whites in the audience. In contrast to a theology privileging whites over blacks, slaves secretly prayed to God as their only master and asked for freedom from their earthly owners.

While keeping their fragmented memories of African traditional religions, slaves reinterpreted Christianity. They strongly identified with the Old Testament Hebrew slaves liberated by God. From this story, theological themes of earthly suffering and hope for deliverance became cornerstones of slave religion. If the Good Book said that God delivered his people from captivity, then, from the black slaves' perspective, this same supreme deity would likewise hear the cries of the oppressed and release them from American slavery.

In interviews with ex-slaves, their autobiographies, and the SPIRITUALS (the unique religious songs created by slaves), an entirely new version of Christianity appeared. Faith now became belief in, and commitment to, a God of the poor who displayed compassion toward the humble and the weak and judgment against the arrogant and the strong. Black slaves felt that this divinity had created them to be free so that they might live life in its fullness. Consequently, God—not the plantation owner—was the true master of the slaves.

This shift in allegiance marked a subversive turn in religion during slavery: Slaves now had a higher court of appeal. God served as their judge and arbitrator, the one who decided in favor of the Old Testament's Daniel in the lion's den, the three little Hebrew boys, and David over Goliath. Just as God sided against the political and religious powers in the Bible, so too would God now work with black bondsmen and women for freedom. Thus, slaves believed in a divinity who worked with the poor toward deliverance. Divine grace and righteousness labored with and empowered the slaves to hope for a better world.

Similarly, slave religion reappropriated the meaning of the New Testament Jesus. The substance of Christian nativity scenes became black slaves' identification with "Mary's baby" born in poverty without a home. This Jesus signified power amidst apparent weakness. Consequently, slaves gravitated toward New Testament stories about Jesus' ability to perform miracles for both society's victims and those cast to the margins of communities. They read tales about Jesus' concern for the lepers of society. And they took seriously his message to bring "good news" to the earth's poor. Bondsmen and women found solace in their own conception of Jesus, the intermediary God, who had divine abilities to bring justice yet suffered the human predicament. Basically, the slaves' Christianity pictured Jesus as comforter of the wounded, friend of the lonely, deliverer of the lost, healer of the sick. As one spiritual commented, "Jesus can do just about anything."

Through their reconfiguration of God and Jesus, slaves were able to reinterpret and give new meaning to their everyday life. Slaves developed a new interpretation of self-identity and ownership of their bodies. No longer could they live in the old way of the slave institution. Some bondsmen and women simply felt liberated within the confines of the plantation. Others found courage to resist by feigning sickness, running away to the woods, breaking farm tools, and fighting individual plantation overseers and masters. To be a child of God and serve Jesus' lordship inspired novel ways of expressing slave religion. For instance, slaves created a "discourse of solidarity" where one slave would not reveal information about another. They redefined "taking" and "stealing," the former referring to objects removed from the master and the latter representing the sin of pilfering from a fellow slave. However, the most collective form of slave religious resistance was manifested in planned rebellion, with the notable cases of Gabriel Prosser (1800 in Richmond, Va.), Denmark VESEY (1822 in Charleston, S.C.), and Nat TURNER (1831 in Southhampton County, Va.). In each case, religious leaders led these revolts and most justified their actions from the Bible.

Slave religion was manifested most clearly in the "Invisible Institution," the secret prayer and worship meetings conducted by slaves far away from the watchful eyes of their masters. In the woods, a ravine, a cabin, or the crops, black chattel crafted a distinct style of religious organization. In the language of the slaves, these "experience" meetings usually were "protected" by a turned-over pot to keep sound from escaping. Now the slaves were ready for the visitation of the "spirit" who caused them to sing, shout, pray, preach, testify, and enjoy their own free religious space in ecstatic behavior.

Inevitably they performed the "ring shout," a counterclockwise circular movement of those gathered. As others outside the ring sang spirituals, the ring participants would begin to shout. Moreover, the Invisible Institution served many purposes. Here slaves learned oratorical skills and leadership abilities. Some received food and clothing. Others gained "counseling" to preserve their sanity. Most underwent and verified conversion experiences—a "born again" movement from the old slave self to a sense of a radically new person.

At times groups planned forms of resistance. Griots (the community's storytellers) passed along tales

and traditions from Africa and ancestors. Elders decided disputes and claims. And all refueled their individual and collective energies to make it through another day. It is in these Invisible Institution rituals that slave religion re-created the slaves from objects of institutional bondage into a self-perceiving free community empowered to survive and hope for ultimate liberation.

REFERENCES

HOPKINS, DWIGHT N., ET AL. *Cut Loose Your Stammering Tongue: Black Theology in the Slave Narratives.* Maryknoll, N.Y., 1991.
RABOTEAU, ALBERT J. *Slave Religion: The "Invisible Institution" in the Antebellum South.* New York, 1980.

DWIGHT N. HOPKINS

Slavery. Slavery in the United States evolved over two centuries, from the middle of the seventeenth century through the 1860s (*see also* SLAVE TRADE). It varied from place to place and changed over time. A host of local factors shaped the institution and the lives of blacks and whites entangled in it. Such factors included the cultivation of particular crops, the size of the slaveholding unit, the local density of white and black populations, the laws of the colony or state, and even the personalities of individual slaveholders and slaves. At the same time, certain general features framed the common experience of slavery regardless of location. Foremost, throughout the New World, was the racial basis of enslavement. In the British North American mainland colonies, and then in the United States, bondage also was characterized by the definition of slaves as chattel property and by slavery's constant expansion westward, from tidewater to piedmont during the colonial period and across the lower South during the nineteenth century. That continuous expansion brought with it both an increasingly vigorous antislavery movement and an ever more assertive political and ideological defense by the slaveholders, so that the institution of slavery in the United States was clothed in controversy from the late eighteenth century through the secession crisis of 1860–1861. All the while, a vibrant African-American culture grew up in the slave quarters that somewhat protected slaves from the masters' demands even as the slaveholders attempted to impose more order on the institution of slavery.

Slavery was more than a labor system. It formed the economic, political, and social matrix from which developed a way of life unique in America at the locus of the clash and mixture of European and African cultures. Slavery also forced Americans to confront their true selves. In a republic born of liberty but prospering from bondage, the expansive energy of freedom collided with that of slavery. Such tensions led to civil war and, finally, to emancipation. But slavery's importance to the American identity did not end at Appomattox or even with the ratification of the THIRTEENTH AMENDMENT in 1865 (*see also* SLAVERY AND THE CONSTITUTION). The cultural worlds of blacks and whites endured, and the economic and political legacies of slavery and the war that came from it burned deep into the American psyche. The historical memory of all that had been wrought by human bondage in the land of the free has made slavery a lasting point of reference for American self-identity.

For that reason alone, the subject has commanded much attention from historians and other scholars. Especially from the days of the modern civil rights movement and the "coming apart" of the United States during the social protests of the 1960s, American scholarship has turned from considering slavery solely from the perspective of planters or abolitionists toward viewing the experience of bondage from the slaves' perspective. The principal shift in focus has been away from the political and institutional aspects of slavery toward the social and cultural ones. Historians now spend less time studying the profitability of slavery than they do the slaves' resistance to masters, less time on the management and marketing of crops than on the rhythms of work, less time in the fields than in the slave quarters.

In trying to reconstruct the world the slaves made, historians increasingly have relied on testimony left by the slaves themselves. Earlier generations of scholars chose to collect and read travel accounts, laws, petitions to legislatures, court cases, newspapers, planters' papers (daybooks, diaries, letters, and business records), and other documents written primarily by whites. Since the 1960s, historians have looked to the slaves' own material culture (the quilts stitched, baskets woven, pots made) and have studied the slaves' folklore, music, speech, naming and kinship patterns, and remembrances of bondage. To do so, the modern student of slavery borrows from archaeology, anthropology, folklore, linguistics, musicology, and other social sciences, as well as reading closely the SLAVE NARRATIVES an earlier generation of historians dismissed as propagandistic and irrelevant to the questions they thought important.

The reprinting of numerous narratives originally written or related by fugitive slaves such as Frederick DOUGLASS during the antebellum period has made available a large cache of slave testimony. So, too, has the publication of the Slave Narrative Collection interviews, which participants in the New Deal's

FEDERAL WRITERS' PROJECT conducted with some two thousand ex-slaves during the 1930s. The abundance of slave-authored autobiographies and narratives, as well as the interviews and folklore handed down by former slaves, has altered forever the way historians approach slavery. The willingness of historians to examine slave-authored sources and to view the experience from the slaves' perspective has inverted the question of slavery's impact on the slaves and their culture. In the words of historian Eugene Genovese, the question now is not so much what was done to the slaves but "what did the slaves do for themselves?"

Answering that question has proved easier when studying the last generation of slaves than the first. No narrative accounts from slaves have survived from the seventeenth century, and the material cultural record for that formative period is fragmentary and sparse. More sources exist for the eighteenth and many for the nineteenth century, when slavery had become a mature institution. But, as historian Willie Lee Rose has reminded scholars, much of that evidence is colored by the political debates swirling about slavery—debates that eventually led to civil war. The richness, abundance, and variety of evidence from the last generation of slaves have fueled an intense examination of every facet of slave life. Adopting the perspectives of anthropology and the "new social history," both of which emphasize case studies, students of slavery have shifted the focus away from national or regional contexts toward studies of specific localities. At the same time, an earlier interest in comparing slave systems between North and South America has given way to comparing slave cultures in different U.S. settings—urban and rural, low-country and up-country, seaboard and Gulf South. In such work, the recognition that slaves were actors rather than objects in the story, struggling to define their own lives amid their travail, has been the underpinning assumption and the point of departure for discussions about the origins, evolution, and nature of slavery in the United States.

Slavery came slowly to British North America. Like so much else, it was imported and then adapted to local conditions. The first black slaves in the mainland British colonies arrived amid the boom years of Virginia tobacco growing. Because land was abundant and labor scarce in early Virginia, planters scrambled for workers to grow "the weed." In August 1619, "twenty and odd Negroes" were bartered for provisions by sailors from a Dutch ship anchored off Point Comfort, downstream from the Jamestown settlement. The status of these first blacks in the English colony is unclear. No doubt some were sold as slaves, although slavery as an institution had no legal standing in the young colony and had been unknown in England for centuries. Others likely entered indentured servitude, a labor arrangement whereby individuals sold their labor but not their person for a fixed term. By 1625, according to the first Virginia census, at least several of the blacks in the colony were free. Ominously, however, most remained locked in some form of bonded labor and, alone of those persons listed in the census, blacks were noted by color as well as condition.

For the next half-century, the number of blacks in the Chesapeake region increased to only a few hundred. While slavery became entrenched in the British West Indian sugar islands, it hardly grew in the British tobacco colonies. Disease and rough handling kept life short and mean for all workers in the tobacco colonies. Planters thus were unwilling to bid high for the lifetime labor of a slave who would most likely die within a few years when the temporary labor of an English servant was both available and quite cheap.

Englishmen in the Chesapeake region were reluctant at first to introduce large numbers of non-Englishmen into their midst. According to historian Winthrop Jordan, the English "discovered" the black African in the mid–sixteenth century, a time when the English were engaged in a process of discovering themselves as a separate people. To English eyes, the black African seemed the antithesis of Englishness. The English recoiled from the Africans' supposed savagery and heathenism, but especially from their color, which was associated with dirt, death, and the Devil in English parlance. The self-conscious English thus approached the black Africans cautiously, unsure whether they could be made over into Englishmen or if the English would be "corrupted" by mingling with them. Such attitudes did not cause the English to enslave black Africans, but once slavery did become established in the New World plantation colonies, such attitudes combined with the status of slaves as chattel property to reinforce the idea of blacks' racial inferiority.

Still, the small number of black slaves in early Chesapeake society initially blurred distinctions between slave and servant and black and white. Free blacks owned property (including slaves), bought and sold the indentures of white servants, sued in courts, served on juries, and participated in a wide range of public activities. Black slaves and white servants worked alongside one another and generally ate, slept, and caroused together. Scattered in ones and twos across farms and plantations separated by thick woods and rivers, the few blacks lost their African ways in the Chesapeake. With few women among them, they entered a male servant culture where racial distinctions mattered little. No rigid system of racial discrimination yet existed in either law or custom.

This began to change by the late seventeenth century. A declining birthrate in England and growing opportunities elsewhere curtailed the supply of white indentured servants. Meanwhile, life spans were lengthening in the Chesapeake region as physical conditions improved and people acclimated. More servants now survived to claim their freedom and the land due them—land planters tried not to grant to new tobacco competitors. Tensions between greedy planters and their angry former servants erupted in Bacon's Rebellion in Virginia in 1676, during which the new "freemen" combined with servants to drive the governor and his planter allies from the capital and threatened to overthrow Virginia altogether before finally disbanding. The shock of the rebellion of lower-class blacks and whites together forced planters to consider the implications of their labor policy. Their abuses of English indentured servants seemed to threaten the rights of all Englishmen. With indentured-servant labor less available and more unruly, and with African slave labor becoming more available and less expensive due to increased English involvement in the African slave trade, planters began to buy Africans in larger numbers.

The improved life expectancy of workers made investment in a permanent labor force of black slaves practical. So, too, did the clarification of the legal definition of slaves as chattel property during the 1660s and 1670s. After 1660, slavery was written into law in Virginia and Maryland. The status of the slave became both perpetual and hereditary. The shift from white indentured labor to black slave labor also promised to relieve class tensions among whites by binding all whites together on the basis of race. By the turn of the eighteenth century, slavery had become the normal condition for blacks in the Chesapeake. The distinctions between servant and slave sharpened as slavery acquired a racial definition and as it came to mean a condition for life as chattel property.

Farther south, slavery took a different course. South Carolina's first permanent English settlers came from Barbados, where slavery was an established institution, bringing with them both their slaves and their expectations of building a plantation colony in South Carolina. After a brief diversion while they engaged in a lucrative deerskin trade with the Indians, in the 1690s the planters turned to rice to make their fortunes. African slaves taught the English planters rice cultivation, cattle herding, and riverboating techniques suitable to the Carolina environment. Possession of these skills, relative immunity to malaria, and adaptability to the humid low-country climate all conspired to make the Africans an attractive labor source to planters eager for profit but loath to stay in Sea Island and Tidewater plantations during the summer "sickly" season.

For a time, Carolina planters supported an Indian slave trade, which peaked in the mid-1720s before the supply gave out due to Indian population declines from disease and warfare. When Indian slavery and white indentured servitude failed to meet the planters' labor needs, they imported large numbers of African slaves. As early as 1708, blacks made up a majority of the South Carolina population. By the 1730s, much of the low country had been converted to a rice culture of large plantations, with blacks outnumbering whites by almost two to one and with newly imported Africans making up a significant proportion of the black slave population.

Early on, whites and blacks in Carolina lived and worked together on small farms and stock-raising plantations, or "cow pens." To defend the colony against Indians and Spaniards, whites had even armed blacks and enlisted them in the militia. Blacks enjoyed considerable autonomy and worked in a wide variety of employments. Rice changed all that.

The heavy black presence that resulted from rice plantation culture fundamentally altered Carolina slavery. The races increasingly lived apart, and nervous whites disarmed blacks and tried to circumscribe their activities with repressive laws borrowed from Caribbean slave codes. Blacks responded with repeated individual acts of resistance and several failed uprisings. Then, in the STONO REBELLION of 1739, nearly one hundred slaves seeking to escape to Spanish Florida seized weapons and killed a score of whites before being defeated by white militia. Whites clamped down hard. The colony's government curtailed African importations for a time afterward and passed the Negro Act of 1740, which imposed the harshest slave code in the British mainland colonies.

By insisting on greater white vigilance and patrols, the slave codes in Carolina and elsewhere discouraged mass uprisings, but they did not end slave resistance or autonomy. Stono was the largest mass slave insurrection during the colonial period—and the last—although smaller rumblings occurred in South Carolina and Georgia, which instituted slavery in 1750; New York City (which had experienced a slave uprising in 1712 during which blacks had killed several whites) panicked in 1741 amid a rumor of revolt (see NEW YORK SLAVE REVOLT OF 1712 and NEW YORK SLAVE CONSPIRACY OF 1741). Instead, slave resistance became more localized and individual, though no less violent at times, as slaves cultivated a new culture of their own in the quarters away from the master.

By the time of the American Revolution, slavery was firmly rooted in British North America. Every colony had slaves, and even those colonies, such as Massachusetts, with little need for mass slave labor found slaves useful in maritime trades, craft occupations, and domestic service and as common laborers.

Bill of sale of a slave for the sum of eighty pounds to Aaron Burr, president of the College of New Jersey, dated 1750. (Photographs and Prints Division, Schomburg Center for Research in Black Culture, The New York Public Library, Astor, Lenox and Tilden Foundations)

New York City and environs were especially tied to slavery, where slaves constituted over 30 percent of the city's laborers by the mid–eighteenth century and the majority of unfree workers on farms along the Hudson River, on Long Island, and in northern New Jersey. Northern colonies were further implicated in slavery by the profits their merchants earned provisioning the sugar islands and trading in slaves. Slav-

ery's principal foothold, however, remained in the southern staple-producing colonies. There, from the Chesapeake Tidewater to the Piedmont and in the Carolinas and Georgia, American slavery acquired the character that would distinguish it thereafter.

More than anything else, dramatic slave-population growth fixed the character of British North American slavery during the eighteenth century. Sev-

eral hundred thousand African slaves were brought into North America, many through the principal slave entry point of Charleston, S.C., but others to the wharves of Chesapeake planters and such ports as Philadelphia. The largest number of African-born slaves arrived at mid-century, at the same time that the native- (or "country"-) born slave population was forming families and reproducing.

The arrival of so many Africans infused African cultural identities into "country"-born slaves at a critical moment. Because the life cycles of marriage and childbirth demanded ritual, the "country"-born slaves readily adapted West African customs to New World conditions. Despite differences in language, sex ratio (the majority of African slaves imported were males), and culture, slaves in America starting families or burying their dead looked toward Africa and themselves rather than to the masters for ritual and meaning. Most slaves were native-born by mid-century, but the African influx between 1740 and 1760 made them more African and less European than they otherwise might have been.

By the early eighteenth century the construction of roads and bridges, the increased number of slaves, and larger plantation sizes all had brought slaves in closer physical contact with one another in the Chesapeake region. More significant, they had broken down language barriers that at one time had separated them. The first generation created a "pidgin" language, and the next incorporated European vocabulary into a "creole" English that retained an underlying West African grammar. Wherever large numbers of African-born slaves congregated, however, African-based language forms grew and persisted. In low-country Georgia and South Carolina, the GULLAH dialect is spoken even today. But an Afro-English had developed virtually everywhere by the mid–eighteenth century, if not earlier, providing a common tongue for slaves across British North America and smoothing the way toward building slave families and community. (See AFRICANISMS for a discussion of African words that have persisted in American English until today.)

The timing varied. The sexual imbalance in the Carolina and Georgia low country, where men outnumbered women two to one as late as the 1770s, retarded the process of family formation there, and the sparse slave populations in New England and the mid-Atlantic region (except for New York City) left many slave men without wives or forced them to postpone marriage. But by the time of the American Revolution, native-born slaves principally defined themselves by their family identities. Therein lay the seeds of the African-American slave community.

Slave family culture grew from West African roots, but largely in response to the demands of bondage. Demography and the strictures of Christianity worked against the transplantation of West African traditions of polygamy to British North America. More telling over the long run was the slave family's lack of security. Slave marriages had no legal standing anywhere in British North America or, later, in the United States. Prevailing norms about masters' duties to slaves and slaves' own insistence on living in and protecting their families became increasingly important factors influencing the strength and inviolability of slave families, especially during the nineteenth century. But more than anything else, the custom of the plantation and the fortunes and interests of the master determined the fate of the slave family.

Masters who fell on hard times might break up slave families by sale—a prospect so feared by slaves that they understood among themselves that they had to work hard enough to ensure the minimum solvency of the master so as to prevent the sale of family members. Slaves were sold to pay debts and to settle estates when masters died. They also were sent to develop new farms farther west or south, were sometimes rented out for years to another master, and were given away as wedding presents or to set up the master's children on a new site.

The vulnerability of slave families to disruption by sale, migration, or death led slaves to create extensive kinship networks, reviving West African cultural traditions that emphasized wide kin connections. Among the slaves on farms and plantations, aunts, uncles, cousins, and grandparents shared child-rearing duties with the slave parents or took over altogether if the parents died or were separated from their children. Women especially developed highly elaborated networks to make up, to some extent, for the absence of menfolk who lived on or had been sold to another farm or plantation.

Parents or related elders taught children crafts, proper work habits, and survival skills, later referred to by slaves as "puttin' on massa." Working in the family garden outside the slave cabin and sharing chores inside it further bound children to the family. Naming patterns identified and reinforced family ties. Boys often were named for fathers who could be sold or who lived off the plantation, while girls commonly were named for aunts or other female relatives. Kin networks stretched across neighborhoods and even states. From the mid–eighteenth century to the end of slavery, native-born slaves lived and learned within a family context, variously as members of a nuclear slave family, as individuals connected to a kinship network, and as heads of their own family households.

Two-parent households were typical for native-born slaves on plantations of twenty or more slaves. On farms with ten or fewer slaves, women usually

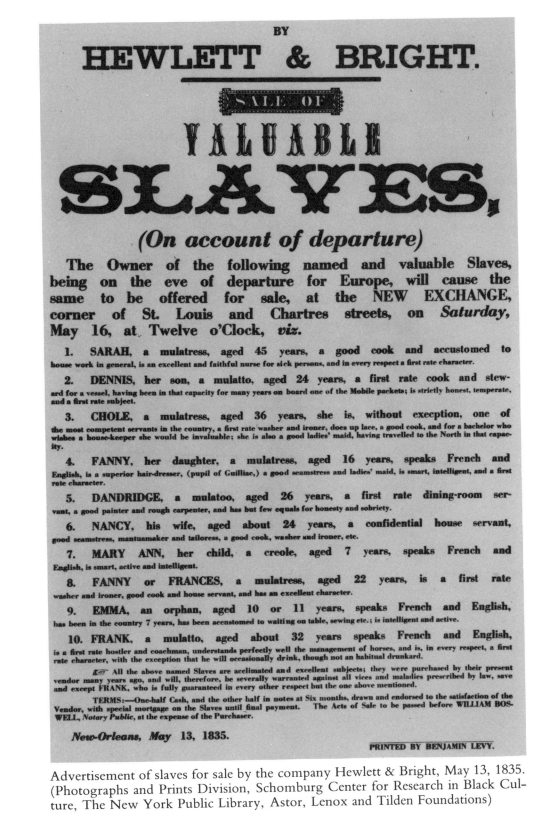

Advertisement of slaves for sale by the company Hewlett & Bright, May 13, 1835. (Photographs and Prints Division, Schomburg Center for Research in Black Culture, The New York Public Library, Astor, Lenox and Tilden Foundations)

lived with their children while their husbands lived "abroad"—that is, off the farm but nearby—visiting on Sundays and holidays or at night whenever possible. Out of self-interest alone, masters sought to keep mothers and children under the age of six or seven together. Slave fathers who lived or worked off the plantation had much less opportunity to rear their children and could not prevent their wives and children from being abused and beaten, though many of them tried to do so with individual acts of bravery.

Fathers hunted, fished, tended garden, and even stole to supplement the family diet and taught their children how to do likewise, but the peculiar and persistent demands of slavery strained traditional roles and sometimes relationships within the household. Although these dynamics of family formation and interaction persisted to the last days of slavery, men quickly asserted their authority as heads of household within the black family during Reconstruction.

The rise of slave families contributed to a dramatic natural increase of population and gave it a distinctly African-American and less African cast from the mid–eighteenth century on. Slave importations virtually halted during the French and Indian War and the Revolutionary War from the 1760s through the 1780s, but South Carolina and Georgia made a burst of African slave purchases between the ratification of the U.S. Constitution and the closing of the African slave trade to the United States by law, effective January 1, 1808. Roughly forty thousand Africans were brought illegally into the United States between 1808 and 1861. Such legal and illegal importations reinvigorated African identities in the South Carolina low country and Louisiana sugar parishes where the Africans were sold, but for American slavery generally, the immediate and powerful infusion of Africans into North America had ceased by the time of the American Revolution.

As the proportion of native-born to African-born slaves went up, the male-female ratio evened out,

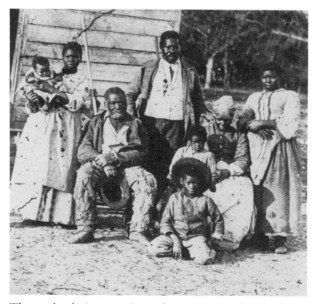

Through their tenacity, slaves were often able to maintain a vibrant family life and kinship connections in the most trying of circumstances. Shown here is a multigenerational, extended family of recently freed slaves, photographed on Beaufort Island, S.C., in 1862. (Prints and Photographs Division, Library of Congress)

making it easier for slaves to find partners. By the early nineteenth century the United States had the only slave population in the New World that was reproducing itself. That demographic fact made all the difference for the kind of slavery and African-American culture that developed here. Slaveholders would depend on natural increase within the context of slave families to sustain and spread their plantation interests, and slaves would look to their own families to define and defend their emerging African-American identities.

American-born slaves responded to bondage differently than did unacculturated African-born ones. Masters sought to acculturate slaves to make them work better and be more responsive to the masters' demands. The slave who could speak English, handle farm or artisans' tools, and understand planting and craft work was more valuable than the slave who could not. Yet the more knowledge the slave acquired about the master's ways, the more independent he or she became and the more dependent the master on the slave. African-born slave resistance generally was sudden, violent, and collective; groups of African-born slaves tended to run away and try to establish maroon colonies (*see* MAROONAGE) in the interior. Colonial governments sent militia and even Indian allies to destroy such settlements and return runaways to their masters. By contrast, acculturated slaves, who were more subtle in their subversion, were less easily detected and stopped.

A slave's place in the plantation hierarchy strongly influenced his or her resistance strategies. Artisans familiar with local customs and geography from having worked off the plantation escaped to towns and seaports where they could find work. Their understanding of the whites' economy, culture, and society and their tendency to run away as individuals rather than in groups allowed them to slip into an urban anonymity that made it difficult for masters to recapture them. Field hands and domestic servants largely confined their resistance to the plantation—feigning stupidity and illness, stealing from plantation stores, and absconding to the woods for a time to escape a punishment or protest an injustice. Field hands broke tools and shirked work, and house servants pilfered from the master's larder and liquor cabinet, inflicted a host of petty nuisances when the master's eyes were turned, and on rare occasions even poisoned the master's food, but both field hands and house servants tended to stay home rather than try to flee to freedom.

Slave drivers often protected their fellow slaves in ways that kept them on the plantation. Serving as foremen on large plantations, drivers ran the day-to-day operations under the direction of an overseer or master and meted out tasks and punishment as necessary. Many drivers set work rules that allowed the

weakest slaves to avoid a whipping, ignored minor lapses in the work rhythms, hid runaways, and settled quarrels among slaves so the master would not intrude.

The more the slave became like the master, the more tenuous became the "logic" of a system of bondage based on difference. For that reason, colonial masters opposed efforts by such missionary groups as the Anglican-led SOCIETY FOR THE PROPAGATION OF THE GOSPEL IN FOREIGN PARTS to try to convert the slaves in the early eighteenth century. Masters who did not want to be bound by Christian obligation also had reason to worry that Christian slaves would prove more restive than "heathen" ones. Only when colonial legislatures made clear that the slaves' religious status did not affect their legal one did it become possible to bring the Gospel to the slaves.

From the Great Awakening of the 1740s through the Great Revival of 1800–1805, many American-born blacks accepted the promise of salvation that evangelical preachers offered to all people regardless of color, condition, or circumstance. The impact of Baptist and Methodist preachers by the early nineteenth century was particularly decisive. The evangelical Protestant emphasis on grace and an enthusiastic "felt," as opposed to an abstract learned, religion appealed to African-American sensibilities. For the slaves, the revivalists' emphasis on being seized by the spirit recalled common West African beliefs in spirit possession, and the symbolic importance evangelicals attached to baptism as a rite of spiritual rebirth paralleled West African religious rites involving water. The laying on of hands, baptism by immersion, religious trances, and the theology of the holy Trinity also corresponded with African ancestral rituals and beliefs. Because African-American slaves could interpret evangelical religious symbols, practices, and theology within an African context, they could and did claim evangelical religion as their own.

The entry of black slaves into white churches challenged the master's absolute authority. As fellow Christians, master and slave were alike in God's eyes and, in many cases, in church discipline. The full implications of Christianizing slaves did not become evident until the nineteenth century (see below), but the antiauthoritarian, and even antislavery, thrust of early evangelicalism shook the planters' power during the eighteenth century.

By the time of the American Revolution, then, the basic contours of an African-American slave culture had been formed. Indeed, the half-century from 1740 on was probably the single most important time for the formation of African-American slave culture.

The AMERICAN REVOLUTION drastically changed the political and ideological context of slavery. In proclaiming the "rights of man," white patriots used radical language that pointed up the contradiction between slavery and their own cries for freedom. Indeed, the Enlightenment thinkers from whom the patriots drew their emphasis on natural rights already had condemned slavery as incompatible with the idea of progress. Also, slavery based on color stressed differentness, but natural rights stressed sameness, the inalienable rights of "all men." The irony was not lost on slaves, such as a group who marched through Charleston in 1766 chanting "Liberty, liberty." At the same time, the evangelical thrust that challenged the political and social assumptions underpinning the hierarchical order the planters had made brought all authority into question.

Influenced by the new political currents as well as by the Great Awakening, some white religious groups worried that slavery was corroding their own piety. QUAKERS sought to cleanse themselves of the sin of slaveholding, which they equated with kidnapping and avarice, and during the 1770s and 1780s they extended their antislavery witness outward by organizing antislavery societies. As historian David Brion Davis argues, slavery, which in Western thought had been linked with progress since the days of classical Greece, now was on the ideological and moral defensive.

Slaves seized the moment to assert their own independence. Thousands of slaves fled to freedom amid the confusion and upheavals of the Revolutionary War, seeking refuge in towns in the Chesapeake and among Indians in Georgia and South Carolina. Others responded to the 1775 proclamation of Lord Dunmore, royal governor of Virginia, promising freedom to any slave who bore arms against his rebel master. In the Chesapeake region virtually every slaveholding family reported at least one slave "lost to the war." Farther south, up-country Loyalists encouraged slave rebellions against low-country "patriots," and British commanders also offered slaves freedom in exchange for service. Such actions did not transform revolts into revolution. As historian Sylvia Frey has observed, the high incidence of escapes and the British commanders' own policy of restricting blacks to support rather than military roles likely "lessened the possibility of organized rebellion." Although the British often reneged on the promise of freedom, thousands of black refugees left with the British armies in 1783 to be resettled in Canada and later Sierra Leone. Desperate for men, the American armies also recruited blacks. States of the lower South resisted the call, but Maryland rewarded slaves who served with MANUMISSION and northern states eagerly met their recruitment quotas by enlisting blacks. About five thousand blacks, slave and free, served in the American armies and navy and helped lay claim to the freedom promised by the American Revolution.

Whatever blacks' claims to freedom, American political leaders remained ambivalent about slavery. Concerns about property rights, racial and social order, and political stability led the Revolutionary War generation to try to contain slavery in the hope it would die a natural death. Hating slavery but fearing any precipitous action against it, the Revolutionary War generation moved indirectly. They abolished slavery only where it was weak or thinly rooted and even then adopted policies that minimized disruption of established labor patterns and property rights. The process was slow and sometimes bitterly contested by slaveholders. Indeed, slavery was so entrenched in the Hudson River valley, where slaves made up 20 percent or more of the population, as well as in northern New Jersey and in New York City and Philadelphia, that its abolition was no foregone conclusion. But the concentration of slaves in wealthy households in cities, where it functioned as a status symbol as much as an important labor source, weakened the institution's support among artisan and laboring classes. Slavery was on the decline in Philadelphia after 1770; only in New York City, where one in five households owned at least one slave as late as 1790, and on the iron plantations in rural Pennsylvania did the institution continue to grow in the region.

Prodded by Quaker example and Revolution-era thought, Pennsylvania led the way to emancipation in 1780 with a plan for a gradual, compensated abolition that allowed slaveholders to retain control over slaves until they reached their age of majority (*see* GRADUAL-EMANCIPATION STATUTES). Likewise, other states freed only the children of slaves born after specific dates—for example, 1799 in New York and 1804 in New Jersey—so that small numbers of slaves continued to labor in several northern states into the antebellum era. In the Northwest Ordinance of 1787, however, the Revolutionary War generation moved more forthrightly to prohibit the *expansion* of slavery outright by barring it from the Northwest Territory. Slavery, which had been a "national" institution in 1776, thus became a regional one, distinguishing "North" from "South" by the early nineteenth century.

The Revolutionary War generation also closed the United States to the African slave trade, and it even raised the issue of abolition in the Chesapeake states. During the 1780s the Virginia and Maryland legislatures openly debated antislavery proposals and passed laws making manumissions easier. Between 1782 and 1790, more than ten thousand slaves in Virginia were freed by masters responding to the idea of natural rights or to Christian impulses. Many other slaves used the new laws to purchase their own freedom and that of their spouses or children.

During the Revolutionary War era, blacks laid the foundations for African-American freedom. Most important in that regard was the increase in the population of FREE BLACKS through escape, manumission, self-purchase, and the immigration of refugees from the revolutionary struggles in Haiti during the 1790s. By 1800, for example, more than 10 percent of all blacks in the Chesapeake region were free. Most of the new free black population gravitated toward towns, where they found work and community. The new free population was darker in complexion and more varied in skill than the small pre–Revolutionary War free black population, which had tended to be lighter-skinned, more highly acculturated, and more skilled than the slave population. As a result, runaway rural slaves were no longer conspicuously different in appearance and skill from the urban free black population. The recentness of their "freedom," however gained, also tied free blacks to slaves more closely than in earlier generations. Free blacks usually had family or friends in bondage.

From Charleston to New York, as the numbers of free blacks grew to critical masses large enough to form distinct African-American cultural and social institutions, blacks established their own churches, mutual-aid societies, and schools, often under the name "African." These institutions formed the matrix from which flowed black leadership during the nineteenth century.

The independence of blacks in towns and the blurring of distinctions between slaves and free blacks drove whites to reassert their control. Virginia imposed strict new rules on manumission in 1792, but such action did not prevent the Gabriel Prosser Rebellion of 1800 that finally shocked the upper South to recant its antislavery interest (*see* GABRIEL PROSSER CONSPIRACY). The Bible-quoting Prosser, a slave from Henrico County, Va., organized a three-pronged attack on Richmond in order to arm slaves for a general rebellion and kidnap Gov. James Monroe as a hostage. The plot failed when two slaves betrayed the scheme and a severe rainstorm made streams impassable. Haunted by accounts of the Haitian slave rebellion of the 1790s, whites executed Prosser, stepped up slave patrols, restricted slave movements, and further tightened manumission procedures. Prosser's rebellion reverberated throughout the slave states, hastening a general retreat from Revolution-era antislavery sympathy. In those states where slavery counted, the chains tightened even before the Revolutionary War generation had passed away.

The Revolutionary War generation's reluctance to kill slavery outright ensured its growth and expansion rather than its natural death. The lower South had resisted all antislavery urgings. Whites there believed slavery was a necessary instrument for controlling the substantial black population. Delegates from South Carolina and Georgia had threatened to bolt the Constitutional Convention in 1787 unless the

new constitution being drafted satisfied their demands to protect slavery's interest. The Founding Fathers obliged by respecting slavery as a local institution in law, providing for the return of fugitives, and counting slaves for purposes of congressional representation. That calculation gave the slaveholding interest a disproportionate power in national government until the Civil War, and the new government enacted a federal fugitive slave law in 1793. Property rights thus superseded human ones, as the interests of political union overrode considerations of human liberty. Southern politicians in the 1840s and 1850s would summon the proslavery tradition of the Constitution and early government in their own defense of slavery's expansion.

The Revolutionary War generation thus bequeathed to America a contradictory legacy of protecting slavery's interest while seeking to limit its growth. During the debate over admitting Missouri to the Union as a slave state in 1819–1821, the Revolutionary War generation made its last bequest by drawing the MISSOURI COMPROMISE line across the rest of the Louisiana Purchase territory and barring slavery north of that line. Thereafter, by reference to the Missouri Compromise as well as the Northwest Ordinance, the Revolutionary War heritage could be invoked to justify opposition to slavery's advance. Ironically, though, such opposition finally broke up the Union that the Founding Fathers had so desperately sought to preserve by accommodating slavery while trying to contain it. Rather than remain in a union that limited slavery's expansion in the hopes of speeding its demise, the slaveholder-dominated southern states seceded in 1860–1861.

Even during the Revolutionary War era, far from falling into decline, slavery was advancing geographically westward into the southern Piedmont and economically into a host of new activities. Planters in the upper South were restoring depleted soils with new agricultural techniques financed by selling surplus slaves southward and westward. From the first days of the republic to the last days of American slavery, the revitalization of the upper South hinged on the expansion of the lower South and thereby strengthened the institution everywhere. Slaveholders also sent slaves to work in lumbering and turpentine production, in coal and gold mining, in iron foundries and textile mills, and in a variety of mechanical and industrial trades in cities and in the countryside. Even though only about 10 percent of the slave population lived in cities or towns and only about 5 percent worked in industrial pursuits by 1860, the diversity of occupations and locations attested to the dynamism and flexibility of slavery.

The chief demand for slave labor, however, always came from agriculture. Although slaves grew tobacco and wheat in the Chesapeake region, hemp in

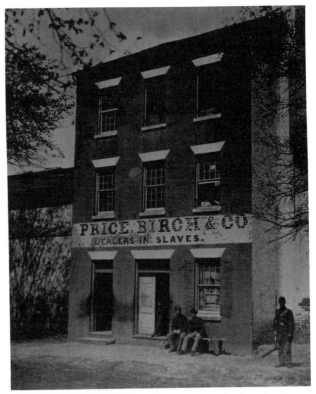

The slave pen of Price, Birch & Co., dealers in slaves in Alexandria, Va. Slave merchants often profited handsomely from their odious trade. (Prints and Photographs Division, Library of Congress)

Kentucky, rice in the Carolina-Georgia low country, and sugar in Louisiana, cotton became the principal southern staple during the nineteenth century. Cotton reigned from the eastern seaboard to Texas. The great cotton boom, spurred by European and northern demand, pushed slavery deep into the Old Southwest. Slave prices rose with cotton prices, and by 1860 slavery's center of gravity had shifted from Virginia and South Carolina to Alabama and Mississippi. From the 1830s through the 1850s the steady shuffle of slave coffles southward and westward uprooted roughly six hundred thousand slaves. Such a mass migration disrupted slave families and taxed slaves with the onerous work of cutting canebrake, draining swamps, building levees, and planting corn and cotton in frontier conditions. Although the slaves, and the plantations, spread across the South, they remained largely concentrated in the tidewater regions of the eastern coast and the deltas in the Gulf states.

Slavery grew because it was a very profitable, flexible labor system. It generated wealth for slaveholders in the form of new lands developed and of the increased value of land and slaves. Planters generally earned a return on their investment in slaves that was equal to the returns on money Northerners invested in manufacturing or railroads, and if they scrimped

on food and maintenance for their slaves and drove them harder than the norm, the slaveholders gained even higher returns. By 1860 the huge capital investment in slaves exceeded in value all other capital worth in the South, including land.

The opening of the lower South also bolstered the southern nonslaveholders' allegiance to the system by keeping alive the prospect that they, too, might acquire slaves as new lands came under the plow. Rising slave prices and growing plantation sizes made acquiring slaves more difficult during the 1850s, but slaveholding remained widespread. In 1860 roughly two million whites, out of a total southern white population of eight million, owned slaves or were members of a slaveholding family; others rented slaves or had owned some at one time. Only ten thousand families owned at least fifty slaves; most slaveholders had few. The desire to own slaves for reasons of profit and social prestige consumed the white South and made the protection and expansion of slavery the dominant political concern there.

The size and location of the farming unit influenced the organization and character of the slaves' work. According to the 1860 federal census, about one-quarter of the nearly four million slaves in the agricultural South lived on farms with ten or fewer slaves. There they toiled alongside their master in the fields and did a host of other farm chores, rarely outside the master's pervasive and persistent presence. About half the slaves lived on plantations with twenty to forty-nine slaves, and about one-quarter of the slaves in 1860 were on plantations of fifty or more slaves, where field hands spent most of their time away from direct contact with the master.

Slaves labored from sunup to sundown, year in and year out, with only the Sabbath and the Christmas holidays off, but each crop set a particular work pace and pattern. In rice cultivation slaves worked at prescribed tasks, and when they completed their daily assignments to the satisfaction of the overseer or driver, they could spend as much as half a day tending their own garden, fishing, hunting, or in any other useful activity. In sugar and cotton cultivation, by contrast, masters organized the slaves into work gangs to plow, hoe, and harvest the crops. Such collective work was highly regimented, but also rhythmic. Consequently, slaves often were able to resist attempts to increase the work load or pace, except during harvest, when the crops had to be picked or cut in time to avoid spoilage from rain or frost. Picking cotton, more than any other activity, engaged the whole family, from children to elderly slaves. House servants, too, were drafted into the picking force, so that slaves on cotton plantations shared a common work experience regardless of age or position. Yet perhaps no more than half of the plantation slaves were full-time field hands. Large plantations func-

tioned as almost self-sufficient enterprises, requiring their own handymen, carpenters, blacksmiths, millers, gardeners, and domestics. On large plantations slaves entered all areas of production, even management, and thereby gained a measure of control over their own work.

The physical conditions of bondage improved over time. By the 1850s many slaveholders had become more aware of the need to increase food allotments, maintain more sanitary living conditions, and provide adequate clothing and shelter for their slaves. Agricultural reformers pointed up the benefits in increased productivity, lengthened life spans, and the control such improvements might bring, and a general interest in bringing "modern" business practices to plantation agriculture, as evidenced in the neatly ruled account books used by many planters during the 1850s, encouraged the trend toward "reform." So, too, paradoxically, did the southern churches' proslavery argument that defended the practice by invoking scriptural passages while reminding masters of their duty toward the slaves. One of the reasons Southerners so tenaciously fought off antislavery criticism and demanded federal protection for slavery in the territories during the 1850s was their belief that they had evolved a more Christian, paternalistic labor system than the "wage slavery" being practiced in the industrializing North. Southerners pointed to the rootlessness and instability of northern society, where countless wage earners groaned under the lords of the loom, and praised the organic South, where the slaves enjoyed the "blessings" of being part of the master's "family." The southern emphasis on maintaining one's honor, which Southerners equated with liberty, demanded public responses to any criticism of one's person or family. The increasingly violent verbal and even physical confrontations in national politics during the 1850s derived in part from Southerners' honor-bound need to respond to what they considered the hypocritical, and fanatical, criticisms leveled against them and from their growing conviction that Northerners could not be trusted. Convinced of the "positive good" of slavery and their own benevolence, slaveholders tightened slave codes, increased efforts to recover fugitive slaves (with the help of the controversial federal FUGITIVE SLAVE ACT OF 1850), closed avenues for slaves to be manumitted or to purchase their own freedom, circumscribed the activities of free blacks, and even debated the wisdom of reopening the African slave trade during the 1850s.

The day-to-day realities of slave management belied the public face slaveholders assumed as the "good massa." Masters sometimes rewarded slaves with extra rations and favors for good work and even paid them for extra work, but violence more than incentive made slavery pay. To punish slaves for real or imagined failings, masters withheld privileges, de-

nied passes to visit relatives off the plantation, cut food allowances—but, mostly, they whipped. Although the frequency of whipping varied from plantation to plantation, few slaves escaped the lash during their lifetimes.

The regular, regimented nature of staple crop production established standards of performance for the slaves. Masters knew what the slaves could do, and the slaves knew what they must do. But both the regularity and the variety of work allowed them some room for social maneuvering. Some jobs took slaves away from whites' supervision. Field hands in gangs talked, sang, and courted among themselves. The regularity of work set time boundaries for slaves, usually fifteen hours a day with a midday break for a meal. From sunup to sundown they adopted the public poses necessary to keep the lash off their backs and the masters out of their lives. From sundown to sunup, however, they were left to themselves. Only house servants had almost continuous association with the masters throughout the day, and they suffered for it in isolation from the regular camaraderie of the field hands and in the constant demands from the master and mistress of the plantation.

African-American culture grew especially in those areas of life where masters rarely intruded. Masters did not recognize the African aesthetic in coiled or plaited baskets, irregular rectangular designs on quilts, or the physiognomic shapes of pottery, nor did they understand the social implications of slaves' imposing their own artistic styles on the materials and social space available. Slaves not only played the fiddle—a European instrument—they also made fiddles of their own from gourds, producing an African-American instrument with its own distinctive sound. They crafted banjos from sheep hides, flute quills from willow stalks, and "bones" from bones. When they were not allowed to make drums, they kept alive complex West African syncopated percussion rhythms with hand-clapping, body-slapping, and foot-tapping known as "playin' Jubba." Slaves received food rations from the master, but they made corn into hoecakes or cornbread, mixed peas with rice, and added fish and game from hunting to create African-American dishes spiced with seasonings that recalled West African tastes. In building their slave cabins they converted the master's material into their own space. Folk architecture varied according to place, with cruder structures more prevalent as one proceeded west into frontier areas such as Texas, but African-American influences were present everywhere. Many slaves, for example, preferred pounded-dirt floors to plank ones because dirt floors harked back to African styles.

Inside the cabins and on the "street"—the row of cabins in the slave quarters—slaves asserted their own identity through story and song. Proverbs employed African styles of speaking by indirection but also provided instruction on how to survive in the New World. Slaves narrated tall tales and especially trickster tales about small, sly animals such as Brer Rabbit outwitting more powerful foes such as Brer Fox or Brer Bear. "John tales" featured John the human trickster, who bested his master with deft wordplay. Whether borrowed from African trickster tales or from the slaves' own experience, such FOLKLORE made language a means of resistance.

Likewise, in their songs slaves expressed their feelings about work and life. Singing regulated the rate of work, from hoeing to husking corn, and celebrated the rituals of the life cycle, from birth to death. Sacred songs, or spirituals (see SPIRITUALS), appeared during the slaves' gradual conversion to Christianity. Along with the "shout," or dance, slave sacred songs imparted a distinctly African-American character to sacred music. Polyrhythms, blue notes, and especially the call-and-response style, which was ideally suited to the singing and preaching of the evangelical camp meeting, marked slave sacred song. Such songs also were a form of protest, laced with double meanings for such common words and phrases as "Canaan" (as both a scriptural reference and a promise of freedom), "crossing the river Jordan," "stealing away with Jesus," and "deliverance." Slaves also sang lullabies and doleful tunes to quiet their children and lament life's travails.

SLAVE RELIGION became the crucible of African-American slave culture. While oblivious or indifferent to the development of an African-American folk culture, masters cared about slave religion. In the 1830s, amid a general religious awakening in the South, many masters sought to bring the Gospel to the quarters, both as an instrument of social control and as a way to convert their slaves. The "mission to the slaves" contributed to increases in slave conversions. By 1860, roughly 15 percent of the slaves were members of a church. The normative church experience for slaves was biracial by 1860, with most "churched" slaves in Baptist or Methodist congregations, where they heard the same sermons as whites, submitted to the same discipline as white members, shared the communion table with whites, and experienced a kind of equality between the races nowhere else possible in slave society.

Religion for slaves was not, however, confined to churches and formal proceedings. Slaves listened to their own black preachers and exhorters translate the Bible in such ways as to claim that the slaves were God's chosen people and that Judgment Day would bring God's wrath down upon the sinful masters. Their message emphasized themes of judgment and deliverance and commingled Moses and Jesus as saviors of people and souls. Slaves con-

verted Christianity into their own terms. They assumed a degree of moral superiority over masters who did not conform to common Christian standards of behavior. Breaking up a slave family violated Christian precepts, whatever the local law might otherwise allow.

In the quarters or off in the woods, slaves gathered at night to sing and dance in a rhythmic style reminiscent of the ring shout of many West African religions. Other religious practices mixed with Christian ones. In the lower Gulf area in and around Louisiana, some slaves followed VOODOO; in places that still received illegal slave importations from Africa, a few practiced Islam. Many slaves subscribed to no formal religion at all. Conjurers tapped West African spiritual roots to find followers everywhere in the South, promising that their incantations, spells, and talismans could bring relief from daily torments, outmatch rivals, and undo curses. African-American slave religion was varied and complex, and beyond the master's knowledge or observation. It could produce contradictory behavior, inspiring rebellion as well as justifying submission, but ultimately it was subversive—for, in the words of Willie Lee Rose, religion encouraged slaves to ponder their human condition, to think for themselves.

The danger of slave religion was made strikingly evident in NAT TURNER'S REBELLION of 1831, the most important uprising in the nineteenth century. There had been earlier revolts or conspiracies, such as the 1811 Pointe Coupee revolt in Louisiana, in which between 150 and 500 slaves marched from their Mississippi Delta plantations toward New Orleans before being defeated, with 65 blacks losing their lives;

and the DENMARK VESEY CONSPIRACY of 1822, in Charleston, S.C., in which as many as several thousand potential rebels were enlisted before the conspiracy was discovered and Vesey and 34 other conspirators were hanged. But these had not been messianic in character or even principally religious in motivation. The leaders of the Pointe Coupee revolt were from Haiti and built on a long period of slave violence in the Pointe Coupee area dating back to a revolt in 1795; Vesey was a free black, born in Africa or St. Thomas, who acted from a mix of ideas, including the principle of the rights of man, the Haitian revolution of 1800, and, to a lesser extent, religious conviction. Nat Turner, a slave in Southampton County, Va., however, believed he was called by God in a religious vision to deliver his people from bondage. Literate, highly articulate, and driven by a messianic impulse, Turner used preaching, conjuring, and cajoling to convince others to join his plan to strike one night following an eclipse of the sun. His original band of six swelled to eighty as it marched to Jerusalem, in Southampton County, killing fifty-seven men, women, and children until white authorities crushed the revolt. Turner avoided capture for over two months before he was caught and executed in November 1831.

Turner's revolt shocked the South. Hysterical white Southerners saw rebellion looming everywhere and killed as many as two hundred slaves in fits of reprisal and fear. Southern states tightened slave codes and muzzled criticism of slavery. Whites also sought to reassert their authority through closer supervision and religious instruction, even as the slaves were whispering Nat Turner's name in the same

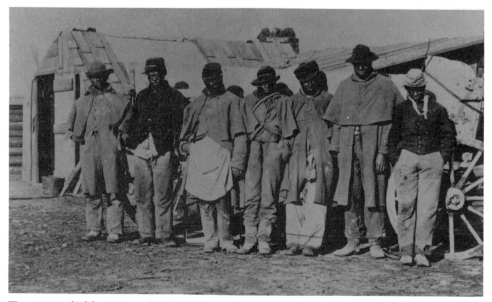

Teamsters held as contraband. (Prints and Photographs Division, Library of Congress)

breath with those of the biblical prophets who fore-told of Judgment Day and deliverance. The Turner revolt and its aftermath revealed how little the whites knew the slaves.

Deliverance came with the CIVIL WAR and the end of slavery. Once northern public opinion recognized that slavery helped sustain the Confederacy's ability to fight, the war for the Union became a war against slavery, the root cause of the conflict. From the slaves' perspective, the war meant both hardship and opportunity. By enduring the hardship and seizing the opportunity, they hastened their own liberation.

The war made burdensome physical demands on slaves. The Confederate impressment policy of 1863, for example, forced many slaves to work away from their homes building fortifications, hauling supplies, or performing other heavy tasks under debilitating conditions that often sent them home sick or injured and sometimes killed them. However coarse and spare, the quality and quantity of food, clothes, and shoes available to slaves had improved before the war, but wartime shortages cost them the modest material "gains" they had earned in the 1850s. It also cost them their own property, as Union and Con-federate "bummers" alike looted slave cabins and took the produce of slave gardens and the crops from the fields. Whatever their attitudes toward the masters and the Confederate cause, slaves had a proprietary interest in the crops they planted, the livestock and fowl they raised, and the land they tilled. The failure of Union soldiers, especially, to respect that interest sowed seeds of distrust among blacks that would make them as wary of their "liberators" as they were of their masters.

The war also created opportunities. With so many white men away from home, the masters' control over the slaves eroded steadily. Some masters entrusted slaves with running plantations; many masters relied on "faithful" slaves, such as house servants and drivers, to assist plantation mistresses in doing so. There were enough instances of slaves hiding the white family's silver from the Yankees and sharing their own produce with the master's family to fuel the postwar myth of the slaves' loyalty. In fact, trusted slaves generally joined the field hands in pursuing their own common interest. During and after the war, masters railed against the "betrayal" by their "black family," thereby acknowledging that they had

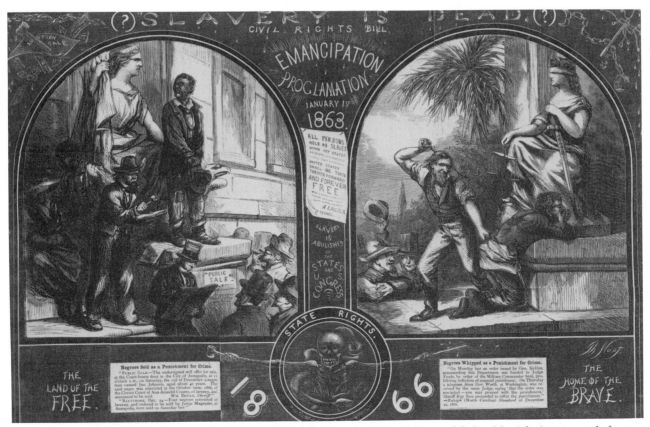

A wood engraving that expresses doubt about the ability of various pieces of federal legislation to end slavery in the United States. The illustration includes two newspaper clippings that tell of blacks being whipped and enslaved as punishment for crimes, despite the passage of the Fourteenth Amendment and the Civil Rights Act of 1866. After Thomas Nast, *Harper's Weekly,* January 12, 1867. (Prints and Photographs Division, Library of Congress)

never known the slaves at all. Slaves dropped their masks during the war, revealing their true feelings and selves. Everywhere they became more openly disobedient and reduced their work. Slaves spied for and gave invading Union armies information about Confederate movements and the whereabouts of the slaveholders' personal property. Even though no outright rebellions occurred, many individual acts of violence against white authority and property, especially in the sugar parishes of Louisiana, reminded whites that the slaves were a restive people. Most bided their time looking for the right moment to seize freedom.

The slaves' most dramatic response to the war was to run away. On the Sea Islands of South Carolina, as elsewhere where the masters fled from Union forces, slaves ran away by staying behind, refusing to follow their masters inland. They then took over the abandoned plantations. Wherever federal troops approached, slaves ran to them. The rush of slaves toward Union armies grew so large that it forced the Union generals to establish a policy of identifying the runaway slaves as "contraband" of war—that is, property that need not be returned to the enemy. By mid-1862 Congress had passed a confiscation act, freeing slaves who entered Union lines, but it excepted those belonging to Unionists. Slaves did not wait for Lincoln to issue his Emancipation Proclamation to seal slavery's doom. During the war, approximately one-seventh of the total slave population crossed over to Union lines. Old and young walked, swam, rode, and were carried over, pressing the issue of emancipation on the Lincoln administration more forcefully than abolitionist criticism had.

Understanding that each Union advance quickened slavery's end, many slaves joined the Union army. Almost a thousand from Florida, Georgia, and South Carolina joined a Union regiment that was formed at Port Royal, S.C., in late 1861, well before it was official government policy to recruit or accept black troops. Over 180,000 blacks, many of them newly escaped slaves, served in the Union army and navy during the war. They fought, and 37,000 of them died, so that emancipation was not something given to slaves but something earned by their own sweat and blood. And that made all the difference in what freedom meant to blacks after the war.

Blacks emerged from the war with a vibrant African-American culture and, in their own preachers and churches, the beginnings of black leadership and institutions that provided the foundations for a successful adjustment to freedom. They readily claimed in freedom what had been denied in slavery—legal recognition of marriages, access to education, and the right to own property and keep what they produced. More important, through folklore, crafts, food, language, music, family, and religion,

blacks had developed a culture in bondage that had freed them from the debasement and self-condemnation that chattel slavery encouraged. They knew where they wanted to go in freedom because they had come to know who they were as a people.

REFERENCES

BERLIN, IRA. *Slaves without Masters: The Free Negro in the Antebellum South.* New York, 1974.

BERLIN, IRA, and RONALD HOFFMAN, eds. *Slavery and Freedom in the Age of the American Revolution.* Charlottesville, Va., 1983.

BLASSINGAME, JOHN W. *The Slave Community: Plantation Life in the Antebellum South.* Rev. ed. New York, 1979.

BOLES, JOHN. *Black Southerners, 1619–1869.* Lexington, Ky., 1983.

———, ed. *Masters and Slaves in the House of the Lord: Race and Religion in the American South, 1740–1870.* Lexington, Ky., 1988.

CAMPBELL, EDWARD D. C., with Kym Rice, eds. *Before Freedom Came: African-American Life in the Antebellum South.* Charlottesville, Va., 1991.

DAVIS, DAVID BRION. *The Problem of Slavery in the Age of Revolution, 1770–1823.* Ithaca, N.Y., 1975.

———. *Slavery and Human Progress.* New York, 1984.

DILLON, MERTON L. *Slavery Attacked: Southern Slaves and Their Allies, 1619–1865.* Baton Rouge, La., 1990.

EPSTEIN, DENA J. *Sinful Tunes and Spirituals: Black Folk Music to the Civil War.* Urbana, Ill., 1977.

ESCOTT, PAUL D. *Slavery Remembered: A Record of Twentieth-Century Slave Narratives.* Chapel Hill, N.C., 1979.

FOX-GENOVESE, ELIZABETH. *Within the Plantation Household: Black and White Women of the Old South.* Chapel Hill, N.C., 1988.

FREY, SYLVIA R. *Water from the Rock: Black Resistance in a Revolutionary Age.* Princeton, N.J., 1991.

GENOVESE, EUGENE. *Roll, Jordan, Roll: The World the Slaves Made.* New York, 1974.

GUTMAN, HERBERT G. *The Black Family in Slavery & Freedom, 1750–1925.* New York, 1976.

HUGGINS, NATHAN I. *Black Odyssey: The Afro-American Ordeal in Slavery.* New York, 1977.

JORDAN, WINTHROP D. *White over Black: American Attitudes toward the Negro, 1550–1812.* Chapel Hill, N.C., 1968.

JOYNER, CHARLES. *Down by the Riverside: A South Carolina Slave Community.* Urbana, Ill., 1984.

KOLCHIN, PETER. *American Slavery, 1619–1877.* New York, 1993.

KULIKOFF, ALLAN. *Tobacco and Slaves: The Development of Southern Cultures in the Chesapeake, 1680–1800.* Chapel Hill, N.C., 1986.

LEVINE, LAWRENCE W. *Black Culture and Black Consciousness: Afro-American Folk Thought from Slavery to Freedom.* New York, 1977.

LITWACK, LEON F. *Been in the Storm So Long: The Aftermath of Slavery.* New York, 1979.

MILLER, RANDALL M., and JOHN DAVID SMITH, eds. *The Dictionary of Afro-American Slavery.* New York and Westport, Conn., 1988.

MORGAN, EDMUND S. *American Slavery, American Freedom: The Ordeal of Colonial Virginia.* New York, 1975.

MULLIN, GERALD W. *Flight and Rebellion: Slave Resistance in Eighteenth-Century Virginia.* New York, 1972.

MULLIN, MICHAEL. *Africa in America: Slave Acculturation and Resistance in the American South and the British Caribbean, 1736–1831.* Urbana, Ill., and Chicago, 1992.

OAKES, JAMES. *The Ruling Race: A History of American Slaveholders.* New York, 1982.

——. *Slavery and Freedom: An Interpretation of the Old South.* New York, 1990.

OWENS, LESLIE HOWARD. *This Species of Property: Slave Life and Culture in the Old South.* New York, 1976.

PARISH, PETER J. *Slavery: History and Historians.* New York, 1989.

PHILLIPS, ULRICH B. *American Negro Slavery: A Survey of the Supply, Employment and Control of Negro Labor As Determined by the Plantation Regime.* New York, 1918.

QUARLES, BENJAMIN. *The Negro in the American Revolution.* Chapel Hill, N.C., 1961.

RABOTEAU, ALBERT J. *Slave Religion: The "Invisible Institution" in the Antebellum South.* New York, 1978.

ROSE, WILLIE LEE, ed. *A Documentary History of Slavery in North America.* New York, 1976.

SOBEL, MECHAL. *The World They Made Together: Black and White Values in Eighteenth-Century Virginia.* Princeton, N.J., 1987.

STAMPP, KENNETH M. *The Peculiar Institution: Slavery in the Ante-Bellum South.* New York, 1956.

STAROBIN, ROBERT S. *Industrial Slavery in the Old South.* New York, 1970.

WADE, RICHARD C. *Slavery in the Cities: The South, 1820–1860.* New York, 1964.

WEBBER, THOMAS L. *Deep like the Rivers: Education in the Slave Quarter Community, 1831–1865.* New York, 1978.

WHITE, DEBORAH G. *Ar'n't I a Woman? Female Slaves in the Plantation South.* New York, 1985.

WOOD, PETER H. *Black Majority: Negroes in Colonial South Carolina from 1670 Through the Stono Rebellion.* New York, 1974.

WRIGHT, GAVIN. *The Political Economy of the Cotton South: Households, Markets, and Wealth in the Nineteenth Century.* New York, 1978.

RANDALL M. MILLER

Slavery and the Constitution. The word "slavery" does not appear in the Constitution, except in the THIRTEENTH AMENDMENT, which abolishes the institution. Yet SLAVERY was the most divisive constitutional issue in pre–Civil War America.

Throughout the Constitutional Convention of 1787, the delegates heatedly debated the role of slavery under the new form of government. Population-based representation in the new Congress raised the issue of whether to count slaves in allocating representatives. The debates were often blunt and pointed. Gouverneur Morris of Pennsylvania argued against counting slaves for representation because "when fairly explained [it] comes to this; that the inhabitant of Georgia and S.C. who goes to the Coast of Africa, and in defiance of the most sacred laws of humanity tears away his fellow creatures from their dearest connections & damns them to the most cruel bondages, shall have more votes in a Govt. instituted for the protections of the rights of mankind, than the Citizen of Pa. or N. Jersey, who views with a laudable horror, so nefarious a practice." On the other hand, Charles Pinckney of South Carolina declared that slavery was "justified by the example of all the world." Pierce Butler, also of South Carolina, declared that "the security the Southen [sic] States want is that their negroes may not be taken from them which some gentlemen within or without doors, have a very good mind to do." Not surprisingly, James Madison of Virginia believed that the split in the convention was not between the large and the small states, but resulted "principally from their having or not having slaves."

The 1787 Constitution explicitly protected slavery in five ways. The three-fifths clause (Art. I, Sec. 2) gave masters extra representation in Congress for their slaves; the capitation-tax clause (Art. I, Sec. 9, Par. 4) limited the potential taxation of slaves; the migration-and-importation clause (Art. I, Sec. 9, Par. 1) prohibited Congress from ending the African SLAVE TRADE before 1808; the fugitives-from-labor clause (Art. IV, Sec. 2, Par. 3) provided for the return of fugitive slaves; and the amendment provision (Art. V) gave added protection to the slave trade by prohibiting any amendment of the migration-and-importation clause before 1808. Other clauses strengthened slavery by granting Congress the power to suppress "insurrections," prohibiting taxes on exports (which would have allowed for the taxation on the products of slave labor), and giving the slave states extra votes in the electoral college under the three-fifths clause. The requirement that three-fourths of the states assent to any constitutional amendment guaranteed that the South could always block any proposed amendments. Finally, and most important of all, under the structure of the Constitution the national government had no power to interfere with slavery in the states where it existed.

These clauses led William Lloyd Garrison, America's most famous Abolitionist, to call the Constitu-

tion a proslavery "covenant with death" and "an agreement in Hell." Southerners also agreed that the document protected their special institution. Shortly after he returned from the Constitutional Convention, Charles Cotesworth Pinckney told the South Carolina legislature, "We have a security that the general government can never emancipate them, for no such authority is granted, and it is admitted on all hands, that the general government has no powers but what are expressly granted by the constitution; and that all rights not expressed were reserved by the several states."

During the struggle over ratification, a number of northern antifederalists complained about the three-fifths provision and the continuation of the slave trade for at least twenty more years. These two clauses have often been misunderstood.

The three-fifths clause was not an assertion that a black was three-fifths of a person. The clause allocated representation in Congress by adding to the free population three-fifths of the total number of slaves. Free blacks were counted the same as whites, and in a number of states, including Massachusetts, New York, and North Carolina, free blacks voted under the same conditions as whites. The three-fifths rule was a compromise over the allocation of political power in the House of Representatives. Southerners at the convention wanted to count slaves fully for purposes of representation, while Northerners did not want to count slaves at all for representation.

The slave-trade clause has been misunderstood to require the end of the trade in 1808. Rather, it only prohibited Congress from ending the trade *before* that date. If the deep South had had the political clout, it could have kept the trade legal after 1808.

Ratification of the Constitution led to Supreme Court decisions on the African slave trade, slaves in interstate commerce, fugitive slaves, federal regulation of slavery in the territories, and the rights of free blacks under the Constitution. With the exception of cases dealing with the African slave trade, the Supreme Court invariably sided with slave owners.

After 1808, the federal courts heard numerous cases involving the importation of slaves from Africa. In the ANTELOPE CASE (1825), Chief Justice John Marshall asserted that the African slave trade was "contrary to the law of nature" but that it was "consistent with the law of nations" and "cannot in itself be piracy." Thus the Court recognized the right of foreigners to engage in the slave trade, if their own nations allowed them to do so.

The Court consistently condemned the trade as a violation of natural law and morality. But this did not affect its judgments. In all of the slave-trading cases the Court enforced concepts of international law; slave traders who violated the laws of their own

country could expect no support from the Court. But when foreign nationals participated in the trade, they were protected by their own laws. As Justice Joseph Story noted in a circuit court opinion in *La Jeune Eugénie* (1822), "I am bound to consider the trade an offence against the universal law of society, and in all cases, where it is not protected by a foreign government, to deal with it as an offence carrying with it the penalty of confiscation."

Soon after the adoption of the Constitution, the nation reached an unstated political consensus on the question of slavery and commerce. Although most lawyers would have conceded that after 1808 Congress had the *power* to regulate the interstate slave trade, the general consensus was that such regulation would be impossible to get through Congress and, in any event, would threaten the Union itself. Arguments of counsel and the opinions of the justices in commerce clause cases recognized the special status of slaves in the general regulation of commerce.

Groves v. *Slaughter* (1841) was the only major slavery case to come before the Supreme Court that directly raised commerce-clause issues. The Mississippi Constitution of 1832 prohibited the importation of slaves for sale. This was not an antislavery provision, but an attempt to reduce the flow of capital out of the state. In violation of this provision, Slaughter sold slaves in Mississippi and received notes signed by Groves, who later defaulted on the notes, arguing that the sale of slaves in Mississippi was void. The Court ruled that the notes were not void because Mississippi's constitutional prohibition on the importation of slaves was not self-executing, and absent legislation implementing the prohibition, the Mississippi constitutional clause was inoperative. In separate concurrences, northern and southern justices agreed that a state might legally ban the importation of slaves. This principle supported Northerners' interested in keeping slaves out of their states and the southern desire to make sure that the federal courts could not interfere with slavery on the local level.

The jurisprudence surrounding fugitive slaves was the most divisive constitutional issue in antebellum America. The federal and state courts heard numerous cases involving fugitive slaves. While settling the legal issues, none of these cases satisfactorily dealt with the moral and political questions raised when human beings escaped to freedom. Such cases only exacerbated the sectional crisis. Ultimately, these issues were decided not by constitutional arguments and ballots but by battlefield tactics and bullets.

The wording of the fugitive slave clause suggests that the Convention did not anticipate any federal enforcement of the law. However, in 1793 Congress passed the first of several FUGITIVE SLAVE LAWS, which spelled out procedures for the return of run-

away slaves. In *Prigg* v. *Pennsylvania* (1842), Justice Joseph Story upheld the 1793 law and struck down state laws passed to protect free blacks from kidnapping if they interfered with the return of fugitive slaves. Story urged state officials to continue to enforce the 1793 law, but concluded that they could not be required to do so. In response to this decision a number of states passed new personal-liberty laws, prohibiting state officials from participating in the return of fugitive slaves and barring the use of state jails and other facilities for such returns.

Jones v. *Van Zandt* (1847) was a civil suit over the value of slaves who had escaped from Kentucky to Ohio, where Van Zandt offered them a ride in his wagon. Van Zandt's attorneys, Salmon P. Chase and William H. Seward, unsuccessfully argued that in Ohio all people were presumed free, and thus Van Zandt had no reason to know he was transporting runaway slaves. In a harsh interpretation of the 1793 law, the Court concluded that Van Zandt should have known the blacks he befriended were slaves. In essence, this meant that all blacks in the North were presumptively slaves.

Hostility to these decisions led to the FUGITIVE SLAVE ACT OF 1850, which provided for federal commissioners to enforce the law through the United States. These commissioners could call on federal marshals, the military, and "bystanders, or *posse comitatus*," as necessary. The law provided stiff prison sentences and high fines for people interfering in its enforcement, while not allowing seized blacks to testify on their own behalf or giving them a jury trial. In *Ableman* v. *Booth* (1859), the Supreme Court upheld this law against a challenge based on the fact that the law violated the U.S. Constitution and the Wisconsin Constitution.

In two monumental acts, the Northwest Ordinance (1787; reenacted in 1789) and the MISSOURI COMPROMISE (1820), Congress prohibited slavery in most of the territories owned by the United States. These acts led to some of the most important, controversial, and complicated cases that ever reached the Supreme Court.

From 1820 until 1850 the issue of slavery in the territories was governed by the Missouri Compromise, which prohibited slavery in almost all of the West. The acquisition of new lands in the Mexican War, and the acceptance throughout the South of a "positive good" theory of slavery, led Southerners to demand access to the western territories. In 1854 Congress repealed some of the Missouri Compromise by opening Kansas and Nebraska to slavery, under a theory of popular sovereignty. Under popular sovereignty the settlers of a territory would decide for themselves whether to have slavery or not. Rather than democratizing the west, popular sover-

eignty led to a mini–Civil War known as "Bleeding Kansas," in which free-state and slave-state settlers fought for control of the territorial government. Meanwhile, in the North the newly organized REPUBLICAN PARTY gained enormous success campaigning against the spread of slavery. In 1856 this party, which was less than two years old, carried all but five northern states in the presidential election.

This set the stage for *the* legal case of the antebellum period, if not the entire history of the Supreme Court, DRED SCOTT V. SANDFORD (1857). The avidly proslavery Chief Justice Roger B. Taney used *Dred Scott* to decide pressing political issues in favor of the South. In his opinion's two most controversial points, Chief Justice Taney ruled that the Missouri Compromise unconstitutionally prohibited citizens from bringing their slaves into federal territories and that free blacks could never be citizens of the United States or sue in federal courts as citizens of the states in which they lived.

This decision, more than anything else, made the constitutionality of slavery into a major political question. In 1860, Abraham Lincoln successfully ran for president by opposing the further expansion of slavery, and by attacking Taney and the *Dred Scott* decision. That in turn led to secession, the Civil War, the issuance of the Emancipation Proclamation, and a formal end to slavery through constitutional amendment. Ratified on December 18, 1865, the Thirteenth Amendment pledged that "neither slavery nor involuntary servitude" shall ever exist in the United States.

REFERENCES

FEHRENBACHER, DON E. *The Dred Scott Case: Its Significance in American Law and Politics.* New York, 1978.

FINKELMAN, PAUL. "Slavery and the Constitutional Convention: Making a Covenant with Death." In Richard Beeman, ed. *Beyond Confederation: Origins of the Constitution and American National Identity.* Chapel Hill, N.C., 1987, pp. 188–225.

MORRIS, THOMAS D. *Free Men All: The Personal Liberty Laws of the North, 1780–1861.* Baltimore, 1974.

WIECEK, WILLIAM M. *The Sources of Antislavery Constitutionalism in America, 1760–1848.* Ithaca, N.Y., 1977.

PAUL FINKELMAN

Slave Trade

This entry is divided into the following sections and subsections, each of which was written by the author cited:

1. The Atlantic Slave Trade: An Overview (*Daniel C. Littlefield*)
2. The Middle Passage (*Daniel C. Littlefield*)

The Atlantic Slave Trade: An Overview

The Atlantic slave trade was one of the most important demographic, social, and economic events of the modern era. Extending over four centuries, it fostered the involuntary migration of millions of African peoples from their homelands in AFRICA to forced labor in the Americas and elsewhere around the globe. In the process it reshaped African societies, provided much of the raw material for constructing new social, economic, and political structures in the New World, promoted the development of a new industrial order, and furnished essential ingredients of modern world culture. It also left an unfortunate legacy of racism by establishing a connection between servility or barbarity and peoples of African descent.

The assumption from which this connection derived was advanced fairly early. The Scottish philosopher and historian David Hume wrote in 1753 that "There never was a civilized nation of any other complexion than white, nor even any individual eminent in action or speculation. No ingenious manufactures amongst them, no arts, no sciences. . . ." The passage related two crucial ideas, namely, that there was a nexus between race and culture, and that European culture was superior. Racial denigration, however, was not always the guiding principle of relationships between Africans and Europeans. There were many in eighteenth-century Europe who were familiar with achievements of African civilization. Indeed, in terms of their general world knowledge, writes historian Philip Curtin (1964, pp. 10–11) "eighteenth-century Europeans knew more and cared more about Africa than they did at any later period up to the 1950s."

The eighteenth-century interest derived from the nature of mercantilist imperial structures based upon the production of tropical staples through plantation labor. Africa was the source of labor. Since the material or technological distance between Africa and Europe was not then as great as it was later to become, Europeans approached Africans as approximate equals.

European traders were highly dependent upon their African partners and associates to ensure an orderly trade. Since trade frequently depended upon the accident of political vagaries on the coast, European traders, to be successful, had to be aware of political and social conditions in the area where they wanted to trade. Consequently, they stationed agents (called "factors") where Africans would permit it; these factors collected slaves and forwarded reports on African conditions to mercantile companies in Europe. Although these reports are colored by ethnocentrism, factors made a serious attempt to understand the local situation because comprehension was crucial to their ability to offer trustworthy advice. In this way, Europeans disseminated important information about Africa and Africans.

Of course, the European-sponsored Atlantic trade was not the only market for bound African labor. Historians have estimated that about six million Africans were taken to Asia and the Middle East, starting as early as the seventh century A.D. but reaching a peak between 1750 and 1900. Moreover, an additional eight million slaves were involved in an internal African trade, mostly between 1850 and 1914. The Atlantic trade, starting as early as the fifteenth century but becoming important after the discovery of America and reaching its height from about 1650 to 1850, carried approximately twelve million people to captivity in the New World. It was the largest mass movement in history up to that time. It can be divided into four epochs determined by source, destination, and major carrier of slaves.

The first is the era of Iberian domination in the sixteenth century, when Portugal was practically the sole carrier. Slaves were taken from Guinea to Spanish colonies and from Congo-Angola to Brazil. In this period, slaves were only one of a number of African commodities of equal importance. The seventeenth century was a period of transition. The Dutch broke up the Spanish control of the seas, destroyed the Portuguese monopoly of the African and Indian trades, and established themselves as the leading European maritime nation. Between 1630 and 1650, Dutch control of the sea and of trade was supreme. Dutch ships carried slaves and supplies to Spanish, French, and English colonies, and New World staples from them back to Europe. After 1650, England and France moved to establish themselves in Africa and to tighten the mercantilist system in their respective imperial spheres. The eighteenth century represented a period of French and English dominance.

The French and English took most slaves from the Slave Coast, east of the Volta River, and in the Niger Delta, while maintaining important interests at the peripheries in Upper Guinea and in southern Africa, along the Loango Coast. They carried these slaves in British and French ships to their respective possessions in the West Indies and to Spanish America. This represented the height of the trade, when human cargo was the overriding European interest in Africa.

Finally, there was an Iberian epoch in the nineteenth century. Northern Europeans abolished the trade north of the equator and deprecated the practice everywhere, but the demand in Brazil and Cuba continued until the middle of the century.

Iberian and Mediterranean Antecedents. Although by the eighteenth century Europeans were accustomed to thinking of slaves as black, it had not always been so. Slavery did not die out in Iberia as it did in northern Europe following the collapse of the Roman Empire. It continued and was an important aspect of life on the Peninsula, especially after the Moslem invasion in the eighth century. During the reconquest, Christians as well as Moslems used slaves, generally prisoners captured from the other side, and so the institution received renewed impetus. Portugal, who freed her territory from Moslem control in the thirteenth century, continued to gain slaves through naval warfare with the Saracens in the Mediterranean and along the Spanish and Moroccan coasts. This practice of slave raiding was extended to the Canary Islands when they were conquered in the fourteenth century, and to the Atlantic coast of Africa when it was reached in the fifteenth century.

Slaves were brought to Iberia from at least as early as the eighth century, and their importation continued during the Middle Ages. They came across the Straits of Gibraltar with Moslems, and were captured through the continuing Christian-Moslem conflict on land and sea, and, occasionally, through trade with Italian city-states in the Mediterranean. The city-states of Venice and Genoa administered a commercial empire that included sugar estates in Cyprus, Crete, and Sicily, the crop eventually reaching southern Iberia. The labor force on Cyprus initially consisted of free peasants, local serfs, and a few slaves, but sugar is extremely labor-intensive. Italians utilized an already existing slave trade to fill the need. These slaves derived from several sources: Italian trading posts (*fondachi*) in the eastern Mediterranean, consisting of various eastern Europeans from the Black Sea area; through trade and conflict with Moslems in southern Iberia (consisting of both Moslem and Christian captives); and from North Africa, consisting, among others, of black Africans from the sub-Sahara. When, in the middle of the fifteenth century, Ottoman Turks cut off the Black Sea trade, Africa remained as the only external source of forced labor for Mediterranean plantations. Black slaves were a small but significant part of this early story of the European experience of slavery before the Age of Discovery.

The Portuguese Hegemony. Although the acquisition of slaves was not the prime motivating force of the Age of Discovery, it was an early consideration. The era is dated from the Portuguese taking of Ceuta,

on the Moroccan coast across the Straits of Gibraltar, in 1415. The first black slaves reached Portugal directly from the Atlantic coast of Africa in 1442, and the first slave trading company was formed in 1444, which obtained slaves through periodic raids. But the Portuguese learned early that trade, whether in slaves or in other commodities, proceeded best in cooperation with rather than in opposition to Africans. In the fifteenth century, when the Portuguese laid claim to all of Africa, they divided the western coast into a series of regional monopolies, the right of exclusive trade in which was sold in Lisbon. They sent agents to locate on the coast. In Upper Guinea, some of these settled, intermarried with local peoples, and became middlemen in the trade between Africans and Europeans. These Afro-Portuguese had been joined by the eighteenth century by a class of Afro-French and Afro-English who operated in competing spheres of influence for the benefit of their respective metropolitan powers. Racially and culturally mixed, they achieved political influence through real or fictitious consanguineous ties to local royalty, and economic power through their control of trade.

Because of their prestige, they, in traditional African fashion, gathered to themselves full-blooded Africans, *grumetes,* who adopted their cultural affectations and became part of a hybrid trade community on the coast. Whereas in the sixteenth century these people were usually in a state of subservience to native chieftains, this condition had reversed by the eighteenth century. By this time also, they were able to repel European attempts to circumvent them and establish direct contact with local peoples in those places where they assumed hegemony.

But Portuguese activities were not uniform over all the coast. While a policy of peaceful penetration was adopted in Upper Guinea, there developed in the Gulf of Benin and in the coastal regions leading to it a relationship of power politics. The Portuguese could not move around freely, but were restricted to fortified coastal stations. The most venerable of these, São Jorge da Mina (established 1482), was important to the Portuguese as a source of gold rather than slaves; the metal was obtained through barter with local peoples. Africans brought gold from the interior, and because of long distances they had to travel, they required porters to carry inland goods secured in trade on the coast. The slave trade that developed was an internal African trade in which the Portuguese participated. To meet the demand, they brought slaves from the African kingdom of Benin, from the Portuguese settlement at São Tomé, an island farther down the coast, and from locations in Upper Guinea. The gold trade was so important that in 1610 the king forbade Portuguese subjects to take captives within several miles of the fortress so as not to disturb it.

The Portuguese utilized Africans in colonial settlements on islands off the African coast, where they produced sugar, and also supplied them to southern Europe and the Mediterranean. Between 1450 and 1500, about 30,000 Africans were shipped to Europe. Lisbon now served as entrepôt for the Mediterranean trade. In 1551, 10 percent of the city's population was servile, consisting of Moorish and Guinea slaves. At the beginning of the seventeenth century, the servile percentage was about the same, but at this period it was nearly all black.

During the sixteenth century, the center of major Portuguese slaving activity gradually shifted from Guinea to south-central Africa, in association with the development of a New World plantation system. São Tomé was entrepôt for this trade, which for most of the century centered around the Congo. Here was played out perhaps the first voluntary African attempt at westernization and Christianization when the Portuguese treated the king of the Congo (Manicongo) as an equal and sent craftsmen and missionaries to aid him. But the attempt foundered on the shoals of the slave trade as Portuguese slaving interests fomented discontent in order to encourage warfare from which they could secure captives. The kingdom broke up under the strain.

The ruler of Angola, however, was not treated as an equal. Instead, the Portuguese king granted the region to one of his nobles. In 1576 the Portuguese founded Luanda, which supplanted São Tomé as the center of slaving operations as Angola replaced the Congo as the major source of slaves. Slaving operations were different in Angola from those on the Guinea coast. Instead of setting up factories to which native chieftains brought captives, merchants sent out their own servants or employees (generally blacks or mulattoes), called *pombeiros,* who went into the interior to secure bondsmen by trading or raiding. When captives were not to be had, they incited wars or rebellions. Captives were brought to Luanda, where they were kept in barracoons, or holding stations, to recuperate until ships arrived to take them away.

As in Upper Guinea, a racially and culturally hybrid Luso-African trading community developed. Unlike their counterparts on the northern coast, however, the Afro-Portuguese in Angola kept control of their slaves through the middle passage and could benefit directly from the price of slaves in Brazil but had also to suffer the loss of slaves at sea. The latter consideration caused them to confine their interests to Africa by the end of the eighteenth century. In the three centuries between 1550 and final abolition of the Brazilian slave trade (1850), Angola furnished the majority of Brazil's captive labor.

The Dutch. The Dutch destroyed Portuguese pretensions to an African monopoly. By 1642, Arguim and Gorée in Upper Guinea, São Tomé in the Gulf of Benin, Luanda in Angola, and all Portuguese forts on the Gold Coast were in Dutch hands. Although Portugal recaptured São Tomé in 1648 and retained the Cape Verde Islands and Cacheu, Holland was the strongest European power in Guinea during the 1650s. Holland's advantage, however, and its virtual control of the whole European carrying trade for a time, directed at Holland the concentrated ire of the English and the French. The latter part of the seventeenth century therefore was a period of keen competition.

Dutch success derived in part from the capitalistic, joint-stock West India Company, formed in 1621. While the Portuguese, claiming all of Africa, granted individual monopolies in various parts of it, the Dutch, claiming parts of Africa, granted a monopoly of trade to one corporation in all of it. Only members of the West India Company were legally enabled to carry slaves or other goods from Africa to Dutch colonies or elsewhere. To better compete, other European nations followed the Dutch model. Most important were the French West Indies Company (1664) and the English Company of Royal Adventurers trading into Africa (1660), which was superseded by the Royal African Company (1672).

The Spanish, largely excluded from African trade but possessing large territories where slaves were useful, resorted to the *asiento.* This slave contract provided exclusive rights to importation of African bondsmen into Spanish colonies for the nation that held it. The movement of this contract from one European nation to another is to some extent a measure of its ascendancy in the slave trade. It was held successively by the Portuguese, Dutch, French, and English.

The French and the English. Although by the eighteenth century slaves were the single most important trade article, gold, ivory, beeswax, rice, camwood, and malagueta pepper saw significant exchange. The French and English followed in the Dutch wake, establishing their own companies, designated as sole carriers of their countries' trade between Europe, Africa, and the American colonies. These companies were responsible for maintaining trading posts or "factories" in areas where Africans would permit in order to secure their nation's position in trade. The British had forts along the Gambia, the French along the Senegal, and each at various other locations in the region where they engaged in competition to attract African middlemen. The two nations, along with other Europeans, had outposts along the Gold Coast and adjacent areas where competition was likewise stiff. The expense of these factories was borne by the companies as partial recompense for their monopoly.

There were generally two kinds of trading operations. One was "ships trade," wherein goods were consigned to a captain who cruised the coast, stop-

ping at various points to dispose of his wares and take on slaves. In the seventeenth century, natives would light fires or send up smoke signals to notify ships' captains of their readiness to trade. Natives either came in canoes and boarded the ship, or waited on the shore for the arrival of the ship's party. By the eighteenth century, however, regular traders had more durable contacts, made arrangements with local merchants, and stopped at prearranged points. Another method was "factory" or "shore trade," wherein goods were consigned to a fort or outpost to which Africans came to trade and from which goods were dispensed to local traders, or, if necessary, to incoming ships that went elsewhere to find business. Slaves were collected in these factories, or in ships along the coast, until there were enough to complete a cargo.

By the end of the eighteenth century British merchants engrossed over half of the slave trade, followed by the French, Portuguese, Dutch, and Danes. The bulk of these laborers went to sugar-producing regions in tropical America, with lesser amounts reaching North America. Averaging fewer than two thousand annually before the seventeenth century, imports rose to over sixty thousand per year by the eighteenth century.

Brazil received almost 40 percent of all slave imports, the trade having begun earlier and lasted longer there than anywhere else. By contrast, the area that became the United States received only about 5 percent of the total. Individual West Indian islands, comprising smaller regions but containing more labor-intensive economies than the United States, absorbed comparatively many more slaves: Jamaica received 8 percent and Barbados 4 percent of slave imports. Nevertheless, the mechanics of crop production in the United States distinguished the region, permitting natural reproduction of the slave population, and it had the largest slave population in the Americas in the nineteenth century.

The African Input. At the height of the trade in the eighteenth century, the whole coast was regulated on the African side by middlemen who were highly conscious and jealous of their own position. They had a monopoly on trade with the interior and insisted that business be conducted through them. Moreover, they refused to be bound by any one European power and insisted on free trade with the outside world. On different parts of the coast, however, variant circumstances required distinctive considerations, all of which changed over time. In Upper Guinea, African polities competed with Afro-Europeans for trade at the posts set up by the French and English in the Senegal and Gambia rivers to attract commerce. On the leeward coast in the Gulf of Guinea, Akan and Fon kingdoms mediated the trade. In the Niger Delta, various city-states—monarchies and repub-

lics—grew up in response to new opportunities for exchange. Ruled by special political associations, they developed a distinctive trade organization known as the "House system." K. Onwuka Dike describes this as "a kind of cooperative trading company based not so much on kinship as on commercial association between the head of a dominant family, his relatives and trading assistants, and all their followers and slaves"—a creative adaptation to business opportunities. In Congo-Angola, local governments also ruled, though the Portuguese, busily creating a colonial preserve, claimed exclusive rights in parts of the region. These disparate governments and people had their own peculiar requirements in articles, seasons, and methods of trade.

Even the trade mediums or units of accounts diverged, with Europeans adopting African practices. In Upper Guinea they used the iron bar; on the leeward coast, the ounce of gold (in the west) and the cowry shell (in the east); in the Niger Delta, the manilla, bracelet of brass or lead; in Congo-Angola, a piece of local cloth. For these reasons, European representatives had to be seriously attentive to peoples and conditions at their station or lose trade to their rivals. They had to treat Africans with considerable respect.

African Slavery. Early European observers often justified slaving activities by arguing that many if not most Africans existed in some form of indigenous servitude and that the European version was preferable. Later Europeans justified imperialism on the same basis of Africans' widespread enslavement which they now sought to abolish. Opponents sought to counter these rationales for injustice by contending that few examples of involuntary servitude existed in Africa before European contact, and that where they existed, they were of such a nature as to be scarcely comparable to the western conception, let alone the American reality. Where observers stated otherwise, they were deluded by racism, ethnocentrism, or ignorance.

Suzanne Miers and Igor Kopytoff (1977) argue that confusion results from a misapprehension of the nature of African society. Based on kinship relations that give people social existence to the extent that they belong to or are part of a local lineage, they regard as nonpersons those outside the group. Outsiders, whether slave or free, are nonpersons. Indeed, in some African societies, the words for "slave" and "outsider" are the same. There is no dichotomy between slavery and freedom (with its emphasis on autonomy and individualism) such as exists in the West, but only between nonperson and person (whose identity is found in his association and obligation to the group). Nor are the dichotomies absolute.

There are degrees of belonging connected with increasing privileges and acceptability. In Upper

Guinea, for example, there were three broad categories of slaves: state, domestic, and trade. The first were at the disposition of government and performed tasks for the general good under the auspices of local authority. They lived apart, cultivated land of their own, had many rights, and suffered no marriage restrictions, though in marriages of inequality, children followed the condition of the mother. Domestics also had many rights, could not be sold, but were subject to endogamous marriage rules. Trade slaves had fewer rights and were subject to sale and endogamous marriage rules, though they were granted land to cultivate for their own use. They were the least integrated and most easily dispensable; however, if they stayed in a community long enough, and particularly if they married and had children, their situation improved. They took on the character of domestic slaves. This progression was in terms of community integration, not task specialization, as their labor activities might not change. Indeed, in most African societies there was little or no differentiation in the labor of slaves and free people.

Those slaves susceptible of sale, or trade slaves, were usually adult males captured in warfare who might never adjust to their captivity and posed a danger to their hosts. At the very least, they might run away. They could best serve the community by what they brought in trade. Women and young children, more pliable, were less likely to be sold and were apt ultimately to be absorbed by the local community. The demands of the Atlantic trade were coincident with these African outlooks in that while Atlantic slavers had more call for adult males, internal African requirements placed more value on women. Consequently, women were not equally available for trade on all parts of the coast, a consideration that slavers had to weigh.

Atlantic slave requirements influenced African societies by encouraging an increase in crimes for which people might be condemned to slavery, spurring warfare, lawlessness, and social disruption, including banditry and kidnapping, to obtain slaves, and deprived the continent of much human potential. Moreover, it accentuated the economic rather than social character of African slavery, transforming it from one among several forms of dependency in kin-based social relations to one having a more important economic role. Yet Africans who participated in the trade made their decisions within their own contexts and for their own reasons. African slaves were seldom viewed as the simple commodities which capitalism made them in the Americas.

The American Demand. New World planters, thinking of slaves as work units and interested in maximum production for the least outlay, ideally desired an adult male in his twenties or thirties. Women, who could also be worked in the fields, were in less demand. Consequently, planters normally asked for slaves in the proportion of two men for every woman. This desire for men was especially great in sugar-producing regions, which had a firm capitalist base by the seventeenth century and considered profit above everything else. Brazilian and Caribbean planters, for example, regarded harsh treatment contributing to high slave mortality in as few as five to seven years after importation to be a more economical management practice than expending either time or money to better the slave's condition and extend his life for labor. They viewed the raising of slave children as equally unprofitable and did not encourage it. Consequently, they had to depend on the slave trade to replenish their labor force for most of the period of slavery's existence in their regions. British North American planters, raising different crops, computed their finances differently, and while they also asked for slaves in the normal proportions, they had come by the first decades of the eighteenth century to recognize the value of a self-perpetuating labor force. They began to encourage reproduction, an effort which required a more equal balance between males and females.

Planters also had distinctive slave preferences, which varied with region and over time. The economy of seventeenth-century Brazil was highly dependent on bound labor from Angola, and planters described these laborers as the best that Africa had to offer. In the eighteenth century, both the source and judgment of African labor changed: Brazilian planters now rated "Sudanese" or "Mina" slaves from the leeward coast of West Africa as superior. Indeed, a special relationship developed between the northern Brazilian city of Bahia and the leeward coast, while southern Brazilian traders, centered in Rio de Janeiro, maintained an attachment to Angola. Eighteenth-century Jamaicans exhibited an affinity for Akan-speaking peoples from the Gold Coast, while South Carolina planters desired Senegambians. Virginians expressed no strong likes or dislikes.

Traders had to consider these slave fashions among other factors when they planned their voyages. They had also to figure climatological conditions and seasonal variations, the winter months in North America or the hurricane season in the West Indies creating hazards to ready sales. Slaves were in greatest demand when they could be put directly to work and sold more briskly in some seasons than in others.

The Middle Passage

The term "Middle Passage" refers to the transit or transportation of African bondspeople from the African coast to the Americas during the slave trade. It was the middle phase of the three-step passage of

Africans from the interior of Africa to the coast, across the Atlantic, and then to their place of servitude in the Americas. The hellish conditions of the passage have long made it a byword for horror and a metaphor for human suffering and cruelty.

There has long been considerable debate on the numbers involved in the Middle Passage. Older estimates, influenced by moral fervor and indignant outrage, projected estimates as high as fifty million Africans transported. The actual figure is probably considerably lower. Philip Curtin's influential *The Atlantic Slave Trade: A Census* (1969) argued that about ten million people survived the passage. The subsequent twenty-five years has seen no scholarly consensus, but many scholars believe between twelve and fifteen million Africans were brought across the ocean during the four-hundred-year history of the African slave trade. There has also been debate on the effects of the slave trade on the regional population of western and central Africa. Patrick Manning (1990) has argued that without the trade, the population of Africa in 1850 would have been 100 million rather than 50 million. Joseph C. Miller (1988), by contrast, argued that high rates of reproduction offset losses taken by slave ships. The dimensions and consequences of the slave trade on African society will likely be debated for some time to come.

The slave trader was part of the commerce between Europeans and Africans. Outside of Angola, where the Portuguese began in the sixteenth century to establish a colonial preserve, Africans controlled their western coast. The cost of slaves, which rose almost steadily over the course of the trade, was determined in negotiations between Africans and Europeans. First of all, Europeans paid ground rent for the use of land in those places where they had trading posts. Monopoly companies, granted exclusive rights of trade by European imperial powers, normally absorbed these costs. In Upper Guinea, European ships paid tolls to use rivers en route to these posts. Individual traders had to hire "linguisters" to translate or act as go-betweens, and to arrange the "palavers" or conferences at which slave prices were determined. Before these conferences could be arranged, a "dash," or bribe, might have to be paid. These charges were part of the cost of doing business and had to be calculated in the accounting of profit and loss.

Part of the greatest cost of slaves, however, involved the prices of European and Asian goods used in trade and the mix of goods comprising the standard unit of account. Europeans adopted African account formulas or standards of equivalence, derived from the barter principle. Slaves were priced in various units of account—bars (based on the iron bar), ounces (form the ounce of gold), cowries (a type of shell), or manillas (copper bracelets)—depending on the region and local practice. Traders would determine slaves' prices (for a prime male, with women and children in proportion) in bars, say, after considerable discussion. They paid for slaves in "bundles," or "assortments," of goods equal to the determined price. Not all European goods were acceptable, nor were all equally desirable. Traders spent considerable time and effort before agreeing on the composition of bundles because the mix of goods could well make the difference between a successful voyage and a failing one. Traders with better or more attractive wares had an advantage over those whose merchandise had less demand. Competition among Europeans in port increased Africans' normal advantage.

Prices differed with time and place. During the height of the trade in the eighteenth century, slave prices were higher in Upper Guinea than in Angola. Portuguese colonization efforts permitted her merchants, often Afro-Portuguese pombeiros, to control every aspect of the trade, from the movement of slaves from the interior to their landing in Brazil. They took part in traditional African commerce and sold "everything from salt and palm cloth to sea shells" (Klein 1978, p. 38), together with the usual goods produced in Europe, Asia, or the Americas. This exclusive control brought them enormous profits, but also subjected them to the risk of loss on the Middle Passage, and they relinquished their interest in that part of the enterprise at the end of the century. In other regions, Africans brought slaves from the interior and sold them to Europeans on the coast.

Europeans could earn substantial profits in the Middle Passage, but there could also be great loss. Depending on the cost of goods dispensed (including their selling price in Europe and their value as part of a bundle), the rate of mortality in passage, and the demand in America, slave voyages could be hazardous. A 10 percent return rate seemed to be average for the century.

Slave mortality was the most striking aspect of the Middle Passage. Crowded and unsanitary conditions, poor food, inadequate supplies, insufficient drinking water, epidemic diseases, and long voyages conspired to make slave ships legendary for their foul smell and high death rate. Seventeenth-century ships of the Royal British African Company averaged a death rate as high as 24 percent. These rates decreased in the eighteenth and nineteenth centuries, reaching an average range of from 10 to 15 percent. The death rate for European sailors involved in the trade was also high, greater even than that of slaves during some periods: in the second half of the eighteenth century, white sailors died at the rate of 169 per thousand, in contrast to a mortality rate for black slaves at 152 per thousand. European immigrants suffered death rates

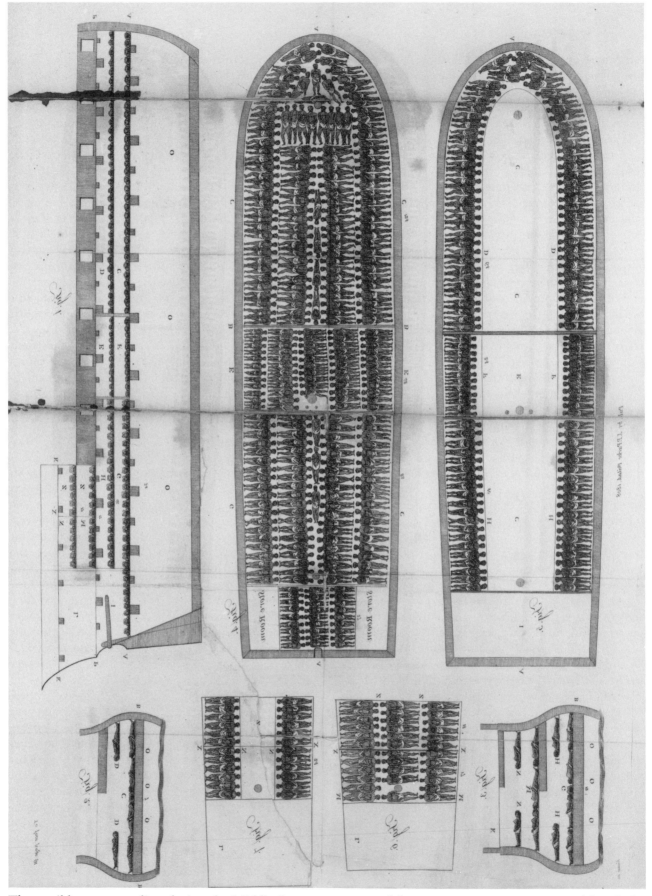

The terrible overcrowding during the Middle Passage was one of the most potent arguments used by aboli-
tionists in their successful campaign to end the slave trade. This cutaway sectional view is from the work of the
noted English abolitionist Thomas Clarkson in his *History of the Abolition of the Slave Trade* (Philadelphia, 1808).
(Prints and Photographs Division, Library of Congress)

comparable to those of slaves during the sea voyage, and their ships had an equal stench. They normally had more space, however, and contained a wider age spread. African slaves consisted of people in their prime whose life expectancy was greater; their mortality consequently was disproportionate.

In the early days of trade, slaving interests used regular merchant vessels and had carpenters insert platforms to hold the human cargo. By the eighteenth century, however, vessels were especially constructed for the trade. They were sleek, narrow vessels, with special grates and portholes to direct air below deck. The space between decks was normally four to five feet and slaves could not stand, and occasionally could not even sit, upright.

In one, presumably atypical, case, the space between decks was only fourteen inches. Under the worst conditions, slaves could be packed like sardines in stifling compartments with inadequate ventilation, little room for movement, and little or no provision for the exigencies of bodily functions or the effects of sea- or other sickness; in sum, they could be transported in pestilential tubs of unimaginable squalor. But the economics of trade encouraged ship captains and their employers to exercise care, as often the captain's wages and commissions and the employer's success depended on the number delivered safely to port. They tried to obtain sufficient food and of the type preferred by the particular African ethnic groups aboard. They sometimes carried peas and beans from the home port, but usually secured food on the African coast: rice and corn in Upper Guinea and Angola; yams in the Niger Delta.

Scholars differ over the relationship between "tight-packing"—carrying an unusually high number of slaves relative to the capacity of the ship—and mortality. Klein (1978, p. 66) argues for little statistical correlation between the two, while Miller (1988, p. 338) suggests the practice increased deaths though "only moderately." But immigrant ships, which allowed more space per passenger, still suffered mortality rates comparable to those of slave ships. Unique among slaving nations, Portugal regulated the carrying capacity of slavers from the end of the seventeenth century, fixed at between 2.5 to 3.5 slaves per ton, depending on vessel construction. At the beginning of the nineteenth century these strictures were tightened to the lower figure, regardless of vessel construction.

At the end of the eighteenth century Britain attempted similar regulations (Dolben's Law, 1788), specifying five slaves per three tons up to two hundred tons, then one slave for each additional ton. An act in 1799 further restricted carrying capacity. It regulated space rather than tonnage and decreed a minimum of eight square feet for each slave, with five

feet as the minimum height for a slave deck. These acts reduced the British ratio of slaves to tonnage from 2.6 before 1788 to 1.5 until 1798 and 1.0 thereafter until the abolition of the trade in 1807. The figures for pre-1799 British ships work out to five to six square feet of deck space for each slave. Although British tonnage measurements changed in the 1780s and although European nations used various methods of construction and measurement, clearly ships operating under less stringent regulations—all ships before 1788 and all except the British thereafter—alloted slaves less than five square feet of deck space.

Conditions deteriorated in the nineteenth century as illegal traders placed themselves beyond effective regulation. Steamships, used by mid-century, increased portage but did not immediately reduce sailing time or achieve a better ratio of slaves to tons. These larger ships carried more slaves—a thousand or more compared to four hundred or more in sailing ships—but did not provide them extra room and often carried them too close to the boiler, adding burning or scalding to other threats of mortality. At that period, observers perceived conditions to be as bad as they had ever been.

Herbert Klein indicates that the greatest single determinant of mortality was time at sea. David Eltis, to the contrary, suggests that, within limits, even that variable was not as important as disease. Dysentery among the shackled voyagers, whether amoebic or bacillary, was the most lethal killer, and its effects seemed to be unrelated to the length of voyage. But the length of voyage, including time spent on the coast, undeniably influenced mortality, and ships traveling from East Africa consistently recorded higher death rates related to their longer passage.

Mortality varied with African region, suggesting that diet, the rigors of travel to the coast, famine, or other factors in Africa had some influence on whether a slave was likely to survive the passage. The rainy season, generally from June to August, but changing with location, was equally hard on blacks and whites, and captives contracted diseases that might flower during the Middle Passage with disastrous consequences. Indeed, the melancholy attrition that began at capture matured on the coast as slaves were kept in unhealthy holding pens—damp dungeons or "trunks" in posts on the Gold Coast; floating ship hulks or "barracoons" in the Niger Delta; open stockades, exposed to the elements, in Angola. Chained, branded, and often subjected to inadequate care, they endured the physical and psychological trauma that mistreatment and uncertainty induced, and the winnowing process that the grim rule of the survival of the fittest obliged.

Individual captains set the tone of the voyage and determined whether slaves got needless abuse or min-

imal consideration. Taken aboard ship, men were chained together below deck, women above. Pregnant women and children roamed free once the ship cleared the coast. Sailors took great care at leavetaking, however, as slaves were most likely to rise as they departed African shores. At sea, they fed slaves twice a day, and they allowed a period of exercise on deck unless the weather forbade. The crew occasionally washed slave platforms with vinegar and water for sanitation. African women assisted in preparing the food, making it as palatable as possible, and carrying African tastes and culinary practices to the Americas.

In the midst of these deplorable conditions began the formation of new cultures and relationships. The shipmate relationship became one that endured among those who survived transport and formed the basis for relationships ashore. Cultural transformation also began, establishing the foundations for New World social reorganization even before the Africans had landed. Along with their capacity for labor and their ability to last, survivors brought an abiding optimism and sense of self-worth that transcended physical and psychological scarring. Therein is found a moving story of human resilience and creativity.

Abolition of the Slave Trade and Caribbean Slavery

ABOLITION OF BRITISH SLAVERY

The abolition of the slave trade by Great Britain in 1807, and the subsequent passage of the British West Indian Emancipation Act in 1833, which ended British Caribbean slavery, coincided with a long-term decline in the economic importance and political influence of Caribbean sugar planters. In the first half of the eighteenth century, the sugar colonies of the British West Indies, especially Jamaica, Antigua, and Barbados, were perhaps the most prized colonial possessions of the British Empire, generating large profits from lucrative sugar exports. The wealth of the British Caribbean was derived in large part from the stability and mercantilist policies of the British imperial system, which protected Caribbean colonies as an apex of the notorious "triangular trade" with British North America and West Africa in slaves, rum, and molasses. This secure system began to unravel with the coming of the American Revolution.

The American Revolution temporarily halted the Atlantic slave trade and drove up the price of food in the West Indies, which had to be imported. Their profits destroyed, West Indian planters went deeply into debt. After American independence, the new United States traded with rival colonies such as France's St. Domingue (later Haiti). In Britain, the economic and ideological shift from mercantilism to

capitalism made protectionist policies unpopular. As West Indian trade declined, British merchants and seamen turned their attention to imports of American cotton, to feed the growing textile industry. West Indian sugar, no longer protected by the British imperial system, was unable to compete with efficient, cheap sugar on the world market. New land was scarce, and absentee landlords lacked the will and capital to modernize.

In the 1780s, a massive antislavery movement, unimaginable fifty years before, began to appear in England. Abolitionist efforts were led by Quakers and by Anglican humanitarians, led by Thomas Clarkson and William Wilberforce, who formed the Society for Effecting the Abolition of the Slave Trade in 1785 and spoke against the trade as immoral and unchristian. They believed that ending the trade would lead to the amelioration or end of West Indian slavery, although abolitionists were careful to deny they wished the government to free existing slaves.

In 1789, Wilberforce introduced twelve resolutions against the slave trade in the House of Commons. The House voted to examine evidence. In 1791, the House postponed action, although it did grant Wilberforce's Society a charter to establish a colony for freed slaves in Sierra Leone. In 1792, the House of Commons officially passed a bill gradually banning the slave trade, but the Bill failed in the House of Lords. Despite Wilberforce's claim that other countries would follow England's lead in ending the slave trade, international inaction led Parliament to fear the economic consequences of unilateral action. Over the next several years, the movement slowed. The Haitian slave revolt and subsequent abolition of slavery by Revolutionary France discredited antislavery efforts as radical.

By 1804, however, the unrelenting efforts of the abolitionists and their political allies gained enough support to get a bill through the House of Commons. The House of Lords failed to pass the Bill, although the government did limit slave imports to 3 percent of the existing slave population of the islands. In 1806, the government issued Orders in Council banning the foreign slave trade, ostensibly to cut American and neutral trade with France. Planters who protested were characterized as unpatriotic. As most of the trade was with other nations, this effectively halted the trade. In 1807, after the U.S. Congress approved the closing of the slave trade the following year, easing fears of American competition, a bill for immediate abolition was introduced in the House of Lords. With government backing, it passed both houses by large margins.

The ending of the British slave trade brought lessened interest in antislavery activity, first through the focusing of national attention on the Napoleonic

Wars, and then through an illiberal political climate after 1815. The British government attempted to combine humanitarianism with economic self-interest by efforts, which proved unsuccessful, to organize a worldwide end to the slave trade, first at the Congress of Vienna in 1815, and then at the Congress of Verona in 1822. By then, abolitionists realized the end of the trade had not helped the condition of West Indian slaves. In 1821, the Liverpool Antislavery Society was founded. Liberal businessmen, led by T. F. Buxton, who opposed the inefficient and feudal nature of the slave system, took control of the movement from Wilberforce and the Quakers. The "emancipists" agitated for gradual granting of civil rights to slaves. Buxton proposed that children of slaves be born free, although he avoided speaking publicly of abolition for fear of arousing slave revolts. Three sets of Orders in Council on amelioration were passed between 1823 and 1831.

By 1831, reform sentiment was high in England, and antislavery speakers and pamphleteers attracted large number of people to the cause. In December 1831, a slave revolt broke out in western Jamaica. The planter government brutally repressed it. Atrocity stories provoked widespread outrage in England. A Commission of Inquiry was appointed. In May 1832, Buxton imprudently introduced a bill in Parliament calling for an immediate end to slavery. While this measure was opposed by many antislavery moderates, it only failed by 162 to 90. This strong showing was taken by many as a sign of the antislavery movement's strength.

By 1833, when a new parliamentary session opened, liberal and antislavery forces were powerful as a result of the Reform Bill of 1832 and the commission's report. Abolitionists presented Parliament a petition signed by 1.5 million people. As antislavery delegates and West Indian lobbyists competed for attention, Buxton called for unconditional emancipation. On May 11, the new Colonial Secretary, E. G. S. Stanley, published a plan for gradual emancipation, with £15 million (later raised to £20 million) of compensation to slaveowners. Slaves would serve as "apprentices" of their former masters at three-quarters their normal work hours for twelve years (later reduced to six years for field hands and four years for domestic slaves), and slaves under six would be considered free. Slaveowners, fearing immediate abolition, decided to support the plan as the best they could obtain. The British West Indian Emancipation Act passed the House of Commons on July 1, 1833, and was adopted by the legislatures of the free colonies shortly thereafter. The apprenticeship system was waived by Antigua and Bermuda, which had too many blacks to make such a proposal feasible. In Jamaica, where the system was adopted, planters abused the system so flagrantly that, following a parliamentary inquiry in 1837, apprenticeships were abolished in favor of total emancipation on May 22, 1838.

FRENCH ABOLITION

In the late seventeenth and early eighteenth centuries, France established colonies in the Caribbean, on the Antillean islands of St. Lucie, Martinique, Guadeloupe, and St. Domingue, and on the island of Hispaniola, the largest colony. In the 1780s, the island's economy boomed as a result of trade with the new United States. At the same time, however, the first important stirrings of opposition to French slavery made themselves felt. While philosophers such as Rousseau and Montesquieu had opposed slavery, the first organized antislavery society in France, the Amis des Noirs, was founded in 1788 in Paris. Made up mostly of radical aristocrats such as Martinique-born white creole Moreau de Mery and enlightened humanitarians such as the Marquis de Condorcet and the Abbés Raynal and Grégoire, the Amis denounced slavery and the accompanying race caste system.

After the coming of the French Revolution, the Amis des Noirs switched the focus of their agitation from enlightened abolitionism, which seemed out of date, to ending the slave trade bounty and supporting the rights of free people of color. On May 15, 1791, the Constituent Assembly enfranchised the free mulatto population of St. Domingue. However, the island's white population resisted the edict so fiercely that enforcement was blocked, and eventually the planters' agents persuaded the assembly to rescind the new suffrage law.

The revolt of slaves on St. Domingue in August 1791, plus the fall of the monarchy, completely altered the nature of slavery in the French colonies. The slave revolt devastated the island's sugar economy and caused many planters to emigrate. The slaves, although defeated in pitched battles, retained control over parts of the colony. At the same time, in Paris, antislavery sentiments were growing. In August 1793, the radical humanitarian Abbé Grégoire obtained the formal cancellation of the slave trade bounty. In January 1794, a delegation, consisting of a free black, a mulatto, and a white republican, traveled to France from the islands. Arrested on their arrival by Jacobins, they obtained their release and moved the question of emancipation at the convention. Slavery, they argued, was incompatible with republican liberty. Freeing the slaves, they argued, was not only the proper course on republican principle, but it would aid the war effort by allying colonial blacks with France. "On 16 Pluviose of the year II of the Revolutionary Calendar" (February 4,

1794), slavery was officially abolished in the colonies. Over the following years, despite white resistance, the decree was upheld in French-held territory. Even after the Jacobins fell from power, the regime of the Directory, led by disciples of the antislavery philosopher Condorcet, retained the ban and even backed large-scale recruitment of blacks into the French colonial army. Slavery was abolished in the Dutch possessions in 1795, after France conquered the Netherlands.

Napoleon, who had dreams of a French New World empire, was anxious to restore economic order to the Caribbean and had no objection to the slave system. In 1802, he sent an expedition to reestablish French authority in St. Domingue, and had Toussaint Louverture, who had named himself governor-for-life in 1801, arrested. The same year, during a short-lived peace, Britain returned Martinique and the British-held portion of Guadeloupe to France, with its slave system intact. In his decree of May 19, 1802, Napoleon reintroduced slavery and slave trade to Martinique and Guadeloupe "to ensure the good security of our neighbors." Although Napoleon claimed he had no wish to reintroduce slavery in St. Domingue, blacks and mulattoes, fearing the return of slavery and racial castes, joined in revolt, and established the Republic of Haiti in 1804.

The slave system remained in Guadeloupe and Martinique throughout the Napoleonic era—although no free blacks were reenslaved—and remained under the Restoration. Abolitionist sentiment was confined to small groups of republicans such as Grégoire and liberals led by Madame de Staël. In 1834, a small, elite abolitionist group, the Société pour l'Abolition de L'Esclavage was founded under the leadership of the Duc de Broglie. It effectively propagandized against slavery, and during the next dozen years it attracted the support of prestigious liberals and artists such as Alphonse de Lamartine and Victor Hugo. In 1839 a member of the society, Alexis de Tocqueville, introduced a proposal for British-style compensated emancipation in the Chamber of Deputies. It was tabled, but a committee was formed to discuss the question, and its 1843 report recommended a ten-year apprenticeship for slaves to buy their freedom, with a "free womb" law liberating children of slaves. Although slavery was largely discredited, planters fearing black revolt resisted, and the government took no action.

The Second Republic, created in February 1848 after the flight of Louis Philippe, was led by radical abolitionists and liberal humanitarians. Conscious of the legacy of the First Republic, the new leaders quickly introduced an abolition proposal, which passed on April 27, 1848. After some disagreement among lawmakers about the method and size of rep-

aration payments, they agreed on a planter compensation package the following year.

DANISH AND DUTCH ABOLITION

Denmark, which had up to twenty-five thousand slaves working on its colonies in the Virgin Islands, chiefly on St. Croix, was the first country to outlaw the slave trade. In 1792, during a period of economic decline, Danish planters sought to stabilize slave values. Danish ships, unable to compete with foreign slaving vessels, had long since abandoned the trade. The king decreed a gradual end of the slave trade over ten years which was enacted and enforced without difficulty. Slavery continued until 1848, when there was revolutionary activity in Europe, and a slave uprising on St. Croix. In response to liberal and insurrectionist pressure, the Danes ordered immediate abolition.

The Dutch, despite their large-scale involvement in slave trading, established few slave colonies. The Dutch West Indies, including Curaçao and Aruba, and the South American colony of Suriname, contained at the most seventy-five thousand slaves. Slavery officially was banned when the Netherlands was taken over by the French in 1795 but was reestablished after 1802 by Napoleon. The Dutch slave trade remained tiny and was eliminated as part of the international convention at the Congress of Vienna in 1815. Slavery continued until 1863, however, despite British and other abolitionist pressure. Slavery was small and marginal to the Dutch economy, and the economic results of British and French abolition were discouraging. No liberal movement rose up against slavery as a drag on the economy, and no mass humanitarian movement sprang up to challenge it. Finally, in the late 1850s, the powerful Dutch Reformed Church began to move against Caribbean slavery, and in 1863, after the EMANCIPATION PROCLAMATION was issued in the United States, it secured a royal emancipation edict.

INTERDICTION AND IBERIAN ABOLITION

Iberian nations were conspicuously absent from the developing consensus against the slave trade. Economic expansion in Brazil, Cuba, and Puerto Rico placed a high premium on slaves, and neither Spain nor Portugal regarded the prospect of restricting its labor supply with any enthusiasm. Britain pressured Portugal in 1810 into confining its trade to Portuguese imperial possessions in Africa and America, an agreement which meant that Portuguese subjects could carry slaves only between those regions in Africa where Portugal already had a claim or sphere of influence and other regions within the Lusitanian monarch's realm, especially Brazil. Portugal agreed to limit the trade to her African possessions below the equator in 1815. At the same date, France pro-

hibited the trade. Spain fell into line in 1820 and Brazil, having separated from Portugal, did so in 1830.

These legal prohibitions bore little relationship to reality, particularly in Cuba and Brazil. A greater volume of slaves came into Brazil in the first half of the nineteenth century (approximately 1.5 million between 1801 and 1850) than had ever gone to any plantation region in the twenty years between its legal cessation and its effective termination by British naval action in 1850. While most of those involved in Brazil's illegal traffic were Brazilian or Portuguese, Spain's replacement of the asiento with a free-trade policy in 1789 opened the Cuban market to United States, British, French, and other merchants, and American traders dominated the market after Spain agreed in 1835 to permit Britain the right of search and seizure. By then, the flag of the United States, as the only important seafaring nation to refuse to come to a reciprocal arrangement with Great Britain, provided slavers with their sole refuge. Some American traders smuggled slaves into the United States, but the market was better in Cuba and Brazil. Not until the Civil War did American official attitudes change, effecting the end of the Cuban trade in 1865. By various ruses the trade continued until the end of the century. For example, the French and Portuguese adopted theoretical systems of contract labor that were nothing short of slavery: the indentured Africans, often bought in Africa as slaves and legally freed on the coast, had little or no say in the matter and were shipped off to colonial possessions in the Americas and elsewhere. Even the British and the Dutch, who considered themselves enlightened in this regard, adopted similar practices for short periods. Nevertheless, the Atlantic slave trade practically came to an end with the closing of the trade of Cuba. Moreover, New World slavery itself was moribund, although it lingered in Cuba and Brazil until the late 1800s.

Nineteenth-Century Trade Distinctions. In the process of a long expiration the nineteenth-century slave trade developed some distinctive features. Economic expansion, together with the prospect of the trade's termination, caused slave prices to rise in the Americas, while the activities of British anti-slave trade squadrons off the African coast caused them to fall there. At the same time, increased demand for the depleted resources near the Congo-Angola coast caused slaves to be brought from regions farther inland involving different African middlemen.

Although slaves might be smuggled from any part of the coast, slaving was heaviest in this region of west-central Africa partly because it was a Portuguese preserve and legal there (for Portuguese subjects) until 1836, which permitted smugglers to use the Portuguese flag for cover, and partly because the British naval presence was not as great there as along the northwestern coast. It remained a focus of activity after the 1830s ban. Few Atlantic slaves went to Mozambique in the eighteenth century, but in the nineteenth century the trade at one point reached a height of 25,000 slaves yearly, encouraged by increased demand and an initial absence of British warships from the eastern coast. Portuguese, Arab, East Indian, and mixed-blood middlemen facilitated the trade and dispensed their human cargo to Spanish, French, Brazilian, and American vessels. The Portuguese edict ending the trade in Angola in 1836 applied equally to Mozambique, but neither ceased before rigorous British action rendered it unfeasible after 1850. Slavers maintained their preference for males over females but accepted more children than formerly because they occupied less room than adults and more could be carried.

By the nineteenth century, then, the trade had come full circle. The Portuguese, having initiated an Atlantic trade in slaves, were among the last to abandon it. Nevertheless, the nineteenth-century Iberian trade would have been much more difficult without active British and American collaboration. Even while their government sought to abolish it, British merchants continued to invest in Brazilian slavetrading voyages and British manufacturers to produce and forward to Brazilian middlemen goods suitable only for the African market. Americans, meanwhile, furnished speedy ships suitable for evading patrolling squadrons and innovated the use of steamships which could carry larger numbers of slaves, though they did not always carry them better. Many of the vessels involved in the west coast trade and most of those involved in Mozambique, though manned by citizens of other nations, were constructed in the United States.

In a final irony, the desire to abolish slave trading and establish "legitimate" commerce in Africa furnished the basis for British imperialism there, an example which other Europeans copied. In many places, the forced migration of African peoples from their homelands either to other parts of Africa or to regions outside of it was ended by the imperial dictates of western Europeans and not completely before the twentieth century. By that time Africans, or peoples with a significant African genetic component, populated much of the globe.

Abolition of the Slave Trade in the United States

While the first efforts to suppress the slave trade in North America came nearly a century after the trade began, the beginning of anti-slave-trade agitation among Quakers and others paralleled the flowering of the trade in the 1680s. The first legal attempts at

regulation came in the North. In 1705, Massachusetts laid a four-pound duty on slaves, which had the stated purpose of preventing "a spurious and mixt issue," and may or may not have been intended to drive the trade out of business. In any case, imports continued into Massachusetts. The first attempt to stop slave trading in the plantation colonies came in 1710, when Virginia's House of Burgesses voted a five-pound duty on slave imports. Royal Governor Spotswood vetoed the measure. In South Carolina, the other main colonial slave importer, the first slave trade regulation came in 1717, in the form of a forty-pound duty on slaves. This duty, meant to slow the rate of slave imports, shut them off so completely that it was lowered to ten pounds two years later. In 1740, on the heels of the Stono Rebellion, South Carolinians fearing slave insurrection laid a prohibitive duty of one hundred pounds, in order to build up a fund to encourage white immigration. In 1760, South Carolina outlawed the trade entirely. The Board of Trade in London nullified the prohibition. Despite official attempts at regulation, Africans poured into South Carolina during the entire Colonial period.

By the beginning of the 1770s, almost all of the American colonies had at least contemplated action against the slave trade at one time or another. However, northern and southern lawmakers had widely differing motives. In the North, anti-slave-trade sentiment was primarily moral; Quakers and other opponents of the trade were primarily interested in limiting the institution of slavery. However, Northerners had few scruples about participating in the trade, an important sector of the New England economy. Northerners built and opened their harbors to slave ships. Southerners, on the other hand, whatever their moral feelings about slavery, were primarily motivated by other considerations. Planters wished to regulate competition by slavers by controlling imports, and their fear of slave insurrection made them uneasy about importing large numbers of Africans. Northern and southern attempts to limit the trade were, in any case, largely ineffective; the trade was too profitable, both for slaveholders and for the northern merchants and others who made money through shipping. Taxes were avoided through smuggling, and antislavery laws were laxly enforced. England, concerned with Colonial profits, also made use of its veto power to ensure a continuous flow of trade. When Virginia petitioned Parliament to halt the slave trade in 1772, the English declined to act.

During the era of the American Revolution, the slave trade was interrupted. The Americans' nonimportation "associations," and then the war itself, effectively stopped maritime commerce with England and with the British West Indies, source of most American slaves. In many revolutionaries' minds, slavery violated the same natural rights principles they were fighting for, and the slave trade seemed its cruelest and most horrible. The trade was also associated with the hated English authorities, who had vetoed all attempts to control it. A section of Thomas Jefferson's draft of the Declaration of Independence, not included in the final version, shifted blame for the slave trade onto the English, declaring that King George III had "waged cruel war against human nature itself, violating its most sacred rights of life and liberty in the persons of a distant people who never offended him, captivating and carrying them into slavery in another hemisphere. . . ." Neither Northerners nor Southerners were willing to renounce completely the "execrable commerce," though, and the passage was removed from the final product. After the end of the war in 1783, northern states definitively banned the trade, but southern planters whose labor force had declined during the previous years again began importing slaves in large numbers.

The Constitutional Convention of 1787 featured a strong debate on abolishing the slave trade. Few Americans approved of the trade, but since there had never previously been a self-sustaining slave population, slaveholders and opponents, both ignoring American slave demographics, equally considered the slave trade vital to the survival of the institution. Northerners demanded an end to the trade. Southerners advocated legal importation of slaves, free from prohibitive duties. The final compromise was to put off the possible prohibition of the slave trade until 1808, by which time, many delegates believed, the trade would have come to a natural end, and to limit import duties to ten dollars on what they termed a "person held to service."

In fact, by 1800 almost all the states, even South Carolina, usually the strongest supporter of the trade, had prohibited the trade or taxed it out of existence. In 1807, Great Britain ended its own slave trade. The next year, on President Jefferson's recommendation, the U.S. Congress formally closed the trade. Slaveholders, hopeful of a rise in slave values and fearful of a Haitian-style slave rebellion, offered no unified opposition. In 1818 and 1820, supplementary acts were passed against the trade to pay informers and punish slave buyers. The colony of Liberia was founded in part to resettle rescued Africans.

By 1808, however, it had become clear that the institution of slavery in the United States was flourishing and expanding to the new southern territories. South Carolina had acknowledged the futility of attempting to enforce its own ban on slave trading, and had reopened the trade in 1803. There was no special enforcement machinery set up by the federal legislation, and naval facilities were primitive. Smuggling of slaves became a lucrative and widespread field.

Americans had a long history of countenancing smuggling, and even many Northerners saw nothing wrong in trading slaves. Bristol, R.I., was a notorious center of outfitting slave traders in the first years after 1808. While figures vary, at least one thousand slaves on average were illegally brought into the United States during the antebellum years. Before they became states of the Union, Florida and Texas were the chief points of origin for smugglers. St. Augustine and Galveston were, respectively, the major ports.

Throughout the first half of the nineteenth century, the government halfheartedly enforced its ban. Great Britain, starting in 1818, suggested reciprocal search agreements on ships plying the African coast, in order to catch smugglers. American Secretary of State John Quincy Adams, who opposed slavery, was suspicious of British intentions in the wake of English impressment of American sailors before the War of 1812, and he refused to agree.

Throughout the antebellum years, the United States hampered interdiction efforts off the African coast. Even after the Webster-Ashburton Treaty of 1842, in which the United States and Britain agreed to joint patrols, Americans refused to allow boarding by British authorities, whom Americans claimed misconstrued the treaty. Since America refused to permit its ships to be searched, smugglers used the American flag as a flag of convenience when carrying illegal cargoes. Americans, suspicious of British intentions, thwarted international efforts to secure right of search on naval vessels, declined to work jointly in anti-slave-trade efforts and refused to use British bases such as Freetown, Sierra Leone. The American Navy's own interdiction forces, a half-dozen old, slow, overgunned ships, were based in the Cape Verde Islands, far north of slave waters. Judges adopted hairsplitting definitions of illegality. The presence of manacles and other slaving paraphernalia on a ship were insufficient proof of smuggling; ships had to be caught with captives aboard. After a few wrongful arrest suits by ship captains, for a time the Navy stayed away from the areas commonly plied by slave ships. Despite congressional apathy and refusal to strengthen interdiction efforts, and the resulting drop in naval morale, the forces did manage to catch some thirty-eight ships between 1837 and 1862. However, American juries often acquitted smugglers. One of the last illegal slave ship journeys, that of the Wanderer in 1858, became well known. Finally, in 1862, during the Civil War, the Union government, anxious to remove American warships from Africa and to placate the British, agreed to reciprocal searches. This policy effectively shut off the illegal trade.

Despite widespread evasions of the law, it was not until the 1850s that the question of reopening the trade was seriously posed. Southern radicals such as Gov. James Adams of South Carolina proposed reopening the trade as a panacea for southern ills. Importing new slaves, Adams and his allies claimed, would bring down the inflated price of labor, halt the erosion of slavery in the upper South resulting from African-Americans being sold further south, make farming labor-intensive crops such as cotton easier, increase the population of the southern states, and increase poor white farmers' prestige and stake in the slave system by making it possible for them to own slaves. The contentious question of reopening the trade would add to sectional tensions, but radicals and secessionists were delighted by such a prospect.

Notwithstanding the logical contradictions inherent in such a position, most Southerners despised the slave trade, and most influential politicians opposed reopening. While they supported slavery, and thus did not dwell so much on the immorality of the trade, they argued that legalization would split the Union and leave the South divided. Slave property values would plummet, and economic chaos would result. The upper South would still be unable to compete economically with its neighbors, and would lose the income it received from breeding and selling slaves. Increased slave competition might wipe out free white farms entirely. Adams's proposal was defeated in both houses of the South Carolina legislature. While proponents of legalization did win the backing of the powerful Southern Commercial Convention at Vicksburg in 1859, most politicians saw that the issue was not popular. Even after secession, in 1861, the Confederate congress voted to retain the ban, and the issue was eventually buried.

As the Atlantic slave trade petered to its end during the middle decades of the nineteenth century, it had already profoundly shaped three continents. It altered and likely stunted the developments of African society and political institutions in ways that are still being debated. It was the most significant population transfer of all time, creating an enormous and enduring African diaspora in the Caribbean, South America, and North America. It remains, above all, a monument to the cruelty that humans perpetrate upon their own kind. If there is any consolation to be found in its sad history, the abolition of the slave trade was the first great humanitarian reform movement. The slave trade, and later slavery itself, was ended by the combined efforts of Europeans, Africans, and Americans to redress and eliminate an enormous evil.

See also the overview article on SLAVERY.

REFERENCES

BETHELL, LESLIE. The Abolition of the Brazilian Slave Trade: Britain, Brazil, and the Slave Trade Question, 1807–1869. Cambridge, U.K., 1970.

BLACKBURN, ROBIN. *The Overthrow of Colonial Slavery, 1776–1848.* London, N.Y., 1988.

BOXER, CHARLES. *The Portuguese Seaborne Empire, 1415–1825.* New York, 1969.

CONRAD, ROBERT E. *World of Sorrow: The African Slave Trade to Brazil.* Baton Rouge, La., 1986.

COUGHTRY, JAY. *The Notorious Triangle: Rhode Island and the African Slave Trade, 1700–1807.* Philadelphia, 1981.

CRATON, MICHAEL. *Sinews of Empire: A Short History of British Slavery.* Garden City, N.Y., 1971.

CURTIN, PHILLIP. *The African Slave Trade: A Census.* Madison, Wis., 1969.

———. *The Atlantic Slave Trade: A Census.* Madison, Wis., 1969.

———. *The Image of Africa: British Ideas and Action, 1780–1850.* Madison, Wis., 1964.

———. *The Rise and Fall of the Plantation Complex: Essays in Atlantic History.* Cambridge, U.K., 1990.

DAVIES, K. G. *The Royal African Company.* New York, 1970.

DAVIS, DAVID BRION. *Slavery in the Age of Revolution.* New York, 1975.

DRESCHER, SEYMOUR. *Capitalism and Slavery.* New York, 1987.

———. *Econocide: British Slavery in the Era of Abolition.* Pittsburgh, 1977.

DU BOIS, W. E. B. *The Suppression of the African Slave Trade to the United States of America.* 1896. Reprint. New York, 1969.

DUFFY, JAMES. *Portugal in Africa.* Cambridge, Mass., 1962.

DUIGNAN, PETER. *The United States and Africa: A History.* New York, 1984.

DUIGNAN, PETER, and CLARENCE CLENDENEN. *The United States and the African Slave Trade, 1619–1862.* Stanford, Calif., 1963.

ELTIS, DAVID. *Economic Growth and the Ending of the Transatlantic Slave Trade.* New York, 1987.

———. "Free and Coerced Transatlantic Migrations: Some Comparisons." *American Historical Review* 88 (1983): 252–280.

FAGE, JOHN D. *A History of West Africa: An Introductory Survey.* Cambridge, U.K., 1969.

GEMERY, HENRY A., and JAN S. HOGENDORN, eds. *The Uncommon Market: Essays in the Economic History of the Atlantic Slave Trade.* New York, 1975.

INIKORI, J. E., ed. *Forced Migrations: The Impact of the Export Slave Trade on African Societies.* New York, 1982.

KLEIN, HERBERT S. *The Middle Passage: Comparative Studies in the Atlantic Slave Trade.* Princeton, N.J., 1978.

KLEIN, HERBERT S., and STANLEY L. ENGERMAN. "Slave Mortality on British Ships, 1791–1797." In *Liverpool, the African Slave Trade, and Abolition: Essays to Illustrate Current Knowledge and Research.* Bristol, U.K., 1976.

KLEIN, HERBERT S., and CHARLES GARLAND. "The Allotment of Space Aboard Eighteenth-Century British Slave Ships." *William and Mary Quarterly,* 3rd Series, 42 (1985): 238–248.

KNIGHT, FRANKLIN K. *The Caribbean: The Genesis of a Fragmented Nationalism.* 2nd ed. New York, 1990.

LITTLEFIELD, DANIEL C. "Abundance of Negroes of That Nation: The Significance of African Ethnicity in Colonial South Carolina." In *The Meaning of South Carolina History: Essays in Honor of George C. Rogers, Jr.* Columbia, S.C., 1991, pp. 19–38.

———. "The Slave Trade to Colonial South Carolina: A Profile." *South Carolina Historical Magazine* 91 (1990): 68–99.

LOVEJOY, PAUL E. *Africans in Bondage: Studies in Slavery and the Slave Trade.* Madison, Wis., 1986.

———. *Transformations in Slavery: A History of Slavery in Africa.* Cambridge, U.K., 1983.

MANNING, PATRICK. *Slavery and African Life: Occidental, Oriental, and African Slave Trades.* Cambridge, U.K., 1990.

MIERS, SUZANNE, and IGOR KOPYTOFF, eds. *Slavery in Africa: Historical and Anthropological Perspectives.* Madison, Wis., 1977.

MILLER, JOSEPH C. *Way of Death: Merchant Capitalism and the Angolan Slave Trade, 1730–1830.* Madison, Wis., 1988.

PALMER, COLIN. *Human Cargoes: The British Slave Trade to Spanish America, 1700–1739.* Urbana, Ill., 1981.

POLANYI, KARL. *Dahomey and the Slave Trade: The Study of an Archaic Economic Institution.* Seattle, 1966.

RODNEY, WALTER. *A History of the Upper Guinea Coast, 1545–1800.* Oxford, U.K., 1970.

TAKAKI, RONALD. *A Proslavery Crusade: The Agitation to Reopen the African Slave Trade.* New York, 1971.

WESTBURY, SUSAN. "Slaves of Colonial Virginia: Where They Came From." *William and Mary Quarterly.* 3rd Series, 42 (1985): 228–237.

DANIEL C. LITTLEFIELD
GREG ROBINSON
PETRA E. LEWIS

Sleeping Car Porters. *See* Brotherhood of Sleeping Car Porters.

Sleet, Moneta J., Jr. (February 14, 1926–), photographer. In 1969 Moneta J. Sleet, Jr., became the first African American to win a Pulitzer Prize in photography, for his now world-renowned image of Coretta Scott KING at her husband's funeral, her upturned face shielded by a heavy veil as she embraced her young daughter Bernice. Sleet, although employed by the monthly EBONY MAGAZINE, became

eligible for the prestigious newspaper award when his black-and-white film containing the image was let into a pool for wire-service use and subsequently published in daily newspapers throughout the country.

Moneta Sleet's major contribution to photojournalism has been his extensive documentation of the marches, meetings, and rallies of the CIVIL RIGHTS MOVEMENT. He also has a special talent for photographing people. Over the years, he produced sensitive, humanistic, and, on occasion, humorous portraits of celebrities as well as ordinary men, women, and children of America, Africa, and the Caribbean. His photographs are powerful and direct and show a genuine respect for his subjects.

Moneta Sleet was born in Owensboro, Ky., where he grew up attending the local segregated public schools. His career as a photographer began in boyhood, when his parents gave him a box camera, and continued into high school. Sleet studied photography at Kentucky State College under the tutelage of John Williams, a family friend who was dean of the college and an accomplished photographer. When Sleet interrupted his studies as a business major to serve in World War II, he resolved to enter photography as a profession, though he returned and finished his degree. His mentor moved on to Maryland State College, and in 1948 invited Sleet to set up a photography department there. After a short time in Maryland, Sleet moved to New York, studying at the School of Modern Photography before attending New York University where he obtained a masters degree in journalism in 1950.

After a brief stint as a sportswriter for the *Amsterdam News,* Sleet joined the staff of *Our World,* a popular black picture magazine. His five years there were training for his photojournalistic sensibility. He and the other staff photographers and writers were subject to the high editorial standards of the publisher, John DAVIS. It was under Davis's auspices that Sleet produced one of his most engaging stories, a 1953 series on the coal-mining town of Superior, W.Va.

Our World ceased publication two years later, and Sleet joined the Johnson Publishing Company's New York–based illustrated monthly magazine *Ebony,* where he continued as staff photographer. Publisher John H. JOHNSON sent him to the far corners of the world on stories. In addition, coverage of the fledgling civil rights movement established the reputation of *Ebony*'s sister publication *Jet,* and in the early years Sleet's photographs appeared in both.

On assignment in 1956, Sleet first met the Rev. Dr. Martin Luther KING, Jr., then a twenty-seven-year-old Atlanta minister, emerging as the leader of the civil rights movement. Their association flourished as the movement dominated the black press,

with Sleet covering King's receiving the Nobel Peace Prize in Sweden in 1964, his marching from Selma to Montgomery in 1965, and his funeral in Atlanta following his assassination in April 1968.

Sleet's recollection of the circumstances leading to his memorable Pulitzer Prize–winning photograph of Coretta Scott King was still vivid:

There was complete pandemonium—nothing was yet organized because the people from SCLC [the Southern Christian Leadership Conference] were all in a state of shock. We had the world press descending upon Atlanta, plus the FBI, who were there investigating.

We were trying to get an arrangement to shoot in the church. They said they were going to "pool it." Normally, the pool meant news services, *Life, Time,* and *Newsweek.* When the pool was selected, there were no black photographers from the black media in it. Lerone Bennett and I got in touch with Mrs. King through Andy Young. She said, "If somebody from Johnson Publishing is not on the pool, there will be no pool." Since I was with Johnson Publishing, I became part of the pool. In those days there weren't many blacks [in journalism], whether writers or photographers.

The day of the funeral, Bob Johnson, the executive editor of *Jet,* had gotten in the church and he beckoned for me and said, Here's a spot right here. It was a wonderful spot. It was then a matter of photographing what was going on. It was so dramatic; everywhere you turned the camera—Daddy King, Vice President Humphrey, Nixon, Jackie Kennedy, Bobby Kennedy, Thurgood Marshall, Dr. Ralph Bunche reading the program with a magnifying glass. I considered myself fortunate to be there documenting everything. If I wasn't there I knew I would be somewhere crying.

We had made arrangements with AP [the Associated Press] that they would process the black-and-white film immediately after the service and put it on the wire. Later I found out which shot they sent out. (Taped interview, New York, 1986)

Moneta Sleet's career has also encompassed the great period of African independence, when in the 1950s autonomous nations emerged from former colonies. His first experience in "pack" journalism abroad came on Vice President Richard Nixon's 1957 trip through Africa, where Sleet photographed in Liberia, Libya, and the Sudan. It was on this trip he photographed Kwame Nkrumah at the moment of Ghana's independence. The results of the trip gained Sleet an Overseas Press Club citation in 1957.

Sleet's long career as a photojournalist has taken him all over the United States and Africa; he has also visited and photographed on assignment in South

America, Russia, the West Indies, and Europe. While photo essays and portrait profiles make up the majority of his output, he has also photographed the children who tagged alongside him as he worked. To Sleet, the father of three grown children, these personal portraits have been the most rewarding.

In addition to winning a Pulitzer Prize in feature photography and a citation for excellence from the Overseas Press Club of America, Sleet has received awards from the National Urban League (1969) and the National Association of Black Journalists (1978). Over the years, his work has appeared in several group exhibitions at museums, including the Studio Museum in Harlem and the Metropolitan Museum of Art. In 1970, solo exhibitions were held at the City Art Museum of St. Louis and the Detroit Public Library. A retrospective exhibition organized by the New York Public Library in 1986 toured nationally for three years.

REFERENCES

"Image Maker: The Artistry of Moneta Sleet, Jr." *Ebony* 42 (January 1987): 66–74.
Moneta Sleet, Jr.: Pulitzer Prize Photojournalist. New York, 1986. New York Public Library exhibit brochure.

JULIA VAN HAAFTEN

Sligh, Clarissa (August 30, 1939–), photographer. Clarissa Sligh was born in Washington, D.C., and attended school in Arlington, Virginia. In 1956 she became the lead plaintiff in the first successful school desegregation case in the state of Virginia, *Clarissa Thompson et al* v. *The Arlington County School Board et al.* Sligh's educational pursuits spanned several areas of interest. In 1963, the year that she married Thomas Sligh (they divorced several years later), she received a B.S. in mathematics from Hampton Institute. In 1972 Sligh earned her B.F.A. in painting from Howard University and a year later she completed her M.B.A. from the University of Pennsylvania. Sligh began her formal education as a photographer at the International Center for Photography from 1979 to 1980.

Sligh's photographic works featured images from family photo albums, often with several snapshots juxtaposed against each other, and framed by Sligh's handwritten passages drawn from overheard conversations (*Ted on Women* 1990; *Bill on Men,* 1990). The bulk of her work explored relationships between men and women, and Sligh often used her compositions to restage events from childhood. One of Sligh's best-known works, *What's Happening with Mamma?*

(1988), was a book of photographs and text that explored the fear and disorientation a young girl felt while hearing the sounds of her mother giving birth to a child. She also created a book of photographs and text, *Reading Dick and Jane with Me* (1990), that used the children's primer to comment on how black children are educated in the United States. Sligh's other well-known works included *Kill or Be Killed* (1990), *Exposure* (1990), and *Work Yourself to Death* (1990).

Sligh's images have been shown at Williams College Museum of Art in Massachusetts, Nexus Gallery in Philadelphia (1989); INTAR Latin American Gallery in New York City (1990), and the Newport Art Museum in Rhode Island (1990). Her exhibit on the civil rights movement, "Witness to Dissent: Memory, Yearning, and Struggle," was shown at the Art in General Gallery in New York City in 1992. In 1987, Sligh joined artists Faith RINGGOLD and Margaret Gallegos to cofound Coast to Coast: Women of Color Artists' Project, for which Sligh has served as national coordinator.

REFERENCES

"Artist Focus." *Women's Quarterly Review.* (Fall 1984): 15.
SLIGH, CLARISSA. *What's Happening with Mamma?* New York, 1988.
WILLIS, DEBORAH. *Convergence, 8 Photographers: Albert Chong, Todd Gray, Jeffrey Scales, Coreen Simpson, Clarissa Sligh, Elisabeth Sunday, Christian Walker, Wendel White.* Boston, 1990.

NASHORMEH N. R. LINDO

Slowe, Lucy Diggs (July 4, 1885–October 21, 1937), educator. Born in Berryville, Va., Lucy Diggs Slowe was raised after the death of her parents by her paternal aunt Martha Slowe Price, in Lexington, Va. They moved to Baltimore in 1898 where Slowe graduated second in her class at the Colored High School in 1904 and received a scholarship to Howard University. At Howard she was one of the founders and officers of Alpha Kappa Alpha, the first Greek-letter sorority for black women.

After graduation Slowe taught English at Baltimore Colored High School. In 1915 she received an M.A. in English from Columbia University. Four years later she became principal of Shaw Junior High School for blacks in Washington, D.C. There she organized a successful training program for junior high school teachers that, because of its high reputation, was attended by white teachers as well.

In 1922 Slowe became the first Dean of Women at Howard University, a position she held until 1937. As Dean of Women, Slowe took an active role in removing restrictions from the lives of female students and increasing the responsibilities of women administrators at the university. Slowe organized a cultural series at Howard University beginning in 1929, presenting leading African-American concert performers.

Beyond her general devotion to the advancement of African Americans, Slowe was committed politically to both the specific concerns of black women and to the economic concerns of poor blacks. In 1923 she cofounded and became the first president of the National Association of College Women (NACW), a black organization created to further opportunities for black women in higher education. In 1929 she helped establish the National Association of Deans of Women and Advisors to Girls in Negro Schools under the auspices of the NACW. In 1935 Slowe, along with Mary McLeod BETHUNE, helped cofound the NATIONAL COUNCIL OF NEGRO WOMEN, an umbrella organization of black women's groups that had a specific feminist focus and commitment to the issues of working class and poor African-American women. She also served on the advisory board of the National Youth Administration and the Women's International League for Peace and Freedom. Slowe was also an active tennis player who won seventeen championships in AMERICAN TENNIS ASSOCIATION tournaments. She died in 1937 of influenza and kidney disease in Washington, D.C.

REFERENCES

HINE, DARLENE CLARK, ed. *Black Women in America.* New York, 1993.

HOLT, RACKHAM. *Mary McLeod Bethune: A Biography.* New York, 1964.

SABRINA FUCHS
JOSEPH W. LOWNDES

Slyde, Jimmy (1927–), tap dancer. Born James Godbolt in Atlanta and raised in Boston, Jimmy Slyde by the age of twelve was studying the violin at the Boston Conservatory and tap dance with Stanley Brown, learning to slide from Eddie "Schoolboy" Ford. With Jimmy ("Sir Slyde") Mitchell he formed the duo the Slyde Brothers and appeared in nightclubs, burlesque houses, and theaters. He became known for his lyrical, sophisticated rhythms and for the slides and glides that are the trademarks of his jazz-tap dancing technique. During the 1940s Slyde appeared with the Count BASIE and Duke ELLINGTON

big bands. After Slyde won a small role in the film *A Star Is Born* (1954) with Judy Garland, choreographer Nick Castle provided him with studio space for work and teaching.

In the 1950s and '60s Slyde, greatly esteemed for his rhythmic dancing, performed at the world's major jazz festivals, including Newport, North Sea (Holland), Umbria (Italy), and Puri (Finland). Slyde, Baby Laurence (*see* Laurence JACKSON), Buster Brown, and Chuck GREEN were billed as Harlem's All-Star Dancers at the Berlin Jazz Festival in 1966. Unable to find work in the United States, Slyde moved to Paris in 1972, where he worked in small jazz clubs, following the long tradition of expatriate black dancers who found in Europe the critical acclaim denied them at home. The performance group One Thousand Years of Jazz Dance with the Original Hoofers drew him back to America.

Slyde's dancing experimented with rhythm and tonality, sliding into cascades of taps close to the floor. Sound was more important to Slyde than the step: Timing was crucial, and music was his driving force. Slyde has appeared in the films *The Cotton Club* (1984), *'Round Midnight* (1986), and *Tap* (1989). He received a Tony nomination for his dancing in the 1989 Broadway production of *Black and Blue*. In the early 1990s he frequently appeared as a surprise guest at jazz clubs in New York City, where he taught the younger generation the fine points of jazz-tap dance.

CONSTANCE VALIS HILL

Smalls, Robert (1839–1915), Civil War navy pilot, politician, and businessman. Born a slave near Beaufort, S.C., Smalls moved to Charleston where he was allowed to hire himself out by paying his owner fifteen dollars a month. The knowledge of coastal waterways that he gained as a boatman made possible one of the Civil War's most daring exploits.

In 1862, the Confederate government made Smalls wheelsman of the steamboat the *Planter* (the title "pilot" being deemed inappropriate for a slave). He learned the signals necessary to pass southern fortifications and the location of mines.

On May 12, 1862, while white crew members were on shore, Smalls seized the opportunity to steer the ship, containing his family and a small group of other slaves, to Union lines. The news spread across the country. The coup was important militarily and symbolically, demonstrating what slaves—supposedly docile and content in their servitude—could accomplish.

Awarded $1,500 for the armed boat and commissioned as a second lieutenant in the U.S. Colored

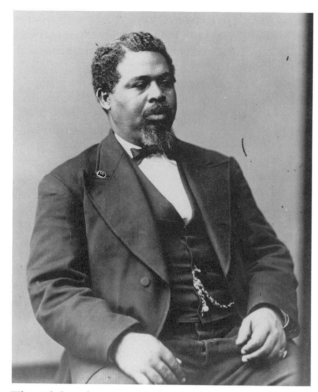

Though best known as a daring hero during the Civil War, Robert Smalls was later a Reconstruction congressman. He remained a political leader in South Carolina for the rest of the nineteenth century. (Prints and Photographs Division, Library of Congress)

Troops, Smalls became pilot of the *Planter,* participated in seventeen battles, and recruited for the army. During and after the war he raised funds in the North for black Southerners' interests. Doggedly pursuing his own education, he bought schools for freedmen while investing extensively in real estate and companies in his native state.

Dramatic as Smalls's escape was, his later career constituted his greatest legacy. During the twelve years that Reconstruction allowed black Southerners political opportunities, Smalls became a South Carolina state congressman and senator and then, for most of the years between 1874 and 1886, a U.S. congressman, known for his repartee. In the state legislature he sponsored bills for free compulsory public education. He attended the 1864 Republican National Convention, helped write the 1868 state constitution, and became a major general of the state militia. In office, he fought not only for freedmen's interests—cheap land prices, continuing eligibility for army enlistment, enforcement of the Civil Rights Act—but for his general constituency's concerns, such as a railroad, reformed penitentiaries, property rights of wives and tenants, and health care for the poor.

When the Compromise of 1877 returned political control to Democrats, they quickly sought to drive

out and discredit all Republican officeholders. Smalls, who enjoyed the admiration of his African-American constituents for the heroic act he never tired of recounting, did not escape controversy. Despite having consistently attacked governmental extravagance and corruption, he faced a bribery charge, which was ultimately dropped. But staying in office became increasingly difficult, with the Democrats using violence and crooked elections to disfranchise black people as the federal government lost interest in the freedmen. Smalls won his final congressional election against the viciously racist "Pitchfork" Ben Tillman in 1884.

Even after elected positions were no longer available, Smalls's loyalty to the Republican party assured him of patronage jobs. He served as Beaufort's customs collector from 1890 until 1913. He also continued to organize his district's black Republicans and to use his influence for former constituents whenever possible.

REFERENCES

HOLT, THOMAS. *Black over White: Negro Political Leadership in South Carolina During Reconstruction.* Chicago, 1979.
UYA, OKON EDET. *From Slavery to Public Service: Robert Smalls, 1839–1915.* New York, 1971.

ELIZABETH FORTSON ARROYO

Smith, Ada Beatrice Queen Victoria Louise Virginia "Bricktop" (August 14, 1894–January 31, 1984), entertainer, nightclub owner. Bricktop, the impresario of racially integrated European nightclubs, was born in Alderson, W.Va., to an Irish mother and African-American father. Neither could decide what to name her, so they allowed their neighbors to contribute, and the result was the name Ada Beatrice Queen Victoria Louise Virginia Smith. After her father died in 1898, the family moved to Chicago. While still a child she appeared in *Uncle Tom's Cabin* at Chicago's Haymarket Theater. At the age of fifteen she briefly sang in the chorus of the black-owned Pekin Theater. Around 1920 she began singing and dancing full-time in minstrel and vaudeville shows, working with Miller and Lyles, McCabe's Georgia Troubadours, and the Oma Crosby Trio on both the THEATER OWNERS BOOKING ASSOCIATION (TOBA) and Pantage black theater circuits. In the early 1920s Bricktop, whose nickname derived from her bright red hair, also worked extensively in Los Angeles, New York, and at Chicago's Panama Cafe, where along with Florence Mills and Cora Green she formed the Panama Trio, with Tony Jackson accompanying them on piano.

(Left to right) Ada "Bricktop" Smith, Mr. Stepter from New York, working in Paris, and Mrs. Alta Douglas, also from New York, are at Bricktop's Paris café. (Photographs and Prints Division, Schomburg Center for Research in Black Culture, The New York Public Library, Astor, Lenox and Tilden Foundations)

In 1924 Bricktop moved to Paris to perform at the Cafe Le Grand Duc. She quickly became friends with members of the American expatriate and European elite, including the Prince of Wales, F. Scott Fitzgerald, Josephine BAKER, and Cole Porter. In 1926 Bricktop opened her own nightclub, the Music Box. After she encountered trouble in securing a permanent operating license, she reopened the Grand Duc under the name Bricktop's. During the late 1920s and '30s, the elegant club was a focal point for the glamorous and raucous nightlife for both blacks and whites in Paris. That era lasted only until the coming of World War II. In the late 1930s, after most Americans had fled Paris, Bricktop made broadcasts for the French government, but she too eventually returned to the United States.

Bricktop settled in New York, where she became part owner of the Brittwood Cafe. However, without her Parisian clientele and the liberal racial climate of Europe, the venture failed. Bricktop tried her luck with a similar club in Mexico City starting in 1943, becoming part owner of the Minuit and Chavez's. Those ventures also proved unsuccessful, and in 1949 Bricktop returned to Paris. She found the city drastically changed, and the new Bricktop's that she opened lasted less than a year. She moved the club to Rome in the late 1950s, and she lived there until her retirement from nightlife in 1964. By the 1970s she was living in New York, and in 1972 she recorded

"So Long Baby" with Cy Coleman. In the mid-1970s she began to perform again at nightclubs in New York. Bricktop, who was married to the New Orleans saxophonist Peter Ducongé from 1929 to 1932, died in New York in 1984.

REFERENCES
"Bricktop, Queen of Saloon Keepers." *Sepia* (August, 1975): 69–78.
SMITH, ADA, with James Haskins. *Bricktop*. New York, 1983.

SUSAN MCINTOSH

Smith, Albert Alexander (1896–1940), painter, printmaker, and jazz musician. As an expatriate to France, Smith mastered dual careers in art and music. Born in New York, he studied piano and guitar while attending the Ethical Culture Art School on scholarship and De Witt Clinton High School. Later, he studied at the National Academy of Design (1915–1918, where he won several prizes) and the Royal Academy in Liège, Belgium. Smith first went abroad with the 807th Pioneer Band of the American Expeditionary Forces during World War I. Once he settled in Paris in 1920, his prints, paintings, and drawings were exhibited there (at the Salon of 1921, among other places) and in Cannes, Brussels, New York, and Boston. He also received Harmon Foundation awards. Smith's frequent illustrations in the NAACP and National Urban League magazines, the CRISIS and OPPORTUNITY, condemned racial prejudice and celebrated African history.

Librarian Arthur Schomburg commissioned Smith to execute a portrait series of great black leaders; in turn, Smith sent him rare books and materials on black culture he found throughout Europe. Smith also produced prints of common European people and famous places, as well as stereotypical scenes of African-American folk, most likely for a predominantly white tourist market. By night, he played the banjo in elite cabarets and did radio and recording work. Smith died suddenly of a brain clot in Haute-Savoie, France.

REFERENCE
Crisis 20 (August 1920): 184–185.

THERESA LEININGER-MILLER

Smith, Amanda Berry (January 1837–February 1915), evangelist and author. Smith was born in Long Green, Md., the oldest girl in a family of thirteen children, five of whom (including Smith) were born

in slavery. Her father, Samuel Berry, married to Marian Matthews, purchased his freedom and that of his family and moved to York County, Pa., where their house became a station on the UNDERGROUND RAILROAD.

Smith's international reputation as a missionary and evangelist was instrumental in creating a prominent role for women in the structure of the AFRICAN METHODIST EPISCOPAL (AME) CHURCH. Ordination to the ministry did not come until the twentieth century, but Smith's success contributed to forces which compelled the church to include women in significant lay capacities as they continued to press for ordination.

Smith's entry into missionary and evangelical work can be traced to the time when, living in Lancaster County, Pa., with Calvin Devine, the first of two husbands, she became ill and had a vision of herself preaching to a crowd. Living in New York City with her second husband, James Smith, she began to realize her vision by preaching in Methodist congregations throughout the city. After the death of this husband in 1869 and with only one surviving daughter from her first marriage, she was free to dedicate herself to evangelical work. Through 1878 she was extremely successful in camp and holiness meetings throughout the New England area.

Although she was a member of the AME church, Smith's fame as an evangelist was earned through association with the predominantly white Methodist Episcopal (ME) church. The ME church invited her to England in 1878, and for twelve years she worked throughout England, Scotland, India, and West Africa, becoming known for her regal stature, resounding singing voice, and the compelling passion of her conversion messages. During this period she spent eight years in Liberia where she dedicated herself to preaching holiness and temperance and to the education of women and children. After her return to the United States in 1890, she continued her evangelical work and wrote and published her autobiography. In 1899 she founded an orphanage and industrial school for black children in Harvey Ill., which she operated until failing health forced her to retire shortly before her death in 1915.

REFERENCE

SMITH, AMANDA. *An Autobiography*. 1893. Reprint. New York, 1988.

JUALYNNE DODSON

Smith, Bessie (April 15, 1894–September 26, 1937), blues singer. Bessie Smith, "Empress of the Blues," was the greatest woman singer of urban blues and, to many, the greatest of all blues singers (*see* BLUES). She was born in Chattanooga, Tenn., the youngest of seven children of Laura and William Smith. Her father, a part-time Baptist preacher, died while she was a baby, and her early childhood, during which her mother and two brothers died, was spent in extreme poverty. Bessie and her brother Andrew earned coins on street corners with Bessie singing and dancing to the guitar playing of her brother.

The involvement of her favorite brother Clarence in the Moses Stokes Show was the impetus for Smith's departure from home in 1912. Having won local amateur shows, she was prepared for the move to vaudeville and tent shows, where her initial role was as a dancer. She came in contact with Gertrude "Ma" RAINEY, who was also with the Stokes troupe, but there is no evidence to support the legend that Rainey taught her how to sing the blues. They did develop a friendship, however, that lasted through Smith's lifetime.

Bessie Smith, c. 1935. (Photographs and Prints Division, Schomburg Center for Research in Black Culture, The New York Public Library, Astor, Lenox and Tilden Foundations)

SMITH, BESSIE 2493

Smith's stint with Stokes ended in 1913, when she moved to Atlanta and established herself as a regular performer at the infamous Charles Bailey's 81 Theatre. By then the THEATER OWNERS BOOKING ASSOCIATION (TOBA) consortium was developing into a major force in the lives and careers of African-American entertainers, and managers/owners often made the lives of performers miserable through low pay, poor working and living conditions, and curfews. Bailey's reputation in this regard was notorious. Smith became one of his most popular singers, although she was paid only ten dollars a week (*see* NIGHTCLUBS).

Smith's singing was rough and unrefined, but she possessed a magnificent vocal style and commanding stage presence, which resulted in additional money in tips. With the 81 Theatre as a home base, Smith traveled on the TOBA circuit throughout the South and up and down the eastern seaboard. By 1918 she was part of a duo-specialty act with Hazel Green but soon moved to her own show as a headliner.

Smith attracted a growing number of black followers in the rural South as well as recent immigrants to northern urban ghettos who missed the down-home style and sound. She was too raw and vulgar, however, for the Tin Pan Alley black songwriters attempting to move into the lucrative world of phonograph recordings. White record company executives found Smith's (and Ma Rainey's) brand of blues too alien and unrefined to consider her for employment. As a result, Smith was not recorded until 1923, when the black buying public had already demonstrated that there was a market for blues songs and the companies became eager to exploit it.

Fortunately, Smith was recorded by the Columbia Gramophone Company, which had equipment and technology superior to any other manufacturer at the time. Columbia touted itself in black newspapers as having more "race" artists than other companies. Into this milieu came Bessie Smith singing "Down Hearted Blues" and "Gulf Coast Blues," the former written and previously performed by Alberta HUNTER and the latter by Clarence Williams, studio musician for Columbia. Sales were astronomical. Advertisements in the black newspapers reported her latest releases, and Smith was able to expand her touring range to include black theaters in all of the major northern cities. By 1924, she was the highest-paid African American in the country.

Smith sang with passion and authenticity about everyday problems, natural disasters, the horrors of the workhouse, abuse and violence, unfaithful lovers, and the longing for someone, anyone, to love. She performed these songs with a conviction and dramatic style that reflected the memory of her own suffering, captured the mood of black people who had experienced pain and anguish, and drew listeners to her with empathy and intimacy. Langston HUGHES said Smith's blues were the essence of "sadness . . . not softened with tears, but hardened with laughter, the absurd, incongruous laughter of a sadness without even a god to appeal to."

Smith connected with her listeners in the same manner as the southern preacher: They were her flock who came seeking relief from the burdens of oppression, poverty, endless labor, injustice, alienation, loneliness, and love gone awry. She was their spiritual leader who sang away the pain by pulling it forth in a direct, honest manner, weaving the notes into a tapestry of moans, wails, and slides. She addressed the vagaries of city life and its mistreatment of women, the depletion of the little respect women tried to maintain. She sanctioned the power of women to be their own independent selves, to love freely, to drink and party and enjoy life to its fullest, to wail, scream, and lambaste anyone who overstepped boundaries in relationships—all of which characterized Smith's own spirit and life.

Columbia was grateful for an artist who filled its coffers and helped move it to supremacy in the recording industry. Smith recorded regularly for Columbia until 1929, producing 150 selections, of which at least two dozen were her own compositions. By the end of the 1920s, women blues singers were fading in popularity, largely because urban audiences were becoming more sophisticated. Smith appeared in an ill-fated Broadway show, *Pansy,* and received good reviews, but the show itself was weak and she left almost immediately. Her single film, *St. Louis Blues* (1929), immortalized her, although time and rough living had taken a toll on her voice and appearance.

Because of the Great Depression, the recording industry was in disarray by 1931. Columbia dismantled its race catalog and dropped Smith along with others. She had already begun to shift to popular ballads and swing tunes in an attempt to keep up with changing public taste. Okeh Records issued four of her selections in 1933. She altered her act and costumes in an attempt to appeal to club patrons, but she did not live to fulfill her hope of a new success with the emerging swing ensembles. On a tour of southern towns, Smith died in an automobile accident.

REFERENCES

ALBERTSON, CHRIS. *Bessie.* New York, 1972.
———. *Bessie Smith, Empress of the Blues.* New York, 1975.
BARLOW, WILLIAM. *Looking Up at Down: The Emergence of Blues Culture.* Philadelphia, 1989.
HARRISON, DAPHNE DUVAL. *Black Pearls: Blues Queens of the 1920s.* New Brunswick, N.J., 1988.

DAPHNE DUVAL HARRISON

Smith, Clara (1894–February 2, 1935), blues singer and pianist. Born in Spartanburg, S.C., Clara Smith began her career at the age of sixteen as a singer and pianist on the southern black theater and vaudeville circuits and emerged as a star of the TOBA (Theater Owners Booking Association) circuit by 1918. Her performances included tours with the Al Wells Smart Set tent show in 1920 and stints at the Dream Theater in Columbus, Ga., in 1921. Smith settled in Harlem in 1923, where she sang in cabarets, nightclubs and speakeasies, becoming famous as one of the first great BLUES singers. During this time she also managed her own theatrical club in New York.

Among Smith's early recordings are "Every Woman's Blues" (1923), "It Won't Be Long Now" (1924), and "That's Why the Undertakers Are Busy This Year" (1927). Nicknamed "Queen of the Moaners," she gave an erotic interpretation to songs that used sexual double entendres, including "Whip It to a Jelly" (1926) and "Ain't Nobody to Grind My Coffee" (1928). Smith's dramatic and emotional style of singing created a friendly rivalry with another great blues singer of the day, Bessie SMITH. The two, who were not related, recorded several duets, including "Far Away Blues" (1923) and "My Man Blues" (1925). Clara Smith also recorded with some of the most prominent instrumentalists in jazz, including Louis ARMSTRONG on "Broken Busted Blues" (1925), Fletcher HENDERSON on "Awful Moanin' Blues" (1924), James P. JOHNSON on "Mr. Mitchell" (1929), and Lonnie Johnson on "Don't Wear It Out" (1930).

In the late 1920s, Smith performed steadily in theater revues, including the *Black Botton Revue* (1927), the *Clara Smith Revue* (1927), the *Swanee Club Revue* (1928), *Ophelia Snow from Baltimo* (1928–1929), the *Candied Sweets Revue* (1929), and the *Hello 1930 Revue* (1929–1930). In 1931 Smith worked with Charlie Johnson's Paradise Band and in *Trouble on the Ranch,* a revue with a Western theme in Philadelphia. She also performed in clubs in Cleveland and Detroit. Heart problems led to her death in Detroit in 1935.

REFERENCES

OLIVER, PAUL. " 'Clara Voce'—A Study in Neglect." *Jazz Monthly* 4, no. 2 (April 1958): 8.
VAN VECHTEN, CARL. "Negro Blues' Singers." *Vanity Fair* 26, no. 1 (March 1926): 67.

JONATHAN GILL

Smith, Clarence "Pinetop" (January 11, 1904–March 15, 1929), boogie-woogie pianist. Clarence "Pinetop" Smith was born in Orion, Ala., and grew up in nearby Troy, where he learned to play piano.

His nickname was thought to have derived from the color of his hair or the shape of his head, but his mother, who outlived him, claimed she called him Pinetop because as a child he liked to play high up in pine trees. In 1918 he began playing piano professionally at the East End Park Club in Birmingham.

In 1920 Smith moved to Pittsburgh but spent most of his time on the road as a vaudeville entertainer. He accompanied acts such as Ma RAINEY, Butterbeans and Susie, and the WHITMAN SISTERS on tours of tent shows and theaters in the deep South and the Midwest, often on the THEATER OWNERS BOOKING ASSOCIATION (TOBA) circuit, as well as at nightclubs and whorehouses. Although Smith would eventually become famous for his piano playing, during this time he was equally skilled as a singer and dancer. In the mid-1920s he met the pianist "Cow Cow" Davenport, who helped Smith refine his style. In 1928 Smith moved his family to Chicago, where he played regularly at rent parties, barrelhouses, and brothels.

Smith recorded only twenty songs, but they are among the most important and influential in the history of JAZZ piano. One of them, "Pine Top's Boogie Woogie" (1928), marked the first known use of the term "boogie woogie." Smith popularized the boogie-woogie style of playing, which was characterized by rolling eight-to-the-bar left-hand figures, and robust right-hand improvised melodies. Among his other recordings, which included blues and popular-style melodies, were "Pine Top Blues" (1928), "Now I Ain't Got Nothing at All" (1929), "I Got More Sense Than That" (1929), and "Driving Wheel Blues" (1929). Smith was a primary influence on later boogie-woogie pianists such as Albert Ammons, Meade Lux Lewis, and Jimmy Yancey. Smith also performed half-sung monologues on tunes such as "I'm Sober Now" (1929) and "Jump Steady Blues" (1929).

Smith, who married Sarah Horton in 1924 and had two children, died at the age of twenty-five when he was accidentally shot during a brawl in a Chicago dance hall.

REFERENCES

HALL, BOB, and RICHARD NOBLETT. "The Birth of Boogie Woogie." *Blues Unlimited* 138 (January/February 1979): 10–11.
SYLVESTER, PETER. *A Left Hand like God: A Study of Boogie-Woogie.* London, 1988.

JONATHAN GILL

Smith, Hale (June 29, 1925–), composer, arranger, editor, and educator. Smith was born June 29, 1925, in Cleveland, Ohio. He received bachelor's

(1959) and master's (1962) degrees in composition and an honorary doctorate (1988) from the Cleveland Institute of Music. His major teaching positions have been at C. W. Post College in New York and the University of Connecticut (1970–1984), where he is professor emeritus. The importance of craft has been a foundation of Smith's compositions and teaching. He was trained as a pianist and his experience in working with notable jazz musicians such as Dizzy GILLESPIE, Ahmad Jamal, Oliver Nelson, and Chico Hamilton is evident in much of his work.

Smith's music also shows a mastery of several major directions in twentieth-century music—particularly serialism, neoclassicism, and expressionism. Sensitivity to timbre in orchestral and chamber music is characteristic of his work, as is a sense of dramatic contrasts. Representative of these qualities are the orchestral works *Contours* (1962), *Ritual and Incantations* (1971), and *Innerflexious* (1977), and the choral work *In Memoriam—Beryl Rubinstein* (1953, 1958). Some of his music, including *Contours* and *The Valley Wind* (art songs), has been recorded. Smith has worked as editor and consultant for several music-publishing companies, including E. B. Marks, C. F. Peters, and Frank Music Co.

REFERENCES

BAKER, DAVID, L. BELT, and H. C. HUDSON, eds. *The Black Composer Speaks.* Metuchen, N.J., 1978.
CALDWELL, HANSONIA. "Conversations with Hale Smith." *Black Perspectives in Music* 3 (1975): 59–76.

CALVERT BEAN

Smith, James McCune (April 18, 1813–November 17, 1865), physician and abolitionist. James McCune Smith was born in New York City, the son of freed slaves. He received his early education at the AFRICAN FREE SCHOOL, but even with an excellent academic record, he was effectively barred from American colleges because of his race. Smith entered Glasgow University in Scotland in 1832, and earned three academic degrees, including a doctorate in medicine. He also gained prominence in the Scottish antislavery movement as an officer of the Glasgow Emancipation Society.

Following a short internship in Paris, Smith returned to New York City in 1837 and established a medical practice and pharmacy. His distinction as the first degree-holding African-American physician assured him a prominent position in the city's black community. He was involved in several charitable and educational organizations, including the Philomathean Society and the Colored Orphan Asylum.

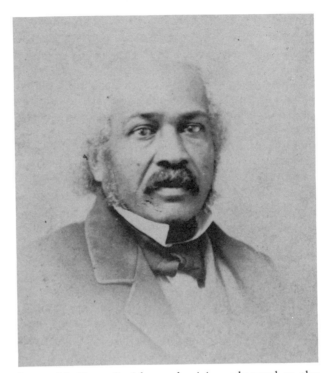

James McCune Smith, a physician educated at the University of Glasgow in Scotland, was one of the most respected abolitionists, a close ally of Frederick Douglass, and a leader in the fight for black voting rights in antebellum New York. (Photographs and Prints Division, Schomburg Center for Research in Black Culture, The New York Public Library, Astor, Lenox and Tilden Foundations)

Smith's intellect, integrity, and lifelong commitment to abolitionism brought him state and national recognition. From the early 1840s, he provided leadership for the campaign to expand black voting rights in New York, although he initially refused to ally with any political party. In the 1850s, Smith continued his suffrage activity through the black state conventions. He eventually gravitated to the political antislavery views of the Radical Abolition party, and received the party's nomination for New York secretary of state in 1857.

As a member of the Committee of Thirteen, he helped organize local resistance to the Fugitive Slave Act of 1850. He was ranked among the steadfast opponents of the colonization and black emigration movements, affirming instead the struggle for the rights of American citizenship. Although committed to racial integration, he understood the practical and symbolic importance of separate black institutions, organizations, and initiatives. He called for an independent black press, and worked with Frederick DOUGLASS in the early 1850s to establish the first permanent national organization—the National Council of the Colored People.

Smith provided intellectual direction as well as personal leadership for the black abolitionist movement. From his critiques of colonization and black emigration in the 1840s and 1850s to his analysis of Reconstruction in the 1860s, his commentary informed the debate on racial identity and the future of African Americans. Smith's published essays include two pamphlets, *A Lecture on the Haytian Revolution* (1841) and *The Destiny of the People of Color* (1843). He wrote several lengthy articles for the *Anglo-African Magazine* in 1859, and also provided introductions to Frederick Douglass's second autobiography and Henry Highland GARNET's *Memorial Discourse* (1865). Although he never published his own journal, he assisted other black editors in all phases of newspaper publishing. His letters to *Frederick Douglass' Paper* often appeared under the pseudonym "Communipaw." He contributed as a correspondent or assistant editor to several other journals, including the *Colored American, Northern Star and Freeman's Advocate, Douglass' Monthly,* and *Weekly Anglo-African*. Smith's professional standing, erudition, and community involvement made his life a triumph over racism, and his name was frequently invoked by contemporaries as a benchmark for black intellect and achievement.

REFERENCES

BLIGHT, DAVID W. "In Search of Learning, Liberty, and Self-Definition: James McCune Smith and the Ordeal of the Antebellum Black Intellectual." *African Americans in New York Life and History* 9 (1985): 7–25.

RIPLEY, C. PETER, ET AL., eds. *The Black Abolitionist Papers.* Vol. 3, *The United States, 1830–1846.* Chapel Hill, N.C., 1991.

———. *The Black Abolitionist Papers.* Vol. 4, *The United States, 1847–1858.* Chapel Hill, N.C., 1991.

 MICHAEL F. HEMBREE

Smith, James Oscar "Jimmy" (1925–) jazz organist. Jimmy Smith, born in Norristown, Pa., in 1925, was one of the first significant jazz organists. His virtuoso style combined bop vocabulary with a gutsy rhythm-and-blues sensibility, and his trios in the early sixties spawned a wave of imitators.

Smith's parents were both pianists, so his musical education was encouraged from an early age. His first performing experiences were at a local church. As a teenager, Smith was an enthusiast of bebop pianist Earl "Bud" POWELL, but he also credited Art TATUM as a powerful influence. In 1947, after serving in the United States Navy, Smith attended the Ornstein School of Music in Philadelphia, where he studied theory, composition, and double bass. During his school years he began to work with bands in Philadelphia. Smith began performing on organ in 1951 with the Don Gardner Sonotones.

In 1955, Smith organized his own trio, with guitar and drums, and the following year he made a successful New York City club debut, attracting attention for duplicating the big band sound on his organ. He made a highly successful appearance at the Newport Jazz Festival in 1957, and by 1962 he had established his own recording company. His 1964 album *The Cat* won a Grammy. Smith played on film soundtracks such as *The Swinging Set* (1964) and *Where the Spies Are* (1965), and he composed the music for *Who's Afraid of Virginia Woolf?* (1966). Critics have credited Smith with inspiring the guitar-organ lounge trios of the 1950s and '60s, establishing an instrumentation and style that continues to influence musicians today.

From 1957 to 1977, Smith developed an international career, and particularly in the 1970s he traveled extensively, playing at clubs and festivals throughout the world. He settled in Los Angeles in 1975, where he opened his own supper club. Smith began touring again in the 1980s and made several New York appearances in 1983 and 1984.

REFERENCES

DOERSHUK, BOB. "Jimmy Smith." *Contemporary Keyboard* (August 1978): 26–36.

GIDDINS, GARY. *"Rhythm-a-ning": Jazz Tradition and Innovation in the Eighties.* New York, 1985.

HITCHCOCK, H. WILEY, ed. *New Grove Dictionary of American Music.* Vol. 4. New York, 1986.

KERNFELD, BARRY, ed. *New Grove Dictionary of Jazz.* New York, 1988, pp. 470–471.

SOUTHERN, EILEEN. *Biographical Dictionary of Afro-American and African Musicians.* Westport, Conn., 1982.

 DOUGLAS J. CORBIN

Smith, Mamie (May 26, 1883–September 16, 1946), blues singer. Many details surrounding the birth of Mamie Smith, the first African-American recording star, are uncertain. It is generally conceded that she was born in Cincinnati, Ohio, but it is not clear what her birth name was. Before reaching adulthood she sang, danced, and acted with white and black traveling vaudeville shows, including the Four Dancing Mitchells and the Salem Tutt-Whitney show. She married the singer William "Smitty" Smith in 1912 and came to New York the next year with the Smart Set revue.

In New York Smith met Perry Bradford, a minstrel performer and popular song composer, who eventually hired her for his show *Made in Harlem* (1918); he also launched her recording career in 1920 when he persuaded technicians at Okeh Records to let her record "That Thing Called Love" and "You Can't Keep a Good Man Down." This disc, one of the earliest known recordings by an African-American popular singer, sold well enough to allow Smith to return to Okeh's studios later that year to record "Crazy Blues," a Bradford composition backed by a jazz band whose members included Willie "The Lion" SMITH. "Crazy Blues" is sometimes considered the first BLUES recording, but the performance shares less with other classic blues records from the 1920s than with popular musical and vaudeville theater songs from the time. Nonetheless, "Crazy Blues" was a huge success that sold more than one million copies and initiated the blues craze of the 1920s. "Crazy Blues" also inaugurated the "race music" industry, which marketed blues and jazz specifically for African-American audiences.

In the 1920s Smith worked extensively with some of the finest improvisers in blues and jazz, including Bubber MILEY on "I'm Gonna Get You" (1922), Coleman HAWKINS on "Got to Cool My Doggies Now" (1922), and Sidney BECHET on "Lady Luck Blues" (1923). She also continued to perform in vaudeville and stage acts, including *Follow Me* (1922), *Struttin' Along* (1923), *Dixie Revue* (1924), *Syncopated Revue* (1925), and *Frolicking Around* (1926). Smith became wealthy, lived lavishly, and toured and recorded frequently.

In the 1930s Smith sang at clubs and concerts with Fats Pichon, Andy Kirk, and the Beale Street Boys. She also performed in the shows *Sun Tan Follies* (1929), *Fireworks of 1930* (1930), *Rhumbaland Avenue* (1931), and *Yelping Hounds Revue* (1932–1934). Smith's film career began in 1929 with *Jailhouse Blues* and continued with *Paradise in Harlem* (1939), *Mystery in Swing* (1940), *Murder on Lenox Avenue* (1941), and *Because I Love You* (1943). By the early 1940s Smith had lost much of her wealth. In 1944 she made her last appearance in New York with Billie HOLIDAY. That year Smith fell ill, and she spent the last two years of her life in Harlem Hospital. Though the generally accepted date of Smith's death is September 16, 1946, it is possible that she died on October 30.

REFERENCES

KUNSTADT, LEN. "Mamie Smith: The First Lady of the Blues." *Record Research* 57 (January 1964): 3–12.

STEWART-BAXTER, DERRICK. *Ma Rainey and the Classic Blues Singers.* New York, 1970.

BUD KLIMENT

Smith, Marvin Pentz (February 16, 1910–), and **Smith, Morgan Sparks** (February 16, 1910–February 17, 1993), photographers. Born in Nicholsville, Ky., Marvin and Morgan Smith were the twin sons of tenant farmers. They grew up in Lexington, Ky., and their creative activity started with painting and drawing in the late 1920s. In 1933, they moved to New York, where they studied art under sculptor Augusta SAVAGE who ran a work space and studio in the basement of her Harlem home. They took full-time jobs as gardeners for New York's Parks Department, and also began working with other artists in the Harlem branch of the WORKS PROJECT ADMINISTRATION (WPA). Assigned to work as artists for the Federal Arts Project, they assisted muralists Vertis Hayes and Charles ALSTON on such projects as that for the Harlem Hospital Nurses Residence.

The Smith brothers had owned cameras since childhood, and during the mid-1930s they began to concentrate on photography. In 1937, they were hired as staff photographers by the New York AMSTERDAM NEWS, and in 1939, they traveled to France to study art. Soon after their return, they opened the M & M photographic studio on Harlem's 125th Street, next door to the famed Apollo Theater. Their studio was frequented by performing artists, writers, historians, and families in the Harlem community. Their cameras captured the political rallies, street demon-

Morgan and Marvin Smith set up lights for a photo session with a model. (Photographs and Prints Division, Schomburg Center for Research in Black Culture, The New York Public Library, Astor, Lenox and Tilden Foundations)

strations, and lindy hoppers in the SAVOY BALLROOM as well as street orators and the breadlines during the Great Depression. Some of their more famous subjects included Adam Clayton POWELL, JR., Adam Clayton POWELL, SR., Nat "King" COLE, FATHER DIVINE, Billie HOLIDAY, Langston HUGHES, and Romare BEARDEN. They also operated the Pictorial News Service, a short-lived newspaper picture service. Their photos were shown in books such as Claude MCKAY's *Harlem: Negro Metropolis,* in newspapers and magazines, and later in gallery exhibitions. In the 1960s, the Smith brothers gave some 2,000 photos to New York's Schomburg Center for Research in Black Culture.

During World War II, Marvin Smith served as a chief photographer's mate in the Navy, and was the first African American to attend the Naval Air Station School of Photography and Motion Pictures in Pensacola, Fla. In the years after World War II, the Smith brothers began creating in other fields. Both brothers spent the next several years as cameramen and recording engineers working on documentaries, and they worked for some years for ABC television, before retiring in 1968. Morgan Smith died of cancer in 1993.

REFERENCE

"Photographers." *Ebony* (September 1965): 154.

DEBORAH WILLIS-THOMAS

Smith, Stuff (August 14, 1909–September 25, 1967), jazz violinist. Stuff Smith was born Hezekiah Leroy Gordon in Portsmouth, Ohio. He began his studies with his father, a professional string and reed performer, and in 1921 he joined his father's band as a violinist. This led to his first professional experience, with Aunt Jemima's touring show from 1924 to 1926. In 1926, Smith joined Alphonso Trent's band, where he remained until 1930. He left for a brief period in 1928 to play with Jelly Roll MORTON, but returned to Trent because he felt that he could not be heard in Morton's band.

Smith was based in Buffalo, N.Y., in the early 1930s, leading his own groups. A turning point came in 1936, when he moved to New York City to lead his quintet at the Onyx Club and began experimenting with amplified violin. In 1943, Smith moved to Chicago and became the leader of Fats Waller's band after the pianist's death. He began extensive touring in the 1960s, settling in Copenhagen, where he was popular until his death.

Smith is important for his pioneering use of amplified violin. His style has been described as "bar-

relhouse" and "demonic." He was innovative in rhythmic and pitch alterations and had an expressive vibrato and tone. His best-known works are "Time and Again," "I'se a Muggin'," and "You'se a Viper." Dizzy GILLESPIE and Leroy JENKINS reported that Smith was an important influence on them.

REFERENCES

GLASER, MATT, and STEPHANE GRAPPELLI. *Jazz Violin.* New York, 1981.
WILMER, VALERIE. "Stuff Smith: The Genius of Jazz Violin." *Jazz Beat* 2, no. 6 (1965): 16.

LYNN KANE

Smith, Venture (c. 1729–September 19, 1805), slave and writer. Venture Smith was the author of a memoir, *A Narrative of the Life and Adventures of Venture, a Native of Africa: But Resident Above Sixty Years in the United States of America, Related by Himself* (1798), one of the earliest American slave narratives, and one of the few to include a discussion of African life and of the Middle Passage (see SLAVE TRADE). Born in Dukandarra, Guinea as Broteer, son of Prince Saugm, Venture Smith was kidnapped and sold into slavery at the age of eight. Brought first to Barbados, then to North America, he received his names from two owners, a steward and a planter.

Smith spent a dozen years as a slave in Stonington, Conn., and Fisher's Island, off Long Island in New York. He was notable in his resistance to slavery. Smith refused to act humble or to accept insults. He grabbed whips away from masters and on one occasion beat his master and his brother after they attacked him. Once he planned an escape in a boat, but he argued with his confederates and the plan collapsed.

During his time in bondage, Smith accumulated money through hunting and fishing; he also hired out his labor, chopping large forests of wood on Long Island. He acquired a reputation as a superhuman laborer, a giant man, a combination Paul Bunyan/John Henry figure who weighed three hundred pounds with a six-foot waist. So phenomenal was his strength that, according to legend, he often paddled a canoe forty-five miles across Long Island Sound and back in a single day, between chopping nine cords of wood.

Eventually Smith saved enough money, and in 1765 he bought his freedom for £76. He supported himself by chopping wood, hunting, fishing, trading on merchant ships, whaling, and farming. With the proceeds of his tireless labor he bought freedom for his wife and children, and for some friends he had made while in slavery. In 1776, Smith moved to Had-

dam Neck, Conn., where he bought a house and hired two black indentured servants. He lived there until his death in 1805. In 1798, his *Narrative*, written with Elisha Niles, was printed. Stories of his prowess followed him to Connecticut and survived for a century after his death.

REFERENCE

KAPLAN, SIDNEY, and EMMA NOGRADY KAPLAN. *The Black Presence in the Era of the American Revolution.* 2nd ed. Amherst, Mass., 1989.

GREG ROBINSON

Smith, Vincent (December 12, 1929–), painter. Vincent Smith was born and raised in Brooklyn, N.Y., by parents who had immigrated from Barbados. As a child, Smith studied piano and saxophone, idolizing jazz musicians as his role models, and did not begin to paint until he was twenty-two years of age. After working for several weeks repairing tracks on the Lackawanna Railroad, enlisting in the United States Army from 1947 to 1948, and working for the U.S. Post Office, Smith attended a Paul Cézanne show at the Museum of Modern Art in 1952 and decided to register for classes at the Art Students' League in New York (1953–1956). In 1955, he won a scholarship to study at the Skowhegan School of Painting and Sculpture in Maine.

Smith's work has gone through several stylistic changes since the 1950s. During the 1950s, Smith painted genre scenes in a style that was influenced by African sculpture, Mexican painting, and the Cubism of Cézanne. Smith focused on depicting family life, as in *Mother and Child* (1953) and images of Harlem's pool rooms, cafés, and dance halls, as in *Saturday Night in Harlem* (1955).

In 1959, Smith was awarded the John Hay Whitney Fellowship, traveled to the South and settled in New York City. His paintings addressed the political and social unrest of the 1960s, and he began placing sand and other found objects on the canvas to explore the effect of various textures in painting (*Jake's Poultry Market*, 1965; *The Caucus Room*, 1968). Urban riots were the subject of his painting *Siege* (1969), which revealed burning buildings reflected in the windows of a dwelling, as well as *Blood on the Forge* (1973), which explored unrest in prisons in the United States.

In 1973, Smith received a National Endowment for the Arts Travel Fellowship to visit East Africa. Subsequently, his paintings were influenced by his experiences abroad. He depicted African landscapes, slave castles, totems, and houses (*Elmina Slave Castle*, 1973; *The Triumph of B.L.S.*, 1975). He incorporated rope, textiles, and tie-dyed fabric into his paintings. In 1974, there was a fire in Smith's New York studio and almost one hundred paintings from as early as 1953 were destroyed. After the fire, Smith returned to Africa several times in the late 1970s and early '80s. By 1975 he was creating geometrical works depicting African themes and landscapes (*African Series No. 2*, 1975–1977) and a series of paintings of African kings (*The Tomb of King Tutankhamen*, 1984). Smith also illustrated Margaret Dolch's children's book *Stories from Africa* (1975).

Throughout his career, Smith has maintained an interest in JAZZ, which culminated in his 1990 traveling retrospective exhibition of works on jazz themes, *Riding on a Blue Note*. Smith has frequented jazz clubs since the 1950s and befriended many well-known musicians, such as Charlie PARKER and Lester YOUNG, but it was not until the 1970s, after studying printmaking at Robert Blackburn's New York workshop, that images of musicians took a central role in Smith's compositions (*A Moment Supreme*, 1971). His works from the 1980s were dominated by musical themes, including such compositions as *I Want Some Pigfeet*, *Scrapple from the Apple*, and *Jonkonnu Festival Wid/ The Frizzly Rooster Band*. An image from the *Riding on a Blue Note* series, *Tootin' Blues*, was given as a gift to President Bill Clinton when he visited the Henry Street Settlement House in New York City in 1993.

Smith's work has been featured in solo exhibitions at the Larcada Gallery in New York City in the late 1960s and early '70s, Fisk University (1970), the Studio Museum in Harlem (1974), the Art Galleries of Ramapo College (1988), the Schenectady Museum (1989), and the Henry Street Settlement in New York (1990).

Smith has also taught at the Whitney Museum's Art Resource Center (1967–1976) and has served as a curator for the Studio Museum in Harlem (1978–1982) as well as Kenkelba House Gallery in New York (1985–1986). From 1986 to 1988 he hosted a weekly radio show that featured his interviews with artists on WBAI-FM in New York City.

REFERENCES

Vincent D. Smith: Passages East/West, A Retrospective—1964–1989. Schenectady, N.Y., 1989.
Vincent D. Smith, Riding on a Blue Note: Monoprints and Works on Paper on Jazz Themes. New York, 1990.
Vincent Smith: An Overview, Combinations Permutations and Transformation. Ramapo, N.J., undated.

TAMARA L. FELTON

Smith, Walker, Jr. *See* Robinson, Sugar Ray.

Smith, Wendell (1914–November 26, 1972), sportswriter. Wendell Smith was born and raised in Detroit. After high school he attended West Virginia State College, where he graduated in 1937. Smith then began to work as a sportswriter with the PITTS-BURGH COURIER, a leading black newspaper. With the *Courier* he became one of the country's leading boxing writers.

In 1945 Smith brought Jackie ROBINSON and two other players from the Negro Leagues (*see* BASEBALL) to a tryout with the Boston Red Sox, who had been issued an ultimatum by the chairman of the Boston City Council to integrate the team or lose their annual permit to play Sunday baseball. The Red Sox reneged on their promise to hire one of the players, but Branch Rickey, the president of the Brooklyn Dodgers, asked Smith if any of the black players would be suitable for the major leagues. Smith recommended Robinson, who was signed by Rickey shortly thereafter and in 1947 became the first African American to play in the major leagues. Smith continued to be a leading voice for integration in sports, and through his columns lobbied for equal treatment of black baseball players in housing and meals during spring training and road games.

In 1947 Smith began covering boxing for the *Chicago American,* becoming the first black sportswriter on a major daily newspaper. The following year he coauthored *Jackie Robinson: My Own Story.* In 1958 Smith won the Hearst Corporation's top sportswriting award. He left print journalism in 1963 to join the staff of WBBM-TV in Chicago. In 1964 Smith was hired as a sportscaster by WGN-TV in Chicago, and won the national Sportscaster of the Year award in 1969. He died in Chicago in 1972. In 1994 Smith was inducted into the baseball writers' wing of the Baseball Hall of Fame in Cooperstown, N.Y.

REFERENCES

GROSS, LARRY. "Smith: A Trailblazing Sportswriter." *Chicago Defender,* February 19, 1994, p. A6.
TYGIEL, JULES. *Baseball's Great Experiment: Jackie Robinson and His Legacy.* New York, 1983.
"Wendell Smith, Sportswriter, Jackie Robinson Booster, Dies." *New York Times,* November 27, 1972, p. A8.

THADDEUS RUSSELL

Smith, William Gardner (February 6, 1927–November 5, 1974), novelist. William Gardner Smith was born in Philadelphia, where he attended public school and Temple University. Drafted into the U.S.

Army in 1946, he served as a clerk-typist in occupied Berlin until his discharge and return to the United States in 1947. His army service began a virtually permanent exile. Smith returned to Paris in 1951, revisiting the United States only briefly before his death in France in 1974. He wrote primarily for black American periodicals until 1954, when he became news editor of English-language services for Agence France-Presse. In 1964, he went to Ghana and became director of the Ghana Institute of Journalism. Forced to leave after the 1966 overthrow of the government, he returned to his Agence France-Press job in Paris.

Smith is the author of four novels: *Last of the Conquerors,* 1948; *Anger at Innocence,* 1950; *South Street,* 1954; *The Stone Face,* 1963; and one nonfiction work, *Return to Black America,* 1970. Although he may be chronologically associated with the protest novel and the 1940s and '50s writings of Richard WRIGHT, Chester HIMES, and Ann PETRY, the direction of Smith's work is away from the social determinism of those writers' works in that period. He was an innovative novelist; his international settings and his introspective protagonists as well as elements of militant protest foreshadowed new themes in African-American fiction.

REFERENCE

HODGES, LEROY. *Portrait of an Expatriate: William Gardner Smith.* Westport, Conn., 1985.

QUANDRA PRETTYMAN

Smith, "Willie the Lion" (Bertholoff, William Henry Joseph Bonaparte) (November 25, 1897–April 18, 1973), jazz pianist and composer. Born in Goshen, N.Y., Smith grew up in Newark, N.J., with his mother and stepfather. (His mother had remarried after the death of her first husband.) Smith began studying piano at the age of six, inspired both by his grandmother, who played organ and banjo, and by the Christian and Jewish religious music he heard in Harlem and Newark. By age fifteen, he had begun to play in clubs and at parties in New York and New Jersey. He married Blanche Merrill in 1916, served in the armed forces in World War I from 1917 to 1918, and played regularly in New York City after his discharge in 1919. However, because he did not record as a soloist until the mid-1930s, he was at first somewhat less well known to the public than his contemporaries James P. JOHNSON and Thomas "Fats" WALLER (although he was Waller's senior by a few years). In the late 1930s, Smith toured in United States and Europe. Duke ELLINGTON, who had heard

Willie "The Lion" Smith. (Photographs and Prints Division, Schomburg Center for Research in Black Culture, The New York Public Library, Astor, Lenox and Tilden Foundations)

Smith in the 1920s, acknowledged him as an important influence, and paid tribute to him with the composition "Portrait of the Lion" (1939). Smith returned the compliment a decade later with "Portrait of the Duke." Between 1934 and 1949 Smith recorded only intermittently, but in the 1950s and '60s Smith's career experienced a resurgence, and he made numerous LPs of his playing, singing, and, in some cases, talking, on a variety of labels. An impressive quantity of his music was thus made available to the jazz public for the first time in the post-bop era, despite the fact that Smith's style had remained firmly rooted in the 1930s language of stride piano.

Although regarded highly by the major stride pianists of his generation (James P. Johnson noted, "Willie Smith was one of the sharpest ticklers I ever met—and I met most of them"), Smith's playing as revealed in his recordings appears somewhat less exuberant and extroverted than theirs. His left hand in particular occasionally lacks the aggressive rhythmic propulsion of Waller's or Johnson's, and his solos are less charged with syncopation as a result. But Smith

infuses melodic lines with lyricism and unexpected rhapsodic turns of phrases ("Between the Devil and the Deep Blue Sea," recorded March 18, 1958), and he can juxtapose contemplative passages with sections of robust stride ("Echoes of Spring," the 1939 version on Commodore, and "Honeysuckle Rose," recorded November 30, 1965). Smith composed several piano vignettes, which he recorded as a set on the Commodore label (January 10, 1939). They demonstrated his mastery of popular song form, an ability to produce imaginative pianistic effects, and an understated but swinging stride.

Smith, whose father was said to be Jewish, claimed inspiration from music he heard in synagogues as a child. He was bar mitzvahed in 1910 and in the 1940s became the cantor of an African-American synagogue in Harlem. Smith published his autobiography, *Music on My Mind,* in 1964, and in 1969 he performed at the White House for Duke Ellington's seventieth birthday celebration. He died in New York City.

REFERENCES

BROWN, SCOTT E. *James P. Johnson: A Case of Mistaken Identity.* Metuchen, N.J., 1986.
SMITH, WILLIE THE LION, with George Hoefer. *Music on My Mind.* New York, 1964.

PAUL S. MACHLIN

Smith, Willie Mae Ford (1906–February 2, 1994), gospel singer. One of fourteen children, Ford was born in Rolling Fort, Miss., and grew up in Memphis, Tenn., and then St. Louis, Mo. Her father was a railroad brakeman and a deacon in a Baptist church. When her mother opened a restaurant in St. Louis, Ford, then in the eighth grade, left school to work there. She began singing as a child and by the age of ten had already performed solo in church. In 1922 Ford and three sisters formed a spirituals quartet that became the talk of the National Baptist Convention that year. In the late 1920s, inspired by singer Artelia Hutchins, Ford settled into her mature style, arranging gospel and spiritual songs such as "What a Friend We Have in Jesus," "Blessed Assurance," and "Take Your Burdens to the Lord" with propulsive rhythms to match her powerful, bluesy contralto, a pioneering style that she admitted owed much to blues and jazz singers. During this time she also became an ordained minister.

In 1929 she married James Peter Smith, who owned a small business. After the start of the depression, she began to perform more frequently as a traveling singer in order to help support her family. Start-

ing in 1930 she worked as an organizer with the Middle State Quartet Convention. In 1932 Smith met in Chicago with Thomas A. DORSEY and Sallie MARTIN to form the National Convention of Gospel Choirs and Choruses, the organization that nurtured the growth of many of the century's greatest gospel singers, and popularized GOSPEL music throughout the country (*see also* GOSPEL QUARTETS). In 1936 she began to teach singing and also became the head of the National Convention's Soloists Bureau, a position she held for the next four decades. Her 1937 solo performance at the National Baptist Convention of "If You Just Keep Still" won her particular praise, and she continued to travel as an organizer.

In 1939 Smith broke from the Baptist Church and joined the Pentecostal Church of God Apostolic. There she served as an evangelist and preacher and began moving toward the "sanctified" style, incorporating heavily rhythmic dances into performances. Always an energetic, emotive singer, she became famous for starting the tradition of opening songs with a spoken introduction known as a "sermonette." Smith, who made very few recordings, taught many singers, including Mahalia JACKSON, Martha Bass, and Brother Joe May. For many years semiretired, Smith performed at the 1972 Newport Jazz Festival and in 1982 was a subject of the documentary *Say Amen, Somebody*. She died in St. Louis on February 2, 1994, having performed in public as recently as the early 1990s.

REFERENCES

HARRIS, MICHAEL W. *The Rise of Gospel Blues.* New York, 1992.
HEILBUT, ANTHONY. *The Gospel Sound: Good News and Bad Times.* New York, 1985.

MICHAEL A. LORD

SNCC. *See* Student Nonviolent Coordinating Committee.

Soccer. The first African-American soccer stars emerged in the 1910s and 1920s, including three players at Springfield College in Massachusetts: William E. Kindle in 1911, John H. Burr in 1921, and Robert Gilham from 1924 through 1926. Another black star during this period was Garth B. M. Crooks, who played for Howard from 1924 through 1926. At the 1950 World Cup in Brazil, Haitian-born Joe Gaetjens scored the only goal in the United States's first-round upset of the powerful English team. In the early

1950s, Gile Heron, an African American who starred for the Detroit Corinthians, became the first American to play in the Scottish premier league when he signed with Glasgow Celtic.

Beginning in the 1950s, HOWARD UNIVERSITY fielded the best soccer teams among historically black universities. Howard's dominance in the sport was largely due to its large number of foreign-born students. The school won the National Association of Intercollegiate Athletics (NAIA) championship in 1961. In 1971 the Howard team defeated perennial powerhouse St. Louis University to win the NCAA Division I title, but was later disqualified for fielding several ineligible players. Three years later, however, Howard legitimately captured the crown from St. Louis University with a 2–1 win in overtime in the championship game.

The 1980s saw a dramatic increase in the number of African-American participants in soccer. Alfonso Smith, Jr., a player for the University of Tampa, became the first black member of the U.S. national team in 1984. Desmond Armstrong and Jimmy Banks represented the United States in the 1990 World Cup. Ernie Stewart and Cobi Jones were significant factors in the relative success of the 1994 U.S. World Cup team, which reached the second round in the tournament for the first time in the team's history.

REFERENCE

ASHE, ARTHUR R., JR. *A Hard Road to Glory: A History of the African-American Athlete.* New York, 1988.

THADDEUS RUSSELL
BENJAMIN K. SCOTT

Social Dance. One of the most notable aspects of the evolution of American social dance from the late seventeenth century to the end of the twentieth century is the emerging dominance of African-American dance styles. During the first two hundred years the development of a recognizable American dance style progressed slowly through a blending of African and European movement and music forms. By the end of the 1890s, however, a distinct pattern unfolded in which dances created in African-American communities spread out to the American mainstream, moving from the United States to Europe and eventually to other parts of the world, such as the Charleston in the 1920s and the hip-hop/freestyle in the 1970s and '80s. During the twentieth century the process accelerated. Propelled by the aggressive exportation of American movies, television, records, and videos,

African-American dances spread quickly. And since the early 1980s, with worldwide satellite television broadcasting and the consequent expansion of the music-video industry, a world youth culture has developed. Linked together through CDs and music videos and tuned to the latest move, an adolescent in Paris or Tokyo dances to the same beat as a New York hip-hopper. The styles they are trying to master are decidedly African American, and the teenagers dance more like each other than like their parents.

Although American dance has been fused from many different cultural sources over hundreds of years, the two main traditions of movement and music that shaped the way we move and those of Western Europe and West Africa. In constant flux, American dance encompasses older traditional dances as well as the newest fads, stage dance and street forms, classical African dances, ballet, square dancing, and the most recent club inventions.

Because popular dances are created democratically by thousands of people over a long period of time and are learned through observation and imitation, traditional movements pass and are recycled from one generation to the next. For example, some of the steps used in hip-hop/RAP/freestyle look like updated versions of the fast, slipping footwork of the Charleston, which, in turn, echo the rapid grinding and crisscrossing steps basic to some of the traditional dances of West Africa. The cycle works the other way as well, and contemporary African social dances recycle and retranslate modes of popular American dances.

Because it is nonverbal, dance information can cross temporal and geographic borders. It slips ethnic boundaries, and it blurs the imaginary lines that separate folk art from fine art, popular dance from classical dance. As a result of this flexibility, original functions and forms get altered, movements get reshaped to fit new situations and contexts. Paradoxically—because body language is learned early and strongly and is a fundamental cultural identifier—dance, the most fugitive of artistic expressions, remains one of the most persistent of all cultural retentions.

Carried in the kinetic memories of African slaves and European immigrants, dances arrived whole or in fragmented forms. Subjected in North America to radically different environmental and cultural mixes as well as the harsh conditions of slavery, dances adapted. Circumventing verbal communication, dance (like music) provided a way for Africans from disparate geographic areas to come together, to move together, to bond together in a strange land. Gradually, over time, an African-American style evolved as dances got re-created by those who recalled their dance inheritances whole, those who recalled them

only partially, and those of other cultural origins for whom it was not a legacy.

In colonial America the majority of African slaves resided in the middle and southern colonies. The rapid establishment of religious circular dances (grouped under the generic name of "ring shouts") and secular circular dances (called "juba" dances) indicates a probable legacy of compatible movement characteristics shared by the various African groups. These early African Americans also practiced seasonal dances that marked seasonal changes and harvesting and planting times, or dances that celebrated rites of passage such as marriage dances. In addition there seemed to have been a variety of animal dances (probably a fusion of hunting dances and mask-cult or religious dances), and processional dances, used during funeral celebrations.

In the late 1730s slaves were forbidden use of their drums in several colonies, in part because of the 1739 Cato Conspiracy of STONO REBELLION in South Carolina, which led to the subsequent passage of a series of laws forbidding slaves to congregate or to play their big *gombe* drums. Deprived of their larger percussion instruments, the slaves turned to smaller means of percussion. They used their bodies as musical instruments. Previously used in complementary rhythmic accompaniment, these now became dominant: hand clapping and body slapping (also known as "patting" or hamboneing), and rhythmic footwork. Small percussive instruments, such as tambourines and "bones" (the legbones, ribs, or jawbones of animals played with pieces of wood or metal rasps) became widespread. (At times the bones could be fashioned into two fine, thin, long pieces that were held in the hand and played like castanets.) In both the religious ring shout and the secular juba, the feet slid, tapped, chugged, and stamped in rhythmic harmony with antiphonal singing and clapping as the dancers moved around the circle. The juba and the ring shout shared other characteristics, such as moving counterclockwise, with the dancers in the surrounding circle providing musical, movement, and percussive motifs in a call-and-response pattern with a changing leader. In the juba, individual improvisations occurred in the middle of the circle; in the ring shout, individual ecstatic possession occurred among some of the participants. In the juba especially there was a fluid relationship between the improvisers and the surrounding circle of watchers and music makers. Those in the center would dance until exhausted; then others from the circle would move in to take their places.

Colonial slave masters rarely allowed religious dances to be performed openly, so religious dances continued to be practiced clandestinely. At times they merged with other, more secular dances and contin-

ued to exist syncretically. Although these new dances retained many characteristics of those from the Old World, they had become their own distinctive dance forms.

Certainly the most powerful changes were caused by the mixing of African and European dance styles. European dance featured an upright posture with head held high and a still torso with no hip rotations. Arms framed the body and—because European dance was usually performed inside, on floors, in shoes—there was careful placement and articulation of the feet. Men and women danced in couples, and in this partnership, body line and placement, as well as couple cooperation, were emphasized over individual movement. In European "figure" dances, floor patterns were valued about personal invention (in "figure" or "set" dances many couples will move together as a group in specific designs, similar to a modern-day Virginia reel or square dance). Music and dance tempos were organized around simple rhythms with regularly stressed beats and syncopations, and musical compositions emphasized melody. The pervasive dynamics of European dancing were control and erectness.

By contrast, African dance "gets down" in a gently crouched position, with bent knees and flexible spine. Traditional African dance tends to be performed in same-sex groups. Danced in bare feet on the bare earth, it favored dragging, sliding, and stamping steps. The supple upper body, with its flexible relationship to the lower limbs, could physically carry many rhythms simultaneously, mirroring the polyrhythms of the music. A polyrhythmic, multimetered, and highly syncopated percussive dynamic propelled movement and music. Movement often initiated from the pelvis, and pelvis rotations caused a sympathetic undulation in the spine and torso. Animal motions were imitated and quite realistically portrayed on the entire body. Improvisations were appreciated as an integral part of the performance ethos.

These last two qualities would make especially important contributions to the development of African-American dance. First, when the dancer imitates the animal's motions fully, habitual patterns of locomotion and gestures are bypassed. Timing and tempos get altered, usual choices are supplanted by fresh movements, fueling the dance vocabulary with new material, expanding the lexicon of motion. For example, "peckin' " (the head thrusts forward and backward like a bird feeding) and "wings" (the arms are flapped like the wings of a great bird, or sharply bent elbows beat quickly) spiced the larger body movements of the Charleston in the 1920s. The monkey and the pony were popular dances of the 1960s, and break dancers of the 1980s did the crab and the spider (see BREAKDANCING). In the early 1990s, the

butterfly (the legs open and close like butterfly wings) became a popular dance in REGGAE and dance hall styles.

The emphasis on improvisation advanced the evolution of dance styles. The improviser accomplishes two things simultaneously. While staying within the known stylistic parameters (reinforcing traditional patterns), the improviser is an inventor whose responsibility is to add individual flavor to the movement or timing that updates and personalizes the dance. This keeps social dance perpetually on the edge of change and also helps explain why social dance fads come and go so quickly.

The inevitable exchange between European and African styles led to incorporation and synthesis, and what evolved was neither wholly African nor European but something in between. As they served at the masters' balls, slaves observed the cotillions, square dances, and other "set" or "figure" dances. In turn, European-American dances were altered by observation and contact with African-American music and dance. Sometimes black musicians played for the white masters' balls. It was also not uncommon on southern plantations for the children of the slaves to play with the masters' children. It was common practice for the masters to go down to the slave quarters to watch slave dances or to have their slaves dance for them on special occasions. At times, slaves engaged in jig dance competitions, where one plantation would pit its best dances against the best dancers from another. At first, "jig dance" was a generic term that European Americans gave to different types of African-American step dances where the feet rhythmically played against the floor, because this fancy footwork resembled the jigs of the British Isles. Informal jig dance contests occurred in northern cities on market days, when freedmen and slaves congregated to dance after the market closed (in Manhattan this happened in the Five Points Catherine Square area), and along the banks of the great transportation river highways, where slaves hired out by their masters worked as stevedores alongside indentured or immigrant workers. In New Orleans, "Congo Square" was designated as the place where slaves could congregate and celebrate in song and dance on Sunday.

The majority of the earlier European colonists came from the British Isles, and within that group were large numbers of poor Irish settlers and Irish indentured servants. More than any other ethnic group, the Irish mixed with African slaves doing heavy labor—the Irish as indentured servants, the Africans as slaves—for the master. Later they lived alongside each other in slums of poverty, so that the mutual influence of Irish step dances like the jig and hornpipe and African step dances was early and strong.

General patterns of fusions suggest the following progression. Between the late 1600s and early 1800s, African and African Americans adopted aspects of European dance for their use. For example, they began early to move in male/female couples (mixed couples and body contact in traditional African dance is extremely rare) in European figure dances, such as quadrilles and reels. However, they retained their own shuffling steps and syncopated movements of feet, limbs, and hips. After the 1820s that trend reversed, as Europeans and European Americans began to copy African-American dance styles—a trend still in effect. In general, as the African elements became more formal and diluted, the European elements got looser and more rhythmic. Religious dancing became secular; group dancing gave way to individual couples on the dance floor; and following the rise of urbanization and industrialization and the consequent migration of black workers, rural dances moved to the towns. Since the late 1930s, in reverse, urban dances that became dance crazes spread back to rural communities and out to the world.

The 1890s was the decade that marked the beginning of the *international* influence of African-American dance. The cakewalk had been developing since the late 1850s, and by the 1890s was well established as an extremely popular dance in both theatrical and nontheatrical contexts. According to ex-slaves, the cakewalk, with its characteristic high-kneed strut walk, probably originated shortly after the mid-1850s. The dance had begun as a parody of the formal comportment and upright posture of the white ballroom dancers as they paraded down the center of the floor, two by two, in the opening figures of a promenade that would have begun the formal balls. The simplicity of this walk made it easy to mimic and exaggerate, it fit easily into the African tradition of satiric song and dance, and the formality of the walk resonated with African processional dances. Apparently the dance had been a "chalkline" dance, where the dancers had to walk a line while balancing containers of water on their heads.

By the 1890s the cakewalk had been adapted as a ballroom dance by the whites, who grafted the high-kneed walking steps with a simple 2/4 or 4/4 rhythm of early RAGTIME jazz and blended it with the promenading steps that were already a central motif in many of the schottisches and gallops popular in the ballrooms of the time. The cakewalk quickly translated to the stage and had been regularly performed in the big African-American touring shows since the beginning of the decade, by such troupes as *Black Patti and her Troubadours* and in shows like *The South Before the War* and *A Trip to Coontown,* among others. The cakewalk was danced on Broadway by excellent black performers in *Clorindy: The Origin of the Cakewalk* (1898). As well, there were numerous cakewalk competitions done regularly by whites (one of the largest annual events took place at Madison Square Garden in Manhattan). The enormous popularity of the dance is clear from even the most cursory perusal of sheet music from 1890 to 1907. A few exhibition dance teams of African-American performers traveled to Europe to perform the dance (the most famous was the husband-and-wife team of Charles JOHNSON and Dora Dean), and in 1904 the cakewalk received the validation of aristocratic society when the Prince of Wales learned the dance from the comedy-and-dance team of African-American performers Bert WILLIAMS and George WALKER. The structural framework of the cakewalk had open sections for improvisation that shifted emphasis to the individual's role, changing the focus from the group to the couple and the person. It was the turn of the century, and as the incubator of individual invention, the cakewalk was the perfect artistic catalyst to launch dance into the modernist sensibility of the twentieth century.

A rash of rollicking animal dances gained ascendancy between 1907 and 1914, overlapping the cakewalk and replacing it in the public's favor. The turkey trot, kangaroo hop, and the grizzly bear (three among many) incorporated eccentric animal gestures into the couple-dance format, a blend that had long been practiced by African-American dancers—elbows flapped, heads pecked, dancers hopped—in bits of motion that were derived from such African-American animal dances as the buzzard lope. The rising popularity of these dances paralleled the rise in sheet music publication. For a small investment, people got music *and* dance instructions, since the song lyrics told how the dance should be done.

A typical example of the instructional song is the well-known ragtime dance ballin' the jack, which developed in about 1910. (The meaning of the title is obscure, but it probably originated from railroad slang, with the general meaning of enjoyable, rollicking good times.) As described in 1913 in its published form by two African-American songwriters, Chris Smith and Jim Burris, the dance had the following steps:

First you put your two knees close up tight,
then you sway 'em to the left, then you sway 'em
to the right.
Step around the floor kind of nice and light,
then you twis' around and twis' around with all
your might.
Stretch your lovin' arms straight out in space,
then you do the eagle rock with style and grace,
swing your foot way 'round, then bring it back,
now that's what I call ballin' the jack.

Between 1900 and 1920 a dance fever gripped America. Since the early 1900s couples have been moving closer together, and with the evolution of the slower, more blusey early JAZZ styles, close-clutching dances like the slow drag, which had always been done at private parties, began to surface in public places. The hip motions and languid gliding feet in such African-American dances as the grind and mooch (both a couple or solo dance) indicate that body contact and postures were already racially shifting. Certainly this prepared the way for the arrival of the tango and its immediate acceptance as a dance craze in 1913. (The tango originated in Argentina. Although its precise origins are quite complex, it was also a likely synthesis of European and African influences.) The tango is a difficult dance to do, necessitating dance lessons, a reality happily exploited by the numerous exhibition tango teams who demonstrated the dance to the eager public, then taught it to them in their studios, or at the local dance hall or tango teas. If few could afford this luxury, thousands of people nevertheless danced what they believed to be the tango. In reality, the frank sensuality of thigh and pelvic contact coincided more readily with familiar close-couple African-American dances of the juke joints, small dance halls, and white-and-tan clubs that peppered mixed neighborhoods of every American city.

By the late 1910s a flood of migrating workers moved northward, seeking jobs in urban industries built for the war effort of WORLD WAR I. As great numbers of African Americans moved into cities, they formed a critical mass of talent that erupted in a variety of artistic expressions. Their energy gave birth to the HARLEM RENAISSANCE of the 1920s and turned Harlem—and black neighborhoods in other industrial cities—into crucibles of creativity in the popular and fine arts. The golden years of black Broadway (1921–1929) began with the hugely successful *Shuffle Along* (1921), written, directed, composed, and choreographed by African Americans (its four major creators were Noble SISSLE, Eubie BLAKE, Flournoy Miller, and Aubrey Lyles). This production, and subsequent road shows, brought African-American jazz music and jazz dances to a wide audience. There was little distinction between social dances and stage adaptions, and current popular dances were simply put onstage with few changes. As a result of *Shuffle Along*'s popularity, Broadway dance began to reshape itself, shifting to a jazz mode, as Florenz Ziegfeld and other producer-directors began to copy *Shuffle Along*'s choreography. A spate of new studios opened in the Broadway area to teach this African-American vernacular jazz dance to professional actors and to an eager public (one important instructor was Buddy BRADLEY, who taught the As-

taires and a host of other Broadway and film actors, then went on to choreograph English revues).

Then with the 1923 Broadway show *Runnin' Wild*, the Charleston burst onstage and into the hearts of the American public, especially through the eponymous song James P. JOHNSON composed for the show. However, the Charleston had been a popular dance among African Americans long before the 1920s. Although its origins are unclear, it probably originated in the South, as its name suggests, then was brought north with the migrating workers. Jazz historian Marshall Stearns reports its existence in about 1904, and the late tap dancer Charles "Honi" COLES said that in about 1916 as a young child he learned a complete version of the dance, which had long been popular in his hometown of Philadelphia.

The Charleston is remarkable for the powerful resurgence of Africanisms in its movements and performance and for shattering the conventions of European partnering. The Charleston could be performed as a solo, a couple dance, partners could dance together side by side or in the closed-couple position. For women in particular, its wild movements and devil-may-care attitude broke codes of correct deportment and propriety. It was quick and decidedly angular, and the slightly crouched position of the body imparted a quality of alert wildness. The steps (and the early jazz music it was performed to) are syncopated, the knees turn in and out, the feet flick to the side, and a rapid forward-and-backward prancing step alternated with pigeon-toed shuffles and high kicks. As the arms and legs fling in oppositional balance, elbows angled and pumping, the head and hands shake in counterpoint. Knock-kneed, then with legs akimbo, body slightly squatted, this beautiful awkwardness signaled the aesthetic demise of European ideals of symmetry and grace in social dance. The fast-driving rhythms of the music smoothed the flow of broken motions into a witty dance punctuated with shimmies, rubber-legging, sudden stops, and dance elements such as the black bottom, spank the baby, or truckin'. Although these new dances often caused alarm because of their seeming anarchy of motion, and the uncontrolled freedom that that implies, the Charleston in particular roused the ire of the guardians of public morality. Warning that the Charleston would lead to sexual and political dissolution, the dance was condemned by several clerics and was banned in several cities.

Although the Charleston was immediately introduced to Europe by American jazz artists touring there, it was Josephine BAKER (she had been a chorus girl in *Shuffle Along*) who personalized the dance. She went to Paris in 1924 and became the darling of the French, and it was Josephine's charming, humorous, and slightly naughty version of the Charleston that

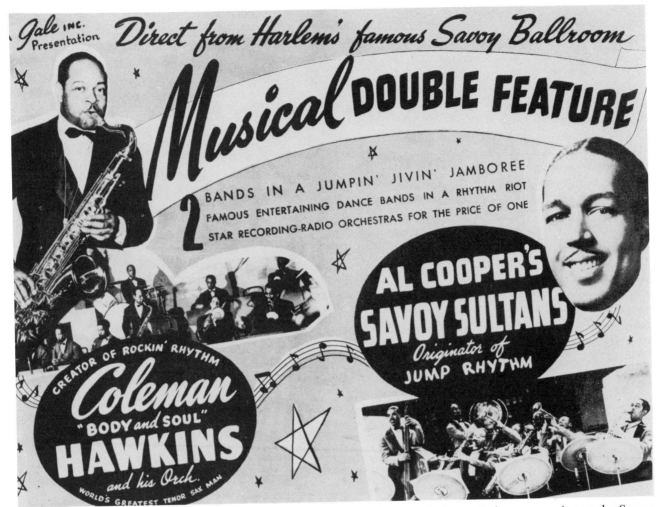

Advertisement for Coleman Hawkins and his Orchestra and Al Cooper's Savoy Sultans appearing at the Savoy Ballroom. (Photographs and Prints Division, Schomburg Center for Research in Black Culture, The New York Public Library, Astor, Lenox and Tilden Foundations)

caused such a sensation in Europe. The Charleston, and all the bold young women who performed it, came to symbolize the liberated woman of the twenties, and the rubber-legging "flapper" became an icon of the era.

Then, in 1926, the SAVOY BALLROOM opened in New York City's Harlem. Nicknamed "The Track" or "Home of Happy Feet," the Savoy could accommodate up to four thousand people. Because it had the reputation of being *the* place to go and hear good music and dance, all the best bands wanted to play there. It was the practice to feature two different bands on the same night, playing one after another on two different bandstands placed at opposite ends of the ballroom. This subsequent "battle of the bands" energized dancers to new heights of daring and improvisation. For thirty years the Savoy would be the center of dance in New York City, and there dances were brought to such a level of excellence that the name "the Savoy" was synonymous with the

best in dancing. As its reputation grew, the Savoy also became a showplace, a kind of informal stage arena where people could go to watch the finest Savoy dancers as each tried to outdance the other.

Great dancing is inspired by great music, and the history of African-American social dance parallels the history of African-American jazz music. In truth these social dances are most accurately described as "vernacular jazz dance" (from the title and subtitle of Marshall and Jean Stearns's magnificent historical study of tap and popular dance, *Jazz Dance: The Story of American Vernacular Dance*). The juke joints of the South and the dance halls of the North served as forums where musicians and dancers worked together. The sharing of ideas, rhythms, and the heated excitement of music and movement feeding each other, produced an environment of experimentation where the spirit moved and dances got created on the spot. Certainly the arrival of big-band swing music, fathered by the great jazzmen and their groups, all of

The exterior of a juke joint in Belle Glade, Fla., in 1939. (Prints and Photographs Division, Library of Congress)

whom played the Savoy, parented the next great African-American dance as well.

Existing concurrently with the Charleston and evolving from it, a kind of Savoy "hop" was getting formulated on the floor of the Savoy Ballroom. Then, in 1928, the dance was christened "the lindy hop" by a well-known Savoy dancer, Shorty Snowden, in honor of Charles Lindbergh's 1927 solo flight across the Atlantic. The dance, which would become an international craze and an American classic, contained many ingredients of the Charleston—the oppositional flinging of the limbs, the wild, unfettered quality of the movement, the upbeat tempos, the side-by-side dancing of partners. But the two most outstanding characteristics were the "breakaway," when two partners split apart completely or barely held on to each other with one hand, while each cut individual variations on basic steps (a syncopated box step with an accent on the offbeat) and the spectacular aerial lifts and throws that appeared in the mid-1930s. The tradition of individual improvisation was, of course, well entrenched. However, with the lindy hop, it was *the* climactic moment of dance, and the aerial work set social dance flying. The lindy hop contained ingredients distilled during the evolution

of social dance since the 1890s. It had a wide range of expressive qualities, yet it was grounded in steps and rhythms that were simple enough to be picked up readily *and* were capable of infinite variations. It would, in fact, become one of the longest lasting of all African-American social dances. Commonly known as the jitterbug in white communities, the dance adapted to any kind of music: There was the mambo lindy, the bebop lindy, and during the 1950s, the lindy/jitterbug changed tempos and syncopations and became known as rock 'n' roll; when looked at carefully, the 1970s "disco hustle" reveals itself as a highly ornamented lindy hop cut down to half time. In the 1980s and '90s, "country-western swing" looks like the lindy hop framed by fancy armwork, and in the South, "the shag" is another regional variation of the lindy hop theme.

On the floor of Harlem's Savoy Ballroom the lindy hop was brought to its highest level of performance, fueled by the big-band swing played by brilliant musicians in orchestras led by such men as Fletcher HENDERSON, Chick WEBB, Al Cooper, Duke ELLINGTON, Earl HINES, Cab CALLOWAY, Count BASIE, Billy ECKSTINE, Benny Goodman, and many more. As the dynamics of swing music heated up to

its full musical sound and fast, driving, propulsive "swing" beat, the dancers matched it with ever more athletic prowess. In the mid-1930s the lindy took to the air, and using steps with names such as the hip to hip, the side flip, the snatch, over the back, and over the top, the men tossed the women, throwing them around their bodies, over their heads, and pulling them through their legs until the women seemed to fly, skid-land, then rebound again.

The Savoy lindy hop was renowned for its spectacular speed and aerials. An entrepreneurial bouncer at the club, Herbert White, decided to capitalize on this dancing talent, and he formed "Whitey's Lindy Hoppers." Choosing a large group of lindy hop dancers, the best from the ballroom, White split them into smaller troupes or teams that toured the country, appearing in movies, vaudeville, on Broadway, at the 1939 World's Fair in New York City, and in many other venues. The lindy spread out to the world, first through newsreels and films, and then the dance was carried personally to Europe and Asia by American GIs during the 1940s.

As the language of jazz moved from swing to bebop, rhythmically more complex and harmonically daring, so did the nature of jazz dance. With the passing of the great dance halls, the smaller venues that featured the five- or six-piece jazz combo that was

Jitterbugging in a juke joint, Memphis, Tenn., November 1939. (Prints and Photographs Division, Library of Congress)

the basic form of bebop became the main site for jazz performance, and though many of these clubs had no space for dancing, bebop-influenced jazz dance nonetheless flourished.

Bebop jazz often sounded barely in control with its fast pace and solo improvisations, and bebop dancers mirrored the music. The at-times private, introverted quality of musical performance was reflected by the bebop dancer's performance, which appeared disassociated and inward. Rather than having the movement scattering outward, as in the Charleston and the lindy, the bebop dancers used footwork that slipped and slid but basically stayed in place, the dynamic of the dance was introverted and personal, and the dancer appeared to gather energy into the center of the body.

Like the music, the dance was dominated by males. And if the bebopper used many of the same steps as the lindy hopper, there were enormous stylistic differences in the focus and body language. Bebop was almost the reverse of the lindy: partners broke away for longer periods of time than they spent together. Bebop dance could be done as a solo, in a couple, or in a small group of three or four. This open relationship was perfect for a dance that placed the strongest significance on individual improvisation and devalued group cooperation. The body rode cool and laidback on top of busy feet that kept switching dynamics, tempo, flow, timing, direction, impulse, and emphasis. Off-balance and asymmetrical, the dance wobbled at the edge of stability. The dance was filled with slips and rapid splits that broke down to the floor and rebounded right back up, and the bebopper was fond of quick skating-hopping steps that appear to be running very fast while remaining in the same place. Elbows pulled into the body, shoulders hitched up, hands lightly paddled the air. Balanced on a small base—the feet remained rather close together—with swiveling body and hips, the dancer seemed made of rubber. Partners rarely touched each other or looked directly at each other. Bebop dancing influenced the dance styles of rhythm and blues and other black popular music of the 1940s. It is also known as "scat" dancing (the comparison is to the vocal freeflights of the scat singer). James BROWN is perhaps the best-known entertainer who dances in bebop mode. Watered down and simplified to rapidly rocking heel-and-toe steps that alternated with pigeon-toed motions in and out, with the occasional splits, bebop lost most of its glittering individualism when translated to the mainstream. Yet the effect of bebop dance was to give the social dancer a new "cool" persona, that of the "hipster," whose sensual slipperiness provided a rest, a contrast, to the heat and speed of the jitterbug lindy. This hip attitude had an enormous

effect on Broadway jazz. Bob Fosse, Jerome Robbins, and Jack Cole, three powerful Broadway and film choreographers, would convert the physical language of bebop dance into a style of laid-back, cool jazz that would be viewed as epitomizing the best of Broadway jazz dance.

During the 1950s, with the explosion of a "teen culture" and a "teen market," an entertainment industry, led by the record companies, was established to service this market. Bepop dance influenced the dance styles of rock 'n' roll. The record industry, ever quick to seize an opportunity, made the crossover, renaming RHYTHM AND BLUES rock 'n' roll. The jitterbug got renamed as well, now called by the music's name of rock 'n' roll dance. Partners continued to split apart. With the infusion of the bebop mentality, a slippery smoothness in the footwork calmed down some of the flinging of the older forms of jitterbug, while the twisting hips were beginning to even out the sharp bouncing of the fast-paced Savoy style. Toward the end off the 1950s, gyrating hips (the trademark of Elvis Presley), previously only one movement phrase in the midst of many, would be singled out and made into an individual dance.

"The twist," which became another worldwide dance fad, structured an entire dance around a single movement. Its simplicity made it easy to do, and its virtues were promoted in Chubby Checker's beguiling rock 'n' roll song "The Twist" (1960, a close copy of Hank Ballard's 1958 original.) Also in the 1950s there was a resurgence of close-clutching couple dances, similar to the older mooch and grind (now known as "dirty dancing"), danced to sweet harmonics of five-part *a cappella* singing groups who were developing a singing style that became known as doo-wop. It is notable and interesting that in the 1950s, during a period when there was a strong sense of conformity, group line dances such as the stroll and the madison became popular.

During the 1960s, the civil rights movement was reflected in a re-Africanization of dance forms in such dances as the Watusi, the monkey, the bugaloo, and a series of spine-whipping, African-inspired dances such as the frug and the jerk. Animal gestures and steps reentered dances with a vengeance, formulated into dances such as the pony, the chicken, and the fish (also known as the swim). Partners did not touch. Instead, they danced face-to-face, but apart,

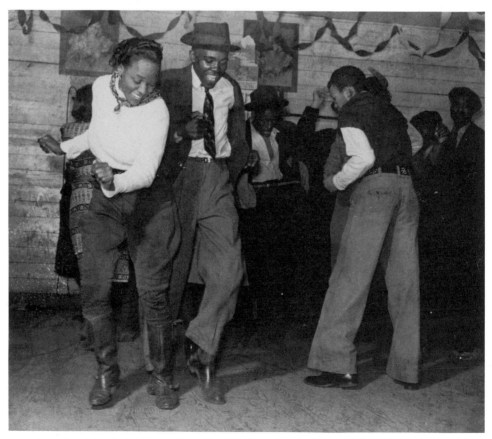

Interior of a juke joint on a Saturday night outside Clarksdale, Miss., November 1939. (Prints and Photographs Division, Library of Congress)

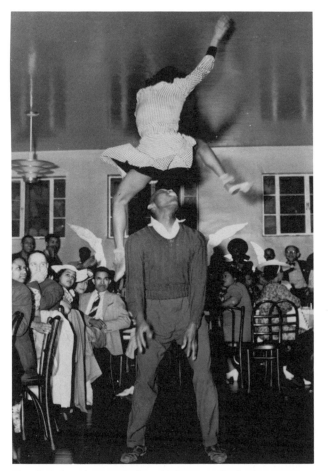

Frank Manning and Ann Johnson, lindy hoppers at Big Georgie, Long Island, N.Y., 1941. (Photographs and Prints Division, Schomburg Center for Research in Black Culture, The New York Public Library, Astor, Lenox and Tilden Foundations)

reflecting each other's movements, using a dialogue of movement that was essentially a call-and-response mode of performance.

MOTOWN singing groups whose carefully tailored and tasty dance routines were choreographed by Cholly ATKINS had an inestimable effect on dance styles. The teenagers who admired these groups and bought their records now watched them perform on television. Then they copied the Motown style, whose choreography was made to underline the message of the song. A variety of pantomimic dances was created in which the words, or story line, of the song were enacted by the dancers. For example, one of the most popular and beautiful of these tunes was Marvin GAYE's "Hitchhiker" (Atkins worked with Gaye on this tune). The major gesture-motif of this dance recurred as the dancer—feet doing little prancing steps, hips swiveling, head bobbing—circled the hand in front of the torso, then swung it off to the side, thumb stuck up, as if he or she were trying to

hitch a ride on the road, watching the cars go by.

The 1970s disco explosion featured the hustle (if one strips away the ornamentation of multiple turns and sharply pointing arms and poses as the man swings out his partner, the lindy hop becomes visible). The line dance made popular by the movie *Saturday Night Fever* (1976) is actually the old madison, retooled for the 1970s (the same is true for the 1980s' bus stop and the 1990s' electric slide). However, with the explosion of breaking and electric boogie in the Bronx during the late 1970s, and popping in Sacramento and Los Angeles, dance styles underwent a radical change in the United States, then in Europe, Asia, and Africa as the styles spread to the world on television and music videos.

Breakdancing was part of a larger cultural movement known as hip-hop, which got established in the South Bronx neighborhood of New York City. Hip-hop had a variety of artistic expressions—graphic arts (graffiti or "writing"), spoken poetry (rapping), music (scratchin', which developed into the rap music of the 1980s and '90s), religion and philosophy (Zulu Nation and the politics put forth in the lyrics of the rap), and dance (breaking, electric boogie, and popping and/or locking). Breakdancing took the structural principle of the breakaway and expanded it into a solo dance form. Accompanying the breakdancers musically were street DJs who were using the techniques of scratchin' (holding the record by its edge, the DJ moves it back and forth on the same groove) and mixing (shifting back and forth between turntables, the DJ replays the same sound bits of a couple of records over and over) to create new syncopations and "breaks" in the old records, thereby improvisationally composing new musical scores. Then, using one or more microphones, rappers would talk rhythmically over the music.

Intensely competitive, breaking was primarily a solo, male dance form that re-Africanized the aesthetics of African-American dance. Visually it retains powerful reverberations of gestures and phrases derived from capoerla, the martial-art dance that came to the New World with the slaves captured in the Angola region of southwestern Africa.

Breaking stressed acrobatic fluency in the spins and in the dancer's buoyancy. In fact, bouncing is one of its most obvious characteristics. Performers effortlessly spring from dancing on their feet in an "uprock" style to "breaking" down to twirl on the floor; then they rebound to an upright position. There is little distinction between up and down, and because the breaker moves within a circle, the focus is multidirectional, as a consequence of its bounding-rebounding quality. Breaking seems to defy gravity, to exist almost at the edge of flight.

Popping and locking are other hip-hop dance styles that were performed along with breaking and were developed first on the West Coast. In these styles the body seems to be broken into segments. As motion moved from the fingers of the left arm through the chest and out the fingers of the right arm, the joints "locked" or "popped" into sharp millisecond freezes. The movement looks as if it were a living rendition of a video game, and popping and locking did evolve from an earlier dance known as the robot. A related but more undulating version of popping and locking, called the electric boogie, developed on the East Coast; in this dance the body seemed to move in fluid, increasingly complex minifreezes.

Breaking was the dance of the young and tough hip-hop subcultures of the ghettos, and the rawness of the sounds and the movements made breaking the dance of protest that rallied against the mainstream disco styles of music and movement. Because of its brilliance, its technical display, its physical virtuosity, and its machismo, and because breaking got immediate and near-hysterical media coverage, it became popular worldwide. Breakers sprung up in Tokyo, Rome, Calcutta, Rio de Janeiro, and Paris, and long after it had faded in popularity in the United States (in about 1984), it was still flourishing in the 1990s in other parts of the world. Breaking was the most powerful and early expression of the hip-hop culture, and because of its worldwide success, it prepared the way for the eventual ascendancy of rap, which deemphasized the dancer for the rapper and was the centerpiece of the hip-hop movement of the 1980s and early 1990s.

In the late 1980s and '90s, the young adults who are creating the current social dances do little that is reminiscent of traditional European dance and much that is reflective of the ancient African legacy. On the dance floor they gather in casual circles that randomly arise, then disintegrate. Male/female partnerships, if they exist at all, change and shift throughout the night, and a partner is simply another dancer who is focused upon for a while. Dancers move in loose groupings that may or may not mix genders (males often dance together, or there will be a group of females dancing). Though they move in stylistic harmony, improvisation is highly prized, and each participant brings individual flavor to the movements.

There are many reverberations with traditional African motion. The body is slightly crouched with bent knees, feet flat on the floor. The footwork favors sliding, stamping, or digging steps. When the music is hard-hitting and fast, dancers burst out in vigorous jumps and athletic maneuvers; a phrase may consist of diving down to the floor ("breaking" down) in belly slides or shoulder rolls, then smoothly pulling the body upright, swinging back into the beat with fast, sliding steps. Digitalized and engineered, the African drum has been transformed into a sonic bass boom that blasts through the speakers. With volume turned up to the "red zone," the bass power pops the body, vibrating bones, internalizing the beat. The dancers use their torsos as as multiunit instrument with an undulating spine, shimmying shoulders, and swiveling hips. Movement is polyrhythmic, and ripples through the body in waves, or it can lead to very briefly held positions known as freezes. Heads circle and bob, arms do not frame the body so much as help it balance. Dances are named for the style of music that is played, such as house, rap, hip-hop or dance hall, or they are called "freestyle" because each dancer improvisationally combines well-known steps as the fancy strikes.

A prime example of an Africanized dance was one performed to Chuck Brown's "The Butt," which hit the top of the commercial pop charts in 1988 and was notable for its bold call-and-response structure. As the title suggests, movement concentrated on shaking buttocks. Dancers "get down" in a deep squat. Placing hands on butts or thighs, they arch their spines, nod their heads, and swivel the pelvis in figure eights. In the early 1990s, this same dance remained popular. It was now called "winding," performed by young, urban, black, and white club goers to reggae or go-go (a Washington, D.C., musical style influenced by Jamaican reggae). "Winding" alludes to the circular winding motion of the hips. In 1901 the same moves were called "the funky butt," and in the 1930s they were known as "grinding."

African-American underground club dancers continue to create new dances that will be picked up by the mainstream tomorrow, disseminated through music videos. All music-video dance styles originate in the clubs and on the streets, so one must look at the places of origination to get a glimpse into the dance styles of tomorrow.

Club dancers, mostly African American and Latino youth, are the most active, influential, and democratic of the social dance choreographers. The club community is a specialized one, which has coalesced around an action rather than a neighborhood or through bloodlines. Relationships are made because of a shared obsession with dancing. Perhaps the distinguishing characteristic of a real "clubhead" is that dance is passion and possession, and through movement, they experience "going off," a kind of secular spirituality that echoes the spiritual possession of the older African circle dances brought to this country four hundred years ago.

Music is provided by DJs mixing at their consoles with a couple of turntables, merging the sounds of one record into another in a seamless musical flow, composing on the spot. They are musicians of con-

soles and amplifiers; they are today's bands and orchestras and conductors. Using raw recorded "cuts" that have not been engineered into their final form (this is not the stuff of commercial radio), DJs are the high priests of the clubs who regulate the emotional and physical heat of the dancing. A good DJ knows how to play the songs that inspire movement. He shifts the mood and pace through musical combinations, acting and reacting to what he sees on the floor. Reading ephemeral signals of movement and energy, breath and beat, a constant flow of information is exchanged between dancer and DJ.

In the early 1990s, dance styles fall into rough generational divisions. Hip-hop *tends* to be done by the younger generation of early through late teens, while lofting (this style of dance is called different names in different parts of the country) and house tend to be done by a slightly older group in their late teens and twenties. Lofting is a softer assimilation of the "old school" breaking, whose immediate predecessors are the lindy hop, and whose older progenitors are the capoeria and other African acrobatic dances. The "New Jack" style of hip-hop uses footwork reminiscent of the Charleston and earlier West African step dances. The pose and punch and stylized gestures of voguing exaggerate the syncopated isolations of jazz, and like the cakewalk, voguing makes satiric commentaries on the mannered postures of the monied classes, as represented in the images of models of high-fashion magazines.

Social dance is a structure of movement that is always open to modification. Propelled by improvisational innovation, dancers can transform a recreational participatory event into a performance within a circle. Perhaps the greatest African aesthetic gift was the reverence for improvisation. It keeps social dance democratic, it is not tied to any one institution or controlled by a small elite group who determine who shall perform and who shall observe. Improvisation and individuals keep dance a celebration of imagination, while the flexibility and power of movement itself is what links the past to the present and the community to the person.

REFERENCES

BRANDMAN, RUSSELLA. The Evolution of Jazz Dance from Folk Origins to Concert Stage. Ph.D. diss., Florida State University, 1977.
EMERY, LYNNE F. *Black Dance in the United States from 1619 to 1970.* 1972. Reprint. Brooklyn, N.Y., 1980.
FRANK, ARTHUR H. *Social Dance.* London, 1963.
GORER, GEOFFREY. *Africa Dances.* London, 1949.
"Jazz Dance, Mambo Dance." *Jazz Review* (November 1958).
"New Orleans Marching Bands: Choreographer's Delight." *Dance* (January 1958).
"Popular Dance in Black America." *Dance Research Journal* 15, no. 2 (Spring 1983). Special issue.
STEARNS, MARSHALL, and JEAN. *Jazz Dance: The Story of American Vernacular Dance.* New York, 1968.
WITTKE, CARL. *Tambo and Bones.* Durham, N.C., 1930.
YARBOROUGH, CAMILLE. "Black Dance in America: The Deep Root and the Strong Branch." *Black Collegian* (April–May 1981): 10–24.
———. "Black Dance in America: The Old Seed." *Black Collegian* (October–November 1980): 46–53.

SALLY SOMMER

Social Gospel. Referring generally to a fresh application of the insights of biblical faith to the problems of the social order, the "social gospel" has usually been identified by historians with the response of reform-minded church men and women to the urban and industrial crises of the post-Reconstruction North. That interpretation runs the risk of truncating the roots of American social Christianity in reform movements of the antebellum period and failing to see the early origins of a distinctive African-American social gospel.

A social gospel began to develop within African-American communities in late eighteenth-century Christian voluntary societies which commonly combined the functions of church, school, and mutual aid society. These included the Newport, R.I., Free African Union Society, founded in 1780; the Free African Society of Philadelphia, founded in 1787; Charleston, S.C.'s Brown Fellowship Society, founded in 1790; the African Society of Providence, R.I., founded in 1793; and Boston's African Society, founded in 1796. In the same period, the earliest semi-autonomous African Baptist congregations were established in the plantation South, first in Virginia and along the Savannah River bordering South Carolina and Georgia.

As these early African-American voluntary societies developed, particularly in the freer setting of the urban North, they articulated a variety of themes within a framework of millennial expectation: economic development and self-help, freedom and social justice, missionary education and racial nationalism. In the antebellum North, black clergymen such as Henry Highland GARNET, James W. C. PENNINGTON, and Theodore WRIGHT built institutions and networks for organizations which promoted education, social reform, and the freedom of their enslaved southern kinsmen. These activities were the preparation for northern African-American missionaries to move into the South during and after the Civil War. There they established missions as the institutional

seeds of rural social settlements, churches and Sunday schools, and schools and colleges for nurturing the former slaves and their children in freedom.

Usually among the race's educated elite in Reconstruction, African-American clergymen gave direction to the social and political aspirations of southern freedmen. They often served in multiple capacities, as pastor, politician, and professor or school administrator. Commonly committed to a conservative theological orthodoxy, they believed in the fatherhood of God, the brotherhood of man, and "uplifting the race." They encouraged the freedman to confirm family ties, acquire property, and get an education. Many of them were active in temperance reform. When male freedmen gained the franchise, some clergymen such as Richard H. CAIN, William H. Heard, James W. HOOD, Hiram R. REVELS, and Henry M. TURNER were elected to political office. In state legislatures, for example, their efforts helped to lay the foundations for public school systems in the southern states.

After Reconstruction, black clergymen and laywomen turned to building the institutions of social redemption—churches, schools, and social settlements—within the African-American community. In rural and urban settings, North and South, black churchwomen founded social settlements to "uplift the race." Between 1890 and 1908, Janie Porter Barrett founded the Locust Street Settlement at Hampton, Va.; Margaret Murray WASHINGTON founded the Elizabeth Russell Settlement at Tuskegee, Ala.; Victoria Earle MATTHEWS founded New York's White Rose Mission; and Lugenia Burns HOPE founded Atlanta's Neighborhood Union.

In urban communities, clergymen built institutional churches to extend the range of church services to migrants from the rural South. Hutchens C. BISHOP of New York's St. Philip's Episcopal Church, Henry Phillips of Philadelphia's Episcopal Church of the Crucifixion, Matthew Anderson of Philadelphia's Berean Presbyterian Church, and Henry H. PROCTOR of Atlanta's First Congregational Church first built institutional churches. Their example was followed by African Methodists Reverdy C. RANSOM, Monroe WORK, and R. R. WRIGHT, Jr., in Chicago. Thereafter, urban Baptist congregations followed suit with remarkable results.

Some churches' pulpits passed from father to son: Washington and Gardner C. TAYLOR presided at Baton Rouge's Mt. Zion First Baptist Church; Richard H. Bowling, Sr., and Jr., at Norfolk's First Baptist Church; Junius Caesar Austin, Sr. and Jr., at Chicago's Pilgrim Baptist Church; Marshall Shepherd, Sr. and Jr., at Philadelphia's Mt. Olivet Baptist Church; and Adam Clayton POWELL, SR. and JR., at New York's Abyssinian Baptist Church. These pastors built centers of urban religious, social, and political power. More remarkable is the passage of the pulpit through three generations of William H. GRAYS, I, II, and III, at Bright Hope Baptist Church in Philadelphia.

Martin Luther King, Sr., who succeeded his father-in-law, A. D. Williams, at Atlanta's Ebenezer Baptist Church, would have passed it on to his sons, Martin Luther KING, Jr., or A. D. Williams King, had their premature deaths not prevented it. Even so, as the heir of many generations of African-American preachers of the social gospel, the Rev. Dr. Martin Luther King, Jr., had already become its foremost American spokesman in his generation.

REFERENCES

LUKER, RALPH E. *The Social Gospel in Black and White: American Racial Reform, 1885–1912.* Chapel Hill, N.C., 1991.
WHEELER, EDWARD L. *Uplifting the Race: The Black Minister in the New South, 1865–1902.* Lanham, Md., 1986.

RALPH E. LUKER

Socialism. American socialism in the nineteenth and twentieth centuries embraced diverse ideological tendencies and organizational approaches. Never a narrow doctrine nor a monolithic movement, socialism inspired numerous groups and individuals to identify themselves by its name. At its core, socialism involved a critique of capitalist production and the values it generated, and posited an alternative system of collective, cooperative, and nonexploitative labor. For pre–World War I socialists, it was the domination of the capitalist class over the working class that constituted the most serious problem facing American workers; all other divisions, however deep, paled in comparison to that of class. In this perspective, racial inequality was of secondary importance to the labor problem. Indeed, racial divisions were fostered by capitalists who sought to divide the working class. Believing in the existence of a "solidarity of interests which unites the workers of the world," many socialists maintained that capitalism's leveling influence would eliminate differences of race, religion, color, or politics as workers recognized their common interests and united on the basis of their common membership in the working class. Not only was "the class struggle colorless," but there was "no Negro question outside of the labor question," in the words of socialist leader Eugene V. Debs. The solution to the race problem, turn-of-the-century socialists argued, lay in the "abolition of

wage slavery and the emancipation of both black and white from the servitude to capitalist masters." The destruction of capitalism, which had promoted racial tensions, would ultimately destroy those racial tensions as well.

The Socialist Party of America, founded in 1901, was the largest and most important socialist organization in the United States. Its stance on issues of race and its relationship with African Americans were never simple, for white party members exhibited no uniform position on racial questions. As the party of the working class, the Socialist party had "nothing special to offer the Negro," observed Debs. Yet he described the history of blacks in America as "a history of crime without parallel," sought the inclusion of blacks into the party, and himself refused to address segregated audiences. Individual white socialists like William English Walling and Mary White Ovington were active participants in civil rights struggles, helping, for example, to found the NAACP in 1909. Other leaders, like German immigrant and Milwaukee reform leader Victor L. Berger, believed blacks were inferior to whites. "There can be no doubt that the negroes and mulattoes constitute a lower race," he wrote in 1902. "Physically," another white socialist, William Noyes, argued the previous year, "the negroes are as a race repulsive to us."

State chapters of the Socialist party pursued a variety of policies toward African Americans. In the first decade of the twentieth century, Oklahoma socialists strongly defended black voting rights, but southern and southwestern white socialists who advocated political and economic equality for blacks expressly denied any support for "social equality"—a term loaded in their view with sexual connotations—between the races. White socialists in Louisiana advocated the speedy organization and inclusion of blacks into the party, but viewed segregated local chapters as the most effective means of assimilating "black comrades" into the movement in the South. The integration of party chapters, they believed, would surely lead to disaster. In contrast, black socialists in some upper South chapters joined racially mixed local chapters, as they did in many northern cities. During the late 1910s and '20s, the Socialist party of New York sometimes nominated African-American candidates, including A. Philip RANDOLPH, Chandler Owen, and Frank Crosswaith, for a variety of municipal and state public offices.

In general, however, the party neither solicited nor received substantial black support. The party's 1901 Unity Convention did adopt a constitution that expressed "sympathy" with blacks in their "subjection to lawlessness, and oppression" and invited them to "fellowship" in the "world movement for economic emancipation." But the party, as an organization,

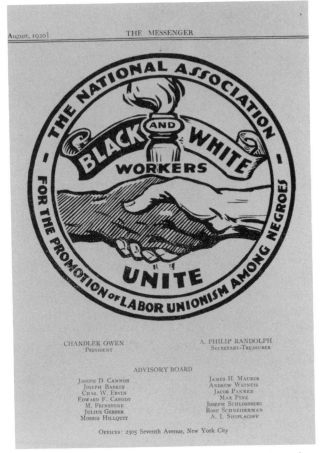

The Messenger, August 1920, was a magazine that emphasized the importance of interracial labor unions and organizing. This illustration symbolizes A. Philip Randolph's belief that only a socialist alliance integrated by race and gender could change the root causes of black oppression. (Photographs and Prints Division, Schomburg Center for Research in Black Culture, The New York Public Library, Astor, Lenox and Tilden Foundations)

paid little attention to racial issues and in practice did little to challenge disfranchisement or lynching and made few efforts to recruit black members. Whatever the specific positions or beliefs of white socialists, few blacks joined the party. It was only after 1917—shortly before it went into sharp decline—that the party devoted more attention to organizing black workers and to demanding citizenship rights for southern African Americans.

Some blacks, however, did espouse socialism and join various socialist organizations. Peter H. Clark of Cincinnati allied with the Workingmen's party in 1877 and later with the Socialist Labor party, while George Washington Woodbey and George W. Slater —both ministers—became members of the Socialist party. From the soapbox and the printed page of journalism, the St. Croix–born black socialist Hubert

H. Harrison invoked the vision of a cooperative society without racial injustice, invited African Americans to join the Socialist party, and chided the party for its narrow understanding of racial inequality during the 1910s. Acknowledging that the "Negro problem is essentially an economic problem with its roots in slavery past and present," Harrison insisted that black workers suffered a "keener" exploitation than whites and that political rights for blacks were the "only sure protection and guarantee" of blacks' economic rights. The crucial test of socialists' sincerity, he argued, was the party's duty to champion the black cause, take a stand against disfranchisement, and carry socialism's message directly to blacks.

Several African-American socialists stand out in the history of the party and the socialist movement. A. Philip Randolph began exploring socialist ideas in 1915, joined the party in 1916, and with fellow socialist Chandler Owen, began publishing the *Messenger*—a self-described radical monthly—in 1917. Unceasingly promoting labor solidarity across the color line, the editors called on black workers to unionize (they preferred the more egalitarian Industrial Workers of the World to the conservative and racially exclusive American Federation of Labor), and they endorsed the Socialist party in electoral campaigns. At the same time, they aggressively denounced lynching, peonage, and mob violence, opposed American participation in World War I, and criticized the philosophies of nationalist Marcus GARVEY and conservative black leaders. By the mid-1920s, Randolph enlisted in the cause of the newly formed Brotherhood of Sleeping Car Porters. He devoted large sections of his journal to attacking the Pullman company and its company union, while promoting the independent black union. Another socialist, Frank Crosswaith, earned the reputation as the "Negro Debs" during the 1920s as a result of his inspiring speeches on the streets of Harlem. A strong supporter of the socialists—"a party free from race and color discrimination," he called it in 1934—Crosswaith founded or participated in a large number of organizations from the 1920s until his death in 1972, including the Trade Union Committee for Organizing Negro Workers, the International Ladies Garment Workers Union, the League for Industrial Democracy, the Harlem Labor Committee, and the Negro Labor Committee.

American socialism—as a doctrine, a philosophy, and a vision—has accommodated numerous views about blacks and race relations. With its insistence upon the primacy of class struggle, it has lent itself to narrow interpretations that minimize the importance of racial oppression. Those white socialists holding negative opinions of blacks were able to shape their organizing strategies and political analyses in accordance with their racial perspective. Yet socialism has also advanced universal values, including the belief in the need to transcend exploitation and usher in a more utopian society based not on profit and the degradation of the wage laborer but rather upon cooperative labor and the uplift of the entire working class. This universal vision has allowed for a more expansive and inclusive approach in which racial oppression is seen as a barrier to class unity and black workers as an especially exploited stratum deserving of socialists' support. By the World War I era, the Socialist party's prior indifference and ambivalence gave way to a more principled stance. Although the party was declining in members and influence after the war, its ideals continued to inspire individuals and organizations in the pursuit of economic equality and racial justice.

REFERENCES

ANDERSON, JERVIS. *A. Philip Randolph: A Biographical Portrait*. New York, 1972.
FONER, PHILIP S. *American Socialism and Black Americans: From the Age of Jackson to World War II*. Westport, Conn., 1977.
———, ed. *Black Socialist Preacher: The Teachings of Reverend George Washington Woodbey and His Disciple, Reverend G. W. Slater, Jr.* San Francisco, 1983.
GREEN, JAMES. *Grass-Roots Socialism: Radical Movements in the Southwest 1895–1943*. Baton Rouge, La., 1978.
HARRISON, HUBERT. "Socialism and the Negro." *International Socialist Review* 13, no. 1 (July 1912): 65–68.

ERIC ARNESEN

Social Work. Social work and social welfare are intended to help people attain the basic necessities of life—food, clothing, and shelter—as well as to aid them in developing their human potential. Throughout the twentieth century such efforts have often, though not always, been carried out in conjunction with programs for social reform. Although social welfare activity initially was the preserve of private services and organizations, over the years government has come to play an increasingly active role. The history of U.S. social work, its relationship to social activism, and its growing importance within government distribution of services have had important implications for the quality of life of African Americans as individuals and as a community.

Long before social work emerged as a professional field, African Americans had carried out a wide range of cooperative self-help and mutual-aid programs in

order to better their lives and their communities. Throughout the eighteenth and nineteenth centuries free black women and men in the North organized benevolent societies; among the earliest was the FREE AFRICAN SOCIETY of Philadelphia, formed in 1787 to provide cradle-to-grave counseling and other assistance, including burial aid. Other groups raised money for educational programs or relief to widows and orphans. Northern blacks not only helped themselves, they extended aid to fugitive slaves and linked their work to a larger effort to improve the standing of African Americans in society.

Following the Civil War, the Freedmen's Bureau, a federal agency, initiated a series of social welfare policies designed to help newly freed black people in their struggle to survive; during Reconstruction many southern states promoted similar relief efforts. But in the context of emancipation, such economic, educational, and other assistance not only improved the lives of individual African Americans, it posed a challenge to the system of racial inequality itself. After Reconstruction, therefore, most states of the former Confederacy resisted adoption of programs that would alter the status quo; when local and state government did intervene on behalf of the aged, infirm, and others in need, it did so on a segregated basis.

Largely excluded from such services, African Americans in the North and the South continued to practice the kind of "social work" that had served them for centuries. Black women were often at the forefront of these efforts, pooling resources and playing a leadership role in establishing orphanages, homes for the poor and aged, educational and health-care services, and kindergartens. The abolitionist Harriet TUBMAN turned her residence in Auburn, New York, into the Home for Indigent and Aged Negroes, one of perhaps a hundred such facilities by 1915. In urban centers black women organized to aid newly arriving migrant women in finding lodging and employment; among the most prominent of these efforts was New York's White Rose Working Girls Home, founded by Victoria Earle MATTHEWS in 1897.

Professional social work emerged around the turn of the twentieth century in response to conditions generated by the processes of industrialization, urbanization, European immigration, and southern migration. Charitable organizations, such as the National Conference of Charities and Corrections, sought to coordinate and professionalize their work, but they continued to emphasize personal misfortune or moral failing instead of larger institutional explanations for the pervasive poverty in urban industrial centers. Before the massive exodus of black people from South to North, most charity workers paid

scant attention to the problems of African Americans. With the Great Migration some charitable reformers came to view black people as another immigrant group needing "Americanization," and they found ample support for their moralistic emphasis on thrift and industry from Booker T. WASHINGTON's philosophy of individual uplift. Other philanthropists insisted that black people were meant to occupy an inferior station in life and urged that they acquire industrial training suited to their "natural" limitations.

In contrast, settlement workers, mostly college-educated white women, sought to learn from immigrants and migrants themselves instead of imposing their own values and assumptions. They proposed to live in impoverished communities, providing services that would help newcomers adjust to urban industrial life without giving up their own beliefs and cultural traditions. Though settlement workers could not always mask their middle-class backgrounds, they did establish job-training and placement programs, health-care services, kindergartens, and recreation facilities. Perhaps the best-known settlement was Chicago's Hull House, founded by Jane Addams and Ellen Gates Starr in 1889.

Unlike charity workers, white activists in the settlement movement were often quicker to recognize that poor housing, educational, and job opportunities in the burgeoning black communities of the urban North were the direct result of segregation and racial discrimination. Using scientific methods to identify and analyze social problems, settlement workers pressed for government reforms in such areas as factory and tenement conditions, juvenile justice, child labor, and public sanitation. Their efforts to fuse social work with social reform also extended to race relations; one-third of the signatories of the 1909 "call" that led to the formation of the NAACP either were or had been settlement workers.

Advocating racial tolerance and an end to discrimination, however, was not the same as calling for social equality. Many social service agencies in Chicago, New York, and elsewhere either refused help to African Americans outright or offered poor quality assistance on a segregated basis; this was especially true for organizations providing lodging, board, and medical care. The settlement houses were no exception. Many were located in white immigrant communities, but a number of settlements that were easily accessible from black neighborhoods still did not serve the African-American population. Some white reformers pursued alliances with black community leaders in establishing "interracial" settlements; one notable example was the Frederick Douglass Center, founded in Chicago in 1904. But the

center disdained "slum work" among the black poor. Rather, its leaders, including white minister Celia Parker Wooley and black clubwoman Fannie Barrier WILLIAMS, sought to bring together the educated elite, black and white, for lectures, concerts, and other cultural activities.

It was often African Americans themselves who, seeking to remedy the inequities in social service provision, seized the initiative in addressing individual and social problems in the black community. But such activists were faced with a stark dilemma. Without the assistance of white philanthropists, they could not hope to match "white" agencies in staffing and programming; indeed, their facilities rarely survived. Between 1900 and 1916 at least nine settlements were established in Chicago's black neighborhoods; by 1919 only one remained. In 1910 renowned anti-lynching agitator Ida B. WELLS-BARNETT formed the Negro Fellowship League, which offered recreational services for black men and boys, an employment agency, and later, lodging. But she was forced to disband it for lack of funds.

The alternative—support from white people—usually meant control by white people. Chicago's Wendell Phillips Center, for example, was initiated in 1907 by a group of twenty black activists, and its staff was mostly black; its board, however, was overwhelmingly dominated by whites. White reformers were thus able to limit the autonomy of black community leaders; in so doing, they often contributed to the preservation of the racial status quo. On the other hand, they helped shape the kinds of programs that were available; services for black girls, for instance, were more likely to win financial support if they emphasized morality and offered training in domestic work. On the other hand, the very involvement of whites in the creation of services "for blacks" often reflected their desire to maintain segregation in social services.

Even when forced to rely on the resources of white philanthropists whose agendas clashed with their own, African Americans often strived to translate their reform activities into a larger program of social action. In 1899 the distinguished Harvard University graduate W. E. B. DU BOIS produced *The Philadelphia Negro,* a meticulously researched study of urban African-American life. The project had been commissioned by the College Settlement Association, whose conservative wing was driven by the conviction that black people were somehow ridden with criminality and vice—an early version of the "culture of poverty" argument advanced in the 1960s to explain why economic misery persisted in much of the urban black community. But Du Bois consciously sought to set his findings within a historical and social context that acknowledged the importance of

economic and political, not personal, solutions. Du Bois's sociological approach pioneered the use of scientific inquiry into the causes and effects of social problems.

The NATIONAL URBAN LEAGUE—formed in 1910–1911 as a merger of the National League for the Protection of Colored Women, the Committee for Improving Industrial Conditions of Negroes in New York, and the National League on Urban Conditions Among Negroes—represented the application of professional social work to the kinds of social services that had long been practiced in the black community. It was founded by George Edmund HAYNES, the first black graduate of the New York School of Philanthropy (later the Columbia University School of Social Work), and Ruth Standish Baldwin, a wealthy white reformer. The league offered counseling and other assistance to African Americans in housing, education, employment, health, recreation, and child care. It relied on scientific research techniques to document the exclusion of African Americans and press for greater opportunities.

The league also played an important role in the training and placement of black social workers. Formal social work education made its debut in 1903 with the University of Chicago's School of Civics and Philanthropy, later known as the School of Social Service Administration. In 1917 the National Conference of Charities and Corrections became the National Conference of Social Work. (In 1956 its name was changed to the National Conference on Social Welfare.) But because of racial segregation blacks were barred from social work education and training outside the North until the 1950s, and they were denied full participation in professional bodies.

Through the able leadership of Urban League personnel, historically black educational institutions stepped in to fill the void. Under Haynes's direction Fisk University developed an undergraduate social service curriculum, including field placement with league affiliates. The Atlanta School of Social Work was founded in 1920 to provide instruction to black students, and it later affiliated with Atlanta University. By 1926 the Urban League itself employed 150 black social workers. Over the years the league continued to preserve important ties to social work education; Whitney M. YOUNG, Jr., for example, served as dean of the Atlanta University School of Social Work before becoming the league's executive director in 1961.

The devastating economic crisis generated by the Great Depression severely strained the capacity of private social service organizations to assist individuals in need. In an extension of the reform impulse of the Progressive period, the federal government under President Franklin D. Roosevelt was forced to inter-

vene with massive programs that placed social work firmly within the public domain. The Social Security Act of 1935 provided old age and survivors' insurance, unemployment insurance (known as entitlement benefits), and public assistance to the aged, the blind, and dependent children.

But for African Americans the impact of government involvement was contradictory, since programs aimed at affected workers automatically excluded large numbers of black people. Nearly half of all African Americans worked in agricultural labor, casual labor, and domestic service, but these occupations were not counted as part of the covered workforce. The Urban League, the NAACP, and others opposed the exclusion, arguing that it would single out black people as a stigmatized, dependent population, but their efforts were unsuccessful. They also openly criticized the unequal distribution of relief and segregated assistance programs.

The CIVIL RIGHTS MOVEMENT of the 1960s, fueled by legal and social gains achieved by African Americans during the previous decade, attacked racism and discrimination on all fronts, and social work was no exception. Concentrated in segregated enclaves, crowded into dilapidated housing, suffering from dramatically high rates of unemployment, black people in the inner cities had not reaped the benefits promised by the advent of civil rights. When Daniel Patrick Moynihan argued in 1965 that the black community was caught in a "tangle of pathology" resulting from "the deterioration of the Negro family," he was articulating a moralistic theme that had persisted in social welfare policy since at least the late nineteenth century. It was activist-oriented African Americans who led the challenge to such interpretations, defending the integrity of the black family and calling for a deeper understanding of the structural causes of poverty.

The antipoverty programs initiated under the Johnson Administration's Great Society, while in part a response to Moynihan's analysis, also created new opportunities for contesting it. African-American social workers condemned racism within the profession and demanded a greater commitment to issues of social justice. In 1967, over opposition from the leadership of the National Association of Social Workers, a nondiscrimination amendment to the association's code of ethics was presented on the floor of the delegate assembly, where it passed. The following year, in San Francisco, African Americans founded the National Association of Black Social Workers (NABSW). While some black individuals gained prominence within existing professional organizations—Whitney Young, Jr., for example, became president of the NASW in 1969—many African Americans turned to the NABSW as a vehicle for articulating the goals of effective, responsive service delivery in the black community and an end to racial exclusion and discrimination within the ranks of the profession.

Social work and social welfare programs, although widely believed to provide services on a nondiscriminatory basis, have always been influenced by larger historical trends and conditions. The historical exclusion of African Americans from social work schools and organizations virtually assured that concerned black people would continue to rely on their own methods for improving individual and community life. At the same time, the profession's dominant strategies and methodologies have reflected the racial, sexual, and class biases of the European-American middle class, often to the detriment of those most commonly under the scrutiny of social workers.

An African-American presence within the social work profession has helped to transform service delivery. Many black social workers have developed innovative models that acknowledge the importance of environmental factors—such as socioeconomic status and citizenship rights—in determining the well-being of African-American people. By asserting positive recognition of extended family formations, they have been able to respond with new flexibility to individual and family concerns. And they have sought to extend these efforts throughout the profession, working to ensure that social work education and training incorporate information about the experiences of people of color. At the same time, many African Americans in social work have rejected the notion of adjustment to the status quo, calling for change in social institutions, laws, and customs that continue to keep African-Americans from achieving their full potential.

In the 1990s the assumptions that have guided social work theory and practice demand renewed attention. The problems facing the black community continued to reflect the racism that persists in employment, health care, education, and other areas. The unemployment rate among African Americans remains twice the national average; the AIDS crisis has reached disproportionately into the black community; and drug-addicted children are now entering an educational system whose capacities are severely constrained by diminishing resources. As in the past, however, the African-American community has been left to tap its own potential in order to address these concerns. At the same time, mainstream social workers have adopted code words—diversity, multiculturalism, biculturalism—that obscure root causes and so fail to confront deep-seated racism, sexism, and class bias. Advocates of social work and social welfare can respond effectively to current problems by

reclaiming a legacy of progressive social reform that acknowledges the need for structural, not personal, solutions.

REFERENCES

APTHEKER, HERBERT, ed. *A Documentary History of the Negro People in the United States.* Vol. 1. New York, 1971.

AXINN, JUNE, and HERMAN LEVIN. *Social Welfare: A History of the American Response to Need.* 3rd ed. White Plains, N.Y., 1992.

BELL, HOWARD R. "National Negro Conventions of the Middle 1840s: Moral Suasion vs. Political Action." In August Meier and Elliott Rudwick, eds. *The Making of Black America: Essays in Negro Life and History.* Vol. 1. New York, 1969.

BENNETT, LERONE, JR. *Before the Mayflower: A History of Black America.* 6th ed. Chicago, 1988.

———. *The Shaping of Black America.* Chicago, 1975.

BREUL, FRANK R., and STEVEN J. DINER, eds. *Compassion and Responsibility: Readings in the History of Social Welfare Policy in the United States.* Chicago, 1980.

CLARK, WILLIAM E. "The Katy Ferguson Home." *Southern Workman* 52 (1923): 228–230.

CROMWELL, CHERYL D. "Black Women as Pioneers in Social Welfare, 1880–1935." *Black Caucus Journal* 7, no. 1 (1976): 7–12.

FRANKLIN, JOHN HOPE, and ALFRED A. MOSS, JR. *From Slavery to Freedom: A History of Negro Americans.* 6th ed. New York, 1988.

HORNSBY, ALTON, JR. *The Black Almanac: From Involuntary Servitude (1619–1860) to a Return to the Mainstream (1973–1976)?* Rev. ed. Woodbury, N.Y., 1977.

JOHNSON, AUDREYE E. "Health Issues and African Americans: Surviving and Endangered." In John S. McNeil and Stanley E. Weinstein, eds. *Innovations in Health Care Practice.* Silver Spring, Md., 1988, pp. 34–49.

———. *The National Association of Black Social Workers, Inc.: A History for the Future.* New York, 1988.

———. "The Sin of Omission: African American Women in Social Work." *Journal of Multicultural Social Work* 1, no. 2 (1991): 7–15.

———. "William Still—Black Social Worker: 1821–1902." *Black Caucus Journal* (Spring 1977): 14–19.

LEWIS, DAVID LEVERING. *W. E. B. Du Bois: Biography of a Race, 1868–1919.* New York, 1993.

LIDE, PAULINE. "The National Conference on Social Welfare and the Black Historical Perspective." *Social Service Review* 47, no. 2 (June 1973): 171–207.

PHILPOTT, THOMAS LEE. *The Slum and the Ghetto: Immigrants, Blacks, and Reformers in Chicago, 1880–1930.* Belmont, Calif., 1991.

ROSS, EDYTH L. *Black Heritage in Social Welfare, 1860–1930.* Metuchen, N.J., 1978.

STILL, WILLIAM. *The Underground Railroad.* 1872. Reprint. Chicago, 1970.

WEAVER, HILARY N. "African-Americans and Social Work: An Overview of the Antebellum Through Progressive Eras." *Journal of Multicultural Social Work* 2, no. 4 (1992).

WILLIAMS, LEON F. "A Study of Discrimination in Social Work Education Programs." *Black Caucus* 14, no. 1 (Spring 1983): 9–13.

AUDREYE E. JOHNSON

Society of Friends (Quakers).

Founded in England in the 1650s, the Religious Society of Friends (Quakers) first encountered Africans as slaves in Barbados and North America in the 1670s. George Fox (1624–1691), the founder of the sect, condemned the inhumane treatment of slaves and urged their religious instruction. William Edmundson (c. 1627–1712), a prominent leader, concluded by 1676 that SLAVERY itself was inherently evil. Other Friends in North America expressed similar views between 1688 and 1740: Dutch Friends in Germantown, Pa., in 1688; followers of the schismatic Pennsylvania minister George Keith in 1693; and several individuals, most notably Benjamin Lay (1677–1759) and Ralph Sandiford (c. 1693–1733).

Most Friends before 1750, however, did not challenge slavery as such or the racial assumptions behind it. Philadelphia and Newport Quakers were involved in the SLAVE TRADE. From Rhode Island to the Carolinas, Quakers owned slaves in much the same proportion as non-Quakers. Friends disowned members who treated slaves harshly, but they also disowned agitators like Lay and Sandiford.

By 1750 there was growing antislavery sentiment among American Friends, one of the fruits of a reform movement that condemned what its leaders perceived as growing religious laxness. They urged renewed emphasis on Quaker peculiarity and discipline, including freeing the society from slavery. Led by John Woolman (1720–1772) of New Jersey and Anthony Benezet (1713–1783) of Philadelphia, reformers condemned slavery both as an injustice to the slave and a temptation to sin for the owner. Gradually, their efforts succeeded. First, the various yearly meetings of Friends banned trading in slaves. By 1784, all had forbidden members to own slaves.

This decision did not come without controversy. Some Quaker communities moved quickly to rid themselves of slaveholding, while others lagged considerably. Many Quakers, given a choice between keeping their slaves and losing their membership, chose the latter. Quaker planters in Virginia and eastern North Carolina were especially reluctant.

Quaker opposition to slavery, however, did not immediately translate into a commitment to equality, or even acceptance of black members. Some scholars have argued that Friends, after emancipating their slaves, anticipated the patterns of segregation and paternalism of later American society. (See, for example, Jean Soderlund, *Quakers and Slavery: A Divided Spirit*.) Most Quaker meetinghouses were segregated, and Friends often set aside back sections in their burying grounds. Eventually, however, Friends accepted black members.

In 1783, the Philadelphia Yearly Meeting admitted its first person of color, Abigail Franks, into membership. In 1797 the Meeting made it part of its discipline that members were to be received "without respect to colour." In 1798, North Carolina Friends received a mulatto, Isaac Linegar (?–1818) in membership. Other blacks joined Friends in the nineteenth century, of whom probably the best known was Paul Cuffe (1759–1817) of Westport, Mass. But black members were few, and many Quakers bemoaned prejudice against people of color within their society.

In the nineteenth century, however, Friends attempted to protect the rights of African Americans in several ways. They established schools for blacks or admitted blacks to Quaker schools, supported orphanages and other charitable institutions, and tried to rescue kidnapped free blacks. Ohio and Indiana Quakers protested their states' Black Laws (*see* BLACK CODES). Historical geographers have noted how black settlements in the Midwest were often in close proximity to Quaker ones. The abolitionist movement, however, divided Friends. Although Quakers were prominent in it, many Friends eschewed it as involving unacceptable links with non-Friends.

The CIVIL WAR and RECONSTRUCTION saw hundreds go south to work along the freed people, almost always as teachers. Most were content with that; few Friends from the East showed interest in proselytizing. Many from west of the Appalachians, however, believed in organizing black Quaker meetings. Only one, however, emerged: in Southland, near Helena, Ark. Southland College, controlled by Indiana Friends, was the first black college west of the Mississippi.

Between 1870 and 1910, there were contradictory trends among Quakers. In the East, acceptance of racism coexisted with generous support for black schools and charities. Eastern Quaker schools, such as Haverford and Swarthmore, remained all white, while those in the Midwest, like Earlham, admitted blacks. In the 1870s, the large Gurneyite wing of Quakerism became pronouncedly evangelistic and revivalist. This probably brought in more black members than in any previous period. At least three

blacks—Daniel Drew of Southland, Noah McLean of Ohio, and William Allan of Canada—became well-known Quaker ministers, often preaching to white congregations. Overall, however, the influx of new members and deemphasis of Quaker peculiarity led to a decline in Quaker interest in African Americans.

In the twentieth century, black Quakers have been relatively few, although the small number includes such eminent figures as Jean TOOMER and Bayard RUSTIN. Most joined the liberal Friends General Conference. There has been a renewed interest in civil rights, manifested especially through the American Friends Service Committee (founded 1917) and the Friends Committee on National Legislation (founded 1943).

REFERENCES

BARBOUR, HUGH, and J. WILLIAM FROST. *The Quakers*. Westport, Conn., 1988.

CADBURY, HENRY J. "Negro Membership in the Society of Friends." *Journal of Negro History* 21 (April 1936): 151–213.

DRAKE, THOMAS E. *Quakers and Slavery in America*. New Haven, Conn., 1950.

SODERLUND, JEAN R. *Quakers and Slavery: A Divided Spirit*. Princeton, N.J., 1985.

THOMAS D. HAMM

Society for the Propagation of the Gospel in Foreign Parts (SPG).

In the spirit of evangelical revival in England, the Society for the Propagation of the Gospel in Foreign Parts was established by royal charter in the Church of England in 1701 to bring Christianity to the American colonies. To that end, the society sent hundreds of missionaries and thousands of Bibles, spelling books, and reading primers to the New World. Although it was originally concerned with the souls of white colonialists, the SPG soon found itself ministering to the spiritual and educational needs of blacks and Native Americans. The organization faced strong opposition from slave owners, who feared that baptism would endow their slaves with a moral claim to liberty and that literacy would endow them with the practical means for attaining it. To allay the slave owners' fears of revolt, the SPG missionaries would exact an oath from slave converts at the baptismal font to the effect that ". . . you do not ask for the Holy Baptism out of any design to free yourself from the duty and obedience you owe to your master while you live."

To further their spiritual aims, SPG operated what were among the earliest schools devoted to African-American education in British North America. The

SPG opened schools for blacks in Goose Creek, S.C. (1702), New York (1705), Philadelphia (1758), and Charleston, S.C. (1743). The school at Charleston was particularly demonstrative of the SPG's determination to bring the light of literacy as well as religion to African Americans without necessarily striving for their emancipation. The SPG bought two promising young slaves in 1742 with the express purpose of training them to be schoolmasters at the Charleston school. Their students were, in turn, to return to their plantations and instruct the slaves remaining there. The Charleston school was quite successful, and continued until the first schoolmaster's death in 1764. The American Revolution disrupted the efforts of the SPG, and the society's last missionary left the United States in 1783. However, the SPG's belief in the need to educate as well as convert slaves, along with their understanding that slaves were capable of learning and would endure many hardships to do so, was, according to Frank J. Klingberg, ". . . the beginning of the whole enterprise which made it possible for Negroes to be Christianized, to become readers, and, passing out of slavery, to have their own churches, bishops, colleges, and institutions."

REFERENCES

CALAM, JOHN. *Parsons and Pedagogues: The S.P.G. Adventure in American Education.* New York, 1971.

KLINGBERG, FRANK J. *An Appraisal of the Negro in Colonial South Carolina: A Study in Americanization.* Washington, D.C., 1941.

NANCY YOUSEF
LYDIA MCNEILL

Sociology.

In the last two decades of the nineteenth century, the new discipline of sociology gave little attention to the race problem (or to the Negro problem; the terms were then used interchangeably) and with a very few exceptions accepted uncritically the scientific racism of the day (*see* RACE, SCIENTIFIC THEORIES OF). That racism advanced the claim that the nonwhite races were inferior to the white race by virtue of being endowed by nature with fewer of the attributes required to sustain a civilized society. In the second decade of the twentieth century, however, a new genetics invalidated biology's racial theorizing, and the study of race moved by default to the social sciences. By the 1920s most sociologists had accepted this shift from biology to culture, and a few of them began to study race as a problem in social relations.

At the outset this change in science's understanding of race had no immediate effect beyond the university environment. Racial segregation remained firmly in place, and a racially intolerant white population was unmoved by the collapse of scientific racism and continued to view the nonwhite population as innately inferior and unassimilable. Still, sociologists accepted the scientific judgment that black people were not biologically inferior, but against the arguments of anthropologists, they retained an image of them as culturally inferior. In those two decisions was the beginning of the sociology of race relations.

That beginning was shaped by a perspective rooted in an infrastructure of assumptions and values drawn from sociology's nineteenth-century typology of modern and traditional (premodern) societies, a heritage of social evolutionary thought that was still a central issue for American sociologists in the 1920s. From that perspective came two basic assumptions. The first was the inevitability of modernization—namely, that the historic sweep of URBANIZATION, secularization, and INDUSTRIALIZATION would wash away all traditional cultures and incorporate into modern society whatever premodern peoples still existed. All people, including the nonwhite races, would need to master the demands of modern civilization.

Their second assumption spelled out the meaning of cultural inferiority: Black people were viewed as a premodern people, culturally backward by modern standards, and still isolated from the socializing currents of modern life. To sociologists that meant they were mostly uneducated, ignorant of the requirements of modern life, and beset with the vices and pathologies peculiar to the poor and ignorant. They were also portrayed as powerless by virtue of white domination and incapable of acting effectively in their own behalf or developing an adequate leadership. Nonetheless, the historic sweep toward modernity made it inevitable that black people would eventually be assimilated.

Given the implacable opposition of white Americans to racial assimilation, however, and the unreadiness of rurally isolated blacks for modern life, sociologists maintained that assimilation would not occur until some unspecified time in the future. It was to be a steady and gradual process, unmarked by large or sudden alterations of existing relations. But there were no immediate prospects of change and no reasons to try to intervene in the structure of racial segregation. Here was a cautious generation's belief in racial progress as a slow but steady process of adjustment and adaptation, not one of conflict and struggle. Until the 1960s such an outlook gave direction and purpose to the sociological study of race; then the events of that decade proved it inadequate.

Studying Race Relations

At the outset, the sociological sense of race relations was expressed by the concepts of assimilation and

prejudice. Together they defined the race problem for sociologists in the 1920s: The assimilation of blacks into American society was blocked for the time by the prejudice of the white population, the overwhelming majority of whom regarded blacks as unassimilable.

Neither term was new. Assimilation had been around since the 1850s and was borrowed from sociologists who studied European immigration. Prejudice was first defined as an instinct, but with the decline of the theory of instincts it was redefined as an attitude. But the emphasis then was not on prejudice as an individual attitude (the psychologizing of the term was to come later) but as a group phenomenon; it invoked the idea of a conservative and defensive group consciousness seeking to protect the interests of an advantaged group against the disadvantaged ones.

In 1932 the concept of minority was added, to place under a single covering term the disadvantaged groups—racial, ethnic, and religious—that suffered from the prejudice of the advantaged. It offered the potential for developing an encompassing theory. But the concept was also problematic; in the minds of sociologists, there was an important distinction to be made between the descendants of African slaves and the immigrants from Europe. The two had reached the United States under different historical circumstances, and their futures also seemed to be different. Assimilation was already under way for the recent immigrants but seemed far off for black people. The matter was resolved by the adoption of the paired concepts race and ethnicity.

This also reflected, however, a narrow conception of culture. Although sociologists understood that culture was humanly created, it was nonetheless defined primarily as a social inheritance passed from one generation to the next. Culture is not only inherited, however, it is also created anew under changed circumstances. In their long endurance of slavery and segregation, blacks created themselves as a single people with a distinct culture of their own making. But in the 1920s sociologists, with the exception of Robert Park, had no comprehension of this.

The now familiar concepts of segregation and discrimination entered the sociological vocabulary later. In the 1930s segregation was still constitutionally sanctioned and accepted as the common status of black people. The concept of discrimination was only rarely used, since the unequal treatment of black people was expected and taken for granted. Only later, when segregation and discrimination became legal and political issues, did the terms enter the sociological vocabulary and the concept of discrimination become paired with prejudice.

In the 1930s, with a new vocabulary at hand, sociologists produced a substantial body of work that exemplified what could be done with the new perspective. Consistent with it, they developed measurements of prejudice and discrimination to document racial progress as a steady trendline into the future. While the work was informative and useful, little of it was groundbreaking. Despite the fact that the 1930s was a decade of economic and political upheaval in the nation undergoing the GREAT DEPRESSION and that blacks were moving from the rural South to the urban North in considerable numbers, sociologists resisted examining that process and focused instead on southern race relations, where, they claimed, a caste system still dominated. A number of studies of black life in the rural South in the 1930s, of which John Dollard's *Caste and Class in a Southern Town* was the most noted, made it clear that race relations were still caste relations, that system-breaking change was not imminent, and that neither precipitate change nor racial conflict seemed likely to occur. A few sociologists, however—notably Park and the black sociologists—challenged this characterization of southern race relations.

This formative period in the sociology of race relations drew to a close with the onset of WORLD WAR II. What sociology had to say about race relations was summarized in Gunnar Myrdal's mammoth study *An American Dilemma* (1944), undoubtedly the most widely read study on race relations in the United States. Myrdal did three things: He advanced a controversial thesis that race relations were a contradiction between America's democratic ideals and its racial beliefs and practices (that was the "dilemma"); he summarized and assessed what sociologists claimed to know about race relations; and, reflecting his role as a European social democrat and social planner, he criticized American sociologists for not advocating social policies that would change existing race relations. Although Myrdal had little effect on the generation that had produced the work summarized in *An American Dilemma,* he did encourage an oncoming generation that had been raised on the social policies and programs of the New Deal to believe that intervention to change race relations was now possible. It encouraged sociologists, therefore, to move closer to the racial liberals.

Perhaps the least satisfactory aspect of Myrdal's work was his seemingly uncritical acceptance of the denigrating image of the black American from the prevailing sociological literature. While Myrdal did not deny that black people had been culturally innovative, he viewed their innovation as a secondary reaction of the powerless to the primary action of the powerful. But mere reaction did not provide an adequate recognition of the social factors that gave cul-

tural distinctiveness to American blacks. From his reading of the book, the distinguished black novelist Ralph ELLISON made this often cited comment in *Shadow and Act* (1964):

> But can a people (its faith in an idealized American Creed nothwithstanding) live and develop for over three hundred years simply by *reacting*? Are American Negroes simply the creation of white men, or have they at least helped to create themselves out of what they have found around them? Men have made a life in caves and upon cliffs, why cannot Negroes have made a way of life upon the horns of the white man's dilemma?

The Black Sociologists

In the first half of the twentieth century, white sociologists did little to penetrate into the separate communities created by blacks as a consequence of segregation. What was known about blacks came mostly from aggregates of statistical data or from observations of blacks in public, white-controlled places. It became the task of the first black sociologists to reveal the internal structure of black social life and, in doing so, to create a more adequate image of American blacks *as a people*.

The work of black sociologists made evident a perspective on race relations different from that of white sociologists. Although both of them understood that black people wanted the opportunities denied them, white sociologists did not seem to understand what black sociologists knew full well: that black people did not want to so fully assimilate as to disappear as a people; that race pride and a lasting resentment at white oppression had produced a distinctive set of attitudes among black people; and that nationalistic, nonassimilative ideas were emerging among young, educated blacks. Furthermore, black sociologists did not, as did their white colleagues, regard efforts at political reform as illusory; instead, they took them seriously. That was because they were more sensitive than white sociologists to the consequences of economic and demographic change in the United States, in particular the urbanization of black people, for change in race relations. In turn, they viewed the white sociologists' fascination with caste as an illusion of stability in the face of oncoming change.

Two black sociologists, E. Franklin FRAZIER and Charles S. JOHNSON, were soon recognized by their white peers as scholars of the first rank. In such books as *The Negro Family in the United States* (1939) and *Negro Youth at the Crossways* (1940), Frazier made a compelling case for understanding black Americans in terms of their life-shaping experiences from slavery to segregation and in the movement from rural South to urban North and not of biology or the residues of an African heritage. For all who would look

to see, he revealed the complexity and distinctiveness of black life in the organization of black communities and in the black class structure.

Charles S. Johnson's *Shadow of the Plantation* (1934) provided a compelling study of black rural life in Alabama in the early 1930s, noting that little had changed since slavery and that the harsh conditions of life for black Americans denied the myth of the spontaneous and happy black. In similar fashion, his *Growing Up in the Black Belt* (1941) revealed the growing aspirations of black youth in the Deep South and their deepening resentment at the treatment of them by white people, while his *Patterns of Negro Segregation* (1943) laid bare the harsh reality of racial segregation.

In 1945 a study begun in the 1930s provided the first detailed examination of black life in the urban North. In *Black Metropolis,* St. Clair DRAKE and Horace CAYTON described "Bronzeville," the black community of Chicago of the 1930s and '40s. It was a large, inclusive work unlike anything before it, a true classic of the field, and the crowning achievement of the prewar black sociologists.

White sociologists read and appreciated the works of black sociologists, especially those of Johnson and Frazier, but they read them selectively, taking what fitted their perspective on race relations and of blacks as a people. They possessed, in short, a mental outlook that left them unable to grasp the full message of the black sociologists. As a consequence, despite the efforts of black sociologists, an inadequate and selective image of the black American remained a basic feature of the sociology of race relations.

Robert Park: An Unrealized Perspective

At the University of Chicago, Frazier and Johnson were students of Robert Park, whose pioneering work did more to develop the sociology of race relations than that of any other sociologist. Park provided the definitive statement on assimilation, developed his well-known race relations cycle, promoted the idea of prejudice as social attitude, and invented the concept of social distance. Yet these contributions, readily accepted by sociologists, were not all that Park had to offer.

When other sociologists saw black people as a quiescent and backward population not yet ready for modern society, Park saw them as a race-conscious people involved, like the national minorities of Eastern Europe, in a struggle for independence. He placed the American race problem within a world process of racial and ethnic conflict and change, where subject peoples sought independence and self-determination. That made of race relations a continuing field of conflict. For Park, this was not to be deplored because it was a stage in the eventual assimilation of the world's

peoples into a common culture and a common historical life.

But all of this was far beyond the parochial worldview of Park's sociological colleagues. As a consequence, a perspective that gave promise of anticipating and better understanding the emergence of a black-led CIVIL RIGHTS MOVEMENT and preparing the nation for significant changes in race relations went unrealized.

The Postwar Sociology of Race Relations

In the 1940s and '50s there was a rush of political and legal actions, neither predicted nor anticipated by sociologists, that changed some basic aspects of race relations and led to expectations of even further changes. Among these were the 1941 March on Washington movement, which led to President Franklin D. Roosevelt's executive order forbidding discrimination in defense industries and which, after the war, stimulated political efforts to promote fair employment practices; the DETROIT RIOT OF 1943 which stimulated the formation of local groups to deal with racial tension in the community; President Harry S. Truman's desegregation of the armed forces; the U.S. Supreme Court's decision rendering restrictive racial convenants illegal and the consequent liberal effort to abolish segregated housing; and the Court's decision in BROWN v. BOARD OF EDUCATION OF TOPEKA to desegregate the public schools. These changes signified that race was finally on the liberal agenda and that the nation was making its first moves to eliminate the established pattern of racial segregation.

In the face of such changes, a new postwar generation of sociologists abandoned the politically detached position of the prewar generation and tried to shift sociology from the "objective" study of race relations to race as a problem in applied research, in service to the liberal activists and the professional practitioners of intergroup relations. It was also an experiment in bringing together scholar and practitioner, in uniting theory and practice.

But it never worked. One reason was that the professionals were too politically constrained by their social agencies; what they could do in practice was limited by what was acceptable to their governing boards. In the public agencies, among a diverse set of politically appointed community representatives, there were always some who were cautious about, if not unsupportive of, decisive action. To work with professional agencies, therefore, was to seek no more change than the civic elite that controlled those agencies was willing to undertake. There was no consideration of organizing a constituency among nonelite groups or of linking the objectives of intergroup relations with other social causes. It was also the case

that a sociology that studied social roles in stable structures had difficulty analyzing the more fluid dynamics of racial conflict and change.

The attempt to construct an applied sociology of race relations and to participate in the liberal effort at racial change did not last long. It emerged in the first decade after the war and then vanished almost without a trace with the coming of the black-led civil rights struggle in the 1960s.

Beyond Prejudice

In the 1950s social psychologists went beyond the measurement of prejudice to examine the relation of race to personality. One direction of study saw prejudice in some whites as an expression of a deeply rooted psychological need, which often led to the projection of hostility on a socially acceptable target such as a racial minority. Such individuals exemplified the authoritarian personality: antidemocratic, rigidly inflexible, and admiring of power. A decade of supporting research claimed that these more prejudiced individuals were likely to be people of lesser social status: the less educated, the working class, the lower class. Whereas prewar sociologists had viewed the whole of the white population as prejudiced, a postwar generation saw racial bias differing by social class. An educated middle class, it seemed, was tolerant and racially progressive, while classes below them were not. This quickly became a fixed element in sociological (and liberal) thought.

While research does indeed show that middle-class whites will more readily endorse principles of equal rights, it also finds that, when it comes to implementation, the difference between the middle class and other classes decreases and even disappears. It also declines when the proportion of blacks increases, and it disappears when blacks become a majority. Sociologists' belief in a racially unprejudiced middle class, it now seems, is unwarranted and has provided no basis for a workable strategy of action.

In 1958 the sociologist Herbert Blumer suggested that prejudice is a sense of group position, not a set of feelings the individuals of one group hold toward those of another. A group's position in the racial order, he argued, produced a proprietary claim to privilege and prerogative, and prejudice emerged when that position was threatened. What Blumer had done was return to the earlier idea of prejudice as defense of social advantage. But sociologists made no effort to develop Blumer's conception of prejudice and its promise of a better way to explain race prejudice among social classes.

The relation between prejudice and discrimination and the proclaimed inverse relation between prejudice and social class were easily incorporated into the postwar sociology of race relations. So was another

idea: that the firm exercise of authority over recalcitrant whites was necessary to attain racial change. An idea first applied to crowd situations with a potential for violence came to be applied to conflicts over desegregation where, it was believed, the firm exercise of authority would prevent resistance from being effective. Given the fact that sociologists defined the prejudiced person as primarily coming from the working and lower classes, the idea of the firm exercise of authority followed logically.

These were social psychological studies of white people, but sociologists had often commented about the psychological damage done to black people by a racially oppressive environment. In the 1930s one sociologist suggested that blacks suffered from an "oppression psychosis," and in the 1940s another claimed that "personality disorders" were one of the pathologies to be found among black people. The most influential expression of this view came in 1951 when the psychiatrists Abram Kardiner and Lionel Ovesey argued, in *The Mark of Oppression,* that the persistent and pervasive consequence of discrimination had a thoroughly destructive effect on the psychological development of black people.

The image of the black person that emerged from their study was that of a psychological cripple: a mentally unhealthy person given to low self-esteem and self-hatred, to resentment, rage, and an aggression for which there was no safe outlet. Blacks, the authors asserted, lacked any "genuine religiosity," had created no religion of their own, and had been unable to develop their own culture. They bolstered their self-esteem with compensatory activities such as flashy dressing, gambling, taking drugs, and vindictive behavior toward one another.

Perhaps the most damning claim the authors made was that American blacks were incapable of the social cohesion that would enable them to act collectively in their own interests. They traced this back to the severe limitations on personal development imposed by slavery and segregation. The frustrations of childhood, they insisted, produced a distrusting personality lacking confidence in human relations.

Kardiner and Ovesey were not intent on condemning blacks for their deficiencies but on demonstrating the "marks" of oppression under which blacks were forced to live. Nonetheless, their message was that blacks were so victimized by this oppression that they were unable to act in their own behalf and required the assistance of sympathetic whites. Only their oppressors, it seemed, could also be their liberators. For sociologists the book became a seminal work that rounded out their conception of American blacks.

No one can deny that oppression leaves a distorting mark on the human personality. But it is not the case that such oppression can fully and forever cripple the human spirit or leave a people permanently

unable to act on its own behalf. Even in the most destructive of environments, a people will create the cultural resources for sustaining hope and preserving a decent sense of their own humanity. From the days of slavery, black Americans did that. Through religion and music they created life-sustaining forces to offset the pain evident in everyday life, while the black church became a force for leadership, for sustaining family, and for building community. But none of this evidence was noted by Kardiner and Ovesey.

Nor did any of this appear in the sociological literature. There was no work to identify and measure cultural resources by which blacks could defend their very humanity against the crippling effects of oppression. Nor did the literature imagine the possibility of black-directed social action. Yet in the 1950s it was already late in the day to be so unaware of the gathering storm already developing in the South.

A Failed Perspective

In the early 1960s that storm of protest and revolt swept through the South and then spread northward, bringing on a decade of black-led civil rights revolution and ending forever the prevailing structure of racial segregation. But the sociologists had provided no warning that such was to occur; a reading of the sociological literature, in fact, would lead one to believe that such was not going to happen. It became painfully obvious to some thoughtful sociologists of race relations that their work could no longer explain what was going on in the world of racial interests and actions. The race relations that appeared in their writings bore little resemblance to the race relations taking shape around them.

Perhaps the greater failure of those writings was their denigrating and inadequate conception of black people as culturally inferior and therefore incapable of acting effectively on their own behalf. The civil rights revolution of the 1960s dispelled that idea once and for all. But it was not until the 1970s that sociologists could acknowledge that blacks were a people with a distinct culture formed in the oppressive heat of slavery and segregation.

Also found wanting was sociology's confident faith that the inevitable outcome of modernization was a steady dissipation of prejudice and discrimination, a gradual assimilation of blacks into the society, and in time, a disappearance of black people as a distinct people. Instead, a heightened race consciousness prevails among black Americans, ethnicity has experienced a worldwide resurgence, and a multicultural movement has arisen to celebrate ethnicity and to seek legal and institutional means to ensure the persistence of ethnic cultures. Furthermore, belief in a progressively more rational social order is now doubted by many and disbelieved by some.

Over the past quarter century sociologists have continued to measure prejudice, discrimination, and still-existing segregation, but they have done little else to inform and educate the citizenry or the political, civic, and educational leadership. Now, late in the twentieth century, the contemporary discourse between white and black and within both races is discordant and without consensus on what to do. New developments, such as the emerging global economy and a new wave of immigration, make more complex the social context in which race relations are embedded. The task for sociologists is to do more than measure prejudice and discrimination, useful as that still is; they must provide analyses that take adequate account of these complexities while finding in them possibilities for racial progress.

REFERENCES

BLUMER, HERBERT. "Race Prejudice as a Sense of Group Position." *Pacific Sociological Review* 1 (1956).

DOLLARD, JOHN. *Caste and Class in a Southern Town.* New Haven, Conn., 1937.

DRAKE, ST. CLAIR, and HORACE R. CAYTON. *Black Metropolis: A Study of Negro Life in a Northern City.* New York, 1945. Rev. ed. New York, 1962.

ELLISON, RALPH. *Shadow and Act.* New York, 1964.

FRAZIER, E. FRANKLIN. *The Negro Family in the United States.* Chicago, 1939.

———. *Negro Youth at the Crossways: Their Personality Development in the Middle States.* Washington, D.C., 1940.

JOHNSON, CHARLES S. *Growing Up in the Black Belt: Negro Youth in the Rural South.* Washington, D.C., 1941.

———. *Patterns of Negro Segregation.* New York, 1943.

———. *Shadow of the Plantation.* Chicago, 1934.

KARDINER, ABRAM, and LIONEL OVESEY. *The Mark of Oppression: A Psychological Study of the American Negro.* New York, 1951.

MYRDAL, GUNNAR, with Richard Sterner and Arnold Rose. *An American Dilemma: The Negro Problem and American Democracy.* New York, 1944.

PARK, ROBERT. *Race and Culture.* Glencoe, Ill., 1950.

JAMES B. MCKEE

Softball. Several black players have excelled in softball, one of the most popular sports in the United States.

Frankie Williams was a player with the Raybestos Cardinals in Stratford, Conn. Williams batted more than .400 in three seasons, led his team in hitting in seven of ten years, and was named to the Amateur Softball Association (ASA) All-American team in 1957, 1958, and 1962.

Charles Justice, known as the Satchel PAIGE of softball, was inducted into the National Softball Hall of Fame in 1974. Justice pitched for various teams from the 1930s to the '60s, recording 873 wins and 92 losses.

Billie Harris was perhaps the greatest black woman softball player of all time. In a career that lasted from 1948 through 1975, Harris pitched 70 no-hitters and 4 perfect games and was named an ASA All-American three times. She was inducted into the National Softball Hall of Fame in 1982.

REFERENCE

ASHE, ARTHUR R. JR. *A Hard Road to Glory: A History of the African-American Athlete.* New York, 1988.

THADDEUS RUSSELL
BENJAMIN K. SCOTT

Sojourner Truth. *See* Truth, Sojourner.

Solomon, Job ben (Jallo) (c. 1703–1773), African prince and linguist. The extraordinary story of Job ben Solomon (an anglicized version of his original Arabic name) was well publicized in its day but has subsequently received little attention. A Fulbe, he was born and raised at Boonba in present-day Senegal, where he was educated as a Muslim and raised a family.

In 1731, Job was sent by his father Solomon to sell two slaves to Captain Pike, a British slaveship captain at Fort James on the Gambia River. After a series of misadventures, he himself was captured and sold by rival Mandingo people to the very same captain, who put him aboard the slave ship *Arabella* and carried him to Annapolis, Md.

Once in North America, he was sold to a planter in Kent Island, who renamed him Simon and put him to work in the tobacco fields. Unused to heavy labor, he collapsed and was transferred to cattle raising. His dignified bearing and cunning evidently pleased his master enough to prevent his getting whipped.

After a year in bondage, Solomon wandered off the plantation, perhaps in search of death. Apprehended and jailed in Delaware, he impressed his jailers (one of whom, Thomas Bluett, later wrote the main account of his life) with his devout Muslim faith. Before being retrieved by his master, he wrote a letter in Arabic asking his father to procure his release, which he had his jailers send to England for transport to Africa.

Once delivered to England, the letter came to the attention of James Oglethorpe, the humanitarian founder of the Georgia colony. Oglethorpe sent it to Sir Hans Sloane, a linguist at Oxford University, who translated it. The letter so intrigued Oglethorpe that he purchased Job ben Solomon and had him taken to England, although Oglethorpe had gone to found the Georgia colony by the time Solomon arrived in 1733. The literate, dignified Solomon soon became a sensation, and English aristocrats raised money to buy his freedom from Oglethorpe's bond. He returned to Africa the following year, and the slavetrading Royal African Company (RAC) hired him as an agent to stimulate trade. We know little of his later life. The Gentleman's Society of Spalding, which had admitted Job ben Solomon as a member during his time in England, listed his year of death as 1773.

REFERENCES

AUSTIN, ALLAN. *African Muslims in Antebellum America: A Sourcebook.* New York, 1984.
KAPLAN, SIDNEY, and EMMA NOGRADY KAPLAN. *The Black Presence in the Era of the American Revolution.* Rev. ed. Amherst, Mass., 1989.

GREG ROBINSON

Solomons, Gus, Jr. (August 27, 1940–), modern dancer. Born and raised in Boston, Mass., Gus Solomons began serious dance study while an architecture student at the Massachusetts Institute of Technology (MIT). Upon graduating in 1961, he moved to New York, where he performed with the companies of Donald McKayle, Pearl Lang, Joyce Trisler, and Paul Sanasardo. In 1965, Solomons joined the Martha Graham company for one season, though his most significant association during this period was with the Merce Cunningham company (1964–1968), for which he created roles in *Winterbranch* (1964) and *Rainforest* (1968).

Solomons formed the Solomons Company/Dance in 1971. Drawing on his experience at MIT, he conceived dance as "melted architecture" and undertook a clinical, postmodern approach to dance making that linked a fascination with puzzles and architectural design to the process of "kinetic autobiography." The resulting abstract, nonsequential choreography was marked by its lean incisiveness and effect of fragmentary collage. Choreography by Solomons has been performed by the Alvin Ailey Repertory Ensemble (*see* Alvin AILEY) and the Berkshire Ballet. About 1980, Solomons began to write exceptionally lucid dance criticism, which appeared in *Ballet News, Dance Magazine,* and the *Village Voice.*

REFERENCES

LONG, RICHARD. *The Black Tradition in American Dance.* New York, 1989.
MCDONAGH, DON. "Gus Solomons, Jr." In *The Complete Guide to Modern Dance.* Garden City, N.Y., 1976, pp. 549–553.

THOMAS F. DEFRANTZ

Sororities. *See* Fraternities and Sororities.

South, Edward "Eddie" (November 17, 1904– April 25, 1963), jazz violinist. Born in the town of Louisiana, Mo., Eddie South attended the Chicago Musical College, where he studied with Charles Elgar and Darnell Howard. He began playing professionally at the age of sixteen with Elgar and later with Mae Brady and Erskine Tate. In 1924, he became the music director of Jimmy Wade's Syncopators. South formed his own group, the Alabamians, and toured Europe beginning in 1928. During this period he studied in Paris and Budapest. In 1931, he came back to Chicago and organized a band with Milt Hinton and Everett Barksdale.

South returned to Europe to play short engagements in Paris and other cities (1937–1938). During this time he made a recording of J. S. Bach's *Concerto in D Minor for Two Violins* with Stephane Grappelli and Django Reinhardt. He moved permanently to the United States in 1938 and played long residencies in nightclubs and hotels in Chicago, New York, and Hollywood. In the 1940s, he had his own radio show, and in the 1950s he was a regular on television.

South is known for his impeccably clean left-hand technique, his dark tone, and his advanced bow technique. In addition to his performing skills, he was a creative composer for jazz violin, as shown in *Tzigane in Rhythm* and *Black Gypsie* (both influenced by his studies in Budapest and his collaboration with Reinhardt), *Fiddle Ditty,* and *Paganini in Rhythm* (a series of virtuoso variations based on Paganini's *Caprice No. 24*).

South left his impression on many musicians not only because of his concept of swing but also because of his classical training and performance. His admirers included Ray Nance, Leroy JENKINS, and the classical virtuoso Jascha Heifetz, who gave South the sobriquet "the Dark Angel of the Violin."

REFERENCES

CROWTHER, B. "The Forgotten Ones: Eddie South." *Jazz Journal International* 36, no. 8 (1983): 12.

GLASER, MATT, and STEPHANE GRAPPELLI. *Jazz Violin*. New York, 1981.

LYNN KANE

South Carolina. "The central fact of the history of black Carolina," concluded historian I. A. Newby, "has been the racism of white Carolina." South Carolina, first in nullification and first in secession, was also the first state to challenge the constitutionality of the 1965 Voting Rights Act. It was fitting that South Carolina should have taken a lead role in challenging the Voting Rights Act. The status of African Americans dominates the history of South Carolina as it does perhaps no other state. A black majority throughout most of the history of South Carolina has meant that the state's culture and history has been extraordinarily influenced by people of African heritage.

The early history of what is now South Carolina was triracial. The first blacks to join the Native American people there were African-Spanish slaves who rebelled against their captivity and were left behind in 1526 when the Spanish abandoned their short-lived settlement.

African Americans were a majority of South Carolina's population possibly as early as 1708, and they always remained the majority in the low country. Starting in 1748, however, the influx of white settlers

TABLE 1 African-American Population in South Carolina

Year	Slave	Free	% of total
1790	107,094	1,801	43.7%
1800	146,151	3,185	43.2
1810	198,365	4,556	48.8
1820	258,475	6,826	53.7
1830	315,401	7,921	55.6
1840	327,083	8,276	56.4
1850	384,984	8,960	58.9
1860	402,406	10,002	58.6
1870		415,939	58.9
1880		604,472	60.7
1890		689,141	59.8
1900		782,509	58.3
1910		836,239	55.1
1920		865,186	51.3
1930		794,716	45.7
1940		815,496	42.9
1950		823,622	38.9
1960		831,572	34.9
1970		796,086	30.7
1980		948,000	30.3
1990		1,400,000	40.1

into the back country gave the colony a white majority until the census of 1820, when African Americans again gained numerical superiority (see table 1). African slaves were introduced in greater numbers in South Carolina after white settlers immigrated to the North American mainland from Barbados, where black slavery was prevalent. African slavery came to predominate over other forms because of African Americans' relative immunity to malarial fever, the increasing profitability of slave labor, and the racial prejudices of white Europeans. By the time of the rice boom of the 1730s, African slavery was fixed upon South Carolina society. Once the cotton culture spread inland, slavery spread throughout South Carolina, so that by the 1820s the black population, while concentrated along the coast and the low country, had also spread throughout the state.

Africans influenced the ecology and the development of the colony since they adapted well to South Carolina's semitropical environment. Many Africans possessed botanical knowledge that Englishmen lacked, and they often had skills which, though common in England, were in short supply in the colony. Africans were particularly knowledgeable in herding cattle and planting rice, two skills that proved essential for survival and success in life on the frontier. In the early colonial frontier years, when skill meant survival, the color of a person had less effect on status than it would in the later history of the state.

The presence of a large number of Africans facilitated the development of the pidgin language Gullah—an amalgamation of European tongues and African dialects. The creolization seen in Gullah was also evident in the complex institutions, social structures, and arrangements that African Americans developed. Scholars who have studied slavery in various locations and periods have found strong families that transmitted values and a sense of community from generation to generation of black South Carolinians. Black families in slavery and in freedom were male headed and patriarchal, and most Africans became Christians, predominantly Methodists and Baptists.

African Americans' manifestations of day-to-day resistance to slavery included insolence, slowdowns, running away, feigning ignorance of procedures or tools, and secretly making fun of the whites. But the history of resistance to slavery in South Carolina was also punctuated by organized slave rebellions. The development of a syncretic African culture, symbolized by the rise of Gullah, led to formal political resistance in the STONO REBELLION of 1739. Many African warriors were active in this rebellion, which was brutally put down. In 1822 the recently freed Denmark Vesey used both African and Christian religious elements to organize a slave rebellion that was

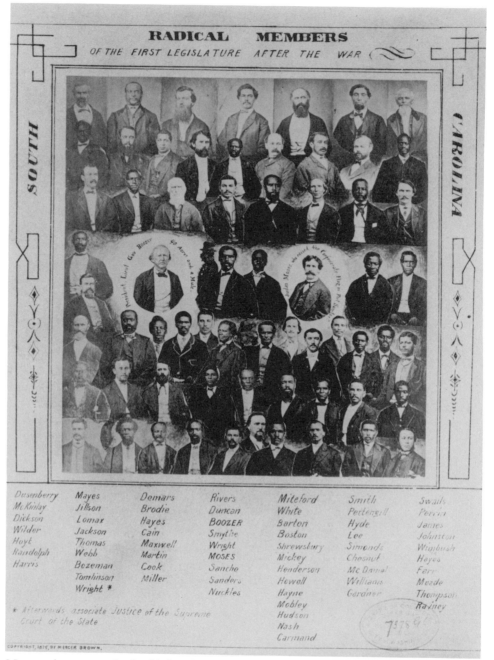

No southern state had a higher level of African-American participation in Reconstruction governments than South Carolina. From 1868 through 1876 a majority of the state legislators were black, and during the same period the state elected two black lieutenant governors, a state treasurer, and six black U.S. congressmen. (Prints and Photographs Division, Library of Congress)

supposed to begin in Charleston (see DENMARK VESEY CONSPIRACY). Many other smaller-scale slave revolts occurred in South Carolina.

African Americans were more successful in their fight for freedom in the two Seminole Wars (1816–1818 and 1835–1842), both of which were fought because Indians refused to surrender their African

American tribespeople. Moreover, white slaveholders wanted to secure their borders to keep slaves from running away to Native American groups. In 1816 native South Carolinian Andrew Jackson attacked a Seminole fort in West Florida because the fort harbored hundreds of runaway slaves, some from South Carolina. African-American participation in slave re-

bellions was heroic in the context of the armed camp that white South Carolinians imposed.

The large black population made most white South Carolinians unusually militant in their defense of slavery, and in the antebellum period the state held a high concentration of "fire-eaters," secession-minded, proslavery militants. South Carolina had been the leading advocate for the rights of slaveholders in the debates over the Declaration of Independence and the Constitution. Under the leadership of John C. Calhoun, South Carolina had attempted to nullify a federal tariff law in 1832 in order to establish a constitutional precedent for nullifying future antislavery legislation. South Carolina was the first state to secede from the Union, and a few months later, South Carolinians fired the first shot of the Civil War at Fort Sumter.

South Carolina possessed an active, though small, free black population. In 1790 three Charleston free blacks petitioned the state legislature, asking that they be recognized as citizens of South Carolina. This was the beginning of a long fight for equal political rights by African Americans in South Carolina. While the petition was denied, free blacks continued to play an active and vital role in South Carolina's life and culture. Charleston and coastal cities were the center of the free black community; however, the lives of free black Americans varied greatly. Free blacks in rural areas sometimes intermarried with whites; others married slaves. Some of South Carolina's free blacks, like ginmaker William Ellison of Statesburg, accommodated to the slavery system and rose to great wealth. Ellison supported the Confederates, and his grandson was wounded defending Fort Wagner from Union assault. Be that as it may, however, black support for the Confederacy during the CIVIL WAR, was minuscule.

If RECONSTRUCTION could have succeeded anywhere, it was in South Carolina, where blacks formed a majority of the population, and Reconstruction indeed lasted longer there than in most southern states. Male African Americans voted freely and won majorities in both houses of the General Assembly. In addition, eight African Americans won election to Congress, two became lieutenant governors, and many others served in nearly every state and local office.

Reconstruction in South Carolina experimented briefly with interracial democracy and responsive government, but most whites preferred the exclusion of African Americans from political power. The KU KLUX KLAN and other white paramilitary organizations violently opposed black enfranchisement. Eight Republican legislators were murdered during South Carolina's Reconstruction. White terror peaked during the critical 1876 election, which resulted in the election of Democrat Wade Hampton as governor and the defeat of the Republican state administration that African Americans had supported. African Americans retained power only in such majority-black areas as Beaufort, where black Civil War hero Robert SMALLS had his constituency. These areas continued to elect blacks to local and state offices and even to the U.S. Congress until most African Americans were totally disfranchised by the state constitution of 1896.

In the late nineteenth century South Carolina, like the rest of the South, witnessed the further erosion of African-American civil liberties and rights. By 1884 African-American registration in South Carolina had fallen to half the 1880 level. With the 1890 election of "Pitchfork" Ben Tillman to the governorship, South Carolina saw the first of several demogogic political leaders attain power. Tillman, Cole Blease, and in the 1940s, "Cotton" Ed Smith rode the race issue to political prominence. They succeeded in codifying segregation laws to further restrict black South Carolinians' voting rights. African Americans unsuccessfully challenged both the literacy test and the poll tax that southern states enacted after Reconstruction, and by 1940 segregation was entrenched in South Carolina society; only three thousand blacks, or 0.8 percent of voting-age African Americans in South Carolina, were registered to vote.

Between the middle of the nineteenth century and 1900, African Americans made up almost 60 percent of the population of South Carolina. This ratio changed as a result of the GREAT MIGRATION of the early twentieth century. Between 1910 and 1920 almost 275,000 blacks left South Carolina and headed north. While rural poverty and JIM CROW segregation provided the initial impetus for black migration, World War I and postwar agricultural depression intensified the desire to leave. A second migration occurred during World War II and the following decades. Between 1940 and 1960 an estimated 339,000 African-American South Carolinians left the state. Recent demographic trends suggest that the migration has reversed and African Americans are now moving back to South Carolina.

The modern CIVIL RIGHTS MOVEMENT in South Carolina began in 1942 when a small group of black activists organized the South Carolina Negro Citizen's Committee to challenge the all-white primary and encourage black voter registration. In the late 1940s and 1950s citizenship schools based on the model of Esau JENKINS and Septima CLARK of Johns Island were founded to help blacks obtain the right to vote and overcome racism. Martin Luther King, Jr.'s SOUTHERN CHRISTIAN LEADERSHIP CONFERENCE assumed the direction of the schools in the early 1960s,

and they became an effective tool of the civil rights movement.

In 1948, South Carolina Governor J. Strom Thurmond became the standard-bearer of the "Dixiecrat" revolt against the civil rights plank of the Democratic party. The South Carolina attorney general's office vociferously defended the principles of public school segregation before the U.S. Supreme Court in *Brown* v. *Board of Education,* in the 1950s, and the South Carolina congressional delegation resolutely opposed every civil rights bill proposed to Congress from 1957 to 1965.

African Americans believed that education was a key to freedom. Mayesville native Mary McLeod BETHUNE worked tirelessly to improve African Americans' educational opportunities. Education also became the foremost target of the civil rights movement in South Carolina. In the early 1940s the NAACP brought court cases to equalize teachers' salaries. Black South Carolinians' most dramatic and influential success against institutionalized racism involved the *Briggs* v. *Elliot* case against Clarendon County. This case initiated the famous *Brown* decision, which eventually outlawed segregated schools, and caused white leaders in South Carolina to begin equalizing the facilities of white and black schools in a desperate attempt to salvage segregation. Most schools in South Carolina did not integrate until the 1970s, however.

Other important developments in South Carolina included the work of NAACP activist and educator Modjeska SIMKINS and CORE activist James McCain, who provided the CONGRESS OF RACIAL EQUALITY its first foray into the South during the late 1950s. By 1958, McCain had established seven CORE groups throughout the state, which later proved instrumental in the South Carolina sit-in movement of 1960. Black activism often brought dire consequences. NAACP members were fired as teachers, and in some cases black leaders fled the state to avoid terrorist activity and legal persecution. However, these actions did not halt black agitation for an end to segregation, equal participation in the political process, and improved educational facilities.

Early civil rights activity helps explain why, on the eve of the 1965 VOTING RIGHTS ACT, 37 percent of eligible African Americans were already registered to vote in South Carolina. Although the struggle for fair elections continues, the Voting Rights Act brought enormous change to South Carolina politics. The increase in African-American voter registration and turnout almost immediately eliminated the white supremacist rhetoric that had been a hallmark of the state's political leaders. Increased African-American

representation has come more slowly. The black vote has become increasingly important to white Democrats. The black vote in South Carolina helped John. F. Kennedy narrowly claim victory in the state and propel him to the presidency in 1960. Black votes also helped Ernest F. Hollings win a Senate seat in 1966. In the state, black political success has come mainly on the county level. In 1970 three African Americans were elected to the lower house of the general assembly, marking the first time since 1902 that any black person had held state office. Even Sen. Strom Thurmond, the one-time segregationist, began to court the black vote.

In South Carolina today, the legal barriers that minimized black participation during the Jim Crow era are now disappearing, though racism is more subtle. Issues of at-large elections, staggered terms of office, numbered post provisions, reapportionment plans designed to keep white incumbents in office and exclude minorities, bloc voting by race, majority vote requirements, and other discriminatory practices banned by the Voting Rights Act remain prevalent today and continue to dilute black voting strength in South Carolina. Because of enforcement of the Voting Rights Act, however, African Americans today register to vote about as freely as whites in South Carolina. The NAACP worked successfully to create a black congressional district, and in 1992 South Carolinians elected a black U.S. congressman, James Clyburn. These gains have come from enforcement of federal laws, not from white leadership within the state.

Black South Carolinians have contributed in great measure to the artistic and cultural development of the state. Jazz great Dizzy GILLESPIE hailed from Cheraw, in the middle of the state, and rock star Chubby CHECKER was born in Trio. "Smokin' " Joe FRAZIER, the heavyweight boxing champion of the late 1960s, came from Laurel Bay, in Beaufort County. Arguably the greatest individual to call South Carolina home, the renowned black educator, preacher, and civil rights leader Benjamin E. MAYS, told an audience of black youths at Benedict College in 1926, "I will live in vain, if I do not live and act so that you will be freer than I am—freer intellectually, freer politically, and freer economically."

REFERENCES

BETHEL, ELIZABETH RAUL. *Promiseland: A Century of Life in a Negro Community*. Philadelphia, 1981.

DAVIS, MARIANNA. *The History of Blacks in South Carolina*. Written for the South Carolina Human Affairs Commission for the Bicentennial. Columbia, S.C., 1979.

"Prelude to Change: Black Carolinians in the War

Years, 1914–1920." *Journal of Negro History* 65, no. 3 (Summer 1980): 212–227.

WOOD, PETER H. *The Black Majority: Negroes in Colonial South Carolina from 1670 Through the Stono Rebellion.* New York, 1974.

ORVILLE VERNON BURTON

South Dakota. Throughout its history, South Dakota's black population has been tiny. Only 3,258 were counted in the 1990 census (a 52 percent increase in ten years), amounting to slightly less than one-half of one percent of the population. Fully a quarter of them lived at Ellsworth Air Force Base, near Rapid City. Despite the dearth of numbers, however, the black community has left a significant imprint on state history.

The first black person recorded in the area was York, a slave owned by William Clark and the only one of his color present on the Lewis and Clark expedition (1804–1806). In 1862, a year after Congress created Dakota Territory, the new territorial legislature considered a bill banning any black—bond or free—from entering the territory; the lower house rejected the proposal only after it had narrowly passed the upper house. However, the act setting up the territorial government barred blacks from voting. In repealing the ban on voting by blacks in 1868, the legislature also made the first provisions for the education of black children. Nevertheless, few former slaves or freedmen entered the area during the years after the Civil War. The 1870 census counted only 94 blacks in the entire territory, out of a population of slightly less than 13,000. Most of them had come from Missouri and the Gulf states. Yankton, on the Missouri River, became kind of a "port of entry" for those coming up the river on their way to Dakota. They made their livings as dockworkers, woodcutters, cattle drovers, and farmers in and around the territorial capital and other towns along the Missouri River.

A black cook, Sarah Campbell, was the only woman accompanying the 1874 Custer Expedition, which confirmed the presence of gold in the Black Hills. The subsequent gold rush included about a hundred blacks. Like their white counterparts, few found much gold; instead, blacks operated a dance hall, a gambling house, and a saloon, and found other ways to sustain themselves. Though discriminated against in the mining communities, blacks were generally tolerated by the white majority and fared better than did the more numerous Chinese.

If the black population of Dakota Territory was seldom the subject of attack before 1880 (by which time it numbered about four hundred), the situation changed with the arrival in that year of the all-black Twenty-fifth Infantry from duty along the Mexican border. They were stationed at three posts—Fort Randall, Fort Hale, and Fort Meade. In 1885, two incidents stirring up animosity between the black troops stationed at Fort Meade and the white population at the nearby town of Sturgis stimulated interracial tensions in the Black Hills. The Twenty-fifth was transferred out of South Dakota in 1892. Fourteen years later, when it was stationed in Brownsville, Texas, the unit ran into more serious prejudice when 167 of its members were summarily dismissed from the Army and the judgment of collective guilt was approved by President Theodore Roosevelt after a murky nighttime shooting affair known as the BROWNSVILLE, TEXAS, INCIDENT.

The effort to avoid such conflict may have motivated many blacks who came to South Dakota after statehood in 1889 to locate on isolated homesteads or as single families or individuals in small towns. The largest rural black settlement in the state—the Sully County Colored Colony, near Oneida—numbered fifty-eight at its peak in the 1920 census. The largest urban agglomeration during the early years of settlement was at Yanktown, which became the destination for a number of families from Alabama and elsewhere. Sixty-two were counted in 1890. Smaller numbers settled in towns like Sioux Falls, Mitchell, and Huron.

World War I was something of a watershed for blacks in South Dakota. At the start of the 1920s, there were 832 blacks in the state out of a total population of 636,547. Yankton was the largest center, with 102; Sioux Falls had 83, Huron had 56, Pierre had 18, and other communities trailed behind. Growing prejudice and discrimination during the decade, especially reflected in the activities of the KU KLUX KLAN, fostered organizational activities by blacks for their own protection and advancement. A chapter of the NATIONAL ASSOCIATION FOR THE ADVANCEMENT OF COLORED PEOPLE (NAACP) was organized in Sioux Falls, followed by one set up in Yankton. Depressed economic conditions in the 1930s further challenged South Dakota's black residents, who joined the heavy out-migration from the state. By the end of the decade, the Sully County Colony numbered only eighteen residents. With black enlistments in the military, even more of their number left the state during World War II, but there was also an influx of black servicemen training at bases in Sioux Falls, Rapid City, and other places. A war being waged against Nazi racism led many increasingly to call into question continued policies of discrimination and de facto segregation.

Though South Dakota was never a major destination for black migration, there were several efforts to establish independent black communities there. The women depicted here were members of Blair Colony County. The settlement numbered about sixty residents at its peak in 1920. (South Dakota Historical Society)

Change proceeded slowly during the years after World War II. Though remaining small in numbers, South Dakota's blacks took encouragement from the national civil rights movement, and overt discrimination began to recede by the late 1950s, sometimes to be replaced by its more subtle forms. Yet improvements in race relations were significant. National attention focused on the state in October 1962, when a *New York Times* story described discrimination against black servicemen in Rapid City bars, restaurants, barbershops, and other places. The state legislature responded by passing a public accommodations law banning racial discrimination in public places. A leader in that effort, Ted Blakey, the owner of a janitorial service and pest control firm in Yankton, served later as a delegate to the 1972 Republican National Convention. In 1988,

Kenny Anderson, the owner of a Sioux Falls laundromat and dry-cleaning establishment, became the first black person to be elected to the city council. Lagging behind most other states, South Dakota made Martin Luther King Day an official state holiday in 1990.

As they had for many years, the five A.M.E. churches in the state (two in Yankton, two in Sioux Falls, and one in Huron) played a central role in fostering cultural continuity among the state's black community. A rejuvenated NAACP chapter in Sioux Falls, whose black population almost tripled during the 1980s, became more active by the early 1990s. As South Dakota businesses attract more out-of-state workers and as colleges and universities enroll more blacks, changes will undoubtedly accelerate in the future.

REFERENCE

BERNSON, SARA L., and ROBERT J. EGGERS. "Black People in South Dakota History." *South Dakota History* 7 (1977): 241–270.

JOHN MILLER

Southern Christian Leadership Conference (SCLC).

Initially founded in January 1957 by the Rev. Dr. Martin Luther KING, Jr., and other young ministers who were active in local civil rights protest efforts across the South, the Southern Christian Leadership Conference (SCLC) soon became the primary organization through which the southern black church made significant contributions to the black freedom struggle of the 1960s.

Viewed by many as simply the institutional reflection of King's individual role as the CIVIL RIGHTS MOVEMENT's principal symbolic leader, SCLC in fact served a somewhat larger function. First, beginning in the late 1950s, SCLC drew together southern ministers who believed that the black church had a responsibility to act in the political arena and who sought an organizational vehicle for coordinating their activism. Second, in the years after 1961, when SCLC possessed a significant full-time staff, the organization pulled together important protest campaigns in Birmingham (1963) and Selma, Ala. (1965), that brought the southern struggle to the forefront of national attention and helped win passage of the landmark Civil Rights Act of 1964 and the VOTING RIGHTS ACT of 1965. Third, between 1965 and 1968, SCLC provided the means by which King extended his own national agenda for economic change to include protest campaigns in northern cities such as Chicago (1966) and Cleveland (1967), as well as supplying the institutional basis for the Poor People's Campaign of 1968.

Three principal influences shaped SCLC's founding. The first was the MONTGOMERY, ALABAMA BUS BOYCOTT of 1955 and 1956, a successful local protest effort that brought King to national attention and made him the symbol of new black activism in the South. Second, young ministers in other cities seeking to emulate the Montgomery example launched bus protests in cities such as Birmingham, Tallahassee, New Orleans, and Atlanta, and sought a forum for exchanging ideas and experiences. Third, New York–based civil rights activists Bayard Rustin, Ella Baker, and Stanley Levison, who already had helped garner northern funds and publicity for the Montgomery protest, began advocating the formation of a region-wide organization in the South that could

The Rev. Ralph Abernathy, who succeeded the Rev. Dr. Martin Luther King, Jr., as head of the Southern Christian Leadership Conference in 1968, stands in front of SCLC headquarters in Atlanta in 1970. (AP/Wide World Photos)

spread the influence of Montgomery's mass movement and provide King a larger platform.

Initially labeled the "Southern Negro Leaders Conference on Transportation and Nonviolent Integration" by King and Rustin, the conference met three times in 1957 before finally adopting Southern Christian Leadership Conference (SCLC) as its actual name. Seeking to avoid competition and conflict with the NAACP, SCLC chose to be composed not of individual members but of local organization "affiliates," such as civic leagues, ministerial alliances, and individual churches. Looking for a goal beyond that of desegregating city bus lines, King and the other ministers leading the conference—C. K. Steele of Tallahassee, Fred L. SHUTTLESWORTH of Birmingham, Joseph E. LOWERY of Mobile, and Ralph D. ABERNATHY of Montgomery—focused on the right to vote and sought to develop a program, staff, and financial resources with which to pursue it. Until 1960, however, their efforts largely floundered, in part because of other demands upon King's time and energy, but also because of personnel problems and relatively meager finances.

Transformation of SCLC into an aggressive, protest-oriented organization began in 1960 with King's own move from Montgomery to Atlanta and his appointment of the energetic Rev. Wyatt Tee WALKER as SCLC's new executive director. The coupling of Walker's organizational skills with King's inspirational prowess as a speaker soon brought about a sevenfold expansion of SCLC's staff, budget, and program. While some staff members concentrated on

voter registration efforts and citizenship training programs funded by northern foundations, Walker and King set out to design a frontal assault on southern segregation. Stymied initially in 1961 and 1962 in the southwest Georgia city of Albany, Walker and King chose the notorious segregation stronghold of Birmingham, Ala., as their next target. In a series of aggressive demonstrations throughout April and May of 1963, SCLC put the violent excesses of racist southern lawmen on the front pages of newspapers throughout the world. Civil rights rose as never before to the top of America's national agenda, and within little more than a year's time, the Civil Rights Act of 1964 began fundamentally altering southern race relations.

Following King's much-heralded success at the 1963 March on Washington and his receipt of the 1964 Nobel Peace Prize, SCLC repeated the Birmingham scenario with an even more successful protest campaign in early 1965 in Selma, focusing on the still widely denied right to register and vote. Out of that heavily publicized campaign emerged quick congressional passage of the Voting Rights Act of 1965. With King deeply convinced that the civil rights agenda required an expansion of the southern struggle into the North so as to directly confront nationwide issues of housing discrimination and inadequate education and jobs, SCLC in early 1966 shifted much of its staff and energies to an intensive organizing campaign in Chicago. Although the "Chicago Freedom Movement" eventually garnered a negotiated accord with Chicago Mayor Richard J. Daley, promising new city efforts to root out racially biased housing practices, most observers—and some participants—adjudged SCLC's Chicago campaign as less than successful.

Following limited 1967 efforts in both Cleveland and Louisville, SCLC late that year at King's insistent behest began planning a massive "Poor People's Campaign" aimed at forcing the country's political elite to confront the issue of poverty in the United States. Following King's assassination on April 4, 1968, however, SCLC's efforts to proceed with the campaign were marred by widespread organizational confusion. Although SCLC played an important role in a successful 1969 strike by hospital workers in Charleston, S.C., the organization's resources and staff shrank precipitously in the years after King's death. Internal tensions surrounding King's designated successor, the Rev. Ralph D. Abernathy, as well as wider changes in the Civil Rights Movement, both contributed significantly to SCLC's decline. Only in the late 1970s, when another of the original founders, Joseph E. Lowery, assumed SCLC's presidency, did the conference regain organizational stability. But throughout the 1980s and into the early 1990s, SCLC continued to exist only as a faint shadow of the organization that had played such a crucially important role in the civil rights struggle between 1963 and 1968.

REFERENCES

FAIRCLOUGH, ADAM. *To Redeem the Soul of America: The Southern Christian Leadership Conference and Martin Luther King, Jr.* Athens, Ga., 1987.
GARROW, DAVID J. *Bearing the Cross: Martin Luther King, Jr., and the Southern Christian Leadership Conference.* New York, 1986.

DAVID J. GARROW

Southern Poverty Law Center. In 1970, the Southern Poverty Law Center (SPLC) was founded in Montgomery, Ala., as a nonprofit civil rights organization by Morris Dees and Joseph Levin, white attorneys and businessmen. The SPLC was originally intended to direct litigation against racist organizations and, despite its name, was not concerned directly with economic legal issues. Civil rights activist and politician Julian BOND was enlisted as president of the SPLC, a largely honorary position, with Dees serving as executive director and Levin as legal director. (Bond resigned in the late 1970s, citing time constraints.)

In the 1970s, the SPLC successfully litigated to compel the Alabama legislature to divide itself into single-member districts, assuring the election of the first black assemblyman since Reconstruction and the desegregation of the Alabama state police. The center also lobbied against the death penalty in the South and raised money for the defense of African Americans prosecuted for murder.

In the 1980s, the SPLC focused its attention on litigation and public education directed against the KU KLUX KLAN and other racist organizations. Randall Williams was hired in 1981 to direct the formation of Klanwatch, a region-wide monitoring and research unit providing public exposure of racist terrorist groups. Klanwatch published annual reports on the size and activities of racist organizations and distributed films and videos documenting their activities.

In 1983, the center's offices were firebombed, destroying much of the building and some of the Klanwatch files. Three suspects associated with white supremacist groups pleaded guilty in 1985 and were sentenced to fifteen-year prison terms. After the firebombing, the SPLC's fund-raising was far more successful, and the organization built a new headquarters building in Montgomery. In the late 1980s and early '90s, the SPLC won a series of court victories against the Ku Klux Klan, including

multimillion-dollar damage judgments in 1987 and 1993 that effectively wiped out several Klan branches. In 1991, NBC promoted the center's renown by broadcasting the television movie *Human Target: The Morris Dees Story*. The center has not been without its critics, however. Some charge that the SPLC's focus on the Klan comes at the expense of more fundamental antipoverty work and that the group has exaggerated the threat posed by hate groups. The SPLC countered with several studies demonstrating a marked increase in the size and militance of racist groups across the United States in the 1980s and the early '90s.

REFERENCES

EGERTON, JOHN. "Poverty Palace: How the Southern Poverty Law Center Got Rich Fighting the Klan." *Progressive* (July 1988): 14.
WILKIE, CURTIS. "Lawsuits Prove to Be a Big Gun in Anti-Klan Arsenal." *Boston Globe*, June 17, 1993, p. 1.

THADDEUS RUSSELL

Southern Regional Council. The Southern Regional Council (SRC), whose headquarters are in Atlanta, is an interracial information and research group. While the SRC officially began its work in 1944, it grew out of an earlier organization, the Commission on Interracial Cooperation (CIC). The CIC was formed in 1919 in an attempt to lessen the widespread racial violence that followed World War I.

The CIC, while devoted to interracial activity, originally had an all-white organizational structure. It sought to bring moderate leaders of both races together to prevent continued rioting and racial violence. Its members, white businessmen and professionals, sought to remove white supremacy as a burden on regional development. CIC leaders relied on moral suasion, conciliation, and education to create change in race relations. The commission, designed for study, investigation, and publication of information on race, avoided taking political stands on racial matters. They attracted funding from major foundations concerned with black welfare, including the Julius Rosenwald Fund and the Carnegie Foundation.

By the mid-1920s, the CIC had become a major conduit for northern philanthropic funds for black activism in the South, a practice the SRC would continue. Under the leadership of Will W. Alexander, a liberal minister, the organization took a more activist role. The Women's Council of the CIC had formed in 1920, following a meeting of representatives of white church and secular women's groups at which black women spoke out against discrimination and

violence in the South. In 1930 Alexander hired the white activist Jessie Daniel Ames to organize the Association of Southern Women for the Prevention of Lynching (ASPWL), which collected signatures from 40,000 white women on a petition challenging the notion that LYNCHING was done in defense of white womanhood.

After 1942 and 1943 conferences in Durham, N.C., Atlanta, and Richmond, Va., the CIC dissolved into a new organization, the Southern Regional Council, designed to be more scientific and interracial and less paternalistic in nature than the CIC. The SRC had a core of black and white college presidents. At first, it remained as conservative as the CIC, but pressure from African-American and liberal white members caused a slow shift. Finally, in 1949, the council's magazine, *New South*, denounced segregation.

Throughout the 1960s, the SRC challenged segregation and discrimination in the South. A primary center for interracial cooperation, the SRC attempted to raise public awareness through publishing and collecting numerous studies, newsletters, and reports on racial conditions and the CIVIL RIGHTS MOVEMENT, including influential reports on the sit-in movement and on the Albany Movement on its first anniversary (*see* SIT-INS). The SRC also offered training in setting up interracial commissions and sent observers to demonstrations and meetings. The SRC had published numerous studies detailing denial of voting rights, and in 1962 the Field and Taconic foundations and the Edgar Stern Family Fund granted the SRC several thousand dollars to establish and direct a two-year VOTER EDUCATION PROJECT (VEP). The VEP, headed by Vernon JORDAN, evaluated and distributed funds to voter-registration programs carried out by various civil rights organizations.

The SRC remains active in interracial regional development efforts through prison reform, conflict resolution, urban planning, and other areas.

REFERENCES

BLUMBERG, RHODA LOIS. *Civil Rights: The 1960s' Freedom Struggle*. Boston, 1991.
HALL, JACQUELYN DOWD. *Revolt Against Chivalry: Jessie Daniel Ames and the Women's Campaign Against Lynching*. New York, 1974.

MARGARET D. JACOBS

Southern Tenant Farmers' Union, labor organization. The Southern Tenant Farmers' Union (STFU) was an interracial labor organization that emerged during the GREAT DEPRESSION of the 1930s. While its greatest strength was in Arkansas, the

STFU also made inroads in Missouri, Alabama, Oklahoma, and parts of Mississippi and Texas. Although composed primarily of black and white tenants, in the Southwest the union attracted Native Americans and Mexican Americans as well, The STFU's initial demand, to obtain a more equitable share of government resources for tenant farmers, quickly metamorphosed into a broad vision of a cooperative commonwealth driven by collective agriculture; its slogan was "Land for the Landless." The STFU weakened considerably in the 1940s and '50s, but it helped lay the basis for the dynamic organization of migrant farm workers in the 1960s and '70s, under the banner of the United Farm Workers of America.

By the 1920s southern agriculture rested on a brutally exploitative labor system built on farm tenancy, sharecropping, and debt peonage. When the depression hit, the price of agricultural goods plummeted, and the condition of black and white tenants deteriorated dramatically. Under the leadership of President Franklin D. Roosevelt, the federal government's efforts to remedy the farm price crisis by curtailing production led to the displacement of many tenant farmers. As a result, New Deal programs such as the Agricultural Adjustment Act not only failed to alleviate the suffering of impoverished tenants, it actually worsened their situation.

In this context, the Southern Tenant Farmers' Union was born. In July 1934, in a schoolhouse on the Fairview Plantation near Tyronza, Ark., eighteen men—eleven of them white and seven black—gathered to organize around the crisis facing tenant farmers in cotton agriculture. Both white and black representatives agreed that their efforts could only succeed if they preserved interracial unity. Isaac "Ike" Shaw, a survivor of the ELAINE, ARKANSAS, RACE RIOT of 1919, recalled the vulnerability of black farmers who had tried to organize on their own. Others noted that if the races organized separately, planters would be better able to divide them. Among the leaders were two white businessmen, H. L. Mitchell and Clay East, who had ties to the Socialist party (see SOCIALISM) and drew on its resources for support.

Southern planters were quick to recognize the potential threat that the STFU posed to their captive labor system. Both the union's interracial character and its left-wing associations drew special wrath. STFU activists were arrested on such charges as "criminal anarchy" and addressing black men as "Mister." Members were viciously attacked, their homes shot up, and their churches burned down. Deputies broke up STFU meetings, and planters conducted wholesale evictions of pro-union tenants. The brutal reign of terror made union activity especially risky for black tenants, and several black STFU organizers were lynched. The union was forced to move its headquarters to Memphis, Tenn.

Despite the forces arrayed against it, however, the STFU continued to grow, peaking at an estimated

The Southern Tenant Farmers' Union was one of the few successful interracial organizing efforts in the South prior to World War II. Members of the union meet in a schoolroom in Muskogee, Okla., May 1939. (Prints and Photographs Division, Library of Congress)

31,000 in 1938. It scored some significant victories through its organizing efforts. In fall 1935 the union called its first strike, demanding payment of $1.00 per 100 pounds of cotton (the prevailing rate was forty to sixty cents) but privately agreeing to accept seventy-five cents. Despite the arrest and intimidation of unionists, the walkout was a tremendous success and brought thousands of new members into the union. At the same time, the publicity generated by mistreatment of sharecroppers forced the federal and Arkansas state governments to investigate conditions in cotton country and to take some limited action on the tenants' behalf. With the help of advocates in Washington, the STFU leadership was able to meet with government officials and press their case. Finally, by focusing the national spotlight on the plight of sharecroppers—most notably in early 1939, when nearly 2,000 evicted tenants camped out on the highways of southeastern Missouri and were forcibly removed by state troopers—the STFU was able to attract support from a variety of sources, including the NATIONAL ASSOCIATION FOR THE ADVANCEMENT OF COLORED PEOPLE, the NATIONAL NEGRO CONGRESS, and the American Civil Liberties Union.

Although the composition of the STFU's membership varied greatly from country to country, African Americans comprised at least half—and at times nearer 80 percent—of the union's total rank and file. The national leadership structure was almost evenly divided between blacks and whites, although it appears that the president was always white and the vice president was always black. Among the union's most prominent black activists were E. B. McKinney, a minister and the STFU's first vice president, who had been influenced by the teachings of Marcus GARVEY. Other black organizers, such as Carrie Dilworth, went on to play an active role in the CIVIL RIGHTS MOVEMENT of the 1950s and '60s. The STFU's early annual conventions were addressed by important African-American leaders, including Walter WHITE, Roy WILKINS, and A. Philip RANDOLPH.

In the late 1930s the STFU split in a struggle between communist and socialist factions that turned on issues of union autonomy and the treatment of black tenants. By the 1940s and '50s, both sides were so weak organizationally, politically and financially, that neither was able to recapture the momentum of the early years. The original STFU was reconstituted as the National Agricultural Workers Union, AFL-CIO, but with the mechanization of agriculture its successes were limited and sporadic. Still, its legacy serves as a potent, if rare, example of interracial labor solidarity, at a place and time—the South in the midst of the depression—when desperate economic circumstances and deep racial divisions might have been expected to doom such a project to failure.

REFERENCES

GRUBBS, DONALD H. *Cry from the Cotton: The Southern Tenant Farmers' Union and the New Deal.* Chapel Hill, N.C., 1971.

KESTER, HOWARD. *Revolt Among the Sharecroppers.* New York, 1936.

MITCHELL, H. L. "The Founding and Early History of the Southern Tenant Farmers Union." *Arkansas Historical Quarterly* 32, no. 4 (Winter 1973): 342–369.

———. *Mean Things Happening in This Land: The Life and Times of H. L. Mitchell, Co-Founder of the Southern Tenant Farmers Union.* Montclair, N.J., 1979.

NAISON, MARK. "Black Agrarian Radicalism in the Great Depression: The Threads of a Lost Tradition." *Journal of Ethnic Studies* 1, no. 3 (1973): 47–65.

TAMI J. FRIEDMAN

Space Program, Blacks in the. *See* Aerospace.

Spanish-American War. During the brief Spanish-American War, African-American soldiers and officers distinguished themselves at home and overseas, on the battlefield, and in the training camps. At the same time, the segregation and racism which was a pervasive part of American society in 1898 was not absent from this conflict.

In February 1898 the U.S.S. *Maine* exploded in Havana harbor. There were 22 African-American seamen among the more than 200 sailors and officers who lost their lives. This event fueled American demands for punishing Spain and freeing Cuba from Spanish control. The initial response of the Army was to transfer some regular regiments to the South, including all four African-American units. Then the War Department decided to expand all of the organizations, and efforts were made to recruit them up to full strength. At the same time, state regiments were getting ready to participate in the war. This included regiments or smaller elements in Virginia, Alabama, North Carolina, Illinois, Ohio, Kansas, and Massachusetts. In April and May, these regiments entered into federal service, sometimes with African-American officers (such as the 9th Ohio Battalion, commanded by Charles Young) and in other cases with whites replacing the African Americans (such as in the case of the 6th Virginia). In addition,

Lieutenant Edward L. Baker of the 49th Infantry of the U.S. Volunteers in San Francisco in 1899. Baker was awarded the Congressional Medal of Honor for bravery in battle in Cuba during the Spanish-American War in 1898. (Photographs and Prints Division, Schomburg Center for Research in Black Culture, The New York Public Library, Astor, Lenox and Tilden Foundations)

Cavalry (the Rough Riders) came under fire first; then other units in the force, including the African-American cavalrymen, joined in the attack. After firing a few rounds, the Spanish retreated. There were only a limited number of casualties among the soldiers during the ninety minutes of fighting.

The major attack on the Spanish occurred on July 1, 1898, at two different positions—the San Juan Hills and El Caney. Gen. Shafter devised a plan which called for an assault on the blockhouse at El Caney and then required those forces to join in a general assault on the positions on the hills. This strategy did not work, and there were two separate battles.

The 25th Infantry was an important element in the assault on El Caney. They approached the position under continual Spanish fire and took a considerable number of casualties (seven killed and 25 wounded) as a result. Pvt. Conny Gray won a commendation for assisting his wounded captain to safety despite the large volume of enemy fire.

The assault on the San Juan Hills involved the largest part of the invasion force and the other three African-American regiments. Individual unit officers and noncommissioned officers displayed tremendous leadership abilities and heroism in the face of enemy fire. Walking through the jungle toward the hills, they began to receive fire from the Spanish artillery. The volume increased as they came to the base of the San Juan Hills. Individual units, in an uncoordinated fashion, began to charge up the hill. This resulted in the Spanish fleeing. Thirteen enlisted men died and 137 were wounded from the three regiments. Nu-

the federal government raised ten volunteer regiments, including four regiments with African-American enlisted personnel and lower-ranking officers (the 7th through 10th Volunteer Infantries).

In May most regular Army regiments gathered in Tampa preparatory to embarking for Cuba. Some white Floridians resented the presence of the four African-American regiments and harassed them. On several occasions the soldiers responded with threats and even a few bullets. The situation remained tense until the expeditionary force embarked for Cuba in June. After an uneventful but hot voyage to Cuba, the expedition disembarked at Daiquiri and Siboney.

There were three major engagements in the Cuban campaign, and the African-American units distinguished themselves in all three.

Elements of the 10th Cavalry participated in a skirmish at Las Guasimas on June 24. Gen. Joseph Wheeler impetuously pushed some units up the trail toward Santiago and encountered a small Spanish position in the jungle. Elements of the 1st Volunteer

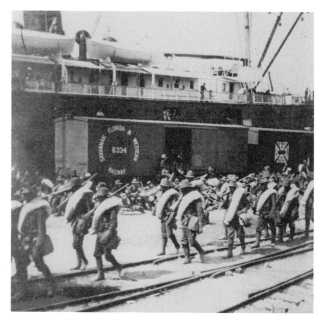

Tenth U.S. Cavalry embarking for Cuba at Port Tampa, Fla., October 29, 1898. (Florida State Archives)

merous spectators, including John J. Pershing, an officer in the 10th Cavalry, praised their heroism. Sgt. Edward Baker, a member of the 10th Cavalry, won a Congressional Medal of Honor for rescuing a wounded soldier who was drowning.

Following the conclusion of the attack, the Spanish retreated into Santiago. The Army laid siege to the city, which surrendered on July 17. During this period, disease was a major problem, as yellow fever became widespread. Medical care was inadequate. Members of the 24th Infantry volunteered for service at the Army hospital at Siboney. They were accepted, apparently out of the widely held belief that African Americans were more immune to the disease than whites. Service at the hospital soon indicated otherwise as most of the men were sick at some point during their month at the facility.

Not all of the Cuban campaign was conducted around Santiago. Some members of the 10th Cavalry participated in a guerrilla operation in conjunction with the Cubans. Four members of the detachment were awarded Congressional Medals of Honor for their activities along the southwestern coast of Cuba. They joined one African-American sailor who also received this award.

The public honored all of the troops, including the African-American units, upon their return to the United States. They participated in some of the victory parades before returning to their regular duties. However, Theodore Roosevelt, in *The Rough Riders*, his account of the war, cast doubt on their courage and leadership abilities. This was hotly disputed by a number of members of the regiments. It served as an indicator of Roosevelt's ambivalent attitude toward African Americans.

Most of the federal and state volunteer regiments spent the Spanish-American War in training camps in the South. In addition to participating in the normal camp activities, they also had to endure racial hostility from some of the white troops and the civilian population. A few of the regiments, such as the 9th United States Volunteer Infantry and the 23rd Kansas, later acted as garrison troops in Cuba. The African-American company in the 6th Massachusetts participated in the invasion of Puerto Rico. All of the units raised during the war were demobilized in early 1899.

REFERENCES

FLETCHER, MARVIN E. *The Black Soldier and Officer in the United States Army, 1891–1917.* Columbia, Mo., 1974.
NALTY, BERNARD C. *Strength for the Fight: A History of Black Americans in the Military.* New York, 1986.

MARVIN E. FLETCHER

Spaulding, Charles Clinton (August 1, 1874–August 1,1952), entrepreneur. C. C. Spaulding was born in Columbus County, N.C. As a youth he worked on his father's farm and attended the local school until 1894, when he joined his uncle, Aaron Moore, the first black physician to practice in Durham, N.C. In Durham, after graduating from high school in 1898, Spaulding held a variety of jobs, before becoming the manager of a cooperative black grocery store. While there, he also sold life insurance policies for the North Carolina Mutual and Provident Association, founded in 1898 by seven black men, including his uncle. When the Mutual floundered in 1900 and most of the founders resigned their positions, Moore became secretary, and John Merrick, who served as president, hired Spaulding to become the general manager. The three men then constituted the board of directors. With the death of Merrick in 1919 and the reorganization of the company as the North Carolina Mutual Life Insurance Company, Spaulding became secretary-treasurer, and with the death of Moore in 1923, president, a position he held until his death in 1952. Under his leadership, the Mutual became the nation's largest black insurance company, a position which it maintains today.

As the head not only of the Mutual but also of its numerous subordinate institutions—banks, a real estate company, and a mortgage company—Spaulding was the most powerful black in Durham and among the most powerful in the nation. His endorsement enabled black initiatives to receive financial support from prominent white foundations, such as the Duke and Rosenwald foundations and the Slater Fund. Spaulding used this power to save such black institutions as Shaw University, Virginia Theological Seminary, and the National Negro Business League from insolvency, and to influence the press, church sermons, school curriculums, and the allocations of public funds. With the onset of the GREAT DEPRESSION, both state and federal governments acknowledged Spaulding's stature, appointing him to relief committees. In 1933 the NATIONAL URBAN LEAGUE made him national chairman of its Emergency Advisory Council, whose purpose was to obtain black support for the National Recovery Administration (NRA) (one of the most important programs of the first phase of President Franklin D. Roosevelt's New Deal), to inform blacks about new laws regarding relief, reemployment and property, and to receive complaints of violations against blacks. Spaulding worked enthusiastically in this position, but his early hope that the NRA would bring a new era of fairness for blacks quickly soured.

As with his work for the Emergency Advisory Council, throughout Spaulding's career there was a

tension between his desire to address the causes of black poverty and his need to protect his moderate image. In 1933 Spaulding introduced two local lawyers, Conrad Pearson and Cecil A. McCoy, who wanted to integrate the University of North Carolina, to NAACP secretary Walter WHITE, but as the case, *Hocutt* v. *North Carolina,* gained publicity, Spaulding withdrew his support, without which it could not be won, and worked instead for reform that did not threaten segregation, such as out-of-state tuition and equal teachers' salaries. However, by the middle of the 1930s, Spaulding actively supported the return of suffrage to blacks and served as chairman of the executive committee of the Durham Committee on Negro Affairs (founded 1935), which was responsible for the registration of thousands of black voters. Because its endorsement insured candidates on average 80 percent of the black vote, the DCNA was a political force on Durham.

With the onset of World War II, Spaulding became concerned almost exclusively with unifying blacks and whites in the name of patriotism. He invested much of the Mutual's assets in the war effort, buying $4,450,000 in war bonds, and traveled and gave speeches as associate administrator of the War Savings Staff. After the war, Spaulding focused on the threat he believed communism posed to business. An article he wrote for *American Magazine* proclaiming its danger was incorporated into high school textbooks and was reprinted in a variety of languages.

REFERENCE

FRANKLIN, JOHN HOPE, and AUGUST MEIER. *Black Leaders of the Twentieth Century.* Chicago, 1982.

SIRAJ AHMED

Speechmaking. *See* Oratory.

Spelman College. Spelman College is the oldest black women's college in the United States. Located in Atlanta, Ga., Spelman is a four-year, liberal arts institution that has traditionally offered both the B.A. and B.S. degrees. Renowned for scholastic excellence and community involvement, Spelman was also one of the founding institutions of the ATLANTA UNIVERSITY CENTER.

Spelman College was founded in April 1881 as the Atlanta Baptist Female Seminary by Sophia B. Packard and Harriet E. Giles, two New England educators who had long been involved in education for women. While Packard and Giles were conducting a survey on the condition of the freepersons in the South for the Women's American Baptist Home Mission Society (WABHMS), they became increasingly distressed over the lack of schools for black women. Upon their return to Boston, they were determined to raise the funds necessary to open a school for black females in the south. After receiving $100 from the First Baptist Church of Medford, Mass., WABHMS finally agreed to sponsor their effort. They arrived in Atlanta where they met with the Reverend Frank Quarles, who offered the basement of his Friendship Baptist Church as the first home for the new school. When the school opened, there were eleven students; fifteen months later there were eighty pupils in regular attendance.

Desperate for financial support, the two women traveled to Cleveland in the summer of 1882 to speak at a church meeting. In attendance at that meeting was John D. Rockefeller, who pledged $250 toward a building for the school. It was the first of his donations toward black education, which eventually totaled millions of dollars.

In 1883 the school moved into what were former Union Army officer barracks, which had been purchased by the American Baptist Home Mission Society (ABHMS). The school had grown to 293 students with over thirty boarders. Industrial courses, paid for by a grant from the SLATER FUND, were also begun that year. A model school was opened for observation and practice teaching, and as a result, an elementary normal course was introduced.

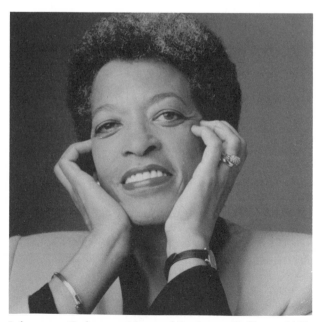

Johnnetta Cole, president of Spelman College. (Allford/Trotman Associates)

The buildings were paid off with the help of financial gifts from Rockefeller, and the school continued to grow. In honor of Laura Spelman Rockefeller (John D. Rockefeller's wife), the name of the school was changed to Spelman Seminary in 1884. The school was officially designated for females only and had grown to over 350 day pupils and 100 boarders. The students were taught a traditional New England classical curriculum. Courses included mathematics, English grammar and literature, geography, and natural philosophy. The girls' education was comparable to the education boys were receiving at nearby Atlanta Baptist Seminary, which later became Atlanta Baptist College and (in 1913) MOREHOUSE COLLEGE. In a spelling match against the boys, the girls from Spelman took top honors. In addition, the girls were also taught cooking, sewing, general housework, and laundry skills.

A printing press was purchased as a result of another gift from the Slater Fund, and the *Spelman Messenger* began publication in March 1885. Students were trained in typesetting and composition and began to contribute articles to the publication. The first six high school graduates of Spelman Seminary completed their work in 1886.

In 1888 Spelman was incorporated and granted a charter from the state of Georgia. Two African Americans were members of the original board, and one was on the executive committee of five. In time, the school was increasingly separated from ABHMS as more and more financial resources were provided by philanthropic organizations.

In 1901 the first baccalaureate degrees were conferred upon two Spelman students who had completed the requirements by taking several college-level courses at Atlanta Baptist College. Spelman continued to grow, new buildings were built, and more lots were purchased. The new buildings led to a constant struggle to stay financially sound, and the board began to seek a source to establish a permanent endowment.

In 1924, after a science building was completed, Spelman was finally in a position to offer a full range of college-level courses. As a result, the name was changed to Spelman College. Sisters chapel was completed in 1927, and Florence Read became the new president of Spelman. Read placed tremendous emphasis on the development of a strong liberal arts college and greatly increased the college's endowment. The endowment was $57,501 in 1928 and grew to $3,612,740 by the time Read retired in 1953. The elementary school was finally abolished in 1928, as was the nurses training department. Cooperation with Morehouse College was expanded in 1928–1929. Three members of the faculty were jointly employed, other teachers were exchanged, courses on each campus were opened to juniors and seniors, and the summer school was in joint operation.

Due to constant financial pressures, in 1929 Spelman agreed to a contract of affiliation with Atlanta University and Morehouse College. This allowed them to pool their financial and administrative sources and thus eliminate redundant functions. Part of the agreement required Spelman to eliminate its high school, whose students and function were shifted to Atlanta University, though they were supported by all three affiliates.

Spelman became fully accredited in 1930 by the Association of American Colleges. The Great Depression led to a financial squeeze, but Spelman survived and maintained its standard of excellence. The 1940s saw further growth, both physically and scholastically.

In 1953 Spelman got its first African-American president with the appointment of Albert E. Manley. The contract of affiliation was expanded in 1957 to include other Atlanta area colleges, and the school became the Atlanta University Center.

Spelman students were very active in the CIVIL RIGHTS MOVEMENT of the 1960s. They participated in sit-ins at segregated public sites in Atlanta, and several were arrested. Two Spelman students were cofounders of the STUDENT NON-VIOLENT COORDINATING COMMITTEE, and in 1960 Martin Luther King, Jr., delivered the Founder's Day address. In 1961 a non-Western studies program (in cooperation with Morehouse College) was initiated with the help of a grant from the Ford Foundation. In 1969 a BLACK STUDIES program was officially added to the curriculum.

In 1976 Dr. Donald Mitchell Stewart assumed the presidency amid protests from students and faculty, who demanded the appointment of a black woman to that post. That was not to take place until 1987, when Dr. Johnnetta Betsch Cole became the first such president of Spelman College. The following year, $20 million was donated by Bill and Camille COSBY, part of which went into a new building program. In 1992 Spelman had close to two thousand students, 97 percent of whom were African Americans.

REFERENCES

GUY SHEFTALL, BEVERLY, and JO MOORE STEWART. *Spelman: A Centennial Celebration.* Atlanta, Ga., 1981.

READ, FLORENCE. *The Story of Spelman College.* Princeton, N.J., 1961.

ROEBUCK, JULIAN B., and KOMANDURI S. MURTY. *The Place of Historically Black Colleges and Universities in American Higher Education.* Westport, Conn., 1993.

CHRISTINE A. LUNARDINI

Spencer, Anne (Scales, Annie Bethel) (February 6, 1882–July 27, 1975), poet. Born on a plantation in Henry County, Va., Annie Bethel Scales moved with her mother to Bramwell, W. Va., a mining town, at the age of five when her parents separated. Her mother, Sarah Louise Scales, the proud daughter of a former slave and of a wealthy white Virginian, would not let Annie attend the local school with the miners' children. As a result, Annie barely knew how to read when she was enrolled, at age eleven, in the Virginia Seminary at Lynchburg, Va. She quickly made up for lost time and discovered a love for literature, writing her first poem, "The Skeptic," in 1896. As the valedictorian at her graduation in 1899, she gave a speech, "Through Sacrifice to Victory," about the plight of blacks in the United States.

This early concern for African Americans prompted Spencer to take an activist's role many times in her life, yet her poetry has been criticized for not reflecting activist issues. A strong individualist who was influenced by Ralph Waldo Emerson's theory of self-reliance, she felt no need to justify her choice of topics, saying simply, "I write about some of the things I love. But have no civilized articulation for the things I hate." In fact, although her poetry deals mostly with love and friendship, it does contain elements of racial pride and indignation, especially in "White Things," written in 1918, after Spencer read reports of the brutal lynching of a pregnant black woman.

After graduation, Scales taught in Maybeury, Elkhorn, and Naola, W. Va., before marrying her high school sweetheart, Edward Spencer, in 1901, and settling with him at 1313 Pierce Street in Lynchburg. There she raised their three children and tended her famous garden, which figured prominently in much of her poetry. Her first poem was published in 1920, after James Weldon JOHNSON discovered her work. As field secretary for the NAACP, he met Annie Spencer when he helped her form a local chapter of the NAACP. He convinced her to use the pen name Anne Spencer, and forwarded her work to publishers. The CRISIS published "Before the Feast at Shushan" in 1920, and subsequently Anne Spencer's work appeared in magazines and anthologies, including Johnson's *The Book of American Negro Poetry* (1922), Louis Untermeyer's *American Poetry Since 1900* (1923), Countee CULLEN's *Caroling Dusk* (1927), and Richard Ellmann and Robert O'Clair's, *The Norton Anthology of Modern Poetry* (1973). Fame brought friendships with such prominent figures as Paul ROBESON, Langston HUGHES, and W. E. B. DU BOIS, who all found the Spencer's home a congenial place to stay in the South, where decent travel accommodations for blacks were scarce.

In 1923, Anne Spencer walked (she refused to ride in segregated buses) to Lynchburg's segregated Jones Memorial Library and applied for a job. She was hired, and, in 1924, at her urging, a new branch of the library was opened at Dunbar High School. Spencer served as librarian of this first public library facility available to blacks in Lynchburg until her retirement in 1945. In 1975, two months before her death, she was awarded an honorary Doctor of Letters degree from her alma mater. In 1977, her house and garden were declared a historical landmark.

REFERENCES

GREENE, J. LEE. *Time's Unfading Garden: Anne Spencer's Life and Poetry.* Baton Rouge, La., 1977.
HINE, DARLENE CLARK, ed. *Black Women in America.* Brooklyn, N.Y., 1993.

LYDIA MCNEILL

Spencer, Peter (1782–1843), church founder. Born a slave in Kent County, Md., Spencer gained his freedom at his master's death and subsequently moved to Wilmington, Del. In Wilmington, he was educated at a school operated by Quakers for free blacks. He joined the Asbury Methodist Episcopal Church, but in 1805, with William Anderson, he led a group of blacks out of the predominantly white congregation to protest the discrimination they experienced there. They found a building to house their own congregation, known as Ezion Church, and continued to worship under the auspices of the Methodist Episcopal Conference until 1813. They were unhappy, however, with the restrictions imposed upon them by the white-led conference. Spencer and his fellow members had no voice in choosing their own ministers or in the administration of the business affairs of their church.

In 1813, the group moved again and this time established a completely independent church, which they called the Union Church of Africans (also known as the African Union Church). Eventually, the church split into two groups, the African Union Methodist Protestant (AUMP) Church and the Union American Methodist Episcopal (UAME) Church. Spencer served as African Union's minister, advocating religious freedom and women's right to preach. A strong proponent of education, Spencer made certain that schools were attached to the more than thirty African Union churches that were built in Maryland, Pennsylvania, New Jersey, and New York by the time of his death in 1843.

Politically, Spencer was opposed to the American Colonization Society and was an early proponent of the Underground Railroad, allowing his church to

serve as a stopover. In 1829 and 1839, he published editions of *The African Union Hymn-Book*. In 1814, Spencer created the Big Quarterly festival to commemorate the founding of his church. A joyous event of family reunions and community outreach, the Big Quarterly is still an annual summertime event in Wilmington. In 1990, the AUMP and UAME churches were ongoing denominations, though each had memberships of fewer than ten thousand. Peter Spencer Plaza in Wilmington, created when the mother African Union Methodist Protestant Church was razed in 1969, is named in Spencer's honor.

REFERENCES

BALDWIN, LEWIS V. *The Mark of a Man: Peter Spencer and the African Union Methodist Tradition.* Lanham, Md., 1987.

MURPHY, LARRY G., J. GORDON MALTON, and GARY L. WARD. *Encyclopedia of African-American Religions.* New York, 1993.

LYDIA MCNEILL

Spingarn Medal. The Spingarn Medal is awarded annually by the NATIONAL ASSOCIATION FOR THE ADVANCEMENT OF COLORED PEOPLE (NAACP) for "the highest or noblest achievement by an American Negro." It is awarded by a nine-member committee selected by the NAACP board of directors. Nominations are open, and the awards ceremony has traditionally been part of the NAACP annual convention. First awarded in 1915, the Spingarn Medal has gone to African Americans who have made significant contributions in different fields of endeavor. It was for many years considered the highest honor in black America, although its prestige has declined somewhat in recent years, due to the NAACP's institution of the Image Awards and perhaps because of the fragmenting of black institutional leadership.

The Spingarn Medal is named for Joel E. Spingarn (1874–1939), who originated the idea of it. Spingarn, who was white, was professor and chair of the Department of Comparative Literature at Columbia University from 1909 until 1911, when he resigned over free-speech issues. He became involved in the NAACP because of civil rights abuses in the South. Spingarn joined the NAACP's board of directors in 1913, and helped establish the NAACP's New York office. In 1913 and 1914, while traveling throughout the country, organizing the association and speaking for the rights of black people, he noticed that newspaper coverage of African Americans tended to be negative, focusing on black murderers and other criminals. A close collaborator of W. E. B. DU BOIS,

Spingarn was sensitive to media portrayal of blacks. Independently wealthy, he endowed an award, a medal to be made of gold "not exceeding $100" in value, that would pinpoint black achievement, strengthen racial pride, and publicize the NAACP. To assure that white attention would be directed toward the award, Spingarn set up an award committee consisting of prominent men, including Oswald Garrison Villard (grandson of abolitionist William Lloyd Garrison) and ex-president William Howard Taft. There were thirty nominations for the first medal, which was awarded to biologist Ernest E. JUST and presented by the first of the celebrity presenters Spingarn would arrange, New York Gov. Charles S. Whitman.

By 1992, the Spingarn Medal winners included five ministers; eight educators; eleven performers, including five classical musicians and one jazz musician, two popular entertainers, and one dancer; two baseball players; two military officers; one labor leader; two historians; and one architect. Beginning with Mary B. TALBERT in 1922, nine women have won the Spingarn Medal. The award has twice been given posthumously.

REFERENCE

ROSS, BARBARA JOYCE. *J.E. Spingarn and the Rise of the NAACP, 1911–1939.* New York, 1972.

GREG ROBINSON

SPINGARN MEDAL WINNERS

1915 Ernest E. Just
1916 Charles Young
1917 Harry T. Burleigh
1918 William S. Braithwhite
1919 Archibald H. Grimké
1920 William E. B. [W. E. B.] Du Bois
1921 Charles S. Gilpin
1922 Mary B. Talbert
1923 George Washington Carver
1924 Roland Hayes
1925 James Weldon Johnson
1926 Carter G. Woodson
1927 Anthony Overton
1928 Charles W. Chesnutt
1929 Mordecai Wyatt Johnson
1930 Henry A. Hunt
1931 Richard Berry Harrison
1932 Robert Russa Moton
1933 Max Yergan
1934 William Taylor Burwell Willliams
1935 Mary McLeod Bethune
1936 John Hope
1937 Walter White
1938 no award given
1939 Marian Anderson

SPINGARN MEDAL WINNERS (continued)

1940	Louis T. Wright
1941	Richard Wright
1942	A. Philip Randolph
1943	William H. Hastie
1944	Charles Drew
1945	Paul Robeson
1946	Thurgood Marshall
1947	Percy Julian
1948	Channing H. Tobias
1949	Ralph J. Bunche
1950	Charles Hamilton Houston
1951	Mabel Keaton Staupers
1952	Harry T. Moore (posthumous award)
1953	Paul R. Williams
1954	Theodore K. Lawless
1955	Carl Murphy
1956	Jack Roosevelt (Jackie) Robinson
1957	Martin Luther King, Jr.
1958	Daisy Bates and the Little Rock Nine
1959	Edward Kennedy (Duke) Ellington
1960	Langston Hughes
1961	Kenneth B. Clark
1962	Robert C. Weaver
1963	Medgar Wiley Evers (posthumous award)
1964	Roy Wilkins
1965	Leontyne Price
1966	John H. Johnson
1967	Edward W. Brooke III
1968	Sammy Davis, Jr.
1969	Clarence Mitchell, Jr.
1970	Jacob Lawrence
1971	Leon Howard Sullivan
1972	Gordon Parks
1973	Wilson C. Riles
1974	Damon J. Keith
1975	Henry Aaron
1976	Alvin Ailey
1977	Alexander Palmer (Alex) Haley
1978	Andrew Jackson Young
1979	Rosa L. Parks
1980	Rayford W. Logan
1981	Coleman Alexander Young
1982	Benjamin E. Mays
1983	Lena Horne
1984	Tom Bradley
1985	William H. (Bill) Cosby, Jr.
1986	Benjamin Lawson Hooks
1987	Percy Ellis Sutton
1988	Frederick Douglass Patterson
1989	Jesse Jackson
1990	Lawrence Douglas Wilder
1991	Colin Powell
1992	Barbara Jordan
1993	Dorothy I. Height
1994	Oprah Winfrey

Spinks, Leon (July 11, 1953–), boxer. Born in St. Louis, Mo., Leon Spinks and his younger brother Michael turned to boxing as a way to defend themselves in their tough inner-city neighborhood and then as a way to make enough money to leave it. Spinks's athletic skill was further developed during his time in the U.S. Marines. In 1976, Spinks and his brother tried out for the Olympic boxing team—Leon as a heavyweight, Michael as a middleweight. Both made the team and won gold medals in Montreal in the 1976 Summer Olympics. Leon then turned professional.

Spinks won his first eight bouts as a professional. Then on February 11, 1978, he faced heavyweight champion Muhammad ALI in a title fight in Las Vegas. Dubbed "the Vampire" by Ali for his gap-toothed grin, Spinks won the title in a fifteen-round decision.

During his time as heavyweight champion, Spinks earned a reputation for "nuttiness" that later haunted him. He was arrested three times for driving without a license. He neglected to stay in training, and promoter Bob Arum accused him of habitual drunkenness. On September 15, 1978, at the Louisiana Superdome in New Orleans, Ali decisively defeated Spinks in a rematch. Defeated again the following year by Gerri Coetzee in one round, Spinks nevertheless boxed his way back to contention. But, in 1981, Larry Holmes knocked him out in three rounds in a World Boxing Council title bout. Bad management and Spinks's own lack of interest in his financial affairs left him almost penniless two years later. From 1985 to 1988, Spinks lost five consecutive bouts. Despite having earned $4.5 million as a boxer, in 1986 Spinks filed for bankruptcy. He eventually found employment as a bartender in Detroit.

REFERENCES

ASHE, ARTHUR R. A Hard Road to Glory: A History of the African-American Athlete Since 1946. Vol. 3. New York, 1988.
PORTER, DAVID L., ed. Biographical Dictionary of American Sports: Basketball and Other Indoor Sports. New York, 1989.

NANCY YOUSEF

Spinks, Michael (July 13, 1956–), boxer. Born in St. Louis, Mo., and raised in the Pruitt-Igoe Housing Project of that city, Michael Spinks took up boxing as a youth in emulation of his brother, Leon, and as a method of self-defense in the tough neighborhood

where the Spinks family lived. Spinks started amateur boxing as a teenager. His amateur career was crowned by success at the 1976 Olympic Games in Montreal, where he won the middleweight gold medal (and Leon won the heavyweight gold). After Montreal, Spinks turned professional, but his career was stalled by poor management and promotion, and by Spinks's overinvolvement in his brother's boxing career.

Spinks remained in relative obscurity until he decided to act as his own manager. Moving up to the light-heavyweight class, he put himself in contention for the title. He became famous for a powerful right-handed overhand punch that was labeled "the Spinks Jinx." Spinks won a twelve-round fight against Eddie Mustafa Muhammad on July 18, 1981, securing the World Boxing Association (WBA) championship, and won recognition as champion from the World Boxing Council (WBC) after defeating the WBC champion, Dwight Muhammad Qawi, in 1983. Spinks remained undefeated in thirty-one fights as a light-heavyweight.

In 1986 Spinks abandoned his light-heavyweight title to fight in the stronger and more lucrative heavyweight class. In 1985, fighting as a heavyweight, Spinks won a disputed world title by defeating Larry HOLMES. In 1986 he beat Holmes again in a rematch, and knocked out contender Gerry Cooney in 1987. Spinks's career came to a lucrative, if embarrassing, end in July of 1988 in Atlantic City when Mike Tyson knocked him out after just ninety seconds. Spinks retired with a thirteen-million-dollar share of the purse. Since his retirement from the ring, Spinks has worked in New York as a promoter of fights with the Butch Lewis organization.

REFERENCES

ASHE, ARTHUR R., JR. *A Hard Road to Glory*. Vol. 3. New York, 1988.

BARICH, BILL. "Prime Time." *New Yorker* (August 9, 1988): 68–75.

NANCY YOUSEF

Spiritual Church Movement. Although some African Americans became involved with Spiritualism in such places as Memphis, Charleston, S.C., Macon, Ga., and New Orleans during the nineteenth century, the Spiritual movement as an institutional form emerged during the first decade of the twentieth century in Chicago—a city that remains the movement's numerical center. Mother Leafy Anderson, who founded the Eternal Life Christian Spiritualist Church in Chicago in 1913, moved to New Orleans sometime between 1918 and 1921 and established an association not only with several congregations there, but also with congregations in Chicago; Little Rock, Ark.; Pensacola, Fla.; Biloxi, Miss.; Houston; and smaller cities.

Mother Anderson accepted elements from Roman Catholicism, and other Spiritual churches also incorporated elements of VOODOO. While the number of Spiritual congregations in Chicago and Detroit surpasses the fifty or so reported in New Orleans, in a very real sense the latter continues to serve as the "soul" of the Spiritual church movement.

Like many other African-American religious groups, the Spiritual movement underwent substantial growth during the Great Migration, particularly in northern cities but also in southern ones. In 1923 Father George W. Hurley, a self-proclaimed god like his contemporary, FATHER DIVINE, established the Universal Hagar's Spiritual Church in Detroit. On September 22, 1925, in Kansas City, Mo., Bishop William F. Taylor and Elder Leviticus L. Boswell established the Metropolitan Spiritual Church of Christ, which became the mother church of the largest of the Spiritual associations. Following the death of Bishop Taylor and a succession crisis that prompted a split in the Metropolitan organization, the Rev. Clarence Cobbs, pastor of the First Church of Deliverance in Chicago, emerged as the president of the principal faction, the Metropolitan Spiritual Churches of Christ. Cobbs came to symbolize the "gods of the black metropolis" (Fauset, 1971) with his dapper mannerisms and love of the "good life."

The Spiritual religion cannot be viewed simply as a black version of white Spiritualism. Initially, congregations affiliated with the movement referred to themselves as Spiritualist, but by the 1930s and '40s most of them had contracted this term to Spiritual. As part of this process, African Americans adapted Spiritualism to their own experience. Consequently, much of the social structure, beliefs, and ritual content of Spiritual churches closely resemble those of other religious groups in the black community, particularly the Baptists and Pentecostalists.

In time, the Spiritual movement became a highly syncretic ensemble that incorporated elements from American Spiritualism, Roman Catholicism, African-American Protestantism, and voodoo (or its diluted form known as "hoodoo"). Specific congregations and associations also added elements from New Thought, Ethiopianism, Judaism, and astrology to this basic core.

The Spiritual church movement has no central organization that defines dogma, ritual, and social structure. Many congregations belong to regional or

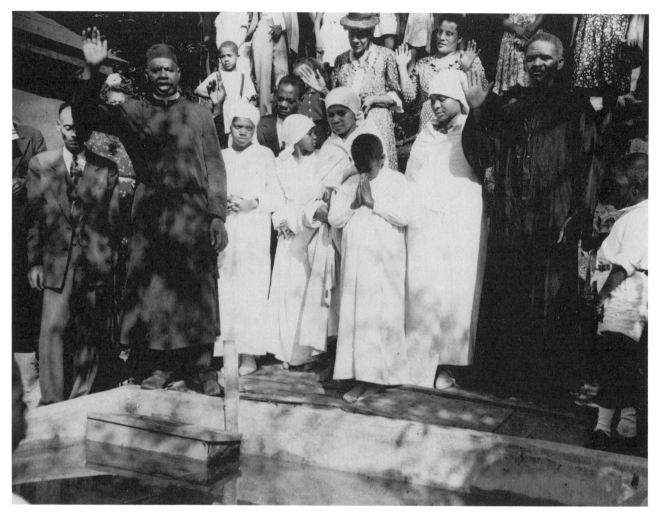

Congregation from the Refuge Church of God in Christ, founded and pastored by the Rev. O. T. Tillman in Lawrenceville, Pa. (Photo by Teenie Harris, Courtesy of the Pittsburgh Courier Photographic Archives)

national associations, but some choose to function independently of such ties. An association charters churches, qualifies ministers, and issues "papers of authority" for the occupants of various politico-religious positions. While associations sometimes attempt to impose certain rules upon their constituent congregations, for the most part they fail to exert effective control.

Instead, the Spiritual movement exhibits an ideology of personal access to power. Theoretically, anyone who is touched by the spirit can claim personal access to knowledge, truth, and authority. Although associations may attempt to place constraints on such claims by requiring individuals exhibiting a "calling" to undergo a process of legitimation, persons can easily thwart such efforts, either by establishing their own congregations or by realigning themselves with some other Spiritual group. The fissioning that results from this process means that Spiritual associations rarely exceed more than one hundred congregations.

Probably more so than even Holiness–Pentecostal (or Sanctified) churches, Spiritual congregations are small, rarely numbering over one hundred. They often meet in storefronts and house churches, and have found their greatest appeal among lower- and working-class African Americans. The larger congregations crosscut socioeconomic lines and may be led by relatively well-educated ministers. In addition to the types of offices found in black Protestant churches, Spiritual churches have mediums who are alleged to possess the gift of prophecy—that is, the ability to "read," or tell people about their past, present, and future. For the most part, mediums focus upon the wide variety of problems of living.

Like many other lower-class religious bodies, Spiritual churches are compensatory in that they substitute religious for social status. As opposed to those of many black religious groups, most Spiritual churches permit women to hold positions of religious leadership. Indeed, most of the earliest Spiritual churches in New Orleans were headed by women. Spiritual

churches with their busy schedule of religious services, musical performances, suppers, and picnics also offer a strong sense of community for their adherents. Furthermore, they provide their members with a variety of opportunities, such as testimony sessions and "shouting," to ventilate their anxieties and frustrations.

Despite the functional similarities between Spiritual churches and other African-American religious groups, particularly those of the Baptist and Sanctified varieties, the former represent a thaumaturgical response to racism and social stratification in the larger society. The Spiritual church movement provides its adherents and clients with a wide variety of magico-religious rituals, such as praying before the image of a saint, burning votive candles, visualization, and public and private divination by a medium for acquiring a slice of the "American dream." While the majority of Spiritual people are lower-class, others—particularly some of those who belong to the larger congregations—are working- and middle-class. In the case of the latter, the Spiritual religion may serve to validate the newly acquired status of the upwardly mobile.

Most Spiritual people eschew social activism and often blame themselves for their miseries, faulting themselves for their failure to engage in positive thinking. Conversely, they occasionally exhibit overt elements of protest, particularly in remarks critical of business practices, politics, and racism in the larger society. Social protest in Spiritual churches, however, generally assumes more subtle forms, such as the rejection of what Spiritual people term "pie-in-the-sky" religion and a refusal to believe that work alone is a sufficient means for social mobility.

REFERENCES

BAER, HANS A. *The Black Spiritual Movement: A Religious Response to Racism.* Knoxville, Tenn., 1984.
BAER, HANS A., and MERRILL SINGER. *African-American Religion in the Twentieth Century: Varieties of Protest and Accommodation.* Knoxville, Tenn., 1992.
FAUSET, ARTHUR. *Black Gods of the Metropolis.* Philadelphia, 1971.
JACOBS, CLAUDE F., and ANDREW F. KASLOW. *The Spiritual Churches of New Orleans: Origins, Beliefs, and Rituals of an African-American Religion.* Knoxville, Tenn., 1991.

HANS A. BAER

Spirituality. Black North American spirituality lies at one end of a topographic continuum, a continuum composed of African diaspora-and-homeland religions and cultures. At the other extreme lie the African homelands of black peoples forcibly relocated to the Americas during almost four hundred years of the Atlantic SLAVE TRADE. The intermediate sectors of the continuum comprise other cultures of the African DIASPORA, intermediate because black cultures in South America and the Caribbean exhibit stronger continuity with African traditional religions. Most obvious are Yoruba continuities in Haitian VOODOO, Cuban Santeria, and Brazilian Candomblé.

In this schema the Atlantic world constitutes the best ethnographic and historical context for understanding the nature and development of African-American spirituality. Europe and Britain are components of this world, too, of course. A triangulation of the Atlantic, then, comprising Africa, the New World, and Europe, represents not only commercial exchanges inaugurated in the slave trade, but also multiple sources of new spiritual traditions.

A minimal set of categories for delineating black North American spirituality, in terms of its multifaceted secular and religious expressions, includes aesthetic, ecstatic, and iconographic or "iconic" features. Compare W. E. B. DU BOIS's description of black religion as "the music, the frenzy, and the preacher." The disparate religious traditions involved are predominantly Christian (Protestant and some Catholic), but also Islamic and Hebraic, folk or indigenous, spiritualist and other sectarian traditions, and even neo-African. Some aesthetic features are common throughout the diaspora, while other ecstatic and iconic features are heightened in certain traditions and thus demarcate contrasting modes of spirituality.

Musical expression is so central that it provides paradigms of creativity for other domains of black culture (e.g., improvisation, call-and-response). "It is only in his music," James BALDWIN declared, "that the Negro in America has been able to tell his story." That story has multiple "scores," Ralph ELLISON has further disclosed: "Often we wanted to share both: the classics and jazz, the Charleston and the Irish reel, spirituals and the blues, the sacred and the profane" (Smith 1989, pp. 387, 389). Indeed, the desire to link black America with cultural expressions from other sources sometimes transcends even ethnic oppression, and perennially revitalizes spiritual experience.

In addition, such bicultural proficiencies reflect a performance rule characterizing ritual and communication processes in the diaspora. "Style-switching" (Marks) is the musical alternation between codes that signify black or African cultural contents, and codes indicating white or European contents. It can also signal ritual transitions to spirit possession and trance phenomena in both religious and secular contexts. A

psychosocial or cognitive basis for this aesthetic feature of African-American spirituality is the "double consciousness" articulated by Du Bois's phenomenon: the intersubjective experience of being both African and American. To generalize: Modes of expression (oral or musical, literary or dramatic, religious or secular) can alternate between forms identified as Afro-American, or "black," and polarized forms identified as Euro-American, or "white."

Spirit possession and ecstatic phenomena typify black religious expression in the New World. Many observers attribute the prominence of ecstatic behaviors in ritual, worship, and everyday life to a common African heritage in which possession "was the height of worship—the supreme religious act" (Mitchell). Parallel Euro-Christian practices allowed this African predisposition to adapt to the predominantly Protestant ethos of North America, through the revival traditions of white Baptists and Methodists. Thus, Albert Raboteau has described spirit possession as a "two-way bridge" that enabled black Americans to "pass over" from African to Christian ecstatic expression.

A similar claim connects European magical traditions to African-American thaumaturgy and pharmacopoeia (e.g., conjure, as discussed below). Finally, ecstatic phenomena occur in secular performance and ritualized group interactions involving political movements and social and entertainment events. For example, Henry Mitchell has suggested that possession and trance behavior occur covertly in jazz clubs with comparable cathartic and therapeutic effects. Ecstatic performances by black preachers and other orators are renowned, and bear shamanic commonalities with American revival preaching generally.

On the other hand, not all African-American spirituality is ecstatic in character. RASTAFARIAN spirituality, displacing possession phenomena with revelatory discourse and poetic biblicism, offers a Jamaican exception. Such examples distinguish the other major spiritual dimension expressed by black North Americans: the iconographic or "iconic" dimension. The term connotes the contemplative tradition in Western spirituality, in which not only pictorial but also textual icons—most notably biblical narratives, symbols, and figures—mediate divine significations and transcendent ideals.

African sources of this imagistic propensity comprise a "ritual cosmos" or ancestral worldview, in which "one must see every thing as symbol" (Zuesse). While (1) an iconic spirituality can be distinguished from (2) emotivist or ecstatic forms of spirituality, it is not necessarily (3) rationalist and discursive in the tradition of the European Enlightenment. Yet it can accompany either of the latter (2, 3) in modes that are iconic-ecstatic (e.g., shamanic

oratory) or iconic-analytic. Perhaps the spiritual-intellectual discourse of the African-American mystical philosopher Howard THURMAN best exemplifies both combinations.

The major instance of iconic expression in black North American spirituality is the figural tradition that improvisationally employs biblical types to configure black experience: Moses (liberator), Exodus (emancipation), Promised Land (destiny). Black religious figuralism emerged in slave religion and bears traces both of Puritan typology and the magical folk healing-and-harming tradition of conjure. Conjure practitioners reenvision and transform reality by performing mimetic (imitative) and medicinal operations (using roots, herbs, etc.) on "material metaphors." Conjurational employment of biblical figures as experiential metaphors operated as recently as the 1960s civil rights movement, in which the Rev. Dr. Martin Luther KING, Jr., represented himself as a Moses and configured the movement as an exodus.

Secular examples include iconic uses of democratic texts and their ideals as found in the U.S. Constitution and Declaration of Independence. Together these secular and religious vectors account for the "biblical republicanism" that black North Americans share with their compatriots. Even black nationalists and pan-African political movements (e.g., Ethiopianism and black Zionism) derive from the missionary uses of such Bible figures as Ethiopia and Egypt. Black Muslim and black militant figuration of (Babylonian) exile or captivity in America converge with the Rastafarians' poetic iconography of postcolonial oppression. The iconic dimension, it is evident, conveys liberating and creative energies for future transformations of religion and culture.

REFERENCES

MARKS, MORTON. "Ritual Structures in Afro-American Music." In Zaretsky and Leone, eds. *Religious Movements in Contemporary America.* Princeton, 1974.
MITCHELL, HENRY H. *Black Belief: Folk Beliefs of Blacks in America and West Africa.* New York, 1975.
RABOTEAU, ALBERT J. *Slave Religion: The "Invisible Institution" in the Antebellum South.* New York, 1978.
SMITH, THEOPHUS H. "The Spirituality of Afro-American Traditions." In Dupré, Meyendorff, and McGinn, eds. *Christian Spirituality III: Post-Reformation and Modern.* New York, 1989, pp. 372–412.
WILMORE, GAYRAUD S. *Black Religion and Black Radicalism: An Interpretation of the Religious History of Afro-American People.* Maryknoll, N.Y., 1983.
ZUESSE, EVAN M. *Ritual Cosmos: The Sanctification of Life in African Religions.* Athens, Ohio, 1979.

THEOPHUS H. SMITH

Spirituals. African-American sacred folk songs are known as anthems, hymns, spiritual songs, jubilees, gospel songs, or spirituals; the distinctions among these terms are not precise. "Spiritual song" was widely used in English and American tune books from the eighteenth century, but "spiritual" has not been found in print before the Civil War. Descriptions of songs that came to be known by that name appeared at least twenty-five years earlier, and African-American distinctive religious singing was described as early as 1819.

Travelers and traders in Africa in the early seventeenth century described the musical elements that later distinguished African-American songs from European folk song: strong, syncopated rhythms reinforced by bodily movement, gapped scales, improvised texts, and the universal call-and-response form in which the leader and responding chorus overlapped. To white contemporaries, the music seemed wholly exotic and barbaric, although later analysts identified elements common also to European music, such as the diatonic scale. The performance style of African music, quite distinct from familiar European styles, has persisted in many forms of African-American music to the present day.

Although the music of Africans has been documented in the West Indies and the North American mainland from the seventeenth century, conversion to Christianity was a necessary precondition for the emergence of the spiritual, a distinctive form of African-American religious music. Conversion proceeded slowly. Individual slaves were converted by the families with whom they lived in the seventeenth century, but on southern plantations, where most of the slaves lived, some planters opposed the baptism of their slaves in the belief that baptism would bring freedom. Moreover, plantations were widely separated, missionaries were few, and travel was difficult. Where religious instruction was permitted, the slaves responded with enthusiasm.

In the mid-eighteenth century a few Presbyterian ministers, led by Samuel Davies of Hanover County, Va., made special efforts to convert blacks within their neighborhoods, teaching them Isaac Watts's hymns from books sent from England. Davies wrote in 1751, "The Negroes, above all the Human Species that I ever knew, have an Ear for Musick, and a kind of extatic Delight in *Psalmody*" (Epstein 1977, p. 104). Whether the blacks injected a distinctive performance style he did not say.

Toward the end of the century, Methodist itinerants like Bishop Francis Asbury, together with his black exhorter, Harry HOSIER, held protracted meetings lasting several days that drew large crowds of blacks and whites. After 1800 the camp meeting developed on the frontier, where settlements were

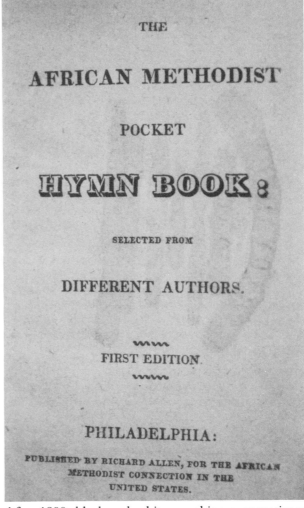

THE

AFRICAN METHODIST

POCKET

HYMN BOOK:

SELECTED FROM

DIFFERENT AUTHORS.

⁓⁓⁓

FIRST EDITION.

⁓⁓⁓

PHILADELPHIA:

PUBLISHED BY RICHARD ALLEN, FOR THE AFRICAN METHODIST CONNECTION IN THE UNITED STATES.

After 1800, black and white worshipers, sometimes seated separately, used hymn books to share songs and styles of singing. (Burke Library of the Union Theological Seminary in the City of New York)

widely scattered. From the first camp meeting, black worshipers were present, sometimes seated separately, but in close proximity to whites. In an atmosphere highly charged with emotion, both groups shared songs, parts of songs, and styles of singing in participatory services where large numbers of people needed musical responses they could learn at once. The call-and-response style of the Africans resembled the whites' time-honored practice of "lining out."

The first documented reports of distinctive black religious singing date from the beginning of the nineteenth century, about twenty years before the first organized missions to plantation slaves. Throughout the antebellum period, spirituals were mentioned in letters, diaries, and magazine articles written by Southerners, but to most Northerners they were quite unknown. As northern men and women went south during the Civil War, they heard spirituals for

the first time. Newspaper reporters included song texts in their stories from the front. Individual songs were published as sheet music, although some editors were well aware that their transcriptions failed to reproduce the music fully. Lucy McKim wrote to the editor of *Dwight's Journal of Music:* "The odd turns made in the throat; and the curious rhythmic effect produced by single voices chiming in at different irregular intervals, seem almost as impossible to place on score, as the singing of birds, or the tones of an Æolian Harp" (21 [November 8, 1862]: 254–255).

When a comprehensive collection of songs, *Slave Songs of the United States,* was published in 1867, the senior editor, William Francis Allen, wrote in the introduction: "The best we can do, however, with paper and types . . . will convey but a faint shadow of the original. . . . [T]he intonations and delicate variations of even one singer cannot be reproduced on paper. And I despair of conveying any notion of the effect of a number singing together" (Allen 1867, pp. iv–v). In effect, the notational system filtered out most of the characteristic African elements, leaving versions that looked like European music. These collectors had heard the music sung by its creators, and they fully realized how defective their transcriptions were. But they feared that the music would be lost

forever if the transcriptions, however unsatisfactory, were not made.

The pattern of transcribing the music in conventional notation was followed in more popular collections of songs transcribed in the 1870s from the singing of the FISK JUBILEE SINGERS, the Hampton Singers, and other touring groups from black schools in the South. These tours of carefully rehearsed ensembles of well-trained singers introduced audiences in the North and Europe to versions of the spirituals that eliminated many of those characteristic elements that had so attracted Lucy McKim and William Allen. The singers had been trained in European music and felt a responsibility to reflect credit on the rising black population.

By the 1890s, spirituals had become widely popular, both in the United States and in Europe, in the versions sung by the college singers. In 1892 a Viennese professor of jurisprudence, Richard Wallaschek, in a book entitled *Primitive Music,* advanced the theory that the spirituals were "mere limitations of European compositions which the negroes have picked up and served up again with slight variations" (p. 60). He never visited the United States or Africa, and his knowledge of the music was wholly derived from the defective transcriptions in *Slave Songs of the*

The Eva Jessey Choir performing spirituals for a BBC broadcast. (Photographs and Prints Division, Schomburg Center for Research in Black Culture, The New York Public Library, Astor, Lenox and Tilden Foundations)

United States and minstrel songs (p. 61). Never having heard the music, Wallaschek was unaware that there were elements that could not be transcribed, but his ideas were taken seriously by several generations of scholars.

The strongest statement of the white-origins school was made by George Pullen Jackson, a professor of German at Vanderbilt University, who explored with enthusiasm the so-called white spiritual. In his book *White Spirituals of the Southern Uplands* (1933), his discussion of black spirituals was based primarily on an analysis of transcribed versions. He cited priority in publication as certain proof of origin, overlooking the irrelevance of this fact for folk music, most especially for the music of a population kept illiterate by force of law. The white-origins theory is no longer widely accepted. Not until the advent of sound recordings was it possible to preserve the performance itself, including improvised details and performance style, for later study and analysis.

Concert arrangements of spirituals for solo singers and choirs have been made, most notably by Harry T. BURLEIGH, James Weldon JOHNSON and J. Rosamund JOHNSON, and William Levi DAWSON. Spiritual thematic materials have permeated diverse genres of American music in the twentieth century.

The musical elements that distinguished African-American spirituals from Euro-American hymnody were virtually impossible to reproduce in standard musical notation. Variable pitches; irregular strong, syncopated rhythms; and freely improvised melodic lines presented insoluble problems to the collector before the age of recording. The performance style also included humming or "moaning" in response to the solo performer (whether singer or preacher), responsive interjections, and ceaseless physical movement in response to the music—patting, hand-clapping, foot-tapping, and swaying. The overlapping of leader and responding chorus provided a complex interplay of voice qualities and rhythms. Slurs and slides modified pitch, while turns in the throat, blue notes, microtones, and sighs were equally impossible to notate. Pentatonic scales, however, and flattened fourth or seventh notes could be captured in notation.

Textual elements covered a whole spectrum of concepts, from trials and suffering, sorrow and tribulations, to hope and affirmation. Events from both the Old and the New Testaments were described, including Elijah's chariot and Ezekiel's wheel, along with more common images such as trains, shoes, wings, harps, robes, and ships. Hypocritical preachers and sinners were scorned, while death, heaven, resurrection, and triumph were often invoked.

Besides the purely religious message, there were also hidden meanings in some spirituals, exhorting the singers to resistance or freedom. Songs such as "Steal Away," "Follow the Drinking Gourd," and "Go Down, Moses"—with its refrain, "Let my people go"—could be interpreted in at least two ways. References to crossing Jordan and the trumpet blast could have both religious and secular interpretations.

REFERENCES

ALLEN, WILLIAM FRANCIS, CHARLES PICKARD WARE, and LUCY MCKIM GARRISON. *Slave Songs of the United States.* New York, 1867.

EPSTEIN, DENA J. *Sinful Tunes and Spirituals: Black Folk Music to the Civil War.* Urbana, Ill., 1977.

———. "A White Origin for the Black Spiritual? An Invalid Theory and How It Grew." *American Music* 1 (1983): 53–59.

KREHBIEL, HENRY EDWARD. *Afro-American Folksongs: A Study in Racial and National Music.* New York, 1914.

LOVELL, JOHN, JR. *Black Song: The Forge and the Flame—The Story of How the Afro-American Spiritual Was Hammered Out.* New York, 1972.

MARSH, J. B. T. *The Story of the Jubilee Singers; with Their Songs.* London, 1875.

DENA J. EPSTEIN

Spivey, Victoria Regina (c. October 6, 1906– October 3, 1976), blues singer. Victoria Spivey was born in Houston, Tex., in 1906 (the exact day is uncertain) and was raised in Dallas. She learned piano as a child and performed at the Lincoln Theater in Dallas at the age of twelve. After her father, the leader of a string band, was killed in an accident, she began to sing and play piano in cinemas, tent shows, and bordellos. There she met prominent BLUES musicians such as Sippie WALLACE, Blind Lemon JEFFERSON, Joe Pullum, and Ida COX. In 1926, Spivey traveled to St. Louis to record her song "Black Snake Blues" on Okeh Records. That song—also recorded that year by Jefferson, who claimed authorship—was a hit for Spivey, and she was hired as a songwriter for the St. Louis Music Company. Within two years she had written and recorded almost forty songs for Okeh, including "Dirty Woman Blues," "Spider Web Blues," "Arkansas Road Blues," and "TB Blues."

The GREAT DEPRESSION ended the careers of many blues singers, but Spivey's angular sound, especially the unique moaning that she termed "tiger squalls," helped her remain popular. In addition to writing and singing the blues, Spivey worked on the stage. In 1927 she performed in the show *Hit Bits from Africana* at New York City's Lincoln Theater, and in 1929 she performed in the all-black musical film *Hallelujah!* She directed Lloyd Hunter's Serenaders in the early

1930s, and in 1933 appeared in the show *Dallas Tan Town Topics*. In 1942 she was featured in *Hellzapoppin'* on Broadway. Spivey also performed with many jazz musicians, including Lonnie Johnson in 1927 ("Steady Grind," "Garter Snake Blues"), Louis ARMSTRONG ("Funny Feathers Blues") and Henry "Red" Allen ("Moaning the Blues") in 1929, and "Georgia" Tom DORSEY in 1931 ("Nebraska Blues").

In 1952, Spivey retired from music, although she continued singing and playing piano and organ in church. In the late 1950s she returned to singing the blues professionally. She appeared in pop and folk music festivals and concerts throughout the 1960s. In 1961 Spivey founded Queen Vee Records, which became Spivey Records the next year. Among her recordings from later in her career are *Songs We Taught Your Mother* (1961), *The Blues Is Life* (1976). Spivey, who married four times and lived in Brooklyn in her last years, died in Manhattan in 1976.

REFERENCES

HARRISON, DAPHNE DUVAL. *Black Pearls: Blues Queens of the 1920s.* New Brunswick, N.J., 1988.
SPIVEY, VICTORIA. "Chords and Dischords: Miss Spivey Speaks Her Mind." *Downbeat* 29, no. 27 (October 25, 1962): 8.

ELIZABETH MUTHER

Sports. Physical competition and display have always been an important component of African culture. In Africa, activities such as dancing and competitions such as foot racing, stone throwing, and wrestling were commonplace. Africans enslaved in the New World continued to hone their athletic abilities in both native African leisure pursuits as well in sports popular among their European masters. The conditions of slavery placed definite limits on the pursuit of sport as a leisure activity among slaves, but on Sundays and holidays many slaves enjoyed such activities as HORSE RACING, BOXING, cockfighting, and various forms of ball-playing.

African Americans attained considerable prominence in antebellum America in both boxing and horse racing. William RICHMOND, born on Staten Island (now part of New York City) in the late eighteenth century, achieved renown in London as a prizefighter. His protégé, Tom MOLINEAUX, a former slave emancipated because of his fighting abilities, followed Richmond to London, where Molineaux had matches with the leading fighters of the day. Horse racing, an immensely popular sport in antebellum America, made extensive use of black jockeys, some of whom became locally celebrated and were victorious in many stake races.

Although blacks participated widely in most sports throughout the antebellum period and thereafter, the spread of JIM CROW in the late nineteenth century limited the opportunities for black participation. The familiar and discouraging pattern of radical discrimination and segregation repeated itself with distressing monotony in almost all sports between 1880 and World War II.

One of the most dramatic exclusions was in horse racing. In the 1870s, black jockeys continued to dominate the sport. Isaac Murphy, the leading jockey, won over 40 percent of his races, including three Kentucky Derby victories. In the first 1875 Kentucky Derby, fourteen of the fifteen jockeys were black men, including the winner Oliver Lewis. Such successes caused increasing concern in racing circles, and by 1894 the newly formed Jockey Club adopted a "whites only" policy. Despite the ban, black jockeys continued to dominate horse racing until about 1906, when the "whites only" policy became pervasive. Black jockeys disappeared from the Kentucky Derby in 1912 and from the sport by World War I.

The color line also fell across the path of Marshall "Major" TAYLOR in cycling. Cycling was a popular sport by the 1890s, and from 1896 until 1910 Taylor reigned as the best cyclist in the world. Yet his membership in the League of American Wheelmen caused the formation of the American Racing Cyclists Union in 1898, another "whites only" group that barred Taylor from its ranks because he could defeat any white cyclist. Taylor's career survived despite this.

A similar fate of rejection characterized the history of blacks in BASEBALL in the late nineteenth century. Before the Civil War, black people had participated in club baseball, but in 1867 the National Association of Baseball Players banned all black players, and in 1876 the newly formed National League reinforced the ban (although a few African Americans continued to play on minor league teams until the 1890s). The first all-black professional teams were also organized in the late nineteenth century.

In sports other than organized team sports, blacks did somewhat better because it was more difficult to draw a color line. By 1880, interracial boxing had gained acceptability. Boxing contests were between individuals, and the boxers were seen as surrogates of promoters and sponsors. The combatants usually met for an hour or two, and then contact was completed, nor did they travel together, share facilities, and socialize as did players in team sports.

But even in boxing, as more black men began to win in the various divisions of the sport, there were complaints about the undue prominence of black athletes. Newspaper writers such as Charles A. Dana, editor for the *New York Sun,* wrote in 1895: "We are in the midst of a growing menace. The Black man is

rapidly put forward to the front ranks in athletics, especially in the field of fisticuffs. We are in the midst of a Black rise against white supremacy. . . . What America needs now is another John L. Sullivan. . . ." (Sullivan, a heavyweight champion, was noted for his negative attitudes toward blacks.)

George Dixon became the first black man to hold an American boxing title. Known as "Little Chocolate," he defeated Cal McCarthy for the bantamweight title in 1891. Joe Gans became the lightweight and welterweight champion in the first decade of the twentieth century. But the most celebrated black boxer of this era was Jack JOHNSON, who in 1908 became the first black heavyweight champion. Because Johnson flouted numerous social mores during his reign as champion, his tenure was extremely controversial. In 1915, to the relief of most white Americans, Johnson lost his heavyweight title to Jess Willard in a dubious decision. Subsequent white heavyweight champions refused to fight black contenders until 1937, when Joe LOUIS won the heavyweight championship.

Of all the team sports, FOOTBALL defied the JIM CROW influence the longest. Unlike baseball, football began in the United States as a college sport, and from its nascence in the 1800s, blacks played on the teams of northern schools such as Harvard University and Brown University. However, when professional football debuted in the 1890s, blacks were not represented. Nevertheless, as early as 1904, Charles Wallace, with the Shelby Athletic Club of Ohio, became the first black to play as a professional, and the next year the Rochester Jeffersons signed another African American, Henry McDonald. Black athletes continued in professional football—though in relatively small numbers—until 1933, when it too drew the color line. In response to the rising tide of racial exclusion, blacks had little choice but to form their own organizations.

Separate Organizations: The Black Colleges

Black colleges became a center of black athletic endeavor soon after their founding in the post–Civil War period. Although most colleges extolled physical exercise, they considered sports a frivolous distraction from serious study. Nevertheless, by the 1890s black colleges began to have intercollegiate athletic competitions, starting in football. Livingston College and Biddle College played the first game between two black colleges on December 27, 1892. By 1894, both TUKSEGEE and HOWARD, despite concerns about frivolity, began competing with other black colleges. Short of funds, the Howard team gladly accepted Harvard University's cast-off football uniforms to suit up for their game against Virginia Normal Institute on December 26, 1894.

Within a few years, other sporting events were staged at black colleges. In *A Hard Road to Glory*, Arthur ASHE suggests that the Atlanta black colleges played baseball among themselves in 1896, and that MOREHOUSE COLLEGE sponsored the first intercollegiate track meet for black colleges in the Southeast in 1907. TENNIS was one of the first sports played at black colleges; Tuskegee had its first tournament as early as 1895. BASKETBALL seems to have been the last important sport adopted by black colleges before World War I, and even after 1920 was considered a minor part of the athletic program. HAMPTON INSTITUTE, Morehouse College, and Howard University fielded the best basketball teams in the 1920s, with Morgan State College gaining ascendancy in the early 1930s. Other sports adopted by black colleges in the interwar period included GOLF and SOCCER.

Because of the prohibition against interracial play, black college athletes were known mostly to the black community, with the larger white population knowing little of them until the integration era. Because of poor training facilities, performance venues, and lack of funds, few black athletes from black colleges were represented in the Olympics prior to 1928.

The Professional Black Leagues

Baseball was the first sport which developed a large number of black professional teams. The first well-known team was the Cuban Giants founded in 1885. While all-white clubs refused to play with African Americans in the United States, they often informally played against people of African ancestry from Cuba and Mexico. Knowing this, Frank Thompson formed an all-black professional team in 1885, naming it the Cuban Giants to avoid discrimination, although after 1890 even casual interracial games became a rarity. The earliest black leagues, which were organized as early as 1885, were short-lived affairs, and it was not until after World War I when Rube FOSTER, former pitcher of the Chicago American Giants, organized the National Negro Baseball League (NNL) with teams in Chicago, Kansas City, St. Louis, Indianapolis, and Detroit, that black professional baseball flourished. The league folded in 1931, but two years later it was revived and played in competition with the Negro American League (NAL), formed in 1936. Although both leagues continued to play against each other until the 1950s, when integration undermined their viability, they were never quite stable. Their financial success was limited because they did not own their ball parks, never made enough money to travel in comfort, and were unable to generate enough profit for reinvestment.

Nevertheless, the black community supported the black teams with great enthusiasm and consistency over the years. The always popular East–West all-

star game began in 1933. Arthur Ashe described the annual all-star game as "the most well-known black sports event on earth." Many of the best-known athletes of the first half of the twentieth century played in the Negro Leagues, including Satchel PAIGE, Josh GIBSON, Cool Papa BELL, Buck LEONARD, and Smokey Joe Williams. The black leagues were also responsible for a number of baseball innovators, such as Bill Monroe, inventor of shin guards, Willie Wells, who introduced the batting helmet, and J. J. Wilkinson, who promoted the first night game.

Because of the weak structure of professional basketball, there were many contests between black and white teams in the early decades of the century. Both the HARLEM GLOBETROTTERS and the Harlem Rens (see RENAISSANCE BIG FIVE) came into being during the 1920s. The Rens were the first black-owned and black-staffed basketball team that earned its living full-time from playing basketball. They operated successfully and profitably until 1949, when integration undermined the viability of black teams. The all-black Harlem Globetrotters, though owned by whites, continues to prosper.

In tennis, too, African Americans had to create their own venues to participate in the sport. The first black tennis players learned the game at white colleges in the 1880s and '90s. By the late nineteenth century, Tuskegee Institute pioneered the game among black colleges. Just prior to World War I, black Americans organized the AMERICAN TENNIS ASSOCIATION and held ATL (American Tennis League) national championship tournaments annually, the first in Baltimore in 1917. Pressure by the NAACP in the 1920s and '30s to integrate the game had little impact, and it was not until 1950 that Althea GIBSON became the first black woman to play in the U.S. Tennis Association tournament. A few years later, in 1957, Gibson won the Ladies Singles title at Wimbledon, a feat she repeated the following year. In 1952, the U.S. Lawn Tennis Association allowed two black men to play in tournaments, and in 1963, Arthur Ashe became the first African American to win a USLTA men's event.

Patriotism

Despite their maltreatment, blacks have frequently been called upon to serve as patriotic symbols, and usually have done so willingly. During World War II, Joe Louis's picture was used on recruiting posters with a caption that read, "Private Joe Louis says, 'We're going to do our part and we'll win because we're on God's side.'" In an article written during the war, Louis was quoted as saying, "I fight for America against the challenge of a foreign invader."

Track star Jesse OWENS also was pressed into service as a patriotic role model during the war, and

both Owens and Louis were used to raise money for armed-services-related charities (this despite the fact that Owens was reduced to running against race horses after winning the 1936 Olympics, and Franklin D. Roosevelt carefully refrained from acknowledging his victories). Nevertheless, despite Owens's patriotic work, the FEDERAL BUREAU OF INVESTIGATION, with the personal knowledge of its director, J. Edgar Hoover, compiled an unsubstantiated negative file on Owens when the Eisenhower administration considered him in 1956 for a position in the U.S. Department of State. This file forever blocked any further serious consideration of Owens for a government job.

The patriotic activities of Owens and Louis, nonetheless, impressed the black community. Owens, Louis, and other black athletes rallied to patriotic appeals because they saw them as living refutations not merely of Nazi Aryan superiority, but of the white population's claims of superiority. They served as symbols to emulate and their successes became harbingers of better times to come. African Americans such as Michael JORDAN and Magic JOHNSON later would become symbols of American success at home and abroad, to some extent obscuring the sharpness of the continuing racial divisions within the United States.

Integration

Although many believe that, with the post–World War II debut of Jackie ROBINSON, professional baseball was the first major team sport to be integrated, that honor actually belongs to professional football, which erased in 1945 the color line it had drawn in 1933. In 1945, the National Football League's (NFL) Cleveland Rams moved to Los Angeles, where they signed two African Americans, Kenny Washington and Woody Strode. The next year, the Cleveland Browns, playing in the All-American Football Conference, a rival of the NFL formed in 1946, had two black players, Bill Willis and Marion MOTLEY. Two years later, the New York Giants hired Emlen Tunnel. From the outset, several of these players, especially Washington, Motley, and Tunnel, were standouts, and the number of African Americans in the game soon increased. Blacks, however, were kept out of the positions that supposedly required the most intelligence. Not until the 1990s did African Americans play regularly at the main leadership position, quarterback.

An enlarged black college population and the growing interest of African-American athletes in basketball, produced increasing numbers of black college basketball stars after World War II. In 1950, the Boston Celtics' Chuck Cooper became the first African American in the National Basketball League

One of Jackie Robinson's greatest talents was his base-running ability. Here in 1946, playing for the minor league Montreal Royals, he slides into a base. When Robinson signed a contract with Brooklyn Dodger general manager Branch Rickey, he became the first African American in major league baseball in the twentieth century. (Photographs and Prints Division, Schomburg Center for Research in Black Culture, The New York Public Library, Astor, Lenox and Tilden Foundations)

(NBA). That same year, the New York Knicks raided the Harlem Globetrotters for Nathaniel "Sweetwater" Clifton. The Washington Capitols signed Earl Lloyd. By the 1980s, black men dominated the ranks of professional basketball.

In golf, the "whites only" policy of the Professional Golfers of America (PGA) continued until after World War II, when black players from the UNITED GOLFERS ASSOCIATION (UGA) sued the PGA for its 1943 decision to have a "whites only" tour. Because of pressure from black players, the PGA finally relinquished its "whites only" policy in 1959, and Charlie SIFFORD became one of its first and most prominent black golfers. He won the Los Angeles Open in 1969, the first black to win on the regular tour, paving the way for such players as Lee ELDER and Jim Dent to compete later.

By the mid-1950s, integration was fairly well established in professional sports and in northern colleges. Nonetheless, the increased numbers, visibility, and popularity of black athletes created problems. Blacks were still expected not to attract attention. College officials instructed them not to fight back when assaulted by prejudiced white players; to show no anger when insulted; and most of all not to date white women. Racism was not a thing of the past, either in the treatment of blacks by colleges, and fans, or in the distribution of awards. Only in 1961 did the first African American, Syracuse University's Ernie Davis, receive the Heisman Trophy for the best college football player.

There were numerous confrontations in the 1950s between integrated and nonintegrated teams. In a 1951 football game between Iowa's Drake University and Oklahoma A&M, the racist behavior of the Oklahoma A&M team against Drake's premier black quarterback caused Drake to withdraw from competition in the Missouri Valley Conference. Five years later, Georgia Tech played the University of Pittsburgh in the 1955 postseason Sugar Bowl game held in New Orleans. The governor of Georgia, Marvin Griffin, found this development intolerable since Pittsburgh had a black player on its roster. Griffin warned, "The battle is joined. . . . There is no more difference in compromising the integrity of race on the playing field than in doing so in the classroom.

One break in the dike and relentless seas will rush in and destroy us.'' The game was played without the coming of Armageddon; but, interestingly, Tech won 7–0 on a disputed penalty called against Bobby Grier, the black player and the source of Governor Griffin's distress. Before the year was out, Louisiana legislators, sharing the governor's anguish, voted to prohibit competition between blacks and whites in athletic games within the state.

Two years after the Pittsburgh/Georgia Tech incident, the University of Oklahoma made history. The football coach, Charles "Bud" Wilkinson, had by 1958 made himself a legend in his own time. Between 1948 and 1964, he enjoyed a remarkable winning record and in 1958 became the first coach of a major southern university to recruit a black player, Prentiss Gault, who played with distinction and without incident.

Soon thereafter, the majority of southern schools recruited black football players, and within a decade

Charlie Venable demonstrating his bowling form. In the 1970s Venable became one of the first black bowlers in the National Bowling Congress. (Photographs and Prints Division, Schomburg Center for Research in Black Culture, The New York Public Library, Astor, Lenox and Tilden Foundations)

after Oklahoma's precedent, the majority of southern schools integrated. The quick integration of southern college football created ambivalent responses in some segments of the black community, particularly among the coaches at the traditionally black colleges, for soon predominantly white southern schools competed for high school stars and sent their own graduates to the National Football League. Nevertheless, the black colleges, such as Grambling, Florida A&M, and Prairie View, continued to flourish and provide their own constellation of stars.

Integration came less quickly to basketball in southern schools. Despite the stellar performance of black basketball players at northern universities between 1952 and 1960, with such greats as Bill RUSSELL and Oscar ROBERTSON, most southern schools, including perennial standouts such as Kentucky, refused both to recruit black players and to play against them.

In 1963 at Mississippi State University in Starkville, a situation developed all too characteristic of southern white schools between 1954 and 1970. Racial conventions prohibited Mississippi State, the Southeastern Conference basketball champions in 1959, 1961, and 1962, from playing in the integrated 1963 NCAA basketball tournaments. However, the Mississippi State president, Dr. D. W. Colvard, decided the time had come to defy tradition and announced that his team would play. This caused such consternation that boosters of the university obtained an injunction prohibiting the team from leaving Mississippi. Disobeying the legal ban, the team secretly left town, arrived at East Lansing, Mich., without mishap and reached the second round against the largely black squad from Loyola of Chicago. Mississippi State lost, 61–51, and when the team returned to their campus fearing the worst, it was surprised by a warm reception from its fans. One white player, Aubrey Nichols, reflected in 1987 that "our game convinced a lot of people that we should have competed earlier."

Three years later, the University of Kentucky's basketball team found itself confronted with a Texas Western University (later Texas–El Paso) team with an all-black lineup. Adolf Rupp, the Kentucky coach, a committed segregationist, faced a dilemma, but since this was a championship game, he decided to let his team play. The final score was Texas Western 72 and Kentucky 65, disproving, once and for all, any doubts about the abilities of African Americans to play basketball. Ten years later, Rupp stated that the 1966 team was his all-time favorite and that it had lost the 1966 NCAA title to "a bunch of crooks." Nevertheless, the dike of segregation had been permanently burst, and five years after his defeat, Rupp signed Tom Payne, his first black player.

Willy T. Ribbs at the Indianapolis Motor Speedway. In 1991 Ribbs became the first African American to compete in the Indianapolis 500. (AP/Wide World Photos)

The 1966 loss of the University of Kentucky's basketball team to an all-black team for the NCAA championship marked a positive watershed in race relations in American sports. Two years later, new tensions emerged during the 1968 Summer Olympics in Mexico City, which took place shortly after the assassination of the Rev. Dr. Martin Luther KING, Jr. Many black athletes, such as basketball star Lew Alcindor (later known as Kareem ABDUL-JABBAR), joined the Olympic boycott proposed by Harry Edwards, then a young sociology professor at the University of California at Berkeley, to protest racism in the United States. Some who chose to participate, such as Tommy Smith and John Carlos, who finished first and third in the Olympic 200-meter finals, created their own protests by raising their fists in a black-gloved black power salute on the victory stand. The black community, for the most part, welcomed the gesture as a timely condemnation of the racism at home, but the International Olympic Committee was outraged. Reprisals began immediately. Smith and Carlos were banned from the Olympic Village and for many years suffered job discrimination. So pervasive was the outrage that many black athletes, even those not supportive of this defiant protest gesture, encountered hostility at home.

Management, Ownership, Coaching

In 1966, Bill Russell became coach of the Boston Celtics, the first African-American head coach in the history of modern professional sports. (All-American football standout Fritz POLLARD had briefly been player-coach for several teams in the early years of the NFL in the 1920s.) Russell had a successful tenure, coaching the Celtics for three years from the 1966–67 season through 1970, winning the NBA championship in both 1968 and 1969. He later coached the Seattle Supersonics from 1973 through the 1976–77 season. Other sports slowly followed basketball. The first black manager in baseball, Hall-of-Famer Frank ROBINSON, managed the Cleveland Indians, Baltimore Orioles, and San Francisco Giants in various stints between 1975 and 1984. Football was the laggard. Not until 1990, when the Los Angeles Raiders named Art SHELL, did the NFL have its first black head coach.

In general, progress in the entrance of blacks into the management or the front office has been halting. On April 6, 1987, on ABC Television's *Nightline,* Al Campanis, vice president of the Los Angeles Dodgers baseball team, explaining why there were so few black managers in baseball, said, "I truly believe that they may not have some of the necessities to be, let's say, a field manager or perhaps a general manager." Campanis' statement may well have revealed the beliefs, attitudes, and prejudices of most of the owners and general managers of major league professional teams. At the time Campanis spoke, baseball had only two black managers and basketball had four head coaches out of twenty-three, also two black general managers. In football, the situation was worse: no black head coaches and few black assistant coaches. By mid-1991, the statistics had changed little, although black players made up 74 percent of professional basketball, 62 percent of football, and 18 percent of baseball.

The commissioner of the NFL, Pete Rozelle, explained the paucity of head coaches in 1986 by comparing the choice of a coach to that of a wife: "It is a very personal thing" (*Sports Illustrated,* February 23, 1987, p. 18). Black coaches were also not given a second chance at managing in any major sport after their first chance. *U.S. News and World Report* explored this topic through the case of Larry DOBY. Doby, the second black player to enter the major baseball leagues, was named manager by the Chicago

White Sox during the 1978 season. But after the 1978 season, Doby was fired after compiling a 37–50 won-lost record. Doby believed his race played a great part in his dismissal, although the White Sox disputed his claim, noting that the White Sox were 90–72 in 1977, the year before Doby took over. However, as *U.S. News and World Report* pointed out, "What's important is that Doby never got a second chance."

With Frank Robinson's retirement, there was only one black manager left in baseball in 1992, perhaps proving Doby's contention that white managers with worse records routinely got second, third, and fourth chances. More important, a number of black baseball players have shown by their work as assistant coaches that they possess all the "necessities" for head coach, but have not been given a chance.

The black athlete faces formidable obstacles in obtaining managerial, coaching, and executive positions in professional sports. In the National Basketball Association (NBA), for example, where in 1991 about 75 percent of the players are black, there were five black head coaches and five general managers. Only one team, the Denver Nuggets, had black ownership. Among professional sports teams, this situation is considered exemplary, since nothing approximates it in either baseball or football. In baseball, Bill White, an African American, was chosen as president of the National League in 1991, but there were no black owners and no black general managers. In 1994, there were only two black field managers, although over 18 percent of the players were African Americans.

In football in 1994, there were only two black head football coaches, even though 62 percent of the players were black. Despite a significant number of assistant coaches, there was little indication that any of them would be invited to fill head coaching positions any time soon.

In college sports the profile was similar. In the NCAA Division I basketball in 1993, only 10 percent of the schools had African-American head coaches, although 65 percent of the players were black. The football scene was more bleak, with only two black head coaches, even though African Americans accounted for more than 55 percent of the players. Interestingly, there were no black coaches in Division I college baseball, where African Americans in general were underrepresented, accounting for only 10 percent of the players.

Athleticism

The prejudice against black athletes as potential managers, head coaches, and sports executives is directly related to the perception of African Americans as being "athletic" and not as intelligent as white people. Although whites had long thought of themselves as physically superior to blacks, this seems to have un-

dergone a change in the 1930s, perhaps because of the achievements of Jessie Owens and Joe Louis. Blacks rapidly went from being thought of as athletic incompetents to brutishly superior. When Joe Louis defeated Primo Carnera in 1935, one white reporter described him as being "sly and sinister and, perhaps, not quite human" in his boxing prowess. Racists argued that blacks such as Louis were physically strong because of their mental inferiority. After the 1938 Joe Louis–Max Schmeling fight, newspaper columnist and high-level Roosevelt appointee Hugh S. Johnson wrote: "The average of White intelligence is above the average of Black intelligence probably because the White race is several thousand years away from jungle savagery. But for the same reason, the average White physical equipment is lower." The stereotyping has become less blatant over the decades, yet many whites still feel that black physical prowess is somehow inimical to intellectual achievements.

The predominance of the black athlete in the professional ranks of football and basketball, their disproportionate representation in those sports at the collegiate level, and their dominance of TRACK AND FIELD in the Olympics and world championships since the 1960s, have fostered the perception among many that the black athlete is naturally physically gifted. Among African Americans this view is not well received because it suggests that the black athlete need not expend the time and energy to excel or impose the discipline or sacrifice necessary to succeed. For some African Americans, the covert implication of this view is that black people, though physically gifted, are therefore less intelligent.

Still, it is difficult to account for the astonishing record of black athletic accomplishment in postwar America. There is no convincing evidence of innate African-American athletic superiority. The most plausible explanation seems to be cultural choice. Given the real or perceived lack of opportunities in other areas of the economy, sports has become an area of upward mobility. Through the influence of a few extraordinarily successful superstars, success in sports has become for many young blacks (especially males) something to emulate and a way of gaining respect among one's peers. As a result, much effort is expended to achieve success in sports.

Since the 1960s, in one of the more visible manifestations of this trend, black athletes have become increasingly dominant at white colleges. Yet the academic performance of black athletes at predominately white institutions has not been commensurate with their athletic performance. Since the 1960s, the graduation rates of black athletes have not been encouraging. Surveys taken during the 1970s and '80s, show that black athletes graduate at almost one-half the rate of white athletes.

Clearly, black athletes enter colleges and universities already disadvantaged from inferior high school training. Consequently, they are not as prepared for college life, either socially or academically. Cognizant of this, a number of universities and colleges have instituted various programs to alleviate this condition. The University of Southern California, for example, instituted the University Access Program (UAP), and reported that in 1987, 89 percent of the football team was made up of UAP students, and in 1988, 58.8 percent. U.S.C., like other schools, provides academic tutors and social counselors in the hope that graduation rates will be increased and the number of dropouts lessened. This is not a widespread approach, and apart from low graduation rates, a substantial number of black athletes who graduate do so with very marginal skills.

Black quarterbacks were a rarity in major colleges and professional teams until the 1980s. By 1990, two of the best college teams in the country, Georgia Tech and the University of Colorado, had black quarterbacks. Charlie Ward, who won the Heisman Trophy in 1993 after leading his school, Florida State University, to the national championship, was not picked in next season's college draft, perhaps indicating that the stigma of the black quarterback has not been entirely eliminated.

Media Acceptance

In the 1990s, the reception of the black athlete by the audience and media has been astonishingly positive. Black athletes now command salaries on average approximating that of whites and several superstars enjoy salaries well above the norm. Significantly, this position has been achieved without the (expected) resentment of white fans. In the 1960s, many feared that as black men began to dominate basketball and predominate football, white fans would be turned off, and both sports would suffer. This expectation has not been realized, and especially among young fans the old feelings of prejudice appear to have vanished.

A 1991 *Sports Illustrated* roundtable asked a number of outstanding former athletes if things were better for the black athlete of the 1980s. While most agreed that a number of things had improved in recent decades, a majority of the panelists (which included Hank AARON, Anita DEFRANTZ, and Bill Walton) believed that racism was still rampant in the treatment of black athletes in all professional and collegiate sports, and that apart from the large salaries for those superstar African Americans, the black athlete is not treated very much better than in the 1960s. More important, there remained the overriding concern that black athletes were underprepared for life after professional sports.

REFERENCES

ASHE, ARTHUR, JR. *A Hard Road to Glory: A History of the African-American Athlete.* 3 vols. New York, 1988.

BAKER, WILLIAM J. *Jesse Owens: An American Life.* New York, 1986.

BERRYMAN, JACK W. "Early Black Leadership in Collegiate Football: Massachusetts as a Pioneer." *Historical Journal of Massachusetts* 9, no. 2 (1981): 17–28.

"The Black Athlete." *Sports Illustrated* (August 5, 1991:38–41; August 12, 1991:26–28, 60–66; August 19, 1991:40–46).

CAPTAIN, GWENDOLYN. "Enter Ladies and Gentlemen of Color: Gender, Sport and the Ideal of African-American Manhood and Womanhood During the Late Nineteenth and Early Twentieth Centuries." *Journal of Sport History* 19, no. 1 (1991): 81–102.

CHAMBERS, TED. *The History of Athletics and Physical Education at Howard University.* New York, 1986.

DAVIS, LENWOOD G., and BELINDA S. DANIELS. *Black Athletes in the United States.* Greenwich, Conn., 1981.

HOLWAY, JOHN B. *Blackball Stars: Negro League Pioneers.* Westport, Conn., 1988.

———. *Black Diamonds: Life in the Negro Leagues from the Men Who Lived It.* Westport, Conn., 1989.

HOOSE, PHILLIP M. *Necessities: Racial Barriers in American Sports.* New York, 1989.

HUNTER, BRUCE. *Quarterback: Shattering the NFL Myth.* Chicago, 1990.

MEAD, CHRIS. *Champion: Joe Louis, Black Hero in White America.* New York, 1985.

OLSEN, JACK. *The Black Athlete.* New York, 1968.

RITCHIE, ANDREW. *Major Taylor: The Extraordinary Career of a Champion Bicycle Racer.* San Francisco, Calif., 1988.

SAMMONS, JEFFREY T. *Beyond the Ring: The Role of Boxing in American Society.* Chicago, 1990.

SHAPIRO, LEONARD. *Big Man on Campus.* New York, 1991.

TYGIEL, JULES. *Baseball's Great Experiment: Jackie Robinson and His Legacy.* New York, 1983.

WHEELER, LONNIE. *I Had a Hammer: The Hank Aaron Story.* New York, 1991.

WIGGINS, DAVID K. "Sport and Popular Pastimes: Shadow of the Slavequarter." *Canadian Journal of History of Sport* 11, no. 1 (1980): 61–88.

YOUNG, A. S. *Negro Firsts in Sports.* Chicago, 1963.

JOHN C. WALTER

Springfield, Illinois, Riot of 1908. Many bloody riots took place in the Midwest in the early decades of the twentieth century. Perhaps the worst, and certainly the most significant, was the 1908 disturbance in Springfield, Ill., because of its symbolic importance as the onetime home of Abraham Lin-

coln. In 1908 the town had about fifty thousand people with a long-established but often despised African-American community. Residents had traditionally blamed blacks for vice in the city. Local coal miners, many of them Irish-Americans and other immigrants, feared economic gains and demands for equality by Springfield's black community.

On August 14, 1908, the wife of a streetcar conductor falsely claimed that a black handyman, George Richardson, had raped her. (Some months later she admitted that she had actually been beaten by a white man.) On the evening of the fourteenth, Richardson and another black man were arrested and led out of town for their own safety. Aroused, a white mob destroyed the car which had been used for Richardson's getaway, invaded the black neighborhood, and began beating residents and destroying homes. A black barber was lynched, and his shop burned. The next day, the governor called in forty-two hundred state militia troops to stop the violence, but they were slow to arrive. A white mob attacked an eighty-four-year-old black man long married to a white woman. By the morning of August 16, eight blacks were dead; seventy blacks and whites had been injured; two thousand blacks had fled Springfield; and the black section of town was destroyed. No rioters were arrested.

Local white newspapers were at first neutral about mob violence; some even encouraged the rioters. Once the riot was over, white residents who were embarrassed by the notoriety the riot brought Springfield tried to pin the blame for it on African Americans, who, they claimed, had corrupted the city with vice, and on poor and immigrant whites, who, they claimed, had been out of control. However, the city offered neither sympathy nor financial support to blacks whose property had been destroyed. The following year, black and white activists held a conference in New York to protest the Springfield riots. From the conference, a new activist civil rights organization was established, the NATIONAL ASSOCIATION FOR THE ADVANCEMENT OF COLORED PEOPLE (NAACP).

REFERENCES

CROUTHAMEL, JAMES L. "The Springfield Race Riot of 1908." *Journal of Negro History* (July 1960): 164–181.
SENECHAL, ROBERT. *The Sociogenesis of a Race Riot: Springfield, Illinois, in 1908.* Urbana, Ill., 1990.

GREG ROBINSON

Spurlock, Jeanne (July 21, 1921–), psychiatrist. Jeanne Spurlock, the eldest of seven children, was born in Ohio and grew up in Detroit. A dedicated student during high school and college, she was interested first in journalism and then in history. However, she had wanted to become a physician since the age of nine. It was during this year that she had an unpleasant hospital experience that led to her desire to try and make patients, especially young patients, feel comfortable about being in a hospital.

Spurlock received her medical degree from Howard University College of Medicine, Washington, D.C., in 1947. She did her internship at Provident Hospital in Chicago from 1947 to 1948 and continued to reside in Chicago, where she completed a two-year residency at the Cook County Psychopathic Hospital. Spurlock chose psychiatry as her field of interest and received a fellowship in child psychiatry at the Institute for Juvenile Research in 1950. She acquired additional experience in adult and child psychoanalysis at the Chicago Institute for Psychoanalysis from 1953 to 1960.

Some of the positions Spurlock held include staff psychiatrist at the Mental Hygiene Clinic of Women's and Children's Hospital in Chicago, from 1951 to 1953; consultant for the Illinois School for the Deaf in Jacksonville, from 1951 to 1952; and clinical assistant professor of psychiatry, from 1960 to 1968 at the University of Illinois College of Medicine.

Spurlock moved to Nashville when she became chair of the department of psychiatry at Meharry Medical College in 1968. In 1973, she moved to Washington, D.C., to set up a private practice and to become clinical professor of psychiatry at Howard University College of Medicine. She held the post of deputy medical director of the American Psychiatric Association from 1974 to 1991. Although retired from her post, Spurlock continued to participate in the organization as a consulting member on the council of national affairs.

Her honors include the Woman of the Year Award in 1969 from the Davidson County (Tenn.) Business and Professional Women's Club and the *Nashville Tennessean,* and the Edward A. Strecker M.D. award in 1971 from the Institute of the Pennsylvania Hospital for outstanding contribution to psychiatric care and treatment. Spurlock was the first African American and the first woman to receive the latter award.

MARGARET J. JERRIDO

Staupers, Mabel Keaton (February 27, 1890– September 29, 1989), nurse and civil rights activist. Born in Barbados, West Indies, Mabel Keaton Staupers and her parents, Thomas and Pauline Doyle, emigrated to the United States in 1903. The family settled in Harlem, where young Staupers attended

Mabel Keaton Staupers. (© Bill Sparrow/Photographs and Prints Division, Schomburg Center for Research in Black Culture, The New York Public Library, Astor, Lenox and Tilden Foundations)

New York City public schools. She graduated with honors in 1917 from Freedmen's Hospital School of Nursing (now Howard University College of Nursing). Her first marriage, shortly thereafter, to Dr. James Max Keaton of Asheville, N.C., ended in divorce. Moving back to Harlem, Staupers began her professional career as a private duty nurse. In 1920, she helped organize the Booker T. Washington Sanitarium, the first inpatient center in Harlem for African-American patients. It was also one of the few city facilities that permitted black physicians to treat their patients. Staupers became the first executive secretary of the Harlem Tuberculosis Committee of the New York Tuberculosis and Health Association.

Acutely aware of the racial discrimination toward African Americans as both patients and health-care professionals, Staupers dedicated much of her life to gaining acceptance for black nurses. Throughout the 1930s, she worked to strengthen the National Association of Colored Graduate Nurses as an avenue to integrating black nurses into the mainstream of American nursing. During World War II, Staupers was able to win a partial victory against discriminatory quotas imposed by the military services. In 1948,

the American Nurses Association finally voted to open its doors to black members.

Staupers, who married Fritz C. Staupers in 1931, was frequently lauded for her leadership role. In 1951, the NAACP awarded her the Spingarn Medal. She won an Outstanding American Leader and Distinguished Citizen of America award given by the City of New York in 1967, and in 1970 she was named the recipient of the Howard University Alumni Award. Mabel Staupers died in Washington, D.C.

REFERENCES

HINE, DARLENE CLARK. *Black Women in White: Racial Conflict and Cooperation in the Nursing Profession, 1890–1950.* Bloomington, Ind., 1989.

———. "Mabel K. Staupers and the Integration of Black Nurses into the Armed Forces." In John Hope Franklin and August Meier, eds. *Black Leaders of the Twentieth Century.* Urbana, Ill., 1982.

CHRISTINE A. LUNARDINI

Stepin Fetchit (May 30, 1902–November 19, 1985), actor. Lincoln Theodore Monroe Andrew Perry, named after four U.S. presidents, became a major star as Stepin Fetchit and the center of a still-ongoing controversy. His supporters see him as a pioneering black comic actor who had a pathbreaking Hollywood career; his detractors see him as one who profited through his demeaning depictions of African Americans.

Perry was born and raised in Key West, Fla. and left home in 1914, after a stint at St. Joseph's College (a Catholic boarding school) to pursue a career in show business, joining the Royal American Shows plantation minstrel revues. With comic Ed Lee, he developed a vaudeville act entitled "Step 'n' Fetchit: Two Dancing Fools from Dixie." When Perry and Lee split, he adopted the name "Stepin Fetchit" as his own.

Stepin Fetchit spent years on the TOBA (THEATER OWNERS BOOKING ASSOCIATION) vaudeville circuit, developing his stage persona as a lazy, dim-witted, slow, shuffling black servant, where he performed for primarily black audiences to great success. Stepin Fetchit came to Hollywood in the 1920s, and his first appearance in the 1927 film *In Old Kentucky,* playing his stereotyped black persona, earned him a positive mention in *Variety.* The next two films in which he appeared—*Salute* (1929) and *Hearts of Dixie* (1929), the first all-black film musical—brought Stepin Fetchit considerable press attention.

Stepin Fetchit went on to make more than forty films between 1927 and 1976, becoming one of the

first black Hollywood stars. He was a favorite of director John Ford, with whom he made five films: *Salute* (1929); *The World Moves On* (1934); *Judge Priest* (1934); *Steamboat Round the Bend* (1935); and *The Sun Shines Bright* (1954). In *Steamboat Round the Bend* and *Judge Priest,* Ford teamed him up with Will Rogers, with whom he had worked years earlier on the vaudeville circuit. The finale of *Judge Priest* consisted of Fetchit's leading a street parade in a top hat to the tune of "Dixie," and thereby stealing the show.

Nonetheless, Stepin Fetchit's main Hollywood career came to an end in the late 1930s. Black audiences were uncomfortable with the caricatures, and white audiences became tired of them. Stepin Fetchit left Hollywood in the early 1940s bankrupt, having reportedly squandered $1 million, and moved to Chicago where he made occasional nightclub appearances. In the 1950s he reemerged, appearing in *Bend of the River* (1952) and *The Sun Shines Bright* (1954), but neither film succeeded in reviving his career. It was not until the late 1960s that he resurfaced as a member of Muhammad ALI's entourage and as the litigant in a 1970 $3 million lawsuit against CBS for, Stepin Fetchit claimed, "taking me, a Negro hero, and converting me into a villain," in a television show on black history. The suit was eventually dismissed.

In 1972 Stepin Fetchit was awarded a Special Image Award by the Hollywood chapter of the NAACP. He also received the Bethune-Cookman Award for Black Leadership (1972), and in 1978 he was presented with the Black Film Makers' Hall of Fame Award. Stepin Fetchit died in Los Angeles in 1985.

REFERENCES

BOGLE, DONALD. *Blacks in American Films and Television.* New York, 1988.

———. *Toms, Coons, Mulattoes, Mammies and Bucks.* New York, 1973.

"Comeback in Movies." *Ebony* (February 1952): 64–67.

SUSAN MCINTOSH

Stereotypes. Stereotypes are the cultural prisms, shaped over time and reinforced through repetition, that predetermine thought and experience. Although based on a semblance of historical reality, once implanted in popular lore, such images penetrate the deepest senses and profoundly affect behavioral actions. Philosopher Walter Lippmann in *Public Opinion* (1922, pp. 89–90) believed that in the twentieth-century stereotypes are "the subtlest and most pervasive of all influences" because people imagine most things before experiencing them.

The collective aspect of stereotyping is self-confirming, and provides a continuing sense of reality, "a kernel of truth," as historian H. R. Trevor-Roper observed in *The Crisis of the Seventeenth Century* (1965, pp. 190–191), a study of the witchcraft frenzy in sixteenth- and seventeenth-century Europe. "Once established, the stereotype creates, as it were, its own folklore, which becomes in itself a centralizing force." As a result, stereotypes pervade personal fantasies and become cultural commodities, and are dislodged only after a series of protracted assaults.

Racist Ideology

In the history of race relations in the United States, stereotypes preceded and accompanied the origins and legalization of slavery. Equipped with stereotypes, whites fastened the dogma of inferiority on Africans and African Americans. With the termination of slavery, stereotypes were then extensively employed to legitimate segregationist policies. Throughout the course of American history, such ingrained stereotypes subverted black identity and have seriously undermined the formation of a biracial society based on egalitarian practices.

The Child and the Savage

The early images of the African American revolved around a conception of primitivism. The English defined this condition as being "uncivilized," a view that posited the individual as "child" and "savage." Intriguingly, many of the stock traits ascribed to American blacks existed in other slave cultures. "The white slaves of antiquity and the Middle Ages," noted David B. Davis in *The Problem of Slavery in Western Culture* (1966), "were often described in terms that fit the later stereotype of the Negro. Throughout history it has been said that slaves, though occasionally as loyal and faithful as good dogs, were for the most part lazy, irresponsible, cunning, rebellious, untrustworthy, and sexually promiscuous."

Thus, on the one hand, American blacks were seen as savages, inherently brutish and vigorously sexual. Males in particular were cast as being physically well endowed. Examples of this were found in southern newspapers in the decades following the Civil War, with their spurious accounts of black assaults on white women resulting in numerous lynchings. The definitive example of this stereotype is undoubtedly D. W. Griffith's early film classic *Birth of a Nation* (1915), which depicted black men as intellectually crude, sexually predatory, and physically volatile.

However, on the whole, the nonthreatening side of the stereotype dominated in the popular culture, perhaps because of a fear of encouraging black

One of the most famous—and notorious—of Hollywood's stereotyped depictions of African Americans was the simpleminded and hysterical slave Prissy, in *Gone with the Wind* (1939). Butterfly McQueen (above, right, with Vivien Leigh), who portrayed Prissy in the film, left the entertainment industry in the early 1950s, largely because of her refusal to play parts that repeatedly demeaned her intelligence. (UPI/Bettmann)

sexuality or retaliation. Traits of nonaggression, servility, loyalty, docility, and comicality were heavily accentuated. Images fixated on male amiability and female nurturing that became labeled, respectively, as *Sambo* and *Mammy*. There were other related images that permeated the culture. In literature and film, women were often delineated as the child "pickaninny," the tragic mulatto, the innocent or ingenue, the hot mama, and the exotically promiscuous. Males were toms, coons, dandies, and bucks who possessed natural rhythm, had flashy dress habits, craved watermelon and chicken, shot dice, and resorted to petty theft.

There were additional factors that led to Mammy and Sambo, not the least of which was Southerners' phobic need for security. Slave rebellions and retaliations, numerous instances of sabotage, acts of mis-

cegenation, and the suspicion that no black person (and especially no black male) could be completely trusted, led whites to yearn for a worker beyond question. For these reasons, Mammy was portrayed, as was her male counterpart, as invariably cheerful, backward, and harmless.

Mammy

As with all stereotypes, these figures held a partial truth. That certain black women achieved relatively high status on the plantation and in other white households is unquestionable. Women were highly skilled workers who supervised a variety of domestic operations, counseled and caressed people of all ages in white homes as well as in their own homes, and played a predominant role in the black community. The portrait of the black woman as being loyal with-

out bounds, caring solely for her white charges, cheerfully administering all duties regardless of personal circumstances, and fulfilling her own wants by being a slave and worker was a creation arising out of white requirements. The stereotype was intended to legitimize her enslavement and serve as a role model for all black women.

A Mammy prototype appeared extensively in diaries, novels, speeches, anecdotes, lithographs, and advertising throughout the South in the nineteenth century. She was invariably portrayed as large-girthed, apron-wrapped, shining-faced, and bandannaed; her face was wreathed in a smile, her wisdom often delivered in comical dialect. It was a portrait that eventually became widely recognized in the 1890s in advertising as *Aunt Jemima,* a popular brand of pancake batter. At various times Mammy was depicted as being tough and domineering, soft and judicious, slow-witted and comical, but she was always the household worker and nurturer, the one person on whom all could depend when needed. White males in particular were unabashed about their "Mammy" and publicly extolled her.

Southern women were no less effusive in their praise of Mammy, although their relationship was more complex. The request of one aging mistress in the antebellum period that her favorite servant—who had been relegated to sleeping near her mistress on the floor—be interred alongside her was unusual but not unheard of. In 1923, at the prodding of the United Daughters of the Confederacy, a bill was submitted to Congress authorizing "the erection in the city of Washington of a monument to the memory of the faithful colored mammies of the South." Strong protest from African-American newspapers and organizations ended the only attempt to place a statue to "Black Mammy" in the nation's capital.

Nonetheless, the durable Mammy stereotype extended well into the twentieth century in all levels of print, from folklore to novels. William Faulkner, for example, depicted several literary Mammies. In *The Sound and the Fury* (1929), the character Dilsey is an interesting literary variation on the Mammy theme. In *Go Down, Moses* (1940), Faulkner poignantly dedicated the novel to his family's servant, whose energies touched many generations: "To Mammy CAROLINE BARR / Mississippi (1840–1940) / Who was born in slavery and gave to my family a fidelity without stint or calculation of recompense and to my childhood an immeasurable devotion and love." But Margaret Mitchell's "Mammy" in *Gone with the Wind* (1936), the book that became one of the most popular novels and films of the twentieth century, was the archetypal portrait. The Mammy, as portrayed by Mitchell and others, was a composite of the different types of women that had worked on the plantation:

firm, compassionate, smart, morally exemplary, and privy to the inner workings of the family. Her language was ungrammatical and provincial, and as was often the case with the black male, her name always lacked family designation. She answered to the call of Jasmine, Aida, Dilsey, Sapphire, Beulah, Hester, Gossip, Stella, Aunt Dinah, and Aunt Petunia.

Mammy was feted in popular songs and ballads. The new immigrants from Eastern Europe, like the older ethnic groups, astutely recognized her iconical status and wrote lyrically about this ideal American servant. In the popular 1919 song "Swanee," written by George Gershwin and Irving Caesar, there is a longing homage to the figure. By far the most famous stage and film scene spotlighting the form was rendered by Al Jolson, one of the most prominent of the blackfaced performers. It came at the end of *The Jazz Singer* (1927), the first major film to include sound. On one knee, his clasped hands in white gloves, eyes rolled upward, Jolson sang to his imaginary servant: "Oh, Oh, Oh, Mammy, My little Mammy / The sun shines East, the sun shines West / I know where the sun shines best. . . . Mammy, Mammy / I'd walk a million miles for one of your smiles / My Mammy." (While Jolson's song is directed at his white mother, the stereotypes of the black Mammy dominate the song's imagery.)

Nowhere was the Mammy stereotype more durable than in film and on radio and television. A number of distinguished actresses, among them Hattie MCDANIEL, Ethel WATERS, and Louise BEAVERS, fashioned careers playing numerous incarnations and variations of the jolly house servant. The first television series to feature a black female actress, *Beulah* (1950–1953), had a housemaid as the central character.

Sambo

That black men presented a sunny and entertaining stance was a constant observation made by whites. Yet it is apparent that Sambo was a form of resistance, a type of disguise used to survive the systems of slavery and segregation by deflecting physical and mental assault. It was also a particular form of retaliatory humor. A nineteenth-century slave song expressed the strategy: "I fooled Ole Master seven years / Fooled the overseer three / Hand me down my banjo / and I'll tickle your bel-lee."

The roots of the name "Sambo" were both African and Hispanic—from the Hausa fashioning of a spirit or the second son, and "Zambo," meaning a type of monkey—but the English "Sam" had an important role in transposing it into popular lingo. From the mid-nineteenth century to the early decades of the twentieth century, Sambo became the nickname for the black male along with other designations that found popular expression: Tambo, Rastus,

Sheet music portraying the stereotype of "Zip Coon." (Photographs and Prints Division, Schomburg Center for Research in Black Culture, The New York Public Library, Astor, Lenox and Tilden Foundations)

John, Pompey, George, Uncle Tom, "Nigger," and "Boy." In popular songs he was called "Old Black Joe" and "Uncle Ned"; in advertising there was "Uncle Ben's Rice" and "Ben the Pullman Porter"; in literature some of the most widely read literary characters were "Uncle Remus" and "Little Black Sambo"; in radio and films he was "Amos 'n' Andy," "Rochester," and "Stepin Fetchit."

The essential features of Sambo consisted of two principal parts. He was childish and comical, employed outlandish gestures, and wore tattered clothes. Irresponsibility was a cardinal characteristic and buffoonery an inherent trait. On the flip side, he was the natural slave and servant who displayed the qualities of patience, humility, nonbelligerence, and faithfulness. Here responsibility was expected and smartness rewarded, though both virtues were carefully monitored by whites.

The two separate forms eventually became translated into theatrical forms. The child became the "plantation darky" called Jim Crow; the servant be-

came the urban mulatto known as Zip Coon or Jim Dandy. There were variations on the Sambo theme, but all varieties involved individuals who fit into the stereotypes of being "lazy and shiftless" and were "natural entertainers." On the plantation, the dancing and singing slave was a common sight. Musical abilities were often an important selling point at slave auctions, and masters pressured slaves to perform in order to increase production, undercut hostility, and enliven everyday life. For their part, slaves resorted to music and dance as a release from sunup to sundown labor, a means of communication and retention of African folkways.

Early forms of Jim Crow made their way into the popular culture in dramatic theater in the latter half of the eighteenth century, but it was in the minstrels of the 1830s and '40s that the figure emerged fully developed. It occurred when the popular white performer Thomas D. Rice applied blackface; dressed in outlandish costume, he caroused around the stage, singing and dancing in a black idiom: "Wheel about, turn about / Do jis do / An' every time I wheel about / I jump Jim Crow."

Sheet music cover for the song "Honey! You'se Ma Lady Love" by Nat D. Mann. (Photographs and Prints Division, Schomburg Center for Research in Black Culture, The New York Public Library, Astor, Lenox and Tilden Foundations)

"Little Black Sambo" board game. (Allford/Trotman Associates)

The heyday of white minstrelsy lasted for more than fifty years, from the 1830s to the '80s, and was one of the prevailing forms of theater, reaching into many of the most remote geographical corners of the United States and beyond. Almost every white community (and many black communities) boasted of a minstrel troupe which performed in blackface and comical dialect. As a neighborhood production, the minstrel continued into the 1960s, reaching millions of persons who had scant knowledge of African-American culture. By distorting black language and emphasizing comicality, the show perpetuated the image of the black male as a natural buffoon.

The plantation black was given heightened profile in the late nineteenth-century stories of Joel Chandler Harris, one of the first writers to use the folktale as a literary medium. Harris's *Uncle Remus* tales, which first appeared in *Uncle Remus: His Songs and Sayings* (1881), were popular with children and adults for decades, and were later adopted by the mass media in radio and film. By the latter decades of the nineteenth century, Sambo existed in every nook and cranny of the popular culture. In journals, weeklies, newspapers, magazines, novels, short stories, children's stories, humor books, comic pamphlets, and burlesque essays there was a Sambo figure speaking in malapropisms and mispronouncing words. His graphic expressions were even more ubiquitous. On the covers of sheet music, Currier & Ives prints, posters, calendars, book illustrations, dime novels, postage stamps, playing cards, stereoscopic slides, children's toys and games, postcards, cartoons, and comic strips there was a saucer-eyed, thick-lipped, round-faced, kinky-haired, grinningly toothed figure clad in plantation clothing or foppishly attired in formal dress. Sambos also filled the material culture as ceramic figurines on dining-room tables, lawn jockeys,

whiskey-pourers, men's canes, placemats, wooden coins, salt shakers, and countless bric-a-brac.

From its earliest years, the electronic media made extensive use of the stereotype. Film companies inserted Sambo characters—some of whom were white men in blackface—who savored watermelon and chicken, shot dice, wielded razors, and fearfully escaped from ghostly spirits in animated cartoons and feature movies. On radio, the long-running serial program AMOS 'N' ANDY (1928–1960) was performed by two white men in simulated blackface. And the most widely recognized servant on radio was Rochester on the *Jack Benny Show* from 1932 through 1958.

Termination and Replacement

Constant pressure from the African-American community, combined with powerful external events, such as World War II, gradually transformed the harshest aspects of the stereotypes. Their eventual elimination, however, was the consequence of the demands of the civil rights and black nationalist movements of the 1950s, '60s, and '70s. For instance, in response to the civil rights movement, some of the more offensive qualities of the *Aunt Jemima* image on the pancake-batter package have been modified by its manufacturer; in the 1960s, the bandanna was changed to a headband, and since 1990 she has been depicted without any headcovering. The rise to prominence of black legislators, writers, intellectuals, filmmakers, performers, and comedians in the latter decades of the century consigned Mammy and Sambo to the historical dustbin. In the 1980s and '90s, such films as *Malcolm X* (1992) by Spike Lee and *Boyz in the Hood* (1991) by John Singleton, as well as the extraordinarily popular television sitcom *The Cosby Show* (1984–1992), brought to national attention the complex levels of black history and community life.

Playwright Ntozake Shange appearing in 1979 with performers made up in blackface. (Reprinted from *In the Shadow of the Great White Way: Images from the Black Theatre,* Thunder's Mouth Press, © 1957–1989 by Bert Andrews. Reprinted by permission of the Estate of Bert Andrews.)

If the Mammy and Sambo stereotypes have faded, new negative images of African Americans have replaced them. In the latter decades of the century, urban blacks have often been stereotypically identified with city crime, gang violence, welfare, and the firebombing and looting arising from urban uprisings. Such extreme emphasis on the negative aspects of blacks continued to impede the democratic dialogue vital for a biracial society.

REFERENCES

ALLPORT, GORDON. *The Nature of Prejudice.* New York, 1954.

BOGLE, DONALD. *Toms, Coons, Mulattoes, Mammies, and Bucks.* New York, 1973. Rev. ed. New York, 1989.
BOSKIN, JOSEPH. *Sambo: The Rise & Demise of an American Jester.* New York, 1986.
CRIPPS, THOMAS F. *Slow Fade to Black: The Negro in American Films.* New York, 1977.
JORDAN, WINTHROP D. *White over Black: American Attitudes Toward the Negro, 1550–1812.* Chapel Hill, N.C., 1968.
LEVINE, LAWRENCE W. *Black Culture and Black Consciousness: Afro-American Folk Thought from Slavery to Freedom.* New York, 1977.
RIGGS, MARLON. *Ethnic Notions: Black Images in the White Mind* (documentary film). California Newsreel, 1987.
SMITH, JESSIE CARNEY, ed. *Images of Blacks in American Culture.* New York, 1988.
TOLL, ROBERT C. *Blacking Up: The Minstrel Show in Nineteenth Century America.* New York, 1974.

JOSEPH BOSKIN

Stevens, Nelson (April 26, 1938–), painter, muralist, and educator. Nelson Stevens was born in Brooklyn, N.Y. He earned an associate arts degree in advertising and design from Mohawk Valley Technical Institute in Utica, N.Y., and then went on to earn a B.F.A. from Ohio State University in 1962. He finished his formal art education with an M.F.A. from Kent State University in 1969. Stevens began his career as a commercial artist working for General Electric, Cramwell Printery, and the *Cleveland Call Post.* In 1969, he joined AFRICOBRA, the African Commune of Bad Relevant Artists, a major group in the BLACK ARTS MOVEMENT, with whom he has remained closely affiliated. Stevens has worked as an educator for more than thirty years. He has taught art in Cleveland's public school system (1962–1966), at the Cleveland Museum of Art, and at Northern Illinois University (1969–1972). Since 1972, he has been a professor of art and African-American studies at the University of Massachusetts at Amherst, residing in nearby Springfield.

Stevens's paintings and murals draw upon such AfriCobra aesthetic principles as "Koolaid color" and "free symmetry" (rhythmic design) to celebrate the history and self-identity of African Americans. During the 1970s, Stevens painted a series of large, semiabstract images of African-American men and women that explore the emotional states of their subjects through the use of vivid colors and irregular, geometric surface patterns. *Towards Identity* (1970), *Sister Spirit* (1972), and *Uhuru* (1978) each present a close-up portrait of a black woman staring confidently into the distance, her face brilliantly colored and profusely patterned with asymmetrical shapes.

Stevens infuses his paintings with a dynamic, jazzlike feeling. As he put it himself, "I create from the rhythmic-color-rappin-life-style of Black Folk."

Stevens has been at the forefront of the public art and mural renaissance that emerged in the late 1960s. He has directed a series of student murals in Springfield, Mass., which are filled with the icons and symbols of trans-African culture. His own murals commonly explore the themes of African-American solidarity and political liberation, as seen in *I Am a Black Woman* (1975), *I Am a Black Man* (1975), *Malcolm X* (1978), and *The Black Worker* (1973). In 1979, Stevens painted a mural to commemorate TUSKEGEE UNIVERSITY's centennial, entitled *Centennial Vision*.

In addition to his painting, Stevens served as the publisher of *Drum Magazine,* a prize-winning artistic and literary journal, from 1976 to 1987. He has designed album covers for saxophonist Archie SHEPP and illustrated several books, including Chinua Achebe's *Okike.* Since 1993, he has published a calendar devoted to black Christian art called "Art in the Service of the Lord." Stevens has exhibited with AfriCobra throughout the United States and in Africa and the West Indies; a retrospective was held at the Nexus Contemporary Art Center in Atlanta, Ga., in 1990. Among other honors, he has received the Aaron Douglas Award for Achievement in Murals (1977).

REFERENCES

AfriCobra: The First Twenty Years. Exhibition catalogue. Atlanta, 1990.
CHANDLER SMITH, ROBIN. "Performing Arts for the People: Master Muralist Creates Renaissance in Western Massachusetts." *Black Art: An International Quarterly* 2 (Winter 1978): 17–27.

ROBERT A. POARCH

Steward, Theophilus Gould (April 17, 1843–January 11, 1924), clergyman and author. Reared in Gouldtown, N.J. (Bridgeton), Theophilus Gould Steward received a grammar school education supplemented by his family's interest in history and literature. His mother, Rebecca Steward, taught him to challenge "established truths." He began preaching in 1862 and received a license in the AFRICAN METHODIST EPISCOPAL (AME) CHURCH on September 26, 1863. On May 9, 1865, he accompanied Bishop Daniel A. PAYNE and two others to South Carolina to reestablish the AME Church, which had been banned there after DENMARK VESEY'S CONSPIRACY of 1822. From 1865 to 1870 he built churches and schools in South Carolina and Georgia, while earning a reputation as a controversial personality.

Steward served as the election registrar for Stewart County, Ga., and in 1870 criticized the practice that limited jury service to whites. From 1870 to 1891, he served as pastor of churches throughout the eastern seaboard. He was briefly a missionary to Haiti in 1873. While there, he wrote two works on theology: *Genesis Re-reread* (1885) and *The End of the World* (1888). In 1891, Steward joined the Twenty-fifth U.S. Colored Infantry as chaplain, since his constant challenges to the AME bishops had alienated their support. While in the military he wrote a novel, *Charleston Love Story* (1899), and *The Colored Regulars,* widely acclaimed for its depiction of African-American soldiers in the Spanish-American War. Steward was then stationed in the Philippines (1900–1902), where he served as superintendent of schools in Luzon.

From 1907 until his death, Steward was a member of the faculty of Wilberforce University in Ohio. During this period, he contributed essays to newspapers and journals. He also wrote *Gouldtown, a Very Remarkable Settlement of Ancient Date* (1913); *The Haitian Revolution* (1914); and *From 1864 to 1914: Fifty Years in the Gospel Ministry* (1921). Steward was married to Elizabeth Gadsden Steward from 1866 to 1893. His second wife, Susan McKinney-Steward, whom he married in 1896, was a prominent physician in Brooklyn and Ohio until her death in 1918.

REFERENCE

SERAILE, WILLIAM. *Voice of Dissent: Theophilus Gould Steward (1843–1924) and Black America.* New York, 1991.

WILLIAM SERAILE

Steward, William Henry (July 26, 1847–January 3, 1935), educator and religious activist. Born free in Brandenburg, Ky., William Steward was raised in Louisville. Educated at the school of the First African Baptist Church, he was baptized in Frankfort, Ky., in 1867 and soon became secretary of the General Association of Negro Baptists in that state. He joined the First African Baptist church (later the Fifth Street Baptist Church) around 1870. A protégé of pastor Henry Adams and black leader Horace Morris, Steward served as secretary of the choir and taught Sunday school for sixteen years.

In 1872, Steward took a position as a teacher in Frankfort and at Louisville's Free Colored School; in 1875, he was hired as a messenger and purchasing agent for the Louisville and Nashville Railroad Company. Several years later, Steward worked as a mail-

man in a wealthy white neighborhood. In the late 1870s, he became involved in civic and political activities as a lay leader of the church. A racial moderate willing to acquiesce in segregated facilities, Steward secured the support of Louisville's white community for a black YMCA, the Colored Orphan Home, and city services in black neighborhoods. He also built up black public schools through his control of the city school board's Committee on Colored Schools, although his Colored Board of Visitors strictly penalized allegedly "immoral" conduct, which included challenging segregation or African-American leadership. In 1879, he became chairman of the Board of Trustees of Kentucky Normal and Theological Institute (now Simmons University), a position he held for the rest of his life, and started the still-active weekly newspaper *American Baptist* to publicize it. The paper's enormous success won Steward the presidency of the National Afro-American Press Association in the mid-1890s.

Throughout his life, Steward worked to improve African-American conditions without alienating white supporters. In 1875, he blocked a celebration of the Civil Rights Act by Louisville blacks which would have offended whites. In the 1890s, in an attempt to elect a Republican mayor, he denounced militant blacks who demanded public commitments of equal treatment for support. Like his idol, Booker T. WASHINGTON, Steward avoided campaigning openly against disfranchisement and segregation, although he successfully fought local streetcar segregation during the 1900s by pledging good conduct by blacks. Ironically, given his support of Washington, in 1914 Steward and other moderate leaders formed a Louisville chapter of the activist NATIONAL ASSOCIATION FOR THE ADVANCEMENT OF COLORED PEOPLE (NAACP) to unite blacks to fight a residential segregation ordinance. The Louisville chapter remained dependent on influential whites for financial support, however, and once the U.S. Supreme Court overturned the ordinance in 1917, disagreements broke out between Steward and younger, more militant blacks. In 1920, after a dispute over support for a bond issue for the University of Louisville, which excluded blacks, Steward left the NAACP and joined the Committee on Interracial Cooperation, which sought to bring together influential whites and blacks to improve race relations within a segregated society. When blacks were excluded from Louisville's parks in 1924, Steward declined to criticize the decision but lobbied for parks in black neighborhoods. The parks proved little more than vacant lots, but Steward, cautious to the end, contended that his militant opponents had won nothing. Steward died in Louisville at age eighty-seven.

REFERENCES

SIMMONS, WILLIAM J. *Men of Mark.* 1887. Reprint. New York, 1968.
WRIGHT, GEORGE C. "William Henry Steward: Moderate Approach to Black Leadership." In August Meier and Elliott Rudwick, eds. *Black Leaders of the Nineteenth Century,* Urbana, Ill., 1988, pp. 275–291.

SABRINA FUCHS

Stewart, Ellen (November 17, 1919–), theater owner. Ellen Stewart was born in Alexandria, La., the daughter of a schoolteacher and a laborer. She was reared in Chicago and attended college at the Arkansas Agricultural Mechanical and Normal College (now the University of Arkansas at Pine Bluff) and the Illinois Institute of Technology in Chicago. Stewart moved to New York from Chicago after deciding she wanted to be a fashion designer. Shortly after arriving in New York in 1950, she began working in the design department of Saks Fifth Avenue. An illness forced her to leave Saks, and Stewart decided to reorient her life toward work in the theater.

In October 1961, Stewart rented a space in the basement of a building on East Ninth Street in Manhattan. When tenants in the building complained about the number of men entering the apartment, suggesting that Stewart might be running a brothel, an inspector was sent to investigate. He turned out to be a former vaudevillian who suggested that she obtain a restaurant license to defer complaints. The restaurant was named Café La Mama, after Stewart's nickname, Mama, and opened with a performance of Tennessee Williams's *One Arm* in July 1962. Over the next four years, the financially struggling theater moved four times before finally settling on East Fourth Street with a new name, La Mama ETC (Experimental Theatre Club). La Mama has grown to include an annex down the street, and it provides performance space, workshop studios, and an art gallery.

La Mama is well known as a home for new and avant-garde playwrights, with Ellen Stewart representing the spirit and mission of the theater. Stewart believes that long runs are detrimental and often produces forty to sixty productions annually. Some of the writers who began their careers at La Mama include Adrienne Kennedy, Sam Shepard, Lanford Wilson, and Israel Horovitz. Stewart presented the first American production of a Harold Pinter play, *The Room,* in 1962 and helped further the careers of directors Andrei Serban and Tom O'Horgan. La Mama also maintains an international audience,

bringing foreign plays to the United States and taking the work of American playwrights abroad. It has links to theaters around the world in such cities as Bogotá and Paris and in Morocco.

Although Stewart continued to work as a fashion designer through 1972 to support La Mama, the theater has never been financially secure. However, the unique place of La Mama ETC in the theater world is recognized, and Stewart has been awarded grants to continue her work by such organizations as the National Endowment for the Arts and the New York State Council on the Arts. In 1985, she was awarded a MacArthur Fellowship for $300,000.

Into the 1990s, Stewart continued to produce varied offerings at Café La Mama. Stewart at times directed productions at La Mama. In 1989, she directed the play *Dionysus Filius Dei*, the stories of Oedipus and Dionysus set to music. In 1992 Stewart adapted and directed the play *Yunus*, based on the life of thirteenth-century Sufi mystical poets.

REFERENCES

HINE, DARLENE CLARK. *Black Women in America: An Historical Encyclopedia.* New York, 1992.
LANKER, BRIAN. *I Dream a World.* New York, 1990.

KENYA DILDAY

Stewart, John (1784–December 17, 1823), missionary to the Wyandott Indians. John Stewart (also known as John Steward) was born in Powhatan County, Va., to free parents of mixed French, African, and Indian descent. In 1811, he migrated to Ohio, where he worked briefly in maple sugaring in Washington county and became a blue-dyer upon moving to Marietta. In 1815 Stewart joined the Methodist Episcopal church in Marietta. He then moved northward to Goshen, Ohio, and then to Sandusky, where he worked as a missionary from 1816 to 1817 to convert the Wyandott Indians. His approach to the Wyandott Indians, as evidenced from one of his few surviving addresses in 1817, was motivated by a sincere desire for the tribe's religious conversion. He sought to impress upon the Wyandott that Jesus "suffered and died for them, as well as for those who are more enlightened," and that Stewart was concerned for their "safety and future happiness."

Stewart was assisted by Jonathan Pointer, an African American who had been born among the Wyandott and served as his interpreter. In March 1819, Stewart was officially licensed to preach at a meeting of the Mad River Circuit. This official recognition

helped dispel the attacks of his detractors upon his credentials. On August 17, 1819, at the Ohio Annual Conference of the Methodist Episcopal Church, Stewart established the first official Methodist Mission to the Wyandott Indians. For the next three years he worked with the Rev. James B. Finley at a missionary school in Big Springs, where he married a mulatto woman named Polly. In 1822 Stewart joined the newly formed AFRICAN METHODIST EPISCOPAL CHURCH. He died in 1823 near Sandusky, Ohio.

REFERENCES

FINLEY, JAMES B. *History of the Wyandott Mission.* Cincinnati, Ohio, 1840.
MITCHELL, JOSEPH. *The Missionary Pioneer; or, A Brief Memoir of the Life, Labours, and Death of John Stewart, Man of Colour.* New York, 1827.

SABRINA FUCHS

Stewart, Leroy Elliott "Slam" (1914–1987), jazz bassist. Originally a violinist, Slam Stewart studied bass at the Boston Conservatory. From 1938 to 1943, he performed and recorded as part of Slim and Slam, a duo that captured the raucous, irreverent spirit of popular black culture of the prewar years on such tunes as "The Flat Foot Floogie" (1938) through the use of broad comedy and the "jive" vocals of guitarist Slim Gaillard. For the remainder of the 1940s, Stewart's most important association was with the Art TATUM trio, although he was much in demand as a freelance player with a variety of musicians, including Benny Goodman, Red Norvo, and Dizzy GILLESPIE, during a time in which the success of small groups depended upon a solid and propulsive rhythmic foundation.

Along with Jimmy BLANTON and Milt HINTON, Stewart was one of the first jazz soloists on the bass. Unlike most of his contemporaries, he preferred to use the bow during solo improvisations, which were characterized by flawless intonation, sly wit, and rhythmic verve. His solos are immediately recognizable by the distinctive timbre created by his simultaneously bowing a melodic line and humming the same line an octave higher.

Perhaps Stewart's best-known recording is the impromptu duet with Don BYAS on "I Got Rhythm" from a Town Hall concert in 1945, preserved on the *Smithsonian Collection of Classic Jazz*. In 1971, Stewart began a career as a music educator, joining the faculty of the State University of New York, Binghamton. He received an honorary doctorate from the same institution in 1984.

REFERENCE

LYONS, LEN, and DON PERLO. "Slam Stewart." In *Jazz Portraits*. New York, 1989, pp. 483–484.

SCOTT DEVEAUX

Stewart, Maria Miller (1803–1879), essayist and lecturer. Stewart was the first American-born black woman to lecture on political themes and leave extant copies of her texts. Born in Hartford, Conn., Maria Miller was orphaned at the age of five. In an autobiographical passage in her first published essay, she wrote that she was then "bound out" as a servant in the home of a clergyman, where she lived until she was fifteen years old. After that, it appears she supported herself as a domestic servant. As a child she attended Sabbath school, where she acquired the rudiments of literacy, along with religious instruction.

In 1826, she married James W. Stewart, a black Bostonian who was in business as a ship's outfitter. At his request, she took both his surname and his middle initial. James Stewart, some years his wife's senior, died of heart failure in 1829, and soon afterward Maria W. Stewart underwent a religious conversion. She felt herself called by God to write and speak against slavery, for racial justice, and for women's rights. An advocate of the teachings of David WALKER, Stewart put forth arguments that were extremely controversial not only because of her gender, but also because of her forthright militancy. She declared the American Revolution a model for all who would be free, calling on blacks to rise up in arms if necessary to claim their freedom.

During a public career in Boston of barely three years' duration, Stewart published a political pamphlet, *Religion and the Pure Principles of Morality* (1831), and a collection of religious meditations, *Meditations from the Pen of Mrs. Maria W. Stewart* (1832). She delivered four public lectures: *A Lecture Delivered at Franklin Hall* (1832), *An Address Delivered Before the Afric-American Female Intelligence Society of America* (1832), *An Address Delivered at the African Masonic Hall* (1833), and *Mrs. Stewart's Farewell Address to Her Friends in the City of Boston* (1833). She delivered her *Farewell Address* at the African Meeting House on Beacon Hill. This building, which housed the African Baptist Church, was the site of the founding of the New England Anti-Slavery Society in 1832, and was known as the "Colored Faneuil Hall" for the abolitionist and other political meetings held there. In 1835, after she had moved to New York City, a volume of Stewart's collected works, *Productions of Mrs. Maria W. Stewart,* was published in Boston under the auspices of William Lloyd Garrison,

who had previously printed her essays and excerpts from her speeches in the *Liberator*.

Stewart supported herself as a teacher in New York and Baltimore. During the Civil War, she moved to Washington, D.C., where she founded a school for black children. In the early 1870s, she was appointed to a position as matron at the Freedmen's Hospital and Asylum, now Howard University Hospital.

In an unexpected turn of events near the end of her life, Stewart came into a modest pension as the widow of a veteran of the War of 1812. She immediately invested the money in the publication of a new edition of her collected speeches and essays. By way of preface to that 1879 volume, she composed an autobiographical sketch that, because of her inventive use of narrative technique, is a significant example of early African-American women's autobiographical writing.

Maria W. Stewart died in December 1879. Following a service conducted by the Reverend Alexander Crummell, rector of Saint Luke's Episcopal Church, she was buried at Washington's Graceland Cemetery.

REFERENCES

HOUCHINS, SUSAN. *Spiritual Narratives*. Schomburg Library of Nineteenth-Century Black Women Writers. New York, 1988.
RICHARDSON, MARILYN. *Maria W. Stewart, America's First Black Woman Political Writer: Essays and Speeches*. Bloomington, Ind., 1987.

MARILYN RICHARDSON

Stewart, Pearl (November 16, 1950–), journalist. Pearl Stewart is known primarily as the first African-American woman to edit a major national daily newspaper, but she also has had a long career as a journalist. A graduate of Howard University, Stewart's first important assignment came in 1978 when she moved to the San Francisco Bay Area and was named features editor of the *Oakland Tribune*, owned by African-American editor Robert C. Maynard. Two years later, however, she moved to the *San Francisco Chronicle,* for which she worked as a reporter, amassing an impressive professional reputation. In 1991 Stewart left the *Chronicle* and took a position as regular columnist for a weekly Oakland community paper, and *East Bay Express*. In 1992, following the death of Robert Maynard, the *Tribune* was bought by the Alameda Newspaper Group, Inc., a newspaper chain. In accordance with Maynard's previously expressed wishes, the group designated Stewart as his successor. On December 1, 1992, she assumed the editorship.

Stewart faced many challenges, notably that of reversing the *Tribune*'s decline in circulation from several hundred thousand in the 1970s to 114,000 in 1991, and encountered many obstacles. Her plan to transform the *Tribune* into a neighborhood paper led critics to accuse her of an overly suburban news focus. Similarly, her introduction of color photographs and improved graphics prompted complaints that the *Tribune* had become too slick. Stewart had a difficult working relationship with the Alameda Newspaper Group's members, especially after David Burgin took over as senior vice president and editor in chief in 1993. Worst of all, a contract dispute between the *Tribune*'s management and staff led employees to call for a boycott of the newspaper. The protest was officially endorsed by the Oakland City Council, which opposed Stewart's policies. Circulation continued to drop, reaching 91,000 by the end of 1993. On December 6, 1993, citing "differences of style" with Burgin, Stewart resigned as editor.

In 1994 Stewart was named journalist-in-residence at Howard University under a Freedom Forum grant.

REFERENCE

"Pearl Stewart Accepts Howard University Post." *Jet* 42 (August 29, 1994).

GREG ROBINSON

Stewart, Thomas McCants (December 28, 1854–January 7, 1923), lawyer, minister, political activist. T. McCants Stewart was born free in Charleston, S.C. In 1869 he graduated from the Avery Institute in Charleston, then enrolled in Howard University in Washington, D.C. In 1871 Stewart received a bachelor's degree in liberal arts from Howard's Preparatory Department and then entered the university's Collegiate Department to study law. In 1873 he returned to his home state to attend the University of South Carolina, which was integrated during RECONSTRUCTION. He graduated with bachelor degrees in arts and law in 1875.

Upon graduation Stewart became a partner in a Charleston law firm with two prominent black South Carolinians, Robert Brown ELLIOTT, a former U.S. congressman, and D. Augustus Straker, a representative in the South Carolina legislature. The following year the firm disbanded, largely as a result of the racist backlash that accompanied the end of Reconstruction. Stewart then took a position teaching mathematics at the State Agricultural College in Orangeburg. In 1878 Stewart was ordained a minister in the AFRICAN METHODIST EPISCOPAL (AME) CHURCH

and made assistant pastor of the AME church in Orangeburg.

In 1878 Stewart moved to Princeton, N.J., where he studied theology and philosophy at the Princeton Theological Seminary and served as a pastor of the Mount Pisgah AME Church. Two years later, he was hired as pastor of Bethel AME Church in New York City, while he continued his law practice.

In 1883 Stewart accepted a position as professor of history and law at the College of Liberia in Monrovia. His two years in Liberia disillusioned Stewart about prospects of African-American emigration. He returned to the United States in 1885, settling in Brooklyn, N.Y., and published a series of letters on his West African experience in the *New York Globe*, a black newspaper edited by T. Thomas FORTUNE. Stewart encouraged commercial relations between African Americans and Liberia but discouraged mass emigration to the African republic.

While in Brooklyn, Stewart became active in electoral politics, and in 1889 he joined several prominent African-American intellectuals and political leaders who switched from the REPUBLICAN to the DEMOCRATIC party, largely in response to the Republicans' apparent inertia on "the race question" and Democratic President Grover Cleveland's encouraging pronouncements on black civil rights. In that year Stewart helped found the Colored Citizen's Chapin Club, the first black Democratic association in Brooklyn, which was established to support the reelection of white Democrat Alfred C. Chapin as mayor of Brooklyn. (At that time, Brooklyn was an independent city.) In 1890 the club changed its name to the Colored Citizens' Independent Club, and, led by Stewart, successfully lobbied for increased numbers of African Americans in the city's civil service. Besides his electoral work Stewart was also practicing law and served most notably in Fortune's successful 1890 suit against a bar that refused him service because of his color.

Stewart served on the Brooklyn Board of Education from 1891 to 1895 and unsuccessfully fought to integrate several of Brooklyn's schools. He called for African-American children to receive an industrial education so that they might compete for manufacturing jobs.

In 1895 Stewart publicly broke with the Democratic party over Cleveland's reluctance to intervene against lynchings in the South. Rather than return to the Republicans, Stewart remained a political independent for the rest of his life. In the late 1890s he gained national attention as an advocate of black political independence and as a critic of both parties' records on civil rights.

In 1898 Stewart moved to Honolulu, where he spent seven years working as a lawyer. In 1906 he

returned to Liberia and was appointed an associate justice of the Liberian Supreme Court. Throughout his tenure on the court, Stewart sharply criticized the Liberian legal system for its corruption and authoritarianism and was ultimately removed from his position in 1915.

Stewart then moved to England and in 1918 founded the African Progress Union to promote solidarity among all people of African descent. Three years later ill health forced Stewart to leave the chilly climate of England for St. Thomas, U.S. Virgin Islands, where he continued to practice law until his death.

REFERENCES

LOGAN, RAYFORD W., and MICHAEL R. WINSTON, eds. *Dictionary of American Negro Biography*. New York, 1982.

SWAN, ROBERT J. Thomas McCants Stewart and the Failure of the Mission of the Talented Tenth in Black America, 1880–1923. Ph.D. diss., New York University, 1990.

THORNBROUGH, EMMA LOU. *T. Thomas Fortune: Militant Journalist*. Chicago, 1972.

THADDEUS RUSSELL

Stewart, William, Jr., "Rex" (1907–1967), cornetist and composer. Born in Philadelphia and raised in Washington, D.C., Stewart, while still under ten, joined a boy's military band and later played at the Howard Theater. From 1926 to 1933, he performed off and on in Fletcher HENDERSON's orchestra and, from 1934 to 1945, enjoyed his most fruitful period as as member of the Duke ELLINGTON Orchestra. Stewart played with humor, great power, versatility, individuality, and unconventionality. Ellington made artistic use of Stewart's conversational cornet style and his freakish half-cocked-valve effects, notably in his feature number *Boy Meets Horn,* introduced in 1938 but recorded more impressively in 1940 and 1943. *Subtle Lament* (1939) offered a hauntingly poignant solo by Stewart, and *Morning Glory* (1940) also featured his lyrical side.

Stewart led a series of notable small-group recordings using other Ellingtonians, including *Rexatious* (1936), a showcase for Stewart's half-cocked-valve work, *Lazy Man's Shuffle* (1936), *Mobile Bay Blues* (1940), and *Subtle Slough* (1941). Stewart shared composing credits with Ellington on *Rexatious, Boy Meets Horn, Chatter Box,* and others. After touring Europe and Australia from 1947 to 1951, he retired from music for a period, then came back to play and record in New York in the late 1950s, making two exceptional recordings: *The Big Challenge* (1957, with Cootie WILLIAMS) and a reunion of the Fletcher Henderson orchestra, *The Big Reunion* (1957). New York City remained his home for the rest of his life. An insightful observer of and stylish writer on jazz, Stewart wrote magazine articles (some collected in 1972 in *Jazz Masters of the Thirties*) and the posthumously published memoir, *Boy Meets Horn.* (1991).

REFERENCES

STEWART, REX. *Boy Meets Horn*. Ann Arbor, Mich., 1991.

———. *Jazz Masters of the Thirties*. New York, 1972.

JOHN EDWARD HASSE

Still, James (April 9, 1812–March 9, 1885), medical practitioner. James Still was born in Washington Township (later Shamong), Burlington County, N.J., the son of Levin Still, a sawmill worker, and his wife, Charity. Levin Still, a Maryland slave who had bought his own freedom, moved to New Jersey before 1810. James Still acquired no formal education other than three months' training in reading, writing, and arithmetic. One of his earliest memories was of being vaccinated for smallpox at age three by a local doctor. This experience stimulated his interest in medicine. Having neither the contacts nor the financial means to study medicine, however, he chopped wood, worked in a glue factory in Philadelphia (1833–1834), and farmed in southern New Jersey (1834–1843).

In 1843, Still bought a distillery and began compounding tinctures from sassafras roots and other herbs, for sale to druggists in Philadelphia. His repertory gradually expanded following his purchase of a medical botany book. He began by treating his family, then his neighbors, for various ailments. Soon his botanical "cures" for piles, scrofula, dyspepsia, erysipelas, and other disorders earned a countywide reputation among both whites and blacks. One of his best-known remedies was a "cough balsam" made from the roots of spikenard and skunk cabbage.

In contrast to the violent therapies advocated by most regular practitioners of the time, Still's methods were benign and gentle. This explains in part why, despite a lack of professional credentials, he was so popular among those seeking treatment. He was opposed, for example, to "the use of the knife in any case whatever." Local white practitioners warned patients not to patronize Still, and at one point sought recourse against him in court on the grounds that he was not duly licensed. His practice continued to thrive, however, because of his proven ability to al-

leviate suffering and the absence of stringent legal controls on medical practice prior to the late nineteenth century.

James Still was the brother of William STILL, prominent abolitionist and author of *The Underground Railroad*. Two sons, James T. and Joseph C., were also medical practitioners. James T. Still, a graduate of the Harvard Medical School (1871), practiced in Boston and became the first African-American member of the Boston School Committee (1875–1878). Joseph followed in his father's footsteps as an irregular botanical practitioner.

REFERENCE

STILL, JAMES. *Early Recollections and Life of Dr. James Still*. 1877. Reprint. Westport, Conn., 1970.

PHILIP N. ALEXANDER

Still, William (1821–July 14, 1902), abolitionist. William Still was the eighteenth and last child born to former slaves near Medford, Burlington County, N.J. His mother had escaped from a plantation in Maryland and his father had bought his own freedom. Still worked on his family's farm until he was twenty, when he went to work for neighboring farmers. He had little formal education and was largely self-taught. In 1844 he left for Philadelphia, where he spent three years working at a number of odd jobs.

Still became involved with the abolitionist movement (*see* ABOLITION) in 1847, when he was employed by the Pennsylvania Society for the Abolition of Slavery. Three years later he was named chairman of the Philadelphia Vigilance Committee, the clandestine wing of the Abolition Society that organized the city's UNDERGROUND RAILROAD. Still and the committee helped shelter FUGITIVE SLAVES stopping in Philadelphia on the way to Canada. One of the slaves he helped was his brother, Peter Still, who had been left behind by his mother during her escape.

While working with the Pennsylvania Society, Still gave material aid to JOHN BROWN'S RAID on Harper's Ferry and housed Brown's wife after the raid. Still also worked as the Philadelphia distribution agent for the national abolitionist paper the *Provincial Freeman*. He discontinued his abolitionist work in 1861 but remained affiliated with the society for the remainder of his life.

During the CIVIL WAR, Still devoted himself to business ventures; he opened a store that sold stoves, he sold provisions to black soldiers stationed at nearby Camp William Penn, and he started a successful coal business. In the late 1860s he led a successful campaign to end discrimination on Philadelphia

In addition to writing the best-known history of the Underground Railroad, William Still was a leader in black Philadelphia after the Civil War, a prominent civic figure, and a businessman. (Photographs and Prints Division, Schomburg Center for Research in Black Culture, The New York Public Library, Astor, Lenox and Tilden Foundations)

streetcars, helped organize a research organization to collect data about African Americans, and played for the all-black Philadelphia Pythians baseball team, which was denied entry into a white league.

In 1872 Still published an extensive account of his work with fugitive slaves, *The Underground Railroad*, one of the few memoirs of this kind written by an African American after emancipation. The book portrays the runaway slaves as courageous, even heroic figures and their escape to freedom as an act of self-determination. Still's work was published in three editions and was the most widely circulated nineteenth-century history of the Underground Railroad.

In the late nineteenth century Still developed several modestly successful businesses and continued to devote himself to black social causes. In the 1870s and '80s he supported local reform candidates, organized a YMCA branch for black youth, served on the Freedmen's Aid Commission, and helped manage homes for African-American elderly and orphans.

In the early 1880s Still was one of a group of older black leaders in the Northeast who left the Republican party to encourage black political independence

and support of Democratic candidates when such support was advantageous to African Americans. Despite his extensive political activities, Still advocated economic self-improvement over politics as the best course for black advancement.

In 1888 Still and his son-in-law Matthew Anderson, a prominent black minister and businessman in Philadelphia, founded the Berean Building and Loan Association, which provided loans to black home buyers. Still served as the association's first president. From 1896 to 1901 he also served as president of the Pennsylvania Society for the Abolition of Slavery, which after 1865 continued to work for African-American rights and added "and for Improving the Condition of the African Race" to its title. Still died in Philadelphia in 1902.

REFERENCES

Buckmaster, Henrietta. *Let My People Go: The Story of the Underground Railroad and the Growth of the Abolition Movement.* 1941. Reprint. Columbia, S.C., 1992.

Lane, Roger. *William Dorsey's Philadelphia and Ours: On the Past and Future of the Black City in America.* New York, 1991.

Still, William. *The Underground Railroad.* 1872. Reprint. New York, 1968.

Thaddeus Russell

Still, William Grant (May 11, 1895–December 3, 1978), composer. Although he was born in Woodville, Miss., William Grant Still grew up in Little Rock, Ark. He attended Wilberforce University and Oberlin College. His private studies in composition were with George Whitefield Chadwick in Boston and Edgard Varèse in New York.

Still's musical style is perhaps best described as nationalist, successfully blending indigenous American musical elements, African-American folk materials, and the blues idiom into a range of musical genres: symphonic and operatic compositions, chamber music, and art songs. Many of his compositions were inspired by the black experience in America. Over the years, he developed an eloquent musical expressiveness in his works. An outstanding achievement was his handling of melody in his strongly lyrical pieces.

Because he was an excellent orchestrator, he was engaged by such celebrities as Paul Whiteman, Don Voorhees, Sophie Tucker, Willard Robison, and Artie Shaw to prepare orchestral arrangements. In his early years, he played in various dance orchestras and pit orchestras for musicals. Still was associated in the music industry with W. C. HANDY, Harry PACE and

William Grant Still, the leading African-American classical composer in the first half of the twentieth century, wrote a symphony, the ballet *Sahdji,* and the opera *Troubled Island,* among other works. (Prints and Photographs Division, Library of Congress)

his Black Swan Phonograph Company, the *Deep River Hour* on CBS Radio, and Columbia Pictures.

Still composed over 150 musical works. His most significant symphonic compositions are the *Afro-American Symphony* (1930), *Symphony No. 2 in G Minor* (1937), *Festive Overture* (1944), *Plain-Chant for America* (1941, revised 1968), *From the Black Belt* (1926), *And They Lynched Him on a Tree* (1940), and *Darker America* (1924). Still composed ten operas, including *Highway 1, U.S.A* (1962), *Troubled Island* (1941), and *A Bayou Legend* (1941). His ballets include *Sadhji* (1930), *Lenox Avenue* (1937), and *La Guiablesse* (1927). Verna Arvey, his wife, collaborated as a librettist in the writing of many works.

Still received many commissions, awards, prizes, and honorary degrees, as well as Guggenheim and Rosenwald fellowships. His contributions to African-American music are significant: He was the first African-American composer to have a symphony

played by a major American orchestra (*Afro-American Symphony*), the first to have an opera performed by a major company, the first black American to conduct a major orchestra, and one of the first African-American composers to write for radio, films, and television.

REFERENCES

ARVEY, VERNA. *In One Lifetime*. Fayetteville, Ark., 1984.
SOUTHERN, EILEEN. "William Grant Still." In *Biographical Dictionary of Afro-American and African Musicians*. Westport, Conn., 1982.

LUCIUS R. WYATT

Stokes, Carl Burton (June 21, 1927–), lawyer, politician. Carl Stokes was born and raised in Cleveland, Ohio. He attended West Virginia State College from 1947 to 1948 and Cleveland College of Western Reserve University from 1948 to 1950. He left college to take a job with the enforcement division of the Ohio State Department of Liquor Control. In 1952 Stokes enrolled in the University of Minnesota at Minneapolis, receiving a B.S. degree in law in 1954. He then entered the Marshall Law School of Cleveland State University and in 1956 received an LL.B. degree. That year he and his brother, Louis STOKES, opened the law firm of Minor, McCurdy, Stokes and Stokes in Cleveland.

In 1958, Stokes began his career in government when Cleveland's Mayor Anthony J. Celebrezze appointed him as an assistant city prosecutor. In the late 1950s, Stokes became involved in the CIVIL RIGHTS MOVEMENT, and in 1958, he was elected to the executive committee of the Cleveland branch of the NAACP. In 1962, Stokes entered electoral politics, becoming the first black Democrat elected to the Ohio General Assembly. He was reelected twice and served through 1967.

In 1965, while serving as a legislator, Stokes ran unsuccessfully for mayor of Cleveland as an independent Democrat in a general election decided by fewer than three thousand votes. In 1967 he ran again, this time in the Democratic primary election and, with the help of voter registration drives conducted by SOUTHERN CHRISTIAN LEADERSHIP CONFERENCE (SCLC) and the CONGRESS OF RACIAL EQUALITY (CORE), defeated his two opponents, including incumbent candidate Ralph Locher. In the general election, Stokes easily defeated his Republican opponent, Seth C. Taft, to become the first black elected mayor of a major American city. He was reelected in 1969 but decided not to run for a third term in 1971.

Carl Burton Stokes, during his tenure as mayor of Cleveland. (Photographs and Prints Division, Schomburg Center for Research in Black Culture, The New York Public Library, Astor, Lenox and Tilden Foundations)

Stokes's tenure as mayor was marked by his efforts to conciliate Cleveland's white and conservative populations while accommodating the demands of a restive black community. His administration succeeded in raising the city income tax to increase spending for schools, welfare, street improvement, the city zoo, and water purification. Stokes faced his greatest challenge in the summer after his election, when a black nationalist group ambushed and killed several city police officers, sparking a nightlong shoot-out and five days of rioting in the predominantly African-American neighborhood of Glenville. Stokes initially responded by mandating that only black police officers patrol the area, but after several days of rioting, he called in the National Guard, finally quelling the uprising. Stokes's administration was rocked the following spring when it was revealed that funds provided by the mayor's "Cleveland: Now!" urban rehabilitation program had been used without approval to purchase the weapons used in the Glenville shoot-out. Resulting conflicts with the police department, as well as the voters' refusal to raise the city income tax again, compelled Stokes to leave office after his second term.

In 1972, Stokes moved to New York City to work as a reporter and anchor for WNBC-TV, an NBC-station. In 1980 he returned to Cleveland to serve as a senior partner in the labor law firm of Green, Schiavoni, Murphy, Haines and Sgambati. Three years later Stokes successfully ran for a seat as Cleveland municipal court judge, a position he held through the early 1990s.

REFERENCES

WILKERSON, ISABEL. "Past Glory Has Faded for Stokes." *New York Times,* December 3, 1989, p. 34.

VAN TASSEL, DAVID D., and JOHN J. GRABOWSKI. *The Encyclopedia of Cleveland History.* Bloomington, Ind., 1987.

THADDEUS RUSSELL

Stokes, Louis (February 23, 1925–), politician. Louis Stokes was born in 1925 in Cleveland, Ohio, the son of Charles and Louise Stokes (and older brother of future Cleveland mayor Carl STOKES). He attended public school in Cleveland, served in the U.S. Army from 1943 through 1946, and attended Western Reserve University (later known as Case Western Reserve) from 1946 to 1948. In 1953, he earned a doctor of law degree from the Cleveland Marshall Law School of Cleveland State University, gained admittance to the Ohio bar, and opened a law practice in Cleveland. From 1965 to 1966, Stokes was vice president of the Cleveland branch of the NATIONAL ASSOCIATION FOR THE ADVANCEMENT OF COLORED PEOPLE (NAACP); he later served as chair of its legal redress committee. Stokes was elected to Congress as a Democratic representative from Ohio's newly created twenty-first congressional district in 1968. Upon his induction as a congressman in 1969, Stokes became a member of the Education and Labor Committee as well as the House Internal Security Committee (formerly the House Un-American Activities Committee). Two years later, Stokes became the first African American elected to the House Appropriations Committee. A founding member of the CONGRESSIONAL BLACK CAUCUS, Stokes served as its chairman from 1972 to 1974; later in 1974 he became a member of House Budget Committee.

Stokes was appointed in September 1976 to the House Select Committee on Assassinations; he was elected its chair in March 1977. From 1976 to December 1978, the committee provided fresh inquiries into the murders of President John F. Kennedy and the Rev. Dr. Martin Luther KING, Jr. From 1981 to 1985, Stokes was chair of the House Subcommittee on Standards of Official Conduct (House Ethics Committee). In this position he investigated the ABSCAM (a contraction of "Arab scam") scandal, in which members of Congress were accused of accepting bribes. In 1984, he led the investigation into the personal finances of the Democratic vice presidential nominee, New York Rep. Geraldine Ferraro. Stokes also served on the House panel to investigate the American invasion of Grenada in 1983. In January 1987, Stokes, as chair of the House Permanent Select Committee on Intelligence, was also made part of the House Select Committee to Investigate Covert Arms Transactions with Iran. He gained public attention for his speech to Lt. Col. Oliver North on the "rule of law" during the subsequent Iran-Contra hearings. Stokes also worked to provide employment and careers for other African Americans in the intelligence and biomedical fields and helped bring minority colleges and businesses into contact with leading scientific industries.

Stokes was renominated for election by the Democratic party in May 1994. Later that month, as chairman of the House Appropriations Subcommittee, he drew controversy by advising the National Aeronautics and Space Administration (NASA) to cut an additional $200 million from its budget. In June 1994, Case Western Reserve University renamed its health sciences compound the Louis Stokes Health Sciences Center. Stokes was again reelected to Congress in November 1994.

REFERENCES

CLAY, WILLIAM L. *Just Permanent Interests: Black Americans in Congress, 1870–1991.* New York, 1992.

RAGSDALE, BRUCE A., and JOEL D. TREESE. *Black Americans in Congress, 1870–1989.* Washington, D.C., 1990.

DURAHN TAYLOR

Stone, Sly (March 15, 1944–), musician. Sly Stone was born Sylvester Stewart in Dallas. He first recorded at the age of four, playing drums and guitar in "On the Battlefield for My Lord," by the Stewart Four, a family ensemble. His family moved to the San Francisco area in the 1950s. There he sang in vocal groups and performed with Joe Piazza and the Continentals. At the age of sixteen he recorded "Long Time Away."

In 1964 Stewart began to work as a producer and songwriter for Autumn Records, which recorded the Beau Brummels, the Great Society, and Bobby "The Swim" Freeman. In 1966 he worked as a disc jockey at radio stations KSOL and KDIA, both in San Fran-

cisco. In the mid-1960s he was also playing with his own group, the Stoners, which eventually changed its name to the Family Stone. Stewart began calling himself Sly Stone, and his group, a groundbreaking interracial rhythm-and-blues ensemble with male and female musicians and singers, rapidly gained popularity for its psychedelic, funky, soul-rock approach on albums such as *A Whole New Thing* (1967), *Dance to the Music* (1968), and *Life!* (1968), which included "Everyday People." In 1969 Sly and the Family Stone performed at Woodstock and released *Stand!* which included "Hot Fun in the Summertime." That was to be the height of Sly Stone's achievement. In the early 1970s his career began to falter. His offstage excesses, marked by a flamboyant, drug-fueled lifestyle, led to numerous show cancelations or late appearances. He was arrested on drug charges several times in the early 1970s, and on his next album, *There's a Riot Going On* (1971), his music took on a darker, more pessimistic tone. Stone's next two albums, *Fresh!* (1973) and *Small Talk* (1974), failed to sell. In June 1974 Stone married Kathy Silva on stage at Madison Square Garden, but they divorced before the year was out.

In the late 1970s Stone's albums, including *Heard Ya Missed Me, Well I'm Back* (1976) and *Back on the Right Track* (1979) were influential among musicians, but failed to gain a wider audience. In 1981 Stone performed on Funkadelic's *The Electric Spanking of War Babies*. The following year he entered a drug treatment program in Florida and attempted a comeback. Stone released *Ain't But the One Way* in 1983, and performed in concert in 1984 with Bobby Womack. In 1985 he performed on George Clinton's album *Some of My Best Jokes Are Friends*. However, Stone soon found himself again in trouble with the law. In 1985 he pleaded guilty to failing to provide child support and was placed on parole for three years. He was jailed the next year in Los Angeles for the same offense and in Florida in 1987 for parole violation. He was held by police in Connecticut on a drug charge in 1989. Despite the brevity of his commercial success, Stone has remained a major influence on African-American popular music and is considered to be one of the founders of funk and disco music. In 1993 Stone was inducted into the Rock 'n' Roll Hall of Fame.

REFERENCES

FONG-TORRES, BEN. "Everybody Is a Star: The Travels of Sylvester Stewart." In Ben Fong-Torres, ed. *The Rolling Stone Rock 'n' Roll Reader*. New York, 1974.

GEORGE, NELSON. *The Death of Rhythm and Blues*. New York, 1988.

JONATHAN GILL

Stono Rebellion.

The Stono Rebellion of 1739 was the largest uprising of enslaved African Americans to take place in Britain's mainland colonies before the American Revolution. South Carolina's black majority outnumbered whites by nearly two to one and by far more in the coastal low country where West African rice-growing skills were providing planters with enormous profits. Though suppressed by local authorities, the revolt came close to succeeding in ways that could have made it a dramatic turning point in American history.

Despite harsh conditions and diverse languages, underground information networks allowed black Carolinians to communicate. Many were aware of recent resistance in other colonies and knew of the Spanish crown's 1733 offer of freedom to fugitive slaves reaching Florida. Harvest pressures upon blacks and seasonal sickness among whites made September a likely time to rebel, and planters selected Sunday morning, since most whites still attended church unarmed and most slaves were released from work on the Sabbath. Much of the leadership came from Angolans, who represented the largest proportion of recently arrived slaves and who brought military experience from Africa.

Led by a man named Jemmy and no doubt spurred by news that the so-called War of Jenkins' Ear had erupted between England and Spain, a score of black Carolinians met near the west branch of the Stono River about twenty miles southwest of Charleston early on Sunday, September 9, 1739. At Stono Bridge they broke into Hutcheson's store, killing the two storekeepers and taking guns and powder. With cries of "Liberty" and beating of drums, the rebels raised a standard and headed south toward Spanish St. Augustine, where escaping Carolina slaves had been granted freedom at Fort Mose. Along the road they gathered black recruits, burned houses, and killed white opponents, sparing one innkeeper who was "kind to his slaves."

By chance, Lt. Gov. William Bull glimpsed the insurgents and alerted white parishioners. Late Sunday afternoon, planters on horseback caught up with the band of sixty to one hundred rebels in an open field, where they had paused hoping news of their action would inspire further support. In the ensuing encounter, some rebels surrendered or were captured; others were wounded or killed. Several dozen managed to escape, but the organized march southward had been broken up. In the next two days, by one account, militiamen and Indians "kill'd twenty odd more, and took about 40; who were immediately some shot, some hang'd, and some Gibbeted alive." Others remained at large for months.

Over twenty whites and nearly twice as many blacks were killed in the uprising, which led quickly

to a harsher slave code and a moratorium on slave imports, as the white minority debated their precarious situation. Had the rebels managed to travel farther, spread word faster, and delay a confrontation a bit longer, their brave attempt might have spiraled into a successful rebellion that challenged the logic and stability of the emerging slave system. But the tide flowed the other way. By the 1750s the neighboring colony of Georgia had legalized African slavery, and a decade later the English had taken over Florida from the Spanish. Occupants of the Carolina gulag would have to wait generations for a plausible opportunity to strike a blow for their release from bondage.

REFERENCES

THORNTON, JOHN K. "African Dimensions of the Stono Rebellion." *American Historical Review* 96 (October 1991): 1101–1113.
WAX, DAROLD D. " 'The Great Risk We Run': The Aftermath of Slave Rebellion at Stono, South Carolina, 1739–1745." *Journal of Negro History* 67 (1982): 136–147.
WOOD, PETER H. *Black Majority: Negroes in Colonial South Carolina from 1670 through the Stono Rebellion.* New York, 1974.

PETER H. WOOD

Storefront Churches. Storefront churches are usually small, sectarian congregations in the Afro-Protestant folk tradition, self-constituted and thus independent of larger mainstream denominational affiliation and control. Their distinction and name come from the fact that they generally meet in unpretentious stores facing the streets of innercity ghettos rather than in more conventional church buildings. The literature on storefront churches is scant, but as a phenomenon they are usually understood and explained in psychological and sociological terms, essentially as providers of personal status and emotional outlets to the socially disinherited and economically marginal of the black urban poor. While this analysis is useful, it tends to ignore the religious centrality of the storefronts by dismissing their spiritual character as primitive and escapist.

Theologically, storefront churches are typically Protestant, evangelical, fundamentalist, and strongly oriented to the Bible. Many are Holiness in the Wesleyan-Arminian tradition, perhaps because the radical perfectionism of the strict Holiness code along with its imperative to "live above sin" are protective armors against the physical dangers and moral threats of the inner city. Many storefronts are Pentecostal and demonstrate such manifestations of New Testament "gifts of the spirit" as speaking in tongues,

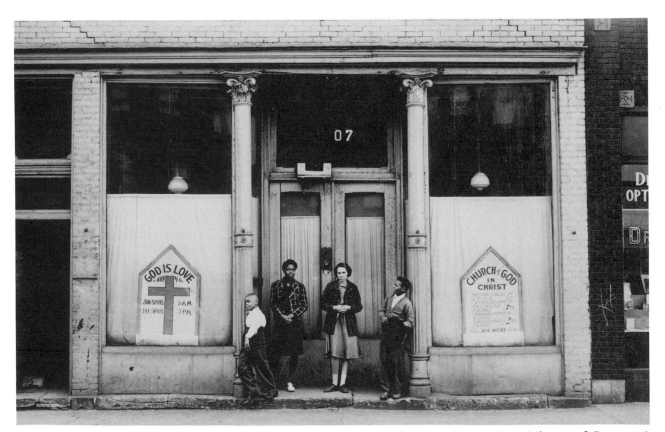

A Church of God in Christ church, Chicago, 1941. (Prints and Photographs Division, Library of Congress)

healing, and ecstatic experience. Increasingly, storefronts are syncretic Spiritual churches or new bodies reflecting Afro-Caribbean and Afro–Latin American beliefs and practices. A few may have a theological focus other than the broad Protestant tradition, such as Old Catholics, for example, and some may be branches of churches led by strongly charismatic figures like Sweet DADDY GRACE.

The origins of storefronts are in the rural South, and they have historically served people by providing continuity with their roots as well as functioning as a place where southern cultural customs survive. Some entire congregations even transplanted themselves from South to North and from country to city. This may also be one reason why storefronts have been looked upon with disdain, as rural black southern churches themselves have often not been taken seriously in the literature. Also, storefronts have appeared pretentious to some because of their eclectic and imaginative names, like Noah's Ark House of Prayer and Baptist Mission (the naming practice is similar to that of the African independent church movement), and because their ministers often assume ecclesiastical titles, such as "bishop" or "overseer."

Storefront church leadership is normally charismatic. A person feels called to preach and simply strikes out on his or her own. Perhaps the call has been to found a church, perhaps one seeks an avenue for leadership, perhaps it was not possible to secure a pastorate or meet some qualification in a more established denomination. More than a few storefront churches are led by women pastors, reflecting the lack of opportunity for ordination, placement, or advancement in other churches. Storefronts are frequently schismatic, splitting and dividing over theological issues, Biblical interpretation, Holiness practices, power relationships, personality clashes, rights of succession, and the like. The underlying ecclesiology is that the true church is pure, exclusivistic, and clearly separated from the world.

As a result, storefront congregations tend to consist of a handful of members with few attendees at services, mainly women and children. But a small congregation better allows for face-to-face intimacy among members and between members and leaders, and it highlights involvement in a like-minded community as well as meaningful participation in worship. Worship is the storefront's chief activity, with services sometimes on weekday evenings as well as several times on Sundays. Preaching is central to worship, as is powerful rhythmic music. Both invoke extensive and even intensive congregational involvement. Musical instruments may include a piano, drums, or tambourines. The people are generally Puritan in their simplicity, and church rooms usually lack adornment, but they may include such amenities

as colored paper pasted over glass windows to simulate stained glass, or Bible verses painted on the walls.

Earlier studies correctly identified storefront congregations as made up of recent migrants and therefore reflective of their religious practices and geared to meeting their special needs as displaced newcomers. Whether this remains true, given the demographic changes since the 1960s and the new influences of Latin American religions, is a subject for future investigation. The tendency has been to think of storefronts as deviations from "normative" churches, as transitory institutions meeting the psychosocial needs of marginal people driven to escape reality, or as institutions existing as a critique of the mainstream denominations which have abandoned poor black neighborhoods. These value judgments slight the storefronts' authenticity as real churches and their legitimacy as valid cultural institutions.

REFERENCES

EDDY, G. NORMAN. "Store-front Religion." *Religion in Life* 28, no. 1 (Winter 1958–1959): 65–85.
WRIGHT, WILLIAM A. The Negro Store Fronts: Churches of the Disinherited. B.D. thesis, Union Theological Seminary, 1942.

RICHARD NEWMAN
MARCIA R. SAWYER

Strayhorn, William Thomas "Billy" (November 29, 1915–May 30, 1967), composer and jazz pianist. Born in Dayton, Ohio, and raised in early childhood in Hillsborough, N.C., Billy Strayhorn gained most of his schooling, including private piano instruction, in Pittsburgh. He sought out Duke ELLINGTON in December 1938, hoping to work with him as a lyricist, introducing himself with his songs "Lush Life" and "Something to Live For." By 1939, Strayhorn had become a regular associate of the Ellington orchestra, contributing themes like "Day Dream" and "Passion Flower" for the alto saxophonist Johnny HODGES, and soon thereafter a melody and arrangement that became the orchestra's theme, "Take the A Train." Strayhorn regularly contributed fully realized instrumental works like "Raincheck," "Chelsea Bridge," and "Johnny Come Lately" (all 1941). Thereafter, Ellington and Strayhorn frequently worked collaboratively, and they said in later years that they were unsure, once a work was completed, which one of them had contributed what.

Strayhorn came to the orchestra with a sophisticated knowledge of chromatic harmony, much of which he had worked out on his own. Ellington himself had evolved from a very different point of de-

parture, beginning with a knowledge only of basic harmony as practiced in ragtime and of blue notes (the lowered, "flatted," third, fifth, and seventh intervals), but he had been headed in a similar direction.

From the middle 1950s until his death, Strayhorn's collaborations with Ellington markedly intensified. There were several extended works such as *Such Sweet Thunder, Suite Thursday,* and the *Far East Suite.* One of Strayhorn's final short works, the compelling "Blood Count," was written for the orchestra's alto saxophonist, Hodges.

REFERENCE

DANCE, STANLEY. "Billy Strayhorn." In *The World of Duke Ellington.* New York, 1973, pp. 29–35.

MARTIN WILLIAMS

Stringer, Charlene Vivian

Stringer, Charlene Vivian (March 16, 1948–), college basketball coach. Charlene Vivian Stoner was born in Edenborn, Pa., and attended Slippery Rock University of Pennsylvania, where she had an award-winning basketball and field hockey career. In 1971 she received a B.S. and became the head coach of women's basketball at Cheney State University, Pa. In 1972, the year that she married fellow student William Stringer, C. Vivian Stringer, as she is known, also earned an M.Ed. in physical education from Slippery Rock. During her eleven years as coach at Cheney State, Stringer had a record of 251 wins and only 51 losses. Her 1981–1982 team made the finals of the first NCAA women's tournament, losing to Louisiana Tech, 76–62.

In 1983 Stringer accepted a position as head coach at the University of Iowa. Her Iowa team won five Big Ten conference titles between 1987 and 1993, and a place in the NCAA national tournament from 1986 to 1993. Through the end of the 1992–1993 season, Stringer had won a total of 485 games as a coach. In addition, she founded the National Women's Basketball Coaches Association in 1980 and was named coach of the year by the NCAA in 1982 and 1988. In 1991 Stringer coached the U.S. women's basketball team to a bronze medal in the Pan American Games in Havana, Cuba. In 1995, Stringer accepted the position of head coach of the Rutgers University women's basketball team. Her reported salary would make her the highest-paid woman in her field.

REFERENCES

TAYLOR, PHIL. "Sports People: Vivian Stringer." *Sports Illustrated* (March 22, 1993): 72–73.

ZAVORALL, NOLAN. "Intense Teaching Wins at Iowa." *New York Times,* March 3, 1985, Sec. 5, p. 6.

LYDIA MCNEILL
PETER SCHILLING

Stubbs, Frederick Douglass

Stubbs, Frederick Douglass (March 16, 1906–February 9, 1947), physician. Frederick Douglass Stubbs was born in Wilmington, Del. He was a 1927 magna cum laude graduate of Dartmouth College and a 1931 cum laude graduate of Harvard Medical School. Stubbs's father was Dr. J. Bacon Stubbs, a Howard University College of Medicine graduate of the class of 1894, and his mother, Florence Blanche Williams Stubbs was a relative of Dr. Daniel Hale WILLIAMS, so medicine was the career that he chose quite naturally. Upon graduation from Harvard he was accepted as an intern at Cleveland City Hospital, but only after considerable haggling. His name was submitted along with those of four other African-American medical-school graduates; with his academic record—he was at the top of his class at both Dartmouth and Harvard—he was the one selected. This made him the first African-American intern in a major teaching hospital in America.

Stubbs thereafter became interested in surgery as a profession and thoracic surgery as a specialty. Studying under Sam Freelander at Cleveland City Hospital, he became the first African-American thoracic surgeon in the United States. He used his proficiency in the surgical treatment of tuberculosis, which was prevalent among African Americans. In 1933 he went to Douglass Memorial Hospital in Philadelphia to complete his general surgery residency.

In 1934 he married Marian Turner, the daughter of a physician. They had two daughters, Marian Patricia and Fredrika Turner. From 1934 to 1937 he worked in general practice with his father-in-law, Dr. John B. Turner, in Philadelphia. In 1937, Stubbs went to Sea View Hospital in New York for further training in thoracic surgery. Back in Philadelphia the following year, he became the first African American on the staff of Philadelphia General Hospital.

Stubbs received numerous other promotions and privileges, culminating in his assignment to head Philadelphia's Jefferson Medical School Hospital, with the privilege of naming his staff. He did not live to fulfill this assignment. The rigors of a heavy surgical schedule, constant attention to those who asked for advice, and contributions to the medical literature proved to be too much, and on February 9, 1947, he succumbed to a myocardial infarction.

Beyond being a pioneer in thoracic surgery, Stubbs opened the way for other African Americans by be-

ing not only first but a competent first in many areas, including the first black Diplomate in the American Board of Surgery. A fellow of the American College of Surgeons, he also held membership in the American Medical Association, the National Medical Association, Laennec Society of Philadelphia, the Pennsylvania Tuberculosis Society, and the American Public Health Association, among others.

REFERENCES

COBB, W. MONTAGUE. "Frederick Douglass Stubbs, 1906–1947." *National Medical Association Journal* 40 (1948): 24–26.

ORGAN, CLAUDE M., and MARGARET M. KOSIBA, eds. *A Century of Black Surgeons: The U.S.A. Experience.* Norman, Okla., 1987.

VIVIAN OVELTON SAMMONS

Student Nonviolent Coordinating Committee. After an initial protest on February 1, 1960, that attempted to integrate a Woolworth lunch counter in Greensboro, N.C., black college students spearheaded a sit-in movement (*see* SIT-INS) that spread rapidly through the South. Reacting to this upsurge of student activism, SOUTHERN CHRISTIAN LEADERSHIP CONFERENCE (SCLC) official Ella BAKER invited student protest leaders to an Easter weekend conference in Raleigh, N.C. The student leaders, believing that existing civil rights organizations were overly cautious, agreed to form a new group, the Student Nonviolent Coordinating Committee (SNCC, or "Snick"), and elected Fisk University graduate student Marion BARRY as chairman.

Originally a means of communication among autonomous local student protest groups, SNCC gradually assumed a more assertive role in the southern CIVIL RIGHTS MOVEMENT. In February 1961, four students affiliated with SNCC traveled to Rock Hill, S.C., to join a group of protesters arrested at a segregated lunch counter. The arrested students utilized a "jail-no-bail" strategy that was designed to demonstrate their militancy and independence from the NAACP and its legal-assistance staff. In May 1961, after a group of Freedom Riders organized by the CONGRESS OF RACIAL EQUALITY (CORE) encountered violence in Alabama, SNCC activists insisted on continuing the protests against segregated transportation facilities. Dozens of black students rode buses from Alabama to Jackson, Miss., where they were arrested, quickly convicted of violating segregation norms, and then incarcerated in Parchman Prison.

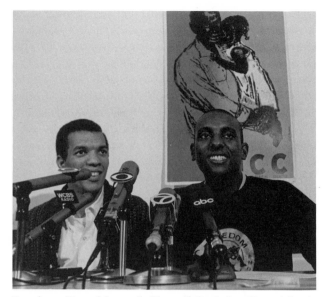

Ivanhoe Donaldson (left) and Stokely Carmichael, SNCC chairman, at the N.Y. SNCC office denouncing the N.Y. City Board of Education's refusal to give control of the school administration to parents at I.S. 201, September 21, 1966. (© Charmian Reading)

From the fall of 1961 through the spring of 1966, SNCC shifted its focus from nonviolent desegregation protests to long-term voting rights campaigns in the deep South. Full-time SNCC field secretaries—many of them veterans of the Mississippi Freedom Rides—gradually displaced representatives of local protest groups as the organization's principal policymakers. Initially dominated by advocates of Christian Gandhianism, SNCC became increasingly composed of secular community organizers devoted to the development of indigenous black leaders and local institutions.

SNCC's ability to work closely with local leaders was evident in the Albany, Ga., protests of 1961 and 1962. Under the leadership of former Virginia Union University student Charles SHERROD, SNCC workers in Albany mobilized black student protesters and spearheaded marches that resulted in hundreds of arrests. Neither the group's brash militancy nor the more cautious leadership of the Rev. Dr. Martin Luther KING, Jr., overcame segregationist opposition in Albany, however, and SNCC's voter-registration campaign in nearby rural areas also achieved few gains in the face of violent white resistance. By 1963, SNCC staff members in southwest Georgia and elsewhere had become dissatisfied with the failure of the federal government to protect them. John LEWIS, who replaced Barry as chairman, expressed this growing disillusionment in his controversial speech given at the massive 1963 March on Washington.

By the time of the march, SNCC's most substantial projects were in Mississippi, where its

community-organizing efforts encountered fierce white resistance. After launching the Mississippi effort in McComb in 1961, Bob MOSES, a former Harvard University graduate student, became voter-registration director of the COUNCIL OF FEDERATED ORGANIZATIONS (COFO), a SNCC-dominated coalition of civil rights groups. Although SNCC's staff was composed mainly of native Mississippians, the campaign for voting rights in the state attracted increasing support from northern whites. Acknowledging the need for more outside support, COFO sponsored a summer project in 1964 that was designed to bring hundreds of white students to Mississippi. The murder of three civil rights workers, two of them white, during the early days of the project brought unprecedented national attention to the suppression of black voting rights in the deep South. SNCC staff members, however, became ever more disillusioned with their conventional liberal allies. In August, this disillusionment increased when leaders at the Democratic National Convention refused to back the MISSISSIPPI FREEDOM DEMOCRATIC PARTY's effort to take the seats of the all-white regular Democratic party delegation.

During 1965 and 1966, the gulf grew larger between SNCC and its former liberal allies. A major series of voting rights protests in Alabama during the spring of 1965 exposed the group's increasing tactical differences with the SCLC. After the killing of Jimmy Lee Jackson in Marion, and a brutal police attack in March on a group marching from Selma to the state capitol in Montgomery, SNCC militants severed many of their ties to the political mainstream. Stokely CARMICHAEL and other SNCC organizers helped establish an independent political entity, the Lowndes County Freedom Organization, better known as the BLACK PANTHER PARTY. In May 1966, SNCC workers' growing willingness to advocate racial separatism and radical social change led to a shift in the group's leadership, with Carmichael replacing Lewis as chairman. The following month, Carmichael publicly expressed SNCC's new political orientation when he began using the Black Power slogan on a voting rights march through Mississippi. The national controversy surrounding his Black Power speeches further separated SNCC from the SCLC, the NAACP, and other elements of the coalition that had supported civil rights reform.

Confronting increasing external opposition and police repression, SNCC also endured serious internal conflicts that made it more vulnerable to external attack. In 1967, executive director Ruby Doris ROBINSON's death from illness further weakened the organization. After H. Rap BROWN became the new chairman in June 1967, Carmichael traveled extensively to build ties with revolutionary movements in

Africa and Asia. Upon his return to the United States, he led an abortive effort to establish an alliance between SNCC and the California-based Black Panther party. The two groups broke their ties in the summer of 1968, and Carmichael remained with the Panthers, leaving James FORMAN as SNCC's dominant figure. By this time, however, SNCC's Black Power rhetoric and support for the Palestinian struggle against Israel had alienated many former supporters. In addition, its leaders' emphasis on ideological issues detracted from long-term community-organizing efforts. SNCC did not have much impact on African-American politics after 1967, although it remained in existence until the early 1970s.

REFERENCES

CARSON, CLAYBORNE. *In Struggle: SNCC and the Black Awakening of the 1960s.* Cambridge, Mass., 1981.
FORMAN, JAMES. *The Making of Black Revolutionaries.* New York, 1972.
SELLERS, CLEVELAND, with Robert Terrell. *The River of No Return: The Autobiography of a Black Militant and the Life and Death of SNCC.* New York, 1973.

CLAYBORNE CARSON

Sublett, John William. *See* Bubbles, John.

Suburbanization. Although the largest number of African Americans moved to the suburbs after 1960, black families have lived in suburbs as long as Americans have found metropolitan life outside the central city desirable.

Historically, African Americans lived in the periphery of southern cities in unplanned enclaves of owner-built houses unserved by city utilities. Settled before EMANCIPATION by urban slaves, freedmen, and FUGITIVE SLAVES, these communities offered freedom from the watchful eyes of masters and security from white predations as well as the chance to live close to urban employers at low cost. Expanded after the Civil War by real estate developers, new lots were subdivided and sold, standard housing was built, and as southern cities expanded during the early twentieth century, many of these "border villages" were absorbed as central city neighborhoods. Others, Carter G. WOODSON noted in 1930, remained "decidedly rural . . . in most of them there are only a few comfortable homes, a small number of stores, a church or two, a school, and a post office. The population is not rich enough to afford taxes to lay

out the place properly, pave the streets and provide proper drainage and sanitation."

By the 1920s, well-to-do African Americans also moved to small neighborhoods at the edge of town, often near black colleges. Fiddleville, a neighborhood in Charlotte, N.C., located at the end of a streetcar line, may have been the nation's first black "streetcar suburb."

In the North, the first significant wave of black suburbanization followed the Great Migration of World War I. Here, black families settled in industrial satellites, domestic service enclaves of affluent railroad suburbs and in semirural, black suburbs similar to the southern "border villages." Like whites, early black suburbanites placed high value on home ownership, gardens, open space, and tightly knit communities. In contrast to the popular image of middle-class suburbia, by 1940, most of the 1.4 million African Americans in suburbs were working class. They often sought jobs as well as homes in the suburbs, and women's earnings played a key role in community-building. Lastly, most wanted these things in a package that suited their taste as rural migrants. As a result, many early black suburbs in the North had a distinctly southern rural atmosphere.

A writer for the WPA described the black suburb of Robbins, Ill., in 1939: "Save for a lumber yard and a dozen shops . . . Robbins is wholly residential, its houses ranging from neat cottages to jerry-built structures of scrap materials." Despite its appearance, home ownership in Robbins and other owner-built subdivisions routinely topped 60 percent—a level comparable to wealthy white suburbs of the era. In River Rouge, Mich., black auto workers lived in the shadow of the Ford Motor Company Factory in tidy wooden homes with gardens, and in Pasadena, Calif., domestic workers raised families in a small neighborhood of stucco houses and apartments down the hill from some of California's richest families.

After World War II, massive white suburbanization curtailed working-class black suburbanization. The changing structure of home finance through federal mortgage programs standardized a biased system of mortgage lending, and trends in the home-building industry toward large-scale builders concentrated power over suburban development in fewer hands. Moreover, new tools—such as zoning and building codes—permitted suburban officials to effectively exclude new black homebuilders and renters. Finally, federal and state support for urban renewal even allowed some municipalities to eliminate existing black communities altogether.

In spite of discrimination, a growing number of middle-class African Americans began moving to the suburbs after 1950. The desire for new, modern housing and the status and comforts of suburban living fueled this movement, but African Americans in the North and South gave the process distinct, regional flavors. In southern cities, black community leaders negotiated with white officials for peripheral "Negro expansion areas" where home builders—often African Americans with financing from black banks and insurance companies—built segregated subdivisions no different from thousands erected for white suburbanites. In the North, there were fewer parcels available for such development, but also, most black leaders rejected the idea of building suburban developments intended to be segregated. Though some African-American subdivisions were built, most new suburbanites struggled for better housing in existing neighborhoods free from the stigma of segregation. Through "white flight" and overwhelming black demand for suburban housing, however, segregation eventually prevailed in most of these neighborhoods as well. In both regions race acted like a wedge in the closed suburban market. "Negro expansion areas" and newly "opened" northern neighborhoods alike tended to be located adjacent to older African-American communities.

After 1960, prosperity and civil rights sparked a flood of African-American suburbanization. Between 1960 and 1990, the number of black suburbanites increased from 2.6 million to more than 7 million—about one quarter of all African Americans. Newcomers tended to be younger, better educated, and more affluent than incumbent suburbanites, and they expressed new freedoms through a greater variety of housing choices—ranging from predominantly white upper income suburbs to luxurious enclaves of the black middle class.

By 1990, segregation—the supposed target of the civil rights movement—had declined only marginally. Most African-American suburbanites moved to places where there were already a large number of black families. Thus, the 1970s and '80s gave rise to dozens of mostly black suburbs. Some of these communities, like west suburban Atlanta and parts of Prince George's County, Md., northeast of Washington, D.C., were as attractive as any in the country. The rise of these places reflected a change in attitudes from the conspicuous integrationism of the 1950s and '60s. After a generation of frustrations with white society, many African American suburbanites explicitly chose mostly black communities as valid expressions of upward mobility. In other suburbs, however, the cycle of crowding, disinvestment, and deterioration characteristic of central city ghettoes plagued new suburbanites. Housing discrimination remained potent even two decades after the Fair Housing Act of 1968. Real estate agents steered clients to communities depending on their race, black buyers found it difficult to get bank loans to purchase

or repair housing, and often speculators took advantage of the desires of lower-income African Americans, crowding multiple families into single-family suburban houses. As a result, by 1990, even many of the most prominent black suburbanites shared their communities with the poor. As John Logan and Mark Schneider have argued, African-American suburbanites tended to pay more taxes, their median income lagged behind neighboring white suburbs, and because of a high incidence of poverty in black suburbs, they provided greater services from a lower tax base. Even though more black families had entered the middle class than ever before, race continued to play a significant role in the quality of housing and their ability to make choices comparable to whites of the same income.

All told, African-American suburbanization after 1960 continued to reflect the remarkable efforts of African American families to improve their lives. It revealed that post–civil rights America offered great new opportunities—particularly for those with the money to pay for them—but it also illustrated that barriers persisted which have long prevented African Americans from sharing equally in the fruits of American society.

REFERENCES

CONNOLLY, HAROLD X. "Black Movement to the Suburbs: Suburbs Doubling Their Population in the 1960s." *Urban Affairs Quarterly* 9, no. 1 (September 1973): 91–111.
JACKSON, KENNETH T. *Crabgrass Frontier: The Suburbanization of the United States.* New York, 1989.
LOGAN, JOHN, and MARK SCHNEIDER. "Fiscal Implications of Class Segregation: Inequalities in the Distribution of Public Goods and Services in Suburban Municipalities." *Urban Affairs Quarterly* 17, no. 1 (September 1981): 23–36.
ROSE, HAROLD M. *Black Suburbanization: Access to Improved Quality of Life or Maintenance of the Status Quo?* Cambridge, Mass., 1976.
WIESE, ANDREW. "Places of Our Own: Suburban Black Towns Before 1960." *Journal of Urban History* 19, no. 3 (May 1993): 30–54.

ANDREW WIESE

Suffrage, Nineteenth-Century. Until 1868, three years into RECONSTRUCTION, most African-American adult males could not and did not vote. A small fraction of African-American males did enjoy the privileges of American citizenship during the colonial and antebellum history of African-American suffrage. The northern members of the original thir-

teen colonies initially permitted African-American voting in the late eighteenth and early nineteenth centuries, at least on paper, and in a few localities in the Carolinas, free blacks also voted. African Americans had played significant roles in the politics of Pennsylvania, New York, and Rhode Island, but by the late 1830s, they had been legally disfranchised in Pennsylvania and New York, and every free state except Maine that entered the Union between 1800 and 1860 (the first was Ohio, in 1803) forbade African-American voting. In other words, as the white adult male franchise expanded with the elimination of property barriers to voting and the establishment of big, full-time political parties, black men were pushed out of politics. The United States was the first polity in the world to have something like broad-based electoral politics, but by the 1830s racial exclusion became part and parcel of such democratic political innovation. In combination with the enslavement of the great majority of African Americans, the informal and legal exclusions of the antebellum period meant that for nearly seven decades of the nineteenth century, very few black Americans wore America's most important badge of citizenship, the right to vote freely.

When African-American voting did come in the South, as the REPUBLICAN PARTY began in 1868 to engineer a truly massive change in the southern political system, it came to men, not women. During the nineteenth century no African-American adult woman voted, first because of enslavement and then because suffrage was monopolized by men. Suffrage would remain a male monopoly until the early twentieth century.

Large-scale male African-American voting resulted from what amounted to a second American revolution. Just as with the first revolution—the war for independence with Great Britain—African Americans played a key role in this new battle. The African-American struggle for citizenship emerged amid the political opportunity provided by a civil war within white America. Equally important, this was a civil war that broke out after it became clear to most Americans, black and white, that its party system could not resolve a public debate over slavery and its relationship to national institutions.

The path to citizenship for southern African Americans—the first of many struggles that would stretch into the late twentieth century—did not, of course, begin with voting. It began instead with daily acts of resistance, mass movement to the Union Army, and gradual self-integration by a large minority of formerly enslaved African Americans into the Union war machine. The possibility of citizenship increased during the course of the Civil War as African-American enlistment in the military conflict was

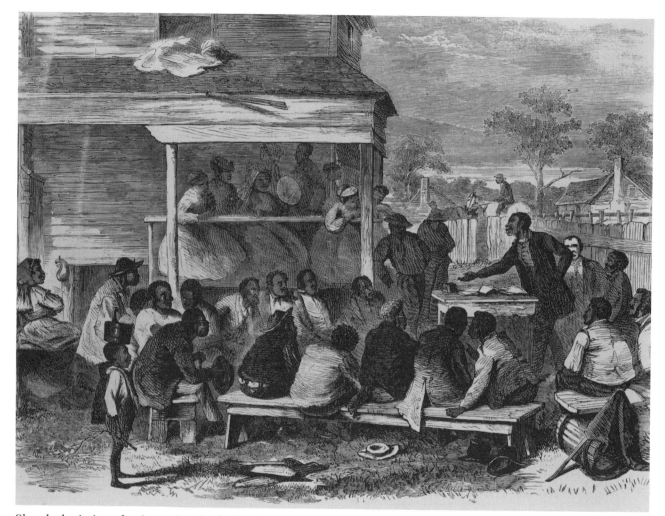

Sketch depicting electioneering in the South. (Prints and Photographs Division, Library of Congress)

widely recognized in the North as critical to the prospects of a Union military success. Military service has historically been widely recognized, in all countries that are even partly democratic, as both an obligation and a privilege of citizenship. Invariably, those who fight on behalf of democracies must also be citizens.

Still, in 1865 the right to vote was not recognized as a national right of citizenship. The 1866 Civil Rights Act and the FOURTEENTH AMENDMENT codified the understanding that such rights as the right to sue, marry, and have contracts enforced were indeed rights of being a citizen of the United States, but voting was left out. The dispute between the White House and Capitol Hill during the first stage of Reconstruction, 1865–1868, helped to establish a national right to vote. The threat posed to the Republican party by President Andrew Johnson's program for reconstructing the ex-Confederate South in turn forced Republican leaders to consider extending their increasingly national view of what citizenship meant into questions of suffrage.

The Republican party stood to lose a great deal from Johnson's plan to restore ex-Confederate states to the Union. It meant the massive reentry into American politics of former Democrats and Confederate leaders. Furthermore, in the South they would have no opposition. The playing field at the national level would thus tilt toward southern politicians. The DEMOCRATIC PARTY would be a powerful national party, and Republicans would be a regional party. In a sense, the victory won by Republicans on the battlefields might be lost in the halls of government.

One option available to Republicans to counter this threat was to promote their own plan for reconstruction of the South. This would include the development of African-American suffrage. Many Republican leaders were genuinely committed to a more egalitarian society. But they also could see that African-American suffrage helped to deal with the threat posed by Andrew Johnson's plans.

The process of building a more democratic order in a region hostile to African-American suffrage had four parts to it: (1) the military reconstruction of the

South in 1867; (2) the FIFTEENTH AMENDMENT, ratified in 1870 and establishing the federal government as a guardian of state electoral rules and institutions; (3) two statutes implementing the amendment, namely, the Enforcement Act of 1870 and the Ku Klux Klan Act of 1871; (4) using the Justice Department and the U.S. Army to defend the new Republican parties from violent attack by the KU KLUX KLAN and white "rifle clubs."

Despite the violence that accompanied the rebuilding of the South, there was a high rate of adult black male electoral participation throughout the South during Reconstruction. Still, the violence that was associated with the incorporation of southern African Americans into the electoral system sharply divided many white Americans in both the North and the South. As early as 1872 the northern Republican party split over how much the national government should do to protect African Americans in the exercise of their rights. This split foretold Republican willingness to abandon the South. With the COMPROMISE OF 1877, Republicans took a big step backward from their southern commitment.

Even so, a highly participatory (if sharply contested) political order lasted in many ex-Confederate states into the late 1880s and in North Carolina into the 1890s. This was partly because Republicans stayed somewhat involved in the South and partly because there were third-party movements of economic protest that were willing to make appeals to black voters. Although African-American political participation declined in South Carolina, Georgia, Alabama, and Louisiana, in other states—including Mississippi—shifts in political opportunities were skillfully negotiated by black leaders. The state of Virginia, for instance, experienced the rise of a militant, biracial party for several years in the 1880s. George White, an African-American politician from North Carolina, to take another example, was elected to the U.S. House of Representatives as late as 1898, and he was to be the last African American to be elected from the South until 1973.

Still, conservative white Democrats had always been opposed to autonomous African-American involvement in electoral politics. Gradually, over several decades, they gained control throughout the entire South. Between about 1890 and 1910, through legislation and, in some states, constitutional conventions, they installed what has been called the "Southern system" of electoral rules. The two most important devices in this system were poll taxes, a fee to be paid prior to voting, and literacy tests. Poll taxes were a significant percentage of the annual income of small farmers, many of whom were already heavily in debt to local merchants or banks. The low rates of

literacy in the region also hit many adult males hard. (See Table 1.)

TABLE 1 **Federal Election Years in Which Poll Taxes and Literacy Tests Were First Used**

States	Poll Tax	Literacy Test
Alabama	1902	1902
Arkansas	1894	
Florida	1890	
Georgia	1878*	1908
Louisiana	1898	1898
Mississippi	1890	1892
North Carolina	1900	1902
South Carolina	1896	1896
Tennessee	1890	
Texas	1904	
Virginia	1904	1902

*Note that Georgia established a poll tax in the early nineteenth century and reenacted it after Reconstruction.
Source: Adaptation of Table 6.1 in Rusk and Stucker (1978) and Kousser (1974).

State legislators and delegates to state constitutional conventions were remarkably candid, often stating their intention to disfranchise African Americans completely. But these rule changes were nevertheless designed to be, on the surface, racially neutral and thus not unconstitutional under the Fifteenth Amendment. Many southern politicians openly called for the repeal of the Fifteenth Amendment, but until repeal could occur, they were careful to make sure that the new rules did not flagrantly violate the letter of the constitutional law. In a narrow sense the rule changes *were* racially neutral, for they made it harder for poor white farmers, many of whom had supported third-party movements, to vote. However, local voter registrars often ensured that many white voters could register nonetheless, by asking far more difficult questions of blacks. Other methods used to circumvent the Fifteenth Amendment included the grandfather clause and the all-white primary.

Disfranchisement gathered as much momentum as it did in part because the Republican party had little need for the South after 1896. Key third-party leaders who once had supported African-American voting, such as the Georgia populist Tom Watson, became white supremacist in their outlook as a tactic for staying in the political arena. By about 1900 nearly all white resistance to disfranchisement and conservative southern Democrats had ended.

REFERENCES

DU BOIS, W. E. B. *Black Reconstruction in America, 1860–1880*. New York, 1935.

FONER, ERIC. "Blacks and the U.S. Constitution, 1789–1989." *New Left Review* 183 (September-October 1990): 63–74.

KOUSSER, J. MORGAN. *The Shaping of Southern Politics: Suffrage Restriction and the Establishment of the One-Party South, 1880–1910.* New Haven, Conn., 1974.

RUSK, JERROLD G., and JOHN J. STUCKER. "The Effect of the Southern System of Election Laws on Voting Participation." In Joel H. Silbey, Allan G. Bogue, and William H. Flanigan, eds. *The History of American Electoral Behavior.* Princeton, N.J., 1978.

VALELLY, RICHARD M. "Party, Coercion, and Inclusion: The Two Reconstructions of the South's Electoral Politics." *Politics and Society* 21 (March 1993): 37–67.

WALTON, HANES, JR. *Black Political Parties: An Historical and Political Analysis.* New York, 1972.

RICHARD M. VALELLY

A man standing outside SNCC headquarters on voting day in Selma, Ala., May 3, 1966. (© Charmian Reading)

Suffrage, Twentieth-Century. With the onset of the twentieth century came the eclipse of African-American suffrage in the South, where the overwhelming majority of blacks lived. The enfranchisement of black men, which began during Reconstruction, drew to a close during the 1890s and early 1900s as the former Confederate states eliminated the mass of blacks from the electorate. Poll-tax payments, literacy and understanding tests, and GRAND-FATHER CLAUSES frustrated poor and uneducated blacks, especially when administered by white registrars who arbitrarily determined whether voter applicants satisfied state requirements. Though impoverished and illiterate whites also suffered, the racial motivation behind disfranchisement was clearly evidenced in the adoption of the white primary. Winning the Democratic primary in the one-party South guaranteed election to office, a system that left blacks virtually excluded by 1910.

African Americans challenged suffrage discrimination from the beginning of the century. In 1915, the NAACP won a Supreme Court victory outlawing the grandfather clause (which had permitted illiterate whites but not blacks to qualify to vote), and it gained a victory against the white primary in 1944. In the meantime, some southern blacks continued to vote in nonpartisan municipal elections, and ratification of the Nineteenth Amendment in 1920 opened the way for participation by black women, albeit subject to the same restrictions handicapping black men. The breakthrough for reenfranchisement came during World War II. Inspired by the war's democratic ideology and encouraged by the overturning of the white primary, black military veterans returned to civilian life intent on exercising full citizenship rights. By the end of the 1950s, nearly 30 percent of adult blacks in the South had enrolled for the ballot, up from 5 percent before World War II.

The postwar black-led CIVIL RIGHTS MOVEMENT succeeded in extending the right to vote to the majority of African Americans. In 1957 and 1960, the NAACP successfully lobbied Congress to approve civil rights laws providing the Justice Department with legal tools to enjoin voter registrars from practicing suffrage discrimination. Relying on litigation for relief, however, allowed white Southerners to devise delaying tactics to avoid compliance. The climax of the enfranchisement struggle came in 1965, when the Rev. Dr. Martin Luther KING, Jr., led nationally publicized demonstrations in Selma, Ala., resulting in passage of the powerful VOTING RIGHTS ACT and registration of the majority of African Americans. Aimed at the South, the landmark law suspended literacy tests, authorized the deployment of federal registrars, and provided the federal government with a veto over proposed voting changes in covered jurisdictions, thereby effectively removing the major obstacles to black suffrage. In addition, the Twenty-

fourth Amendment (1964), together with a 1966 Supreme Court ruling, eliminated the poll-tax requirement in national and state elections, respectively.

Following the overthrow of these frontline barriers to voter registration, suffrage reformers attacked election rules diluting the strength of black ballots. Successful court challenges curtailed such practices as racial gerrymandering of legislatures and at-large election procedures that operated to the disadvantage of minority candidates. However, in 1993 the Supreme Court began to limit the efforts of lawmakers to shape electoral districts for the purpose of enhancing the election of blacks. Although African Americans had not reached their officeholding potential by 1990, blacks held 7,370 elected positions nationwide. More than half (4,369) governed in the South, once the bastion of white-supremacist opposition to black suffrage.

While African-American political participation expanded, black voting behavior changed significantly. The legacy of Republican-sponsored emancipation dating from the Civil War and Reconstruction eras placed those black voters who continued to exercise the franchise in the early twentieth century mainly in the GOP camp. African Americans cast their ballots solidly for the party of Abraham Lincoln until the economic crash of the Great Depression and the relief programs of Franklin D. Roosevelt's New Deal swung them into the Democratic column. President Harry Truman's civil rights policies cemented black partisan loyalties, and after 1948 African-American voters increasingly supported Democrats. In the decades following Lyndon Johnson's 1964 election, Democratic presidential candidates garnered around 90 percent of black ballots. However, this steadfast black support did not generally succeed in electing Democratic presidents, and from 1968 to 1992, Republicans captured the White House in five of seven contests.

REFERENCES

HINE, DARLENE CLARK. *Black Victory: The Rise and Fall of the White Primary in Texas.* Millwood, N.Y., 1979.

KOUSSER, J. MORGAN. *The Shaping of Southern Politics: Suffrage Restriction and the Establishment of the One-Party South, 1880–1910.* New Haven, Conn., 1974.

LAWSON, STEVEN F. *Black Ballots: Voting Rights in the South, 1944–1969.* New York, 1976.

———. *In Pursuit of Power: Southern Blacks and Electoral Politics, 1965–1982.* New York, 1985.

———. *Running for Freedom: Civil Rights and Black Politics in America Since 1941.* New York, 1991.

WEISS, NANCY. *Farewell to the Party of Lincoln: Black Politics in the Age of FDR.* Princeton, N.J., 1983.

STEVEN F. LAWSON

Sullivan, Leon Howard (October 16, 1922–), civil rights teacher. Leon Sullivan was born in Charleston, W.Va. As a young man he was encouraged by his grandmother to improve the lives of the disadvantaged; after receiving a B.A. from West Virginia State College in 1943, he decided he could do this best by entering the ministry. That year he moved to New York and, on a scholarship, enrolled in the Union Theological Seminary, where he came to the attention of the Rev. Adam Clayton POWELL, JR. Powell hired Sullivan as an assistant minister at the ABYSSINIAN BAPTIST CHURCH in Harlem. Another mentor, A. Philip RANDOLPH, instructed Sullivan in community mobilization tactics. These lessons stood Sullivan in good stead when, after receiving his seminary degree in 1945 and an M.A. from Columbia University in religious education in 1947, he worked as a community organizer in South Orange, N.J.

In 1950 Sullivan was named pastor of the Zion Baptist Church in Philadelphia. A small church of six hundred members, it had grown to a membership of three thousand by the time Sullivan retired and became pastor emeritus in 1988. He was active in numerous efforts in the late 1950s and early '60s to encourage local businesses to hire minorities, although he came to the conclusion that many African Americans were unprepared for a number of employment opportunities. To address that need, Sullivan founded Opportunities Industrialization Centers of America (OIC) in 1964. "Integration without preparation is frustration," he claimed. A not-for-profit organization that provided motivation and job training to unskilled workers of all races, OIC grew by 1980 into a network of nationwide comprehensive training centers with 140 affiliates and funding of over $130 million a year. With the advent of the Reagan administration, however, federal funding for OIC dwindled, and the organization was forced to make deep cuts in its programs and budget. Nevertheless, by 1993 the OIC still had training programs in eighty cities, had trained a total of one million men and women for jobs, and had established branches in at least thirteen sub-Saharan African countries.

Sullivan is probably best known, however, for formulating what became known as the Sullivan Principles, a set of guidelines for American corporations doing business in South Africa aimed at obtaining fair treatment of black South African workers. Using his prominent position as the first black director of General Motors (he was appointed to that post in 1971), Sullivan enumerated the principles in 1977. The original six called for nonsegregation of the races in all eating, comfort, and work facilities; equal and fair employment practices for all employees; equal pay for all employees doing equal or comparable

work for the same period of time; initiation and development of training programs to prepare substantial numbers of blacks and other nonwhites for supervisory, administrative, clerical, and technical jobs; increasing the number of blacks and other nonwhites in supervisory positions; and improving the quality of employees' lives outside the work environment in such areas as housing, transportation, schooling, recreation, and health facilities.

In 1984, the principles were revised to require American corporations doing business in South Africa to work to overturn the country's racial policies, to allow black workers freedom of mobility in order to take advantage of work opportunities wherever they existed, and to provide adequate housing for workers close to the workplace. By this time, about 150 of the 350 American corporations with investments in South Africa were voluntarily complying with the principles.

From the beginning, however, the principles were controversial. Some South African trade unionists and many Americans who favored complete corporate disinvestment in South Africa claimed that the principles enabled corporations to say they were fighting racism while profiting from apartheid. But Sullivan claimed that without the principles, the enormous leverage of American corporate power could not create changes in the lives of black South Africans.

Nevertheless, in 1987 Sullivan declared that the principles had failed to undermine apartheid. He called on American corporations to sell their investments in South Africa and on the Reagan administration to sever all diplomatic ties. He also urged a complete trade embargo with South Africa.

At the same time, Sullivan was expanding his self-help and educational efforts in Africa. In 1983 he established the International Foundation for Education and Self-Help (IFESH) to fight illiteracy, hunger, and unemployment in fifteen sub-Saharan African countries alongside the OIC.

Sullivan received numerous awards and honorary degrees. The NAACP awarded him the SPINGARN MEDAL in 1971 for training inner-city workers for new job opportunities. In 1991 he received the highest U.S. civilian award, the Presidential Medal of Freedom, for his life's work in helping the poor and disadvantaged in both America and Africa. That same year he received the Ivory Coast's highest honor, the Distinguished Service Award, in recognition of his efforts to improve the lives of sub-Saharan Africans.

REFERENCES

"Negro on G.M. Board Ready for Challenge." *New York Times*, January 9, 1975, p. 35.

"Rev. Sullivan Steps Up." *New York Times*, November 6, 1983, Sec. 4, pp. 12–13.
SULLIVAN, LEON. *Build, Baby, Build*. Philadelphia, 1969.
WALKER, JIM. "Interview: Elton Jolly." *Crisis* (April 1985): 34–48.

MICHAEL PALLER

Sullivan, Louis (November 3, 1933–), physician and cabinet member. Louis Sullivan was born in Atlanta, Ga., to undertaker Walter Wade Sullivan and Lubirda Elizabeth Sullivan, a schoolteacher. Sullivan's parents moved to Blakely, Ga., where they later founded the Blakely chapter of the NAACP. Louis stayed in Atlanta with relatives because of the better educational opportunities and graduated from Morehouse College in 1954. Winning a scholarship to Boston University Medical School, he graduated cum laude as the only black member of his class in 1958. He finished his internship and residency at New York Hospital–Cornell Medical Center in New York City in 1960 and subsequently won a fellowship in pathology at Massachusetts General Hospital in Boston. In 1961 he was awarded a research fellowship to the Thorndike Memorial Laboratory at Harvard Medical School, where he was named instructor of medicine in 1963. From 1964 to 1966, he served as assistant professor of medicine at the New Jersey College of Medicine. He returned to Boston University in 1966 and became assistant professor of medicine at the medical school as well as codirector of hematology at the medical center. In 1974 he became a full professor of medicine and physiology.

In 1978 Sullivan helped found a new medical school, Morehouse School of Medicine (affiliated with Morehouse College yet independent of it), to train African-American doctors to practice in the South. With Sullivan as its first dean and president, Morehouse School of Medicine became accredited in 1981. Sullivan got personal support for his school from Vice President George Bush and his wife, Barbara. Mrs. Bush became a trustee of the school in 1983, and following her husband's election to the presidency five years later, led the effort to secure Sullivan's nomination as secretary of health and human services. Despite a moderate position on abortion, Sullivan was nominated by Bush and confirmed in 1989 after calling for the reversal of the U.S. Supreme Court *Roe* v. *Wade* abortion decision.

As secretary, Sullivan devoted most of his attention to minority health care and preventive medicine and opposed further cutbacks in Medicare. He encouraged Congress to reverse the budget cuts for

medical education that had occurred under the Reagan administration, and he initiated a program to curtail the spread of tuberculosis. Sullivan incurred controversy when he initially supported needle exchanges with drug users to prevent the spread of AIDS; he later reversed his position.

After Bush left the White House in 1993, Sullivan returned to full-time service as president of the Morehouse School of Medicine.

REFERENCES

JENSEN, KRIS. "*Emerge* Profiles Morehouse's Sullivan," *Atlanta Constitution,* December 7, 1993, Sec. F, p. 3.

"Louis Sullivan's Record." *Boston Globe,* December 15, 1992, p. 22.

DURAHN TAYLOR

Sun Ra (Blount, Herman "Sonny") (May 1914–May 30, 1993), jazz bandleader and pianist. Born in Birmingham, Ala., Herman "Sonny" Blount played piano as a child and led his own band while still in high school. He studied music education at Alabama A&M University and studied classical piano with Willa Randolph. Blount moved to Chicago while still in his teens, and in the mid-1930s he toured with John "Fess" Whatley's band. He gradually gained a reputation as a sideman and arranger for shows. From 1946 to 1947 Blount worked at Chicago's Club de Lisa, leading his own group and also serving as pianist and arranger for Fletcher HENDERSON.

In the late 1940s Blount completely reinvented himself, changing his name to Sun Ra and claiming the planet Saturn as his birthplace. Thereafter his music carried strong science fiction overtones, and he took as his motto "Space Is the Place." At the same time, he also began to turn to ancient Egypt and Ethiopia for his spiritual outlook and sartorial style. In 1953 he formed a big band called the Arkestra, and over the next forty years the group pioneered the use of modern collective improvisation and exemplified the anarchic spirit of free jazz (*Sound of Joy,* 1957). Sun Ra also established a core of remarkable soloists, including saxophonists Marshall Allen, John Gilmore, and Pat Patrick. Sun Ra was himself an accomplished pianist capable of contemplative modal moments as well as roiling solos, never losing the energetic drive of his stride piano roots. He was a pioneer in the use of electric instruments, playing the electric piano as early as 1956. He also gained renown as a composer of songs such as "A Call for All Demons" (1956) and "Cosmic Chaos" (1965).

Sun Ra created a distinctive fusion of big band, hard bop, Afro-Cuban, and avant-garde jazz styles from the 1950s through the early 1990s, even gravitating guardedly toward punk rock in his last years. The exotic robes and "cosmic" compositions of Sun Ra, who claimed to have been born on Saturn, were an integral part of his musical ideas. (Photographs and Prints Division, Schomburg Center for Research in Black Culture, The New York Public Library, Astor, Lenox and Tilden Foundations)

While in Chicago in the 1950s, Sun Ra found his music rejected by established jazz musicians, but he proved enormously influential to the new generation of avant-garde musicians. In the late 1950s he started Saturn Records, which released dozens of his albums during the next few decades. In the early 1960s the Arkestra set up communal living quarters in New York and thereafter became a mainstay in avant-garde jazz (*The Heliocentric Worlds of Sun Ra,* 1965; *Nothing Is,* 1966). They participated in Bill Dixon's October Revolution series of concerts in 1964 and joined the cooperative Jazz Composers Guild. In the late 1960s and throughout the 1970s, the Arkestra continued to record (*The Solar Myth Approach,* 1970–1971) and tour.

Although Sun Ra's work was always heavily influenced by Henderson's work, it was not until the late 1970s, when the Arkestra moved to Philadelphia, that Sun Ra began to incorporate traditional arrangements of tunes by Henderson, Jelly Roll MORTON, Duke ELLINGTON, and Thelonious MONK into its rep-

ertoire. Nonetheless, the Arkestra never lost its futuristic eccentricity. During this time Sun Ra directed circuslike concerts, complete with dancers and spectacular costumes, chants of "next stop Mars!" space-age prophecy, and tales of intergalactic travel (*Live at Montreux,* 1976; *Sunrise in Different Dimensions,* 1980). By the 1980s Sun Ra had become an internationally acclaimed figure, recording frequently (e.g., *Blue Delight,* 1989) and taking his extravagant show on tours of Europe and Asia. The subject of two documentary films, *The Cry of Jazz* (1959) and *Sun Ra: A Joyful Noise* (1980), Sun Ra died in 1993 in Birmingham, Ala.

REFERENCES

LITWEILER, JOHN. *The Freedom Principle: Jazz After 1958.* New York, 1984.
PEKAR, HARVEY. "Sun Ra." *Coda* 139 (1975): 2.
WILMER, VALERIE. *As Serious As Your Life: The Story of the New Jazz.* Westport, Conn., 1980. ‹

ERNEST BROWN

Supremes, The. The female soul vocal trio called the Supremes was one of MOTOWN's most successful rhythm and blues acts and one of the most successful recorded groups of all time. They earned twelve number-one hits and sold over twenty million records; their rise to national fame signaled the elimination of the color barrier in the pop market.

Originally a quartet known as the Primettes, the Detroit-based group had several personnel changes during its eighteen-year history. At the height of its popularity (1962–1967), the group included Diana ROSS, Florence Ballard, and Mary Wilson. Their hits included "Where Did Our Love Go," "Baby Love," "Come See About Me," "Stop! In the Name of Love" (no. 1, *Billboard* charts 1965), "Back in My Arms Again" (no. 1, 1965), and "I Hear a Symphony" (no. 1, 1965), written by Motown's Holland-Dozier-Holland songwriting team. The Supremes' earliest recordings featured Ballard's strong lead vocals (produced by Smokey ROBINSON), but the hits from 1964 and 1965 featured Ross's bright, cooing vocals.

In 1967 Cindy Birdsong (formerly with Patti Labelle and the Blue Belles) replaced Ballard, and the group was billed as Diana Ross and the Supremes. Their hits included "Love Child" (no. 1, 1968), "Someday We'll Be Together" (no. 1, 1969), and, with the TEMPTATIONS, "I'm Gonna Make You Love Me" (no. 2, 1968). In 1970, Ross departed for a solo career and Jean Terrell led the trio, but their popularity declined by 1973. The 1981 Broadway show

Dreamgirls supposedly depicts Ballard's perspective on the group, and in 1984 Wilson published her own memoir, *Dreamgirl: My Life as a Supreme.*

REFERENCE

GEORGE, NELSON. *Where Did Our Love Go? The Rise and Fall of the Motown Sound.* New York, 1985.

KYRA D. GAUNT

Surgery. Every aspect of American society has been affected by racial discrimination and segregation, and the careers of African-American surgeons are no exception. These doctors were historically victimized by such a legally sanctioned system, but they possessed a hardworking pursuit of knowledge and an instinct for survival in their struggles.

Before 1900 there is sparse information on the accomplishments of African-American surgeons in the United States. The formation of the black National Medical Association (NMA) in 1895, however, was certainly closely allied with their development and experiences in the twentieth century. In 1908 the Surgical Section of the NMA was established. It became the most accessible forum during the early years for black surgeons to present their work through lectures, panel discussions, exhibits, and films. The *Journal of the National Medical Association* was founded in 1909 and became the primary publication vehicle for their clinical work and research ideas. Credit must be given to W. Montague Cobb, who chronicled the work of black physicians in the *Journal.*

Several surgeons became well known as a result of this first historical documentation: (1) Daniel Hale Williams of Chicago, who successfully repaired a laceration of the pericardium; (2) Frederick D. Stubbs, the first black intern in a predominantly white hospital (Cleveland), who worked in thoracic surgery; (3) Roscoe C. Giles and Ulysses G. Dailey, of Chicago; and (4) Louis D. Wright, of Harlem Hospital.

Prior to World War II, the opportunities for blacks to obtain surgical training were limited and consisted of a restricted number of hospital training appointments, observational visits to famous European and American clinics, the trial-and-error method, and apprenticeships with one another. Surgeons from Chicago, Philadelphia, Washington, D.C., and New York City would conduct clinics in the South for aspiring young blacks seeking surgical expertise.

The most popular of these clinics was the Annual Surgical Forum at the Tuskegee V.A. Hospital established by Asa G. Yancey, Sr. Hospital training appointments to which blacks had access were very competitive and available at only six hospitals: Hub-

Students observing a mock operation in Chicago's Provident Hospital in 1942. Provident Hospital had been the site of the first successful open-heart surgery in 1893. (Prints and Photographs Division, Library of Congress)

bard (Nashville, Tenn.), Freedmen's (Washington, D.C.), the Provident hospitals (Baltimore and Chicago), Homer G. Phillips (St. Louis, Mo.), and Kansas City General No. 2. (See Table 1.) After 1949, additional programs were developed at Mercy Douglass Hospital (Philadelphia, 1949), the Tuskegee V.A. Medical Center (Tuskegee, Ala., 1949), Kate B. Reynolds (Durham, N.C., 1959), and the King-Drew Medical Center (Los Angeles, 1973).

These hospitals belonged to a group of more than 150 "Negro" hospitals that were in operation in this country until the 1960s, when they became integrated. Such hospitals arose out of necessity, since black surgeons had very limited access to white-

TABLE 1 Surgery Residency Training Programs*

Hospital	Yr/Approval	Yr/Withdrawal	Continued Approval
Homer G. Phillips (St. Louis)	1927	1979	No
Provident (Chicago)	1934	1963	No
Provident (Baltimore)	1934	1972	No
Howard (Freedman's, Washington, D.C.)	1935	—	Yes
Kansas City (Mo.) General No. 2	1938	1952	No
Mercy Douglass (Philadelphia)	1949	1972	No
Meharry (Nashville)	1950	1990	No
Tuskegee V.A. (Ala.)	1949	1972	No
Kate B. Reynolds (N.C.)	1959	1967	No
King-Drew (Los Angeles)	1973	—	Yes

* From C. H. Organ, Jr., and M. M. Kosiba, eds., *A Century of Black Surgeons: The U.S.A. Experience.* Norman, Okla., 1987.

TABLE 2 Specialty Certification Pioneers*

Specialty	Surgeon	Year
Otorhinolaryngology	William H. Barnes	1927
Obstetrics/Gynecology	Peter M. Murray	1931
Ophthalmology	Chester Chinn	1933
Urology	Richard F. Jones	1936
General Surgery	Roscoe C. Giles	1938
Orthopedics	James R. Gladden	1949
Thoracic	James R. Laurey	1949
Neurosurgery	Clarence S. Greene	1953
Plastic Surgery	Vincent Porter	1968
Colorectal Surgery	Bobby J. Harris	1971
Pediatric Surgery	Samuel R. Rosser	1975

* From Claude H. Organ, Jr., and M. M. Kosiba, eds., *A Century of Black Surgeons: The U.S.A. Experience.* Norman, Okla., 1987.

controlled segregated hospitals. In many instances they were allowed only "visitation privileges" in segregated hospitals to see their own patients who had been admitted by Caucasian surgeons.

Often, with hospital facilities unavailable to them or their patients, these surgeons performed operations in private homes, at great risk to patients but surely with great skill. Twenty years after World War II, a few prestigious hospitals continued to have "separate colored and white male and female surgery wards." The segregation of the black patients was total, and the discrimination against them was dehumanizing. The establishment of black hospitals provided relief for these patients and a forum for educating black physicians and nurses.

Special attention must be given to Robert Boyd, John Hale, Julius McMillan, and Matthew Walker of Meharry Medical College (Nashville) who struggled at great odds to develop and maintain a training program in surgery there. With minimal resources and a small patient volume, the viability of their residency program at Meharry was maintained by supplemental clinical experiences at Mound Bayou, Miss.; Baltimore; and Columbus, Ohio. The Department of Surgery at Meharry established a lectureship (the Hale-McMillan Lecture series) in honor of two of these surgical pioneers.

After World War II, there emerged at Howard University a "rara avis individual," Charles R. DREW, who later became the dean of African-American surgeons. Drew's establishment of the first blood bank during World War II and his scientific contributions to blood plasma preservation were major events. In 1981, the American Red Cross established the Charles R. Drew Award to honor these contributions. The surgical training program established by Drew at his alma mater became the center for talented young blacks interested in a modern sur-

gical education. His death in an automobile accident in 1950 was a significant loss. It was erroneously reported in the national news media that he was refused entry to a whites-only hospital after the accident. Howard University endowed a chair in his honor.

In the latter half of the twentieth century, the involvement of African-American surgeons at all levels dramatically improved (see Table 2), beginning with (1) the renal transplantation contributions of Samuel L. Kountz (Stanford) and his election to the presidency of the Society of University Surgeons; (2) the work of John Norman (Harvard University), a prolific researcher, in the field of cardiac support devices;

Dr. Harold Freeman, chief of surgery at Harlem Hospital. (Allford/Trotman Associates)

and (3) the appointment of Haile Debas, distinguished surgeon and gastrointestinal physiologist, as chairman of the Department of Surgery at the University of California, San Francisco.

Training and educational conditions for black surgeons also improved. Howard University Hospital established a transplant program under the direction of Clive Callender. The Morehouse Medical School implemented a postgraduate training program in surgery. The first chief of surgery at the King-Drew Complex was Joseph Alexander, a distinguished surgeon recruited from Walter Reed Army Medical Center. Alexander developed and obtained approval for a surgical training program in 1973 (Table 1). He was succeeded by Arthur Fleming, also from Walter Reed, who established a trauma fellowship at King-Drew and expanded their research efforts. The annual Drew-Walker Forum was created in honor of Charles Drew and Matthew Walker and serves as a platform from which young investigators, residents, and fellows present their work. And the NMA Surgery Section has established three lectureships to honor the surgical contributions of William H. Sinkler (St. Louis), Frederick D. Stubbs (Philadelphia), and William E. Matory (Washington, D.C.).

REFERENCE

ORGAN, CLAUDE H., JR., and M. M. KOSIBA, eds. *A Century of Black Surgeons: The USA Experience.* Norman, Okla., 1987.

CLAUDE H. ORGAN, JR.
VERNON J. HENDERSON

Sutton, Percy Ellis (November 24, 1920–), politician and media businessman. Percy Ellis Sutton was born in San Antonio, Tex. His parents, Samuel J. Sutton and Lillian Smith, were educators and philanthropists. Percy Sutton graduated from Phillis Wheatley High School in San Antonio, and subsequently attended Prairie View Agricultural and Mechanical College, Tuskegee Institute, and Hampton Institute. When he attempted to join the Army Air Force in Texas during WORLD WAR II, he was rejected (for reasons having to do with his racial background). He then successfully enlisted in New York City. As an intelligence officer with the black ninety-ninth Fighter Squadron serving in the Italian and Mediterranean theaters, Sutton earned combat stars and rose to the rank of captain.

After the war, Sutton completed his education under the G.I. Bill, graduating from Brooklyn Law School in 1950. During the KOREAN WAR, Sutton

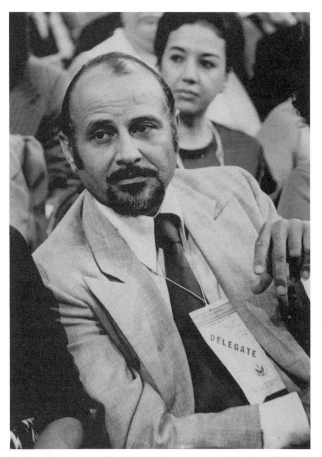

Percy Sutton at the 1972 Democratic National Convention. (Photographs and Prints Division, Schomburg Center for Research in Black Culture, The New York Public Library, Astor, Lenox and Tilden Foundations)

reentered the Air Force as an intelligence officer and trial judge advocate. When the war ended in 1953, Sutton opened a law partnership in Harlem with his brother, Oliver, and George Covington and worked with the NAACP on several civil rights cases throughout the 1950s. In addition to its work with the NAACP, the firm served other clients such as MALCOLM X and the Baptist Ministers Conference of Greater New York.

From 1961 to 1962 Sutton served as branch president of the New York City NAACP, participating in demonstrations and freedom rides in the South. During the winter of 1963–1964, Sutton and Charles RANGEL cofounded the John F. Kennedy Democratic Club, later known as the Martin Luther King, Jr., Club. Sutton was elected to the New York State Assembly in 1964. In 1966, after Manhattan borough president Constance Baker MOTLEY accepted an appointment as a federal judge, the New York City Council chose Sutton to finish Motley's term. Sutton was reelected in his own right later that year, and was subsequently reelected in 1969 and 1973. As borough

president, Sutton focused on decentralizing the municipal bureaucracy, cutting city spending, and addressing the broader social causes of urban crime and poverty.

In 1970 Sutton endorsed Rangel's campaign to replace Adam Clayton POWELL, JR., as congressman from Harlem. Rangel's victory marked the ascendancy of a new black political coalition in Harlem, a coalition that included not only Percy Sutton but also future New York City mayor David DINKINS. In 1971, while still Manhattan borough president, Sutton set out to purchase several black-owned media enterprises, beginning with the New York AMSTERDAM NEWS (which he sold in 1975) and radio station WLIB-AM. In 1977 Sutton became owner and board chairman of the Inner-City Broadcasting Company, a nationwide media corporation, and through the corporation he subsequently purchased radio stations in New York, California, and Michigan. He also formed Percy Sutton International, Inc., the investments of which encouraged the agricultural, manufacturing, and trade industries in Africa, Southeast Asia, and Brazil.

In September 1977 Sutton was an unsuccessful candidate for the nomination for mayor. He retired from public office after finishing his second full term as borough president in December 1977, but he continued to advise Rangel, Dinkins, and other black politicians on electoral strategy and urban policy. In 1981 he acquired Harlem's APOLLO THEATER as a base for producing cable television programs. By the end of the decade Sutton's estimated net worth was $170 million. In 1990 he was succeeded as head of Inner-City Broadcasting by his son, Pierre Montea ("PePe"), who raised the company's net worth to $28 million by 1992.

Sutton has been a guest lecturer at many universities and corporations and has held leadership positions in the Association for a Better New York, the NATIONAL URBAN LEAGUE, the Congressional Black Caucus Foundation, and several other civil rights organizations. A founding member and director of OPERATION PUSH (People United to Save Humanity), Sutton was also a close adviser to the Rev. Jesse JACKSON. He was awarded the NAACP's SPINGARN MEDAL in 1987 at the Apollo Theater, which under Sutton's management had been restored as a major Harlem cultural center and landmark.

REFERENCES

GREEN, CHARLES. *The Struggle for Black Empowerment in New York City: Beyond the Politics of Pigmentation.* New York, 1989.

LEWINSON, EDWIN R. *Black Politics in New York City.* New York, 1974.

DURAHN TAYLOR

Swanson, Howard (August 18, 1907–November 12, 1978), composer. Born in Atlanta and reared in Cleveland, Howard Swanson studied at the Cleveland Institute of Music (1930–1938) and with Nadia Boulanger in Paris (1938–1940). Swanson's two best-known works are his song "The Negro Speaks of Rivers," which was introduced to the public by Marian ANDERSON in 1950, two years after its composition, and *Short Symphony* (his second symphony), which won the Music Critics' Circle Award in 1952. Swanson's published works were composed between 1942 and 1977 and consist of songs, chamber music, piano music, choral music, and orchestral works, including three symphonies, a concerto for orchestra, and a piano concerto.

Swanson was the recipient of a Rosenwald Fellowship, two Guggenheim Fellowships, grants from the National Academy of Arts and Letters and the National Endowment for the Arts, and the Distinguished Achievement Award from the National Association of Negro Musicians. In addition, he received commissions from the Louisville Orchestra, the Juilliard School of Music, and the New World Trio. The influence of neoclassicism is evident in Swanson's music in its use of traditional forms, its contrapuntal textures, its goal-oriented melodic writing, and its polytonality. But his music is firmly grounded in his African-American musical heritage and is representative of black cultural nationalism.

REFERENCE

REISSER, MARSHA J. "Howard Swanson: Distinguished Composer." *Black Perspective in Music* 17 (1989): 5–26.

MARSHA J. REISSER

Sweatt v. Painter. Through much of the 1930s and 1940s, the legal staff of the NATIONAL ASSOCIATION FOR THE ADVANCEMENT OF COLORED PEOPLE (NAACP) had pursued an "indirect" strategy against segregation in public education. The NAACP reasoned that black exclusion from white schools might be most immediately challenged in graduate and professional schools, because separate black facilities had not generally been provided by states enforcing segregation—and would likely prove too expensive to provide. Accordingly, the organization in 1946 backed Heman Sweatt, an African-American postal employee from Houston, in a suit to compel his admission to the University of Texas School of Law. Segregation in education had been mandated by the state constitution and endorsed in PLESSY V. FERGUSON, but no black law school existed in Texas. Rather than force university president T. S. Painter to admit

Sweatt, however, state courts allowed Texas to make efforts to provide "substantially equal" segregated facilities. The state authorized its black college to expand professional programs, provided for the establishment of a new black university and law school, and, as a stopgap measure, opened a temporary law school for blacks in an Austin basement.

In response, NAACP lawyers, led by Thurgood MARSHALL, more directly attacked separate-but-equal doctrine. They argued that no newly minted JIM CROW school could offer an education comparable to that of a longstanding and prestigious state institution, but also that segregation itself was intellectually indefensible. Though state appellate courts denied Sweatt's petitions, the U.S. Supreme Court ruled in June 1950 that the FOURTEENTH AMENDMENT's "equal protection" language required his admission to the University of Texas. Blacks could not receive a substantially equal legal education in existing segregated facilities, because they did not compare to the University of Texas law school either in material resources *or* in less tangible realms, such as reputation and prestige. Though the Court had not thereby abandoned the separate-but-equal precedent, it had made it more difficult to apply. More important, *Sweatt* foreshadowed the more exacting definitions of equality that would shape the 1954 BROWN V. BOARD OF EDUCATION decision. (*See also* CIVIL RIGHTS AND THE LAW.)

REFERENCE

GILLETTE, MICHAEL. "Herman Marion Sweatt: Civil Rights Plaintiff." In Alwyn Barr and Robert Calvert, eds. *Black Leaders: Texans for Their Times.* Austin, Tex., 1981.

PATRICK G. WILLIAMS

Swimming and Aquatic Sports. Inez Patterson, who lettered in five sports and excelled on the swim team for Temple University in the 1920s, is generally considered to be the first African-American swimming star.

In the 1940s and '50s, a few historically black universities formed swimming teams and staged intercollegiate competitions. Morgan State, Tennessee State, and Howard University had the most successful teams during this period. Frank Stewart of Tennessee State was generally regarded to be the greatest black swimmer of the mid-twentieth century. In 1945, Stewart won the Far Western Amateur Athletic Union 100-meter freestyle. The next year he matched the world's record for the 50-meter freestyle. In 1951, Stewart equaled the world's record for the 220-yard freestyle and broke the 440-yard freestyle record.

Among the Tennessee State swimming stars who followed Stewart were Donald E. Jackson, Stanley Gainor, Leroy Jones, John Swann, and Clyde James. In 1958, Swann won the 100-meter butterfly, and James won the 100-yard backstroke in 1960 and 1961, making the conference all-American team both years.

Alabama A&M has traditionally fielded the best women's swimming team, particularly since 1980. Several A&M swimmers have gained national recognition, including Cathy Merriweather, the first black woman to be named to the all-American team.

Several black swimmers have excelled at predominantly white universities. Fred Evans, a member of the swimming team at the University of Illinois at Chicago, won the 100-meter breaststroke championship in 1975 and placed first in the event at the National Collegiate Athletic Association (NCAA) Division II championships in 1976 and 1977. Evans was later inducted into the U.S. Swimming Hall of Fame. Bob Murray of the University of Michigan won the 1978 Big Ten Conference championship in the 50-meter freestyle. In 1980 Murray repeated as Big Ten champion in the 50-meter freestyle and also won the 400-meter freestyle event.

Perhaps the most successful black swimmer ever was Chris Silva of the University of California at Los Angeles. He was a member of UCLA's 400-meter freestyle relay team, which won both the PAC-10 and NCAA championships in 1982. Silva was named an All-American in 1982 and 1983 and won a silver medal in the 400-meter freestyle at the 1983 World University Games.

In 1981 Charles Chapman became the first African American to swim the English Channel, completing the 37.5-mile journey from Dover, England, to Sangatte Bay, France, in thirteen hours and ten minutes.

In 1915 Joseph E. Trigg became the first known African-American member of a varsity crew team when he rowed for Syracuse University. Among the first African-American women to participate in the sport, Harriet Pickens and Hilda Anderson of Smith College were among the most notable. Anita DeFrantz became the most prominent black rower when she won a bronze medal at the 1976 Olympic Games. She later became the first black woman member of the International Olympic Committee (IOC). Pat Spratlan, a member of the women's crew team at the University of California at Berkeley, rowed for the 1984 U.S. Olympic Team.

REFERENCE

ASHE, ARTHUR R. JR. *A Hard Road to Glory: A History of the African-American Athlete.* New York, 1988.

THADDEUS RUSSELL
BENJAMIN K. SCOTT

2600 SYMPHONIC MUSIC, BLACK

Symphonic Music, Black. *See* Concert Music.

Symphony of the New World. The Symphony of the New World, an orchestra having largely interracial personnel, was active from 1965 to 1976. The orchestra originated from ongoing professional and musical partnerships between several African-American musicians in New York, together with the dream of Benjamin Steinberg, a white conductor, of forming an interracial performing ensemble of the highest musical caliber. The first organizational committee and founding members of the Symphony of the New World included oboist Harry Smyles, cellist Kermit Moore, flutist Harold Jones, timpanists Frederick King and Elaine Jones, violists Selward Clarke and Alfred Brown, bassists Arthur Davis, Richard Davis, and Lucille Dixon, trumpeter Joseph Wilder, violinist Ross Shub, conductor Benjamin Steinberg, and associate conductor Coleridge-Taylor Perkinson. All but two of the founding members, Steinberg and Shub, were African-American. The inaugural concert of the orchestra took place in April 1965 at Carnegie Hall and was a critical success. The orchestra grew quickly after its auspicious first season, performing the standard orchestral repertoire as well as works of African-American composers. In its eleven-year history, the Symphony of the New World performed over thirty works of African-American composers; these included fourteen premieres and one commission (Howard Swanson's *Third Symphony*, 1969). By 1970 forty-three of its eighty-eight members were African-American. The orchestra featured a long and distinguished list of African-American conductors and soloists, including James DEPREIST, Everett Lee, Denis DeCoteau, Leon Thompson, James Frazier, Paul FREEMAN, George Byrd, Natalie HINDERAS, André WATTS, Leon Bates, Don Shirley, Sanford Allen, Marcus Thompson, William Warfield, and Duke ELLINGTON.

REFERENCES

HARE, MAUDE CUNEY. *Negro Musicians and Their Music*. Washington, D.C., 1936.
PEYSER, JOAN. "The Negro in Search of an Orchestra." *New York Times,* November 26, 1967.
SOUTHERN, EILEEN. *The Music of Black Americans: A History*. New York, 1983.

TIMOTHY W. HOLLEY

T

Talbert, Mary Morris Burnett (September 17, 1866–October 15, 1923), activist, human rights advocate. Mary Burnett was born in Oberlin, Ohio, in 1866 to Cornelius Burnett, a barber, the son of free-born parents, and Caroline Nichols Burnett, who operated several businesses near Oberlin College. Burnett attended the public schools of Oberlin and then Oberlin College. In 1886 she assumed a teaching position in the segregated school system of Little Rock, Ark. She became assistant principal of Bethel University and in 1888 principal of Union High School. In 1891 she married William H. Talbert, city clerk of Buffalo, N.Y. They were parents of one child, Sarah May.

Talbert became active in several local and national organizations: the Phillis WHEATLEY Club, Empire Federation of Women's Clubs, Order of the Eastern Star, Delta Sigma Theta, and the recently organized NAACP. As national president of the National Association of Colored Women's Clubs (NACWC) from 1916 to 1920, Talbert arranged for the purchase and restoration of Frederick DOUGLASS's Anacostia, D.C., home. Talbert was also a member of the Education Committee of the International Council of Women of the Darker Races, an organization committed to attacking racism internationally and founded by NACWC members in 1922 with participants from Africa, the Caribbean, the Middle East, and Asia.

The NAACP provided an avenue for many of Talbert's activities. She wrote King Albert of Belgium regarding his African colonies. There is evidence she influenced the NAACP to investigate U.S. atrocities in Haiti in 1921. That same year she directed the NAACP's antilynching campaign that worked for passage of the Dyer Anti-Lynching Bill in Congress (*see* DYER BILL; LYNCHING). She raised $12,000, enabling the NAACP to publicize the atrocities of lynching. Talbert helped extend NAACP influence in the South when she established several branches in Texas and Louisiana, including Galveston, Austin, Texarkana, and Alexandria. In 1922 the NAACP awarded Talbert the SPINGARN MEDAL; she was the first woman to be so honored.

Talbert contributed to the NAACP's *Crisis* and served on the editorial boards of *Woman's Voice* and *Champion*. Her essay on the status of nineteenth-century African Americans, "Did the Negro Make, in the Nineteenth Century, Achievements along the Lines of Wealth, Morality, Education, etc., Commensurate with Opportunities? If So, What Achievements Did He Make?" appeared in D. W. Culp's *Twentieth-Century Negro Literature,* published in 1901. After a long illness, Talbert died of coronary thrombosis in Buffalo.

REFERENCES

LOGAN, RAYFORD. "Mary Burnett Talbert." In Rayford Logan and Michael Winston, eds. *Dictionary of American Negro Biography*. New York, 1984.

WILLIAMS, LILLIAN S. "Mary Burnett Talbert." In Darlene Clark Hine, ed. *Black Women in America: An Historical Encyclopedia*. Brooklyn, N.Y., 1993.

LILLIAN SERECE WILLIAMS

Tampa Red (Whittaker, Hudson) (December 25, 1900–December 19, 1981), blues guitarist and singer. Tampa Red was born Hudson Woodbridge in Smithville, Ga. He was raised by his grandmother and took her last name, Whittaker. Little is known about his life before he arrived in Chicago and began recording in the mid-1920s. His stage name, Tampa Red, was derived from both his residence in Florida prior to his move to Chicago and his light-tan skin color.

Tampa Red forms a crucial link between the country blues of the 1920s and 1930s and the urban BLUES sound of the post–World War II years. His first important work was as an accompanist: his expert bottleneck slide guitar playing earned him the nickname "the guitar wizard" on recordings for Ma RAINEY, Victoria SPIVEY, and MEMPHIS MINNIE. Starting in the mid-1920s, Tampa Red performed on the black theater circuit as a duo with "Georgia Tom," who would later come to fame as the GOSPEL composer and impresario Thomas DORSEY. Together they wrote "It's Tight like That" (1928), a risqué RAGTIME-flavored blues that sold hundreds of thousands of copies and made Tampa Red such a popular figure that he was among the few blues musicians to maintain a recording career after the 1929 stock market crash that led to the demise of many record companies. Indeed, he recorded more than three hundred songs, characterized by sharp humor and sexual innuendo, over a period of two decades with Victor recording labels. Many of those songs became blues standards.

In 1932, after Dorsey began to devote himself to sacred music, Tampa Red, who had occasionally recorded with the Hokum Jug Band in the late 1920s, began to lead a quintet. His recordings from this period, including "Black Angel Blues" (1934), "Let's Get Drunk and Truck" (1936), "All Night Long" (1936), "Suzie-Q" (1936), "Anna Lou Blues" (1940), and "It Hurts Me Too" (1940), helped establish many of the conventions of the urban blues style, including the larger ensembles, harsher rhythms, and faster tempos that characterized the Chicago blues.

Starting in 1941, Tampa Red performed with Big Maceo as a partner. He continued to play a major role in Chicago's blues scene, both as a performer and as the host of regular jam sessions at his home. After the death in 1953 of his wife, Frances, Tampa Red's career faltered, and he retired from music. He attempted a comeback with two albums, *Don't Tampa with the Blues* (1960) and *Don't Jive with Me* (1961), but they failed to win wide recognition. Tampa Red fell into poverty, and from 1974 until his death in 1981 he lived in a psychiatric nursing home in Chicago.

REFERENCES

O'NEAL, JIM. "Tampa Red." *Living Blues* 50 (Spring 1981): 42.
PALMER, ROBERT. *Deep Blues.* New York, 1981.

JONATHAN GILL

Tandy, Vertner Woodson (May 17, 1885–November 7, 1949), architect. Vertner Woodson Tandy was born in Lexington, Ky., the son of Emma Brice and Henry Tandy, a contractor who worked on many prominent residential and municipal buildings in that city. He studied at the Chandler Normal School and graduated from Tuskegee Institute (1905) and the Cornell University School of Architecture (1908). At Cornell, he received an honorable mention in a competition sponsored by the Society of Beaux Arts. He also cofounded Alpha Phi Alpha (1906), the first fraternity for African Americans.

Tandy, the first African-American architect licensed in New York state and one of the first elected to the American Institute of Architects, worked in partnership with an older architect, George Foster (1866–1923) from 1910 to 1915. Their projects included St. Philip's Episcopal Church and Old Rectory (1910–1911), located at West 134th Street, a neo-Gothic church for a middle-class black congregation.

Like his father, Tandy designed both public and residential buildings, from mansions to housing projects. Much of his work is characterized by axial symmetry and reflects the influence of the Spanish stucco style. Other major commissions he undertook include the Presbyterian Hospital in Puerto Rico (1915), Madam C. J. WALKER's Villa Lewaro in Irvington-on-Hudson, N.Y. (1917–1918), the Children's Aid Society in Bronx, N.Y. (1922), and the Abraham Lincoln Houses in Bronx, N.Y. (1945), the latter a joint project with the architectural firm of Skidmore, Owings, and Merrill. In 1992 the Cornell University Minority Organization on Architecture, Art, and Planning named their annual spring conference in honor of Tandy.

REFERENCES

MACK, ANDRE ANTOINETTE. "Preserving the Afro-American Influence in History Through Architecture and Planning." Cornell University Archives, Ithaca, N.Y., 1982.
Obituary. *New York Times,* November 8, 1949, p. 31.

DEREK SCHEIPS

Tanner, Benjamin Tucker (December 25, 1835–January 14, 1923), AME bishop, editor. Born in

Pittsburgh, Pa., Benjamin T. Tanner worked as a barber while he attended Avery College (1852–1857) and Western Theological Seminary (1857–1860). In 1860 he was ordained a deacon and then an elder in the AFRICAN METHODIST EPISCOPAL CHURCH (AME). In 1867 Tanner became the principal of the AME Conference School in Frederickstown, Md. Later he was appointed to Bethel Church in Philadelphia. From 1868 to 1884 Tanner edited the CHRISTIAN RECORDER, an AME publication. During the 1870s he was awarded a master's degree from Avery and an honorary doctor of divinity degree from Wilberforce. In 1884, Tanner founded the *A.M.E. Church Review,* a quarterly journal focusing on African-American issues. Tanner became known as the "king of the Negro editors." A black nationalist, he believed that racial solidarity was needed to combat racial injustice and he encouraged black-owned business. In 1888 Tanner was consecrated a bishop. In 1901 he served as dean of Payne Theological Seminary at Wilberforce University. Tanner retired in 1908 at the AME General Conference. He and his wife, Sarah Miller, whom he had married in 1858, had seven children, including the painter Henry Ossawa TANNER. Benjamin Tanner wrote several books, including *An Apology for African Methodism* (1867).

REFERENCE

BOWDEN, HENRY WARNER. *Dictionary of American Religious Biography.* 2nd ed. Westport, Conn., 1993, pp. 538–539.

SASHA THOMAS

Benjamin T. Tanner, father of painter Henry Ossawa Tanner, was a leader of the AME church, editor of the *A.M.E. Church Review,* and a bishop in Philadelphia. (Photographs and Prints Division, Schomburg Center for Research in Black Culture, The New York Public Library, Astor, Lenox and Tilden Foundations)

Tanner, Henry Ossawa (June 21, 1859–May 25, 1937), painter and illustrator. Tanner's father, Benjamin Tucker Tanner (1835–1923) and his mother, Sarah Elizabeth Miller (1840–1914), lived in Pittsburgh at the time of Henry's birth. They gave their son the middle name Ossawa, after the Kansas town of Osawatomie, where white abolitionist John Brown had started an antislavery campaign in 1856. After entering the ministry in 1863, Tanner's father rose to the rank of bishop in the AFRICAN METHODIST EPISCOPAL CHURCH by 1888. The Rev. Tanner relocated the family to Philadelphia in 1868 so that he could serve as editor of the CHRISTIAN RECORDER. Tanner attended Lombard Street School for Colored Students in 1868. The next year he enrolled at the Robert Vaux Consolidated School for Colored Students, then the only secondary school for black students in Philadelphia, which was renamed Robert Vaux Grammar School the year before Tanner graduated as valedictorian in 1877.

Tanner began painting when he was thirteen years old, and although his parents supported his early efforts, he did not receive formal training until 1880, studying with Thomas Eakins at the Pennsylvania Academy of the Fine Arts. He remained a student with Eakins until 1885. During his academy years and through 1890, Tanner was primarily a painter of seascapes, landscapes, and animal life. Many of his paintings engaged a particular technical challenge in representing natural phenomena such as waves breaking on rocks in stormy seas (*Seascape-Jetty,* 1876–1879), rippling autumn foliage (*Fauna,* 1878–1879), or the light in a lion's mane at the Philadelphia Zoo (*Lion Licking Its Paw,* 1886). While his work in each genre was influenced by numerous, lesser-known local artists, Tanner was developing his own style and becoming skilled at controlling effects of light, giving objects form through a subdued color scheme and a subtle sense of tonality, and creating decorative effects with tiny flecks of color. Tanner strategically organized space by surrounding central figures with vast areas of opaque color—representing grass or sky,

The best known of Henry Ossawa Tanner's genre studies of African Americans, *The Banjo Lesson* (1893) depicts the intergenerational transmission of African-American culture, symbolized by the banjo. (Hampton University, Hampton, Va.)

for example—and using the emptiness to draw the viewer's attention to the locus of dramatic activity.

While Tanner met with some critical success as a landscape painter during his academy years, he was unable to support himself by painting and worked for a flour business owned by friends of his family. In 1889 he relocated to Atlanta, where he taught at Clark University and worked for a year as a photographer. There was a lull in Tanner's painting from 1889 to 1890, but he used some photographs from this year, taken on a trip to North Carolina, as studies for paintings such as his well-known work *The Banjo Lesson* (1893).

In Atlanta, Tanner met Joseph Crane Hartzell, a white Methodist Episcopal bishop, and his wife. They became his patrons, sponsoring the first exhibition of his work in Cincinnati in 1890. They supported Tanner when he traveled to Europe in 1891 and set up a studio in Paris, where he began studying with Jean-Joseph Benjamin Constant and Jean-Paul Laurens. Tanner returned to Philadelphia in 1893,

though he found the racial restrictions onerous and soon returned to Paris. In 1899 he married Jessie Macauley Olssen (1873–1925), a white American of Swedish descent who was living abroad in Paris. The two remained happily married and lived in France for most of their lives, except for the years Tanner spent at an artists' colony in Mount Kisco, N.Y., from 1901 to 1904. Tanner's Paris studio became a hub of activity for visiting African-American artists and other visitors from abroad in the early part of twentieth century.

During the 1890s, Tanner's work shifted from landscape painting to genre scenes depicting black life in America. The change has been attributed to Tanner's 1893 participation as a speaker in the Columbian Exposition's Congress on Africa, where he asserted the achievements of African-American artists and listened to speakers give an overview of post-Emancipation black leadership across the nation. With his thoughts focused on issues of black identity and productivity, Tanner began depicting genre scenes of African-American life. While he painted relatively few genre scenes, some of them, such as *The Banjo Lesson* and *The Thankful Poor* (1894), are among his best-known paintings. *The Banjo Lesson* depicted one of the acclaimed themes in American genre painting, an older musician teaching his art to a young boy. *The Thankful Poor* also featured an old man and a boy to show how the black family passed on moral and spiritual lessons to its children.

Tanner's style during his genre period had several influences. In 1889 Tanner spent time in the Brittany region of France, involved in the impressionist and postimpressionist movements, particularly those in the circle of Gaugin. While some critics have noted that Tanner borrowed the impressionists' techniques and was influenced by their use of color and spatial organization to communicate mood, the overall character of his work was shaped by academic romantic realism.

Tanner's illustrations appeared in American journals such as *Harper's Young People* and *Our Continent,* as well as in exhibition catalogs at the Pennsylvania Academy of the Fine Arts. His work was seen in exhibitions at the academy in 1888, 1889, 1898, and 1906, and was frequently shown at the prestigious Salon de la Société des Artistes Français in Paris during the period 1894 to 1914.

In the later stages of his career, Tanner was most active as a religious painter, and while these works were based on biblical stories and did not directly address issues of black life, they were continually concerned with broad themes of social justice in the earthly world, using the stories as metaphors for more contemporary issues such as slavery and emancipation in America. An early representation of *Dan-*

iel in the Lions' Den (1896), one of his two known paintings of this well-known religious theme, was exhibited at the salon, where it received honorable mention. In 1897, shortly after he painted *Daniel in the Lions' Den,* Tanner traveled to the Middle East to observe the people and geography of the ancient lands, and to enhance the historical accuracy of his paintings with biblical themes. Among the most celebrated religious compositions was *The Raising of Lazarus* (1896), now located at the Musée d'Orsay in Paris. Other paintings on sacred subjects included *Nicodemus Visiting Jesus* (1899), *Flight into Egypt* (1899), *Mary* (1900), *Return of the Holy Women* (1904), *Christ at the Home of Mary and Martha* (1905), *Two Disciples at the Tomb* (1906), *The Holy Family* (1909–1910), *Christ Learning to Read* (1910), *The Disciples on the Sea of Galilee* (1910), and *The Good Shepherd* (1922).

Tanner's religious work went through multiple stylistic phases and had diverse influences, including Velazquez's portraiture, El Greco's elongated figures, David's scale of historical paintings, and Georges Rouault's use of color in contemporary religious paintings. The style of his paintings after 1920 was marked by an overall conservatism. He remained uninfluenced by contemporary developments. Despite some brilliant coloristic effects, the overall impact of his religious compositions, with their limited range of tonality and virtually absent source of light, is a brooding, somber, and contemplative mood.

He exhibited widely in the United States after 1900, with paintings appearing at the Pan-American Exposition (Buffalo) in 1901, the Louisiana Purchase Exposition in 1904, the St. Louis Exposition in 1904, the Carnegie Institute Annual Exhibition in Pittsburgh in 1906, the Anglo-American Art Exhibition (London) in 1914, the Panama-Pacific Exposition (San Francisco) in 1915, the Los Angeles County Museum in 1920, and the Grand Central Art Galleries in New York in 1920. Since 1968, Tanner's works have been shown in major United States exhibitions celebrating the accomplishments of American artists of African descent.

Tanner served his country during World War I as a lieutenant in the American Red Cross in the Farm Service Bureau. In 1918 he worked in the Bureau of Publicity as resident artist. Though his academic style was increasingly out of fashion, in his later years he was given many honors. He received the coveted Legion of Honor from the French Government in 1923. Tanner's son Jesse graduated from Cambridge University in 1924 and became an engineer upon his return to France. In 1927 Tanner became the first African American elected to full membership in the National Academy of Design. He continued to work as a painter until his death in Paris.

REFERENCES

DRISKELL, DAVID C. *Hidden Heritage: Afro-American Art 1800–1950.* New York, 1985.
———. *Two Centuries of Black American Art.* Washington, D.C., 1976.
MATTHEWS, MARCIA M. *Henry Ossawa Tanner, American Artist.* Chicago, 1969.
MOSBY, DEWEY F., DARREL SEWELL, and RAE ALEXANDER-MINTER. *Henry Ossawa Tanner.* Philadelphia, 1991.

DAVID C. DRISKELL

Tap Dance. Tap is a form of American percussive dance that emphasizes the interplay of rhythms produced by the feet. Fused from African and European music and dance styles, tap evolved over hundreds of years, shaped by the constant exchanges and imitations that occurred between the black and white cultures as they converged in America. However, since it is JAZZ syncopations that distinguish tap's rhythms and define its inflections, the heritage of African percussive sensibilities has exerted the strongest influence on tap's evolution.

Unlike ballet, whose techniques were codified and taught in the academies, tap developed informally from black and white vernacular social dances (*see* SOCIAL DANCE), from people watching each other dance in the streets and dance halls. As a result of the offstage challenges and onstage competitions where steps were shared, stolen, and reinvented, tap gradually got fashioned into a virtuosic stage dance. Because tap must be *heard,* it must be considered a musical form—as well as a dance form—that evolved as a unique percussive expression of American jazz music. Tappers consider themselves musicians and describe their feet as a set of drums—the heels playing the bass, the toes the melody. Like jazz, tap uses improvisation, polyrhythms, and a pattern of rhythmic accenting to give it a propulsive, or swinging, quality. Many of tap's choreographic structures reflect the formal musical structures of BLUES, RAGTIME or Dixieland, swing, bebop, and cool jazz.

Perhaps the most distinguishing characteristic of tap is the amplification of the feet's rhythms. Early styles of tapping utilized boards laid across barrels, sawhorses, or cobblestones; hard-soled shoes, wooden clogs, hobnailed boots, hollow-heeled shoes, as well as soft-soled shoes (and even heavily calloused feet) played against a wooden, oily, or abrasive surface, such as sand. Specially made metal plates attached to the heel and toe of the shoes did not commonly appear until the early 1910s, in chorus lines of Broadway shows and revues.

Opportunities for whites and blacks to watch each other dance began in the early 1500s when enslaved Africans were shipped to the West Indies. During the infamous "middle passage" across the Atlantic (see SLAVE TRADE), slaves were brought to the upper decks and forced to dance ("exercise"). Without traditional drums, slaves played on upturned buckets and tubs, and thus, the rattle and restriction of chains, the metallic thunk of buckets, were some of the first changes in African dance as it evolved toward an African-American style. Sailors witnessing these events set an early precedent of the white observers who would serve as social arbiters, onlookers, and participants at urban slave dances and plantation slave "frolicks." Upon arriving in North and South America and the West Indies, Africans, and African-Americans exposed to European court dances like the quadrille, cotillion, and contredanse adopted those dances, keeping the patterns and figures, but retaining their African rhythms.

Slaves purchased on the stopover in the Caribbean islands came into contact with thousands of Irishmen and Scotsmen who were deported, exiled, or sold in the new English plantation islands. The cultural exchange between first-generation enslaved Africans and indentured Irishmen, which had Ibo men playing fiddles and Kerrymen learning how to play jubi drums, continued through the late 1600s on plantations and in urban centers during the transition from white indentured servitude to African slave labor.

In colonial America a new percussive dance began to fuse from a stylistic meld of two great dance traditions. The African-American style tended to center movement in the hips and favored flat-footed, gliding, dragging, stamping, shuffling steps, with a relaxed torso gently bent at the waist and spine remaining flexible. Gradually that style blended with the British-European style, which centered movement in dexterous footwork that favored bounding, hopping, precisely placed toe-and-heel work, and complicated patterns, with carefully placed arms, an upright torso and erect spine, and little if any hip action.

Between 1600 and 1800, the new American tap-hybrid slowly emerged from British step dances and a variety of secular and religious African step dances labeled "juba" dances and "ring-shouts." The Irish jig, with its rapid toe and heelwork, and the Lancashire clog, which was danced in wooden-soled shoes, developed quickly. The clog invented faster and more complex percussive techniques while the jig developed a range of styles and functions that extended from a ballroom dance of articulate footwork and formal figures to a fast-stomping competitive solo performed by men on the frontier.

By contrast, the African-American juba (derived from the African *djouba*), moved in a counterclock-

wise circle and was distinguished by its rhythmically shuffling footwork, the clapping of hands and "patting" or "hamboning" (the hands rhythmically slap the thighs, arms, torso, cheeks, playing the body as if it were a large drum), the use of call-and-response patterning (vocal and physical), and solo or couple improvisation within the circle. The religious ringshout, a similar countercircle dance driven by singing, stomping, and clapping, became an acceptable mode of worship in the Baptist church as long as dancers did not defy the ban against the crossing of the legs. With the arrival of the slave laws of 1740 prohibiting the beating of drums came substitutes for the forbidden drum: bone clappers, jawbones, tambourines, hand-clapping, hamboning, and the percussive footwork that was so crucial in the evolution of tap.

By 1800, "jigging" was a term applied to any black style of dancing in which the dancer, with relaxed and responsive torso, emphasized movement from the hips down with quickly shuffling feet beating tempos as fast as trip-hammers. Jigging competitions which featured buck-and-wing, shuffling ring dances, and breakdowns abounded on plantations and urban centers where freedmen and slave congregated.

Though African-Americans and European-Americans both utilized a solo, vernacular style of dancing, there was a stronger and earlier draw of African-American folk material by white performers. By the 1750s "Ethiopian delineators," most of them English and Irish actors, arrived in America. John Durang's 1789 "Hornpipe," a clog dance that mixed ballet steps with African-American shuffle-and-wings, was performed in blackface. By 1810 the singing-dancing "Negro boy" was an established stage character of blackface impersonators who performed jigs and clogs to popular songs. Thomas Dartmouth Rice's "Jump Jim Crow," which was less a copy of an African-American dance than it was Rice's "black" version of the Irish jig that appropriated a Negro worksong and dance, was a phenomenal success in 1829. After Rice, Irishmen George Churty and Dan Emmett organized troupes of blackface minstrelmen who brought their Irish-American interpretations of African-American song and dance styles to the minstrel stage (see MINSTRELS/MINSTRELSY). By 1840, the minstrel show as a blackface act of songs, fast-talking repartee in black dialects, and shuffle-and-wing tap dancing became the most popular form of entertainment in America.

That the oddly cross-bred and newly emerging percussive dance was able to retain its African-American integrity is due, in large measure, to William Henry Lane (c. 1825–1852). Known as Master Juba, he was perhaps the most influential single

performer in nineteenth-century American dance. Born a free man in Rhode Island, Lane grew up in the Five Points district of Manhattan (now South Street Seaport). An accomplished Irish jig dancer, Lane was unsurpassed in grace and technique, popular for his imitations of famous minstrel dancers, and famous as the undisputed champion of fierce dance competitions. This African-American dancer broke the whites-only barrier of the major minstrel companies, and as a young teenager, Lane toured as featured dancer with four of the biggest troupes. Lane was an innovator who grafted authentic African-American performance styles and rhythms onto the exacting techniques of jig and clog dancing. Because of his excellence, he influenced the direction of tap, and, because he was so admired and imitated during his life and after his death, it fostered the spread of this new dance style.

When black performers finally gained access to the minstrel stage after the Civil War, the tap vocabulary was infused with a variety of fresh new steps and choreographic structures that jolted its growth. The "Essence of Old Virginia," originally a rapid, pigeon-toed sliding step, got slowed down and popularized in the 1870s by Billy Kersands, then refined by George Primrose in the 1890s to a graceful soft shoe, or song and dance. From the minstrel show came the walk-around finale, dances that included competitive and improvisatory sections, and a format of performance that combined songs, jokes, and specialty dances. By the late 1800s big touring shows such as *Sam T. Jack's Creole Company* and *South Before the War* brought black vernacular dance to audiences across America. With the success of *Clorindy* (1898), which featured a small chorus line of elegantly dancing women, fashionably dressed, and the *Creole Show* (1889), which replaced the usual black-face comedians with stylish cakewalk teams like Johnson and Dean, the stereotypes set by minstrelsy began to be displaced, and new images of the black performer were formed.

Turn-of-the-century medicine shows, gillies, carnivals and circuses helped establish the black dancer in show business and provided seeds for the growth of professional dancing. During the late 1890s touring roadshows like *In Old Kentucky* featured Friday night "buck dance" contests (another early term for "tap dancing"). *Black Patti's Troubadours* featured cakewalkers and buck-and-wing specialists, while the "jig top" circus tent had chorus lines and comedians dancing an early jazz style that combined shuffles, twists, grinds, struts, flat-footed buck and eccentric dancing. Tap dance incorporated rubber-legging, the shimmy and animal dances (peckin', camel-walk, scratchin') from social dance, as well as an entire vocabulary of wings, slides, chugs, and drags.

Performing opportunities increased with the rise of vaudeville (a kind of variety show). Vaudeville, which began in the 1880s, was the most popular stage form in America by 1900. It was controlled by syndicates that brought together large numbers of theaters under a single management, which hired and toured the various acts. Because of racist policies, however, two separate vaudevilles developed, one black and one white.

Because of the nature of vaudeville, where performers spent years perfecting their acts before audiences, tap artists were able to refine the steps and styles that expanded tap's vocabulary. The black vaudeville syndicate, THEATRE OWNERS BOOKING ASSOCIATION (TOBA), offered grueling schedules and hard-earned but widespread exposure for such artists as the WHITMAN SISTERS and the Four Covans. Although many black artists—such as "Covan and Ruffin," "Reed and Bryant" and "Greenlee and Drayton"—crossed over to appear on the white vaudeville circuits, they were bound by the "two colored" rule, which restricted blacks to pairs.

Rising from the minstrel show and vaudeville, "Williams and Walker" (Burt WILLIAMS and George WALKER) introduced a black vernacular dance style to Broadway that was an eccentric blend of the shuffle, strut-turned cakewalk and grind, or mooch; other important contributions were made by younger tap stylists, such as Ulysses "Slow Kid" Thompson and Bill BAILEY, whose styles were descendants of the flat-footed hoofing of King Rastus Brown. All together the combined contributions of many such artists added to tap's endowment and, as importantly, helped shape another stage dance, Broadway jazz.

The *Darktown Follies* (1913) serves as an example of how black shows disseminated African-American dance styles to the wider culture. Opening in Harlem's Lafayette Theater, *Darktown Follies* introduced the Texas Tommy, forerunner of the lindy hop, and tap dancer Eddie RECTOR's smooth style of "stage dancing," Toots Davis's "over-the-top" and "through-the-trenches" (high-flying air steps that would become the tap act's traditional flash finale). Then the black musicals *Shuffle Along* (1921) and *Runnin' Wild* (1923) on Broadway created rapid-fire tapping by chorus lines dancing to ragtime jazz, combining tap and stylish vernacular dances, such as the Charleston, while the speciality solo and duo tappers blended tap with flips, somersaults and twisting shimmies.

Bill "Bojangles" ROBINSON gained wide public attention on Broadway in Lew Leslie's *Blackbirds of 1928* at the age of fifty, although he had performed in vaudeville houses since 1921. Wearing wooden, split-soled shoes that gave mellow tones to his tapping, Robinson was known for bringing tap up on its toes,

Before Ralph Cooper achieved fame as the emcee of the Apollo Theater, he and his partner, Eddie Rector, made up one of the premiere soft-shoe acts in theatrical dancing in the 1920s and '30s. Rector was famed for his elegant and subtle dancing in routines such as the "sand dance" and the "waltz clog." (Photographs and Prints Division, Schomburg Center for Research in Black Culture, The New York Public Library, Astor, Lenox and Tilden Foundations)

dancing upright and swinging. The 1920s also saw the rise of John "BUBBLES" Sublett, credited with inventing "rhythm tap," a fuller and more dimensional rhythmic concept that utilized the dropping of the heels as bass accents and added more taps to the bar. The team of "Buck and Bubbles," formed with Ford Lee "Buck" Washington, was a sensation in the *Ziegfeld Follies of 1931*. White Broadway stars had African-American dance directors, like Clarence "Buddy" Bradley, who created routines that blended easy tap with black vernacular dance and jazz accenting. Bradley coached such stars as Ruby Keeler, Adele and Fred Astaire, Eleanor Powell and Paul Draper.

While white dancers learned tap in the classroom, black dancers developed on their own, often on street corners where dance challenges were hotly contested events. If tap had an institution of learning and apprenticeship, it was the Hoofers Club, next to the

Lafayette Theatre in Harlem, where rookie and veteran tappers assembled to share, steal and compete with each other. During the 1930s, tap dancers were often featured performing in front of swing bands in dance halls like Harlem's SAVOY BALLROOM. The swinging 4/4 bounce of the music of bands like Count BASIE's and Duke ELLINGTON's proved ideal for hoofers, while the smaller vaudeville houses and intimate nightclubs, such as the COTTON CLUB, featured excellent tap and specialty dancers and small (six-to eight-member) tap chorus lines like the Cotton Club Boys.

Tap was immortalized in the Hollywood film musicals of the 1930s and '40s, which featured Bill Robinson, Robinson and Shirley Temple, Buck and Bubbles, the NICHOLAS BROTHERS and the BERRY BROTHERS. However, these were exceptions, and for the most part, black dancers were denied access to the white film industry. Because of continued segregation and different budgets, a distinction in tap styles developed. In general, black artists like John Bubbles

Sammy Davis, Jr. (Photographs and Prints Division, Schomburg Center for Research in Black Culture, The New York Public Library, Astor, Lenox and Tilden Foundations)

kept the tradition of rhythm-jazz tapping with its flights of percussive improvisation, while white artists like Fred Astaire polished the high style of tapping seen on films, where rhythms were often less important than the integration of choreography with scenography.

As tap became the favorite form of American theatrical dance, its many stylistic genres got bunched into loose categories: The *Eccentric* style was comedic, virtuosic and idiosyncratic, exemplified by the routines (progenitors of later breakdancing moves) of Jigsaw Jackson, who circled and tapped while keeping his face against the floor; or the tapping of Alberta Whitman, who executed high-kicking legomania as a male impersonator. A *Russian* style, pioneered by Ida Forsyne in the teens, popularized Russian "kazotsky" kicks; then it was taken to Broadway by Dewey Weinglass and Ulysses "Slow Kid" Thompson. (A profusion of similar kicks and twisting, rubbery legs is reemerging in new style hip-hop dance).

The *Acrobatic* style made famous by Willie COVAN, Three Little Words, and the FOUR STEP BROTHERS, specialized in flips, somersaults, cartwheels, and splits. A cousin of this form, the *Flash Act,* brought to a peak of perfection by the Nicholas Brothers (Harold and Fayard), combined elegant tap dancing with highly stylized acrobatics and precision-timed stunts.

Comedy Dance teams such as Slap and Happy, Stump and Stumpy, Chuck and Chuckles, and Cook and Brown inculcated their tap routines with jokes, knockabout acrobatics, grassroots characterizations, and rambunctious translations of vernacular dance in a physically robust style.

The *Class Act* brought the art of elegance and nuance, complexity and musicality to tap. From the first decades of the century, the debonair song-and-dance teams of Johnson and Cole and Greenlee and Drayton and soloists such as Maxie McCree, Aaron Palmer and Jack Wiggins traversed the stage, creating beautiful pictures with each motion. Eddie Rector dovetailed one step into another in a graceful flow of sound and movement, while the act of Pete, Peaches and Duke brought precision and unison work to a peak. (Charles "Honi") COLES and (Cholly) ATKINS, certainly the most famous of the Class Act tappers of the 1930s to '60s, combined flawless, high-speed rhythm-tapping with the slowest soft shoe in the business. Lena Horne said that "Honi" Coles made butterflies seem clumsy.

By the mid-1940s big bands were being replaced by smaller, streamlined bebop groups whose racing tempos and complex rhythms were too challenging for most tappers accustomed to the clear rhythms of swing. However, led by the greatly admired "Baby" Laurence, who meshed into bop combos by improvising and using tap as another percussive voice within the combo, many younger tappers took flight with bop and made the transition. From a current perspective, these early tap bopsters of the 1940s and '50s broke ground for the rapid and dense tap style that is gaining popularity in the 1990s.

By the 1950s tap was in a sharp decline that has been attributed to various causes: the demise of vaudeville and the variety act; the devaluing of tap dance on film; the shift toward ballet and modern dance on the Broadway stage; the imposition of a federal tax on dance floors which closed ballrooms and eclipsed the big bands; and the advent of the jazz combo and the desire of musicians to play in a more intimate and concertized format. "Tap didn't die," says tap dancer Howard "Sandman" Sims. "It was just neglected." In fact the neglect was so thorough that this indigenous American dance form was almost lost, except for television reruns of old Hollywood musicals.

Those hoofers who lived through tap's lean years reveled in tap's resurgence. Jazz and tap historian Marshall Stearns, recognizing the danger of tap's im-

In shows such as *Sophisticated Ladies* (1981), based on the music of Duke Ellington, Gregory Hines helped revive interest in the art of tap dancing. (AP/Wide World Photos)

minent demise, arranged for a group of tap masters to perform at the 1962 Newport Jazz Festival. It was viewed as the last farewell, but it actually marked a rebirth that continued with Leticia Jay's historic *Tap Happening* (1969) at the Hotel Dixie in New York.

By the mid-1970s young dancers began to seek out elder tap masters to teach them. Tap dance—previously ignored as art and dismissed as popular entertainment—now made one of the biggest shifts of its long history and moved to the concert stage. The African-American aesthetic fit the postmodern dance taste: it was a minimalist art that fused musician and dancer; it celebrated pedestrian movement and improvisation; its art seemed casual and democratic; and tap could be performed in any venue, from the street to the stage. Enthusiastic critical and public response placed tap firmly within the larger context of dance as art, fueling the flames of its renaissance.

The 1970s produced video documentaries *Jazz Hoofer: The Legendary Baby Laurence, Great Feats of Feet* and *No Maps On My Taps* while the 1980s exploded with the films *White Nights, The Cotton Club* and *Tap,* tap festivals across the country and *Black and Blue* on Broadway. On television, *Tap Dance in America,* hosted by Gregory HINES and featuring tap masters and young virtuosos such as Savion Glover, bridged the gap between tap and mainstream entertainment.

In the 1990s tap dance is a concertized art form danced, though not exclusively, to jazz music, infused with upper-body shapes of jazz dance and new spatial forms from modern dance. Incorporating new technologies for amplifying sounds and embellishing rhythms, new generations of tap artists are not only continuing tap's heritage, but forging new styles for the future.

REFERENCES

EMERY, LYNNE FAULEY. *Black Dance: From 1619 to Today.* 2nd ed. Princeton, N.J., 1988.

FLETCHER, TOM. *100 Years of the Negro in Show Business: The Tom Fletcher Story.* New York, 1986.

NATHAN, HANS. *Dan Emmett and the Rise of Early Negro Minstrelsey.* Norman, Okla., 1962.

SLOAN, LENI. "Irish Mornings and African Days On the Old Minstrel Stage." *Callahan's Irish Quarterly* no. 2 (Spring 1982): 50–53.

SOMMER, SALLY. "Feet, Talk to Me!" *Dance Magazine* (September 1988): 56–60.

STEARNS, MARSHALL, and JEAN STEARNS. *Jazz Dance: The Story of American Vernacular Dance.* New York, 1968.

SZWED, JOHN, and MORTON MARKS. "The Afro-American Transformation of European Set Dances and Dance Suites." *Dance Research Journal* 20, no. 1 (Summer 1988): 29–36.

TOLL, ROBERT. *Blacking Up: The Minstrel Show in Nineteenth Century America.* New York, 1974.

WILLIAMS, JOSEPH J. *Whence the Black Irish of Jamaica?* New York, 1932.

WINTER, MARIA HANNAH. "Juba and American Minstrelsey," In Paul Magriel, ed. *Chronicles of the American Dance,* 1978.

WOLL, ALLEN. *Black Musical Theatre: From Coontown to Dreamgirls.* Baton Rouge, La., and London, 1989.

CONSTANCE VALIS HILL
SALLY SOMMER

Tatum, Arthur, Jr., "Art" (October 13, 1909–November 5, 1956), jazz pianist. Tatum was born in Toledo, Ohio, partially blind because of cataracts in both eyes. Encouraged by his mother, who played piano, and his father, who played guitar, Tatum began playing piano as a child. At first he learned songs from the radio and from piano rolls and recordings by stride pianists James P. JOHNSON and Fats WALLER. Tatum, who also learned guitar, violin, and accordion, continued his musical education at Cousino School for the Blind in Columbus, Ohio. He then studied classical piano at the Toledo School of Music. By 1926 Tatum was performing with local bands led by Speed Webb and Milton Senior. By the late 1920s, Tatum's prodigious technique had earned him a local reputation, and in 1929 he was hired to play daily radio spots on a Toledo radio station. Singer Adelaide Hall hired him in 1930. Two years later she brought him to New York. There he went solo, making his reputation by publicly defeating his idols, Johnson, Waller, and Willie "The Lion" SMITH, in a traditional Harlem "cutting" contest. Thereafter Tatum began playing to a cultlike following at the after-hours clubs that lined 52nd Street. Tatum first recorded in 1933 ("Tea for Two," "Tiger Rag"). Over the next decade he also performed at nightclubs in Cleveland, Chicago, and Los Angeles, and in 1938 he toured England. He also continued to record, both solo ("Sweet Lorraine," 1940; "Rosetta," 1940) and as a leader ("Body and Soul," 1937). He also recorded with tenor saxophonist Coleman HAWKINS in 1943 ("Esquire Blues").

Starting in 1944, Tatum worked with guitarist Tiny Grimes and bassist Slam Stewart, and it was with a trio that he gained popular success over the next decade. But it was as a solo artist that he earned the almost unanimous critical judgment that he was the greatest pianist in jazz. Waller, his one-time idol, once announced during a Tatum set that "I play piano, but God is in the house tonight." Tatum established new standards for virtuosity among jazz

musicians, and his magnificent technique proved enormously influential to the early bebop musicians, particularly saxophonist Charlie PARKER and pianists Bud POWELL and Oscar PETERSON. Although Tatum was renowned for his astonishing speed, he also experimented with exotic harmonies within his headlong, stop-time runs. That style is perhaps best on display on a series of recordings he made for Capitol Records in 1949 ("Willow Weep for Me," "Nice Work If You Can Get It"). Tatum was most widely known as an interpreter of jazz standards and show tunes, but he also integrated classical music into his repertory, particularly pieces that showed off his technique, such as Dvořák's "Humoresque" and Massenet's "Elégie." Tatum rarely played the blues, and he composed few songs, both of which tendencies were unusual for pianists of his generation.

Despite health problems caused by years of overindulgence of food and alcohol, from 1953 to 1955 Tatum recorded more than 100 solo performances. In the years before his death, Tatum also coled a variety of small ensemble recordings with some of the finest soloists of the day, including alto saxophonist Benny CARTER, tenor saxophonist Ben WEBSTER, vibraphonist Lionel HAMPTON, trumpeter Roy ELDRIDGE, and clarinetist Buddy DeFranco. In 1956 he played at the Hollywood Bowl for almost nineteen thousand people. Tatum died later that year of kidney disease in Los Angeles.

REFERENCES

LAUBICH, A., and R. SPENCER. *Art Tatum: A Guide to His Recorded Music*. Metuchen, N.J., 1982.
SCHULLER, GUNTHER. *The Swing Era*. New York, 1989.

DOUGLAS J. CORBIN

Tavares, Ward Martin. *See* Silver, Horace.

Taylor, Cecil Percival (March 15, 1933–), jazz pianist. Born in Long Island City, N.Y., Cecil Taylor was an important figure in the development of avant-garde jazz in the late 1950s and '60s, and must be considered one of the strongest and most original voices in jazz.

Taylor began piano lessons at age five, and later studied percussion as well. As a youth, he heard the leading swing bands of the time, including those of Chick WEBB, Count BASIE, Jimmie LUNCEFORD, Benny GOODMAN, and Duke ELLINGTON. He was also impressed by dancers he saw, most notably the

FOUR STEP BROTHERS and Baby Laurence (*see* Laurence JACKSON).

In 1952 Taylor entered the New England Conservatory of Music. He has noted that while bigotry kept him out of the conservatory composition department, he probably learned more outside the school. While in Boston, he performed frequently with Oran "Hot Lips" Page, and also with Lawrence Brown and Johnny HODGES from the Ellington orchestra. Taylor fashioned a distinctive musical voice, influenced by Igor Stravinsky, Horace SILVER, and especially Ellington. His career began in earnest in 1956, when he recorded *Jazz Advance* with Steve Lacy, Buell Neidlinger, and Dennis Charles; that year he also completed a long and critically acclaimed engagement at the Five Spot, which established both the artist and the club.

Taylor's style was unique from the beginning. His single-note melodic lines were combined with occasional sharp dissonances and jarring rhythmic figures. By the late 1960s, his style had evolved into a highly dissonant and percussive style that featured series of violent clusters and washes of sound imbued with an astonishing kinetic energy. He has taught at the University of Wisconsin at Madison, at Antioch College, and at Glassboro State College in New Jersey.

REFERENCES

DARTER, TOM. "Piano Giants of Jazz: Cecil Taylor." *Contemporary Keyboard* (May 1981): 56.
SPELLMAN, A. B. *Four Lives in the Be Bop Business*. New York, 1966.

DOUGLAS J. CORBIN

Taylor, Gardner Calvin (June 8, 1918–), Baptist minister. Gardner Taylor was born in Baton Rouge, La. He received his B.A. degree from Leland College in 1937. Taylor aspired to be a lawyer and was accepted to the University of Michigan law school. Before he was to leave for Ann Arbor, however, he narrowly survived a traffic accident; after this incident, he decided to devote his life to religion.

Taylor attended Oberlin Theological Seminary in Oberlin, Ohio, and was ordained a Baptist minister in 1939. During his studies he served the pastorate at nearby Elyria, from 1938 to 1940. After earning his B.D. in 1940, he moved back to Louisiana and headed congregations at New Orleans and Baton Rouge. In 1948, Taylor accepted the pastorate of the Concord Baptist Church of Christ in Brooklyn's Bedford-Stuyvesant neighborhood in New York.

After the Concord Church burned down in 1952, Taylor helped to raise nearly $2 million for a large new church. Dedicated in 1956, the church expanded to include a nursing home and a clothing exchange. Taylor and his wife, Laura S. Taylor, a teacher educated at Oberlin, opened the Concord Elementary Day School in 1961 as an alternative to public schools. Laura Taylor developed much of the curriculum, which emphasized black history and culture and used innovative teaching methods. Appointed by Mayor Robert F. Wagner to the New York City Board of Education in 1958, Gardner Taylor campaigned for equity in funding for predominantly minority school districts. He often disagreed with the other six members of the board over cases like the 1958–1959 Harlem Nine controversy, in which parents of African-American and Puerto Rican students withdrew their children from school, protesting the substandard conditions of the schools that poor and minority students were compelled by the state to attend. Taylor sided with the parents in their call for a citywide boycott. He was also active in the Citywide Committee for Integrated Schools and worked for employment opportunities for African Americans with the Urban League of Greater New York throughout the 1950s and 1960s.

By the early 1960s, Taylor was a respected leader in the CIVIL RIGHTS MOVEMENT. He was active in the top echelons of the CONGRESS ON RACIAL EQUALITY (CORE) and instrumental in the selection of James FARMER as the organization's national director in 1961. Taylor was a close friend of the Rev. Dr. Martin Luther KING, Jr. Taylor and several like-minded BAPTIST ministers challenged the autocratic, conservative leadership of Joseph H. JACKSON of the National Baptist Convention, USA, Inc., the governing board of the National Baptists. Jackson, who was lukewarm at best toward the civil rights activism of King, was challenged by a slate headed by Taylor. A power struggle already in progress over the legitimacy of Jackson's presidency erupted in 1961 between Taylor's supporters, who included King, Ralph ABERNATHY, and Adam Clayton POWELL, Jr., and the faction led by Jackson. At the Philadelphia convention, the Taylor team protested the reelection of Jackson, whereupon Jackson's partisans adjourned the meeting. The Taylor team nevertheless remained, elected Taylor, and organized a sit-in to enforce the election. When the controversy was decided in Jackson's favor in court, Taylor and his supporters formed the Progressive National Baptist Convention, which openly supported activist organizations, especially the SOUTHERN CHRISTIAN LEADERSHIP CONFERENCE (SCLC) and CORE. Taylor was president of the PNBC from 1967 to 1968, when the convention became the first predominantly black religious body to denounce the VIETNAM WAR.

In 1962, Taylor served a term as president of the Protestant Council of New York City, the first African American and Baptist to hold that position. Under his leadership, the Concord Baptist Church grew to twelve-thousand members, five thousand of them active. It became the largest Protestant congregation in the United States. Known as the "dean of black pastors," Taylor was acknowledged to be one of the most effective preachers in American history. He delivered Yale University's prestigious Lyman Beecher Lectures in 1977, published in *How Shall They Preach?* A book of sermons, *The Scarlet Thread,* was published in 1981. Taylor received an honorary degree from Brooklyn's Long Island University in 1984. Shortly before he retired in 1990, Taylor introduced Nelson Mandela at New York City's Riverside Church on the occasion of the South African leader's historic visit to the United States. In the 1990s, Taylor continued to live in Bedford-Stuyvesant and delivered lectures and sermons in podiums and pulpits across the country.

REFERENCES

LINCOLN, C. ERIC, and LAWRENCE H. MAMIYA. *The Black Church in the African American Experience.* Durham, N.C. 1990.
MURPHY, LARRY G., J. GORDON MELTON, and GARY L. WARD. *Encyclopedia of African American Religions.* New York, 1993.

ALLISON X. MILLER

Taylor, Susie Baker King (August 6, 1848–1912), teacher, nurse, and writer. Susie Baker was born into slavery on Grest Farm, in Liberty County, Ga., and secretly learned to read and write through the efforts of a neighboring free woman of color, a white female playmate, and the son of her family's white landlord. She put these skills to use by writing passes for African Americans, both slave and free.

At the opening of the Civil War, when the Union army captured Fort Pulaski off the Georgia coast, Baker went with her uncle and his family to St. Simon's Island, on one of the Union-controlled Sea Islands. The men in her family became part of Company E of the First South Carolina Infantry, later the 33rd U.S. Colored Infantry commanded by Thomas Wentworth Higginson. Baker accompanied this regiment throughout the Civil War, going with the men to Camp Saxton in Beaufort, S.C., in late 1862 and joining them in their military expeditions up and down the coast.

Baker's literacy earned her the role of teacher; she taught children during the day, adults at night, and

black soldiers when they had a free moment. She also served as laundress, cook, weapons cleaner, and nurse. As a nurse she worked with Clara Barton during the latter's stay at the Sea Islands in 1863. Baker was almost killed in a boating accident in 1864, but soon returned to service, where she tended to soldiers of the famous 54th Massachusetts Volunteers. All her labor was performed without pay.

Baker married Edward King, a black sergeant, in 1862, and after the war the couple lived in Savannah. As a means of support, and because there was no free school for black children, she ran a private school out of her home, teaching young students for a dollar a month, as well as adults in the evenings. She continued this work until a free school opened. Her husband, who worked as a carpenter and longshoreman, died in 1866, just before the birth of their only child.

In 1867, King opened a school in rural Liberty County, Ga., in which she taught for a year, before deciding to return to city life. Upon her return to Savannah, she opened a private night school for adults, again until a free school was established. King then worked as a domestic servant, traveling to New England in the summer with a white family, and later seeking employment there on her own, in order to support herself and her son.

In 1879, she married Russell L. Taylor and moved to Boston where in 1886 she helped organize Corps 67, Women's Relief Corps, an auxiliary women's relief organization for Union army veterans. She served as guard, secretary, treasurer, and in 1893, president. When Taylor traveled to Louisiana in 1898 to tend to her son, who had fallen ill, she was greatly affected by being forced to travel in segregated railway cars, and by witnessing a lynching.

Taylor is best remembered for her memoir, *Reminiscences of My Life in Camp with the 33rd United States Colored Troops*. Published in 1902, the work describes not only her labor for the Union army and her memory of the reading of the Emancipation Proclamation, but also her observations and experiences of discrimination and violence in America after the Civil War. It is the only published account of the military experience of the Civil War from the perspective of a black female participant.

REFERENCE

TAYLOR, SUSIE KING. *Reminiscences of My Life in Camp with the 33rd United States Colored Troops*. Boston, 1902. Reprint. New York, 1988.

MARTHA E. HODES

Susie King Taylor, Civil War nurse. (Photographs and Prints Division, Schomburg Center for Research in Black Culture, The New York Public Library, Astor, Lenox and Tilden Foundations)

Taylor, William, Jr., "Billy" (July 24, 1921–), pianist and educator. Born in Greenville, N.C., Taylor became interested in music as a child after his parents moved to Washington, D.C. He studied guitar, tenor saxophone, and piano, and eventually entered Virginia State College in Petersburg, Va. After graduating in 1942 with a degree in music, he moved to New York. His first important engagement was with tenor saxophonist Ben WEBSTER, and he eventually worked as a sideman with some of the most important swing and bebop musicians, including Roy ELDRIDGE, Coleman HAWKINS, Dizzy GILLESPIE, and Charlie PARKER. Taylor started his own trio in 1949, and served as the house pianist at Birdland, then New York's most prominent jazz nightclub, in the early 1950s. Since then, Taylor has recorded and toured regularly, and his urbane bebop style, derived from Fats WALLER, Art TATUM, and Bud POWELL, is featured on albums such as *Piano Panorama* (1951), *One for Fun* (1959), *Sleeping Bee* (1969), and *Billy Taylor: Solo* (1988).

As a composer, Taylor has also written music outside strict jazz formats. His 1964 gospel-tinged "I Wish I Knew (How It Would Feel to Be Free)" became a hit for singer Solomon Burke in 1968. His longer works include *Suite for Jazz Orchestra* (1973) and *Peaceful Warrior,* a tribute to Martin Luther KING, Jr., that was premiered by the Atlanta Symphony Orchestra in 1984.

Taylor has also had a prominent career as a disc jockey, television personality, promoter, and educator. He produced radio and television shows on jazz from the 1950s through the 1990s on both network and public television. In 1964 he founded Jazzmobile, an organization that sponsors outdoor summertime concerts in New York City, where he lives. Taylor, who published a series of piano instruction books in 1949, received a doctorate in music education from the University of Massachusetts at Amherst in 1975. He published *Jazz Piano: A History and Development* in 1982.

REFERENCES

OWENS, JIMMY. "Billy Taylor." *Jazz Educators Journal* 23, no. 2 (1991): 30–34.

ROBERTS, J. "Billy Taylor: Primarily Piano." *Downbeat* 52, no. 3 (1985): 26.

EDDIE S. MEADOWS

Teer, Barbara Ann (June 18, 1937–), actress and theater director. Barbara Teer was born and raised in East St. Louis, Ill. She received a B.A. with honors in dance education from the University of Illinois in 1957 and continued her dance studies in Germany, Switzerland, and France. She also studied acting with Sanford Meisner, Paul Mann, Philip Burton, and Lloyd Richards, the former director of the Yale Drama School.

In the 1960s Teer acted in numerous stage and film productions. She first performed on Broadway in the musical *Kwamina* in 1961. She then went on to appear in twelve off-Broadway productions, winning the Drama Desk Vernon Award in 1964–1965 for outstanding achievement in *Home Movies* (1965). Her other credits include *Living Premise* (1963), *Prodigal Son* (1965), *Who's Got His Own* (1966), *The Experiment* (1967), and *Where's Daddy?* (1970). Teer also appeared in such films as *The Pawnbroker* (1965), Ossie Davis's *Gone Are the Days* (1963), *Slaves* (1969), and *Angel Levine* (1970). In addition she worked as a dancer with Alvin AILEY, Duke ELLINGTON, Pearl BAILEY, and Louis JOHNSON.

In 1967, in response to the negative treatment of African Americans in mainstream theater, Teer and Robert Hooks founded the Group Theater Workshop in HARLEM, which offered tuition-free acting instruction to local residents and shortly thereafter became part of the Negro Ensemble Company. The following year Teer founded the National Black Theatre (NBT) in Harlem, dedicated to exploring and maintaining African-American art, culture, and expression. The NBT distinguished itself from the polemical works typical of black theater at the time by offering naturalistic interpretations of African-American life.

In 1972 Teer's interest in portraying the collective personality, or "ethos-soul," of African Americans was enhanced when she received a Ford Foundation Fellowship to study native cultures in Africa. She spent four months in western Nigeria studying the Yoruba tribe and subsequently attempted to translate that culture into theatrical expression through her "Black Art Standard," a ritualistic technique used to teach "God Conscious Art" in the theater. The works produced from this technique have included *The Ritual* on the television show *Soul* in 1970, and the New York productions *Change/Love Together/Organize: A Revival* (1972), *We Sing a New Song* (1972), *Sojourn into Truth* (1976), and *Softly Comes the Whirlwind, Whispering in Your Ear* (1978).

In addition to her work as an actor, Teer has worked extensively as a writer and director. In 1969 she directed the off-Broadway musical *The Believers,* and in 1972 adapted and produced *We Sing a New Song.* She cowrote the plays *Change/Love Together/Organize: A Revival* (1972) and *Sojourn into Truth* (1972). In 1975 she wrote, directed and coproduced the film *Rise: A Love Song for a Love People,* based on the life of MALCOLM X, for which she received the National Association of Media Women's Black Film Festival award for best film.

In 1983 after the National Black Theatre's building burned down, Teer purchased a city block–front of property on 125th Street in Harlem where she relocated the NBT. Through the 1980s and early 1990s she continued to work with the NBT and developed the National Black Institute of Communication Through Theatre Arts (NBICTA), an organization blending retail and office space rentals with theater arts activities.

REFERENCES

HINE, DARLENE CLARK. *Black Women in America.* New York, 1993.

MAPP, EDWARD. *Directory of Blacks in the Performing Arts.* Metuchen, N.J., 1990.

SUSAN MCINTOSH

Television. The growing participation of African Americans in television, both in front of and behind the camera, has coincided with the radical restructuring of race relations in the United States from the end of WORLD WAR II to the present day. Throughout this period, the specific characteristics of the television industry have complicated the ways in which these changing relations have been represented in television programming.

Television was conceived as a form of commercialized mass entertainment. Its standard fare—comedy, melodrama, and variety shows—favors simple plot structures, family situations, light treatment of social issues, and reassuring happy endings, all of which greatly delimit character and thematic developments. Perhaps more than any other group in American society, African Americans have suffered from the tendencies of these shows to depict one-dimensional character STEREOTYPES.

Because commercial networks are primarily concerned with the avoidance of controversy and the creation of shows with the greatest possible appeal, African Americans were rarely featured in network series during the early years of television. Since the 1960s, the growing recognition by network executives that African Americans are an important group of consumers has led to greater visibility; however, in most cases, fear of controversy has led programmers to promote an unrealistic view of African-American life. Black performers, writers, directors, and producers have had to struggle against the effects of persistent typecasting and enforced sanitization in exchange for acceptance in white households. Only when African Americans made headway into positions of power in the production of television programs were alternative modes of representing African Americans developed.

Although experiments with television technology date back to the 1880s, it was not until the 1930s that sufficient technical expertise and financial backing were secured for the establishment of viable television networks. The National Broadcasting Company (NBC), a subsidiary of the Radio Corporation of America (RCA), wanted to begin commercial television broadcasting on a wide scale but was interrupted by the outbreak of WORLD WAR II, and the television age did not commence in earnest until after peace was declared.

In 1948 the three major networks—the National Broadcasting Company (NBC), the Columbia Broadcasting System (CBS), and the American Broadcasting Company (ABC)—began regularly scheduled prime-time programming. That same year, the DEMOCRATIC PARTY adopted a strong civil rights platform at the Democratic convention, and the Truman ad-

ministration issued a report entitled *To Secure These Rights,* the first statement made by the federal government in support of desegregation. Yet these two epochal revolutions—television and the CIVIL RIGHTS MOVEMENT—had little influence on one another for many years. While NBC, as early as 1951, stipulated that programs dealing with race and ethnicity should avoid ridiculing any social or racial group, most network programming rarely reflected the turbulence caused by the agitation for civil rights, nor did activists look to television as a medium for effecting social change. The effort to obtain fair and honest representation of African Americans and African-American issues on television remains a complex and protracted struggle.

In the early years of television, African Americans appeared most often as occasional guests on variety shows. Music entertainment artists, sports personalities, comedians, and political figures of the stature of Ella FITZGERALD, Lena HORNE, Sarah VAUGHAN, Louis ARMSTRONG, Duke ELLINGTON, Cab CALLOWAY, Pearl BAILEY, Eartha KITT, the HARLEM GLOBETROTTERS, Dewey "Pigmeat" MARKHAM, Bill "Bojangles" ROBINSON, Ethel WATERS, Joe LOUIS, Sammy DAVIS, Jr., Ralph BUNCHE, and Paul ROBESON appeared in such shows as Milton Berle's *Texaco Star Theater* (1948–1953), Ed Sullivan's *Toast of the Town* (1948–1955), the *Steve Allen Show* (1950–1952; 1956–1961), and *Cavalcade of Stars* (1949–1952). Quiz shows like *Strike It Rich* (1951–1958), amateur talent contests like *Chance of a Lifetime* (1950–1953; 1955–1956), and shows concentrating on sporting events (particularly boxing matches), like *The Gillette Cavalcade of Sports* (1948–1960), provided another venue in which prominent blacks occasionally took part.

Rarely did African Americans host their own shows. Short-run exceptions included *The Bob Howard Show* (1948–1950); *Sugar Hill Times* (1949), an all-black variety show featuring Willie Bryant and Harry BELAFONTE; the *Hazel Scott Show* (1950), the first show featuring a black female host; the *Billy Daniels Show* (1952); and the *Nat "King" Cole Show* (1956–1957). There were even fewer all-black shows designed to appeal to all-black audiences or shows directed and produced by blacks. Short-lived local productions constituted the bulk of the latter category. In the early 1950s, a black amateur show called *Spotlight on Harlem* was broadcast on WJZ-TV in New York City; in 1955, the religious *Mahalia Jackson Show* appeared on Chicago's WBBM-TV.

Comedy was the only fiction-oriented genre in which African Americans were visible participants. Comedy linked television with the deeply entrenched cultural tradition of minstrelsy and blackface practices dating back to the antebellum period (*see* MIN-

STRELS/MINSTRELSY). In this cultural tradition, the representation of African Americans was confined either to degrading stereotypes of questionable intelligence and integrity (such as coons, mammies, Uncle Toms, or STEPIN FETCHITs) or to characterizations of people in willingly subservient positions (maids, chauffeurs, elevator operators, train conductors, shoeshine boys, handypeople, and the like). Beginning in the 1920s, radio comedies had perpetuated this cultural tradition, tailored to the needs of the medium.

The dominant television genre, the situation comedy, was invented on the radio. Like its television successor, the radio comedy—self-contained fifteen-minute or half-hour episodes, with a fixed set of characters, usually involving minor domestic or familial disputes, and painlessly resolved in the allotted time period—lent itself to caricature. Since all radio comedy was verbal, it relied for much of its humor on the misuse of language, such as malapropisms or syntax error; and jokes made at the expense of African Americans (and their supposed difficulties with the English language) were a staple of radio comedies.

The first successful radio comedy, and the series that in many ways defined the genre, was AMOS 'N' ANDY, (1929–1960), which employed white actors to depict unflattering black characters. *Amos 'n' Andy* featured two white comedians, Freeman Gosden and Charles Correll, working in the style of minstrelsy and vaudeville. Another radio show that was successfully transferred to television was *Beulah* (1950–1953). The character Beulah was originally created for a radio show called *Fibber McGee and Molly* (1935–1957), in which she was played by Marlin Hurt, a white man. These two shows, which adopted an attitude of contempt and condescending sympathy toward the black persona, were re-created on television with few changes, except that the verisimilitude of the genre demanded the use of black actors rather than whites in blackface and "blackvoice." As with *Amos 'n' Andy* (1951–1953)—in its first season the thirteenth most-watched show on television—the creators of *Beulah* had no trouble securing commercial support; both television shows turned out to be as popular as their radio predecessors, though both were short-lived in their network television incarnations.

Beulah (played first by Ethel Waters, then by Louise BEAVERS) developed the story of the faithful, complacent Aunt Jemima, who worked for a white suburban middle-class nuclear family. Her unquestioning devotion to solving familial problems in the household of her white employers, the Hendersons, validated a social structure that forced black domestic workers to profess unconditional fidelity to white families, while neglecting their personal relations to their own kin. When blacks were included in Beulah's personal world, they appeared only as stereotypes. For instance, the neighbor's maid, Oriole (played by Butterfly MCQUEEN), was an even more pronounced Aunt Jemima character; and Beulah's boyfriend, Bill Jackson (played by Percy Harris and Dooley WILSON), the Henderson's handyperson, was a coon. The dynamics between the white world of the Hendersons and Beulah's black world were those of the perfect object with a defective mirror image. The Hendersons represented a well-adjusted family, supported by a strong yet loving working father whose sizable income made it possible for the mother to remain at home. In contrast, Beulah was condemned to chasing after an idealized version of the family because her boyfriend did not seem too interested in a stable relationship; and she was destined to work forever because Bill Jackson did not seem capable of taking full financial responsibility in the event of a marriage. As the show could only exist as long as Beulah was a maid, it was evident that her desires were never to be fulfilled. If Beulah seemed to enjoy channeling all her energy toward the solution of a white family's conflicts, it was because her own problems deserved no solution.

Amos 'n' Andy, on the other hand, belonged to the category of folkish programs that focused on the daily life and family affairs of various ethnic groups. Several such programs, among them *Mama* (1949–1956), *The Goldbergs* (1949–1955), and *Life with Luigi* (1952–1953)—depicting the lives of Norwegians, Jews, and Italians, respectively—were popularized in the early 1950s. In *Amos 'n' Andy,* the main roles comprised an assortment of stereotypical black characters. Amos Jones (played by Alvin Childress) and his wife, Ruby (played by Jane Adams), were passive Uncle Toms, while Andrew "Andy" Hogg Brown (played by Spencer WILLIAMS) was gullible and half-witted. George "Kingfish" Stevens (played by Tim MOORE) was a deceiving, unemployed coon, whose authority was constantly being undermined by his shrewd wife Sapphire (played by Ernestine Wade) and overbearing mother-in-law "Mama" (played by Amanda Randolph). "Lightnin' " (played by Horace Stewart) was a janitor; and Algonquin J. Calhoun (played by Johnny Lee) was a fast-talking lawyer. These stereotypical characters were contrasted, in turn, with serious, level-headed black supporting characters, such as doctors, business people, judges, law enforcers, and so forth. The humorous situations created by the juxtapositions of these two types of characters—stereotypical and realistic—made *Amos 'n' Andy* an exceptionally intricate comedy and the first all-black television comedy that opened a window for white audiences on the everyday lives of African-American families in Harlem.

Having an all-black cast made it possible for *Amos 'n' Andy* to neglect relevant but controversial issues like race relations. The Harlem of this show was a world of separate but equal contentment, where happy losers, always ready to make fools of themselves, coexisted with regular people. Furthermore, the show's reliance on stereotypes precluded both the full-fledged development of its characters and the possibility of an authentic investigation into the pathos of black daily life. Even though the performers often showed themselves to be masters of comedy and vaudeville, it is unfortunate that someone like Spencer Williams, who was also a prolific maker of all-black films, would only be remembered by the general public as Andy.

While a number of African Americans were able to enjoy shows like *Beulah* and *Amos 'n' Andy,* many were offended by their portrayal of stereotypes, as well as by the marked absence of African Americans from other fictional genres. Black opposition had rallied without success to protest the airing of this kind of show on the radio in the 1930s. Before *Amos 'n' Andy* aired in 1951, the NATIONAL ASSOCIATION FOR THE ADVANCEMENT OF COLORED PEOPLE (NAACP) began suing CBS for the show's demeaning depiction of blacks, and the organization did not rest until the show was canceled in 1953. Yet the viewership of white and black audiences alike kept *Amos 'n' Andy* in syndication until 1966. The NAACP's victory in terminating *Amos 'n' Andy* and *Beulah* also proved somewhat pyrrhic, since during the subsequent decade, the networks produced no dramatic series with African Americans as central characters, while stereotyped portrayals of minor characters continued.

Many secondary comic characters from the radio and cinema found a niche for themselves in television. In the *Jack Benny Show* (1950–1965), Rochester Van Jones (played by Eddie "Rochester" ANDERSON) appeared as Benny's valet and chauffeur. For Anderson, whose Rochester had amounted to a combination of the coon and the faithful servant in the radio show, the shift to television proved advantageous, as he was able to give his character greater depth on the television screen. Indeed, through their outlandish employer-employee relationship, Benny and Anderson established one of the first interracial on-screen partnerships in which the deployment of power alternated evenly from one character to the other. The same may not be said of Willie Best's characterizations in shows like *The Stu Erwin Show* (1950–1955) and *My Little Margie* (1952–1955). Best tended to confine his antics to the Stepin Fetchit style and thereby reinforced the worst aspects of the master-slave dynamic.

African-American participation in dramatic series was confined to supporting roles in specific episodes

in which the color-line tradition was maintained, such as the *Philco Television Playhouse* (1948–1955), which featured a young Sidney POITIER in "A Man Is Ten Feet Tall" in 1955; the *General Electric Theater* (1953–1962), which featured Ethel Waters and Harry Belafonte in "Winner by Decision" in 1955; and *The Hallmark Hall of Fame* (1952–) productions in 1957 and 1959 of Marc Connelly's "Green Pastures," a biblical retelling performed by an all-black cast. African Americans also appeared as jungle savages in such shows as *Ramar of the Jungle* (1952–1953), *Jungle Jim* (1955), and *Sheena, Queen of the Jungle* (1955–1956). The television western, one of the most important dramatic genres of the time, almost entirely excluded African Americans, despite their importance to the real American West. In the case of those narratives set in contemporary cities, if African Americans were ever included, it was only as props signifying urban deviance and decay. A rare exception to this was *Harlem Detective* (1953–1954), an extremely low-budget, local program about an interracial pair of detectives (with William MARSHALL and William Harriston playing the roles of the black and white detectives, respectively) produced by New York's WOR-TV.

Despite the sporadic opening of white households to exceptional African Americans and the effectiveness of the NAACP's action in canceling *Amos 'n' Andy,* the networks succumbed to the growing political conservatism and racial antagonism of the mid-1950s. The cancellation of the *Nat "King" Cole Show* (1956–1957) exemplifies the attitude that prevailed among programmers during that time. Nat "King" COLE had an impeccable record: his excellent musical and vocal training complemented his noncontroversial, delicate, and urbane delivery; he had a nationally successful radio show on NBC in the 1940s; and over forty of his recordings had been listed for their top sales by *Billboard* magazine between 1940 and 1955. Cole's great popularity was demonstrated in his frequent appearances as guest or host on the most important television variety shows. NBC first backed Cole completely, as is evidenced by the network's willingness to pour money into the show's budget, to increase the show's format from fifteen to thirty minutes, and to experiment with different time slots. Cole also had the support of reputable musicians and singers who were willing to perform for nominal fees. His guests included Count BASIE, Mahalia JACKSON, Pearl BAILEY, and all-star musicians from "Jazz at the Philharmonic." Yet the *Nat "King" Cole Show* did not gain enough popularity among white audiences to survive the competition for top ratings; nor was it able to secure a stable national sponsor. After little more than fifty performances, the show was canceled.

African Americans exhibited great courage in these early years of television by supporting some shows and boycotting others. Organizations such as the Committee on Employment Opportunities for Negroes, the Coordinating Council for Negro Performers, and the Committee for the Negro in the Arts constantly fought for greater and fairer inclusion.

During the height of the CIVIL RIGHTS MOVEMENT, the participation of African Americans in television intensified. Both Africans and African Americans became the object of scrutiny for daily news shows and network documentaries. The profound effects of the radical recomposition of race relations in the United States and the independence movement in Africa could not go unreported. "The Red and the Black" (January 1961), a segment of the *Close Up!* documentary series, analyzed the potential encroachment of the Soviet Union in Africa as European nations withdrew from the continent; "Robert Ruark's Africa" (May 1962), a documentary special shot on location in Kenya, defended the colonial presence in the continent. The series *See It Now* (1951–1958) started reporting on the civil rights movement as early as 1954, when the Supreme Court had ruled to desegregate public schools, and exposed the measures that had been taken to hinder desegregation in Norfolk high schools in an episode titled "The Lost Class of '59," aired in January 1959. *CBS Reports* (1959–) examined, among other matters, the living conditions of blacks in the rural South in specials such as "Harvest of Shame" (November 1960). *NBC White Paper* aired "Sit-In" in December 1960, a special report on desegregation conflicts in Nashville. "Crucial Summer" (which started airing in August 1963) was a five-part series of half-hour reports on discrimination practices in housing, education, and employment. It was followed by "The American Revolution of '63" (which started airing in September 1963), a three-hour documentary on discrimination in different areas of daily life across the nation.

However, the gains made by the airing of these programs were offset by the effects of poor scheduling, and they were often made to compete with popular series programs and variety and game shows from which blacks had been virtually erased. As the civil rights movement gained momentum, some southern local stations preempted programming that focused on racial issues, while other southern stations served as a means for the propagation of segregationist propaganda.

As black issues came to be scrutinized in news reports and documentaries, African Americans began to appear in the growing genre of socially relevant dramas, such as *The Naked City* (1958–1963), *Dr. Kildare* (1961–1966), *Ben Casey* (1961–1966), *The Defenders* (1961–1965), *The Nurses* (1962–1965), *Chan-*

ning (1963–1964), *The Fugitive* (1963–1967), and *Slattery's People* (1963–1965). These shows, which usually relied on news stories for their dramatic material, explored social problems from the perspective of white doctors, nurses, educators, social workers, or lawyers. Although social issues were seriously treated, their impact was much diminished by the easy and felicitous resolution with which each episode was brought to a close. Furthermore, the African Americans who appeared in these programs— Ruby DEE, Louis GOSSETT, Jr., Ossie DAVIS, and others—were given roles in episodes where topics were racially defined, and the color line was strictly maintained.

The short-lived social drama *East Side/West Side* (1963–1964) proved an exception to this rule. It was the first noncomedy in the history of television to cast an African American (Cicely TYSON) as a regular character. The program portrayed the dreary realities of urban America without supplying artificial happy endings; on occasion, parts of the show were censored because of their liberal treatment of interracial relations. *East Side/West Side* ran into difficulties when programmers tried to obtain commercial sponsors for the hour during which it was aired; eventually, despite changes in format, it was canceled after little more than twenty episodes.

Unquestionably, the more realistic television genres that evolved as a result of the civil rights movement served as powerful mechanisms for sensitizing audiences to the predicaments of those affected by racism. But as television grew to occupy center stage in American popular entertainment, the gains of the civil rights movement came to be ambiguously manifested. By 1965, a profusion of top-rated programs had begun casting African Americans both in leading and supporting roles. The networks and commercial sponsors became aware of the purchasing power of African-American audiences, and at the same time they discovered that products could be advertised to African-American consumers without necessarily offending white tastes. Arguably the growing inclusion of African Americans in fiction-oriented genres was premised on a radical inversion of previous patterns. If blacks were to be freed from stereotypical and subservient representation, they were nevertheless portrayed in ways designed to please white audiences. Their emergence as a presence in television was to be facilitated by a thorough cleansing.

A sign of the changing times was the popular police comedy *Car 54, Where Are You?* (1961–1963). Set in a run-down part of the Bronx, this comedy featured black officers in secondary roles (played by Nipsey RUSSELL and Frederick O'Neal). However, the real turning point in characterizations came with

I Spy (1965–1968), a dramatic series featuring Bill COSBY and Robert Culp as Alexander Scott and Kelly Robinson, two secret agents whose adventures took them to the world's most sophisticated spots, where racial tensions did not exist. In this role, Cosby played an immaculate, disciplined, intelligent, highly educated, and cultured black man who engaged in occasional romances but did not appear sexually threatening and whose sense of humor was neither eccentric nor vulgar. While inverting stereotypical roles, *I Spy* also created a one-to-one harmonious interracial friendship between two men.

I Spy was followed by other top-rated programs. In *Mission Impossible* (1966–1973), Greg Morris played Barney Collier, a mechanic and electronics expert and member of the espionage team; in *Mannix* (1967–1975), a crime series about a private eye, Gail Fisher played Peggy Fair, Mannix's secretary; in *Ironside* (1967–1975), Don Mitchell played Mark Sanger, Ironside's personal assistant and bodyguard; and in the crime show *Mod Squad* (1968–1973), Clarence Williams III played Linc Hayes, one of the three undercover police officers working for the Los Angeles Police Department. This trend was manifested in other top-ranked shows: *Peyton Place* (1964–1969), the first prime-time soap opera, featured Ruby Dee, Percy Rodriguez, and Glynn Turman as the Miles Family; in *Hogan's Heroes* (1965–1971), a sitcom about U.S. World War II prisoners in a German POW camp, Ivan DIXON played Sergeant Kinchloe; in *Daktari* (1966–1969), Hari Rhodes played an African zoologist; in *Batman* (1966–1968), Eartha KITT appeared as Catwoman; in *Star Trek* (1966–1969), Nichelle Nichols was Lieutenant Uhura; in the variety show *Rowan and Martin's Laugh-In* (1966–1973), Chelsea Brown, Johnny Brown, and Teresa Graves appeared regularly; and in the soap opera *The Guiding Light* (1952–), Cicely Tyson started appearing regularly after 1967.

Julia (1968–1971) was the first sitcom in over fifteen years to feature African Americans in the main roles. It placed seventh in its first season, thereby becoming as popular as *Amos 'n' Andy* had been in its time. Julia Baker (played by Diahann CARROLL) was a middle-class, cultured widow who spoke standard English. Her occupation as a nurse suggested that she had attended college. She was economically and emotionally self-sufficient; a caring parent to her little son Corey (played by Marc Copage); and equipped with enough sophistication and wit to solve the typical comic dilemmas presented in the series. However, many African Americans criticized the show for neglecting the more pressing social issues of their day. In Julia's suburban world, it was not so much that racism did not matter, but that integration had been accomplished at the expense of black culture. Julia's

cast of black friends and relatives (played by Virginia Capers, Diana Sands, Paul Winfield, and Fred Williamson) appeared equally sanitized. Ironically, *Julia* perpetuated some of the same misrepresentations of the black family as *Beulah*—for despite its elegant trappings, Julia's was yet another female-headed African-American household.

As successful as *Julia* was the *Bill Cosby Show* (1969–1971), which featured Bill Cosby as Chet Kincaid, a single, middle-class high school gym teacher. In contrast to *Julia,* however, this comedy series presented narrative conflicts that involved Cosby in the affairs of black relatives and inner-city friends as well as in those of white associates and suburban students. The *Bill Cosby Show* sought to integrate the elements of African-American culture through the use of sound, setting, and character: African-American music played in the background, props reminded one of contemporary political events, Jackie "Moms" MABLEY and Mantan Moreland appeared frequently as Cosby's aunt and uncle, and Cosby's jokes often invested events from black everyday life with comic

Bill Cosby in a publicity photograph for his 1972 television cartoon series *Fat Albert and the Cosby Kids,* an evocation of Cosby's Philadelphia boyhood. (AP/ Wide World Photos)

pathos. A less provocative but long-running sitcom, *Room 222* (1969–1974), concerned an integrated school in Los Angeles. Pete Dixon (played by Lloyd Haynes), a black history teacher, combined the recounting of important events of black history with attempts to address his students' daily problems. Another comic series, *Barefoot in the Park* (1970–1971)—with Scoey Mitchell, Tracey Reed, Thelma Carpenter, and Nipsey Russell—was attempted, but failed after thirteen episodes; it was an adaptation of the film by the same name but with African Americans playing the leading roles.

By the end of the 1960s, many of the shows in which blacks could either demonstrate their decision-making abilities or investigate the complexities of their lives had been canceled. Two black variety shows failed due to poor scheduling and lack of white viewer support: The *Sammy Davis, Jr., Show,* the first variety show hosted by a black since the *Nat "King" Cole Show* (1966); and *The Leslie Uggams Show* (1969), the first variety show hosted by a woman since Hazel Scott. A similar fate befell *The Outcasts* (1968–1969), an unusual western set in the period immediately following the Civil War. The show, which featured two bounty hunters, a former slave and a former slave owner, and addressed without qualms many of the same controversial themes associated with the civil rights movement, was canceled due to poor ratings. Equally short-lived was *Hawk* (1966), a police drama shot on location in New York City, which featured a full-blooded Native American detective (played by Burt Reynolds) and his black partner (played by Wayne Grice). An interracial friendship was also featured in the series *Gentle Ben* (1967–1969), which concerned the adventures of a white boy and his pet bear; Angelo Rutherford played Willie, the boy's close friend. While interracial friendships were cautiously permitted, the slightest indication of romance was instantly suppressed: The musical variety show *Petula* (1968) was canceled because it showed Harry Belafonte and Petula Clark touching hands.

Despite these limitations, the programs of the 1960s, '70s, and '80s represented a drastic departure from the racial landscape of early television. In the late 1940s, African Americans were typically confined to occasional guest roles; by the end of the 1980s, most top-rated shows featured at least one black person. It had become possible for television shows to violate racial taboos without completely losing commercial and viewer sponsorship. However, greater visibility in front of the camera did not necessarily translate into equal opportunity for all in all branches of television: the question remained as to whether discriminatory practices had in fact been curtailed, or had simply survived in more sophisticated ways. It was true that the presence of blacks had

increased in many areas of television, including, for example, the national news: Bryant GUMBEL began coanchoring *Today* (1952–) in 1983; Ed BRADLEY joined *60 Minutes* (1968–) in1981; Carole Simpson became a weekend anchor for *ABC World News Tonight,* where she had started as a correspondent in 1982. Nevertheless, comedy remained the dominant form for expressing black lifestyles. Dramatic shows centering on the African-American experience have had to struggle to obtain high enough ratings to remain on the air—the majority of the successful dramas have been those where blacks share the leading roles with other white protagonists.

During the 1970s and '80s, the number of social dramas, crime shows, or police stories centering on African Americans or featuring an African American in a major role steadily increased. Most of the series were canceled within a year. These included *The Young Lawyers* (1970–1971), *The Young Rebels* (1970–1971), *The Interns* (1970–1971), *The Silent Force* (1970–1971), *Tenafly* (1973–1974), *Get Christie Love!* (1974–1975), *Shaft* (1977), *Paris* (1979–1980), *The Lazarus Syndrome* (1979), *Harris & Co.* (1979), *Palmerstown, USA* (1980–1981), *Double Dare* (1985), *Fortune Dane* (1986), *The Insiders* (1986), *Gideon Oliver* (1989), *A Man Called Hawk* (1989), and *Sonny Spoon* (1988). The most popular dramatic series with African-American leads were *Miami Vice* (1984–1989), *In the Heat of the Night* (1988–), and *The A-Team* (1983–1987). On *Miami Vice* and *In the Heat of the Night,* Philip Michael Thomas and Howard Rollins, the black leads, were partnered with better-known white actors who became the most identifiable character for each series. Perhaps the most popular actor on a dramatic series was the somewhat cartoonish Mr. T, who played Sgt. Bosco "B.A." Baracus on *The A-Team,* an action-adventure series in which soldiers of fortune set out to eradicate crime. Although, in the comedy *Barney Miller* (1975–1980), Ron Glass played an ambitious middle-class black detective, the guest spots or supporting roles in police series generally portrayed African Americans as sleazy informants, such as Rooster (Michael D. Roberts) on *Baretta* (1975–1978), or Huggy Bear (Antonio Fargas) on *Starsky and Hutch* (1975–1979).

In prime-time serials, African Americans appeared to have been unproblematically assimilated into a middle-class lifestyle. *Dynasty* (1981–1989) featured Diahann CARROLL as one of the series' innumerable variations on the "rich bitch" persona; while *Knots Landing* (1979–1993), *L.A. Law* (1986–1994), *China Beach* (1988–1990), and *The Trials of Rosie O'Neal* (1991–1992) developed story lines with leading black roles as well as interracial romance themes.

MTM Enterprises produced some of the most successful treatments of African Americans in the 1980s. In their programs, which often combined drama and

satire, characters of different ethnic backgrounds were accorded full magnitude. *Fame* (1982–1983) was an important drama about teenagers of different ethnicities coping with the complexities of contemporary life. *Frank's Place* (1987–1988), an offbeat and imaginative show about a professor who inherits a restaurant in a black neighborhood in New Orleans, provided viewers with a realistic treatment of black family affairs. Though acclaimed by critics, *Frank's Place* did not manage to gain a large audience, and the show was canceled after having been assigned four different time slots in one year.

African Americans have been featured in relatively minor roles on science fiction series. *Star Trek*'s communications officer Lt. Uhura (played by Nichelle Nichols) was little more than a glorified telephone operator. *Star Trek: The Next Generation* (1987–1994) featured LeVar Burton as Lt. Geordi La Forge, a blind engineer who can see through a visor. A heavily made-up Michael Dorn was cast as Lt. Worf, a horny-headed Klingon officer, and Whoopi GOLDBERG appeared frequently as the supremely empathetic, long-lived bartender Guinan. In *Deep Space 9* (1993–), the third *Star Trek* series, a major role was given to Avery Brooks as Commander Sisko, head of the space station on which much of the show's action takes place.

Until recently, blacks played an extremely marginal role in daytime soap operas. In 1966, *Another World* became the first daytime soap opera to introduce a story line about a black character, a nurse named Peggy Harris Nolan (played by Micki Grant). In 1968, the character of Carla Hall was introduced as the daughter of housekeeper Sadie Gray (played by Lillian Hayman). Embarrassed by her social and ethnic origins, Carla was passing for a white in order to be engaged to a successful white doctor. Some network affiliates canceled the show after Carla appeared. Since then, many more African Americans have appeared in soap operas, including Al Freeman, Jr., Darnell Williams, Phylicia Rashad, Jackée, Blair Underwood, Nell Carter, Billy Dee WILLIAMS, Cicely Tyson, and Ruby Dee. However, in most cases, character development has been minor, with blacks subsisting on the margins of activity, not at the centers of power. An exception was the interracial marriage between a black woman pediatrician and a white male psychiatrist on *General Hospital* in 1987. *Generations,* the only soap opera which focused exclusively on African-American family affairs, was canceled in 1990 after a year-long run.

The dramatic miniseries, *Roots* (1977) and *Roots: The Next Generation* (1979)—more commonly known as "Roots II"—were unusually successful. For the first time in the history of television, close to 130 million Americans dedicated almost twenty-four hours to following a 300-year saga chronicling the tribulations of African Americans in their sojourn from Africa to slavery and, finally, to emancipation. Yet *Roots* and "Roots II" were constrained by the requirements of linear narrative, and characters were seldom placed in situations where they could explore the full range of their historical involvement in the struggle against slavery. The miniseries *Beulah Land* (1980), a reconstruction of the southern experience during the Civil War, attempted to recapture the success of *Roots,* but ended up doing no more than reviving some of the worst aspects of *Gone with the Wind*. Other important but less commercially successful dramatic historical reconstructions include *The Autobiography of Miss Jane Pittman* (1973), *King* (1978), *One in a Million: The Ron LeFlore Story* (1978), *A Woman Called Moses* (1978), *Backstairs at the White House* (1979), *Freedom Road* (1979), *Sadat* (1983), and *Mandela* (1987).

Roots, the 1977 miniseries dramatization of Alex Haley's epic of black history from Africa to Emancipation, was one of the greatest successes in the history of television. In this image from the series, Kunta Kinte, played by LeVar Burton, is chained in the hold of a slave ship during passage to America. (Photographs and Prints Division, Schomburg Center for Research in Black Culture, The New York Public Library, Astor, Lenox and Tilden Foundations)

A number of miniseries and made-for-television movies about black family affairs and romance were broadcast in the 1980s. *Crisis at Central High* (1981) was based on the desegregation dispute in Little Rock, Ark.; while *Benny's Place* (1982), *Sister, Sister* (1982), *The Defiant Ones* (1985), and *The Women of Brewster Place* (1989) were set in various African-American communities.

The 1970s witnessed the emergence of several television sitcoms featuring black family affairs. In these shows, grave issues such as poverty and upward mobility were embedded in racially centered jokes. A source of inspiration for these sitcoms may have been *The Flip Wilson Show* (1970–1974), the first successful variety show hosted by an African American. The show, which featured celebrity guests like Lucille Ball, Johnny Cash, Muhammad ALI, Sammy DAVIS, Jr., Bill Cosby, Richard PRYOR, and B.B. KING, was perhaps best known for the skits Wilson performed. The skits were about black characters (Geraldine Jones, Reverend Leroy, Sonny the janitor, Freddy Johnson the playboy, and Charley the chef) who flaunted their outlandishness to such a degree that most viewers were unable to determine whether they were meant to be cruel reminders of minstrelsy or parodies of stereotypes.

A number of family comedies, mostly produced by Tandem Productions (Norman Lear and Bud Yoking), became popular around the same time as *The Flip Wilson Show: All in the Family* (1971–1983), *Sanford and Son* (1972–1977), *Maude* (1972–1978), *That's My Mama* (1974–1975), *The Jeffersons* (1975–1985), *Good Times* (1974–1979), and *What's Happening* (1976–1979). On *Sanford and Son*, Redd FOXX and Demond Wilson played father-and-son Los Angeles junk dealers. *Good Times*, set in a housing development on the South Side of Chicago, portrayed a working-class black family. Jimmie Walker, who played J.J., became an overnight celebrity with his "jive-talking" and use of catchphrases like "Dy-No-Mite." On *The Jeffersons*, Sherman Hemsley played George Jefferson, an obnoxious and upwardly mobile owner of a dry-cleaning business. As with *Amos 'n' Andy*, these comedies relied principally on stereotypes—the bigot, the screaming woman, the grinning idiot, and so on—for their humor. However, unlike their predecessor of the 1950s, the comedies of the 1970s integrated social commentary into the joke situations. Many of the situations reflected contemporary discussions in a country divided by, among other things, the VIETNAM WAR. And because of the serialized form of the episodes, most characters were able to grow and learn from experience.

By the late 1970s and early '80s, the focus of sitcoms had shifted from family affairs to nontraditional familial arrangements. *The Cop and the Kid* (1975–1976), *Diff'rent Strokes* (1978–1986), *The Facts of Life*

(1979–1988), and *Webster* (1983–1987) were about white families and their adopted black children. Several comic formulas were also reworked, as a sassy maid (played by Nell Carter) raised several white children in *Gimme a Break!* (1981–1987), and a wise-cracking and strong-willed butler (played by Robert Guillaume) dominated the parody "Soap" (1977–1981). Guillaume played an equally daring budget-director for a state governor in *Benson* (1979–1986). Several less successful comedies were also developed during this time, including *The Sanford Arms* (1976), *The New Odd Couple* (1982–1983), *One in a Million* (1980), and *The Red Foxx Show* (1986).

The most significant comedies of the 1980s were those in which black culture was explored on its own terms. The extraordinarily successful *Cosby Show*, the first African-American series to top the annual Nielsen ratings, featured Bill Cosby as Cliff Huxtable, a comfortable middle-class paterfamilias to his Brooklyn family, which included his successful lawyer wife Clair Huxtable (played by Phylicia Rashad) and their six children. The long-running show *227* (1985–1990) starred Marla Gibbs, who had previously played a sassy maid on *The Jeffersons*, in a family comedy set in a black section of Washington, D.C. *A Different World* (1987–1993), a spin-off of *The Cosby Show*, was set in a black college in the South. *Amen* (1986–1991), featuring Sherman Hemsley as Deacon Ernest Frye, was centered on a black church in Philadelphia. In all of these series, the black-white confrontations that had been the staple of African-American television comedy were replaced by situations in which the humor was provided by the diversity and difference within the African-American community.

Some of the most recent black comedies—*Charlie & Company* (1986), *Family Matters* (1989–), *Fresh Prince of Bel Air* (1990–), and *True Colors* (1990–)—have followed the style set by *The Cosby Show*. Others like *In Living Color* (1990–) have taken the route of reworking a combination of variety show and skits in a manner reminiscent of *The Flip Wilson Show*. Much of the originality and freshness of these comedies is due to the fact that some of them have been produced by African Americans (*The Cosby Show, A Different World, Fresh Prince of Bel Air*, and *In Living Color*). *Carter Country* (1977–1979), a sitcom which pitted a redneck police chief against his black deputy (played by Kene Holliday), inspired several programs with similar plot lines: *Just Our Luck* (1983) *He's the Mayor* (1986), *The Powers of Matthew Star* (1982–1983), *Stir Crazy* (1985), *Tenspeed and Brown Shoe* (1980), and *Enos* (1980–1981).

Alternatives

Local stations, public television outlets, syndication, and cable networks have provided important alter-

Demond Wilson (left) and Redd Foxx, the stars of the popular television series *Sanford and Son* (1972–1977). Foxx, a stand-up comedian noted for his risqué material, cleaned up his act for his depiction of an irascible and sharp-tongued Los Angeles junk dealer. (Photographs and Prints Division, Schomburg Center for Research in Black Culture, The New York Public Library, Astor, Lenox and Tilden Foundations)

natives for the production of authentic African-American programming. In the late 1960s, local television stations began opening their doors to the production of all-black shows and the training of African-American actors, commentators, and crews. Examples of these efforts include *Black Journal*—later known as *Tony Brown's Journal*—(1968–), a national public affairs program; *Soul* (1970–1975), a variety show produced by Ellis Haizlip at WNET in New York; *Inside Bedford-Stuyvesant* (1968–1973), a public affairs program serving the black communities in New York City; and *Like It Is,* a public affairs show featuring Gil Noble as the outspoken host.

At the national level, public television has also addressed African-American everyday life and culture in such series and special programs as *History of the Negro People* (1965), *Black Omnibus* (1973), *The Righ-*

teous Apples (1979–1981), *With Ossie and Ruby* (1980–1981), *Gotta Make This Journey: Sweet Honey and the Rock* (1984), *The Africans* (1986), *Eyes on the Prize* (1987), and *Eyes on the Prize II* (1990).

Syndication, the system of selling programming to individual stations on a one-to-one basis, has been crucial for the distribution of shows such as *Soul Train* (1971–), *Solid Gold* (1980–1988), *The Arsenio Hall Show* (1989–1994), *The Oprah Winfrey Show* (1986–), and *The Montel Williams Show* (1992–). A wider range of programming has also been made possible by the growth and proliferation of cable services. Robert Johnson took a personal loan for $15,000 in the early 1980s to start a cable business—Black Entertainment Television (BET)—catering to the African Americans living in the Washington, D.C., area. At that time BET consisted of a few hours a day of music

Oprah Winfrey at the 1994 Daytime Emmy Awards, holding her third consecutive award for outstanding talk-show host. (AP/Wide World Photos)

videos. By the early 1990s, the network had expanded across the country, servicing about 25 million subscribers, and had a net worth of more than $150 million. (Its programming had expanded to include black collegiate sports, music videos, public affairs programs, and reruns of, among others, *The Cosby Show* and *Frank's Place*.)

Children's Programming

As late as 1969, children's programming did not include African Americans. The first exceptions were *Sesame Street* (1969–) and *Fat Albert and the Cosby Kids* (1972–1989). These two shows were groundbreaking in content and format; they emphasized altruistic themes, the solution of everyday problems, and the development of reading skills and basic arithmetic. Other children's shows which have focused on or incorporated African Americans include *The Jackson Five* (1971), *ABC After-School Specials* (1972–), *The Harlem Globetrotters Popcorn Machine* (1974–1976), *Rebop* (1976–1979), *30 Minutes* (1978–1982); *Reading Rainbow* (1983–), *Pee-Wee's Playhouse*

(1986–1991); *Saved by the Bell* (1989–), *Kid's Play* (1990–), and *Carmen San Diego* (1991–).

Although African Americans have had to struggle against both racial tension and the inherent limitations of television, they have become prominent in all aspects of the television industry. As we progress toward the twenty-first century, the format and impact of television programming will undergo some radical changes, and the potential to provoke and inform audiences will grow. Television programs are thus likely to become more controversial than ever, but they will also become an even richer medium for effecting social change. Perhaps African Americans will be able to use these technical changes to allay the racial discord and prejudice that persists off-camera in America.

REFERENCES

ALLEN, ROBERT C., ed. *Channels of Discourse: Television and Contemporary Criticism*. Chapel Hill, N.C., 1987.

DATES, JANNETTE L., and WILLIAM BARLOW, eds. *Split Image: African Americans in the Mass Media*. Washington, D.C., 1990.

MACDONALD, J. FRED. *Blacks and White TV: Afro-Americans in Television since 1948*. Chicago, 1983.

MCNEIL, ALEX. *Total Television: A Comprehensive Guide to Programming from 1948 to the Present*. 3rd ed. New York, 1991.

NEALE, STEVE, and FRANK KRUTNIK. *Popular Film and Television Comedy*. London, 1990.

RIGGS, MARLON. *Color Adjustment*. San Francisco, 1991.

WHITE, MIMI. "What's the Difference? 'Frank's Place' in Television." *Wide Angle* 13 (1990): 82–93.

CHARLES HOBSON

Temple, Lewis (1800–May 18, 1854), inventor. Lewis Temple was born at some time in 1800 in Richmond, Va. Information on his early life is scarce, and it is unclear if he was born free or into slavery. He left Virginia for the whaling port of New Bedford, Mass., and in 1829 married Mary Clark, a native of Maryland. Together the couple had three children. Although Temple was unable to write his name, in 1836 he was operating a whalecraft shop on Coffin's Wharf, and by 1845 he had achieved a measure of prosperity and was able to open his own blacksmith shop on Walnut Street Wharf. Three years later he invented a whaling harpoon known as "Temple's Toggle" or the "Temple Iron." This first toggle harpoon was shaped with a barbed head that stood at right angles to the shaft, thereby enabling it to hold securely to the whale's body. The Temple Toggle

used a wooden pin that lay parallel to the shank. When the harpoon entered the whale, the wooden pin would break, causing the barbed head to turn and become securely embedded in the whale's body.

Temple's harpoon revolutionized the whaling industry and is said to have doubled the whaling catch of nineteenth-century New England. Temple never patented his invention, however, leading others to copy and mass-produce the harpoon. Nevertheless, Temple continued to prosper, and in 1854 he began construction of a larger blacksmith practice at Steamboat Wharf. The shop was never finished, however, because Temple died in the spring of 1854, after having tripped on a plank, incurring serious injury, the previous autumn. His wife was awarded $2,000 in damages for the accident, but never received it. She was eventually forced to sell both Temple's old shop and what remained of the newly built shop to pay his debts.

REFERENCES

JAMES, PORTIA P. *The Real McCoy: African-American Invention and Innovation, 1619–1930.* Washington, D.C., 1989.

KAPLAN, SIDNEY. "Lewis Temple and the Hunting of the Whale." *Negro History Bulletin* 17 (October 1953): 7–10.

LOGAN, RAYFORD W., and MICHAEL R. WINSTON, eds. *Dictionary of American Negro Biography.* New York, 1982.

SABRINA FUCHS
PAM NADASEN

Temptations, The, vocal group. During their more than three decades of entertaining, the Temptation's rhythm and blues quintet has included Eldridge Bryant (replaced by David Ruffin in 1963; Ruffin was replaced by Dennis Edwards in 1967, Edwards by Louis Price in 1976, Price by Ali-Ollie Woodson in the 1980s), Eddie Kendricks (replaced by Damon Harris in 1971; Harris was replaced by Glenn Leonard in 1975, Leonard by Ron Tyson in the 1980s), Paul Williams (replaced by Richard Street in 1971), Otis Williams, and Melvin Franklin. First called the Elgins, the original quintet of Bryant (lead), Otis Williams (baritone), Franklin (bass), Paul Williams (lead), and Kendricks (tenor/falsetto) was signed by Berry Gordy to MOTOWN in 1960.

The group's success in the 1960s and early 1970s was marked by two distinct styles. First, a polished gospel-inspired pop style resulted in several hit singles: "The Way You Do the Things You Do" (number eleven, 1964), "My Girl" (number one,

1965), "Since I Lost My Baby" (number seventeen, 1965), "Ain't Too Proud to Beg" (number thirteen, 1966), and "I Know I'm Losing You'" (number eight, 1966). These early successes were marked by Kendricks's creamy falsetto and David Ruffin's rugged baritone. After Dennis Edwards replaced Ruffin in 1967, producer Norman Whitfield gave the group a new sound—"psychedelic soul," characterized by loud, brassy arrangements and lyrics containing moralizing social commentary. This style produced another string of hits, including "Cloud Nine" (number six, 1969), "Psychedelic Shack" (number seven, 1970), and "Ball of Confusion" (number three, 1970). After Damon Harris and Richard Street replaced Kendricks and Paul Williams, respectively, the new group created one of its most important hits, "Papa Was a Rolling Stone" (number one, 1972), a powerful piece that depicted the chilling despair of black family life. In 1989 the group was inducted into the Rock and Roll Hall of Fame.

REFERENCE

GEORGE, NELSON. *Where Did Our Love Go? The Rise and Fall of the Motown Sound.* New York, 1985.

KYRA D. GAUNT

Tennessee. Black Tennesseans, the first of whom came with the settlers in the colonial period, share a common past with other blacks in the South, a past broadly characterized by slavery, servitude, segregation, and racial violence. In spite of this, blacks in Tennessee managed to establish for themselves a significant record in education and in the civil rights movement.

African-American history in Tennessee has been shaped by the state's geographical divisions. Rough, mountainous East Tennessee was not an area with a large slave population, and has not traditionally had many African-American residents. The middle region contains the city of Nashville, and the fertile plain where tobacco and cotton farming was practiced. West Tennessee was slow to be settled, but became densely populated due both to agriculture and to traffic on the Mississippi River. East of the great port of Memphis lies Fayette County and neighboring districts, an African-American majority population area.

The territory of Tennessee was organized in 1790. Most settlers lived in East Tennessee, and were yeoman farmers, owning one slave or two at most, or relying on free labor. In areas near the bottom and creek beds of rivers, there were sizable numbers of slaves. Tennessee joined the Union in 1796. By 1800

over ten thousand slaves had entered the state, and more would come as settlement spread to the flatter, more fertile areas farther west.

The Manumission Society of Tennessee was founded in 1814, and by the 1820s there was a strong antislavery faction in the state, led by Quakers in the East and Presbyterians in the West. In 1826 they succeeded in banning the interstate slave trade from Tennessee. However, the invention of the cotton gin and the opening of flatter and better lands made slavery too profitable to touch. When abolitionists forced the slavery issue at the 1834 state Constitutional Convention, the delegates, two-thirds of whom came from the middle or west of the state, instead codified slavery in the Tennessee Constitution. The state's almost five thousand free blacks were disfranchised and barred from militia service, and a harsh slave code was put into effect.

The percentage of slaves in the population of East Tennessee remained constant throughout the antebellum period at under ten percent of the total. However, in the Nashville Basin of Middle Tennessee, whose lands resembled the neighboring bluegrass region of Kentucky, the enslaved population burgeoned. In West Tennessee, where there had been practically no slaves in 1820, there were fifty-six thousand by 1840. Most of the state's free black population was also in cities such as Memphis, where there were enormous slave markets. The slave trade prohibition, which had been laxly enforced, was repealed in 1855.

After Tennessee seceded from the Union in 1861, parts of the state were conquered and quickly occupied by the Union Army. After the preliminary Emancipation Proclamation was issued in 1862, and blacks were accepted into the Union Army, Tennessee blacks volunteered in large numbers—nearly four thousand enlisted. In 1864 black Tennesseans fought bravely at the Battle of Nashville, suffering 20 percent of the casualties. That same year, in one of the most horrific incidents in the state's history, southern troops led by Gen. Nathan Bedford Forrest, a former Memphis slave trader, overran Fort Pillow in West Tennessee. They fell upon the black garrison and massacred three hundred black troops, many of whom attempted to surrender, and their family members.

In 1865, after accepting the THIRTEENTH AMENDMENT, Tennessee was restored to the Union under a Radical Republican governor, William B. Brownlow. Black Tennesseans sought land and freedom and relied on the freedmen's bureaus to aid in their quest. Blacks, such as the light-skinned orator Ed Shaw, gained positions in the government and ran for elected office, and James Burrus was a Tennessee delegate to the 1876 Republican Convention. Both the freedmen's bureaus and Republican power in Tennessee proved ephemeral. The KU KLUX KLAN first organized in the state in order to terrorize blacks and white Republicans and keep them from voting. Conservative southern unionists allied with Democrats to "redeem" the white government in 1869. The next year a constitutional convention instituted a poll tax, labor contract and vagrancy laws, and other devices to limit black independence. Blacks throughout the state were forced into sharecropping, many of them bound by one-sided or fraudulent contracts. By 1883 less than 10 percent of Tennessee's blacks owned their own land. Starting in the early 1880s, JIM CROW laws further restricted black activity. Nevertheless, Samuel A. McElwee, a Fisk University student, was elected to a term in the state legislature in 1883. In 1889 suffrage restrictions and a new poll tax were enacted, and black voter registration became difficult. Eventually many blacks left the state. A wave of lynchings in 1892 prompted Memphis editor Ida B. WELLS (see Ida B. WELLS-BARNETT) to begin her activist career. Many other black Tennesseans, such as Nashville's James Caroll Napier and Richard H. BOYD, spoke out against injustice.

At the same time, black Tennesseans did succeed in building up lasting educational institutions. Central Tennessee College (later Walden University) was founded in Nashville in 1865; in 1870 Knoxville College was opened, and in 1871 Memphis's LeMoyne Institute (later LeMoyne-Owen College) began. Later schools that were established included Meharry Medical College (1876), Tennessee A & I University (1909; now Tennessee State University) in Nashville; the University of Western Tennessee (1900–1923) and Howe College (1888) in Memphis; Knoxville College (1875) in Knoxville; and Lane College (1882) in Jackson. Undoubtedly the most important African-American institution in Tennessee, however, was FISK UNIVERSITY (1866). Fisk provided a model of black institutional leadership and higher education that remained strong through the Jim Crow era and after.

At the turn of the century, three-quarters of Tennessee's blacks still worked on the land. A few blacks worked in trade and industry, in the iron foundries and rolling mills near Knoxville and Chattanooga, or in sawmills, ports, and mines. Textile factory labor was closed to them. Many African-American women worked in domestic service. A few blacks, mostly in cities, practiced medicine or other professions. Nashville became a major publishing center for church literature. The city's Citizen's Bank was founded as the One-Cent Savings Bank and Trust Company in 1904. It is the oldest continuing black-owned bank in America. Chattanooga's Mutual Trust Company, founded in 1889, was another large black bank.

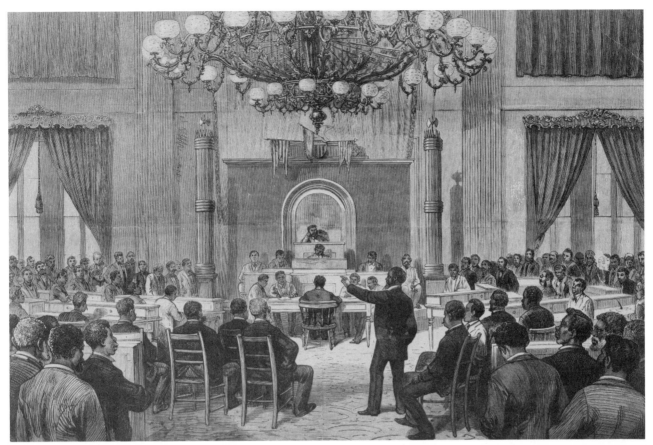

The most significant attempt to re-create the antebellum Negro Convention movement took place from April 5 to 7, 1876, with the gathering in Nashville, Tenn., of the Colored National Convention, depicted here. A second African-American leadership convention, the National Conference of Colored Men, was also held in Nashville in 1879. (Prints and Photographs Division, Library of Congress)

Falling cotton and corn prices meant widespread poverty, poor health and living conditions, and inadequate diet. When employment opportunities generated by World War I drew many blacks from the countryside into the cities, a wave of violence was set off. In Knoxville, a city usually known for white paternalism and racial peace, the Ku Klux Klan reappeared in large numbers in 1918, and there was a bitter race riot during "RED SUMMER" in 1919. In the wake of the disorders, the Tennessee Legislature passed an effective antilynching bill.

After 1920, cotton prices remained chronically low, and the farm economy remained depressed until World War II. Despite the growing violence, the state's black urban population increased and its rural population decreased during the first half of the twentieth century. Many rural blacks chose to leave the region entirely, Chicago being their preferred destination. However, Tennessee's cities, notably Knoxville and Chattanooga, became magnets for out-migrant blacks from the eastern southern states. Their black populations—7,638 and 17,942, respectively, in 1910—more than doubled over the following thirty

years. Memphis remained both a destination and a way station for deep South blacks migrating north.

The depression brought further masses of blacks into urban industrial areas. Black and white sharecroppers joined to form the Southern Tenant Farmers' Union to keep control over the land they farmed. New Deal programs, such as the Agricultural Adjustment Administration (AAA), were led by whites who preferred to work within the state's racial status quo and did little to alleviate black rural poverty. The Tennessee Valley Authority (TVA), whose operations were designed to bring electrical power and employment to rural Tennessee, was centered in East Tennessee, where only a handful of blacks lived. Few blacks were employed until African-American political pressure, combined with the coming of World War II, forced massive hiring on a segregated basis.

By 1940 the state's black population was 55 percent urban. Blacks in cities faced as many difficulties as their rural counterparts. During the 1930s, Fisk University sociologist Charles S. JOHNSON prepared a study for the TVA detailing the shocking condition

of urban blacks in the state. Wages remained low, and the integration of the labor movement was a slow, painful process.

Interracial tensions generated during World War II flared up after the war's end. In 1946, amid postwar racial tension, an interracial dispute led to white rioting in Columbia. A mob invaded the black community, whose members fired on the mob in self-defense. The following day, four blacks were killed, dozens were beaten, and houses in the black community were severely damaged by police and National Guardsmen. Blacks, many of them veterans, were arrested without charge. Twenty-five blacks were tried on attempted murder charges, but an all-white jury acquitted all but two.

After World War II, those remaining in rural areas suffered badly. Newly mechanized cotton fields made black sharecroppers' labor dispensable. Many attempted to educate themselves and tried to find new careers. The Highlander Folk School, an interracial school in Monteagle, established Citizenship Schools, starting in 1953, to train an interracial group in methods of achieving educational equality. Efforts soon expanded, after the BROWN V. BOARD OF EDUCATION OF TOPEKA, KANSAS school desegregation case. In 1955 Oak Ridge's schools desegregated peacefully, but in 1956 the Tennessee National Guard was called to Clinton to quell riots after twelve black students integrated the local school. Two years later, the

school was destroyed by a bomb. In 1957 Tennessee's state college system desegregated.

By 1960, 59 percent of the state's blacks had become registered voters. In some places, such as Haywood County, many blacks voted for the first time since RECONSTRUCTION. The path to voting was seldom easy. In 1959 blacks in Fayette County, led by Viola McFerrin, formed the Fayette County Civic and Welfare League and attempted to register to vote. They were denied, and were victimized by white economic reprisals. Evicted from their homes, 100 blacks set up a tent city. The next year, Justice Department officials, using the 1960 Civil Rights Act, stepped in with injunctions to protect black voters. In 1960, twelve thousand blacks voted, and Fayette County went Republican for the first time in ninety years.

In 1960, the sit-in movement (see SIT-INS) started and quickly came to Tennessee. In February Fisk University students, supported by the local NAACP, organized a wave of sit-ins and nonviolent protests in Nashville. However, another February sit-in, in Chattanooga, led to white rioting. By May African Americans were being served in public accommodations in Nashville and shortly thereafter in Chattanooga.

Throughout the 1960s black Tennesseans concentrated more on changing the system through voting than through protests. However, demonstrations over civil rights denials continued sporadically for

Jubilee Hall at Fisk University on graduation day in 1929. Fisk University was one of the preeminent black colleges and universities from its founding in 1866. (Photographs and Prints Division, Schomburg Center for Research in Black Culture, The New York Public Library, Astor, Lenox and Tilden Foundations)

five years. Tennesseans, such as Memphis's Marion BARRY, became movement leaders. In 1968, while in Memphis to support a strike by garbage workers, the Reverend Dr. Martin Luther KING, Jr., was killed.

For most of the last third of the twentieth century, Tennessee blacks experienced both advances and racial difficulties. Outstanding figures such as civil rights leader Rev. Benjamin HOOKS, author Alex HALEY, country singer Charley PRIDE, and basketball coach Wade Hampton came to prominence. During the 1970s and 1980s, numerous black Tennesseans were elected to municipal and state offices. In 1974 Harold FORD, former minority whip in the Tennessee House of Representatives, became the state's first African American in Congress since Reconstruction. In 1991 Memphis elected its first black mayor, W. W. Herenton. However, the state's African-American population was still victimized by poverty, discrimination, and police harassment. In 1992 Reginald Miller, a black undercover policeman on duty, was savagely beaten by a group of white uniformed officers.

In the early 1990s the troubles of Harold Ford, by then an influential member of the House of Representatives, symbolized the racial situation. In 1990 federal authorities brought Ford to trial in Memphis on bank fraud charges. Many black Tennesseans felt the prosecution of Ford, the state's lone black congressman, was racially motivated. The jury at his trial split along racial lines, and a mistrial was declared. Ford's second trial, which began in 1992, was conducted in an atmosphere of great racial tension. Ford accused both prosecutors and the judge of racial bias, and Memphis blacks threatened to riot if Ford was convicted. In 1993 Ford's jury acquitted him on all charges. Despite the apparent political gains, Ford's trial displayed the continuing racial disharmony and potential difficulties facing African Americans in Tennessee.

REFERENCES

CARTWRIGHT, JOSEPH H. *The Triumph of Jim Crow: Tennessee Race Relations in the 1880s.* Knoxville, Tenn., 1976.

GRAHAM, HUGH DAVIS. *Crisis in Print: Desegregation and the Press in Tennessee.* Nashville, Tenn., 1967.

GRANT, NANCY. *The TVA and Black Americans: Planning for the Status Quo.* Philadelphia, 1990.

LAMON, LESTER C. *Blacks in Tennessee, 1791–1970.* Knoxville, Tenn., 1981.

———. *Black Tennesseans, 1900–1930.* Knoxville, Tenn., 1977.

PROUDFOOT, MERRILL. *Diary of a Sit-In.* 2nd ed. Urbana, Ill., 1990.

SCOTT, MINGO. *The Negro in Tennessee Politics and Governmental Affairs, 1865–1965.* Nashville, Tenn., 1965.

TAYLOR, ALUTHEUS AMBUS. *The Negro in Tennessee, 1865–1880.* Spartanburg, S.C., 1941.

MICHAEL J. McDONALD

Tennis. Tennis in the African-American community paralleled the rise of the historic black college and university. A Bermuda socialite, Mary Outerbridge, brought tennis to America in 1874 and national tournaments restricted to whites began in 1881. But enterprising black players organized local tournaments as early as 1895 at Tuskegee Institute. The first courts were laid out by hand, and the balls, rackets, nets, net posts, and so on, were ordered from catalogues. Tennis quickly became the favored competitive sport of blacks from the so-called "sacred six" status occupations of teacher, preacher, mortician, doctor, dentist, and lawyer.

In the early twentieth century, varsity teams were formed at Howard University, Lincoln University, Tuskegee Institute, Atlanta University, and Hampton Institute. Howard's coach, Charles Chaveau Cook, had attended Cornell and he was earnestly supported by a Washington, D.C.–based group led by John F. N. Wilkinson, Henry Freeman, Dora Cole Norman, and Lucy Diggs SLOWE. Edwin B. Henderson, who trained at Harvard and was appointed as director of Physical Culture for the Colored Public Schools, introduced tennis as part of the recreation programs. On the eve of World War I, tennis was firmly rooted in black communities in the Northeast, in the South, in parts of Texas, and in northern California.

In 1916, a group of black tennis enthusiasts formed the AMERICAN TENNIS ASSOCIATION (ATA). The ATA is the oldest continuously operated independent black sports organization in America. (Only the Central Intercollegiate Athletic Association predates the ATA, by four years.) The Association Tennis Club of Washington, D.C., asked fellow players from Baltimore to form a national body. Henry Freeman, John F. N. Wilkinson, Talley Holmes, H. Stanton McCard, William H. Wright, B. M. Rhetta, Ralph Cook (Charles's brother), and Gerald Norman attended. McCard was elected president, and Norman was the first executive director. The first ATA National Championships were held in 1917 at Druid Hill Park in Baltimore, and twenty-three clubs sent thirty-nine players for the inaugural men's singles event. The first ATA women's champion, Lucy D. Slowe, became the first black female national titleholder in any sport.

The ATA has formed the backbone of black tennis participation in the United States, the Caribbean, and

Arthur Ashe at the U.S. Open, the West Side Tennis Club, September 8, 1968. (© Claud Meyer/Black Star)

Bermuda. It sponsored traveling tours by good players, and sought assistance for top black college players such as Richard Hudlin, at the University of Chicago, who was captain of the university's tennis team in 1927; Douglas Turner, at the University of Illinois; Henry Graham, at the University of Michigan; and Reginald WEIR, at the City College of New York.

The ATA began serious junior development programs in the late 1930s. Hundreds of tennis courts were built by the federal government during the depression to help provide work, and the ATA wanted to take advantage of these public facilities as well as ensure a steady flow of players for its events. Robert W. Johnson, Elwood Downing, Hubert Eaton, Charles Williams, of Hampton's faculty, and Cleveland Abbott, of Tuskegee, joined the ATA to provide tournaments, coaching, and encouragement for black juniors and college players.

A major breakthrough occurred in 1940, when Don Budge, then the world's best player, played an exhibition match against ATA champion Jimmy McDaniel at the Cosmopolitan Tennis Club in Harlem. Budge won 6-1, 6-2, and then partnered Reginald Weir against McDaniel and Richard Cohen. Attempts were made to arrange a similar match between the ATA women's champion and the United States Tennis Association (USTA) national champion, but it never materialized.

Following a critical letter by Alice Marble (the number-one ranked female player in America) to the USTA admonishing them for their stalling tactics, Althea GIBSON in September 1950 became the first black player to participate at the West Side Tennis Club in Forest Hills, N.Y., the site of the USTA National Championships. In addition to winning the ATA junior and senior singles and doubles titles, Gibson also captured the French singles and doubles (1956), the Wimbledon singles crown (twice, in 1957 and 1958), and the United States singles title (twice, in 1957 and 1958), as well as the Australian mixed doubles event (1957). She was a member of the American Wightman Cup squad in 1957 and 1958. After Gibson's initial appearance at Forest Hills in 1950, the USTA and the ATA announced that they had arrived at an arrangement whereby for twenty years to come the ATA would nominate black players who would be automatically entered in the main draw.

Althea Gibson's coach, Robert W. Johnson, led the ATA junior development effort as his son, Robert Johnson, Jr., provided much of the on-court expertise. One of the products of the program was Arthur ASHE, Jr., who in the years 1955 to 1962 won 11 ATA titles. Ashe went on to capture singles crowns in the U.S. Open in 1968, in the Australian Open in 1970, and at Wimbledon in 1975. He was coranked number one in the world in 1968 and again in 1975, and was a member of the American Davis Cup team in the years 1963, 1965–1970, 1975, 1977, and 1978. He served as team captain from 1981 to 1985.

The era of "open" tennis (with amateurs and professionals playing together) began in 1968, and black players, schools, and coaches responded. Hampton Institute won two NCAA Division II team titles. Hampton's coach, Robert Screen, and Herbert Provost, of Texas Southern University, earned national reputations. Among officials Henry Talbert became head of USTA's amateur competitions, Rodney Harmon was a player liaison with the USTA's Player Development program, and Claranella Morris became a certified match umpire.

Non-American black players have excelled. Richard Russell and Lance Lumsden played for Jamaica, and William N'Godrella of New Caledonia played for France, as did Yannick Noah, who was French-born but reared in Cameroon. Part-aboriginal Evonne Goolagong of Australia won several major titles. Yaya Doumbia of Senegal, Nduka Odizor and

Zina Garrison in action in Newport, R.I., in 1989. The next year Garrison became the first black woman since Althea Gibson to play in a Wimbledon women's final. (AP/Wide World Photos)

Tony Mmoh of Nigeria, and Peter Lamb of South Africa scored impressive wins.

In the United States, Rodney Harmon, Leslie Allen, Kim Sands, Arthur Carrington, Chip Hooper, Marcel Freeman, and Lloyd Bourne were professional tour regulars. In the early 1990s, four African-American players—Zina GARRISON, Lori McNeil, Bryan Shelton, and MalVai Washington—were particularly successful tour players.

REFERENCES

ASHE, ARTHUR R., JR. *A Hard Road to Glory*. 3 vols. New York, 1988.
———. *Off the Court*. New York, 1981.
EVANS, RICHARD. *Open Tennis: The First 20 Years*. London, 1988.
TRENGONE, ALAN. *The Story of the Davis Cup*. London, 1985.

ARTHUR R. ASHE, JR.

Terrell, Mary Eliza Church (September 26, 1863–July 24, 1954), civil rights activist and women's rights advocate. She was born in Memphis, into a prosperous family of former slaves; she graduated from Oberlin College (1884) at the head of her class, then taught at Wilberforce University (1885–1887) and briefly in a high school in Washington, D.C. After receiving an M.A. from Oberlin (1888), she traveled in Europe for two years, studying French, German, and Italian. In 1891 she married Robert Terrell, who was appointed judge of District of Columbia Municipal Court in 1901.

The overlapping concerns that characterized Terrell's life—public-education reform, women's rights, and civil rights—found expression in community work and organizational activities. She served as the first woman president of Bethel Literary and Historical Association (1892–1893). She was the first black woman appointed to the District of Columbia Board of Education (1895–1901, 1906–1911).

In spite of elements of racism and nativism, Terrell was an active member of the National American Woman Suffrage Association and addressed their convention in 1898 and 1900. She joined the Woman's Party picket line at the White House, and, after the achievement of suffrage, was active in the Republican party.

Women's international affairs involved her as well. She addressed the International Council of Women (Berlin, 1904) in English, German, and French, the only American to do so; was a delegate to the Women's International League for Peace and Freedom (Zurich, 1919); was a vice president of the International Council of Women of the Darker Races; and addressed the International Assembly of the World Fellowship of Faiths (London, 1937).

Terrell participated in the founding of the NATIONAL ASSOCIATION FOR THE ADVANCEMENT OF COLORED PEOPLE (NAACP) and was vice president of the Washington, D.C., branch for many years. Her various causes coalesced around her concern with the quality of black women's lives. In 1892, she helped organize and headed the NATIONAL LEAGUE FOR THE PROTECTION OF COLORED WOMEN in Washington, D.C.; she was the first president of the NATIONAL ASSOCIATION OF COLORED WOMEN, serving three terms (1896–1901) before being named honorary president for life and a vice president of the NATIONAL COUNCIL OF NEGRO WOMEN.

Terrell worked for the unionization of black women and for their inclusion in established women's affairs. In 1919 she campaigned, unsuccessfully, for a Colored Women's Division within the Women's Bureau of the Department of Labor, and to have the First International Congress of Working Women directly address the concerns of black working women.

Age did not diminish Terrell's activism. Denied admission to the Washington chapter of the American Association of University Women (AAUW) in 1946 on racial grounds, she entered a three-year legal

A founder and first president of the National Association of Colored Women (NACW) in 1896, Mary Church Terrell was an effective advocate for both black and women's causes. She devoted the last years of her long life to the desegregation of public facilities in Washington, D.C., a goal realized the year before her death in 1954. (Prints and Photographs Division, Library of Congress)

battle that led the national group to clarify its bylaws to read that a college degree was the only requirement for membership. In 1949, Terrell joined the sit-ins, which challenged segregation in public accommodations, a landmark civil rights case, as well as serving as chairwoman of the Coordinating Committee for the Enforcement of the District of Columbia Anti-Discrimination Laws.

In addition to her picketing and sit-ins, Terrell wrote many magazine articles treating disfranchisement, discrimination, and racism, as well as her autobiography, *A Colored Woman in a White World* (1940).

REFERENCE

STERLING, DOROTHY. "Mary Eliza Church Terrell." In Barbara Sicherman et al., eds. *Notable American Women: The Modern Period.* Cambridge, Mass., 1980, pp. 678–680.

QUANDRA PRETTYMAN

Terry, Clark (December 14, 1920–), trumpeter. Born in St. Louis, Clark Terry studied brass instruments as a child, playing in a drum-and-bugle corps before taking up the valve trombone in high school. His brother-in-law played tuba with Dewey Jackson's Musical Ambassadors and introduced Terry to professional music as a trumpeter. Terry's first jobs were with traveling bands such as Dollar Bill and His Small Change and Fate Marable's riverboat band, with Willie Austin in the Reuben and Cherry Carnival Show, and with Ida COX and her Dark Town Scandal Show. Terry served in the Navy from 1942 to 1945 and played trumpet in the service's all-star band in Chicago. After World War II ended, he resumed playing professionally, and joined Lionel HAMPTON's band in 1945. He played with George Hudson in 1945–1946, and also with Charlie Barnett, Eddie "Cleanhead" Vinson, and Charlie Ventura. He also played for Count BASIE in 1948, and again in 1950.

Terry's breakthrough came in 1950, when Duke ELLINGTON hired him away from Basie, making him one of the few musicians to have worked for both Ellington and Basie. Terry, who served for a decade with Ellington, lent an irreverent wit and humor to the trumpet section. He also made recordings with his own groups, including *Serenade to a Bus Seat* (1957), *Duke with a Difference* (1957), and *In Orbit* (1958) with Thelonious MONK. Terry left Ellington in 1960 to become the first black musician on staff at NBC, where he eventually became the lead trumpeter on the *Tonight Show.* While his television persona featured his mumbling style of scat singing, Terry also continued to perform on trumpet on numerous television commercials, jingles, and sound tracks, as well as on tour with mainstream jazz musicians such as Quincy JONES (1960), trombonist J. J. JOHNSON (1964), and Oscar PETERSON and Ella FITZGERALD (1965). During the 1960s he also led an ensemble with valve trombonist Bob Brookmeyer (*Tonight,* 1964; *The Power of Positive Swinging,* 1964; *Mumbles,* 1965; and *Gingerbread Man,* 1966). Terry left the *Tonight Show* in 1972, when Johnny Carson moved the show from New York to Los Angeles. In the 1970s and 1980s Terry became active in music education, and published *Let's Talk Trumpet* (1973), *Interpretations of Jazz Language* (1976), and *Circular Breathing* (1977). He made many recordings on Norman Granz's Pablo label, continued performing with Brookmeyer, and recorded with a big band on *Live! at Buddy's Place* (1976). Terry, who has lived in Queens, N.Y., for many years, continues to travel, perform, and record.

REFERENCES

DEMPSEY, J. TRAVIS. *The Autobiography of Black Jazz.* Chicago, 1983.

VOCE, S. "Clark Terry." *Jazz Journal International* 39, no. 12 (1986): 10; 11, no. 1 (1987): 16.

WILLIAM C. BANFIELD

Terry, Sonny (Terrell, Saunders) (October 24, 1911–March 12, 1986), blues musician. Born Saunders Terrell in Greensboro, Ga., this influential harmonica player adopted the name Sonny Terry in the late 1920s. He was raised on a farm and tutored on the harp by his father, Reuben Terrell. Two separate accidents in 1927 left him totally blind. By 1929 he had moved to Shelby, N.C., playing for local dances and at tobacco houses. He supported himself through music for the rest of his life.

Terry wandered throughout central North Carolina during the 1930s and early 1940s, working and recording with "Piedmont"-style blues guitarists Blind Boy Fuller and Brownie MCGHEE. In 1942, Terry joined the Great Migration to New York City, along with McGhee. They recorded prolifically, and worked at house parties, on radio programs, and for nearly four years on the stage, in the casts of *Finian's Rainbow* (1947–1948) and *Cat on a Hot Tin Roof* (1955–1957). By 1958, at the beginning of the folk revival, they worked the first of their overseas tours. Around 1970 this long-standing duo split up due to personality conflicts, though they later occasionally reunited for concerts, and Terry performed solo or as leader of a small band. He died in 1986, following a heart attack.

Terry is best known for his virtuosic "cross-note" playing technique (playing in a key other than the key of the harmonica) and his skill in executing special effects, such as train whistles, animal cries, and vocal moans, by simultaneously using his voice while he played. By controlling his breath and cupping his hands over the harmonica, Terry developed a particular skill in modulating from key to key and pitch blending.

REFERENCES

OLIVER, PAUL. "Sonny Terry." In *The New Grove Dictionary of American Music*. New York, 1986.

TERRY, SONNY, and KENT COOPER. *The Harp Styles of Sonny Terry*. New York, 1957.

KIP LORNELL

Texas. In most respects, the experiences of black Texans have paralleled those of African Americans elsewhere—enslavement and EMANCIPATION, empowerment and disfranchisement, urbanization, migration, and the renewal of political and civil rights. Yet Texas's history of settlement and its position on the American South's western frontier shaped those experiences in distinctive ways—even as Texas's profound diversity ensured that black Texans led widely varied lives.

Persons of African descent preceded Anglo-Americans to Texas by many years. Spanish exploring parties in the sixteenth century included Africans. In the 1530s, for instance, the Moor Estevanico wandered through Texas with Cabeza de Vaca. Intermingling of ethnic groups in Spanish America assured, too, that people of African and mixed descent would be well represented in later settlement efforts and several hundred lived in Texas by the 1790s, composing up to 15 percent of the settler population. Free Africans and mulattoes significantly outnumbered slaves in the Spanish period, but that would change very abruptly with Mexican independence and American immigration in the 1820s.

Many Americans settling on Mexico's northeastern frontier believed they could prosper in labor-scarce Texas only through slave cultivation of staple crops. Mexican authorities passed a series of measures prohibiting the further importation of slaves and providing for the emancipation of slave children, but slaveholders managed to evade these laws (by claiming, for instance, that their bondsmen worked under long-term contracts). By 1836 the slave population numbered about five thousand. The insecurity the restrictions bred, however, contributed to some Texans' determination to be rid of Mexican rule. Independence, secured in 1836 (*see* MEXICAN WAR), guaranteed slavery's survival. The enslaved population grew even more quickly than the free, increasing to some 30,000 by Texas's annexation in 1845.

African-American labor proved essential to the rapid growth of Texas's antebellum economy. Slaves worked as cowhands in ranching areas along the Gulf Coast, and their numbers steadily increased in cities like Houston and Galveston. But a considerable majority of them lived in holdings of ten or more, generally on larger farms and plantations. These were most concentrated in areas more accessible to markets for cotton and sugar—along the lower Brazos, Colorado, and middle Trinity rivers and in northeast Texas along Red River trade routes.

Little evidence exists to sustain earlier generations' claims that Texas slaves generally fared better in terms of food, shelter, clothing, or treatment than those elsewhere. In fact, by the mid-1850s, several thousand had found cause to exercise an option generally unavailable to other American slaves—escape to Mexico. Still, over 182,000 black Texans remained in bondage in 1860, representing, together with less

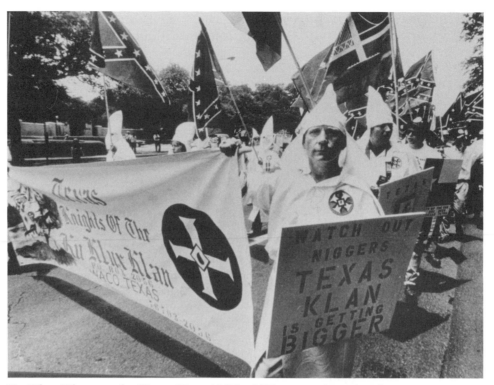

Ku Klux Klan march, Waco, Tex. (Allford/Trotman Associates)

than a thousand free blacks, more than 30 percent of the population.

As Union troops never advanced beyond the fringes of the state during the Civil War, Texas slaves had fewer opportunities to emancipate themselves than their counterparts in areas such as the Mississippi valley and the border states, which were seats of conflict. Only forty-seven black Texans would be recorded as having served with federal armies. Indeed, Texas appeared so secure that out-of-state masters transferred tens of thousands of slaves there. Some 250,000 African Americans would wait until June 19, 1865, for their freedom to be decreed by Union occupation forces (the anniversary of that date, known as "Juneteenth," continues to be celebrated by black Texans).

In the months and years following, landless freedpeople and white landlords, Freedmen's Bureau agents and lawmakers, struggled to shape a new economic and political order. This contest was notably violent, for soldiers and federal officials were spread too thinly across Texas's vast expanse to guarantee the safety, civil rights, and even the liberty of blacks. The contending parties groped toward a system of sharecropping and tenancy—not only in old plantation districts, but in prairie counties to the north and west, which were just hitting their stride as cotton producers. Yet the state's diversity—its various sections' differing resources, labor needs, and trajectories of development—meant share tenancy coexisted

with other labor and tenure arrangements, such as wage work and cash rental, and that black workers might secure nonagricultural employment in railroad construction, the growing east Texas timber industry, or expanding commercial centers. Thousands labored, too, in the west Texas cattle industry (relatively few had the resources to homestead there, though). Confined largely to agricultural labor and unskilled and service work, black Texans found their efforts rarely yielded much more than a bare survival. The homes of tenants and sharecroppers, for instance, typically were even smaller, more crowded, and more lacking in amenities than those of landless whites. Still, freedpeople quickly built institutions, particularly churches and schools, to serve their higher aspirations.

In the thirty-five years after emancipation, black Texans won, then lost, a significant degree of influence in public life. By far the most important component of the state's REPUBLICAN PARTY at its formation in 1867, blacks helped elect a state government in 1869 that established both a public school system and an integrated state police force to combat lawlessness and racial violence. Though rarely nominated by the Republican leadership for statewide or congressional office, dozens of African Americans served in the state legislature and constitutional conventions between 1868 and 1897.

These officeholders were a varied lot, ranging from militant former slave Matthew Gaines to the politi-

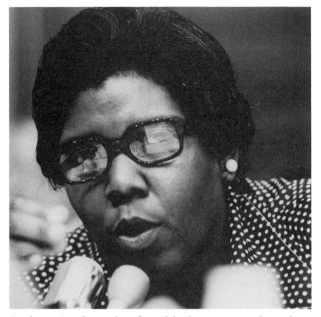

Barbara Jordan, the first black woman elected to Congress from a southern state. She represented Texas in the U.S. House of Representatives from 1973 to 1979. (© Dennis Brack/Black Star)

cally adept mulatto carpetbagger George Ruby (*see* CARPETBAGGERS). Black voting and officeholding, moreover, clearly affected the workings of local government—especally the administration of justice—in the old plantation counties and in several municipalities. The extraordinary expansion of Texas's population in these decades, fueled chiefly by westward movement of white southerners, would render black Texans a rapidly dwindling proportion of the citizenry, however. This demographic fact, unique to Texas of all the former Confederate states, doomed Republican influence over state affairs—as did the collapse of RECONSTRUCTION nationally in the mid-1870s.

African Americans, furthermore, would not subsequently retain that influence in black-majority counties or the Republican Party that their numbers might yet have dictated. County by county, white Democrats destroyed what remained of Republican government in predominantly black areas through chicanery, coercion, and outright violence. After the death of its black leader, Norris Wright CUNEY, in 1898, the state Republican Party fell to a faction devoted to restoring white leadership. The passage of a poll tax suffrage requirement in 1902, after several decades of black participation in third party efforts, and the spread of exclusively white primaries, dissipated African-American political influence even further (though some black citizens, such as those in San Antonio organized by black businessman Charles

Bellinger, would continue to vote in urban and general elections).

Coincident with disfranchisement came an institutionalization of segregation in all manner of public facilities and accommodations. Though practiced previously, segregation from the 1890s onward would be more extensively mandated by the state and local governments. (JIM CROW restrictions would also be fixed on Hispanics, though the nature and extent of this discrimination was more locally varied.) The lynching of hundreds of African Americans in Texas between 1890 and the mid-1920s provides another grim index of powerlessness.

Disfranchisement and segregation prevailed in the first half of the twentieth century, yet these were decades of profound change for black Texans. In 1900, most of Texas's more than 600,000 African Americans remained in the countryside. With the discovery of vast oil reserves the following year, however, a new industrial economy emerged. Many black people moved to cities like Houston and Beaumont to take advantage of job opportunities unavailable to many other Southerners—though they remained confined to the least-skilled, lowest-paying occupations (and, generally, to segregated neighborhoods). By 1930, nearly two-thirds of the black labor force worked outside agriculture; by 1950 a majority of the nearly one million black Texans lived in urban areas. The number of black workers employed in industry rose particularly sharply during World War II, though many of these jobs were lost at war's end.

Urbanization involved push as well as pull. Low cotton prices, New Deal acreage reduction programs, and the mechanization of cotton cultivation drove tens of thousands of tenants off their plots. Displaced or ambitious blacks did not move to nearby cities alone. Some left the state—many for California, rather than for the northern cities favored by many black Southerners. Texas jobs remained attractive enough to other black migrants, however, that substantial net outmigration of African Americans began only in the 1940s and remained smaller than in most of Dixie.

The renewal of full political and civil rights required decades of arduous effort. From the 1920s to the 1940s, black Texans served as plaintiffs in crucial NAACP litigation against the white primary and educational segregation (e.g., *Smith* v. *Allwright* and *Sweatt* v. *Painter*). In cities, black leaders like Antonio Maceo Smith organized voters' leagues and business associations. Following World War II, white resistance to black political and civil rights initiatives seems to have been somewhat less fierce in Texas than in much of the deep South, where African Americans represented a larger proportion of the population. Texas's booming economy, based on oil

and defense industries, and the enormous growth of urban areas and of western and southern Texas, rendered the racial concerns of black belt conservatives somewhat less central. Certain business and civic leaders preferred some accommodation of black and Hispanic demands for change to the bad publicity overt resistance might generate, and several prominent politicians, most notably Lyndon B. Johnson, backed federal civil rights legislation. Still, a significant degree of obstructionism occurred, especially in school integration. In the 1950s, the state government and local school boards actively evaded federal mandates, and only long-term intervention on the part of federal courts moved Texas toward an integration that, with white suburbanization and the continued concentration of black people in central cities, would remain incomplete.

Black political participation, particularly in the cities, had begun to climb after the Supreme Court's 1944 prohibition of the white primary. By 1960 Texas had far more black voters than most southern states. But only with the 1965 VOTING RIGHTS ACT, the end of the poll tax, and the Supreme Court's "one man, one vote" decisions and attendant redistricting did a renaissance of black officeholding occur. State Senator and Congresswoman Barbara Jordan would become the most nationally prominent of this new generation of black public servants, but by 1989, over 300 African Americans held office at federal, state, or local levels. They chiefly represented the large cities and the east Texas counties and municipalities where the black population remained concentrated.

The reconstitution of public life and genuine expansion in economic opportunity, however, had not eliminated long-standing racial disparities. Overwhelmingly an urban population, black Texans—numbering over two million, or 12 percent of the population in 1990—shared the burdens of ill health, poor education, and underemployment with blacks in cities nationwide. Progress, furthermore, had proved far from steady—with greater proportions of female-headed households and families living below the poverty line, and black median family income a smaller fraction of white—in the latter half of the 1980s than at certain points in the booming 1970s. The devastating collapse of the oil economy in the 1980s indicated that, as central as their labor had been to building Texas's prosperity, African Americans would continue to suffer disproportionately when it faltered.

REFERENCES

BARR, ALWYN. *Black Texans: A History of Negroes in Texas, 1528–1971.* Austin, Tex., 1973.

BARR, ALWYN, and ROBERT CALVERT. *Black Leaders: Texans for Their Times.* Austin, Tex., 1981.

CALVERT, ROBERT, and ARNOLDO DE LEON. *The History of Texas.* Arlington Heights, Ill., 1990.

CAMPBELL, RANDOLPH. *An Empire for Slavery: The Peculiar Institution in Texas 1821–1865.* Baton Rouge, La., 1989.

CROUCH, BARRY. *The Freedmen's Bureau and Black Texans.* Austin, Tex., 1992.

RICE, LAWRENCE. *The Negro in Texas 1874–1900.* Baton Rouge, La., 1971.

SMALLWOOD, JAMES. *Time of Hope, Time of Despair: Black Texans During Reconstruction.* Port Washington, N.Y., 1981.

PATRICK G. WILLIAMS

Tharpe, "Sister" Rosetta (March 20, 1915–October 9, 1973), gospel singer and guitarist. Sister Rosetta Tharpe was born Rosetta Nubin in Cotton Plant, Ark. She began her musical apprenticeship playing guitar and singing in the Church of God in Christ, a Pentecostal church, and gained professional experience traveling with her mother, Katie Bell Nubin, a missionary. In her teens she followed her mother to Chicago. It is not clear whether she took a new last name as the result of a marriage, but it was as Sister Rosetta Tharpe that she came to prominence in 1938 in New York. At first she was known for performing in secular venues, a controversial practice for a GOSPEL singer. In that year she performed at Harlem's COTTON CLUB with bandleader Cab CALLOWAY and at the famous "Spirituals to Swing" concert at Carnegie Hall. Those performances helped her land a contract with Decca, making her the first gospel singer to record for a major label. In 1943 she performed at the APOLLO THEATER, the first time that a major gospel singer had appeared there. Her 1944 rendition of "Strange Things Happen Every Day" was widely popular.

Starting in the 1940s, Tharpe performed in churches, concert halls, nightclubs, on the radio, and later even on television. She gained fame not only because of her practice of playing secular venues, a practice she defended by calling all of her music evangelical, but also because of her jazz and blues-influenced guitar playing. Tharpe, who recorded "Daniel in the Lion's Den" in 1949 with her mother, eventually toured with such jazz and blues groups as those led by Benny Goodman, Count BASIE, Muddy WATERS, Sammy PRICE, and Lucky Millinder, as well as with gospel groups such as the Caravans, the James Cleveland Singers, the Dixie Hummingbirds, the Richmond Harmonizing Four, and the Sally Jenkins Singers, with whom she recorded "I Have Good News to Bring" in 1960. Tharpe, who was the first major gospel singer to tour Europe, was also widely

known for her live performances and recordings of "That's All," "I Looked Down the Line," "Up Above My Head," and "This Train." She died in Philadelphia.

REFERENCES

BROUGHTON, VIV. *Black Gospel.* New York, 1985.
HEILBUT, TONY. *The Gospel Sound: Good News and Bad Times.* New York, 1975.

IRENE V. JACKSON

Theater Owners Booking Association (TOBA). The Theater Owners Booking Association, known by the acronym TOBA, was a circuit of theater owners in the 1920s who brought to African-American audiences shows ranging from BLUES, big band JAZZ, and GOSPEL MUSIC to plays, musicals, dance and comedy routines, and latter-day vaudeville and minstrel shows. Although many of the most important African-American entertainers of the twentieth century built their careers through the organization, which at its peak booked acts into more than eighty theaters across the South and Midwest, TOBA had a reputation for exploitation, with notorious contracts that guaranteed wide exposure in return for pitifully small salaries, dismal performing conditions, and arduous schedules. TOBA's reputation was reflected in the joke that "TOBA" euphemistically stood for "Tough on Black Actors," or even "Tough on Black Asses."

TOBA's historical roots remain obscure, but it appears that several booking organizations based in the South and dating from the 1910s merged to form TOBA sometime after 1920. It is also not clear how TOBA worked. While it was a theatrical syndicate similar to the Keith and Albee vaudeville circuits, which established touring routes for performers, individual TOBA theater operators seem to have been able to negotiate contracts with some independence. The theater owners became franchisees by purchasing stock in the association, which gave them the right to stage appearances by TOBA artists. TOBA membership gave theater managers a decided economic advantage over show producers with whom they contracted, but despite thin profits on the part of the performers and producers, the circuit grew as the demand for vaudeville increased, and by the end of the decade there were more than eighty "Toby Time" theaters throughout the South and Midwest, as well as in Chicago and Philadelphia.

During its heyday in the 1920s TOBA exercised enormous influence over the world of black and white entertainment. Nonetheless, TOBA was known derisively as the "Chittlin' Circuit" and was at times accused of perpetuating the negative stereotypes of African Americans through broadly comic blackface minstrel-style shows. Indeed, light-skinned performers were favored in troupes of "Sepia Lovelies," and the dimwitted but happy-go-lucky ex-slave was a staple of TOBA comedy routines.

TOBA's successes were artistic as well as popular. The roster of entertainers who worked the TOBA circuit included the greatest African-American performing artists between the wars. TOBA was particularly well known for presenting female blues singers, including the major figures of the classic blues of the 1920s such as Ma RAINEY and Bessie SMITH as well as Ida COX, Edmonia Henderson, Alberta HUNTER, Clara SMITH, Mamie SMITH, Trixie Smith, Victoria SPIVEY, Eva Taylor, Ethel WATERS, and Sippie WALLACE. Jazz musicians and ensembles included Louis ARMSTRONG, Duke ELLINGTON, Fletcher HENDERSON, the McKinney Cotton Pickers, Bennie MOTEN, King OLIVER, Sammy PRICE, Clarence "Pine Top" SMITH, and Mary Lou WILLIAMS. Count BASIE was a TOBA accompanist early in his career, and the blues singer and guitarist Lonnie JOHNSON won a TOBA talent contest at St. Louis's Washington Theater in 1925.

TOBA was just as famous for vaudeville as it was for popular music. Among the performers who acted, joked, juggled, danced, and snake-charmed their way through the TOBA circuit were Bert WILLIAMS and Bill "Bojangles" ROBINSON, as well as the BERRY Brothers, Buck and Bubbles, Buzzin' Burton, Ralph COOPER, the husband-and-wife team of Cow Cow Davenport and Dora Carr, Jodie "Butterbeans" Edwards and his wife Susie (married onstage in 1917), Ida Forsyne, Bill Jackson, Dewey "Pigmeat" Markham, Moms MABLEY, Baby and Emma Seals, the Whitman Sisters, "Ginger" Jack Wiggins, George Williams and Bessie Brown, Henry "Rubberlegs" Williams, and Wesley "Kid Sox" Wilson and his wife Leola "Coot Grant" Wilson.

Among the dozens of theaters in the TOBA circuit were the Grand Theater in Baton Rouge, La., the Monogram Theater in Chicago, the Roosevelt Theater in Cincinnati, the Hummingbird Theater in Dallas, the Koppin Theater in Detroit, the Liberty Theater in Greenville, S.C., the Walker Theater in Indianapolis, the Lincoln Theater in Kansas City, the Palace Theater in Memphis, the Pike Theater in Mobile, the Lyric Theater in New Orleans, and the Washington Theater in St. Louis. Oddly, theaters in the biggest black metropolises, New York and Washington, were never members.

By the end of the 1920s TOBA was weakened by internal financial squabbles. Exploitative business practices may have led to poorer quality shows, and

therefore smaller audiences. More likely, its decline was hastened by new forms of entertainment. The "talkie" films that were beginning to attract mass audiences, as well as the growing trend towards dancing to live jazz accompaniment spelled the gradual demise of the African-American vaudeville tradition that TOBA had inherited.

REFERENCES

OLIVER, PAUL. *The Story of the Blues*. London, 1969, pp. 69–71.

RIIS, THOMAS L. *Just Before Jazz: Black Musical Theater in New York, 1890–1915*. Washington, D.C., 1989, pp. 144–5.

SAMPSON, HENRY T. *Blacks in Blackface: A Source Book on Early Black Musical Shows*, Metuchen, N.J., 1980, pp. 14–19.

STEARNS, MARSHALL, and JEAN. *Jazz Dance: The Story of American Vernacular Dance*. New York, 1968, pp. 78–80.

JONATHAN GILL

Theatrical Dance. Africans who came to the Americas brought with them a rich tradition in instrumental music, song, and dance. By the early eighteen-hundreds, not long after the official creation of the United States as a country, white men were carrying their versions of slave dances to the minstrel stage, arguably America's first indigenous theater form. According to Robert Toll, the arena in which early minstrelsy showed the strongest debt to African Americans was that of dance.

Several African-American minstrel performers were international stars and extraordinary dancers. William Henry LANE, known as Master Juba, ingeniously combined the Irish jig and reel with African derived movements and rhythms to lay the foundation for what we know as American tap dance. Billy Kersands, who introduced the Virginia Essence, was both an excellent dancer and black minstrelsy's most famous comedian. Black minstrel men and women brought fresh and original dance material to the American stage: stop time dances, various trick dances, and authentic exhibitions of the jig, the cakewalk, and the buck-and-wing.

During the last quarter of the nineteenth century, white road shows generally did not open their stages to black actors and actresses. However, during those same years, such shows as *Uncle Tom's Cabin* and *In Old Kentucky* often featured black dancers and choral groups. Some nineteenth-century traveling shows attracted new talent by holding weekly dance contests.

Many touring shows began and ended in New York around the turn-of-the-century. With more

theaters than any other American city and a solid theatrical tradition for black artists, it was a logical place to plant the seeds for the development of black musical theater. Bob COLES and Billy Johnson's production of *A Trip to Coontown* (1898) was the first musical play organized, managed, produced, and written by African Americans. An excellent dancer, Coles staged several specialty acts that included dance. Will Marion COOK's *Clorindy: The Origin of the Cakewalk* (1898) closely followed *A Trip to Coontown*. *Clorindy* set a new standard for the Broadway stage by introducing exuberant dancing and "Negro syncopated music." Cook's model was adapted for the white stage by George Lederer, who produced *Clorindy* at the Casino Roof Garden.

At the end of the nineteenth century, the cakewalk became the rage of Manhattan, with Bert WILLIAMS and George WALKER the dancing masters of white New York society. The Williams and Walker musical comedy *In Dahomey* (1902) lifted the cakewalk to the status of an international dance craze after the show's smashing London run of 1903. Walker's wife, Aida Overton WALKER, was America's leading black female singer and dancer of that era. She played the female lead in and created most of the choreography for *In Dahomey* and the shows that followed and was probably the first woman to receive program credit as choreographer.

A strong influence on many twentieth-century dance steps, the cakewalk initiated the evolution of American social and theatrical dances that would upstage and then replace the nineteenth-century cotillions, schottisches, and waltzes. The long-standing impact of the cakewalk led James Weldon JOHNSON to observe in 1930: "The influence [of the cakewalk] can be seen today on any American stage where there is dancing. . . . Anyone who witnesses a musical production in which there is dancing cannot fail to notice the Negro stamp on all the movements."

Between 1910 and 1920 black theatrical development in New York took place away from Broadway, allowing African-American musical theater to develop without the constraints of white critics. *Darktown Follies* (1913), the most important musical of the decade leading into the twenties, exploded with such dances as ballin' the jack, tap air steps, the Texas Tommy, the cakewalk, and the tango. Several critics shared the *New York World*'s claim that the dancing was the best New York had ever seen. Astounded by the energy, vitality, and dynamic dancing of the cast, these critics eventually lured downtown visitors to Harlem. Florenz Ziegfeld, one such visitor, bought the rights to "At the Ball," the *Darktown Follies*' finale, and put it in his *Follies* of 1914.

In 1921 Eubie BLAKE, Noble SISSLE, Flourney Miller and Aubrey Lyles joined forces and created the

Aida Overton Walker, the leading female performer in black musical theater in the first decade of the twentieth century, was equally accomplished as a dancer and singer. She appeared before the British royal family in 1903 and was one of the first African-American musical performers to have an international reputation. (Photographs and Prints Division, Schomburg Center for Research in Black Culture, The New York Public Library, Astor, Lenox and Tilden Foundations)

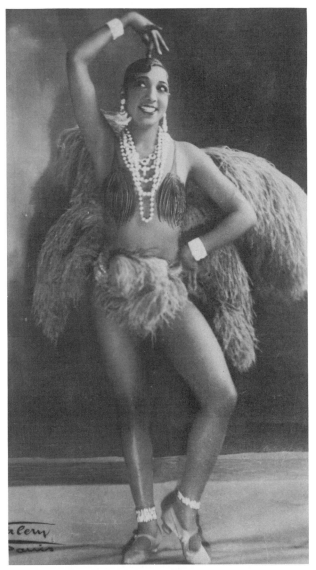

Josephine Baker. (Photographs and Prints Division, Schomburg Center for Research in Black Culture, The New York Public Library, Astor, Lenox and Tilden Foundations)

most important black musical comedy of the 1920s, *Shuffle Along*. The dancing in *Shuffle Along* included buck-and-wing, slow-motion acrobatics, tap air steps, eccentric steps, legomania, the soft shoe, and high kicking. Several members of the cast later became international stars, notably Josephine BAKER and Florence MILLS.

Shuffle Along's greatest contribution and innovation was the dancing of its sixteen-woman chorus line. According to Marshall and Jean Stearns, "musical comedy took on a new and rhythmic life and [white] chorus girls began learning to dance to jazz." Numerous white stars of the theater learned jazz routines from downtown and uptown African-American dance instructors.

Shuffle Along was followed by a wave of African-American cast shows that continued to feature exciting dance. *Runnin' Wild* (1923) introduced the

Charleston, *Dinah* (1924) introduced the Black Bottom, and *Chocolate Dandies* (1924), starring Josephine Baker, featured a female chorus line that presented swinging and complex ensemble tap sequences, a new development created by choreographer Toots Davis.

The opening of white producer Lew Leslie's *Dixie to Broadway* (1924) helped stabilize a trend that stifled the evolution of black musicals for years to come: All the performers were black, but all the producers and off-stage creative talents were white. White dance directors were often credited with choreography created by black dancers. Leslie's *Blackbirds of 1928* showcased the talents of Bill "Bojangles" ROBINSON and Earl "Snake Hips" Tucker, and *Blackbirds of 1930*

featured Buck and BUBBLES, the BERRY BROTHERS, and "Jazzlips" Richardson.

The musical comedy hit of 1929 was *Hot Chocolates,* which began as a revue at Connie's Inn, a Harlem cabaret. Fats WALLER, Andy RAZAF, and Harry Brooks provided the music and lyrics; Leroy Smith's band played in the orchestra pit; and for part of the show's run, Louis ARMSTRONG played his trumpet during intermission. Even with all the musical talent on hand, however, it was the dancing of the Six Crackerjacks, tap dancer Roland Holder, and, "Jazzlips" Richardson that prevailed in the reviews. Cecil Smith commented in 1950 that "the rhythm of Broadway musical comedies is suffused with syncopations and figures which became rooted in our national consciousness in the 1920s."

While black musicals of the twenties were revolutionizing American theatrical dance on Broadway, African-American vaudevillians were impressing theater audiences throughout the country. Since the 1900s black dance teams were rising in popularity on vaudeville stages, and many original and inventive combinations of comic, tap, and acrobatic routines

As a "flash act," an acrobatic, show-stopping kind of tap dance, the Berry Brothers had few peers. (Left to right) Ananias, Warren, and James Berry perform their famous strut step. (Photographs and Prints Division, Schomburg Center for Research in Black Culture, The New York Public Library, Astor, Lenox and Tilden Foundations)

thrilled audiences and inspired emerging artists. Although some black dancers performed on white theater circuits, most were restricted to black theaters. Jack Wiggins, Bill Robinson, Eddie RECTOR, the Berry Brothers, and a host of other star dancers served their apprenticeships on the THEATER OWNERS BOOKING ASSOCIATION (TOBA), the black circuit. Free of the constraints imposed on aspiring artists in schools and studios, black artists in this setting could experiment and advance the development of vernacular dance at breakneck speed. The WHITMAN SISTERS troupe (1900–1943), the greatest developer of black dancing talent, toured on the TOBA circuit for many years.

While TOBA and black musicals were enjoying their golden years, HARLEM was fast establishing itself as one of the entertainment centers of the world. In Harlem cabarets and night clubs, dancers, musicians, and singers participated jointly in revues that rivaled Broadway shows. Business was booming in Connie's Inn, Smalls Paradise, and the COTTON CLUB, where revues were usually built around popular dance fads. Many of America's most exciting dancers appear on the roll call of Cotton Club dancers: the Berry Brothers, Cora La Redd, the NICHOLAS BROTHERS, Peg Leg BATES, Bill Robinson, the FOUR STEP BROTHERS, Buck and Bubbles, WHITEY'S LINDY HOPPERS, the Three Chocolateers, Bessie Dudley, and Earl "Shakehips" Tucker.

The early thirties saw American vernacular dance slowly disappear from Broadway shows. Between the late thirties and the late fifties there were only occasional shows that featured leading dancers of authentic jazz dance: the *Hot Mikado* (1939) showcased the fancy footwork of Bill "Bojangles" Robinson and Whitey's Lindy Hoppers; the short-lived *Swingin' the Dream* (1939) presented Whitey's Lindy Hoppers, including Norma MILLER and Frankie MANNING; Avon Long played the role of Sportin' Life in a revival of *Porgy and Bess* (1941); and Cholly ATKINS and Honi COLES stole the show every night in *Gentlemen Prefer Blondes* (1949). In addition, modern dance pioneer Katherine DUNHAM included African indigenous dances in some of her revues. For the most part, however, it was during this period that the American theater turned its back on indigenous dance.

A new performance format called "presentation" evolved in the early thirties, as vaudeville theaters slowly converted to movie theaters. By this time, radio broadcasts helped create a demand for jazz bands throughout the country at hotels, supper clubs, theaters, nightclubs, and dance halls. Big bands took center stage, and many showcased two or three dancing acts. Tap dancer Honi Coles reported that during the late twenties through the early forties, there were as many as fifty topflight dance acts. There was also

Cab Calloway (right foreground) with tap dancer Bill Robinson at the Cotton Club in the early 1930s. Calloway led one of the most popular big bands through the late 1940s and remained an engaging entertainer into the 1990s. (Photographs and Prints Division, Schomburg Center for Research in Black Culture, The New York Public Library, Astor, Lenox and Tilden Foundations)

a diversity of tap dancing acts, among them: eccentric dancing, a catchall term to describe dancers' use of individual styles and movements; flash dancing, which uses acrobatic combinations and fast-paced syncopations; adagio dancing, which features a slow style; comedy dancing, which includes singing, dancing, and dialogue; and acrobatic dancing, which includes somersaults, cartwheels, flips, and spins.

The fruitful years that dancers had enjoyed with jazz musicians and singers were brought to a halt in the mid-forties. Although several factors led to the separation of jazz music and classic jazz dance, the single most detrimental factor was the imposition of a 20 percent tax against dancing nightclubs by federal, state, and city governments. Many theatrical dancers turned to other jobs, such as choreographing stage routines for pop musicians. With the help of choreographer and tap dancer Cholly Atkins, these artists became the new disseminators of vernacular dance on stage. Dancing singers appeared primarily on television, in films, and in rhythm and blues concerts in the United States and abroad. In the 1990s dancing singers continue to have a major impact on American vernacular dance from the Cadillacs through James BROWN, the TEMPTATIONS, the O'Jays, and Michael JACKSON to the hip-hop generation.

During the sixties vernacular dance was kept alive in part by such television variety shows as *The Ed Sullivan Show, The Lawrence Welk Show, Hollywood Palace, The Tonite Show,* and *American Bandstand.* On Broadway there remained an implied African-American presence in the work of Broadway choreographers who combined ballet and modern dance with elements of their own particular interpretations of classic jazz dance. On the concert dance stage, black choreographers Alvin AILEY, Talley BEATTY, Eleo POMARE, and Donald MCKAYLE successfully presented works influenced by jazz dance. Ailey collaborated with Duke ELLINGTON on several projects, and in 1976 the Alvin Ailey American Dance Theater presented "Ailey Celebrates Ellington," featuring fifteen new ballets set to his music.

Fueled by the appearance of several tap masters at the 1962 Newport Jazz festival, jazz music critics began to write about rhythm tap as an art form. By the seventies, Broadway was once again embracing this genre. Tapping feet figured prominently in musicals of the 1970s and 1980s: *No! No! Nanette!* (1971), *The Wiz* (1975), *Bubbling Brown Sugar* (1976), *Eubie!* (1978), *Black Broadway* (1980), *Sophisticated Ladies* (1981), *Tap Dance Kid* (1983), and *My One and Only* (1983), which featured tap master Honi Coles. Cholly Atkins, Frankie Manning, Henry LETANG, and Fayard Nicholas won Tony Awards for their tap and jazz choreography in *Black and Blue* (1989), a musical revue that also featured tap artists Bunny BRIGGS, Ralph Brown, Lon Chaney, Jimmy SLYDE, Diane WALKER, and the talented young dancer Savion Glover.

As Americans dance through the nineties, African-American vernacular dance has taken center stage on television, in films, and in American musical theater. The last jazz music critic Martin Williams made this observation in *Jazz Heritage* (1985):

> Most of the characteristics that we think of as "American" in our musicals are Afro-American. . . . The same sort of thing is true of our theatrical dance. Tap dancing is obvious enough. . . . But actually, almost any dancing in which the body moves with hips loose and flexible, with easy horizontal body movement below the waist, is Afro-influenced.

On the North American continent African-American culture has been a wellspring of new creations in music, dance, comedy, and pantomime. For well over a century, African-American theatrical dancers have graced the stages of the United States and infused American culture with elegance in movement and an unmistakable style that has been embraced worldwide.

REFERENCES

BOSKIN, JOSEPH. *Sambo*. New York, 1986.

COLES, HONI. "The Dance." In *The Apollo Theater Story*. New York, 1966.

DIXON-STOWELL, BRENDA. "Popular Dance in the Twentieth Century." In Lynne Fauley Emery, ed. *Black Dance from 1619 to Today*. 1972. Reprint. Princeton, N.J., 1988.

EPSTEIN, DENA J. *Sinful Tunes and Spirituals: Black Folk Music to the Civil War*. Chicago, 1977.

FLETCHER, TOM. *100 Years of the Negro in Show Business*. New York, 1954.

HASKINS, JAMES. *The Cotton Club*. New York, 1977.

ISAACS, EDITH J. R. *The Negro in American Theater*. New York, 1947.

JOHNSON, JAMES WELDON. *Black Manhattan*. 1930. Reprint. New York, 1968.

LONG, RICHARD A. "A Dance in the Jazz Mode." In *100 Years of Jazz & Blues* [festival booklet]. New York, 1992.

MALONE, JACQUI. "Let the Punishment Fit the Crime: The Vocal Choreography of Cholly Atkins." *Dance Research Journal* (Summer 1988): 11–18.

RIIS, THOMAS. *Just Before Jazz*. Washington, D.C., 1988.

SOMMER, SALLY. "Tap and How It Got That Way: Feet Talk to Me!" *Dance Magazine* (September 1988).

STEARNS, MARSHALL, and JEAN STEARNS. *Jazz Dance: American Vernacular Dance*. New York, 1968.

TOLL, ROBERT C. *Blacking Up: The Minstrel Show in Nineteenth-Century America*. New York, 1974.

———. *On with the Show*. New York, 1976.

WILLIAMS, MARTIN. "Cautions and Congratulations: An Outsider's Comments on the Black Contribution to American Musical Theater." In *Jazz Heritage*. New York, 1985.

WOLL, ALLEN. *Black Musical Theater: From Coontown to Dreamgirls*. Baton Rouge, La., 1989.

JACQUI MALONE

Theological Education. Throughout the seventeenth and eighteenth centuries most clergy were educated by serving apprenticeships to established pastors. Lemuel HAYNES was one of the first African Americans to be ordained in America and, like most freedmen prior to the CIVIL WAR, was tutored by several respected clergymen. The Connecticut-born and -raised Haynes was recommended as "qualified to preach the gospel" on November 29, 1780. Theological seminaries did not emerge until the first half of the nineteenth century. Few African Americans were graduated from these schools. Theodore WRIGHT (Princeton Theological Seminary, 1828) and John B. Reeve (Union, 1861) were notable exceptions. There were no African-American theological seminaries prior to EMANCIPATION.

Following the Civil War, boards and agencies of northern churches established schools, colleges, and universities in the South to train African-American teachers and preachers. Predominantly white denominations, such as the Congregational, Methodist, Presbyterian, Baptist, Episcopal, and Evangelical Lutheran churches, were most active in this development. In smaller numbers—because of much smaller financial resources—the AFRICAN METHODIST EPISCOPAL, the AFRICAN METHODIST EPISCOPAL ZION CHURCH, the Colored Methodist Episcopal (CME) church, and black Baptist churches (*see* BAPTISTS) also provided education for the freedpersons. A typical college had a theological department whose graduates provided leadership for a growing number of African-American churches.

Gammon Theological Seminary, founded in Atlanta in 1882 by the METHODIST CHURCH, was the first freestanding school designed to provide theological education for African Americans. W. E. B. DU BOIS reported in 1903 that there were 13 theological schools with a total of 368 students. By that year a total of 1,168 students had graduated from the theological departments and seminaries. By 1923 there were 28 seminaries or departments of theology offering training for clergy, with a combined enrollment of 667 students. However, there would soon be a shaking out among African-American theological denominations. A decade later, Benjamin MAYS and Joseph Nicholson reported that 12 theological departments had closed and an additional 8 schools reported no enrollment—a net decrease of 20 departments or

schools with a total enrollment of 657. The attrition among the schools offering degrees in theological studies reflected increasing secularization of governing boards, declining interest in the ministry by students, and erosion of interest by northern church home mission boards or other agencies. In the meantime, increasing numbers of African-American college graduates were matriculating at theological seminaries in the North, though still many of these did not admit blacks.

After WORLD WAR II the CIVIL RIGHTS MOVEMENT contributed to a surge in the enrollment of African Americans in theological education. In the 1976–1977 academic year 1,524 African Americans were enrolled in theological education, and comprised about 4 percent of all students enrolled. Approximately 29 percent were enrolled in minority institutions. The *Fact Book on Theological Education for the Academic Years 1988–1989* reveals that 7.3 percent (3,961) of the 54,628 students matriculated in the fall of 1980 were African Americans. Seven hundred sixty-one, or 19.2 percent, were enrolled in the six African-American seminaries (HOWARD UNIVERSITY School of Divinity, Virginia Union School of Theology, Interdenominational Theological Center (ITC), Payne Theological Seminary at Wilberforce University (AME), Hood Theological Seminary in Salisbury, N.C. (AME Zion), and Shaw University Divinity School (Baptist). ITC is a consortium of denominational seminaries created in 1958: Phillips School of Theology (CME), Turner Theological Seminary (AME), C. H. Mason Theological Seminary (Church of God in Christ), Johnson C. Smith Theological Seminary (Presbyterian), Morehouse School of Religion (Baptist), and Gammon Theological Seminary (United Methodist). The Absalom Jones Institute was a member of the center for a short period of time. The Howard School of Divinity, the Virginia Union School of Theology, and the ITC are fully accredited by the Association of Theological Schools (ATS) and offer doctor of ministry degrees. Payne Theological Seminary, Hood Theological Seminary, and Shaw University Divinity School are associate members of the ATS. There are no African-American theological seminaries that offer graduate programs beyond the master's degree.

The fact that most African Americans matriculated in graduate theological education are in institutions that are not historically black reflects several realities. There had long been a few African Americans in northern seminaries; beginning in the 1930s, a few southern white seminaries began to admit African Americans. By the mid-1960s virtually all such institutions were open to African Americans, though the actual number with such students remains relatively small. Among the other factors contributing to

the matriculation of African Americans at other than minority institutions are denominational pressure upon its clergy to attend denominational schools; the availability of financial aid or tuition remission; the perceived status of the institutions in communities of higher education; and the accessibility of these schools, particularly in metropolitan areas. Broadened access to white theological schools contributed directly to the closing of Payne Divinity School (Episcopal) in 1949 and Lincoln University's seminary in 1959. Despite the presence of institutions devoted to providing theological education for clergy, it is estimated that only 10 percent to 20 percent of clergy nationwide have completed their professional training at an accredited divinity school or seminary.

There are problems endemic to all seminaries but especially to African-American schools engaged in theological education. Among these are the following: (1) how to address the broad array of pressing social issues—for example, AIDS, homelessness, teenage parents, disintegrating families—that are outside the purview of the traditional theological education curriculum; (2) how to strengthen the financial endowments and resources of the seminaries; (3) how to provide financial aid to students whose resources are not sufficient to underwrite the escalating costs of theological education; (4) how to sustain high-quality faculties in the face of the reality of declining enrollments of African Americans in advanced degree programs; (5) how to facilitate the entry of female graduates into the ranks of clergy; and (6) how to assist clergy without formal academic credentials to serve their congregations more effectively.

REFERENCES

BUCHWALTER-KING, GAIL, ed. *Fact Book on Theological Education for the Academic Years 1988–1989 and 1989–1990.* Pittsburgh, 1990.
DANIEL, W. A. *Education of the Negro Minister.* New York, 1925.
LINCOLN, C. ERIC, and LAWRENCE H. MAMIYA. *The Black Church in the African American Experience.* Durham, N.C., 1990.
MAYS, BENJAMIN ELIJAH E., and JOSEPH W. NICHOLSON. *The Negro's Church.* New York, 1933.

LAWRENCE N. JONES

Theology, Black. The phrase "black theology" was first used by a small group of African-American ministers and religious leaders in the late 1960s. It referred to their rejection of the dominant view of Christianity as passive and otherworldly and their definition of Christianity as a religion of liberation, consistent with black people's political struggle for

justice in America and their cultural identification with Africa. The origin of black theology has two contexts: the CIVIL RIGHTS MOVEMENT of the 1950s and 1960s, largely associated with the Rev. Dr. Martin Luther KING, Jr. and the rise of the BLACK POWER MOVEMENT, strongly influenced by MALCOLM X's philosophy of BLACK NATIONALISM.

All persons who advocated the need for a black theology were deeply involved in the civil rights movement, and they participated in the protest demonstrations led by King. Unlike most theological movements in Europe and North America, black theology's origin did not take place in the seminary or university. It was created in the context of black people's struggle for racial justice, organized in the churches, and often led by ministers.

From the beginning, black theology was understood by its interpreters as a theological reflection upon the black struggle for liberation, defined primarily by King's ministry. When King and other black church people began to connect the Christian gospel with the struggle for racial justice, the great majority of the white churches and their theologians denied that such a connection existed. Conservative white Christians said that religion and politics did not mix. Liberals, with few exceptions during the 1950s and early '60s, remained silent or advocated a form of gradualism that questioned the morality of boycotts, SIT-INS, and freedom rides.

Contrary to popular opinion, King was not well received by the white church establishment when he and other blacks inaugurated the civil rights movement with the Montgomery bus boycott in 1955. Because black clergy received no theological support from white churches, they searched African-American history for the religious basis of their prior political commitment to fight for justice alongside of the black poor. Black clergy found support in Henry Highland GARNET, Nat Turner (see NAT TURNER'S REBELLION), Sojourner TRUTH, Harriet TUBMAN, Henry McNeal TURNER, and many other pre– and post–Civil War black Christians.

They discovered that the black freedom movement did not begin in the 1950s but had roots going back many years. Black Christians played major leadership roles in the ABOLITION movement, always citing their religious faith as the primary reason for their political commitment. They claimed that the God of the Bible did not create them to be slaves or second-class citizens in the United States. In order to give an intellectual account of this religious conviction, black clergy radicals created a black theology that rejected racism and affirmed black liberation as identical with the gospel of Jesus.

After the March on Washington in August 1963, the integration theme began to lose ground to the black nationalist philosophy of Malcolm X. The riots in the ghettoes of U.S. cities were evidence that many blacks agreed with Malcolm's contention that America was not a dream but a nightmare.

It was not until the summer of 1966, however, after Malcolm's assassination (1965), that the term "Black Power" began to replace the word "integration" among many civil rights activists. The occasion was the continuation of James MEREDITH's 1966 March against Fear (in Mississippi) by King, Stokely CARMICHAEL, and other civil rights activists. Carmichael seized the occasion to proclaim the Black Power slogan, and it was heard throughout the United States.

The rise of Black Power had a profound effect on the appearance of black theology. When Carmichael and other radicals separated themselves from King's absolute commitment to nonviolence by proclaiming Black Power, white liberal Christians, especially clergymen, urged black clergy to denounce Black Power as un-Christian. To the surprise of these white Christians, a small but significant group of black ministers refused to condemn Black Power. Instead they embraced it and wrote a "Black Power" statement that was published in the New York Times on July 31, 1966.

The publication of the "Black Power" statement was the beginning of the conscious development of a black theology. While blacks have always recognized the ethical heresy of white Christians ("Everybody talking about heaven ain't going there"), they still assumed that whites had the correct understanding of the Christian faith. However, the call of a black theology meant that black ministers, for the first time since the founding of black churches, recognized that white people's privilege in society created a defect not only in their ethical behavior but also in their theological reflections.

No longer able to accept white theology, black theologians began to make their own theology by rereading the Bible in the context of their participation in the liberation struggles of the black poor. They denounced white theology as racist and were unrelenting in their attack on the manifestations of racism in white denominations. Black clergy also created an ecumenical organization called the National Conference of Black Churchmen and black caucuses in the National Council of Churches and in nearly all the white denominations. It was in this context that the phrase "black theology" emerged.

It was one thing to proclaim the need for a black theology, however, and another to define its intellectual content. Nearly all white ministers and theologians initially dismissed it as ideological rhetoric having nothing to do with real Christian theology. Since white theologians controlled public theological dis-

course in seminaries and university departments of religion, they made many blacks feel that only Europeans and persons who think like them could define what theology is. In order to challenge the white monopoly on the definition of theology, many young black scholars realized that they had to carry the fight on to the seminaries and universities where theology was being taught and written.

The first book on black theology was written in 1969 by James H. Cone under the title *Black Theology and Black Power*. It identified the liberating elements of black power with the Christian gospel. Cone's second book, *A Black Theology of Liberation* (1970), made the liberation of the poor from oppression the organizing center of his theological perspective.

After Cone's works appeared, other black theologians joined him, supporting his theological project and also pointing to what they believed to be some of his limitations. In his *Liberation and Reconciliation: A Black Theology* (1971), J. Deotis Roberts, while supporting Cone's accent on liberation, claimed that Cone overlooked reconciliation as central to the gospel in black-white relations. Other black scholars argued that Cone's view of black theology was too dependent on the white European theology he claimed to have rejected and thus not sufficiently aware of the African origin of black religion. This position was taken by Gayraud S. Wilmore, author of *Black Religion and Black Radicalism* (1972).

While black scholars debated about black theology, they agreed that liberation is the central core of the gospel as found in the scriptures and the religious history of the African Americans. They claimed that the *political* meaning of the gospel is best illustrated in the Exodus, and its *spiritual* meaning is found in the ministry of Jesus. The Exodus was interpreted as analogous to Nat Turner's slave insurrection, Harriet Tubman's liberation of an estimated 300 slaves, and the black power revolution in 1960s. Slave spirituals, sermons, prayers, and the religious fervor that characterized the contemporary civil rights movement expressed the spiritual character of liberation found in the ministry of Jesus.

During the early part of the 1970s, black theology in the United States influenced the development of black theology in South Africa. Black theologians in the United States also began to have contact with theologians of liberation in Latin America and Asia. Although Latin American theologians emphasized classism in contrast to black theologians' accent on racism, they became partners in their opposition to the dominant theologies of Europe and the United States and in their identification of the gospel with the liberation of the poor. A similar partnership occurred with Asians regarding the importance of culture in defining theology.

In the late 1970s, a feminist consciousness began to emerge among black women as more women entered the ministry and the seminaries. Their critique of black theology as sexist led to the development of a "womanist theology." The term "womanist" was derived from Alice Walker's *In Search of Our Mothers' Gardens: Womanist Prose* (1983) and was applied to theology by Delores Williams, Katie G. Cannon, Jacquelyn Grant, Kelly D. Brown, and other black women scholars. It has been within the context of black theologians' dialogue with women and Third World peoples that the theological meaning of liberation has been enlarged and the universal character of the Christian faith reaffirmed.

REFERENCES

CONE, JAMES H. *For My People: Black Theology and the Black Church*. Maryknoll, N.Y., 1984.
———. *God of the Oppressed*. New York, 1975.
CONE, JAMES H., and GAYRAUD S. WILMORE, eds. *Black Theology: A Documentary History*. Vol. One: 1966–1979. Rev. ed. Maryknoll, N.Y., 1992.
———. *Black Theology: A Documentary History*. Vol. Two: 1980–1992. Maryknoll, N.Y., 1992.

JAMES H. CONE

Third World Press, publishing company. Established in 1967 by Johari Kunjufu, Carolyn Rodgers, and Haki MADHUBUTI (Don L. Lee), Third World Press (TWP) is one of the oldest existing African-American publishing houses in the United States. It publishes fiction, history, essays, poetry, drama, and young adult and children's literature. TWP's stated mission is to "publish literature that contributes to the positive development of people of African descent." In the early years, TWP published only poetry (e.g., *Black Essence* by Johari Amini, 1968, and *Portable Souls* by Sterling Plumpp, 1968). Through the 1970s and '80s, TWP's list expanded to include Chancelor Williams's *The Destruction of Black Civilization* (1974) and children's books by such noted authors as Gwendolyn BROOKS and Sonia SANCHEZ.

During the early 1990s, TWP continued to provide a vehicle for black authors who found acceptance by white publishers difficult because of the controversial content of their books. TWP's issuing of such titles as Francis Cress-Welsing's *Isis Papers: The Keys to the Colors* (1991) and TWP president Haki Madhubuti's *Black Men: Single, Obsolete, Dangerous?* (1989) has been profitable because of the demand for this type of book in the African-American community. By responding to this market, TWP has become one of the more financially stable black-owned publishing houses in the United States.

REFERENCE

JOYCE, DONALD FRANKLIN. *Black Book Publishers in the United States: A Historical Dictionary of the Presses, 1817–1990.* Westport, Conn., 1991.

SASHA THOMAS

Third World Women's Alliance. The Third World Women's Alliance was a collective founded in 1971 as the Women's Liberation Committee of the STUDENT NONVIOLENT COORDINATING COMMITTEE (SNCC). Under the leadership of founding member Frances Beale, the group later became autonomous, with a mandate to work for African Americans and other minority communities by exposing the relationship between racism, economic exploitation, and sexual oppression. The organization saw the creation of a socialist society as a necessary part of this process.

Although the Third World Women's Alliance's focus was an international one, the issues of racism and sexism in the United States played an integral part in their work. The magazine produced by the group, *Triple Jeopardy,* carried articles about African-American and Hispanic women in the United States. The journal explored topics such as black women's role in Vietnam protests, the sterilization of women of color in the United States, and the relationship between feminism and the black liberation movement.

During the early 1970s the group, which was based in New York City, established several chapters across the country. By the 1980s, it was the last surviving part of its parent organization, SNCC.

REFERENCE

KING, DEBORAH K. "Multiple Jeopardy, Multiple Consciousness: The Context of a Black Feminist Ideology." *Signs: Journal of Women in Culture and Society* 14, no. 1 (1988).

MARIAN AGUIAR

Thirteenth Amendment. The Thirteenth Amendment to the U.S. Constitution, ratified in 1865, abolished SLAVERY. Its first section provided that "neither slavery nor involuntary servitude" should exist within the United States or in any place subject to its jurisdiction. The second section granted Congress the power to "enforce this article by appropriate legislation."

Early in the CIVIL WAR, President Abraham Lincoln repeatedly assured "loyal" planters that they would be able to keep their slaves, and the Emancipation Proclamation (*see* EMANCIPATION), issued in 1863, specifically exempted most slaves held in areas already under federal military occupation and the loyal border states. Yet, by encouraging abolitionist sentiment and authorizing the enlistment of African Americans in the Union Army, the Emancipation Proclamation also changed the focus of the war into a struggle against slavery itself—regardless of where it existed.

Because the Emancipation Proclamation had been issued as a war measure, some feared that it might be judged unconstitutional after the war's end. Lincoln came under increasing political pressure from within his REPUBLICAN PARTY to resolve the issue with a constitutional amendment abolishing slavery. The Republican platform of 1864 strongly supported such an amendment, and when Lincoln won in November, he began an aggressive attempt to win passage from the "lame duck" Congress in early 1865. The DEMOCRATIC opposition had the votes to prevent passage of the amendment in the House of Representatives, but Lincoln's electoral mandate served to undermine their unity. Furthermore, secret promises of administration patronage, approaching outright bribery, secured sufficient Democratic votes and absences to allow passage by a vote of 119 to 56—two votes above the required two-thirds margin.

After passage, the proposed amendment then required endorsement by three-quarters of the state legislature for ratification. It was rapidly passed by most of the northern states, and so its ratification rested with the actions of the southern states, then in constitutional limbo after the collapse of the Confederacy in April 1865. President Andrew Johnson, eager to readmit the southern states to the Union under the "lenient" terms of presidential RECONSTRUCTION, told southern legislatures that ratification of the amendment was a prerequisite for restoration to the Union. The southern constitutional conventions were very uncomfortable with this condition, especially the second section of the amendment, which apparently legitimated federal intervention to secure civil rights against state intrusion. Mississippi refused to ratify the amendment altogether, but most southern states complied with the president's emphatic instruction, and the amendment was declared ratified on December 18, 1865. Despite the end of the war, the border states of Kentucky and Delaware had refused to emancipate their slaves, so the amendment had a direct and practical effect in those states. In Oklahoma, slavery was abolished in 1866 by treaty with the Cherokee nation, thus bringing a formal end to the institution in the entire United States.

The legal interpretation of the Thirteen Amendment engenders continuing controversy, specifically the section granting Congress enforcement powers. Many proponents of the legislation offered an expansive view of the amendment, maintaining that it gave Congress the power to overturn all state legislation inconsistent with basic civil liberties. Other contemporaries took a more restrained view of the powers it granted, arguing that it only abolished slavery, narrowly defined.

REFERENCES

COX, LAWANDA, and JOHN H. COX. *Politics, Principle, and Prejudice, 1865–1866: Dilemma of Reconstruction America*. New York, 1969.

HYMAN, HAROLD M. *A More Perfect Union: The Impact of the Civil War and Reconstruction on the Constitution*. Boston, 1975.

MALTZ, EARL M. *Civil Rights, the Constitution, and Congress, 1863–1869*. Lawrence, Kans., 1990.

MICHAEL W. FITZGERALD

Thomas, Alma (September 22, 1891–February 24, 1978), painter. Alma Thomas was born in Columbus, Ga.; her family moved to Washington, D.C., in 1907 after the Atlanta race riots (1906) to seek better educational opportunities. In Washington, D.C., Thomas attended Armstrong Technical High School, from which she graduated in 1911. That year she began studying at Miner Teachers Normal School in Washington, D.C., and received a certificate to teach kindergarten in 1913. From 1915 to 1921 she taught art at Thomas Garrett Settlement House in Wilmington, Del.

Thomas attended HOWARD UNIVERSITY from 1921 to 1924. There she pursued a B.S. in Fine Arts as one of the first students in the newly organized Department of Fine Arts. In 1924, she began teaching art at Shaw Junior High School in northwest Washington and she remained there until her retirement in 1960. From 1930 to 1934, she pursued a master's degree at Columbia University's Teachers College, where she studied puppet making. In 1943, Thomas became one of the founders of the Barnett-Aden Gallery in Washington, D.C. The gallery exhibited works by men and women of all races, and Thomas remained active as its codirector for twenty years.

Thomas's early work was largely representational, reflecting her academic training. Although she was influenced by abstract expressionism in the 1950s, she maintained an interest in depicting forms as they appeared in the world as in her work *Joe Summerford's Still Life Study* (1952). After 1960, when she retired

from teaching and began to paint full time, her work became more abstract and was comprised of patterns and textures of color (*Watusi*, 1963). Working with a palette knife rather than a brush, Thomas painted abstract impressions of her grandfather's plantation in Alabama, the view of a tree from her kitchen window, the flower garden in her backyard, and the blossoms around Washington, D.C. in a work entitled *Earth Paintings* from the late 1960s. Thomas used the white of the canvas as a backdrop for splotches of color and long horizontal strips made from short brush strokes in paintings such as *A Joyful Scene of Spring* (1968). In 1970, she created a series of *Space Paintings* which were inspired by the U.S. Space Program (*The Eclipse*, 1970). Other works from the 1970s include *Wind and Crepe Myrtle Concerto* (1973), and *Red Azaleas Singing and Dancing Rock and Roll* (1976).

Thomas's exhibitions included a show at Howard University organized by James PORTER in 1966, the Whitney Museum of American Art (1972), Corcoran Gallery in Washington, D.C. (1972), Martha Jackson Gallery in New York City (1973), and the Franz Bader Gallery in Washington, D.C. (1974).

REFERENCES

DRISKELL, DAVID C. *Two Centuries of Black American Art*. New York, 1976.

FORESTA, MERRY A. *A Life in Art: Alma Thomas 1891–1978*. Washington, D.C., 1981.

JANE LUSAKA

Thomas, Clarence (June 23, 1948–), justice of U.S. Supreme Court. Born in Pin Point, Ga., Clarence Thomas was the second of three children of M. C. and Leola (Anderson) Thomas. M. C. Thomas left when his son was two, and Leola Thomas supported the family. They had little money, and after the family house burned down, Clarence Thomas went to live with grandparents in Savannah, Ga. Thomas attended Catholic schools, whose teachers he later credited with giving him hope and self-confidence.

In 1967, Thomas entered the Immaculate Conception Seminary in Conception, Mo., intending to become a Catholic priest. He decided to leave after hearing white classmates happily report the assassination of the Reverend Dr. Martin Luther KING, Jr. Thomas transferred to Holy Cross College in Worcester, Mass., on the school's first Martin Luther King Scholarship. At Holy Cross, Thomas majored in English literature, graduating cum laude in 1971. An admirer of MALCOLM X, Thomas helped form the Black Stu-

dents League, joined the BLACK PANTHER PARTY, and ran a free-breakfast program for black children.

Rejected for military service on medical grounds, Thomas entered Yale University Law School in fall 1971 under the university's affirmative action program. He was admitted to the bar in 1974, then accepted a position as an aide to John Danforth, Missouri's attorney general. Shortly thereafter, he read the conservative African-American economist Thomas Sowell's book *Race and Economics* (1975), which he later claimed as his intellectual "salvation." Thomas adopted Sowell's pro-market, anti–affirmative action theories. In 1977, Thomas became a staff attorney for the Monsanto Company in St. Louis. In 1979, he joined Danforth, by that time a U.S. senator, as an energy and environmental specialist on his staff.

In 1980, Thomas spoke at the Fairmount Conference in San Francisco, a meeting of black conservatives. He denounced the social welfare system for fostering dependency. The publicity Thomas's conservative views received won him the interest of the Reagan administration. In 1981, despite his reluctance to be "typed" as a civil rights specialist, Thomas was named Assistant Secretary for Civil Rights in the Department of Education, where he drew criticism for refusing to push integration orders on southern colleges. In 1982, Thomas was appointed chair of the

Equal Employment Opportunity Commission. Reappointed in 1986, he served until 1990. His tenure was controversial. An opponent of activist judicial action, he refused to press pending class-action suits, and opposed the use of comparable-worth guidelines in gender discrimination cases. The commission allowed thousands of age-discrimination lawsuits to lapse, through what he claimed was "bad management." Yet Thomas opposed efforts to secure tax-exempt status for racially discriminatory colleges, and in 1983 he secured an important affirmative action agreement with General Motors.

In 1989, President George Bush nominated Thomas for a seat on the U.S. Circuit Court of Appeals for the District of Columbia. The appointment was widely understood as preliminary to a possible Supreme Court appointment, as a replacement for aging African-American Justice Thurgood MARSHALL. Thomas was easily confirmed for the district court in February 1990. In July 1991, Marshall retired, and Bush nominated Thomas as his successor. Bush claimed race had nothing to do with the nomination and that Thomas was the "most qualified candidate" to succeed Marshall, an assertion widely viewed as disingenuous. Nevertheless, many blacks who opposed Thomas's conservative ideas initially felt torn by the nomination and supported him or remained neutral on racial grounds.

Clarence Thomas takes the oath of office as a U.S. Supreme Court justice from Justice Byron R. White on October 19, 1991, on the White House lawn. From left to right, First Lady Barbara Bush; Thomas; President George Bush; Thomas's wife, Virginia Thomas; and White. (AP/Wide World Photos)

Thomas's confirmation hearings were acrimonious. He denounced the reasoning of the Court's *Brown* v. *Board of Education* (1954) desegregation case as "dubious social engineering." He refused to take a position on the *Roe* v. *Wade* (1973) abortion decision and aroused doubts by his assertion that he had never discussed it, even in private conversation. On September 27, 1991, the Senate Judiciary Committee deadlocked on Thomas's nomination, and sent it to the Senate floor without recommendation. Shortly thereafter, testimony by Anita Hill, Thomas's former assistant who claimed he had sexually harassed her, was leaked to media sources. The committee reopened hearings in order to discuss the issue. The questioning of Hill and Thomas became a national television event and a source of universal debate over issues of sexual harassment and Hill's truthfulness (*see also* HILL–THOMAS HEARINGS). Despite the damaging allegations, on October 15, Thomas was confirmed, 52–48.

In his first years on the Supreme Court, Thomas voted consistently with the Court's conservative wing. His decisions narrowed the scope of the 1965 Voting Rights Act, upheld new limits on abortion rights (he pronounced himself ready to overturn *Roe* v. *Wade*), and curbed affirmative action policies. In *Hudson* v. *McMillian* (1992), perhaps his most controversial opinion, Thomas held that the Eighth Amendment did not proscribe beating of prison inmates by guards. Thomas remained bitter about the treatment he had received during his confirmation process. In 1993 he gave a controversial speech linking society's treatment of conservative African-American intellectuals to lynching.

REFERENCES

"Court of Appeal: The Black Community Speaks Out on the Racial and Sexual Politics of Thomas v. Hill." *Black Scholar* (1992).

MORRISON, TONI, ed. *Race-ing Justice, Engendering Power*. New York, 1992.

PHELPS, TIMOTHY, and HELEN WINTERNITZ. *Capital Games*. New York, 1992.

TOOBIN, JEFFREY. "The Burden of Clarence Thomas." *New Yorker* (September 27, 1993): 38–51.

CLARENCE E. WALKER

Thomas, Debra J. "Debi" (March 25, 1967–), ice skater. A native of Poughkeepsie, N.Y., Debi Thomas moved to northern California with her family when she was a small child. Fascinated by an ice show she watched at the age of three, Thomas became a competitive skater by the time she was in junior high school.

Thomas began to achieve national honors as a skater while a student at San Mateo High School and moved quickly to the senior women's division before graduating. She excelled academically as well as on the ice and became the first prominent female skater to attend college since Tenley Albright in the 1950s; Thomas graduated from Stanford in 1991.

At 5' 6", Thomas was taller than most of her competitors, with extra height on her double and triple jumps. She thrilled audiences and pleased judges with her graceful choreography blended with a powerful athleticism. She also excelled in the mandatory school figures required during her years of competition. In 1985 she was named Figure Skater of the Year, and in 1986 she became the first black woman to win the United States and Women's World Figure Championships. That same year she was named Amateur Female Athlete of the Year and Wide World of Sports Athlete of the Year. She developed tendonitis in 1987 but managed to place second in the U.S. and World Championships. In 1988 she placed third in both the World Championships and at the Winter Olympics in Calgary, Alberta.

Thomas turned professional in 1988, winning the World Professional Championships in 1988, 1989, and 1991. In 1991 she also won the World Challenge of Champions and entered Northwestern University

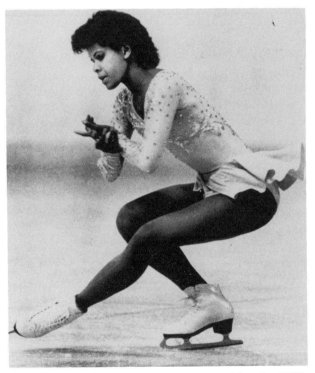

Figure skater Debi Thomas in competition in 1985. In 1988 Thomas became the first African American to secure a medal in the Winter Olympics when she won a bronze medal at the 1988 Calgary Games. (AP/Wide World Photos)

Medical School that same year to study orthopedic and sports medicine.

REFERENCES

ASHE, ARTHUR, JR. *A Hard Road to Glory: A History of the African-American Athlete Since 1946.* New York, 1988.

GUTTMAN, ALLEN. *Women's Sports: A History.* New York, 1991.

GAYLE PEMBERTON

Thomas, Franklin Augustine (May 27, 1934–), lawyer and foundation director. Born in Bedford-Stuyvesant, Brooklyn, Franklin Augustine Thomas attended Franklin K. Lane High School, where he was captain of the basketball team. In 1956, he received a B.A. from Columbia University, where he was the first black captain of the basketball team, and in 1963 he graduated from Columbia Law School.

In 1963, Thomas became an attorney for the Federal Housing and Home Finance Agency, and in 1964, he was named an Assistant District Attorney for the Southern District of New York, where he met Chief Assistant Vincent L. Broderick. When Broderick became Police Commissioner of New York City, he appointed Thomas Deputy Commissioner of Legal Affairs, a position he held from 1965 to 1967. From 1967 until 1977 Thomas was President and Chief Executive Officer of Bedford-Stuyvesant Restoration Corporation, where he helped establish neighborhood businesses, create new jobs, and build new housing units. In 1979, he was elected President of the Ford Foundation, the first African American to hold the position.

Thomas has been the recipient of numerous honors and awards, including the Lyndon Baines Johnson Foundation Award (1974) and the Columbia College Alexander Hamilton Medal (1983). He has also served as the director and trustee of the John Hay Whitney Foundation, the Foreign Policy Study Foundation, and the Columbia Law School Alumni Association. Thomas serves as the chair of the Study Commission on U.S. Policy Toward Southern Africa, whose report, *Time Running Out,* was published in 1981 and updated in 1991 and 1992.

REFERENCES

BLAUNER, PETER. "Wanna-Bes and Could-Bes." *New York* (May 23, 1988): 34–39.

"Franklin Thomas." In Barbara Carlisle Bigelow, ed. *Contemporary Black Biography,* Vol. 5. Detroit, 1994, pp. 252–255.

SABRINA FUCHS

Thomas, Vivien Theodore (August 29, 1910–November 26, 1985), surgical technician. Vivien Thomas was born in Lake Providence, La., the son of William Maceo Thomas, a carpenter and contractor, and his wife, Mary Eaton Thomas. After graduating from Pearl High School in Nashville, Tenn., in 1929, he planned to use carpentry skills he had learned from his father to work his way through Tennessee Agricultural and Industrial State Normal School in preparation for entry to medical school and a career as a physician. That fall, the financial crash put an end to these plans. In 1930, Thomas accepted a full-time job as a laboratory assistant at Vanderbilt University Medical School.

Thomas worked with the eminent white surgeon Alfred Blalock on experiments in surgical shock. Using dogs, they gathered evidence that linked shock to decreases in blood volume and to fluid loss outside the vascular system. Their research led to applications in blood and plasma treatments for trauma during World War II. Blalock relied on Thomas to develop procedures, refine experiments, and test ideas in the laboratory. They were an inseparable team. When Blalock accepted the chairmanship of the surgery department of Johns Hopkins University in 1941, Thomas went with him and continued their research in vascular surgery at Hopkins's Hunterian Laboratory. A crowning achievement was their "blue baby" work. On November 29, 1944, Blalock and Helen Taussig performed a novel surgical procedure to bypass the cardiac defects that restrict blood flow to the lungs in certain infants. Thomas was on hand to offer technical advice. Thereafter, the procedure saved countless newborns from certain death.

Thomas served as research associate, supervisor of surgical laboratories, and instructor in surgery at Johns Hopkins University. The university awarded him an honorary doctor of laws degree in 1976.

REFERENCE

THOMAS, VIVIEN T. *Pioneering Research in Surgical Shock and Cardiovascular Surgery: Vivien Thomas and His Work with Alfred Blalock.* Philadelphia, 1985.

KENNETH R. MANNING

Thomas, William Hannibal (May 4, 1843–November 15, 1935), lawyer and author. Descended from Pennsylvania and Virginia free mulattoes, William Hannibal Thomas was born in Pickaway County, Ohio, in 1843. He performed farm labor, attended school briefly, and in 1859 broke the color barrier at Otterbein College in Westerville, Ohio. His enrollment led to a race riot, and Thomas soon

left the school. Denied admission to the Union Army in 1861 because of his color, Thomas labored as a civilian in the Forty-second Ohio Regiment and in 1863 enlisted in the Fifth U.S. Colored Troops. Thomas quickly was promoted to sergeant, served with distinction, and in February 1865 received a gunshot wound in his right arm that led to its amputation.

After the war Thomas studied theology, contributed to religious newspapers, and raised money for African-American schools. In the early 1870s he went south to run a freedmen's school in Georgia and later served on the faculty at Clark Theological Seminary in Atlanta. Thomas next moved to Newberry, S.C., where he practiced law and was appointed trial justice and colonel in the militia. In the contested 1876 election Thomas went as a Republican to the state legislature. He lost his seat when Gov. Wade Hampton and the "Bourbon" Democrats took office in 1877.

Over the next two decades Thomas lived in Boston, where he published widely. In 1886 he launched a magazine, *The Negro,* which failed. In 1890 he published *Land and Education,* urging African Americans to improve themselves through prayer, education, and land acquisition. During the 1890s Thomas grew increasingly critical of his race. His pessimism appeared full blown in 1901, when he published *The American Negro.* In this work Thomas distanced himself from other African Americans and attacked the black race, especially women, relentlessly. No contemporary white critic assaulted the race with as much crude venom. *The American Negro* received widespread national attention. It appealed to white racists and served to unify African Americans against one they deemed to be a traitor. Thomas died in obscurity in Columbus, Ohio.

REFERENCES

FRIEDMAN, LAWRENCE J. *The White Savage: Racial Fantasies in the Postbellum South.* Englewood Cliffs, N.J., 1970.
HANCOCK, HAROLD B. "Otterbein's First Black Student: William Hannibal Thomas." *Otterbein Miscellany* 8 (1972): 7–12.

JOHN DAVID SMITH

Thompson, Clive (October 20, c. 1935–), dancer. Born in Kingston, Jamaica, Clive Thompson began his dance career in high school when he joined Ivy Baxter's Dance Company, Jamaica's first modern dance troupe. Thompson studied traditional West Indian and modern dance with Baxter, ballet at the

Soohih School of Classical Dance, and participated in master classes with guest teachers Lavinia Williams, Neville Black, and Anna Niala at the University College of the West Indies. In 1960, he moved to California, where he danced with Lester Horton and Jack Cole. Late that same year, Thompson received a scholarship to study at the Martha Graham School in New York City, and started dancing with Graham's company in 1961. He created roles in Graham's *One More Gaudy Night* (1961), *Secular Games* (1962), and *Circe* (1963). From 1965 to 1967 he was a member of the Alvin AILEY American Dance Theater. He then spent several years as a freelance artist.

A striking-looking dancer with a graceful body, strong technique, and dramatic abilities. Thompson was much in demand, and would frequently perform with Yuriko (another Graham dancer) in her concerts; he also performed with John Butler, Pearl Lang, Talley BEATTY, and Geoffrey HOLDER. Thompson rejoined Ailey's company in 1970; capitalizing on Thompson's balletic abilities, Ailey choreographed roles for him in *Myth* (1971), *The Lark Ascending* (1972), and *Hidden Rites* (1973). Thompson was a leading dancer in the company for many years, leaving it in the mid-1980s. He returned to live in Jamaica where he intermittently taught and worked with the National Dance Theater of Jamaica.

REFERENCES

COHEN-STRATYNER, BARBARA NAOMI. *Biographical Dictionary of Dance.* New York, 1989.
EMERY, LYNNE FAULEY. *Black Dance from 1619 to Today.* 2nd rev. ed. Princeton, N.J., 1988.
LONG, RICHARD. *The Black Tradition in American Dance.* New York, 1989.

KIMBERLY PITTMAN

Thompson, Holland (c. 1840–1887), political leader. Born a slave in Alabama, the son of slaves recently brought to that state from South Carolina, Holland Thompson became the outstanding black legislator in Reconstruction Alabama. Handsome and literate, Thompson was the slave of William Taylor and worked as a waiter at his master's posh Madison House Hotel in Montgomery, Ala., when the Civil War ended. In 1865, Thompson married a literate mulatto woman, Binah Yancey (with whom he had already had a son, Holland, Jr., three years before), and the following year he opened a grocery store, which soon prospered. By 1870, Thompson owned some $500 in real estate, plus $200 in personal property. A leading member of the Baptist Church, Thompson was President of the Sabbath School of the First Colored Baptist Church, and helped found

the Second Colored Baptist Church (later the Dexter Ave. Baptist Church, made famous by the Reverend Dr. Martin Luther King, Jr.).

Thompson entered politics shortly after the end of the Civil War, as a delegate to the state's Negro Convention in Mobile in November 1865. Popular with both whites and blacks, Thompson was elected a delegate to Alabama's Union Republican convention in May 1867, and later that year was one of only two African Americans named for a grand jury of the City Court.

In February 1868, Thompson was elected to the Alabama legislature. When the legislature ruled all municipal offices vacant, Thompson was named by Montgomery Mayor Thomas Glasscock to the city council. He won election in his own right in 1869. Reelected to his state legislature seat in November 1870, Thompson ran successfully for the Montgomery City Council in 1871 and 1873.

As an elected official, Thompson stood up firmly for the rights of blacks. Though he acquiesced to segregation, believing social equality would "work out in good time," he worked for black schools (he served four years on Montgomery's school board), soup kitchens, and the creation of proper cemeteries. His most significant fight was his yearly struggle to assure that half of Montgomery's police were black. In some years he won his point; in others, the percentage was 60–40 white.

By 1873, Thompson's business was in trouble, and he lost his Republican party support in factional struggles. He left the legislature but retained his City Council seat, served on the Credentials Committee of the state's Equal Rights Association, and was briefly named Deputy Collector of the Port of Delivery of the Mobile District. In 1875, Alabama returned to white control, and Thompson, turned out of office, returned to his failing business. He served that year as vice-president of the state's Baptist Convention, and subsequently left public life. He died in poverty.

REFERENCE

RABINOWITZ, HOWARD N. "Holland Thompson and Black Political Participation." In *Southern Black Leaders of the Reconstruction Era.* Urbana, Ill., 1982.

GREG ROBINSON

Thompson, John Robert, Jr. (September 2, 1941–), basketball coach. John Thompson was born in Washington, D.C., to working-class parents. He played basketball at Providence College in Rhode Island, and in 1964, the year he received a B.A. in economics, he set the school's single-season scoring record. That year the Boston Celtics drafted him to play backup to center Bill RUSSELL. Although the Celtics won the NBA title in both seasons that Thompson was with the team, he saw very little action and returned to Washington in 1966 to coach basketball at St. Anthony's High School and earn an M.A. in guidance and counseling from the University of the District of Columbia (1971).

In 1972 Georgetown University appointed Thompson head coach of its men's basketball team. In little more than two years, Thompson turned Georgetown's losing program (3–23 in 1971–1972) into a nationally reputable team. By the early 1980s Georgetown, popularly known as the Hoyas, was among the most dominant, aggressive, and successful teams in Big East and Division I college basketball. In 1982 Georgetown lost to North Carolina in the NCAA final by one point. The Hoyas came back two years later to beat Houston for the NCAA Championship. Thompson also sent many players into professional basketball, most notably Patrick Ewing and Alonso Mourning.

Thompson's often intimidating and combative style of play made Georgetown's program one of the most respected in NCAA basketball. Due to his presence and approach, the Hoyas became one of the most popular teams in the country for black Americans. In 1976 Thompson was named assistant coach for the Olympic basketball team. During the 1980s several news and basketball organizations selected Thompson as Coach of the Year (the U.S. Basketball Writers' Association and *The Sporting News*, 1983–1984; the National Association of Basketball Coaches, 1984–1985; and the Big East, 1979–1980 and 1986–1987). In 1988 Thompson was selected to coach the U.S. Olympic basketball team. The team's failure to win the gold medal was perhaps the outstanding disappointment in Thompson's extraordinary career.

By virtue of his national stature in college athletics, Thompson became the most visible and ardent opponent of the NCAA's controversial Proposition 48 and the more strict follow-up, Proposition 42. Thompson objected to the NCAA's use of the SAT or the ACT as indicators of academic achievement or learning potential because he felt this discriminated against the culturally deprived. He argued that colleges should weigh grade-point average (GPA) as more important indicators of academic achievement. (Thompson's stance was criticized by some members of the African-American sporting community, most notably Arthur ASHE.) When Proposition 42 instituted tighter measures for athletic scholarships, Thompson intensified his protest. He boycotted two of Georgetown's 1989 regular-season games, which

led to the NCAA's modifying Proposition 42. In the fall of 1993, Thompson and the Black Coaches Association met with the CONGRESSIONAL BLACK CAUCUS to consider further protests against what they perceived as the NCAA's racist academic policies, stating that the issue would not be forgotten.

By the end of the 1992–1993 season, Thompson's twenty-first at Georgetown, his record stood at 484 wins and 178 losses and included four Big East Championships. His teams advanced to sixteen NCAA tournaments, making the Final Four three times.

REFERENCES

AIKEN, MICHAEL. "Basketball at Georgetown College." In Joseph Durkin, S.J., ed. *Swift Potomac's Lovely Daughter: Two Centuries at Georgetown Through Students' Eyes.* Washington, D.C., 1990, pp. 361–365.
BOSWELL, THOMAS. "Commission on the Ball with Focus on Education." *Washington Post,* June 28, 1991, p. C1.
FIMRITE, RON. "The Head Hoya—a Revealing Look." *Sports Illustrated* (February 18, 1991): 6.
REYNOLDS, BILL. " 'Mr. Georgetown' Finally Seems to Be Enjoying It All." *Chicago Tribune,* February 3, 1991, p. C5.

PETER SCHILLING

Thompson, Louise (September 9, 1901–), social worker, political activist. Born in Chicago, Louise Thompson and her family moved frequently between various western towns before settling in Oakland, Calif. in 1919. She graduated in 1923 from the University of California at Berkeley with a degree in economics. While there, she heard a speech by W. E. B. DU BOIS which stirred her racial pride and eventually inspired her to move east to participate in the black literary renaissance. Thompson studied briefly at the University of Chicago, then went south in 1925 to teach at the Agricultural, Mechanical and Normal School in Pine Bluff, Ark. One year later, she began teaching business administration at HAMPTON INSTITUTE in Virginia. The rigid racial attitudes of Hampton's mostly white administration offended Thompson and many of her students. She was forced out of her position for supporting a 1927 student strike protesting the administration's request that they sing spirituals for the South African prime minister before a segregated audience.

Thompson then moved to New York City, where she was an Urban League Fellow at the New School for Social Work. In 1928 she married author Wallace

THURMAN. The couple separated six months later, but remained legally married until Thurman's death in 1934. Unhappy with the middle-class paternalism of social work, Thompson quit school in 1930 and took a job with the Congregational Education Society, a liberal organization dealing with labor and race relations. At the same time she worked as a secretary for Langston HUGHES and Zora Neale HURSTON during their abortive collaboration on a play, *Mule Bone.* Thompson became a prominent figure in the HARLEM RENAISSANCE, offering her apartment as a meeting space for artists and intellectuals and developing a deep and lasting friendship with Hughes.

Urged by her friend William PATTERSON to read Karl Marx, Thompson soon became active in Communist party circles. She served as an important link between communists and the black artistic and literary community, politicizing black artists as well as broadening the base of the left. She and Augusta SAVAGE organized the Vanguard, an artistic and political organization which became the Harlem chapter of Friends of the Soviet Union. In 1932 Thompson was the principle organizer of an effort to recruit black artists to go to the U.S.S.R. to participate in a Soviet film about African-American workers. Once the artists were there, however, the film was cancelled.

On her return Thompson remained active in numerous Communist-related activities. She began to organize on behalf of the SCOTTSBORO defendants and in 1933 became assistant secretary of the National Committee for the Defense of Political Prisoners. She was asked to join the Communist Party, U.S.A. and from 1934 to 1948 she worked for the International Workers Order (IWO). In 1938, under the aegis of the Harlem section of the IWO, Thompson and Hughes organized the Harlem Suitcase Theatre, which was one of the first black "people's theaters." In 1940 Thompson and Patterson married and moved to Chicago where she served as national recording secretary for the IWO and continued her passionate opposition to racism and economic injustice. In 1946 she was one of the founders of the CIVIL RIGHTS CONGRESS (CRC) and in the 1950s helped form the Sojourners for Truth and Justice, a black women's auxiliary of the CRC. In the 1960s Louise Patterson organized support for Angela DAVIS in New York and Europe. Since the death of William Patterson in 1980, she has attempted to record and preserve the history of which she was a part by granting interviews, collecting her papers, and writing a memoir.

REFERENCES

HUNTON, DOROTHY. *Alphaeus Hunton: The Unsung Valiant.* Richmond Hill, N.Y., 1986.
KELLNER, BRUCE. *The Harlem Renaissance: A Historical Dictionary for the Era.* Westport, Conn., 1984.

NAISON, MARK. *Communists in Harlem During the Depression.* Urbana, Ill., 1983.

PAM NADASEN

Thompson, Robert Louis

Thompson, Robert Louis (June 26, 1937–May 30, 1966), painter. A twenty-one-year-old student at the University of Louisville when he made his first major sale (to collector Walter Chrysler) in 1958, Bob Thompson enjoyed early recognition and acceptance at a level that was unprecedented for U. S. blacks in the visual arts. Only the African-American sculptor Richard HUNT—who sold one of his welded steel constructions to the Museum of Modern Art in 1957 at age twenty-one—anticipated Thompson's precocious success. And not until the emergence of neo-expressionist painter Jean-Michel BASQUIAT, in the 1980s, would another black artist be so thoroughly ensconced as Thompson in the cultural vanguard of his day. Photographed by Robert Frank, sketched by Larry Rivers, filmed by Alfred Leslie, and included in two of the earliest multimedia Happenings (Allan Kaprow's *18 Happenings in 6 Parts* and Red Grooms's *The Burning Building,* both 1959), Thompson was, along with such authors as Ted JOANS, Bob KAUFMAN, LeRoi Jones (*see* AMIRI BARAKA), and Adrienne KENNEDY, among the few blacks to gain prominence in a late 1950s/early 1960s bohemia that would profoundly alter American arts and social life. Yet because he painted in what formalist art critics and historians consider a noncanonical style, and because his death coincided with the birth of a BLACK ARTS MOVEMENT that rejected his work's integrationist content, Thompson has posthumously lapsed into relative obscurity.

Tree with Dog, oil on canvas, by Robert Thompson, 1958–1959. (The Studio Museum in Harlem)

Born in Louisville, Ky., Bob Thompson was the youngest of three children and the only son of Cecil DeWitt Thompson, a successful small businessman, and Bessie Shauntee Thompson, a schoolteacher. Within a year of his birth, the family moved to a small town forty miles south of Louisville. Shattered by his father's death in a 1950 automobile accident, the thirteen-year-old Thompson was sent to Louisville to live with a sister and her husband, a Fort Knox cartographer whose love of art and jazz would leave a lasting impression. Upon graduating from Louisville's Central High School in 1955, Thompson spent an unhappy year in the School of Education at Boston University, then took his brother-in-law's advice and, returning to Louisville, found work as a department store window decorator and enrolled in evening art classes. By the following spring, he had won a full scholarship to the University of Louisville's Hite Art Institute.

Thompson's training at the Hite overlapped that of painter Sam GILLIAM and several other blacks, who shared a taste for modern poetry, progressive jazz, and contemporary art. Yet, awed by the Old Masters he studied in art history classes, Thompson gradually shifted from painting in a large-scale, gestural, abstract mode to figurative expressionism. His summer 1958 stay in Provincetown, Mass., proved decisive. There, he encountered a revelatory blend of brooding narrative, voluptuous color, and bluntly efficient drawing in the art of the late Jan Müller, met older, relatively established New York gestural realists Lester Johnson and Gandy Brodie, and joined a circle of younger artists, including Red Grooms, Mimi Gross, and Alex Katz, who were determined to wed their elders' stylistic candor to new, egalitarian subject matter. Precursors of pop art, these artists' adherence to a style rooted in abstract expressionism would subsequently be considered anomalous.

Encouraged by his Provincetown friends, Thompson withdrew from the University of Louisville and moved to New York in the spring of 1959. By the time his first New York solo exhibition opened less than a year later at the Delancey Street Museum, Thompson had already developed many of the elements of his signature style. Reviewing the show in *Art News,* critic Lawrence Campbell noted his use of "flat patterns, like silhouettes on rifle ranges, and synthetic colors" to create "hallucinating visions" with "the content of fairy stories" or "events ritualized by oral tradition" (Campbell 1960, p. 19).

Married to Carol Plenda in December 1960, Thompson left with her for Europe the following spring. Funded by a Walter Gutman Foundation Grant and a John Hay Whitney Fellowship, the couple spent the next two and a half years living abroad: first in Paris, then in Spain, on the island of Ibiza and

at Portintiax. In Europe, Thompson refined his technique and let his debts from Old Master compositions, previously disguised or avoided, become obvious—a deliberate assertion of his desire to rival the best of Western art and to reinvent it, much in the way jazz musicians routinely appropriated and transformed standard songs.

Returning to New York in the fall of 1963, Thompson joined one of the period's top galleries, the Martha Jackson Gallery, and was given his first midtown solo show. By 1965, along with Jackson in New York, his representatives included Chicago's Richard Gray and Detroit's Donald Morris, two of the Midwest's leading dealers. Thompson's show at the Martha Jackson Gallery that year broke attendance records.

Despite this public triumph and his sustained productivity, the artist's private life was a shambles, increasingly plagued by the alcohol and drug abuse that had troubled him for years. In November 1965, he and his wife fled to Italy, hoping the changed environment might help solve his problems. Instead, on Memorial Day 1966, less than a month short of his twenty-ninth birthday, the painter was found dead in the couple's apartment in Rome, apparently the victim of a drug overdose.

Since his death, Thompson's art has been the subject of a retrospective at the New School for Social Research (1969) and a memorial exhibition at Louisville's J. B. Speed Museum (1971), as well as surveys at the University of Massachusetts at Amherst (1974), the National Collection of Fine Arts, now the National Museum of American Art, in Washington, D.C. (1975), the Studio Museum in Harlem (1978), the Wadsworth Atheneum in Hartford, Conn. (1986), and the California Afro-American Museum in Los Angeles (1990). Today his work can be found in many of the leading museums, including the Museum of the Art Institute of Chicago, the Detroit Institute of Arts, the Hirschhorn Museum and Sculpture Garden, the Metropolitan Museum of Art, the Minneapolis Institute of Art, the Museum of Modern Art, the Museum of the National Center of Afro-American Artists, the New Orleans Museum, the Solomon R. Guggenheim Museum, and the Whitney Museum of American Art.

REFERENCES

C[AMPBELL], L[AWRENCE]. "Reviews and Previews: New Names This Month: Bob Thompson. *Art News* (February 1960): 19.

SIEGEL, JEANNE. "Robert Thompson and the Old Masters." *Harvard Art Review* 2 (1967): 10–14.

WILSON, JUDITH. "Bob Thompson." In *Novae: William H. Johnson and Bob Thompson.* Los Angeles, 1990, pp. 22–32, 54–55.

———. "Bob Thompson." In Paul Schimmel and Judith E. Stein, eds. *The Figurative Fifties: New York Figurative Expressionism.* New York, 1988, pp. 154–162.

JUDITH WILSON

Thompson, Solomon Henry (August 10, 1870–1950), physician. Solomon Henry Thompson was born in Charleston, W.Va. He worked his way through college and medical school, earning a B.S. in 1886 from Storer College in Harpers Ferry and an M.D. from HOWARD UNIVERSITY in 1892. After serving an internship at the FREEDMAN'S HOSPITAL in Washington, D.C., Thompson traveled to Kansas City, Kans., where he founded Douglass Hospital and Training School for Nurses. When Douglass officially opened its doors in 1898, it was the first hospital owned and operated by the American Methodist Episcopal church, and the first hospital for blacks west of the Mississippi River.

From the time of its opening until 1946, Thompson served as Douglass's surgeon-in-chief. He also lectured in physiology and hygiene at Western University in Kansas, and worked as an assistant surgeon in St. Mary's Hospital, Kansas City. Thompson belonged to many fraternal organizations and clubs; he was elected Grand Chancellor of the Knights of Pythias and Grand Commander of the Grand Commandory of Kansas.

In 1946 Douglass Hospital merged with Mercy Hospital. Thompson died four years later at the age of eighty.

REFERENCE

SAMMONS, VIVIAN OVELTON. *Blacks in Science and Medicine.* New York, 1990.

PETER SCHILLING

Thoms, Adah Belle Samuels (c. 1870–February 21, 1943), nurse. Born in Richmond, Va., Thoms moved to New York in 1893 after a short career as a schoolteacher. She studied elocution at the Cooper Union in New York City before deciding to train as a nurse. In 1900, she was the only black in the graduating class of the Woman's Infirmary and School of Therapeutic Massage, also in New York City. She worked for a while as a private-duty nurse, then spent a year as head nurse at St. Agnes Hospital in Raleigh, N.C., returning to New York to seek more training. In 1903, Thoms enrolled in Lincoln Hospital and Home's School of NURSING in New York. When she

graduated in 1905, she began working full-time at Lincoln Hospital as the head nurse on the surgical ward. In 1906, Thoms was named assistant superintendent of nurses. She was in effect the acting director, but because of her race she did not receive that title. She retired in 1924.

As president of the Lincoln Alumnae Association, Thoms helped organize the National Association of Colored Graduate Nurses in 1908. She was president of the organization from 1916 to 1923. In 1912, she was one of the first black delegates to the International Council of Nurses held in Cologne, Germany.

During World War I, she campaigned indefatigably to have black nurses admitted into the U.S. Army Nurse Corps. Though met with fierce resistance, she finally succeeded in seeing eighteen black nurses inducted into the Corps in December 1918. Three years later, she was appointed to the Woman's Advisory Council on Venereal Diseases of the U.S. Public Health Service. In 1929, she wrote *Pathfinders: A History of the Progress of Colored Graduate Nurses,* the first work to chronicle the experiences of black nurses in America. In 1936, she became the first recipient of the NACGN's Mary Mahoney Award, named in honor of the first black woman, Mary Eliza MAHONEY, to graduate from a NURSING school. In recognition of her many contributions to nursing, Thoms was elected into the Nursing Hall of Fame in 1976.

REFERENCES

BULLOUGH, VERN L., OLGA MARANJIAN CHURCH, and ALICE P. STEIN, eds. *American Nursing: A Biographical Dictionary.* New York, 1988.
HINE, DARLENE CLARK, ed. *Black Women in America.* Brooklyn, N.Y., 1993.

 LYDIA MCNEILL

Thornton, Willie Mae "Big Mama" (December 11, 1926–July 25, 1984), blues singer. Born in Montgomery, Ala., the daughter of a minister, Willie Mae Thornton left home after her mother died. She joined Sammy Green's Hot Harlem Revue at the age of fourteen. In 1948 she moved to Houston, where Peacock Records owner Don Robey arranged for her to sing with the Johnny Otis Rhythm and Blues Caravan. Her 250-pound size earned her the nickname "Big Mama," and she became popular for her boisterous, shouting style. "Hound Dog" (1953), a BLUES song later made famous by Elvis Presley, was her only hit, but it enabled her to tour nationally with Johnny ACE as the "reigning king and queen of the blues" until Ace's Russian roulette death in 1954.

Thornton's career never recovered from that event.

Thornton struggled in the San Francisco Bay area until the blues revival of the mid-1960s created a demand for older blues singers after which time she performed at jazz, folk, and blues festivals in the United States and abroad. The rock singer Janis Joplin remade Thornton's "Ball and Chain" into her signature song in 1968, but Thornton had signed away the copyright to the tune years before, and she earned no money for Joplin's version. Thornton's recordings include *In Europe* (1965), *Ball and Chain* (1968), *Stronger Than Dirt* (1969), *Saved* (1973), *Jail* (1975), and *Mama's Pride* (1978).

Throughout her career, Thornton drank heavily and dressed in men's clothing, sometimes wearing a dress over trousers and brogans. Her audiences, however, forgave the eccentricity. She was frail from cirrhosis and weighed only ninety-five pounds when she died of a heart attack at the age of fifty-seven in a Los Angeles boarding house. At a funeral conducted by the Rev. Johnny Otis, money was raised to pay for her burial expenses.

REFERENCES

GART, GALEN, and ROY C. AMES. *Duke/Peacock Records: An Illustrated History with Discography.* Milford, N.H., 1990.
WINDHAM, BEN. "Big Mama Thornton." *Alabama Heritage* Series 6 (Fall 1987): 30–43.

 JAMES M. SALEM

Thrash, Dox (March 22, 1892/93–1965), painter, printmaker, and inventor. Dox Thrash was born on March 22 in Griffin, Ga., though there is some uncertainty as to whether he was born in 1892 or 1893. In 1900, he began studying art through correspondence courses. Thrash left Georgia in 1909 and headed north to Chicago, where he enrolled as a part-time art student in the School at the Art Institute of Chicago in 1914. In 1917, he was drafted into the Army and served with the American Expeditionary Force in France. He was wounded in action, and his disability pension enabled him to resume his studies at the Art Institute until 1923. Thrash spent the next several years traveling around the country, living for a few years in Boston, Connecticut, and New York. He later described these years in an unpublished autobiography as a time of "hobo-ing . . . and painting people of America, especially the 'Negro.' " Thrash finally settled in Philadelphia, where he painted signs for a living and studied privately with Earl Hortor of the Graphic Sketch Club. He also worked with the Pennsylvania Federal Arts Project (FAP) from 1934 to 1942.

While working in the Fine Print Workshop within the FAP's Graphic Division, Thrash—together with fellow FAP artists Michael Gallagher and Hubert Mesibov—developed a new, more effective lithographic technique known as the carborundum print-process. By resurfacing lithographic stones with carborundum, an industrial product made of carbon and silicon crystals, Thrash was able to produce prints with softer, more expressive hues and greater tonal variation. His carbographs, or "opheliagraphs," as he named them for his mother, Ophelia, treat a wide range of subject matter including portraits of African Americans, landscapes, and scenes of Philadelphia street and slum life. Portraits like *Abraham* (n.d.) and *My Neighbor* (1937) demonstrate Thrash's expressive abilities. Both prints present the face of a black man emerging from shadows and staring moodily into the distance. The deeply emotional and personal quality of these images is enhanced by the subtle range of soft, black tones achieved through the carborundum print-process. Thrash's carbographic landscapes, such as *Deserted Cabin* (1939) and *Boats at Night* (1940), have a similarly dark and atmospheric feeling. In addition to his carbographs, Thrash worked with lithographs, etchings, aquatints, paintings, and drawings. His penchant for deep, contrasting shades of black and broad, gestural lines is clearly evident in his graphite drawing, *Man with Harmonica* (n.d.).

Thrash exhibited his prints extensively in the late 1930s and early '40s. His work was shown at the New York World's Fair in 1939–1940 and the 1940 American Negro Exposition in Chicago. The Philadelphia Museum of Art held a solo exhibition of his work in 1942, and the Smithsonian Institution featured his carbographs and etchings in 1948. Thrash died in Philadelphia in 1965.

REFERENCES

DRISKELL, DAVID C. *Two Centuries of Black American Art.* New York, 1976.
Lehman College Art Gallery. *Black Printmakers and the W.P.A.* New York, 1989.
LOCKE, ALAIN. *The Negro in Art: A Pictorial Record of the Negro Artist and of the Negro Theme in Art.* New York, 1971.

JANE LUSAKA

Threadgill, Henry Luther (February 15, 1944–), composer, saxophonist. One of the most original and innovative jazz musicians of the generation that came of age in the 1960s, Henry Threadgill's main concern has been to create musical environments that integrate improvisation and composition. Born in Chicago, Threadgill learned to play baritone saxophone and clarinet in his teens. In the early 1960s he was a member of Muhal Richard Abrams's Experimental Band, which became the Association for the Advancement of Creative Musicians (AACM), an important avant garde jazz collective. In the 1960s Threadgill also played with church revivals, rhythm and blues bands, and an army rock band. He studied composition, flute, and piano at the American Conservatory of Music. In 1969 he performed on Abrams's *Young at Heart, Wise in Time.* In 1971 Threadgill formed the trio Reflection, with bassist Fred Hopkins and drummer Steve McCall, with the intention of performing the music of Scott JOPLIN. In the mid-1970s the trio reformed as Air and began a prolific concert and recording career. Threadgill composed the bulk of the group's material. McCall was replaced by drummer Pheeroan akLaff in 1982.

In the early 1980s Threadgill organized an unusual seven-member ensemble called the Henry Threadgill Sextett, including a cellist and two drummers. His music for this group managed a seamless integration of composed and improvised elements, often referring to the tradition of funeral marching bands with considerable wit and humor. Among their recordings are *When Was That* (1982), *Just the Facts and Pass the Bucket* (1983), *Subject to Change* (1986), *You Know the Number* (1986), and *Easily Slip into Another World* (1987). Threadgill also composed for the concert stage, and his chamber work *Run Silent, Run Deep, Run Loud, Run High* premiered in New York in 1987. In 1989 Threadgill formed another ensemble, the Very Very Circus, which has recorded *Spirit of Nuff . . . Nuff* (1991) and *Too Much Sugar for a Dime* (1993). Threadgill, who has lived in New York since the 1970s, has remained one of the leading figures in modern jazz while also maintaining contacts with avant-garde classical and rock figures.

REFERENCE

EPHLAND, JOHN. "Rag, Bush and All." *Downbeat* 56 (July 1989): 40.

TRAVIS JACKSON

Thurman, Howard (November 18, 1900–April 10, 1981), minister and educator. Howard Thurman, whose career as pastor, scholar, teacher, and university chaplain extended over fifty years, was the author of over twenty books. One of the most creative religious minds of the twentieth century, Thurman touched the lives of many cultural leaders within and beyond the modern CIVIL RIGHTS MOVEMENT, including Martin Luther KING, Jr., A. Philip RAN-

DOLPH, Alan Paton, Eleanor Roosevelt, Mary McLeod BETHUNE, Mordecai Wyatt JOHNSON, Rabbi Alvin Fine, and Arthur ASHE. "The search for common ground" was the defining motif of Thurman's life and thought. This vision of the kinship of all peoples, born of Thurman's own personal struggles with the prohibitions of race, religion, and culture, propelled him into the mainstream of American Christianity as a distinctive interpreter of the church's role in a pluralistic society.

The grandson of slaves, Thurman was born in Daytona, Fla., and raised in the segregated black community of Daytona. He was educated in the local black school, where he was the first African Ameri-

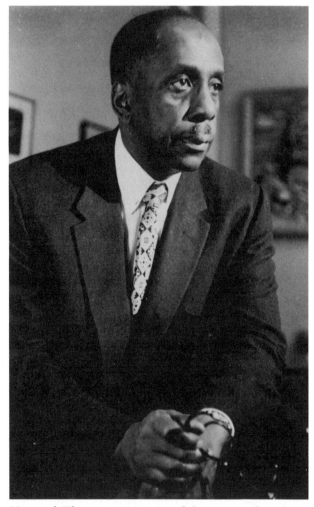

Howard Thurman was one of the most gifted theologians of his generation. His combination of deeply felt religious calling and abiding concern with the rights of African Americans was an inspiration to many black Christians, including the young Rev. Dr. Martin Luther King., Jr. (Photographs and Prints Division, Schomburg Center for Research in Black Culture, The New York Public Library, Astor, Lenox and Tilden Foundations)

can to complete the eighth grade. He attended high school at Florida Baptist Academy (1915–1919), one of only three public high schools for blacks in the state. Upon graduation, Thurman attended Morehouse College (1919–1923) and Rochester Theological Seminary (1923–1926). After serving as pastor of Mt. Zion Baptist Church in Oberlin, Ohio, for two years (1926–1928), he studied with the Quaker mystic Rufus Jones in the spring of 1929. He served as Director of Religious Life and Professor of Religion at MOREHOUSE and SPELMAN Colleges (1929–1930), and Dean of Rankin Chapel and Professor of Religion at HOWARD UNIVERSITY (1932–1944).

Thurman was cofounder and copastor of the pioneering interracial, interfaith Fellowship Church for All Peoples in San Francisco from 1944 to 1953. In 1953, he assumed the dual appointment of Professor of Spiritual Resources and Disciplines and Dean of Marsh Chapel at Boston University. He founded the Howard Thurman Educational Trust in San Francisco in 1961, which he administered after his retirement in 1965 until his death in 1981.

REFERENCES

MITCHELL, MOZELLA GORDON. *Spiritual Dynamics of Howard Thurman's Theology*. Bristol, Conn., 1985.
SMITH, LUTHER E. *Howard Thurman: The Mystic as Prophet*. Washington, 1981.

WALTER EARL FLUKER

Thurman, Wallace (August 16, 1902–December 22, 1934), writer. Born in Salt Lake City, Utah, Wallace Thurman's literary career began shortly after he left the University of Utah to begin studies at the University of Southern California. Although his intent was to study medicine, Thurman soon rediscovered an earlier enthusiasm for writing. According to Arna BONTEMPS, whom he first met during this period, Thurman "lost sight of degrees" and began to pursue courses related to his interest in literature and writing at the University of Southern California. In Los Angeles he also wrote a column called "Inklings" for a local black newspaper. Having heard about the NEW NEGRO movement in New York, Thurman attempted to establish a West Coast counterpart to the HARLEM RENAISSANCE and began editing his own literary magazine, the *Outlet*. The publication lasted for only six months but was described by his friend Theophilus Lewis, the Harlem theater critic, as Thurman's "first and most successful venture at the editorial desk."

Dissatisfied, Thurman left for New York where, as he put it, he "began to live on Labor Day, 1925." Later, he became known for his declaration that he

was a man who hated "every damned spot in these United States outside of Manhattan Island." In New York Thurman secured his first position, an editorial assistant at the *Looking Glass,* another small, short-lived review magazine. His first important position was as temporary editor for the leftist-oriented MES-SENGER, published by A. Phillip RANDOLPH and Chandler OWEN. When the managing editor, George SCHUYLER, went on leave, Thurman's role provided him with a forum not only for his own work but for that of other nascent Renaissance talent, including Langston HUGHES, Arna Bontemps, Zora Neale HURSTON, and Dorothy WEST.

When Schuyler returned, Thurman became associated with a white publication, *The World Tomorrow,* and at the same time joined a group of young black writers and artists—Hurston, Hughes, Aaron DOUGLAS, John P. DAVIS, Bruce Nugent, and Gwendolyn BENNETT—to launch "a new experimental quarterly," *Fire,* in 1926. The purpose of *Fire,* according to its founders, was to "burn up a lot of the old, dead conventional Negro-white ideas of the past, *épater la bourgeoisie* into the realization of the existence of the younger Negro writers and artists." Yet Thurman's enduring ambition to become editor of "a financially secure magazine" seemed ill fated. *Fire* itself became a casualty of a real fire in a basement where several hundred copies had been stored, and the disaster led to its demise after only the first issue. Thurman's next editorial venture came two years later when he began publishing *Harlem, a Forum of Negro Life.* Although this magazine lasted a little longer than its predecessor, it too folded due to a lack of funds.

Thurman also wrote critical articles on African-American life and culture for such magazines as the *New Republic,* the *Independent,* the *Bookman,* and *Dance Magazine.* The black writer, he contended, had left a "great deal of fresh, vital material untouched" because of his tendency to view his own people as "sociological problems rather than as human beings." Like Hughes, he also criticized those writers who felt "that they must always exhibit specimens from the college rather than from the kindergarten, specimens from the parlor rather than from the pantry." He exhorted black writers to exploit those authentic and unique aspects of black life and culture ignored by writers who suppressed the seamy or sordid or low-down, common aspects of black existence.

Thurman published his first novel, *The Blacker the Berry* (1929) while working for the staff of MacFadden Publications. Although the book was acclaimed by the critics, the author remained characteristically skeptical of his own efforts. Doubtlessly invoking some of his own experiences, Thurman's novel deals with the problems of a dark-skinned woman who

struggles with intraracial schisms caused by colorism. Later that same year Thurman collaborated with a white writer, William Jourdan Rapp, on the play *Harlem,* which opened at the Apollo Theater. Thurman based the plot and dialogue on his short story "Cordelia the Crude," which was originally published in *Fire.* The play was described by Hughes as "a compelling study . . . of the impact of Harlem on a Negro family fresh from the south." After its production Thurman continued to write prolifically, sometimes ghostwriting popular "true confessions" fiction.

In 1932 Thurman published his second novel, *Infants of the Spring,* an autobiographical roman à clef, documenting the period from a contemporary and fictionalized perspective. It also constitutes a biting satire and poignant critique of the Harlem Renaissance. For Thurman the failure of the movement lay in the race consciousness emanating from the literary propagandists on the one hand and the assimilationists on the other, both undermining any expression of racial authenticity and individuality.

His final novel, *The Interne,* written in collaboration with Abraham L. Furman, was also published in 1932. It was a muckraking novel exposing the corrupt conditions of City Hospital in New York. Both of these novels were published by Macaulay, where Thurman became editor in chief in 1932. Two years later he negotiated a contract with Foy Productions Ltd. to write scenarios for two films, *High School Girl* and *Tomorrow's Children.* But the strain of life in Hollywood took its toll on Thurman, who became ill and returned to New York in the spring of 1934. Not only had he been marked by a certain physical fragility, he had also been plagued with chronic alcoholism. Shortly after his return Thurman was taken to City Hospital, ironically the very institution he had written about in *The Interne.* After remaining for six months in the incurable ward, he died of consumption on December 22, 1934.

Thurman had arrived in New York in 1925 at the peak of the Harlem Renaissance, whose rise and ebb paralleled his own life and career. Thurman early became one of the leading critics of the older bourgeoisie, both black and white; his lifestyle and literary criticism were calculated to outrage their sensibilities and articulate a New Negro attitude toward the black arts. His importance to the Harlem Renaissance can be measured in terms of both his literary contributions and his influence on younger and perhaps more successful writers of the period. His criticism also set a standard of judgment for subsequent scholars of the Harlem Renaissance. Perhaps his evaluation of Alain Locke's *The New Negro* (1925), a collection inaugurating the movement, best summarizes his own life and contribution: "In [*The New Negro*] are exempli-

fied all the virtues and all the faults of this new movement." Thurman's life itself became a symbol of the possibilities and limitations of the Harlem Renaissance.

REFERENCES

HUGGINS, NATHAN I. *Harlem Renaissance.* New York, 1971.

——, ed. *Voices from The Harlem Renaissance.* New York, 1976.

LEWIS, DAVID LEVERING. *When Harlem Was in Vogue.* New York, 1981.

MAE G. HENDERSON

Till, Emmett Louis (July 25, 1941–August 28, 1955). Emmett Till was born and raised in Chicago, Ill. When he was fourteen, his parents sent him to LeFlore County, Miss., to visit his uncle for the summer. That summer Till bragged to his friends about northern social freedoms and showed them pictures of a white girl he claimed was his girlfriend. His friends, schooled in the southern rules of caste based on black deference and white supremacy, were incredulous. One evening, they dared Till to enter a store and ask the white woman inside, Carolyn Bryant, for a date. Till entered the store, squeezed Bryant's hand, grabbed her around the waist, and propositioned her. When she fled and returned with a gun, he wolf-whistled at her before being hurried away by his friends.

Till's act of youthful brashness crossed southern social barriers that strictly governed contact between black men and white women. In Mississippi, where the KU KLUX KLAN was newly revived and African Americans were impoverished and disfranchised, these barriers were strictly enforced by the threat of social violence. On August 28, 1955, Carolyn Bryant's husband, Roy, and his half brother, J. W. Milam, abducted Till from his uncle's home, brutally beat him, shot him in the head, and then dumped his naked body in the Tallahatchie river. Till's mangled and decomposed body was found three days later, and his uncle named both men as the assailants. Bryant and Milam were tried for murder. Despite the fact that the two men had admitted abducting Till, they were acquitted on September 23 by an all-white jury because the body was too mangled to be definitively identified.

The verdict unleashed a storm of protest. Till's mother had insisted on an open-casket funeral, and pictures of Till's disfigured body featured in JET MAGAZINE had focused national attention on the trial. Till's age, the innocence of his act, and his killers'

immunity from retribution represented a stark and definitive expression of southern racism to many African Americans. Demonstrations were organized by the NATIONAL ASSOCIATION FOR THE ADVANCEMENT OF COLORED PEOPLE (NAACP), and the BROTHERHOOD OF SLEEPING CAR PORTERS and black leaders like W. E. B. DU BOIS demanded antilynching legislation and federal action on civil rights.

Emmett Till's lynching was a milestone in the emergent CIVIL RIGHTS MOVEMENT. Outrage over his death was key to mobilizing black resistance in the deep South. In addition, black protest over the lack of federal intervention in the Till case was integral to the inclusion of legal mechanisms for federal investigation of civil rights violations in the Civil Rights Act of 1957 (see CIVIL RIGHTS AND THE LAW).

In 1959, Roy and Carolyn Bryant and Milam told their stories to journalist William Bradford Huie. Only Milam spoke for the record, but what he revealed was tantamount to a confession. Huie's interviews were subsequently published in 1959 as a book entitled *Wolf Whistle.*

REFERENCE

WHITFIELD, STEPHEN J. *A Death in the Delta: The Story of Emmett Till.* New York, 1988.

ROBYN SPENCER

Tindley, Charles Albert (c. July 7, 1851–1933), gospel musician. Charles Albert Tindley was born July 7, probably in 1851, in Berlin, on Maryland's Eastern Shore, the son of Charles and Hester Miller Tindley. His father hired him out as a child. Tindley spent his adult life in South Philadelphia, Pa., where he served as minister of several Methodist Episcopal churches. In 1902 he became pastor of the Bainbridge Saint M.E. Church where by 1924 his music and dynamic preaching resulted in a church of ten thousand members; that year it was renamed Tindley Temple. Tindley was first married to Daisy Henry (d. 1924) and then in 1927 to Jenny Cotton.

As a hymn writer Tindley pioneered the song tradition that became the basis for the music of the twentieth-century African-American church. His compositions inspired the gospel songs of Thomas A. DORSEY, Lucy Campbell, Robert MARTIN, and the Rev. Herbert Brewster. Among Tindley's most popular titles are "Stand By Me," "The Storm is Passing Over," "We'll Understand It Better By and By," and "I'll Overcome Someday." In 1916 Tindley published *New Songs of Paradise,* a collection of hymns for worship. In 1921 several of his songs came to the attention of a wider audience when they were

sung at the NATIONAL BAPTIST CONVENTION and published in that denomination's collection, *Gospel Pearls.*

Tindley's gospel songs found their way into the worship, hymnals, and popular life of the African-American church, and his better-known titles have become gospel standards. Following a foot injury and gangrene infection, Tindley died in Philadelphia on July 26, 1933.

See also AFRICAN METHODIST EPISCOPAL CHURCH; GOSPEL MUSIC.

REFERENCES

JONES, RALPH H. *Charles Albert Tindley: Prince of Preachers.* Nashville, Tenn., 1982.
REAGON, BERNICE JOHNSON, ed. *We'll Understand It Better By and By.* Washington, D.C., 1992.

IRENE V. JACKSON

Tizol, Juan (Martinez, Vincente) (January 22, 1900–April 23, 1984), jazz trombonist and composer. Although he had wide-ranging professional experiences, Juan Tizol is best known as a member of the Duke Ellington Orchestra. Tizol was born in San Juan, Puerto Rico, where he was trained in the Italian concert/military band tradition. He arrived in Washington, D.C., in the 1920s with the Marie Lucas Orchestra. There, he worked for several years at the Howard Theatre, where he met Duke ELLINGTON. He became a member of Ellington's band in 1929, during its four-year tenure at the COTTON CLUB. His valve-trombone sound, different from the usual "slide" trombone, blended well with the sounds of Ellington's other trombonists at the time, Lawrence BROWN and Tricky Sam NANTON. While in the Ellington Orchestra, Tizol took very few solos but, as Gunther Schuller has noted, clearly enriched Ellington's sound palette on recordings such as "Caravan" (1937), "Ko-Ko" and "Conga Brava" (1940), "Blue Serge" (1941), and "Moon Mist" (1942). In addition, Tizol contributed compositions to the Ellington Orchestra's repertory that became jazz standards, such as "Caravan" (1937), "Conga Brava" (1940), and "Perdido" (1942). Another of his compositions, "Night Song" (1939), was written for Cootie WILLIAMS and recorded by Bunny Berigan, but never by Duke Ellington.

Tizol left the Ellington band in 1944 to join the Harry James band, although he returned for brief periods (1951–1953 and 1960–1961). After leaving Ellington, he worked with drummer Louie Bellson and Pearl BAILEY, among others, and also worked as a studio musician. After retiring, he moved to the West Coast. He died in Inglewood, Calif.

REFERENCES

ELLINGTON, DUKE. *Music Is My Mistress.* New York, 1973.
LAMBERT, EDDIE. "Juan Tizol." In *The New Grove Dictionary of Jazz.* New York, 1988.
SCHULLER, GUNTHER. *The Swing Era: The Development of Jazz, 1930–1945.* New York, 1989.

TRAVIS JACKSON

Tobias, Channing Heggie (February 1, 1882–November 5, 1961), YMCA official, civic leader. Channing Tobias was born in Augusta, Ga., the son of Fair Tobias, a coachman, and Clara Belle (Robinson) Tobias, a house servant. He was ordained a minister of the Colored Methodist Episcopal Church in 1900, received a Bachelor of Arts degree from Paine College (then the Paine Institute) in Augusta, Ga., in 1902, and a Bachelor of Divinity degree from Drew University in Madison, N.J., in 1905. From 1905 to 1911, Tobias was Professor of Biblical Literature at Paine College.

In 1911 Tobias was hired as secretary of the National Council of the YOUNG MEN'S CHRISTIAN ASSOCIATION (YMCA) in Washington, D.C. He held this post until 1923, when he was named Senior Secretary of the Colored Men's Department of the National Council of the YMCA, in New York City. Originally Tobias accepted segregated YMCA branches as a way to ensure black influence in the national organization, but he was also conscious of the need for racial integration, and worked to improve ethnic and race relations both in the United States and abroad. In 1921 he was a member of the second Pan-African Congress in Paris (*see* PAN-AFRICANISM). During the 1920s he visited YMCAs in Finland, Poland, Czechoslovakia, and other places in Europe. He also worked in various organizations dedicated to improving race relations. In 1928, he served on the executive committee of the National Interracial Conference in Washington, D.C., and in 1934 he was a member of the planning committee of the National Conference on the Fundamental Problems of the Negro.

In 1937 Tobias traveled to Mysore, India, where he served as a U.S. delegate (one of two blacks out of a total of twelve delegates) to the World Conference of the YMCAs. Named chairman of the Commission on Race Relationships, Tobias made a forceful, though unsuccessful, appeal for desegregation, claiming that the United States and South Africa were the only remaining nations whose YMCAs had racially exclusionist policies. During the trip, he met Mohandas Gandhi, whose ideas on mass action and decolonization greatly influenced him.

In 1941 Tobias briefly campaigned for a seat on New York's City Council. Following the outbreak of World War II, Tobias became a member of the National Advisory Committee on Selective Service. In 1943 following the Harlem Riot, he was named to the Emergency Conference on Racial Unity, and in 1945 helped draft New York State's Ives-Quinn Fair Employment Practices Bill.

In 1946 Tobias left the YMCA to become the first black director of the PHELPS-STOKES FUND, which supported black American and African education. Tobias inaugurated grants for projects to improve race relations. He also served on President Harry Truman's Committee on Civil Rights. In honor of his civil rights efforts, Tobias was awarded the NAACP's SPINGARN MEDAL in 1948. In 1951 he was named an alternate U.S. Delegate to the General Assembly of the United Nations, where he was assigned to the Committee on Trusts and Non-Self Governing Territories. Though a political moderate, in 1952 Tobias was attacked by the Senate Internal Security Committee for alleged COMMUNIST PARTY associations. In 1953 he left the Phelps-Stokes Fund to become chairman of the board of the NAACP. By the time he retired in 1959, Tobias was considered (in *Ebony*'s words) "the elder statesman of Negro America." Tobias died in 1961, following a long illness.

REFERENCES

"Channing Tobias." *Current Biography* (May 1946).
TOBIAS, CHANNING. "Autobiography." In *Thirteen Americans: Their Spiritual Biographies*. New York, 1953.

SABRINA FUCHS

Tolson, Melvin Beaunorus (February 6, 1898–August 29, 1966), poet and educator. Tolson was born in Howard County, Mo., to Alonzo, a Methodist minister, and Lera Tolson. He attended Lincoln High School in Kansas City, Mo., spent a year (1918) at Fisk University in Nashville, and then transferred to Lincoln University in Pennsylvania, where he received his B.A. With his wife, Ruth, whom he married in 1922, he would raise several highly successful children. In 1923, Tolson secured a post at Wiley College in Marshall, Tex., where he taught English literature and coached one of the country's most successful debating teams.

As early as 1917, Tolson had begun to write poems and short tales that reveal and foreshadow the intensity of his intellectual life and his preoccupation with esoteric knowledge. His poetic interests took off, however, while he was attending Columbia University on a Rockefeller Foundation scholarship during 1931 and 1932, the dimming of the so-called HARLEM RENAISSANCE. His M.A. thesis presents a somewhat brief but accurate portrait of some of the leading figures of the Renaissance, including Langston HUGHES, whom he knew fairly well. The fervor and ferment of the Harlem community inspired Tolson in 1932 to write a sonnet about Harlem's denizens. This sonnet was the germ of an extended poetic work, which was published posthumously as *A Gallery of Harlem Portraits* (1979). Lyrics from the blues and spirituals freely intermix with conventional poetic language to create stylized "portraits" of Harlemites of the 1930s and 1940s. Several years after his return to Wiley College, Tolson's enormous success as a debating coach prompted the *Washington Tribune* in 1938 to request that he write a guest column, which for almost seven years flourished as a regular feature entitled "Caviar and Cabbages."

With the publication of "Dark Symphony" in the *Atlantic Monthly* (1941), Tolson demonstrates his earliest preoccupation with, and mastery of, the poetic

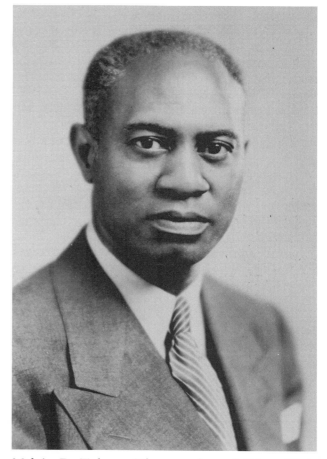

Melvin B. Tolson. (Photographs and Prints Division, Schomburg Center for Research in Black Culture, The New York Public Library, Astor, Lenox and Tilden Foundations)

sequence. Constructed around the personalities of major historical black figures, the poem won first prize at the American Negro Exposition in Chicago in 1940. The award assisted Tolson in getting *Rendezvous with America* (1944)—his first major poetic composition—published.

In his early phase Tolson's poems, which appeared in magazines such as the *Atlantic Monthly* and *Prairie Schooner,* were fairly accessible and transparent. But the poems of his second phase became more esoteric and highly allusive. His work then began appearing in magazines such as the *Modern Quarterly,* the *Arts Quarterly,* and *Poetry.* In the intervening years, Tolson was elected four times as mayor of Langston, Okla. And in 1947, the government of Liberia commissioned him to write a work to be read at the International Exposition in Liberia, commemorating the country's centennial, and simultaneously made him their poet laureate. To celebrate the ideals upon which Liberia was founded, Tolson wrote *Libretto for the Republic of Liberia* (1953), a difficult and enormously complex work about intellectual freedom and international brotherhood—a virtual constant in his writings. The primary work upon which Tolson's fame rests, however, is *Harlem Gallery* (1965), a lengthy poetic sequence of portraits or odes devoted as much to the modern Anglo-American poetic tradition as to African-American culture. *Harlem Gallery* is primarily concerned, for example, with the integrity of the black artist and his cultural allegiances.

Although Tolson is often grouped with the major poetic figures of the 1950s and early 1960s such as Gwendolyn BROOKS and Robert HAYDEN, his reputation remains far behind those of his peers, and readers and scholars alike are kept at bay by the erudition and monumentality of his work.

REFERENCES

FARNSWORTH, ROBERT M. *Melvin B. Tolson, 1898–1966, Plain Talk and Poetic Prophecy.* Columbia, Mich., 1984.

FLASCH, JOY. *Melvin B. Tolson.* New York, 1972.

RUSSELL, MARIANN. *Melvin B. Tolson's "Harlem Gallery": A Literary Analysis.* Columbia, Mich., 1980.

THOMPSON, GORDON, E. Charles W. Chesnutt, Zora Neale Hurston, Melvin B. Tolson: Folk and Non-Folk Representation of the Fantastic. Ph.D. diss. Yale University, 1987.

GORDON THOMPSON

Tolton, Augustus (1854–July 9, 1897), Catholic priest. Augustus Tolton was born to slaves in Brush Creek, Mo. In 1861 his father escaped to join the Union Army; he probably died during the Civil War. His mother escaped shortly thereafter with her three children, and settled in Quincy, Ill. Because of the family's poverty, Tolton worked in various factories, and studied only when his work allowed. Though initially refused admission by the Roman Catholic schools in Quincy, Tolton was eventually allowed to enroll at one, and decided to become a priest. Because no American seminary would accept him, German Franciscan priests tutored him privately in Greek, Latin, German, English, and history before and after work from 1873 until 1878. However, from 1878 to 1880, he studied at Quincy College, newly established by the Franciscans, before and after work.

In March 1880, Tolton enrolled at Urban College at the Congregation for the Propagation of the Faith in Rome, after a Franciscan priest in Quincy had written the minister general of the Franciscan Order in Rome. Urban College trained its students to undertake proselytical work, and Tolton was initially expected to become a missionary in Africa. Instead, he was sent to the United States, because of its need for black priests, with a mission to form a black congregation in Quincy. Tolton was ordained a priest in Rome on April 24, 1886, and after returning to the United States, he celebrated his first Solemn Mass on July 11, at St. Benedict the Moor Church in New York City, to a congregation filled to capacity with black Catholics, some of whom had come from outside the city to hear what they thought was the first black priest in the country. (In fact, the first black Roman Catholic priests were the brothers James, Patrick, and Sherwood HEALY, although Patrick passed as white throughout his life, while James and Sherwood never identified themselves with a black community.) By the end of that month, Tolton was the pastor of St. Joseph's Church, a black congregation in Quincy, which had grown out of a Sunday school he had organized in 1877. A small number of poor blacks made up the parish, but more than two hundred whites came from other parishes to attend his church. Tolton believed that the priests in Quincy, who had initially welcomed him, had grown jealous of him, and that at least one of them, along with the bishop of the diocese, wanted him to leave. Feeling persecuted, Tolton requested a transfer, and was accepted into the archdiocese of Chicago, where he went in December 1889, taking the nineteen black converts he had made in Quincy, feeling that he had failed in his mission there. St. Joseph's was then closed.

In Chicago, Tolton took over a black congregation that worshipped in the basement of a white church, because its members were not allowed to worship alongside whites, and by 1893 moved into a new church, St. Monica's, with a grant from the philan-

thropist Ann O'Neill. He worked for the last four years of his life in this church, living in poverty with his mother, as he had throughout his life, and spending much of his time attempting to raise funds for the church. Tolton had a personality characterized by extreme humility and devoutness: Some of his superiors felt he lacked sufficient self-assertion. Whatever his personal character, he was a prominent participant in the black Catholic congresses which met between 1889 and 1894, and which emphasized the potential of the Catholic church to lead a civil rights movement, while also criticizing discrimination within the church. The final address of the Fourth Congress referred to Tolton's ordination as proof that the Roman Catholic Church considered blacks to share in the priesthood of Christ, regardless of prejudice within American Catholicism.

REFERENCE

DAVIS, CYPRIAN. *The History of Black Catholics in the United States*. New York, 1990.

SIRAJ AHMED

Tomlinson, Mel (January 3, 1954–), dancer. Born one of six siblings in Raleigh, N.C., Mel Tomlinson became interested in dance after studying high school gymnastics. When he was seventeen he began formal dance study at the North Carolina School of the Arts. Tomlinson received his B.F.A. degree in only two years, while he also toured as a principal dancer in Agnes De Mille's Heritage Dance Theatre and switched from a modern dance concentration to ballet. In 1974 he moved to New York to join the DANCE THEATER OF HARLEM (DTH), where his powerful build, crystalline articulation of line, and supple flexibility propelled him to soloist, most notably as the snake in Arthur Mitchell's *Manifestations* (1975). In 1976 he took a leave of absence to perform with the Alvin AILEY American Dance Theater, where he took over the male role in Ailey's *Pas de Duke* with Judith JAMISON and premiered the revival of Lar Lubovitch's *The Time Before the Time After* (*After the Time Before*) with Sara YARBOROUGH. Discouraged by the heavy touring responsibilities of the Ailey company, Tomlinson returned to the DTH in 1978 to perform principal roles in *Swan Lake* and *Scheherazade*. In 1981 he joined the New York City Ballet as its only African-American member. He was quickly promoted to the rank of soloist, and his performance in George Balanchine's *Agon* was called "dynamic and electric" by the *New York Times*. Tomlinson left that company in 1987 to join the faculty at the North Carolina School of Arts. In 1991 he

joined the Boston Ballet as a dancer and master teacher in the CITYDANCE program, bringing classical dance to public school children in the Boston area.

REFERENCES

STUART, OTIS. "Black and White in Color." *Ballet International* (November 1983).
WILSON, ARTHUR. "Mel Tomlinson in the Spotlight." *Attitude* 1, no. 8 (1983).

THOMAS F. DEFRANTZ

Toomer, Jean (December 26, 1894–March 30, 1967), writer. Jean Toomer was born Nathan Pinchback Toomer in Washington, D.C. (He changed his name to Jean Toomer in 1920.) His maternal grandfather, Pinckney Benton Stewart PINCHBACK, a dominant figure in Toomer's childhood and adolescence, was acting governor of LOUISIANA for about five weeks in 1872 and 1873. Because Toomer's father, Nathan, deserted his wife and child in 1895, and his mother, Nina, died in 1909, Toomer spent much of his youth in the home of his Pinchback grandparents in Washington, D.C. After graduating from Dunbar High School in 1914, Toomer spent about six months studying agriculture at the University of Wisconsin. During 1916 and 1917, he attended classes at various colleges, among them the American College of Physical Training in Chicago, New York University, and the City College of New York.

By 1918, Toomer had written "Bona and Paul," a story that became part of *Cane*, his masterpiece. This early story signaled a theme that Toomer was preoccupied with in most of his subsequent writing: the search for and development of personal identity and harmony with other people. Throughout his life, Toomer, who had light skin, felt uncomfortable with the rigid racial and ethnic classifications in the United States. He felt such classifications limited the individual and inhibited personal psychic development. Having lived in both white and black neighborhoods in Washington, D.C., and having various racial and ethnic strains within him, he thought it ridiculous to define himself simplistically.

Two events early in Toomer's literary career were of great importance to his development as a writer. In 1920, he met the novelist and essayist Waldo Frank, and in 1921, he was a substitute principal at the Sparta Agricultural and Industrial Institute in Georgia. Toomer and Frank became close friends, sharing their ideas about writing, and Frank, the established writer, encouraged Toomer in his fledgling work. However, it was in Georgia that Toomer became most inspired. He was moved and excited by

Jean Toomer, the author of *Cane,* a lyrical and experimental evocation of black life in the South, was one of the most highly regarded writers of the Harlem Renaissance. Toomer was only twenty–eight when *Cane* was published in 1923. (Moorland–Spingarn Research Center, Howard University)

the rural black people and their land. He felt he had found a part of himself that he had not known well, and perhaps for the first time in his life truly identified with his black heritage. The result was an outpouring of writing, bringing forth most of the southern pieces that would be in *Cane.*

Cane, stylistically avant–garde, an impressionistic collection of stories, sketches, and poems, some of which had been previously published in *Crisis, Double Dealer, Liberator, Modern Review,* and *Broom,* was published in 1923. While only about 1,000 copies were sold, it received mostly good reviews and was proclaimed an important book by the writers who were then establishing what was to become the HARLEM RENAISSANCE. Alain LOCKE praised *Cane*'s "musical folk-lilt" and "glamorous sensuous ecstasy." William Stanley BRAITHWAITE called Toomer "the very first artist of the race, who . . . can write about the Negro without the surrender of compromise of the artist's vision. . . . Toomer is a bright morning star of a new day of the race in literature." A review in *The New Republic* lauded *Cane* for its unstereotyped picture of the South, and Allen Tate

compared Toomer's avant-garde style favorably to other modern works.

However, despite the critical praise for *Cane,* by 1924 Toomer was feeling restless and unhappy with himself. His struggle with personal identity continued. He went to France to study at Georges I. Gurdjieff's Institute for the Harmonious Development of Man at Fontainebleau. Gurdjieff believed that human beings were made up of two parts: "personality" and "essence." Personality is superficial, created by our social environment. It usually obscures our essence, which is our true nature and the core of our being. Gurdjieff claimed that he could help people discover their essence. Toomer soon embraced Gurdjieff's ideas of personal development, and when he returned to the United States, he became an advocate of Gurdjieff's philosophy, leading Gurdjieff workshops at first briefly in Harlem and then in Chicago until 1930.

Due to Gurdjieff's influence and Toomer's continuing search for a meaningful identity, after 1923 he largely abandoned the style and subject matter he had used in *Cane.* To a great extent he abandoned black writing. From 1924 until his death, he wrote voluminously, but with little critical or publishing success. He wrote in all genres: plays, poems, essays, stories, novels, and autobiographies. While his writing became noticeably more didactic, some of it was not without interesting stylistic experimentation, especially his expressionistic drama, most notably *The Sacred Factory,* published posthumously in 1980. During this period, Toomer also wrote a number of autobiographies and provocative social, political, and personal essays, some of which were published posthumously. Works that Toomer did publish after *Cane* include: *Balo* (1927), a play of Southern rural black life, written during the *Cane* period; "Mr. Costyve Duditch" and "Winter on Earth," stories published in 1928; "Race Problems and Modern Society" (1929), an important essay on the racial situation in the United States that complements "The Negro Emergent," published posthumously in 1993; and "Blue Meridian" (1936), a long poem in which Toomer depicts the development of the American race as the coming together of the black, red, and white races.

A decade after the publication of *Cane,* Toomer had dropped into relative obscurity. It was not until the 1960s and the renewed interest in earlier African-American writing and the republication of *Cane* that Toomer began to have a large readership and an influence on the young black writers of the day. Since then, four posthumous collections of mostly previously unpublished material have appeared: *The Wayward and the Seeking* (ed. Darwin T. Turner, 1980); *The Collected Poems of Jean Toomer* (ed. Robert B. Jones and Margery Toomer Latimer, 1988); *Essentials*

(ed. Rudolph P. Byrd, 1991, a republication of a collection of aphorisms originally privately printed in 1931); and *A Jean Toomer Reader: Selected Unpublished Writings* (ed. Frederik L. Rusch, 1993).

Toomer had two wives. He married Margery Latimer in 1931, and she died the following year giving birth to their daughter, also named Margery. In 1934, he married Marjorie Content. From 1936 to his death, Toomer resided in Bucks County, Pa.

REFERENCES

BYRD, RUDOLPH P. *Jean Toomer's Years with Gurdjieff: A Portrait of an Artist, 1923–1936.* Athens, Ga., 1990.

KERMAN, CYNTHIA EARL, and RICHARD ELDRIDGE. *The Lives of Jean Toomer: A Hunger for Wholeness.* Baton Rouge, La., 1987.

MCKAY, NELLIE Y. *Jean Toomer, Artist: A Study of His Life and Work, 1894–1936.* Chapel Hill, N.C., 1984.

FREDERIK L. RUSCH

Tories, Black. *See* Loyalists in the American Revolution.

Toure, Kwame. *See* Carmichael, Stokely.

Toussaint, Pierre (c. 1766–1853), businessman, philanthropist, candidate for canonization. Pierre Toussaint was probably born in Haiti in 1766, the slave of a planter, Jean Berard. Toussaint, a house servant, was looked upon affectionately by the Berards and treated as a member of the family. His grandmother taught him to read and his master permitted him use of the home library. In 1787, during the early stages of a slave revolt, the Berards fled Haiti to go to New York City, taking Toussaint and his sister with them. Toussaint remained loyal to his masters throughout the unrest and rebellion. After arriving in New York, he was apprenticed to a hairdresser and, while still a slave, was able to set up a successful business of his own. His services were desired by many of the wealthiest and most distinguished women in the city. As a hairdresser he earned enough to become quite wealthy and to support his mistress after his master died. Although he had the means to purchase his own freedom, he chose to remain with his mistress even after she remarried.

In 1809, upon her deathbed, Madame Berard granted Toussaint his freedom. His loyalty did not end with his manumission, however, and he continued to support Madame Berard's daughter for several years. With his considerable wealth he was able to purchase the freedom of his sister, Rosalie, and his future wife, Juliette Noel, in 1811. Three years later he purchased the freedom of his niece, Euphemia, and cared for and educated her. Following Euphemia's death of tuberculosis in 1829, the grief-stricken Toussaint turned to benevolent activities.

Toussaint had been a devout Roman Catholic since he was a child, and after arriving in New York he attended mass every day for sixty-six years at Saint Peter's Roman Catholic Church in lower Manhattan. He was the most notable black layperson in the antebellum Roman Catholic church in New York City. The kindhearted Toussaint was also generous and charitable. He and his wife took black orphans into their home and raised money in support of the Catholic Orphan Asylum for white children. In 1841 he was the first person to respond to the request of Monsignor de Forbin-Jasson for donations to erect a Roman Catholic church for French-speakers (now Saint Vincent de Paul's) with what was then a considerable contribution of one hundred dollars. When Toussaint died in 1853, he was buried beside his wife in Saint Patrick's Cemetery.

In response to the many voices that called for recognition of Toussaint's exemplary piety, in the early 1990s the New York archdiocese began the process of his canonization. This effort led to some conflict and disagreement within the church. New York's John Cardinal O'Connor and other Catholics, black and white, regarded Toussaint as a model of faith and charity who deserved the honor of sainthood. Others saw his career as marked by passivity and servility and therefore unworthy of veneration. The canonization is to be decided by a commission in Rome. Despite the controversy surrounding Toussaint's legacy, he remains an important figure within nineteenth-century African-American history.

REFERENCES

LEE, HANNAH FARNHAM. *Memoir of Pierre Toussaint: Born a Slave in St. Domingo.* Boston, 1854.

OTTLEY, ROI, and WILLIAM J. WEATHERBY, eds. *The Negro in New York.* New York, 1967.

SHEEHAN, ARTHUR T. *Pierre Toussaint: A Modern Biography of Pierre Toussaint, a Post-Revolutionary Black.* Boston, 1981.

WILLIAM J. MOSES

Track and Field. African-American men and women have played a significant role in track and field. They have won an impressive number of cham-

pionships, set numerous Olympic and world records, and contributed enormously to American success in international competition. These achievements have been especially prominent in the 100-meter and 200-meter dashes and in the long jump.

Track and field competition in the United States emerged in the late nineteenth century as a popular amateur sport for men. Women did not participate extensively until the 1930s. Prior to World War I, only a few black athletes won major honors. William Tecumseh Sherman Jackson of Amherst College was the first notable black runner. Jackson regularly won the 880-yard run at collegiate meets in the Northeast from 1890 to 1892. George C. Poage was another early champion. The first African American to receive an Olympic medal, Poage captured third place in the 400-meter hurdles at the 1904 games in St. Louis. The first international star was the University of Pennsylvania's John B. Taylor, the collegiate champion and record holder in the 440-yard run. In 1908 he became the first African-American gold medalist at the Olympics, running a leg on the winning 1600-meter relay team. Howard Porter Drew was the first famous black sprinter. From 1912 to 1916 Drew dominated the sprints in the U.S. and set world records in the 100-meter and 220-yard dashes.

After World War I, African-American competitors gained increased respect. The new willingness of predominantly white northern colleges and elite track clubs to recruit and train promising black athletes greatly expanded their opportunities. Probably the most gifted black track athlete of the 1920s was William DeHart HUBBARD, a graduate of the University of Michigan. During his illustrious career as a long jumper, Hubbard earned the gold medal in the 1924 Olympics, captured two NCAA titles, won six consecutive Amateur Athletic Union (AAU) championships, and held the world record. Distance runner Earl Johnson also enjoyed considerable success. Johnson won a bronze medal in the 1924 Olympics in

Officials stand at attention during the playing of the U.S. National Anthem as gold medal winner Vincent Matthews (second from left) and silver medal winner Wayne Collett (left) are honored during the Munich Olympics, 1972. (Photographs and Prints Division, Schomburg Center for Research in Black Culture, The New York Public Library, Astor, Lenox and Tilden Foundations)

the 10,000-meter run and claimed three AAU titles in the event.

The 1930s were a golden age for African-American sprinters, especially Eddie Tolan (Michigan), Ralph METCALFE (Marquette), and Jesse OWENS (Ohio State). Tolan won one NCAA spring championship and four AAU titles. Metcalf swept both the 100- and 220-yard NCAA championships for three straight years, and he also won seven AAU titles. But at the 1932 Olympics in Los Angeles, it was Tolan who won the head-to-head showdown, earning gold medals in both the 100- and 200-meter dashes in record time.

Owens, an Alabama native, burst onto the world scene in 1935. On May 25, at the Big Ten Championships, he delivered the greatest one-day performance in track and field history. Within the span of two hours he set three world records (long jump, 220-yard dash, and 220-yard low hurdles) and tied a fourth (100-yard dash). Owens's accomplishments at the so-called Nazi Olympics in Berlin the following year were only slightly less spectacular, as he became the first runner to earn four gold medals. He won the 100- and 200-meter dashes and the long jump, setting Olympic records in the latter two events. Owens earned his final gold medal as a late addition to the 400-meter relay squad, after U.S. coaches dropped two Jewish runners from the team. Four additional African-Americans also claimed gold medals in Berlin: Archie Williams in the 400-meter run, John Woodruff in the 800, Ralph Metcalfe in the 400-meter relay, and Cornelius Johnson in the high jump. When Johnson went to receive his award, Adolph Hitler abruptly left the stadium to avoid congratulating him, an apparent racial snub which journalists later erroneously reported to have been aimed at Owens.

Opportunities for African-American women still lagged far behind those for men. Only in the mid-1930s did black women finally gain the opportunity to demonstrate their potential. Tuskegee Institute captured its first AAU team title in 1937 and dominated national competition for a decade. Leading Tuskegee's rise to prominence was Lula Hymes, who won the AAU long jump in 1937 and 1938 and the 100-meter dash in 1938. Another Tuskegee product, Alice Coachman, became the first African-American female superstar. Coachman won three AAU 100-meter dash titles, but even more impressively she captured the AAU high jump championship every year from 1939 to 1948. She also became the first African-American woman to receive an Olympic gold medal, winning the high jump in 1948.

During the late 1940s and '50s, two black champions dominated their events—William Harrison Dillard and Mal Whitfield. The premier hurdler of his day, Dillard won two gold medals at the 1948 Olympics and two more in 1952. Whitfield was an amazingly consistent 800-meter runner and earned Olympic gold medals in both 1948 and 1952. During the 1950s African-American athletes also excelled in the decathlon. Milton Campbell took the silver medal in the event at the 1952 summer games and the gold in 1956. Rafer Johnson finished second behind Campbell in 1956 and claimed first place in 1960, setting both Olympic and world records during the year. In 1956 Charlie Dumas became the first high jumper to clear the seven-foot barrier, and later in the year he won the Olympic gold medal in the event.

During the 1950s Tennessee State University replaced Tuskegee as the women's track powerhouse. The most successful of the school's famous Tigerbelle runners was Wilma RUDOLPH. Born into a family of twenty-two children, Rudolph overcame a childhood bout with polio that forced her to wear a leg brace for several years. In 1960 she became the first American woman ever to earn three gold medals at one Olympics, winning the 100-meter and 200-meter dashes and running a leg on the champion 400-meter relay team. Her athletic success and her inspiring personal story stimulated new interest in women's track. Randolph's successor as a Tigerbelle star and queen of the sprints was Wyomia TYUS, who won the 100-meter dash in both the 1964 and 1968 Olympics, establishing a world record of 11.0 seconds in her 1968 victory.

The late 1960s were a time of widespread social protests, and sports were not exempt. The 1968 summer games in Mexico City, which sociologist Harry Edwards and other black activists had urged African Americans to boycott, combined memorable athletic achievements with political protest. Bob Beamon delivered the most spectacular individual performance, setting a world record of 29 feet, $2\frac{1}{2}$ inches in the long jump. His leap, arguably the greatest single effort in track and field history, surpassed the previous mark by almost two feet and stood for twenty-four years. Three African-American sprinters also won individual gold medals while setting or tying world records at Mexico City: James Hines in the 100-meter dash, Tommie Smith in the 200-meter dash, and Lee Evans in the 400-meter run. Evans's outstanding mark of 43.8 seconds lasted for almost two decades. Also attracting considerable attention were several protests against racism by African-American athletes, especially one at the awards ceremony for the 200-meter dash winners. Standing on the victory stand during the American national anthem, Smith and John Carlos, the bronze medalist, each bowed their heads and raised one clinched fist inside a black glove in a "black power" salute, a controversial gesture for which they were suspended from the U.S. team.

The leading track superstar of the 1970s was hurdler Edwin MOSES. A physics major at Morehouse

(Left) Evelyn Ashford, 35 years old, at the start of her first heat in the Olympic women's 100-meter event in Barcelona, Spain, 1992. Four-time Olympian Ashford won the heat in 11.23 seconds, having also won three gold medals and one silver medal in previous games. (Right) Jackie Joyner-Kersee in the women's long jump at the Yokohama International Track and Field Meet, March 1992. Joyner-Kersee scored 7.04 meters to break her own national indoor record. (AP/Wide World Photos)

College in Atlanta, Moses dominated the 400-meter hurdles, winning 122 consecutive races from 1977 to 1987. He set the world record for the event on several occasions and won gold medals in the 1976 and 1984 Olympics (the United States boycotted the 1980 Moscow games). The 1984 summer games in Los Angeles witnessed the emergence of another superstar—Carl LEWIS. In a brilliant performance reminiscent of Jesse Owens at Berlin in 1936, Lewis became only the second male track competitor in history to claim four gold medals, winning individual titles in the 100-meter dash, the 200-meter dash, and the long jump, and sharing the 400-meter relay team's victory. Lewis successfully defended his 100-meter and long jump championships in 1988, and in 1992 he claimed an unprecedented third gold medal in the long jump. To do so he outdueled Mike Powell, who

one month earlier had beaten Lewis and broken Bob Beamon's old long jump record with a leap of 29 feet $4\frac{1}{2}$ inches.

The top women stars of the 1980s included Florence Griffith JOYNER, Jackie JOYNER-KERSEE, and Valerie Brisco-Hooks. At the Los Angeles games Brisco-Hooks set Olympic records in winning the 200-meter dash and the 400-meter run, adding a third gold medal with the American 1600-meter relay team. Known for her colorful running attire, Griffith-Joyner earned three gold medals (100-meter dash, 200-meter dash, and 400-meter relay) and one silver (1600-meter relay) at the 1988 Olympics and held world records in the first two events. Joyner-Kersee won the Olympic long rump competition in 1988, captured the heptathlon in 1988 and 1992, and set a new world record in the latter event.

The remarkable achievements of African-American athletes in the sprints, long jump, and hurdles, and their limited success in the distance and weight events, have perpetuated an old debate over whether sociological and cultural forces or physical tendencies help explain their success. Scholars continue to disagree vigorously over these issues. Nonetheless, they all concur that African-American men and women have made an impressive contribution to international track and field.

REFERENCES

ASHE, ARTHUR R., JR. *A Hard Road to Glory: A History of the African American Athlete.* 3 vols. New York, 1988.

BAKER, WILLIAM J. *Jesse Owens: An American Life.* New York, 1986.

EDWARDS, HARRY. *The Revolt of the Black Athlete.* New York, 1969.

WIGGINS, DAVID K. " 'Great Speed But Little Stamina': The Historical Debate over Black Athletic Superiority." *Journal of Sport History* 16 (1989): 158–185.

CHARLES H. MARTIN

TransAfrica.

TransAfrica is the African-American lobby for Africa and the Caribbean. Incorporated in September 1977, it became the first national-level advocacy organization to exist solely for the purpose of articulating an African-American voice in the formulation of U.S. foreign policy. TransAfrica Forum, the lobby's research and educational affiliate, was established in 1981. It publishes the journal *TransAfrica Forum,* sponsors an annual foreign policy conference, and administers a Library and Resource Center. Operating in tandem under a shared Executive Director, the parent body and its educational offshoot promote progressive, nonracialist policies that address political, economic, and humanitarian concerns in the black world.

The history of African-American activism in foreign policy pre-dates the Civil War. Indeed, while slavery was still practiced on American soil, abolitionists, among them Frederick Douglass, pressed for official recognition of the independent black republics of Haiti and Liberia. African-Americans opposed the U.S. invasion and occupation of Haiti (1915–1934); tried at the end of World War I to petition the Versailles Peace Conference on behalf of colonial populations; mobilized to circumvent Washington's neutrality toward the Italian invasion of Ethiopia in 1934; and criticized U.S. policy toward the Belgian Congo in the 1960s.

TransAfrica executive director Randall Robinson ended his twenty-seven-day hunger strike on May 8, 1994, when the United States agreed to ease its admission policy for Haitian refugees. Later in the year, in part because of Robinson's urgings, the United States acted to restore ousted Haitian president Jean-Bertrand Aristide to power. (AP/Wide World Photos)

But the impact of these early campaigns was largely symbolic. Not until the 1970s—in the aftermath of the civil rights movement and the emergence of a critical mass of black elected officials—did African-Americans command the political resources necessary to promote a foreign policy agenda.

The decision to institutionalize a foreign policy lobby was the direct result of a Leadership Conference convened by the Congressional Black Caucus under the direction of Congressmen Charles DIGGS and Andrew YOUNG. On September 25, 1976, leaders from civil rights organizations, church, labor, business, and community development groups, as well as academics and elected officials gathered in Washington to discuss Africa policy. Their immediate concern was Secretary of State Henry Kissinger's maneuvers to protect white minority interests in Southern Rhodesia (now Zimbabwe), which was moving rapidly toward black majority rule. The conferees issued an African-American Manifesto on Southern Africa and pledged to mobilize a constituency for Africa. TransAfrica formed one year later, with Randall ROBINSON as its Executive Director.

Emerging out of support for liberation movements in Southern Africa, TransAfrica quickly developed an image as an anti-apartheid group. This perception was further enhanced in 1985 by the success of its

yearlong civil disobedience campaign in front of the South African embassy in Washington. The demonstrations drew thousands of protesters from around the country, culminating with the 1986 Anti-Apartheid Act that imposed sanctions over President Ronald Reagan's veto.

TransAfrica is in fact interested in all aspects of policy that affect Africa and the Caribbean: development aid, debt relief, human rights and democratization, refugee issues, famine assistance, covert operations, the drug war, and advocacy for a post-apartheid South Africa. In 1990 the forum began an International Careers Program to prepare black students for the foreign service exam. The Washington-based lobby has chapters in Boston, the District of Columbia, Chicago, Detroit, and Cincinnati.

REFERENCES

CHALLENOR, HERCHELLE SULLIVAN. "The Influence of Black Americans on U.S. Foreign Policy Toward Africa." In *Ethnicity and U.S. Foreign Policy*. New York, 1981, pp. 143–181.

TransAfrica Forum. *A Retrospective: Blacks in U.S. Foreign Policy*. Washington, D.C., 1987.

PEARL T. ROBINSON

Tropical Diseases. The field of tropical medicine was first defined by European colonial explorers and settlers whose morbidity and mortality rates skyrocketed in areas such as West Africa and the Caribbean. Malaria, cholera, yellow fever, dysentery, leprosy, yaws, and elephantiasis were among the most common afflictions. In some cases, notably the use of quinine among the Incas, indigenous medical systems provided an important basis for therapy. Theories surrounding the origin and proliferation of these diseases focused on local climatic factors until the late nineteenth century, when scientists established the germ theory (Robert Koch and Louis Pasteur) and the transmissibility of infection by insect vectors (Patrick Manson).

With the increasing mobility of populations in the twentieth century, the notion of tropical disease broadened beyond geographic considerations to include biological, social, and cultural factors as well. The role of nutrition and sanitation in the spread (and control) of disease became clear. Studies undertaken by the National Medical Association (NMA) among selected black populations in the United States during the 1910s helped draw attention to these crucial environmental influences. The NMA's commissions on pellagra, hookworm, and tuberculosis performed investigations and issued annual reports. A prime

mover in these studies was H. M. Green, a black physician from Knoxville, Tenn., who cofounded the National Hospital Association in 1923. Another black physician, Hildrus A. POINDEXTER, became a specialist in tropical medicine and produced numerous epidemiological studies between 1931 and 1970. The work of such researchers became a prototype for the use of objective scientific criteria, rather than racial or geographic stereotypes, in the study of disease.

REFERENCES

GREEN, H. M. "Report of the Pellagra Commission." *Journal of the National Medical Association* 9 (October–December 1917): 223–227.

POINDEXTER, HILDRUS A. *My World of Reality*. Detroit, 1973.

PHILIP N. ALEXANDER

Trotter, James Monroe (Feburary 7, 1842–February 26, 1892), politician and author. James Monroe Trotter was born in Grand Gulf, Miss., to Letitia, a slave, and Richard S. Trotter, her owner. Around 1854, Trotter sent Letitia and her children to the free city of Cincinnati, Ohio, where James attended the Gilmore School for former slaves. He continued his education in Hamilton and Athens, specializing in music and art, and he taught school in the area.

During the CIVIL WAR, Trotter enlisted as a private in the all-black 55th Massachusetts Regiment. Although initially the officers were white, Trotter rose rapidly through the ranks; by April 1864 he was a second lieutenant. The U.S. War Department, however, was slow to recognize the field commissions granted to Trotter and several other black men, and Trotter openly protested this discrimination. He also participated in the struggle for equal pay. In both the North and the South, black Union soldiers insisted on the same recognition that their white counterparts received. To Trotter and many of his fellow troops, the principle of racial justice was more important than immediate gratification; the two black regiments in Massachusetts went without pay for a full year before the U.S. Congress approved equal compensation.

After the war, Trotter moved to Boston and was appointed as a clerk in the U.S. Post Office. In 1868 he married Virginia Isaacs of Chillicothe, Ohio. The Trotters intended to demonstrate that black people could achieve the highest standards set by white society; thus they settled in a white neighborhood and sent their children to white schools. At the same time,

they remained deeply committed to their racial identity, and they associated with prominent black families steeped in the abolitionist tradition. In 1878 Trotter realized his aims through the publication of *Music and Some Highly Musical People,* a pioneering tribute to African-American musical talent that employed a European model of artistic quality. The book sold more than seven thousand copies.

Trotter, like most African Americans during this period, was a Republican. He had been dismayed, however, by the Republicans' withdrawal of federal troops from the South in 1877. Personal evidence of the party's indifference to racial justice came in 1882, when Trotter himself was passed over for a promotion in favor of a white man. Trotter resigned from the Post Office and broke openly with the REPUBLICAN party. He became active in DEMOCRATIC party politics, campaigning for a successful gubernatorial candidate in 1883 and organizing a conference of black Democrats in Boston in 1886.

Meanwhile, Trotter pursued a variety of employment strategies, ranging from musical promotion to real estate. His shift in political allegiances, though, brought unexpected rewards. In 1887 President Grover Cleveland nominated Trotter for U.S. Recorder of Deeds, a position formerly held by Frederick DOUGLASS. Although a U.S. Senate committee voted narrowly against confirmation, Trotter's appointment was approved by a majority in the full Senate, due largely to Republican support. He served the administration until 1889, when the Republicans were returned to the presidency.

Trotter died in February 1892 of the effects of tuberculosis. As a result of his lucrative recordership, he was able to leave substantial property to his family. His son, William Monroe, absorbed James Trotter's legacy of militance and his commitment to integration and racial equality.

REFERENCES

BERLIN, IRA, ed. *Freedom: A Documentary History of Emancipation, 1861–1867.* Series II. *The Black Military Experience.* Cambridge, U.K., 1982.

FOX, STEPHEN B. *The Guardian of Boston: William Monroe Trotter.* New York, 1970.

TAMI J. FRIEDMAN

Trotter, William Monroe

Trotter, William Monroe (April 7, 1872–April 7, 1934), newspaper editor and civil rights activist. William Monroe Trotter was born in 1872 in Chillicothe, Ohio, the son of James Monroe Trotter and Virginia Isaacs Trotter. Raised in a well-to-do white Boston neighborhood, young Trotter absorbed the militant integrationism of his politically active father,

a tradition that he carried on throughout his own life.

Elected president of his senior class by his white high school classmates, Trotter worked briefly as a clerk and entered Harvard College in the fall of 1891. He graduated *magna cum laude* in June 1895, and moved easily into Boston's elite black social set. In June 1899, he married Geraldine Louise Pindell. That same year he opened his own real estate firm.

By the turn of the century, Trotter and his peers were deeply concerned about worsening race relations in the South and signs of growing racial antagonism in the North. In March 1901, Trotter helped form the Boston Literary and Historical Association, which fostered intellectual debate among prosperous African Americans; he also joined the more politically active Massachusetts Racial Protective Association (MRPA). These organizations served as early forums for his denunciation of the virtually undisputed accommodationist leadership of Booker T. WASHINGTON. In contrast to Washington, Trotter defended liberal arts education for black people, championed electoral participation as a means of securing basic rights, and counseled agitation on behalf of racial justice. With fellow MRPA member George W. Forbes, Trotter embarked on what became his life work: the uncompromising advocacy of civil and political equality for African Americans, through the pages of the Boston *Guardian*.

The *Guardian* newspaper, which began weekly publication in November 1901, offered news and analysis of the African-American condition. At the same time, it served as a base for independent political organizing led by Trotter himself. The "Trotterites" not only vilified their enemies in the pages of the *Guardian*, they also resorted to direct confrontation. On several occasions, Trotter and his supporters attempted (without success) to wrest control of the Afro-American Council from the pro–Booker T. Washington camp. More effective was their disruption of a speech Washington himself was scheduled to deliver in July 1903. Amid the fracas, Trotter delivered a litany of accusations and demanded of Washington, "Are the rope and the torch all the race is to get under your leadership?" He served a month in jail for his role in what was dubbed the "Boston Riot." After the incident, Trotter founded the Boston Suffrage League and the New England Suffrage League, through which he called for federal antilynching legislation, enforcement of the FIFTEENTH AMENDMENT, and the end of racial segregation.

While Trotter's editorial belligerence and unorthodox tactics were often disapproved of, many nonetheless respected his unswerving commitment to the cause of racial equality. They rose to Trotter's defense in the aftermath of the "riot" when Washington launched a malicious campaign—including surveil-

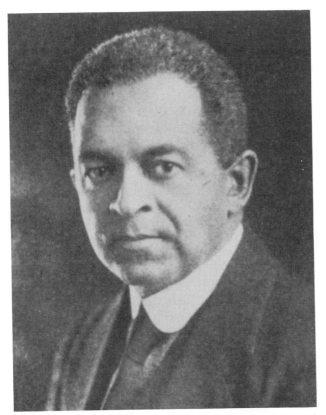

William Monroe Trotter, 1920. (Photographs and Prints Division, Schomburg Center for Research in Black Culture, The New York Public Library, Astor, Lenox and Tilden Foundations)

lance, threats of libel, and the secret financing of competing publications—to intimidate and silence the *Guardian* and its editor. In this sense, Trotter's actions, and Washington's heavy-handed efforts to squelch them, helped crystallize the growing disaffection with Washington into an organizational alternative. Trotter was able to forge a successful, if temporary, alliance with W. E. B. DU BOIS and other proponents of racial integration, and he participated in founding the NIAGARA MOVEMENT in 1905.

Trotter's political independence and confrontational style went beyond the fight against Booker T. Washington, however. He clashed repeatedly with the Niagara Movement over questions of personality and leadership, and he resolved to wage the fight for racial justice under the auspices of his own virtually all-black organization, the National Equal Rights League, or NERL (originally founded as the Negro-American Political League in April 1908). While Trotter attended the founding convention of the NAACP in May 1909, he kept his distance from the white-dominated association; relations between NERL and the NAACP remained cool over the years, with occasional instances of cooperation to achieve common goals.

Trotter's zeal for direct action remained undiminished through the 1910s and 1920s. In a much-celebrated audience with Woodrow Wilson in 1914, Trotter challenged the president's segregationist policies; Wilson, viewing his adversary's candor as insolent and offensive, ordered the meeting to a close. The following year, Trotter led public protests against the showing of the film *The Birth of a Nation;* as a result of his renewed efforts in 1921, the movie was banned in Boston. In early 1919, denied a passport to travel to the Paris Peace Conference, he made his way to France disguised as a ship's cook, hoping to ensure that the Treaty of Versailles contained guarantees of racial equality; unable to influence the proceedings, he later testified against the treaty before the U.S. Congress. In 1926 Trotter again visited the White House to make the case against segregation in the federal government, this time before President Calvin Coolidge.

The *Guardian,* however, remained the primary outlet for Trotter's political convictions. Dependent largely on the contributions of black subscribers, the paper had often been on shaky financial ground. It not only absorbed Trotter's time and energy, it also drained his assets: Having abandoned the real estate business early on in order to devote himself entirely to the *Guardian,* he gradually sold off his property to keep the enterprise afloat. By 1920, with Trotter's standing as a national figure eclipsed by both the NAACP and the GARVEY movement, publication of the *Guardian* became even more difficult to sustain.

Over the years, the impassioned advocacy of militant integrationism remained the hallmark of Trotter's *Guardian.* Back in 1908, Trotter, rather than supporting the black community's creation of its own hospital, had called for integration of Boston's medical training facilities. He had insisted that short-term benefits could not outweigh the "far more ultimate harm in causing the Jim Crow lines to be drawn about us." Trotter was driven by that philosophy throughout his life, even in the face of opposition from other African Americans.

On April 7, 1934, Trotter either fell or jumped to his death from the roof of his apartment building. Although he no longer enjoyed a mass following, he was remembered as one who had made enormous personal sacrifices for the cause of racial equality.

REFERENCES

BENNETT, LERONE, JR. *Pioneers in Protest.* Baltimore, 1968.

FOX, STEPHEN R. *The Guardian of Boston: William Monroe Trotter.* New York, 1970.

HARLAN, LOUIS R. *Booker T. Washington: The Wizard of Tuskegee, 1901–1915.* New York, 1983.

TAMI J. FRIEDMAN

Truitte, James (February 2, 1923–August 21, 1995), modern dancer, teacher, and choreographer. Truitte was born the younger of two boys in Chicago; his family moved to Los Angeles when he was seven. He began dance study with Archie Savage, formerly of Katherine DUNHAM's company, and ballet dancer Janet Collins before embarking on a successful career as a show dancer that included a national tour in CARMEN JONES. In 1947 Truitte began study at the Lester Horton school in Los Angeles, where he quickly became a valued interpreter and teacher of the Horton technique. A frequent partner to Carmen DE LAVALLADE, Truitte performed leading roles in several of Horton's concert works, including *The Beloved* (1948) and *To Federico Garcia Lorca* (1935). Truitte moved to New York City to study labanotation in 1959, and the next year joined the Alvin AILEY American Dance Theater, where his dancing was distinguished by its strength, dignity, and radiant masculinity. He remained the associate director of the Ailey company until 1968, garnering significant critical praise for heartfeld performances as the male soloist in "I Want to Be Ready" and as partner to Judith JAMISON in "Fix Me Jesus," both of Ailey's suite *Revelations* (1960). In 1970 Truitte joined the faculty of the Cincinnati College Conservatory of Music, where he remained until 1994. Among his choreographic works is an abstract solo *Variegations* (1958), composed primarily of Horton's deep-floor exercises and pelvic lift balances, tempered by sustained strength and control.

REFERENCE

MCDONAGH, DON. "James Truitte." In *The Complete Guide to Modern Dance*. Garden City, N.Y., 1976, pp. 268–269.

THOMAS F. DEFRANTZ

Truth, Sojourner (c. 1797–November 26, 1883), abolitionist, suffragist, and spiritualist. Sojourner Truth was born Isabella Bomefree in Ulster County, N.Y., the second youngest of thirteen children born in slavery to Elizabeth (usually called Mau-Mau Bett) and James Bomefree. The other siblings were either sold or given away before her birth. The family was owned by Johannes Hardenbergh, a patroon and Revolutionary War patriot, the head of one of the most prominent Dutch families in late eighteenth-century New York.

Mau-Mau Bett was mystical and unlettered but imparted to her daughter strong faith, filial devotion, and a strong sense of individual integrity. Isabella Bomefree, whose first language was Dutch, was taken from her parents and sold to an English-speaking owner in 1808, who maltreated her because of her inability to understand English. Through her own defiance—what she later called her "talks with God"—and her father's intercession, a Dutch tavern keeper soon purchased her. Kindly treated but surrounded by the rough tavern culture and probably sexually abused, the girl prayed for a new master. In 1810 John I. Dumont of New Paltz, N.Y., purchased Isabella Bomefree for three hundred dollars.

Isabella remained Dumont's slave for eighteen years. Dumont boasted that Belle, as he called her, was "better to me than a man." She planted, plowed, cultivated, and harvested crops. She milked the farm animals, sewed, weaved, cooked, and cleaned house. But Mrs. Dumont despised and tormented her, possibly because Dumont fathered one of her children.

Isabella had two relationships with slave men. Bob, her first love, a man from a neighboring estate, was beaten senseless for "taking up" with her and was forced to take another woman. She later became associated with Thomas, with whom she remained until her freedom. Four of her five children survived to adulthood.

Although New York slavery ended for adults in 1827, Dumont promised Isabella her freedom a year earlier. When he refused to keep his promise, she fled with an infant child, guided by "the word of God" as she later related. She took refuge with Isaac Van Wagenen, who purchased her for the remainder of her time as a slave. She later adopted his family name.

Isabella Van Wagenen was profoundly shaped by a religious experience she underwent in 1827 at Pinkster time, the popular early summer African-Dutch slave holiday. As she recounted it, she forgot God's deliverance of his people from bondage and prepared to return to Dumont's farm for Pinkster: "I looked back in Egypt," she said, "and everything seemed so pleasant there." But she felt the mighty, luminous, and wrathful presence of an angry God blocking her path. Stalemated and momentarily blinded and suffocated under "God's breath," she claimed in her *Narrative,* Jesus mercifully intervened and proclaimed her salvation. This conversion enabled Isabella Van Wagenen to claim direct and special communication with Jesus and the Trinity for the remainder of her life, and she subsequently became involved with a number of highly spiritual religious groups.

A major test of faith followed Isabella Van Wagenen's conversion when she discovered that Dumont had illegally sold her son, Peter. Armed with spiritual assurance and a mother's rage, she scoured the countryside, gaining moral and financial support from prominent Dutch residents, antislavery Quakers, and local Methodists. She brought suit, and Peter was eventually returned from Alabama and freed.

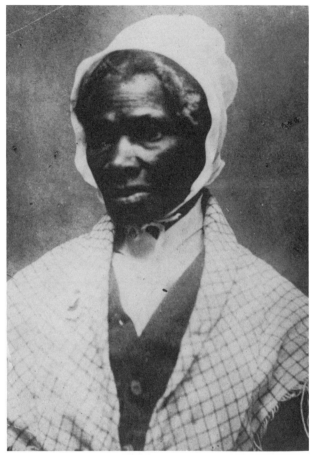

Sojourner Truth. (Photographs and Prints Division, Schomburg Center for Research in Black Culture, The New York Public Library, Astor, Lenox and Tilden Foundations)

In 1829 Isabella, now a Methodist, moved to New York City. She joined the AFRICAN METHODIST EPISCOPAL ZION CHURCH, where she discovered a brother and two sisters. She also began to attract attention for her extraordinary preaching, praying, and singing, though these talents were mainly employed among the Perfectionists (a sect of white radical mystics emerging from the Second Great Awakening who championed millennial doctrines, equated spiritual piety with morality, and social justice with true Christianity). As housekeeper for Perfectionist Elijah Pierson, Isabella was involved in "the Kingdom," a sect organized by the spiritual zealot, Robert Matthias. Among other practices he engaged in "spirit-matching," or wife swapping, with Ann Folger, wife of Pierson's business partner. Elijah Pierson's unexplained death brought public outcries of foul play. To conceal Ann Pierson's promiscuity, the Folgers suggested that there had been an erotic attachment between Matthias and Isabella Van Wagenen and that they murdered Pierson with poisoned blackberries. Challenging her accusers, Isabella Van

Wagenen vowed to "crush them with the truth." Lack of evidence and prejudice about blacks testifying against whites led to dismissal of the case. Isabella Van Wagenen triumphed by successfully suing the Folgers for slander. Though chastened by this experience with religious extremism, the association with New York Perfectionists enhanced her biblical knowledge, oratorical skills, and commitment to reform.

Isabella Van Wagenen encouraged her beloved son Peter to take up seafaring to avoid the pitfalls of urban crime. In 1843 his vessel returned without him. Devastated by this loss, facing (at forty-six) a bleak future in domestic service, and influenced by the millennarian (known as the Millerite movement) ferment sweeping the Northeast at the time, she decided to radically change her life. She became an itinerant preacher and adopted the name Sojourner Truth because voices directed her to sojourn the countryside and speak God's truth. In the fall of 1843 she became ill and was taken to the Northampton utopian community in Florence, Mass., where black abolitionist David RUGGLES nursed her at his water-cure establishment. Sojourner Truth impressed residents, who included a number of abolitionists, with her slavery accounts, scriptural interpretations, wit, and simple oral eloquence.

By 1846 Sojourner Truth had joined the antislavery circuit, traveling with Abby Kelly Foster, Frederick DOUGLASS, William Lloyd Garrison, and British M.P. George Thompson. An electrifying public orator, she soon became one of the most popular speakers for the abolitionist cause. Her fame was heightened by the publication of her *Narrative* in 1850, related and transcribed by Olive Gilbert. With proceeds from its sale she purchased a Northampton home. In 1851, speaking before a National Women's Convention in Akron, Ohio, Sojourner Truth defended the physical and spiritual strength of women, in her famous "Ain't I a Woman?" speech. In 1853 Sojourner's antislavery, spiritualist, and temperance advocacy took her to the Midwest, where she settled among spiritualists in Harmonia, Mich.

"I cannot read a book," said Sojourner Truth, "but I can read the people." She dissected political and social issues through parables of everyday life. The Constitution, silent on black rights, had a "little weevil in it." She was known for her captivating one-line retorts. An Indiana audience threatened to torch the building if she spoke. Sojourner Truth replied, "Then I will speak to the ashes." In the late 1840s, grounded in faith that God and moral suasion would eradicate bondage, she challenged her despairing friend Douglass with "Frederick, is God dead?" In 1858, when a group of men questioned her gender, claiming she wasn't properly feminine in her demeanor, Sojourner

Truth, a bold early feminist, exposed her bosom to the entire assembly, proclaiming that shame was not hers but theirs.

During the Civil War Sojourner Truth recruited and supported Michigan's black regiment, counseled freedwomen, set up employment operations for freedpeople willing to relocate, and initiated desegregation of streetcars in Washington, D.C. In 1864 she had an audience with Abraham Lincoln. Following the war, Sojourner Truth moved to Michigan, settling in Battle Creek, but remained active in numerous reform causes. She supported the Fifteenth Amendment and women's suffrage.

Disillusioned by the failure of RECONSTRUCTION, Sojourner Truth devoted her last years to the support of a black western homeland. In her later years, despite decades of interracial cooperation, she became skeptical of collaboration with whites and became an advocate of racial separation. She died in 1883 in Battle Creek, attended by the famous physician and breakfast cereal founder John Harvey Kellogg.

REFERENCES

FAUSET, ARTHUR H. *Sojourner Truth*. Chapel Hill, N.C., 1938.

WASHINGTON, MARGARET, ed. *Narrative of Sojourner Truth*. New York, 1993.

YELLIN, JEAN FAGAN. *Women and Sisters: The Antislavery Feminists in American Culture*. New Haven, 1989.

MARGARET WASHINGTON

Tubman, Harriet Ross (c. 1820–March 10, 1913), abolitionist, nurse, and feminist. Harriet Ross, one of eleven children born to slaves Benjamin Ross and Harriet Green, was born about 1820 in Dorchester County in Maryland. Although she was known on the plantation as Harriet Ross, her family called her Araminta, or "Minty," a name given to her by her mother.

Like most slaves, Ross had no formal education and began work on the plantation as a child. When she was five years old, her master rented her out to a neighboring family, the Cooks, as a domestic servant. At age thirteen, Ross suffered permanent neurological damage after either her overseer or owner struck her in the head with a two-pound lead weight when she placed herself between her master and a fleeing slave. For the rest of her life, she experienced sudden blackouts.

In 1844, she married John Tubman, a free black who lived on a nearby plantation. Her husband's free status, however, did not transfer to Harriet upon their marriage. Between 1847 and 1849, after the death of her master, Tubman worked in the household of Anthony Thompson, a physician and preacher. Thompson was the legal guardian of Tubman's new master, who was still too young to operate the plantation. When the young master died, Tubman faced an uncertain future, and rumors circulated that Thompson would sell slaves out of the state.

In response, Tubman escaped from SLAVERY in 1849, leaving behind her husband, who refused to accompany her. She settled in Philadelphia, where she found work as a scrubwoman. She returned to Maryland for her husband two years later, but John Tubman had remarried.

Tubman's successful escape to the free state of Pennsylvania, however, did not guarantee her safety, particularly after the passage of the FUGITIVE SLAVE LAW of 1850, which facilitated southern slaveholding efforts to recover runaway slaves. Shortly after her escape from slavery, Tubman became involved in the ABOLITION movement, forming friendships with one of the black leaders of the UNDERGROUND RAILROAD, William STILL, and white abolitionist Thomas Gar-

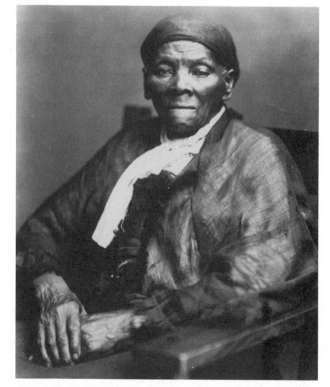

An escaped Maryland slave, Harriet Tubman became the best-known leader of rescue expeditions on the Underground Railroad, bringing more than two hundred persons to freedom on at least fifteen trips to the South. Well before the Civil War, she had attained a legendary status among both slaves and abolitionists. (Prints and Photographs Division, Library of Congress)

rett. While many of her abolitionist colleagues organized antislavery societies, wrote and spoke against slavery, and raised money for the cause, Tubman's abolitionist activities were more directly related to the actual freeing of slaves on the Underground Railroad. She worked as an agent on the railroad, assuming different disguises to assist runaways in obtaining food, shelter, clothing, cash, and transportation. Tubman might appear as a feeble, old woman or as a demented, impoverished man, and she was known for the rifle she carried on rescue missions, both for her own protection and to intimidate fugitives who might become fainthearted along the journey.

Tubman traveled to the South nineteen times to rescue approximately three hundred African-American men, women, and children from bondage. Her first rescue mission was to Baltimore, Md., in 1850 to help her sister and two children escape from slavery. Her noteriety as a leader of the Underground Railroad led some Maryland planters to offer a $40,000 bounty for her capture. Having relocated many runaways to Canada, Tubman herself settled in the village of St. Catharines, Canada West (now Ontario), in the early 1850s. She traveled to the South in 1851 to rescue her brother and his wife, and returned in 1857 to rescue her parents, with whom she resettled in Auburn, N.Y., shortly thereafter.

Tubman's involvement in the abolitionist movement placed her in contact with many progressive social leaders in the North, including John Brown, whom she met in 1858. She helped Brown plan his raid on Harpers Ferry, Va., in 1859 (*see* JOHN BROWN'S RAID AT HARPERS FERRY, VIRGINIA), but illness prevented her from participating. Tubman's last trip to the South took place in 1860, after which she returned to Canada. In 1861, she moved back to the United States as the last of eleven southern states seceded from the Union.

When the CIVIL WAR broke out, Tubman served in the Union Army as a scout, spy, and nurse. In 1862, she went to Beaufort, S.C., where she nursed both white soldiers and black refugees from neighboring southern plantations. Tubman traveled from camp to camp in the coastal regions of South Carolina, Georgia, and Florida, administering her nursing skills wherever they were needed. Tubman also worked as a scout for the Union Army, traveling behind enemy lines to gather information and recruit slaves. She supported herself by selling chickens, eggs, root beer, and pies. After returning briefly to Beaufort, Tubman worked during the spring and summer of 1865 at a freedman's hospital in Fortress Monroe, Va.

After the war's end, Tubman eventually returned to Auburn to care for her elderly parents. Penniless, she helped support her family by farming. In 1869, Tubman married Nelson Davis, a Civil War veteran.

That same year, she published *Scenes in the Life of Harriet Tubman,* written for her by Sarah H. Bradford and printed and circulated by Gerrit Smith and Wendall Phillips. Tubman received some royalties from the book, but she was less successful in her effort to obtain financial compensation for her war work. She agitated for nearly thirty years for $1,800 compensation for her service as a Civil War nurse and cook. In 1890, Congress finally awarded Tubman a monthly pension of $20 as a widow of a war veteran.

Tubman's activism continued on many fronts after the Civil War ended. She was an ardent supporter of women's suffrage and regularly attended women's rights meetings. To Tubman, racial liberation and women's rights were inextricably linked. Tubman formed close relationships with Susan B. Anthony and other feminists. She was a delegate to the first convention of the NATIONAL FEDERATION OF AFRO-AMERICAN WOMEN in 1896 (later called the NATIONAL ASSOCIATION OF COLORED WOMEN). The following year, the New England Women's Suffrage Association held a reception in Tubman's honor.

While living in Auburn, Tubman continued her work in the black community by taking in orphans and the elderly, often receiving assistance from wealthier neighbors. She helped establish schools for former slaves and wanted to establish a permanent home for poor and sick blacks. Tubman secured twenty-five acres in Auburn through a bank loan, but lacked the necessary funds to build on the land. In 1903, she deeded the land to the AFRICAN METHODIST EPISCOPAL ZION CHURCH, and five years later, the congregation built the Harriet Tubman Home for Indigent and Aged Negroes, which continued to operate for several years after Tubman's death and was declared a National Historic Landmark in 1974.

Tubman died on March 10, 1913, at the age of ninety-three. Local Civil War veterans led the funeral march. The National Association of Colored Women later paid for the funeral and for the marble tombstone over Tubman's grave. A year after her death, black educator Booker T. WASHINGTON delivered a memorial address in celebration of Tubman's life and labors and on behalf of freedom. In 1978, the United States Postal Service issued the first stamp in its Black Heritage USA Series to honor Tubman.

Tubman, dubbed "the Moses of her people," had obtained legendary status in the African-American community within ten years of her escape to freedom. Perhaps more than any other figure of her time, Tubman personified resistance to slavery, and she became a symbol of courage and strength to African Americans—slave and free. The secrecy surrounding Tubman's activities on the Underground Railroad and her own reticence to talk about her role contributed to her mythic status. Heroic images of the rifle-

carrying Tubman have persisted well into the twentieth century as Tubman has become the leading symbol of the Underground Railroad.

REFERENCES

BRADFORD, SARA. *Harriet Tubman: The Moses of Her People.* 1886. Reprint. New York, 1961.
CONRAD, CARL. *Harriet Tubman.* New York, 1943.
LITWACK, LEON, and AUGUST MEIER. *Black Leaders of the Nineteenth Century.* Urbana, Ill., 1988.

LOUISE P. MAXWELL

Tucker, Lorenzo (June 28, 1907–August 19, 1986), actor. Lorenzo Tucker, a light-skinned matinee idol of all-black cinema, was born in Philadelphia. Tucker's father, a construction laborer, died when he was six, and he accompanied his mother to her birthplace, the all-black town of Ware Neck, Va. After Tucker finished high school, the family returned to Philadelphia. Tucker's mother wanted him to study medicine, and he enrolled at Temple University, but in the summer of 1925 he left for Atlantic City, N.J., to become a waiter. There he became involved in the entertainment industry. In 1927, Tucker moved to Harlem, and was hired by singer Bessie Smith as the emcee of her show *The Harlem Follies* at the Lenox Theater. He also joined the noted Lafayette Stock Company, playing minor roles.

In 1927, at a theatrical audition, Tucker was "discovered" by African-American filmmaker Oscar MICHEAUX, who cast him as leading man in *A Fool's Errand* and *When Men Betray*. After *The Wages of Sin* (1928), which established him as a star in the black community, Micheaux dubbed him "The Colored Valentino." Tucker made nine films for Micheaux in the next four years, including *The Exile* (1931), the first all-talking black-made film. Tucker played such roles as doctors, professors, and detectives. In 1931, Tucker left Micheaux's company. The following year, he played a supporting role in *The Black King*, a white-produced satire on Garveyism, and in 1933 he was an extra in *The Emperor Jones*.

In 1931, playwright–actress Mae West hired Tucker to play a pimp, her lover in the Broadway production of *The Constant Sinner*. West's producers persuaded her to cast a white man in blackface, and Tucker played a lesser role in the original production. During the national tour, beginning in Washington, D.C., West insisted that Tucker play the role. After two performances, police closed the show.

In 1933, married and unable to find good roles, Tucker quit performing and established a painting business. A few years later, in need of money, he

returned to acting. Oscar Micheaux cast him in supporting roles in *Temptation* (1936) and *Underworld* (1937), and Tucker appeared in the white-produced films *Straight to Heaven* (1938) and *Paradise in Harlem* (1939). In 1937 he helped form the Negro Actors Guild (today the Afro-American Guild of Performing Artists). During World War II, Tucker was drafted into the Army Air Corps, where he organized variety shows. In 1945, Tucker, passing as white, was road manager and bit player in a black U.S.O. tour of *Porgy and Bess*. Afterward, he returned to movies, playing small parts in the Bert and Jack Goldberg productions *Boy! What a Girl* (1946) and *Sepia Cinderella* (1947). His last film was *Reet, Petite and Gone* (1947). During the ensuing years, Tucker toured in all-black productions of such shows as *Harvey* and *Anna Lucasta*.

Tucker spent the 1960s as an assistant to the Medical Examiner of New York City, helping perform autopsies. (He later was present at the autopsy of MALCOLM X.) In the 1970s and 1980s, he was employed as a résumé photographer in New York and Los Angeles, and unsuccessfully sought acting work. He was inducted into the Black Filmmakers' Hall of Fame in 1974, and that year received the first Oscar Micheaux Award.

REFERENCES

BOGLE, DONALD. *Toms, Coons, Mulattos, Mammies, and Bucks: An Interpretive History of Blacks in American Films.* New York, 1989.
GRUPENHOFF, RICHARD. *The Black Valentino: The Stage and Screen Career of Lorenzo Tucker.* Metuchen, N.J., 1988.

GREG ROBINSON

Tulsa Riot of 1921. In 1921, Tulsa, Okla., had a booming economy, thanks to the growth of the oil industry. Its population had quintupled in ten years, reaching almost 100,000 in 1921. It was also a major KU KLUX KLAN center. Several LYNCHINGS had occurred in the area, and "whipping parties" attacked African Americans on the average of once a day. Blacks armed themselves to resist white mobs.

On May 30, 1921, Dick Rowland, a black bootblack, jostled a white woman, Sarah Page, in an elevator in a crowded downtown building. Page claimed Rowland had tried to rape her. The next day, the *Tulsa Tribune* reported the story of the fictitious attack and added a headline that said Rowland would be lynched that night. That evening, a white mob surrounded the courthouse where Rowland was being held. Police did nothing to disperse the crowd.

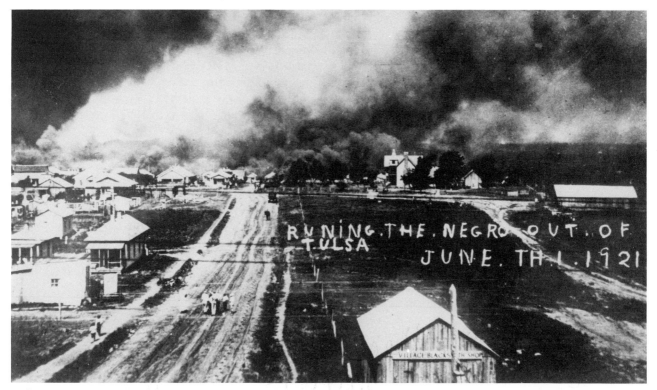

Tulsa race riot, June 1, 1921. (Archives & Manuscripts Division of the Oklahoma Historical Society)

When a group of seventy-five African Americans arrived and offered to help the police defend Rowland, authorities dismissed them and tried to disarm them. An argument ensued, a shot was fired, and rioting began. Whites and blacks exchanged gunfire and fought. The blacks, vastly outnumbered, retreated to the black section of Greenwood. Police refused to intervene. While blacks desprately held off the mob, whites surrounded the area and began drive-through raids, shooting from automobiles. Black Tulsa was eventually completely leveled by fire (according to some accounts, two airplanes flew over the neighborhood and dropped bombs). African Americans with no place to hide ran from the flames and were shot down or beaten. Police began arresting blacks for their own safety; eventually half of Tulsa's black population of 11,000 was interned in tents outside the city.

At 11:30 P.M., the mayor declared martial law, and the rioting began to slow. By the time the National Guard was called in the following morning, the violence was all but over. At least 36 people, 26 of them black, and possibly up to 175, had been killed, and 11,000 blacks were homeless. White officials, embarrassed by the negative publicity, promised to rebuild black Tulsa, but the internments lasted weeks, and city authorities played only a minimal role in the reconstruction of the black areas. The grand jury report predictably blamed the incident on black agitation for equality and hoarding of firearms and declined to charge any whites for rioting or murder. However, the shock of the riot calmed racial tensions, and after the riot, there were no further lynchings in the Tulsa area. Rowland was released, as were 27 blacks arrested on murder charges following their self-defense efforts.

In certain respects, the Tulsa riot was related to the lynch riots of the 1990s and to the epidemic of violence during RED SUMMER two years previously—although the burning of an entire neighborhood was unprecedented as was the full-scale bombing of black houses. The ferocity of white rioters and the magnitude of black self-defense efforts mark the Tulsa riot as the beginning of an ugly new epoch in American racial violence.

REFERENCE

ELLSWORTH, SCOTT. *Death in a Promised Land: The Tulsa Race Riot of 1921.* Baton Rouge, La., 1982.

GREG ROBINSON

Turner, Benjamin Sterling (March 17, 1825–March 21, 1894), congressman and merchant. Born into slavery near Weldon, N.C., Benjamin S. Turner was taken by his owner, a widow, to Alabama when

he was five. Allegedly taught by his owner's children to read, Turner was sold when he was twenty. His new master permitted him to hire his own time. As a result, Turner became a successful merchant and ran a thriving livery stable. After the Civil War, he ran an omnibus company and accumulated property in Selma, Ala.

Turner got involved in local politics, serving as a tax collector for Dallas County and later on the city council of Selma. In 1870 Turner was easily elected to Congress. While he never addressed the floor, two of Turner's eloquent speeches were read into the Congressional Record. One speech called for a refund of the cotton tax levied on the South which Turner claimed was economically crippling to blacks and whites alike. The other, much less controversial, proposed federal grants to help rebuild government buildings in Selma destroyed by the war.

Turner was generally loyal to the REPUBLICAN PARTY, almost always voting the party line on such issues as education, the test-oath, and civil rights. A proponent of reconciliation, Turner also urged amnesty for ex-Confederates. In 1872 Turner faced freeborn African American Philip Joseph for the nomination. Both candidates ran anyway, split the vote, and the Democrat won. In March 1873, Turner returned to Alabama and his business. Although he participated in Republican conventions, he never again ran for office. After losing much of his fortune during the recession in the 1870s, he returned to farming and died in Alabama in 1894 in relative poverty and obscurity.

REFERENCES

CHRISTOPHER, MAURINE. *Black Americans in Congress.* New York, 1976.

FONER, ERIC. *Freedom's Lawmakers: A Directory of Black Officeholders during Reconstruction.* New York, 1993.

MCFARLIN, ANNJENNETTE SOPHIE. *Black Congressional Reconstruction Orators and their Orations, 1869–1879.* Metuchen, N.J., 1976.

ALANA J. ERICKSON

Benjamin S. Turner, Alabama's first African-American member of Congress (1871–1872). (Prints and Photographs Division, Library of Congress)

Turner, Charles Henry (February 3, 1867–1923), zoologist. Charles Turner was born in Cincinnati, Ohio, where he completed high school and graduated from the University of Cincinnati with a B.S. in 1891 and an M.A. in biology in 1892. The following year he became an instructor at CLARK College in Atlanta, Ga., where he served until 1895. From 1895 to 1905 he taught in the public high schools of Evansville, Ind., and Cincinnati, and then moved to Cleveland, Tenn., to become the principal of College Hill High School. In the following year, he moved to Augusta, Ga., to become a professor of biology at Haines Normal and Industrial Institute. In 1907 he earned a Ph.D. from the University of Chicago in zoology, writing a dissertation entitled "The Homing of Ants—an Experimental Study of Ant Behavior." In 1908, Turner traveled to St. Louis, Mo., to become a biology teacher at Sumner High School, where he remained for the rest of his life.

After receiving his doctorate, Turner published numerous articles on the behavior of arthropods, including "Habits of Mound-Building Ants," "Experiments on the Color Vision of the Honeybee," "Hunting Habits of an American Sand Wasp," and "Psychological Notes on the Gallery Spider." These and other articles appeared in various journals—*Biological Bulletin, Journal of Comparative Neurology, Zoological Bulletin, Journal of Animal Behavior and Psychological Bulletin.* His work appeared in several books, including *The Animal Mind* (1908), *The Psychic Life of Insects* (1922), and *Wheeler's Ant Book* (1926). A characteristic ant movement (toward a ground nest) first observed and described by Turner, became known as

"Turner's circling." In 1925, two years after his death, a school for disabled black children in St. Louis was named in his honor.

REFERENCES

"Dr. Charles Henry Turner." *Transactions of the Academy of Science of St. Louis* (May 25, 1923).
HAYDEN, ROBERT C. "Dr. Charles H. Turner." In *Seven African American Scientists,* Frederick, Md., 1992.

ROBERT C. HAYDEN

Turner, Henry McNeal (February 1, 1834–May 8, 1915), theologian, African colonizationist. Born free in Newberry Courthouse, S.C., Henry McNeal Turner worked picking cotton during his youth. He experienced an emotional conversion at a camp meeting as a teenager. Licensed to preach by the Methodist Episcopal Church-South in 1853, he took to the road as a traveling evangelist. In 1858, he joined the AFRICAN METHODIST EPISCOPAL (AME) CHURCH in St. Louis and spent the next five years as an AME pastor in Baltimore and in Washington, D.C. In 1863, Turner organized the first regiment of the U.S. Colored Troops in his churchyard and was commissioned as chaplain, becoming probably the first African-American army chaplain. He was present at battles in Petersburg, Va., and Fort Fisher, N.C.

Following the end of the Civil War, Turner traveled to Georgia, where he was briefly a Freedmen's Bureau agent. Appointed presiding elder of AME missions in Georgia, Turner was largely responsible for the tremendous growth of the AME church in the state. In 1867, Turner was elected a delegate to the Georgia constitutional convention. There he primarily supported conservative and elitist positions, such as a clemency petition for Jefferson Davis and opposition to land reform and tax sales of planter property, though he supported the creation of public schools. In 1868, Turner was elected to the Georgia legislature. The following year, all African-American representatives were illegally expelled from the legislature. Turner was named postmaster in Macon, Ga., but resigned after white Macon residents exposed his association with a prostitute. In 1870, he returned to the legislature. His political career was marked by growing distrust for whites and support for problack measures such as protection for sharecroppers. He largely abandoned politics in the early 1870s, although he was a candidate to the national convention of the Prohibition party in the mid-1880s. Turner did continue to speak out on issues, however.

Henry McNeal Turner. (Photographs and Prints Division, Schomburg Center for Research in Black Culture, The New York Public Library, Astor, Lenox and Tilden Foundations)

He was an outspoken advocate of the Civil Rights Act of 1875, and strongly denounced the U.S. Supreme Court for voiding most of that legislation eight years later. During the late 1890s, he was a passionate opponent of imperialist measures, such as the United States' annexation of Hawaii, and called the takeover of the Philippines "the crime of the century." In 1906, Turner joined with W. E. B. DU BOIS and others in founding the Georgia Equal Rights League.

In 1876, Turner was named manager of the AME Book Concern in Philadelphia. During the following years, he published the *Christian Recorder* journal, compiled a hymnbook, wrote *The Genius of Methodist Polity* (1885), and put together a *Catechism of the AME Church*. In 1880, Turner was elected a bishop in the AME church. One of the first southerners to become a church leader, his election was opposed by several northern bishops. He soon became a controversial figure in the church as a result of his advocacy of services with elaborate vestments and rituals along with his emotional preaching style. Turner believed it was the church's duty to instill pride and self-respect in its members. A forerunner of the black theology movement, he rejected white teachings of black inferiority. Explaining that blacks had no less right than whites to depict the Creator in their own

image, he called for a black translation of the Bible and often stated that "God is a Negro." In 1885, Turner became the first minister to ordain a woman, Sarah Ann Hughes, to the ministry. His act was later rescinded by Bishop Jabez Campbell at the 1887 North Carolina Annual Conference of Bishops. In 1890, he was named chairman of the board of Atlanta's Morris Brown College, which in 1900 founded the Turner Theological Seminary in his honor. In 1892 Turner became editor of the monthly AME magazine, *Voice of Missions,* and published articles on discrimination, black history, and other issues. In 1900, Turner left the journal and began his own organ, *Voice of the People.*

Turner is best known for his black nationalist ideas and advocacy of African colonization. As early as 1866, he had expressed interest in emigration, and in 1876 drew widespread black criticism by serving as vice president of the American Colonization Society, still despised by many blacks as a racist group. By the 1880s, he had become convinced that there was no future for blacks in the United States, and in 1893 Turner organized an Afro-American convention in Cincinnati, where he strongly urged blacks to emigrate to Africa in order to Christianize the continent and to build up black businesses and governments. He insisted that the federal government finance the project as reparation for slavery. Turner himself made four trips to Africa during the 1890s. In 1891, he traveled to Liberia to found schools and to convert Liberians to Christianity. He founded annual conferences there, in Sierra Leone, in British South Africa (where he named a "vicar-bishop"), and in the Transvaal. Turner's opponents attacked him for his overly positive depiction of life in Africa and his unrealistic plans for mass emigration. His conservatism and belief in building separate black institutions led him, on occasion, like Marcus GARVEY in a later generation, into questionable alliances with race-baiting white politicians.

In the mid-1890s, two boatloads of African Americans left for Liberia, but they faced hardship and many later returned. The failure of this mission helped discredit Turner's emigration program. His influence waned after 1900, but he remained active. In 1915, while in Windsor, Ontario, for a church function, he died of a stroke. Despite some idiosyncrasies, Turner was a passionate defender of the cultural and political independence of African Americans and was the most influential black nationalist of the second half of the nineteenth century.

REFERENCES

ANGELL, STEPHEN WARD. *Bishop Henry McNeal Turner and African-American Religion in the South.* Knoxville, Tenn., 1992.

REDKEY, EDWIN. *Black Exodus: Black Nationalist and Back-to-Africa Movements, 1890–1910.* New Haven, Conn., 1969.

———, ed. *Respect Black: The Writings and Speeches of Henry McNeal Turner.* New York, 1971.

STEPHEN W. ANGELL

Turner, Joseph Vernon "Big Joe" (1911–November 24, 1985), blues singer. Big Joe Turner was one of the pioneering blues and rhythm-and-blues "shouters." Always interested in singing, Turner worked as a combination bartender/cook/bouncer/singer in local establishments such as the Black & Tan Club and Piney Brown's Place during the Great Depression. He was soon in demand as a vocalist for local jump-blues and jazz bands led by Bennie MOTEN, Andy Kirk, and COUNT BASIE. His recording career began in the late 1930s, often in the company of boogie-woogie stylist Pete Johnson or other blues pianists.

Turner gained his initial major exposure as part of the first "Spirituals to Swing" Carnegie Hall concerts in 1938, which led to other radio network jobs and live performances at clubs throughout the United States. He continued to work regularly in primarily African-American clubs until he crossed over to a white audience with his recording of "Shake, Rattle, and Roll" in 1954. His rhythm and blues recordings for Atlantic Records (1951–1959) were crucial in bringing Turner to a larger audience. He remained a performer in demand throughout the rest of his career, shouting standards such as "T.V. Mama," "Roll 'em Pete," and "Piney Brown Blues" up until his death.

REFERENCES

CLINCO, P. "Interview with Joe Turner." *Living Blues* 10 (1972): 20.

OLIVER, PAUL. "Turner, (Big) Joe." In *The New Grove Dictionary of American Music.* Vol. 4. New York, 1986, p. 427.

KIP LORNELL

Turner, Lorenzo Dow (January 1895–February 10, 1972), linguist and ethnologist. Lorenzo Dow Turner, the first important African-American linguist, is best known for the book *Africanisms in the Gullah Dialect* (1949), and for scholarly articles tracing the influence of African languages on African-American speech. He was born in Elizabeth City, N.C. He attended Howard University Academy, graduating in 1910, then entered HOWARD UNIVER-

SITY, where he received his bachelor's degree in 1914. He then attended Harvard University, where he received a master's degree in English in 1917. The same year, Turner was hired as chair of the English Department of Howard University. During his time at Howard, Turner studied for a doctoral degree in English at the University of Chicago, and received his Ph.D. in 1926. His thesis, *Anti-Slavery Sentiment in American Literature Prior to 1865*, was published in 1929.

In 1928 Turner left Howard University, and he and his brother Arthur began a short-lived newspaper, the *Washington Sun*, with Turner serving as editor. After the paper's demise, Turner accepted a position as head of the English Department at FISK UNIVERSITY in Nashville, Tenn. In addition to teaching, Turner was coeditor with Otelia Cromwell and Eva Dykes of a literary textbook, *Readings from Negro Authors for Schools and Colleges* (1931).

During the period, Turner taught summer courses at assorted black colleges. Through his work, he became interested in rural southern black English dialects. In 1929 he first heard and became interested in the Gullah dialect. The following year, he began to attend summer Institutes of the Linguistics Society (of which he became the first African-American member in 1931) and from 1932 through 1935 he did field work and collected data for the Linguistics Atlas Project on Gullah and Louisiana Creole. Turner and other scholars, notably Melville Herskovits, rebutted the popular assumption that no artifacts of African culture had survived in the New World. Having studied Gullah, Turner began to study African languages to find similarities. In the late 1930s, Turner received a series of grants, with which he studied African languages in England and France. In 1940, he spent a year in Brazil, where he compiled large amounts of data on customs and language. In the years following his return, Turner published a series of articles based on his research. Turner's research culminated in a book, *Africanisms in the Gullah Dialect* (1949). In this work, Turner presented transcribed texts and word lists, and explained the relationship between Gullah and African languages of the Niger-Kordofanian family in terms of etymology, syntax, grammar, and pronunciation. His work inspired linguistic studies of creole dialects, a reevaluation of the role of Black English, and more generally, the nature of African retentions in southern African-American cultures.

In 1944 Turner moved from Fisk's English Department to become Director of its Inter-Departmental Curriculum in African Studies. Two years later, he accepted an invitation to join the faculty of Roosevelt College, an experimental integrated college in Chicago, as professor of English and lecturer in African culture. Turner remained at Roosevelt until his death. During these years, he published articles on JAZZ, Zulu culture, Western education in Africa, and African-American literature. Turner's expertise in African linguistics served him well when he was made Peace Corps Faculty Coordinator at Roosevelt in the early 1960s. He prepared two works dealing with the Krio language, spoken in Sierra Leone, for Peace Corps volunteers assigned there: *An Anthology of Krio Folklore and Literature with Notes and Inter-linear Translations in English* (1963) and *Krio Texts: With Grammatical Notes and Translations in English* (1965). Turner died in Chicago.

REFERENCES

TURNER, LORENZO DOW. *Africanisms in the Gullah Dialect*. Chicago, 1949. Reprint, with a foreword by David DeCamp. Ann Arbor, Mich., 1974.

WADE-LEWIS, MARGARET. "Lorenzo Dow Turner: Pioneer African-American Linguist." *Black Scholar* 21, no. 4 (Fall 1991): 10–24.

GREG ROBINSON

Turner, Nat. *See* Nat Turner Controversy; Nat Turner's Rebellion.

Turner, Thomas Wyatt (March 16, 1877–April 21, 1978), teacher, botanist. Born in Hughesville, Md., the son of Eli Turner, a former slave who became a sharecropper, and his wife, Linnie Gross, Thomas Wyatt Turner received his early education in rural schools in Charles County, Md., and then at Howard University Preparatory School. To get to Howard, Turner walked the fifty miles from his hometown. He graduated with an A.B. from Howard in 1901. Later, he earned an A.M. at Howard (1905) and a Ph.D. in botany at Cornell University (1921).

Turner taught biology at Tuskegee Institute (1901–1902) and at high schools in Baltimore and St. Louis (1902–1912). In 1913, he joined the faculty of Howard University as professor of applied biology. He served as acting dean of Howard's School of Education from 1914 to 1920. The year after he earned a Ph.D. at Cornell, his doctoral thesis was published in *American Journal of Botany*. His research focused on plant physiology and pathology, and especially the effects of mineral nutrients on root growth. In 1924, he became professor and head of the department of natural sciences at HAMPTON INSTITUTE, where he remained until 1945.

From 1947 to 1948 Turner served as consultant to Florida Normal College in St. Augustine, and from

1949 to 1950 he was professor of biology at Texas Southern University. In 1952 he received the Howard University Alumni Award for distinguished achievement in the field of education. In 1976 he was awarded an honorary doctorate of science degree from Catholic University, and two years later Hampton Institute renamed its science building Turner Hall in his honor.

Turner was a charter member of the NAACP in 1909. A devout Roman Catholic, in 1915 he founded and served several terms as president of the Federated Colored Catholics of the United States. This organization fought discrimination and promoted interracial harmony within the Church. Turner wrote several papers on science education in black colleges and universities. He was the first black permitted to present a paper before the Virginia Academy of Science. At the 1925 conference of the American Association for the Advancement of Science in Kansas City, he stood his ground when hotel personnel ordered him to use the freight elevator. "I am not freight," he said—and joined the other delegates in the passenger elevator.

REFERENCES

KERNAN, MICHAEL. "100 Years of Fortitude." *Washington Post,* March 16, 1977, pp. B1, B5.
"Turner, Thomas Wyatt." *The National Cyclopedia of American Biography.* Vol. 61. Clifton, N.J., 1982, pp. 10–11.

KENNETH R. MANNING

Turner, Tina (November 26, 1939–), pop singer. Tina Turner was born Anna Mae Bullock in Brownsville, Tenn., where she lived until the age of eleven when her parents separated. As a child she sang and danced with Bootsie Whitelaw, a local trombonist. She lived with her grandmother until the age of sixteen, and then moved to St. Louis to live again with her mother. With her older sister Alline, she frequented night clubs across the river in East St. Louis to see the popular Kings of Rhythm band, led by the rhythm and blues singer, guitarist, producer, and disc jockey Ike Turner. One night Anna Mae took the stage and sang with Turner, and, soon after, she joined the group and went on tour with Ike and the Kings of Rhythm.

In 1960 Ike Turner declared that Anna Mae Bullock would be publicly known as "Tina" and announced that her first lead-vocal debut, "A Fool in Love" (1960), would be credited to Ike and Tina Turner. In 1962 Ike and Tina were married. The couple toured and recorded until 1974 as the "Ike and Tina Turner Revue" which featured Tina with her

Tina Turner, one of the most dynamic of all pop performers, during her 1987 tour, which traveled to twenty-five countries and reached an audience of more than 3.5 million persons. A 1993 film biography of Turner's turbulent relations with her ex-husband, Ike Turner, *What's Love Got to Do with It?* had both critical and popular success. (AP/Wide World Photos)

flamboyant back-up singers and dancers, the Ikettes, accompanied by the Kings of Rhythm. They became one of the foremost rhythm and blues groups of the 1960s, distinguished by Ike's hard-driving accompaniment and Tina's hard-edged singing and seductive dancing. Their most important and popular recordings from the 1960s include "It's Gonna Work Out Fine" (1961) and "River Deep, Mountain High" (1966). A tour of the United States with the Rolling Stones in 1969 launched Ike and Tina Turner into the rock mainstream, and in 1970, they recorded Sly Stone's "I Want to Take You Higher." The next year they won a Grammy Award for "Proud Mary."

Their other hits from this period include "Nutbush City Limits" (1973) and "Sweet Rhode Island Red" (1974). In 1974 Tina Turner embarked upon an acting career, starring in the movie version of the Who's rock opera, *Tommy*.

Ike and Tina Turner separated in 1975, with Tina claiming she was the victim of frequent domestic abuse. Their divorce came in 1978, and Tina built her solo career. Her appearances with Rod Stewart and the Rolling Stones led to her signing with Capitol Records in 1983. Her 1984 album *Private Dancer,* including a revival of Al Green's "Let's Stay Together," marked her arrival as a solo performer. Turner won three Grammys for *Private Dancer* (1984) which included, "What's Love Got to Do with It?"

By the mid-1980s Turner had become a major pop singer in her own right, and was famed for her towering mane of hair, revealing costumes, and sexually charged strutting dances. In 1985 she resumed her acting career with the film *Mad Max 3: Beyond Thunderdome* whose soundtrack included her performances of "We Don't Need Another Hero" and the Grammy-winning "One of the Living." After publishing her autobiography, *I, Tina,* in 1986, Turner released *Break Every Rule,* a best-selling album that also won another Grammy. Turner then went on a 145-city tour, parts of which were released as *Tina Live in Europe!* (1988). In 1988, Turner announced that she was retiring from touring to focus on her acting career, but the following year she toured to promote her *Foreign Affair* album (1989). She continues to tour and record and has also remained involved in film, serving as consultant for the feature film *What's Love Got to Do with It?* (1993) which was based on her autobiography.

REFERENCES

HIRSHEY, GERRI. "Woman Warrior." GQ 63 (June 1993): 180.
TURNER, TINA, with Kurt Loder. *I, Tina.* New York, 1986.

KYRA D. GAUNT

Tuskegee Civic Association.

The Tuskegee Civic Association (TCA) has functioned in Alabama since 1941. It was founded to ensure equality of opportunity and full citizenship rights for the African Americans of Macon County, of which Tuskegee is the seat of government.

The predecessor of the TCA was the Tuskegee Men's Club, begun in 1910; this organization included Tuskegee Institute (later known as TUSKEGEE UNIVERSITY) faculty and administrators, as well as some of the staff of the Tuskegee Veterans Hospital.

Charles Gomillion, a Tuskegee Institute sociology professor and long-standing Men's Club member, favored the inclusion in the latter organization of activist women. This change was accepted, and in 1941 Gomillion became head of the Tuskegee Civic Association.

The TCA's primary goals were to stop the disfranchisement of African Americans, to improve public and social services, and to increase employment and education opportunities for African Americans. Gomillion and other TCA members engaged in a protracted, but eventually victorious, struggle to register to vote despite the opposition of local whites. Moreover, Gomillion sued Tuskegee mayor Philip Lightfoot, charging that the Alabama legislature had, in May 1957, redefined the city limits to exclude blacks and to give whites political control. The Supreme Court ruled that the Fifteenth Amendment rights of Tuskegee blacks had been violated by the gerrymander. *Gomillion* v. *Lightfoot* (1960) gave blacks a major triumph over segregationists who had tried to crush the political power of the predominantly black Macon County population.

REFERENCES

GUZMAN, JESSIE PARKHURST. *Crusade for Civic Democracy: The Story of the Tuskegee Civic Association, 1941–1970.* New York, 1984.
NORRELL, ROBERT. *Reaping the Whirlwind: The Civil Rights Movement in Tuskegee.* New York, 1985.

LOIS LYLES

Tuskegee Syphilis Experiment.

In the early twentieth century, African Americans in the South faced numerous public health problems, including tuberculosis, hookworm, pellagra, and rickets; their death rates far exceeded those of whites. The public health problems of blacks had several causes—poverty, ignorance of proper health procedures, and inadequate medical care—all compounded by racism that systematically denied African Americans equal services. In an affort to alleviate these problems, in 1912 the federal government united all of its health-related activities under the Public Health Service (PHS). One of the primary concerns of the PHS was syphilis, a disease that was thought to have a moral as well as a physiological dimension. In 1918 a special Division of Venereal Diseases of PHS was created.

In the late 1920s, the PHS joined forces with the Rosenwald fund (a private philanthropic foundation based in Chicago) to develop a syphilis control program for blacks in the South. Most doctors assumed that blacks suffered a much higher infection rate than whites because blacks abandoned themselves to pro-

miscuity. And once infected, the argument went, blacks remained infected because they were too poor and too ignorant to seek medical care. To test these theories, PHS officers selected communities in six different southern states, examined the local black populations to ascertain the incidence of syphilis, and offered free treatment to those who were infected. This pilot program had hardly gotten underway, however, when the stock market collapse in 1929 forced the Rosenwald Fund to terminate its support, and the PHS was left without sufficient funds to follow up its syphilis control work among blacks in the South.

Macon County, Ala., was the site of one of those original pilot programs. Its county seat, Tuskegee, was the home of the famed Tuskegee Institute. It was in and around Tuskegee that the PHS had discovered an infection rate of 35 percent among those tested,

Medical tests conducted in 1954 during the Tuskegee study of venereal disease, including (above) electrocardiogram and pulse rate and (below) spinal tap.

the highest incidence in the six communities studied. In fact, despite the presence of the Tuskegee Institute, which boasted a well-equipped hospital that might have provided low-cost health care to blacks in the region, Macon County was home not only to the worst poverty but the most sickly residents the PHS uncovered anywhere in the South. It was precisely this ready-made laboratory of human suffering that prompted the PHS to return to Macon County in 1932. Since they could not afford to treat syphilis, the PHS officers decided to document the damage to its victims by launching a study of the effects of untreated syphilis on black males. Many white Southerners (including physicians) believed that although practically all blacks had syphilis, it did not harm them as severely as it did whites. PHS officials knew that syphilis was a serious threat to the health of black Americans, and they intended to use the results of the study to pressure southern state legislatures into appropriating funds for syphilis control work among rural blacks.

Armed with these good motives, the PHS launched the Tuskegee Study in 1932. It involved approximately four hundred black males, who tested positive for the disease, and two hundred nonsyphilitic black males to serve as controls. In order to secure cooperation, the PHS told the local residents that they had returned to Macon County to treat people who were ill. The PHS did not inform them that they had syphilis. Instead, the men were told they had "bad blood," a catchall phrase rural blacks used to describe a host of ailments.

While the PHS had not intended to treat the men, state health officials demanded, as the price of their cooperation, that the men be given at least enough medication to render them noninfectious. Consequently, all of the men received a little treatment. No one worried much about the glaring contradiction of offering treatment in a study of untreated syphilis because the men had not received enough treatment to cure them. Thus, the experiment was scientifically flawed from the outset.

Although the original plan called for a one-year experiment, the Tuskegee Study continued until 1972 partly because many of the health officers became fascinated by the scientific potential of a long-range study of syphilis. No doubt others rationalized the study by telling themselves that the men were too poor to afford proper treatment, or that too much time had passed for treatment to be of any benefit. The health officials, in some cases, may have seen the men as clinical material rather than human beings.

At any rate, as a result of the Tuskegee Study approximately one hundred black men died of untreated syphilis, scores went blind or insane, and still others endured lives of chronic ill health from syphilis-related complications. Throughout this suffering, the

PHS made no effort to treat the men and on several occasions took steps to prevent them from getting treatment on their own. As a result, the men did not receive penicillin when it became widely available after World War II.

During those same four decades, civil protests raised America's concern for the rights of black people, and the ethical standards of the medical profession regarding the treatment of nonwhite patients changed dramatically. These changes had no impact, however, on the Tuskegee Study. PHS officials published no fewer than 13 scientific papers on the experiment (several of which appeared in the nation's leading medical journals), and the PHS routinely presented sessions on it at medical conventions. The Tuskegee Study ended in 1972 because a whistle-blower in the PHS, Peter Buxtun, leaked the story to the press. At first health officials tried to defend their actions, but public outrage quickly silenced them, and they agreed to end the experiment. As part of an out-of-court settlement, the survivors were finally treated for syphilis. In addition, the men, and the families of the deceased, received small cash payments.

The forty-year deathwatch had finally ended, but its legacy can still be felt. In the wake of its hearings, Congress enacted new legislation to protect the subjects of human experiments. The Tuskegee Study left behind a host of unanswered questions about the social and racial attitudes of the medical establishment in the United States. It served as a cruel reminder of how class distinctions and racism could negate ethical and scientific standards.

REFERENCES

JONES, JAMES H. *Bad Blood*. New York, 1981.
"The Tuskegee Study." 3 parts. *Jet* (November 9, 16, 23, 1972).

JAMES H. JONES

Tuskegee University. Tuskegee University was founded in 1881 as the Normal School for colored teachers at Tuskegee in Alabama's Macon County, as the result of a political deal made between local white politicians and Lewis Adams, a leading black citizen. In exchange for black votes, Arthur Brooks and Col. Wilbur Foster, candidates for the Alabama legislature, promised to seek state appropriation for a black normal school in Tuskegee. Adams successfully rallied black support, and on February 10, 1881, House Bill No. 165 was passed, appropriating $2,000 annually for a black state and normal school in Tuskegee. The act prohibited the charge of tuition and mandated a minimum of twenty-five students to open.

Booker T. WASHINGTON was recommended to organize the school by his mentor, Gen. Samuel Chapman Armstrong, the founder of Virginia's HAMPTON INSTITUTE, although Tuskegee's trustees had specifically requested a white man. Washington had been Armstrong's best student at Hampton, where he fully accepted Armstrong's philosophy that the first step for blacks was economic and moral uplift.

When Booker T. Washington arrived at Tuskegee on June 24, 1881, there was no actual school to open, just an appropriation and authorization by the Alabama state legislature. Before selecting a location, Washington met with local white supporters, toured the area to recruit students, and investigated existing living and educational conditions for Tuskegee's black population. Washington selected a shack next to Butler Chapel, the African Methodist Episcopal church on Zion Hill, where Lewis Adams was superintendent, as the site for the school. The school officially opened on July 4, 1881, as a secondary normal school with thirty students.

By July 14, 1881, Tuskegee Normal School had more than forty students ranging in age from sixteen to forty, most of whom were already public school teachers in Macon County. As enrollment increased, Washington recruited other Hampton and Fisk graduates to teach, including Olivia A. DAVIDSON (who served as lady principal from 1881 until her death in 1889 and who married Washington in 1886). He decided that a larger facility would soon be needed. He wrote to J. F. B. Marshall, the treasurer of Hampton Institute, and requested a loan of $200 to purchase a new farm site. While the school could not make such loans, Marshall personally loaned Washington the money, enabling him to make a down payment on the Bowen estate.

The Bowen estate, owned by William B. Bowen, was located one mile south of town. The main house had been burned down during the Civil War, leaving two cabins, a stable, and a chicken house. In keeping with his philosophy of self-knowledge, self-help, and self-control, Washington required students to clean and rebuild the Bowen estate while attending classes. By requiring such manual labor of his students, Washington was attempting to demonstrate that others were willing to help them—provided that they help themselves.

The money acquired to complete the payments on the Bowen estate came from many sources, including northern philanthropy and student fund-raisers, such as benefit suppers and student "literary entertainments," organized by Olivia Davidson. Payments on the Bowen estate were completed in April 1882.

Washington's philosophy of industrial education made Tuskegee Normal School a controversial model of black progress. Washington supported the use of manual labor as a moral training device, and he believed that manual labor would build students' character and improve their minds. In implementing a program of mandatory labor and industrial education, Washington had four basic objectives: to teach the dignity of labor, to teach the trades, to fulfill the demand for trained industrial leaders, and to offer students a way to pay expenses while attending the school (although no student, regardless of his or her economic standing was exempt from this labor requirement). Washington also considered industrial education to be valuable because it trained students in specific skills that would prepare them for jobs. However, Tuskegee's graduates primarily became members of the teaching profession. Instructors also offered academic and normal courses in botany, literature, rhetoric, astronomy, and geography in addition to the much publicized industrial courses.

Tuskegee expanded steadily over the years with money acquired from the northern speaking tours of Olivia Davidson and Booker T. Washington. Davidson began touring New England in spring 1882, soliciting support door to door on weekdays and speaking in churches and Sunday schools during the evenings and on weekends. Washington began his own fund-raising tour on May 1, 1882, in Farmington, Conn. He traveled through the North with letters of introduction from such prominent southern officials as Henry Clay Armstrong, the state superintendent, and Gov. Rufus W. Cobb. By the end of May, they had collected more than $5,000 for the expansion of Tuskegee Normal and Industrial Institute.

Porter Hall was the first new building erected, named in honor of a generous Brooklyn businessman, Alfred Haynes Porter. The three-story building housed recitation rooms on the first floor, a chapel and library on the second floor, and the girls' dormitory on the third floor. Up to this time the boys stayed with neighboring black families. Shortly after Porter Hall was completed, Washington arranged to rent several nearby cottages to house the boys, until their three-story dormitory, Armstrong Hall, was completed in 1888.

State funding for Tuskegee was increased in 1883 when the Alabama state legislature approved an additional $1,000 appropriation. The school also began receiving a $500 annual appropriation from the Peabody Fund in 1883 and $1,000 annual awards from the SLATER FUND in 1884. Philanthropic funding to Tuskegee Normal and Industrial Institute signified the extent of northern support for black industrial education.

In addition to fund-raisers, grants, and philanthropic support, money was raised for Tuskegee through brick making, which Washington began at

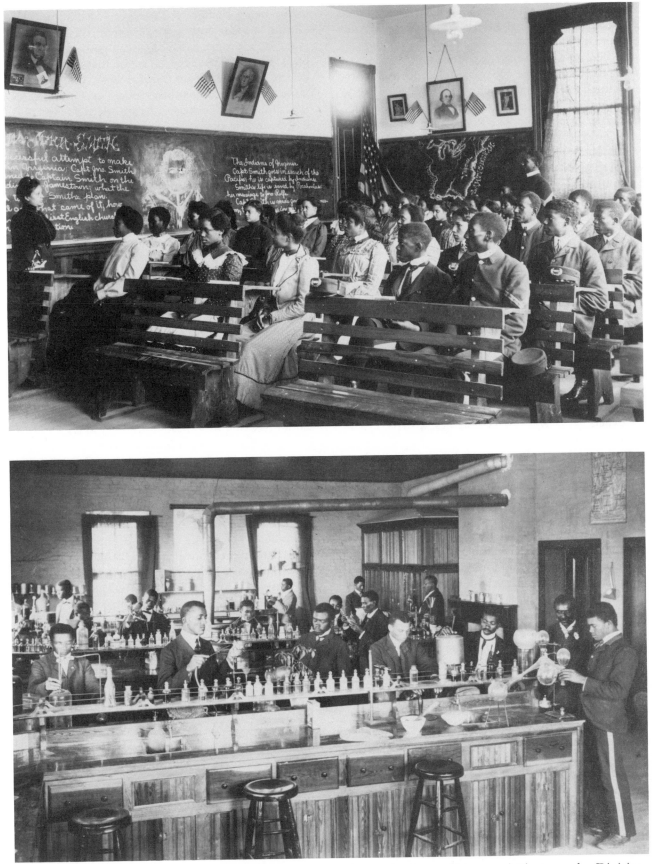

(Top) history class; (bottom) chemistry laboratory, Tuskegee Institute. (Prints and Photographs Division, Library of Congress)

the school in 1883, though its long-term contribution to Tuskegee's financial health was more symbolic than practical.

In 1892, the Alabama legislature adopted an Act to incorporate Tuskegee Normal and Industrial Institute, legally changing the school's name. After 1895, new buildings replaced those built from northern philanthropy. With names like Rockefeller, Huntington, and Carnegie, these buildings indicated support from the northern, chiefly New York-based business community. Such support increased Tuskegee property value to more than $300,000 by 1901 and facilitated the growth of the faculty and student body.

On April 1, 1896, Booker T. Washington wrote to George Washington CARVER, an agricultural chemist who had just completed his M.A. from Iowa State College of Agricultural and Mechanical Arts, and offered him a position as the head of the agriculture department at a salary of $1,500. Carver arrived shortly thereafter and established the Agriculture Experiment Station, where research was conducted in crop diversification. Carver taught Tuskegee's students, emphasizing the need for improved agricultural practices and self-reliance, and also made a great effort to educate Tuskegee's black residents. He garnered national and international fame in the 1920s for his experiments with sweet potatoes, cowpeas, and peanuts.

Both Carver and Washington left a powerful legacy of manual and agricultural training at Tuskegee. Their educational philosophies had a lasting impact upon Tuskegee's curriculum and continued to influence the school's direction. After Washington's death in 1915, it had become apparent to many that Tuskegee's industrial training was increasingly obsolete in the face of rapid technological transformation in American business. The school thus entered a new era, shifting its emphasis from industrial to vocational education.

In 1915, Robert R. MOTON became the second principal of Tuskegee, and although he practiced Washington's accommodationist style (see ACCOMMODATIONISM), he moved the school forward in directions that Washington had refused to move. Despite white opposition, Moton was instrumental in bringing a veterans' hospital to Tuskegee in 1923. He ensured that the institution, like Tuskegee Normal and Industrial Institute, was staffed entirely by blacks. Under Moton's direction, a college curriculum was developed in 1927. Two years later, Tuskegee's students demanded a shift away from "Washington's education." Moton heeded their voices and coordinated a new emphasis on science and technology.

Robert R. Moton was succeeded by Frederick D. PATTERSON in 1935. Patterson's administration also brought fundamental changes to the school, reflected in the name change to Tuskegee Institute in 1937. During WORLD WAR II, Patterson pursued the placement of a program for the segregated training of black pilots in Tuskegee, an action that was criticized by the NAACP. From 1939 to 1943, the Air Force trained more than 900 black pilots at Tuskegee, establishing the Tuskegee Army Airfield in 1941. Patterson also obtained significant state funding for the establishment of a graduate program (1943), a school of veterinary medicine (1945), and a school of nursing (1953).

Subsequent presidents have included Luther H. Foster (1953–1981) and Benjamin F. Payton (1981–). Foster modernized and expanded Washington's emphasis on the trade industry and established the College of Arts and Sciences and the School of Business. He led Tuskegee through the CIVIL RIGHTS MOVEMENT, when in 1968, Tuskegee students briefly held members of the board of trustees hostage in an attempt to force changes in campus policies. When Benjamin E. Payton assumed control of the school in its centennial anniversary, Tuskegee boasted 5,000 acres, 150 buildings, and an endowment of more than $22 million. Payton presided over the school's name change to Tuskegee University in 1985, and in 1989 he also undertook a major fund-raising effort for the school (seeking $150 million in donations), the largest ever attempted by a black college.

Although the school's curriculum and focus shifted over the years, the school continued to emphasize business, scientific, and technical instruction, a legacy of both Washington and Carver. In 1994, Tuskegee University had 3,598 students. It offered 45 undergraduate majors, 21 master's degrees, and a doctor of veterinary medicine degree. Distinguished alumni include novelist Ralph ELLISON, actor Keenan Ivory Wayans, and Arthur W. MITCHELL, the first black Democratic congressman.

REFERENCES

ANDERSON, JAMES. *The Education of Blacks in the South, 1865–1935.* Chapel Hill, N.C., 1988.

BOWMAN, J. WILSON. *America's Black Colleges: The Comprehensive Guide to Historically & Predominantly Black 4-Year Colleges and Universities.* Pasadena, Calif., 1992.

HARLAN, LOUIS R. *Booker T. Washington: The Wizard of Tuskegee, 1901–1915.* New York, 1983.

MANBER, DAVID. *Wizard of Tuskegee: The Life of George Washington Carver.* New York, 1967.

MARABLE, MANNING. "Tuskegee Institute in the 1920s." *Negro History Bulletin* 40 (November–December 1977): 64–68.

NORELL, ROBERT J. *Reaping the Whirlwind: The Civil Rights Movement in Tuskegee.* New York, 1983.

LISA MARIE MOORE

Twelve Knights of Tabor. The International Order of the Twelve Knights of Tabor was founded by the Methodist minister Moses DICKSON in Independence, Mo., in 1871. Dickson claimed the organization was founded to commemorate an earlier organization, the Twelve Knights of Tabor (sometimes referred to as the Knights of Liberty), founded in St. Louis in 1846 for the purpose of liberating African Americans from slavery. This secret society had supposedly numbered over forty-seven thousand members by 1856, though Dickson refused to reveal the names of any of his original eleven followers, and claimed all had died in the Civil War except himself. Since Dickson's is the only account of this group, many historians doubt the existence of the original Twelve Knights of Tabor.

The International Order of the Twelve Knights and Daughters of Tabor, Royal House of Media, and Maids and Pages of Honor—its full name—was organized as a secret fraternal order of African Americans (see FRATERNAL ORDERS AND MUTUAL AID ASSOCIATIONS). Beginning in 1879, and continuing as late as 1924, the organization printed a lengthy member's manual specifying rules, activities, rituals, titles, and positions, including medals, uniforms, and furniture. Structured hierarchically, the order stipulated that Dickson must be "venerated" as "Father and Founder" and first "International Chief Grand Mentor." The Order's manual stressed "belief in God and the Christian Religion," "patriotism," and "the advancement and protection of the Negro race." Ceremonies mixed Masonic forms and Methodist services, including spirituals, sermons, and Scripture readings, with military parades and drilling. The Knights of Tabor also offered money for burials and for pensions to widows and children of members. In 1902, Booker T. WASHINGTON mentioned the Knights of Tabor as one of about twenty national Negro secret societies in existence, and extolled these societies for helping blacks to create capital, learn business techniques, and practice thrifty habits. These secret societies served as precursors to black-owned insurance companies, banks, and other commercial enterprises (see BANKING; INSURANCE COMPANIES).

REFERENCES

HARDING, VINCENT. *There Is a River: The Black Struggle for Freedom in America.* New York, 1981.
PALMER, EDWARD NELSON. "Negro Secret Societies." *Social Forces* 23, no. 2 (December 1944): 207–212.

MARGARET D. JACOBS

Twilight, Alexander Lucius (1795–June 1857), educator, legislator. Born free in Bradford, Vt., in 1795, Alexander Twilight was the third of six children of Mary and Ichabod Twilight. Indentured to a local farmer, Twilight worked in his spare time and eventually saved enough to purchase the last year of his indenture in 1815. Twilight went on to attend Randolph Academy, and in 1821 graduated with the equivalent of a high school degree and two years of college. He then entered Middlebury College and in 1823 received his B.A. degree. Twilight was probably the first African American to graduate from an American college.

After completing college, Twilight accepted a teaching position in Peru, N.Y. He studied theology, and was granted a license to preach by the Champlain Presbytery of Plattsburgh, N.Y. In 1829, he moved to Brownington, Vt., where he took over as principal of the Orleans County Grammar School as well as minister of the local congregation, which prayed in the school building. Twilight began a campaign to raise money for a new, larger school building to house an intermediate school, Brownington Academy. He received little funding either from public or private sources, but he supervised the construction of Athenian Hall, a three-story granite structure with sufficient room.

Twilight became so popular through his various activities that in 1836 he was elected by the village to a one-year term in the Vermont state legislature in Montpelier. He thus became the first African-American state representative and probably the first black elected official in America. His term of office was unexceptional, and at its close Twilight returned to Brownington Academy. In 1847, Twilight left Brownington to teach in other villages, but he returned to his ministerial and educational functions in Brownington in 1852. He retired in 1855, following a stroke, and died in June 1857.

REFERENCE

HILEMAN, GREGOR. "The Iron-Willed Black Schoolmaster and His Granite Academy." *Middlebury College News Letter* (Spring 1974): 6–26.

GREG ROBINSON

Tyson, Cicely (December 19, 1939–), television, screen, and stage actress. Born to immigrant parents from Nevis, one of the Leeward Islands in the Caribbean, Cicely Tyson grew up in East Harlem in New York City. Her father worked as a carpenter, at times selling fruit and vegetables from a pushcart, while her mother worked as a domestic. After the divorce of her parents she lived with her mother, who forbade secular theatrical entertainment such as movies. It was in Saint John's Episcopal Church in

Harlem, where she sang and played the organ, that Tyson's theatrical talents surfaced.

After graduating from high school and taking a job as a secretary with the American Red Cross, Tyson was asked to model hairstyles by her hairdresser. He encouraged her to enroll in the Barbara Watson Modeling School where she met *Ebony* fashion editor Freda DeKnight. Soon she was appearing on the covers of the major fashion magazines in the United States, such as *Vogue* and *Harper's Bazaar*.

In 1957, Tyson had a small part in the film *Twelve Angry Men* with Henry Fonda. Two years later she made her stage debut, starring in *Dark of the Moon* directed by Vinnette CARROLL and produced by the Harlem YMCA's Drama Guild. In 1962 she appeared in both *Moon on the Rainbow Shawl* and Jean Genet's *The Blacks,* for which she received a Vernon Rice Award.

Tyson was recruited in 1963 for a lead role in the CBS television series *East Side/West Side,* becoming the first African-American actress to be a regular on a dramatic television series. The same year she appeared on stage with Alvin AILEY in the Broadway production of *Tiger, Tiger, Burning Bright* and in the

off-Broadway production of *The Blue Boy in Black,* playing opposite Billy Dee WILLIAMS. In 1968 she appeared in the film *The Heart Is a Lonely Hunter,* for which she received critical and public acclaim for her performance.

Tyson waited four years before doing film work again because of her decision not to accept roles that added to the negative stereotypes of African Americans. Then, in 1972, she accepted the role of Rebecca in the film *Sounder.* Her performance earned her an Academy Award nomination for best actress.

In 1974, Tyson received two Emmy awards—one for best lead actress in a drama and the other for actress of the year—for her portrayal of aged ex-slave Jane Pittman in *The Autobiography of Miss Jane Pittman.* She went on to play other socially conscious roles for television, including the part of Harriet TUBMAN in *A Woman Called Moses* (1976), Kunte Kinte's mother in *Roots* (1977), and Coretta Scott KING in *King* (1978).

On Thanksgiving Day 1981, Tyson married jazz trumpeter Miles DAVIS. Davis's third attempt at marriage and Tyson's first, the arrangement lasted seven years. Tyson continues to be active in film and television, appearing with Oprah WINFREY in the television miniseries *The Women of Brewster Place* in 1989 and in the film *Fried Green Tomatoes* in 1991.

REFERENCES

DAVIS, MILES, with Quincy Troupe. *Miles: The Autobiography.* New York, 1989.
HINE, DARLENE CLARK. *Black Women in America.* New York, 1993.
MAPP, EDWARD, ed. *Directory of Blacks in the Performing Arts.* Metuchen, N.J., 1990.

SABRINA FUCHS
JOSEPH W. LOWNDES

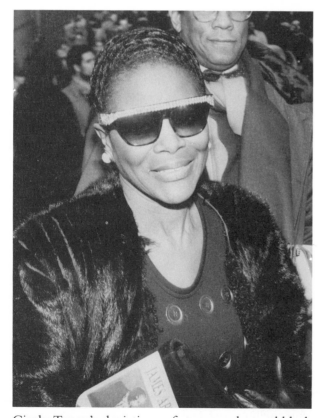

Cicely Tyson's depictions of strong and proud black women include her roles in *The Heart Is a Lonely Hunter* and *Sounder* as well as the title role in *The Autobiography of Miss Jane Pittman.* She is attending the memorial service for James Baldwin in this 1987 photograph. (Shawn Walker)

Tyson, Michael Gerald "Mike" (June 30, 1966–), professional boxer. Born in Brooklyn, N.Y., Mike Tyson, raised in a crime-ridden neighborhood, became a young street tough, committing muggings and other crimes. At the age of thirteen, he was sent to the Tryon School, a juvenile detention facility in Johnstown, N.Y. There he met Cus D'Amato, an experienced boxing trainer who recognized Tyson's potential as a fighter. D'Amato took Tyson under his wing, becoming both his coach and his legal guardian.

After winning the 1984 Golden Gloves amateur heavyweight championship, Tyson had his first professional fight in Albany, N.Y., on March 5, 1985. By the end of the year, he had defeated fifteen oppo-

nents, not one of whom lasted more than four rounds. On November 22, 1986, in Las Vegas, Nev., Tyson won the World Boxing Council heavyweight title from Trevor Berbick with a technical knockout in the second round—becoming the youngest heavyweight champion in history. Tyson captured the World Boxing Association championship by beating James "Bonecrusher" Smith in Las Vegas on March 7, 1987, and on August 1 of that year defeated Tony Tucker in Las Vegas to gain the International Boxing Federation (IBF) title. One of Tyson's most impressive efforts came in Atlantic City, N.J., on June 27, 1988, when he knocked out the former IBF champion Michael Spinks in 91 seconds of the first round.

At 5'11" and with a fighting weight of 212 to 221 pounds, "Iron Mike" Tyson was known as a devastating puncher. His seeming invincibility made him a favorite of many sports fans. In 1989 he was awarded an honorary Doctorate of Humane Letters by Central State University in Wilberforce, Ohio. In six years as a professional boxer, Tyson amassed some $60 million dollars, including more than $20 million from the Spinks fight alone.

Even as Tyson won respect for his accomplishments in the ring, controversy surrounded his personal life, especially after D'Amato died in 1985. After D'Amato's death, his associates Jim Jacobs and Bill Cayton became Tyson's managers, but after Jacobs died in 1988, Tyson split with Cayton in a dispute over the management of his financial affairs. That same year, the controversial Don KING became Tyson's promoter. Also in 1988, Tyson married actress Robin Givens. After months of a stormy and well-publicized conflict, including allegations that he had beaten her, the couple divorced. Before the year ended, Tyson was arrested after engaging in a late-night brawl with boxer Mitch Green in a Harlem clothing store.

In Tokyo, Japan, on February 11, 1990, an out-of-shape Tyson lost the championship in a stunning tenth-round knockout by the unheralded Buster Douglass. Before he had a chance to regain the title in an anticipated match with Evander HOLYFIELD (who had subsequently taken the championship from Douglass), Tyson's career was interrupted by his arrest for the July 1991 rape of Desiree Washington, an eighteen-year-old contestant in the Miss Black America pageant in Indianapolis. Even after his conviction on February 10, 1992, Tyson asserted his innocence, contending that Washington had voluntarily consented to sexual relations with him.

While serving a six-year sentence at the Indiana Youth Center in Plainfield, Tyson maintained his physical condition in the hope of resuming his boxing career after an early release from prison. He also began to read widely but failed a high school equivalency examination in March 1994. Tyson announced that he had adopted Islam in 1994, declaring his affection for Minister Louis FARRAKHAN, leader of the NATION OF ISLAM. Upon Tyson's release from prison in 1995, a parade was planned in New York City to celebrate his return, but strong opposition emerged within the black community, and the parade was canceled. He announced his return to the ring shortly thereafter.

REFERENCES

BERGER, PHIL. *Blood Season: Tyson and the World of Boxing.* New York, 1989.
HELLER, PETER. *Bad Intentions: The Mike Tyson Story.* New York, 1989.
ILLINGWORTH, MONTIETH. *Mike Tyson: Money, Myth and Betrayal.* Secaucus, N.J., 1991.
TORRES, JOSE. *Fire and Fear: The Inside Story of Mike Tyson.* New York, 1989.

DANIEL SOYER

Tyus, Wyomia (August 29, 1945–), athlete. Wyomia Tyus was born and raised in Griffin, Ga. While she was still in high school, her abilities as a runner

Wyomia Tyus (foreground) at the start of her anchor leg in the 4-by-100 relay in the Summer Olympic Games in Mexico City, 1968. The United States won the race, setting a new world record for the event in the process. This was one of three gold medals Tyus won in Olympic competition. (AP/Wide World Photos)

were noticed by Ed Temple, the women's track coach at Tennessee State University (TSU), and brought her to the AAU Championships in both 1962 and 1963. Tyus won the Girls' 100-yards in both years. She enrolled at TSU on an athletic scholarship in 1963 and earned her B.A. in 1968.

In the 1960s Tyus set world records in the 50-, 60-, 70-, and 100-yards, as well as the 100-meters. She held five AAU titles (three in the 100-meters and two in the 200-meters), won the 200-meters in the 1967 Pan Am games, and was the first sprinter (male or female) to win back-to-back Olympic gold medals in the 100-meters (1964 and 1968). At the 1964 Olympic games in Tokyo, Tyus ran an 11.2 100-meters in a qualifying heat to set a world record. She won the 100 and her 4 by 100-meter relay team earned a silver. The 100-meter race at the 1968 Olympics in Mexico City fielded five women who had run at 11.1. In the final, Tyus finished in 11.0 to set a new world record and take the gold medal, which she dedicated to Tommie Smith and John Carlos, the two African-American sprinters expelled from the Olympics for their victory-stand demonstration of black power. In addition, the U.S. 4 by 100 women's relay team, anchored by Tyus, ran a 42.8 to set another world record and win the gold medal.

Tyus retired from track in 1968, though in the early 1970s she returned to run on the short-lived professional circuit. The U.S. Track and Field Hall of Fame inducted her in 1976, as did the Black Athletes Hall of Fame (1978) and the National Track and Field Hall of Fame (1980). She worked as a television commentator during the Montreal Olympics and carried the flag in the 1984 Los Angeles games.

In the early 1990s, Tyus remained active in track through her participation in sports clinics and forums on the role of sports in culture. She has also worked as a teacher and counselor in Los Angeles, and she has been a spokesperson for such corporations as Coca-Cola.

REFERENCES

ASHE, ARTHUR R., JR. A Hard Road to Glory: A History of the African-American Athlete Since 1946. New York, 1988.
CONDON, ROBERT J. Great Women Athletes of the Twentieth Century. Jefferson, N.C., 1991.
DAVIS, MICHAEL D. Black American Women in Olympic Track and Field: A Complete Illustrated Reference. Jefferson, N.C., 1992.

PETER SCHILLING

U

Umbra Writers Workshop. New York's Umbra Writers Workshop, the source of a seminal literary movement of the early 1960s, exerted a significant influence on the direction of African-American literature. Though its members did not subscribe to any uniform aesthetic or political ideology, Umbra's guiding philosophy was expressed in a manifesto that prefaced the first issue of the group's magazine, promising to publish works of "literary integrity" that would illumine "social and racial reality."

Umbra magazine, appearing sporadically between 1963 and 1975, was the product of an intense poetry workshop, founded by Tom Dent in the summer of 1962. Each Friday night, the poets met to recite and discuss their works in Dent's apartment at 242 East Second Street on New York's Lower East Side. These sessions lasted about a year and, by all accounts, were volatile and energetic. Despite the often personal attacks that constituted criticism in this setting, members thought of themselves as a collective. Umbra attracted a group of talented young writers who offered a unique combination of civil rights activism, artistic ambition, experience in community cultural development, and interest in local and international politics.

Umbra Workshop members came from varied backgrounds and included several who went on to become prominent literary figures. The core of the group was Dent, Calvin C. Hernton, David Henderson, Askia Muhammad Touré, Lorenzo Thomas, Art Berger, Ishmael REED, Leroy McLucas, Jane Logan Poindexter, Norman H. Pritchard, Joe Johnson, Steve Cannon, Charles Patterson, Alvin Simon, Brenda Walcott, George Hayes, Nora Hicks, Albert Haynes, Lennox Raphael, and James W. Thompson. Others who were closely associated at various times included Raymond R. Patterson, Lloyd Addison, Asaman Byron, Herbert Woodward Martin, Oliver Pitcher, folksinger Len Chandler, and civil rights activists Julian BOND and Robert Brookins Gore.

These people were actively at the center of the New York avant-garde and were close to such jazz musicians as Archie SHEPP, Cecil TAYLOR, Marion Brown, SUN RA, and Eric DOLPHY, to the painter Joe Overstreet, and to experimental artists and writers of other ethnic backgrounds, such as Ree Dragonette, Jackson MacLow, Aldo Tambellini, Paul Blackburn, Allen Ginsberg, and Walter Lowenfels. These cultural contacts are reflected in the Umbra poets' early work, which reveals a thorough grasp of modernist technique—ranging from T. S. Eliot and Ezra Pound to the HARLEM RENAISSANCE styles of Langston HUGHES and Sterling A. BROWN—as well as innovative approaches to African-American rhetorical traditions and experiments being pursued in music and the visual arts.

In general, Umbra writers represented a transition from protest literature toward a more race-conscious celebration of African-American culture and a critique of "mainstream" values. Rejecting the alienated pose of the modernist artist, Umbra poets viewed themselves as "cultural workers." The political involvement of some included the radical On Guard for Freedom group (founded by Calvin Hicks)

as well as the CONGRESS OF RACIAL EQUALITY and the short-lived, FBI-infiltrated REVOLUTIONARY ACTION MOVEMENT. Other members, however, preferred the advocacy role represented by artistic production rather than involvement in political organizations.

The Umbra Workshop was influential for two major reasons. In addition to launching the careers of several important and prolific writers such as Reed, Hernton, and Henderson, the group also provided the core membership and intellectual direction of the BLACK ARTS MOVEMENT, which had a nationwide impact during the decade from 1965 to 1975. Similarly, the Black Arts movement—with activities often led by former Umbra members in various cities—provided models, such as Reed's Before Columbus Foundation, for artists of other ethnic groups and helped shape the focus of multiculturalism during the 1980s and '90s.

REFERENCE

DENT, TOM. "Umbra Days." *Black American Literature Forum* 14 (Fall 1980): 105–108.

LORENZO THOMAS

Uncle Tom. *See* Stereotypes.

Uncle Tom's Cabin. Harriet Beecher Stowe's fiery abolitionist novel was published in 1852. Stowe came from a prominent family of public figures that included her father, clergyman Lyman Beecher; her sister, author Catharine Beecher; and her brother, clergyman Henry Ward Beecher. The wife of clergyman Calvin Stowe, Harriet was outraged by the COMPROMISE OF 1850, the group of legislative measures that effected a compromise between North and South on the increasingly divisive issue of slavery. The most notorious article of the compromise was the provision for the legal return to their owners of escaped slaves (the FUGITIVE SLAVE LAW, enacted in 1851), which effectively legitimized the rule of slavery in the North and South. This measure, as well as the passionate advocacy of the compromise by trusted Vermont Sen. Daniel Webster, particularly infuriated Stowe and other New England intellectuals such as Ralph Waldo Emerson and John Greenleaf Whittier (whose poem "Ichabod" excoriates Webster). Stowe's first literary response to the legislation was a story called "The Freeman's Dream" (1850), about the divine retribution that visits a man who refuses to aid a group of slaves being led to market in a coffle (i.e., fastened together to form a train). Her

One of the earliest editions of Harriet Beecher Stowe's *Uncle Tom's Cabin.* In her novel, Stowe combined a skilled handling of conventions of nineteenth-century sentimental fiction with her abolitionist convictions to produce a masterpiece of political protest literature. (Prints and Photographs Division, Library of Congress)

literary career thus launched, Stowe experienced a vision, she later said, of an old black male slave being whipped to death. This image sparked the composition of *Uncle Tom's Cabin; or, Life Among the Lowly,* which was serialized in the antislavery newspaper *National Era* in 1851–1852 and published in book form on March 20, 1852.

Uncle Tom's Cabin so swarms with character, action, voice, and social detail that it defies adequate synopsis. Its multiple, intertwining plots begin with the imminent sale of the beautiful slave Eliza Harris. Her owner, Arthur Shelby, is in debt and must sell his slaves for money. Hearing of this, Eliza, with her small son and slave husband, George Harris, decides to escape, and before going informs the other slaves

of Mr. Shelby's predicament. Uncle Tom, a slave on the Shelby plantation, bids Eliza to go but refuses to join her, preferring to sacrifice himself in sale for the possible preservation of the other slaves. Eliza's vividly rendered escape with her son Harry across the ice floes of the Ohio River allows Stowe to elicit sympathy for the slaves and hatred for the slave traders, even though relatively kindly masters such as Shelby are spared neither the moral taint of slavery nor Stowe's disdain. Eliza's husband George escapes separately in disguise, while Eliza is sheltered by Ohio Quakers; George and Eliza reunite at the Quaker settlement. There they fight off the slave traders who have pursued them, whereupon George makes an impassioned defense of his right to freedom. Soon, George, Eliza, and Harry escape to Canada. Meanwhile Uncle Tom is indeed sold down the river, and upon the boat of transport he meets Evangeline (Little Eva) St. Clare and her father, a New Orleans slaveowner, who buys Tom at Little Eva's behest. St. Clare is gentle, passive, but sharply reflective on the social system of slavery; he airs himself on a variety of subjects in conversation with the Vermonter Aunt Ophelia, who brings to the plantation her aid (St. Claire's wife, Marie, is perennially languid and abed) and her liberal northern perspective (some of the hypocrisies of which—for instance, advocating freedom yet feeling repulsed by slaves like Topsy—Stowe tellingly punctures). St. Clare is subject to Tom's religious influence, and under it, as well as that of the death of Little Eva, who suffers from her knowledge of slavery's oppression, decides to reform his life and to set Tom free. Before he is able to do this, however, St. Clare is killed attempting to mediate a bar fight, and once again, Tom is sold. He is purchased by Simon Legree, another Vermonter by origin, who abuses Uncle Tom the more the slave passively resists. Legree is at the same time haunted by Cassy, a slave woman on his plantation who exploits Legree's guilt over his abandonment of his mother. Cassy and another slave, Emmeline, pretend to escape but stay in an attic and drive Legree to distraction impersonating the ghosts that he believes dwell there. Legree ultimately kills Uncle Tom as young George Shelby, the son of Tom's former master, arrives; George superintends the burial of Tom and knocks Legree to the ground. He also helps Cassy and Emmeline escape, and in doing so learns that Cassy is in fact Eliza's mother. At the novel's end, everyone reunites in Canada, where they decide to voyage to Africa and establish a black Christian homeland in Liberia. George Shelby returns to Kentucky and sets all the Shelby slaves free; refusing to leave, the slaves stay to work as free people. The novel concludes with the kind of hectoring condemnations of slavery that lace the rest of the text.

So told, the novel is clearly rife with contradictions that both enrich and hobble it. For one thing the novel is misnamed, since we only see Uncle Tom's cabin briefly and most of the novel recounts Tom's painful longing to return to his family from whom he has been sold. This tale of the horrors of slavery is animated by a passion for and belief in the redemptive capacities of women. It presents a protofeminist orientation that vivifies the stories of slave and disempowered white women, and advances a feminized ethic of the antislavery struggle—most notably in the piously submissive Tom himself—even as it somewhat exploitatively uses the predicament of slaves to meditate on the oppression of women. What is more, this quite radical novel by the standards of 1852, depends on black stereotypes and seems to accept a long-discredited notion of innate racial traits (however positively rendered); thus, the blacker Uncle Tom submits while the lighter-skinned George Harris asserts the fighting spirit of his partial Anglo-Saxon blood. Finally, this story, so often accused of revolutionary intent by most of the South, is not only as hard on the North's apologists for slavery as it is on the South, it is also a fundamentally Christian novel whose social prescriptions revolve around transformations of individual feeling rather than collective struggle.

Contradictory or not, these sentimental, women-centered, radical Christian emphases achieved for *Uncle Tom's Cabin* an immediate and sustained success and influence. It sold 300,000 copies in its first year alone and inspired novelistic rebuttals and documentary defenses (one of them, *The Key to Uncle Tom's Cabin,* [1853], by Stowe herself), stage dramatizations and minstrel-show parodies, commercial take-offs, and popular-cultural iconography. The novel made national struggles over slavery—a dangerous social issue subject to persistent denial—henceforth an acknowledged fact of everyday life. Yet it was probably *Uncle Tom's Cabin*'s long stage presence in the form of the "Tom show" that was ultimately responsible for the enormity of its influence. As popularly written as the novel was, for every person who read it, very many more saw the stage play. The competing ideological inflections of *Uncle Tom*'s many dramatizations amplified the novel's political impact. With nonexistent copyright laws for stage adaptations, and Stowe declining participation in or permission for an authorized stage version, the field was open to the lowest bidder. In January 1852, attending to the novel's serialization, an anti-Tom play called *Uncle Tom's Cabin as It Is; The Southern Uncle Tom* appeared at the Baltimore Museum; in late August 1852, C. W. Taylor's crude and foreshortened version of the recently published novel ran briefly at New York's National Theatre—inspiring

New York Herald editor James Gordon Bennett to denounce the advent of abolitionist drama. This pattern of dramatic conflict—a kind of prelude to the Civil War on stage—characterized productions of *Uncle Tom's Cabin* not only in the 1850s, but well into the 1870s.

The chief competing productions in the 1850s were those of George Aiken and H. J. Conway. Aiken's relatively faithful version of *Uncle Tom* gestated for a year in Troy, N.Y., first recounting only Little Eva's story, then only Uncle Tom's, then combining the two into the first full-length, night-long theatrical production in history. This version, which vents many of Stowe's criticisms of slavery, opened at New York's National Theatre on July 18, 1853. Conway's much more ambiguous rendition took shape in Boston, and takes away with minstrel parody or outright racism that it occasionally renders with accuracy to Stowe's novel. P. T. Barnum heard of Conway's Compromise politics and the impressive Boston run of the show and booked this version for his American Museum beginning November 7, 1853. These adaptations, to be sure, appeared amid a dizzying array of offshoots, thefts, reworkings, rebuttals, and parodies, including (in New York alone) a "magic lantern" version (tableaux from the play) at New York's Franklin Museum; a Bowery Theatre version starring blackface originator T. D. Rice (not so outrageous as it appears, since even the "respectable" adaptations featured blackface performers in black roles); blackface lampoons such as Charles White's *Uncle Dad's Cabin* (1855), and Christy and Wood's Minstrels' *Uncle Tom's Cabin, or, Hearts and Homes* (1854); Irish parodies such as *Uncle Pat's Cabin* (by H. J. Conway) and *Uncle Mike's Cabin* (1853); and scores of others. But all this could not obscure the great theatrical rivalry that existed between the Aiken and Conway versions, encompassing everything from journalistic debate to street fights and making inescapably evident—in fact institutionalizing—the sectional conflicts that would soon eventuate in civil war. Perhaps this accounts for what Lincoln is supposed to have said upon meeting Stowe: "So this is the little lady who made this great war." Even after the war, Tom shows (which continued to be produced well into the twentieth century) and films (the first of many film versions of *Uncle Tom's Cabin* appeared in 1903) effortlessly invoked ongoing American political debate and upheavals over race and the legacy of slavery. While the novel's aesthetic and politics now seem obsolete, *Uncle Tom's Cabin* had a mighty and often radical cultural and social impact for over half a century.

REFERENCES

BIRDOFF, HARRY. *The World's Greatest Hit*. New York, 1947.

FREDERICKSON, GEORGE F. *The Black Image in the White Mind: The Debate on Afro-American Character and Destiny, 1817–1914*. New York, 1971.

GOSSETT, THOMAS F. *Uncle Tom's Cabin and American Culture*. Dallas, 1985.

LOTT, ERIC. *Love and Theft: Blackface Minstrelsy and the American Working Class*. New York, 1993.

ROURKE, CONSTANCE. *Trumpets of Jubilee*. New York, 1927.

SANCHEZ-EPPLER, KAREN. *Touching Liberty: Abolition, Feminism, and the Politics of the Body*. Berkeley, Calif., 1993.

TOMPKINS, JANE. *Sensational Designs: The Cultural Work of American Fiction, 1790–1860*. New York, 1985.

ERIC LOTT

Uncles, Charles Randolph

Uncles, Charles Randolph (1859–1933), priest. Born in Baltimore, Md., Uncles was baptized as a Roman Catholic at the age of sixteen at St. Francis Xavier's Church, founded in 1863 by Archbishop Spalding for the exclusive use of blacks. Uncles attended Baltimore Normal School and taught in the Baltimore County Schools from 1880 to 1883. Unable to gain admittance to local Roman Catholic colleges and seminaries because of his race, Uncles traveled to Canada in 1883 to matriculate at St. Hyacinthe's College in Quebec. He graduated with honors in 1888 and returned to Baltimore to attend St. Mary's Seminary, whose all-white student body voted unanimously to allow him to enter.

On December 22, 1891, Uncles became the first black to be ordained a Roman Catholic priest in the United States. (Previous African-American priests had been ordained in Europe.) The ceremony took place in Baltimore Cathedral and was conducted by His Eminence James Cardinal Gibbons. After his ordination, Uncles served as a professor of English, Latin, and Greek at Epiphany Apostolic Church in Walbrook, Md., transferring to Newburgh, N.Y., when the college moved there in the 1920s. He was recognized as a Latin-language expert and published a Latin grammar. The Rev. Charles Uncles was a member of the Josephite Brothers, a society founded in England in 1871 with the specific purpose of serving as missionaries to emancipated blacks in the United States.

REFERENCES

FOLEY, ALBERT S. *God's Men of Color: The Colored Catholic Priests of the United States, 1854–1954*. New York, 1955.

O'NEIL, MICHAEL J. *Some Outstanding People: Interesting Facts in the Lives of Representative Negroes*. Baltimore, 1943.

LYDIA MCNEILL

Underground Railroad.

Underground Railroad. Few aspects of the antislavery movement have been more shrouded in myth and misunderstanding than the Underground Railroad. Although white abolitionists, including QUAKERS, played an important role in helping to free thousands of African Americans (*see* ABOLITION; SLAVERY), the degree of their involvement has been overemphasized. In the years before the Civil War, the Underground Railroad was primarily run, maintained, and funded by African Americans. Black working-class men and women collected the bulk of money, food, and clothing, and provided the shelter and transportation for the fugitives (*see* FUGITIVE SLAVES). Wealthier, better educated blacks such as Pennsylvania's Robert PURVIS and William WHIPPER arranged for legal assistance and offered leadership, financial support, and indispensable contacts among sympathetic and influential white political leaders. Philadelphia's William STILL, who ran the city's vigilance committee and later recorded the stories of many of the people he helped, managed the pivotal point in the North's most successful underground system. He personally assisted thousands of escaping slaves and helped settle them in northern African-American communities or in Canada. As one white abolitionist leader admitted about the Underground Railroad in 1837, "Such matters are almost uniformly managed by the colored people."

Although the origins of the term are uncertain, by 1850 both those who participated in the Underground Railroad and those who sought to destroy it freely employed metaphors from the railroad business to describe its activities. More important, Northerners and Southerners understood both its symbolic and its real meanings. The numbers of African Americans who fled or were smuggled out of the South were never large enough to threaten the institutional stability of slavery. Yet the number actually freed was, in a way, less important than what such activities said about the institution of slavery and the true character of southern slaves. Apologists for slavery described blacks as inferior, incapable of living in freedom, and content in their bondage. Those who escaped from the South, and the free African Americans who assisted them, undermined slavery by irrefutably disproving its racist ideology.

Most slaves who reached freedom in the North initiated their own escapes. After their initial flight, however, fugitives needed guidance and assistance to keep their hard-won liberty. Many did not have to travel far before finding help. Although the black underground's effectiveness varied over time and place, there was an astonishingly large number of semiautonomous networks that operated across the North and upper South. They were best organized in Ohio, Pennsylvania, and New York, but surprisingly

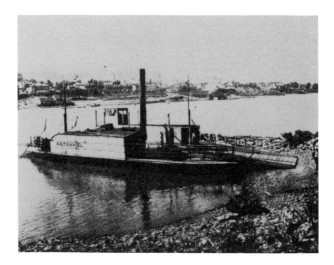

A crossing place for fugitive slaves on the Ohio River, at Steubenville, Ohio. (Photographs and Prints Division, Schomburg Center for Research in Black Culture, The New York Public Library, Astor, Lenox and Tilden Foundations)

efficient networks, often centered in local black churches, existed in most northern and border states, and even in Virginia. At hundreds of locations along the Ohio River, where many former slaves lived, fugitives encountered networks of black underground laborers who offered sanctuary and passed them progressively northward to other black communities. African-American settlements from New Jersey to Missouri served as asylums for fugitive slaves and provided contacts along well-established routes to Michigan, Ohio, Pennsylvania, and New York for easy transit to Canada.

Urban vigilance committees served as the hub for most of the black undergrounds. Along the East Coast, where the black underground was most effective, the Philadelphia and New York vigilance committees operated as central distribution points for many underground routes. Committee leaders such as William Still and David RUGGLES directed fugitives to smaller black "stations," such as that of Stephen A. Myers in Albany, N.Y., who in turn provided transportation direct to Canada or further west to Syracuse. Vigilance committees also warned local blacks of kidnapping rings, and members hazarded their lives in searching vessels for illegal slaves. Such black leaders also maintained contacts among influential whites who covertly warned of the movement of slave owners and federal marshals. Where formal committees did not exist, ad hoc ones functioned, supplied with information from, for example, black clerks who worked in hotels frequented by slave-catchers. Black leaders such as William Still, who helped finance the famous exploits of Harriet TUBMAN, employed the latest technology to facilitate

their work; during the 1850s these committees regularly used the telegraph to communicate with far-flung "stations."

The most daring and best-organized "station" toiled in the very shadow of the U.S. Capitol. Run by free blacks from Washington, D.C., and Baltimore, this underground network rescued slaves from plantations in Maryland and Virginia, supplied them with free papers, and sent them north by a variety of land and water routes. These free blacks used their good standing among whites—as craftsmen, porters, and federal marshals' assistants—to facilitate their work. One free black used his painting business as a cover to visit plantations and arrange escapes; another employed his carriage service to transport slaves; others sustained the charges of slave owners and used their positions as plantation preachers and exhorters to pass escape plans to their "parishioners."

When stealth and secrecy failed, heroic members of the Washington, D.C., "station" successfully attacked a slave pen to free some of its captives.

Members of this eastern network occasionally worked with white abolitionists such as Charles T. Torrey and the Quaker leader Thomas Garrett. But they primarily worked with other blacks, sending fugitives to Philadelphia where, either singly or in large groups, the escapees were directed to New York City and dispersed along many routes reaching into New England and Canada, or toward western New York. This network was temporarily disrupted during the 1840s, when race riots in northern cities and escalated southern surveillance forced the removal of Washington's most active agents. Nevertheless, by one estimate, between 1830 and 1860 over 9,000 fugitive slaves passed through Philadelphia alone on their way to freedom.

Postwar accounts of the Underground Railroad kept its legacy and mystique alive for later generations. Its best-known African-American historian was William Still, a leader of the Philadelphia Vigilance Committee, from whose *History of the Underground Railroad* (1870) this rather romantic image was taken. (Prints and Photographs Division, Library of Congress)

The Underground Railroad never freed as many slaves as its most vocal supporters claimed, and far fewer whites helped than the mythology suggests. Undeniably, however, the existence and history of the system reflect the African-American quest for freedom and equality.

REFERENCES

Blockson, Charles L. *The Underground Railroad: First Person Narratives of Escapes to Freedom in the North.* New York, 1987.

Gara, Larry. *The Liberty Line: The Legend of the Underground Railroad.* Lexington, Ky., 1961.

Ripley, C. Peter, et al., eds. *The Black Abolitionist Papers.* Vol. 3, *The United States.* Chapel Hill, N.C., 1991.

Siebert, Wilbur H. *The Underground Railroad: From Slavery to Freedom.* New York, 1898.

Still, William. *The Underground Railroad.* Philadelphia, 1872.

Donald Yacovone

Undertakers, Embalmers, Morticians.

EBONY magazine editorialized in 1953, "Death is big business," and nowhere is it more so than in the black community, where mortality rates exceed the national average. One estimate at the time held that 3,000 black funeral parlors grossed over 120 million dollars annually from the burial of 150,000 people. Statistics, however, are emblems of a larger culture of death and dying that permeates American society and is reinforced by institutions such as the church, the insurance industry, and the funeral business. It is no accident, therefore, that undertakers became some of the most prominent, wealthy, and influential individuals in the black community.

The profession started out modestly enough and, until the end of the nineteenth century, was essentially unregulated. Just about anyone could set himself up in the mortuary business. Since disposing of corpses was a distasteful and emotionally difficult task for family members, the job often fell to operators of livery stables, who had horses and wagons to transport the dead to cemeteries. One of the earliest black funeral establishments was started by William Ragsdale, who ran a livery stable in the all-black township of Muskogee, Indian Territory (later Oklahoma). In 1889, Ragsdale purchased a horse-drawn hearse that he rented to bereaved families. The enterprise grew quickly and was incorporated as the People's Undertaking Company in 1895. Ragsdale's seven sons all followed in their father's footsteps and opened branches of the company (as Ragsdale & Sons) as far afield as San Diego and Phoenix.

The Ragsdale business first blossomed at about the time that undertaking became fully professional. The

National Funeral Directors Association (NFDA) was founded in the early 1880s, and by 1910 several states had licensing requirements such as a period of internship and a course in embalming or mortuary science. William Ragsdale received training from Auguste Renouard, who toured the country giving two-week courses in embalming and who ran a school in New York. Many blacks turned to Renouard, since most other white schools excluded them. Of twenty-six undertakers identified in the first five editions of *Who's Who in Colored America* (1927–1944), eight were trained under Renouard. The others were dispersed among schools of embalming, anatomy, and sanitary science in Boston, Columbus, Cincinnati, Cleveland, Buffalo, Chicago, Philadelphia, and New York. In some cases, diplomas were granted—JIM CROW style—on the basis of a "home training course" separate from that of the other (white) graduates. A few prospective undertakers satisfied the licensing requirements by taking preclinical courses at all-black schools such as Meharry Medical College and Louisville National Medical College.

Undertaking provided blacks with a lucrative career opportunity primarily for two reasons. First, the culture demanded what Gunnar Myrdal has described as "conspicuous consumption in luxurious funerals." This stemmed in part from strong socioreligious beliefs (with traditions going back to slavery) that a decent, even opulent funeral was a fitting send-off for those who were about to enter a better world, one without struggle, poverty, and oppression. Funerals were an event in the black community. When Louis ARMSTRONG died in 1971, for example, one black periodical unfavorably compared the "white and dead" ceremony in New York to the "black, alive and swinging" one in New Orleans.

Second, black undertakers prior to 1960 exercised a virtual monopoly. Unlike other professions (e.g., medicine) where blacks often competed with their white counterparts for a share of the black clientele, undertaking remained completely segregated. Black undertakers were protected from competition because white undertakers generally refused to handle black corpses. In many small towns, the most viable black business was the funeral parlor, and the parlor's owner was often the town's wealthiest citizen. There are elements of truth in Shields McIlwaine's harsh caricature of black undertakers in *Memphis down in Dixie* (1948):

Death and dead folks . . . have made more Negroes rich than anything else. Most Negroes crave a big funeral. They will pay their weekly burial 'inshoance' if they have to go hungry. When they quit living, as is likely some Saturday night, the Negro undertakers come running. Then the body needs a coffin and both need a hole in the ground. Result: the most prosperous

Negro families . . . are undertakers or are financially interested in coffin factories or cemeteries or both.

Since black and white undertakers rarely communicated with one another on a professional basis before 1960, the black group founded its own national equivalent of the NFDA in 1938: the National Negro Funeral Directors and Morticians Association (the word *Negro* was dropped in 1957). The association remained strong despite the erosion of the competitive advantage of black undertakers following the civil rights movement and the passage of antisegregation laws. In 1992, the association comprised two thousand members and twenty-six state subsidiaries.

REFERENCES

"The Business Side of Bereavement." *Black Enterprise* 8 (November 1977): 55–58, 61.
"Death Is Big Business." *Ebony* 8 (May 1953): 17–31.
MYRDAL, GUNNAR. *An American Dilemma: The Negro Problem and Modern Democracy.* New York, 1944.

PHILIP N. ALEXANDER

Union League of America. The Union League (or Loyal League) was the first mass-based African-American political organization. During congressional RECONSTRUCTION it was the vehicle of mobilizing the newly enfranchised voters for the REPUBLICAN PARTY. The league was severely maligned by turn-of-the-century historians, but recently scholars have taken a more favorable view.

The Union League originated during the CIVIL WAR as a white patriotic organization supporting the Union war effort. Under its longtime president James M. Edmunds, it spawned both the patrician Union League Clubs and many mass organizations in the northern states, and these were generally secret and oath-bound. With the end of the war, Republican leaders decided that the clandestine character of the organization made it appropriate for southern operations, and during presidential Reconstruction thousands of white Unionists, particularly in the mountains, joined the order.

With the passage of the Military Reconstruction acts in March 1867, Republican leaders turned their attention to the freedmen. Republican donors underwrote an organizing campaign, and paid speakers, black and white, swept through the southern states. Encouraged by sympathetic Freedmen's Bureau and other government officials, hundreds of thousands of blacks joined in the spring and summer of 1867. This mobilization was the freedmen's first introduction to partisan politics and the mechanics of voting, and it

was instrumental in the overwhelming vote they gave the Republican party. The league thus helped "reconstruct" southern governments under the congressional plan.

The social impact of the movement was pronounced as well, coming at a critical moment in the evolution of the plantation system. After the war, planters tried to reconstruct production on familial lines: gang labor, physical coercion, tight supervision, and women and children in the work force. The vigorous black response to the league can be seen as a measure of frustration to the similarity their condition still bore to slavery. Their politicization around egalitarian slogans undermined plantation discipline and encouraged the transition to decentralized tenant farming and "sharecropping."

The Union League was repressed by the KU KLUX KLAN in 1868 and after, and consciously demobilized by the Republican leadership as a conciliatory ges-

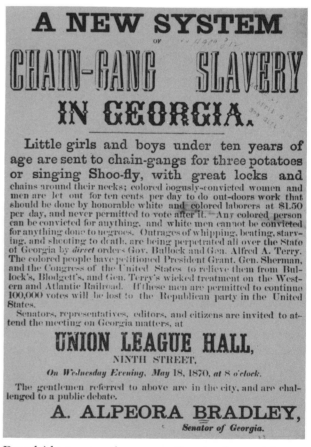

Broadside announcing a meeting to demand better treatment of African Americans, Georgia, 1870. (Photographs and Prints Division, Schomburg Center for Research in Black Culture, The New York Public Library, Astor, Lenox and Tilden Foundations)

ture. Its influence on black voting patterns and on the plantation system was to prove more enduring.

REFERENCES

FITZGERALD, MICHAEL W. *The Union League Movement in the Deep South: Politics and Agricultural Change during Reconstruction.* Baton Rouge, La., 1989.

FONER, ERIC. *Reconstruction: America's Unfinished Revolution, 1863–1877.* New York, 1988, pp. 281–345.

SILVESTRO, CLEMENT MARIO. None but Patriots: The Union Leagues in Civil War and Reconstruction. Ph.D. diss., University of Wisconsin, 1959.

MICHAEL W. FITZGERALD

Unions. *See* Labor and Labor Unions.

Unitarian Universalist Association, religious denomination. The Unitarian Universalist Association (UUA) was formed in 1961. It resulted from a merger of the American Unitarian Association and the Universalist Church of America. Both movements originated in opposition to Puritan theology and its Calvinist-based belief in predestination, human sinfulness, and a punitive God. Unitarianism appeared in the early nineteenth century as a quiet rebellion within the established church; its proponents insisted on the oneness and benevolence of God. Adherents to Universalism, on the other hand, posed a vocal challenge from without; emerging on the eve of the AMERICAN REVOLUTION, they proclaimed universal, rather than selective, salvation.

With their emphasis on the moral authority of the individual and the power of reason, both denominations produced prominent abolitionists (*see* ABOLITION). In 1784, Benjamin Rush, signer of the Declaration of Independence, and a Universalist, helped reestablish and later became president of the Pennsylvania Society for Promoting the Abolition of Slavery. William Ellery Channing (1780–1842), the preeminent Unitarian minister of his day, came to oppose slavery. Perhaps the most outspoken white Unitarian abolitionist, Theodore Parker, declared his defiance of the Fugitive Slave Law of 1850 by saying, "I have in my church black men, fugitive slaves [and] I have been obliged to take [them] into my house to keep them out of the clutches of the kidnappers." Black Unitarians included Frances Ellen Watkins HARPER, an abolitionist, writer, lecturer, and advocate of universal suffrage.

At the same time, many Unitarians tolerated slavery or defended it outright. Thomas Jefferson, closely associated with the Unitarian theology, came to an accommodation with the institution of slavery. Unitarians John C. Calhoun and Daniel Webster argued for the COMPROMISE OF 1850, which was signed into law by another Unitarian, President Millard Fillmore.

After the Civil War, neither the Unitarians nor the Universalists were active in proselytizing African Americans. Although black converts to Unitarianism and Universalism tried to establish congregations on at least ten occasions between 1860 and 1948, they received meager support. Nonetheless, several black Unitarian ministers established churches in black communities. The Rev. Egbert Ethelred Brown (1875–1956), an activist leader in a number of Jamaican organizations in New York City and a Socialist party candidate for the New York State Assembly, founded the Harlem Unitarian Church in 1920; among those it attracted were black socialists W. A. DOMINGO and Frank CROSSWAITH. The Rev. Lewis Allen McGee (1893–1979), a former African Methodist Episcopal minister, became a leader in the American Humanist Association and established a Unitarian congregation—the Free Religious Fellowship—on Chicago's south side in 1948.

A few white ministers shared their broader vision. In 1903, Franklin C. Southworth, president of Meadville Theological School, wrote that "liberal Christianity has a mission to the blacks, whether it is labeled Unitarian or not." He wanted Meadville to "help in solving the race problem." Among its students were the Rev. Brown and Don Speed Smith Goodloe, who became the first black principal of Maryland Normal School No. 3, later Bowie State College.

The Rev. John Haynes Holmes was another visionary. The minister of the Community Church of New York, he was a founder of the NATIONAL ASSOCIATION FOR THE ADVANCEMENT OF COLORED PEOPLE (NAACP) in 1909 and soon thereafter racially integrated his own congregation. But it was not until the 1950s that other congregations—mostly major urban churches—made the effort. Their members participated in struggles for civil rights and open housing and, in 1965, hundreds of Unitarian Universalists responded to the Rev. Dr. Martin Luther King, Jr.'s call during the fight for voting rights in Selma, Ala. Among them was the Rev. James Reeb, whose brutal murder galvanized support among Unitarian Universalists. Duncan Howlett, Reeb's colleague at All Souls Unitarian Church of Washington, D.C., became the first chair of the U.S. Civil Rights Commission. Another Unitarian, educator Whitney M. YOUNG, Jr., served as executive director of the NATIONAL URBAN LEAGUE.

Unitarian Universalist Association leaders remained at the forefront of change even as the emphasis of the CIVIL RIGHTS MOVEMENT shifted to black power. In 1967, a Black Unitarian Universalist Caucus was formed to promote social change and combat racism. A year later, in an emotional general assembly, the UUA agreed to commit $1 million to support a BUUC-sponsored Black Affairs Council. Although the measure was backed by almost 75 percent of the assembly delegates, it threatened to split the organization. In 1970, the UUA sharply reduced the resources that had been allocated for black empowerment. The organizational conflict and resulting paralysis led to the departure of a number of African Americans from the denomination.

Since it conducted an institutional racism audit in 1981, the UUA has continued to face the challenge of becoming a more inclusive movement. It remains an advocate of racial justice, continues to publish, through Beacon Press, black authors such as Marian Wright EDELMAN, James BALDWIN, Paul ROBESON, and Cornel West, and has established race awareness programs. But in 1987, of the UUA's 140,000 adult members, only 1,800 were African American.

REFERENCES

MORRISON-REED, MARK D. *Black Pioneers in a White Denomination.* Boston, 1984.

ROBINSON, DAVID. *The Unitarians and the Universalists.* Westport, Conn., 1985

STANGE, DOUGLAS S. *Patterns of Antislavery Among American Unitarians, 1831–1860.* Rutherford, N.J., 1977.

MARK D. MORRISON-REED

United Church of Christ.

The United Church of Christ (UCC) was formed in 1957 by the union of the Congregational Christian church (itself formed by the merger of the Congregational and Christian churches in 1931) and the Evangelical and Reformed church, a denomination formed in 1934 by the conjunction of the Lutheran and Reformed churches, two small Lutheran groups (*see* LUTHERANISM; REFORMED CHURCH IN AMERICA). The UCC has a continuing historical connection to African Americans, principally through the Congregational and Christian church components.

The Congregational Tradition

African Americans became involved in Congregational churches in the seventeenth century, beginning in New England, where enslaved blacks attended church with their Puritan slavemasters. The first convert, an unidentified slave woman belonging to the Rev. John Stoughton, was recorded in 1641. While religious attendance was required, only a few slaves and free blacks actually volunteered to be baptized. Congregationalism was never widely popular among blacks. Not only were blacks forced into subservient roles in church services, but the style of worship was generally too didactic to appeal to the black masses. In 1698, the Congregational minister Cotton Mather (1663–1728) expressed his pleasure at the conversion of four enslaved blacks. In an effort to aid conversion, in 1738 the powerful General Association of Connecticut ruled that children of slaves, irrespective of their enslaved parents' religion, could be baptized if the master was part of the covenant.

By the AMERICAN REVOLUTION, a few blacks—such as future Masonic leader Prince HALL, who joined the church in 1763; John Quammnie, a future applicant for African missionary service, admitted to the church at Newport in 1765; and the poet Phillis WHEATLEY, who became a member of Boston's Old South Meeting House in 1775—were admitted to full membership. Most African Americans were required to sit apart from whites, often in church galleries or balconies far from the pulpit. However, slave marriages solemnized in church proceedings were recognized as valid. In the first decade of the eighteenth century, at the request of some Massachusetts slaves, a "Religious Society of Negroes" was gathered under the tutelage of minister Cotton Mather, who paid a schoolmistress to teach slaves to read. Like many ministers, Mather held special meetings (particularly at night gatherings) for black congregants. Mather's writings are an important reflection of the condescending and mistrustful attitudes of the Puritan fathers toward Africans. In *The Negro Christianized* (1706), Mather admonished slave masters to convert "the Blackest instances of Blindness and Baseness into Admirable Candidates of Eternal Blessedness." Some Congregationalists, notably Samuel Sewall (1652–1730), inveighed against the institution of SLAVERY, but few favored the full assimilation of blacks into colonial society and politics.

By the end of the eighteenth century, the revolutionary spirit sparked a rise in antislavery and egalitarian sentiment within the church, which opened up spaces for certain blacks. In 1780, the Rev. Lemuel HYNES, an eloquent African American, was ordained as a minister, and in 1785 he was named pastor of the all-white Congregational church in Torrington, Conn. He later went on to pastor largely white congregations in Rutland, Vt., and New York. At the same time, however, Congregationalism generally declined in popularity. The first Great Awakening of the 1740s had divided the Congregationalists. The church was further weakened by its disestablishment

in most of New England in the early part of the nineteenth century. Both whites and blacks left the church to become Methodists or Baptists. Following the Act of Union between the Congregationalists and the Presbyterian church in 1801, many church members, particularly in the frontier states, chose to affiliate with the Presbyterians.

During the antebellum period, the Congregational church experienced a modest revival of interest among northern blacks, due in part to its developing antislavery position, as well as the doctrinal independence enjoyed by individual congregations. Individual Congregationalist ministers and lay people such as Lewis Tappan, Simeon S. Jocelyn, William E. Jackson, and, later, Henry Ward Beecher, were influential abolitionists (see ABOLITION). In 1835, Weld's disciples, chased from Cincinnati's Lane Seminary, took over newly established Oberlin College in Ohio, and turned it into an abolitionist stronghold and pioneer interracial community. The principal outreach instrument of the Congregationalists to African Americans was the AMERICAN MISSIONARY ASSOCIATION (AMA), officially nondenominational but heavily Congregational, founded in 1846. Missionaries aided FUGITIVE SLAVES and went on speaking tours in order to persuade Southerners of the sinfulness of slavery.

Racial pride and self-affirmation also led to the foundation of black Congregational churches, starting in 1820 with the establishment of the Dixwell (later Dixwell St.) Congregational Church in New Haven, Conn., and continuing with Hartford, Conn.'s Talcott St. Church (1833). By 1850, there were also congregations in Pittsfield, Mass.; Portland, Me.; Providence, R.I.; and Cincinnati, Ohio. These churches, as well as neighboring white churches, were pastored by such well-known African-American abolitionist clergymen as Charles B. RAY, Samuel Ringgold WARD, Amos G. BEMAN, and J. W. C. PENNINGTON. These and other black ministers, who were active in the largely Congregational AMERICAN ANTISLAVERY SOCIETY, were instrumental in founding the Union Missionary Society (UMS) in 1841 as an antislavery mission. After the UMS was absorbed into the American Missionary Association Society, they served as board members and agents of the AMA.

There were also a few Congregational churches in the colonial and antebellum South. Circular Church in Charleston, S.C., established in 1691, was the first non-Anglican congregation in the city. The church, staffed largely by immigrants from New England, had several slave and free black members. Eventually they were absorbed into all church activities, including readings, the singing of hymns, and exhorting, though they were forbidden to preach. Meanwhile, Midway Church, founded in Liberty County, Ga., in

1752, had a congregation which from the beginning was composed in large part of African Americans, and ultimately had some 800 black members. When a new church building was constructed, an enormous balcony was set aside for black congregants. In 1830, Midway's leadership organized the Liberty Country Association for Religious Instruction, and organized missionary efforts on plantations. Sunday schools were led by African-American "watchmen" trained in catechism. Beginning in the 1840s, integrated churches were started in Missouri and Kentucky by American Missionary Association home missionaries.

Following the end of the Civil War, the American Missionary Association sent workers into the South in large numbers in a mission to the freedmen. The AMA's chief concern was education, and in the decade following the inauguration of its mandate in 1861, the AMA commissioned 3,470 ministers, missionaries, and teachers, who taught a total of 321,099 students in some 355 schools. The AMA released control of most of the schools to state authorities, but six so-called AMA Colleges are still affiliated with the UCC: Fisk University, Dillard University, LeMoyne-Owen College, Houston-Tillotson College, Talladega College, and Tougaloo College.

Despite the church's policy of education and racial uplift before evangelization, several black Congregational churches were set up during RECONSTRUCTION. Most were small congregations—the largest had 225 members—in large urban areas and/or AMA college towns, with largely middle-class congregations. Northern churches included the First Congregational Church in Washington, D.C., where Frederick DOUGLASS was a frequent worshipper. The first Southern churches were set up in 1868 in Charleston and Atlanta. More were founded within a few years in Chattanooga (led by African-American missionary E. D. Tade), Memphis; Nashville; Macon, Ga.; Talladega, Ala.; and Berea, Ky. By 1895, a total of 143 black Congregational churches had been organized in the eleven southern states, with a total membership of about 10,000 people. Membership began to decline soon thereafter. For example, by 1901, 22 of the 122 churches that had been set up in the turpentine fields of Georgia closed. The attrition was due in part to rapidly changing economic, political, and social conditions, which caused thousands of African Americans to flee the farms for the cities of the North and South. The churches were never fully self-supporting, and white congregations became increasingly reluctant to provide funds. In 1913, the American Missionary Association officially associated with the Congregational church, and in 1921 created an Office of the Superintendent of Negro Work to supervise financial support for the budgets of black

Congregational churches. (The American Missionary Association would become a "corporate entity" within the church's Bureau of Home Missions in 1937.)

The Congregational church was never a truly popular religious institution among African Americans. Not only was the denomination too "white"—elite in membership and unemotional in ritual—for the needs of many poor blacks but also churches had difficulty in setting up outside urban areas in the South. Local whites feared the introduction of such "outside" houses of worship with messages of individual liberty and thought. Congregational leaders did try to build churches into "community centers" to meet the needs of the black masses. The most significant attempt during the turn of the century to create a community church was Atlanta's First Congregational church, whose pastor, Henry H. Proctor, set up educational, recreational, and social welfare facilities in his church.

The Congregational Christian Church

The origins of the Congregational Christian church, or Christian church as it was also known, can be traced to the Cane Ridge, Ky., revivals of 1801, a four-way gathering of 25,000 Baptists, Presbyterians, Methodists, and other denominations, almost all from the Upper South, and their subsequent joining together to form a denomination based on emotional preaching and only on "simple" elements of Christianity, such as belief in Jesus Christ and the Bible. (The roots of the Congregational Christian church are somewhat similar to those of the DISCIPLES OF CHRIST, the latter of whom also are known as the Christian church. The two groups, however, should not be confused.) The African Americans who joined the Congregational Christian church were admitted as members of white-dominated churches, and there is little evidence that they held official positions or enjoyed significant influence within the church. The first black Congregational Christian church, Providence Church, in Chesapeake, Va., was founded by free blacks in 1852. In 1853, Congregational Christian church congregations in Christian County, Ky., purchased the freedom of an enslaved black, Alexander Cross, and sent him to Africa as a missionary. After the end of the Civil War, black Congregational Christian church members broke from white congregations and established their own African-American churches in North Carolina and Virginia. The number of black Congregational Christian church congregations quickly multiplied. In 1867, the North Carolina Colored Christian Conference, representing twenty African-American churches, was formed under white supervision. In 1873, twenty-seven ministers met at the Christian Chapel in Wake County,

N.C., and formed a West North Carolina Conference. Two years later, a Virginia Colored Christian Conference also formed. In 1892, at Watson Tabernacle in New Bern, N.C., the Afro-Christian Convention was founded under the auspices of the (white) Christian Convention of the South. Three years later, there were approximately sixty-nine black Congregational Christian churches in eighteen licentiates, with thirty-three ministers and 6,000 church members.

The black Congregational Christian church became involved early in missionary activities, publishing, and education. In 1883, with the help of a tax on congregations, church members founded the Franklinton Literary and Theological Institute in Franklinton, N.C. (The first president was a white Northerner, the Rev. Henry E. Long.) In 1905, the institute became Franklinton Christian College. Poorly funded, it closed in 1930. Another important educational institution connected with the black Congregational Christians was Palmer Memorial Institute in Sedalia, N.C., a high school directed by noted educator Charlotte Hawkins Brown.

The black Congregational Christian movement did not have indigenous leadership until 1915, when the Rev. Smith A. Howell became its president. Despite its new structure and leadership, the growth in the number of churches and in membership was quite modest in the next years.

United Church of Christ

In 1931, the General Council of the Congregational Churches and the General Council of the Christian Churches merged. Not all black churches participated in the merger. Many Afro-Christian Conferences retained their independence, and remained separate until 1965. In 1950, the Office of Superintendent, which had governed the black churches, was dissolved, and the 106 former Congregational churches and 129 former Christian churches formed the Convention of the South. Although the pattern of racially segregated congregations and judicatories in the South continued within the new church, several blacks were elected to prominent positions within the church, adding to today's African-American influence in the UCC. Some notable black ministers include Andrew YOUNG, who was a pastor in Georgia from 1955 to 1957, Earl Murphy of Birmingham, Ala., and Theodore Friedy from the Bronx, N.Y. In 1961, four years after the Congregational Christian church was absorbed into the United Church of Christ, the General Synod enacted legislation eliminating all segregated judicatories within the UCC. Although this process would take several years to be fully implemented, its ultimate impact was to scatter the African-American congre-

gations among new conferences, thus weakening their sense of unity.

However, African Americans within the UCC helped establish the Commission for Racial Justice in 1967 and the Council for Racial/Ethnic Minorities in 1983, both of which advocate for concerns pertaining to ethnic and racial minorities within the church. In addition, African Americans formed two special-interest advocacy groups: Ministers for Racial and Social Justice (MRSJ), founded as the Committee for Racial Justice Now in 1963, and the United Black Christians (UBC). In 1969 black militants from these groups occupied the offices of the United Church's Board for World Ministries and Board for Homeland Ministries in an unsuccessful attempt to obtain the creation of a black university. In 1976, the Committee for Racial Justice printed a directory of black churches and ministers in the UCC, and the same year joined several other church groups to form the Black Church Development Program, an effort at black outreach. The Commission for Racial Justice, which achieved further renown under the direction of the Rev. Benjamin CHAVIS from 1986 to 1993, operated such programs as the annual Amistad Awards in race relations and the annual Institutes on Race Relations at Fisk University.

As of 1988, there were 280 predominantly African-American churches within the United Church of Christ, with a total black membership of more than 62,000, representing 4 percent of the total UCC membership. There were also three African-American conference ministers and a number of African Americans in administrative and supervisory posts.

REFERENCES

ALSTON, PERCEL D. "The Afro-Christian Connection." In Barbara Brown Zikmund, ed. *Hidden Histories in the United Church of Christ,* Vol. 1. New York, 1984, pp. 21–36.

DE BOER, CLARA MERRITT. *Be Jubilant My Feet: African American Abolitionists in the American Missionary Association, 1839–1862.* New York, 1994.

———. "Blacks and the American Missionary Association." In Barbara Brown Zikmund, ed. *Hidden Histories in the United Church of Christ,* Vol. 1. New York, 1984, pp. 81–95.

GREENE, LORENZO J. *The Negro in Colonial New England.* New York, 1968.

GUNNEMANN, LOUIS. *The Shaping of the United Church of Christ.* New York, 1977.

HOTCHKISS, WESLEY A. "Congregationalists and Negro Education." *Journal of Negro Education* (Summer 1960): 289–298.

STANLEY, A. KNIGHTON. *The Children Is Crying: Congregationalism Among Black People.* New York, 1979.

STANLEY, J. TAYLOR. *A History of Black Congregational Churches of the South.* New York, 1978.

 LAWRENCE N. JONES

United Colored Democracy, Harlem-based Democratic club. The United Colored Democracy (UCD) was founded in January 1898 by James Carr, Edward Lee, and other African-American political activists whose demands for greater patronage for blacks at the municipal level had been rejected by Lemuel Twigg, REPUBLICAN PARTY leader in Manhattan. Carr and Lee reached a more favorable patronage agreement with Richard Croker, leader of Tammany Hall (the regular DEMOCRATIC PARTY in Manhattan), in return for a concerted effort by Carr and Lee to attract black voters to the Democratic party. Croker supervised the establishment of the United Colored Democracy in the hopes of cultivating an African-American Democratic constituency. Lee became the first president of the UCD in 1898; both he and Carr were awarded patronage positions that year. Lee received a position as a New York county sheriff, and Carr became an assistant district attorney.

The UDC was a distinct, racially isolated institution within New York's Democratic party. While other Democrats were organized into regional districts within the county, with each district having its own local leader, all black Democrats were placed under Lee's leadership under the UCD; blacks were not integrated into the mainstream Tammany Hall organization. This development prevented Democrats from organizing effectively among blacks at the grass-roots level.

Tammany and its Democratic affiliates controlled most of the municipal patronage within New York City. However, the UCD faced patronage competition at the state government level from black Republican leader Charles ANDERSON. Anderson became president of the Young Men's Colored Republican Club of New York County in 1890. For the next four decades, Anderson provided state patronage for black Republicans as attorneys, clerks, and other civil service workers. Ferdinand Q. Morton, who ascended to the UCD presidency in 1915, met Anderson's challenge by helping Democratic mayoral candidates to recognize the potential of the new black migrants entering New York between 1915 and 1930. Morton contributed to mayoral candidate John F. Hylan's unprecedented successful showing among Harlem blacks in 1921, and James "Jimmy" Walker's similar success in 1925. Hylan and Walker, in turn, rewarded this burgeoning constituency with substantial patron-

age increases; Hylan made Morton New York's first black chairman of the Municipal Civil Service Commission in 1922, and Walker renewed Morton's appointment in 1927.

Throughout the 1920s, Caribbean-born Democrats, led by J. Raymond Jones, found themselves disappointed when they expected municipal patronage from the UCD. The combined demands of American and Caribbean-born blacks for greater patronage and representation from Tammany, and the decline of the regular Democratic organization itself, led to the breakdown of the UCD. The resignation of Mayor Jimmy Walker in 1932 in the wake of the Seabury corruption scandal, followed by the elections of anti-Tammany President (and former New York governor) Franklin D. Roosevelt and Mayor Fiorello La Guardia, weakened Tammany's influence. La Guardia made Morton's reappointment as civil service commissioner conditional upon Morton's defection from the Democratic party. Morton resigned his UCD leadership and his Democratic party membership in 1935, and joined the American Labor party in order to retain his commission.

Without Morton's centralizing influence, local black Democrats were able to take complete control over the party apparatus in Harlem's black Assembly districts (District 19 in 1935, District 21 in 1939). The UCD collapsed as a result, and New York's Democratic party began the process of becoming a more racially and ethnically inclusive political body.

REFERENCES

HAMILTON, CHARLES V. *Adam Clayton Powell, Jr.: The Political Biography of an American Dilemma.* New York, 1991.

MORSELL, JOHN A. The Political Behavior of Negroes in New York City. Ph.D. diss., Columbia University, 1951.

OSOFSKY, GILBERT. *Harlem, The Making of a Ghetto: Negro New York, 1890–1930.* New York, 1971.

WALTER, JOHN C. *The Harlem Fox: J. Raymond Jones and Tammany, 1920–1970.* Albany, N.Y., 1989.

DURAHN TAYLOR

pledale Country Club in Stow, Mass., three years later.

The UGA consisted of regional organizations of black golfers, such as the Eastern Golfers Association, which periodically staged competitions for individual members and interclub matches. The UGA coordinated the scheduling of these events, and sponsored an annual national championship held at various black clubs throughout the country. The first championship of what would become the UGA was played in 1925 at the Shady Rest Country Club in New Jersey. The winner of the inaugural event was Harry Jackson of Washington, D.C., and the runner-up was John Shippen.

Throughout the years when black professional golfers were unable to compete on the Professional Golfers Association tour, the UGA provided the only opportunity for these golfers to showcase their abilities and, for some, to earn at least a modest living playing golf. It also represented a social network for middle-class blacks who were otherwise excluded from the social institutions associated with the game.

The principal people involved in the history of the UGA were Anna Mae Robinson, the first president and founder of the Black Golfers Hall of Fame; Paris Brown, former tour director of the UGA; and Ethel Williams, founding member of the Wake-Robins Golf Club, the first black women's golf club. As restrictions on African-American golfers diminished throughout the 1950s and '60s, the role of the UGA also diminished. The organization is attempting to establish a permanent home for the Black Golfers Hall of Fame at Wilberforce University in Ohio.

REFERENCES

JONES, GUILFORD. "Past Greats." *Black Sports* (July 1973): 65–66.

PREISS, RICHARD PORTER. "Black Country Clubs Along the East Coast, 1920–1929." Paper presented at the American Culture Association convention, Atlanta, April 2–6, 1986.

LAWRENCE LONDINO

United Golfers Association. The United Golfers Association (UGA) was formed in 1928 to provide African-American golfers the opportunity to compete in regional and national tournaments (*see* GOLF). They were excluded from participation in most golf competitions sponsored by whites-only private and public golf clubs. A forerunner to the UGA, the Colored Golfers Association, established in Washington, D.C., in 1925, changed its name to the United Golfers Association during its annual tournament at the Ma-

United Negro College Fund. The United Negro College Fund, an alliance of forty-one black colleges and institutions of higher education, is a philanthropic enterprise established to fund black education. It was created during World War II, at a time when almost all black colleges were in dangerously poor financial shape. The GREAT DEPRESSION and wartime shortages had cut deeply into charitable donations, and many students were unable to pay their own tuition. In 1943 Tuskegee Institute President

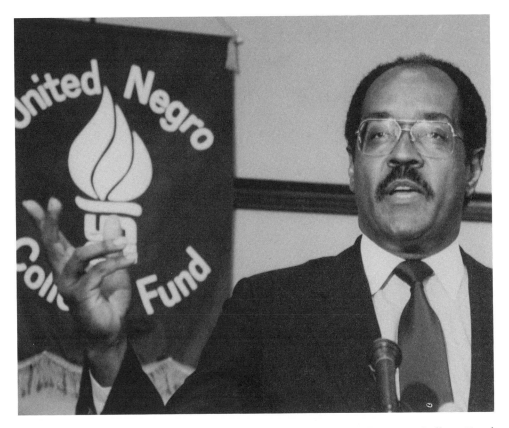

In 1991 William H. Gray was named president of the United Negro College Fund (UNCF). UNCF was established during World War II to help fund higher education at African-American colleges and institutions. (AP/Wide World Photos)

Frederick Douglass PATTERSON wrote an article in the *Pittsburgh Courier*, proposing that black colleges streamline their fundraising by uniting in a joint funding appeal. The next year, presidents of twenty-seven colleges met and agreed to support a united mass fundraising campaign, the proceeds of which they would divide among themselves. With the aid of donations from the Julius Rosenwald Fund and by the Rockefeller-based General Education Board, the organization, named the United Negro College Fund (UNCF) and based in New York, was founded. It was composed of privately supported (largely southern) black colleges, which authorized the UNCF to raise all funds for operating expenses such as scholarships, teachers' salaries, and equipment. Each college president agreed to serve revolving thirty-day terms leading UNCF efforts. William Trent, a manager trained at the University of Pennsylvania's Wharton School, was its first executive director.

In 1944 the UNCF inaugurated its first national campaign. It was an enormous success: the organization raised $765,000, three times the combined amount that its member colleges had collected in the previous year. Fueled by its rapid success, the UNCF soon grew, hiring a permanent independent staff. In

1951 the UNCF began a separate capital campaign, the National Mobilization of Resources, for the United Negro Colleges to pay for building and endowment funds, and raised $18 million in four years with the help of John D. Rockefeller, Jr. In 1963 the UNCF, with the support of President John F. Kennedy and the Ford Foundation, began an additional appeal for funds for long-neglected maintenance and expansion of campus physical plants, and raised $30 million in a single year.

In 1964 Trent resigned. As it struggled to redefine its mission and to promote the legitimacy of black college education in the face of mainstream university desegregation, the UNCF went through six presidents, beginning with Patterson, in the next ten years. The turbulence of the Civil Rights Movement scared away potential donors, and funding levels dropped.

In 1972 the UNCF was accepted by the Advertising Council, and television and radio advertising became a major avenue for fundraising. The UNCF's slogan, "A mind is a terrible thing to waste," became so well known it was featured in *Bartlett's Familiar Quotations*. Under the leadership of Christopher Edley (president from 1973 to 1990), the UNCF's an-

nual campaign receipts went from $11.1 million to $48.1 million; its membership grew to forty-one colleges. In 1978 the UNCF inaugurated a Capital Resources Development Program, which raised $60 million for its member institutions, and a College Endowment Funding Program, designed by Patterson to reduce college dependence on federal funding for permanent expenses. In 1980 the UNCF also began a yearly fundraising telethon, "The Lou Rawls Parade of Stars."

In 1990 Christopher Edley resigned, and the following year, U.S. House Majority Whip William GRAY III left his seat in Congress to become the UNCF's new president, underlining its importance in the black community. That year, the UNCF started "Campaign 2000," a drive to raise $250 million by the year 2000. With the support of President George Bush and a $50 million gift from media magnate Walter Annenberg, it raised $86 million in its first year.

The United Negro College Fund remains the premier nongovernmental funding source for historically black colleges. Its narrow goal of endowment fund-raising and appeal to donors across the political spectrum has brought it a certain amount of criticism as a politically "safe" charity. However, its defenders have emphasized that quality black colleges remain a necessary alternative for students seeking higher education, and the UNCF's efforts have assured the survival and growth of these institutions.

REFERENCE

PATTERSON, FREDERICK DOUGLASS. *Chronicles of Faith: The Autobiography of Frederick Douglass Patterson.* Tuscaloosa, Ala., 1991.

GREG ROBINSON

United States Commission on Civil Rights.

The Commission on Civil Rights was established as part of the Civil Rights Act of 1957. Originally known as the President's Commission on Civil Rights, it was intended to be a temporary commission. The commission's purpose was to investigate complaints about voting rights infringement due to race, color, religion, or ethnicity; to compile information on the denial of equal protection under the law that could be used in further civil rights protection; to serve as a clearinghouse of information on equal protection in the United States; and to submit a final report and recommendations to Congress and the President within two years.

Of the first six commissioners appointed by the President and Congress, only one was black—J. Er-

nest Wilkins, an assistant secretary of labor in the Eisenhower administration. The first chairman was Stanley Reed, a former U.S. Supreme Court Justice who resigned almost immediately, citing "judicial improprieties" in the commission's charter. Reed was replaced by Dr. John Hannah, who served as chairman until 1969. The commission, which had its mandate extended by the Civil Rights Act of 1960, served to focus attention on the U.S. government's responsibilities regarding civil rights. The commission was also a place to which African Americans could bring complaints about legislative and extralegal, violent attempts to keep them from voting. In February 1963, the commission issued *Freedom to the Free,* a report marking the centennial of the Emancipation Proclamation. It pointed out that while the problem in the South remained de jure segregation and discrimination, in the North it was de facto: "The condition of citizenship is not yet full-blown or fully realized for the American Negro. . . . The final chapter in the struggle for equality has yet to be written." The commission's powers were enlarged and its existence extended by the 1964 Civil Rights Act to encompass investigation of allegations of denial of equal protection of any kind. Its two-volume report, *Racial Isolation in the Public Schools* (1967), pointed out increasing racial segregation in schools, especially in metropolitan areas, as whites left the cities for the suburbs, laying responsibility at the feet of housing discrimination as practiced by private citizens and local, state, and federal government. In 1969, the Rev. Theodore Hesburgh of the University of Notre Dame, a noted liberal on civil rights and segregation issues, succeeded Hannah as chairman.

During the busing crisis of the early 1970s, the commission reaffirmed the view that Congress had the responsibility for establishing a "uniform standard to provide for the elimination of racial isolation." It chided President Richard Nixon for being overly cautious about ending de facto segregation in the North in a 1970 report. Largely because of this, Nixon forced Chairman Hesburgh to resign in 1972 and replaced him with the more conservative Arthur S. Fleming the following year. The fifth report of the commission, released in November 1974, documented the failure of the government to fulfill its obligations to blacks in employment. The commission's term was extended by the Civil Rights Commission Authorization Act of 1978, as it had been previously extended every time its term was up.

During Ronald Reagan's administration, the commission became the stage for a debate about affirmative action. In 1980 it endorsed racially based employment quotas in a report entitled "Civil Rights in the 1980s: Dismantling the Process of Discrimination." However, in 1981 President Reagan fired

Chairman Arthur Fleming and replaced him with Clarence Pendleton, Jr., an arch-conservative and the first African American to serve as chairman; all subsequent chairpersons have also been African-American. In 1983 Reagan dismissed three other commissioners because they were critical of his administration's civil rights policies. One of the dismissed members, noted African-American historian Mary Frances Berry, successfully sued the Reagan administration to retain her position on the board, citing the commission's loss of independence. Following several months of negotiations involving the administration, Congress, and the commission itself, a compromise was reached and the body was reconstituted as the U.S. Commission on Civil Rights, with the President and Congress each appointing half the members, now numbering eight. More importantly, commissioners now had eight-year terms that could be terminated "only for neglect of duty or malfeasance in office."

In 1985 Chairman Pendleton declared that AFFIRMATIVE ACTION programs should be ended and the commission ultimately abolished. The next year he proposed that minority contract set-asides (see MINORITY BUSINESS SET-ASIDES) should be ended; the rest of the commission disagreed with him, as did the National Black Republican Council, so the plan did not go forward. During the George Bush administration, the debate over quotas continued. Pendleton died in 1988 and was replaced by William Barclay Allen, an African American, who was forced to resign in October 1989 following the disclosure that he had been arrested for kidnapping a fourteen-year-old girl in a child custody battle. The commission's authorization expired September 30, 1989, and the reauthorization process was an occasion for Congress to examine the body's composition and future. Its new chairman, Arthur A. Fletcher, former executive director of the NATIONAL URBAN LEAGUE, appointed in February 1990, vowed to be more active than his predecessors and to make the commission the nation's conscience once again. In August 1991 the commission issued its first significant report on discrimination on six military bases in Germany, and followed it six months later with a report on pervasive discrimination against Asians, based on barriers of language and culture.

See also CIVIL RIGHTS AND THE LAW.

REFERENCES

BLAUSTEIN, ALBERT P., and ROBERT L. ZANGRANDO, eds. *Civil Rights and the American Negro: A Documentary History.* New York, 1968.

LOWERY, CHARLES D., and JOHN F. MARSZALEK, eds. *Encyclopedia of African-American Civil Rights: From Emancipation to the Present.* New York, 1992.

PLOSKI, HARRY A., and JAMES WILLIAMS, eds. *The Negro Almanac: A Reference Work on the African American.* 5th ed. Detroit, 1989.

ALANA J. ERICKSON

Universalism. *See* Unitarian Universalist Association.

Universal Negro Improvement Association. The Universal Negro Improvement Association (UNIA), with its motto "One God, One Aim, One Destiny" stands as one of the most important political and social organizations in African American history. It was founded by Marcus GARVEY in July 1914, in Kingston, Jamaica, West Indies.

At the time of its establishment, its full name was the Universal Negro Improvement and Conservation Association and African Communities (Imperial) League (ACL). Originally organized as a mutual benefit and reform association dedicated to racial uplift, the UNIA and ACL migrated with Garvey to the United States in 1916. Incorporated in New York in 1918, the UNIA gradually began to give voice to the rising mood of New Negro radicalism that emerged within the African-American population following the signing of the Armistice ending World War I in November 1918.

The UNIA experienced a sudden, massive expansion of membership beginning in the spring of 1919, spearheaded by the spectacular success of the stock-selling promotion of the Black Star Line, Inc. (BSL). Together with the Negro Factories Corporation and other commercial endeavors, all of which were constituted under the ACL, the BSL represented the heart of the economic program of the movement.

Outfitted with its own flag, national anthem, Universal African Legion and other uniformed ranks, official organ (*The Negro World*), African repatriation and resettlement scheme in Liberia, constitution, and laws, the UNIA attempted to function as a sort of provisional government of Africa. The result was that by 1920–1921, the UNIA became the dominant voice advocating black self-determination, under its irredentist program of African Redemption. Accompanied by spectacular parades, annual month-long conventions were held at Liberty Hall in Harlem in New York City between 1920 and 1924, at all of which Garvey presided. The document with the greatest lasting significance to emerge was the "Declaration of the Rights of the Negro Peoples of the

World," passed at the first UNIA convention in August 1920.

Nearly a thousand local divisions and chapters of the UNIA were established by the mid-twenties in the United States, Canada, the West Indies, Central and South America, Africa, and the United Kingdom, causing the influence of the UNIA to be felt wherever peoples of African descent lived. With actual membership running into the hundreds of thousands, if not millions, the UNIA is reputed to have been the largest political organization in African-American history.

After Garvey's conviction on charges of mail fraud in 1923, following the ill-fated collapse of the Black Star Line, and his incarceration in the Atlanta Federal Penitentiary starting in 1925, membership in the UNIA declined rapidly. When President Calvin Coolidge commuted Garvey's sentence and he was deported from the United States in 1927, the organization found itself racked by increasing factionalization.

A new UNIA and ACL of the World was incorporated by Garvey in Jamaica at the August 1929 convention, competing with the New York-based

UNIA parent body headed at the time by Fred A. Toote, who was succeeded by Lionel Francis in 1931. With the worldwide economic collapse following the 1929 stockmarket crash, however, the UNIA went into further decline, as members' resources dwindled, making it difficult to support two separate wings of the movement. Demoralization also set in as a result of the increasing fragmentation of the UNIA leadership. Garvey was able to retain the loyalty of only a part of the movement, notably the Garvey Club and the Tiger division of the New York UNIA.

When Garvey moved his headquarters in 1935 from Jamaica to London, he tried once again to revive the movement, but soon found himself confronting considerable opposition by members who were in the forefront of the pro-Ethiopian support campaign during the Italo-Ethiopian War of 1935. These members repudiated the criticisms leveled by Garvey against Ethiopia's Emperor Haile Selassie I, following invasion by Mussolini and the Fascist Italian Army.

After Garvey's death in 1940, loyalists moved the headquarters of the organization to Cleveland, Ohio, under the leadership of the new president general,

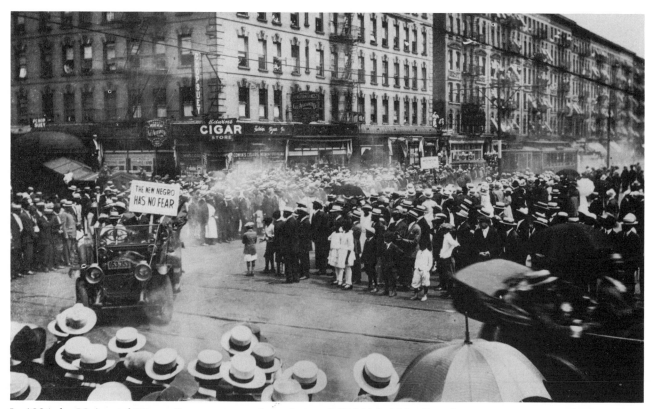

In 1924 the Universal Negro Improvement Association (UNIA) held its fourth International Convention of the Negro Peoples of the World, in Harlem. In 1920 the UNIA's "Declaration of the Rights of the Negro Peoples of the World" had called for the immediate end of colonial control of black Africa. (Photographs and Prints Division, Schomburg Center for Research in Black Culture, The New York Public Library, Astor, Lenox and Tilden Foundations)

James Stewart, who thereafter relocated with it to Liberia. By the 1940s and '50s, the UNIA was a mere shadow of its former strength, but it still continues to function today.

REFERENCES

HILL, ROBERT A., ed. *The Marcus Garvey and Universal Negro Improvement Association Papers.* Vols. 1–7. Berkeley and Los Angeles, Calif., 1983–1991.

HILL, ROBERT A., and BARBARA BAIR. *Marcus Garvey: Life and Lessons.* Berkeley and Los Angeles, Calif., 1987.

ROBERT A. HILL

Upshaw, Eugene Thurman "Gene" (August 15, 1945–), football player and labor leader. Born and raised in Robstown, Tex., Gene Upshaw worked long hours as a child picking cotton in the fields. After graduating from Robstown High School, he entered Texas Agricultural and Industrial College (Texas A & I) in Kingsville as a paying student. When the football coach noticed him watching practice, he was invited to join the team and was offered a scholarship. In his last year in college, 1966–1967, he played in the College All-Star Game.

Selected by the Oakland Raiders in the first round of the 1967 National Football League (NFL) draft, Upshaw played left offensive guard for the team from 1967 to 1982. The Raiders' captain, he was selected for six Pro Bowls, and his three Super Bowl appearances in three different decades stands as a record. In 1987, he was inducted into the Pro Football Hall of Fame.

In 1970, Upshaw became an alternative player-representative for the NFL Players Association (NFLPA). By 1976, he was a member of the NFLPA's Executive Committee, and in 1980 he became its president. Three years later, he became the NFLPA's executive director, the first former athlete and the first African American to hold that position. That same year, 1983, Upshaw also became the President of the AFL-CIO's Federation of Professional Athletes. In 1985, with his election as the only black member to the Executive Council of the AFL-CIO, Upshaw established himself as the highest-ranking black union leader since A. Philip RANDOLPH.

In 1982 and again in 1987, Upshaw led strikes by the NFL players in protest against, among other things, the owners' refusal to allow true free agency in the collective bargaining agreement. In 1987, after a six-week unsuccessful strike, Upshaw, in a strategic move, disbanded the union and filed an antitrust suit against the owners in federal court in Minneapolis. On September 10, 1992, a jury ruled in favor of

the players, and on January 6, 1993, Upshaw negotiated an agreement with the owners that created a new system of free-agency in the NFL and awarded the NFLPA a $195 million settlement. In the spring of 1993, the NFLPA was recertified as a union in order to begin collective bargaining. After 10 years without an agreement, 96 percent of the union members voted in favor of Upshaw's collective bargaining agreement, which runs through March 1, 2000. After the signing, the NFLPA awarded Upshaw, who had gone without pay during his first year as executive director, a six-year contract at $1 million per year.

Among the many honors Upshaw has received are the NFLPA's Whizzer White Humanitarian Award (1980) and the A. Phillip Randolph Award (1982).

REFERENCE

DEFORD, FRANK. "The Guard Who Would Be Quarterback." *Sports Illustrated* (September 14, 1987).

LYDIA MCNEILL

Urbanization. Cities have played a crucial role in African-American history and have exercised a powerful influence, both positive and negative, on the lives of black people in America. As centers of trade and communication, they have fostered the growth of African-American culture and communities. In addition, they have held out the promise of greater economic opportunity, and their scale and structure have often allowed blacks a certain freedom from white domination not possible in rural areas.

Colonial America

The African-American experience in cities began in the seventeenth century. SLAVERY brought the first African Americans to cities as early as the mid-1600s (*See also* SLAVE TRADE), and as cities grew, so in most cases did their African-American populations. In many cases, slaves had a virtual monopoly on ironworking, carpentry, and other forms of skilled labor necessary for the growth of urban areas. Some cities, such as CHARLESTON, S.C., were built with the help of slave labor. (NEW ORLEANS, then under French control, was largely built by enslaved Africans). Furthermore, particularly in southern states, urban white families overcame chronic white domestic labor shortages by employing enslaved or free black servants. By the 1740s, slaves and freemen represented one-fifth of the population of NEW YORK CITY and more than half of the residents of cities like Charleston and Savannah, Ga. The close atmosphere of cities both promoted interracial contacts and fueled white fears. A slave rebellion in New York City in 1712 led

to the torture and execution of a score of accused African Americans. In 1741, a series of unexplained fires, blamed on New York slaves, led to similar atrocities.

Antebellum America

Following the AMERICAN REVOLUTION, a new class of free blacks grew out of manumissions and northern state abolition. Many of the freemen settled in cities. Black communities, with their own churches and social institutions, appeared in such places as PHILADELPHIA, BALTIMORE, and Charleston. In response to prejudice and exclusion from white institutions, these free communities built independent religious and social networks. Blacks usually lived in small enclaves on the city's periphery and in a checkerboard pattern of mostly black streets near places of employment. As centers of production in an industrializing economy and seats of culture and learning, cities offered African Americans greater opportunities to become educated and to find employment. Still, urban freedoms were relative, and slaves and free people alike remained at the bottom of the urban occupational structure.

During the antebellum period, slavery continued in southern cities, though the urban slave population declined relatively and in some cases absolutely throughout the era, as slaves either were sold to rural areas or freed. Slaves continued as domestics and as skilled and menial workers, and some worked in factories such as Richmond, Va.'s Tredegar Iron Works. Urban slaves often hired out their labor and kept part of their wages, although few slaves were able to accumulate enough property to purchase their freedom. Slaves enjoyed significant autonomy in the urban milieu, and owners were often unable to control them. Frederick DOUGLASS, who spent his childhood in Baltimore, remarked that "a city slave is almost a freedman compared with a slave on the plantation." The problem of discipline was an important element in the decline of urban slavery. Masters were unable to assure compliance with their orders. Conversely, Douglass noted that his ability to find paid employment and the requirement that he turn over money he had earned to his master revealed fully to him the exploitative nature of slavery, and made him yearn for freedom. Richard WADE, in his classic work, *Slavery in the Cities* (1964), argued that while in theory slave labor was adaptable to cities, the problem of controlling and disciplining slaves in the city made slavery fundamentally incompatible with city life. Later historians such as Robert Starobin, in *Industrial Slavery in the Old South* (1970), have stressed the adaptability of slave labor to industrial work but many have questioned whether, given white labor competition, slave labor in cities was ever as economically efficient as in agriculture.

Reconstruction and After

After the CIVIL WAR, the existing urban black communities of the North and South expanded. At the same time, many southern cities were endowed for the first time with significant black populations. Almost all of the South's educated and affluent African Americans lived within these urban black communities. A large percentage had been free before the war—many were light-skinned—and they provided the basis for a nascent middle class of ministers, professionals, morticians, barbers, politicians, and other professions. Within this group was a tiny elite of wealthy, cultured blacks. As whites worked to enforce a new system of racial subordination after the end of RECONSTRUCTION, the black elites mobilized to improve the quality of life within their segregated enclaves. Through their efforts, black neighborhoods received their first paved streets, city water, and public parks, as well as public support for segregated hospitals, schools, and colleges. Still, many skilled urban blacks, impatient with southern legal and social limitations, migrated to industrial northern and midwestern towns such as DETROIT and CLEVELAND, where they formed small but relatively affluent middle-class communities.

By 1900 there were diversified and lively black communities in many cities, North and South. While residents generally suffered from poor housing and municipal services, W. E. B. DU BOIS underlined their cohesiveness and supportive function in his pioneering sociological study, *The Philadelphia Negro* (1899). Still, at the turn of the century less than one quarter of all African Americans lived in urban areas with more than 2,500 residents. In the next seventy years, however, over half of the African-American population would relocate to cities. If slavery and its aftermath were the central themes of the nineteenth century African-American experience, urbanization and its consequences played the same role in the life and culture of African Americans in the twentieth century.

The Great Migration

Beginning with the Great Migration around the time of World War I and increasingly during and after World War II, an exodus of African Americans from the rural South to northern cities occurred. It became one of the most significant demographic movements of the twentieth century (*see also* MIGRATION/POPULATION). Migration to the urban North meant the chance for better education, better wages, political rights, and a more open social structure. While mass population movement continued throughout the century, the largest numbers came in two waves. The first "Great Migration" began around 1915, in response to the large-scale demand for black workers

prompted by wartime industrial labor shortages and the parallel cutoff—and a few years later the outright banning—of most white European immigrants, and ended in the 1920s. The second wave began during World War II and continued through the 1960s. Black migration to urban areas mirrored a larger move away from the farm economy into the industrial sector, and was also influenced by increased social and economic opportunity generated by civil rights activism. By 1970, less than a quarter of black Americans remained in rural areas. A few cities, such as WASHINGTON, D.C., and NEWARK, N.J., already had black majority populations, and more would develop within a few years.

African-American urbanization was not restricted to the North. Far more dramatic, in certain respects, was the rate of black community growth in southern cities, especially in the Deep South. In 1910, the six Deep South states (Florida, Alabama, Georgia, South Carolina, Mississippi, and Louisiana) had rural populations approaching 90 percent. By 1960, all had majority urban populations, and Florida actually exceeded the national average of urbanization. The rise of "New South" financial and industrial centers such as ATLANTA, Ga., and BIRMINGHAM, Ala., led to explosive population increases. Blacks flocked to the cities, where wages and living conditions were better than on farms and education was easily available.

The migrations remade the face both of American cities and of the black communities within them. Res-

idences had previously been located in vice districts or within larger white working-class neighborhoods. The seeds of the modern ghetto were apparent on the checkerboard pattern of urban neighborhoods in turn-of-the-century cities. Mass migration brought pressure for expansion, and led to increased racial tension as blacks and whites competed for scarce housing and leisure resources. Blacks, denied access to white districts, remained in the old areas, which whites left. By 1930, cities had developed clearly defined sectors characterized by nearly complete racial segregation and unequal distribution of resources. The expanded black areas developed into full-fledged neighborhoods with identifiable social and cultural institutions.

The early migrants were generally optimistic about the possibilities of urban life. The cities represented for them the promise of a new life, with greater economic opportunity and freedom. As large, independent black communities grew, they fostered widespread black pride. The migration transformed social, economic, and political structures within black communities. Northern black communities had been small and largely middle class in their leadership and structure. As the migrations began, existing elites formed chapters of the NATIONAL URBAN LEAGUE and other groups to control the rate of migration, socialize the immigrants, and find them jobs and housing. The newcomers, denied outside economic outlets, spent most of their wages within the com-

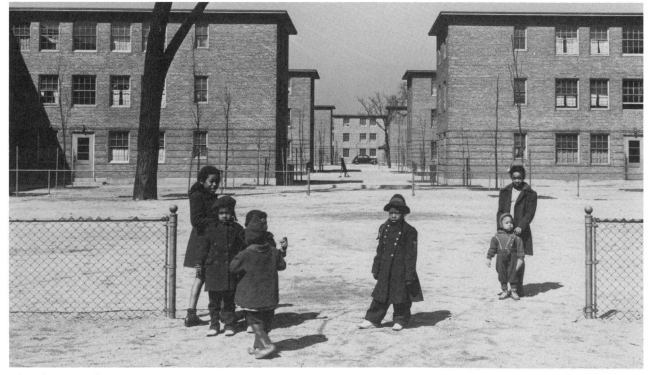

The Ida B. Wells Homes in 1942. Opened in 1938 on Chicago's South Side, this development included a public park and a beach. (Prints and Photographs Division, Library of Congress)

munities, and helped finance banks, insurance companies, real estate agencies, and a wide range of small businesses that were operated by a growing black middle class.

However, elite political dominance was undermined by the new arrivals, who demanded leaders more responsive to industrial working-class needs and interests. Class tensions eroded the facade of political unity in black communities, and elite leaders were no longer able to claim they spoke for such a diverse, fractious body. Politicians were forced to court the black community's vote, and patronage positions became an important source of community employment. Impatient with domination by whites and traditional black elites, working-class and lower middle-class blacks supported various alternative political and social movements (including those of Marcus GARVEY and other nationalist leaders), as well as union organizing by such groups as the BROTHERHOOD OF SLEEPING CAR PORTERS, and COMMUNIST PARTY activities. By the 1930s, coalitions with white workers provoked a reordering of electoral politics in the United States, pushing blacks into the urban Democratic Party. Eventually, first in Chicago and Harlem in the 1920s, '30s, and '40s, and in other cities by the 1960s, the black vote grew large enough to elect black representatives to political office. Social leadership changed as well. New fraternities and social clubs were created by newcomers excluded from or uncomfortable with the old ones.

The religious structure of the urban black community was largely altered by the Great Migration. Many existing Baptist churches increased their congregations, and new ones grew up which soon rivaled more established religious groups like the African Methodist Episcopal Church in church size and community influence. Meanwhile, a proliferation of small PENTECOSTAL denominations were established, and the tiny storefront church, often Pentacostal in affiliation, with its small congregation became a common sight in black neighborhoods. As Arthur Huff FAUSET discussed in his landmark study *Black Gods of the Metropolis: Negro Religious Cults of the Urban North* (1944), heterodox religious groups such as the NATION OF ISLAM and the FATHER DIVINE movement were created through the support of the migrants. Religious forms and activities underwent a strong southernizing influence. A more emotional style became customary during religious services, and new forms of African-American music were introduced. GOSPEL MUSIC, developed by southern-born blacks such as Thomas A. DORSEY, developed and matured in the churches and theaters of the urban North.

The migration fostered literary and artistic flowerings in the cities, most notably the HARLEM RENAISSANCE. Works such as Alain LOCKE's *The New Negro* (1925) expressed the excitement of African Americans in this new environment. Migration itself remained a central theme in African-American literature and music throughout the century. The new mass audience also inspired the development of a distinctive urban "jive" style in speech and dress, as well as music theaters, dancehalls, nightclubs, and bars, black-owned and/or featuring specifically black entertainment. Music was ubiquitous in these entertainment centers, and urbanization was crucial to the growth of JAZZ and the BLUES.

Urbanization played an important role in fostering the modern CIVIL RIGHTS MOVEMENT. Newspapers such as the *Chicago Defender,* which forthrightly denounced American racial injustice and expressed the feelings of urban blacks, were able to prosper on their sales and advertising revenue, and to reach a national audience. Direct, mass action campaigns such as the MONTGOMERY BUS BOYCOTT were distinctly urban phenomena. Led by middle-class Southerners free from direct control by whites, they attacked urban targets and were dependent on mass communities of urban shock troops. Furthermore, passage of the Civil Rights Act of 1964 and the 1965 VOTING RIGHTS ACT would have been inconceivable without the assemblage of new black voters in northern cities who gave white politicians compelling reason to support them, and elected black representatives to lobby for them.

If urbanization provided a way out of agricultural servitude and into the mainstream of American society, it also gave birth to a host of social problems not immediately apparent either to political leaders or to the migrants themselves. Social scientists, as early as W. E. B. DU BOIS in *The Philadelphia Negro* (1899) and continuing with such works as the Chicago Commission on Race Relations's *The Negro in Chicago* (1922), E. Franklin FRAZIER's *The Negro Family in the United States* (1939) and St. Clair DRAKE and Horace CAYTON's *Black Metropolis* (1945), warned of the dangers that poverty, crowding, and urban racism represented for growing black communities, although they recognized the vitality and power of black community life.

Post–World War II Conditions

The dream of a better life which had brought so many African Americans to urban areas had always been somewhat illusory, and it rapidly began to sour in the period which followed World War II. Despite widespread prosperity in the United States, black community residents continued to face problems of high unemployment, poor (and in some cases deteriorating) housing stock, education, health care, and city services, and chronically high crime rates. Drug abuse and its effects became an additional plague on

inner-city life. Housing in American cities and sub-urbs remained a bulwark of segregation, limiting the power and effect of civil rights legislation to correct race-based inequities. Post-war federal and state government policies promoted suburban segregation, and even more affluent blacks and veterans eligible for mortgage subsidies under the G.I. Bill were usually unable to secure housing outside black areas. At the same time, "urban renewal" policies, often opposed by black community residents, broke up cohesive black neighborhoods and forced displaced residents into competition for scarce housing. Public housing projects, initially touted as decent, affordable housing for low-income people, were often badly planned or inadequate, and rapidly gave birth to their own set of difficulties. Ghetto tensions remained chronically high and exploded into urban riots, the first few during World War II and then dozens in the 1960s. Rioters typically listed police brutality, employment discrimination, and price-gouging by landlords and storeowners as their chief grievances.

Ghetto Studies

The harmful effects of urbanization on black families and community life remained largely unexplored. It was only in the 1960s, as affluent blacks began moving to suburbs and as unemployment and welfare rates diverged, that scholars set out to examine the culture of the ghetto, the most visible product of urbanization, and its particular difficulties. Pointing to a rising incidence of out-of-wedlock births, female-headed families, infant mortality, homicide, drug addiction, and chronic unemployment in central city neighborhoods, scholars discussed the existence of a "culture of poverty" blocking individual advancement. The best known description of the "pathology" of ghetto life was Daniel Patrick Moynihan's controversial report, *The Negro Family: The Case for National Action* (1965). Moynihan claimed that African-American culture perpetuated these problems. The report and its meaning were hotly debated. Many scholars countered that ghetto pathology and black family disintegration were a result of the shift from agricultural to urban industrial life.

Several "ghetto studies" specialists, who took a more positive view of urban black life, investigated the spatial and institutional development of these communities. Gilbert Osofsky's *Harlem: The Making of a Ghetto* (1966) was perhaps the best known of these works. While hostile relations with white neighbors defined ghetto borders, they claimed, the ghetto was not simply a zone of pathology. African Americans in urban communities created social, intellectual, religious, and political institutions.

Urban black culture continued to have its celebrators in the 1960s. But if the supporters of the Harlem Renaissance pleaded its cause to argue for the inclusion of blacks in the mainstream of American culture, those who favored the black culture of the 1960s saw it as oppositional, if not antagonistic, to the values of white America. The ghetto had distinctive music and food, its own language, and its own styles of dress and behavior. These were not badges of a "culture of poverty" but the product of a rich and vital tradition.

For these theorists, the inner city also provided a haven against the intrusion of the values of white America, and a place for further raising of political consciousness. African-American militants such as Maulana KARENGA and Amiri BARAKA, conscious of the need for black pride, agreed that black culture was the force that bound African Americans into a single people. They argued further, however, that African Americans had to develop an urban cultural style rooted in African traditions. The political dimension of ghetto cultural nationalism was the theory of "internal colonization." African Americans, borrowing from the writings of Frantz Fanon on colonialism, visualized the ghetto as an area owned and controlled by outside forces, who brainwashed residents to believe in their own inferiority. Whites kept blacks economically dependent by discouraging indigenous business and industry, and politically powerless through military (that is, police) domination. Therefore, they called for black political and economic autonomy within black majority urban areas.

The federal government made several attempts to deal with urbanization and its consequences. The first was the Great Society antipoverty and "model city" policies of the 1960s. Journalist and historian Nicholas Lemann later made an extensive study of the effect of the Great Society programs on families from Chicago's South Side, and concluded that the policies had been well formulated but that insufficient political will had been devoted to attacking obstacles to change. Nevertheless, as the central city situation worsened, the apparent failure of the programs prompted a backlash by conservatives who blamed government and individual values for high unemployment and the high incidence of poor, female-headed families. The conservatives, the electoral backbone of successive Republican presidential victories in the 1970s and 1980s, cut government transfer payments and recommended a concentration on the use of "enterprise zones," inner city areas where tax abatements were used to stimulate individual enterprise.

Contemporary Issues

After 1965, the nature of black urban life became so complex and diverse as to defy easy characterization. Segregation became less absolute, and many blacks were able to move into integrated areas. In many

cities, black ethnic diversity within nonwhite districts increased as African Americans mixed with growing numbers of Caribbean blacks and Latinos. In some places, middle-class blacks settled into distinctive urban neighborhoods, whose condition differed significantly from inner-city ghettos.

The ghetto remained, however, the focus of much of African-American life. By the 1980s, central cities in the United States revealed social indices dramatically different from all other areas of American society. With a declining percentage of the metropolitan job base and a rising share of its service needs, various economic studies indicated that the quality of life was lower in the poorest ghetto neighborhoods than anywhere else in the country. Several scholars, such as Joe William Trotter, Jr., in his *Black Milwaukee: The Making of an Industrial Proletariat, 1915–1945* (1985), argued that the key influence shaping black urban life was "proletarianization." Trotter, turning away from the spatial and institutional focus of the "ghetto studies," emphasized socioeconomic factors to explain the creation and persistence of African American ghettos. He pointed out that African Americans had flooded urban industrial areas just as the "smokestack" (heavy industry) economy fell apart in United States. The disappearance of well-paid industrial labor led to the concentration of urban African Americans at the bottom of the American occupational hierarchy as well as to emerging class divisions in the black community itself. The ghetto was the product of this subordination.

William Julius Wilson took this contention further. In *The Truly Disadvantaged* (1987), he argued that the deindustrialized economy, combined with the migration of more affluent blacks to formerly all-white neighborhoods, undermined central-city black business institutions and removed role models of success. Within such an environment, a black "underclass" of undereducated and unemployable blacks remained. Barriers to mobility and discrimination in the job market tended to limit the options of central-city blacks to low-wage, dead end jobs or unemployment, and assured continued poverty. The theory of the underclass was extremely controversial among African-American scholars, many of whom claimed it understated the impact of racism on all blacks, and that whites would abandon attempts to ameliorate ghetto life if they believed the "underclass" resisted economic self-improvement.

Urban black culture continued to have its champions. Parallel to outside shifts, a new style took hold in inner-city areas during the 1980s. Often known as "hip-hop," it coalesced out of myriad elements such as BREAKDANCING and RAP MUSIC. The most significant aspect of the new culture was its emphasis on rage and violence, reflecting the violence—gang and drug warfare, police brutality, and both white-on-black and black-on-black beatings and shootings—of the ghetto experience. Many African-American youths extolled the values of guns as signs of power and masculinity.

By the last decade of the century, urban life, which had previously been the source of so much African-American success, posed the greatest challenge to it. The cities, which had so recently been the prized destination of African Americans anxious for a better life, had become areas from which many blacks were desperate to flee.

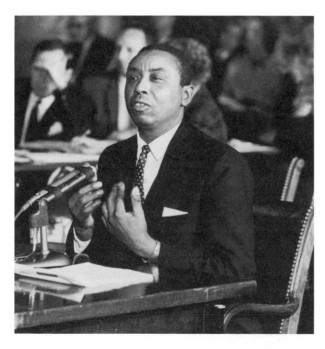

Floyd McKissick of the Congress of Racial Equality (CORE) speaking at a Senate hearing on the federal role in urban development, December 1966. (Prints and Photographs Division, Library of Congress)

REFERENCES

ABRAHAMS, ROGER D. *Positively Black.* Englewood Cliffs, N.J., 1970.

CURRY, LEONARD. *The Free Black in Urban America, 1800–1850.* New York, 1981.

DRAKE, ST. CLAIR, and HORACE CAYTON. *Black Metropolis.* Chicago, 1945.

DU BOIS, W. E. B. *The Philadelphia Negro.* Philadelphia, 1899.

FAUSET, ARTHUR HUFF. *Black Gods of the Metropolis: Negro Religious Cults of the Urban North.* New York, 1944.

GATEWOOD, WILLARD B. *Aristocrats of Color: The Black Elite, 1880–1920.* Bloomington, Ind., 1990.

GOTTLIEB, PETER. *Making Their Own Way: Southern Blacks' Migration to Pittsburgh, 1916–1930.* Chicago, 1987.

GROSSMAN, JAMES R. *Land of Hope: Chicago, Black Southerners and the Great Migration*. Chicago, 1989.

KUSMER, KENNETH. *A Ghetto Takes Shape: Black Cleveland, 1870–1930*. Chicago, 1976.

LANE, ROGER. *William Dorsey's Philadelphia and Ours: On the Past and Future of the Black City in America*. New York, 1991.

LEMANN, NICHOLAS. *The Promised Land: The Great Black Migration and How It Changed America*. New York, 1991.

MILLER, ZANE L. "Urban Blacks in the South, 1865–1920: The Richmond, Savannah, New Orleans, Louisville and Birmingham Experience." In Leo Schnore, ed. *The New Urban History*. Princeton, N.J., 1975.

OSOFSKY, GILBERT. *Harlem: The Making of a Ghetto, Negro New York, 1890–1930*. New York, 1966.

RABINOWITZ, HOWARD N. *Race Relations in the Urban South, 1865–1900*. New York, 1978.

RAINWATER, LEE, ed. *Soul*. Chicago, 1970.

SPEAR, ALLAN H. *Black Chicago: The Making of a Negro Ghetto, 1890–1920*. Chicago, 1967.

STAROBIN, ROBERT. *Industrial Slavery in the Old South*. New York, 1970.

TROTTER, JOE WILLIAM, JR. *Black Milwaukee: The Making of an Industrial Proletariat, 1915–1945*. Chicago, 1985.

WADE, RICHARD. *Slavery in the Cities*. New York, 1964.

WILSON, WILLIAM JULIUS. *The Truly Disadvantaged: The Inner City, the Underclass and Public Policy*. Chicago, 1987.

GREG ROBINSON
PETER EISENSTADT

Urban Riots and Rebellions. Few social phenomena are as dramatic as urban riots and rebellions. Their ugly power displays many aspects of the negative underside of American life and their attention-grabbing force has shaped political debates. While they are as much a product of despair as of conscious political protest, they often expose long-festering social problems generally ignored or sidestepped by mainstream politics and news sources. Above all, they are often expressions of rage—by whites against blacks, blacks against whites, and blacks against their sense of hopelessness at their surroundings and situation.

Since the days of slavery, racial mob violence has been a crucial aspect of African-American history. Violence has taken two distinct forms. Up to 1940, racial rioting in the United States almost exclusively took the form of white attacks on African Americans, generally sparked by fears over black challenges to the social order. The traditional powerlessness of African Americans has made them easy scapegoats for social problems.

Since the 1940s, outbreaks of violence by African Americans have expressed frustration with the pace and efficacy of nonviolent change. Far from being simple acts of mindless violence, rebellions have been a way for a relatively powerless group to express and publicize grievances. Riots have called attention to critical problems in African-American life, such as poverty, unemployment, poor housing, price gouging, inadequate municipal services, poor medical and social services, inadequate educational and recreational facilities, and police brutality.

As the aftermath of the 1992 Los Angeles riot showed, riots can shock and startle complacent people into reconsidering the underlying basis of race relations and can catalyze reform efforts. Yet in other ways they compound the problems of inner-city blacks by frightening authorities into repressive measures, obscuring nonviolent protests of grievances, destroying the local economy, and generating a white backlash for the preservation of "law and order."

Causes

Riots and rebellions, though generally sparked by specific incidents, are carried out for a variety of underlying causes. Almost all of the different studies of urban violence have discussed the fundamental causes of rioting according to one of three distinct models.

One view, developed in the 1960s and expounded by black nationalists such as the BLACK PANTHERS (*see also* BLACK NATIONALISM) is the ultimate expression of collective African-American political consciousness. According to this view, uprisings are deliberate—if not actually planned—demonstrations of black community will, directed at the achievement of particular goals. Riot participants seek either to overturn established authority through revolutionary change, or to force disruptive shifts in institutional arrangements in order to demand inclusion in urban decision-making processes.

Fundamental to this view is the model of ghettos as areas of internal colonization. The theory of violent colonial revolt advocated by Frantz Fanon in *The Wretched of the Earth* (1960) was influential in 1960s black nationalist thought. African-American thinkers saw connections between the struggle of Third World peoples fighting economic and political domination by foreign whites and the state of their own communities. If black ghettos were analogous to countries whose citizens used violence to achieve independence from foreign control, then looting, sniper gunfire, and destruction of property were justifiable methods of asserting African-American control over ghetto communities and compelling outside forces to leave.

Another school of thought on urban riots claims that rebellions, whether justifiable or otherwise, are spontaneous individual expressions of African-American anger over real political or economic injustices, and protests against their involuntary segregation and marginal existence in urban ghettos. This view was popularized by the President's National Advisory Commission on Civil Disorders in its 1968 report (usually referred to as the KERNER REPORT). According to such a model, looting is a reaction to widespread price gouging by storekeepers, as well as a protest against barriers to black economic advancement and acquisition of consumer goods. Arson is an expression of anger against the merchants and landlords who live outside the community but take money from it.

History

Throughout African-American history, periods of urban racial violence have appeared. The slave conspiracies of the colonial era, the NEW YORK CITY DRAFT RIOTS OF 1863, the ATLANTA RIOT OF 1906, the RED SUMMER of 1919, the DETROIT RIOT OF 1943, and the LOS ANGELES WATTS RIOT OF 1965 have all served to demarcate and separate periods of African-American history. In each new period, the position of African Americans in the United States changed, and the context and nature of the outbreaks was transformed.

The first and most fundamental expression of white violence against blacks was the institution of slavery, particularly the chattel slavery of the South. Blacks were forced against their will to toil for whites and were subject at the master's pleasure to harsh punishment for disobedience. In most cases, enslaved African Americans were unable to retaliate. On occasion they responded with direct physical violence, by beating or murdering masters. More often, their rage was expressed indirectly, either by escaping to freedom or more commonly by looting, abusing, or destroying slaveowner property.

On very rare occasions African Americans were able to organize rebellions, despite the extraordinary, near-absolute control that masters, backed by the government, exerted over slaves. Slave rebellions were violent revolts of anywhere from a dozen to 1,000 conspirators against the degradation of human enslavement. Captured insurgents were often decapitated, hanged, or put to death to serve as examples and thwart other rebellious slaves.

While some of the most famous incidents, such as NAT TURNER'S REBELLION of 1831 in Virginia, were rural affairs, most of the more celebrated slave conspiracies and revolts took place in urban environments, the most notable examples being the NEW YORK SLAVE REVOLT OF 1712, which was uncovered and foiled; the abortive GABRIEL PROSSER CONSPIRACY near Richmond, Va., in 1800; and the failed DENMARK VESEY CONSPIRACY in Charleston, S.C., 1822. City life facilitated the formulation of plans. Slaves in urban areas had greater autonomy, frequent contacts with other slaves and with free black supporters, and faster means of communication.

Urban free blacks also resorted to collective violence, particularly after the passage of the 1850 FUGITIVE SLAVE ACT, in order to protest slavecatchers and protect fugitives. African Americans formed armed bands to fight off slavenappers and rioters. They formed vigilante committees to oppose, violently if necessary, the recapture of slaves. Violent attempts to prevent the rendition of fugitive slaves to the South took place in communities as diverse as Boston, New York, Philadelphia, Detroit, and Christiana, Pa. Mobs challenged police and judicial officers to force the liberation and spiriting away of captured blacks threatened with removal south.

Large-scale urban violence in the antebellum United States was also directed against African Americans and their white allies. White resentment of African-American inhabitants in "white man's country" led to mob violence designed to force black residents to flee. Numerous antiblack outbreaks occurred during the 1830s and '40s in such cities as Philadelphia, "the northernmost southern city." The most notorious cases of racial violence were in Cincinnati in 1829 and 1841. After the disturbance of 1829, half of Cincinnati's black population departed, and in 1841, blacks were forced to seek protection from mobs in the city jail. At the same time, southerners and their northern business associates incited and often paid mobs to harass and threaten white and black abolitionists. Speakers were beaten and newspaper offices destroyed. In 1837, white abolitionist Elijah Lovejoy of Alton, Ill., was lynched by a mob. A number of blacks were also killed in antiabolitionist violence, such as in the 1842 Philadelphia riot, among other places.

As white immigrants from Ireland, Germany, and other places arrived in America, social tensions and labor unrest increased. Enraged by competition with black labor, there were racial attacks such as the 1849 Philadelphia election riot, in which Irish immigrants targeted blacks as scapegoats for the political and economic discrimination they faced. Native-born whites often condoned this violence, which eased pressure on them to improve conditions for all laborers. Antiblack violence climaxed during the CIVIL WAR in outbreaks of communal violence in such cities as Detroit, Baltimore, and Cincinnati.

By far the most bloody incident was the NEW YORK CITY DRAFT RIOTS OF 1863, a four-day urban

upheaval largely initiated by poor Irish immigrants protesting a new Union conscription law that provided for workers to be drafted into the army but allowed rich men to hire substitutes. Irish workers, indifferent or hostile to the war, were enraged by the discriminatory policy. They invaded draft offices, halted their operation, and beat ordinary bystanders. Resentful of blacks, whom they viewed as strikebreakers and the cause of the war, they targeted the black community for their rage. Blacks were beaten and hanged from lampposts, and the Colored Orphans' Home was burned to the ground. Once the rioters turned their focus from antiblack violence and threatened to overturn city authority, the rebellion was violently put down by Union troops. Over 100 deaths resulted from the rebellion, including blacks, police, militia, fire fighters, and the rioters themselves.

Post-Emancipation

RECONSTRUCTION brought renewed antiblack mob violence, particularly in the South, as white groups used extralegal means to restore conservative white-dominated governments, overturn black civil rights, and restrain blacks from exercising suffrage rights. Vigilante groups such as the KU KLUX KLAN and the KNIGHTS OF THE WHITE CAMELLIA were the most visible sources of racist violence. Riots in cities, such as in Memphis and New Orleans in 1866, followed campaigns by African Americans, many of them veterans, for suffrage and an end to racial discrimination. While blacks organized into militia for self-defense in certain areas, the urban riots clearly demonstrated the defenselessness of blacks against southern white mobs. Northern opinion was influenced by the riots into supporting the FOURTEENTH AMENDMENT and the FIFTEENTH AMENDMENT, which constitutionally guaranteed blacks the exercise of social and political rights, and into passing the Reconstruction acts which brought occupying military forces to protect blacks' constitutional rights against white terrorism.

Once the federal government withdrew its troops in 1877, and blacks lost that measure of protection, white conservatives used legal and extralegal tactics to end black political influence. By the 1890s, almost all vestiges of black political power in the South had been eliminated. A "Radical" (antiblack) movement, which called for an expanded color bar, gained influence. Radicals effectively used the specter of black-male rape of white women as a vehicle for brutal enforcement of white domination, as well as the curtailing of black economic power. In the classic "race riot" (i.e., whites attacking blacks), white mobs, usually operating with the tacit support of the police, invaded a city's black community. The attacks were directed against both persons and property, and were in many respects similar to lynch mobs with larger targets. Intimidated African Americans made sporadic efforts to defend themselves, but were quickly overwhelmed and forced to flee or retreat from their political or economic positions.

In 1892, white storeowners in Memphis, Tenn., angered by black competition, threatened mob violence. After African Americans, defending themselves against the threat, mistakenly shot a police officer, they were lynched by a white mob. In 1893, white waterfront workers in New Orleans rioted in an attempt to exclude African-American stevedores from the docks. In 1898, radical antiblack forces instigated a riot in Wilmington, N.C. (see WILMINGTON RIOT OF 1908), a city politically controlled by blacks and white allies, as well as one of the few remaining outposts of black economic and political power in the South. Rioters overturned the city government and drove black officeholders from the area. Eight years later, in Atlanta, a center of black college and middle-class life, whites were aroused by a race-baiting gubernatorial campaign by radical demagogue Hoke Smith and by sensational newspaper stories about black rapists. Atlanta was swept by a racial uprising, as whites stormed the streets of the black community, destroyed homes and businesses, and beat and lynched residents (see also ATLANTA RIOT OF 1906).

A somewhat earlier outbreak in New Orleans in 1900 furnished an interesting counterpoint to the pattern. African-American Robert Charles, harassed by police, defended himself violently and shot several officers before going into hiding. While a police manhunt for Charles continued without pause, aroused whites rioted, beating blacks and destroying property. After Charles was discovered and shot, the relative painlessness of his death prompted further white retaliation against innocent blacks.

The brutality was not confined to the Deep South. Elite whites scorned blacks as inferior, and depended on their subordination for cheap labor, for which they were in turn despised by immigrant labor competition. Riots broke out in such places as New York and Brownsville, Tex. In 1908, whites of all classes in Springfield, Ill., Abraham Lincoln's hometown, exploded after a false report of a rape was spread. White rioters lynched several blacks and destroyed the entire black section of the town. The symbolism of Springfield added to the shock of the riot, and catalyzed liberal whites and blacks in New York City into the organization of the NATIONAL ASSOCIATION FOR THE ADVANCEMENT OF COLORED PEOPLE (NAACP).

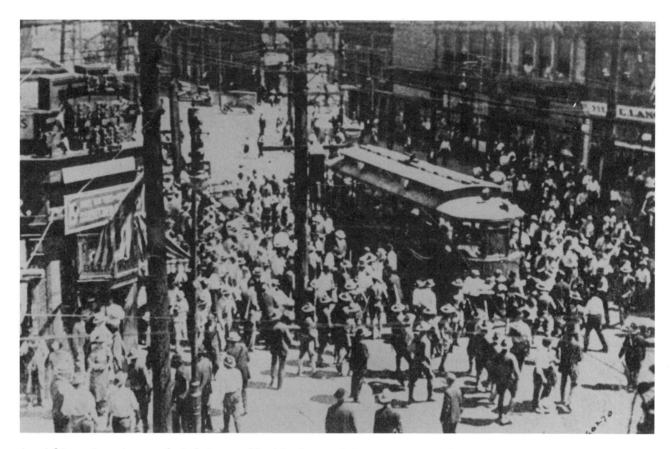

An African-American male is being mobbed in front of the street car while the military looks on, St. Louis, 1917. (Moorland-Spingarn Research Center, Howard University)

Great Migration

The next cycle of riots, which lasted from 1917 into the early 1920s, was a product of the Great Migration north by southern African Americans during the era of WORLD WAR I. The wartime labor shortage and the cutoff of immigration from Europe opened up industrial and other jobs in industrial centers of the North such as Chicago, Detroit, and Pittsburgh. However, the need for African-American labor did not transform widely held white racial attitudes, and racial tensions grew apace. Furthermore, competition with white workers for better paying jobs and for housing, leisure, and health facilities remained intense. While the riots of this period, like their predecessors, tended to be instigated by whites, they differed in a number of important ways. Their size and intensity far surpassed previous outbreaks. Their savagery resulted in part from the collision of blacks catalyzed by their contribution to the war effort into demanding equal treatment with whites who remained unwilling to countenance changes in the racial status quo. After the end of World War I, widespread fears of radicalism and social change fed the hysteria of whites determined to maintain control over large black populations.

The first large riot in the cycle occurred in the drab industrial town of EAST ST. LOUIS, Ill., in the summer of 1917. Tensions following a bitter white labor strike were intensified by white fears over competition from the influx of black workers into the area. White leaders were content to allow African Americans to serve as scapegoats for worker anger. They did little to increase security measures following a small-scale riot, and a series of episodes of racial harassment ensued. In July white workers exploded into violence. Hundreds of blacks were killed, and the black section of the town was heavily damaged.

The pattern of violence escalated to a fever pitch following the end of World War I, during the RED SUMMER of 1919. Countless riots erupted, some in towns such as LONGVIEW, Tex., and ELAINE, Ark., but most occurred in large urban areas such as CHARLESTON, S.C., WASHINGTON, and CHICAGO.

The Red Summer marked one significant change from the previous pattern of riots: African Americans frequently responded to violent attacks with organized self-defense efforts. During Red Summer, militant black leaders such as A. Philip RANDOLPH wrote articles justifying the use of firearms against lynching and white mob violence. Blacks in several areas or-

ganized to beat off white attacks on their neighborhoods, and in Chicago gangs of black youths beat whites they caught in the black section. Black self-defense efforts intensified in the TULSA, Okla., riot of 1921, the last in the postwar period. Black snipers shot back at white rioters, and blacks organized armed squads.

Modern Urban Rebellions

A new pattern of urban violence appeared in the HARLEM RIOTS OF 1935 AND 1943 in New York City, and in the DETROIT RIOT OF 1943. Initiated by inner-city African Americans, and involving attacks primarily on white-owned property within the black community, this "modern" urban race riot style has come to be accepted as the standard pattern of an urban rebellion. Like subsequent outbreaks, the Harlem riots were the generalized fallout of the frustrations of ghetto life, sparked by a pattern of aggravating incidents. In both cases, acts of police brutality inspired rumors of killings, which led aroused African Americans into the streets. Rioters broke store windows and looted merchandise. Meanwhile, in Detroit, a wartime surge in population bred interracial tension over scarce housing and recreation resources. Black youths unable to escape the summer heat took out their frustration on a group of whites. As inflated rumors of conflict spread, the city erupted. Whites attacked blacks in white neighborhoods. Meanwhile, the black community actively burned and looted shops and attacked any whites whom they encountered. City police, unwilling to

defend African Americans from white rioting, were massed in the black neighborhood. Nevertheless, the rebellion was so powerful that the mayor was forced to call in military assistance.

During the late 1940s and '50s, there were no major race riots in the United States, despite chronic tension in inner city African-American neighborhoods. The next wave of urban rebellions occurred in the 1960s. These established the urban race riot as a central social phenomenon. The largest rebellions were those in HARLEM (1964), Watts (1965) (*see also* LOS ANGELES WATTS RIOT OF 1965), NEWARK (1967), and DETROIT (1967). Many "copycat" riots, inspired by these larger outbreaks, erupted in other cities. Unlike the earlier riots, black residents and community leaders justified the outbreak of riots as a natural response to ghetto living, and many militant blacks who spoke positively of violence became folk heroes in black communities.

In 1968, following the assassination of the Rev. Dr. Martin Luther KING, Jr., riots erupted in cities throughout the nation, the largest ones occurring in such cities as Baltimore and Kansas City. Inner cities throughout the United States were scarred by the results of violent action by African Americans.

A significant underlying element in the development of the urban rebellions of the mid-1960s was the CIVIL RIGHTS MOVEMENT, and the parallel development of black nationalism. The fight for equality energized masses of blacks into action in defense of equal rights, and made them acutely conscious of their right to fair treatment. The movement also in-

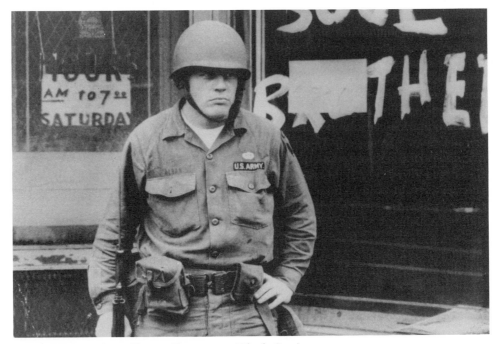

Detroit Riot, 1967. (Bruce Baumann, Black Star)

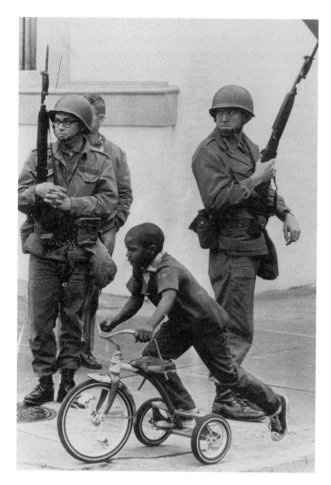

A young boy charges by on his tricycle, April 8, 1968, as federal troops stand alert to preserve order in Baltimore, Md., after three days of violence. (UPI/Bettman)

spired blacks to a new unity and pride in their identity. In the midst of important changes in the South and nationwide calls for equality, however, northern inner–city blacks saw little change or improvement, and sometimes even a decline, in their living conditions. Furthermore, the violent opposition the movement faced, and its perceived failure to achieve the goal of freedom angered and radicalized large numbers of African Americans.

Kerner Commission

Following the burst of violence that King's assassination provoked in American cities, the Kerner Commission was set up in 1968 to investigate the causes and solution to the pressing problem of collective urban violence. The resulting Kerner Report noted that while each riot was a response to a separate set of circumstances, it was possible to speak of common characteristics. Of course, it is impossible to denote the myriad individual reactions and motivations of riot participants, but the report pointed to several general factors in the riots of the 1960s.

The commission reported that riots tended to flare up in hot weather, during a "long hot summer." Racial violence has historically been slight in winter, when the cold weather presumably makes the prospect of extended activity in the street distasteful. During the summer, African Americans, unable to find adequate relief from the uncomfortable heat, were easily aroused. The contrast with affluent whites, who possessed air conditioning and could flee the city on vacations, was also the most glaring at such times.

Another common factor the commission noted was that incidents of perceived police brutality were usually the trigger for urban violence. Police brutality was a common African-American complaint. Not only was police harassment infuriating in itself, it symbolized ghetto residents' sense of being "occupied" by a foreign power. Government institutions were often biased in providing services to poor black neighborhoods and insensitive to their residents' needs and concerns. Police were the most visible (and sometimes openly racist) representatives of the "outside" government, and their abuse of law enforcement authority reminded inner city residents of their powerlessness against white society and eroded African Americans' respect for "law and order."

The most common pattern of the 1960s incidents was that small numbers of ghetto blacks would become involved in altercations with police, and rumors would spread of brutal treatment. Crowds, often egged on by black militants, would confront the police with bricks, stones, and sometimes guns. Once police retreated from the area, aroused African Americans would take to the streets of ghetto neighborhoods, smashing windows, looting and setting fire to houses and stores (the popular arsonist's cry "Burn, baby, burn" is said to have originated in the Watts rebellion). Usually rioters singled out only white-owned stores; those known to be black-owned were spared. While these uprisings were generally referred to as "property riots," in which rioters attacked homes and buildings, they also featured beatings of whites in black communities (as well as reports, usually fictitious or greatly exaggerated, of sniper attacks). Police and firefighters who attempted to quench blazes were particular targets for violence.

Eventually, police coverage would be reinforced, and often martial law would be declared. National Guard or military units tended to be brought in to quell disturbances. A curfew would be put into effect, with troops ordered to shoot looters, and houses would be entered without warrant to search for snipers. After a certain amount of time, usually several days, sometimes with the help of rainstorms or cooler temperatures, the riot would wind down.

The Kerner Commission stressed the importance of daily ghetto conditions in sparking riots. Originally, many white politicians and commentators, notably the MCCONE COMMISSION report after the Watts riot, shifted blame for them onto new migrants to cities or black radical groups. Yet, the epidemic of rebellions and the Kerner Commission report sparked a number of sociological studies of riots, such as Nathan Cohen's 1970 study of the Watts uprising (*The Los Angeles Riots: A Socio-Psychological View*), which indicated that many rioters were longtime ghetto residents with comparatively high levels of income and education.

After the end of the 1960s, riots more or less disappeared as part of the American urban landscape. Except for the Liberty City uprising in MIAMI OF 1980, there were no large-scale uprisings for the following twenty years. African-American rage over inequality was not reduced, but the original hope for improvement that had fed rage subsided. The increasingly high social cost of riots, in terms of housing and business facilities lost to the black community, was another factor. Also, white flight and black electoral gains assured largely black-led or black-influenced urban governments, and in some cases police departments, which were more attentive to the troubles of black urbanites. Black militant organizations grew less popular under the pressure of official harassment and a changing black political landscape.

However, starting in the late 1970s, economic recession and reductions in federal aid devastated the black urban economy, and black-on-black crime made most ghetto neighborhoods war zones. Poor public health care, education, and safety services, coupled with an attractive underground drug economy, made inner cities ever more unlivable and oppressive. Police harassment of blacks in all areas remained a chronic concern. Discriminatory sentencing policies, and the gentle treatment given police accused of brutal acts, convinced many blacks that the legal system offered them no justice. By the 1990s, racial violence had again become a powerful threat. Rap lyrics expressed the rage of inner-city blacks, and glorified violence and guns as signs of virility. Movies such as Spike LEE's *Do the Right Thing* (1991), which dramatized a racial riot, were denounced by white critics as incitements to violence. Despite these

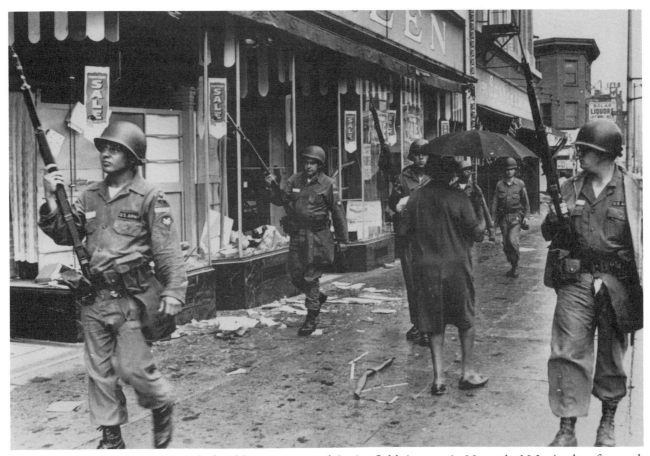

Armed National Guardsmen with fixed bayonets patrol Springfield Avenue in Newark, N.J., in the aftermath of three days of looting, July 15, 1967. (UPI/Bettman)

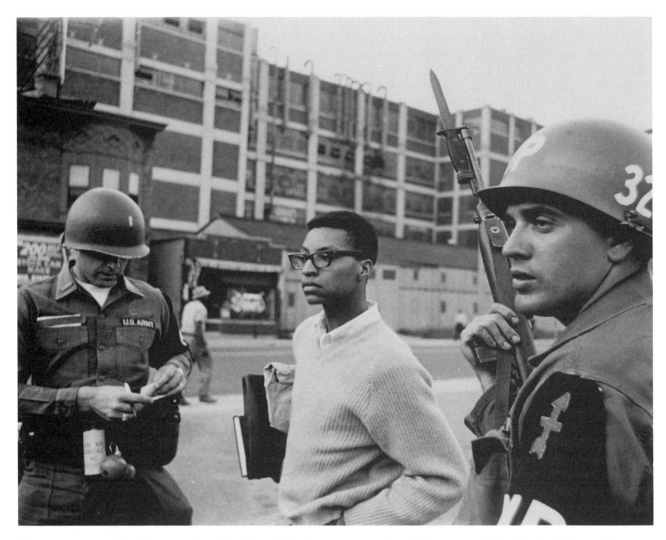

Nineteen-year-old college student John Daniels is issued a pass after being stopped by National Guard Troops. Daniels's job at the post office kept him out during the curfew imposed in the wake of rioting, Milwaukee, Wis., August 1967. (UPI/Bettman)

various possible causative factors, spontaneous riots did not break out.

In 1992, Rodney King, a black motorist, was arrested and beaten by Los Angeles police. The incident, recorded by a clandestine video camera, was played on national television along with tapes of police conversations, laced with racial epithets, transforming the incident into a *cause célèbre* of police violence against blacks. Nevertheless, when the officers were brought to trial on assault charges, an all-white suburban jury acquitted all the assailants. When news of the verdict reached the African-American area of south central Los Angeles, riots broke out. The uprising, which surpassed the 1960s riots in scope, lasted for several days. Blacks and other participants burned buildings, looted stores, and savagely beat white motorists dragged from vehicles. Local Korean-American shopowners, whom blacks per-

ceived as unfriendly, were particularly targeted. While the 1992 riot, unlike earlier uprisings, was not confined to black areas, most outside damage was confined to commercial areas, and Los Angeles' heavily white sections were undamaged. Copycat riots erupted in several cities in the United States and Canada.

The Los Angeles Riots of 1992 demonstrated America's continuing racial difficulties, and highlighted the chronic problem of poor conditions in urban African-American communities (*see also* LOS ANGELES). Urban rebellions are once again central to Americans' perception of racial issues, and the threat of rioting, a central feature of the 1993 federal trial of King's assailants, has been an element of other trial verdicts involving blacks in the early 1990s. The threat and reality of urban rebellions remains one of the touchstones of race relations in the United States.

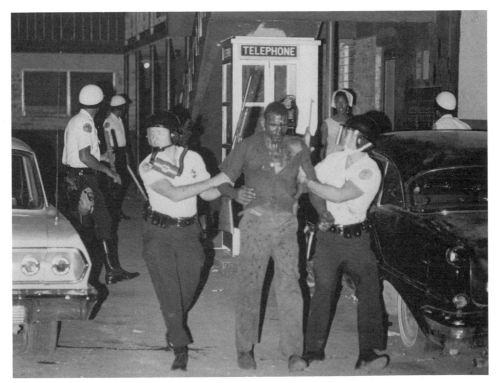

A bloodied man is led away by Miami police officers after he was injured in a clash with police on August 7, 1968. (UPI/Bettman)

Riots serve as a chastening reminder of the lack of progress toward a final resolution of the issues of race and class in our cities despite the achievements of the civil rights movement.

REFERENCES

APTHEKER, HERBERT. *American Negro Slave Revolts.* New York, 1952.

BELKNAP, MICHAEL, ed. *Urban Race Riots.* New York, 1991.

BOSKIN, JOSEPH, ed. *Urban Racial Violence in the Twentieth Century.* Beverly Hills, Calif., 1969.

BROWN, RICHARD MAXWELL. *Strain of Violence.* New York, 1975.

BUTTON, JAMES W. *Black Violence: The Political Impact of the 1960s Riots.* Princeton, N.J., 1978.

CAPECI, DOMINIC J. *The Harlem Riot of 1943.* Philadelphia, 1977.

Chicago Commission on Race Relations. *The Negro In Chicago: A Study of Race Relations and a Race Riot.* Chicago, 1992.

CONNERY, ROBERT H., ed. *Urban Riots: Violence and Social Change.* New York, 1968.

FEAGIN, JOE R., and HARLAN HAHN. *Ghetto Revolts: The Politics of Violence in American Cities.* New York, 1973.

FINE, SIDNEY. *Violence in the Model City: The Cavanaugh Administration, Race Relations, and the Detroit Riot of 1967.* Detroit, 1989.

GRAHAM, HUGH D., and TED R. GURR, eds. *Violence in America.* New York, 1969.

McCAGUE, JAMES. *The Second Rebellion.* New York, 1968.

Report of the National Advisory Commission on Civil Disorders. Washington, D.C., 1968.

RUDWICK, ELLIOTT M. *Race Riot at East St. Louis. July 2, 1917.* 2nd ed. Urbana, Ill., 1982.

SHOGAN, ROBERT, and TOM CRAIG. *The Detroit Race Riot: A Study in Violence.* Philadelphia, 1964.

WASKOW, ARTHUR I. *From Race Riot to Sit-in, 1919 and the 1960s: A Study in the Connections Between Conflict and Violence.* Garden City, N.Y., 1966.

WEST, CORNEL. *Race Matters.* Boston, 1993.

WILLIAMSON, JOEL. *The Crucible of Race: Black-White Relations in the American South Since Emancipation.* New York, 1984.

GAYLE T. TATE

Utah. Although Utah readily invokes images of Mormonism and the Church of Jesus Christ of Latter Day Saints (LDS), one rarely thinks of African Americans in connection with the state. Yet the history and experiences of African Americans in Utah is intricately intertwined with the history of MORMONS in the West, of other indigenous western cultures, and of the national African-American community. African Americans have resided in Utah continuously since non-Indians first settled the area in 1847. Black

Utahans have worked, established families, confronted racism, and established institutions and organizations; they have provided meaning to their lives in much the same ways as have African Americans throughout the United States. Ties to the larger African-American community and involvement in national black issues have been and remain important to the Utah black community's efforts to sustain and enhance their identity as African Americans in a state where their numbers have historically been less than 1 percent of the total population.

The African-American presence in Utah preceded that of the Mormon pioneers. Persons of African descent were present in Utah before the Mormons. For example, James P. BECKWOURTH, the noted mountain man, traversed the Utah landscape in search of beaver and other valuable animal skins. Jacob Dodson was eighteen years old when he volunteered to be a member of John C. Frémont's second expedition to the West. However, permanent settlement of African Americans began with the arrival of the advance Mormon party in July 1847. Led by Brigham Young, the first group included three African Americans: Green Flake, Oscar Crosby, and Hark Lay. Along with those of the first pioneers, their names are engraved on the Brigham Young Monument located in the very heart of Salt Lake City, at the intersection of South Temple and Main streets.

Identified as "colored servants," Flake, Crosby, and Lay were slaves of southern converts to the Mormon Church. They had been sent by their owners to help prepare for the arrival of Mormon pioneers who were to follow the vanguard party. By 1850, approximately sixty African Americans lived in the Utah Territory. The majority were slaves, although laws sanctioning SLAVERY were not enacted until 1852. The LDS community generally accepted the slave status of most African-American residents. Although a few worked in small shops in Salt Lake City, the majority worked on small farms. Most Mormons, including Brigham Young, believed that Utah's climate was not suitable for profitable slave labor. Nevertheless, Young and some of his followers subscribed to the veracity of biblical passages used to justify black bondage. Slaves were bought and sold in Utah. A few escaped and joined wagon trains going west to California and other destinations. In 1862, in the midst of the CIVIL WAR, slavery was officially ended when Congress abolished slavery in the territories. Whether or not the few Utah slaveholders complied with the congressional act remains unknown.

As important as the slave population is the free African-American population that migrated to Utah during the pioneer period. For example, in fall 1847, Isaac and Jane James and their two sons, Sylvester

and Silas, were the first free African Americans to settle in Utah Territory. They were among the believers who endured the hardships of the early years. Elijah Abel, who brought his family to Utah in 1853, joined the Mormon Church in 1832. He was one of two African Americans known to hold the priesthood prior to the establishment of an LDS edict in 1847 prohibiting black males from joining the priesthood. Abel used his skill as a carpenter to help build the LDS temple in Salt Lake City. The primary objectives of these free black migrants were religious. As members of the Church of Jesus Christ of Latter Day Saints, they, too, wished to escape influences hostile to the Mormons and to join their fellow Saints. For some black Mormons, adherence to religious beliefs took precedent over racial identity. Consequently, they were in Utah to help build the Mormon Church's newest Zion.

The African-American population in Utah increased with the expansion and completion of the national railroad network and the growth of the mining and military facilities. African-American men found employment as cooks, waiters, and porters in hotels and on railroads. Hopes of striking it rich led a few African Americans to pool their resources in 1871 to form "The Elevator Prospecting Company," which was named in honor of the *Elevator*, an African-American newspaper published in San Francisco. Although few blacks actually worked in the mines, the wealth derived from mining and other commercial ventures created an economic class of white Utah residents that employed many African-American women in domestic positions.

The African-American presence was most visible during the difficulties between white residents and the Ute Indians. In 1886, the Army decided to send two companies of the Ninth Cavalry's "Buffalo Soldiers," African-American men, to help establish and maintain a post on the Uintah frontier in eastern Utah. Various companies of the Ninth Cavalry were stationed at Fort Duchesne for nearly fifteen years. Lieutenants John Alexander and Charles YOUNG, two of only three African Americans to graduate from the United States Military Academy at West Point in the nineteenth century, and America's first African-American general, Benjamin O. DAVIS, SR., served at Fort Duchesne.

Despite opposition from segments of the white community, the Army transferred the entire Twenty-fourth Infantry, comprising primarily African-American soldiers, with a few white officers, to Fort Douglas in 1896. The transfer was a reward in recognition of their more than thirty years of outstanding service in the western frontiers of the nation. Located in Salt Lake City, Fort Douglas was considered one of the better military posts in the

West. Delighted to learn of the decision, the African-American community turned out to welcome the unit upon its arrival. During their three years at Fort Douglas, the members of the Twenty-fourth were an integral part of the African-American community and contributed to the social and cultural life for all segments within the community.

By the 1890s, the small African-American community had numbers sufficient to establish their own churches, which have historically served the secular as well as spiritual interests of African Americans. In addition, newspapers, and political, social, and fraternal organizations were established. Black Utahans maintained communication ties with other national African-American communities by regularly sending information on local activities to African-American newspapers in Butte, Portland, Seattle, San Francisco, Denver, and St. Paul–Minneapolis. Similarly, the African-American press provided blacks in Utah with information on issues of concern to all African Americans. Prominent African Americans such as Booker T. WASHINGTON were warmly received by black residents when they visited Utah. A chapter of the NAACP was organized in 1919, approximately ten years after the national organization (*see* NATIONAL ASSOCIATION FOR THE ADVANCEMENT OF COLORED PEOPLE) was created. The Elks, Masons, and their female counterparts are examples of organizations that have historically served the needs of many blacks in Utah.

During the last decade of the nineteenth century and the early decades of the twentieth century, racially based discriminatory practices in Utah expanded with the growth of the African-American population. For example, the first African American selected to serve on a jury in Utah was removed after complaints from white jurors. State law prohibited the issuance of a marriage license to couples if one person was white and the other person black or Asian. African Americans were routinely denied access to public accommodations. Black residents of Utah were in a position similar to other African Americans. They were residing in a nation where the majority white population believed in notions of white superiority and black inferiority.

The generally limited employment opportunities for African Americans influenced a number of young African Americans to relocate elsewhere. Restricted covenants limited access to housing, and where they were permitted to enter, African Americans had to sit in the balcony sections of theaters. They were allowed to use the skating rink only one night a week, and were made to stand outside the ballrooms where African-American entertainers were performing. Many African Americans in Utah recognized how the priesthood issue in the LDS Church affected the status of African Americans in Utah. Blacks were viewed as "unworthy" by many Mormons, and religious beliefs and practices had strengthened the color line that emerged and crystallized by the early twentieth century. Many non-Mormon whites in Utah shared beliefs in white superiority as well.

WORLD WAR II and the postwar years had a dramatic impact on African-American life in the West. In Utah, the location and growth of railroad centers, defense contract industries, and military installations influenced a number of African Americans to relocate in search of better opportunities. Utah's black population grew significantly, particularly in Weber County, near Ogden. Black Utah residents became increasingly vocal about local and national injustices and responded in ways similar to those of African Americans elsewhere, though their numbers were so small in Utah that their response was often muted. There was a resurgence in support for the Salt Lake Branch of the NAACP; a branch was established in Ogden. Recognizing the influence of the Mormon leadership in local affairs, African Americans protested nonviolently in support of the national civil rights agenda and in hopes of influencing the Utah legislature to pass open housing legislation at the LDS Church Office Building, which was located on South Temple Street.

The racial climate in Utah gradually improved during the late 1960s and the 1970s. This was primarily due to civil rights legislation at the federal level. In July 1974, the Salt Lake Chapter of the NAACP filed a suit on behalf of two African-American boy scouts who were denied leadership posts in a troop sponsored by the LDS Church. The position of senior patrol leader was linked with the church priesthood, and since blacks could not hold the priesthood, they could not aspire to the senior patrol leadership position. The suit was dismissed in November when the LDS Church agreed to open all positions in church-sponsored scout troops to all boys.

In 1978, the First Presidency of the Church of Jesus Christ of Latter Day Saints announced that the priesthood was open to "all worthy male members of the church without regard to race or color." This "revelation" was a landmark in the gradual changing racial landscape for African Americans in Utah. Two African Americans have served in the Utah legislature in recent years. Sen. Terry Williams played a major role in the Utah State Legislature's adoption of the Rev. Dr. Martin Luther KING, Jr.'s birthday as a state holiday in 1986. Judge Tyrone Medley was appointed to the Third District Court of Utah in 1993.

Athletics at the college and professional levels have been a positive influence on improving the racial climate in Utah. This is especially true for the

professional basketball franchises. The American Basketball Association (ABA)'s Los Angeles Stars moved to Utah in 1970. They changed their name to the Utah Stars, and some of the African-American players were popular not only for their athletic ability, but also for their contributions to the community off the court. In 1979, the National Basketball Association's New Orleans Jazz relocated to Utah and became the Utah Jazz. The popularity of the NBA, the organization's public relations efforts involving the players, and consistent winning records in recent years have elevated players like Karl Malone to celebrity status.

The visibility and acceptance of African Americans in a variety of positions is gradually increasing in the private, public, and educational sectors as Utah residents become more tolerant and learn to recognize, value, and celebrate its diversity. The 1988 efforts of the Aryan Nation, a white supremacist group, to establish an office in the Salt Lake area was strongly rebuffed by a cross-section of the community representing a variety of religious, racial, political, and ethnic groups. Although the number of African Americans in Utah remains relatively small, their linkages with the larger African-American community continue to bolster their spirits and their sense of identity in ways similar to Utah's African-American pioneers of the late nineteenth and early twentieth centuries.

REFERENCES

BRINGHURST, NEWELL. *Saints, Slaves and Blacks: The Changing Place of Black People Within Mormonism.* Westport, Conn., 1981.

COLEMAN, RONALD G. "Blacks in Utah History: An Unknown Legacy." In Helen Papanikolas, ed. *The Peoples of Utah.* Salt Lake City, 1976.

———. A History of Blacks in Utah 1825–1910. Ph.D. diss., University of Utah, 1980.

RONALD G. COLEMAN

V

Vails, Nelson "The Cheetah" (1960–), cyclist. The youngest of ten children, Nelson Vails was born in Harlem in New York in 1960. Raised in the King Towers housing project, Vails became a father at fifteen and dropped out of high school in the tenth grade. He longed to get out of the ghetto and discovered that cycling might offer a means. At sixteen, he began riding in local races, including the Harlem Championships, and worked as a bicycle messenger in New York City. Representing New York clubs, Vails was soon racing at a national level, winning his first major race in 1981. In 1982, he was named to the United States Olympic Team. One of a handful of African Americans in international cycling at the time, Vails went on to win a gold medal in the 1,000-meter sprint at the 1983 Pan American Games and a silver medal at the 1984 Olympic Games in Los Angeles. He failed to qualify for the 1988 Olympic Games, but continued to race in several national circuits and began to work as a television sportscaster and cycling analyst.

REFERENCES

COBB, KEVIN. "Unveiling Nelson Vails." *American Health* (May 1989): 84.

DONAHUE, DIERDRE. "For Terror of the Streets Nelson Vails, L.A. Is the Place to Deliver His Message." *People Weekly* (April 30, 1984): 68–70.

BENJAMIN K. SCOTT

VanDerZee, James Augustus (June 29, 1886–May 15, 1983), photographer. James VanDerZee was born in Lenox, Mass., the eldest son and second child of Susan Brister and John VanDerZee. He grew up in Lenox and attended the public schools there. In 1900, he won a small box camera as the premium for selling packets of sachet powder. Shortly afterward he purchased a larger camera and began photographing family members, friends, and residents in Lenox. Thus began his lifelong commitment to photography. In 1906, VanDerZee and his brother Walter moved to New York City to join their father, who was working there. By this time VanDerZee was already an accomplished photographer; however, his first New York job was waiting tables in the private dining room of a bank. In New York he met his first wife, Kate L. Brown, whom he married in 1907. The next year he and Kate moved to Phoebus, Va., then a small resort town near her home at Newport News. He worked as a waiter at the popular Hotel Chamberlin, a favored resort for the wealthy in Hampton. While in Virginia, VanDerZee continued photographing and made some of his most notable early images: photographs of the faculty and students of the Whittier School, a preparatory academy for Hampton Institute.

In 1908, after the birth of their first child, Rachel, the family returned to New York. VanDerZee continued working at a variety of jobs, including photography. For a brief period he commuted to Newark, N.J., where he operated the camera in a

The carefully composed romantic image "Day-dreams" (c. 1915) depicting a young woman's reverie, was taken early in James VanDerZee's long and illustrious career as the premier photographer of Harlem life. (Courtesy Donna VanDerZee)

department-store portrait studio. In 1910, a son, Emile, was born. At the end of the first quarter-century of his life, James VanDerZee had much to celebrate—he was twice a father, happily married, and a success in the economically competitive world of pre–World War I New York. But this period of happiness did not last long. Emile died in 1911, and the following year, VanDerZee and Kate separated.

VanDerZee had recovered sufficiently by 1916 to open his first photography portrait studio. It was in Harlem, on 135th Street at Lenox Avenue. He also had a partner in the enterprise, his new wife, Gaynella Greenlee Katz. From 1916 to 1931 VanDerZee stayed at this location, and the studio became one of Harlem's most prominent photographic operations. He specialized in portraits and wedding photographs, but also took on assignments away from the studio. Among these assignments was his work for Marcus

GARVEY in 1924. It was also during these years that VanDerZee began his experimental photomontage assemblages.

VanDerZee and his wife weathered the Great Depression and in 1943, in the midst of World War II, they purchased the building they had been renting at 272 Lenox Avenue. For the rest of the decade he continued his portrait work and took assignments for a variety of Harlem customers. However, a decline in business began to set in during the early 1950s. Ultimately, all he could maintain was a mail-order restoration business. Through a complicated series of loans and second mortgages, the VanDerZees were able to keep their property until 1969, when they were evicted. Ironically, VanDerZee's greatest fame and success as a photographer were yet to come.

Two years before his eviction, VanDerZee had met Reginald McGhee, who was a curator for the Metropolitan Museum exhibition *Harlem on My Mind*. Through McGhee's efforts, his work of the previous four decades became the central visual focus of the exhibition. The photographs became some of the most written-about images in the history of photography, while their maker was reduced to living on welfare. VanDerZee's fame grew when, in 1969, McGhee and other young black photographers formed the James VanDerZee Institute, which showed his work in the United States and abroad. His photographs became even more widely known when three monographs were published during the 1970s. By the second half of that decade, VanDerZee's work was being sought out by both institutional and individual collectors. By the time Gaynella died, in 1976, VanDerZee had become a symbol of artistry and courage to the Harlem community. He resumed making portraits, spoke at conferences, and gave countless interviews. In 1978, he was named the first recipient of the New York Archdiocese Pierre Toussaint Award. That year he married for the third time, to Donna Mussendon, a woman sixty years his junior.

In 1980, with his wife's help, VanDerZee began a series of portraits of African-American celebrities. Among his sitters were Eubie BLAKE, Miles DAVIS, Cicely TYSON, and Muhammad ALI. He made his last portrait, for art historian Reginia Perry, in February 1983. VanDerZee died on May 15, 1983. That day he had received an honorary doctorate of humane letters at the Howard University commencement. He was ninety-six years old.

REFERENCES

DE COCK, LILIANE, and REGINALD McGHEE. *James VanDerZee*. New York, 1973.

McGHEE, REGINALD. *The World of James VanDerZee: A Visual Record of Black Americans.* New York, 1969.

VANDERZEE, JAMES, et al. *The Harlem Book of the Dead.* New York, 1978.

RODGER C. BIRT

Vann, Robert Lee (August 27, 1879–October 24, 1940), journalist. Born in Hertford County, N.C., the son of Lucy Peoples, who was a cook for the Albert Vann family, and an unidentified father, Robert Vann spent his boyhood years on the Vann and Askew farms. When Vann was sixteen, he enrolled in the Waters Training School in nearby Winston, and in 1901 he entered Virginia Union University in Richmond, Va. Two years later he moved to Pittsburgh, where he became the only African-American student at Western University of Pennsylvania. While at Western, he wrote for the student newspaper, the *Courant.* After graduating in 1906, he enrolled in Western's Law School. Vann passed the Pennsylvania bar examination in 1909.

In 1910 Vann set up a law practice in Pittsburgh but found few clients. He soon became involved in a new black newspaper, the PITTSBURGH COURIER. Vann drew up the paper's incorporation papers and was named its treasurer. That fall, Vann became editor. Because the position paid poorly, he continued his law practice, which he used the *Courier* to promote. Vann soon thereafter became a community leader, calling for improvements in housing and city services, and for the enactment of civil rights laws. In 1917 he successfully opposed the city's political machine in a mayoral election, and in return was named fourth assistant city solicitor. He also joined the Committee of One Hundred, a group of black leaders supporting the entry of the United States into WORLD WAR I.

Vann, a disciple of Booker T. WASHINGTON, vigorously promoted black entrepreneurship. During the 1920s Vann made the *Courier* more profitable by raising its price and by reporting on such issues as A. Philip RANDOLPH's efforts to unionize sleeping car porters. (*See* BROTHERHOOD OF SLEEPING CAR PORTERS.) Vann was one of the few black leaders to support the effort. In the 1930s Vann made the *Courier* the largest African-American newspaper in the United States by enlarging its sports section—he was credited with "discovering" and promoting the career of boxer Joe LOUIS—and by sending a correspondent to report on the Italo-Ethiopian War. In

1939, as WORLD WAR II dawned, Vann launched a popular campaign to end limits on black enlistment in the Army. In the same year, he started the Interstate United Newspaper Company to sell advertising for black newspapers. Vann's other business efforts were less successful. In 1920 he started a magazine, *The Competitor,* which ran just eighteen months. In 1925 he lost large amounts of money in a Gold Coast export firm. In the same year, he tried to found a black community bank, but was unable to secure backing.

Vann was also involved in political matters. During the 1920s he controlled local political patronage, and feuded with NAACP leaders such as James Weldon JOHNSON over control of funds raised for civil rights causes. He twice ran unsuccessfully for a local judgeship. Vann's political activism increased in the 1930s, when he challenged Republican support of JIM CROW and inaction on the GREAT DEPRESSION. On September 11, 1932, during a speech in Cleveland, he appealed to blacks to "[turn] their pictures of Lincoln to the wall" and vote for the DEMOCRATIC PARTY. The speech did not influence many blacks in 1932, but Vann received some credit for the shift of blacks to the Democrats in 1936.

Vann served briefly in Washington, D.C., where he was a special adviser to the attorney general and he also served on a Commerce Department advisory committee. However, he lacked influence on the Washington bureaucracy and on Franklin D. ROOSEVELT'S BLACK CABINET of African-American advisers. He returned to Pittsburgh in 1935. Vann died of cancer in 1940.

REFERENCE

BUNI, ANDREW J. *Robert L. Vann of the Pittsburgh Courier: Politics and Black Journalism.* Pittsburgh, 1974.

GREG ROBINSON

Van Peebles, Melvin (August 21, 1932–), filmmaker. Melvin Van Peebles was born on the South Side of Chicago in 1932. He grew up in Phoenix, Ill., a middle-class suburb of Chicago. Van Peebles attended West Virginia State College in Institute, W.Va., and Ohio Wesleyan University in Delaware, Ohio, where he received a B.A. degree in literature in 1953.

After graduation, Van Peebles enlisted in the U.S. Air Force, where he spent three-and-a-half years as a flight navigator. Facing a lack of employment oppor-

tunities for blacks at commercial airlines, Van Peebles was unable to continue this career after his military service. Instead, he became a cable-car gripman in San Francisco. In 1957, he published *The Big Heart,* a sentimental portrait of the cable cars illustrated with photographs by Ruth Bernard. Shortly afterward, he was fired from his job.

Van Peebles spent the next two years making a number of short films in an unsuccessful attempt to interest Hollywood in his ideas. Frustrated, he emigrated to the Netherlands, where he studied with the Dutch National Theatre and toured as an actor in Brendan Behan's play *The Hostage.* Van Peebles then moved to Paris to continue his attempt to get his work produced. Van Peebles discovered that the French film directors' union would grant a union card to any writer who wished to make a film on his or her own. He wrote five works of fiction that were published in French: the novels *Un Ours pour le FBI* (translated as *A Bear for the FBI,* 1968); *Un Americain en enfer* (1965; translated as *The American: A Folk Fable,* 1965); *La Fête à Harlem* and *La Permission* (published jointly, 1965; the former translated as *Don't Play Us Cheap: A Harlem Party,* 1973); and a collection of short stories, *Le Chinois du XIVe* (1966). He filmed *La Permission,* under the title of *The Story of a Three Day Pass,* in 1967 for $200,000. The film concerns a black U.S. serviceman and the harassment he experiences when his army buddies discover that he has a white girlfriend. It was shown at the 1967 San Francisco Film Festival, where it won the Critics Choice award for best film. The film garnered sufficient attention to earn Van Peebles a studio contract with Columbia Pictures.

In 1969, Van Peebles directed *Watermelon Man,* a farce about a white racist insurance salesman who wakes up one morning to discover that he has become black. Though the film was a moderate success, Van Peebles found that he disliked working in the studio system. He set out to make his next film, *Sweet Sweetback's Baadasssss Song* (1971), without studio financing. By employing nonunion technicians, investing his own money, and receiving financial support from friends and investors, Van Peebles was able to shoot the film for $500,000. Although *Sweetback,* an unconventional fantasy film about a pimp-turned-revolutionary avenger, had difficulty finding distribution through mainstream sources, Van Peebles successfully promoted the film, and it had a large black audience. *Sweetback* became one of the top-grossing independently produced features, and its success proved that there was a large black audience ready for something other than mainstream films. Along with *Shaft,* released later in the same year, *Sweetback* inaugurated the era of the BLAXPLOITATION FILM. By portraying kinetic and picaresque

Director and novelist Melvin Van Peebles. (© Atlantic Records)

black heroes in opposition to the white establishment, these films played out contemporary urban black fantasies of power and retribution.

The financial success of *Sweetback* made it possible for Van Peebles to open his musical play *Ain't Supposed to Die a Natural Death* on Broadway in 1972. The play's gritty portrayal of life in the black ghetto included frank and controversial discussions of lesbians and prostitution. When the play had difficulty attracting an audience, Van Peebles employed the same kind of tactics he had used to promote *Sweetback,* including the recruitment of black celebrities to attend the performances. Van Peebles's vigorous promotion efforts expanded the play's Broadway run to 325 performances.

While this show was still running, Van Peebles was able to mount another Broadway production, *Don't Play Us Cheap* (1972), adapted from his novel *A Harlem Party* (1973). A few months later, he shot a film version of *Don't Play Us Cheap.*

In 1973, Van Peebles went on tour throughout the United States with his one-man show *Out There By Your Lonesome,* his last stage work of the 1970s. In the middle of the 1970s, he shifted to television, writing two scripts that were produced as television films for

NBC. *Just an Old Sweet Song* was broadcast in 1976, and the highly regarded *Sophisticated Gents*, filmed in 1979, was broadcast in 1981. In 1982, Van Peebles returned to the stage to appear with his son Mario in his own *Waltz of the Stork*.

After *Waltz of the Stork* ended its run, Van Peebles temporarily set aside entertainment in favor of business, becoming an options trader on the floor of the American Stock Exchange in 1983. At the time, he was the only black trader at the exchange. In the middle of the decade, he followed up on his success in options trading with two books, *Bold Money: A New Way to Play the Options Market* (1986) and *Bold Money: How to Get Rich in the Options Market* (1987).

At the end of the decade, Van Peebles returned to entertainment to direct *Identity Crisis* (1989), a comedy film written by and starring his son Mario. He later acted in another of his son's films, *Posse* (1993), an all-black Western.

In the 1990s, Van Peebles's work received renewed attention as an influence on the second wave of black filmmaking. His films have been featured at several film festivals. In 1990, the Museum of Modern Art honored him with a retrospective showing of his film *oeuvre*.

REFERENCES

CRIPPS, THOMAS. *"Sweet Sweetback's Baadasssss Song and the Changing Politics of Genre Film."* In Peter Lehman, ed. *Close Viewings: Recent Film*. Tampa, Fla., 1990.

PARRISH, JAMES ROBERT, and GEORGE C. HILL. *Black Action Films*. Chapel Hill, N.C., 1989.

ELIZABETH V. FOLEY

Varick, James (1750–July 22, 1827), church founder, bishop, and abolitionist. James Varick was born near Newburgh, N.Y. to a slave mother (manumitted when Varick was a small boy), and a free father. When he was sixteen, he joined the John St. Methodist Episcopal Church in New York City, where he was eventually licensed to preach. He learned the shoemaking trade and had opened his own business by 1783. In 1790, he married Aurelia Jones and they had seven children, four of whom lived to adulthood.

As black membership in the John St. Church grew, segregation was introduced and black members had to sit in the back pews. In response, a small group of black men, led by Varick, obtained church approval to hold separate services for the black congregation in 1796. By 1800, they had purchased a lot and built their own church and secured an independent charter in 1801. This church, the AFRICAN METHODIST EPISCOPAL ZION CHURCH, became the mother church of the AME Zion Church movement.

In 1806, Varick was ordained with two others as the first black deacons in New York. His intelligence, oratorical skills, and piety were well-known and he became a spokesperson for African Americans and a pioneer in the independent black church movement. He assisted in and encouraged the formation of the Zion Church in New Haven in 1818, and in Philadelphia in 1820. He also fought for twenty years to free his church from white Methodist Episcopal control. In 1820, Varick led his congregation to adopt resolutions (which he had written) that would formally separate the Zion church from the white denomination. Not only was he able to formally charter this new denomination based on Wesleyan Methodist doctrines (not to be confused with the AFRICAN METHODIST EPISCOPAL CHURCH founded in 1816 by Richard Allen), but he made sure that the church maintained undisputed rights to their finances and properties. In 1821, he was elected district elder during a conference with other black Methodist leaders. And, after a two-year struggle with the white church hierarchy, he was finally ordained as the first black Bishop of the independent African Methodist Episcopal Zion Church in 1822.

Varick was a gifted preacher, but black preachers were paid little or nothing. During the twenty-year struggle to break away from white control, the white pastor of his church made a full time salary. Varick was forced to continue in the shoemaking trade and also taught classes out of his home. Yet this could not slow him down in his efforts for equality. He was named the first chaplain of the New York African Society for Mutual Relief in 1810. In 1817, he became one of the vice presidents of the New York African Bible Society. Having been deeply influenced by the spirit of the Revolution, in 1821 he joined a group of black businessmen and clergy and petitioned the New York State Constitutional Convention to obtain black suffrage. He was strongly opposed to the colonization movement and worked to enlighten white supporters as to its unfairness.

Shortly before his death in his home on July 22, 1827, Varick became one of the founders of the first black newspaper in the United States, FREEDOM'S JOURNAL. His commitment to freedom for all and universal dignity were in evidence in all of the articles he contributed.

REFERENCES

LOGAN, RAYFORD W., and MICHAEL R. WINSTON, eds. *Dictionary of American Negro Biography*. New York, 1982.

WASHINGTON, JOSEPH R., JR. *Black Religion*. Boston, 1964.

WILMORE, GAYRAUD S. *Black Religion and Black Radicalism*. New York, 1972.

SASHA THOMAS
DEBI BROOME

Vassa, Gustavus. *See* Equiano, Olaudah.

Vaughan, Sarah (March 29, 1924–April 3, 1990), jazz singer. Nicknamed "Sassy" and "the Divine One," Sarah Vaughan is considered one of America's greatest vocalists and part of the triumvirate of women jazz singers that includes Ella FITZGERALD and Billie HOLIDAY. A unique stylist, she possessed vocal capabilities—lush tones, perfect pitch, and a range exceeding three octaves—that were matched by her adventurous, sometimes radical sense of improvisation. Born in Newark, N.J., she began singing and playing organ in the Mount Zion Baptist Church when she was twelve.

In October 1942, she sang "Body and Soul" to win an amateur-night contest at Harlem's Apollo Theater. Billy ECKSTINE, the singer for Earl "Fatha" HINES's big band, happened to hear her and was so impressed that he persuaded Hines to hire Vaughan as a second pianist and singer in early 1943. Later that year, when Eckstine left Hines to organize his own big band, she went with him. In his group, one of the incubators of bebop jazz, Vaughan was influenced by Eckstine's vibrato-laced baritone, and by the innovations of such fellow musicians as Dizzy GILLESPIE and Charlie PARKER. Besides inspiring her to forge a personal style, they instilled in her a lifelong desire to improvise. ("It was just like going to school," she said.)

Vaughan made her first records for the Continental label on New Year's Eve 1944, and began working as a solo act the following year at New York's Cafe Society. At the club she met trumpeter George Treadwell, who became her manager and the first of her four husbands. Treadwell promoted Vaughan and helped create her glamorous image. Following hits on Musicraft (including "It's Magic" and "If They Could See Me Now") and Columbia ("Black Coffee"), her success was assured. From 1947 through 1952, she was voted top female vocalist in polls in *Down Beat* and *Metronome* jazz magazines.

Throughout the 1950s, Vaughan recorded pop material for Mercury records, including such hits as "Make Yourself Comfortable" and "Broken-Hearted Melody" and songbooks (like those made by Ella Fitzgerald) of classic American songs by George Gershwin and Irving Berlin; she also recorded jazz sessions on the EmArcy label (Mercury's jazz label) with trumpeter Clifford BROWN, the Count BASIE Orchestra, and other jazz musicians. By the mid-1960s, frustrated by the tactics of record companies trying to sustain her commercially, Vaughan took a five-year hiatus from recording. By the 1970s, her voice had become darker and richer.

Vaughan was noted for a style in which she treated her voice like a jazz instrument rather than as a conduit for the lyrics. A contralto, she sang wide leaps easily, improvised sometimes subtle, sometimes dramatic melodic and rhythmic lines, and made full use of timbral expressiveness—from clear tones to bluesy growls with vibrato. By the end of her career, she had performed in more than sixty countries, in small

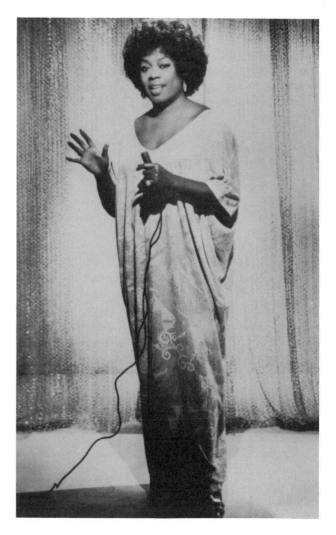

Sarah Vaughan. (Photographs and Prints Division, Schomburg Center for Research in Black Culture, The New York Public Library, Astor, Lenox and Tilden Foundations)

boîtes and in football stadiums, with jazz trios as well as symphony orchestras. Her signature songs, featured at almost all of her shows, included "Misty," "Tenderly," and "Send In the Clowns." She died of cancer in 1990, survived by one daughter.

REFERENCES

GIDDINS, GARY. "Sarah Vaughan." In *Rhythm-a-Ning,* New York, 1985, pp. 26–34.
JONES, MAX. "Sarah Vaughan." In *Talking Jazz,* New York, 1988, pp. 260–265.

BUD KLIMENT

Vermont. African Americans have maintained a small presence in Vermont throughout its history. In 1790, census enumerators identified 269 people, or 0.31 percent of Vermont's population in the "other person" category associated with free blacks; in 1990 there were 1,951 African Americans in Vermont, or 0.35 percent. This population has shifted in response to local and national events; men and women have moved into and out of and within the state in search of jobs or schooling. African Americans in the Green Mountain state have manufactured potash, spun flax, sheared sheep, milked cows, driven cabs, and worked in woolen mills, supermarkets, and banks. They have also occupied pulpits, taught classes, argued cases, and fought in the nation's wars. Vermont, despite its constitution of 1777 that banned slavery, did not consistently afford its black residents equality of opportunity or the full rights of citizenship. Consequently African Americans in Vermont had to struggle in hard times and flush to attain their liberties and earn their livelihoods.

On the morning of February 12, 1789, Ethan Allen, returning to his Burlington farm with a load of hay, collapsed and later died; a mulatto "servant"—his exact status is unclear—carried Allen into his house and attended to his last moments. Allen's "servant" suggests some of the quandaries faced by historians of African Americans in Vermont; he is glimpsed rather than seen in a historical record that reveals nothing of his legal status, economic circumstances, or personal identity. A similar obscurity has shadowed the lives of thousands of African Americans over the generations; many stories of ordinary lives—of sorrow and struggle or of joy and achievement—have forever been lost.

The lives of Jeremiah Virginia and his children hint at some of the vicissitudes experienced by African Americans in Vermont. Virginia, a Revolutionary War veteran, lived independently with his wife in Newbury, in the northern reaches of the Connecticut River Valley, according to the censuses of 1790 and 1800; by the latter year, their household included eight children. Sometime in the following decade, the Virginia family moved to Sheldon, a small rural community in northwest Vermont. In 1820 three Virginia households appeared in Fletcher. In January of that same year Luther Virginia, perhaps a son of Jeremiah, was convicted of murder in St. Albans and hanged. In 1830 only a Calvin Virginia remained in Vermont living in Burlington. Jeremiah, over a hundred years old, reappeared living with a white family in St. Albans in 1840.

Census reports raise more questions than they answer, but they hint at a complex tale of economic insecurity and a struggle for survival. Other census stories reveal persistence and family success; in 1840 Thomas Hazzard (later spelled "Hazard"), along with his wife and six children, lived and worked in Woodstock; descendants of Thomas Hazard have remained in Vermont ever since, often maintaining independent households and seeking quiet lives as useful citizens.

Some African Americans took advantage of a small window of opportunity shaped by Vermont's frontier boom to achieve prominence. In the late 1760s, Abijah and Lucy Terry PRINCE settled on one hundred acres in Guilford. Lucy Terry Prince traveled to Norwich to seek help from the Governor's Council against the harassment of their neighbors in 1785, and at the age of sixty-seven, she argued and won a land dispute case. Lemuel HAYNES joined the four hundred men recruited by Benedict Arnold to besiege Fort Ticonderoga in 1775. After his ordination following the Revolutionary War, Haynes accepted the pulpit of the Congregational Church in West Rutland, where he served from 1788 to 1810. Haynes tripled the membership of the church, preached fifty-five hundred sermons and was honored with an honorary Master of Arts degree from Middlebury College in 1805.

Alexander TWILIGHT, born in Corinth in 1795, was indentured to a local farmer as a teenager. He purchased the last year of his indenture and enrolled in Randolph Academy in 1815. Twilight went on to Middlebury College, graduating in 1823 as one of the first African Americans to earn a college degree. Twilight moved to Vermont's Northeast Kingdom in 1829 to become a preceptor of the Orleans County Grammar School and to serve as pastor of the village church that met in the school building in Brownington. Later Twilight designed and supervised the building of a four-story granite school and dormitory (which still stands) in the village. Twilight was also the first African American to serve in a state legislature, serving one term as Brownington's representative from 1836 to 1837.

The collapse of Vermont's frontier boom severely restricted opportunities for African Americans and other residents of the state. Although families and individuals continued to seek their livelihood, the potential for achievement opened to some of the revolutionary generation seemed dramatically reduced.

The CIVIL WAR and EMANCIPATION changed circumstances somewhat. Some 150 African Americans in Vermont served the Union cause (more than 20 percent of the black population), and after the war a number of freedmen came north to Vermont. William Anderson came to Shoreham in 1866. He worked as a hired man and later bought his own farm. Anderson married Philomen Langwire of French-Canadian and Indian heritage.

The Andersons' daughter Mary Annette, as a member of Phi Beta Kappa and class valedictorian, graduated from Middlebury College in 1899 and went on to teach at HOWARD UNIVERSITY. Their son, William John, operated a successful apple orchard in Shoreham and later became the second African American to sit in the Vermont legislature. George Washington Henderson, born a slave in Virginia, came to Underhill after the war. He attended local schools and the University of Vermont. In 1877, nine years after his manumission, Henderson became the first African-American graduate of the university, as valedictorian and a member of Phi Beta Kappa. Henderson went on to a distinguished career as a teacher, pastor, and editor. Despite Emancipation and the postwar achievements of individuals like Anderson and Henderson, black Vermonters continued to face prejudice and racism that barred them from obtaining their full rights as citizens.

Little historical work has been done on African Americans in twentieth-century Vermont. Census data shows unusual shifts in the state's black population. The 1910 census revealed 1,621 African Americans in Vermont, double the total ten years before. By 1920 it had dropped to 572, and by 1940 to 384. The population increased slowly over the following twenty years, and from 1960 to 1990 it quadrupled. Vermont remained, however, the "whitest state"—that is, the one with the smallest percentage of African Americans in the population. From 1946 through at least the mid–1950s, A. Richie Louie, a pastor in Johnson, operated the Vermont Summer of Race Relations, through which African-American youth from Harlem were invited to stay for two weeks with white Vermont families to promote interracial education.

Many of the undercurrents of discrimination and racism that have troubled the history of race relations in Vermont have continued in more recent times. In June 1968, the Rev. David Johnson, an African American, had his house strafed by a night rider in Irasburg. Police allegedly harassed Johnson after he filed a complaint. Johnson's assailant pleaded "no contest" but was given no legal punishment. Employment discrimination remained a problem through the 1990s, and many black lawyers, editors, and other professionals trained in Vermont were forced to leave the state. In 1989, Patricia Lewis, a black student at Goddard College, won $102,000 in a bias suit after being excluded from a school conference on racism.

Still, black Vermonters made numerous gains in the last third of the twentieth century. In the 1970s, black leaders convinced the state to change the name of a mountain long known as "Niggerhead" Mountain. By 1980, the state had the highest average black family income in the nation, and average black income exceeded white income in the state. In 1982, Francis Brooks, an African American, ran successfully for the state legislature, the first of two blacks elected in the 1980s. When a KU KLUX KLAN contingent came to the state to protest Brooks's candidacy, an interracial crowd booed them and the legislature passed a resolution denouncing them. Delores Sandoval, a professor at the University of Vermont, ran unsuccessfully as the Democratic candidate for Congress in 1990. In 1989, the state's first black church, the New Alpha Missionary Baptist Church, was organized. In 1991, Aljaray Nails, Jr., became the state's first black police officer. To demonstrate the continuing significance of African Americans in the state's history, a mural was painted at the Vermont Law School in South Royalton in 1993, depicting events in Vermont's black history.

REFERENCES

DALEY, YVONNE. "Vermont's History Reveals Uneven Race Relations." *Boston Globe,* February 18, 1990, p. 75.

GUYETTE, ELISE A. Black Lives and White Racism in Vermont. M.A. Thesis, University of Vermont, 1992.

RANDOLPH, LAURA. "How Blacks Fare in the Whitest State." *Ebony* (December 1987): 44–48.

SIEBERT, WILBUR H. *Vermont's Anti-Slavery and Underground Railroad Record.* New York, 1937.

MARSHALL TRUE

Vernacular Architecture. *See* Architecture, Vernacular.

Verrett, Shirley (May 31, 1931–), opera singer. Born in New Orleans, Shirley Verrett grew up in Los Angeles. She studied music in her youth and received a degree from Venture College in Los An-

geles in 1951. After her performance of "Mon coeur s'ouvre à ta voix" from Saint-Saëns' *Samson et Dalila* earned her first prize in Arthur Godfrey's 1955 Talent Scout competition, she was invited to study at the Juilliard School of Music in New York City. Before receiving a degree in 1961, she debuted in Benjamin Britten's *The Rape of Lucretia* at Yellow Springs, Ohio, in 1957; appeared at New York's Town Hall in 1958; and performed in the New York City Opera's 1958 production of Kurt Weill's *Lost in the Stars.*

Verrett first came to international acclaim as a mezzo-soprano after singing the title role in Bizet's *Carmen* at the 1962 Spoleto Festival in Italy. She made her Covent Garden debut to critical acclaim in 1966 as Ulrica in Verdi's *Un Ballo in Maschera,* and returned to England the next year as Queen Elizabeth in Donizetti's *Maria Stuarda.* Verrett made her Metropolitan Opera debut in 1968 as Carmen. In 1972 she performed the role of Queen Selika in Meyerbeer's *L'Africaine* in San Francisco. At the Metropolitan's 1973 premiere of Berlioz's *Les Troyens* she created a sensation by singing the roles of both Cassandra and Dido. Thereafter Verrett concentrated on soprano roles. In 1976 she sang in Verdi's *Macbeth* in Washington, D.C., and in 1978 and 1979 Verrett performed in Donizetti's *La Favorita* and the title role in Bellini's *Norma* at the Metropolitan Opera.

By the 1980s, Verrett's magnetic stage presence and her ability to sing both soprano and mezzo-soprano roles made her one of the leading divas of the international opera stage. She sang in Puccini's *Tosca* at Tanglewood in 1980, and returned the next year to perform in Verdi's *Requiem.* In 1982, Verrett performed Chausson's song cycle *Poème de l'amour et de la mer* with the New York Philharmonic. That same year she participated in a Carnegie Hall tribute to Marian ANDERSON. In 1986 she sang the Verdian role of Lady Macbeth in San Francisco. In the 1990s Verrett branched out of the operatic repertory. In 1991 she performed songs by George Gershwin in Moscow, and in 1994 she sang the role of Nettie in the Lincoln Center production of Rodgers and Hammerstein's *Carousel.*

REFERENCES

DYER, RICHARD. "Characteristically Verrett." *Opera News* 54 (February 17, 1990): 8.
STORY, ROSALYN M. *And So I Sing: African-American Divas of Opera and Concert.* New York, 1990, p. 157.

A. LOUISE TOPPIN

Vesey, Denmark. *See* Denmark Vesey Conspiracy.

Veterinary Medicine. Veterinary medicine, the science dealing with animal health, was practiced almost exclusively by farriers (horseshoers) until the establishment of specialized veterinary schools in France in the mid–eighteenth century. The first such school in the United States, founded in 1879, was the Division of Veterinary Medicine of the Iowa State College of Agriculture and Mechanic Arts (later Iowa State University). Although the eminent agriculturist George Washington CARVER earned science degrees at the college and taught there in the 1890s, Iowa graduated no African Americans in veterinary medicine until 1918, when Edward Bertram Evans and Samuel Alonzo Richardson took their degrees.

Among the health professions, veterinary medicine has traditionally had the lowest ratio of blacks to total practitioners in the field (1.6 percent in 1980). At first glance this is a surprising statistic, considering the role that blacks played during slavery and afterward (with the encouragement of Booker T. WASHINGTON and the proponents of the "manual service" approach to self-improvement) as farmhands, caretakers of livestock, horse drivers, and so forth. Other factors, however, discouraged participation. During the nineteenth and early twentieth centuries, black veterinarians encountered numerous obstacles to acquiring housing and office or clinic space, and they often had to rely on contract work from white farmers or pet owners, many of whom preferred to hire white practitioners. Private practice was therefore risky. Black veterinarians generally ended up on the staff of agricultural departments attached to southern black colleges, or in minor posts with the U.S. Department of Agriculture.

One of the earliest blacks to earn a doctor of veterinary medicine (D.V.M. or V.M.D.) degree was Augustus Nathaniel Lushington, who graduated from the University of Pennsylvania in 1897. He is said to have been the first black licensed as a veterinarian in the United States. A native of Trinidad, Lushington practiced for two years in Philadelphia before accepting a post as instructor in veterinary sanitation and hygiene at Bell Mead Industrial and Agricultural College, Rock Castle, Va. He later moved to Lynchburg, Va., where he remained until his death in 1939. In Lynchburg, Lushington operated a private practice, served as a government meat inspector, and also did statistical work for the Bureau of Animal Industry of the U.S. Department of Agriculture.

Among other pioneering black veterinarians who earned degrees at the University of Pennsylvania were John B. Taylor (1908), Cornelius Vanderbilt Lowe (1909), L. E. Baxter (1910), and Augustus M. Fisher (1912). Except for Taylor, who died shortly after graduation, they went on to careers in agricul-

tural teaching, private practice, or government meat inspection. George C. Cooper (Colorado State University, 1916) was the first black admitted to membership in the American Veterinary Medical Association. A Penn graduate, William H. Waddell (1935), worked for fifteen years as head of the veterinary division of Tuskegee Institute. He helped lay the groundwork for Tuskegee's veterinary school, which was established in 1945. Walter C. Bowie (Kansas State University, 1947) devoted his career to building the School of Veterinary Medicine at Tuskegee. One of the earliest black female veterinarians was Jane Hinton (University of Pennsylvania, 1949), daughter of the eminent Harvard syphilologist William Augustus HINTON.

Before 1960, African-American veterinarians graduated from Kansas State University (25), Ohio State University (16), Iowa State University (10), Michigan State University (9), the University of Pennsylvania (7), and Colorado State University (5). In 1981–1982, Tuskegee accounted for approximately three-quarters of all black veterinary students (137 of 179). Other schools that turned out black veterinarians between 1960 and 1982 were the University of Pennsylvania (23), the University of California at Davis (14), and Cornell University (12).

REFERENCES

WADDELL, WILLIAM H. *The Black Man in Veterinary Medicine*. Fargo, N. Dak., 1969.

———. *The Black Man in Veterinary Medicine: Afro-American–Negro–Colored*. Honolulu, 1982.

PHILIP N. ALEXANDER

Vietnam War. The active American involvement in the Vietnam War (1961–1973) imposed demands for manpower on a populace that grew increasingly less supportive of the conflict as the fighting continued. The Selective Service System, which gathered involuntary recruits for the army and (in much smaller numbers) the Marine Corps and also persuaded potential draftees to volunteer for less dangerous duty in the navy or air force, bore down hardest on those too poor or too poorly educated to take advantage of deferments or exemptions. The draft, for example, called up a disproportionate number of black high school graduates unable to attend college. Perceived inequities in the draft and racial animosity brought into the services from civilian life contributed to an erosion of discipline and an increase in tensions between whites and blacks. Friction in the ranks gradually abated for several reasons: the adoption in December 1969 of a lottery to reduce loopholes and exemptions in the administration of the

draft; the launching in January 1972 of a formal program to assist men and women in uniform and civilian employees to put aside racial prejudice and work together in harmony; the pullout of combat troops from Vietnam in January 1973; and reliance afterward on volunteers to man the peacetime armed forces.

The Gesell Committee

The Vietnam War tested the commitment of the armed forces to racial integration. During the advisory phase (1961–1965), when the United States provided material assistance and combat support for South Vietnam against North Vietnam, a committee headed by Gerhard A. Gesell, a Washington, D.C., attorney and later a federal judge, reviewed the status of racial integration in the services, a task assigned it in the summer of 1962 by Secretary of Defense Robert S. McNamara. The committee issued two reports: the first, in June 1963, dealt with active-duty forces; the second, in November 1964, focused on the National Guard. The Gesell Committee concluded that racial discrimination undermined morale and performance. To eliminate discrimination, the panel recommended that the fight against racism become a responsibility of commanders, who would direct the campaign for equal treatment and opportunity on military and naval installations and also in nearby communities where African-American personnel and their families often had only limited access to housing and public accommodation. In addition, the committee recommended that the federal government should enforce existing civil rights laws in towns and cities near the bases and, if persuasion failed, cut off federal funds for National Guard units that persisted in racial discrimination.

Secretary McNamara tried hard to carry out the committee's recommendations. In 1967, for example, at the request of the state legislature, he had the commander at Fort Meade, Md., declare off-limits to servicemen the rental properties of landlords who discriminated against blacks. Civil rights legislation, especially the Fair Housing Act of April 1968, became part of the campaign against racism that Clark Clifford directed after succeeding McNamara as secretary of defense on March 1 of that year. The National Guard opened its ranks to African Americans, with some states launching intensive recruiting efforts, but the response proved uneven because of a lingering wariness about joining. Certain National Guard units had earned a reputation as agents of repression during the CIVIL RIGHTS MOVEMENT, and as the decade progressed, state authorities frequently called on the National Guard to deal with riots in black communities, further alienating potential African-American recruits. The urban uprisings reached their peak immediately after the murder on April 4, 1968, of the Rev.

Dr. Martin Luther KING, Jr., when violence flared in 110 American cities.

The context to the racial tension within the armed forces during the Vietnam era came to be summarized in two catchphrases: black power and white backlash. Many African Americans, especially the younger generation, advocated black power and sought to take control of their own destinies, advocating the employment of violence if necessary. They had grown weary of King's nonviolent struggle, which seemed to depend on shaming an increasingly resistant white America into acknowledging the rights of black citizens and an often insensitive federal government, influenced by the hardening white attitude, into protecting them. The new defensiveness among whites reflected fear that the administration of Lyndon B. Johnson had taken power from them and redistributed it to blacks. White backlash focused on control of public schools—many of which had yet to integrate more than a decade after BROWN V. BOARD OF EDUCATION OF TOPEKA, KANSAS—and on jobs at a time when industrial employment was shrinking. As the armed forces expanded to fight the war in Vietnam, many new recruits, white and black, had attitudes shaped by these resentments. The armed forces, disproportionately composed of urban blacks and rural (often conservative) Southerners, were a cynosure for the racial tension of the 1960s.

While the racial divisions within society grew deeper, the nature of the Vietnam conflict changed. From 1965 through early 1968, the United States in effect took over the fighting from the South Vietnamese, and the resulting increase in American casualties created a demand for manpower and also strengthened opposition to the conflict. The communist Tet offensive—so called because it was timed to coincide with Tet, the celebration of the lunar new year, on January 31, 1968—disillusioned the Johnson administration, which imposed a ceiling on the American commitment and took the initial steps to return the burden of the fighting to the South Vietnamese, the policy of so-called Vietnamization. President Richard M. Nixon took office in January 1969 and soon began to implement this policy. He withdrew those Marine Corps and army forces that suffered the greatest proportion of American casualties and included a large proportion of draftees. Since the last American ground combat troops did not leave South Vietnam until August 1972, opposition to the war and the need for manpower faded slowly.

Wartime Expansion

As the United States took over the war, commanders at every level tended to ignore the interrelationship of racism, morale, and effectiveness. Emphasis shifted from ensuring equal treatment and opportunity by carrying out the reforms recommended by the Gesell Committee to preparing for imminent combat; the former still seemed desirable, but the latter was essential. Meanwhile, the wartime expansion attracted a large number of recruits, whites as well as blacks, whose attitudes reflected the growing racial hostility. An influx of volatile individuals, most of whom entered the service reluctantly, overwhelmed the stable, professional enlisted force toward which Gesell and his colleagues had directed their reforms.

Secretary McNamara hoped to use the wartime demand for manpower to improve opportunities for poorly educated youth, especially African Americans. In August 1966 he launched Project 100,000, intended to admit that number of recruits who did not score highly enough on the classification tests to meet the usual standards for enlistment and give them training they could use to obtain jobs after leaving the service. In effect, the secretary of defense anticipated events, for by the time the Vietnam War ended, standards had so declined that the armed forces were routinely accepting persons who would have qualified for Project 100,000. He failed nonetheless to achieve his ultimate goal. Those males with the lowest scores gravitated toward assignments, such as rifleman in the army or Marine Corps, that taught few skills transferable to civilian life.

Project 100,000, along with inequities in the draft such as the liberal granting of educational deferments, enhanced the perception that the Vietnam War was a rich man's war but a poor man's fight, with African Americans doing a disproportionate share of the fighting. During the buildup of American strength, the Selective Service System inducted as many as 60 percent of the blacks eligible for the draft, compared to 30 percent of whites. The disparity may have reflected the few African Americans on draft boards throughout the nation, a mere 1.5 percent of the total membership in 1967 and only 6.6 percent after a three-year effort to increase their number. Moreover, poorer blacks lacked the opportunity to obtain deferments available to middle-class whites who could continue their education, document medical disability, or simply take advantage of counseling on ways to beat the draft. Upon entering the service, educational disadvantages resulting from second-rate schools and at times outright racism—African-American servicemen tended to emphasize the latter—steered blacks into combat units, although the prestige and extra pay associated with hazardous duty proved attractive to some. No longer did military service seem to offer better treatment and opportunity than civilian employment, as indicated by declining reenlistment rates for African Americans—from 66.5 percent in 1966 to 31.7 percent in 1967 to just 12.8 percent in 1970.

As the war intensified after 1965, opposition to American involvement became an important issue

Between 1960 and 1975, several hundred thousand African Americans served in the United States Army in the Vietnam War. Black soldiers played a major role in all of the war's many bitter battles and skirmishes. Here a soldier participates in the battle for Hill 484. (Photographs and Prints Division, Schomburg Center for Research in Black Culture, The New York Public Library, Astor, Lenox and Tilden Foundations)

among African-American activists. In the last years of his life, Martin Luther King, Jr., was vociferous in his opposition to the war, as were many of the various groups in the Black Power movement. In 1967, when heavyweight boxing champion Muhammad ALI refused induction into the army, he was stripped of his title. However, opposition to the war was far from unanimous among African Americans. In addition to the many members of the armed forces, some leaders of the CIVIL RIGHTS MOVEMENT, including Whitney M. YOUNG, Jr., and Bayard RUSTIN, either supported or with great reluctance criticized the Johnson administration over the war.

Racial tensions within the armed forces imposed a strain on the system of military justice as the services tried to cull out undesirables, especially those considered black militants. Many an African-American soldier accepted a general discharge under honorable conditions as an easy way out of the army only to discover that employers sometimes failed to make a distinction between a general and an undesirable, bad conduct, or dishonorable discharge. Punishment, especially that meted out by commanding officers under article 15 of the Uniform Code of Military Justice, also fell more heavily on those categorized as black militants, and a series of punishments for minor infractions made it more difficult to earn an honorable discharge. In November 1972, after investigating the administration of military justice, a majority of an interracial panel with military and civilian members warned of systemic discrimination, in which the armed forces as an institution down-

graded the ability of minorities to profit from training, accept discipline, or carry out assignments.

Spreading Violence

The perception of discrimination against African Americans undermined respect for military law, and the resulting feeling of contempt reinforced the existing injustice, crowding stockades with blacks. At Long Binh in South Vietnam, overcrowding and cruel conditions—maritime shipping containers sometimes served as cells—contributed to a riot in August 1968 that pitted black prisoners against a predominantly white guard force.

Before the violence at Long Binh, the murder of Martin Luther King, Jr., in April had led to a series of racial incidents in Southeast Asia. Since the civil rights leader had denounced the war as a waste of scarce resources needed in America's cities, some white servicemen rejoiced in his death. Sailors at Cua Viet donned makeshift white robes and paraded in imitation of the KU KLUX KLAN, and Confederate flags, symbols of slavery, were unfurled over Cam Ranh Bay and Da Nang.

Racial clashes erupted wherever American forces served. In February 1969 the army had to deal with rioting at Fort Benning, Ga., where black soldiers, awaiting discharge after returning from Southeast Asia, vented their frustration at being assigned to night maneuvers or menial labor by attacking white troops. At Camp Lejeune, N.C., recurring violence in the spring of that year resulted in the death of a white marine just returned from South Vietnam. At Goose Bay, Labrador, Canada, during March 1970, a white airman, apparently angered because local white women danced with blacks serving at the air force installation, stabbed one of the African Americans, inflicting superficial wounds and triggering random beatings of whites in retaliation. In July 1970, at Great Lakes Naval Base, Ill., the shore patrol arrested four black WAVES (Women Appointed for Voluntary Emergency Service) for beating up another female sailor, also an African American. A mob of angry male sailors, whites and blacks, gathered, but the authorities defused the explosive situation by explaining that race had not been a factor and that the four women had been placed on report and released. In Europe violence occurred with such frequency that in September 1970 the Department of Defense sent an interracial team headed by Deputy Assistant Secretary of Defense Frank Render II, an African American, to investigate conditions.

To deal with the causes of these incidents and prevent further clashes, the services granted various concessions, substantial as well as symbolic. These included acceptance of a modified Afro hairstyle, toleration of the clenched-fist black power salute, a crackdown on racially offensive terms, and the stocking in exchanges of products used by African Americans and magazines of interest to them. The services also tried to ensure fairness in the administration of justice, in part by commissioning black attorneys and by monitoring article 15 proceedings and the award of other than honorable discharges. Additional measures included the removal of references to race from all records reviewed by promotion boards and further emphasis on the recommendations of the Gesell Committee to attack all forms of racial discrimination on bases and in nearby communities. Finally, the services created discussion groups and councils—ranging from advisory agencies for commanders to mere gripe sessions—to improve communication between the races.

Education in Race Relations

In November 1969 Secretary of Defense Melvin R. Laird established a task force under an African-American officer, air force Col. Lucius D. Theus, to devise a program of education in race relations. The group recommended mandatory courses taught by trained instructors. Laird approved the plan in March 1970, but momentum dissipated. Other reforms seemed to deserve a chance, among them an attempt to steer members of racial minorities into specialties where they remained underrepresented. Moreover, a growing problem of drug abuse consumed resources that might otherwise have been invested in improving race relations.

The recommendations of Theus and his colleagues remained in limbo, approved but not implemented, on May 21, 1971, when, at Travis Air Force Base, Calif., a four-day riot erupted caused by an accumulation of incidents varying from the serious to the trivial, from racial discrimination in off-base housing to a quarrel over music (country and western versus soul). On June 24 the assistant secretary of defense for manpower and reserve affairs assumed responsibility for race relations, advised by the Defense Race Relations Education Board with representatives from each of the services. In January 1972 the Defense Race Relations Institute opened its doors at Patrick Air Force Base, Fla., and began producing instructors to administer the mandatory training in racial harmony.

The program of education that radiated from the Defense Race Relations Institute (known after July 1979 as the Defense Equal Opportunity Management Institute) did not bring immediate harmony to the armed forces. Indeed, some commanders resisted the efforts of junior officers and noncommissioned officers, whose zeal was at times unalloyed with tact. Despite occasional misunderstandings, however, se-

nior officers came to realize the value of the program in promoting racial amity.

As active American involvement in the Vietnam War drew to a close, some ten months after the Defense Race Relations Institute admitted its first class, racial violence jolted the navy. On October 12 and 13, 1972, a brawl between black and white sailors in the port of Olongapao in the Philippines reignited on board the aircraft carrier *Kitty Hawk*, but the ship's executive officer, an African American, restored order. On October 16, when the executive officer of the fleet oiler *Hassayampa* failed to move swiftly against a white sailor accused of stealing from his black shipmates, African Americans in the crew randomly attacked whites until a detachment of marines came on board and halted the violence. Yet another incident occurred on the aircraft carrier *Constellation*, where the crew included a large number of sailors whose scores on the general qualification test would have disqualified them from serving in the navy if the Vietnam conflict had not created a need for men. A decision to give general discharges under honorable conditions to a half dozen African Americans who not only scored poorly on the test but also performed indifferently inspired rumors of mass discharges, and more than a hundred sailors refused to sail with the *Constellation* when the ship left San Diego, Calif. Ten of the dissidents, including all the whites, rejoined the ship in time to sail on November 9. Of those who stayed behind, sixty-nine received new assignments and the remaining fifty-one left the service, ten of them with the general discharges under honorable conditions that had triggered the incident.

Racial strife had erupted in the navy despite the vigorous efforts of the chief of naval operations, Admiral Elmo Zumwalt, to ensure equal treatment and opportunity regardless of race. Zumwalt interpreted the incidents in the fall of 1972 as evidence that his reforms were being ignored. His program had encountered strong opposition within the officer corps, and conservatives in Congress, such as Rep. F. Edward Hebert of Louisiana, blamed all the navy's troubles on Zumwalt's "permissiveness." Many of the Zumwalt reforms did not survive his tenure as chief of naval operations, but the program of education in race relations and the objective of equal treatment and opportunity prevailed.

Despite the navy's troubles, race relations in the armed forces were improving as the Vietnam War came to an end. The functioning of the Defense Race Relations Institute and the work of the instructors it trained, reinforced by statements from senior officers and civilian officials, underscored for blacks and whites the importance of racial harmony. As the program of education gathered momentum, the armed forces contracted in size and could no longer could rely on the draft, which survived after 1973 only as a possible source of manpower in some future emergency. Nevertheless, the new all-volunteer armed forces did not lack for recruits. The disappearance of high-paying industrial jobs made the services attractive to whites and blacks, and as the Vietnam War receded into the past, those who entered the service proved more willing than the wartime draftees or reluctant volunteers to conform to those rules and practices designed to promote racial amity.

The Vietnam War had an impact on African Americans and on the military. Black veterans gained access to benefits, but these, especially the payments for education, proved less generous than those allotted after WORLD WAR II, and there were fewer veterans, black or white, to take advantage of them. For many African-American officers, including the future chairman of the Joint Chiefs of Staff, Colin POWELL, the war provided the opportunity for combat commands and rapid advancement through the military hierarchy. Fears that African-American ex-servicemen might take up arms against whites proved groundless. Relative calm prevailed in civil society immediately after the war, and the armed services not only survived the turmoil of the Vietnam conflict but again attracted black recruits, in part because of poor opportunities for civilian employment. Indeed, the postwar all-volunteer armed forces had a greater proportion of African Americans than did the wartime services—15 percent in 1974 compared to 11 percent in 1970, with a higher percentage yet to come—though the numbers remained concentrated in the army and the Marine Corps and, except for the army, in the enlisted ranks, rather than being divided more evenly among the services and between commissioned and enlisted personnel.

REFERENCES

BOYD, GEORGE M. "A Look at Racial Polarity in the Armed Forces." *Air University Review* 21 (September-October 1970): 42–50.

FONER, JACK S. "The Vietnam War and Black Servicemen." In *Blacks and the Military in American History: A New Perspective.* New York, 1974, pp. 201–260.

GLINES, C. V. "Black vs. White—Trouble in the Ranks." *Armed Forces Management* 16 (June 1970): 20–27.

MACGREGOR, MORRIS J., JR. "Equal Treatment and Opportunity Redefined." In *Defense Studies: Integration of the Armed Forces, 1940–1965.* Washington, D.C., 1981, pp. 530–555.

MOSKOS, CHARLES C., JR. "Surviving the War in Vietnam." In Charles R. Figley and Seymour Leventman, eds. *Strangers at Home: Vietnam Veterans Since the War.* New York, 1980, pp. 71–85.

NALTY, BERNARD C. "From Nonviolence to Violence," "Turbulence in the Armed Forces," and "Emphasis on Education." In *Strength for the Fight:*

A History of Black Americans in the Military. New York, 1986, pp. 287–332.

RYAN, PAUL B. "USS *Constellation* Flare-Up: Was It Mutiny?" *U.S. Naval Institute Proceedings* 102 (February 1975): 68–83.

SHIELDS, PATRICIA M. "The Burden of the Draft: The Vietnam Years." *Journal of Political and Military Sociology 9* (Fall 1981): 215–228.

SPECTOR, RONALD H. "The End of Racial Harmony." In *After Tet: The Bloodiest Year in Vietnam.* New York, 1993, pp. 242–259.

TERRY, WALLACE. *Bloods: An Oral History of the Vietnam War by Black Veterans.* New York, 1984.

BERNARD C. NALTY

Virginia. On November 7, 1989, by a margin of seven thousand votes, L. Douglas WILDER of Virginia became the first African American to win popular election as governor of a state. This grandson of slaves completed a political journey that began in 1619, when a Dutch ship set anchor at Jamestown on the James River and sold the settlers there a cargo of "twenty Negars," the first Africans imported to the British colonies. The history of African Americans and the history of Virginia were thenceforward intimately intertwined.

The number of Africans remained small through the first half of the eighteenth century. In 1630 roughly one hundred of the twenty-five hundred inhabitants of Virginia were African or African American; by 1690 blacks accounted for little more than 7 percent of the population of the Chesapeake region. Thereafter, the black population jumped dramatically. By 1720 one of five Virginians and by 1740 two of five Virginians were African or African American.

This increased African presence paralleled shifts in the makeup of the labor force, as well as shifting attitudes about race. For much of the seventeenth century, most Africans brought to Virginia died within the first five years of residency. As a consequence, a white servant, who cost less to secure and whose indenture averaged six years, proved a better investment. European indentured servants thus accounted for the majority of forced laborers in Virginia through the 1730s. The supply of indentured servants decreased in the eighteenth century as good land became scarce. At the same time, the colony reached a size large enough to absorb cargoes of slaves imported directly from Africa. As sugar prices stabilized and tobacco prices increased, slave labor became relatively more affordable. Moreover, as a result of the increased importation of African women, by the late eighteenth century, when the Atlantic slave trade was cut off by the AMERICAN REVOLUTION, slaves

had become a self-reproducing labor force and a profitable long-term investment.

Shifting attitudes about race made the transition to a slave system possible as well. Some historians, notably Oscar Handlin, have characterized black slavery in Virginia as an "unthinking decision," with racial lines only gradually hardening. Slavery evolved as a fluid system of social, political, and economic subordination. The codification of a racial system began in 1639; the first description of Africans as slaves, however, entered the statue books only in 1659, and it was not until 1670 that Virginia ruled that imported Africans were slaves for life. From the very beginning, moreover, some African Americans lived as other than chattel. The record contains the names of men and women who lived as freeholders or owners of a notable amount of land. They tended to be scattered across the colony's terrain, often living in greater proximity to whites than to other blacks. Among this group were Tony Longo and his wife, who owned a 250-acre farm on the Eastern Shore in the seventeenth century.

Large-scale African slavery, according to historian Edmund Morgan, was instituted after 1680 to check the rising class conflict among whites, which culminated in 1676 in Bacon's Rebellion. Nathaniel Bacon, who had assembled an army to push back or exterminate local Indians, then joined with other discontented planters and freeholders in revolt against the landed gentry and other planters loyal to the regime of Governor William Berkeley. Bacon's forces had some support among free African Americans. After the rebellion was crushed, the Virginia elite decided to de-emphasize imports of indentured servants from England—who became free and anxious for land after serving their indentures—in favor of slaves who served for life.

In any case, Virginians waited until the 1690s to introduce discriminatory legislation in the form of laws designed to end the common practice of marriages and intimate relations across the color divide. Subsequent statutes penalized whites for such transgressions. Well after the passage of more restrictive legislation, however, intimacy across the color line continued. Blacks and whites, men and women, continued to live together as couples, oftentimes with the full approval of the local elite. The best-known example of interracial relations in Virginia was the putative affair between Thomas Jefferson and his slave Sally Hemings.

Slave laborers in Virginia were primarily employed in the growing of tobacco, the region's main cash crop, as well as foodstuffs, such as wheat. Both slaves and free blacks worked as artisans, masons, ironworkers, and blacksmiths and at other trades and monopolized the market for skilled labor. Blacks also worked as carriage drivers, loaded and unloaded

ships, and manned wharves. On larger plantations some slaves worked as house servants.

Africans had a profound effect on eighteenth-century Virginia life and culture. African-style architecture influenced housing design and the layout of plantations, according to Mechal Sobel. Africans and African Americans shared their cultural heritage with European Americans through folktales, ethnomedical practices, agricultural techniques, and religious beliefs. Baptists, for example, adopted such African forms as call-and-response. Such congregations as the Negro Baptist Church in Williamsburg, the Harrison Street Baptist Church in Petersburg, and the First African Baptist Church in Richmond, all established in the 1770s and 1780s, were among the first black Baptist churches built in the United States. Virginia's continuing African-American religious history eventually included such figures as David GEORGE, leader of the Sierra Leone colony; missionary-colonizationist Lott Cary; evangelist-memoirist Zilpha Elaw; fundamentalist preacher John JASPER; and Baptist minister Adam Clayton POWELL, Sr.

Freedom remained the paramount desire. Blacks in Virginia, as in other locales, resisted slavery in many ways. During the 1676 period of civil conflict between Bacon and Berkeley, several dozen enslaved Africans used the opportunity to pursue their own freedom. In the eighteenth century runaways found safe haven in the Dismal Swamp and other remote settings and formed maroon colonies. Others, as advertisements in Virginia newspapers attest, simply stole away to freedom.

The Revolutionary War opened many paths to freedom. Some enslaved blacks responded to Lord Dunmore's 1775 promise of emancipation for slaves who supported the British and made their way to his offshore base. Many in this group eventually made their way to Nova Scotia, Great Britain, and later Sierra Leone. Others availed themselves of the (temporary) change in political thought sparked by the revolutionary spirit to purchase, receive (as, for instance, a bequest), or earn their freedom. In 1782 a new state law facilitated manumission. Between 1790 and 1810 the state's free black population increased from 4.2 to 7.2 percent of the total population (12,766 to 30,570).

Another element in the decline of slavery in Virginia was the change in tobacco culture. As early as the 1780s, as soils became exhausted by tobacco, many planters in the tidewater region began switching to other crops. Other planters settled in the piedmont region, which became the center of the state's slave economy. The growing city of Richmond replaced Williamsburg as the state's capital in 1780. Nonslaveholding white farmers entered the state, mostly settling in the mountainous western counties

that later became the state of West Virginia. By 1820, as white immigration increased and tobacco cultivation continued to decline, the percentage of African Americans in the population began to fall. Excess slaves were liberated or employed as laborers. Some were used in industrial labor in factories such as Richmond Tredegar Iron Works. Many slaves were sold further south. Such sales became an important part of Virginia's economy.

Even as the slave economy grew less dominant in Virginia, the slave system became further entrenched, in part as a result of the abortive attack on Richmond planned by GABRIEL PROSSER in 1800 and the modestly successfully NAT TURNER'S REBELLION of 1831. Both the Prosser and Turner contingents consisted of highly skilled and assimilated native-born Virginia slave artisans. Each rebellion was followed by a wave of repression. Slave codes were enforced even more harshly. Manumission became difficult and, after Turner, nearly impossible. Free blacks were also subjected to legal limitations and harassment. Views of slavery also hardened as a result of the uprisings. At the beginning of the century, a Virginian like Thomas Jefferson considered the "execrable commerce" a necessary evil; by the 1830s a southern apologist like William and Mary professor Thomas Dew was arguing that the institution was a positive good. Repression did not, however, end the practice of stealing one's own freedom. Thomas Bayne of Norfolk escaped to New Bedford, Mass., where he practiced dentistry. Lewis Temple escaped from Richmond, also settled in New Bedford, and invented the toggle harpoon.

Enslavement remained the fate of most blacks until Lee's surrender at Appomattox. Nevertheless, a noticeable free black population persevered through the antebellum period despite chronic outmigration of free black Virginians (including future abolitonist Martin R. DELANEY, born in Charles Town) in response to increasingly reactionary legislation. While most free blacks were unskilled laborers, some worked in skilled occupations. In Petersburg, Richmond, and Norfolk there were several black property owners, including Daniel Jackson, a preacher; Reuben West, a barber; and Ned Keeling, a drayman. Jackson's Petersburg neighbor Molly James also owned property, although the number of African-American women property owners is not clear. A few rural free blacks owned slaves until such ownership was limited in 1858. These men and women, in conjunction with slaves who lived independently, organized urban community institutions—such as Norfolk's First Baptist Church—as well as numerous fraternal organizations.

As the debate over slavery and freedom pushed the country closer to a great divide during the 1850s,

Virginia leaned toward its southern neighbors. When John Brown and his party, which included several African Americans, attacked a federal arsenal at Harpers Ferry, Va. (now in West Virginia) in 1859, the country edged closer to armed conflict. Once fighting broke out, shortly after the inauguration of Abraham Lincoln in 1861, Virginia seceded from the Union. Richmond was established as the capital of the Confederacy. The state's nonslave western areas remained loyal and broke away from Virginia, entering the Union as the state of West Virginia in 1863.

Virginia was the core of the Confederacy and the site of some of the worst fighting in the CIVIL WAR. During the war years scores of blacks fled farms, plantations, and factories for the so-called contraband camps. Almost as soon as the war began, Union troops took over Hampton. Soon after, the American Missionary Association opened up its first southern school there to educate and employ the contrabands. Mary S. PEAKE, a free mulatto, was hired as teacher. After the EMANCIPATION PROCLAMATION thousands of African-American ex-slaves from Virginia joined the Union army. When President Lincoln visited Richmond after the Union takeover of the city in April 1865, he was surrounded by cheering African Americans, who welcomed him as their liberator. When word came of the final surrender a few days later, blacks across the state danced, paraded, and sang in exhilaration, proclaiming that jubilee had finally arrived.

Almost immediately thereafter, blacks in Virginia articulated a vision of freedom. In Norfolk African Americans issued an equal suffrage address; the 1865 statement encouraged other blacks to battle to secure the franchise and form land and labor associations. However, most blacks were unable to secure freeholdings and were forced to work as laborers or sharecroppers on poor or exhausted land, growing tobacco or other cash crops. Others found employment in industrial labor in the state's coal mines and factories. African Americans founded businesses, petitioned the federal government for pensions, moved from the countryside into urban areas, searched—sometimes in vain—for loved ones lost during slavery, and began a tireless fight for the full range of social and civil rights. They also remained active in the labor movement. In 1869 Norfolk's black dockworkers were organized by Isaac MYERS, a representative of the National Labor Union, and they later formed the National League of Longshoremen. In the 1880s many blacks joined the interracial Knights of Labor.

In 1868 a new state constitution enfranchised blacks, and in 1870 Virginia established public schools. (While almost all schools were segregated, a few institutions, such as Richmond Normal School,

remained integrated through the turn of the century.) The same year, however, conservative forces gained control of the government, and they blocked further progressive reform. In the early 1880s an alliance of black and radical white legislators (known as Readjusters) came to power. They abolished the state's poll tax, increased public school funding, and eliminated whippings. At the local level thirty-three blacks, ranging in occupation from a doctor to a huckster, served on Richmond's city council between 1871 and 1896. In 1888 the distinguished scholar John Mercer LANGSTON ran for Congress as an Independent Republican from the fourth district. Seemingly defeated by the regular Republican candidate, he challenged the election and was seated shortly before the end of what would have been his term.

Education ranked high among the priorities of African Americans. In 1865 Virginia Union University began classes in a former jail in Richmond. In 1868 the American Missionary Association established the Hampton Normal and Agricultural Institute out of Mary Peake's school in Hampton. A generation of leading black men and women, including Virginia native Booker T. WASHINGTON and his successor at Tuskegee, Robert Russa MOTON, matriculated at HAMPTON INSTITUTE. Virginia State University in Petersburg was founded in 1883 as a teacher's college. The same year, the Hartshorn Memorial College, the first black women's college in the United States, was founded in Richmond. Later, industrial and normal schools, such as the Virginia Industrial School for Colored Girls in Richmond, founded in 1815 by social activist Janie Porter BARRETT, were also created.

The codification of segregation between 1890 and 1910 was a response to the political ascendancy of blacks during and after RECONSTRUCTION. In 1885 the Readjusters were defeated with the aid of electoral fraud and violence, and a conservative Democratic regime took hold. In the 1890s, during a severe agricultural depression, the Democrats were challenged by the Populist party, of which blacks were the main supporters. Segregation ordinances reflected both conservative attempts to split class-based coalitions, such as the Readjusters, and widespread anti-black feelings among Virginia whites. In 1900 the state passed a railroad segregation ordinance and called a new constitutional convention to erase Reconstruction-era civil rights gains. Despite the efforts of the Negro Industrial and Agricultural League, the Virginia Educational and Industrial Association, and other groups, the state in 1902 established a literacy test and poll tax that effectively disenfranchised the black population.

Blacks responded to segregation by further developing their institutional infrastructure and strategies

for empowerment. Black churches, community organizations, labor unions, schools and colleges, and civil rights groups multiplied. Black newspapers were set up, the most notable being the *Richmond Planet,* and *Richmond Afro-American,* and the *Norfolk Journal and Guide.* The *Journal and Guide*'s publisher, P. B. Young, remained the most powerful figure in Virginia black life for four decades. Black financial and mutual-aid societies were also set up. In 1903 Maggie Lena Walker, secretary of the Order of St. Luke fraternal organization, founded the St. Luke Penny Savings Bank. The bank, the first financial institution headed by an African-American woman, eventually grew into the Consolidated Bank and Trust Company.

After 1910 the continuing agricultural depression plus the growth of urban railroad and manufacturing centers drove large numbers of African Americans from the towns and hamlets of the state. Many went north as part of the Great Migration of the 1910s and early 1920s. During that period Virginia suffered a net loss of some fifty thousand black residents. Others from Virginia and elsewhere settled in cities such as Richmond and Norfolk, especially after U.S. entry into World War I brought an increased demand for labor. Employment rates were high during these years although most blacks were restricted to low-level industrial or service work on railroads and in the huge Norfolk Navy Yard, completed in 1917. Segregation was firmly entrenched in the cities. Schools and housing remained poor despite projects such as Truxton, a model all-black community built by the U.S. Housing Corporation to accommodate black navy yard workers. The black workers organized unions, and their wages made possible the growth of a local black middle class that included such figures as C. C. Dogan, chairman of the giant Home Building and Loan Association, and W. M. Rich, chairman of Metropolitan Bank and Trust Company, the country's largest black bank in the early 1920s. The end of the wartime boom led to a job shortage in the mid-1920s. The black Virginia economy would remain depressed, despite large-scale aid from New Deal federal programs, until the revival of defense work at the onset of World War II.

Civil rights efforts in Virginia continued. In 1904, after streetcar companies in Richmond began segregating passengers, black residents led by *Planet* editor and city council member John Mitchell, Jr., instituted a year-long boycott that bankrupted the transportation company. Blacks in Petersburg and Manchester also instituted successful boycotts. The NAACP was established in the state in 1913 and helped overturn residential segregation ordinances in Richmond and Norfolk four years later. In 1915 African Americans lobbied forcefully, though in vain, against

a state law segregating theaters and concert halls. Three years later they successfully challenged the state Democratic party's "white primary" elections. During the GREAT DEPRESSION Virginia Union University professor Gordon B. HANCOCK devised the "double-duty dollar" campaign to boost black patronage of black-owned businesses. In the late 1930s, with the help of Richmond lawyer Spotswood Robinson and Norfolk residents Aline Black and Melvin Alston, the NAACP successfully challenged the constitutionality of unequal pay for teachers based on race.

Following the end of World War II, many African Americans left Virginia, whose black population continued to decline in relative terms. (Ironically, "Carry Me Back to Old Virginny," a minstrel song written in 1878 by African-American James BLAND, had become the state's official song in 1940). Furthermore, the state's black population shifted from the rural south to urban areas, particularly in the north of the state. Alexandria and other suburbs of Washington, D.C., became home to increasing numbers of Virginia blacks. Meanwhile, civil rights efforts increased. The NAACP, led by Robinson and by Oliver Hill (who in 1948 became the first African American in a half-century to sit on Richmond's city council) began efforts to desegregate schools. They put together as plaintiffs a list of students in Prince Edward County led by fourteen-year-old Dorothy Davis. *Davis* v. *County School Board of Prince Edward County* ultimately became one of several cases decided as part of the landmark U.S. Supreme Court decision BROWN V. BOARD OF EDUCATION in 1954. The *Brown* decision sparked a campaign of massive resistance to desegregation among white Virginia officials. In 1956 Governor Thomas Stanley closed all integrated public schools and instituted a tuition-grant policy for segregated private schools. The public schools were reopened by court order in 1959, but school officials delayed implementation, and many white children continued to attend segregated academies. In the meantime the state attempted to ban NAACP legal efforts. In 1962 the Supreme Court ruled in *National Association for the Advancement of Colored People* v. *Blossom* that the NAACP's operations were constitutionally protected. Despite the efforts of black parents and their children, who sacrificed time, dignity, and education to see schools desegregated in Prince Edward County, county schools did not reopen until 1964.

A total assault on segregation came in the 1960s. On New Year's Day 1959 some two thousand marchers led by Petersburg minister Wyatt Tee WALKER marched in a civil rights "pilgrimage" in Richmond. On February 10, 1960, students in Hampton became the first outside North Carolina to stage

a sit-in. Soon movement sites appeared in Norfolk, Portsmouth, Suffolk, Danville, and other cities. A ten-year legal challenge to miscegenation laws by Mildred Loving of Bowling Green ended in triumph in 1967 when prohibitions against interracial marriage were overturned by the Supreme Court in *Loving v. Virginia*. Black activists forced repeal of segregation laws, and black political power helped break up the entrenched regime of Harry Byrd. While economic empowerment lagged, the changes the activists helped engineer resulted in the election in the following decades of several state public officials, including Wilder, who in 1969 became the first black Virginia state senator since Reconstruction and in the 1980s was successively elected lieutenant governor and governor.

Since the early 1960s many black Virginians have achieved national renown. Virginia native Ella BAKER, the "godmother of the civil rights movement," helped found the STUDENT NONVIOLENT COORDINATING COMMITTEE. Richmond-born Arthur ASHE, who labored for causes from AIDS research to the end of apartheid, became in 1968 the youngest tennis player and the only black male to win the U.S. Open championship; in 1975 he won the Wimbledon championship. Norfolk resident David Alston, who became the state's first AFL labor recruiter in 1946, rose to the position of second international vice president of the International Longshoreman's Union. In 1975 entertainer Pearl BAILEY was named alternate U.S. delegate to the United Nations. In 1983 Mary Futrell became the first black president of the National Education Association.

The state has been the birthplace of many notable African Americans, including civil rights leaders Dorothy HEIGHT and Lester Granger and journalist-broadcaster Max Robinson and his brother, TransAfrica director Randall Robinson. Important African-American artists and intellectuals range from Charles S. JOHNSON, Leslie Pinky Hill, Addison Gayle, Robert Deane Pharr, and Randolph Edmonds to Bill "Bojangles" ROBINSON, Dorothy MAYNOR, Lloyd "Tiny" Grimes, George "Red" Callender, and Wayman Carver.

REFERENCES

BREEN, T. H., and STEPHEN INNES. *"Myne Owne Ground": Race and Freedom on Virginia's Eastern Shore, 1640–1676.* New York, 1980.

BUNI, ANDREW. *The Negro in Virginia Politics, 1902–1965.* Charlottesville, Va., 1967.

CHESSOM, MARK. "Richmond's Black Councilmen, 1871–1896." In Howard Rabinowitz, ed. *Southern Black Leaders of the Reconstruction Era.* Urbana, Ill. 1982, pp. 191–222.

HUCLES, MICHAEL. "Many Voices, Similar Concerns: Traditional Methods of African-American Political Activity in Norfolk, Virginia, 1865–1875." *Virginia Magazine of History and Biography* 100 (October 1992): 543–566.

JACKSON, LUTHER P. *Free Negro Labor and Property Holding in Virginia, 1830–1860.* 1942. Reprint. New York, 1969.

LEWIS, EARL. *In Their Own Interests: Race, Class, and Power in Twentieth-Century Norfolk, Virginia.* Berkeley, Calif. 1991.

MORGAN, EDMUND S. *American Slavery, American Freedom: The Ordeal of Colonial Virginia.* New York, 1975.

MULLIN, GERALD. *Flight and Rebellion: Slave Resistance in Eighteenth-Century Virginia.* New York, 1972.

RACHLEFF, PETER. *Black Labor in the South: Richmond, Virginia, 1865–1890.* Philadelphia, 1987.

SOBEL, MECHAL. *The World They Made Together.* Princeton, N.J., 1987.

TAYLOR, ALRUTHEUS AMBUSH. *The Negro in the Reconstruction of Virginia.* 1926. Reprint. New York, 1969.

WYNES, CHARLES. *Race Relations in Virginia, 1870–1902.* 1961. Reprint. Totowa, N.J., 1971.

EARL LEWIS

Vodery, William Henry Bennett "Will" (October 8, 1885–November 18, 1951), composer and arranger. Vodery was born in Philadelphia and as a child was encouraged by his mother, a pianist, to study music. He was also inspired by traveling entertainers, including singer Bert WILLIAMS, who stayed at the family's boardinghouse. Before his teens Vodery played piano and organ at church. He studied piano and violin with Hugh Clarke from the University of Pennsylvania. In 1904 Williams took Vodery to New York, where he wrote his first show, *A Trip to Africa*. When the show, which traveled with Black Patti's Minstrels, broke up in Chicago, Vodery remained in the city. He worked as an arranger for Charles K. Harris's music publishing house. Vodery also studied informally with Frederick Stock, the conductor of the Chicago Symphony Orchestra. While in Chicago, Vodery wrote the music for several musicals, including *The Isle of Bang-Bang, South Africa,* and *Time, Place and Girl*.

In 1906 Williams brought Vodery to New York to write music for his new show, *Abyssinia*. There Vodery composed and arranged for Broadway musicals, and organized and led small orchestras and vocal groups at white ballrooms. His first important show was *The Man from 'Bam* (1906), followed the next year by *Oyster Man*. He arranged music for *Bandanna Land,* and traveled with the show in the United States and Europe. In 1910 he led the pit orchestra at the Howard Theater in Washington, D.C. The next year,

Vodery's show *My Friend From Dixie* caught the attention of the vaudeville impresario Florenz Ziegfeld, who hired him as music supervisor for the Ziegfeld Follies, a position he held until 1932. Also in 1911 Vodery took a two-year position as the leader of Aida Overton WALKER's vaudeville troupe. During World War I he served as a commissioned lieutenant, leading the 807th Infantry band in performances throughout Europe. At this time Vodery composed his tone poem *Two Months at the Old Mill,* which won acclaim throughout Europe.

After returning to the United States, Vodery found that his impeccable musicianship and organizing skills led to associations with the most important shows in black musical theater. In 1921 he arranged music for Eubie BLAKE and Noble SISSLE's *Shuffle Along.* In 1922 he formed the Will Vodery Plantation Show and Dance Orchestra, featuring singer Florence MILLS. That same year, he orchestrated George Gershwin's first significant work for the musical theater, *Blue Monday.* In 1924 he contributed a sketch, the "Swing Mikado," to the show at the Plantation Club. During this time Vodery, who often encouraged younger musicians, gave the young Duke ELLINGTON lessons in arranging. He conducted *Blackbirds* in Europe in 1927, and that same year was choral director for Jerome Kern's *Show Boat.* In 1928 he orchestrated *Keep Shufflin',* for which he also wrote the song "Dusky Love." From 1929 to 1932 Vodery lived in California, where as music director for the Fox Film Company he was one of Hollywood's first composers and arrangers. After returning to New York, Vodery continued to write for the stage, including *Cotton Club Parade* (1935). Vodery also composed or contributed to numerous popular songs, including "Please Take Me to the Ball Again," "Girls From Happy Land," "Saucy Maid," and "Hills of Old New Hampshire." He died in New York in 1951.

REFERENCES

FLETCHER, TOM. *100 Years of the Negro in Show Business: The Tom Fletcher Story.* New York, 1954.

SAMPSON, HENRY. *Blacks in Blackface: A Source Book on Early Black Musical Shows.* Metuchen, N.J., 1980.

THEODORE R. HUDSON

Volleyball. African-American women, in far greater numbers than African-American men, have participated and excelled in volleyball.

Through the 1980s and early '90s, the best black women's teams have been at historically black universities, notably Howard University; St. Augustine's College in Raleigh, N.C., and Tuskegee University, which in 1977 became the first black school to win a state title sanctioned by the Association of Intercollegiate Athletics for Women (AIAW).

Black volleyball players first gained national recognition at the 1984 Olympics, where Flo Hyman, Rita Crockett, and Rose Magers led the U.S. women's team to a silver medal over China. Flo HYMAN, who died at the height of her powers in 1986, is generally acknowledged as one of the greatest female volleyball players. In the 1992 Olympics, black volleyballers Tara Cross-Battle, Ruth Lewanson, Elaina Oden, Kimberly Yvette Oden, and Tonya Sanders brought home bronze medals. The Oden sisters and several other black women players joined professional women's beach-volleyball leagues in the early 1990s as the sport began to achieve national popularity and television contracts. One of the people who helped popularize volleyball in the 1980s and '90s was basketball great Wilt CHAMBERLAIN, who, after his basketball playing days were over, toured with a professional volleyball team and helped promote the sport.

REFERENCE

ASHE, ARTHUR R., JR. *A Hard Road to Glory: A History of the African-American Athlete Since 1946.* New York, 1988.

THADDEUS RUSSELL
BENJAMIN K. SCOTT

Voodoo. Voodoo, also spelled Vodou (following the official Haitian Creole orthography) or vodoun, refers to traditional religious practices in Haiti and in Haitian-American communities such as the sizable ones in New York City and Miami. New Orleans has the oldest Haitian immigrant community; it dates from the eighteenth century. In New Orleans priests and priestesses are sometimes called "voodoos," and throughout the southern United States the term is also used as a verb, to "voodoo" someone, meaning to bewitch or punish by magical means. More frequently "voodoo," or "hoodoo"—as well as "conjure," "rootwork," and "witchcraft"—is a term used to refer to a diverse collection of traditional spiritual practices among descendants of African slaves in the United States.

Haiti, a small, mountainous, and impoverished West Indian country, was a French slave colony and a major sugar producer during the eighteenth century. The strongest African influences on Haitian vodou came form the Fon and Mahi peoples of old

Dahomey (now the Republic of Benin); the Yoruba peoples, mostly in Nigeria; and the Kongo peoples of Angola and Zaire. The term *vodun* is West African, probably Ewe, in origin and came to the Western Hemisphere with Dahomean slaves. Today, "vodun" is the most common Fon term for a traditional spirit or deity.

Haitian Vodou is said to have played a key role in the only successful slave revolution in the history of trans-Atlantic slavery, the plotters being bound to one another by a blood oath taken during a Vodou ceremony. The ceremony, conducted by the legendary priest Makandal, took place in Bois Cayman in northern Haiti. It is also claimed that word of the uprising spread via Vodou talking drums, and Vodou charms gave strength and courage to the rebels.

Haiti declared its independence in 1804, when the United States and much of Europe still held slaves. For approximately fifty years the Catholic church refused to send priests to Haiti, and for nearly a century the struggling black republic was economically isolated from the larger world. Political concerns played a major role in shaping the negative image of Haitian Vodou in the West. Vodou has been caricatured as a religion obsessed with sex, blood, death, and evil. The reality of Haitian Vodou, a religion that blends African traditions with Catholicism, is strikingly different from the stereotypes.

Following independence, large numbers of Haitians acquired small plots of land and became subsistence farmers. This agricultural base distinguishes Vodou from other New World African religions. Central to Vodou are three loyalties: to land (even urban practitioners return to conduct ceremonies on ancestral land), to family (including the dead), and to the Vodou spirits. Most Haitians do not call their religion Vodou, a word that more precisely refers to one style of drumming and dancing. Haitians prefer a verbal form. "Li sevi lwa-yo," they say, he (or she) serves the spirits. Most spirits have two names, a Catholic saint's name and an African name. Daily acts of devotion include lighting candles and pouring libations. Devotees wear a favored spirit's color and observe food and behavior prohibitions the spirits request. When there are special problems, they make pilgrimages to Catholic shrines and churches and undertake other trials. Most important, they stage elaborate ceremonies that include singing, drumming, dancing, and sumptuous meals, the most prestigious of which necessitate killing an animal. Possession, central in Vodou, provides direct communication with the *lwa,* or spirits. A devotee who becomes a "horse" of one of the spirits turns over body and voice to that lwa. The spirit can then sing and dance with the faithful, bless them, chastise them, and give advice. In Vodou persons are defined by webs of relationship with family, friends, ancestors, and spirits. The central work of Vodou ritual, whether performed in a community setting or one-on-one, is enhancing and healing relationships. Gifts of praise, food, song and dance are necessary to sustain spirits and ancestors and to enable them to reciprocate by providing wisdom and protection to the living.

The large Haitian immigrant communities that have grown up in the United States over the last forty years are thriving centers for Vodou practice. Hundreds of Vodou healers serve thousands of clients who are taxi drivers, restaurant workers, and nurse's aides. Most of the rituals performed in Haiti are now also staged, albeit in truncated form, in living rooms and basements in New York and Miami. Vodou "families" provide struggling immigrants with connections to Haitian roots and an alternative to American individualism.

Voodoo in New Orleans is more distant from its Haitian roots. Scholars believe there were three generations of women called Marie Laveau who worked as spiritual counselors in New Orleans. The first was a slave brought from Haiti to Louisiana during the time of the slave revolution. The most famous Marie Laveau, the "voodoo queen of New Orleans," born in 1827, was the granddaughter of this slave woman. Her religion was a distillation of Haitian Vodou. She kept a large snake on her altar (a representative of the spirit Danbala Wedo), went into possession while dancing in Congo Square, presided over an elaborate annual ceremony on the banks of Lake Pontchartrain on St. John's Eve (June 24), and above all, worked with individual clients as a spiritual adviser, healer, and supplier of charms, or gris-gris. Contemporary New Orleans voodoo is largely limited to these last activities.

Hoodoo, or voodoo as practiced throughout the American South, is similarly limited to discrete client/practitioner interactions. This type of voodoo is not a child of Haiti but the legacy of Dahomean and Kongo persons among North American slaves. As with Haitian Vodou, engagement with hoodoo has typically worked as a supplement to Christianity, most likely because hoodoo addresses issues Christianity ignores—issues of spiritual protection, romantic love, and luck. Harry M. Hyatt said it well: "To catch a spirit or to protect your spirit against the catching or to release your caught spirit—this is the complete theory and practice of hoodoo." The spiritual powers used in voodoo or hoodoo are morally neutral (e.g., souls of persons not properly buried) and can therefore be used constructively or destructively. Yet clear moral distinctions in how they are used are not always easy to make.

In hoodoo the illness in one person may be traced to an emotion in another, jealousy being the most

destructive. In such a case, attacking the jealous person may be the only way to a cure. A related dynamic emerges in love magic, a very common type of healing that inevitably tries to control another's will. Zora Neale HURSTON collected this cure for a restless husband: "Take sugar, cinnamon and mix together: Write name of a husband and wife nine times. Roll paper . . . and put in a bottle of holy water with sugar and honey. Lay it under the back step." There have been root doctors—conjure men and women—who have used their powers unethically and maliciously, but hoodoo's fear-provoking reputation is unmerited. Most hoodoo or voodoo is of the type described in Hurston's example.

REFERENCES

BROWN, KAREN McCARTHY. *Mama Lola: A Vodou Priestess in Brooklyn.* Los Angeles and Berkeley, 1991.

———. "The Power to Heal: Reflections on Women, Religion, and Medicine." In Clarissa W. Atkinson, Constance H. Buchanan, and Margaret R. Miles, eds. *Shaping New Vision: Gender and Values in American Culture.* Ann Arbor, Mich., 1987, pp. 123–141.

DEREN, MAYA. *Divine Horsemen: The Voodoo Gods of Haiti.* 1970. Reprint. New Paltz, N.Y., 1983.

HERSKOVITS, MELVILLE. *Life in a Haitian Valley.* Garden City, N.Y., 1971.

HURSTON, ZORA NEALE. "Hoodoo in America." *Journal of American Folklore* 44 (1931): 316–417.

———. *Mules and Men.* New York, 1970.

HYATT, HARRY MIDDLETON. *Hoodoo-Conjuration-Witchcraft-Rootwork: Beliefs Accepted by Many Negroes and White Persons, These Being Orally Recorded Among Blacks and Whites.* Hannibal, Mo., 1970.

LAGUERRE, MICHEL S. *American Odyssey: Haitians in New York City.* Ithaca, N.Y., 1984.

METRAUX, ALFRED. *Voodoo in Haiti.* New York, 1972.

KAREN McCARTHY BROWN

Voter Education Project. In the 1960s, members of President John F. Kennedy's administration quietly urged the SOUTHERN REGIONAL COUNCIL, a biracial and nonprofit organization founded in 1943, to promote voter registration among African Americans in the South. By increasing the number of blacks participating in voting, the administration believed it would be easier for the Democratic party to become more assertive in civil rights in the South. Furthermore, administration officials anticipated that if hundreds of thousands of newly registered black voters existed, these people would vote for the Democratic party in the South.

On the other hand, the interest of the Southern Regional Council had been consistently nonpartisan. Since the 1940s, the council had tried to capitalize upon federal court decisions that empowered black Southerners as voters. It had documented racial discrimination against blacks trying to vote and assessed satistical date related to black voter registration in the South. Therefore, it was not unnatural for the council to be enthusiastic about conducting a voter registration drive among blacks in the South.

In 1962, the Southern Regional Council founded the Voter Education Project (VEP) to collect statistical data on voter registration in the South. Moreover, it assigned the VEP the task of conducting the registration drive among black Southerners. Having considerable monies and other resources at its disposal, the VEP worked with major civil rights groups in an effort to coordinate a voter registration campaign.

Wiley A. Branton, a prominent civil rights attorney who had been the legal counsel for the black schoolchildren of the LITTLE ROCK, ARKANSAS desegregation case, accepted a position as the first head of the VEP. Executive director Branton had been informed by the officials of the Southern Regional Council that they anticipated that the VEP would operate for three years. In its first years, the VEP gave seed money to the major civil rights groups as well as to local black nonpartisan groups in the South.

Grants were intended to promote voter registration and voter education. Moreover, the role of the VEP called for it to decide where the various groups operated to avoid duplication of effort and to minimize infighting. It also closely monitored the budgetary process to reduce the likelihood of corruption and fraud. The VEP did not want any hint of scandal or partisanship to jeopardize its credibility or its tax-exempt status.

In 1965, the Southern Regional Council decided to give the VEP a freer hand in its efforts in the areas of voter registration and voter education by granting it the right to select its own board of directors and to establish its own tax-exempt status. During the time that the council made these changes, it appointed Vernon JORDAN as the second executive director of the VEP.

Under the leadership of Jordan, the VEP for the first time emphasized voter education to the same degree it had stressed voter registration. It added nonpartisan training of black political leaders who were running for political office after the passage of the Voting Rights Act of 1965. The work of the VEP in all these areas had bore fruit over the years of its existence.

Due to a tax reform law passed by Congress in 1969 that placed certain restrictions on the use of tax-

exempt funds for voter registration, the Southern Regional Council granted the VEP its independence. Perhaps the VEP's greatest contribution has been in the area of voter registration among blacks in the South. Hundreds of thousands of newly registered voters resulted from its work. The democratization of southern politics was greatly hastened by the work of the VEP.

REFERENCES

BASS, JACK. *The Transformation of Southern Politics.* Athens, Ga., 1995.

LAWSON, STEVEN F. *Black Ballots: Voting Rights in the South.* New York, 1976.

MICHAEL A. COOKE

Voting. *See* Suffrage, Nineteenth-Century; Suffrage, Twentieth-Century.

Voting Rights Act of 1965. The Voting Rights Act of 1965, signed into law by President Lyndon B. Johnson on August 6, 1965, was intended to reverse the historic disenfranchisement of the black electorate, which had been the hallmark of southern politics since the end of Reconstruction. It applied to states and counties in which a test or other device was used to determine voter eligibility, and where voter registration or turnout for the 1964 presidential election had been less than 50 percent of potentially eligible voters. In those "covered jurisdictions," it suspended literacy and other racially discriminatory tests; authorized federal examiners to replace or supplement local registrars; allowed federal observers at polling sites; and required advance federal approval for changes in election laws and voting procedures. It also expanded the voting rights of non–English-speaking citizens.

Although the Fifteenth and Nineteenth Amendments to the Constitution had conferred voting rights on black men and black women, respectively, violence and economic reprisals, as well as more subtle methods, had effectively barred African Americans from the election rolls for generations. While the Civil Rights Acts of 1957, 1960, and 1964 contained some voting rights provisions, their enforcement depended on the cooperation of recalcitrant Southerners and on appeals through a slow, cumbersome judicial process.

In the context of rising demands for more substantive redress of race-based discrimination, the Johnson administration proposed to restore suffrage by a more direct route. In Selma, Ala., black people had tried to register to vote in the early 1960s; obstructed from doing so, they appealed to the Justice Department for support. By late 1964, the SOUTHERN CHRISTIAN LEADERSHIP CONFERENCE (SCLC) decided to launch an all-out campaign in Selma aimed at winning new federal voting rights legislation. Their efforts were met with police attacks and mass arrests, which culminated in a brutal assault on peaceful demonstrators marching to Montgomery on March 7, 1965. While "Bloody Sunday" was not the direct catalyst for Johnson's initiative, it proved decisive for rallying public and congressional sentiment around his plan.

Congressional passage of the bill was marked by intense controversy, however. The Johnson administration successfully resisted efforts to impose an outright ban on poll taxes (although the Supreme Court struck down the poll tax in 1966), and House Republican leaders and southern Democrats failed in their bid to weaken the legislation. Still, in its final form, the measure was overwhelmingly approved, by a vote of 328 to 74 in the House and 79 to 18 in the Senate.

In the immediate aftermath of the act's passage, impressive gains were made by federal authorities; in the first six months, they registered more than 100,000 southern blacks, while local officials, aware of the new threat of federal action, added another 200,000. In 1965, some 2 million African Americans were registered to vote in the South; by mid-1970, that figure had jumped to 3.3 million.

But the Justice Department preferred voluntary compliance with the new directives; moreover, since enforcement depended on the department's own vigorous commitment, during the Nixon and Ford years it was significantly weaker than in the early period. The Nixon administration, in fact, sought to dramatically curtail the act's powers when it came up for Congressional extension in 1970.

Many southern officials resisted the Voting Rights Act, challenging its constitutionality in court and continuing to withhold the ballot through arbitrary means. They also adopted new mechanisms that, while not directly denying the right to register and vote, diluted the black community's electoral power. Using a variety of techniques—redrawing districts to break up black majorities (racial gerrymandering), imposing new restrictions and property qualifications on candidates, and holding at-large races in which an expanded electoral base ensured a white majority—southern politicians made it difficult for black candidates to run for and win office. These measures were contested by civil rights advocates in litigation that lasted well into the 1980s. In the case of *Mobile v. Bolden* in 1980, the Supreme Court upheld the use of at-large elections, arguing that their practical effect—preventing minority black populations from electing

their own candidates—was not the same as discriminatory intent.

The Voting Rights Act has been extended three times since its initial passage. Originally, its targets included Alabama, Georgia, Louisiana, Mississippi, South Carolina, Virginia, parts of North Carolina, and Alaska. In 1970, the ban on literacy tests was expanded nationwide and the formula for identifying covered areas was altered to broaden its scope. It was again extended in 1975, with less southern resistance than in the past. In 1982, the Reagan administration fought vigorously against another extension. But it was not only extended, it was also amended to address the wide range of strategies designed to circumvent its authority, effectively nullifying the *Mobile* decision. By 1989, a total of 7,200 African-Americans held elected office in the United States (compared to just 500 in 1965); of these, 67 percent were in the South.

REFERENCES

GARROW, DAVID J. *Protest at Selma: Martin Luther King, Jr., and the Voting Rights Act of 1965.* New Haven and London, 1978.

PARKER, FRANK R. *Black Votes Count: Political Empowerment in Mississippi After 1965.* Chapel Hill, N.C., 1990.

MICHAEL PALLER
TAMI J. FRIEDMAN

W-X

Walcott, Derek Alton (January 23, 1930–), poet, playwright, and essayist. The son of Warwick Walcott, a civil servant and skilled painter in watercolor who wrote verse, and Alix Walcott, a school teacher who took part in amateur theater, Derek Walcott was born along with a twin brother in Castries, Saint Lucia, a small island in the Lesser Antilles of the West Indies. He grew up in a house he describes as haunted by the absence of a father who had died quite young, because all around the drawing room were his father's watercolors. His beginnings as an artist, he regards, therefore, as a natural and direct inheritance: "I feel that I have continued where my father left off." After completing St. Mary's College in his native Saint Lucia, he continued his education at the University of the West Indies in Kingston, Jamaica.

His literary career began in 1948 with his first book of verse, *25 Poems* (1948), followed not long thereafter by *Epitaph for the Young, XII Cantos* (1949), and *Poems* (1951), all privately published in the Caribbean. The decade of the 1950s, however, marked the emergence of his reputation as a playwright-director in Trinidad. His first theater piece, *Henri Cristophe* (1950), a historical play about the tyrant-liberator of Haiti, was followed by a series of well-received folk-dramas in verse. *The Sea at Dauphin* (1954), *Ione* (1957), and *Ti-Jean and His Brothers* (1958) are usually cited among the most noteworthy, along with his most celebrated dramatic work, *Dream on Monkey Mountain,* awarded an Obie, which he began in the late 1950s but did not produce until 1967 in Toronto. After a brief stay in the United States as a Rockefeller

Fellow, Walcott returned to Trinidad in 1959 to become founding director of the Trinidad Theatre Workshop. He continues to work as a dramatist, and he is still more likely to be identified by a West Indian audience as a playwright.

Walcott's international debut as a poet came with *In a Green Night: Poems 1948–1960* (1962), followed shortly thereafter by *Selected Poems* (1964), established the qualities usually identified with his verse: virtuosity in traditional, particularly European literary forms; enthusiasm for allegory and classical allusion for which he is both praised and criticized; and the struggle within himself over the cruel history and layered cultural legacy of Africa and Europe reflected in the Caribbean landscape which some critics have interpreted as the divided consciousness of a Caribbean ex-colonial in the twilight of empire. A prolific quarter-century of work has been shaped by recurrent patterns of departure, wandering, and return, in his life as well as in his poetry, and a powerful preoccupation with the visual imagery of the sea, beginning with *Castaway and Other Poems* (1965), in which he establishes an imaginative topography (e.g., of "seas and coasts as white pages"), and a repertory of myths, themes, and motifs (e.g., of "words like migrating birds") for the titular exile, a repertory that recurs in later volumes.

In *The Gulf and Other Poems* (1969), reprinted with *Castaway and Other Poems* in a single volume as *The Gulf* (1970) in the United States, he sounds an ever more personal note as he considers the Caribbean from the alienating perspective of the political turbu-

West Indian poet Derek Walcott (left) is congratulated by King Carl Gustav of Sweden after receiving the 1992 Nobel Prize for Literature. Walcott, who has taught and lived in the United States for many years, was the first North American of African descent to win this prize. (AP/Wide World Photos)

lence of the late 1960s in the southern and Gulf states of the United States. In *Another Life* (1973), his book-length self-portrait both as a young man and at forty-one, he contemplates the suicide of his mentor and alter-ego with whom he discovered the promise, and the disappointment, of their lives dedicated to art. In *Seagrapes* (1976) he identifies the Caribbean wanderer as caught up in the same ancient and unresolved dilemmas as the exiles Adam and Odysseus, whose pain the poems of a West Indian artist, like the language of the Old Testament and the Greek and Latin classics, can console but never cure.

At his most eloquent in *The Star-Apple Kingdom* (1979), Walcott fingers the rosary of the Antilles in the title poem in order to expose the inhumanity and corruption belied by the gilt-framed Caribbean pastoral of the colonialist's star-apple kingdom, and in the volume's other verse narrative, "The Schooner Flight," he finds a powerful voice in the West Indian vernacular of the common man endowed with "no weapon but poetry and the lances of palms of the sea's shiny shields." In *The Fortunate Traveler* (1981) he sounds repeated and painful notes of exhaustion, isolation, and disappointment of the peripatetic poet in exile and at home, perhaps most sharply in the satirical mode of the *kaiso* vernacular of "The Spoiler Returns."

In *Midsummer* (1984), published in his fifty-fourth year, he probes the situation of the poet as prodigal *nel mezzo del camin* of exile in fifty-four untitled stanzas of elegiac meter. In *The Arkansas Testament* (1987), divided into sections "Here" and "Elsewhere" recalling the divisions of "North" and "South" of *The Fortunate Traveler,* he succumbs once again to pangs of art's estrangement. However, in *Omeros* (1990), his overlay of his problematic but richly figured Caribbean environment with Homer's transformative Mediterranean domain in his most ambitious verse narrative yet, he weaves together the myths, themes, motifs, and imaginary geography of a prolific career to attempt a consummation and reconciliation of the psychic divisions and the spiritual and moral wounds of history and exile in the visionary and restorative middle passage of Achilles, the West Indian fisherman, to the ancestral slave coast of Africa and back to the island, once named for Helen, where he was born.

Although he has described himself as a citizen of "no nation but the imagination," and has lived as an international bard, directing plays, creating poetry, and teaching at a number of colleges and universities, he had remained faithful to the Caribbean as his normative landscape. His affirmation of identity and of the significance of myth over history for the poetic imagination is inseparable from a discussion of the historic drama played out over recent centuries across the islands of the Caribbean and from which the odyssean wayfarer ventures in a lifelong cycle of escape and return. This profound engagement with the Caribbean, explored in a series of early essays, "What the Twilight Says: An Overture," "Meanings," and "The Muse of History," and restated in his Nobel lecture "The Antilles: Fragments of Epic Memory," is summed up in a particularly poignant credo: "I accept this archipelago of the Americas. I say to the ancestor who sold me, and to the ancestor who bought me . . . and also you, father in the filth-ridden gut of the slave ship . . . to you inwardly forgiven grandfathers, I like the more honest of my race, give a strange thanks. I give the strange and bitter and yet ennobling thanks for the monumental groaning and soldering of two great worlds, like the halves of a fruit seamed by its own bitter juices, that exiled from your own Edens you have placed me in the wonder of another, that was my inheritance and your gift."

Since 1981 Walcott has been a professor of English and creative writing at Boston University. In 1992 he was awarded the Nobel Prize for literature.

REFERENCES

ATLAS, JAMES. "Poet of Two Worlds." *New York Times Magazine* (May 23, 1982).

GOLDSTRAW, IRMA E. *Derek Walcott: An Annotated Bibliography*. New York: Garland, 1984.

JAMES DE JONGH

Walcott, Jersey Joe (Cream, Arnold Raymond) (January 13, 1914–February 25, 1994), boxer. Arnold Raymond Cream was born and raised in Merchantville, near Camden, N.J. He was one of twelve children of Ella and Joseph Cream. His father, an immigrant from Barbados, died when Arnold was fourteen. In order to help support the family, the boy began working in a soup factory and did odd jobs. He also began to train as a boxer. In 1930 he started his professional career as a lightweight. Soon after, he took the name "Jersey Joe Walcott" in honor of Joe Walcott, a well-known Barbadian welterweight champion.

Walcott fought, largely in obscurity, for fifteen years before becoming a championship contender. In 1933, after growing into the light-heavyweight class, Walcott knocked out Al King to become the light-heavyweight champion of south Jersey. In 1936, in a heavyweight bout at Coney Island in Brooklyn, N.Y., Walcott attracted significant attention for the first time by knocking out Larry LaPage in three rounds. Unable to support himself and his family on his small boxing earnings, he worked in a number of manual labor jobs, fighting only sporadically.

In 1945, after a two-year stint working at the Camden shipyards, Walcott returned once more to boxing. Over the following two years, he won 11 of 14 fights, including 7 by knockouts. On December 5, 1947, he fought a heavyweight bout against champion Joe LOUIS. He knocked Louis down twice, but lost in a split decision. Many commentators felt that Walcott had defeated the champion, and he appealed the ruling unsuccessfully to the New York Athletic Commission. On June 25, 1948, he and Louis fought again. Although Walcott floored Louis, Louis knocked him out in the eleventh round.

The following year, Louis retired, and Walcott signed to box Ezzard CHARLES for the championship. On June 22, 1949, Charles beat Walcott in a fifteen-round decision for the title, and then defeated him again in March 1951. Undaunted, Walcott signed to face Charles a third time. On July 18, 1951, in Pittsburgh, Pa., Walcott knocked Charles out in the seventh round, thus becoming the oldest man to that time to hold the heavyweight title. On June 15, 1952, Walcott successfully defended his title in a rematch with Charles. However, on September 23, 1952, Walcott fought Rocky Marciano, who knocked him

Heavyweight champion "Jersey" Joe Walcott preparing for his bout with Rocky Marciano in 1952. Walcott lost the fight and his title to Marciano in a hard-fought match that ended in a thirteenth-round knockout. (AP/Wide World Photos)

out to take the heavyweight championship. Walcott met Marciano in a rematch on May 15, 1953, but was knocked out in the first round. He retired after the fight.

After retiring, Walcott worked as a fight referee and acted in the 1956 film *The Harder They Fall*. In 1972 he became sheriff of Camden County, N.J., and in 1975 was made chairman of the New Jersey State Athletic Commission. Following his retirement in 1984, Walcott spent his time working with children for the New Jersey Department of Community Affairs. A longtime diabetic, he died in Camden, in 1994, of complications resulting from the disease.

REFERENCE

"Jersey Joe Walcott, Boxing Champion, Dies at 80." *New York Times*, February 26, 1994.

GREG ROBINSON

Waldron, John Milton (May 19, 1863–c. 1925), minister, journalist, and civil rights activist. Born in Lynchburg, Va., Milton Waldron received a B.A. in 1886 from Lincoln University in Chester County, Pa. In 1889, he graduated from the Newton Theo-

logical Institute in Newton, Mass., and returned to Virginia, where he worked briefly as the general secretary of the Richmond YMCA.

In 1890, Waldron became pastor of Berean Baptist Church in Washington, D.C., where he served for a year and a half. During this time he was also active in journalism and political causes. In 1890, he edited the *Young Men's Field Magazine* and published the *Alley Mission Herald* in 1890–1892.

Waldron moved to Florida in 1891 and became pastor of Bethel Baptist Church in Jacksonville, where he served for fifteen years and became known for involving the church with social service activities. In Jacksonville, he edited the *Florida Evangelist* (1896–1901) and the *Florida Standard* (1904–1906). From 1899 to 1905, he was president of the Afro-American Industrial and Benefit Association. By the time Waldron returned to Washington in 1906 to take the pastorate of Shiloh Baptist Church, he was a recognized African-American BAPTIST church leader.

In Washington, Waldron became president of the National Negro American Political League and a member of the NIAGARA MOVEMENT started by W. E. B. DU BOIS. As a founding member of the NATIONAL ASSOCIATION FOR THE ADVANCEMENT OF COLORED PEOPLE (NAACP), he attended the founding convention in May 1909. Because of his militant opposition to Booker T. WASHINGTON, however, he was excluded from the Committee of Forty, the governing body of the fledgling organization. Waldron served for a time as president of the District of Columbia branch of the NAACP, but was ousted in 1913 by a faction led by Archibald H. GRIMKE, following allegations that he used his office to seek political favors from the DEMOCRATIC PARTY.

Waldron had become active in Democratic party politics following a 1912 meeting with Woodrow Wilson, during which the Virginia-born New Jersey governor and presidential candidate promised to advance black rights if African Americans voted for him. Subsequently, and partly as a result of Waldron's efforts, W. E. B. Du Bois's the CRISIS endorsed Wilson's candidacy. After Wilson's victory, Waldron was a member of his inaugural committee.

In 1916, Waldron became a director of the National Race Congress, a short-lived, exclusively black organization formed in Washington, D.C., to rival the NAACP. In 1918, he was among eighty-one black leaders, calling themselves the National Liberty Congress, who met under the leadership of William Monroe TROTTER to petition the House of Representatives to end segregation, federal-government discrimination, lynching, and to generally improve the conditions of African Americans.

Waldron's politics leaned toward socialism; he advocated public ownership of utility companies and increased minority representation in federal and state legislative bodies.

Little is known about his last years or the date and circumstances of his death.

REFERENCES

APTHEKER, HERBERT. *Documentary History of the Negro People in the United States.* Vol. 1. Secaucus, N.J., 1973.

KELLOGG, CHARLES FLINT. *NAACP: A History of the National Association for the Advancement of Colored People.* Vol. 1. Baltimore, 1967.

ROSS, JOYCE. *J. E. Spingarn and the Rise of the NAACP.* New York, 1972.

SUGGS, HENRY LEWIS. *The Black Press in the South, 1865–1979.* Westport, Conn., 1983.

WILMORE, GAYRAUD S. *Black Religion and Black Radicalism.* Garden City, N.Y., 1972.

LYDIA McNEILL

Walker, Aaron Thibeaux "T-Bone" (May 28, 1910–March 17, 1975), blues singer and guitarist. Born in Linden, Tex., Walker grew up in Dallas. His mother was friends with Huddie Ledbetter and Blind Lemon Jefferson, and Walker often helped Jefferson collect money during street-corner performances. While still a child, Walker danced in a group run by his stepfather, a bassist. He played the banjo, and then the guitar, at church socials, and while in high school, joined a jazz band led by Lawson Brooks. He left that group (replaced by Charlie CHRISTIAN) to work as a solo act, singing, dancing, and playing guitar and piano in Dallas, and in the late 1920s he toured with Ida COX and Ma RAINEY, as well as with various "medicine shows."

As the winner of an amateur show contest in 1929, Walker was allowed to sit in with Cab CALLOWAY's orchestra in Houston. That year he made his first record, "Witchita Falls Blues," under the name "Oak Cliff T-Bone." He then traveled throughout the South and Southwest, playing acoustic guitar and singing in traveling revues, where he was as well known for his dancing as for his guitar playing. He lived and worked in California starting in 1935, and performed with Les Hite's band in 1939 and 1940. In the mid-1940s he began recording again. His performances of "Call It Stormy Monday" (1947), "Alimony Blues" (1951), and "Mean Old World" (1956) stand as classics of the urban BLUES genre, and earned him his reputation as one of the founding figures of electric blues. For the rest of his life Walker was a major attraction at blues nightclubs and concerts throughout the world, having won great acclaim for bringing elements of the Texas folk tradition to the

Aaron "T-Bone" Walker, one of the first electric guitarists, was a popular and influential blues musician of the 1940s and '50s. Among his many recordings is the classic "Call It Stormy Monday." (Frank Driggs Collection)

modern urban blues. His later recordings include *The Truth* (1968) and *Good Feelin'* (1971), which won a Grammy Award. Walker suffered a stroke in late 1974, and died in Los Angeles the next year.

REFERENCES

DANCE, HELEN. *Stormy Monday: The T-Bone Walter Story.* Baton, Rouge, La., 1987.

O'NEAL, J., and A. O'NEAL. "Interview with T-Bone Walker." *Living Blues* 11 (1972): 20.

JONATHAN GILL

Walker, Aida Overton

Walker, Aida Overton (1880–1914), entertainer. Aida Overton Walker was the leading African-American female performing artist at the turn of the twentieth century. Unsurpassed as a RAGTIME singer and cakewalk dancer, she became a national, then international, star at a time when authentic black folk culture was replacing minstrelsy (*see* MINSTRELS/MINSTRELSY) and making a powerful and permanent impact on American vernacular entertainment. Born in New York City, Walker began her career in the chorus of "Black Patti's Troubadours." She married George William WALKER, of the vaudeville comedy team Williams and Walker (*see also* Bert WILLIAMS), and soon became the female lead in their series of major musical comedies: *The Policy Players, Sons of Ham, In Dahomey, Abyssinia,* and *Bandanna Land.*

In Dahomey played London in 1903, including a command performance before the royal family on the lawn of Buckingham Palace. Walker also choreographed these shows, perhaps the first woman to receive program credit for doing so. Among her best-known songs were "Miss Hannah from Savannah," "A Rich Coon's Babe," and "Why Adam Sinned." At George Walker's death she continued in musical theater and vaudeville, playing the best houses, including Hammerstein's Victoria Theater in New York, where she performed *Salome* in 1912. She died in New York in 1914, at the age of thirty-four. Critics considered Walker a singer and dancer superior to both her better-known successors, Florence MILLS and Josephine BAKER.

REFERENCE

NEWMAN, RICHARD. "'The Brightest Star': Aida Overton Walker in the Age of Ragtime and Cakewalk." *Prospects* (forthcoming).

RICHARD NEWMAN

Walker, A'Lelia

Walker, A'Lelia (June 6, 1885–August 17, 1931), entrepreneur. Through the lavish parties she hosted, A'Lelia Walker made herself the center of elite social life during the HARLEM RENAISSANCE. She was born Lelia Walker to Sarah and Moses McWilliams in Vicksburg, Miss. (She changed her name to "A'Lelia" as an adult.) After her father died when she was two, her mother took her to St. Louis. She attended public schools there and graduated from Knoxville College, a private black school in Knoxville, Tenn.

She and her mother then moved to Denver, where her mother married C. J. Walker, from whom they took their surnames. A'Lelia also married, but while she took the surname Robinson from her husband, she only occasionally used it, and the marriage was as short-lived as two subsequent unions. While in Denver, the Walkers began their hair care business. Madam C. J. WALKER developed products that straightened and softened African-American women's hair, and assisted by her daughter, she quickly created a vast empire. She moved parts of her operations and her residence to Pittsburgh and Indianapolis before finally settling in New York. In 1917, the Walkers built a thirty-four-room mansion in Irvington-on-Hudson, N.Y., which A'Lelia's friend, the opera

singer Enrico Caruso, dubbed "Villa Lewaro" (short for Lelia Walker Robinson).

With her mother's death on May 25, 1919, A'Lelia inherited the bulk of her mother's estate, including Villa Lewaro and two twin brownstones at 108–110 West 136th St. in Harlem. Soon after her mother's death, Walker also bought an apartment at 80 Edgecombe Avenue, in Harlem. While she was the titular director of the Walker business interests, A'Lelia Walker devoted most of her money and attention to social life. She threw parties at Villa Lewaro and in Harlem. She established "at-homes" at which she introduced African-American writers, artists, and performers to each other and to such white celebrities as Carl Van Vechten. Her "salon" was regarded as a place where artistic people, particularly male and female homosexuals, could go to eat and drink, and hear music. In 1927 and 1928, she turned part of the brownstones into a nightclub, which she named "The Dark Tower."

When the depression came, Walker experienced grave financial difficulties. She was forced to close her nightclub, and she mortgaged Villa Lewaro. When she died suddenly on August 17, 1931, Langston HUGHES wrote that this "was really the end of the gay times of the New Negro era in Harlem." The NAACP, to whom Walker had willed Villa Lewaro, was unable to keep up the payments on the estate and ended up putting it on the auction block.

REFERENCES

HUGHES, LANGSTON. *The Big Sea: An Autobiography.* New York, 1940.
LEWIS, DAVID LEVERING. *When Harlem Was in Vogue.* New York, 1981.

SIRAJ AHMED

Walker, Alice (February 9, 1944–), novelist. Alice Walker was born in Eatonton, Ga., the eighth child of sharecroppers Willie Lee and Minnie Lou Grant Walker. The vision in Walker's right eye was destroyed when she was eight years old by a brother's BB gun shot, an event that caused her to become an introverted child. Six years later, Walker's self-confidence and commitment to school increased dramatically after a minor surgical procedure removed disfiguring scar tissue from around her injured eye. Encouraged by her family and community, Walker won a scholarship for the handicapped and matriculated at Spelman College in 1961.

After two years, Walker transferred to Sarah Lawrence College because she felt that Spelman stifled the

intellectual growth and maturation of its students, an issue she explores in the novel *Meridian*. At Sarah Lawrence, Walker studied works by European and white American writers, but the school failed to provide her with an opportunity to explore the intellectual and cultural traditions of black people. Walker sought to broaden her education by traveling to Africa during the summer before her senior year. During her stay there, Walker became pregnant, and the urgency of her desire to terminate the pregnancy (she was prepared to commit suicide had she not been able to get an abortion), along with her experiences in Africa and as a participant in the CIVIL RIGHTS MOVEMENT, became the subject of her first book, a collection of poems entitled *Once* (1968).

Walker moved to Mississippi in 1965, where she taught, worked with Head Start programs, and helped to register voters. There she met and married Melvyn Leventhal, a civil rights lawyer whom she subsequently divorced (a daughter, Rebecca, was born in 1969), and wrote her first novel, *The Third Life of Grange Copeland* (1970), a chilling exploration of the causes and consequences of black intrafamilial violence. While doing research on black folk medicine for a story that became "The Revenge of Hannah Kemhuff," collected in *In Love and Trouble* (1973), Walker first learned of Zora Neale HURSTON.

In Hurston, Walker discovered a figure who had been virtually erased from American literary history in large part because she held views—on the beauty and complexity of black southern rural culture; on the necessity of what Walker termed a "womanist" critique of sexism; and on racism and sexism as intersecting forms of oppression—for which she had herself been condemned. In Hurston, Walker found legitimacy for her own literary project. Walker obtained a tombstone for Hurston's grave, which pro-

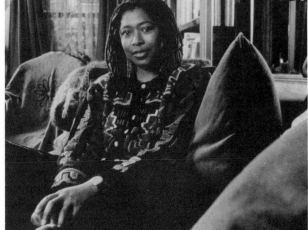

Author Alice Walker. (© Lawrence Barns/Black Star)

claimed her "A Genius of the South," and focused public attention on her neglected work, including the novel *Their Eyes Were Watching God.*

In her influential essay "In Search of Our Mothers' Gardens" Walker asked, with Hurston and other marginalized women in mind, "How was the creativity of the black woman kept alive, year after year and century after century?" Some of the most celebrated of Walker's works—from the short stories "Everyday Use" and "1955" to the novel *The Color Purple* (1982)—explore this question. By acknowledging her artistic debt to writers like Phillis WHEATLEY, Virginia Woolf, and Hurston, as well as to her own verbally and horticulturally adept mother, Walker encouraged a generation of readers and scholars to question traditional evaluative norms.

After *In Love and Trouble,* Walker published several novels (including *Meridian, The Temple of My Familiar,* and *Possessing the Secret of Joy*), volumes of poetry (including *Horses Make a Landscape Look More Beautiful*), collections of essays, and another short story collection, *You Can't Keep a Good Woman Down* (1981). In all these works, she examined the racial and gendered inequities that affect black Americans generally and black women in particular. The most celebrated and controversial of these works is her Pulitzer Prize- and National Book Award-winning epistolary novel, *The Color Purple,* which explores, among other matters, incest, marital violence, lesbianism, alternative religious practices, and black attitudes about gender. Since the early 1980s, Walker has lived in northern California and continues to produce work that challenges and inspires its readers.

REFERENCE

AWKWARD, MICHAEL. *Inspiriting Influences: Tradition, Revision, and Afro-American Women's Novels.* New York, 1989.

MICHAEL AWKWARD

Walker, David (c. 1785–June 28, 1830), civil rights activist and pamphleteer. Born free in Wilmington, N.C., the son of a free white mother and a slave father, David Walker traveled extensively in the South and observed the cruelty of slavery firsthand. Little is known about his life until he settled in Boston, where he was living as early as 1826. A tall, dark-complexioned mulatto, he operated a clothing store, selling both new and secondhand clothes, and became a leader in Boston's black community. Walker was a member of Father Snowden's Methodist Church, and was active in the Massachusetts General Colored Association formed in 1826. He was a

contributor of funds to emancipate George M. Horton, a slave poet in North Carolina, and also served as an agent for *Freedom's Journal* (New York), established in 1827. Walker and his wife, Eliza, had one son, Edwin G. Walker, who later became the first black elected to the Massachusetts legislature.

Walker represented a new generation of black leaders forged by the experience of creating the first extensive free black communities in urban centers of the United States in the half-century after the American Revolution. The achievement of African Americans in establishing institutions (churches, schools, and mutual aid and fraternal societies) and in producing leaders (ministers, educators, businessmen) emboldened some in Walker's generation to challenge the reigning view among whites that African Americans, even if freed, were destined to remain a degraded people, a caste apart, better served by the removal of free blacks to Africa, which became the objective of the AMERICAN COLONIZATION SOCIETY (ACS), formed in 1817 by leading statesmen and clergy.

In an address in 1828 delivered before the Massachusetts General Colored Association, Walker laid out a strategy of opposition. Overcoming resistance to organization from within the black community, Walker and others recognized the need for a formal association to advance the race by uniting "the colored population, so far, through the United States of America, as may be practicable and expedient; forming societies, opening, extending, and keeping up correspondences" (*Freedom's Journal,* December 19, 1828). Presaging his famous *Appeal to the Colored Citizens of the World,* Walker sought to arouse blacks to mutual aid and self-help, to cast off passive acquiescence in injustice, and to persuade his people of the potential power that hundreds of thousands of free blacks possessed once mobilized.

Published in 1829, Walker's *Appeal* aimed at encouraging black organization and individual activism. It went through three editions in two years, each one longer than the previous one, the final version reaching eighty-eight pages. For many readers, the most startling aspect of the *Appeal* was its call for the violent revolt of slaves against their masters. But Walker was also vitally concerned with the institutions of free blacks in the North. Walker understood that the formation of organizations such as the Massachusetts General Colored Association and the appearance of *Freedom's Journal* in 1827 were evidence of a rising tide of black opposition to slavery and racism. Walker, along with many African-American activists of his era, was profoundly opposed to the African colonization schemes of the American Colonization Society. Colonizationists ignored and suppressed the prevailing black opposition and sought

support among African Americans. For Walker, colonization represented an immediate threat to any long-term hopes of black advancement since its cardinal assumption was that such advancement was impossible.

Walker's *Appeal* was thus much more than a cry of conscience, for all its impassioned rhetoric. Despite its rambling organization, its prophetic denunciations of injustice and apocalyptic predictions, the *Appeal* forms a complex, cogent argument with political purpose: to persuade blacks to struggle with whites to abandon colonization and to strive toward racial equality. The essay culminates in an attack on colonization and concludes with an affirmation of the *Declaration of Independence*.

Walker aimed the *Appeal* at two audiences simultaneously. His first target was blacks, whose achievements in history, Walker argued, rebutted the degraded view popularized by colonizationists and the "suspicion" of Thomas Jefferson of inherent black intellectual inferiority. Walker insisted on the importance of black self-help through rigorous education and occupational training to refute Jefferson and others. He was also unsparing in his condemnation of the ignorance and passivity of free blacks and the complicity of the enslaved, their acquiescence in helping to sustain the American racial regime. Yet in justifying physical resistance—the element which most alarmed many readers in his own day and since—Walker carefully qualified his views. He relied primarily on the power of persuasion to convince white people to recognize that slavery and racism perverted Christianity and republicanism, though his apocalyptic warnings undoubtedly were designed to stir fear in the hearts of tyrants.

Walker succeeded. He circulated copies of the *Appeal* through the mails and via black and white seamen who carried them to southern ports in Virginia, North Carolina, Georgia, and Louisiana. Southern leaders became alarmed and adopted new laws against teaching free blacks to read or write and demanded that Mayor Harrison Gray Otis of Boston take action against Walker. Otis gave assurances that Walker's was an isolated voice, without sympathy in the white community, but Walker had violated no laws. Georgians, however, placed a large sum on Walker's head. In 1830, Walker died from causes unknown amid suspicion, never confirmed, of foul play.

Few documents in American history have elicited such diverse contemporary and historical evaluations as Walker's *Appeal*. Benjamin Lundy, the pioneer abolitionist, condemned it as incendiary. William Lloyd Garrison admired the *Appeal's* "impassioned and determined spirit," and its "bravery and intelligence," but thought it "a most injudicious publication, yet warranted by the creed of an independent people."

The black leader Henry Highland GARNET in 1848 proclaimed it "among the first, and . . . the boldest and most direct appeals in behalf of freedom, which was made in the early part of the Antislavery Reformation." In 1908 a modern white historian, Alice D. Adams, deemed it "a most bloodthirsty document," while in 1950 the African-American scholar Saunders REDDING thought "it was scurrilous, ranting, mad—but these were the temper of the times." In their biography of their father, the Garrison children probably came closest to the truth about Walker: "his noble intensity, pride, disgust, fierceness, his eloquence, and his general intellectual ability have not been commemorated as they deserve."

REFERENCES

APTHEKER, HERBERT. *"One Continual Cry": David Walker's Appeal to the Colored Citizens of the World (1829–1830)*. New York, 1965.
GARRISON, W. P., and F. J. GARRISON. *William Lloyd Garrison, 1805–1879. The Story of His Life, Told by His Children*. Vol. 1. New York, 1885.
HORTON, JAMES O., and LOIS E. HORTON. *Black Bostonians*. New York, 1979.
LITWACK, LEON F. *North of Slavery: The Negro in the Free States, 1790–1860*. Chicago, 1961.

PAUL GOODMAN

Walker, Dianne (1951–), tap dancer. Born in Boston, Dianne Walker learned the intricacies of rhythm-tap from Leon COLLINS, who became her mentor and partner. Walker has become known for her gracious and fluid style, which earned her the nickname "Lady Di." Her footwork, delicate and yet rhythmically complex, is embroidered and subtle, its sound crystalline. Walker performed with Willie Spencer, and her style was greatly influenced by Jimmy "Sir" SLYDE. An important figure in tap education, Walker became codirector (with Pamela Raff) of the Leon Collins tap school in Boston, following the death of Collins in 1985. Since that time, the focus of her teaching has been to bring black rhythm-tap back to the black community.

A principal dancer in the first Paris production of *Black and Blue* (1987), Walker joined the 1989 Broadway production as assistant choreographer and dance captain; she was featured in "Memories of You," a subtly nuanced soft-shoe choreographed by Cholly Atkins. One of the few, and certainly among the finest, black female tap dancers, Walker also holds her own among male hoofers. Walker appeared in the film *Tap* (1989), and in the public television special *Tap: Dance in America* (1988), hosted by Gregory

HINES. She has performed at numerous tap festivals throughout the United States and Europe.

CONSTANCE VALIS HILL

Walker, George Theophilus (June 27, 1922–), composer, pianist, and educator. George Walker was born in Washington, D.C., the son of George T. and Rosa K. Walker. He came from a musical family: his father was an amateur pianist, and his sister, Frances Walker Slocum, became a concert pianist. After studying in the public schools of Washington, D.C., Walker graduated from Oberlin Conservatory in Ohio in 1941. He studied piano with Rudolf Serkin at the Curtis Institute in Philadelphia (1945), and later studied composition with Nadia Boulanger in Paris. In 1957, he received a doctorate at the Eastman School of Music in Rochester, N.Y., and afterward continued his studies with Gian-Carlo Menotti and others.

Walker began to gain recognition as a performer soon after his graduation from Oberlin. In 1941 he was a winner of the Philadelphia Youth Auditions where he performed Sergei Rachmaninoff's Third Piano Concerto with the Philadelphia Orchestra. In 1945 he made his debut as a concert pianist at Town Hall in New York. During the 1950s, he toured extensively in the United States, Europe, Canada, and the Caribbean, giving recitals and performing with leading symphony orchestras.

Walker began composing at an early age, and in 1946 he published his first major composition, *Lament for Strings* (later retitled *Lyrics for Strings*), which became a widely performed composition. Walker's music is complex and technically demanding. He writes both tonal and atonal music, and favors complex rhythms. In many of his works he uses traditional compositional forms such as sonatas, concertos, and theme and variations, which are often infused with African-American folk and JAZZ idioms. For example, his Sonata for Cello and Piano (1957) used a boogie-woogie bass; his song "A Red, Red Rose" (1971, poem by Robert Burns) is in a BLUES style; his *Spirituals for Orchestra* (1974) used Negro SPIRITUALS; and his Piano Concerto (1976) exhibited the spirit of the music of Duke ELLINGTON. Among Walker's other well-known works are *Address for Orchestra* (1959), Trombone Concerto (1957), *Variations for Orchestra* (1971), *Music for Brass–Sacred and Profane* (1976), Cello Concerto (1982), *An Eastman Overture* (1983), Violin Concerto (1984), and *Sinfonia* (1984).

In 1969 Walker began teaching at Rutgers University in Newark, N.J., where he served as the acting chairperson of the Music Department from 1974 to 1977. He continued to teach at Rutgers until his retirement in 1992.

REFERENCES

GRAY, JOHN. *Blacks in Classical Music*. New York, 1988.

SOUTHERN, EILEEN. *Biographical Dictionary of Afro-American and African Musicians*. Westport, Conn., 1982.

JO H. KIM

Walker, George William (1873–January 6, 1911), entertainer. George Walker was born in Lawrence, Kans. While still a teenager he joined a traveling "medicine-man" show in which he rattled bones, shook a tambourine, and mugged for the audience. The show took Walker to San Francisco, where he settled in the early 1890s to look for theater work. There, in 1893, Walker met Bert WILLIAMS, a comedian with whom he began a sixteen-year stage career.

The Williams and Walker comedy team found little success in San Francisco, but in 1895 the pair gained popular acclaim when they appeared in Chicago with John Isham's Octoroons, a black vaudeville company. During that production the two developed their act into the classic minstrel interaction between the slapstick buffoon—played by Williams—and the cocky, flamboyant huckster—played by Walker.

In 1896 Williams and Walker came into their own at Koster and Bial's Music Hall, then New York's most important vaudeville theater. Billed as "The Two Real Coons," the duo introduced their famous "cakewalk" routine during their highly successful, forty-week run at Koster and Bial's. Having established themselves as a major Broadway attraction, the comedy team went on to perform in a number of major musicals, including *Clorindy, The Origin of the Cakewalk* in 1898.

Williams and Walker became major entertainment figures over the first decade of the twentieth century with a series of Broadway shows in which they were the featured attraction. Their successful, all-black shows included *The Policy Players* (1900), *Sons of Ham* (1900), *In Dahomey* (1902), *Abyssinia* (1906), and *Bandanna Land* (1908). *In Dahomey* was the first all-black production in a major Broadway theater. In these productions the pair's roles evolved from that of two-dimensional parodies of African Americans into more human, complex, and often tragic charac-

terizations. During the production of *Bandanna Land* Walker began to show symptoms of the final stage of syphilis and was forced to leave the cast in February 1909. Over the next two years Walker gradually and painfully deteriorated from the disease. He died in Islip, N.Y., in 1911. Bert Williams went on to a highly successful solo career on Broadway.

REFERENCES

RIIS, THOMAS LAURENCE. *Just Before Jazz: Black Musical Theater in New York, 1890–1915.* Washington, D.C., 1989.

———. *More Than Just Minstrel Shows: The Rise of Black Musical Theatre at the Turn of the Century.* Brooklyn, N.Y., 1992.

SAMPSON, HENRY T. *Blacks in Blackface: A Source Book on Early Black Musical Shows.* Metuchen, N.J., 1980.

SMITH, ERIC LEDELL. *Bert Williams: A Biography of the Pioneer Black Comedian.* Jefferson, N.C., 1992.

WOLL, ALLEN. *Black Musical Theatre: From Coontown to Dreamgirls.* Baton Rouge, La., 1989.

THADDEUS RUSSELL

Walker, Joseph A. (February 23, 1935–), playwright. Born in Washington, D.C., in 1935, Joseph Walker attended Howard University and Catholic University. He was introduced to the theater at Howard, where, in 1955, he played Luke in the premiere of James BALDWIN's *The Amen Corner.* Although Walker went on to do graduate work in philosophy and serve in the U.S. Air Force, his acting experience eventually led to a career in the theater. He was an actor with the NEGRO ENSEMBLE COMPANY when, in 1969, the company produced his *The Harangues.* A group of four one-act plays, *The Harangues* expressed the frustrations of blacks in an oppressive society, with settings from a fifteenth-century slave dungeon to a not-too-distant future following a black revolution.

Ododo (1970) is a musical revue that traces African-American history from early slavery days through the late 1960s; *Yin Yang* (1972) is a highly stylized piece depicting the battle between good and evil that draws much of its material from the biblical books of Job and Revelation. His best-known play, *The River Niger* (1972), explores in detail the differing values and aspirations of the black community within a single family. The play opened off-Broadway in December 1972, then moved to Broadway three months later, and won a number of awards, including a Tony Award, a Drama Desk Award, and an Off-Broadway (Obie) Award. Other plays by Walker include *Out of*

the Ashes (1972), *Antigone Africanus* (1975), *The Lion is a Soul Brother* (1976), and *District Line* (1984).

REFERENCE

PETERSON, BERNARD L., JR. *Contemporary Black American Playwrights and Their Plays.* New York, 1988.

MICHAEL PALLER

Walker, LeRoy Tashreau (June 4, 1918–), U.S. Olympic Committee president. LeRoy Walker, the first African American to head the United States Olympic Committee (USOC), was born in Atlanta, Ga., the youngest of thirteen children of Mary and William Walker. Walker's father, a railroad fireman, died when LeRoy was still a child, and the boy moved to New York's Harlem to live with an older brother. During this time LeRoy worked as a valet for a jazz group and at odd jobs. In 1936 he enrolled in Benedict College in South Carolina on a basketball scholarship. After receiving a bachelor's degree in 1940, Walker wished to attend medical school, but Howard University and Meharry Medical College, which had the country's two black medical schools, each had long waiting lists, so he enrolled in the physical education program at Columbia University, where he received a master's degree in 1941. In 1957 he received a Ph.D. in health and physical education from New York University.

Walker spent the years of World War II as chairman of the physical education department and as basketball and football coach at several small colleges, including Benedict College, Bishop College, and Prairie View State College. In 1945 Walker was hired at North Carolina Central University in Durham, N.C., where he remained as professor and coach until 1973. That year he was made vice chancellor for university relations, and in 1983 he was named chancellor of the university.

During his coaching years, Walker became involved in international sports. Over the years, he served as coach or consultant to numerous nations' Olympic teams, including squads from Israel and Ethiopia in 1960, Trinidad in 1964, Jamaica in 1968, and Kenya in 1972. In 1970, he cofounded the annual Pan African-U.S.A. track meet, which solidified the links between American and African athletes. (Halted in 1982 to protest South Africa's apartheid policies, the event was revived in 1994.) In 1972 Walker was elected to the board of the USOC. Four years later he was named coach of the U.S. Olympic track and field team. In 1988 he retired from North Carolina Central and was named USOC treasurer. That year he served as chief of mission with the U.S. delegation

at the Olympics in Seoul. During the following years, Walker served as vice president and director of sports for the Atlanta Committee for the Olympic Games.

In 1992 the USOC's presidency fell vacant. Walker was a popular choice, given his evident abilities and the large representation of African Americans among Olympic athletes. On October 11, 1992, he was unanimously elected USOC president. As USOC president, Walker maintained a strong profile. His first two years were not free of controversy, however. Walker's support of Beijing as the site for the 2000 Olympics was widely condemned by critics of China's human rights record. Similarly, Walker was embarrassed by criticism from other African Americans of the USOC's minority hiring practices. In 1994 he established a special task force on minority hiring for USOC executive positions.

REFERENCES

"Introducing LeRoy Walker, USOC President." *Ebony* 49, no. 8, (1994): 38.

NEWMAN, BRUCE. "An Inspired Choice." *Sports Illustrated* 77, no. 16 (1992): 9.

GREG ROBINSON

Walker, Madam C. J. (December 23, 1867–May 25, 1919), entrepreneur, hair-care industry pioneer, philanthropist, and political activist. Born Sarah Breedlove to ex-slaves Owen and Minerva Breedlove on a Delta, La., cotton plantation, she was orphaned by age seven. She lived with her sister, Louvenia, in Vicksburg, Miss., until 1882, when she married Moses McWilliams, in part to escape Louvenia's cruel husband. In 1887, when her daughter, Lelia (later known as A'Lelia WALKER), was two years old, Moses McWilliams died. For the next eighteen years she worked as a laundress in St. Louis. But in 1905, with $1.50 in savings, the thirty-seven-year-old McWilliams moved to Denver to start her own business after developing a formula to treat her problem with baldness—an ailment common among African-American women at the time, brought on by poor diet, stress, illness, damaging hair-care treatments, and scalp disease. In January 1906 she married Charles Joseph Walker, a newspaper sales agent, who helped design her advertisements and mail-order operation.

While Madam Walker is often said to have invented the "hot comb," it is more likely that she adapted metal implements popularized by the French to suit black women's hair. Acutely aware of the debate about whether black women should alter the appearance of their natural hair texture, she insisted years later that her Walker System was not intended as a hair "straightener," but rather as a grooming method to heal and condition the scalp to promote hair growth and prevent baldness.

From 1906 to 1916 Madam Walker traveled throughout the United States, Central America, and the West Indies promoting her business. She settled briefly in Pittsburgh, establishing the first Lelia College of Hair Culture there in 1908, then moved the company to Indianapolis in 1910, building a factory and vastly increasing her annual sales. Her reputation as a philanthropist was solidified in 1911, when she contributed one thousand dollars to the building fund of the Indianapolis YMCA. In 1912 she and C. J. Walker divorced, but she retained his name. Madam Walker joined her daughter, A'Lelia, and A'Lelia's adopted daughter, Mae (later Mae Walker Perry), in Harlem in 1916. She left the daily management of her manufacturing operation in Indianapolis to her longtime attorney and general manager, Freeman B. Ransom, factory forewoman Alice Kelly, and assistant general manager Robert L. Brokenburr.

Madam Walker's business philosophy stressed economic independence for the 20,000 former maids, farm laborers, housewives, and schoolteachers she employed as agents and factory and office workers. To further strengthen her company, she created the Madam C. J. Walker Hair Culturists Union of America and held annual conventions.

During World War I, she was among those who supported the government's black recruitment efforts and War Bond drives. But after the bloody 1917 East St. Louis riot, she joined the planning committee of the Negro Silent Protest Parade, traveling to Washington to present a petition urging President Wilson to support legislation that would make lynching a federal crime. As her wealth and visibility grew, Walker became increasingly outspoken, joining those blacks who advocated an alternative peace conference at Versailles after the war to monitor proceedings affecting the world's people of color. She intended her estate in Irvington-on-Hudson, N.Y.—Villa Lewaro, which was designed by black architect Vertner W. TANDY—not only as a showplace but as an inspiration to other blacks.

During the spring of 1919, aware that her long battle with hypertension was taking its final toll, Madam Walker revamped her will, directing her attorney to donate five thousand dollars to the NATIONAL ASSOCIATION FOR THE ADVANCEMENT OF COLORED PEOPLE's antilynching campaign and to contribute thousands of dollars to black educational, civic, and social institutions and organizations.

When she died at age fifty-one, at Villa Lewaro, she was widely considered the wealthiest black

Businesswoman, philanthropist, inventor, and the first self-made U.S. woman millionaire, Madam C. J. Walker sits behind the wheel, with her niece Anjetta Breedlove in the front seat; Alice Kelly, the forewoman of Walker's factory, is in the backseat behind Walker; next to Kelly is Lucy Flint, Walker's secretary, c. 1912. (Photographs and Prints Division, Schomburg Center for Research in Black Culture, The New York Public Library, Astor, Lenox and Tilden Foundations)

woman in America and was reputed to be the first African-American woman millionaire. Her daughter, A'Lelia Walker—a central figure of the HARLEM RENAISSANCE—succeeded her as president of the Mme. C. J. Walker Manufacturing Company.

Walker's significance is rooted not only in her innovative (and sometimes controversial) hair-care system, but also in her advocacy of black women's economic independence and her creation of business opportunities at a time when most black women worked as servants and sharecroppers. Her entrepreneurial strategies and organizational skills revolutionized what would become a multibillion-dollar ethnic hair-care and cosmetics industry by the last decade of the twentieth century. Having led an early life of hardship, she became a trailblazer of black philanthropy, using her wealth and influence to leverage social, political, and economic rights for women and blacks. In 1992 Madam Walker was elected to the National Business Hall of Fame.

REFERENCES

BUNDLES, A'LELIA PERRY. *Madam C. J. Walker—Entrepreneur.* New York, 1991.
GIDDINGS, PAULA. *When and Where I Enter.* New York, 1984.
LOGAN, RAYFORD W., and MICHAEL R. WINSTON. *Dictionary of American Negro Biography.* New York, 1982.
The Textbook of the Madam C. J. Walker Schools of Beauty Culture. Indianapolis, 1928.

A'LELIA PERRY BUNDLES

Walker, Maggie Lena (July 15, 1867–December 15, 1934), business and newspaper executive. Maggie Lena Walker was born in Richmond, Va. Her mother, Elizabeth Draper, was a former slave who worked as a cook in the home of Elizabeth Van Lew, a wealthy abolitionist from Virginia. Her Irish-born father, Eccles Cuthbert, was a Union sympathizer and reporter for the *New York Herald*. Walker's stepfather, William Mitchell, worked as a butler in the Van Lew household.

Walker attended Richmond's Armstrong Normal School. Upon graduation in 1883, she taught at the Lancaster School for three years. In 1886, she married Armstead Walker, who worked with his father's prosperous bricklaying and construction business. Together the couple had three sons and adopted a daughter.

In 1880, Walker joined the Grand United Order of St. Luke in Richmond, a mutual aid society established by Mary Prout in 1867 to ensure health benefits and proper burial for African-American veterans of the Civil War. At a time of little government relief and assistance for the poor and elderly, these societies were important in the lives of African Americans. In the late 1880s and 1890s, the Richmond order grew and slowly came to resemble a diversified business which included a bank, a real estate division, a newspaper, a hotel, and a grocery store.

In 1899, Walker became executive secretary and treasurer of the consolidated and renamed Independent Order of St. Luke in Richmond. Under her leadership the organization grew rapidly. Walker's goal was to create businesses that would provide employment for African Americans, especially African-American women, through cooperative effort and mutual support. In 1902, she founded the *St. Luke Herald,* a paper addressing business as well as political issues, such as lynching and economic independence of the African-American community. The following year, she founded the St. Luke Penny Savings Bank, and was probably the first woman bank president in the United States. When, in 1929, the St. Luke Bank merged with other African-American banks in Richmond to become the Consolidated Bank and Trust Company, Walker became chairperson of the board.

In addition to these activities, in 1912, Walker joined the National Association of Colored Women and was a member of the executive committee for the remainder of her life. In the same year, she founded and became president of the Richmond's Council of Colored Women and helped raise $5,000 for the Virginia Industrial School for Colored Girls. Although she was confined to a wheelchair after an accident in 1907, she continued until her death in 1934 to work unrelentingly to improve job opportunities for African Americans, to speak out against black political disfranchisement, and to advocate the cooperative enterprising and economic independence of African Americans.

REFERENCES

BLANCH, MURIEL, and DOROTHY RICE. *Miss Maggie: A Biography of Maggie Lena Walker.* Richmond, Va., 1984.

BROWN, ELSA BARKLEY. "Womanist Consciousness: Maggie Lena Walker and the Independent Order of St. Luke." *Signs* 14, no. 2 (Spring 1989): 610–633.

DABNEY, WENDELL P. *Maggie L. Walker and the I. O. of St. Luke: The Woman and the Work.* Cincinnati, Ohio, 1927.

SABRINA FUCHS
PAM NADASEN

Maggie Lena Walker took over direction of the Independent Order of St. Luke, headquartered in Richmond, in 1899. In 1903 she became the first female bank president in the United States. (Photographs and Prints Division, Schomburg Center for Research in Black Culture, The New York Public Library, Astor, Lenox and Tilden Foundations)

Walker, Margaret (July 7, 1915–), writer. Margaret Abigail Walker was born in Birmingham, Ala. She received her early education in New Orleans, and completed undergraduate work at Northwestern University at the age of nineteen. Although Walker had published some of her poems before she moved to Chicago, it was there her talent matured. She wrote as a college student and as a member of the federal government's WORKS PROJECT ADMINISTRATION, and she shared cultural and professional interests with black and white intellectuals in Chicago, the best known of whom was Richard WRIGHT. Wright and Walker were close friends until Walker left Chicago for graduate work at the University of Iowa in 1939, by which time she was on her way to becoming a major poet.

In 1942 Walker completed the manuscript of a collection of poems entitled *For My People,* the title poem of which she had written and published in Chi-

cago in 1937. The book served as her master's thesis at the Iowa Writers Workshop, and won a measure of national literary prominence. In 1942 *For My People* won the Yale Younger Poets Award. About the same time, Walker began work on a historical novel based on the life of her grandmother, Elvira Dozier Ware, a work she did not finish until she returned to Iowa in the 1960s to complete her Ph.D. In the interim, she joined the faculty at Jackson State University in Jackson, Miss., where she and her husband, Firnist James Alexander, raised their four children.

Walker played an active role in the civil rights movement in Mississippi, and continued to write. The novel she created from her grandmother's stories was published in 1966 as *Jubilee,* and received the Houghton Mifflin Literary Award. It was translated into seven languages and enjoyed popularity as one of the first modern novels of slavery and the Reconstruction South told from an African-American perspective. Other books followed: *Prophets for a New Day* (1970), *How I Wrote Jubilee* (1972), *October Journey* (1973), and *A Poetic Equation: Conversations Between Nikki Giovanni and Margaret Walker* (1974). Throughout her long career, Walker received numer-

ous awards and honors for her contribution to American letters. She holds several honorary degrees and in 1991 received a Senior Fellowship from the National Endowment for the Arts.

Walker retired from full-time teaching in 1979, remained in Jackson, and worked on several projects, especially a controversial biography of Richard Wright, published in 1988 as *Richard Wright: Daemonic Genius.* In 1989 Walker brought together new and earlier poems in *This Is My Century: New and Collected Poems.* A year later she published her first volume of essays, *How I Wrote Jubilee and Other Essays on Life and Literature.*

Throughout her work, Walker incorporates a strong sense of her own humanistic vision together with an autobiographical recall of her own past and cogent themes from black history. Her artistic vision recognizes the distinctiveness of black cultural life and the values associated with it. She is outspoken on matters of political justice and social equality, for women as well as for men.

Jubilee tells the story of Vyry, a slave on an antebellum Georgia plantation, the unacknowledged daughter of the master, who aspires to freedom. She marries a fellow slave, and assumes responsibility for the plantation during the Civil War. After the war she moves away and discovers that her courage and determination make it possible for her to triumph over numerous adversities. In a 1992 interview Walker stated, "The body of my work springs from my interest in the historical point of view that is central to the development of black people as we approach the twenty-first century."

REFERENCES

WALKER, MARGARET. *How I Wrote Jubilee and Other Essays on Life and Literature.* Maryemma Graham, ed. New York, 1990.

MARYEMMA GRAHAM

Walker, Sidney. *See* Jack, Beau.

Walker, Wyatt Tee (August 16, 1929–), minister and civil rights activist. Born in Brockton, Mass., Walker was educated at Virginia Union University in Richmond, Va. (B.S., 1950, M.Div., 1953). He received a D.Min. from Colgate Rochester Bexley Hall/ Crozer in 1975. Walker was minister of Gillfield Baptist Church in Petersburg, Va., from 1953 to 1960. In 1960, with his wife, two children, and several followers, Walker entered Petersburg's segregated public library and asked for the first volume of Douglas Southall Freeman's biography of Robert E. Lee. Arrested for trespassing, Walker refused to post bail,

For more than half a century, Margaret Walker—poet, novelist, essayist, biographer, and author of *For My People* and *Jubilee*—has sensitively chronicled the African-American experience. (© Leandre Jackson)

and spent three days in jail. This event attracted the attention of Martin Luther KING, Jr., who invited Walker to join him in Atlanta.

From 1960 to 1964, Walker worked closely with King as executive director of the SOUTHERN CHRISTIAN LEADERSHIP CONFERENCE (SCLC). Combining an intense personality with strong tactical skills, Walker was at the forefront of the civil rights movement. In addition to his administrative duties he was often on the frontline of the protests, enduring police beatings and arrests. On June 16, 1961, Walker was one of the delegates from the Freedom Ride Coordinating Committee to meet with Attorney General Robert Kennedy. Walker is credited with organizing "Project C," the detailed plan for the Birmingham campaign in April 1963. He controlled the marches and sit-ins by walkie-talkie all day, and stayed up at night personally typing King's famous "Letter from Birmingham Jail" as it was smuggled to him in installments.

In the summer of 1964, Walker resigned his position with the SCLC and moved to New York City where, as assistant to Adam Clayton POWELL, JR., he served as pulpit minister at the Abyssinian Baptist Church. He was also vice president of American Education Heritage, publishers of a multivolume series

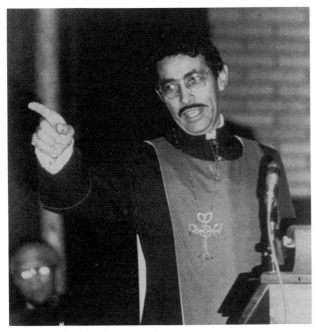

Wyatt Tee Walker was a key associate of the Rev. Dr. Martin Luther King, Jr., at the Southern Christian Leadership Conference. Walker became pastor of the Canaan Baptist Church of Christ in Harlem in 1967 and has lectured extensively on black religion, music, and politics. (Photographs and Prints Division, Schomburg Center for Research in Black Culture, The New York Public Library, Astor, Lenox and Tilden Foundations)

on the history and culture of black America. In 1966 he was appointed assistant on urban affairs to Gov. Nelson Rockefeller. In 1967, having left Abyssinian, he became minister (and subsequently senior pastor) of the Canaan Baptist Church of Christ in Harlem. From this pulpit Walker continued to work on behalf of the African-American community into the 1990s. As CEO of the Church Housing Development Fund, Walker supervised the construction of housing for the elderly known as the Wyatt Tee Walker Apartments. From 1977 to 1987 Walker was director of the Freedom National Bank, which later failed. In August 1979, Walker was a member of the controversial SCLC delegation that met with the U.N. Representative of the Palestinian Liberation Organization in order to promote peace in the Middle East. He served as an advisor to Jesse JACKSON and was National Coordinator for Church and Clergy during Jackson's 1984 and 1988 presidential bids. An expert in black GOSPEL MUSIC, in February 1985 Walker participated in "Thank God!" a four-part TV "docu-drama" about black church music.

In the early 1990s Walker was active in the Consortium for Central Harlem Development, a group of religious, civic and business leaders working to improve living conditions for the needy; as National Chairman of the Religious Action Network of the American Committee on Africa, Walker raised funds for Nelson Mandela and the African National Conference.

Walker has authored several books, including *Somebody's Calling My Name: Black Sacred Music and Social Change* (1979) and *Road to Damascus* (1985), which tells of the group he and Jesse Jackson led to Syria in 1984 to obtain the freedom of a black Navy flier, Lt. Robert O. Goodman, held hostage there.

REFERENCES

CLOYD, IRIS, and WILLIAM C. MATNEY, JR., eds. *Who's Who Among Black Americans.* 6th ed. Detroit, 1990.

COLAIACO, JAMES A. *Martin Luther King, Jr.: Apostle of Militant Nonviolence.* New York, 1988.

LYDIA MCNEILL

Wallace, Ruby Ann. *See* Dee, Ruby.

Wallace, Sippie (Thomas, Beulah Belle)

(November 1, 1898–November 1, 1986), blues singer. Sippie Wallace was born Beulah Belle Thomas in Houston. She was first exposed to music by her father, a church deacon at Houston's Shiloh Baptist Church. She was given the nickname "Sippie" as

a child. In 1912 her family moved to New Orleans, and there her brother, George Jr., also a musician, became friends with Louis ARMSTRONG and Joe "King" OLIVER. In 1914 she married Frank Seals; the marriage lasted three years, and she married Matt Wallace in 1917. After her family returned to Houston the next year, she worked as an assistant to Madame Dante, a snake dancer in Philip's Reptile Show there. She also began to sing and play piano at picnics, parties, dances, and traveling tent shows, where she became known as the "Texas Nightingale" because of her mellow style of blues singing; most of her songs she wrote herself.

In 1923 Wallace recorded "Shorty George" and "Up the Country Blues" for Okeh Records, which had already recorded her brother. "Shorty George" sold more than 100,000 copies, and Wallace quickly became one of the most popular blues singers in the country, famed for a weighty, rocking style that combined Chicago and southwestern influences. In the mid-1920s Wallace moved to Detroit, but she continued to tour on the TOBA circuit of black theaters. Wallace recorded numerous songs, including "Special Delivery Blues" (1926), "Jack o' Diamond Blues" (1926), "I'm a Mighty Tight Woman" (1929), "You Gonna Need My Help" (1929). Many of her songs were recorded with the finest jazz instrumentalists of the day, including Claude Williams on "Caledonia Blues" (1924), Louis Armstrong and Sidney BECHET on "Baby, I Can't Use You No More" (1924), King Oliver on "Morning Dove Blues" (1925), and Louis Armstrong again on "Dead Drunk Blues" (1927), "Have You Ever Been Down?" (1927), and "The Flood Blues" (1927).

Wallace's career was hit hard by the GREAT DEPRESSION, and she fell into relative obscurity, concentrating on church music but also performing occasionally in public. From 1929 through the 1970s, Wallace served as the organist at the Leland Baptist Church in Detroit. Starting in the 1930s, she was also director of the National Convention of Gospel Choirs and Congregations. In 1966, with encouragement from another great blues singer, Victoria SPIVEY, Wallace began singing blues again to great acclaim. She toured Europe in 1966, and in the 1970s toured with rock singer Bonnie Raitt. In 1982 she recorded *Sippie*, and in 1986 she again toured Europe. Wallace died later that year in Detroit.

REFERENCES

HARRISON, DAPHNE DUVAL. *Black Pearls: Blues Queens of the 1920s*. New Brunswick, N.J., 1988.
RUSCH, BOB. "Sippie Wallace Interview." *Cadence* 4, no. 10 (1978): 14.

ELIZABETH MUTHER

Waller, Thomas Wright "Fats" (May 21, 1904–December 15, 1943), jazz pianist, organist, and composer. The most ebullient and popular of the Harlem stride pianists, Waller was also an accomplished performer on the pipe organ, a prolific composer of songs and musical comedy scores, and a gifted comic. Waller, whose father was a lay preacher and member of Harlem's Abyssinian Baptist Church, was born in New York City in 1904, and lived most of his life there. He learned the rudiments of piano in his childhood, won a talent contest in 1918 playing James P. JOHNSON's "Carolina Shout" at the Roosevelt Theater, and eventually studied stride piano with Russell Brooks after leaving home in 1920. Thereafter he studied privately with Johnson, from whom he acquired further knowledge of the techniques and gestures of the stride style. Fascinated by the sound of the pipe organ, he secured occasional employment in his teens as an organist to accompany silent movies at Harlem's LINCOLN THEATER and later at the Lafayette Theater. In 1920 he married Edith Hatchett. They were divorced three years later, and in 1926 he married Anita Rutherford.

Waller gained local fame in New York early in the 1920s on the Harlem rent party circuit, but before 1927 he recorded only very occasionally as a soloist, accompanist for singers, or (even more rarely) with other groups. In 1927 and 1929, however, he recorded numerous sides at Victor's Camden, N.J., studio (a converted church), often playing his own compositions. These included organ solos ("Rusty Pail"), piano solos ("Gladyse," "Ain't Misbehavin' "), and small ensemble sessions ("Fats Waller Stomp," "The Minor Drag"). On April 27, 1928, Waller premiered James P. Johnson's *Yamekraw: Negro Rhapsody* (1928) at Carnegie Hall in New York City, and during the last half of the decade he composed music for shows and revues (*Tan Town Topics*, 1925, with Spencer WILLIAMS; *Keep Shufflin'*, 1928, with James P. Johnson; *Load of Coal* and *Hot Chocolates*, 1929, both with lyricist Andy RAZAF).

In the 1930s, Waller became one of the most well-known and well-loved figures in jazz, through the hundreds of sides he recorded for Victor as well as through frequent appearances on radio and at night clubs; he also performed in films (*Hooray For Love*, 1935; *The King of Burlesque*, 1935), on European and domestic tours, and composed numerous popular songs on the Tin Pan Alley model. Usually, he worked from a given text; his most frequent collaborator was lyricist Andy Razaf. As a composer, Waller was as efficient as his fund of ideas was fertile. The elegance and sophistication of the majority of his songs (from "Ain't Misbehavin,' " 1929, to "Stayin' at Home," 1940) attest to a high level of craft in his composition.

Waller developed a flawless technique ("Gladyse," "Numb Fumblin'," both recorded in 1929), aided by exceptionally large hands, a physical characteristic he shared with both James P. Johnson and Luckey ROBERTS. Unlike most stride pianists, however, Waller occasionally exhibited a genuinely lyrical, introspective quality in both melodic line and accompaniment ("Inside This Heart of Mine," 1938). He was also the only stride pianist to play the pipe organ as a jazz instrument and to produce a substantial body of recorded jazz on this seemingly cumbersome instrument. As a singer, Waller's loose, energetic vocal style contributed to the sense of immediacy in his performances, and he often (but not always) indulged a penchant for satire, savaging mawkish or nonsensical lyrics by using exaggerated timbres, affected pronunciation, and rhythmic displacement. In addition, he would interpolate devastating asides, mocking the original intent of the text ("I'm Crazy 'Bout My Baby," 1931; "It's a Sin to Tell a Lie," 1936). He also created sophisticated African-American musical tropes on a style of piano technique one might loosely term "European virtuoso"; his most extensive effort in this type of parody may be found in his 1941 recording of "Honeysuckle Rose (à la Bach, Beethoven, Brahms, and Waller)."

Waller contracted a bronchial infection during an engagement at the Club Zanzibar in Los Angeles in December 1943; he died in the early hours of December 15 in or near Kansas City, Mo., while returning to New York aboard the Santa Fe Super Chief train.

REFERENCES

BROWN, SCOTT E. *James P. Johnson: A Case of Mistaken Identity*. Metuchen, N.J., 1986.

"Fats Waller Demonstrates Swing, Even Defines It." *Metronome* 52, no. 2 (February 1936): 19, 33.

MACHLIN, PAUL S. *Stride: The Music of Fats Waller*. Boston, 1985.

SCHUMACH, MURRAY. "Interviewing Fats Waller and His Piano." *New York Times,* July 25, 1943, Sec. 2, p. 1.

SHIPTON, ALYN. *Fats Waller*. Tunbridge Wells, U.K., 1988.

SINGER, BARRY. *Black and Blue: The Life and Lyrics of Andy Razaf*. New York, 1992.

PAUL S. MACHLIN

Walls, Josiah Thomas (December 30, 1842–May 15, 1905), congressman. Born into slavery in Winchester, Va., Josiah Walls had little or no formal education. Impressed into the Confederate Army during the CIVIL WAR, he served until captured by the Union in 1862. After he joined the Union Army,

Walls's unit, the 3rd U.S. Colored Infantry, participated in several battles, including the bloody assault on Fort Wagner, S.C., in 1863.

Discharged a sergeant in 1865, Walls settled in Alachua County, Fla., where he quickly established himself as a prosperous farmer. He also became involved in local Republican politics, eventually attending the Florida Constitutional Convention in 1868. Because many whites boycotted Florida politics at the time, African Americans were able to play a large role both in drafting Florida's RECONSTRUCTION constitution and in electoral politics.

Despite internal party squabbling, Walls won election to the state legislature in 1868 and to the state Senate in 1869. He, along with other African-American legislators, was dismayed by the body's legislative agenda, which included no civil rights legislation. One of his bills, an attempt to permit law clerks and court clerks to practice law, was a clear attempt to widen eligibility in a field previously unavailable to blacks.

Intraparty debate was often intense. In 1869 the Republican party leadership decided that they should nominate an African-American candidate for election to Florida's only seat in the U.S. House of Representatives. Active lobbying by Walls and his supporters won him the nomination. In an election marred by questionable campaign practices and electoral fraud on both sides, Walls carried the 1870 election by a

Josiah T. Walls was the first African American elected to Congress from Florida, serving three terms. (Florida State Archives)

plurality of only 627 votes. Despite a challenge by his Democratic opponent, Silas Niblack, Walls took his seat in early 1871 to become Florida's first black congressman.

Walls went to Congress with an agenda for African-American empowerment. The primary components of this strategy were education, civil rights, and foreign affairs. Walls lobbied vigorously for improved and equal education for all Americans. Since he questioned whether southern states could be counted on to allocate resources in an impartial and equitable way, Walls proposed that the federal government have control of public schooling. At the end of Walls's term, however, a House committee determined that Niblack was the properly elected candidate and seated him for the remaining two months of the term.

Even before Congress could rule on Niblack's challenge, Walls was campaigning again and beat Niblack convincingly in their second contest in 1872. In his new term, Walls continued to support civil rights legislation vigorously. In an effort to increase white support, Walls proposed a general amnesty for ex-Confederates penalized and disfranchised after the war. He wanted the issue of amnesty to be linked with that of effective civil rights. While the House passed the amnesty legislation, the Civil Rights Bill suffered major damage from amendments and hostile committees. Since it had been greatly weakened and contained no clauses about education, Walls abstained from voting on its passage in early 1875.

Walls's final term began in 1875 after a bitterly contested election, which he won with a plurality of only several hundred votes. Spending much of his time replying to charges of electoral fraud and intimidation, Walls was unable to be an effective legislator. After Walls had served a little over a year, the Democrat-controlled Congress declared Democrat Jesse Finley the winner of the 1874 election and seated him.

Returning to Florida in 1876, Walls once again became a state senator, from 1876 until 1879. Walls then unsuccessfully ran for Congress in 1882 and 1884. He remained on his farm until 1895, when frost destroyed his orange groves. Ruined financially, he left for Tallahassee and became director of the farm at the Florida Normal College (later Florida A&M). Lapsing into relative obscurity, he died in Tallahassee in 1905.

REFERENCES

CHRISTOPHER, MAURINE. *Black Americans in Congress.* New York, 1976.
KLINGMAN, PETER. *Josiah Walls: Florida's Black Congressman of Reconstruction.* Gainsville, Fla., 1976.
MCFARLIN, ANNJENNETTE SOPHIE. *Black Congressional Reconstruction Orators and Their Orations, 1869–1879.* Metuchen, N.J., 1976, pp. 320–330.

JOHN C. STONER

Walrond, Eric Derwent (1898–1966), writer. Eric Walrond was born in Georgetown, British Guiana. He immigrated to Barbados in 1906, and in 1910 left for the Panama Canal Zone, where he worked as a clerk for the Health Department of the Canal Commission. From 1916 to 1918 he worked as a reporter and sportswriter for the *Panama Star and Herald.* In 1918 Walrond moved to New York, where he attended the College of the City of New York until 1921. During this time he also worked as an associate editor of Marcus GARVEY's *The Negro World.* Walrond soon broke with Garvey's UNIVERSAL NEGRO IMPROVEMENT ASSOCIATION, and eventually became one of its chief African-American critics. From 1922 to 1924 Walrond took writing classes at Columbia University. He contributed fiction and nonfiction to magazines such as *The New Republic, The* MESSENGER, *Vanity Fair,* and *The New Age.* His short story "The Palm Porch" was included in the well-known 1925 anthology edited by Alain LOCKE, *The New Negro.*

From 1925 to 1927 Walrond served as the busines manager for the Urban League's *Opportunity: Journal of Negro Life.* He also published a critically acclaimed collection of short stories, *Tropic Death* (1926), about life in Barbados, the Canal Zone, and British Guiana. Using native dialects and an impressionistic style, Walrond addressed the problems of physical suffering and discrimination facing African Americans in the tropics. His work was anthologized in *The American Caravan* (1927).

In 1928 Walrond received a Guggenheim Fellowship and became a Zona Gale scholar at the University of Wisconsin. That same year he moved to Europe. Although Walrond had been considered one of the brightest young voices of the HARLEM RENAISSANCE, when interest in black literature waned in the 1930s, he disappeared from American literary life. In the late 1930s, when Walrond and Garvey were both living in London, the two grew close again, and Walrond contributed to a Garveyite magazine, the *Black Man.* His contributions included one short story and articles that dealt with American literature and politics. Thereafter, Walrond virtually ceased writing. He traveled throughout Europe, and lived for several years in France before settling again in London. He was at work on a novel set in the Panama Canal region when he died in England in 1966.

REFERENCES

BONE, ROBERT. *Down Home: A History of Afro-American Short Fiction from Its Beginnings to the End of the Harlem Renaissance.* New York, 1975.

MARTIN, TONY. *Literary Garveyism: Black Arts and the Harlem Renaissance.* Dover, Mass., 1983.

JONATHAN GILL

Walters, Alexander (August 1, 1858–February 1, 1917), church leader and civil rights activist. Alexander Walters was born a slave in 1858 in Bardstown, Ky. He was educated for the ministry in the AFRICAN METHODIST EPISCOPAL ZION CHURCH (AMEZ), which licensed him to preach in 1877 in Indianapolis. In 1882, he was ordained an elder at the Fifth Street Church. The following year Walters transferred to the West Coast, presiding as an elder in San Francisco. From there he transferred to Tennessee, serving in 1886 as the pastor of a church in Chattanooga, and from 1886 to 1888 as the pastor of a church in Knoxville. In 1888, he was appointed pastor of Mother Zion Church in New York City, and in 1892, he was elected a bishop for the Seventh District of the AMEZ Church, the district which included New York City.

On September 15, 1898, Walters, along with T. Thomas FORTUNE (publisher of the *New York Age*), chaired a meeting of black leaders in Rochester, N.Y. They organized the National Afro-American Council, of which Walters became president. It was the largest organization of national African-American leaders at that time. As president, Walters was an outspoken opponent of the "separate but equal" decision of the U.S. Supreme Court in *Plessy* v. *Ferguson* (1896). In his address to the council's second meeting on December 29, 1898, Walters challenged Booker T. WASHINGTON's accommodationist views (*see* ACCOMMODATIONISM). However, over the next ten years, Walters's allegiance would often vacillate between the positions of Washington and W. E. B. DU BOIS, who favored direct protest over accommodation.

In 1899 Walters also spoke out at the council against Bishop Henry McNeal Turner's plan to encourage African Americans to move to Africa. Walters attended the Pan-African Conference in London in July 1900, where he was elected president of the Pan-African Association (*see* PAN AFRICANISM). T. Thomas Fortune, by this time an ally of Washington, removed Walters as President of the Afro-American Council in 1902; deprived of the presidency, Walters remained a council member and continued urging Washington to take more direct action against segregation. The council itself largely ceased to function after 1908, due to controversy among its leaders over Washington's personal and philosophical influence over the organization. Walters joined Du Bois's NIAGARA MOVEMENT in 1908, and was one of the few blacks who helped organize the founding conference of the NATIONAL ASSOCIATION FOR THE ADVANCEMENT OF COLORED PEOPLE in 1909. In 1911, he was elected vice-president of the NAACP.

In 1910, Walters reorganized AMEZ churches in West Africa. His additional visits to other regions of Africa and the Caribbean led him to urge the United States government to take a more active role in strengthening the economies of those developing areas, so that they would not become European colonies. He supported Democrat Woodrow Wilson's candidacy for president in 1912. In 1915, President Wilson offered Walters the post of minister to Liberia, but Walters declined in order to continue improving church-based education systems in the United States and abroad.

Walters died on February 2, 1917, and was buried in Brooklyn, N.Y.

REFERENCES

HARLAN, LOUIS R. *Booker T. Washington: The Wizard of Tuskegee, 1901–1915.* New York, 1983.

MILLER, GEORGE MASON. "This Worldly Mission": The Life and Career of Alexander Walters (1858–1917). Ph.D. diss., State University of New York at Stony Brook, 1984.

WALLS, WILLIAM JACOB. *The African Methodist Episcopal Zion Church, Reality of the Black Church.* Charlotte, N.C., 1974.

WALTERS, ALEXANDER. *My Life and Work.* Chicago, 1917.

SASHA THOMAS

War Between the States. *See* Civil War.

War of 1812. The War of 1812 resulted from indignities the United States suffered due to English-French disputes. Britain, needing manpower, forced Englishmen off neutral American ships, sometimes mistakenly seizing Americans, and refusing to return them. Britain also hoped to undermine America's commercial independence and illegal slave trade. The United States went to war to reassert national sovereignty, hoping also to weaken Britain as a barrier to territorial expansion to Canada and the West. The war was also important to African Americans, who fought both for and against the United States.

With the onset of the war, the nation temporarily allowed blacks to fill its military needs. The navy

initiated enlistment, with blacks filling 10 percent of its ranks. Two free-black companies from New Orleans were crucial in the 1814 battle there. New York State freed slaves whose masters allowed them to serve. Overall, black fighters were praised even by initially hostile commanders. Other African Americans sided with Britain, hoping that country might offer freedom, as it had during the Revolution. Thousands of slaves escaped from their American masters, but England had few opportunities to use them. Two hundred participated in the campaign that attacked Washington, and South Carolina blacks planned an insurrection to coincide with a hoped-for invasion.

For many years Florida, not then part of the United States, had offered extralegal sanctuary to blacks, whites, and Native Americans. Britain recruited black and Indian refugees there, offering at least four hundred blacks freedom and land. At the war's end, some black soldiers left with the British, but most stayed. England left a fort to a group of them, their families, and their Indian allies. This "Negro Fort" at Prospect Bluff became a base for attacks against slaveholders, attracting refugees from as far as Tennessee. In July 1816, U.S. troops sent to re-enslave its occupants destroyed the fort, and few survived.

The Treaty of Ghent, ending the war, simply restored the status quo. Napoleon's fall made British-French antagonisms moot, and war-weary Britain's treasury was depleted. But the United States had proved it could resist European encroachments and depend on its own manufactures, and it was now freer to expand westward.

For black people, any gains were not so permanent. Nationally, only the navy continued enlisting blacks, up to a 5 percent quota. Louisiana's militia was exceptional in continuing free-black units, but future African-American fighters would still face questions regarding their abilities and rights.

REFERENCES

FOSTER, WILLIAM Z. *The Negro People in America.* New York, 1970.

HARDING, VINCENT. *There Is a River: The Black Struggle for Freedom.* New York, 1981.

ELIZABETH FORTSON ARROYO

Ward, Douglas Turner (May 5, 1930–), African-American actor, playwright. Born in Burnside, La., in 1930, Douglas Turner Ward attended Wilberforce University in Ohio from 1946 to 1947 and the University of Michigan from 1947 to 1948. In 1948 he went to New York City, where he worked as a journalist for several years.

During the early 1950s, Ward wrote entertaining skits for a political group with which he was involved and later a more ambitious work, a cantata on the life of Nat Turner (see NAT TURNER'S REBELLION). This early writing experience awakened in him a serious interest in playwriting. He enrolled in Paul Mann's Actors Workshop to learn the craft of acting and to learn about plays and playwriting. In this environment, he realized he also had talent as an actor. He made his acting debut in an Off-Broadway production of Eugene O'Neill's *The Iceman Cometh* (1956). Other roles followed. He first appeared on Broadway as an actor in a small role in Lorraine Hansberry's *A Raisin in the Sun* (1959) and as an understudy to leading man Sidney POITIER before assuming the principal role on a national tour. As an actor Ward appeared under the name Douglas Turner.

In 1965, *Happy Ending* and *Day of Absence*, Ward's first plays to be produced professionally, were presented Off-Broadway. As a result of these productions he received an Obie Award for his acting and a Drama Desk–Vernon Rice Award for his writing. Other plays by Ward include *The Reckoning* (1969), *Brotherhood* (1970), and *The Redeemer* (1979). They are mainly satirical comedies.

In 1966, Ward wrote an article for the *New York Times* entitled "American Theater: For Whites Only?" in which he proposed the creation of a professional African-American theater that would give opportunities to black playwrights, actors, and other theater craftspersons. In 1968, with the aid of a Ford Foundation Grant, the NEGRO ENSEMBLE COMPANY (NEC) was founded in New York City with Ward as artistic director, Robert Hooks as executive director, and Gerald Krone as administrative director. Ward has acted in and directed many NEC productions, including Joseph Walker's *The River Niger* (1973), for which he received an Obie Award for his acting. After *The River Niger* moved to Broadway from its Off-Broadway location, the play won such awards as a Tony for the Best Play of 1973–74, and Ward received a Tony nomination as Best Supporting Actor. Other significant NEC productions include Charles Fuller's *A Soldier's Play* (1981), which was directed by Ward and won several honors, among them a New York Drama Critics Circle Award and the Pulitzer Prize for Drama for 1982.

Though a professional company, the NEC is not in competition with the profit-oriented theaters on Broadway. When the initial funding ended after its third year, the NEC could not afford a resident company and its training program was reduced and replaced partially by on-the-job training. Ellen Foreman has described NEC as being "in image and in

substance, the single national Black Theater Company in America."

REFERENCES

FOREMAN, ELLEN. "The Negro Ensemble Company: A Transcendent Vision." In Errol Hill, ed., *The Theater of Black Americans*. Vol. 2, *The Presenters: Companies of Players. The Participators: Audiences and Critics.* Englewood Cliffs, N.J., 1980, pp. 72–84.

WARD, DOUGLAS TURNER. "American Theater: For Whites Only?" *New York Times,* August 14, 1966, Sec. 2, pp. D1, D3.

JEANNE-MARIE A. MILLER

Ward, Samuel Ringgold (October 17, 1817–c. 1866), abolitionist and clergyman. Samuel Ward was born on Maryland's Eastern Shore. His parents, William Ward and Anne Harper (?), escaped from slavery to Greenwich, N.J., in 1820 and moved to New York City in 1826. Samuel Ward attended the African Free School, where Alexander CRUMMELL and Henry Highland GARNET were fellow students.

Ward taught in black schools in Newark, N.J., until 1839, when he was ordained by the New York Congregational (General) Association. From 1841 to 1843 he served as pastor to a white congregation in South Butler, N.Y., and from 1846 to 1851 to a white congregation in Cortland, N.Y. During a period of poor health between the two ministries, he studied medicine and law.

In 1839, Ward was also appointed an agent of the AMERICAN ANTI-SLAVERY SOCIETY, and he embarked upon a career as an orator in abolition and party politics for which he became known as "the black Daniel Webster." Active in the Liberty party from its establishment in 1840, he addressed its convention in 1843, and lectured under its auspices, having particular effect in the defeat of Henry Clay in New York State. In 1846 Ward served as a vice president of the AMERICAN MISSIONARY ASSOCIATION, an ABOLITION-oriented missionary group.

Ward fled to Canada in 1851 because of his involvement in the rescue of the "fugitive slave" William ("Jerry") Henry. Between 1851 and 1866, he served as an agent of the Anti-Slavery Society of Canada, as well as a member of its executive committee, lecturing against slavery as he had done in the United States. Under its auspices, he traveled to England seeking aid for the exiled and immigrant former slaves. He addressed the British and Foreign Anti-Slavery Society in 1853 and 1854.

Ward was associated as agent or editor with a number of black periodicals, including the *True American*

Author Samuel Ringgold Ward. (Photographs and Prints Division, Schomburg Center for Research in Black Culture, The New York Public Library, Astor, Lenox and Tilden Foundations)

and *Religious Examiner* and the *Impartial Citizen;* in Canada he was the nominal editor of the *Provincial Freeman.* Ward also was the author of *The Autobiography of a Fugitive Slave: His Anti-Slavery Labours in the United States, Canada, & England* (London, 1855) and an account of the Jamaica Rebellion of 1865, *Reflections upon the Gordon Rebellion* (1866).

Ward was given land in Jamaica by an English Quaker and moved there in 1855, serving as a Baptist minister in Kingston. Little is known of his last years.

REFERENCE

WINKS, ROBIN. "Samuel Ringgold Ward." *Dictionary of Canadian Biography.* Vol. 9. Toronto, 1976.

QUANDRA PRETTYMAN

Ward, Theodore (September 15, 1902–May 8, 1983), playwright. Theodore Ward was born into a large family in Thibodeaux, La. He left home at his mother's death when he was about thirteen. During

his teenage years he made his way through St. Louis, Chicago, and other cities in the Midwest, often earning what money he could as a bootblack. Although he only attended school intermittently, he won a scholarship to the University of Wisconsin and was awarded the University's Zona Gale Fellowship in Creative Writing both years of his attendance (1931–1933).

Ward joined the Federal Theatre's Chicago unit in 1938. The same year it produced his three-act play, *Big White Fog,* which, at the time Langston HUGHES called, "the greatest encompassing play on Negro life that has ever been written." Set in Chicago during the 1920s, *Big White Fog* documents an African-American family's involvement with socialism, communism, and, especially, Marcus GARVEY's black nationalism. In the play Ward reveals his ongoing concern with the political situation of African Americans in a white society, but he also pointedly addresses color prejudice among African Americans themselves. Sections of the press condemned the play for its supposed "communist" tendencies. In 1940 Ward came to New York City and cofounded the Negro Playwrights Company, whose first (and only) production, his *Big White Fog,* ran for sixty-four performances at the Lincoln Theater in Harlem.

Ward spent most of World War II working as an inspector of motors in a war plant. But in 1945 the Office of War Information hired him as a script writer for its overseas broadcasts. Later that year Ward received a fellowship from the Theatre Guild to finish what proved to be his most successful work, *Our Lan'.* Set during RECONSTRUCTION and documenting the efforts of freed blacks to claim the land promised them by Gen. William Tecumseh Sherman, the play had such a successful Off-Broadway run in 1946 that it moved to Broadway's Royale Theatre the following year. In 1947 the *New York Times* declared *Our Lan'* "one of the best" plays of the season. As a result, in part, of this critical success, Ward received a National Theater Conference Fellowship (1947) and a Guggenheim Fellowship (1948) for creative writing.

Ward wrote many plays after *Our Lan'*—*John Brown* (a version of which was performed in New York in 1950), *The Daubers* (1953), and *Candle in the Wind* (1967), for example—but never again received the acclaim he did for *Big White Fog* or *Our Lan'.* Ward returned to Chicago in 1964 and opened the South Side Center for the Performing Arts in 1967. In the later years of his life, he taught at a number of universities and colleges and was involved with many small theater groups around the country. In 1978, with the aid of a Rockefeller Foundation grant, Ward became the writer-in-residence at the Free Southern

Theater of New Orleans, and put on a production of *Our Lan'.* Ward died in Chicago.

REFERENCES

ABRAMSON, DORIS E. *Negro Playwrights in the American Theatre, 1925–1959.* New York, 1969, pp. 109–136.

FRASER, GERALD. "Theodore Ward" (obituary). *New York Times,* May 11, 1983, p. D23.

HATCH, JAMES V. ed. *Black Theater, U.S.A.: Forty-Five Plays by Black Americans: 1847–1974.* New York, 1974, pp. 278–319.

PETER SCHILLING

Waring, Laura Wheeler (May 26, 1887–February 3, 1948), painter and educator. Laura Wheeler was born in Hartford, Conn., into a prominent, upper-class black family. Her father, the Rev. Robert Forster Wheeler, served for many years as the minister of the Talcott Street Congregational Church. Her mother, Mary (Freeman) Wheeler, had graduated from Oberlin College in Ohio. Wheeler, who displayed artistic talent from an early age, acquired extensive artistic training. After graduating with honors from Hartford High School, she attended the Pennsylvania Academy of the Fine Arts from 1908 to 1915, where she studied under Henry McCarter, William Merritt Chase, and Thomas Anshutz. She won the academy's Cresson Memorial Travel Scholarship in 1914, which allowed her to study art in Paris during a summer.

After graduating from the academy, Wheeler was invited to found the art and music departments at the State Normal School at Cheyney (now Cheyney University) outside Philadelphia, where she taught for more than thirty years. Wheeler made a second trip to Europe in 1924–1925 and studied at the Academie de la Grande Chaumière in Paris. In Philadelphia, Wheeler married Walter E. Waring, a professor at Lincoln University in Pennsylvania. She continued to teach while gaining acclaim as a portraitist and, to a lesser extent, as a painter of landscapes and still lifes. In 1927, she received a Harmon Gold Award for her portrait, *Anne Washington Derry* (1926). Waring became involved in a broad range of artistic activities: For the Philadelphia Sesquicentennial Exposition (1926), she worked on a mural for the Pennsylvania Building and served as director of "Negro art exhibits." (She also took charge of Negro art exhibits for the Texas Centennial Exposition of 1937.) Her illustrations of African-American subjects appeared in various books and magazines, including the CRISIS. In 1943, the Harmon Foundation commissioned her,

with Betsy Reyneau, to paint the series, *Portraits of Outstanding American Citizens of Negro Origin.*

Waring was best known for her classical, dignified portraits. Her subjects included many persons prominent in African-American affairs: W. E. B. DU BOIS, James Weldon JOHNSON, and George Washington CARVER. A typical portrait of contralto Marian ANDERSON depicts the singer in a flowing, full-length gown with clasped hands and an introspective expression, as she might appear moments before a performance. The striking though unfinished *Self-Portrait* (c. 1940) presents a bespectacled intellectual whose probing, serious expression is balanced by playful and impressionistic brushwork. Of sociological interest is Waring's *Mother and Daughter* (1927), which presents in double profile a mother and daughter of mixed races. Waring's landscapes of the Pennsylvania countryside and her *Houses at Semur, France* (1924) reveal her interest in French impressionism, as do paintings like *Still Life* (1928), a particularly exuberant and colorful vase of flowers commissioned by opera singer Lillian Evanti. In her later years, Waring turned to religious scenes from African-American spirituals in works such as *Heaven, Heaven* (1946), *Jacob's Ladder* (n.d.), and *The Coming of the Lord* (n.d.).

Waring exhibited paintings at the Harmon Foundation between 1927 and 1931, at the Smithsonian Institution, and at the Art Institute of Chicago, among others. During a third and final trip to Europe, Waring's work was shown in a solo exhibition at the Galerie du Luxembourg in Paris. Waring died after a long illness in Philadelphia in 1948. A posthumous solo exhibition was held at the Howard University Gallery of Art, Washington, D.C., in 1949.

REFERENCES

JAMES, MILTON M. "Laura Wheeler Waring." *Negro History Bulletin* (March 1956): 126–128.
LOGAN, RAYFORD W., and MICHAEL R. WINSTON, eds. *Dictionary of American Negro Biography.* New York, 1982.

DEBORAH M. REHN

Warwick, Dionne

Warwick, Dionne (December 12, 1941–), singer. Marie Dionne Warwick, one of the most important African-American pop soul artists outside Motown in the 1960s, was born in East Orange, N.J. Warwick studied voice at the Hartt College of Music in Connecticut, but decided to pursue her interests in gospel music with the Drinkard Singers and the Gospelaires, a trio she formed with her sister Dee Dee and cousin Cissy Houston. In 1960, she met the songwriters Burt Bacharach and Hal David while supporting herself in New York as a studio session vocalist. They helped Warwick obtain a contract with Scepter Records, for whom she recorded from 1962 to 1971. Bacharach and David wrote sophisticated songs for her that were well suited to her dark, warm alto voice and impeccable diction. She was particularly adept at conveying the immediacy and emotionalism of David's lyrics to a wide audience.

Bacharach and David wrote and produced most of her hit songs, including "Anyone Who Had a Heart" (number one, 1964), "A House Is Not a Home" (1964), and "Do You Know the Way to San Jose?" (number ten, 1968). During the 1970s, Warwick had the hit "Then Came You" with the Spinners (number one, 1974); her next major hit was on Arista Records with "I'll Never Love This Way Again" (number five, 1979; produced by Barry Manilow), which sold one million copies. Other hits include "Déjà Vu" (1979) and "That's What Friends Are For" (1986). The proceeds from the latter were donated for AIDS research. She also participated in the famine effort U.S.A. for Africa, which resulted in the worldwide hit "We Are the World."

REFERENCE

HINE, DARLENE CLARK. *Black Women in America: An Historical Encyclopedia.* Vol. 2. New York, 1993, pp. 1225–1226.

KYRA D. GAUNT

Washington, Booker Taliaferro

Washington, Booker Taliaferro (c. 1856–November 14, 1915), educator. Founder of Tuskegee Institute (*see* TUSKEGEE UNIVERSITY) in Alabama and prominent race leader of the late nineteenth and early twentieth centuries, Booker T. Washington was born a slave on the plantation of James Burroughs near Hale's Ford, Va. He spent his childhood as a houseboy and servant. His mother was a cook on the Burroughs plantation, and he never knew his white father. With Emancipation in 1865, he moved with his family—consisting of his mother, Jane; his stepfather, Washington Ferguson; a half-brother, John; and a half-sister, Amanda—to West Virginia, where he worked briefly in the salt furnaces and coal mines near Malden. Quickly, however, he obtained work as a houseboy in the mansion of the wealthiest white man in Malden, Gen. Lewis Ruffner. There, under the tutelage of the general's wife, Viola Ruffner, a former New England schoolteacher, he learned to read. He also attended a local school for African Americans in Malden.

From 1872 to 1875 Washington attended HAMP-TON INSTITUTE, in Hampton, Va., where he came under the influence of the school's founder, Gen. Samuel Chapman Armstrong, who inculcated in Washington the work ethic that would stay with him his entire life and that became a hallmark of his educational philosophy. Washington was an outstanding pupil during his tenure at Hampton and was placed in charge of the Native American students there. After graduation he returned to Malden, where he taught school for several years and became active as a public speaker on local matters, including the issue of the removal of the capital of West Virginia to Charleston.

In 1881, Washington founded a school of his own in Tuskegee, Ala. Beginning with a few ramshackle buildings and a small sum from the state of Alabama, he built Tuskegee Institute into the best-known African-American school in the nation. While not neglecting academic training entirely, the school's curriculum stressed industrial education, training in specific skills and crafts that would prepare students for jobs. Washington built his school and his influence by tapping the generosity of northern philan-

Booker T. Washington headed Tuskegee Institute for thirty-four years, founded the National Negro Business League, and was the first African American elected to the New York University Hall of Fame. (Photographs and Prints Division, Schomburg Center for Research in Black Culture, The New York Public Library, Astor, Lenox and Tilden Foundations)

thropists, receiving donations from wealthy New Englanders and some of the leading industrialists and businessmen of his time, such as Andrew Carnegie, William H. Baldwin, Jr., Julius Rosenwald, and Robert C. Ogden.

In 1882 Washington married his childhood sweetheart from Malden, Fanny Norton Smith, a graduate of Hampton Institute, who died two years later as a result of injuries suffered in a fall from a wagon. Subsequently Washington married Olivia A. DAVIDSON, a graduate of Hampton and the Framingham State Normal School in Massachusetts, who held the title of lady principal of Tuskegee. She was a tireless worker for the school and an effective fund-raiser in her own right. Always in rather frail health, Davidson died in 1889. Washington's third wife, Margaret James Murray (*see* Margaret Murray WASHINGTON), a graduate of Fisk University, also held the title of lady principal and was a leader of the National Association of Colored Women's Clubs and the Southern Federation of Colored Women's Clubs.

Washington's reputation as the principal of Tuskegee Institute grew through the late 1880s and the 1890s; his school was considered the exemplar of industrial education, viewed as the best method of training the generations of African Americans who were either born in slavery or were the sons and daughters of freed slaves. His control of the purse strings of many of the northern donors to his school increased his influence with other African-American schools in the South. His fame and recognition as a national race leader, however, resulted from the impact of a single speech he delivered before the Cotton States and International Exposition in Atlanta, in 1895. This important speech, often called the AT-LANTA COMPROMISE, is the best single statement of Washington's philosophy of racial advancement and his political accommodation with the predominant racial ideology of his time (*see also* ACCOMMODA-TIONISM). For the next twenty years, until the end of his life, Washington seldom deviated publicly from the positions taken in the Atlanta address.

In his speech, Washington urged African Americans to "cast down your bucket where you are"— that is, in the South—and to accommodate to the segregation and discrimination imposed upon them by custom and by state and local laws. He said the races could exist separately from the standpoint of social relationships but should work together for mutual economic advancement. He advocated a gradualist advancement of the race, through hard work, economic improvement, and self-help. This message found instant acceptance from white Americans, north and south, and almost universal approval among African Americans. Even W. E. B. DU BOIS, later one of Washington's harshest critics, wrote to

him immediately after the Atlanta address that the speech was "a word fitly spoken."

While Washington's public stance on racial matters seldom varied from the Atlanta Compromise, privately he was a more complicated individual. His voluminous private papers, housed at the Library of Congress, document an elaborate secret life that contradicted many of his public utterances. He secretly financed test cases to challenge JIM CROW laws. He held great power over the African-American press, both north and south, and secretly owned stock in several newspapers. While Washington himself never held political office of any kind, he became the most powerful African-American politician of his time as an adviser to presidents Theodore Roosevelt and William Howard Taft and as a dispenser of REPUBLICAN PARTY patronage.

Washington's biographer, Louis R. Harlan, called the Tuskegean's extensive political network "the Tuskegee Machine" for its resemblance to the machines established by big-city political bosses of the era. With his network of informants and access to both northern philanthropy and political patronage, Washington could make or break careers, and he was the central figure in African-American public life during his heyday. Arguably no other black leader, before or since, has exerted similar dominance. He founded the NATIONAL NEGRO BUSINESS LEAGUE in 1900, to foster African-American business and create a loyal corps of supporters throughout the country. Indirectly he influenced the National Afro American Council, the leading African-American civil rights group of his day. The publication of his autobiography, *Up from Slavery*, in 1901 spread his fame even more in the United States and abroad. In this classic American tale, Washington portrayed his life in terms of a Horatio Alger success story. Its great popularity in the first decade of the twentieth century won many new financial supporters for Tuskegee Institute and for Washington personally.

Washington remained the dominant African-American leader in the country until the time of his death from exhaustion and overwork in 1915. But other voices rose to challenge his conservative, accommodationist leadership. William Monroe TROTTER, the editor of the *Boston Guardian*, was a persistent gadfly. Beginning in 1903 with the publication of Du Bois's *The Souls of Black Folk*, and continuing for the rest of his life, Washington was criticized for his failure to be more publicly aggressive in fighting the deterioration of race relations in the United States, for his avoidance of direct public support for civil rights legislation, and for his single-minded emphasis on industrial education as opposed to academic training for a "talented tenth" of the race. Washington, however, was adept at outmaneuvering his crit-

ics, even resorting to the use of spies to infiltrate organizations critical of his leadership, such as the NIAGARA MOVEMENT, led by Du Bois. His intimate friends called Washington "the Wizard" for his mastery of political intrigue and his exercise of power.

Washington's leadership ultimately gave way to new forces in the twentieth century, which placed less emphasis on individual leadership and more on organizational power. The founding of the NATIONAL ASSOCIATION FOR THE ADVANCEMENT OF COLORED PEOPLE (NAACP) in 1909 and of the NATIONAL URBAN LEAGUE in 1911 challenged Washington in the areas of civil rights and for his failure to address problems related to the growth of an urban black population. The defeat of the Republican party in the presidential election of 1912 also spelled the end of Washington's power as a dispenser of political patronage. Nevertheless, he remained active as a speaker and public figure until his death, in 1915, at Tuskegee.

Washington's place in the pantheon of African-American leaders is unclear. He was the first African American to appear on a United States postage stamp (1940) and commemorative coin (1946). While he was eulogized by friend and foe alike at the time of his death, his outmoded philosophy of accommodation to segregation and racism in American society caused his historical reputation to suffer. New generations of Americans, who took their inspiration from those who were more outspoken critics of segregation and the second-class status endured by African Americans, rejected Washington's leadership role. While much recent scholarship has explored his racial philosophy and political activity in considerable depth, he remains a largely forgotten man in the consciousness of the general public, both black and white. In recent years, however, there has been some revival of interest in his economic thought by those who seek to develop African-American businesses and entrepreneurial skills. Indeed, no serious student of the African-American experience in the United States can afford to ignore the lessons that can be gleaned from Washington's life and from the manner in which he exercised power.

REFERENCES

HARLAN, LOUIS R. *Booker T. Washington: The Making of a Black Leader, 1856–1901.* Urbana, Ill., 1972.

———. *Booker T. Washington: The Wizard of Tuskegee, 1901–1915.* Urbana, Ill., 1983.

HARLAN, LOUIS R., and RAYMOND W. SMOCK, eds. *The Booker T. Washington Papers.* 14 vols. Urbana, Ill., 1972–1989.

MEIER, AUGUST. *Negro Thought in America: Racial Ideologies in the Age of Accommodation, 1880–1915.* Ann Arbor, Mich., 1963.

SMOCK, RAYMOND W., ed. *Booker T. Washington in Perspective: The Essays of Louis R. Harlan.* Jackson, Miss., 1988.

WASHINGTON, BOOKER T. *Up from Slavery: An Autobiography.* New York, 1901.

RAYMOND W. SMOCK

Washington, Denzel (December 28, 1954–), actor. Born into a middle class family in Mount Vernon, N.Y., Denzel Washington is one of three children of a Pentecostal minister and a beauty shop owner. His parents divorced when he was fourteen, and Washington went through a rebellious period. Consequently, his mother sent him to boarding school at Oakland Academy in Windsor, N.Y. He went on to matriculate at Fordham University in New York City.

Washington became interested in acting while at college. When he was a senior at Fordham, he won a small role in the television film *Wilma,* the story of Olympic track star Wilma RUDOLPH. After graduating with a B.A. in journalism in 1978, Washington spent a year at San Francisco's American Conservatory Theater.

Washington's first film, *Carbon Copy* (1981), received little notice. However, his portrayals of MALCOLM X in *When the Chickens Come Home to Roost* by Laurence Holder (Audelco Award, 1980) and Private Peterson in *A Soldier's Play* by Charles Fuller (Obie Award, 1981) brought him to the attention of New York's theater critics. After refusing to take roles that he deemed degrading, Washington took the part of the idealistic surgeon Dr. Philip Chandler on the popular hospital television drama series *St. Elsewhere* (1982–1988). In 1984, accompanied by most of the original stage cast, Washington reprised his role as Private Peterson in *A Soldier's Story,* the film version of *A Soldier's Play.*

Despite his consistently powerful performances, it was not until the end of the 1980s that Washington was acknowledged as one of America's leading actors. He appeared as martyred South African activist Stephen Biko in *Cry Freedom* (1987), a policeman in *The Mighty Quinn,* and the embittered ex-slave and Union soldier Trip in *Glory,* both in 1989. Washington received an Academy Award nomination for his work in *Cry Freedom* and in 1990 won an Academy Award for best supporting actor for his performance in *Glory.* That same year he played the title role of *Richard III* in the New York Shakespeare Festival.

In 1990 Washington starred as a jazz musician in director Spike LEE's film *Mo' Better Blues.* He teamed with Lee again in 1992 playing the title role in the controversial film *Malcolm X.* The film received mixed reviews, but Washington's performance as the black nationalist was a critical success, and he received an Oscar nomination as best actor. The following year he appeared in leading roles in three films to much acclaim. He portrayed Don Pedro, Prince of Aragon, in Kenneth Branagh's version of the Shakespearean comedy *Much Ado About Nothing,* an investigative reporter in the thriller *The Pelican Brief,* and a trial lawyer in *Philadelphia.* In 1995 he starred with Gene Hackman in *Crimson Tide.*

REFERENCES

DAVIS, THULANI. "Denzel in the Swing." *American Film* (August 1990): 26–31.

HOBAN, PHOEBE. "Days of Glory: Denzel Washington—From Spike Lee's *Blues* to *Richard III.*" *New York Magazine* (August 13, 1990): 35–38.

RANDOLPH, LAURA B. "The Glory Days of Denzel Washington." *Ebony* (September 1990): 80–82.

JANE LUSAKA

Washington, Dinah (Jones, Ruth Lee) (August 19, 1924–December 14, 1963), singer. Dinah Washington's versatile, commanding, expressive delivery allowed her to cross over from rhythm and blues to pop, earning her the sobriquet of "Queen of the Blues" or simply "the Queen." "I can sing anything," she once claimed, for anything she sang sounded deeply felt. Clarion-clear, yet edged with emotion, her voice recalled both the gospel "shout" and the rawness of the blues.

Born Ruth Jones in Tuscaloosa, Ala., Washington was raised in Chicago and sang both in Saint Luke's Baptist Church and Sallie MARTIN's Gospel Group. At fifteen, she won an amateur-night contest at the Regal Theater and began appearing in local nightclubs. During an engagement at the Garrick Lounge, Washington was recommended by agent Joe Glaser to bandleader Lionel HAMPTON, who hired her as a vocalist from 1943 until 1946, when she left to sing solo.

On December 29, 1943, Washington cut her first records, "Evil Gal Blues" and "Salty Papa Blues," for the Keynote label. In 1946 she contracted with Mercury, for which she made over four hundred recordings before signing with Roulette. Between 1949 and 1954, ten of her singles were in the Top Five of the R&B charts. Following her 1959 breakthrough, "What a Difference a Day Makes," Washington regularly reached the pop Top Twenty. Alternating be-

tween jazz and orchestral accompaniments, she often completed recordings in one take. Her demeanor was feisty and uninhibited, and she was married (at best count) seven times. Her death in 1963 came from an accidental overdose of pills and liquor.

REFERENCES

HASKINS, JIM. *Queen of the Blues: A Biography of Dinah Washington*. New York, 1987.
SHAW, ARNOLD. "Gospel Song and Dinah Washington." In *Honkers and Shouters*. New York, 1978. pp. 144–150.

BUD KLIMENT

Washington, Fredericka Carolyn "Fredi"

(December 23, 1903–June 28, 1994), actress. Fredi Washington was born in Savannah, Ga., and attended school at St. Elizabeth Convent in Cornwell Heights, Pa. When still a teenager she moved to New York City, where she began her career as a stage performer.

Washington's first performance was at the age of sixteen as a member of the Happy Honeysuckles chorus line. In 1921 she was a chorus girl in Eubie BLAKE and Noble SISSLE's musical *Shuffle Along* and toured with the production from 1922 through 1926. Washington moved into acting when she was cast as the lead opposite Paul ROBESON in the Broadway production *Black Boy* (1926), for which she temporarily adopted the stage name Edith Warren. In *Black Boy* the light-skinned, green-eyed Washington played what came to be a typical role for her, that of a black woman who wants to pass as white.

Despite her Broadway debut Washington had trouble finding work in New York and left for Europe, where she toured as a dancer. She returned to the United States in the late 1920s and reestablished her acting career in film and stage. Her film credits during this period include "Black and Tan" (1929), a short with Duke ELLINGTON in which she performs a memorable, frenzied dance, and *The Emperor Jones* (1933) opposite Paul ROBESON, in which she was made to darken her skin by the producers, who feared white audiences would think Robeson was playing romantic scenes with a white actress. Washington also appeared in several New York stage productions, including *Sweet Chariot* (1930), *Singin' the Blues* (1931), and *Run, Little Chillun* (1933).

Washington's most famous film role was in *Imitation of Life* (1934), in which her performance as a black woman who rejects her family to pass for white was so convincing that several black journalists believed her to be a self-hater. In fact, Washington was often asked to play white women in Hollywood roles, but she refused, to the detriment of her career. Following *Imitation of Life* she received only one more major film role, that of a black woman who wants to adopt a white child in *One Mile From Heaven* (1937).

Washington vigorously supported black civil rights and worked against discrimination in theater and film. She co-founded the Negro Actors Guild in 1937 and served as the organization's first executive secretary. In the 1940s she was a drama editor and columnist for *The People's Voice*, a Harlem-based left-wing weekly newspaper published by Adam Clayton POWELL, JR.

In her later career Washington returned to the stage, appearing in productions of *Lysistrata* (1946), *A Long Way from Home* (1948), and *How Long Till Summer* (1949). She retired from performing in the early 1950s and moved to Connecticut.

In 1975 Washington was inducted into the Black Filmmakers Hall of Fame in Oakland, Calif. She died in Stamford, Conn.

REFERENCE

RULE, SHEILA. "Fredi Washington, 90, Actress; Broke Ground for Black Artists." *New York Times*, June 30, 1994, p. D21.

THADDEUS RUSSELL

Washington, Harold

(April 15, 1922–November 25, 1987), politician. Harold Washington was born on the South Side of Chicago to Bertha and Roy Lee Washington, Sr. His parents separated, and Roy Washington, a stockyard worker, raised the children; he also earned a law degree at night and became a DEMOCRATIC PARTY precinct captain in the Third Ward.

The son attended DuSable High School but dropped out after his junior year. He was drafted during World War II and while in the Army earned a high school equivalency diploma. In 1941 he married Dorothy Finch; they divorced in 1950.

After the war, Washington entered Roosevelt University in Chicago, where he was the first black student to be elected senior class president. He graduated in 1949 with a degree in political science. He completed law school at Northwestern University in 1952, by "quota" the only black student in his class.

When Roy Washington died in 1953, Ralph METCALFE, an alderman and Democratic party committeeman, invited Harold Washington to take over his father's precinct. Washington proved to be a talented organizer, successfully mobilizing votes for Metcalfe

and training new Democratic party leadership. At the same time, he was also involved in independent black political organizations.

Washington served in the Illinois House of Representatives from 1965 to 1976, and in the state Senate from 1976 to 1980. In office, he selectively dissented from "machine" policies, incurring special wrath in the late 1960s by calling for a police review board with civilian participation. In 1969, he helped organize the Illinois Legislative Black Caucus. He fought for consumer protection for the poor and elderly, supported the Equal Rights Amendment, and strengthened the Fair Employment Practices Act.

In 1977, Washington openly broke with the machine, running for mayor of Chicago in the special election that followed Richard J. Daley's death. He lost the Democratic primary but won 10.7 percent of the vote. A year later, Washington returned to the state senate despite a machine-orchestrated challenge. In 1980 he was elected to the U.S. Congress, where he demonstrated leadership on issues important to blacks and Latinos. Washington played a key role in the 1982 fight to extend the 1965 VOTING RIGHTS ACT, and he was secretary of the CONGRESSIONAL BLACK CAUCUS. He also supported a nuclear freeze and a 20 percent cut in defense spending.

Shortly after Washington's election, he was approached by independent political and community groups hoping to draft a black candidate for mayor of Chicago. After a massive campaign that registered at least 20,000 new voters by October 1982, Washington agreed to run. The media slighted his candidacy, casting the Democratic primary as a contest between incumbent Mayor Jane Byrne and State's Attorney Richard M. Daley, son of the former mayor. But Washington's overwhelming support in the black community, his debate performance, and a high level of grass-roots mobilization tipped the balance in his favor. He won with a plurality of 38 percent.

In the 1983 general election many white Democrats, including some key party leaders, backed Republican Bernard Epton. The campaign was volatile and racially charged, as whites jeered Washington and hurled accusations of personal impropriety. Still, he prevailed with 51.5 percent of the vote due to record-breaking turnouts and support in the black community, and strong support from Latino and liberal white neighborhoods.

Washington's first term was marred by opposition on the City Council, led by Democratic party machine stalwarts Edward Vrydolyak and Ed Burke. Washington lacked majority support on the council, and his initiatives often were defeated. The "Council Wars" raged from 1983 through 1986, when a federal court ruled the ward map was racially biased. When Washington sought reelection in 1987, he was challenged by former mayor Jane Byrne in the primary and by Vrydolyak, running as an independent, in the general election. He outpolled his rivals, garnering 99.6 percent of the black vote and significant backing among gays, Latinos, and Asian-Americans.

Despite resistance, Washington's structural and programmatic reforms were substantial. He signed the Shakman Decree, outlawing patronage hiring and firing, and he imposed a $1,500 cap on campaign contributions from companies doing business with the city. He increased racial and ethnic diversity in the city administration, and he aided women and minorities in competing with white male contractors. He appointed Chicago's first black police chief, and he sought to provide city services more equitably in the black community.

On November 25, 1987, Washington suffered a heart attack at his desk in city hall. He died later that day, mourned by many who believed his career had both reflected, and helped to create, new avenues for political participation among African Americans.

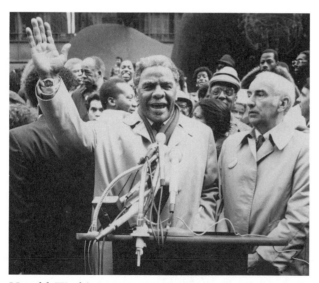

Harold Washington campaigning in the Democratic primary in Chicago in February 1983. Washington won the primary and the general election and became Chicago's first black mayor later that year. (AP/Wide World Photos)

REFERENCES

GOVE, SAMUEL K., and LOUIS A. MASOTTI, eds. *After Daley: Chicago Politics in Transition.* Urbana, Ill., 1982.

KLEPPNER, PAUL. *Chicago Divided: The Making of a Black Mayor.* DeKalb, Ill., 1985.

RIVLIN, GARY. *Fire on the Prairie: Chicago's Harold Washington and the Politics of Race.* New York, 1992.

TRAVIS, DEMPSEY J. *An Autobiography of Black Politics.* Chicago, Ill., 1987.

DIANNE M. PINDERHUGHES

Washington, Margaret Murray (c. 1861–June 4, 1925), educator and clubwoman. The child of a black mother, Lucy Murray, and a white father, Margaret Murray was born in Macon, Miss. March 9, 1865 is inscribed on her gravestone as her birthday, but she was listed as being nine years old in the census of 1870. She may have lowered her age in 1881, when she began Fisk Preparatory School in Nashville, Tenn. Taken in by a Quaker brother and sister after her father's death when she was seven, Washington was educated by them, and it was they who suggested she become a teacher.

Margaret Murray became Booker T. WASHINGTON's third wife. After completing her Fisk University education in 1889, she joined the Tuskegee faculty and the next academic year became dean of the women's department. Washington, who was recently widowed and had three small children, proposed to her in 1891 and they married on October 12, 1892. Margaret Murray Washington advised her husband in his speaking and fund-raising work, and she shared his advocacy of accommodation with whites while uplifting the black race. As an educated woman, Margaret Washington believed she had a responsibility to help those of her race who had fewer opportunities. She pursued her own work at Tuskegee and was a leader in the black women's club movement.

Washington was the director of the Girls' Institute at Tuskegee, which provided courses in laundering, cooking, dressmaking, sewing, millinery, and mattress making, skills which students were to use in maintaining healthy, efficient, and gracious homes. She founded the women's club at Tuskegee for female faculty and faculty wives, which was active, especially in the temperance movement. She also worked with people in the surrounding rural area on self-improvement. By 1904 nearly 300 women attended her mothers' meetings each Sunday. Especially concerned about high rates of black mortality and illegitimate births, Washington instructed the women on diet and personal hygiene for better health and urged them to set good moral examples at home for both boys and girls.

These sentiments found expression in the motto of the influential National Association of Colored Women's Clubs (NACW)—"Lifting as we climb." Washington was one of the women invited by Josephine St. Pierre RUFFIN to meet in Boston in July 1895 to form the NATIONAL FEDERATION OF AFRO-AMERICAN WOMEN. She became vice president and then, in 1896, president of the federation, which was now sixty-seven clubs strong; it joined with the Colored Women's League to form the NACW that year. In 1914, Washington was elected president of the NACW after holding numerous other offices and

The lady principal of Tuskegee Institute (later Tuskegee University), Margaret Murray married Tuskegee's president, Booker T. Washington, in 1892. After her marriage she continued to be active in the running of Tuskegee and in the black women's club movement. From 1914 to 1918 she was the president of the National Association of Colored Women and later was a leader of the International Council of Women of Darker Races. (Moorland-Spingarn Research Center, Howard University)

served two terms. She also edited the NACW's *National Notes* until her death.

President of the Alabama Association of Women's Clubs from 1919 until her death in 1925, Margaret Murray Washington led the movement to establish a boys' reform school as an alternative to prison, and later the Rescue Home for Girls, both in Mt. Meigs, Ala. Through the AAWC, she worked with the Commission on Interracial Cooperation to provide educational opportunities for blacks in Alabama. A lifelong friend of W. E. B. DU BOIS, in 1920, Margaret Washington helped found the International Council of Women of the Darker Races to promote

race pride through knowledge of black culture around the world.

REFERENCES

HALL, JACQUELYN DOWD. *Revolt Against Chivalry: Jessie Daniel Ames and the Women's Campaign Against Lynching.* New York, 1974.

JOHNS, ROBERT L. "Margaret Murray Washington." In Jessie Carney Smith, ed. *Notable Black American Women.* Detroit, Mich., 1992.

MOTON, JENNIE B. "Margaret M. Washington." In Hallie Q. Brown, *Homespun Heroines and Other Women of Distinction.* New York, 1988.

ALANA J. ERICKSON

Washington, Ora Mae (1898–May 28, 1971), tennis player. Ora Washington was born in 1898 in Philadelphia and is best remembered for her twelve years of undefeated play in the all-black AMERICAN TENNIS ASSOCIATION (ATA; 1924–1936). She won eight ATA National Crowns in women's TENNIS singles between 1929 and 1937 (suffering from heat stroke and losing in 1936). With various partners, Washington also won every ATA women's doubles championship between 1925 and 1936, as well as mixed-doubles championships in 1939, 1946, and 1947.

In addition to tennis, throughout the 1930s and 1940s Washington was center, top scorer, and coach for the *Philadelphia Tribune*'s women's basketball team, which traveled across the country playing white, black, men's or women's teams. Washington also played with the Germantown Hornets, another Philadelphia basketball team.

Washington spent most of her life in relative obscurity in her home town. When the Black Athletes Hall of Fame inducted her in March 1976, it was unaware that she had died in Philadelphia five years earlier.

REFERENCES

ASHE, ARTHUR R., JR. *A Hard Road to Glory: A History of the African-American Athlete 1919–1945.* New York, 1988.

Obituary. *Black Sports* 1, no. 4 (July-August 1971).

PETER SCHILLING

SASHA THOMAS

Washington, Valores J. "Val" (1903–), journalist and politician. Born in Columbus, Ind., Val Washington worked as a porter to support himself while attending Indiana University. He graduated with a degree in business administration and journalism. In 1924, he started to work for the Chicago magazine *Reflections,* then became editor and publisher of the *Gary Sun* in Indiana. His next job was in the publicity department of the Atlanta Casualty Insurance Company, the first company to offer casualty insurance to blacks. In 1934, Washington became general manager for the CHICAGO DEFENDER. He left that position in 1941 to serve on the Illinois State Commerce Commission.

In the mid 1940s, Washington moved to the District of Columbia, where he was director of the Republican National Committee's (RNC) minority division. At a time of rapidly diminishing African-American support for Republican candidates, Washington was instrumental in persuading 20 percent of black voters to cast their ballots for Republican Dwight D. Eisenhower in the 1952 presidential election. After Eisenhower's election, Washington used his influence with the president to lobby for key appointments of blacks in the administration as well as the greater presence of African Americans at White House affairs. E. Frederick MORROW, the Eisenhower appointee who was the first black White House aide, credits Washington's efforts on his behalf in securing Morrow's position.

In January 1961, upon John F. Kennedy's inauguration, Washington resigned his position with the RNC. He and several partners started an import-export business. For many years he headed the Booker T. Washington Foundation, a nonprofit ecnomic research organization headquartered in Washington, D.C. The foundation's research was conducted to foster the economic advancement of minorities. Washington was replaced as the organization's chairman on October 19, 1987, when he was named chairman emeritus of the board. In 1992, Washington, who at the age of eighty-nine was still managing his export business, spoke at the National Republican (GOP) convention held in Texas. The GOP Council, an organization founded in 1993, honored Washington at its first meeting.

REFERENCES

BOOKER, SIMEON. "Ticker Tape U.S.A." *Jet,* August 24, 1992, and August 9, 1993.

"Ike's Man Val." *Baltimore Afro-American,* September 22, 1956, p. 1.

MORROW, E. FREDERICK. *Forty Years a Guinea Pig.* New York, 1980, pp. 74 and 86.

"Washington's Notebook." *Ebony* (July 1981): 21.

LYDIA MCNEILL

Washington. African-American residence in the state of Washington began with the first settlement party in 1845. Their numbers have always been small

by comparison with their counterparts in other states, or by comparison with other groups in Washington, but they have been actively involved with the growth and development of the state since its beginning.

Wealthy Missouri landowner George Washington Bush and his family crossed the Oregon Trail in 1844, arriving in Oregon Territory shortly after a provisional government declared its opposition to the settling of persons of African descent. In 1845 the Bushes and their Missouri neighbors settled on land near Olympia, the state capital, where Bush became a successful farmer on what was considered unproductive soil.

Bush was the only African American to obtain original title to land in Washington. Some of his former Missouri neighbors serving in the new Washington Territorial legislature in 1854 knew of his integrity and generosity to newcomers, and persuaded the legislature to petition Congress to waive the provision in the 1850 Land Grant Act that withheld Donation Land claims from persons of African descent. A similar effort to have citizenship bestowed on Bush failed in the territorial legislature.

Bush's eldest son, William Owen, also a highly skilled farmer, represented the territory at the 1876 Centennial Exhibition in Philadelphia, earning several prizes for his grain specimens. Upon Washington's obtaining statehood in 1889, he became the first African American to serve in the state legislature, where he presented bills with an agricultural focus, particularly those promoting the establishment of a state agricultural college. Nine African Americans have served as legislators since 1891. A few others served in low-ranking appointed posts. From his position as assistant sergeant-at-arms of the first senate session, Civil War veteran John Conna successfully lobbied for inclusion of a public accommodations clause in the state's new constitution, which was ratified in 1890 (*Republican,* 1896).

Among the thirty African Americans enumerated in the first territorial census in 1860 was George Washington, a native of Virginia who settled in Lewis County on 160 acres after traveling from Missouri and stopping over in Oregon for a few years. In 1873 he and his wife, Mary Jane, and his stepson, Stacy Cooness, platted the town of Centralia, which had 12,000 residents in 1990 (Lewis County, 1873). Seven years before, a man referred to as "Big Antoine" began cultivating land that was later platted for the small eastern Washington town of Entiat (Kirk and Alexander 1990).

By the late 1860s most towns had African-American barbers, bootblacks, bathhouse operators, and restaurateurs, and in larger towns, hotel-keepers. By the end of the territorial period, people with professional training and skills arrived. Mississippi-born Horace CAYTON moved to Seattle in 1889 after stopping in Kansas for a few years, where he worked briefly for a newspaper. Four years later he assumed publication of the city's first African-American newspaper, which began in 1891. From 1894 until 1915 he published the *Seattle Republican,* which carried news of African-American communities throughout the state. In 1900 his wife, Susie Revels Cayton, daughter of Senator Hiram REVELS of Mississippi, became associate editor of the *Republican.* The paper was a staunch advocate of the REPUBLICAN PARTY, sobriety, and women's suffrage. Most of the major cities of Washington have had African-American newspapers for varying lengths of time. Seattle has had at least one black newspaper throughout the past hundred years (Mumford 1980).

Washington's African-American population did not reach 1,000 until hundreds of coal miners were brought into the central part of the state during a strike in the late 1880s. Before the close of the century, some of the mining families moved to eastern Washington homesteads, where some became hop farmers. After irrigation was introduced, some became truck farmers and orchardists. A few moved to cities, where they joined other African Americans as laborers or in menial work. African-American women were mostly domestics.

Spurts in population growth were evident during the Gold Rush of the 1890s, and during World War I, with a small decline in the 1920s. The 1940 African-American population of fewer than 8,000 quadrupled in response to the military buildup, which provided job openings in the state's shipyards, aircraft and aluminum manufacturing, and plutonium production. A decline in population accompanied the war's end, but a steady increase has been recorded in the past three census enumerations, with the 1990 census listing almost 150,000 (Bureau of the Census 1990).

During World War II African Americans worked in jobs from which they had previously been barred, and which some whites viewed as temporary, but African Americans were determined to maintain. After much resistance in many occupations, African Americans now work in a variety of occupations well removed from the traditional menial ones in which most were employed before the war. Their average household income in two western Washington cities, Kent and Redmond, exceeded that of whites in 1990.

In the 1960s Washington experienced racial tensions in the major cities which led to efforts to avert violence. Open housing laws were passed after initial rejections. Seattle schools established a citywide voluntary desegregation system. Public accommodation laws were enforced and job training programs established. Since 1975 African Americans have served as mayors of Seattle, Spokane, and Roslyn, a small east-

ern Washington town. African Americans also serve in a variety of official county and local capacities, ranging from fire chief to county assessor.

A few months before statehood, the first African-American church in the state, the African Methodist Episcopal Church, was established in Tacoma. Others quickly followed in major population centers. An upsurge in the number of denominations and churches came with the burgeoning population of World War II. Churches continue to be major focal points in the life of the population.

Washington has been the home of some of America's foremost artists over the years. Such musicians as Jimi HENDRIX, Quincy JONES, Ray CHARLES, Ernestine Anderson, and Robert Cray lived in the state at some period in their lives. The painter Jacob LAWRENCE lives in Seattle, as does 1990 National Book Award winner Charles JOHNSON. Dramatist August WILSON moved to Seattle in 1990.

In 1990 African Americans constituted three percent of Washington's population, a small number compared to African Americans in other states. They came seeking freedom, land, and economic opportunity, and for the most part, the majority have achieved at least part of their goal.

REFERENCES

Bureau of the Census. *1990 Census of Population, Housing, Summary of Population and Housing Characteristics, Washington.* Washington, D.C., 1991.

KIRK, RUTH, and CARMELA ALEXANDER. *Exploring Washington's Past: A Road Guide to History.* Seattle, 1990.

Lewis County Auditor. *Plat of the Town of Centerville.* Vol. 1. Lewis County, Wash., 1875.

MUMFORD, ESTHER H. *Seattle's Black Victorians, 1852–1901.* Seattle, 1980.

"Special Edition." *Seattle Republican* 3, no. 1, January 3, 1896.

ESTHER HALL MUMFORD

Washington, D.C. The ten-mile-square District of Columbia, carved from Maryland and Virginia, the two most populous slave states in the United States, was created in 1791. (The Virginia portion reverted to Virginia early in the nineteenth century.) Blacks were the largest population group in the area when the site was selected for a federal district, and their labor supported the region's plantation economy. The black mathematician and almanac-maker Benjamin BANNEKER helped survey the land for the planned city. In 1800, when the nation's capital was moved there, more than a quarter of its population was black, and about a quarter of those were free. In 1814, when Washington was attacked by British troops, free blacks helped build barricades, and several volunteered as soldiers to defend the city.

As the district's population grew, slavery remained common. While there were plantations in its outlying areas as well as estates such as those of Robert E. Lee in Alexandria and Arlington, most slaves worked as skilled and unskilled laborers—as domestics, coachmen, carpenters, barbers, and teamsters and in other trades—in the capital city. Washington's central location and position as a port made it an important nucleus of the domestic slave trade. Slave jails, known as "Georgia pens," dotted the city, Kephart, Armfield and Franklin, and other large traders were established in the area.

The city of Washington developed into an entrenched slave society. Slaves and free blacks were tightly restricted by a series of BLACK CODES more restrictive than those of either of the surrounding states. Free blacks had a curfew, were required to post good behavior bonds, forbidden to operate businesses, and, after NAT TURNER'S REBELLION in 1831 (*see also* NAT TURNER CONTROVERSY), banned from preaching. Slavenapping and antiblack violence were chronic problems. For example, in 1835, white mobs at the Washington Navy Yard rioted. Mobs broke into and burned several homes and tore down schools, forcing dozens of black residents to flee. The same year, blacks in Georgetown were set upon by an antiabolitionist lynch mob, and Ben Snow's restaurant was burned down by a group of white workers.

Despite the restrictions, a vibrant free black community, led by such figures as merchant Absalom Shadd, stablekeeper James Wormley, and feed dealer Alfred Lee, grew up in Washington in the years before the CIVIL WAR. Blacks in Washington managed to provide for many of their own community needs. No institution played a more significant role in the community's viability than did the church. When segregated by white churches, blacks built their own. The first independent congregation, Mount Zion Negro Church of Georgetown, was formed in 1814. Several important churches, such as Union Bethel Church (later Metropolitan African Methodist Episcopal Church) in 1838, the First Negro Baptist Church in 1839, and First Colored (late Fifteenth Street) Presbyterian Church in 1841 were established during the period; all continue to form a large part of the backbone of the community's social and political infrastructure. Under the guidance of John F. Cook, a former slave who was pastor of the Fifteenth Street Church, and founder of its Union Seminary school, a strong District of Columbia chapter of the Negro Convention movement was founded. Blacks also organized fraternal societies, notably the Resolute

Beneficial Society, and developed cultural institutions. In 1853, for example, Anthony Bower organized a black branch of the YOUNG MEN'S CHRISTIAN ASSOCIATION.

Educational institutions were a primary concern of black Washingtonians. In 1807, former slaves George Bell, Moses Liverpool, and Nicholas Franklin founded a school. Several schools were later set up by African-American women, such as Louise Parke Costin; Maria Becroft, who founded a short-lived school in 1820 and seven years later cofounded what may have been the nation's first black girl's school; and Mary Wormley, who founded a school in 1830 with donations from her well-to-do brother. In 1851, Myrtilla Miner, a white woman, set up a black women's academy, which grew into the Miner Normal School after the Civil War and became the University of the District of Columbia in the 1970s.

As abolitionist activity increased (*see* ABOLITION), Washington became a symbol and a battleground in the struggle for freedom and equality. Its slaves served as an embarrassing reminder of the hold of the institution of slavery on the federal government. Congress had the power to abolish SLAVERY in the district, and many congressmen (including Abraham Lincoln during his term in the House) called for gradual, compensated EMANCIPATION, but southern influence prevented passage of such a measure, though the slave trade was restricted in the city as part of the COMPROMISE OF 1850.

The Civil War radically transformed Washington. Slavery was abolished in the District of Columbia with compensation to loyal slaveholders in the spring of 1862. With the freeing of the district's slaves and the Emancipation Proclamation in the following year, blacks volunteered en masse for the Union Army, and some 3,000 black District of Columbia troops saw action in the Civil War. Meanwhile, the city and its surrounding forts became a haven for blacks seeking to escape slavery and the ravages of war. The government considered various schemes to colonize the black residents. Several hundred freed slaves were transported to a short-lived colony at Ile de Vache, Haiti, before returning to "Freedmen's Village" on the Arlington estate of Maria Syphax, an African American. Despite such efforts, housing resources were strained by the migration, and many newcomers were housed in tents or barracks. "Alleys" were hastily constructed in back of existing houses to provide makeshift housing. Though badly lit and unsanitary, they housed the majority of blacks in the city for decades.

By the end of the Civil War, some 40,000 contrabands and emancipated slaves had settled in the nation's capital, and more followed in subsequent years. By 1870, the black population had tripled in ten years and represented one-third of the total. The newcomers came primarily from Maryland and Virginia, had little education and few skills to aid them in adapting to an urban environment, and were largely unable to secure employment. Several black charitable organizations sprang up to aid them. The first was the Contraband Relief Association, established by White House seamstress Elizabeth KECKLEY in 1862. The following year, the Freedman's Hospital was created under the leadership of African-American physician Alexander AUGUSTA. Other private philanthropy coupled with national efforts—such as the Association for the Relief of Destitute Colored Women and Children, the National Freedmen's Relief Association of the District of Columbia, and the Freedmen's Bureau (*see* BUREAU OF REFUGEES, FREEDMEN, AND ABANDONED LANDS)—contributed much to the survival of Washington's fast-growing black population during and after the war.

During RECONSTRUCTION, Washington became the center of African-American life. The area became a focus of activity as the federal government became the benefactor of black Americans. Federal government organizations such as the Freedmen's Bureau and the FREEDMAN'S BANK were created in the city. Meanwhile, the government became the city's largest employer, and black workers found jobs as clerks, messengers, and laborers in government facilities. Notable blacks, among them Alexander CRUMMELL, Frederick DOUGLASS, John Mercer LANGSTON, and Francis J. GRIMKE, settled in the city, and formed the core of a growing black elite. Black politicians, notably Mississippi Sen. Blanche K. BRUCE, arrived to serve their terms. Bruce was among the many of this group who settled in Washington after leaving office and occupied patronage positions. Others, such as elite hotelkeeper William Wormley, entered business.

A vibrant press developed to serve this highly literate black community, starting with Frederick Douglass's *New National Era* (1870–1874) and continuing with the founding of the *Washington Bee* by William Calvin Chase in 1882. Chase edited and published the journal until his death in 1922. Unswerving in his advocacy on behalf of his people, Chase was often caustic in his indictment of those aligned against the best interests of blacks as he saw them, and the paper lived up to its slogan, "Stings for Our Enemies—Honey for Our Friends." While E. E. Cooper's *Colored American* (1898–1904), the *Tatler,* the *Washington Tribune,* and the Washington edition of the *Baltimore Afro-American* would also contribute to a lively black press through the years, no paper was as bold, or as historically and politically important, as the *Bee.*

An important focus of community effort was education. Segregated public education was provided as

early as 1862, and a black school board was created in 1865. Equal school funding was obtained in 1868. That year, George Cook became superintendent, and he remained in the post until 1900. In 1865, Wayland Seminary (later part of the Richmond, Va.–based Virginia Union University) was established.

In 1867, HOWARD UNIVERSITY was established with the support of the Freedmen's Bureau, members of the First Congregational Church, and the federal government; it offered a wide range of educational programs, including the country's first and most important black law school. In many ways its Preparatory Department was the first essentially public black high school in the city. However, the Colored Preparatory High School, created out of the 15th Street Presbyterian Church's Union Seminary in 1870, is generally credited as the first such school in the city. In 1891, it became the renowned M Street (later Dunbar) High School.

In Washington, as in other southern cities, most of the gains blacks made during Reconstruction were quickly overcome. The most significant reverse was in political power. In 1866, suffrage was extended to black males and in 1868, John F. Cook, Jr., and Stewart Barber were elected to the board of aldermen. Many conservative whites, fearing the influence enfranchised blacks might have in elections, formed the Citizens Reform Association in opposition to liberal mayor Sayles Bowen and in 1870 submitted to the Congress a plan for territorial government, which was adopted in a revised form in 1871. In 1874, with the support of the majority white population, Congress abolished all local suffrage and established an appointive three-commissioner system. The board remained all-white until 1961.

Blacks in Washington were stifled by discrimination in the last quarter of the nineteenth century and first quarter of the twentieth. Some prominent blacks such as Frederick Douglass continued to occupy patronage positions in government. Douglass and Blanche Bruce were recorders of deeds for the District, while others such as Andrew HILLYER served as register of the Treasury. Still, most black people remained in low-level positions regardless of their education or skills. Although black professionals contributed to Washington's stable, influential middle class, they also often found too few opportunities to use their talents. The black community, isolated from mainstream white society, developed an elaborate pecking order based upon education, economic status, social standing, and in some instances color consciousness. Differences among blacks were generally ignored in relations with whites, who made little distinction between classes of blacks. In any case, while this color and class consciousness has often served to divide Washington's black community, it never pre-

vented the established black community from assisting its less fortunate brethren wherever possible.

In the face of discrimination, blacks built their own institutions. They would achieve a level of attainment that was envied by those in regions where such achievement was more difficult and often impossible. Whatever was lacking in physical resources and fiscal commitment was offset by the efforts of well-qualified and talented black teachers. Both the M Street High School and Howard University attracted faculties representing the highest quality of academic attainment. Under the leadership of its longtime dean Kelly MILLER, Howard hired large numbers of black faculty and became a leading center for African-American thought. Meanwhile, in 1884 former South Carolina Secretary of State Francis CARDOZO became the M Street High School's first black principal. He was succeeded by Robert Terrell, a future District of Columbia municipal judge. He was followed by writer-educator Anna Julia COOPER, who was ousted as principal in 1906 after leading the effort to maintain the school's strong academic curriculum in the face of a Booker T. WASHINGTON–influenced attempt to focus the school's courses primarily upon industrial and manual arts. In 1929, Cooper became the president of Frelinghuysen University, a pioneer night school for working adult African Americans.

Between the end of Reconstruction and the end of World War I, several important social and fraternal organizations were established in the city. These included the Colored American Opera Company (1879); Bethel Literary and Historical Association (1881); Medico-Chirurgical Society (1884); Colored Women's League (1892); MuSoLit Club (1905); Second Baptist Lyceum and Congressional Lyceum; and local branches of the Elks, Oddfellows, Masons, and Knights of Pythias. In addition, the Twelfth Street YMCA (1912) and the Phillis Wheatley YWCA (1905) were important additions to the city's community life. Music was ubiquitous in the city. In 1903, Andrew and Mamie Hillyer founded the Samuel Coleridge-Taylor Choral Society. The Amphion Glee Club and the Washington Folk-Song Singers, led by composer Will Marion COOK, were also popular.

During the period, such important national groups as the AMERICAN NEGRO ACADEMY (1897) and Carter G. WOODSON's Association for the Study of Negro Life and History (1915) were founded in Washington. Omega Psi Phi fraternity and Alpha Kappa Alpha and Delta Sigma Theta sororities were developed at Howard University (see FRATERNITIES AND SORORITIES). In 1912 the NAACP established a Washington branch.

While Washington's black elites coalesced around issues important to the uplift of the race during the

first part of the twentieth century, the city's masses of poor, undereducated residents attempted merely to survive. Washington continued to be a magnet attracting black migrants. By 1920, it had the third largest urban black population (110,000) in the country and was one-fourth black.

While well-to-do blacks, such as Robert and Mary Church TERRELL, Anna Julia Cooper, and Paul Laurence DUNBAR, settled in Le Droit Park, an exclusive, originally white enclave near Howard University, the migrants settled largely in Southwest Washington, as well as Capitol Hill and the northwest parts of the city, where they were plagued by disease, poor housing, and crime. In 1891, the black mortality rate was nearly twice the white rate. The overcrowded and underfunded FREEDMEN'S HOSPITAL was the only city facility open to blacks. Housing and public facilities were largely segregated. Racially restrictive housing covenants were strictly enforced. As early as 1914 the Congress outlawed alley housing, and the Alley Dwelling Act of 1934 provided that the worst areas be razed and inhabitants relocated. However, little was done during the first half of the century.

Black employment opportunity declined significantly during the period, even though many craftsmen were able to use their skills in the development of various large city projects. Union Station, which opened in 1907, was a notable instance. (Its snack bar long remained the only restaurant in the Capitol area open to blacks.) Because most unions remained closed to blacks, however, service trades offered the main opportunity to enter business. A large percentage of blacks worked as unskilled laborers and domestics. Blacks in the federal service, who numbered some 10 percent of the work force in 1891 (almost all in the lowest-paying and least responsible positions), found fewer jobs under presidents Theodore Roosevelt and William Howard Taft, partly as a result of civil service reform. Jobs open to blacks were further reduced under Woodrow Wilson, who approved the segregation of the workforce and signed a bill segregating public transportation in the city.

The period after World War I changed black Washington forever. During the RED SUMMER of 1919, exaggerated reports by the city's white press created a climate of discord among thousands of white troops stationed in Washington, while many blacks were inflamed by the failure of the city to include the city's First Separate Battalion—a highly decorated black unit—in the local victory parade. In July two black men allegedly attacking a white woman were set upon by an unruly mob of sailors and marines armed with clubs and guns, who then proceeded to attack blacks throughout the city indiscriminately. Many black servicemen responded with armed violence in self-defense.

The riot continued for two days and focused national attention on race relations in Washington. It also catalyzed black civil rights efforts. A Parents League, formed that year to protest the treatment of blacks in the public schools, campaigned unsuccessfully for the dismissal of Roscoe Conkling Bruce, an African American, as the assistant superintendent for colored schools. The league was an important development in the city's race relations; it provided a unifying influence and helped restore calm after the riots. In 1920, Community Services, an organization of civic volunteers, and the Council of Social Workers were established to improve race relations. Neither effort lasted; segregation persisted. The dedication ceremony in 1922 of the Lincoln Memorial was held under segregated conditions. A decade later, the Community Chest was founded to provide much needed cooperation among blacks and whites in tackling community problems.

Washington's black community played a significant role in the formation of the NEW NEGRO during the 1920s and '30s. Alain LOCKE and Sterling A. BROWN were important teachers and writers contributing to the period's flowering of black culture. Washington natives Duke ELLINGTON, Florence MILLS, and Jean TOOMER were among those who sought the more enlightened atmosphere of New York. The poet Georgia Douglas JOHNSON held gatherings known as Saturday Nighters, which attracted a large group of writers and intellectuals.

Black culture continued to thrive. U Street became the center of a vibrant entertainment district. The Howard Theater presented movies and shows; cabarets and dance halls proliferated; and jazz musicians such as Ellington, Sonny GREER, and Otto Hardwick got their start in the city's clubs. Sports were also popular. The city had several sandlot BASEBALL teams, as well as Negro League clubs such as the Washington Elite Giants. The AMERICAN TENNIS ASSOCIATION was formed by local tennis enthusiasts.

During the Great Depression, blacks in Washington were as affected as those in other areas. Black community sources were mobilized to aid the needy. Elder Lightfoot MICHAUX's Church of God provided significant relief, while Sweet Daddy GRACE created a pension plan for his Apostolic church members. The coming of Franklin Roosevelt and the New Deal raised the hopes of black Americans everywhere, and Roosevelt's Black Cabinet of African-American advisers drew heavily on local black talent. Public works such as the Langston Terrace projects were built for blacks. However, government aid was hardly enough to stem the effects of the depression.

Civil rights efforts increased during the era. The New Negro Alliance (NNA) was formed in 1933 to fight against rampant discrimination in the city. The

NNA's "Don't Buy Where You Can't Work" protest and boycott campaign was instrumental in reducing employment exclusion. Walter E. Washington, Charles H. HOUSTON, William HASTIE, Robert C. WEAVER, Mary Church Terrell, Nannie Helen BURROUGHS, and Mary McLeod BETHUNE were among those who played an important role in its efforts. National organizations such as the Joint Committee on National Recovery and the NATIONAL NEGRO CONGRESS were also founded in the city. In 1935, Howard University students picketed the segregated National Theater. In 1939, after being denied the use of Constitution Hall, Marian ANDERSON sang before 75,000 at the Lincoln Memorial, where blacks had earlier been second-class citizens. Two years later, A. Philip RANDOLPH's threat of a march on Washington forced the Roosevelt administration to create the FAIR EMPLOYMENT PRACTICES COMMITTEE (FEPC). In 1942, the NAACP opened a powerful Washington bureau to lobby for civil rights legislation.

The coming of World War II led to an influx of black workers, which strained the city's limited black housing resources. While Foggy Bottom and Southwest remained large black areas, the greatest number

Government charwoman Ella Watson, Washington, D.C., 1942, photograph by Gordon Parks. (Prints and Photographs Division, Library of Congress)

of blacks settled around U Street, and others were scattered among the city's Ivy City, Barry Farm, Deanwood, Fort Reno, Kingman Park, and Capitol View districts.

Discrimination remained widespread. In 1945, FEPC advisor Charles H. Houston resigned when President Truman refused to press an antidiscrimination suit against the city's Capital Transport Company. In 1949, Nobel laureate Ralph BUNCHE, a former Howard University professor, publicly declined Truman's offer to name him assistant secretary of state, refusing to raise his family in segregated Washington. In 1949, the Co-ordinating Committee for the Enforcement of the District of Columbia Anti-Discrimination Laws, led by the venerable Mary Church Terrell, was formed, and began boycotting and picketing department stores that refused service to blacks. In 1950, the committee brought suit against the Thompson Restaurant, based on two civil rights ordinances passed in 1872 and 1873 and long unenforced. In 1953, the U.S. Supreme Court upheld the laws. The protests, capped by the legal victory, led to the end of Jim Crow in the city. Meanwhile, the Consolidated Parents Group formed to fight school segregation. In 1954, in *Bolling v. Sharpe* (one of the BROWN V. BOARD OF EDUCATION cases), the U.S. Supreme Court integrated District schools.

The early years of desegregation witnessed the migration of whites from the city and their virtual abandonment of the public school system. By the late 1950s, Washington was a black majority city—the first such large city in the nation. Housing remained an enormous problem. The city's slums became the targets of urban renewal, which resulted in the removal of many blacks. Banks refused to make loans to blacks for houses outside black areas, and owners, builders, and realtors all hindered black housing mobility. Even after the courts outlawed such practices, generations of discrimination in housing and economic opportunity limited black urban residential migration.

The CIVIL RIGHTS MOVEMENT focused attention on the nation's capital with the Prayer Pilgrimage in 1957; the Youth March for Integrated Schools in 1958; the great March on Washington in 1963; and the POOR PEOPLE'S WASHINGTON CAMPAIGN of 1968, during which Resurrection City, a tent city, was set up in the capital (*see also* Ralph ABERNATHY). In 1968, after the assassination of the Reverend Dr. Martin Luther KING, Jr., the city was shaken by rioting.

Since 1960, Washington has changed significantly. Black outmigration has increased the suburban population dramatically, while the city's population has fallen. The most important gain for blacks has been in political power. In 1961, John Duncan was ap-

pointed to the district board of commissioners. The same year, ratification of the Twenty-third Amendment gave district residents the right to vote in presidential elections. In 1967, after pressure by the "Free D.C." home rule movement, the board of commissioners was abolished, and Walter WASHINGTON was appointed as the city's first black mayor; he was elected in 1974. Although Congress continues to wield an important degree of power, blacks and the city in general made great strides in self-determination during the 1970s and '80s. In 1971, Walter Fauntroy was elected the district's nonvoting delegate to Congress. Although a constitutional amendment to give Washington representation in the Senate and House failed to achieve ratification in 1985, in 1991 the District House delegate, Eleanor Holmes NORTON, received limited voting powers.

Despite these gains, many problems remain. While African Americans are employed throughout the city's agencies and private institutions, and numerous black professionals have obtained important private and government positions, many blacks continue to be employed in the lower-paying and least-responsible positions. Many blacks remain in decrepit housing, and the gentrification of black areas has increased housing costs. Health services and education continue to be uneven. Drugs and crime remain blots upon the reputation of the city and its residents. Mayor Marion BARRY's conviction on drug charges in 1989 led to embarrassing revelations of corruption and drug use in his administration. In 1993, Barry's successor, Sharon Pratt Dixon (the first African-American woman mayor of a city of over 500,000 residents) called unsuccessfully for federal troops to help fight crime.

Washington remains a black cultural center, with such notable institutions as Howard's Moorland-Spingarn Research Center and the Smithsonian Institution's National Museum of African-American Art. The city has been the birthplace in recent decades to many distinguished blacks, including singer Marvin GAYE; basketball star Elgin BAYLOR; U.S. Sen. Edward BROOKE; educator Allison Davis; writer and artist Richard Bruce Nugent; poet Dudley RANDALL; and writer John Edgar WIDEMAN. It has also become the home of government officials and of such figures as activist Marian Wright EDELMAN, poet Essex Hemphill, journalists Carl ROWAN and Roger Wilkins, and basketball coach John THOMPSON.

REFERENCES

BORCHERT, JAMES. *Alley Life in Washington: Family, Community, Religion, and Folklife in the City, 1850–1970.* Urbana, Ill., 1980.

BROWN, LETITIA W. *Free Negroes in the District of Columbia, 1790–1846.* New York, 1972.

GREEN, CONSTANCE MCGLAUGHLIN. *The Secret City: A History of Race Relations in the Nation's Capital.* Princeton, N.J., 1967.

INGLE, EDWARD. *The Negro in the District of Columbia.* 1893. Reprint. New York, 1973.

JOHNSTON, ALLAN JOHN. *Surviving Freedom: The Black Community of Washington, D.C., 1860–1880.* New York, 1993.

LIEBOW, ELLIOTT. *Talley's Corner: A Study of Negro Streetcorner Men.* Boston, 1967.

"The Negro in Washington." In *Washington, City and Capital.* Washington, D.C., 1937, pp. 68–90.

THOMAS C. BATTLE

Washington, D.C., Riot of 1919.

The 1919 riot in Washington, D.C., part of the racial violence of the RED SUMMER, focused national attention on the issues of violence and racial inequality in the nation's capital. The city's African-American population had increased substantially during the previous years, and racial tension was increased at the end of WORLD WAR I by the increasingly assertive demands of proud black veterans. The riot came about as a result of sensational articles which appeared in the white press, notably the *Washington Post,* during July 1919. Articles focused on an alleged black crime wave and claimed black men had attempted rapes of white women. NATIONAL ASSOCIATION FOR THE ADVANCEMENT OF COLORED PEOPLE (NAACP) officials protested the falsehoods and exaggerations to the newspaper and the federal government, and warned of possible repercussions, but to no avail.

On July 19, *Post* reporters distorted a minor interracial argument, charging that a group of blacks had sexually assaulted a white girl. White sailors and marines, seeking to lynch the black culprits, advanced into African-American areas of Washington, beating black passersby and illegally breaking into black homes. Police dispersed the mob and arrested two sailors. Eight blacks were brought in for questioning. The NAACP implored Secretary of the Navy Josephus Daniels to cancel all naval shore leave, but he refused. Despite the NAACP's demands, no action was taken against the guilty military personnel.

The next night, Sunday, brought massive violence. When police arrested a young black man on a minor charge, a large crowd of blacks and whites gathered. White rioters grabbed the man and began to beat him before he was rescued by police. Sailors and soldiers in the area roamed the streets all night, and attacked at least four other blacks. The following morning, the *Post* offered an unsubstantiated report of a major mobilization of service men in the city. During daylight hours, blacks armed themselves and

began attacking whites on streetcars and shooting guns from automobiles. Monday evening the violence escalated. Over 1,000 white rioters converged on the black areas of Washington but were held back by police barricades. Blacks behind the barrier fired on the mob.

The following day, Maj. Gen. William G. Hann took control and called in provost guard troops to supplant ineffective police efforts at riot control. With help from black and white clergy, and the NAACP, the day remained peaceful. During the night, there was a heavy rain, and the riot dissipated. Black leaders were assured there would be no racial discrimination in the sentences given the hundreds of rioters arrested during the riot, but black rioters drew harsh sentences. The NAACP led an unsuccessful drive for executive clemency, and collected 30,000 signatures on a petition.

The underlying causes of the riot remain uncertain. One unique feature of Washington race relations that might have led to the riots was the rise of black economic power in the city. During the 1910s, many southern whites came to the city to take on civil service jobs in the Wilson administration. Blacks faced segregation and exclusion in government work, and left the civil service. The expanding economy during World War I made work in private industry more lucrative than public service, and soon many blacks were making more money than whites, who resented their success.

See also URBAN RIOTS AND REBELLIONS.

REFERENCES

BERGMAN, PETER M. *The Chronological History of the Negro in America.* New York, 1969, p. 388.
GREEN, CONSTANCE McGLAUGHLIN. *The Secret City: a History of Race Relations in the Nation's Capital.* Princeton, N.J., 1967.

GAYLE T. TATE

Waters, Ethel (October 31, 1896?–September 1, 1977), singer and actress. Ethel Waters was born in Chester, Pa. She came from a musical family; her father played piano, and her mother and maternal relatives sang. Her first public performance was as a five-year-old billed as Baby Star in a church program. Waters began her singing career in Baltimore with a small vaudeville company where she sang W. C. HANDY's "St. Louis Blues," becoming, apparently, the first woman to sing the song professionally. She was billed as Sweet Mama Stringbean.

About 1919 Waters moved to New York and became a leading entertainer in Harlem, where her first

engagement was at a small black club, Edmond's Cellar. As an entertainer, she reached stardom during the HARLEM RENAISSANCE of the 1920s. In 1924, Earl Dancer, later the producer of the Broadway musical *Africana,* got her a booking in the Plantation Club as a replacement for Florence MILLS, who was on tour. When Mills returned, Waters toured in Dancer's *Miss Calico.* By then, Waters had begun to establish herself as an interpreter of the blues with such songs as Perry Bradford's "Messin' Around." In 1921, she recorded "Down Home Blues" and "Oh Daddy" for Black Swan Records. The success of her first recording led her to embark on one of the first personal promotion tours in the United States.

In 1932 and 1933 Waters recorded with Duke ELLINGTON and Benny Goodman, respectively. Her renditions of "Stormy Weather," "Taking a Chance on Love," and "Lady Be Good" were closer stylistically to jazz than to popular music. She sang with the swing orchestra of Fletcher HENDERSON, who was her conductor on the Black Swan tours. Though her performances were unquestionably potent, many

Ethel Waters, a leading entertainer of the 1920s and '30s, in costume in 1935. (AP/Wide World Photos)

critics did not consider her a real jazz performer but rather a singer who possessed a style that was more dramatic and histrionic than jazz-oriented. However, Waters, along with Billie HOLIDAY and Louis ARMSTRONG, significantly influenced the sound of American popular music. Though generally regarded as blues or jazz singers, all of them sang the popular songs of their day like no other singers of the period.

"Dinah" (first performed in 1925), "Stormy Weather," and "Miss Otis Regrets" were among Waters's most popular songs. Later she recorded with Russell Wooding and Eddie Mallory, among others. Beginning in 1927 she appeared in Broadway musicals, including *Africana* (1927), Lew Leslie's *Blackbirds of 1930, Rhapsody in Black* (1931), *As Thousands Cheer* (1933), *At Home Abroad* (1936), and *Cabin in the Sky* (1940). All these roles primarily involved singing.

It was not until the Federal Theatre Project (FTP) that she had the chance to do more serious and dramatic roles. Waters received excellent reviews for her performance in Shaw's *Androcles and the Lion,* which led to her being cast as Hagar in Dubose and Dorothy Heyward's *Mamba's Daughters* (1939), for which she again received good notices. Ten years later, she was acclaimed for her performance as Berenice in Carson McCullers' *The Member of the Wedding* (which won the Drama Critics Circle Award for Best American Play of the Year in 1950).

Waters appeared in nine films between 1929 and 1959, the most popular being *Pinky,* which garnered her an Academy Award nomination as Best Supporting Actress (1949). From 1957 to 1976 she toured with evangelist Billy Graham's religious crusades in the United States and abroad and became celebrated for singing "His Eye Is on the Sparrow." This song became the title of her first autobiography, which was published in 1951. A second autobiography, *To Me It's Wonderful,* was published in 1972. Waters died in 1977, following a long bout with cancer.

REFERENCE

HASKINS, JAMES. *Black Theater in America.* New York, 1982.

JAMES E. MUMFORD

Waters, Maxine Moore (August 15, 1938–), congresswoman. The daughter of Remus Carr and Velma Moore, Maxine Moore was born in St. Louis, Mo. She attended the public schools in St. Louis and married Edward Waters immediately upon graduation from high school. In 1961, she moved with her husband and two children to the Watts section of Los Angeles. After working at a garment factory and as an operator for Pacific Telephone, Waters was hired in 1966 as an assistant teacher in a local Head Start program and later was promoted to supervisor.

In 1971 Waters received her bachelor's degree in sociology from California State University at Los Angeles. She became active in local and state politics, serving as a chief advisor for David S. Cunningham's successful race for a city council seat in 1973. After Cunningham's election, Waters became his chief deputy.

In 1976 Waters was elected to the California State Assembly, where she served for fourteen years. She represented the Watts area and was a noted spokesperson for women's issues. In 1978 she cofounded the Black Women's Forum, a national organization designed to provide a platform for the discussion of issues of concern to black women—programs for the poor and minorities, and divestiture of investments in South Africa. Among her many achievements, Waters helped establish the Child Abuse Prevention Training Program and sponsored legislation to protect tenants and small businesses, to impose stringent standards on vocational schools, and to limit police strip-and-search authority. Waters served as the assembly's first black female member of the Rules Committee and the first nonlawyer on the Judiciary Committee.

In 1990 Waters was elected to represent a wide area of South Central Los Angeles in the United States House of Representatives. In the ensuing years, she voiced her criticism of the United States involvement in the Persian Gulf War and advocated a number of reintegration services for black troops upon their return home.

Following the outbreak of riots in her Los Angeles district after the acquittal of the police officers charged in the Rodney King case in April 1992, Waters received national attention for her statements about the root social causes of the riots. In 1993 Waters proposed legislation for the Youth Fair Chance Program, an inner-city job training program, and supported passage of AIDS and abortion-rights legislation. Over the course of her first two terms, Waters rapidly emerged as a major spokesperson for the black community and one of the most prominent women in Congress.

REFERENCES

MATHEWS, JAY. "California Freshman Brings a Warm Touch to Her Firm Stance." *Washington Post,* February 19, 1991, p. A14.
NEWMAN, MARIA. "Lawmaker from Riot Zone Insists on a New Role for Black Politicians." *Washington Post,* May 19, 1992, p. A18.

LOUISE P. MAXWELL

Waters, Muddy. *See* Muddy Waters.

Waters, Sylvia (c. January 22, 1940–), dancer and artistic director. Born and raised in New York City, Waters began modern dance study in junior high school, continued formal training at the New Dance Group of New York City, and in 1962 graduated from the dance department of the prestigious Juilliard School. In the early 1960s Waters performed with Donald McKayle's dance company, and received a scholarship to study at the Martha Graham School of Contemporary Dance. In 1964 she embarked on a seven-month European tour dancing in Langston HUGHES's musical *Black Nativity*. She settled in Paris for three years, where she worked on television and with Michel Descombey of the Paris Opera Ballet. Living in Europe made her "homesick for modern dance," and after dancing at the 1968 Olympics in Mexico City with Maurice Béjart's Ballet of the Twentieth Century, Waters returned to the United States. She joined the Alvin Ailey American Dance Theater in 1968 (*see* Alvin AILEY) and remained a company member until 1975, at which time she took over directorship of the Alvin Ailey Repertory Ensemble. Under Water's direction, the ensemble, a junior performance group created to provide an introduction to dance through lecture demonstrations and master classes, garnered significant recognition from the dance press and the public by performing the works of experimental choreographers Donald Byrd, Ulysses DOVE, Ralph Lemon, Bebe MILLER, Kevin Wynn, and classic works by Ailey.

REFERENCE

JOHNSON, ROBERT. "Alvin Ailey Repertory Ensemble Carries on Without Ailey." *Dance Magazine* (February 1990): 20.

THOMAS F. DEFRANTZ

Wattleton, Faye (July 8, 1943–), activist. Faye Wattleton has dedicated her career to securing reproductive rights and equal access to health care for poor women and men. Wattleton was born and raised in St. Louis, in a working-class home. She received a degree in NURSING in 1964 from Ohio State University and an M.S. degree in maternal and infant health care from Columbia University. While studying at Columbia, Wattleton interned at Harlem Hospital and began to focus her attention on the devastating effects of illegal abortions. She went on to work for the public health department in Dayton, Ohio, and there became involved with the local Planned Parenthood. Soon she was head of this local organization.

In 1978 Wattleton became president of the Planned Parenthood Federation of America, the oldest organization in the country to provide information on BIRTH CONTROL, and one that serves millions of people around the world each year. As the head of this organization, Wattleton has confronted the federal and state governments and the courts on the issue of abortion, protesting restrictions on women's health choices. She has also made Planned Parenthood an important resource for information on AIDS prevention.

Wattleton is the author of *How to Talk to Your Children About Sex,* and has received many honors for her years of service. In 1992 she resigned from her position at Planned Parenthood to pursue other career interests that would give her experience in a broader range of issues.

REFERENCES

GILLESPIE, MARCIA ANN. "Repro Woman." *Ms.* (October 1989): 50–53.
LANKER, BRIAN. *I Dream a World: Portraits of Black Women Who Changed the World.* New York, 1989.
SZEGAEDY-MASZAK, MARIANNE. "Calm, Cool, and Beleaguered." *New York Times Magazine* (August 6, 1989): 16–19.

JUDITH WEISENFELD

Watts, André (June 20, 1946–), concert pianist. Born in Nuremberg, West Germany, at an army base, the son of a Hungarian mother and African-American soldier father, André Watts started piano study at age six with his mother. As a young man he studied at the Philadelphia Academy of Music and at Peabody Institute in Baltimore, Maryland. During this period he had the opportunity to perform as a soloist several times with the Philadelphia Orchestra, performing concerted piano works by Haydn, Mendelssohn, and Franck. In 1962, at sixteen, he achieved instant star status with his performance of the Liszt E-flat Piano Concerto with the New York Philharmonic Orchestra under Leonard Bernstein when the scheduled performer, Glenn Gould, became ill. During this period and until 1974, he studied with Leon Fleisher. His European debut dates from 1966 with the London Symphony Orchestra, and his solo tours have included the United States, Europe, Japan, Israel, and the former U.S.S.R. Watts's performances and recordings, known for their vitality and energy, range from Haydn to Debussy, though he is best known for his interpretations of the Romantic rep-

ertory, especially Liszt. In January 1988 he celebrated the twenty-fifth anniversary of his New York Philharmonic debut with a nationally televised concert. His honors include a 1964 Grammy for Most Promising Classical Artist, the Lincoln Center Medallion (1974), and honorary doctorates from Yale University (1973) and Albright College (1975).

REFERENCES

"A Promise Fulfilled." *Encore* (May 9, 1977): 32–34.
"A Universe of Music." *Sepia* (March 1974): 48–53.

OTHA DAY

Waymon, Eunice. *See* Simone, Nina.

Weaver, Robert Clifton (December 29, 1907–), economist. Robert Weaver's maternal grandfather, Robert Tanner FREEMAN, the son of a slave who bought freedom for himself and his wife in 1830 and took his surname as the badge of his liberty, graduated from Harvard University in 1869 with a degree in dentistry, the first African American to do so. His daughter Florence attended Virginia Union University, then married Mortimer Grover Weaver, a Washington, D.C., postal clerk, and gave birth to Robert Weaver. Raising Robert and his older brother, Mortimer, Jr., in a mostly white Washington neighborhood, Florence Weaver repeatedly emphasized to her sons that "the way to offset color prejudice is to be awfully good at whatever you do."

The Weaver boys did exceptionally well in Washington's segregated school system: Mortimer went on to Williams College and then to Harvard for advanced study in English; Robert joined him at Harvard as a freshman, and when refused a room in the dormitory because he was African-American, lived with his brother off-campus. Robert Weaver graduated cum laude in 1929, the year his brother died of an unexplained illness, and stayed at Harvard to earn his master's degree in 1931 and doctorate in economics in 1934. In 1933, with the advent of the New Deal, Weaver was hired by Secretary of the Interior Harold Ickes to be the race-relations adviser in the Housing Division. While holding that post, Weaver helped desegregate the cafeteria of the Interior Department and became an active member of the "Black Cabinet," an influential group of African Americans in the Roosevelt administration who met regularly to

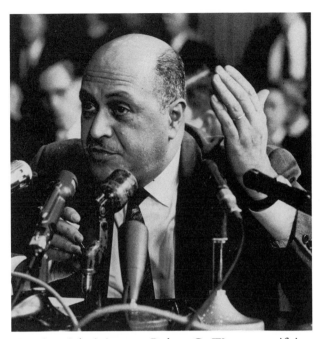

Housing Administrator Robert C. Weaver testifying before the Senate Banking and Currency Committee on the 1961 Housing Bill. (Photographs and Prints Division, Schomburg Center for Research in Black Culture, The New York Public Library, Astor, Lenox and Tilden Foundations)

combat racial discrimination and segregation in New Deal programs and within the government itself.

In 1935, Weaver married Ella V. Haith, a graduate of Carnegie Tech, and from 1937 to 1940 served as the special assistant to the administrator of the U.S. Housing Authority. During World War II he held positions on the National Defense Advisory Committee, the War Manpower Commission, and the War Production Board. In 1944, Weaver left the government to direct the Mayor's Committee on Race Relations, in Chicago, and then the American Council on Race Relations. After the war, he worked for the United Nations Relief and Rehabilitation Administration, headed a fellowship program for the John Hay Whitney Foundation, and published two critical studies of discrimination against African Americans —*Negro Labor: A National Problem* (1946) and *The Negro Ghetto* (1948)—before being chosen by New York's Democratic governor, Averell Harriman, in 1955 as the state rent commissioner, the first African American to hold a Cabinet office in the state's history.

This was followed by Weaver's appointment by President John F. Kennedy after the 1960 election to be director of the U.S. Housing and Home Finance Agency, at the time the highest federal position ever held by an African American. While heading what he termed an "administrative monstrosity," Weaver au-

thored the acclaimed *The Urban Complex* (1964) and *Dilemmas of Urban America* (1965), which focused attention on the inadequate public services and the inferior schools in lower-class inner cities, but he achieved only minor successes in his endeavors to stimulate better-designed public housing, provide housing for families of low or moderate incomes, and institute federal rent subsidies for the ailing and the elderly.

Kennedy had promised in 1960 to launch a comprehensive program to assist cities, run by a Cabinet-level department. But because of his intention to select Weaver as department secretary, and thus the first African-American Cabinet member, Congress twice rebuffed Kennedy's plan. Southern Democrats opposed Weaver because of his race and his strong support of racially integrated housing. Following the landslide election of Lyndon B. Johnson in 1964, however, Congress approved a bill to establish a new Department of Housing and Urban Development (HUD) in 1965, and, because of Johnson's influence, confirmed his choice of Weaver to head it. By then, Weaver's moderation and reputation for being professionally cautious had won over even southern Democrats who had formerly voted against him, like Sen. A. Willis Robertson of Virginia, who claimed: "I thought he was going to be prejudiced. But I have seen no evidence of prejudice."

Weaver ably administered HUD's diffuse federal programs and the billions of dollars spent to attack urban blight, but innovative policies and plans, such as those in the Demonstration Cities and Metropolitan Development Act, soon fell victim to the escalating expenditures for the Vietnam War and to the conservative backlash fueled by ghetto rioting from 1965 to 1968. In 1969, after more than a third of a century of government service, Weaver left Washington to preside over the City University of New York's Baruch College for two years and then to be Distinguished Professor of Urban Affairs at CUNY's Hunter College until 1978, when he became professor emeritus.

Although never an active frontline fighter in the civil rights movement, Weaver chaired the board of directors of the NAACP in 1960, served on the executive committee of the NAACP Legal Defense Fund from 1973 to 1990, and was president of the National Committee against Discrimination in Housing from 1973 to 1987. He has received numerous awards, including the Spingarn Medal of the NAACP (1962), the New York City Urban League's Frederick Douglass Award (1977), the Schomburg Collection Award (1978), and the Equal Opportunity Day Award of the National Urban League (1987), and has been the recipient of some thirty honorary degrees from colleges and universities.

REFERENCES

"New Cabinet Member." *Crisis* (February 1966): 76, 120ff.
WEAVER, ROBERT C. "The Health Care of Our Cities." *National Medical Association Journal* (January 1968): 42–46.

HARVARD SITKOFF

Webb, Frank J. (1828–c. 1894), writer. Born in Philadelphia, Frank Webb was personally burdened by an omnipresent racial prejudice, as are the African-American characters in his well-written but neglected novel *The Garies and Their Friends* (London, 1857). The novel depicts striving Philadelphia blacks, a white mob attack, and the folly of passing for white in the 1840s. Webb may be discerned in two of his characters: young Charlie Ellis and the mysterious Mr. Winston. Like them, he was unusually sophisticated in art, literature, and manners. Like his character Charlie, Webb visited England and southern France for the health of his light-skinned wife, Mary E. Webb, a popular dramatic reader. Like Winston, however, Webb decided not to stay in the United States. In 1858, he was appointed to the post office in Kingston, Jamaica, after being denied passage to Brazil because, as Mary said, he was "somewhat more brown" than she was.

In 1859, Webb's wife died and he married a Jamaican, Mary Rodgers. Around 1869 he repatriated to Washington, D.C., where in early 1870, the black *New National Era* carried two of his tales (which included no black characters), three articles on ways to fight racial prejudice, and two melancholy poems. By 1871 the Webbs were in Galveston, Tex.; seven years later a sixth child was born. Webb edited a short-lived radical newspaper (1871), was again a postal clerk (1872–1880), then a principal/school teacher from 1881 until his death.

REFERENCE

LAPSANSKY, PHILIP S. "Afro-Americana: Frank J. Webb and His Friends." In *The Annual Report of the Library Company of Philadelphia for 1990*. Philadelphia, 1991, pp. 27–37.

ALLAN D. AUSTIN

Webb, William Henry "Chick" (February 10, 1909–June 16, 1939), drummer and bandleader. Born in Baltimore, Webb first played in a local children's orchestra, and in his teens played in bands working on local riverboats. He moved to New York in 1925

and played with Edgar Dowell before forming his own group, which by 1927 was a featured attraction at the SAVOY BALLROOM in Harlem. By 1931, the group was the house orchestra there. Webb's dynamic drumming and distinctive compositions, arranged by Edgar Sampson, earned the band an enthusiastic following ("Stompin' at the Savoy" and "Don't Be That Way," both 1934). During the 1930s, Webb's orchestra was one of the most famous jazz groups in the United States, touring and recording regularly and broadcasting frequently on a national radio network. He repeatedly defended his title of "King of the Savoy" in highly publicized "battles of the bands" by maintaining a vast, ever-changing repertory to satisfy throngs of dancers. Among his leading soloists were Johnny HODGES, Benny CARTER, Louis JORDAN, John Kirby, and Taft Jordan. Ella FITZGERALD, who would become the band's leading attraction, sang on Webb's hit recordings of "A-tisket, A-tasket" (1938) and "Undecided" (1939).

Despite a lifelong battle with tuberculosis of the spine, a painful condition that left him a hunchback, Webb was a virtuoso on the most physically demanding instrument in jazz. He directed his orchestra from his drum set, supplying entrance cues, indicating dynamic shadings and setting dramatic tempo changes ("Harlem Congo," 1937, "Liza," 1938). Webb was hospitalized in 1938 and 1939 and died in Baltimore at the age of 30 from complications following a urological operation.

REFERENCES

KORALL, B. "Chick Webb: The Total Experience on Drums," *Modern Drummer* 12, no. 1 (1988): 26.
SCHULLER, GUNTHER. *The Swing Era*. New York, 1989.

ANTHONY BROWN

Webster, Benjamin Francis "Ben" (February 27, 1909–September 20, 1973), tenor saxophonist. Born in Kansas City, Mo., Webster was the first of Duke ELLINGTON's great tenor saxophonists, contributing breathy, sentimental solos on ballads and blustery, passionate improvisations on up-tempo numbers in recordings that exemplify the greatest achievements of the big-band era. During his youth Webster studied violin and piano, the latter with the famed boogie-woogie performer Pete Johnson. Webster, who attended Ohio's Wilberforce College, first played professionally on piano with Bretho Nelson in Enid, Okla. In the late 1920s he joined the band of Lester YOUNG's father, W. H. Young, and began performing on tenor saxophone.

Webster played with Blanche Calloway (1931), Bennie MOTEN (1931–1933), and Andy Kirk (1933) before coming to New York in 1934 to replace Lester Young in Fletcher HENDERSON's orchestra. He also played briefly with Ellington, Benny CARTER, and Willie Bryant before taking a two-year engagement with Cab CALLOWAY. Webster played for Teddy Wilson in 1939–1940, before joining the Ellington orchestra full-time (1940–1943). He was a key soloist during the ensemble's peak in the early 1940s, providing a sorely needed tenor presence on both hard-driving compositions like "Cotton Tail" (1940) and lush ballads like "Star Dust" (1940). Although he was associated with Ellington for a relatively brief period, his performances on songs such as "Conga Brava" (1940), "All Too Soon" (1940), "Blue Serge" (1941), and "Main Stem" (1942) linked his name permanently with Ellington's.

Webster left Ellington in 1943, leading his own groups and working as a sideman in New York and Kansas City, but returned to Ellington in 1948–1949. Although he was an early disciple of Coleman HAWKINS, his powerful rhythmic sense and unfocused pitch made his sound instantly recognizable, and he recorded in the 1950s with Roy ELDRIDGE, Art TATUM, Harry "Sweets" Edison, Hawkins, and Carmen MCRAE. By the late 1950s, however, Webster was shamefully neglected, and had great difficulty finding regular work. He moved from New York to Los Angeles in order to care for his mother and grandmother, and after their deaths he moved in 1964 to Amsterdam, which he used as a base for performances throughout Europe for the rest of his life. Webster, who was the subject of a 1967 video documentary called *The Brute and the Beautiful,* lived briefly in Copenhagen before returning to Amsterdam, where he died.

JOHN EDWARD HASSE

Weekly Advocate, newspaper. The *Weekly Advocate,* first published in New York City on January 7, 1837, was founded by Philip A. BELL and Robert Sears. In March of the same year, Samuel E. CORNISH took editorial control of the *Weekly Advocate* and highlighted its African-American identity by renaming it the *Colored American.* Cornish gave the *Colored American* a more aggressive editorial edge, and opened the paper's columns to a wide range of racial issues that the white reform press ignored or considered too controversial. From 1837 to its demise in December 1841, the *Colored American* underwent several management and staff changes. Bell relinquished ownership to a twenty-eight-member

committee of publication and then regained control of the paper in association with Stephen Gloucester and Charles B. RAY. As with many antebellum reform newspapers, the *Colored American* struggled financially, hampered by meager advertising revenues and a limited subscription list. Generous support from Gerrit Smith, Arthur Tappan, and other white philanthropists helped sustain the enterprise. The paper suffered from frequent editorial squabbles and a devastating libel suit, and eventually alienated many of its white patrons. Despite these difficulties, the *Colored American* became the most widely circulated and influential black newspaper of the 1830s, and marked an important stage in the development of a more assertive, independent black press in the antebellum period.

REFERENCES

JACOBS, DONALD M., ed. *Antebellum Black Newspapers.* Westport, Conn., 1976.

RIPLEY, C. PETER, et al., eds. *The Black Abolitionist Papers, Volume 3: The United States, 1830–1846.* Chapel Hill, N.C., 1991.

MICHAEL F. HEMBREE

Weems, Carrie Mae (April 20, 1953–), photographer. Born in Portland, Oreg., Carrie Mae Weems began taking pictures in 1976 after a friend gave her a camera as a gift. Weems worked as a professional modern dancer and also held odd jobs on farms and in restaurants and offices until 1979, when she began taking classes in art, folklore, and literature at the California Institute of the Arts (B.F.A., 1981). She traveled to Mexico and Fiji, and then studied photography at the University of California, San Diego, where she worked with Fred Lonidier (M.F.A., 1984).

In 1978, Weems began taking her first series of images, *Environmental Profits,* which focused on life in Portland. Weems continued to develop her interest in autobiographical images in *Family Pictures and Stories* (1978–1984), which took the format of a family photo album and featured images of relatives at their jobs and at home, often with accompanying narrative text and audio recordings. *Family Pictures* was Weems's response to the MOYNIHAN REPORT of ten years earlier, which claimed that a matriarchal system of authority was responsible for a systemic crisis in the black family (*Mom at Work*). Images in the series were arranged to look like snapshots of ordinary moments to show that the process of passing on family history is an aspect of everyday life.

Weems's work on *Family Pictures* intensified her interest in folklore, and she took graduate classes in the folklore program at University of California, Berkeley, during 1984–1987. Her work *Ain't Jokin* (1987–1988), which grew out of her studes at the university, was a series of captioned photographs that prompts viewers to question racial stereotypes (*Black Woman with Chicken*).

In 1990, Weems explored the conflict between a woman's political ideals and her emotional desires in *Untitled (Kitchen Table Series).* Shot with a large-format camera, the images record episodes in the relationship between a woman and man; they are taken from a single vantage point in front of the receding kitchen table.

In the same year, Weems completed *Then What? Photographs and Folklore,* a collection of images that illustrates or comments upon folk sayings, signs, and omens. Weems's image of a coffee pot highlights a superstition by quoting parents who tell their child not to drink coffee because "coffee'll make you black." *Then What?* also includes *Colored People* (1989–1990), a series of front- and sideview mug shots of girls and boys that explores the process of color stereotyping.

In 1991, Weems began creating large-scale color still lifes and portraits that were included in *And 22 Million Very Tired and Angry People* (1992). Selecting a title that echoes Richard WRIGHT's 1941 work *12 Million Black Voices,* Weems combines photos of ordinary objects such as an alarm clock (*A Precise Moment in Time*), a fan (*A Hot Day*), and a typewriter (*An Informational System*) with text from thinkers such as Ntozake SHANGE, MALCOLM X, and Fannie Lou HAMER, to educate viewers about historical causes of political change. In 1992, Weems exhibited a series of images on the GULLAH culture of the Sea Islands, located off the coast of South Carolina and Georgia, at the P.P.O.W. Gallery in New York City.

Weems has taught photography at institutions such as San Diego City College in California (1984); Hampshire College in Amherst, Mass. (1987–1992), Hunter College in New York City (1988–1989), and California College of Arts and Crafts in Oakland, Calif. (1991). She has been artist-in-residence at the Visual Studies Workshop in Rochester, N.Y. (1986); Rhode Island School of Design in Providence, R.I. (1989–1990); and the Art Institute of Chicago (1990).

Weems's work has been shown in solo exhibitions at the Alternative Space Gallery, San Diego (1984); Hampshire College Art Gallery (1987), CEPA Gallery, Buffalo (1990); P.P.O.W. Gallery (1990, 1992); New Museum of Contemporary Art, New York City (1991); and the National Museum of Women in the Arts, Washington, D.C. (1993).

REFERENCES

KIRSH, ANDREA, and SUSAN FISHER STERLING. *Carrie Mae Weems*. Washington, D.C., 1993.

WEEMS, CARRIE MAE. *And 22 Million Very Tired and Angry People*. San Francisco, 1992.

———. *Then What? Photographs and Folklore*. Buffalo, N.Y., 1990.

RENEE NEWMAN

Weir, Reginald (September 30, 1911–August 22, 1987), tennis player. Born in New York City in 1911, Reginald Weir began playing tennis on public courts in Harlem at the age of ten. After becoming the first African American to play tennis for Dewitt Clinton High School, Weir attended the City College of New York, where he was elected captain of the tennis team for three consecutive years beginning in the late 1920s. Weir won the men's singles title of the AMERICAN TENNIS ASSOCIATION (ATA), the black counterpart to the all-white United States Lawn Tennis Association (USLTA), in 1931, 1932, 1933, 1937, and 1942.

In 1929 Weir, along with another black player, Gerald Norman, Jr., attempted to enter the USLTA's Junior Indoor event being held at New York City's Seventh Regiment Armory. While denied access despite lobbying by the NAACP, this marked the first public action by blacks toward desegregating American tennis. Weir was again instrumental in this process when in 1948 he became the first African American to play in a USLTA sponsored tournament. After winning his first match, Weir was defeated by Bill Talbert in the next round. In 1952 Weir and doubles partner George Stewart also became the first black men to play at the national tournament at Forest Hills, N.Y., paving the way for such future African American stars as Althea GIBSON and Arthur ASHE.

During his tennis career, Weir pursued and received his medical degree from New York University in 1935 and practiced family medicine in New York City for more than fifty years. He died in 1987 at the age of seventy-six.

REFERENCES

ASHE, ARTHUR R., JR. *A Hard Road to Glory*. New York, 1988, pp. 61–62.

NELSON, GEORGE. "Reginald Weir, A Champ to Remember." *New York Amsterdam News*, December 22, 1979, p. 59.

NEIL MAHER

Wells, James Lesesne (November 2, 1902–1993), printmaker. Although born in Atlanta, Ga., in 1902, James Lesesne Wells spent his early adolescence in Palatka, Fla., where his father, a Baptist minister, officiated at a local church. Arriving in Harlem around 1919, Wells divided his time between working at various odd jobs and teaching himself to paint. This latter exercise was conducted in the galleries of the Metropolitan Museum of Art, where aspiring artists were sometimes allowed to set up easels and copy selected paintings from the permanent collection. After a brief stint as a student at Lincoln University (c. 1922–1924), Wells returned to New York and eventually enrolled at Columbia University's Teachers College.

In 1927, Wells began supplementing his studies there with evening courses in drawing and printmaking at the National Academy of Design. Although Wells had been exhibiting his art—primarily paintings and drawings—in and around Harlem as early as 1921, it was in the late 1920s and early 1930s that his work—mostly black-and-white relief prints, lithographs, and paintings—became more widely known. Bold, expressionistic, and radical in its racial subject matter, Wells's art was featured in countless New York exhibitions throughout the 1930s and was acquired by major collectors such as Duncan Phillips, who purchased *Journey to Egypt* (1931) and *Flight into Egypt* (1931) for The Phillips Collection in Washington, D.C.

It was also during this time period that Wells began to sell his prints as illustrations for periodicals and books. Classic prints like *Ethiopia at the Bar of Justice* (1928), *Primitive Boy* (1928), and *African Fantasy* (1929) were all first seen in *The Crisis, Opportunity,* and other magazines and journals of the day. After accepting a teaching position at HOWARD UNIVERSITY in 1929, Wells moved to Washington, D.C., where in addition to teaching, he continued to make art. The 1930s were rewarding for Wells, beginning with his receiving the William E. Harmon gold medal in 1931, and concluding with the inclusion of his work in the important Baltimore Museum of Art exhibition "Contemporary Negro Art" in 1939.

For the next fifty years, and despite a constantly evolving, ever-changing American art scene, Wells continued to be a productive figure in American printmaking and in African-American art and culture. Semiabstract wood engravings with mythological and religious themes (*Saint Francis and the Birds,* 1958, and *The Temptation of Eve,* 1965) reflect Wells's artist-in-residency in 1948 at the New York printmaking workshop Atelier 17.

Beginning in the late 1960s, Wells undertook the creation of large-scale multicolored linoleum relief

prints (*Bus Stop, Ghana*, 1972; *Standing Nude*, 1978; and *The Vamp*, 1983), initially in response to his three-month tour of West Africa in 1968, but also in the expressionistic vein he had forged many years earlier. In addition to having a critically acclaimed retrospective of his work in 1988, Wells and his life achievements were recognized in 1980 by President Jimmy Carter on the occasion of the National Conference of Artists.

REFERENCE

POWELL, RICHARD J., and JOCK REYNOLDS. *James Lesesne Wells: Sixty Years in Art*. Washington, D.C., 1986.

RICHARD J. POWELL

Wells, Mary Esther (May 13, 1943–July 26, 1992), soul singer. Born in Detroit, Mary Wells began singing at the age of ten. In 1961, she approached MOTOWN Records founder Berry Gordy, and convinced him to record her rendition of her song "Bye Bye Baby." That recording, released as a single in 1961, began for her a long and fruitful association with Motown. There, in addition to working alongside Smokey ROBINSON, the SUPREMES, and the TEMPTATIONS, Wells also gained prominence for her solo vocals, touring the United States and Europe with the Motown Revue, and in 1964 touring England with the Beatles. Wells brought a simple and tender approach to such hit rhythm-and-blues songs as "The One Who Really Loves You" (1962), "You Beat Me to the Punch" (1962), and a duet with Marvin GAYE, "Once upon a Time" (1964). She had her greatest success with "My Guy" (1964), which she co-wrote with Robinson.

In 1964 Wells left Motown, and during the next decade she signed record contracts with a number of companies, including Twentieth Century Fox Records, Atco, and Jubilee, but she never repeated her earlier success. She was married for a while to Cecil Womack, and in the 1970s she stopped performing professionally in order to raise her four children. She resumed her career in 1978, performing in nightclubs and theaters, and in 1983 she appeared on Motown's twenty-fifth anniversary television show. But Wells's attempt to regain her former popularity was unsuccessful.

In 1990 Wells, an inveterate smoker, was diagnosed with terminal cancer of the larynx. With little savings and no medical insurance, she was threatened with destitution and was forced to sell her home in Los Angeles, where she had lived for many years.

During her illness, financial support was provided by the fledgling Rhythm and Blues Foundation and by the American Federation of Television and Radio Artists. After an extended period of hospitalization, Wells died in Los Angeles.

REFERENCES

HIRSHEY, GERRY. *Nowhere to Run: The Story of Soul Music*. New York, 1984.
"Tribute." *Rolling Stone* (September 3, 1992): 18.

SABRINA FUCHS

Wells-Barnett, Ida Bell (July 6, 1862–March 25, 1931), journalist and civil rights activist. Ida Bell Wells was born to Jim and Elizabeth Wells in Holly Springs, Miss., the first of eight children. Her father, the son of his master and a slave woman, worked on a plantation as a carpenter. There he met his future wife, who served as a cook. After emancipation, Jim Wells was active in local RECONSTRUCTION politics.

Young Ida Wells received her early education in the grammar school of Shaw University (now Rust College) in Holly Springs, where her father served on the original board of trustees. Her schooling was halted, however, when a yellow fever epidemic claimed the lives of both her parents in 1878 and she assumed responsibility for her siblings. The next year, the family moved to Memphis, Tenn. with an aunt. There Ida found work as a teacher. She later studied at Fisk University and Lemoyne Institute.

A turning point in Wells's life occurred on May 4, 1884. While riding a train to a teaching assignment, she was asked to leave her seat and move to a segregated car. Wells refused, and she was physically ejected from the railway car. She sued the railroad, and though she was awarded $500 by a lower court, the Tennessee Supreme Court reversed the decision in 1887. In the same year, she launched her career in journalism, writing of her experiences in an African-American weekly called *The Living Way*. In 1892, she became the co-owner of a small black newspaper in Memphis, the *Free Speech*. Her articles on the injustices faced by southern blacks, written under the pen name "Iola," were reprinted in a number of black newspapers, including the *New York Age*, the *Detroit Plain-Dealer*, and the *Indianapolis Freeman*.

In March 1892, the lynching of three young black businessmen, Thomas Moss, Calvin McDowell, and Henry Steward, in a suburb of Memphis focused Wells's attention on the pressing need to address the increasing prevalence of this terrible crime in the post-Reconstruction South. Her approach was characteristically forthright. She argued that though most lynchings were fueled by accusations of rape, they

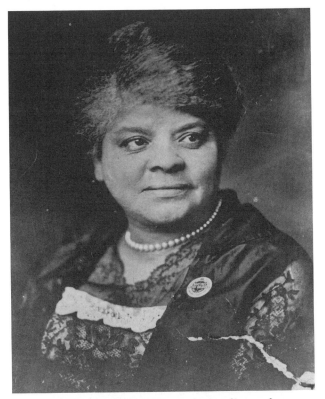

An outspoken and courageous journalist and an un-relenting foe of lynching and racism, Ida B. Wells was one of the dominant voices of black America in the late nineteenth century and an inspiration to later black protest thought. (Photographs and Prints Division, Schomburg Center for Research in Black Culture, The New York Public Library, Astor, Lenox and Tilden Foundations)

actually were prompted by economic competition between whites and blacks. Wells infuriated most whites by asserting that many sexual liaisons between black men and white women were not rape but mutually consensual.

She urged African Americans in Memphis to move to the West (where, presumably, conditions were more favorable) and to boycott segregated streetcars and discriminatory merchants. Her challenges to the preventing racial orthodoxy of the South were met by mob violence, and in May 1892, while she was out of town, the offices of the *Free Speech* were destroyed by an angry throng of whites.

After her press was destroyed, Wells began to work for the *New York Age*. There, Wells continued to write extensively on lynching and other African-American issues. She penned exposés of southern injustice and decried the situation before European audiences in 1893 and 1894. During these European tours, she criticized some white American supporters of black causes for their halfhearted opposition to lynching. Wells's most extended treatment of the

subject, *A Red Record: Tabulated Statistics and Alleged Causes of Lynchings in the United States,* appeared in 1895. This was the first serious statistical study of lynchings in the post-emancipation South. She continued this work for the rest of her life. Some of her more widely read articles in this area include "Lynching and the Excuse for It" (1901) and "Our Country's Lynching Record" (1913). Perhaps her greatest effort in this arena was her tireless campaign for national antilynching legislation. In 1901, she met with President McKinley to convince him of the importance of such legislation. Her appeal was to no avail.

Another issue that provoked Wells's ire was the decision not to permit an African-American pavilion at the 1893 World's Fair. Wells, with the financial support of Frederick DOUGLASS, among others, published a widely circulated booklet entitled *The Reason Why the Colored American Is Not in the World's Exposition* (1893).

In 1895, Wells married Chicago lawyer-editor Ferdinand L. Barnett, who was appointed assistant state attorney for Cook County in 1896. The couple had four children. Chicago would remain their home for the rest of their lives, and though she was a devoted mother and homemaker, Wells-Barnett's political and reform activities were unceasing. She served as Secretary of the National Afro-American Council from 1898 to 1902 and headed its Antilynching Speakers Bureau. She organized, and played an important role in, the founding of the NATIONAL ASSOCIATION OF COLORED WOMEN in 1896. In 1910 she founded the Negro Fellowship League in Chicago, which provided housing and employment for black male migrants. As early as 1901, the Barnetts challenged restrictive housing covenants when they moved to the all-white East Side of Chicago. Her concern for the welfare of Chicago's black community led her to become, in 1913, the first black woman probation officer in the nation. She lost her appointment in 1916, when a new city administration came to power.

Wells-Barnett was also active in the fight for women's suffrage. In 1913, she organized the Alpha Suffrage Club, the first black women's suffrage club in Illinois. That year, and again in 1918, she marched with suffragists in Washington, D.C. On the former occasion she insisted on marching with the Illinois contingent, integrating it over the objection of many white women marchers.

Wells-Barnett's militant opposition to the southern status quo placed her at odds with Booker T. WASHINGTON and his strategy of accommodationism. She was much more sympathetic to the ideology of W. E. B. DU BOIS and in 1906 she attended the founding meeting of the NIAGARA MOVEMENT. She was a member of the original Executive Committee

of the NATIONAL ASSOCIATION FOR THE ADVANCEMENT OF COLORED PEOPLE (NAACP) in 1910. She was, however, uneasy about the integrated hierarchy at the organization and felt their public stance was too tempered, and she ceased active participation in 1912.

In 1916 Wells-Barnett began an affiliation with Marcus GARVEY's UNIVERSAL NEGRO IMPROVEMENT ASSOCIATION (UNIA). In December 1918, at a UNIA meeting in New York, Wells-Barnett was chosen along with A. Philip RANDOLPH to represent the organization as a delegate to the upcoming Versailles Conference. Both representatives were repeatedly denied U.S. State Department clearance, however, so they never attended the meeting. Wells-Barnett, however, did speak on behalf of the UNIA at Bethel AME Church in Baltimore at the end of December 1918. Her continued affiliation with the organization after this was less public.

In the last decades of her life, Wells-Barnett continued to write about racial issues and American injustice. The East St. Louis race riot of July 1917 and the Chicago riot of July and August 1919 provided the impetus for impassioned denunciations of the treatment of African Americans in the United States. She wrote *The Arkansas Race Riot* in 1922 in response to the accusation of murder aimed at several black farmers, an accusation that was said to have instigated the disturbance. Most of her later work targeted social and political issues in Chicago. In 1930, Wells-Barnett ran, unsuccessfully as an independent candidate for the Senate from Illinois.

She died the next year, on March 25, 1931. In 1941, the Chicago Housing Authority named one of its first low-rent housing developments the Ida B. Wells Homes. In 1990 the U.S. Postal Service issued an Ida B. Wells stamp.

REFERENCES

BURT, OLIVE W. *Black Women of Valor.* New York, 1974, pp. 54–70.
DUSTER, ALFREDA, ed. *Crusade for Justice: The Autobiography of Ida B. Wells.* New York, 1970.
STERLING, DOROTHY. *Black Foremothers.* New York, 1979.

MARGARET L. DWIGHT

Wesley, Charles Harris (December 2, 1891–August 16, 1987), historian, educator, minister. Charles Wesley was a native of Louisville, Ky., where he attended public schools. He received a B.A. from Fisk University in 1911, an M.A. from Yale University in 1913, and a Ph.D. from Harvard University in 1925. He was the third black American to receive a Ph.D. in history from Harvard, following W. E. B. DU BOIS and Carter G. WOODSON.

Upon graduation, Wesley accepted a position on the faculty of HOWARD UNIVERSITY, where he served from 1913 to 1942 (leaving briefly, from 1920–1921, to attend Harvard). Wesley rose from the position of instructor to that of professor, then to chairman of the history department and finally to dean of the Graduate School. In 1930, he was the first black historian to receive a Guggenheim Fellowship, and he spent the following year in England studying slave emancipation in the British Empire.

Wesley was an ordained minister and a presiding elder of the African Methodist Episcopal church (1914–1937). He was also general president of the black fraternity Alpha Phi Alpha (1931–1946) about which he wrote *The History of Alpha Phi Alpha*

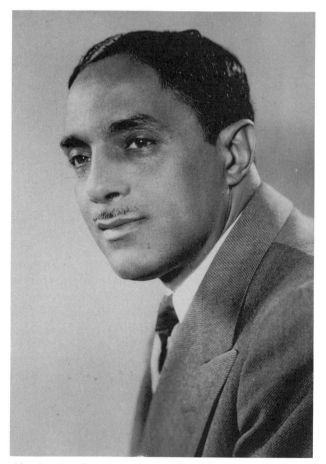

Charles Wesley, historian and educator, was one of the most productive African-American historians in the first half of the twentieth century. In addition to writing biographies of Richard Allen and Prince Hall, as well as numerous other works of history, Wesley succeeded Carter Woodson as president and executive director of the Association for the Study of Negro Life and History. (Photographs and Prints Division, Schomburg Center for Research in Black Culture, The New York Public Library, Astor, Lenox and Tilden Foundations)

(1953). He was one of Carter G. Woodson's principal associates at the ASSOCIATION FOR THE STUDY OF NEGRO LIFE AND HISTORY (ASNLH), with which he was involved from 1916 to 1987. Wesley worked with Woodson on several important research projects. He was also cofounder of the Association of Social Science Teachers at Negro Colleges (1936).

Wesley's *Negro Labor in the United States, 1850–1925* (1927) grew out of his dissertation at Harvard and was the first comprehensive historical study of black workers. It is still one of the basic works on the subject, and was pioneering in its use of economic and social analysis for black history. The *Collapse of the Confederacy* (1937) established Wesley's expertise in southern history, and his scholarly articles on subjects ranging from black abolitionists to the diplomatic history of Haiti and Liberia helped to legitimize and popularize the emerging discipline of black history. Wesley also wrote several other histories of black organizations and their leaders, such as *Richard Allen, Apostle of Freedom* (1935), *History of the Improved Benevolent and Protective Order of Elks of the World* (1955), and *Prince Hall: Life and Legacy* (1977).

Wesley was a vocal critic of the limited curriculum and paternalistic procedures at black colleges. In 1942 he was elected president of Wilberforce University in Ohio, an AME church-supported school. In the spring of 1947, church trustees, led by his former mentor Bishop Reverdy RANSOM, dismissed Wesley. Student protests followed, and afterward an acrimonious legal battle between the Wilberforce University and the state of Ohio, which provided funds for the School of Education. The school was permanently split into two institutions, and Wesley became the first president of Wilberforce State College (later renamed Central State University). Wesley upgraded the faculty, integrated the student body, and introduced new programs such as African Studies.

During this period, Wesley also served as president of the ASNLH (1950–1965), and when he retired as president of Central State University in 1965, he assumed the executive directorship of the Association. Wesley continued to write histories of African Americans, including *Neglected History: Essays in Negro History by a College President* (1965), *In Freedom's Footsteps, From the African Background to the Civil War* (1968), *The Quest for Equality: From Civil War to Civil Rights* (1968), and a new introduction for Woodson's treatise, the *Mis-Education of the Negro* (1969). In 1972 Wesley resigned his position as executive director of the ASNLH.

Wesley came out of retirement in 1974 to direct the new Afro-American Historical and Cultural Museum in Philadelphia, serving until 1976. In 1979 Wesley, a widower of six years, married Dorothy B. Porter, a librarian and bibliographer. Wesley continued to write in his later years, publishing his last book, *The* *History of the National Association of Colored Women's Clubs: A Legacy of Service* in 1984 at the age of ninety-two. He died in Washington, D.C., three years later.

REFERENCES

MEIER, AUGUST, and ELLIOT RUDWICK. *Black History and Historical Profession, 1915–1980*. Urbana, Ill., 1986.

WESLEY, CHARLES H. *Negro Labor in the United States, 1950–1925*. New York, 1927.

FRANCILLE RUSAN WILSON

Wesley, Dorothy Burnett Porter

Wesley, Dorothy Burnett Porter (May 25, 1905–), librarian. Born in Warrenton, Va., Dorothy Burnett grew up in Montclair, N.J. She received a B.A. from HOWARD UNIVERSITY, a B.S. and M.S. in library science from Columbia University (the first African American to graduate from its library school), and honorary doctorates from Susquehanna, Syracuse, and Radcliffe. In 1930 she became curator of Howard University's "Negro Collection," and almost singlehandedly built it into the Moorland-Spingarn Research Center, one of the world's preeminent collections of African-American books, manuscripts, and related materials. From some 6,500 catalogued items in 1933, it grew to over 180,000 items when she retired in 1973, including the great private library of Arthur B. Spingarn.

Wesley established herself as the leading bibliographer of publications by and about people of African descent, a serious historian of the black experience, the arbiter of standards for African-American research, and a prolific author of books, articles, and reviews. From 1962 to 1964 she was Ford Foundation consultant to the National Library of Nigeria. Her first marriage was to James A. PORTER, the artist and chairman of Howard's Fine Arts Department. Following his death, she married Charles H. WESLEY, the dean of black historians. She is the mother of a daughter, Constance Porter Uzclac.

REFERENCE

SCARUPA, HARRIET JACKSON. "The Energy-Charged Life of Dorothy Porter Wesley." *New Directions: The Howard University Magazine* 17, no. 1 (January 1990): 6–17.

RICHARD NEWMAN

Wesley, Richard

Wesley, Richard (July 11, 1945–), playwright. Richard Wesley was born in Newark, N.J. He graduated from Howard University in 1967, the same year that his play *Put My Dignity on 307* was produced and broadcast on television in Washington, D.C. After graduating, Wesley returned to Newark,

where he worked as a ticket agent at Newark airport. In 1968, he joined the playwrighting workshop of the New Lafayette Theater in New York City, where he studied with Ed BULLINS. From 1969 to 1973, Wesley was a playwright-in-residence with Bullins and Ed Gaines at the New Lafayette and was also the managing editor of *Black Theatre Magazine* (1969–1973). Wesley wrote a number of plays during this period, including *The Streetcorner* (1970), *Headline News* (1970), *Black Terror* (1971), and *Gettin' It Together* (1971).

Black Terror, for which Wesley received a Drama Desk Award for outstanding playwrighting, examines and criticizes the inflexible ideology of a group of black revolutionaries. The play is typical of Wesley's best works in its focus on the difficulties faced by individuals caught in self-destructive patterns of behavior that arise in response to oppression.

In 1973, the production of a new play by Wesley, *Strike Heaven in the Face,* brought him to the attention of Sidney Poitier, who asked Wesley to write the script for his film *Uptown Saturday Night* (1974). The film was a popular and critical success, prompting a sequel, *Let's Do It Again* (1975), as well as an NAACP Image Award for Wesley.

In 1974, several of Wesley's new plays were produced, including *Goin' Through Changes, The Sirens, The Past Is the Past,* and *The Mighty Gents. The Past Is the Past,* perhaps Wesley's finest one-act play, earned Wesley an Audelco Award for Playwright of the Year in 1974. *Mighty Gents,* produced again in New York in 1977 as *The Last Street Play* and then restaged under its original title on Broadway the following year, is often considered to be Wesley's finest work. It examines the attempts of former members of a Newark street gang to confront the loss of youth and opportunity.

In the 1980s and 1990s, Wesley continued to write plays, including *Butterfly* (1985) and *The Talented Tenth* (1989), an examination of the new black middle class, which was produced in several cities during the early 1990s. He also wrote two screenplays that were produced as films, *Fast Forward* (1985) and *Native Son* (1986).

REFERENCE

PETERSON, BERNARD L., JR. *Contemporary Black American Playwrights and Their Plays.* Westport, Conn., 1988.

MICHAEL PALLER

West, Blacks in the. Although the migration of African Americans from the rural South to the urban North has long held the attention of urban historians and public-policy planners, it was the American West—the nineteen states west of the 100th meridian—that epitomized both social freedom and economic opportunity for thousands of nineteenth- and twentieth-century blacks. Even when racial restrictions appeared in the region, many black Westerners persisted in the belief that the move west was, according to one historian, "a journey towards hope."

The image of the West as a region of hope and opportunity evolved early in African-American history as a consequence of the experiences of black migrants and the attitudes of white settlers. In the 1830s, for example, fugitive slaves escaped from southern states and settled in Mexican Texas and Indian territory. In the 1840s, after Texas became independent, runaway slaves continued to find refuge in the predominantly Mexican communities of Corpus Christi, Waco, and San Antonio. After 1865, African Americans were supported in their beliefs about western racial toleration by the pronouncements of progressive Republican leaders such as Nevada senator William Stewart, a consistent supporter of black suffrage. That image of toleration, at least for African Americans, extended well into the twentieth century; in 1951 the CHICAGO DEFENDER, the nation's largest black newspaper, urged its readers to move west to seek opportunities denied them in the South and Midwest.

Nineteenth-century black western migration took place in an environment of particular challenges. Unlike the South-to-North movement, migration to the West entailed greater traveling distances through difficult countryside, and thus larger expense. Moreover, there was the prospect of settling not only in Euro-American communities but also among or in close proximity to other, culturally different people—Mexican Americans in the Southwest, Asian Americans on the West Coast, Native Americans throughout the region. Yet numerous African Americans willingly faced the uncertainty of the frontier rather than the perceptible oppression of the South or East.

The history of blacks in the West begins with Afro-Spaniards in northern Mexico. These Spanish-speaking blacks accompanied Hernando Cortés and other conquistadors who superimposed Spanish rule over MEXICO in 1519. Many of these Afro-Spaniards, and the slaves who were later brought to colonial Mexico, intermarried with the Indian population, generating a large Zambo (part Indian, part African) population; some of these settled on the northern frontier of Mexico, which would later become Texas, California, New Mexico, and Arizona.

In 1794, for example, 23 percent of Mexican California's population was classified as mulatto or Zambo. The first census of Los Angeles, in 1781, indicated 56 percent of the original settlers as part black. During the same year, 25 percent of San Jose's

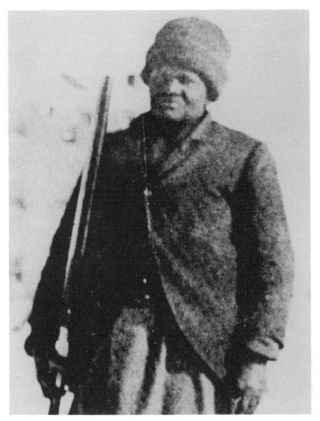

Six feet tall and tough as nails, Mary Fields, born a slave in Tennessee, lived from the 1880s to her death in 1914 in Cascade, Mont. She worked there as a freight hauler, a stagecoach driver, and a mail deliverer. (Photographs and Prints Division, Schomburg Center for Research in Black Culture, The New York Public Library, Astor, Lenox and Tilden Foundations)

population was listed as Zambo or mulatto, as was 14 percent in San Francisco. Similarly, 28 percent of Albuquerque's 1790 population was Zambo or mulatto, and in San Antonio in 1794, 35 percent fell into the two categories.

By the early years of the nineteenth century, African Americans were involved in the fur-trading industry as both traders and trappers, and consequently were responsible for exploring much of the Rocky Mountain region. Trapper Peter Ranne in 1824 was a member of the first party of Americans to reach California overland. One year later, Moses Harris was the first non-Indian to explore the Great Salt Lake region. James Beckworth and Edward Rose, among other "mountain men," traversed much of what would become Montana, Idaho, Wyoming, and Colorado.

Although some black settlers—including the farmers who migrated to Texas or the Pacific Northwest and the miners who participated in the California gold rush of the 1850s—entered the West before the Civil War, the destruction of American slavery in

1865 for the first time allowed for large-scale migration. Between 1870 and 1900, 1,000 blacks homesteaded in Colorado, 4,000 in Nebraska, 40,000 in Kansas, and over 100,000 in Oklahoma. Smaller numbers migrated to California, Montana, the Dakotas, and Arizona. Some southern African Americans organized political migrations to Kansas, Colorado, California, Montana, and Oklahoma, creating all-black settlements such as Boley and Langston in the Oklahoma Territory, Nicodemus in Kansas, and Allensworth in California, to put to practice theories of economic and political self-determination. The largest of these migrations was led by Benjamin "Pap" Singleton, a Tennessee carpenter who in 1874 distributed a circular entitled "The Advantage of Living in a Free State," which extolled the political freedom and economic opportunities in Kansas. Because of his efforts, at least 25,000 blacks settled in Kansas between 1874 and 1880 (see EXODUSTERS).

Many African Americans manipulated their status as first settlers in a particular frontier region to achieve wealth and prominence. Barney L. Ford, a former slave who arrived in Denver in 1859, had by 1890 become one of the wealthiest men in Colorado. His property, which included a hotel, a dry-goods store, and real estate in Denver and Cheyenne, Wyo., made him a millionaire. Sarah Gammon Bickford, who from 1888 to 1931 owned and operated the water system for Virginia City, Mont., became one of the city's most prominent citizens. William Gross arrived in Seattle in 1861 and opened the city's second hotel, as well as a restaurant and barbershop, and later bought a farm that would become the site of Seattle's black community. Biddy MASON, a former slave, acquired—and donated to African-American community institutions—a fortune in Los Angeles real estate before her death in 1891.

Even those African Americans who were not wealthy often found themselves with uncharacteristic influence over white lives and fates. Wagon trains crossing the Rocky Mountains relied on experienced guides such as Moses Harris and James Beckworth to lead them. When the first settlers arrived in Oregon's Willamette Valley in the 1840s, they found themselves dependent upon two former fur traders, Winslow Anderson and James Saules, for food and provisions. When white farmers moved to the Washington Territory in the 1850s, two African-American homesteaders, George Washington Bush and George Washington Cochrane, were there to lend advice and assistance. In San Francisco in the 1850s, miners bought provisions from West Indian–born merchant William Liedesdorff.

Post-1860 African Americans worked in virtually every western industry, including mining; they participated in the gold rushes to Idaho, Montana, Colorado, and the Black Hills in South Dakota. A few

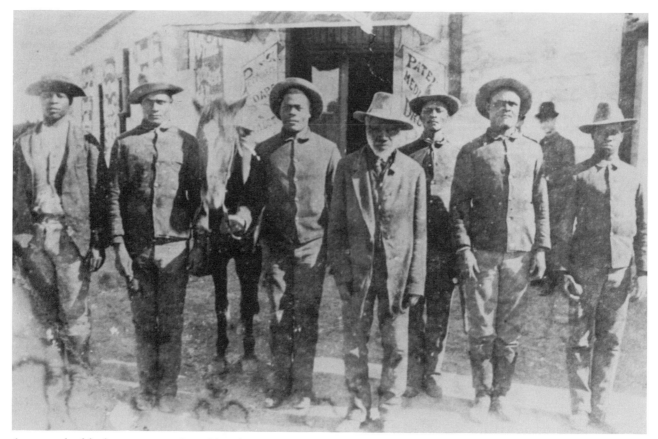

Among the black troops employed by the U.S. Army in the Indian Wars in the West after the Civil War were these Seminole scouts, the descendants of escaped slaves. In 1870 they were recruited by the U.S. Army in Mexico, where they had gone before the Civil War to escape re-enslavement. They served with distinction until 1881, when the unit was disabled. Most of the scouts, angered by the racism they encountered, returned to Mexico. (Photographs and Prints Division, Schomburg Center for Research in Black Culture, The New York Public Library, Astor, Lenox and Tilden Foundations)

blacks found gold on their claims. Californian Albert Callis amassed $90,000 in gold from his efforts in the 1850s, and John Frazier extracted $100,000 from his Colorado mine in 1866. Thaddeus Mundy, a soldier mustered out of service in Helena, Mont., in 1870, made a strike of $50,000 in nearby Dry Gulch the same year. Of course, most African Americans' experiences in mining camps were similar to that of Sarah Campbell. One of the earliest miners to reach the South Dakota Black Hills in 1874, Campbell never found gold on her claim but made a handsome living cooking, washing, and sewing for other miners.

African-American men also worked in the range cattle industry in virtually every state and territory of the West prior to 1900. They constituted nearly 25 percent, or approximately 9,000, of the 35,000 cowboys in the West between 1860 and 1895. In 1870 one black Texas trail boss, Bose Ikard, created the "Goodnight-Loving Trail" through New Mexico and Colorado, on which at least 100,000 cattle were driven north in fifteen years. Similarly, African-American soldiers after the Civil War were organized into the Ninth and Tenth cavalries and the Twenty-fourth and Twenty-fifth infantries, which were assigned to numerous locations through the West. Such assignments entailed protecting homesteaders, capturing outlaws, and quelling labor unrest. Eleven black soldiers earned the Congressional Medal of Honor while serving in the West.

The postbellum West also included political leaders and civil rights advocates such as William J. Hardin of Denver, who organized the campaign for equal suffrage in the Colorado Territory, and his Kansas counterpart, Charles LANGSTON of Leavenworth. Western newspaper editors such as Philip BELL of the San Francisco *Elevator* and Horace Clayton of the Seattle *Republican* not only defended black rights in the West, but spoke out against the growing southern movement to segregate and disfranchise African Americans in that region.

The image of the West as a region of opportunity for African Americans continued into the twentieth century, even when that image was contradicted by racially based employment restrictions. After 1900,

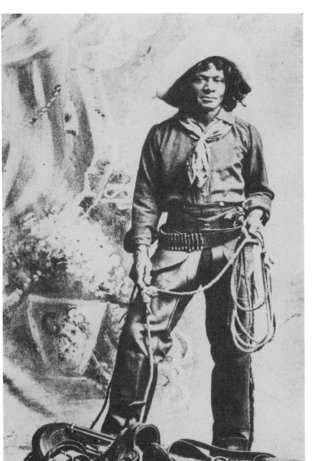

Nat Love, or "Deadwood Dick," one of the earliest and most celebrated black rodeo performers, outfitted in the equipment of his profession in this 1907 photograph. (Photographs and Prints Division, Schomburg Center for Research in Black Culture, The New York Public Library, Astor, Lenox and Tilden Foundations)

the urban West would be the destination for most African American western migrants. Yet blacks who moved to western cities between 1900 and 1940 usually found themselves confined to certain occupations: longshoremen, railway porters, hotel cooks and waiters, maids, ship stewards, and cannery workers. A few professionals—physicians, attorneys, ministers, and schoolteachers—provided services for black communities and many whites. Despite palpable poverty stemming from underemployment, black communities in cities such as Denver, San Francisco, Los Angeles, and Seattle nonetheless supported various community institutions—churches, social clubs, political organizations, fraternal groups, as well as civil rights defense organizations like the NATIONAL

ASSOCIATION FOR THE ADVANCEMENT OF COLORED PEOPLE (NAACP), the NATIONAL URBAN LEAGUE, and the UNIVERSAL NEGRO IMPROVEMENT ASSOCIATION.

During World War II, the black West was transformed by the influx of thousands of defense workers into the region's shipyards, aircraft factories, and other war-related businesses. Between 1940 and 1950, the total number of African Americans in the region grew 49 percent, from 1,343,930 to 1,996,036. Communities in specific cities grew even more dramatically. Between 1940 and 1944, the combined African-American populations of San Francisco and Oakland jumped from 19,000 to 147,000; Portland's black population rose from 1,300 to 22,000; that in Los Angeles grew from 75,000 to 218,000. Vallejo, Calif., which became a wartime shipbuilding center in the San Francisco Bay Area, saw its black population leap from 0 to 16,000 during the war years.

It was the World War II migration, however, that brought into sharp relief underlying racial tensions and rivalries, as African Americans and Euro-Americans competed for employment and housing. Moreover, the fact that the rapidly rising black populations were now concentrated in segregated residential districts produced de facto school segregation, which exacerbated African Americans' poverty and social alienation. The black communities of the West were increasingly sharing the conditions that had long plagued eastern and southern ghettos.

By the 1960s, such conditions prompted locally based civil rights movements in such cities as Seattle, Denver, and Los Angeles. Organizations such as CORE, the NAACP, and the Urban League, adopting many of the direct-action tactics successfully employed in the South, challenged the major problems of their communities—job discrimination, housing restrictions, and school segregation. As with the southern campaigns, their efforts were not always successful, but these protests registered community dissatisfaction with the evolving conditions in the region and forced political leaders to remove the most egregious examples of discrimination.

The black western migration continued into the 1980s, raising the regional population total by 1990 to 5,290,705. Such growth generated greater power and influence for specific black communities, as in the election of black mayors such as Tom BRADLEY in Los Angeles, Wellington Webb in Denver, and Norman Rice in Seattle. But persistent unemployment and underemployment, privation, and crime in those communities also suggest that Westerners, despite their region's reputation as the land of hope for African Americans and others, must still address the troubling nexus of race, class, and poverty in the urban milieu.

REFERENCES

BERWANGER, EUGENE. *The West and Reconstruction.* Urbana, Ill., 1981.

FRANKLIN, JIMMIE LEWIS. *Journey toward Hope: A History of Blacks in Oklahoma.* Norman, Okla., 1982.

PAINTER, NELL IRVIN. *Exodusters: Black Migration to Kansas after Reconstruction.* New York, 1977.

PORTER, KENNETH W. *The Negro on the American Frontier.* New York, 1971.

SAVAGE, W. SHERMAN. *Blacks in the West.* Westport, Conn., 1976.

TAYLOR, QUINTARD. "The Great Migration: The Afro-American Communities of Seattle and Portland during the 40s." *Arizona and the West* 23 (1981): 109–126.

———. "Slaves and Free Men: Blacks in the Oregon Country, 1840–1860." *Oregon Historical Quarterly* 83 (1982): 153–170.

QUINTARD TAYLOR

Author Dorothy West. (Moorland-Spingarn Research Center, Howard University)

West, Dorothy (1912–), writer. Dorothy West was born to Rachel Pease West and Isaac Christopher West in Boston, where she attended Girls' Latin School and Boston University. Hers has been a long and varied writing career that spans over seventy years, beginning with a short story she wrote at age seven. When she was barely fifteen, she was selling short stories to the *Boston Post.* And before she was eighteen, already living in New York, West had won second place in the national competition sponsored by OPPORTUNITY magazine, an honor she shared with Zora Neale HURSTON. The winning story, "The Typewriter," was later included in Edward O'Brien's *The Best Short Stories of 1926.*

As friend of such luminaries as Countee CULLEN, Langston HUGHES, Claude MCKAY, and Wallace THURMAN, Dorothy West judged them and herself harshly for "degenerat[ing] through [their] vices" and for failing, in general, to live up to their promise. Thus, in what many consider the waning days of the HARLEM RENAISSANCE and in the lean years of the depression, West used personal funds to start *Challenge,* a literary quarterly, hoping to recapture some of this failed promise. She served as its editor from 1934 until the last issue appeared in the spring of 1937. It was succeeded in the fall of that year by *New Challenge.* The renamed journal listed West and Marian Minus as coeditors and Richard WRIGHT as associate editor, but West's involvement with the new project was short-lived.

The shift from *Challenge* to *New Challenge* is variously explained but can perhaps be summed up in Wallace Thurman's observation to West that *Challenge* had been too "high schoolish" and "pink tea."

Whether *Challenge* was to *New Challenge* what "pink tea" was to "red" is debatable, but West has admitted that *New Challenge* turned resolutely toward a strict Communist party line that she found increasingly difficult to toe. Despite her resistance to this turn in the journal's emphasis, *Challenge,* under West's editorship, succeeded in encouraging and publishing submissions that explored the desperate conditions of the black working class.

Because of her involvement with *Challenge* and her early associations with the figures and events that gave the period its singular status and acclaim, West is now generally designated the "last surviving member of the Harlem Renaissance." The bulk of her writing, however, actually began to be published long after what most literary historians consider the height of the movement.

In the more than sixty short stories written throughout her career, West has shown that form to be her forte. Many of these stories were published in the *New York Daily News.* The first to appear there was "Jack in the Pot" (retitled "Jackpot" by the editors), which won the Blue Ribbon Fiction contest and was anthologized in John Henrik Clarke's 1970

collection *Harlem: Voices from the Soul of Black America*. Another story, "For Richer, for Poorer," has been widely anthologized in textbooks and various collections.

Although the short story has been the mainstay of her career, West is best known for her novel, *The Living Is Easy*. Published in 1948, the novel has been praised for its engaging portrayal of Cleo Judson, the unscrupulous and manipulative woman who brings ruin on herself as well as on family members who fall under her domination and control. But the novel has also earned West high marks for its treatment of the class snobbery, insularity, and all-around shallowness of the New England black bourgeoisie, whom West has termed the "genteel poor." While Mary Helen Washington commends *The Living Is Easy* for its array of feminist themes—"the silencing of women, the need for female community, anger over the limitations and restrictions of women's lives"—in the final analysis she faults it for silencing the mother's voice.

For the past forty years and more, Dorothy West has lived on Martha's Vineyard, contributing since 1968 a generous sampling of occasional pieces and columns to its newspaper, the *Vineyard Gazette*. She is currently at work on a number of projects and recently published a novel titled *The Wedding*.

REFERENCE

WASHINGTON, MARY HELEN. *Invented Lives: Narratives of Black Women 1860–1960*. New York, 1987.

DEBORAH MCDOWELL

West, Harold Dadforth (July 16, 1904–March 5, 1974), scientist, educator. Born in Flemington, N.J., Harold West attended the University of Illinois and received a bachelor of arts degree in the premedical curriculum in 1925. For financial reasons, West was unable to pursue a medical career; instead, he accepted a teaching position at Morris Brown College in Atlanta. A Julius Rosenwald fellowship enabled West to continue his education at the University of Illinois, where he was awarded a master's degree in biochemistry in 1932 and a doctorate in 1937. His dissertation was a study entitled "The Chemistry and Nutritive Value of Essential Amino Acids."

The following year, West was named professor and chairman of the biochemistry department at Meharry Medical College in Nashville, Tenn., becoming the first Ph.D. on the faculty. While teaching at Meharry, West did research on the synthesis of the essential amino acid threonine, helped discover the antibiotic eucerin and was among the first scientists to use radioactive silver in locating infections and tumors.

West became Meharry's first black president in 1952, serving until 1965. During his academic career, he earned a reputation for being an excellent teacher and efficient administrator. Among his many awards were a Rockefeller Foundation Fellowship (1937) and two honorary doctorates—from Morris Brown College (1955) and Meharry Medical College (1970). West died in Nashville in 1974. Two years later, Meharry Medical College dedicated the Harold D. West Basic Sciences Center in his honor.

REFERENCES

SAMMONS, VIVIAN OVELTON. *Blacks in Science and Medicine*. New York: 1989.
SUMMERVILLE, JAMES. *Educating Black Doctors: A History of Meharry Medical College*. University, Ala., 1983.

QADRI ISMAIL

West Virginia. West Virginia's African-American history is inextricably connected to the history of SLAVERY in VIRGINIA. In 1619, when "a Dutch man of warre" sold twenty Africans to the British settlers in Virginia (*see also* SLAVE TRADE), a beachhead was established for the growth of West Virginia's black population. African Americans first entered the western region of the Virginia colony in the 1750s. They settled in the Greenbrier and New River valleys with the slaveholding family of William and Mary Ingles.

While some African Americans soon joined Native Americans against European invaders, most sided with Europeans, partly because they were frequently, along with whites, the target of Indian attacks. In April 1782, for instance, Native Americans captured the wife, children, and slaves of Thomas Ingles. Under the impact of the French and Indian Wars, the AMERICAN REVOLUTION, and the westward expansion of the new nation, slavery continued to spread into western Virginia.

Although the Continental Congress rejected proposals to use black troops, the Virginia legislature approved the enlistment of slaves, promising masters $1,000 for each enlisted slave, and promising slaves $50 each and freedom at war's end. African-American enlistees defended the colony and helped to broaden the base of European settlement in western Virginia. Slaves cleared land and posted claims for white men like George Washington in Kanawha, Randolph, Monongalia, Mason, Greenbrier, and other counties in the future state of West Virginia.

After NAT TURNER'S REBELLION in 1831, restrictions on the activities on slaves and free blacks led many free blacks to leave. As a result, both the percentage and the absolute numbers of free blacks in the western part of the state declined. The number of slaves increased from just over 5,200 in 1790 to almost 20,000 in 1830, while free blacks rose from just over 600 to nearly 2,200. While some blacks worked on large plantations in Greenbrier, Hampshire, Pendleton, and Berkeley counties, most labored on small farms, in households, and as laborers in the region's slowly developing iron, coal, and salt industries.

The advent of the CIVIL WAR transformed the lives of African Americans in western Virginia. In 1861, Virginia seceded from the Union and joined the Confederacy, but the western delegates voted against secession, and set in motion a movement for statehood. When West Virginia gained statehood in 1863, however, it did not become a haven for slaves and free blacks. It entered the Union as a slave state, though an act of gradual EMANCIPATION was passed. During the war years, the state's black population actually dropped from over 21,000 in 1860 to some 17,000, or 3 percent of the total, at war's end. Most whites hoped to make West Virginia a white man's state. Before the constitutional convention approved legislation for gradual emancipation, the original provisions stated that "No slave shall be brought or free person of color come into this state for permanent residence after this constitution goes into effect." Only in February 1865 did the state end chattel slavery in West Virginia.

As elsewhere, blacks in West Virginia played a crucial role in their own liberation. Some "voted for freedom with their feet." During the Civil War, Washington Ferguson, Booker T. WASHINGTON's stepfather, escaped from slavery and followed Union soldiers into the Kanawha Valley. He later sent for his wife Jane and his children, including the young Booker T. Other blacks migrated further north and joined the Union Army there. West Virginia blacks served in the Union forces of Ohio, Pennsylvania, and other northern states, making up four companies in all. Born in Charlestown, Jefferson County, Martin R. DELANY, the most renowned of the West Virginia blacks to serve, became a medical officer and attained the rank of major. When emancipation came in 1865, African Americans in West Virginia could claim a role in bringing it about.

The status of blacks in the first years of freedom remained ambiguous. In February 1865, the state ratified the THIRTEENTH AMENDMENT, which outlawed slavery. In 1866, when the legislature introduced a measure permitting blacks to testify and serve as witnesses in courts of law, opposition to the bill was fierce and bitter. In 1872, a new constitution enfran-chised blacks—the governor of West Virginia eloquently defended the measure and it finally passed after a sharp debate at the constitutional convention—but it denied African Americans the right to serve on juries, and it mandated segregated schools.

Unlike the situation in several other southern states, however, West Virginia's blacks comprised a smaller percentage of the total electorate. Thus they carefully allied with key REPUBLICAN PARTY leaders and pushed their claims upon the state with substantial success. Drawing their cues from the sentiments of blacks, some whites, such as Gov. Arthur Boreman, eloquently articulated the position of African Americans. Only during the 1890s and early twentieth century, however, did blacks increase their proportion of the state's voting age male population from negligible numbers following the Civil War to about 17 percent.

Under the impact of industrialization following RECONSTRUCTION, African Americans faced the complicated transition from southern agriculture to life in coal mining towns. The black population increased from 25,800 in 1880 to over 64,000 in 1910, and to nearly 115,000 in 1930. The growth of the bituminous coal industry underlay this dynamic population growth. Coal production increased from less than 5 million tons in 1885 to nearly 40 million tons in the southern counties alone by 1910. Although the industry experienced sharp cyclical swings, southern West Virginia mines produced over 120 million tons in 1925.

Blacks made up over 20 percent of West Virginia's total coal mining labor force from the 1890s through the early twentieth century and played a key role in the growth of the state's coal industry. Blacks from rural areas of the upper South, mainly Virginia, assisted in laying track for the three major railroads that helped to open up the bituminous fields: the Chesapeake and Ohio, the Norfolk and Western, and the Virginian. It was work on the Chesapeake and Ohio that produced the black folk hero JOHN HENRY. As each railroad completed lines through the region, contingents of black railroad men remained behind to work in the coal mines. They were later joined by growing numbers of blacks who went directly into the mines. While blacks from the nearby upper South and border states of Virginia, Kentucky, and Tennessee dominated the migratory stream to West Virginia during the period, the advent of WORLD WAR I brought growing numbers of migrants from the deep South states of Alabama, Georgia, and Mississippi.

From the turn of the century through the early 1930s, African Americans made up between 20 and 26 percent of the total coal mining labor force in southern West Virginia. They also gradually increased their percentage in the mines in northern

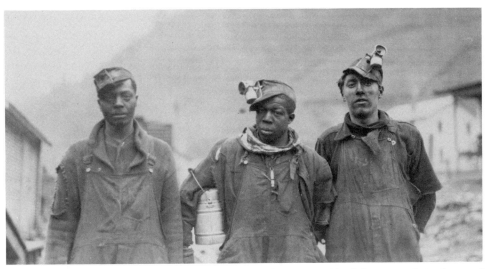

Large numbers of African Americans migrated to West Virginia to work in the coal fields. These men were photographed in April 1918. (Prints and Photographs Division, Library of Congress)

West Virginia, but they would remain a much smaller percentage of the total there. Coal companies actively recruited black workers, but black men and women also established their own kin and friendship networks, and helped to facilitate their own movement into the coal mining towns. Moreover, since coal mining required the acquisition of new skills and work habits—especially safety procedures in the new volatile work environment—blacks also helped to transform themselves into a new industrial working class.

As the African American population increased, racial hostility escalated. In 1919, for example, a white mob lynched two black miners at Chapmanville in Logan County. During the early 1920s, chapters of the KU KLUX KLAN emerged in Logan, Mercer, and Kanawha counties. Moreover, racial injustice before the law also prevailed, as in several cases of black men accused of crimes against whites, especially rape. In 1921, for example, the governor denied a plea for clemency and permitted a black man to be hanged, despite evidence suggesting his innocence.

As they made the transition to the new industrial era, African Americans developed a variety of institutional and political responses to inequality. While black businessmen and professionals dominated leadership positions, black workers and women also shaped the growth of black community life. As the numbers of African Americans in West Virginia increased, black institutions and associations also flourished. Black churches and fraternal organizations underwent a striking growth in the first three decades of the twentieth century. West Virginia had active branches of the NATIONAL ASSOCIATION FOR THE ADVANCEMENT OF COLORED PEOPLE and the Garveyist United Negro Improvement Association. McDowell was the center of black life in West Virginia, and the weekly *McDowell Times*, edited by Matthew Thomas Whittico, was the most influential organ of black opinion during these years. (Whittico popularized the phrase "the Free State of McDowell," in reference to the state's largest center of black population and influence.)

Unlike their counterparts in most southern states, African Americans retained the franchise in West Virginia. In 1918, for example, three black Republicans were elected to the state legislature: the Charleston attorney T. G. Nutter, Keystone attorney Harry J. Capehart, and coal miner John V. Coleman, of Fayette County. In 1927, Minnie Buckingham Harper completed the term of her deceased husband in the state legislature, the first black women to serve in any American legislative body. Memphis Tennessee Garrison (1890–1988), a schoolteacher and civil rights activist, was active in the institutional, social, and political life of the state from the 1920s through the 1960s. During the 1920s, she initiated the NAACP's national Christmas Seal campaign, and later won the organization's coveted Madam C. J. Walker Gold Medal Award for her work.

Based on the activities of black men and women, elites and workers, African-American political campaigns produced significant results in the Mountain State. Black legislators soon helped to pass a state antilynching law, a statute barring the showing of inflammatory films like THE BIRTH OF A NATION, and appropriations for the expansion of old and the creation of new social welfare and educational institutions. By 1930, African Americans had access to two state colleges (West Virginia State and Bluefield

State); a tuberculosis sanitarium; homes for the deaf, blind, aged, and infirm; schools for delinquent youth; a Bureau of Negro Welfare and Statistics; and an expanding number of public elementary, junior high, and high schools.

Under the impact of the GREAT DEPRESSION of the 1930s, blacks shouldered a disproportionate share of the unemployment and hard times. Their percentage in the state's coal mining labor force dropped from over 22 percent in 1930 to about 17 percent in 1940. The depression and WORLD WAR II also unleashed new technological and social forces that transformed the coal industry and stimulated massive outmigration in the postwar years. Although coal companies had installed undercutting machines in their mines during the 1890s, the handloading of coal remained intact until the advent of the mechanical loader during the late 1930s. Loading machines rapidly displaced miners during the 1940s and 1950s. The percentage of black miners dropped steadily to about 12 percent in 1950, 6.6 percent in 1960, and 5.2 percent in 1970. By 1980, African Americans made up less than 3 percent of the state's coal miners. To be sure, the white labor force had also declined, dropping by nearly 36 percent, but the black proportion had declined by over 90 percent. Under the leadership of John L. Lewis, the United Mine Workers of America adopted a policy on technological change that reinforced the unequal impact of mechanization on black workers. As Lewis put it, "Shut down 4,000 coal mines, force 200,000 miners into other industries, and the coal problem will settle itself."

As the state's black coal mining labor force declined, racial discrimination persisted in all facets of life in the Mountain State. In 1961, according to the West Virginia Human Rights Commission, most of the state's public accommodations—restaurants, motels, hotels, swimming pools, and medical facilities—still discriminated against blacks. Moreover, applications for institutions of higher learning contained questions on race and religion, designed to exclude so-called undesirable groups. Finally, and most important, as blacks lost coal mining jobs, they found few alternative employment opportunities. The state's Human Rights Commission reported that "Numerous factories, department stores, and smaller private firms had obvious, if unwritten, policies whereby blacks were not hired or promoted to jobs of importance or positions in which they would have day-to-day contact with white clientele."

Building upon the traditions bequeathed by preceding generations, African Americans responded to declining economic and social conditions in a variety of ways. Many moved to the large metropolitan areas of the Northeast and Midwest. Smaller networks of West Virginia blacks emerged in cities like Cleveland, Chicago, Detroit, and New York. Others moved to the nearby upper South and border cities of Washington, D.C. and Alexandria, Va. Still others moved as far west as California. Indicative of the rapid outmigration of West Virginia blacks, the state's total African-American population dropped from a peak of 117,700 in 1940 to 65,000 in 1980, a decline from 6 to 3 percent of the total.

Still, other West Virginia blacks remained behind and struggled to make a living in the emerging new order. The dwindling numbers of African Americans did not sit quietly waiting for things to change under them. Charles Brooks, a black miner from Kanawha County, served as the first president of the Black Lung Association, which in 1969 marched on the state capital in Charleston to demand compensation for miners suffering from the disease. In 1972, the Black Lung Association also played a key role in the coalition of forces that made up Miners for Democracy, a rank-and-file movement that resisted the growing autocratic rule of the United Mine Workers of America's top leaders like Tony Boyle. As early as the mid-1930s, along with blacks elsewhere in America, West Virginia blacks had reevaluated their historic links to the Republican party and found them lacking. They joined the Democratic party and helped to buttress the volatile New Deal coalition of northern urban ethnic groups, organized labor, and devotees of the so-called "solid South." As suggested

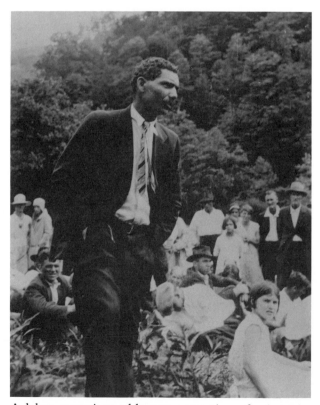

A labor organizer addresses a meeting of miners in Edwight, W.Va., in 1931. (Prints and Photographs Division, Library of Congress)

by their declining numbers in the coal industry, however, the black alliance with the Democratic party produced few lasting benefits in the Mountain State.

Under the impact of the 1954 BROWN V. BOARD OF EDUCATION OF TOPEKA, KANSAS decision, blacks in West Virginia pushed for full access to the state's public schools, colleges, and universities. As late as 1963, most African Americans continued to receive education within a segregated public school system. The tradition of all-black public institutions nonetheless gradually came to an end. As early as 1956, the state had terminated the Bureau of Negro Welfare and Statistics. Bluefield State College and West Virginia State College became predominantly white by the mid-1970s. At the same time, local school boards shut down one black high school after another, bringing to a close one of the major public institutions in black life during the era of JIM CROW. As R. Charles Byers, professor of education at West Virginia State College, remarks, the fall of black high schools was a "heartbreaking" development, "but what was more deplorable was the injustice that took place in West Virginia. The artifacts, trophies, books, yearbooks, and records now referred to as memorabilia were burned or placed away in boxes and forgotten."

Partly because of the often bitter fruits of integration, African Americans in the Mountain State retained their own institutions. They struggled to maintain black churches, fraternal orders, social clubs, civil rights and political organizations, and the black press. Formed in the 1950s, the *Beacon Journal* replaced the *McDowell Times* as the preeminent organ of black public opinion in the state. In 1988, the First Baptist Church of Charleston hosted the First Annual Conference on West Virginia's Black History. Spearheaded by the Alliance for the Collection, Preservation, and Dissemination of West Virginia's Black History, the annual conference features a variety of papers, speeches, and comments on the state's black heritage. It also reflects an enduring commitment to African-American institutions, values, and beliefs.

Although characterized by enduring patterns of class and racial inequality, the history of African Americans in West Virginia is not one story, but many. The first generation faced the challenge of transforming themselves from slaves into citizens in the larger body politic. While this goal was only partially realized and would persist over the next century, the next generation confronted its own unique challenge. During the late nineteenth and early twentieth centuries, African Americans in the Mountain State faced the difficult transition from life in southern agriculture to life in coal mining towns. Despite important class and gender differences, both between black men and women and between black workers and black elites, African Americans built upon the traditions of their predecessors, bridged social cleavages, and protected their collective interests. Like preceding generations, the current generation is reckoning with the impact of mechanization, the decline of the coal industry, and the massive outmigration of blacks to cities throughout the nation. How well they will succeed in building upon the lessons of the past is yet to be seen.

REFERENCES

CORBIN, DAVID A. *Life, Work, and Rebellion in the Coal Fields: Southern West Virginia Miners, 1880–1922.* Urbana, Ill., 1981.

DIX, KEITH. *What's a Coal Miner to Do? The Mechanization of Coal Mining.* Pittsburgh, Pa. 1988.

ELLER, RONALD D. *Miners, Millhands, and Mountaineers: Industrialization of the Appalachian South, 1880–1930.* Knoxville, Tenn., 1982.

HENRY, FLORETTE. *Black Migration: Movement North, 1900–1920.* New York, 1975.

JACKAMEIT, WILLIAM P. "A Short History of Negro Public Higher Education in West Virginia, 1890–1965." *West Virginia History* 37, no. 4 (July 1976): 309–324.

LEWIS, RONALD L. *Black Coal Miners in America: Race, Class, and Community Conflict, 1780–1980.* Lexington, Ky., 1987.

POSEY, THOMAS E. *The Negro Citizen of West Virginia.* Institute, W.Va., 1934.

RICE, OTIS K. *West Virginia: A History.* Lexington, Ky., 1985.

SHEELER, JOHN REUBEN. The Negro in West Virginia. Ph.D. diss., West Virginia University, 1954.

SMITH, DOUGLAS C. "In Quest of Equality: The West Virginia Experience." *West Virginia History* 37, no. 3 (April 1976): 211–219.

STEALEY, JOHN E. "The Freedmen's Bureau in West Virginia." *West Virginia History* 39, nos. 2–3 (January/April 1978): 99–142.

TROTTER, JOE W. *Coal, Class, and Color: Blacks in Southern West Virginia, 1915–32.* Urbana, Ill., 1990.

TURNER, WILLIAM H., and EDWARD CABBELL, eds. *Blacks in Appalachia.* Lexington, Ky., 1985.

West Virginia Human Rights Commission. *Public Hearing in Wheeling, February 1971.* Charleston, W.Va., 1971.

———. *Annual Reports.* Charleston, W.Va., 1985–1986, 1986–1989.

JOE W. TROTTER, JR.

Wharton, Clifton Reginald, Jr.

(September 13, 1926–), business executive, educator. Clifton R. Wharton, Jr. was born in Boston, the son of Clifton Reginald Wharton, the first African American to obtain the rank of ambassador in the foreign service. After spending most of his childhood in the Canary Islands, during his father's diplomatic posting, Whar-

ton returned to Boston and graduated from Boston Latin School in 1943. In 1947 he received a B.A. in history from Harvard University, and in 1948 he became the first African American to receive an M.A. from the School of Advanced International Studies at Johns Hopkins University. In 1958 he received a Ph.D. in economics from the University of Chicago.

Wharton worked as a development economist from 1948 to 1953 for Nelson A. Rockefeller's American International Association for Economic and Social Development. From 1957 to 1969 he spent time in Latin America working for the Agricultural Development Council, spending six years of that time directing programs in Southeast Asia. In 1969 Wharton became the first African-American director of a major life insurance company, Equitable Life Assurance Society of the United States.

From 1970 to 1978 Wharton served as the first African-American president of Michigan State University, and from 1978 to 1987 as the first African-American chancellor of the State University of New York (SUNY). In 1978 Wharton assumed the position of CEO of the Teachers Insurance Annuity Association and College Retirement Fund (TIAA-CREF), the nation's largest private pension system, managing pension funds for more than 1.6 million people at nearly 5,000 colleges, universities, and related institutions. At TIAA-CREF, Wharton diversified the clients' financial products, creating a money-market fund, a bond fund, and a social-choice stock fund.

On December 22, 1992, calling the management skills Wharton demonstrated at TIAA-CREF "truly legendary," President-elect Bill Clinton nominated Wharton to the post of deputy secretary of state, making him the highest ranking African-American in the State Department's history. However, in early November 1993, Wharton resigned saying that he was unwilling to allow "sustained anonymous press leaks" to erode his effectiveness. In his brief tenure, Wharton worked to reform the Agency for International Development (AID), redirect foreign aid procedures, and reorganize the State Department.

After leaving the State Department, Wharton returned to TIAA-CREF with the title of Former Chairman/CEO. His honors include the President's Award on World Hunger (1983), forty-three honorary degrees, and buildings named after him and his wife on the campuses of Michigan State and SUNY–Albany.

REFERENCE

"Clifton Wharton, Jr.: America's Most Powerful Black Executive." *Black Enterprise* 23 (February 1993): 134.

SIRAJ AHMED
SABRINA FUCHS

Wharton, Clifton Reginald, Sr. (May 11, 1899–April 28, 1990), lawyer and ambassador. Clifton Wharton was born in Baltimore and grew up in Boston, graduating from English High School. In 1920 he received a law degree from Boston University, and from 1920 until 1923 he practiced law in Boston. Upon receiving an advanced legal degree from Boston University in 1923, he moved to Washington, D.C., serving first as an examiner in the Veterans Bureau and then as a law clerk in the State Department.

In 1925 the United States Foreign Service was established, and Wharton became the first black to enter it. For the next two decades, he was the only African-American career diplomat. He served in Monrovia, Liberia (1925–1929), Las Palmas, Canary Islands, Spain (1930–1941), and Tananarive, Madagascar (1942–1945). In April 1945, he served as the maritime delegate consul in Ponta Delgada, Azores Islands, Portugal.

In October 1949, he was appointed consul and first secretary, and in 1950 consul general, at the U.S. embassy in Lisbon, Portugal. Until he was posted in

Clifton Wharton, Sr., in 1958, at the time of his appointment as ambassador to Norway, the first African-American diplomat to head a European mission. (Photographs and Prints Division, Schomburg Center for Research in Black Culture, The New York Public Library, Astor, Lenox and Tilden Foundations)

Lisbon, Wharton's duties were typical for consular officers in low-level positions: he was concerned with the protection of American citizens' rights and American corporations' interests, and with visas. As first secretary in Lisbon, he became a member of a political section of a U.S. embassy, writing political reports for the State Department and participating in political negotiations.

In 1953 Wharton became consul general in Marseilles, France, and in 1958 President Dwight D. Eisenhower appointed him U.S. minister to Romania, making him the first black diplomat to head a U.S. delegation to a European country. The appointment may have been an attempt by the U.S. government to silence Communist-bloc criticism that the U.S. discriminated against blacks, although the State Department reassured Wharton that he was appointed because of his qualifications, not because of race. In 1961 President John F. Kennedy appointed Wharton U.S. ambassador to Norway, perhaps as part of his pledge to give blacks greater representation in public office. Although he was not the first black to serve as U.S. ambassador, Wharton was the first to attain this position by rising through the ranks of the foreign service, rather than by political appointment. During this period, he was also alternative representative of the U.S. delegation to the sixteenth session of the United Nations General Assembly. In 1963 Wharton received an honorary doctorate of law from Boston University and retired from the foreign service the following year. He died in Phoenix, Ariz.

REFERENCE

Obituary. *Washington Times*, April 25, 1990, p. B4.

SIRAJ AHMED

Wheatley, Phillis (c. 1753–December 5, 1784), poet. Phillis Wheatley was born, according to her own testimony, in Gambia, West Africa, along the fertile lowlands of the Gambia River. She was abducted as a small child of seven or eight, and sold in Boston to John and Susanna Wheatley on July 11, 1761. The horrors of the middle passage (*see* SLAVE TRADE) very likely contributed to the persistent asthma that plagued her throughout her short life. The Wheatleys apparently named the girl, who had nothing but a piece of dirty carpet to conceal her nakedness, after the slaver, the *Phillis*, that transported her. Nonetheless, unlike most slave owners of the time, the Wheatleys permitted Phillis to learn to read, and her poetic talent soon began to emerge.

Her earliest known piece of writing was an undated letter from 1765 (no known copy now exists) to Samson Occom, the Native American Mohegan minister and one of Dartmouth College's first graduates. The budding poet first appeared in print on December 21, 1767, in the *Newport Mercury* newspaper, when the author was about fourteen. The poem, "On Messrs. Hussey and Coffin," relates how the two gentlemen of the title narrowly escaped being drowned off Cape Cod in Massachusetts. Much of her subsequent poetry deals, as well, with events occurring close to her Boston circle. Of her fifty-five extant poems, for example, nineteen are elegies; all but the last of these are devoted to commemorating someone known by the poet. Her last elegy is written about herself and her career.

In early October 1770, Wheatley published an elegy that was pivotal to her career. The subject of the elegy was George Whitefield, an evangelical Methodist minister and privy chaplain to Selina Hastings, countess of Huntingdon. Whitefield made seven journeys to the American colonies, where he was known as "the Voice of the Great Awakening" and "the Great Awakener." Only a week before his death in Newburyport, Mass., on September 30, 1770, Whitefield preached in Boston, where Wheatley very likely heard him. As Susanna Wheatley regularly corresponded with the countess, she and the Wheatley household may well have entertained the Great Awakener. Wheatley's vivid, ostensibly firsthand account in the elegy, replete with quotations, may have been based on an actual acquaintance with Whitefield. In any case, Wheatley's deft elegy became an overnight sensation and was often reprinted.

It is almost certain that the ship that carried news of Whitefield's death to the countess also carried a copy of Wheatley's elegy, which brought Wheatley to the sympathetic attention of the countess. Such an acquaintance ensured that Wheatley's elegy was also reprinted many times in London, giving the young poet the distinction of an international reputation. When Wheatley's *Poems* was denied publication in Boston for racist reasons, the countess of Huntingdon generously financed its publication in London by Archibald Bell.

Wheatley's support by Selina Hastings and her rejection by male-dominated Boston signal her nourishment as a literary artist by a community of women. All these women—the countess, who encouraged and financed the publication of her *Poems* in 1773; Mary and Susanna Wheatley, who taught her the rudiments of reading and writing; and Obour Tanner, who could empathize probably better than anyone with her condition as a slave—were much older than Wheatley and obviously nurtured her creative development.

During the summer of 1772, Wheatley actually journeyed to England, where she assisted in the preparation of her volume for the press. While in London

POEMS

ON

VARIOUS SUBJECTS,

RELIGIOUS AND MORAL.

BY

PHILLIS WHEATLEY,

NEGRO SERVANT to Mr. JOHN WHEATLEY,
of BOSTON, in NEW ENGLAND.

LONDON:
Printed for A. BELL, Bookseller, Aldgate; and sold by
Messrs. COX and BERRY, King-Street, BOSTON.
MDCCLXXIII.

Published according to Act of Parliament, Sept.ʳ 1, 1773 by Archᵈ Bell.
Bookseller Nº 8 near the Saracens Head Aldgate.

Phillis Wheatley, a Boston slave, was the first African American—and only the third American woman—to publish a volume of poetry. She achieved international celebrity unmatched by any other eighteenth-century American black. This frontispiece engraving in the 1773 London edition of her verse is most likely taken from a painting by Scipio Moorhead, a black Boston artist. (Prints and Photographs Division, Library of Congress)

she enjoyed considerable recognition by such dignitaries as Lord Dartmouth, Lord Lincoln, Granville Sharp (who escorted Wheatley on several tours about London), Benjamin Franklin, and Brook Watson, a wealthy merchant who presented Wheatley with a folio edition of John Milton's *Paradise Lost* and who would later become lord mayor of London. Wheatley was to have been presented at court when Susanna Wheatley became ill. Wheatley was summoned to return to Boston in early August 1773. Sometime before October 18, 1773, she was granted her freedom, according to her own testimony, "at the desire of my friends in England." It seems likely, then, that if Selina Hastings had not agreed to finance Wheatley's *Poems* and if the poet had not journeyed to London, she would never have been manumitted.

As the American Revolution erupted, Wheatley's patriotic feelings began to separate her even more from the Wheatleys, who were loyalists. Her patriotism is clearly underscored in her two most famous Revolutionary War poems. "To His Excellency General Washington" (1775) closes with this justly famous encomium: "A crown, a mansion, and a throne that shine, / With gold unfading WASHINGTON! be thine." "Liberty and Peace" (1784), written to celebrate the Treaty of Paris (September 1783), de-

clares: "And new-born Rome [i.e., America] shall give *Britannia* Law."

Phillis Wheatley's attitude toward slavery has also been misunderstood. Because some of her antislavery statements have been recovered only in the 1970s and '80s, she has often been criticized for ignoring the issue. But her position was clear: In February 1774, for example, Wheatley wrote to Samson Occom that "in every human breast, God has implanted a Principle, which we call Love of Freedom; it is impatient of Oppression, and pants for Deliverance." This letter was reprinted a dozen times in American newspapers over the course of the next twelve months. Certainly Americans of Wheatley's time never questioned her attitude toward slavery after the publication of this letter.

In 1778 Wheatley married John Peters, a free African American who was a jack-of-all-trades, serving in various capacities from storekeeper to advocate for African Americans before the courts. But given the turbulent conditions of a nation caught up in the Revolution, Wheatley's fortunes began to decline steadily. In 1779 she published a set of *Proposals* for a new volume of poems. While the *Proposals* failed to attract subscribers, these *Proposals* attest that the poet had been diligent with her pen since the 1773 *Poems*

and that she had indeed produced some 300 pages of new poetry. This volume never appeared, however, and most of its poems are now lost.

Phillis Wheatley Peters and her newborn child died in a shack on the edge of Boston on December 5, 1784. Preceded in death by two other young children, Wheatley's tragic end resembles her beginning in America. Yet Wheatley has left to her largely unappreciative country a legacy of firsts: She was the first African American to publish a book, the first woman writer whose publication was urged and nurtured by a community of women, and the first American woman author who tried to earn a living by means of her writing.

REFERENCES

DAVIS, ARTHUR P. "Personal Elements in the Poetry of Phillis Wheatley." *Phylon* 13 (1953): 191–198.

O'NEALE, SONDRA A. "A Slave's Subtle War: Phillis Wheatley's Use of Biblical Myth and Symbol." *Early American Literature* 21 (1986): 144–165.

ROBINSON, WILLIAM H. *Black New England Letters: The Uses of Writing in Black New England.* Boston, 1977.

———, ed. *Critical Essays on Phillis Wheatley.* Boston, 1982.

———, ed. *Phillis Wheatley in the Black American Beginnings.* Detroit, 1975.

SHIELDS, JOHN C. "Phillis Wheatley." In Valerie Smith, gen. ed. *African American Writers.* New York, 1991, pp. 473–491.

———. "Phillis Wheatley and Mather Byles: A Study of Literature Relationship." *College Language Association Journal* 23 (1980): 377–390.

———. "Phillis Wheatley's Struggle for Freedom in Her Poetry and Prose." In John C. Shields, ed. *The Collected Works of Phillis Wheatley.* New York, 1988, pp. 229–270, 324–336.

———. "Phillis Wheatley's Use of Classicism." *American Literature* 52 (1980): 97–111.

JOHN C. SHIELDS

Whipper, William (c. February 22, 1804–March 9, 1876), moral reformer and businessman. William Whipper was born in Little Britain Township, in Lancaster County, Pa. While the inscription on Whipper's tombstone gives 1804 as his date of birth, census data list his year of birth as 1806. Little is known about Whipper's early life, but by 1830 he was living in Philadelphia and working as a steam scourer, cleaning clothing with a steam process.

By the early 1830s, Whipper, who was operating a "free labor and temperance grocery" in Philadelphia, had become active in the intellectual life of the city's black community. In 1828 he delivered an "Address Before the Colored Reading Society of Philadelphia," and in 1833, he was selected to deliver a public eulogy on the British abolitionist William Wilberforce. That same year, he was among the nine founders of the Philadelphia Library of Colored Persons.

Whipper attended every annual National Negro Convention from 1830 to 1835 and was chosen to help draft the movement's declaration of sentiments. In 1834, Whipper, who had earned a reputation among Philadelphia's black elite for his support of moral reform, delivered an address to the Colored Temperance Society of Philadelphia that emphasized the importance of virtue in promoting racial uplift.

At the 1835 national convention, Whipper spearheaded the movement to form the AMERICAN MORAL REFORM SOCIETY (AMRS), an interracial organization with a broad reform agenda, one that did not focus exclusively on the slavery issue. Whipper was appointed to the committee to draft the society's constitution, was elected as secretary, and delivered the address *To the American People* at the society's first annual meeting in Philadelphia in 1837. Whipper also helped establish and served as editor of the society's journal, the *National Reformer* (1838–1839).

By 1835, Whipper had moved to Columbia, Pa., on the Susquehanna River, where he became active in the UNDERGROUND RAILROAD, providing economic aid to fugitive slaves who passed through the city. While in Columbia, Whipper joined with Stephen Smith, a wealthy African-American lumber merchant, to establish Smith and Whipper, a lucrative lumber business with operations in Philadelphia and Columbia.

The AMRS lost most of its support in the late 1830s, and with the collapse of the AMRS in 1841, Whipper's public career began to fade. Whipper focused his attention on his lumber company, although he continued to participate in the activities of the northern black leadership. In 1848, he attended the State Convention in Philadelphia, reversing his previous denunciation of "complexional" gatherings, and participated in the national conventions of 1853 (Rochester, N.Y.) and 1855 (Philadelphia).

After the passage of the Fugitive Slave Act of 1850, Whipper became interested in emigration to Canada West (now Ontario), shifting his longtime opposition to emigrationist schemes. In 1853, Whipper traveled to Canada and decided to purchase property in the town of Dresden. He was on the verge of moving his family there in 1861, when the outbreak of the U.S. Civil War caused him to abandon his plans.

Whipper moved to New Brunswick, N.J., in 1868, but he retained his residence in Philadelphia. In 1870, he was appointed as a cashier in the Philadelphia branch of the Freedmen's Savings Bank, and two years later, he relocated to that city. When the bank

collapsed in 1873, Whipper apparently lost a large portion of his substantial personal savings. He died at his home in Philadelphia.

REFERENCES

McCORMICK, RICHARD P. "William Whipper: Moral Reformer." *Pennsylvania History* 43 (January 1976): 22–46.
STILL, WILLIAM. *The Underground Railroad.* Philadelphia, 1879.

LOUISE P. MAXWELL

White, Augustus Aaron, III

White, Augustus Aaron, III (June 4, 1936–), surgeon and medical scientist. Born in Memphis Tenn., Augustus White graduated from Brown University (B.A., 1957) and then became the first African American to attend the Stanford University School of Medicine (M.D., 1961). He completed his orthopedic residency at Yale Medical Center and did further study at the Karolinska Institute in Sweden where he earned a doctorate in medicine for his research on the biomechanics of the spine. In 1977, he became the first African American to become a full professor of surgery at the Yale Medical School. In 1978, he became professor of orthopedic surgery at Harvard Medical School and the Harvard/MIT Division of Health Sciences and Technology as well as orthopaedic surgeon-in-chief at Boston's Beth Israel Hospital.

As a researcher, White's major efforts have been directed at the study of spinal injury and bone-fracture healing. He has written and collaborated on more than 130 scientific publications, most notably *The Clinical Biomechanics of the Spine* (1990). This book incorporated new scientific material about spinal mechanics in a way that could be directly applied to the comprehensive care of patients. White is also the author of a popular book for patients entitled *Your Aching Back: A Doctor's Guide to Relief* (1970).

White's biomedical research led to the development of an internationally utilized system for evaluating the function of the neck following disease and injury, known as the "Checklist for Clinical Stability." He helped found two biochemical laboratories, the Engineering Laboratory of Musculoskeletal Diseases at Yale University School of Medicine in 1970 and the Orthopaedic Biomechanics Laboratory at Harvard Medical School/Beth Israel Hospital in 1979.

White was a recipient of the Bronze Star, earned when he was stationed as a captain in the U.S. Army Medical Corps in Vietnam. (While overseas, he did extensive volunteer work in a leper colony.) White's other awards included the United States Jaycees "Ten Outstanding Young Men" award and the Martin Luther King, Jr. Medical Achievement Award.

REFERENCE

HOWELL, ROBERT. "Oh My Aching Back!" *Ebony Magazine* (June 1979): 44–52.

ROBERT C. HAYDEN

Augustus White, professor of orthopedic surgery at Harvard Medical School, is one of the nation's leading experts on spinal problems and back pain. (Photographs and Prints Division, Schomburg Center for Research in Black Culture, The New York Public Library, Astor, Lenox and Tilden Foundations)

White, Bill

White, Bill (January 28, 1934–), baseball player and league executive. Bill White was born William Dekova White in Lakewood, Fla., and raised in Warren, Ohio. He entered professional baseball by joining a New York Giants farm team in Danville, Va., in 1953 and first played for the Giants in 1956. He served in the military in 1957 and returned to join the Giants in 1958 after the team moved to San Francisco. He was traded to the St. Louis Cardinals in 1959, where he stayed until 1965, when he was traded to the Philadelphia Phillies. He returned to St. Louis in 1969 for his final year. White batted over .300 four times and finished his career with a lifetime average of .286. For his defensive play, he won consecutive Golden Glove awards from 1960 to 1966.

In 1960 White led the Cardinals to integrate its Spring-training camp in Florida, where still existing JIM CROW laws barred blacks from hotels, theaters, restaurants, and other public facilities. Angered by an incident in which only white team members had been invited to a breakfast at a local yacht club, White notified the Associated Press, causing embarrassment

After successful careers as a first baseman for the St. Louis Cardinals and Philadelphia Phillies and as a broadcaster for the New York Yankees, in 1989 Bill White became president of the National League, the first African American to head a major professional sports league. (AP/Wide World Photos)

for the Cardinals' owners, who denounced segregation and quickly moved to set up integrated facilities for team members and their families.

In 1971 White became a broadcaster for the New York Yankees and announced games for the next eighteen years. In 1989 he was appointed president of the National League and held this position as the highest-ranking black official in the history of major league baseball until his retirement early in 1994. As president of the National League, White was outspoken in his expression of disappointment and frustration at major league baseball's poor record of hiring women and its failure to employ more African Americans and other minorities in managerial capacities.

REFERENCES

The Baseball Encyclopedia, 8th ed. New York, 1990.
SMITH, CLAIRE. "Baseball's Angry Man." *New York Times.* October 13, 1991, Sec. 6, p. 28.

JOSEPH W. LOWNDES

White, Charles (April 2, 1918–October 6, 1979), artist, educator. In his blending of the fully realized figure in an abstract space, Charles White demonstrates that social and political statements can be derived from the sometimes private language of modernist art. Born in Chicago, White received an early education in art from discussions at the Arts and Crafts Guild, a local group of black artists. A product of the supportive cultural environment of black Chicago, he was taken at age sixteen to Katherine DUNHAM's studio, where he met, among others, Gwendolyn BROOKS, Archibald MOTLEY, and Richard WRIGHT. In 1937, after he was rejected by two art schools that withdrew awards on discovering his race, White won a scholarship to the School of the Art Institute of Chicago (AIC). His style was forged in the late 1930s in the WPA, the government-sponsored art program which promoted the common people as heroes. Throughout his career, White made African-American working people and historical figures his focus. His murals of the period include *Five Great American Negro Heroes* (1939) for a branch of the Chicago Public Library, *History of the Negro Press* (1940) for the American Negro Exposition in Chicago, and *Contribution of the American Negro to American Democracy* (1943) for the Hampton Institute in Hampton, Va. Teaching at the South Side Community Art Center placed him within another influential institution of black Chicago.

A Julius Rosenwald Fellowship (1941–1943) enabled White to travel to the South. In 1942, he studied at the Art Students League in New York. Drafted into the Army in 1944, White depicted the ironic plight of black soldiers defending democracy in a segregated society. This period reveals the impact of the Mexican muralists Diego Rivera, David Siqueiros, and José Clemente Orozco in its portrayal of everyday life monumentalized by distortions of scale to the figure and background. On a six-week trip to Mexico in 1947, White studied at the printmaking workshop Taller de Grafica. The same year also saw a divorce from his wife, the sculptor Elizabeth CATLETT, whom he had married in 1941.

Always strong in drawing, by the early 1950s White had made it his primary medium, especially as he also sought to expand his audience beyond the wealthy art-buying public to those who could only afford drawings and prints. The result were works with the reportorial immediacy of photographs. The focused inner strength of the figures placed in an indefinable space creates a spiritual quality that conveys the tenacity and ascendency of African Americans over privation.

White won Atlanta University Purchase Awards in 1949, 1951, 1953, and 1961 (*see* Hale WOODRUFF). In 1945 he was appointed artist-in-residence at Howard University. In 1975 he was appointed a member

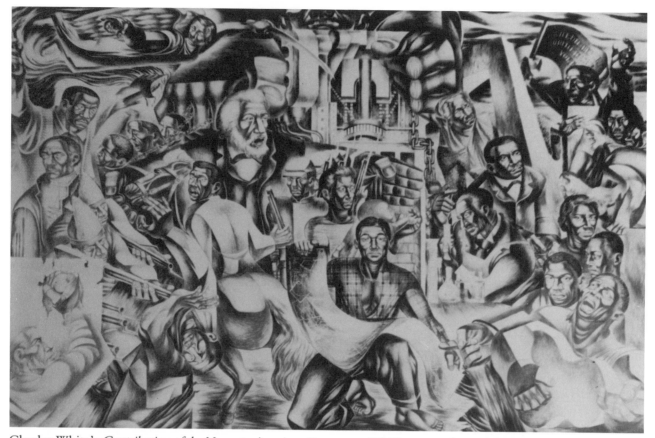

Charles White's *Contribution of the Negro to American Democracy* (1943), a mural created at the Hampton Institute in Virginia, presented a panoramic view of African-American history, including representations of leading black figures from Crispus Attucks to Paul Robeson. (Photographs and Prints Division, Schomburg Center for Research in Black Culture, The New York Public Library, Astor, Lenox and Tilden Foundations)

of the National Academy of Design. He served on the board of the National Center for Afro-American Artists and was appointed commissioner of the California Museum of Afro-American History and Culture Advisory Board. White served as professor and chairman of the drawing department at Otis Art Institute (Los Angeles) and distinguished professor of the School of Art at Howard University. His works were exhibited across the United States and abroad.

REFERENCES

Freedomways 20 (Fall 1980). (The entire issue is devoted to Charles White.)

The Studio Museum in Harlem. *Images of Dignity: A Retrospective of the Works of Charles White.* New York, 1982.

HELEN M. SHANNON

White, Clarence Cameron (August 10, 1880–June 30, 1960), violinist and composer. Clarence Cameron White was born in Clarksville, Tenn. He began violin lessons in Oberlin, Ohio, and continued

studying in Washington, D.C., under Will Marion COOK and Joseph Douglass. In 1894 White attended Howard University and then Oberlin Conservatory. He left Oberlin in 1901 before graduation to accept teaching positions in the Washington, D.C., public schools (1902–1905) and the Washington Conservatory of Music (1903–1907) as head of the strings department.

In 1904 White met composer Samuel Coleridge-Taylor, with whom he had corresponded since his years at Oberlin. He played Coleridge-Taylor's *African Dances* with the composer at the piano during the African-English composer's United States tour. In the summer of 1906 and from 1908 to 1910 White studied composition with Coleridge-Taylor and violin with M. Zacharewitsch in London on a scholarship provided by E. Azalia Hackley. From 1912 to 1923 White toured extensively with his wife as accompanist. In 1924 he accepted a position at West Virginia College as director of music, but left to study with Raoul Laparra (1930–1932) in Paris after winning a Rosenwald Fellowship. White returned to the United States in 1932 to chair the music department at the Hampton Institute in Virginia (until 1935).

During this period the Hampton Choir performed at the White House for President Franklin D. Roosevelt, and toward the end of the Great Depression, White was named music specialist with the National Recreation Association.

White began publishing his compositions in 1912. His early works were written in the salon style of the period and were based upon African-American folk idioms. They became popular concert pieces after the noted violinist Fritz Kreisler recorded "Nobody Knows the Trouble I See" from White's 1919 *Bandanna Sketches*. In 1931, White composed the opera *Ouanga* (libretto by John Mathaus), which depicts the life of Dessalines, Haiti's first emperor. It was premiered in 1949 in South Bend, Ind., by the Burleigh Musical Association. A second performance was given in 1950 in Philadelphia by the Dra-Mu Negro Opera Company; in 1956 two performances were given by the National Negro Opera Company at the Metropolitan Opera House.

White composed in a variety of genres, including works for solo violin, orchestra, chorus, piano, and chamber ensemble. In addition to his opera *Ouanga*, his best-known works are *Bandanna Sketches* (1919) and *From the Cotton Fields* (1921) for violin, *Forty Negro Spirituals* (1927), *Traditional Negro Spirituals* (1940), *Symphony in D Minor* (1952), and *Dance Rhapsody* for orchestra (1955). He also composed works for beginning violin students and was the author of a number of articles, many of them devoted to the Negro spiritual.

White's awards include the Harmon Foundation Award (1927), an honorary degree from Atlanta University (1928), the David Bispham Award for his opera *Ouanga* (1932), an honorary degree from Wilberforce University (1933), and the Benjamin Award for *Elegy* (1955), first performed in 1954 by the National Symphony Orchestra in Constitution Hall and then again on May 15, 1960, for the Festival of American Music at the National Gallery, a little more than a month before his death.

REFERENCES

EDWARDS, V., and M. MARK. "In Retrospect: Clarence Cameron White." *The Black Perspective in Music* 9 (1981): 51.

SHIRLEY, WAYNE. "Letters of Clarence Cameron White in the Collections of the Music Division of the Library of Congress." *The Black Perspective in Music* 10 (1982): 189.

LYNN KANE

White, Edgar Nkose (April 4, 1947–), playwright, novelist. Edgar White was born in Montserrat, British West Indies to Charles and Phyllis White, who emigrated to the New York City area in 1952. His first play, *The Mummer's Play,* was produced by the New York Public Theatre in 1965, when White was eighteen. White may be distinguished from other African-American playwrights of his generation by his use of a wide range of Asian, African, European, and American dramatic techniques. Fable and allegory are particularly important components of his work, as is a style that freely mixes farce, comedy, tragedy, and a strong ironic sense. *The Wonderfull Yeare* (1969) employs the stock characters and improvisational techniques of *commedia dell'arte* to tell the story of a group of Puerto Ricans trying to survive in a plague-ridden American city. Other plays of this period include *The Burghers of Calais* (1970), a treatment of the story of the Scottsboro Boys, and *Fun in Lethe* (1970), which used elements of Chinese classical theater and Greek comedy. White wrote prolifically throughout the 1970s, producing *Crucificado* (1972), *La Gente* (1973), *Ode to Charlie Parker* (1973), *Offering for Nightworld* (1973), *Les Femmes Noires* (1974), and *The Pygmies and the Pyramid* (1976). *The Rastafarian* (1971) is a play for children that draws on White's religious and political beliefs.

White moved to England in the early 1980s. He continued writing in his witty, erudite style, but a more explicit anger began to creep into his work. Even so, plays from this period, including *Trinity— The Long and Cheerful Road to Slavery* (1982) and *Like Them That Dream* (1983), rarely express the kind of undiluted rage found in many plays of the BLACK ARTS MOVEMENT.

REFERENCE

FABRE, GENEVIEVE. *Drumbeats, Masks, and Metaphors: Contemporary Afro-American Theatre.* Translated by Melvin Dixon. Cambridge, Mass., 1985.

MICHAEL PALLER

White, George Henry (December 18, 1852– December 28, 1918), politician. George H. White was born a slave in Rosindale, N.C., in 1852. By the time of the Emancipation Proclamation (*see* EMANCIPATION), he had begun studies with a white tutor. After the CIVIL WAR, he continued his education in local schools while working at caskmaking or on the family farm. He managed to save enough money to enter Howard University in 1873, supporting himself by teaching school in North Carolina during the summer. After graduating from Howard in 1877, White studied law with a North Carolina Superior Court judge and passed the bar in 1879. He moved to New Bern, N.C., and began a law practice as well as taught school.

White was active in REPUBLICAN PARTY politics and was elected to the North Carolina legislature in 1880, after he campaigned vigorously to maintain the public schools established during RECONSTRUCTION and increase funding for African-American schools. In 1895, he was elected solicitor and prosecuting attorney for the second judicial district, where he served until 1893. His first bid for election to Congress in 1894 saw White pitted against his brother-in-law Henry CHEATHAM, who received the nomination. In the next election, however, White secured the nomination and was elected by the "black second" district. He was the only black in Congress when he took office in 1897, the last former slave to serve in this capacity.

In his first term, White tried to open doors for African Americans to serve in the SPANISH-AMERICAN WAR. He also attempted to introduce a resolution to aid a South Carolina postmaster whose family and property had been destroyed by a lynch mob. During his second term in 1900, White introduced an antilynching bill that equated lynching with treason. While petitions from around the country in support of the legislation arrived at the House of Representatives, the House refused to hear the bill. At a time when whites openly and viciously castigated African Americans on the floor of the House, White was one of the few who routinely railed against Congress's racism. White was the last African American to serve in the U.S. Congress until the election of Oscar DEPRIEST in 1928. In his farewell address to the House, he promised that African Americans would someday once again be elected to the House.

After his retirement from politics in 1901, White resumed his law practice in Washington, D.C. With other investors, White bought 1,700 acres in New Jersey, thereby helping to found Whitesboro, an all-black town. Families began to move to Whitesboro in 1903, and by 1906, the town had a population of 800, most of whom lived in single-family homes and worked at farming, fishing, and in a sawmill.

White moved to Philadelphia in 1905. He incorporated the People's Savings Bank in 1907, through which he made loans to enterprising Whitesboro townspeople. In addition to his law practice, he worked on behalf of the Brownsville defendants. He also served on the executive committee of the NAACP Philadelphia branch. White died in Philadelphia in 1918.

REFERENCES

APTHEKER, HERBERT, ed. *A Documentary History of the Negro People in the United States.* Vol. 2: *From the Reconstruction Era to 1910.* New York, 1989, pp. 816–817.

CHRISTOPHER, MAURINE. *Black Americans in Congress.* New York, 1976.

ALLISON X. MILLER

White, Joshua Daniel "Josh" (February 11, 1915–September 5, 1969), blues and folk singer and guitarist. Josh White was born in Greenville, S.C., and sang in churches as a child. He left school in the early 1920s to work in South Carolina, North Carolina, Chicago, and elsewhere as a guide and accompanist to blind street singers, including Blind John Henry Arnold, Blind Joe Taggart, Blind Blake, and Blind Lemon JEFFERSON. He also recorded with Taggart and with the Carver Boys before returning to Greenville in 1929 to go back to school.

In 1932 White moved to New York and began to make a living as a professional guitarist and singer. He worked with Clarence Williams, and made numerous recordings, including "Black and Evil Blues" (1932) and "Lazy Black Snake Blues" (1932). He also recorded religious songs such as "Pure Religion Hallilu" (1933) under the name the Singing Christian, and blues material such as "Greenville Sheik" (1932) under the name Pinewood Tom. By the late 1930s White was well known in New York for his wide repertory of folk and BLUES songs, and for his smooth stage demeanor. In 1939 he shared the stage in New York and Philadelphia with Paul ROBESON in the show *John Henry.* That same year he also began a long engagement at the Cafe Society Downtown, leading the Josh White Singers.

In the 1940s White, who made no secret of his leftist politics, was embraced by a larger white audience that gravitated toward folk music and radical politics. He played with Woody Guthrie, LEADBELLY, Sonny Terry, and Brownie McGhee at numerous hootenannies, rent parties, and lofts in New York, as well as at nightclubs and concerts across the United States. He also recorded prolifically ("Get Thee Behind Me" with Pete Seeger and Woody Guthrie, 1941). During World War II he appeared on radio programs sponsored by the Office of War Information, and performed and recorded at the Library of Congress. White went on a State Department tour to Mexico with the Golden Gate Quartet in 1942, and in 1944 he performed with Robeson in *The Man Who Went to War,* a radio operetta with a text by Langston HUGHES and sponsored by the Office of War Information. By 1945 White had become so popular that he performed at President Roosevelt's inaugural ball. During this period White made numerous television appearances, and appeared in many films, including *Tall Tales* (1941), *Crimson Canary*

Born in South Carolina, Josh White originally made his reputation as a blues and gospel singer during the 1930s. He later moved to New York, where he became a mainstay of the folk song revival of the 1940s. (Photographs and Prints Division, Schomburg Center for Research in Black Culture, The New York Public Library, Astor, Lenox and Tilden Foundations)

(1945), *To Hear Your Banjo Play* (1947), and *The Walking Hills* (1949).

After World War II, White became a prominent international entertainer. After denying communist sympathies before the House Un-American Activities Committee in 1950, he made numerous tours to England, France, Italy, and Australia, in addition to his heavy schedule of performances at concert halls, universities and nightclubs in the United States and Canada. In the 1960s he turned to protest songs, and recorded numerous albums before a 1966 automobile accident forced him into retirement. White, who married Carol Carr in 1934 and had five children, died during open-heart surgery in Manhasset, N.Y., in 1969.

REFERENCES

JONES, MAX. "Josh White Looks Back." *Blues Unlimited* 55 (July 1968): 16–17; 56 (September 1968): 15–16.

SIEGEL, DOROTHY SCHAINMAN. *Glory Road: The Story of Josh White*. San Diego, Calif., 1982.

JONATHAN GILL

White, Paulette Childress (December 1, 1948–), poet. Born in Hamtramck, Mich., White attended high school in Ecorse, Mich., then settled in Detroit, where she pursued a career as both painter and writer. Her poems and stories explore such themes as love, marriage, sexuality, and African-American history and tradition. In 1975, she published *Love Poem to a Black Junkie,* a volume of poetry for young adults. *The Watermelon Dress: Portrait of a Woman: Poems and Illustrations* (1984) follows the thirty-year history of a calico dress made in the 1950s, focusing on the symbolic importance of the article of clothing in the woman's life as she matures, marries, and bears children. The cloth of the dress itself provides an image of cultural patterns that shift as the years progress from the civil rights era to the mid-1980s. White's work has appeared in such journals as *Essence, Redbook,* and *Callaloo,* and in the anthologies *Sturdy Black Bridges* (1979) and *Midnight Birds* (1980).

REFERENCES

BROWN, BETH. "Four From Lotus Press." Review of *The Watermelon Dress. CLA Journal* 29, no. 2 (December 1985): 250–252.

GLIKIN, RONDA. *Black American Women in Literature: A Bibliography, 1976 Through 1987.* Jefferson, N.C., 1989, p. 179.

CAMERON BARDRICK

White, Walter Francis (July 1, 1893–March 21, 1955), civil rights leader. Walter White, executive secretary of the NATIONAL ASSOCIATION FOR THE ADVANCEMENT OF COLORED PEOPLE (NAACP) from 1931 to 1955, was born in Atlanta, Ga. Blond and blue-eyed, he was an African American by choice and social circumstance. In 1906, at age thirteen, he stood, rifle in hand, with his father to protect their home and faced down a mob of whites who had invaded their neighborhood in search of "nigger" blood. He later explained: "I knew then who I was. I was a Negro, a human being with an invisible pigmentation which marked me a person to be hunted, hanged, abused, discriminated against, kept in poverty and ignorance, in order that those whose skin was white would have readily at hand a proof of their superiority, a proof patent and inclusive, accessible to the moron and the idiot as well as to the wise man and the genius."

In 1918, when the NAACP hired him as assistant executive secretary to investigate LYNCHINGS, there were sixty-seven such crimes committed that year in sixteen states. By 1955, when he died, there were only three lynchings, all in Mississippi, and the NAACP no

longer regarded the problem as its top priority. White investigated forty-two lynchings mostly in the deep South and eight race riots in the North that developed between World War I and after World War II in such cities as Chicago, Philadelphia, Washington, D.C., Omaha, and Detroit.

In August 1946 he helped to create a National Emergency Committee Against Mob Violence. The following month, he led a delegation of labor and civil leaders in a visit with President Harry S. Truman to demand federal action to end the problem. Truman responded by creating the President's Committee on Civil Rights, headed by Charles E. Wilson, chairman and president of General Electric. The committee's report, *To Secure These Rights,* provided the blueprint for the NAACP legislative struggle.

The NAACP's successful struggle against segregation in the armed services was one of White's major achievements. In 1940, as a result of the NAACP's intense protests, President Franklin D. Roosevelt appointed Judge William H. Hastie as civilian aide to the secretary of war, promoted Colonel Benjamin O. Davis, the highest-ranking black officer in the Army, to brigadier general, and appointed Colonel Campbell Johnson special aide to the director of Selective

Walter White, who became executive director of the NAACP in 1931, managed the organization's legal and political challenge to racial inequality for a quarter century. (Prints and Photographs Division, Library of Congress)

Service. As significant as these steps were, they did not satisfy White because they were woefully inadequate. So he increasingly intensified the NAACP's efforts in this area.

White then attempted to get the U.S. Senate to investigate employment discrimination and segregation in the armed services, but the effort failed. He therefore persuaded the NAACP board to express its support for the threat by A. Philip RANDOLPH, president of the BROTHERHOOD OF SLEEPING CAR PORTERS, to lead a march on Washington in demand for jobs for blacks in the defense industries and an end to segregation in the military. To avoid the protest, President Roosevelt on June 25, 1941, issued Executive Order 8802, barring discrimination in the defense industries and creating the Fair Employment Practice Committee. That was the first time a U.S. president acted to end racial discrimination, and the date marked the launching of the modern civil rights movement. Subsequently, the NAACP made the quest for presidential leadership in protecting the rights of blacks central to its programs.

As a special war correspondent for the *New York Post* in 1943 and 1945, White visited the European, Mediterranean, Middle Eastern, and Pacific theaters of operations and provided the War Department with extensive recommendations for ending racial discrimination in the military. His book *A Rising Wind* reported on the status of black troops in the European and Mediterranean theaters.

White was as much an internationalist as a civil rights leader. In 1921 he attended the second Pan-African Congress sessions in England, Belgium, and France, which were sponsored by the NAACP and led by W. E. B. DU BOIS. While on a year's leave of absence from the NAACP in 1949 and 1950, he participated in the "Round the World Town Meeting of the Air," visiting Europe, Israel, Egypt, India, and Japan.

In 1945 White, Du Bois, and Mary McLeod BETHUNE represented the NAACP as consultants to the American delegation at the founding of the United Nations in San Francisco. They urged that the colonial system be abolished; that the United Nations recognize equality of the races; that it adopt a bill of rights for all people; and that an international agency be established to replace the colonial system. Many of their recommendations were adopted by the United Nations.

White similarly protested the menial roles that blacks were forced to play in Hollywood films and sought an end to the harmful and dangerous stereotypes of the race that the industry was spreading. He enlisted the aid of Wendell Willkie, the Republican presidential candidate who was defeated in 1940 and who had become counsel to the motion picture in-

dustry, in appealing to Twentieth Century Fox, Warner Brothers, Metro-Goldwyn-Mayer, and other major studios and producers for more representative roles for blacks in films. He then contemplated creating an NAACP bureau in Hollywood to implement the organization's programs there. Although the bureau's idea fizzled, the NAACP did create a Beverly Hills–Hollywood branch in addition to others in California.

During White's tenure as executive secretary, the NAACP won the right to vote for blacks in the South by getting the Supreme Court to declare the white Democratic primary unconstitutional; opposed the poll tax and other devices that were used to discriminate against blacks at the polls; forged an alliance between the organization and the industrial trade unions; removed constitutional roadblocks to residential integration; equalized teachers' salaries in the South; and ended segregation in higher education institutions in addition to winning the landmark *Brown v. Board of Education* decision in 1954, overturning the Supreme Court's "separate but equal" doctrine. Overall, White led the NAACP to become the nation's dominant force in the struggle to get the national government to uphold the Constitution and protect the rights of African Americans.

White was a gregarious, sociable man who courted on a first-name basis a vast variety of people of accomplishment and influence like Willkie, Eleanor Roosevelt, Harold Ickes, and Governor Averell Harriman of New York. In 1949 he created a furor by divorcing his first wife, Gladys, and marrying Poppy Cannon, a white woman who was a magazine food editor.

In addition to his many articles, White wrote two weekly newspaper columns. One was for the *Chicago Defender,* a respected black newspaper, and the other for white newspapers like the Sunday *Herald Tribune.* He wrote two novels, *The Fire in the Flint* (1924) and *Flight* (1926); *Rope and Faggot* (1929, reprint 1969), an exhaustive study of lynchings; *A Man Called White* (1948), an autobiography; and *A Rising Wind* (1945). An assessment of civil rights progress, *How Far the Promised Land?* was published shortly after White's death in 1955.

REFERENCES

Report of the Secretary to the NAACP National Board of Directors, 1940, 1941, 1942.
SITKOFF, HARVARD. *A New Deal for Blacks, The Emergence of Civil Rights as a National Issue: the Depression Decade.* New York, 1978.
WATSON, DENTON L. *Lion in the Lobby, Clarence Mitchell, Jr.'s Struggle for the Passage of Civil Rights Laws.* New York, 1990.
WOLTERS, RAYMOND. *Negroes and the Great Depression.* Westport, Conn., 1970.

DENTON L. WATSON

White Citizens' Councils. As rumors circulated in 1953 that the U.S. Supreme Court would rescind the "separate but equal" doctrine and force school desegregation, white southerners began organizing to resist implementation of the law. Groups committed to "law-abiding resistance" appeared across the South, but those affiliated with the Citizens' Councils proved the most enduring and powerful. Compared with the KU KLUX KLAN, the Citizens' Councils were less overtly violent and more restrained and dignified, but their basic ideology, like that of the Klan, was white supremacy. While always representing a minority in the South, the Citizens' Councils nevertheless served as a mouthpiece of southern defiance.

Mississippi Circuit Judge Thomas Pickens Brady spearheaded the movement for the councils, encouraging the formation of resistance organizations across the South. In July 1954, Robert "Tut" Patterson responded to Brady's call, forming the first chapter of the Citizens' Council in Indianola, Miss.

From its base in Mississippi, the councils spread throughout the South. The varied names of the local councils—Southern Gentlemen, White Brotherhood, Christian Civic League, Patriots of North Carolina—reflected a broad range of community concerns, yet all shared the directives set forth by the original council in Indianola: to maintain segregation in public schools and prevent blacks from exercising the right to vote. The Councils found their most receptive audience among white inhabitants of the rural southern Black Belt, where African Americans made up the majority of the population. Activists from previously established councils laid the groundwork for new chapters, using community-service clubs as a foundation for membership. Each council tried to recruit directors from among a community's prominent leaders, but the bulk of the membership usually came from the rural white population.

A month after the council's founding in Indianola, local organizations from twenty counties formed the Association of Citizens' Councils of Mississippi, with headquarters in Winona. Within a year, the association boasted 253 chapters in the state with a total of 60,000 members. The association established a hierarchical statewide structure, but local councils remained largely autonomous and self-governing, thus allowing the individual councils to develop their own operating tactics and procedures.

The Citizens' Councils' expansion in the South was sporadic. During periods of racial unrest when blacks challenged the status quo, such as in the aftermath of the 1954 BROWN V. BOARD OF EDUCATION decision, membership in the organizations soared. As popular furor over these events subsided, however, membership enrollment declined. In November 1954, Selma, Ala., formed the first Citizens' Council outside of Mississippi. Only five additional chapters were formed in Alabama prior to implementation of the *Brown* decision, but with mounting pressure from blacks to desegregate the public schools, the number of councils soared. Following Autherine Lucy's (*see* Autherine LUCY FOSTER) challenge of the admission policies of the University of Alabama in 1956, the number of councils in the state increased from forty to sixty.

The councils experienced similar patterns of growth in other southern states, with membership growing as a result of increasing pressure for equal rights from the black population. Georgia's first local council was formed in December 1954; the first in Louisiana was set up in April 1955, and the first in South Carolina in summer 1955. In December 1955, representatives from twelve southern states met in Memphis to form the Federation for Constitutional Government to coordinate the councils' regional activities and to expand their influence. The following year, the leaders formed a unified Citizens' Council of America. However, there was much less organized resistance in the upper South where the black population was smaller than in the deep South. Although the council flourished in certain majority-black regions in the upper South, it never established a strong foothold in Arkansas, Texas, Florida, Virginia, North Carolina, or Tennessee. Despite the council's newly formed regional network, it was unable to achieve formal unity, since local chapters continued to differ in their ideas about the council's objectives and methods.

Although the council's membership figures are unreliable, it is clear that organized resistance profited tremendously from black challenges to the South's racially segregated system. As a consequence, however, the fate of the organized resistance movement depended upon developments on the racial front and black actions. In an effort to break this dependency and stimulate support across the South, the council stepped up its propaganda campaign, distributing form letters and offering a monthly newspaper, *The Citizens' Council* (published from 1956 to 1962), at cut-rate subscription prices. In 1955, council members in Mississippi distributed a doctored audiotape of Howard professor "Roosevelt Williams" delivering an inflammatory address to an NAACP audience in Jackson. Though obviously a fake—Howard had no professor by this name—the council hoped to play on white southerners' fears of social equality and miscegenation to gain support.

In an effort to disseminate its message throughout the South, the council established the Educational Fund of the Citizens' Council in December 1956 to reach the national media. The following year, the council produced a fifteen-minute telecast, the *Citizens' Council Forum,* which was shown on twelve television stations in Alabama, Georgia, Louisiana, Mississippi, Texas, and Virginia. With the financial support of Mississippi congressional members, the council also produced a tape that was broadcast free of charge on fifty radio stations throughout the South.

The council's tactics varied from state to state, and although the organization officially eschewed violence, it often used intimidation to prevent integration. Individual members, moreover, were frequently implicated in vigilante actions. When NAACP branches filed petitions with the local boards of education in seven southern states, the council responded with economic and social pressure against all persons, black and white, affiliated with the NAACP and against all the petitioners. Blacks who advocated desegregation of public schools might lose their jobs, be evicted from their homes, have their credit terminated, or their mortgages recalled. And black businessmen who supported the civil rights agenda often found it difficult to get supplies. As a result of this economic pressure, many blacks eventually withdrew their names from the petitions.

But blacks also occasionally fought back with their own reprisals, boycotting white merchants who depended upon them for business. In the "Battle of Orangeburg," blacks in Orangeburg joined with students at the nearby all-black South Carolina State College to boycott twenty-three businesses owned by white councilmen. Similarly, the all-black Tuskegee Civic Association staged a highly successful boycott against the city's white merchants who supported the state's new gerrymandering law. Frequently, however, actions taken by African Americans were more defensive in nature. To help black victims of white boycotts, the NAACP sponsored a nationwide drive in 1955 to raise money for the black-owned Tri-State Bank in Memphis, which agreed to offer loans to the victims.

While the council often used economic intimidation against black activists, it frequently resorted to more violent tactics. In Belzoni, Miss., the Rev. George Washington Lee, the first black in the county to register to vote, was shot to death in May 1955. Gus Courts, who helped Lee lead the voter-registration campaign in Belzoni, was evicted from his store, and when he reopened at another location, he had difficulty obtaining supplies. In an act of open intimida-

tion, Courts was summoned before a three-member council committee and questioned about his activities, yet he refused to back down. After leading twenty-two blacks to register to vote, Courts was critically wounded by a shotgun blast in 1956 and shortly thereafter relocated his family to Chicago.

Mississippi was the site of two other race-related murders in 1955. In late summer, Lamar Smith, who reportedly advocated the defeat of the incumbent in the Pike County supervisor's race, was lynched on the courthouse lawn in Brookhaven. Two weeks later, fourteen-year-old Chicago native Emmett TILL was lynched in Money, Miss. The third reported lynching occurred in 1959 when Mack Charles Parker, accused of raping a young white woman, was taken from jail and murdered in Poplarville, Miss.

Violence occurred outside Mississippi as well. In 1964, Lemuel A. Penn, a black school administrator from Washington, D.C., was killed while driving through Georgia. The following year, Jimmy Lee Jackson, a participant in the Alabama project for voting rights, was shot in the stomach while marching outside of Marion, Ala.

The council's efforts at intimidation of black voters frequently proved effective: In 1956, not a single black voter in Mississippi's Black Belt attempted to cast a ballot. However, by the early 1960s, blacks were becoming more openly resistant to the Citizens' Council and other similar groups, and moderate white southerners were beginning to turn against the tactics used by the council.

Organized resistance reached its zenith in the South in 1957. By 1960, grassroots support for racism had declined or vanished in most states. Moderate white southerners proved particularly hostile to council-sponsored "Freedom Rides North." Organized as a counterpart to the Freedom Rides sponsored by the CONGRESS OF RACIAL EQUALITY (CORE) and the STUDENT NONVIOLENT COORDINATING COMMITTEE (SNCC), the Mississippi council began in 1962 to send poor, unemployed, or criminal blacks to northern cities that were proponents of desegregation.

Despite the council's limited success outside the South and mounting opposition within the region, the organization's leaders maintained the hope of forging a national movement. In an effort to appeal to non-Southerners, the council muted its hard line on race, focusing on issues such as communism that were more important to conservatives. In the summer of 1963, the council launched "Operation Information," sending speakers across the country and setting up organizers in every state. The council was unprepared for the fierce resistance that it met from civil rights organizations outside the South, however, and was forced to hold secret meetings and maintain tight security.

Meanwhile, changes in the legal structure and the passage of civil rights legislation allowed blacks greater latitude to resist violence and intimidation by organized resistance movements in the South. In the mid-1960s, the more militant Deacons for Defense and Justice and early Black Power groups opposed nonviolent protest and advocated (and on occasion practiced) use of black self-defense against white aggression.

With growing national support for the CIVIL RIGHTS MOVEMENT and the steady erosion of segregation, some council members began to realize that their actions served only as delaying tactics. Black protest was bringing desegregation to the South despite the council's resistance. Membership in the council declined as a result, and Southerners shifted their focus to more evasive tactics such as support for the private school movement. As long as African Americans continued to assert their right to equality, however, the council has continued to exist in more muted forms throughout the South.

REFERENCES

GEYER, ELIZABETH. "The 'New' Ku Klux Klan." Crisis (March 1956): 139–148.
McMILLEN, NEIL R. The Citizens' Council: Organized Resistance to the Seecond Reconstruction, 1954–64. Chicago, 1971.

LOUISE P. MAXWELL

White Rose Mission and Industrial Association. The White Rose Home embodies the spirit, methods, and commitment of African-American women dealing with the difficulties of urban life in the late nineteenth and early twentieth centuries. The White Rose Association was founded in 1897 by Victoria Earle MATTHEWS, a prominent New York journalist, activist, and novelist, who served as the home's superintendent until her death in 1907. The first aim of the association was to address the housing and employment needs of young working women arriving in the city from the South. Safe lodging as well as social activities and job training could be found at the White Rose for very little money. The association also provided travelers' aid services at piers and stations, both in the South and in New York.

Lectures were a staple of the activities at the White Rose, and speakers included Booker T. WASHINGTON, W. E. B. DU BOIS, Mary Church TERRELL, and Paul Laurence DUNBAR. Instructors for various classes included Alice Moore Dunbar (see Alice DUNBAR-NELSON) and Hallie Quinn BROWN. The association's

race history class was well known both in New York and elsewhere, as was the library collection begun by Matthews, which covered a wide range of topics and included rare books and documents.

As with most organizations of its kind, the White Rose was funded through donations from members of New York's black community, such as Du Bois and Adam Clayton POWELL, SR., and from whites including Andrew Carnegie, Grace Dodge, and Seth Low. The association began to experience financial difficulties following World War I, and although it persevered for more than seventy years after its founding, it never again reached the prominence it enjoyed in the community in the early part of the century.

REFERENCES

BEST, LASSALLE. *History of the White Rose Mission and Industrial Association.* New York, n.d.
SALEM, DOROTHY. *To Better Our World: Black Women in Organized Reform, 1890–1920.* Brooklyn, N.Y., 1990.

JUDITH WEISENFELD

Whitfield, James Monroe

Whitfield, James Monroe (April 10, 1822–April 23, 1871), poet. Born in Exeter, N.H., James Whitfield was trained as a barber during his youth. In 1838 he contributed a paper on emigration to California to a convention in Cleveland, Ohio. Sometime before 1839, he moved to Buffalo, N.Y., where he found work as a barber. Though never formally educated, he began to write poetry on abolitionist themes. In 1846 he published a collection, *Poems.* Most of his poetry also appeared in Frederick DOUGLASS's newspapers, *The North Star* (1847–1851) and *Frederick Douglass' Paper* (1851–1860).

In 1853 Whitfield published a second collection of poems, *America, and Other Poems.* The title work, a set of variations on the famous song lyric of that name, spoke forcefully of the hollowness of the country's "boasted liberty" and of the coming retribution for American slavery and other crimes. The critical and financial success of the work led Whitfield to join the abolitionist and emigrationist movements as writer and propagandist. He helped sponsor the National Emigration Convention of Colored Men in Cleveland in 1854, and edited a short-lived emigrationist journal, the *Africa-American Repository* (1858). In 1859 Whitfield began a two-year tour scouting Central America for emigration sites.

Whitfield settled in San Francisco in 1861 and returned to barbering; three years later he became Grand Master of the California lodge of the Prince Hall Masons. He continued to write letters and poems, including a long work, "A Poem Written For the Celebration of President Lincoln's Emancipation Proclamation" (1867), which was printed in the San Francisco African-American newspapers *The Elevator* and *The Pacific Appeal.* During the 1860s he traveled around Oregon, Idaho, and Nevada, supporting himself through barbershop work. He died in San Francisco.

REFERENCE

SHERMAN, JOAN R. *Invisible Poets.* Urbana, Ill. 1989.

GREG ROBINSON

Whitman Sisters, entertainers. The Whitman Sisters—Mabel (d. 1942), Essie (1881–May 7, 1963), and Alice (d. 1969)—comprise a family of entertainers who owned and produced their own traveling show, which played the major cities of the United States between 1900 and 1943. They were one of the longest-running and highest-paid acts on the THEATER OWNERS BOOKING ASSOCIATION (TOBA) circuit and one of the most popular acts in all of black vaudeville.

Their father was a bishop of the African Methodist Episcopal church, first in Lawrence, Kan., and later in Atlanta, Ga., where he was also dean of Morris Brown College. In Atlanta, Mabel and Essie Whitman sang at benefits to help raise money for the church; inspired by their reception, they formed a professional act that eventually went on tour with their mother as chaperone. On their return they were joined by Alberta. In 1904, while in New Orleans, they organized a company called "The Whitman Sisters New Orleans Troubadours" with Mabel as manager. After the death of their mother, Alice joined the troupe in 1909.

In 1910, Mabel organized the group Mabel Whitman and the Dixie Boys, an act consisting of key performers from the New Orleans Troubadours who toured the United States, Europe, and Australia. After the tour, Mabel returned to go on the road with her sisters. The Whitman Sisters, as they were now known, was almost entirely family-run: Mabel handled bookings and business matters, Essie designed and made costumes, Alberta composed music and handled finances, and Alice was the star dancer. Their fast-paced show, based on a variety format of songs, dances, and comedy skits, included a cast of up to thirty performers, a twelve-to-fourteen-woman chorus line and a well-regarded jazz ensemble that included, for a time, guitarist Lonnie Johnson. Mabel, a singer, soon retired from the stage and devoted her

time to managing the company. Essie, a singer and comedian, became known especially for her drunk act and powerful contralto voice. With her hair cut short and dressed as a man, Alberta excelled as a male impersonator: A singer and flash dancer, "Bert" topped her strut with high kicking-legomania (in which the legs are loose and rubbery, appearing to twine around each other, acting in contradiction to the fast-moving feet). Alice was billed as "The Queen of Taps" and performed such popular dances as Ballin' the Jack, Walkin' the Dog, and the Shim-Sham-Shimmy. She was admired for her clean tapping and was considered the best female tap dancer of the 1920s. Alice's son, "Pops" Whitman (1919–1950), who first performed with the show at the age of four, became one of the era's finest acrobatic tap dancers and was one of the first dancers to execute cartwheels, spins, flips, and splits while tapping to swinging rhythms.

The Whitman Sisters marked the emergence of black vaudeville acts that stressed dancing rather than comedy as their main attraction. Many performers, including Bill ROBINSON, Jack Wiggins, Eddie RECTOR, Leonard Reed, and the BERRY BROTHERS received their first exposure to big-time vaudeville with the Whitman Sisters. After the death of Mabel in 1942, the act soon disbanded (though Pops continued to perform primarily with Louis Williams until his death in 1950). Thereafter, Essie, Alice, and Alberta lived the rest of their lives primarily in Chicago.

REFERENCES

MILLSTEIN, GILBERT. "Harlem Stompers." *New York World Telegram Weekend Magazine* (January 23, 1937): 3.
STEARNS, MARSHALL, and JEAN STEARNS. *Jazz Dance: The Story of American Vernacular Dance*. New York, 1968.

CONSTANCE VALIS HILL

Whitten, Jack (December 5, 1939–), painter. Jack Whitten was born in Bessemer, Ala. After two years of premedical studies at Tuskegee Institute (*see* TUSKEGEE UNIVERSITY) beginning in 1957, he transferred to Southern University in Baton Rouge, La., to study art. Whitten moved to New York City in 1960 and attended Cooper Union for the Advancement of Science and Art, where he earned his B.F.A. in 1964.

Whitten's earliest images, created in the late 1960s, were representational and used the figure to explore autobiographical and political subjects. From 1969 to 1974, Whitten made paintings he called "energy fields," which were organized around the geometry of the grid. In these paintings, which were primarily black, white, and gray, Whitten tried to understand the physical and psychological experience of viewing an image, a process he referred to as uncovering the "DNA . . . of visual perception." He used tools that he called "developers," such as Afro combs and saw blades, to move paint across the canvas (*Psychic Square 1,* 1971; *First Frame,* 1971; *Golden Spaces,* mid-1970s). These early abstract works were not solely concerned with the mechanics of optical illusion, but also maintained a connection to Whitten's emotional life and were influenced by his reading of German philosophy and his interest in the writings of psychologist Carl Jung (*Satori,* 1969).

In 1974, Whitten received a grant from the Xerox Corporation and created a series of images which experimented with Xerox materials, machinery, and the dry printing process as an artistic medium. By the end of the decade, he began integrating scientific and technological metaphors into his paintings, using symbols from navigational maps and cosmological charts. In 1985, he painted images comprised of one-quarter-inch squares, each consisting of a spectrum of colors that made the image flicker like lights from a distant, urban skyline (*Manhattan Odyssey,* 1985). Whitten developed his interest in metropolitan images through a group of collage-like reliefs he made from castings of objects and surfaces that are ordinarily found in urban landscapes (*Door to Manhattan,* 1990).

Dead Reckoning I by Jack Whitten, acrylic on canvas, 1980. (The Studio Museum in Harlem)

Whitten has been the recipient of several fellowships, including the John Hay Whitney Fellowship (1964), a National Endowment for the Arts Fellowship (1973), and a Solomon R. Guggenheim Fellowship (1976). His work has been featured in solo exhibitions at the Allan Stone Gallery in New York (1969, 1970), the Whitney Museum of American Art (1974), the Studio Museum in Harlem (1983), and the Newark Museum of Art (1990). Since the late 1960s, Whitten has taught art at various schools, including Manhattan Community College (1970–1975), Cooper Union for the Advancement of Science and Art (1971–), Fordham University (1978–1983), and the School of the Visual Arts in New York (1979–).

REFERENCE

WRIGHT, BERYL. *Jack Whitten*. Newark, N.J. 1990.

ROBERT A. POARCH

Wideman, John Edgar (June l4, 1941–), novelist. Born in Washington, D.C., John Edgar Wideman spent much of his early life first in Homewood, Pa., and then in Shadyside, an upper-middle-class area of Pittsburgh. In 1960 he received a scholarship to the University of Pennsylvania, where he proved himself equally outstanding in his undergraduate studies and on the basketball court. He graduated Phi Beta Kappa in 1963, and his athletic achievements led to his induction into the Big Five Basketball Hall of Fame. Upon graduation, Wideman became only the second African American to be awarded a Rhodes Scholarship (Alain LOCKE had received one almost fifty-five years earlier), an honor which allowed him to study for three years at Oxford University in England, where he earned a degree in eighteenth-century literature.

After returning to the United States in 1966 and attending the Creative Writing Workshop at the University of Iowa as a Kent Fellow, Wideman returned to the University of Pennsylvania, where he served as an instructor (and later, professor) of English. In 1967, at the age of twenty-six, he published his first novel, *A Glance Away*. The novel was well received by critics, and two years after its appearance Wideman published *Hurry Home* (1969), a novel that chronicled its protagonist's struggle to reconcile the past and the present. After publishing a third novel in 1973, a dense and technically complex work entitled *The Lynchers,* Wideman found his name was increasingly associated with a diverse set of literary forebears including James Joyce, William Faulkner, and Ralph ELLISON.

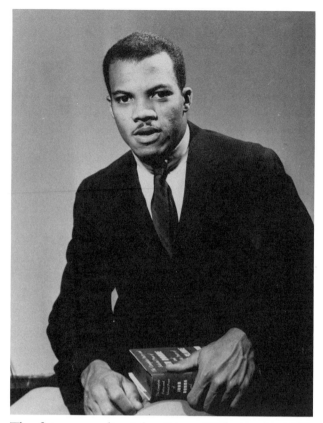

The future novelist John Edgar Wideman in 1962, when he was awarded a Rhodes Scholarship for study at Oxford University in England. (AP/Wide World Photos)

During this period, Wideman served as the assistant basketball coach (1968–1972) at the University of Pennsylvania, as well as director of the Afro-American Studies Program (1971–1973). In 1975 he left Philadelphia to teach at the University of Wyoming in Laramie. Six years later he ended a long literary silence with the publication of two books: a collection of stories, *Damballah,* and *Hiding Place,* a novel. Both books focus on Wideman's Homewood neighborhood. And with the publication in 1983 of the third book in the trilogy, Wideman's reputation as a major literary talent was assured. *Sent for You Yesterday* won the 1984 P.E.N./Faulkner Award, winning over several more established writers.

At this point, Wideman was drawn (by circumstance rather than choice) into the world of nonfiction after his brother, Robbie, was convicted of armed robbery and sentenced to life imprisonment. At times angry, at others deeply introspective and brooding, *Brothers and Keepers* (1984) relates the paradoxical circumstances of two brothers: one a successful college professor and author, the other a drug addict struggling to establish an identity apart from his older, famous brother. Nominated for the 1985

National Book Award, the memoir set the stage for what arguably might be called Wideman's "next phase."

In 1986, after seeing his son, Jake, tried and convicted for the murder of a camping companion, Wideman moved back east to teach at the University of Massachusetts, Amherst. The following year saw the publication of his less than successful but nonetheless intriguing novel *Reuben.* Two years later, Wideman published a collection of stories, *Fever* (1989), and followed that in 1990 with a novel, *Philadelphia Fire.* Both of these works reflect Wideman's ability to interrogate his own experiences, even as his fiction takes up pertinent social issues. In the short stories and the novel, Wideman weaves fiction into the fabric of historical events (the former involves an outbreak of yellow fever in eighteenth-century Philadelphia, and the latter the aftermath of the confrontation with and subsequent bombing by Philadelphia police of the radical group MOVE). In 1992 Wideman brought out *The Stories of John Edgar Wideman* (1992), which contains ten new stories written especially for the collection, themselves entitled *All Stories Are True.* What distinguishes these ten stories is their extraordinary repositioning of the reader's attention, away from the source of the stories and toward the human issues they depict. As he works to make sense of his own assets and losses, one finds in Wideman's fiction a continuing engagement with the complexity of history as layered narrative and an ability to articulate the inner essence of events that often elude us.

REFERENCES

COLEMAN, JAMES W. "Going Back Home: The Literary Development of John Edgar Wideman." *CLA Journal* 28, no. 3 (March 1985): 326–343.

"The Novels of John Wideman." *Black World* (June 1975): 18–38.

O'BRIEN, JOHN. *Interviews with Black Writers.* New York, 1973.

HERMAN BEAVERS

Wilberforce University. Wilberforce University, one of the oldest historically black colleges and universities, was founded by the Methodist Episcopal Church in 1856 on the site of Tarawa Springs, a former summer resort in Greene County in Ohio. The school, which had as its purpose the education of African Americans, was named for British abolitionist William Wilberforce; its first president was Richard S. Rust. From the outset, the Methodist Episcopal Church and the AFRICAN METHODIST EPISCOPAL (AME) Church had a cooperative mainte-

nance of Wilberforce University, despite the earlier founding of an AME school, the Union Seminary, in Columbus, Ohio.

The exigencies of the CIVIL WAR led to dwindling funds, declining enrollments, and the closing of both Union and Wilberforce University. In 1863, the AME Church purchased Wilberforce University from the Methodist Episcopal Church for $10,000, sold the property of Union Seminary, and combined the faculty of the two institutions. The prime mover of the transformation, AME Bishop Daniel PAYNE, served as president from 1863 to 1873, the first African-American college president in the United States; Payne continued to be involved in Wilberforce's affairs until his death in 1893. Under Payne's direction, a theology department was established in 1866 (it became the autonomous Payne Theological Seminary in 1891). Payne, concerned with establishing Wilberforce as a serious academic institution, introduced classical and science departments the following year. Among the faculty members in its first decades was the classicist William Scarborough (1856–1926), born to slavery in Georgia, who was the author of a standard textbook for Greek, translator of Aristophanes, and president of Wilberforce from 1908 to 1920. Occasional lecturers included Alexander CRUMMELL and Paul Laurence DUNBAR.

In 1887, AME Bishop Benjamin W. ARNETT, also a successful Ohio politician, convinced the state legislature to establish a normal and industrial department at Wilberforce with its own campus, providing Wilberforce with unusual joint denominational and public supervision and sources of financial support. Shortly thereafter, from 1894 to 1896, W. E. B. DU BOIS was an instructor at Wilberforce (he left in part because he was uncomfortable with the intense evangelical piety he found on the campus). Hallie Quinn BROWN, a leader of the women's club movement, was an 1873 graduate of Wilberforce, joined the faculty in 1893 as professor of elocution (i.e., public speaking), and remained on the faculty of the English department and the board of trustees for many years. The university library was named in her honor. In 1894, a military department was created under the leadership of Charles YOUNG, one of the most distinguished African-American military officers.

In 1922, Wilberforce instituted a four-year degree program, and in 1939 it was formally accredited. A Wilberforce graduate, Horace Henderson, gained attention for his alma mater through a student jazz band, the Wilberforce Collegians, which he founded in the early 1920s and that went on to considerable national success. From 1942 to 1947, the historian Charles WESLEY was president. In 1947, the former normal and industrial department was formally separated from Wilberforce as Wilberforce State Col-

lege. Later renamed Central State University, it remains a predominantly black school, with an enrollment more than triple that of Wilberforce University.

The removal of state support for Wilberforce caused a financial crisis, a decline of enrollment, and a loss of accreditation. Under the leadership of Pembert E. Stokes, Wilberforce began to return to academic and financial health, and its accreditation was restored in 1960. In 1967 construction was begun on a new campus, a quarter mile from the old campus. In 1991, Wilberforce initiated a continuing education program for nontraditional students, Credentials for Leadership in Management and Business Education (CLIMB).

REFERENCES

LEWIS, DAVID LEVERING. *W. E. B. Du Bois: Biography of the Race*. New York, 1993.
McGINNIS, FREDERICK. *A History of an Interpretation of Wilberforce University*. Blanchester, Ohio, 1941.
TALBERT, HORACE. *The Sons of Allen: Together with a Sketch of the Rise and Progress of Wilberforce University*. Xenia, Ohio, 1906.

VALENA RANDOLPH
JACQUELINE BROWN

Wilder, Lawrence Douglas (January 17, 1931–), politician. L. Douglas Wilder was born into a large, poor family in Richmond, Va. He graduated from high school in 1947 and enrolled as a chemistry major at Virginia Union University, a historically black college in Richmond. After graduating, Wilder was drafted into the Army and served during the Korean War. He received a Bronze Star medal for bravery. After returning home, Wilder worked as a chemist in the state medical examiner's office. In 1956 he enrolled in Howard University Law School in Washington, D.C. Two years later Wilder married Eunice Montogmery; they subsequently had three children.

Upon graduation from law school, Wilder returned to Richmond to practice law. His law practice brought him both local notoriety and financial prosperity. While Wilder served lower-income clients free of charge, he represented wealthy and powerful clients as well, and became a self-made millionaire in the course of his career. His professional success inspired him to run for the state senate in 1969. Wilder's victory made him the first African-American state senator in Virginia since Reconstruction. Wilder successfully advocated legislation that prohibited racially discriminatory housing and employment practices,

and he helped to create a state holiday to honor the Rev. Dr. Martin Luther King, Jr. He chaired the senate's powerful Privileges and Elections Committee that oversaw state appointments and voting legislation. As a result, he was able to increase the hiring of African Americans to various positions in the state government.

In a 1985 newspaper poll, Wilder was rated as one of the five most influential members of the Virginia senate. That same year Wilder ran for the statewide office of lieutenant governor. Since African Americans constituted only 18 percent of Virginia's population at the time, Wilder conducted an extensive campaign at the grass-roots level to win the support of white voters, running as a moderate. Wilder won the lieutenant governorship in November 1985, and his ability to retain the support of black and white voters and legislators helped him win election as chairman of the National Democratic Lieutenant Governors Association.

In the 1989 Virginia election that was decided by less than 2 percentage points, Wilder became the first African-American governor of a state since Reconstruction. As governor he balanced the state's budgets, created a surplus fund during an economic recession, and increased the number of African-Americans working in the state government. He also obtained legislative approval for gun control laws, and barred state agencies from investing in companies doing business with South Africa.

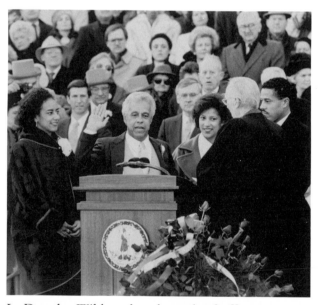

L. Douglas Wilder takes the oath of office as governor of Virginia in Richmond from retired U.S. Supreme Court justice Lewis F. Powell, Jr., in 1990. Wilder's children—from left, Lynn, Loren, and Larry—witness the ceremony. (AP/Wide World Photos)

Wilder was also involved in an ongoing feud with Charles Robb, his predecessor as governor and later U.S. Senator. The political rivalry between the men gradually became bitterly personal, and they accused each other of electronic eavesdropping on private communications and other indiscretions.

The historical uniqueness of Wilder's position, his resistance of traditional ideological labels, and his feud with Robb attracted much attention for Wilder. In 1992 he made an unsuccessful bid to become U.S. President. He completed his gubernatorial tenure in January 1994, the Virginia constitution prohibiting him from seeking a second consecutive term. In an attempt to unseat Robb from the U.S. Senate, Wilder enetered the Virginia senatorial race as an independent in June 1994. Wilder maintained his independent candidacy for a time after Robb's renomination, turning the election into a four-way contest among Wilder, Robb, Republican nominee Oliver North, and Marshall Coleman (a Republican running as an independent). Later in the campaign, Wilder withdrew, endorsed Robb, and actively campaigned for him. Wilder's endorsement was a major factor in the defeat of Oliver North in a predominantly Republican state and in the face of a general Republican landslide in November 1994.

REFERENCES

BAKER, DONALD P. *Wilder: Hold Fast to Dreams*. Cabin John, Md., 1989.
EDDS, MARGARET. *Claiming the Dream: The Victorious Campaign of Douglas Wilder of Virginia*. Chapel Hill, N.C., 1990.
YANCEY, DWAYNE. *When Hell Froze Over: The Untold Story of Doug Wilder: A Black Politician's Rise to Power*. Dallas, 1988.

MANLEY ELLIOTT BANKS II

Wilkens, Leonard Randolph "Lenny" (October 28, 1937–), basketball player and coach. Lenny Wilkens was born in the Bedford-Stuyvesant section of Brooklyn, N.Y. His father died when he was five, leaving his Irish-American mother to support four children. She sent Lenny to Roman Catholic schools through his first year of high school, when he transferred to Boys High, a public school. In his senior year, Wilkens, a 6'1" guard, earned a basketball scholarship to Providence College. In 1960, he began a professional basketball career as a first-round draft pick of the St. Louis Hawks. A nine-time All-Star, Wilkens spent eight years with the Hawks, and then played for the Seattle Supersonics (1968–1972), the Cleveland Cavaliers (1972–1973), and the Portland

Trailblazers (1974–1975). Serving as a vice president of the Players Association, Wilkens gained firsthand knowledge of basketball management.

In Seattle and Portland, Wilkens worked as a player-coach, becoming the second African American to coach in the National Basketball Association (NBA). Wilkens's first season in Portland was his last as a player, but he stayed on as the Blazers' head coach. When Portland fired him following an unsuccessful 1975–1976 season, Wilkens returned to Seattle as director of player personnel. He was named head coach of the Sonics in 1977 and coached the team to an NBA championship in 1979. In 1985, he left the court for the front office, becoming Seattle's general manager. The following year, however, he accepted a position as head coach of the Cleveland Cavaliers. Under Wilkens, the Cavaliers consistently posted

Lenny Wilkens, player-coach of the Seattle Super-Sonics, in 1971. In the 1994–1995 season, after twenty-five years of coaching, Wilkens surpassed Red Auerbach to become the most successful coach in the history of the NBA. (AP/Wide World Photos)

winning records, but failed to capture a championship. After seven seasons in Cleveland, he resigned and was soon named head coach of the Atlanta Hawks. In the 1994–1995 season, Wilkens became the all-time winningest NBA coach. He was inducted, as a player, into the Professional Basketball Hall of Fame in 1989.

REFERENCES

ASHE, ARTHUR R., JR. *A Hard Road to Glory: A History of the African American Athlete.* New York, 1988.
LUPICA, MIKE. "The Wayne and Lenny Show." *Esquire* (June 1989).
REVERON, DEREK. "A Cool Coach Who Wins." *Ebony* (March 1979).

BENJAMIN K. SCOTT

Wilkerson, Doxey Alphonso (April 25, 1905–June 17, 1993), educator and Communist party official. Doxey Wilkerson was born in Excelsior Springs, Mo., but grew up in Kansas City, Mo. He attended the University of Kansas, receiving an A.B. in 1926 and an A.M. in 1927.

Wilkerson taught English and education at Virginia State College at Petersburg before joining the faculty of HOWARD UNIVERSITY in 1935, where he stayed until 1943. From 1937 to 1940, Wilkerson served as national vice president of the American Federation of Teachers, then affiliated with the American Federation of Labor. In 1942 he was hired as an education specialist for the federal Office of Price Administration, but resigned the following year to become the COMMUNIST PARTY, U.S.A.'s education director for Maryland and the District of Columbia. In the mid-1940s Wilkerson moved to New York, where he was executive editor of the communist-led HARLEM newspaper *The People's Voice* and a columnist for *The Daily Worker,* the official newspaper of the party.

Through the late 1940s and much of the 1950s Wilkerson served as one of the Communist party's leading spokesmen on "the Negro question." He published an article in *What the Negro Wants,* an influential 1944 collection of essays, in which he linked the African-American struggle for civil and economic rights with the Allied cause in World War II. In other writings Wilkerson urged the party to treat African-American culture as a distinct and separate form within American culture. He was a central figure in the NATIONAL NEGRO CONGRESS (1936–1946) and its successor, the CIVIL RIGHTS CONGRESS (1946–1956), both of which were prominent, Communist party–dominated civil rights organizations. Wilkerson was

investigated repeatedly by the House Committee on Un-American Activities (HUAC), and refused to answer questions during a HUAC hearing in 1953. In 1957, following Soviet leader Nikita Khrushchev's revelations in 1956 about the brutality of the Stalin regime, Wilkerson joined thousands of American Communists in publicly resigning from the party.

In the late 1950s and 1960s Wilkerson was active in the CIVIL RIGHTS MOVEMENT. He led and participated in several sit-in demonstrations to integrate lunch counters in the Dallas area, where he was a member of the Bishop College faculty. In 1960 he was fired by the college for his civil rights activism.

After his dismissal from Bishop College, Wilkerson moved back to New York, where he continued his civil rights work and career in education, and from 1963 to 1973 he served as chairman of Yeshiva University's Education Department of Curriculum and Instruction. Wilkerson then became vice president of Mediax Associates, a consulting firm that evaluated the Head Start education programs. He held that position until his retirement in 1984.

Wilkerson died in Norwalk, Conn., in 1993.

REFERENCES

LOGAN, RAYFORD W., ed. *What the Negro Wants.* Chapel Hill, N.C., 1944.
Obituary. *New York Times,* June 18, 1993, p. D16.
WILKERSON, DOXEY. "Negro Culture—Heritage and Weapon." *Masses and Mainstream* (August 1949): 3–24.

THADDEUS RUSSELL

Wilkins, Frederick. *See* Frederick Wilkins Slave Rescue.

Wilkins, J. Ernest, Jr. (November 27, 1923–), mathematician. J. Ernest Wilkins, Jr., was born in Chicago, Ill., the son of J. Ernest and Lucille B. Wilkins. His father was a Chicago attorney who earned his A.B. degree with special honors in mathematics at the University of Illinois. Young Wilkins was a child prodigy in mathematics who sustained his early promise. Such was Wilkins's precocity that he took his Ph.D. in mathematics at the age of nineteen in 1942 from the University of Chicago, one of the youngest to earn a mathematics doctorate. As an undergraduate, he was among the top six students in a national mathematics contest sponsored by the Mathematics Association of America and was elected to Phi Beta Kappa. Wilkins received from the Uni-

versity of Chicago his S.B. with honors in 1940 and his S.M. in 1941.

Wilkins was a postdoctoral research fellow at the Institute of Advanced Studies in 1942–1943. After one year as a mathematics instructor at Tuskegee Institute and several years in government and industry, he returned to school, earning a bachelor's of mechanical engineering degree (1957) and a master's of mechanical engineering degree (1960), both from New York University.

He worked as a physicist at the University of Chicago Metallurgical Laboratory (the Manhattan Project), 1944–1946; was a mathematician at the American Optical Company, 1946–1950; senior mathematician at United Nuclear Corporation, 1950–1960; an administrator at Gulf General Atomic Incorporated, 1960–1970; and distinguished professor of applied mathematical physics at Howard University, 1970–1977. Wilkins returned to industry in 1977, accepting the position of associate general manager at EG&G Idaho, Inc. He was made deputy general manager of that company in 1980, a position that he held until his retirement in 1984.

Wilkins's scientific contributions in several areas—differential and integral equations, special functions theory, calculus of variations, and nuclear reactors—have earned him the respect of other scientists. He is an elected member of the National Academy of Engineering, a former president of the American Nuclear Society, and a former member of the Council of the American Mathematical Society. He is also a member of the Optical Society of America, the Society for Industrial and Applied Mathematicians, the

American Association for the Advancement of Science, the Mathematical Association of America, and the National Association of Mathematicians.

Wilkins came out of retirement in 1990 to accept a distinguished university professorship at Clark-Atlanta University.

REFERENCE

"Ernest J. Wilkins, Jr.—Inspiration to Young Scientists." *New York Amsterdam News,* June 14, 1958, p. 10.

JAMES A. DONALDSON

Wilkins, Roy Ottoway (August 30, 1901–September 8, 1981), civil rights leader, laborer, and journalist. Born in a first-floor flat in a black section of St. Louis, Mo., Roy Wilkins got his middle name from the African-American physician who delivered him, Dr. Ottoway Fields. At age four, following his mother's death, Wilkins went to St. Paul, Minn. to live with his Aunt Elizabeth (Edmundson) and Uncle Sam Williams. The Williamses wrested legal guardianship of Roy, his brother, Earl, and sister, Armeda, from their absentee, footloose father, William.

After graduating from the University of Minnesota (1923) and following a stint as night editor of the college newspaper and editor of the black weekly, the *St. Paul Appeal,* Wilkins moved to Kansas City where he was editor of the *Kansas City Call* for eight years. In 1929 in Kansas City he married Aminda Badeau. In St. Paul and Kansas City, he was active in the local NATIONAL ASSOCIATION FOR THE ADVANCEMENT OF COLORED PEOPLE chapters during a period when the NAACP was waging a full-scale attack against America's JIM CROW practices. Under Wilkins's stewardship the *Call* gave banner headline coverage to NAACP (Acting) Executive Secretary Walter WHITE's 1930 campaign to defeat President Herbert Hoover's nomination of Circuit Court Judge John J. Parker to the United States Supreme Court. Parker, in a race for North Carolina governor ten years earlier, had declared his antipathy toward blacks. The *Call* published Parker's photo alongside his quote during the campaign: "If I should be elected Governor . . . and find that my election was due to one Negro vote, I would immediately resign my office." The *Kansas City Call* editorialized that "for a man who would be judge, prejudice is the unpardonable sin. . . ." The NAACP's success in blocking Parker's ascension to the U.S. Supreme Court gave Walter White national prominence and a friendship was forged between White, in New York, and Wilkins, in Kansas City.

J. Ernest Wilkins, 1975. (© Leandre Jackson)

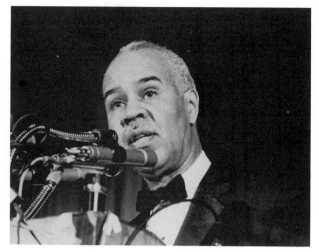

Roy Wilkins. (Photographs and Prints Division, Schomburg Center for Research in Black Culture, The New York Public Library, Astor, Lenox and Tilden Foundations)

In 1931 White invited Wilkins to join the national staff of the NAACP in New York as assistant secretary. Wilkins accepted the post with great excitement and anticipation, regarding the NAACP at the time as "the most militant civil rights organization in the country." Wilkins, in his autobiography, recalled that the NAACP during the 1920s and '30s, had "pounded down the South's infamous grandfather clauses, exposed lynchings, and pushed for a federal anti-lynching law" and had "exposed the spread of peonage among black sharecroppers in the South, prodded the Supreme Court into throwing out verdicts reached by mob-dominated juries, and blotted out residential segregation by municipal ordinance." The NAACP was overturning the racial status quo and Wilkins wanted to be involved.

But there was also dissent within the NAACP. In 1934, following a blistering public attack on Walter White's leadership and on the NAACP's integrationist philosophy from NAACP cofounder W. E. B. DU BOIS, who subsequently resigned as editor of the NAACP's penetrating and influential magazine, *The Crisis,* Wilkins succeeded Du Bois as editor of *The Crisis* while he continued in his post as assistant secretary. Wilkins was editor of *The Crisis* for fifteen years (1934–1949).

Du Bois's open flirtation with voluntary segregation did not alter the NAACP's course; throughout the 1930s, '40s, and '50s, the NAACP continued to attack Jim Crow laws and to work on behalf of blacks' full integration into American society. But by 1950, Walter White's leadership was on the wane; in that year Wilkins was designated NAACP administrator. White lost key support because of a divorce and his remarriage to a white woman; failing health

made him especially vulnerable to his detractors. Upon White's death in 1955, Wilkins became executive secretary of the NAACP in the wake of its momentous victory in BROWN V. BOARD OF EDUCATION OF TOPEKA, KANSAS (1954), where NAACP lawyers had successfully argued that racially separate public schools were *inherently* unequal.

Wilkins served as the NAACP's executive secretary/director for twenty-two years, longer than any other NAACP leader. His tenure characterized him as a pragmatist and strategist who believed that reasoned arguments, both in the courtroom and in public discourse, would sway public opinion and public officials to purposeful actions on behalf of racial equality. During the 1960s, Wilkins was widely regarded as "Mr. Civil Rights," employing the NAACP's huge nationwide membership of 400,000 and lawyers' network to back up the direct-action campaigns of more fiery leaders like the Rev. Dr. Martin Luther KING, Jr., and James FARMER. The NAACP supplied money and member support to the massive March on Washington in 1963. Always moderate in language and temperament, and lacking a charismatic personal style, Wilkins was most comfortable as a strategist and adviser, had meetings with presidents from Franklin D. Roosevelt to Jimmy Carter, and was a friend of President Lyndon B. Johnson. Major civil rights legislation was signed into law in Wilkins's presence, including the Civil Rights Act of 1964, the Voting Rights Act of 1965, and the Fair Housing Act of 1968.

As standard-bearer of integration, the NAACP during the turbulent 1960s and throughout the 1970s, was pilloried with criticism from black separatists and from whites who opposed school busing and affirmative action programs. Wilkins steered a steady course, however, eschewing racial quotas but insisting on effective legal remedies to purposeful and systemic racial discrimination that included race-conscious methods of desegregating schools, colleges, and the work place. He simultaneously took to task the exponents of black nationalism. During the height of the Black Power movement, in 1966, Wilkins denounced calls for black separatism, saying black power "can mean in the end only black death." Although one of America's most influential and well-known leaders, Wilkins refused to arrogate to himself the plaudits due him because of his successes. He was a frugal administrator and humble individual who routinely took the subway to work and back home.

By 1976, after forty-five years with the NAACP, Wilkins, at age seventy-five, was barely holding on to his post at the NAACP's helm. A year later, in failing health, he retired to his home in Queens, N.Y., where he spent his last years in the company of

his wife. The winner of the NAACP's SPINGARN MEDAL in 1964, and the recipient of many other awards, including over fifty honorary degrees, Wilkins died in September 1981. At his funeral in New York City hundreds of mourners, black and white, remembered him as a man who refused to bend to fashion.

REFERENCES

WILKINS, RODGER. *A Man's Life.* Woodbridge, Conn., 1982.
WILKINS, ROY, with Tom Mathews. *Standing Fast: The Autobiography of Roy Wilkins.* New York, 1982.

MICHAEL MEYERS

Williams, Anthony "Tony" (December 12, 1945–), jazz drummer, composer. Born in Chicago and raised in Boston in a musical family, Williams was introduced to jazz by his father, tenor saxophonist Tillmon Williams. Williams was still a child when he sat in with Max ROACH and Art BLAKEY at local jazz clubs. He studied drums privately with Alan Dawson and by age fifteen was performing in experimental concerts with Sam Rivers and the Improvisational Ensemble. In 1962 Williams moved to New York, where he performed and recorded with Jackie MCLEAN (*One Step Beyond*), and appeared in the band of the theater production *The Connection.* The next year he joined the Miles DAVIS Quintet, where he remained for seven years.

While Williams was with Davis, his drumming evolved from a mainstream, hard-bop style into one characterized by a forceful yet melodic intensity which paved the way for jazz-rock drumming. His trademark prestissimo cymbal ride on records with Davis from 1963 to 1968 (*Seven Steps to Heaven, ESP, Live at the Plugged Nickel, Miles Smiles, Sorcerer, Nefertiti*), his polyrhythmic accompaniment, and his energetic solos are the salient characteristics of this period. During this time Williams also recorded under his own name (*Lifetime,* 1964; *Spring,* 1965), and performed on several landmark albums led by Eric DOLPHY (*Out to Lunch,* 1964), Sam Rivers (*Fuchsia Swing Song,* 1964) and Herbie HANCOCK (*Maiden Voyage,* 1965).

Before leaving Davis in 1969, Williams had developed a style that integrated rock rhythms with phrases extrapolated from the melody (*In a Silent Way,* 1969). He recorded with his own trio in 1969 and 1970 (*Emergency,* 1969). After a period of inactivity in the early 1970s, Williams again began performing in a variety of jazz contexts, most notably

with V.S.O.P., a reformation of the Davis Quintet, but with Freddie HUBBARD replacing Davis on trumpet, (*The Quintet,* 1977). In 1981, he performed on Wynton MARSALIS's recording debut as a leader (*Wynton Marsalis*). After relocating in the San Francisco Bay Area in the mid-1980s, Williams pursued private lessons in composition with Bob Greenberg and resumed recording and performing, both as a leader and as a sideman. He also began leading a quintet that helped establish younger musicians such as Wallace Roney, Mulgrew Miller, Charnet Moffet, and Bill Pierce.

REFERENCES

DE BARROS, P. "Tony Williams: Two Decades of Drum Innovation." *Downbeat* 1/2 (1983): 14.
TAYLOR, ARTHUR. *Notes and Tones.* Liège, Belgium, 1977. 2nd ed. 1982.

ANTHONY BROWN

Williams, Billy Dee (December, William) (April 6, 1937–), actor. Born in Harlem, Billy Dee Williams originally studied art at New York's High School of Music and Art and the National Academy of Fine Arts and Design. Despite the fact that he was training as an artist, Williams also participated in the Actors Workshop in Harlem, where he was able to study with Sidney POITIER and Paul MANN. His first appearance on the stage came at the age of seven in *The Firebrand of Florence* (1945), but Williams did not begin regularly performing in Broadway and off-Broadway productions until the late 1950s and early '60s. His early stage credits include *Take a Giant Step* (1956), *A Taste of Honey* (1960), *The Cool World* (1961), and *The Blacks* (1962).

After his initial success on the stage, Williams traveled to the West Coast seeking roles in movies and on television. While his first movie role, as a rebellious ghetto youth in *The Last Angry Man,* came in 1959, he would not gain substantial fame for more than a decade. In 1970, he received an Emmy nomination for his portrayal of Chicago Bears football player Gale SAYERS in the made-for-TV movie *Brian's Song.* He also made numerous television appearances, including guest roles in *Hawk, The Mod Squad,* as well as soap operas like *Another World.*

Williams's early success earned him a seven-year film contract with Motown's Berry Gordy. Through vehicles such as *Lady Sings the Blues* (1972) and *Mahogany* (1975), both with Diana Ross, Williams gained a reputation as a romantic male lead. He also starred in *The Bingo Long Travelling All Stars and Motor Kings* (1976), a movie with James Earl JONES and

Richard PRYOR about an itinerant baseball team of African Americans during the Negro League era. In Universal's *Scott Joplin* (1978), he portrayed the famous composer.

In the 1980s, Williams played leading roles in George Lucas's *The Empire Strikes Back* (1980) and *Return of the Jedi* (1983) and opposite Sylvester Stallone in *Nighthawks* (1981). His role with Diahann CARROLL on the television prime-time soap opera *Dynasty* in the mid 1980s further reinforced his image as a sex symbol. In 1985, he also played in *Double Dare,* a short-lived television detective series. In the late 1980s, Williams had roles in *Deadly Illusions* (1987) and *Batman* (1989). Other ventures were slightly more controversial; he came under harsh attack from African-American community groups in 1989 for taking part in beer commercials.

It was also in the 1980s that Williams began to receive recognition for his professional achievements. Shortly after being inducted into the Black Filmmakers Hall of Fame in 1984, Williams received a star on the Hollywood Walk of Fame in 1985. In 1988, the Black American Cinema Society awarded him their Phoenix Award.

In the early 1990s, Williams continued to play parts in television movies. He also began to exhibit some of his artwork, which had become an increasingly neglected hobby as his acting career flourished. Exhibitions in galleries in New York and Washington, D.C., received favorable reviews. In 1993, the Schomburg Center for Research in Black Culture also sponsored a display of Williams's work.

REFERENCES

BOGLE, DONALD M., ed. *Blacks in American Films and Television.* New York, 1988.
MAPP, EDWARD, ed. *Directory of Blacks in the Performing Arts.* 2nd ed. Metuchen, N.J., 1990.

JOHN C. STONER

Williams, Charles Melvin "Cootie" (c. July 10, 1911–September 15, 1985), jazz trumpeter. Williams, the exact year of whose birth in Mobile, Ala., has been the subject of some dispute, began playing drums in his early teens, and performed with the Young Family Band, which included the saxophonist Lester YOUNG. He later switched to trumpet and by 1925 was playing in the Florida band of "Eagle Eye" Shields. The next year Williams joined Alonzo Ross's ensemble, and when the group arrived in New York in 1928, Williams decided to stay. He made his first recordings that year with pianist James P. JOHNSON, and eventually performed in the orchestras of Chick Webb and Fletcher HENDERSON.

In 1929 Duke ELLINGTON invited Williams to replace Bubber MILEY, and it was in Ellington's trumpet section that Williams made his greatest impact. Williams refined Miley's plunger-muted style to allow for more flexible and subtle sonorities, produced not only by muting the open trumpet with a toilet plunger, but using the plunger over a normal, straight mute as well. Williams's sound was so distinctive and thrilling that Ellington wrote two of his greatest miniature concertos, "Echoes of Harlem" (1936) and "Concerto for Cootie" (1940), for Williams. During the 1930s Williams also joined recording dates with Billie Holiday, Charlie Christian, and Teddy Wilson.

In late 1940 Williams left Ellington for a brief stint with Benny Goodman. He then formed his own big band, which, although successful ("West End Blues," 1941), was better known for its personnel, which included Eddie "Cleanhead" Vinson, Charlie PARKER, and Earl "Bud" POWELL. It was during this time that Williams had a hand in the Thelonious MONK composition "Round Midnight." During the 1940s Williams gradually reduced the size of his big band, until it was a mid-sized group that in 1948 became the house band at the Savoy Ballroom. In the 1950s Williams's popularity waned, and he found work in rhythm and blues bands until he made a burst of new jazz recordings in 1957–1958 (*The Big Challenge,* with Rex Stewart, and *Cootie in Hi-Fi*). Williams briefly rejoined Goodman in the early 1960s before returning to his seat in Ellington's trumpet section in 1962. He remained there even after Ellington's death in 1974, when Mercer Ellington assumed control. For most of the late 1970s Williams was in poor health, although he did rejoin the Ellington Orchestra in 1979. He died in 1985 in New York.

REFERENCES

BURKE, T., and D. PENNY. "The Cootie Williams Orchestra, 1942–50." In *Blues and Rhythm: The Gospel Truth* No. 3 (1984): 12.
DANCE, STANLEY. "Cootie Williams." In *The World of Duke Ellington.* New York, 1973.

MARTIN WILLIAMS

Williams, Daniel Hale (January 18, 1856–August 4, 1931), surgeon. Daniel Hale Williams was born in Hollidaysburg, Pa., where his father was a barber. In his youth, he traveled with his sister to Janesville, Wis., where he found work in a barbershop. There he had the good fortune to meet Henry Palmer, a leading physician who had served ten years as surgeon general of Wisconsin. Palmer provided a med-

ical apprenticeship for Williams, beginning in 1878, and helped to pay for his entry into Chicago Medical College.

After receiving an M.D. from the Chicago Medical College in 1883, Williams opened a medical office in an interracial neighborhood on Michigan Avenue. He was appointed an attending physician at the Protestant Orphan Asylum and joined the surgical staff of the South Side Dispensary. Williams also became a clinical instructor at the Chicago Medical College and a physician for the City Railway Company. In 1889 he was named to the Illinois State Board of Health, where he served four years and helped develop and enforce medical standards for the treatment of contagious diseases.

Because African-American doctors were not granted staff positions at Chicago's public and private hospitals, they were unable to use modern facilities and equipment to complete their medical training and care for patients. The city's hospitals also refused to train African-American women who aspired to be nurses. These conditions led Williams to found Provident Hospital in 1891, the first black-owned hospital

in the United States. From the outset, Provident had an interracial staff of doctors and maintained a nurses' training school.

It was at Provident Hospital that Williams performed the operation for which he is best known—the first successful open-heart surgery. On a July evening in 1893, James Cornish was rushed to Provident's emergency room with a knife wound in his chest. While the wound appeared to be superficial and external bleeding had stopped, with no x-ray procedures available to doctors, Williams could not rule out the possibility of internal damage. During the course of the night, Cornish's condition worsened. Severe pain in the heart region developed and his pulse weakened. Signs of shock appeared; internal bleeding was apparent. Williams decided to operate on the left side of the chest cavity. Finding that a blood vessel had been pierced and that the pericardium tissue around the heart had also received a stroke of the knife blade, Williams proceeded to close both lacerations with stitches of catgut thread. Cornish lived for twenty years after the operation.

In 1894, Williams received an appointment as chief surgeon at Freedmen's Hospital in Washington, D.C., a federally funded hospital associated with Howard University's medical school. He reorganized the hospital into departments, established an internship program, and revitalized the nurses' training school. Williams returned to Chicago in 1898, reopened his private practice, and rejoined the staff at Provident Hospital. He began to publish articles in prominent medical journals and became active in black public health issues. In 1900, Williams undertook a tour of several states, in which he helped to improve or establish hospitals for African Americans. Before the Phillis Wheatley Club in Nashville, Tenn., he read a paper entitled, "The Needs of Hospitals and Training Schools for the Colored People in the South." In 1913, Williams received an appointment as associate attending surgeon at the white-staffed St. Luke's Hospital in Chicago, a position that caused some controversy among his colleagues at Provident. In the same year, he became the only African-American charter member of the American College of Surgeons. After his wife's death in 1924, Williams entered semiretirement in Idlewild, Mich., where he died in 1931. Williams bequeathed portions of his estate to Meharry Medical School and to the NAACP, of which he had been a longtime member.

Daniel Hale Williams, a Chicago physician, performed the first open-heart surgery in 1893. (Illinois State Historical Library)

REFERENCES

BUCKLER, HELEN. *Daniel Hale Williams: Negro Surgeon.* Boston, 1968.
FENDERSON, LEWIS, H. *Daniel Hale Williams: Open Heart Doctor.* New York, 1971.

HAYDEN, ROBERT C. *Eleven African American Doctors.* Frederick, Md., 1992.

WILLIAMS, DANIEL HALE. *Report of Surgical Cases.* Chicago, 1899.

ROBERT C. HAYDEN

Williams, Douglas Lee (August 9, 1955–), football player. Doug Williams was raised in Zachary, La., the sixth of eight children born to Laura and Robert Williams, Sr. A star athlete who excelled at several sports during high school, Williams accepted a football scholarship to Grambling State University in Grambling, La., where he played at quarterback for coach Eddie ROBINSON. While at Grambling, Williams completed ninety-three touchdowns and passed for a total of 8,411 yards. During his senior year in 1978 Williams was named to the Associated Press All-American team and finished fourth in the balloting for the Heisman trophy, the highest ranking at the time for a black quarterback.

Williams was chosen by the Tampa Bay Buccaneers in the first round of the 1978 National Football League draft. Over the next five years he led the Buccaneers to the National Football Conference playoffs three times, only to be released by the team in 1982. Williams then played in the fledgling United States Football League (USFL), first for the Oklahoma Outlaws and then for the Arizona Wranglers, until the league folded in 1985. The following year Williams was signed by the Washington Redskins as a backup quarterback. During the regular season in 1988, he took over as starting quarterback and eventually led the Redskins to a victory over the Denver Broncos in Super Bowl XXII (played in January 1989). The first African American ever to start as quarterback in a Super Bowl game, Williams was also named Super Bowl Most Valuable Player.

Due to a chronic back injury Williams was released by the Redskins after the 1989 season, ending his eleven-year professional career. In 1990 he wrote a book titled *Quarterblack: Shattering the NFL Myth,* in which he argued that substantial racism existed in the NFL. According to Williams, unexceptional black athletes were less likely to be given playing time than their white counterparts, black players were underpaid, and white players were sometimes informed in advance of random drug tests.

In 1990 Williams became a college football commentator for the Black Entertainment Network. In 1991 he received a reported one million dollars in a workman's compensation suit.

REFERENCES

LIEBER, JILL. "Free-Fall from the Top." *Sports Illustrated* (January 28, 1991); pp. 82–84.

WILLIAMS, DOUG. *Quarterblack: Shattering the NFL Myth.* Chicago, 1990.

NEIL MAHER
THOMAS PITONIAK

Williams, Dudley (August 18, 1938–), dancer. Born and reared in New York City, Dudley Williams became interested in dance after observing classes at a local arts school while waiting for an uncle who was studying voice. He began training at age twelve with Sheldon Hoskins in Harlem, then attended New York's High School for the Performing Arts. Williams graduated in 1958 after winning a dance award and received a scholarship to the Juilliard School. He attended Juilliard at intervals for the next several years while taking time off to dance with various companies, including those of May McDonnell, Donald MCKAYLE, and Talley BEATTY. In 1961 Williams joined the Martha Graham Company. He also began to appear with the Alvin AILEY American Dance Theater. In 1964 he left Martha Graham to become a member of Alvin Ailey.

Passionate leading performances in Donald McKayle's *Rainbow Round My Shoulder* (1959), Ailey's *Reflections in D* (1962), Lucas Hoving's *Icarus* (revived 1968), and Louis Falco's *Caravan* (1976) made Williams a central member of the company. He galvanized audiences with his virtuosity in performances of Ailey's sixteen-minute solo "Love Songs" (1972); his comic "backwoods huckster" role in Ailey's *Blues Suite* (1958); and his moving, deeply felt solo "I Want to Be Ready" in Ailey's renowned *Revelations* (1960). In 1984 he celebrated his twentieth anniversary with Ailey in a gala performance at the City Center in New York City. In the early 1990s he remains a performing member of the Alvin Ailey American Dance Theater as well as a company teacher.

REFERENCES

COHEN-STRATYNER, BARBARA NAOMI. *Biographical Dictionary of Dance.* New York, 1982.

GOODMAN, SAUL. "Dudley Williams." *Dance* (November 1967): 58.

THOMAS F. DEFRANTZ

Williams, Egbert Austin "Bert" (ca. November 12, 1874–March 4, 1922), entertainer. It is likely, though unconfirmed, that Williams was born in Antigua, the West Indies, on November 12, 1874. In 1885 he moved with his parents, Fred and Julia, to Riverside, Calif., where his father became a railroad conductor. After high school, Bert moved to San Francisco, seeking an entertainment career. He sang

in rough saloons, toured lumber camps in a small minstrel troupe, learned minstrel dialect, became a comedian, and in 1893 formed a partnership with George Walker that lasted sixteen years and brought them fame.

After years of trial and error, by 1896 they had evolved their act—the classic minstrel contrast of the "darky" and the "dandy." The large, light-skinned Williams used blackface makeup, ill-fitting clothes, heavy dialect, and a shuffle to play hapless bumblers while the smaller, darker Walker played well-dressed, cocky, nimble-footed hustlers. In 1899, they launched the first of a string of successful African-American musicals, *A Lucky Coon*. In 1903, *In Daho-mey*, with exotic African elements, exciting chorus numbers, hard-luck songs and comedy for Williams, and snappy dances and a wise-guy role for Walker, brought them international acclaim, from appearances on Broadway to a command performance at Buckingham Palace in London. Their successes continued until Walker fell ill and retired in 1909.

Without Walker, Williams became a "single" in vaudeville and in 1910 was the first African American to perform in the *Ziegfeld Follies*. He was at the center of American show business, where he remained—in the *Follies* (1910–1912, 1914–1917, 1919), other top-notch revues and vaudeville (1913, 1918), and his own shows (1920–1922). A master of pantomime, pathos, understatement, and timing, he gave universal appeal to his poignant hit songs, such as "Nobody" and "I'm a Jonah Man," and his comedy sketches of sad-sack bellhops, gamblers, and porters, despite heavy dialect and caricatures. The critic Ashton Stevens in 1910 hailed Williams as "the Mark Twain of his color," whose "kindly, infectious human . . . made humans of us all."

Williams felt blackface and dialect liberated him as a comedian by letting him become "another person" onstage, but offstage this racially stereotyped minstrel mask stifled a man who longed to be accepted as a human being. "Bert Williams is the funniest man I ever saw," observed *Follies* veteran W. C. Fields, "and the saddest man I ever knew." Suffering discrimination and rejection everywhere except onstage and at home with his devoted wife, Lottie, whom he married in 1900, he became a heavy drinker plagued by depression. Despite failing health, he drove himself mercilessly onstage, where he was happiest. On February 25, 1922, weakened by pneumonia, he struggled through a matinee of his new show, *Under the Bamboo Tree*. During the performance that evening, he collapsed. He died a week later.

Caribbean-born Bert Williams (left) was the first African-American comic to become a major vaudeville star. From 1893 through 1909 his stage partner was the comedian George William Walker. Songs such as "The Johan Man" (1903), from Will Marion Cook's musical *In Dahomey*, revealed Williams in a familiar role as a victim of habitual bad luck. (Photographs and Prints Division, Schomburg Center for Research in Black Culture, The New York Public Library, Astor, Lenox and Tilden Foundations)

REFERENCES

CHARTERS, ANN. *Nobody: The Story of Bert Williams*. New York, 1970.

ROWLAND, MABEL, ed. *Bert Williams, Son of Laughter*. Reprint. New York, 1969.

TOLL, ROBERT C. *On with the Show: The First Century of Show Business in America*. New York, 1976, pp. 121–133.

WILLIAMS, BERT. "The Comic Side of Trouble." *American Magazine* 85 (January 1918): 33–35, 58–61.

ROBERT C. TOLL

Williams, Fannie Barrier (February 12, 1855–1944), club woman. Fannie Barrier Williams's career in the black women's club movement of the late nine

teenth and early twentieth centuries is representative of the hard work and dedication of this network of women and of their success as community organizers. Fannie Barrier was born to a free black family in Brockport, N.Y. After graduating from the State Normal School in her hometown, she taught school in the South and in Washington, D.C. Her experiences with racism in these contexts focused her interests on working for racial uplift.

Barrier married S. Laing Williams, a young lawyer, in 1887 and the two settled in Chicago, where they worked closely with Ida WELLS-BARNETT and her husband, Ferdinand Barnett. From this point, Williams became involved with a wide range of organizations and activities. She, along with Wells-Barnett, pressed for the inclusion of African Americans in the World's Columbian Exposition of 1893. She worked with women's clubs, black and white, in Chicago and across the country and gained a reputation as an effective leader and lecturer.

In 1893, Williams became one of the founding members of the NATIONAL LEAGUE FOR THE PROTECTION OF COLORED WOMEN, which would be among the founding organizations of the NATIONAL ASSOCIATION OF COLORED WOMEN three years later. She was also a close associate of T. Thomas FORTUNE and Emmett SCOTT, the founders of the NATIONAL NEGRO BUSINESS LEAGUE, and was elected the organization's corresponding secretary in 1902. The league was ideologically aligned with Booker T. WASHINGTON's economic and political program, and Williams's work here caused a break with the more radical Barnetts.

Williams went on to work with the NATIONAL ASSOCIATION FOR THE ADVANCEMENT OF COLORED PEOPLE (NAACP) and to be a strong advocate of women's suffrage. After her husband's death in 1921, she returned to her hometown, where she lived until her own death.

REFERENCE

LOEWENBERG, BERT JAMES, and RUTH BOGIN, eds. *Black Women in Nineteenth Century American Life*. University Park, Pa., 1976.

JUDITH WEISENFELD

Williams, Franklin Hall (1917–1990), civil rights activist and ambassador. Franklin H. Williams's forebears came from the confluence of Algonquin Indians, black freedmen, runaway slaves, and Dutch and English immigrant populations that characterized the people of color living on Long Island, New York, in the early nineteenth century. Williams and two older brothers were born a century later in Flushing, Queens, New York. After their mother's death in 1919, the children were raised by maternal grandparents Thaddeus and Caroline Lowry, and an uncle, John Edward Lowry. Williams attended local schools, and in his formative years he demonstrated the leadership skills that would characterize his adult achievements.

Seeking self-definition in Harlem, he encountered black achievers who were race-proud and sensitive to social issues. Among them was May Chinn, Harlem's first female physician, who urged him to apply to Lincoln University. He graduated as salutatorian in 1941 and, after service in the U.S. Army, completed Fordham University Law School in 1945, passing the New York State bar examination before receiving his degree. In the fourteen years that followed, Williams was employed by the National Association for the Advancement of Colored People, first as assistant special counsel to Thurgood MARSHALL in the organization's legal department, where he received recognition for the eloquence of his arguments before the Supreme Court, and then as West Coast regional director.

During his tenure as director, he conducted drives for legislation on minority employment, won the first judgment in a case involving school desegregation, and effectuated the removal of restrictive covenants on real estate. His outstanding performance led to a request from the attorney general of California that he create that state's first Constitutional Rights Section within the Department of Justice. Williams organized a voter registration drive among blacks in 1960 that helped to elect President John F. Kennedy. He was invited to join the administration as special assistant to Sargent Shriver, promoting the newly formed Peace Corps around the world and at the United Nations; ultimately, he became African Regional Director.

In 1962, President Lyndon B. Johnson appointed Williams as U.S. representative to the Economic and Social Council of the United Nations, and in 1965, he named him U.S. ambassador to Ghana. Williams arrived in that country three weeks prior to the coup that toppled President Kwame Nkrumah, who initially implicated Williams in the insurrection and later retracted the charge. Simon Baynham argues that there is no evidence of complicity in the event. Returning from Ghana in 1968, Williams assumed directorship of the Urban Center at Columbia University and in 1970 became president of the PHELPS-STOKES FUND, an organization established to enhance educational opportunities for Africans, African-Americans, and American Indians.

Williams was named to the boards of many corporations, including Consolidated Edison, Chemical Bank, and the American Stock Exchange. He also served as vice chairman of the New York City Board of Higher Education, as chairman of the New York State Judicial Commission on Minorities, and on the boards of Lincoln University, the Boys' Choir of Harlem, and the Barnes Foundation.

REFERENCES

ASSENSOH, A. B. *Kwame Nkrumah: Six Years in Exile, 1966–1972*. London, 1978.

BAYNHAM, SIMON. *The Military and Politics in Nkrumah's Ghana*. Boulder, Colo., 1988.

NKRUMAH, KWAME. *Dark Days in Ghana*. London, 1968.

REDMON, COATES. *Come As You Are: The Peace Corps Story*. New York, 1986.

ENID GORT

Williams, George Washington (October 16, 1849–August 2, 1891), clergyman and legislator. Born in Bedford Springs, Pa., Williams had no formal schooling until after the Civil War. He enlisted with the Union troops in 1864, with the revolutionary forces in Mexico, and with the Tenth Cavalry in 1868. He studied briefly at Howard University and the Wayland Seminary before going to the Newton Theological Institution, where, in 1874, he became the first African American to graduate. Successively he became pastor of the Twelfth Baptist Church in Boston, editor of the *Commoner* in Washington, D.C., and pastor of the Union Baptist Church in Cincinnati. There he contributed articles regularly to the Cincinnati *Commercial* under the pen name "Aristides," became the first African American to serve in the stage legislature, and manifested a lively interest in public affairs. He had a reputation as a skillful politician and a gifted orator. After studying law in the office of Judge Alfonso Taft, he passed the Ohio bar.

Meanwhile, one of Williams's greatest interests was in the study of history. He had already written a history of the Twelfth Baptist Church, as well as a historical sketch of blacks from 1776 to 1876. In 1882 he published his two-volume *History of the Negro Race in America, 1619–1880*. As the first serious work in the field, it was widely reviewed among critics, whose judgments ranged from very favorable to unenthusiastic. Williams was nevertheless an immediate success, and in such great demand as a lecturer that he hired one of the major literary agents in New York to handle his engagements. After publishing a *History of Negro Troops in the War of Rebellion* in 1887, Williams

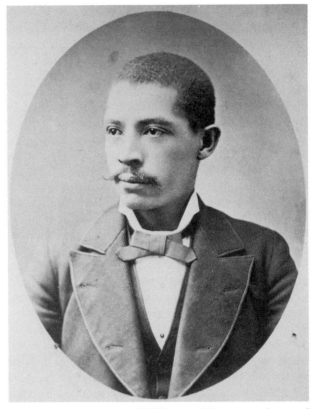

George Washington Williams. (Photographs and Prints Division, Schomburg Center for Research in Black Culture, The New York Public Library, Astor, Lenox and Tilden Foundations)

turned his interests largely to international affairs. He had received an appointment in 1885 as United States minister to Haiti, but the incoming administration of President Benjamin Harrison refused him a commission. Crushed and embittered, Williams decided to make his mark abroad. In 1889 he attended the antislavery conference in Brussels, and in the following year he journeyed to the Congo. He found conditions there so miserable that he published for circulation throughout Europe and the United States *An Open Letter to His Serene Majesty, Leopold II, King of the Belgians*. He roundly condemned the king for his cruel oppression and exploitation of the people of the Congo. This first general criticism of Leopold was followed some years later by similar strictures in Europe and the United States.

Williams did not return to the United States. After traveling extensively in South Africa and East Africa, he went to England, where he died.

REFERENCE

FRANKLIN, JOHN HOPE. *George Washington Williams: A Biography*. Chicago, 1985.

JOHN HOPE FRANKLIN

Williams, Hosea Lorenzo (January 5, 1926–), civil rights leader and politician. Hosea Williams was born and raised in Attapalgus, Ga. He served in the military from 1944 to 1946. In 1951, he graduated from Morris Brown College in Atlanta with a B.A. in chemistry, and went on to earn a master's of science degree from Atlanta University. Upon graduation, Williams worked for the U.S. Department of Agriculture as a research chemist in Savannah, Ga. In the late 1950s and early 1960s, he became active in the NAACP and participated in desegregation drives and other civil rights activities. In 1960, he became head of the Southeastern Georgia Crusade for Voters. Williams was an outspoken believer in direct action, and under his direction, the crusade waged one of the most successful voter registration drives in the South.

In 1962, the crusade affiliated with the SOUTHERN CHRISTIAN LEADERSHIP CONFERENCE (SCLC), and one year later Williams moved to Atlanta to join the staff of SCLC as a full-time project director. He became a top assistant to SCLC's president, the Rev. Dr. Martin Luther KING, Jr., and organized grassroots voter registration drives. In 1965, he led the civil rights march from Selma to Montgomery, Ala., in which marchers were brutally attacked by state troopers and local police.

After King's assassination in 1968, Williams remained active in SCLC. From 1969 to 1971, he served as executive director of SCLC under the leadership of the Rev. Ralph ABERNATHY. Williams led a militant faction in SCLC who called for "black power" and self-help, and rejected integration as a movement goal. In 1971, Williams resigned his position and founded an SCLC chapter in Atlanta with his supporters to practice the type of grass-roots activism he favored.

In 1974, Williams entered the political arena and was elected to the Georgia General Assembly as Atlanta representative. From 1977 to 1979, Williams returned to the position of SCLC national executive director, but he was removed from his post by members of the board of directors who were critical of his outside activities and insisted that he devote more time to his position. (In 1972, Williams had founded and served as the pastor of the Martin Luther King, Jr., People's Church of Love in Atlanta; since 1976, he was been proprietor of his own business, the Southeast Chemical Manufacturing and Distributing Corporation.)

Although Williams has maintained his commitment to grass-roots organizing and direct action, his political allegiances have shifted to the REPUBLICAN PARTY, and in 1980 he endorsed Ronald Reagan for President. He argued that African Americans should seek to make the Republican party accountable to them, and that few Democratic candidates were willing to deal with the "meat and bread" issues facing blacks and the poor. Four years later, running as a Republican, he lost the race for the Fifth District U.S. congressional seat from Atlanta, but the next year he was elected to the Atlanta city council.

Williams's consistent championing of issues that affect the poor, and his flamboyant and often contentious personal style, have made him a well-known figure in Atlanta politics. In 1987, he led a march into Georgia's Forsyth County, a nearly all-white suburb, to protest residential segregation. The march attracted national attention when the participants were attacked by members of the Ku Klux Klan. In 1989, Williams made an unsuccessful bid for mayor of Atlanta on the Republican ticket. Three years later, he once again led a protest march into Forsyth County.

REFERENCES

FAIRCLOUGH, ADAM. *To Redeem the Soul of America: The Southern Christian Leadership Conference and Martin Luther King, Jr.* Athens, Ga., 1987.

GARROW, DAVID J. *Bearing the Cross: Martin Luther King and the Southern Christian Leadership Conferences.* New York, 1986.

STEVEN J. LESLIE
ROBYN SPENCER

Williams, James Henry, Jr. (April 4, 1941–), mechanical engineer. James Henry Williams, Jr., was born in Newport News, Va., the son of James Henry Williams and Margaret L. Mitchell Williams. As a junior in public high school in Newport News, he was named the state's outstanding math and science student. In 1960, he enrolled as an apprentice machinist at the Newport News Shipbuilding and Dry Dock Company Apprentice School, graduating as a mechanical designer in 1965. He earned bachelor's (1967) and master's (1968) degrees in mechanical engineering at the Massachusetts Institute of Technology. In 1970, he was awarded a Ph.D. at Cambridge University with a thesis entitled "Elastic Cylindrical Shells with Open and Closed Ends."

Williams was appointed assistant professor of mechanical engineering at MIT in 1970, rising to the rank of associate professor in 1974 and professor in 1981. His primary teaching responsibilities have been in the area of solid mechanics, dynamics, and experimental engineering. A gifted teacher, Williams is the recipient of several awards for excellence in teaching. His research program is broadly based within the areas of applied mechanics, mechanical and systems design, and the mechanical behavior of fiber composites and other materials. He is widely regarded in

industrial and other circles as an expert on stress analysis (e.g., the dynamics of structures subjected to earthquakes). He designed a surgical implant known as the femoral-pelvic prosthetic cap, helpful in reducing the incidence of postoperative failure.

Williams served on the National Science Foundation's advisory committee for engineering science in mechanics, structures, and materials engineering. He is active in a number of efforts to increase the representation of minorities in science and engineering careers.

REFERENCES

WILLIAMS, JAMES H., JR. "Dilemmas, Colonialism, and Protest." *MIT Faculty Newsletter* (March 1991): 9, 16–17.

"Williams, James H., Jr." *Who's Who among Black Americans.* Detroit, 1992, p. 1523.

KENNETH R. MANNING

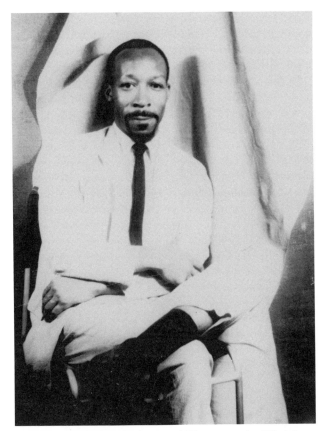

John A. Williams. (Prints and Photographs Division, Library of Congress)

Williams, John Alfred (1925–), writer, editor, and educator. Williams was born in Jackson, Miss., but raised in Syracuse, N.Y. After service in the Navy in World War II, he returned to Syracuse, married, and fathered two sons. When his marriage ended in 1952, he turned to writing. With a degree in journalism and English from Syracuse University, he began a series of jobs in public relations, radio and television, and publishing. In the late 1950s and early 1960s he traveled the world as a correspondent for EBONY, *Holiday,* JET, *Newsweek,* and other magazines, and completed two novels, one of which was published as *The Angry Ones.*

The diverse characters and plots of Williams's many novels are unified by an impulse to correct history and analyze American life from an uncompromisingly black perspective. His protagonists are African-American or African professionals with the courage to battle their weaknesses as human beings as well as their ambiguous status as blacks in a racist society. His narratives are always informed by the problems and possibilities of the human capacity to give and receive love.

Williams's novels are often grouped in three phases. In the first phase, an initial optimism balances a frank depiction of racial struggle. In *The Angry Ones* (1960), he establishes major themes: guilt, racial equity, institutionalized racism, black male–black female tensions, blacks in the military, and the mutual exploitation of interracial sex. In *Night Song* (1962), he evokes the Greenwich Village jazz environment with symbolic resonances between the white world of day and the black underworld of night. *Sissie*

(1965) portrays a black family seeking refuge in success, but driven by memories of earlier hard times. A darker vision of racial apocalypse runs through the middle novels. In *The Man Who Cried I Am* (1967), Williams juxtaposes the poisonous racism of the body politic on the larger scale with the cancer destroying Max Reddick's physical system, as the dying reporter struggles to complete the task laid on him by his murdered mentor and rival Harry Ames, who resembles Richard WRIGHT. In *Sons of Darkness, Sons of Light* (1969), Williams dramatizes the plight of a decent man who can only put his own household in order, as the American social order explodes around him. Captain Blackman (1972) asserts the ubiquitous history of African Americans in the military, from the Revolutionary War to Vietnam, and extrapolates from that experience to an impending racial coup d'état.

Consciousness of an emerging black unity underlies the novels of Williams's third phase. In *Mothersill and the Foxes* (1975), the author takes the reader on a comic odyssey of social service and sexual adventurism that lurches past mass murder and suicide, to the verge of incest, but ends in domestic tranquillity. In *The Junior Bachelor Society* (1976) he portrays middle-class African Americans uniting to confront internal

and external threats. In *!Click Song* (1982), Williams intertwines the careers of a black writer and a Jewish writer, affirming writing itself as one of the few instrumentalities of human possibility and hope.

Jacob's Ladder (1987) perhaps signals a new period in Williams's work, returning to the atmosphere of conspiracy and betrayal of the middle period but with the optimism of the first and the sense of emerging unity of the third phase. The powerful and innovative *The Man Who Cried I Am* is acclaimed as his masterpiece, placing him in the first rank of American novelists, although *!Click Song* is thought by some critics to be an even greater achievement. Yet Williams still is, as he was characterized in 1969 in the *New York Times Book Review,* "probably the most important—and least recognized—Negro writer in America" of his generation.

REFERENCES

DE JONGH, JAMES L. "John A. Williams." In *Dictionary of Literary Biography,* vol. 33, pp. 279–288.
GAYLE, ADDISON. *The Way of the New World.* Garden City, N.Y., 1975.

JAMES DE JONGH

Williams, Joseph Goreed "Joe"

Williams, Joseph Goreed "Joe" (December 12, 1918–), jazz and blues singer. Born in Cordele, Ga., Joe Williams was raised in Chicago, where he began singing in the local church with his mother and aunt and was singing professionally by the age of seventeen. When he was twenty-five, he began singing with Lionel HAMPTON, sharing the spotlight with Dinah WASHINGTON. His tenure with the Count BASIE Orchestra (1954–1961) brought success, including the hit single "All Right, Okay, You Win" in 1955, which allowed him to maintain a career as a soloist after leaving the band. He rejoined the Basie band frequently, including a 1985 tour under the direction of Thad JONES.

A Grammy-winning vocalist, Williams has a warm, passionate vocal style that weds jazz and blues approaches. Williams was introduced to a new generation through his role as Dr. Cliff Huxtable's father in the long running sitcom *The Cosby Show* in the 1980's. Williams's recording of "Every Day I Have the Blues" with the Basie band (1955) has become a classic.

REFERENCE

GOURSE, L. *Every Day: The Story of Joe Williams* (New York, 1985).

WILLIAM C. BANFIELD

Williams, Lacey Kirk (July 11, 1871–October 27, 1940), minister and businessman. Born in Eufala, Ala., in a one-room cabin on the plantation where his recently emancipated parents had worked as slaves, Lacey Kirk Williams moved with his family to Texas at the age of six. His parents, sharecroppers at Brazos Bottom, a farm near the town of Bryan, were pious people who helped to establish the Thankful Baptist Church, where their son was baptized and converted in April 1884, and where he would later return to preach. After receiving instruction in a colored school, Williams passed the teaching certificate examination in 1890. In 1895, after teaching in local schools for five years, he was ordained a BAPTIST minister. He preached in a circuit of Texas churches before becoming pastor in 1909 of Mount Gilead Baptist Church in Fort Worth. Continuing his studies, Williams enrolled in Bishop College in Marshall, Tex., in 1902. The college awarded him a bachelor of theology degree, but sources differ on whether it was in 1905 or 1912. From 1905 to 1916 he served as president of the Baptist Missionary and Educational Convention of Texas.

In 1916 Williams left Mount Gilead to assume the pastorate of Olivet Church in Chicago. During Williams's pastorship the church membership grew from approximately 4,000 to more than 12,000 and was considered the largest Protestant congregation in the world. Under his guidance Olivet established itself as a major force within Chicago's African-American community, providing such social services as a labor bureau, a soup kitchen, and an adult education program. In addition, a large staff ran the Olivet Health Bureau and Free Clinic as well as the Olivet Day Nursery and Kindergarten. During the race riots of 1919 (*see* CHICAGO RIOT OF 1919), Williams, cofounder of the Chicago Peace and Protection Association, offered his church as a safe haven. Later, he was a gubernatorial appointee to the Chicago Interracial Commission, a member of the board of governors of the Victory Life Insurance Company, director of a publishing company, and a lecturer at the divinity schools of the University of Chicago and Northwestern University.

Alongside his pastoral work, Williams achieved national prominence within the NATIONAL BAPTIST CONVENTION U.S.A., INC. (NBC, Inc.), the largest African-American organization in the United States. He was president of the General Baptist Convention of Illinois from 1917 until 1922, when he was elected president of the NBC, Inc. In 1928 Williams became vice president of the Baptist World Alliance. He held both of these positions until his death in an airplane crash in 1940.

REFERENCES

BOONE, THEODORE S. *Negro Baptist Chief Executives in National Places.* Detroit, 1948.

HORACE, LILLIAN B. *"Crowned with Glory and Honor": The Life of Rev. Lacey Kirk Williams.* Hicksville, N.Y., 1978.

MURPHY, LARRY G., J. GORDON MALTON, and GARY L. WARD. *Encyclopedia of African-American Religions.* New York, 1993.

LYDIA MCNEILL

Williams, Lavinia (1916–July 19, 1989), dancer. Lavinia Williams was born in Philadelphia and began taking dance lessons at the age of three. Her family relocated to Portsmouth, Va., in 1920, where she studied ballet through her high school years. As a young adult, Williams moved to New York after she won a scholarship to the Art Students' League in 1935. In order to raise money to buy supplies, she became a dance teacher at the Urban League in Brooklyn. One of the models at the Art Students' League was a dancer with Eugene Von Grona's American Negro Ballet. When Williams began attending rehearsals to sketch the dancers, Van Grona invited her to audition, and she was accepted into the company. Williams danced with the American Negro Ballet for three years in the late 1930s; when the company disbanded in 1940, she danced for one season with Agnes de Mille's American Ballet Theatre, appearing in the debut of de Mille's *"Obeah!"* (*Black Ritual*).

Katherine DUNHAM, who had recently relocated from Chicago to New York, saw Williams perform with the American Ballet Theatre and asked her to join the Dunham company, where Williams remained from 1940 through 1945 as a dancer and instructor. In her work with Dunham, Williams received a solid background in Caribbean dance, with an emphasis on Haitian traditions, and she discovered an interest in ethnic dance that she developed throughout her life. She danced numerous solos with the company in works such as *Rites de Passage, Bolero, Rara Tonga,* as well as the broadway musical *Cabin in the Sky* (1940) and films such as *Stormy Weather* (1943). Williams left the Dunham Company to join Sivilla Ford as a ballet instructor at the first Katherine Dunham School of Dance in Manhattan, where Williams remained for one year, drawing upon her knowledge of folk dance as well as her skills in classical ballet. She then toured Europe in Noble SISSLE's revival of *Shuffle Along* (1945–1946) and returned to New York in 1946 to dance in a revival of *Showboat*

and the first production of *Finian's Rainbow*. She later appeared in a production of *My Darlin' Aida* (1952).

While she was performing in *Finian's Rainbow,* Williams married Shannon Yarborough, purchased a house in Brooklyn, and converted the basement into a dance school. In 1953 the Haitian Education Bureau and the Bureau of Tourism hired Williams to develop their national school of dance. In Haiti, she trained the National Folklore Group, taught at a girls' high school, and trained monitors from the Bureau of Sports to become dance teachers. In 1954, she founded the Haitian Institute of Folklore and Classic Dance and became the director of Haiti's Theatre de Verdure. She remained in Haiti for twenty-six years, training hundreds of dancers, including her daughter, Sara YARBOROUGH, who became a professional dancer.

From 1972 to 1980 Williams traveled to other countries—including Guyana (1972—1976) and the Bahamas (1976—1980)—to develop national schools of dance. In 1985 she returned to Haiti to assist the government in organizing the National School of Dance of Haiti and the Ballet National d'Haiti. She returned to New York in the late 1980s and taught dance at Alvin AILEY American Dance Center School, New York University, Steps, and Jo Jo's Dance Factory until she suffered a heart attack and died on July 19, 1989.

REFERENCES

DUNNING, JENNIFER. "Lavinia Williams, 73, A Dancer." *New York Times,* August 10, 1989.

"Lavinia Williams: History in Motion." *In-Step* (April 1980): 3, 16.

YARBOROUGH, LAVINIA WILLIAMS. "Haiti Where I Dance and Teach." *Dance Magazine* (October 1956): 42–44, 76–79.

ZITA ALLEN

Williams, Marion (August 19, 1927–), gospel singer. Marion Williams was born in Miami, Fla., and was first exposed to music in church. She also was influenced by the BLUES and West Indian music she often heard in her neighborhood. Williams quit school in her early teens and worked as a maid and nurse, on weekends singing at revivals and Sanctified churches. She became well-known in Miami in the 1940s for her renditions of "What Could I Do" and "Live the Life I Sing About."

In 1947 Williams joined the Ward Singers, perhaps the most prominent gospel group of the day. Her passionate and lyrical soprano, capable of thrilling

improvisations, including chants and moans, made her the star of the group, which travelled almost constantly to churches and revivals across the United States. During her time with the Ward Singers, she recorded numerous songs, most of which were also features of her concerts. These songs include "How Far Am I From Canaan," "Surely God Is Able," "I'm Climbing Higher and Higher," "Take Your Burdens to the Lord," "I Known It Was the Lord," and "Packin' Up." Although Williams sang religious material exclusively, her impact was felt in the blues and JAZZ worlds, as well as in GOSPEL MUSIC, and her achievements have been comparable to the finest singers of all three idioms.

Williams left the Ward singers in 1958 and started a new group, the Stars of Faith, with Frances Steadman, Kitty Parham and Henrietta Waddy. Although the group's repertoire was similar to that of the Ward Singers, Williams played a more prominent role in both singing and composing. During this time she wrote "Holy Ghost Don't Leave Me" and "We Shall Be Changed."

In 1961 Williams began singing in *Black Nativity,* a gospel song-play with a script by Langston HUGHES. She toured Europe with the show, and when she returned to the United States she again performed with the Stars of Faith. Williams left the group in 1965, and began singing solo in concert. She toured Africa in 1966. She was a featured attraction at jazz festivals in the late 1960s and 1970s, but began to work less regularly, because she refused to be paid a percentage of profits, as opposed to a guaranteed fee.

In the 1980s Williams's career had a resurgence. Her albums include *I've Come So Far* (1987), *Born to Sing the Gospel* (1988), *Gospel Warriors* (1988), *Surely God Is Able* (1990), *The Gospel Sound* (1991), *Strong Again* (1991), *The Great Gospel Women* (1992), and *Can't Keep It To Myself* (1994). She has also received numerous awards and honors, including a Mac-Arthur Award in 1993. That same year she was honored by President Bill Clinton at the Kennedy Center for the Performing Arts.

REFERENCES

FRUCHTER, RENA. "Giving a 'Lift' with Gospel Songs." *New York Times,* January 13, 1991, Sec. 15, p. 1.

HEILBUT, ANTHONY. *The Gospel Sound: Good News and Bad Times.* New York, 1985.

JONATHAN GILL

Williams, Mary Lou (Scruggs, Mary Elfrieda) (May 8, 1910–May 28, 1981) jazz pianist, arranger. Although she never led her own big band,

and recorded only occasionally as a leader, Mary Lou Williams is generally acknowledged as the most significant female instrumentalist in the history of jazz, composing and arranging works that exemplify the rhythmic drive and harmonic sophistication of the swing era. Born Mary Elfrieda Scruggs in Atlanta, Ga., she moved to Pittsburgh, Penn., with her mother in 1914, and performed professionally on piano at age six. Using the surname of her two stepfathers, she performed as Mary Lou Burley and Mary Lou Winn at private parties in Pittsburgh and in East Liberty, Penn., before the age of ten. At fifteen, while a student at Pittsburgh's Lincoln High School, she played piano on the Theater Owners Booking Association (TOBA) black vaudeville circuit. Two years later she married John Williams, a baritone saxophonist, and moved with him to Memphis. They next lived in Oklahoma City and then Kansas City, where Mary Lou Williams quickly became a prominent member of the developing swing scene. In 1929, her husband arranged for her to have an audition with bandleader Andy Kirk. Williams became a full-time member of Kirk's Clouds of Joy in 1930, and its star soloist, composer, and arranger, one of the few well-known instrumentalists of the swing era.

Although Williams's early style as a soloist was influenced by Earl HINES, Jelly Roll MORTON, and Fats WALLER, by the late 1920s she was a well-known exponent of Kansas City swing, a somewhat lighter style of swing derived from stride influences. As one of her Kirk recordings pointed out in its title, Williams was "The Lady Who Swings the Band" (1936). She was significant as both a composer and arranger, lending harmonic sophistication and a bold sense of swing to Kirk's repertory, including "Messa-Stomp" (1929 and 1938), "Walkin' and Swingin' " (1936), "Froggy Bottom" (1936), "Moten Swing" (1936), "In the Groove" (1937), and "Mary's Idea" (1938). In the mid-1930s the Clouds of Joy moved to New York, where Williams also worked as an arranger for Louis ARMSTRONG, Earl Hines, Tommy Dorsey, and Benny Goodman, for whom she arranged the famous 1937 versions of "Roll 'Em," "Camel Hop," and "Whistle Blues." In 1940, she arranged and recorded "Baby Dear" and "Harmony Blues" as Mary Lou Williams and Her Kansas City Seven, an ensemble drawn from the Kirk band. Williams, who had divorced her husband in the late 1930s, left Kirk's band in 1942. That year she married and began performing with trumpeter Shorty Baker. That marriage also ended in divorce. Throughout the 1940s, Williams continued to work as an arranger, again with Goodman, as well as on "Trumpets No End," her 1945 arrangement of "Blue Skies" for Duke ELLINGTON. She also continued to perform, as a solo act in the mid-to-late 1940s at both the uptown

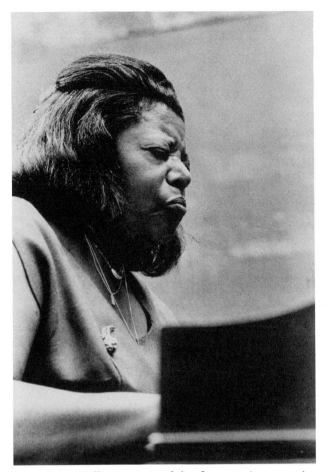

Mary Lou Williams, one of the finest swing-era pianists, was an active performer for more than fifty years. In her later years she wrote several extended religious works. She is photographed here at Rockefeller Center in New York City, 1972. (Photographs and Prints Division, Schomburg Center for Research in Black Culture, The New York Public Library, Astor, Lenox and Tilden Foundations)

and downtown Cafe Society in New York, and with an all-female group (1945–1946). At Carnegie Hall in 1946 the New York Philharmonic performed three movements of her *Zodiac* suite, a version of which she had recorded the year before.

While many giants of the swing era failed to make the transition to bebop, Williams readily assimilated into her playing the developments of Thelonious MONK and Bud POWELL, both of whom were regular guests at the informal piano salon she held at her Harlem home throughout the 1940s and 1950s. In 1952 Williams began a two-year tour of England and France. In 1954, she underwent a religious experience while performing at a Paris nightclub, and walked off the bandstand in mid-set. Back home in Harlem, Williams, who had been raised a Baptist, joined a Roman Catholic church because she was allowed to pray there at any time of the day or night. She re-

fused to play in public until 1957, when, urged on by Dizzy GILLESPIE, she performed at the Newport Jazz Festival. From the late 1950s on, she regularly toured and performed, including a concert with fellow pianists Willie "The Lion" SMITH, Duke Ellington, Earl Hines, and Billy TAYLOR in Pittsburgh in 1965.

In the 1960s, Williams, who had become a devout Roman Catholic, composed several large-scale liturgical works (*Black Christ of the Andes*, 1963; *St. Martin de Porres*, 1965), culminating in *Mary Lou's Mass* (1969), which was commissioned by the Vatican and choreographed by Alvin AILEY. In the 1970s she continued to perform and record (*Solo Recital*, 1977), particularly with the intention of educating listeners about the history of jazz. She also performed with avant-garde pianist Cecil TAYLOR at Carnegie Hall (*Embraced*, 1977), and in that year became an artist in residence at Duke University in Durham, N.C., where she died.

REFERENCES

DAHL, LINDA. *Stormy Weather: The Music and Lives of a Century of Jazzwomen.* New York, 1984.

HANDY, D. ANTOINETTE. "Conversation with Mary Lou Williams: First Lady of the Jazz Keyboard." *The Black Perspective in Music* 8 (1980): 194–214.

D. ANTOINETTE HANDY

Williams, Pat Ward (March 19, 1948–), artist, photographer. Pat Ward Williams was raised in Yeadon, Pa., and was interested in art from a young age. During her childhood, Williams spent Saturdays taking art classes and studied art throughout high school. It was not until she was thirty years old, however, newly divorced and a single mother, that Williams began her formal art education at Moore College of Art in Philadelphia and later at the Maryland Institute, College of Art.

At Moore College, Williams focused on photography and began using unorthodox methods of presentation to make viewers aware of her own identity, her family history, and her connection to African-American history. In her best-known images from the 1980s and 1990s, Williams used multiple images from different perspectives to sensitize the viewer to her manipulation of space and time (*Loa*, 1986). In some works she incorporated images from her family photo albums or American magazines (*The Cost of Living*, 1990), or bracketed images with discarded window frames to create an ecclesiastical effect. In other pieces she incorporated small stones to make a symbolic connection to African-American burial rituals (*Gods That Smell Like Cornbread*, 1986). In *Ac-*

cused/Blowtorch/Padlock (1986) she added handwritten commentaries in the borders of photographs.

One year earlier, Williams produced one of her most innovative works, *Oh, She Got a Head Fulla Hair,* which explores identity and class issues surrounding black women's hair styles by presenting multiple images of women, with their hair hand-colored by Williams and accompanied by a Ntozake SHANGE text sliced into hundreds of strands which, taken together, tell the story of one woman's obsession with her hair. *Oh, She Got a Head Fulla Hair* was followed three years later by the provocative and widely acclaimed photo and document display *MOVE* (1988), which was inspired by the May 1985 Philadelphia police bombing of the African-American alternative community known as MOVE.

In 1984 Williams left Philadelphia to teach in Baltimore, where she initiated a photography program at the Baltimore School for the Arts (1984–1989) and taught at the College of Notre Dame of Maryland and Bowie State University (1987–1989). From 1987–1988 she was staff photographer for the *Baltimore Afro-American* and contributor to the *City Paper.* Williams relocated to Los Angeles in 1989, where she teaches photography at California Institute of the Arts.

Williams has been featured in solo exhibitions at numerous college galleries; her work also has been included in group shows by contemporary African-American artists, including "Race and Representation" at Hunter College in New York in 1987 and "Political Varieties" at INTAR Latin American Gallery in New York a year later. A solo exhibition of Williams's work, titled "Pat Ward Williams: Probable Cause," was shown at the Goldie Paley Gallery, Moore College of Art and Design in Philadelphia in 1992.

REFERENCES

"Pat Ward Williams." *Art in America* (September 1990): 82–83.
Pat Ward Williams: Probable Cause. Philadelphia, 1992.
ROTH, MOIRA, and PORTIA COBB. "An Interview With Pat Ward Williams." *Afterimage* 16 (January 1989): 5–7.

NASHORMEH N. R. LINDO

Williams, Paulette. *See* Shange, Ntozake.

Williams, Paul Revere (February 18, 1894– January 23, 1980), architect. Born in Los Angeles, Calif., Williams worked his way through the Uni-

versity of Southern California and became a certified architect in 1915. In 1923, he established his own practice (in Los Angeles) and over the next fifty years he designed more than 400 houses and over 3,000 buildings, most in the Los Angeles area.

Williams became known as an "architect to the stars," designing homes in a variety of architectural styles for Cary Grant, Groucho Marx, Lucille Ball, and Frank Sinatra. But Williams also designed many landmarks in the African-American community, including the First African Methodist Episcopal Church and the Second Baptist Church.

Williams was appointed in 1929 by President Herbert Hoover to direct plans for the Negro Memorial to be erected in Washington, D.C., and was commissioned by the national convention of Disabled American Veterans in 1952 to design the Grave of the Unknown Soldier at Pearl Harbor. Williams received honorary degrees from Howard, Lincoln, and Atlanta universities, and in 1953, he received the SPIN-GARN MEDAL of the NAACP.

REFERENCES

KOYL, GEORGE S., ed. *American Architects Directory.* New York, 1955.
Who's Who in Colored America, 1941–1944. New York, 1945.

DAVID B. IGLER

Williams, Peter, Jr. (1780?–Oct. 18, 1840), church founder, abolitionist, and priest. Peter Williams was born in New Brunswick, N.J., about 1780. Schooled at the New York African Free School, he was also tutored by his white pastor at the John St. Methodist Episcopal Church, the Rev. Thomas Lyell. When Lyell left the John St. Church for the Trinity Protestant Episcopal Church, Williams followed him. He was elected lay reader by the congregation in 1812.

Under his leadership, with the approval and assistance of the whites of Trinity Church, Williams organized blacks into a separate congregation in 1818. They acquired a lot and built a church that was formally consecrated as St. Philip's African Church on July 3, 1819. Williams was licensed to preach and became rector in 1820, and after a number of years of study under Bishop John Henry Hobart, Williams was ordained as the first black Episcopalian priest in 1826.

A firm believer in equality, Williams was one of the cofounders in 1827 of the first black newspaper in the United States, FREEDOM'S JOURNAL. Dedicated to the universal welfare of mankind, unity between the races, and the elevation of all races and people,

the *Journal* focused many articles on the abolition of slavery. Williams was an abolitionist who strongly opposed the ideals of the American Colonization Society. In 1830, he and other black leaders called for a national convention of African Americans. They gathered in Philadelphia and resolved to "devise ways and means for the bettering of our condition" and "to somewhat combat the lack of government recognition and equal opportunities."

Williams continued his efforts to help other blacks by establishing the Phoenix Society, a benevolent organization, in 1833. That same year, he became one of six managers of the AMERICAN ANTI-SLAVERY SOCIETY. Fueled by a rumor that Williams had performed an interracial marriage, St. Philip's church was looted and burned during a riot on July 4, 1934, and Williams was forced to flee for his life. Bowing to the pressure of Bishop Benjamin T. Onderdonk, Williams publically resigned from the Board of Managers of the American Anti-Slavery Society. This action cost him severely in prestige with large sections of the black community. Although he lost his position of influence in the community, he remained at his church, where he continued to act as a mentor to promising young black men. He died on October 18, 1840.

REFERENCES

DeCosta, B. F. *Three Score and Ten: The Story of St. Philip's Church.* New York, 1889.
Loggins, Vernon. *Negro Author.* New York, 1931.
Ottley, Roi. *Black Odyssey.* New York, 1948.
———. *The Negro in New York.* New York, 1967.
Wakely, Joseph Beaumont. *Lost Chapters in the Early History of African Methodism.* New York, 1858.

DEBI BROOME

Williams, Peter, Sr. (c. 1749–February 1823), church founder. Peter Williams was born a slave in the New York City area around 1749. By the 1770s, his owner was a New York City tobacco manufacturer named Ayers who taught Williams his trade. Williams was deeply pious and joined the John St. Church, one of the first Methodist churches in North America, where he became sexton in 1778. Williams had developed a very warm and personal relationship with the trustees of the church, so they agreed to purchase him in 1783 when his master, a Loyalist, was forced to return to England. Williams repaid the £40 purchase price in 1785, but was not formally manumitted until 1796. In addition to his work as sexton and undertaker at the church, Williams established a very successful tobacco business. He pur-

chased a lot and a home in New York City, where he lived with his wife, Molly.

Peter and Molly Williams were very popular and highly respected in the John St. Methodist Episcopal Church. Visiting preachers and leading members of the church were frequent guests for dinner or tea. Williams never learned to read or write, but he was a very effective communicator whose characteristic honesty bordered on bluntness.

Believing in the revolutionary rhetoric of freedom for all Americans, Williams was distressed when religious services became increasingly segregated. Blacks were assigned pews in the back of the church marked "B.M.," for "black members." In 1795, Williams, with the approval of the church, led a number of black members to worship separately. Three years later they were able to purchase a lot, and after laying the cornerstone with his own hands, the new church was completed in 1800 and formally chartered as the African Methodist Episcopal Zion Church in 1801. It was the first church built for blacks in New York and the mother congregation in the African Methodist Episcopal Zion denomination.

Williams's good humor, generous hospitality, deep faith, and commitment to equality made him exceedingly popular with whites as well as blacks. He died in February 1823.

REFERENCES

Ottley, Roi. *Black Odyssey.* New York, 1948.
———. *The Negro in New York.* New York, 1967.
Wakely, Joseph Beaumont. *Lost Chapters in the Early History of African Methodism.* New York, 1858.

DEBI BROOME

Williams, Robert Franklin (February 26, 1925–), revolutionary nationalist. Robert Franklin Williams, founder of the revolutionary action movement and former head of a local NAACP branch in North Carolina, was born in Monroe, N.C., where he attended segregated public schools. He graduated from Winchester Street High School in 1944, was drafted into the Army, and after his discharge, worked briefly for the Ford Motor Company in Michigan before attending West Virginia State College in 1949. Williams enlisted in the Marine Corps in 1954 but was released when he protested being denied a position for which he was well qualified. In 1955 he returned to Monroe and one year later he was elected president of the local branch of the NATIONAL ASSOCIATION FOR THE ADVANCEMENT OF COLORED PEOPLE (NAACP), an ineffective branch with only six members. Williams recruited working class and

poor people of Monroe—domestic workers and sharecroppers—to the NAACP and wrote numerous articles to local newspapers denouncing racism and segregation. Under Williams's leadership, the Monroe NAACP developed into a forthright and militant organization of over 250 members.

The group pursued several cases in the late 1950s that demonstrate Williams's growing effectiveness. In 1958 Williams worked on behalf of two young black boys, aged seven and nine, who were found guilty and sent to reform school for playing a kissing game with white children. As a result of his efforts, they were eventually released after widespread publicity and international pressure. Williams and other NAACP members also mounted protests when Louis Medlin, a white Monroe resident charged in 1959 with assault with intent to rape a black woman who was eight months pregnant, was acquitted, despite an independent eyewitness.

White vigilante violence and legal setbacks that Williams and his allies encountered in their quest for racial justice made them increasingly skeptical of the impartiality of the legal system, the ability of the federal government to protect black citizens, and the nonviolent reform agenda of mainstream civil rights groups. Williams expressed this new militant consciousness in 1959, shortly after the Medlin case was decided, when he said, "If it's necessary to stop lynching with lynching, then we must be willing to resort to that method. We must meet violence with violence." As a result of this statement, national leaders immediately expelled Williams from the NAACP.

Despite his expulsion by the national board of the NAACP, Williams was reelected president of the local branch the next year. He then continued to lead protests and pickets in Monroe, and with his wife, Mabel, started a newsletter, *Crusader*. On August 27, 1961, Williams and other Monroe residents organized a demonstration in downtown Monroe to protest the segregated white swimming pool. As a white mob gathered to challenge the protesters, tension rose and violence erupted. Later that night a white couple driving past Williams's house met a group of angry black protesters. The couple claimed Williams had kidnapped them, and a county grand jury later indicted him on two counts of kidnapping. Williams, however, asserted that he was trying to protect the couple from the angry protesters outside his house.

Fearing for their safety, Williams, his wife, and their two children escaped that night and eventually went to Cuba, where they stayed until 1966. In 1962 he published an account of his experiences in Monroe, *Negroes with Guns*. While in Cuba, Williams helped form the REVOLUTIONARY ACTION MOVEMENT (RAM), a Marxist organization which sought to achieve black liberation through the fundamental restructuring of the economic and political system of the United States. In 1966, the Williamses went to China for three years, finally returning to the United States in 1969. Williams lived in Michigan, where he got a job in 1971 at the Center for Chinese Studies at the University of Michigan. He fought extradition to North Carolina until the charges against him were dropped in 1976. Williams has since become a symbol of resistance for subsequent proponents of black self-defense and revolutionary nationalism.

REFERENCES

BARKSDALE, MARCELLUS C. "Robert F. Williams and the Indigenous Civil Rights Movement in Monroe, North Carolina, 1961." *Journal of Negro History* 69 (Spring 1984): 73–89.
FORMAN, JAMES. *The Making of Black Revolutionaries.* New York, 1972.
WILLIAMS, ROBERT FRANKLIN. *Negroes with Guns.* New York, 1962.

PAM NADASEN

Williams, Samm-Art (January 20, 1946–), playwright and actor. Samm-Art Williams was born Samuel Arthur Williams in Burgaw, N.C. His mother, Valdosia Williams, taught drama at the local high school and encouraged Williams to write by providing him with scripts and recordings of Shakespeare's plays. She also introduced him to a wide range of black authors, including Langston HUGHES and James Weldon JOHNSON, who were important early influences. After graduating from Morgan State University in Baltimore with a B.A. degree in political science, Williams moved to Philadelphia, where he studied acting at the Freedom Theater. He moved to New York City in 1973, and the next year he joined the NEGRO ENSEMBLE COMPANY (NEC) as an actor and a member of its playwrighting workshop.

Williams's first produced play was *Welcome to Black River,* staged by NEC in 1975. His other plays, some produced by NEC and some by Williams himself, included *The Coming* (1974), *Do Unto Others* (1974), *A Love Play* (1976), *Brass Birds Don't Sing* (1978), *Home* (1979), *The Sixteenth Round* (1980), *Friends* (1983), and *Cork* (1986). Williams's primary concern in his plays has been to portray the efforts of individuals to struggle against the difficult circumstances into which they are placed. This focus was a deliberate reaction to the foregrounding of socioeconomic and political issues that was characteristic of many black playwrights of the 1960s and 1970s. While the characters of his best-known play *Home* (1979) are

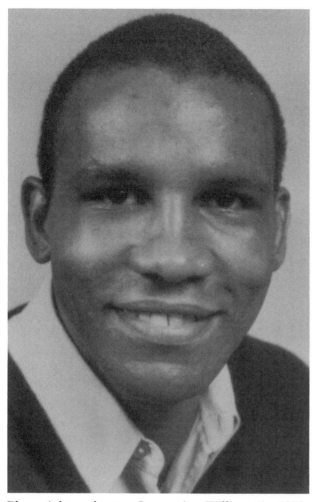

Playwright and actor Samm-Art Williams in 1979. (Reprinted from *In the Shadow of the Great White Way: Images from the Black Theatre,* Thunder's Mouth Press, © 1957–1989 by Bert Andrews. Reprinted by permission of the Estate of Bert Andrews)

deeply affected by large issues (the VIETNAM WAR, drug addiction, urban and rural poverty), the play's foremost concern is with the lead character's relationships with family and friends as he moves from a rural community to the big city and eventually back home. The play's plot centers on the lead character's transition from a rural to an urban community. Williams won a number of awards for *Home,* including the Governor's Award from North Carolina, the Outer Circle Award for 1979–1980, the John Gassner Playwrighting Medallion, and an Audelco Recognition Award.

Williams has also appeared as an actor in a number of NEC productions, including *Nowhere to Run, Nowhere to Hide* (1974); *The First Breeze of Summer* (1975); *Eden* (1976); *The Brownsville Raid* (1976–1977); and *Nevis Mountain Dew* (1978–1979), as well as in several films and television productions, includ-

ing small parts in *Dressed to Kill* (1980), *Blood Simple* (1984), and the role of Jim in *Huckleberry Finn* (American Playhouse, 1986).

Through the late 1980s and early 1990s, several of Williams's plays were produced, most notably *Home,* which was performed in several major cities and received widespread critical praise.

REFERENCE

PETERSON, BERNARD L., JR. *Contemporary Black American Playwrights and Their Plays.* Westport, Conn., 1988.

MICHAEL PALLER
MATTHEW BUCKLEY

Williams, Sherley Anne (Shirley) (August 25, 1944–), writer. Born in Bakersfield, Calif., to migrant farmworkers, Shirley Williams worked as a child picking cotton in the fields. She grew up in a Fresno, Calif., housing project. Her father died of tuberculosis when she was seven, and her mother died when she was sixteen. Williams received her B.A. in 1966 from Fresno State College (now California State University at Fresno). Her first story, "Tell Martha Not to Moan," was published in the *Massachusetts Review* in 1967. She was inspired to write stories because "I wanted specifically to write about lower-income black women. . . . I felt they had significance, that something could be learned from them." In 1972 she earned an M.A. from Brown University. That same year she published *Give Birth to Brightness: A Thematic Study in Neo-Black Literature.* In it she discussed the writing of James BALDWIN, Amiri BARAKA, and Ernest GAINES.

From 1972 to 1973 Williams was an assistant professor at California State University at Fresno. In 1973 she joined the Afro-American Literature Department of the University of California at San Diego, eventually becoming the department chairperson. In 1984 she was a Fulbright lecturer at the University of Ghana. In her literary criticism Williams focuses on the black oral tradition and the BLUES idiom. She has said, "Blues is basis of historical continuity for black people. It is a ritualized way of talking about ourselves and passing it on." Her own blues-inspired poetry has been collected in two volumes, *The Peacock Poems* (1975), which was nominated for a National Book Award, and *Some One Sweet Angel Chile* (1982).

Williams's first novel, *Dessa Rose* (1986), recounts the relationship between the protagonist, Dessa Rose, a rebellious slave, and Rufel Sutton, a poor white woman. When Dessa escapes from prison after killing her master, Rufel harbors her and other run-

aways. Together they carry out a money-making scheme in which Rufel sells the escapees as slaves, helps them to escape, and resells them. The novel was both a critical and commercial success. In 1992 her one-woman play, "Letters from a New England Negro," premiered in Chicago. In 1993 Williams published a book for children, *Working Cotton,* about a family that picks cotton. *Working Cotton* was named a 1993 Caldecott Honor Book.

REFERENCES

DAVIS, THADIOUS M. and TRUDIER HARRIS, eds. *Dictionary of Literary Biography, Volume 33: Afro American Fiction Writers After 1955.* Detroit, 1984.
TATE, CLAUDIA, ed. *Black Women Writers at Work.* New York, 1983.

LYDIA MCNEILL

Williams, Spencer, Jr. (1893–December 13, 1969), director, actor, writer. Spencer Williams was born in Vidalia, La. He attended the University of Minnesota but left school to join the Army. In 1917 he traveled with the Army to France as an intelligence sergeant and continued to travel in Europe while in the service. Williams returned to the South after his discharge in 1923.

In the mid 1920s, Williams was hired on location in the South by Christie Comedies to write for a series of black short films derived from the stories of Octavsus Roy Cohen. Christie Comedies was an affiliate of Paramount Pictures, and Williams moved with them to Hollywood and worked out of an office on the Paramount Picture lot. His acting talents landed him roles in several films, which made him a central figure on some of the first African-American talking movies. These included *The Lady Fare, Oft in the Silly Night, The Framing of the Shrew,* and *Music Hath Charms,* all distributed in the late 1920s.

Williams produced silent films during his early years in Hollywood. He finished his first film, *Hot Biscuits,* in 1929. During the 1930s his career entered a hiatus but he reemerged in some of the first black Westerns including *Bronze Buckaroo* (1938) and *Harlem Rides the Range* (1939) which he also cowrote. Williams went on to form a partnership with producer Lester Sack and together they promoted films written, directed by, and starring Williams. Williams's productions covered a range of genres stretching from *Marching On* (1940), a portrayal of blacks in the military, to *The Blood of Jesus* (1941), the story of a husband who kills his wife and is subsequently redeemed by her spirit, to the broad comedy of *Juke Joint* (1947).

Williams took a break from Hollywood in the late 1940s and worked at the American Business and Industrial College, a school for veterans, teaching photography and radio in Tulsa, Okla. In 1951 he returned to Hollywood to play the role for which he is best known, that of Andy Brown in the CBS television version of the popular radio series AMOS 'N' ANDY. The adventures of two bosom buddies and their scheming friend the Kingfish, *Amos 'n' Andy* employed exaggerated dialogue and unflattering stereotypes as comedic devices. The show struck a discordant note in the political climate of the times and was denounced by the NAACP; what had been an extremely popular radio show did well during its first year on television (1951), but succumbed to lack of support from wary sponsors and declining ratings in 1953. However, *Amos 'n' Andy* thrived in syndication through 1966.

Following the show's cancellation, Williams and other members of the *Amos 'n' Andy* cast traveled as part of a touring company, "The TV Stars of Amos 'n' Andy." The venture ended when CBS learned of the unsanctioned group and forced them to retire the short-lived road show. Williams remained in Los Angeles, where he lived on a veteran's pension and social security checks until his death from a kidney ailment on December 13, 1969.

REFERENCES

BOGLE, DONALD. *Blacks in American Film and Television: An Illustrated Encyclopedia.* New York, 1988.
CRIPPS, THOMAS. "The Films of Spencer Williams." *Black American Literature Forum* 12 (Winter 1978): 128–34.
———. *Making Movies Black.* New York, 1993.
ELY, MELVIN PATRICK. *The Adventures of Amos 'n' Andy: A Social History of an American Phenomenon.* New York, 1991.

KENYA DILDAY

Williams, William Taylor Burwell (July 3, 1869–March 26, 1941), educator. William Williams was born in Stonebridge, Va., in 1869. After receiving an education in the local public schools, Williams went on to graduate from the Normal course at the Hampton Institute (1888), Phillips Academy in Massachusetts (1893), and Harvard University (1897). After working for five years as a school teacher in Indiana, Williams returned to the South as the field agent for the Hampton Institute and the Southern Education Board; his primary role was to study and report on educational conditions in the South.

Williams's aptitude was soon apparent, and he received increasing responsibility as a result. In 1906 he

became an agent for both the John F. Slater Fund, which helped to establish county training schools for African Americans, and, in 1910, for the Anna T. Jeanes Fund, which devoted resources to improving conditions in rural schools. Increasingly seen as one of the primary authorities on southern education, Williams was in demand as a consultant for both private and state agencies. During World War I, the federal government made Williams the only African-American contributor to the Department of Labor's 1917 report, *Negro Migration in 1916–1917,* which examined the massive migration of African Americans from the South to the North during World War I. Williams also served the War Department in planning how educational policies of technical training could be shaped to serve war needs.

In 1919 Williams became a consultant for the Tuskeegee Institute, a relationship that would last until his death more than twenty years later. Tuskeegee offered its first B.S. degrees in 1926, in agriculture and education, and Williams became the first dean of the College Department in 1927. While carrying out his duties at Tuskeegee, Williams continued to act as a consultant to the government. He traveled to Haiti in 1922 and 1930 as an official American emissary to gauge the depth and severity of educational problems there; in 1928, he traveled to the Virgin Islands on a similar mission. His efforts to improve education for African Americans earned him the NAACP's SPINGARN MEDAL in 1934. In 1936 Williams became a vice president at Tuskeegee. He died there on March 26, 1941.

REFERENCES

BULLOCK, HENRY ALLEN. *A History of Negro Education in the South: From 1619 to the Present.* Cambridge, Mass., 1967.

Obituary. *Journal of Negro History* 26, no. 3 (July 1941): 411–412.

JOHN C. STONER

Williams, William Thomas (July 17, 1942–), painter. William Williams was born in Cross Creek, N.C., near Fort Bragg. As a youth he became acquainted with many Japanese prisoners of war housed at Fort Bragg and absorbed an awareness of a cultural tradition far removed from the United States. He studied and later taught at the Pratt Institute in Brooklyn, N.Y. He also attended Yale University, with its strong allegiance to the Bauhaus style, receiving an M.F.A. in 1968.

Williams' earlier works are largely abstract, created when he was intent on exploring form rather

Trane by William T. Williams, acrylic on canvas, 1969. (The Studio Museum in Harlem)

than society. "We're too concerned with history," he said in a 1972 interview. The bold colors, stark lines, and sharp contrasts in his paintings (several of which are on display at the Museum of Modern Art in New York City) exhibit a sense of motion and conflict that Williams explains as a "purging of aggression." He has defined aggression as the pressure of "reactionary" forces on the mind: "Reactionary art is controlled art . . . and history has forced black artists to be reactionary."

In 1992, the Studio Museum in Harlem exhibited a number of Williams's later paintings, in which he experiments with mark-making techniques and bold use of color. These paintings are the result of a significant change in Williams's artistic intent, as he felt the need to free himself from the constraints of formalism, and began to include aspects of his personal life in his work.

In addition to teaching at the Pratt Institute, Williams was a member of the painting faculty at the School of Visual Arts, a professor of art at Brooklyn College, and a visiting professor at the Skowhegan School of Visual Arts and at Virginia Commonwealth University. He received awards from the National Endowment for the Arts and Humanities in 1965 and 1970, and a John Simon Guggenheim Fellowship in 1987.

REFERENCES

FINE, ELSA HONIG. *The African-American Artist: A Search for Identity.* New York, 1973.

MERCER, VALERIE J. *William T. Williams: Paintings and Works on Paper.* New York, 1992.

LYDIA MCNEILL

Williamson, John Lee "Sonny Boy"

Williamson, John Lee "Sonny Boy" (March 30, 1914–June 1, 1948), blues harmonica player and singer. John Williamson, whose year of birth is sometimes given as 1916, was born in Jackson, Tenn. While still a child he taught himself to play the harmonica. He left home as a teenager and performed with the guitarist Sleepy John Estes and mandolinist Yank Rachel in juke joints, taverns, and at private parties in Tennessee and Arkansas. In the early 1930s, Williamson settled in Chicago and began working as a sideman in nightclubs with Big Bill BROONZY and Big Joe Williams. He married the singer Lacey Belle in 1937.

In the years before World War II, Williamson provided the bridge between country and electric blues and was largely responsible for making the harmonica, or "blues harp," a legitimate blues solo instrument. He perfected the techniques of using the tongue and fingers to shape the sound of the instrument, and pioneered both "squeezed" tones and the habit of playing in key signatures that were different from the song being performed. Williamson was also a singer, famed for rapidly switching back and forth between the harmonica and his "tongue-tied" or "mumbling" voice. His first recording, "Good Morning School Girl" (1937), became a hit. His other well-known records, including "My Black Name" (1941), "Win the War Blues" (1944), "You Got to Step Back" (1941), "Elevator Woman" (1945), "Stop Breaking Down" (1945), "I Been Dealing with the Devil" (1940), "Sloppy Drunk" (1947), and "Mellow Chick Swing" (1947), proved enormously influential to the postwar blues scene in Chicago. Williamson died in 1948 in Chicago after being attacked while leaving a nightclub. He is sometimes referred to as Sonny Boy Williamson I in order to distinguish him from the blues singer and harmonica player, Rice Miller (1897–1965), who after Williamson's death recorded under the name Sonny Boy Williamson, and is sometimes referred to as Sonny Boy Williamson II.

REFERENCES

OLIVER, PAUL. "Sonny Boy Williamson." In A. McCarthy, ed. *Jazz on Record.* New York, 1968.

PALMER, ROBERT. *Deep Blues.* New York, 1981.

KIP LORNELL

Wills, Harry

Wills, Harry (January 20, 1889–December 21, 1958), boxer. Harry Wills was born in 1889, probably on January 20, in New Orleans, where he was raised. He first entered the ring as a boxer in 1911, near the end of Jack JOHNSON's reign as heavyweight champion. Largely as a result of the animosity that white Americans felt for Johnson's flashy and conspicuous style, Wills, known as the "Brown Panther," often found it necessary to leave the United States and fight in Panama and Cuba. In addition, Wills, unlike Johnson, Joe Jeanette, Sam LANGFORD, and many other African-American fighters, did not want to box the same black men year after year and "mixed" fights were often more accepted in other countries.

After he won the unofficial "colored" heavyweight title in 1920, Wills wanted to fight Jack Dempsey for the heavyweight crown. Once Wills became the number one contender, boxing regulations required Dempsey to give him a fight. But Dempsey never entered the ring with Wills. In 1923 the country's leading promoter, George Louis "Tex" Rickard, initially assured Wills he would be given an opportunity to fight Dempsey for the heavyweight title; but then, Rickard claimed, politicians forced him to back out of his agreement with Wills. Waiting vainly for a title bout, Wills continued to fight until age gradually removed him from the list of contenders. Wills ended his boxing career in 1932 with a won-lost record of 94–8 in official fights, though in his twenty-one years he actually fought more than 200 bouts.

Wills, who had invested his earnings in Harlem real estate, retired from the ring financially secure. He died in New York City.

REFERENCES

ASHE, ARTHUR R., JR. *A Hard Road to Glory: A History of the African-American Athlete Since 1946.* New York, 1988.

HEIMER, MEL. *The Long Count.* New York, 1969.

Obituary. *New York Times,* December 22, 1958, p. 2.

PETER SCHILLING

Wills, Maurice Morning "Maury"

Wills, Maurice Morning "Maury" (October 2, 1932–), professional baseball player. The son of a minister, Maury Wills was born and grew up in Washington, D.C., with twelve siblings. By the time he signed his first major league contract with the Los Angeles Dodgers in June 1959, Wills had spent 8½ years with various minor league teams, slowly gaining confidence and improving his batting skills. Primarily a shortstop, he played all nine positions while

he was in the minor leagues. Combining speed with a fine eye for reading pitchers' movements, Wills turned base stealing into a major offensive weapon and changed the game of baseball. He made stealing bases a subtle art: His lead-off from the base was exact, his break toward second base was precisely timed with the pitcher's move to the plate, and he was expert at avoiding a tag.

In September 1962, in a game against the St. Louis Cardinals, Wills stole his ninth-seventh base of the season, breaking Ty Cobb's 47-year-old record for stolen bases in a single season (Wills went on to steal a total of 104 bases in 1962). Combining a .299 batting average for the year, Wills earned the Most Valuable Player Award in the National League. Through his fifteen years in the major leagues, Wills led the National League in stolen bases six consecutive times (1960–1965). Wills played for the Pittsburgh Pirates in 1967–1968, and then for the Montreal Expos. He returned to the Dodgers in 1969, where he stayed until he was released at the age of forty after the 1972 season. Wills then worked as a baseball commentator, managed winter league teams in Mexico, and served as an instructor for the Dodgers.

In 1980, Wills was named manager of the Seattle Mariners, becoming only the third black manager in the major leagues. He lasted one full season and was let go two months into his second season. After a several-year struggle with drug addiction, Wills recovered and, with the support of the Dodgers' organization, went on to become an eloquent spokesman for drug counseling and rehabilitation in the early 1990s.

REFERENCES

LOW, W. AUGUSTUS, and VIRGIL A. CLIFT, eds. *Encyclopedia of Black America.* New York, 1981.
PORTER, DAVID L., ed. *Biographical Dictionary of American Sports: Baseball.* Westport, Conn., 1987.
RUST, ART, JR., *Art Rust's Illustrated History of the Black Athlete.* Garden City, N.Y., 1985.

LINDA SALZMAN

Wilmington, North Carolina, Riot of 1898

In 1898, the town of Wilmington, N.C., one of the few remaining outposts of black political power in the South, was transformed by savage, white-versus-black political violence. The riot was a brutal expression of the "Radical" movement in the South in the 1890s, whose leaders advocated a strict color line to assure white supremacy and destroy black economic and political power. In 1898, Wilmington's population was approximately 20,000, with African Americans making up the majority of the residents. Wilmington had a large cadre of black businesspeople and professionals. These white-collar workers, as well as the town's black craftsmen and laborers, successfully competed against whites for jobs. Blacks occupied important municipal positions such as police chief, deputy sheriff, and federal collector of customs. Four of the town's aldermen were African Americans. Alex Manly, African-American editor of the *Wilmington Record,* wrote several articles attacking white supremacists. In one issue, he decried whites' false accusations of rape, claming white women willingly engaged in sexual relations with black men.

During the summer of 1898, conservative white Democrats led by Alfred M. Waddell stumped for election by promising to turn blacks out of office, by murder if necessary, and end black economic competition. On November 9, the day after the Democrats won large victories against blacks and their white allies, Wilmington's white leaders formed a "secret nine" and issued a "Declaration of White Independence," which called for the displacement of black officials and professionals and the closing of the *Record.* Later that day white mobs—with official backing—invaded the town's black sections, killing blacks and burning buildings. At least thirty blacks were killed, and the business center was damaged. The remaining blacks were forced from office. Once Waddell became mayor, black leaders were forced to flee north. By 1900 the town had a white majority.

REFERENCES

PRATHER, H. LEON. *We Have Taken a City: Wilmington Racial Massacre and Coup of 1898.* Rutherford, N.J., 1984.
WILLIAMSON, JOEL. *The Crucible of Race: Black-White Relations in the American South Since Emancipation.* New York, 1984.

GREG ROBINSON

Wilson, Arthur Eric "Dooley" (April 3, 1894–May 30, 1953), drummer and actor. Arthur Eric Wilson was born in Tyler, Tex., to an impoverished family. He became interested in performing by watching traveling minstrel shows (*see* MINSTRELS/MINSTRELSY) and circuses and was an active vaudevillian by his early teenage years. During the first part of the twentieth century, he played Irish characters in whiteface with Chicago's Pekin Stock Company. One song he sang, "Mr. Dooley," was probably the source of his nickname.

Wilson likely developed his instrumental music talents during his experience in vaudeville, when pro-

ductions demanded versatility from small companies. Besides singing, Wilson could also play drums and alto saxophone. He moved to New York in 1910 and began to work at James Reese EUROPE's Clef Club, then one of the foremost African-American popular music venues. Wilson also helped popularize RAGTIME at the fashionable Manhattan restaurants such as Delmonico's and Sherry's. After World War I, he formed his own jazz quintet, the Red Devils, with which he toured Europe from 1919 to 1934.

Wilson resumed acting upon his return to the States. During the thirties, he worked on several productions for the Federal Theatre Project, a New Deal arts program. His most notable role during this time was in the New York production of *Androcles and the Lion* in 1938. One year later, he made his Hollywood debut in the film *Keep Punching*. In 1940, Wilson starred on Broadway as Little Joe Jackson with Ethel WATERS in *Cabin in the Sky*. He appeared in six features in 1942, including *Casablanca*, which featured him in his best-known role, the pianist Sam. Although he appeared to play the song, "As Time Goes By" in the film, Wilson did not actually play the piano. Wilson appeared in several of Hollywood's all-black musicals, such as *Night in New Orleans* (1942) and *Stormy Weather* (1943). He created one of his most successful stage roles, Pompey, in the 1944 Broadway hit *Bloomer Girl*, which ran until 1945. He continued to act in films until 1951. In 1952, he accepted his first television role as Bill Jackson in the comedy series *Beulah*, which ran until 1953. Dooley Wilson died in Los Angeles in 1953.

REFERENCES

BOGLE, DONALD. *Blacks in American Films and Television*. New York, 1988.
NULL, GARY. *Black Hollywood: The Black Performer in Motion Pictures*. Secaucus, N.J., 1975.

ALLISON X. MILLER

Wilson, August (April 27, 1945–), playwright. August Wilson was born Frederick August Kittel in Pittsburgh, the fourth of six children. Growing up in a neighborhood near the steel mills called the Hill, populated by poor African Americans, Italians, and Jews, he had a childhood of poverty and hardship. He rarely saw his father, a German baker who visited only occasionally, and the family subsisted on public assistance and on his mother's earnings as a janitor. Wilson adopted his mother's maiden name in the 1970s as a way of disavowing his father.

Wilson's stepfather, David Bedford, moved the family to a white suburb when Wilson was a teen-

ager. This change, however, also proved difficult: Wilson was ostracized by his white schoolmates and frequently found notes on his desk reading "Nigger go home." When he was fourteen, he dropped out of school.

Wilson continued his education in the library, where he discovered the works of Ralph ELLISON, Langston HUGHES, Richard WRIGHT, and other African-American writers, as well as the poetry of Dylan Thomas, which was to influence him greatly. About 1965 he heard recordings of the blues for the first time, and their lyrical expression of the hardships of life was to become another major influence on his work. Except for a one-year stint in the Army (1967), Wilson spent the middle sixties writing poetry at night while holding a series of menial jobs during the day.

In 1968 he returned to Pittsburgh, where he became caught up in the BLACK ARTS MOVEMENT. Influenced now by the plays and polemical writings of Amiri BARAKA, Wilson and his friend Rob Penny founded the Black Horizons Theatre in 1968—although he had no previous theater experience. Their

August Wilson discussing his new play *Fences* shortly after its world premiere at Yale Repertory Theater in New Haven, Conn., in 1985. (AP/Wide World Photos)

aim was to use theater to provoke social change. His earliest one-act plays—*Recycle* (1973), *The Homecoming* (1976), and *The Coldest Day of the Year* (1977)—were written for this theater.

In 1977 Wilson moved to St. Paul, Minn., where he wrote a musical satire with a western theme, *Black Bart and the Sacred Hills,* which was staged a year later by the Inner City Cultural Center in Los Angeles. While supporting himself by writing educational dramas for the Minnesota Science Center, Wilson wrote *Jitney!* and *Fullerton Street* in 1982. Both were produced that year by the Minneapolis Playwrights' Center.

But it was *Ma Rainey's Black Bottom,* written in 1983 and first produced by the Eugene O'Neill National Playwrights Conference, that gained Wilson national attention. Produced at the Yale Repertory Theatre in 1984 under the direction of Lloyd RICHARDS and later that year on Broadway, the play won the New York Drama Critics Circle Award for Best Play. *Ma Rainey,* which depicts a day in the life of the famous blues singer, explores not only the exploitation of black artists of the era but also the lack of knowledge that blacks had about one another. Wilson's next play, *Fences* (1985), is set in 1957 and focuses on the frustrations of Troy Maxon, a Pittsburgh garbage collector who had been a star ball player in the Negro Leagues (*see* BASEBALL) before Jackie ROBINSON broke baseball's color line. The play was awarded the Pulitzer Prize and the Tony Award for best play of the year. After *Fences,* Wilson decided to make it and *Ma Rainey's Black Botton* the opening plays of a ten-play cycle, each set in a different decade of the twentieth century and examining what Wilson considered to be the best important issues facing African Americans in that period. In *Joe Turner's Come and Gone* (1986), set in 1911, Wilson explored the emotional and physical displacement experienced by former slaves in the early twentieth century. Produced on Broadway in 1988, it won the New York Drama Critics Circle Award for Best Play.

The Piano Lesson (1987), set in 1936, concerns the ownership of a piano that had been built by the slave grandfather of a black brother and sister. This play perhaps best expresses Wilson's view of black history as something to be neither sold nor denied, but employed to create an ongoing, nurturing cultural identity. Produced on Broadway in 1990, the play received the Drama Desk Best Play award and the New York Drama Critics Circle Award, and won for Wilson his second Pulitzer Prize.

Wilson's play about the 1960s, *Two Trains Running* (1990), is again set in Pittsburgh, in 1968. It explores the allegiances and frictions among a group of friends who find themselves confronted with the era's radical social changes and by a sense that they will be swept along by large forces beyond their control. It was produced on Broadway in 1992 and won the New York Drama Critics Circle Award for Best Play.

Perhaps the leading African-American playwright of his generation, Wilson's view of black life in America is alternately affectionate and unsparing.

REFERENCES

BROWN, CHIP. "The Light in August." *Esquire* (April 1989): 116–120.
SAVRAN, DAVID. *In Their Own Words: Contemporary American Playwrights,* New York, 1988.

SANDRA G. SHANNON

Wilson, Ellis (April 30, 1899–January 1, 1977), painter. Born in Mayfield, Ky., Ellis Wilson's work continually drew from the lives of blacks in his native South and from Haiti. His training, however, had to be pursued in the North. Wilson studied at the School of the Art Institute of Chicago from 1919 until his graduation in 1923. After working as a commercial artist in that city, he moved to New York City in 1928, where he found work in a brokerage house while taking art lessons paid for by his employer. For six years, from the late 1930s through the early 1940s, Wilson, as part of the WORKS PROJECT ADMINISTRATION (WPA), made architectural models for a three-dimensional map of New York City.

Not until he traveled south again on two successive Guggenheim fellowships in 1944 and 1945 did Wilson's mature style coalesce. These paintings captured fishermen, field workers, merchants, coal miners, and factory and defense workers. In 1952 after winning a sizable prize in an art competition, he traveled to Haiti where he maintained his interest in the forebearance of the working class. While the faces of his subjects are often not detailed, these are not anonymous men and women; Wilson's strong sense of the inflections of body language reveal biographies of demanding labor borne with dignity.

Wilson exhibited in the HARMON FOUNDATION Shows of 1930 and 1933 (honorable mention), in the Augusta Savage Studios in 1939, in his native Mayfield in 1945, and in the South Side Community Art Center in 1946, as well as in the Atlanta University annual exhibitions of 1944, 1945, and 1946. Wilson died in New York City.

REFERENCE

"Ellis Wilson." In Romare Bearden and Harry Henderson. *A History of African-American Artists.* New York, 1993, pp. 337–343.

HELEN M. SHANNON

Charleston Sisters by Ellis Wilson. (National Archives)

Wilson, Harriet E. Adams (c. 1830–1870), author. Harriet E. Wilson is believed to be the pseudonymous "Our Nig," who wrote what may have been the first novel by an African American published in the United States: *Our Nig; or, Sketches from the Life of a Free Black, in a Two-Story White House, North. Showing That Slavery's Shadows Fall Even There* (1859). Some scholars also include her with Maria F. dos Reis, who in 1859 published a novel in Brazil, as the first two women of African descent to publish a novel in any language. "Our Nig's" work describes the life of Alfredo, a mulatto indentured servant, and condemns Northern whites for a magnitude of racial prejudice and cruelty more commonly associated with slavery and the South. Three letters presumably written by friends of the novelist are appended to the novel, and it is because of the correspondences between the seemingly supplementary biographical information included there that the novel has been considered semi-autobiographical.

Despite these letters, however, little definite is known about Harriet Wilson's life. For instance, according to the 1850 federal census for the state of New Hampshire, a twenty-two-year-old "Black" (not "mulatto") woman originally from New Hampshire named Harriet Adams lived in the town of Milford with the family of Samuel Boyles, which in part corresponds to information included in the novel. This suggests that Wilson was born about 1827–1828. However, the 1860 federal census for the city of Boston, where Wilson moved in approximately 1855, and where she had her novel printed, lists a "Black" woman named Harriet E. Wilson born in Fredericksburg, Va. in about 1807–1808.

The appended letters, as well as the end of *Our Nig,* provide details of the author's life between 1850 and 1860, when she lived in Massachusetts and worked as a weaver of straw hats. About 1851 Harriet Adams met Thomas Wilson, a fugitive slave from Virginia, and together they moved to Milford, N.H. and married, perhaps on October 6, 1851. By the time Harriet Wilson gave birth in May or June of 1852 to their son, George Mason Wilson, Thomas Wilson had abandoned his wife and she had gone to a charity establishment in Goffstown, N.H., the Hillsborough County Farm. Thomas Wilson returned and supported his wife and child for a short time, but then suddenly left them again and never returned.

Harriet Wilson, whose health had been bad since she was eighteen, was rescued by a couple who took in and cared for her and her son. When her health failed, Wilson began writing her novel in an effort to make money: "Deserted by kindred, disabled by failing health," she wrote in her preface to *Our Nig,* "I am forced to some experiment, which shall aid me in maintaining myself and child without extinguishing this feeble life." Little is known of Wilson's life after the publication of *Our Nig,* on September 5, 1859. Her son died in New Hampshire in February 1860, and Harriet Wilson died sometime between the death of her son and January 1870.

For more than 100 years, *Our Nig* was barely noticed. In 1983, however, the critic Henry Louis Gates, Jr., raised scholarly interest in Wilson and the novel by arranging to have the book republished, the text being an exact reprint of the 1859 edition.

REFERENCES

GATES, HENRY LOUIS, JR. "Introduction." In *Our Nig; or, Sketches from the Life of a Free Black, in a Two-Story White House, North. Showing That Slavery's Shadows Fall Even There.* New York, 1983, pp. xi–lv.

———. "Parallel Discursive Universes: Fictions of the Self in Harriet E. Wilson's *Our Nig.*" In *Figures in Black: Words, Signs, and the "Racial" Self.* New York, 1987, pp. 125–163.

PETER SCHILLING

Wilson, Jackie (June 9, 1934–January 21, 1984), rhythm and blues singer. Jackie Wilson grew up in Detroit and learned to sing as a child. An avid boxer,

at the age of sixteen he lied about his age in order to enter a Golden Gloves eighteen-year-old division boxing competition, which he won. However, his mother prevailed upon him to give up boxing, and after graduating from high school he turned to music. Wilson's pure, soaring tenor voice and his friendship with Berry GORDY made him a popular RHYTHM AND BLUES singer in local nightclubs. He sang with two rhythm and blues vocal groups, first the Thrillers, and then the Royals, which by 1951 were known as Hank Ballard and the Midnighters. Wilson recorded under the name Sonny Wilson for Dizzy GILLESPIE's record label, but it was not until 1953, when he replaced Clyde McPhatter in Billy Ward and his Dominoes, that he began to achieve a wide reputation.

In 1956 Wilson went solo, and the next year he recorded "Reet Petite," the first of a string of hits that included "To Be Loved" and "Lonely Teardrops" in 1958, and "That's Why," "I'll Be Satisfied," "You Better Know It," and "Talk That Talk" in 1959. Wilson achieved great popularity among both black and white audiences, and was one of the leading pop artists of the late 1950s. Gordy cowrote several of Wilson's hits, and Gordy's portion of the royalties from these songs helped him found Motown Records, but Wilson never joined the label. Wilson's promoters tried to groom him as a Bing Crosby–style crooner, and gave his songs heavily arranged backgrounds. He recorded "Night" (1960), an adaptation of a Saint-Saëns aria, and "Alone at Last" (1960), based on a theme from Tchaikovsky's First Piano Concerto. His more conventional hits from this period include "Doggin' Around," "All My Love," "Am I the Man," and "A Woman, A Lover, A Friend." Wilson's ballads and frenzied dance numbers are classics of early ROCK AND ROLL, but in the late 1950s and early '60s he was equally famous for his thrilling live performances, with his sexually charged dance moves and acrobatic leaps earning him the nickname "Mr. Excitement."

In 1961 Wilson was shot and injured by a fan in New York. Although he recovered, his career began a slow decline. Nonetheless, he did produce several more hits in the 1960s, including "Baby Workout" (1963), "Squeeze Her, Please Her" (1964), "Whispers" (1966), "Higher and Higher" (1966), and "I Get the Sweetest Feeling" (1968), but they never rivaled his early successes. After 1968 Wilson never produced another hit record, but he did continue as a popular concert artist, crooning his old songs before large audiences. In 1975 he suffered a heart attack, which resulted in brain damage that left him in a coma. He spent the next eight years in the hospital, and died in Mount Holly, N.J., at the age of forty-nine. Wilson was inducted into the Rock and Roll Hall of Fame in 1987.

REFERENCES

COHEN, MITCHELL. "Jackie Wilson Story." *High Fidelity* 33 (August 1983): 98.

HOLSEY, STEVE. *Jackie Wilson: R&B's Master Showman. Michigan Chronicle,* September 11, 1991, p. 1

JONATHAN GILL

Wilson, John Woodrow (1922–), painter, printmaker, illustrator, and sculptor. John Woodrow Wilson was born in Boston, Mass. During high school, Wilson took art classes at night at the Roxbury Boys' Club, where an instructor encouraged his artistic ambitions. At sixteen, Wilson won a scholarship to the Boston Museum School, graduating with the highest honors in 1944. Between 1945 and 1949, Wilson taught art at various Boston art schools while earning a B.S. in education from Tufts University in 1947. He won a Paige Traveling Fellowship (1946), which he used to attend the Fernand Léger School in Paris in 1949. There, Wilson studied directly under Léger, who inspired his interest in large, solid forms. Wilson's artistic horizons were further broadened when he received the John Hay Whitney and the International Institute Fellowships for travel and study in Mexico. In Mexico, Wilson studied at the Esmeralda School of Arts (1952) and the Escuela de las Artes in Mexico City (1954). There he met the Mexican muralists Diego Rivera and David Siqueiros, whose work deeply influenced his own, and painted his first fresco mural, *Incident* (1952). Upon his return to the United States, Wilson moved to Chicago and then New York City, where he taught art in the public schools and anatomy at the Pratt Institute in Brooklyn, N.Y. In 1964 he joined the faculty of Boston University's School for the Arts, where he was professor of art until 1993.

Though Wilson has experimented with a variety of styles, he has often returned to realistic depictions of human forms and the themes of human dignity and vulnerability. He favors working in prints and public art forms (murals and sculpture) in order to reach the broadest audience possible. Wilson's best-known work draws upon the social-realist tradition of the Mexican muralists. His prints and paintings deliver a powerful commentary on the social and political issues affecting African-American life. The lithograph *Deliver Us from Evil* (c. 1945) compares German anti-Semitism to American racism; violent images of Hitler's Gestapo and the KU KLUX KLAN merge seamlessly into each other. Another lithograph, *Adolescence* (1943), invokes the despair and isolation of black youth trapped in urban poverty.

Since the 1980s, Wilson has worked almost entirely in sculpture. In 1985, U.S. Congress and the

National Endowment for the Arts commissioned Wilson to create a monument to the Rev. Dr. Martin Luther KING, Jr., for the Capitol Rotunda. The three-foot-high bronze bust depicts a young, pensive, and brooding King looking down upon the viewer. The simple, powerful piece conveys at once King's serenity and the force of his struggle. In 1987, Wilson created *Eternal Presence,* a Buddha-like, eight-foot-tall bronze head with African features for the National Center for Afro-American Artists in Roxbury, Mass.

Wilson has received numerous awards for his work, including the John Hope Landscape Award (1943) for his oil painting *Black Soldier,* and ten first prizes in Atlanta University's Annual Exhibitions (1950–1965). His work has been shown at the Library of Congress, the Boston Museum of Fine Arts, and the Metropolitan Museum of Art. In 1967, the Gropper Art Gallery in Boston held a solo exhibit. The Museum of Modern Art in New York City, the Bezalel Museum in Israel, and the French government have acquired Wilson's works.

REFERENCES

POWELL, RICHARD J. "I, Too, Am America; Protest and Black Power: Philosophical Continuities in Prints by Black Americans." *Black Art: An International Quarterly* 2, no. 3 (Spring 1978): 9–10.

TUCK, LON. "Shaping a Legend: The Sculptor's Story." *Washington Post,* January 16, 1986: p. B1.

ROBERT A. POARCH

Wilson, Nancy Sue (February 20, 1937–), jazz and pop singer. Born in Chillicothe, Ohio, Nancy Wilson toured the Midwest with Rusty Bryant's band from 1956 until 1958, and made her first record for Dot in 1956. After moving to New York City, she sang in clubs while working as a secretary by day. In 1959 her first album, *Like in Love,* was released by Capitol Records. She ultimately made some thirty albums for the label, including notable sessions with two of her most enthusiastic supporters, pianist George Shearing and alto saxophonist Julian "Cannonball" ADDERLEY. Two of her singles, "(You Don't Know) How Glad I Am" and "Face It Girl, It's Over," made the top thirty. A third recording— "Guess Who I Saw Today?"—became her signature song. She was a perennial favorite with audiences at the Apollo Theater and also worked in the civil rights movement, notably for the congressional Black Caucus.

After her success in popular music, in the early 1980s, Wilson concentrated again on jazz, performing with Hank Jones, Art Farmer, and Benny Golson. On her noteworthy 1991 album *With My Lover Beside Me* (Columbia), she premiered several songs with lyrics by the late songwriter Johnny Mercer that had been found after his death. Wilson's style is distinguished by her clear phrasing and her poised, sophisticated delivery. A versatile singer, she was most notably influenced by Dinah WASHINGTON.

REFERENCE

TRAVIS, D. J. *An Autobiography of Black Jazz.* Chicago, 1983.

BUD KLIMENT

Wilson, Olly Woodrow (September 7, 1937–), composer and educator. Olly Wilson was born in St. Louis, Mo., earned a bachelor of music degree from Washington University, St. Louis (1959), a master of music from the University of Illinois (1960), and his doctorate from the University of Iowa (1964). He has held teaching positions at Florida A&M University, the Oberlin Conservatory, and, since 1970, the University of California at Berkeley.

Wilson's influences are diverse. As a young man he played piano and double bass in jazz groups and orchestras. At the University of Illinois, he participated in the experimental electronic music program. From 1971 to 1972 he studied West African music in Ghana. His compositional style is avant-garde, featuring a range of instrumentation and technical demands. Wilson's oeuvre brings together a knowledge of black musical traditions and contemporary musical styles. His compositions include works for orchestra, chamber ensemble, and electronic music. Orchestral music includes *Spirit Song* (1973), with soprano and double chorus; *Lumina* (1981); *Sinfonia* (1983); and *Viola Concerto* (1991–1992). A wide variety of chamber pieces includes *Trio* (1977) for violin, cello, and piano; *A City Called Heaven* (1988–1989) for chamber ensemble; *Of Visions and Truth: A Song Cycle* (1990–1991) for mezzo-soprano, tenor, baritone, and large chamber ensemble; and *And I Shall Not Be Moved* (1992) for soprano and chamber ensemble. From 1967 to 1976 Wilson produced much electronic music: *Cetus* (1967); *In Memoriam Martin Luther King, Jr.* (1968), with chorus; *Akwan* (1972), with piano, electronic piano, and orchestra; and *Sometimes* (1976) with tenor.

Scholarly articles by Wilson have appeared in the *Black Music Research Journal* and *The Black Perspective in Music.*

Wilson's numerous awards include the Dartmouth Arts Council Prize for *Cetus* (awarded in the Inter-

national Electronic Music Competition, 1968), two Guggenheim Fellowships (1971–1972, 1977–1978), an Award of Distinction from the NATIONAL ASSOCIATION OF NEGRO MUSICIANS (1974), an Award for Achievement in Music Composition from the American Academy of Arts and Letters and the National Institute of Arts and Letters (1974), and the Elise Stoeger Prize from the Chamber Society of Lincoln Center (1992). He was a visiting artist at the American Academy in Rome (1977–1978) and received a residency at the Rockefeller Foundation Center in Bellagio, Italy (1991). Wilson has received commissions from the Boston Symphony Orchestra (1970), the National Endowment for the Arts (1975–1976, 1985, 1990), the Black Music Research Center (1989), the New York Philharmonic (1990), and the Lila Wallace–Readers Digest Fund (1990).

REFERENCES

BAKER, DAVID, L. M. BELT, and H. C. HUDSON, eds. *The Black Composer Speaks*. Metuchen, N.J., 1978.
SOUTHERN, EILEEN. "Conversations with Olly Wilson," *The Black Perspective in Music*, 5 (1977), 90; 12 (1978), 5–7.
———. *Readings in Black American Music*. New York, 1971.

CALVERT BEAN

Wilson, William Adolphus "Billy" (April 21, 1935–August 14, 1994), dancer.

Born in Philadelphia, one of four children, Billy Wilson began dance training in the public school system. At sixteen he was awarded a scholarship to study ballet with Anthony Tudor at the Philadelphia Ballet Guild, and within two years he performed with its associated company. He moved to New York in 1956 and danced in *Carmen Jones, Bells Are Ringing,* and *Jamaica* on Broadway; in 1958 he went to London to perform in *West Side Story*. At the invitation of artistic director Sonia Gaskell, Wilson joined the National Ballet of Holland, where he created the title role in Serge Lifar's *Othello* (1960). In 1965 Wilson married Sonja van Beers, prima ballerina of the National Ballet of Holland, and the couple returned to the United States, where he taught at Brandeis University, in Waltham, Mass.; staged several seasons of the *Hasty Pudding Show* at Harvard University; and directed the dance company of the National Center of Afro-American Artists in Boston. Wilson choreographed several Broadway productions, including *Bubbling Brown Sugar* (1976); an all-black revival of *Guys and Dolls* (1976); *Eubie* (1978); and the children's television program *Zoom* (1976–1981), for which he received an Emmy Award. Many of his immensely popular concert dances have been performed by the Alvin AILEY American Dance Theater, DANCE THEATER OF HARLEM, Dayton Contemporary Dance Ensemble, and Philadanco, including the frisky *Concerto in F* (1981), set to the music of Gershwin; *Rosa* (1990), a moving dance tribute to Rosa Parks; the atmospheric dance-drama *Ginastera* (1991); and *The Winter in Lisbon* (1992), a boisterous celebration of the music of trumpeter Dizzy GILLESPIE.

REFERENCES

FANGER, IRIS M. "Billy Wilson—Curtain Going Up." *Dance Magazine* (June 1976).
KISSELGOFF, ANNA. "Prep Students Toe Mark—for Ballet." *New York Times,* June 5, 1969.

THOMAS F. DEFRANTZ

Winfrey, Oprah Gail (January 29, 1954–), talk-show host, actress.

Born on a farm in Kosciusko, Miss., to Vernita Lee and Vernon Winfrey, Oprah Winfrey was reared by her grandmother for the early part of her life. At age six, she was sent to live with her mother, who worked as a domestic, and two half brothers in Milwaukee. It was in Milwaukee that Winfrey began to display her oratorical gifts, reciting poetry at socials and teas. During her adolescence, Winfrey began to misbehave to such a degree that she was sent to live with her father in Nashville. Under the strict disciplinary regime imposed by her father, Winfrey started to flourish, distinguishing herself in debate and oratory. At sixteen, she won an Elks Club oratorical contest that awarded her a scholarship to Tennessee State University.

While a freshman in college, Winfrey won the Miss Black Nashville and Miss Black Tennessee pageants. As a result of this exposure, she received a job offer from a local television station and in her sophomore year became a news anchor at WTVF-TV in Nashville. After graduating in 1976, Winfrey took a job with WJZ-TV in Baltimore as a reporter and coanchor of the evening news. In 1977 she was switched to updates on local news, which appeared during the ABC national morning show *Good Morning America*. That same year she found her niche as a talk-show host, cohosting WJZ-TV's morning show, *Baltimore Is Talking*.

In 1984 Winfrey moved to Chicago to take over *A.M. Chicago,* a talk show losing in the ratings to Phil Donahue's popular morning program. Within a month Winfrey's ratings were equal to Donahue's. In three months she surpassed him. A year and a half later the show extended to an hour and was renamed *The Oprah Winfrey Show*. The show, which covers a wide range of topics from the lighthearted to the

sensational or the tragic, was picked up for national syndication by King World Productions in 1986. By 1993 *The Oprah Winfrey Show* was seen in 99 percent of U.S. television markets and sixty-four countries. Since the show first became eligible in 1986, it has won Emmy awards for best talk show, or best talk-show hostess each year except one.

In 1985 Winfrey was cast as the strong-willed Sofia in the film version of Alice WALKER's *The Color Purple,* for which she received an Oscar nomination. The following year she formed her own production company, HARPO Productions, to develop projects. In 1989 Winfrey produced and acted in a television miniseries based on Gloria NAYLOR's novel *The Women of Brewster Place,* and in 1993 she starred in and produced the television drama *There Are No Children Here.* That same year *Forbes* magazine listed Winfrey as America's richest entertainer based on her 1992 and 1993 earnings of approximately $98 million.

REFERENCES

HARRISON, BARBARA GRIZUTTI. "The Importance of Being Oprah." *New York Times Magazine* (June 11, 1989): 28–30.

HINE, DARLENE CLARK, ed. *Black Women in America.* New York, 1993.

NEWCOMB, PETER, and LISA GUBERNICK. "The Top 40." *Forbes* (September 27, 1993): 97.

KENYA DILDAY

Wings Over Jordan. While serving as pastor of Gethsemane Baptist Church in Cleveland, Ohio, the Rev. Glen T. Settle started evolving an idea for his highly musical choir in July 1937. He embarked on a plan to preserve the choir's African-American choral tradition and present it to a larger audience. Settle formed an alliance with Worth Kramer, then the program director of radio station WGAR, who eventually retired from this position to become his choral director. Together, they originated "The National Negro Hour," featuring the Gethsemane choir, which aired every Sunday morning in the mid- and late 1930s. From 1939 to 1965, the choir was internationally famous, recording on major labels and becoming a concert attraction both in the United States and abroad. Its regular Sunday radio program be-

Wings Over Jordan, a gospel choir that had a popular radio hour in the 1930s and '40s, greeted by New York City mayor Fiorello LaGuardia after a performance at Carnegie Hall. (Photographs and Prints Division, Schomburg Center for Research in Black Culture, The New York Public Library, Astor, Lenox and Tilden Foundations)

came a national forum for such notables as Mary McCleod BETHUNE and Dr. Adam Clayton POWELL, Jr.

Although there were seventeen conductors in the history of the choir as well as considerable membership turnover, the end result was always quality sound. Spirituals and gospel songs were interpreted with a strong emotional vocal technique and perfected artistry made their performance consistent and the messages memorable.

(Note: The Wings Over Jordan Choir collection is owned by the National Afro-American Museum and Cultural Center in Wilberforce, Ohio. It will become available in the late 1990s for research and exhibition. Some of the information from the collection was used to write this article.)

REFERENCES

BARBER, SAMUEL. The Choral Style of the Wings Over Jordan Choir. Ph.D. diss., University of Cincinnati, 1978.

Souvenir Booklet. Cleveland Heights, Ohio, 1974.

Wings Over Jordan Remembered by Alumni and Friends, 50th Year Anniversary Celebration. Cuyahoga Community College Metro Campus, June 11, 1988.

IVY V. CARTER

Winter Sports.

Bobsledding, skiing, and figure skating are winter sports that have no professional league or have not had major African-American participation.

Bobsledding

American bobsledding on the highest competitive level was first integrated in 1988, when Willie Gault, a wide receiver with the Chicago Bears, was chosen to the U.S. team that competed in the Calgary Winter Olympics. Because of the importance of the opening running push prior to the beginning of the bobsled run proper, the U.S. bobsledding team has made an effort to get world-class sprinters to join the team. Gault later recruited various football and track stars to try out for the U.S. team, including the hurdler Edwin MOSES and NFL running back Herschel Walker. In 1991 Moses won a bronze medal on the U.S. two-man team at the World Cup championships in Germany.

At the 1992 Winter Olympics in Albertville, France, Herschel Walker, Jeff Woodard, and Chris Coleman competed on the U.S. team but failed to win a medal. At the 1994 Olympics in Lillehammer, Norway, one-third of the U.S. bobsled team was made up of African Americans, as Randy Jones and Karlos Kirby joined Woodard and Coleman. None of the U.S. sleds fared well in the competition. In the related sport of luge, an African-American member of the 1994 U.S. Olympic team was the target of a racial incident during training for the Olympics in Germany.

Skiing

In 1960 David Lucy of Denver University became the first black member of a college skiing team. Bonnie Saint John, a Harvard student whose right leg was amputated above the knee when she was five years old, finished first in the women's skiing competition at the 1984 Handicapped Olympics in Innsbruck, Austria, and recorded the second fastest time by a female disabled skier.

Figure Skating

Bobby Beauchamp is the only black man ever to earn national or international honors in figure skating. He placed second in both the U.S. and world junior championships. In 1981 Beauchamp finished seventh in the U.S. senior championships and sixth in the NHK Trophy event in Japan.

Debi THOMAS became the first African American to win a medal in a Winter Olympics when she earned the women's figure skating bronze at the 1988 games in Calgary, Alberta.

REFERENCE

ASHE, ARTHUR R., JR. *A Hard Road to Glory: A History of the African-American Athlete.* 3 vols. New York, 1988.

THADDEUS RUSSELL
BENJAMIN K. SCOTT

Wisconsin.

Three generalizations characterize the history of African Americans in Wisconsin. First, relatively few, in both number and percentage of total population, have lived in the state historically, although substantial increases have occurred since 1950. Second, despite their small number, African Americans have participated in virtually all of the broad historic developments in the state from the colonial era under the Canadian French and British, through the American territorial period, to the present. Third, African Americans have experienced the same problems in Wisconsin as they experienced in the South or in the nation's metropolises.

A transient black presence with Canadian roots can be documented in connection with the Native American fur trade and diplomacy in the region west of

Lake Michigan by the 1750s, so it can be presumed that other African Americans from Canada participated in or witnessed activities in and around Wisconsin somewhat before then.

A permanent black presence in Wisconsin, both American via the Mississippi Valley and Canadian via the Great Lakes, does not seem to have been achieved until the 1790s as part of the two nations' reaction to the Revolutionary War. In the early 1790s a Canadian black family, that of Jean Bonga, settled permanently along the south shore of Lake Superior and engaged in the fur trade. And by 1793, Marie Anne la Buche, a New Orleans-born black woman, was living in Prairie du Chien along the Mississippi River with her second husband, Claude Gagnier. The family farmed and worked in the fur trade, and Marie Anne Gagnier served as midwife and healer for the local French and Native American community.

American desire to exploit lead ores in the southwestern corner of the state brought other blacks to territorial Wisconsin in the 1820s and 1830s, some of them slaves owned by miners of southern background and by officers at Fort Crawford in Prairie du Chien and Fort Winnebago at Portage.

Simultaneously others of African descent came to Wisconsin as members of three New York Indian tribes that were "removed" to the Green Bay and Fox River region in the northeastern part of the state—the Oneida, the Brotherton, and the Stockbridge-Munsee, who had given refuge to escaped Rhode Island slaves and others. Ever since that time, most of these persons' choice to live and regard themselves as Native Americans has confused census figures and the histories of the state's Indian and African-American communities.

Development of what is now the state's most populous region—the Lake Michigan shoreline counties north of Chicago—trailed these earlier events somewhat. But by the middle of 1830s and on the eve of achievement of territorial status in 1836, Milwaukee began the transition from Native American trading post to community. Joe Oliver, a black cook, was there by 1835, working for trader and land speculator Solomon Juneau. William Green, a barber, was there by 1838 and persisted for many years with his family. By 1840, thirty-two African Americans were found in Milwaukee County, which incorporated Waukesha County, a center of abolitionism, until 1846 (see ABOLITION).

Achievement of statehood in 1848 occasioned further immigration from both the East and the South, establishing a pattern for the future. Most newcomers settled in cities (especially Milwaukee, Racine, Beloit, and, to a lesser extent, Madison). Some chose small towns. Generally they engaged in service occupations (personal care, food preparation) and industrial labor, the last of which grew in importance over the years, especially in the less desirable aspects of the foundry and tanning industries. Initially, a few farmed, often clustering in specific rural neighborhoods. But the farming component dwindled in the twentieth century and virtually disappeared by the 1960s.

Two such agricultural clusters have attracted study—Pleasant Ridge founded by Virginians in 1848 near Lancaster in Grant County, and Cheyenne Valley founded by North Carolinians (some of mixed Cherokee ancestry) about 1855 near Hillsboro in Vernon County, which grew at least in part in conjunction with a Quaker settlement. Less well known rural settlements grew up near Delavan in Walworth County, at Fox Lake in Dodge County (where the residents lived in the village and worked on nearby farms), near Prescott in Pierce County, and, in the twentieth century, in northern Clark County. All were small, Pleasant Ridge and Cheyenne Valley numbering around a hundred persons at their peak. Few descendants have remained in the areas; most scattered widely, moving to Madison, Milwaukee, St. Paul, and other midwestern cities.

Until 1910, fewer than 3,000 blacks lived in Wisconsin, in proportions varying from one-tenth to

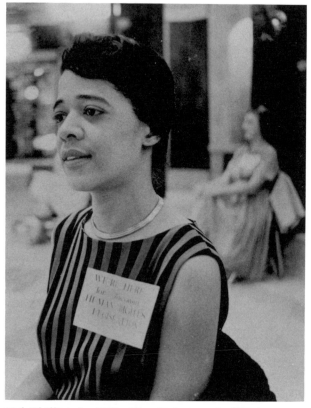

Vel Phillips in 1961. Her badge reads "We're Here for Wisconsin Human Rights Legislation." (State Historical Society of Wisconsin)

two-tenths of 1 percent. Industrial needs in Milwaukee and the state's smaller manufacturing centers during both world wars led to significant recruitment of southern blacks, especially from Mississippi. Then after World War II, migration soared, many migrants coming directly from the South, others via other northern cities such as Chicago. Figures from 1910 through 1990 demonstrate dramatic growth: 2,900 in 1910 (0.1 percent); 5,201 in 1920 (0.2 percent); 10,739 in 1930 (0.4 percent); 12,158 in 1940 (0.4 percent); 28,182 in 1950 (0.8 percent); 74,546 in 1960 (1.9 percent); 128,224 in 1970 (2.9 percent); 182,592 in 1980 (3.9 percent); and 244,305 in 1990 (5.0 percent).

Similarly, the proportion of the state's African-American population associated with Milwaukee County also has grown dramatically: 458 persons in 1890 (18.7 percent of the state's total African-American population); 895 in 1900 (35.2 percent); 996 in 1910 (34.3 percent); 2,346 in 1920 (45.1 percent); 7,723 in 1930 (71.9 percent); 9,069 in 1940 (74.6 percent); 22,129 in 1950 (78.5 percent); 63,024 in 1960 (84.5 percent); 106,033 in 1970 (82.7 percent); 149,385 in 1980 (81.8 percent); and 195,551 in 1990 (85 percent). Comparable growth spurts have occurred since 1950 in Racine, Beloit, Madison, and, to a lesser extent, Kenosha.

In the middle 1800's, Racine, Beloit, and Milwaukee had African-American populations of nearly equal size. The Racine community was the first to establish churches, organizing both Baptist and Methodist congregations before 1860; St. Paul Baptist Church, formed in 1857, has survived to the present. Milwaukee's first church followed in 1869, when Ezekiel and Catherine Gillespie, probably the most prominent black residents of the state from the 1850s into the 1880s, helped establish St. Mark African Methodist Episcopal Church, which also has survived.

In the struggle for civil rights, Milwaukeeans traditionally have led the way for Wisconsin. The constitution that had launched statehood in 1848 left the suffrage question (see SUFFRAGE, NINETEENTH CENTURY) to a referendum. One was held in 1849, but was declared to have failed. Then in 1866 the state's Supreme Court interpreted the results differently after a Milwaukee poll-watcher turned Ezekiel Gillespie away as he tried to vote. Gillespie then brought suit and won the right to vote for all blacks in Wisconsin.

Segregation had plagued Wisconsin since the territorial period. Slaves (28 in total) were more numerous in the state in 1830 than were free blacks (23 in total). In 1854, an escaped Missouri slave, Joshua Glover, was captured, jailed in Milwaukee, then freed by a mob and spirited to Canada; but as a consequence his principal rescuer, Sherman M. Booth, a

white abolitionist editor, spent five years in the courts and some time in jail for violating the fugitive slave act (see FUGITIVE SLAVE LAWS). And Wisconsin was not free of LYNCHING. In 1861, a largely Irish mob killed Marshall Clark in Milwaukee for participating in the murder of an Irishman who had accosted Clark and a companion for escorting two white women.

The national movement for state civil rights laws in the 1880s found expression as well in Milwaukee, where an 1889 case of discrimination against a theater patron led to a Civil Rights League convention call and the introduction of legislation. William T. Green, a black Milwaukeean who was then a law student at the state university in Madison, helped lead the biracially organized struggle, which finally resulted in passage in 1895, three years after Green had become a member of the bar.

Establishment in Milwaukee in 1892 of a monthly newspaper, the *Wisconsin Afro-American* (later called the *Northwestern Recorder*), coincided with this civil rights struggle. It survived two years, being succeeded eventually by the *Wisconsin Weekly Advocate* (1898–1915), published by Richard B. Montgomery, and the *Wisconsin Enterprise-Blade* (1916–1943), edited by J. Anthony Josey for a quarter of a century.

After the initial efforts in the 1890s, civil rights organizations did not flourish in Wisconsin until immediately after World War I, inspired by race riots elsewhere and the problems related to the substantial wartime immigration of industrial workers from the South. In 1919, chapters of the NATIONAL ASSOCIATION FOR THE ADVANCEMENT OF COLORED PEOPLE and URBAN LEAGUE were established in Milwaukee, and an NAACP chapter took shape in Beloit led by a local black dentist, F. E. Norman. Two members of the Beloit chapter, Ardie and Wilbur Halyard, shortly moved to Milwaukee where they encountered deplorable housing conditions and opportunities. In 1924, after four years' effort, they received a state charter for the Columbia Savings and Loan Association, which by 1968 boasted $4 million in assets.

From the late 1800s until the present, opportunities for housing, jobs, and education have been limited for blacks in Wisconsin's cities. Even in Madison, home of a historically liberal state university and progressive state government, blacks lived principally in isolated neighborhoods of old and substandard housing until the 1960s and 1970s, and in 1990 they still formed distinct neighborhoods.

As early as 1941, Milwaukee was characterized by one black man as "a southern town that lost its way and got stranded a hundred miles north of Chicago." The city's black neighborhoods first developed north of the downtown business district and west of the Milwaukee River, then generally expanded in those directions to the present. In 1967 and 1968, a Catholic

priest, James E. Groppi, and the Milwaukee NAACP Youth Council marched for 200 continuous days in support of an open-housing ordinance, the successful battle for which was led in the city council by Vel Phillips, who later became secretary of state and the first black constitutional officeholder in Wisconsin. (In the midst of this struggle, rioting broke out in Milwaukee in July 1967, as it had in other cities during the 1960s.) Despite legislation and court rulings, the 1990 census returns found that Milwaukee housing remained among the most segregated of major cities in the United States. A nearly fifteen-year fight to desegregate Milwaukee's public schools, led principally by Lloyd Barbee, a black attorney who filed suit in 1965 in behalf of forty-one black children and white children, finally reached settlement in federal court in 1979.

Numerous prominent African Americans such as baseball star Henry AARON and talk-show host and actress Oprah WINFREY have associations with Milwaukee. The most overlooked Wisconsin African-American figure of unusual attainment is perhaps George Coleman Poage of La Crosse, the first black American to win a medal in the modern Olympics. Poage, a high school and University of Wisconsin-Madison track star before his graduation in 1904, won bronze medals in the 200-meter and 400-meter hurdles in the 1904 games at St. Louis. He subsequently taught in Chicago.

For research into African-American history of the middle and late twentieth century, scholars from around the world have turned to the collections of the State Historical Society of Wisconsin in Madison, which since the late 1800s recognized the significance to United States history of African-American publications and manuscripts. Important civil rights manuscript collections in its archives include the papers of the CONGRESS OF RACIAL EQUALITY (CORE), the MISSISSIPPI FREEDOM DEMOCRATIC PARTY, and Daisy BATES, who headed Little Rock's NAACP chapter during that city's school integration crisis.

REFERENCES

COOPER, ZACHARY. *Black Settlers in Rural Wisconsin.* Madison, Wisc., 1977.

CURRENT, RICHARD N. *The History of Wisconsin. Vol. II. The Civil War Era, 1848–1873.* Madison, Wisc., 1976.

HOLZHEUTER, JOHN O. Negro Admixture Among the Brothertown, Stockbridge, and Oneida Indians of Wisconsin. Unpublished paper, State Historical Society of Wisconsin, 1966.

MARIN, JOSEPH. *Journal of Joseph Marin.* Edited and translated by Kenneth P. Bailey. Irvine, Calif., 1975.

State Historical Society of Wisconsin. *Wisconsin Historical Collections.* V: 145–146; XVIII: 497.

THOMPSON, WILLIAM F. *The History of Wisconsin. Vol. VI. Continuity and Change, 1940–1965* (Madison, Wisc., 1988.

TROTTER, JOE WILLIAM JR. *Black Milwaukee: The Making of an Industrial Proletariat, 1915–45* Urbana, Ill., 1985.

JOHN O. HOLZHEUTER

Withers, Ernest C. (August 7, 1922–), photographer and journalist. Born in Memphis, Tenn., Ernest Withers graduated from Memphis's Manassas High School in 1941 and married his high-school sweetheart, Dorothy Mae Curry, in 1942. They are the parents of seven sons and one daughter.

He received his photographic training with the U.S. Army Corps of Engineers in the South Pacific (1943–1946), and after the war traveled as a photographer with Negro League baseball teams. He served briefly as a Memphis policeman, one of the first African Americans hired and the first fired. In 1948 he established a studio on Beale Street, recording the rich Memphis blues scene.

Though he has been called "the dean of Beale Street," civil rights was Withers's real "beat": the trial of Emmett TILL's murderers, the Montgomery bus boycott, school desegregation in Little Rock, the funeral of Medgar EVERS (where Withers was beaten and arrested by Jackson police, his camera damaged, and his film exposed), the Selma march, and the assassination of the Rev. Dr. Martin Luther KING, Jr., in 1968, for which he won the National Newspaper Publishers Association's Best Photo of the Year award. In 1988 he was inducted into the Black Press Hall of Fame. His photographs have appeared in *Time, Newsweek, Ebony, Jet, People,* the *New York Times,* the *Washington Post,* and the *Defender* chain of newspapers, with which he has been associated since 1946.

Withers's work as a freelance "chronicling photographer" has been anthologized in *Southern Eye—Southern Mind* (1981), *Homespun Images* (1989), and *Let Us March On!* (1992), and is displayed in a permanent exhibit at the Handy House, located within the Beale Street Historic District of downtown Memphis. In 1992, he received an honorary doctor of fine arts degree from Memphis College of Art for his photographs, which "with elegance and honesty chronicled our nation's struggle with civil rights," and for his "vision in recognizing history as it happened, and capturing that history so that we might all learn its lessons."

REFERENCES

BAILEY, RON, and MICHELE FURST, eds. *Let Us March On! Selected Civil Rights Photographs of Ernest C. Withers, 1955–1968.* Boston, 1992.

GRAVES, TOM. "A Dream Deferred." *American Way*, February 15, 1993, pp. 54–59.

JAMES M. SALEM

Wolf, Howlin'. *See* Howlin' Wolf.

Wolfe, George C. (September 23, 1954–), playwright and director. Born in Frankfort, Ky., George Wolfe was the third of four children in a middle-class black family. His mother was the principal of a private black elementary school; his father worked for the state Department of Corrections. An introspective child, he soon became a voracious reader.

Wolfe was thirteen when, on a visit to New York, he saw his first professional play. The performance of *Hello, Dolly!,* starring Pearl BAILEY, made Wolfe realize he wanted to work in the theater. He soon began directing plays in high school.

After earning a B.A. in theater from Pomona College in Claremont, Calif. (1977), Wolfe pursued an acting career in Los Angeles, while also teaching and directing at the Inner-City Cultural Center. In 1979 he came to New York City, where he earned an M.F.A. in dramatic writing and musical theater at New York University. He taught at City College and the Richard Allen Center for Cultural Art while pursuing a writing career.

In 1985, his musical about colonization, *Paradise,* was produced off-Broadway at Playwrights Horizons. But it was *The Colored Museum,* produced in 1986 at the New York Public Theater, that established him as an important voice in contemporary American theater. The play, a satire of popular stereotypes from African-American culture, raised questions concerning the uses (by blacks as well as whites) and meanings of black cultural icons. It went on to major productions in London and Los Angeles; in 1991 it aired as part of the "Great Performances" series on public television.

In 1990, Wolfe was one of four artistic associates at the Public Theater. In this capacity he directed *Spunk,* his adaptation of three short stories by Zora Neale HURSTON (for which he was given an Obie Award), and Bertolt Brecht's *The Caucasian Chalk Circle,* adapted by Thulani Davis. That same year he directed the Los Angeles premiere of *Jelly's Last Jam,* a musical based on the life of Jelly Roll MORTON, for which Wolfe also wrote the book. It moved to Broadway in 1992 to considerable acclaim. Also in 1992 he directed the PBS "Great Performances" production of Anna Deavere Smith's *Fires in the Mirror,* about

George C. Wolfe, director of the Broadway play *Angels In America: Millennium Approaches,* stands with his 1993 Tony Award for best director of a play. (AP/Wide World Photos)

unrest between blacks and Jews in the Crown Heights section of Brooklyn in 1991. In 1993, he directed the Broadway production of Tony Kushner's *Angels in America: Millennium Approaches,* for which he won the Tony Award for Best Direction of a Play. That same year he was named producer of the New York Public Theater.

REFERENCES

LUBOW, ARTHUR. "George Wolfe in Progress." *New Yorker* 69, no. 30 (1993): 48–62.
NIXON, WILL. "George C. Wolfe Creates Visions of Black Culture." *American Visions* 6 (1991): 50–52.

MICHAEL PALLER

Woman's Era, women's journal. *Woman's Era,* the first monthly journal published by African-American women, was a key factor in the creation of national networks of middle-class black activist women at the turn of the twentieth century. The paper was established in 1894 by Josephine St. Pierre RUFFIN and her daughter, Florida Ruffin Ridley. The two had founded the Boston Woman's Era Club that same year, and Ruffin served both as the club's president

and as editor of the paper until 1903. The paper dealt with issues of politics, family, health, fashion, and community. It had correspondents from around the country, many of whom were renowned activists. Victoria Earle MATTHEWS reported from New York, Fannie Barrier WILLIAMS from Chicago, Josephine Silone-Yates from Kansas City, Mary Church TERRELL from Washington, D.C., Elizabeth Ensley from Denver, and Alice Ruth Moore (later known as Alice DUNBAR-NELSON) from New Orleans.

The paper was of great use in 1895 in calling a meeting to protest a letter insulting the character of black women. Using the vehicle of the *Woman's Era,* Ruffin insisted that African-American women could no longer stand idle while whites asserted that black men were natural rapists and that black women were amoral. Out of this national conference, at which 100 women represented ten states, came the NATIONAL FEDERATION OF AFRO-AMERICAN WOMEN. The federation pledged itself to deal with these attacks, among other pressing issues. The organization would become part of the larger NATIONAL ASSOCIATION OF COLORED WOMEN the following year.

While the *Woman's Era* did not have the longevity of many other periodicals, it played a key role at a critical time for black women. Ruffin's creation of the paper as a means of linking the work of various women from around the country made possible the creation of such vitally important organizations as the National Association of Colored Women.

Josephine St. Pierce Ruffin. (Photographs and Prints Division, Schomburg Center for Research in Black Culture, The New York Public Library, Astor, Lenox and Tilden Foundations)

REFERENCES

NEVERDON-MORTON, CYNTHIA. "The Black Woman's Struggle for Equality in the South, 1895–1925." In Sharon Harley and Rosalyn Terborg-Penn, eds. *The Afro-American Woman: Struggles and Images.* Port Washington, N.Y., 1978, pp. 43–57.

SALEM, DOROTHY. *To Better Our World: Black Women in Organized Reform, 1890–1920.* Brooklyn, N.Y., 1990.

JUDITH WEISENFELD

Women's Organizations. *See* Early African-American Women's Organizations.

Women Wage-Earners' Association. The fields of labor in which black women have historically found work—domestic labor, needle trades, agricultural work—have been areas largely unprotected and unaffected by the gains won by American labor unions (*see* LABOR AND LABOR UNIONS). African-American men and women alike were barred from membership in most white unions, leaving them vulnerable to their employers. As the First World War raged in Europe, prominent women in the club movement in Washington, D.C., took on this matter and formed the Women Wage-Earners' Association, an organization for black working women across occupational lines. Among its founders were Mary Church TERRELL, Julia F. Coleman, and Jeanette Carter. Chapters were also formed in other southern cities.

In 1917 the Norfolk, Va., chapter of the association organized a strike among women working for the American Cigar Company. Domestic laborers, waitresses, and other members of the association, along with some male laborers, also went on strike in support of the tobacco workers. The company broke the strike with the help of the federal government's "slacker" laws, passsed to mobilize workers for the war effort. Norfolk's striking black workers were arrested as slackers and charged with hindering the war effort. The Women Wage-Earners' Association was also targeted for investigation as a subversive organization.

Although this particular strike was broken, the Norfolk chapter folded, and African-American women were not able to form a lasting labor union to address their particular needs, the effort is representative of many important short-term and ad hoc unionization endeavors on the part of African-American women.

REFERENCES

FONER, PHILIP. *Women and the American Labor Movement from World War I to the Present.* New York, 1980.

GIDDINGS, PAULA. *When and Where I Enter: The Impact of Black Women on Race and Sex in America.* New York, 1984.

JUDITH WEISENFELD

Wonder, Stevie (Morris, Stevland) (May 13, 1950–), singer and songwriter. Born Stevland Morris on May 13, 1950, in Saginaw, Mich., Stevie Wonder has been blind since birth. He grew up in Detroit and by the age of nine had mastered the harmonica, drums, bongos, and piano. His early influences included rhythm-and-blues artists "B. B." KING and Ray CHARLES (*see* RHYTHM AND BLUES). Once his youthful talent as a musician and composer was discerned, Berry Gordy signed him to Hitsville, U.S.A. (later known as MOTOWN) in 1961. He was soon dubbed "Little Stevie Wonder" and in 1963 achieved the first of many number one pop singles with "Fingertips—Pt. 2," a live recording featuring blues-flavored harmonica solos. The album of the same year, *Twelve-Year-Old Genius,* was Motown's first number one pop album. From 1964 to 1971, Wonder had several top twenty hits, including "Uptight (Everything's Alright)" (1966), "Mon Cherie Amour" (1969), and "Signed, Sealed, Delivered I'm Yours" (1970), cowritten with Syreeta Wright, to whom he was married for eighteen months.

In 1971 at the age of twenty-one, Wonder obtained a release from his Motown contract that allowed him to break free of the strict Motown production sound. With his substantial earnings he employed the latest electronic technology, the ARP and Moog synthesizers, to record original material for future use, playing most of the instruments himself. That same year he negotiated a new contract with Motown for complete artistic control over his career and production. The album *Music in My Mind* that followed was the first fruit of his new artistic freedom. In 1975, he renegotiated with Motown for an unprecedented $13 million advance for a seven-year contract.

Wonder's humanitarian interests have charged his music since the early 1970s. His material has consistently reflected an effort to incorporate contemporary musical trends (REGGAE and RAP) and social commentary that has given a voice to the evolution of American black consciousness. This is demonstrated in "Living for the City" (1973), a ghetto-dweller's narrative; "Happy Birthday" (1980), the anthem for a nationwide appeal to honor the Rev. Dr. Martin

The versatile soul musician Stevie Wonder in 1973, at the time of the release of his album *Inversions.* (AP/Wide World Photos)

Luther KING, Jr.'s birthday as a national holiday; "Don't Drive Drunk" (1984); and "It's Wrong," (1985), a critique of South African apartheid. He also supported such causes as the elimination of world hunger (U.S.A. for Africa's recording "We Are the World"), AIDS research ("That's What Friends Are For" with singer Dionne WARWICK and friends, 1987), and cancer research.

Wonder's popularity has been strengthened by his scores for various films including *The Woman in Red* (1984), which won an Oscar for Best Original Song ("I Just Called to Say I Love You") and *Jungle Fever* (1991), a film about interracial relationships by Spike LEE. Wonder has been the recipient of more than sixteen Grammys, eighteen gold records, five platinum records, and five gold albums. He was inducted into the Songwriters Hall of Fame in 1982.

REFERENCES

HARDY, PHIL, and DAVE LAING. *The Faber Companion to Twentieth-Century Popular Music.* London, 1990.

"Stevie Wonder." *Current Biography.* New York, 1975.

KYRA D. GAUNT

Wood, Donna (November 21, 1954–), modern dancer. Born in New York City as the middle child of seven children, Donna Wood was raised in Dayton, Ohio, where she began studying dance with the Dayton Contemporary Dance Company at the age of five. She trained extensively in ballet under Josephine

Schwartz of the Dayton Ballet. Wood moved to New York in 1972 and joined the Alvin Ailey American Dance Theater in September of that year (*see* Alvin AILEY). Five years later, she became a leading dancer with the company, noted for her lyrical musicality, supple extensions, and strong, graceful jumps. Wood's performances in Ailey's *Memoria* (1979) and Todd Bolender's *The Still Point* (1954, revived 1980) propelled her to international recognition as a significant interpreter of dramatic dance roles. Her artistry was underscored by a quiet simplicity in performance, and in 1980 she told the *New York Times*, "I have learned never to force a movement, but to arrive at it naturally."

During the early 1980s Wood guest-starred with the Hamburg Ballet, the Vienna State Opera, and the Royal Danish Ballet. In 1985 she left the Ailey company, and took a two-year faculty appointment at CalArts of Valencia, Calif. In 1987 she starred in a production of *Sophisticated Ladies,* which toured the Soviet Union and Japan. Three years later Wood retired from performing and married attorney Peter Michael Sanders. In 1991 she and Sanders created the Donna Wood Foundation, "to assist young dancers as they are embarking on careers, giving advice on additional education and skill development" necessary to survival in the dance world.

REFERENCES

FLATOW, SHERYL. "Down to the Earth: Donna Wood, Ailey's Shining Star." *Ballet News* (November 1983): 19–22.

GRUEN, JOHN. "Donna Wood—'Alvin Ailey Taught Me To Be Myself.' " *New York Times,* December 14, 1980.

SMALL, LINDA. "Donna Wood: Catch the Gazelle." *Dance Magazine* (December 1979): 76–79.

THOMAS F. DEFRANTZ

Woodard, Lynette (August 12, 1959–), basketball player. Lynette Woodard was born and raised in Wichita, Kan., the youngest child of a fireman and a housewife. After leading the Wichita North High School basketball team to two state championships, Woodard, though heavily recruited nationwide, chose to accept a scholarship to the nearby Kansas University in 1977.

At college, Woodard, an honor student and four-time All-American, amassed an impressive record. She set the all-time NCAA women's basketball scoring record of 3,649 points and the all-time Kansas University basketball scoring record for a single game of 49 points, surpassing the old record held by Wilt CHAMBERLAIN. Although the United States boycotted the 1980 Olympics, Woodard was selected to be a member of the women's basketball team should they have competed.

Despite Woodard's impressive college performance, there were few professional opportunities for female basketball players in the United States when she graduated from college in 1981. Woodard played in a professional league in Italy for one year, but, disillusioned, she returned to the University of Kansas. There she accepted a paid position as an academic adviser and a volunteer position as assistant women's basketball coach. Woodard also began training for her second trip to the Olympics. In 1984 she and her teammates succeeded in capturing the first gold medal for the U.S. women's basketball team since it became an Olympic sport in 1976.

The signing of Woodard from a field of eighteen female candidates by the Harlem Globetrotters in 1985 temporarily revived the economic fortunes of the flagging club. During her stint as a Globetrotter, Woodard's court performances alerted people to the high skill level characteristic of women's basketball in the 1980s and 1990s. In 1993 Woodard retired from the Globetrotters and accepted a position as athletic director for the Kansas City (Kansas) school district.

REFERENCES

"Basketball's Crown Princess." *Ebony* (December 1985): 131–132ff.

KORT, MICHELE. "Lynette Woodard." *Ms* (January 1986): 44–45ff.

CINDY HIMES GISSENDANNER

Woodruff, Hale Aspacio (August 26, 1900– September 10, 1980), painter, educator. Born in Cairo, Ill., Hale Woodruff moved with his mother to Nashville, Tenn., where he attended public schools. In 1920, he moved to Indianapolis to study at the John Herron Art Institute while working part-time as a political cartoonist for the black newspaper the *Indiana Ledger*. In 1927, he traveled to Europe and lived in France for the next four years. He studied with the African-American painter Henry O. TANNER and at the Académie Scandinave and Académie Moderne in 1927 and 1928. Like other American artists who sought an education in the center of the art world, Woodruff spent his time recapitulating the succession of avant-garde art movements of the previous fifty years. His landscapes and figure paintings first synthesized elements of the late-nineteenth-century styles of impressionism and postimpressionism in

their interest in the nonrealistic shifts of color and the manipulation of the texture of the brushstroke. His key work of the period, *The Card Players* (1930; repainted in 1978), plays on the distortions of figure and space found in the work of Paul Cézanne and the cubists Pablo Picasso and Georges Braque. This work emphasizes Woodruff's debt to African art (which had also been a source for the cubists) in the masklike nature of the faces. Woodruff had first encountered African art in Indianapolis in the early 1920s, when he saw one of the first books on the subject. As it was written in German, he could not read it; but he was intrigued by the objects. Woodruff and the African-American philosopher and teacher Dr. Alain LOCKE visited flea markets in Paris where the artist bought his first works of African art.

In 1931, Woodruff returned to the United States to found the art department at Atlanta University. Through his pioneering efforts, the national African-American arts community developed the kind of cohesion that previously had been lacking. Woodruff himself taught painting, drawing, and printmaking. To teach sculpture, he recruited the artist Nancy Elizabeth Prophet. The works that came from the department's faculty and students came to be known as the "Atlanta School" because their subjects were the African-American population of that city. Fully representational with modernist nuances, they fall into the style of American regionalism practiced throughout the country at that time. The use of woodcuts and linoleum prints added a populist tone to these works, which dealt with everyday life. Besides teaching, he brought to Atlanta University exhibitions of a wide range of works, including those of historical and contemporary black artists and the Harmon Foundation exhibitions, providing a unique opportunity for the entire black Atlanta community, since the local art museum was then segregated. The year 1942 saw the initiation of the Atlanta University Annuals, a national juried exhibition for black artists that expanded opportunities for many who were frequently excluded from the American art scene. Woodruff's legacy can be seen in the remarkable list of his students—Frederick Flemister, Eugene Grigsby, Wilmer JENNINGS, and Hayward Oubré—and of the artists who showed in the Annuals, including Charles ALSTON, Lois Mailou JONES, Elizabeth CATLETT, Claude Clark, Ernest CRICHLOW, Aaron DOUGLAS, William H. JOHNSON, Norman LEWIS, Hughie LEE-SMITH, Jacob LAWRENCE, and Charles WHITE. The exhibitions continued until 1970.

During this same period, Woodruff, as part of his efforts to present a populist art, produced a series of murals. Two of his inspirations were the murals placed in public buildings across the country by WPA artists, and the Mexican mural movement. Woodruff himself received a grant to study with Diego Rivera for six weeks in the summer of 1934, when he assisted in fresco painting. After completing two WPA murals, he painted the major work of this period, the *Amistad Murals* (1938–1939) at Talladega College (Alabama). Designed in the boldly figurative style associated with social realism, the murals depict the mutiny led by Cinqué aboard the slave ship *Amistad* in 1834 and the subsequent trial and repatriation of the Africans. Other mural projects included *The Founding of Talladega College* (1938–1939), murals at the Golden State Mutual Life Insurance Company (Los Angeles) on the contribution of blacks to the development of California (1948), and *The Art of the Negro* for Atlanta University (1950–1951).

In 1946, after receiving a two-year Julius Rosenwald Foundation Fellowship to study in New York (1943–1945), Woodruff moved to that city permanently to teach in the art education department of New York University. The move was not a rejection of the South, but came as an attempt by Woodruff to be part of the new art capital which had shifted from Paris to New York. Woodruff changed his style from that of a figurative painter of the American scene to a practitioner of the ideas of abstract expressionism. While employing the gestural spontaneity of that style, he incorporated design elements from the African art he had studied since his student days in Indianapolis. Worked into his compositions are motifs from a variety of African cultural objects, including Asante goldweights, Dogon masks, and Yoruba Shango implements—a kind of aesthetic pan-Africanism. This, the third major style of his career, demonstrates the adaptability of an artist always open to new currents in both the aesthetic and political worlds. He continued to be supportive of African-American artists by being one of the founders in 1963 of Spiral, a group of black New York artists (including Charles Alston, Emma Amos, Romare BEARDEN, Norman Lewis, and Richard Mayhew) who sought to weave the visual arts into the fabric of the civil rights struggle.

Woodruff received awards from the Harmon Foundation in 1926, 1928 and 1929, 1931, 1933, and 1935, and an Atlanta University Purchase Prize in 1955. He received a Great Teacher Award at NYU in 1966 and became professor emeritus in 1968.

REFERENCES

REYNOLDS, GARY, and BERYL J. WRIGHT. "Hale Aspacio Woodruff." In *Against the Odds: African-American Artists and the Harmon Foundation*. Newark, N.J., 1989, pp. 275–279.

STOELTING, WINIFRED L. Hale Woodruff, Artist and Teacher: Through the Atlanta Years. Ph.D. diss., Emory University, 1978.

Studio Museum in Harlem. *Hale Woodruff: 50 Years of His Art*. New York, 1979.

WILSON, JUDITH. " 'Go Back and Retrieve It': Hale Woodruff, Afro-American Modernist." In *Selected Essays: Art and Artists from the Harlem Renaissance to the 1980s*. Atlanta, 1988.

HELEN M. SHANNON

Woods, Granville T. (April 23, 1856–January 18, 1910), inventor. Born in Columbus, Ohio, Granville Woods began work at age ten as an apprentice in a machine shop that repaired railroad equipment. From 1882 to 1884, he worked as an engineer for the Danniville Southern railroad. He then decided to become an inventor and opened a shop with his brother in Cincinnati. From 1884 to 1907, Woods received thirty-five U.S. patents for inventions that contributed to the development of the transportation and communication industries. He received his first patent in early 1884 for a steam-boiler furnace that required less fuel than the existing models. That same year, he was awarded a second patent for a telephone transmitter. This invention, which he sold to American Bell Telephone Company in Boston, produced voice signals clearer than those of other telephonic devices at the time. His third patent, granted in April 1885, made it possible for telephone messages to be transmitted over the same wires used for carrying telegraphic messages. In November 1887, Woods patented an Induction Telegraph System, which improved communication between moving trains. It also allowed station houses to ascertain the exact location of trains on the rails, thereby greatly reducing accidental train collisions, which were frequent in the early days of the railroads. Other inventions in the late 1880s also improved the safety of railway travel. They included an electromagnetic brake, an automatic cutoff for electric circuits, and a regulator for electric motors.

In 1890, Woods moved to New York City. There he patented more electrical devices. Despite his prolific work, Woods was never able to market his inventions successfully. Instead, Woods had to sell his inventions at little profit to the well-financed white-owned corporations, such as General Electric and American Bell Telephone. The last years of Woods's life were difficult. He lived in virtual poverty and turmoil in New York City as he faced costly legal and court fees battling businessmen for control of his inventions. In 1892, he was briefly jailed for libel after accusing the American Engineering Company of infringing on his patents. Three years before his death, Woods was still receiving patents. His last re-

Granville T. Woods. (Photographs and Prints Division, Schomburg Center for Research in Black Culture, The New York Public Library, Astor, Lenox and Tilden Foundations)

corded invention was a vehicle controlling device in 1907. Woods died in New York City in 1910.

REFERENCES

BAKER, HENRY E. "The Negro in the Field of Invention." *Journal of Negro History* (January 1917): 21–36.

HAYDEN, ROBERT C. "The Inventive Genius of Granville T. Woods." *Journal of the National Technical Association* (Summer 1990): 44.

SIMMONS, WILLIAM J. *Men of Mark: Eminent, Progressive and Rising*. Louisville, Ky., 1887.

ROBERT C. HAYDEN

Woodson, Carter Godwin (December 19, 1875–April 3, 1950), historian, educator. He was born in New Canton, in Buckingham County, Va. Woodson probably descended from slaves held by Dr. John Woodson, who migrated from Devonshire, England, to Jamestown, Va., in 1619. He was the first and only black American of slave parents to earn a Ph.D. in history. After the Civil War, Woodson's grandfather and father, who were skilled carpenters, were forced into sharecropping. After saving for many years, the

family purchased land and eked out a meager living in the late 1870s and 1880s.

Although they were poor, James Henry and Anne Eliza Woodson instilled in their son high morality and strong character through religious teachings and a thirst for education. One of nine children, the youngest boy and a frail child, Carter purportedly was his mother's favorite and was sheltered. He belonged to that first generation of blacks whose mothers did not have to curry favor with whites to provide an education for their children. As a boy Woodson worked on the family farm, and in his teens he was an agricultural day laborer. In the late 1880s the family moved to West Virginia, where Woodson's father worked in railroad construction and Woodson worked as a coal miner in Fayette County. In 1895, at the age of twenty, Woodson enrolled at Frederick Douglass High School. Perhaps because he was older than the rest of the students and felt that he needed to catch up, he completed four years of course work in two years and graduated in 1897. He then enrolled at BEREA COLLEGE in Berea, Ky., which had been founded by abolitionists in the 1850s for the education of ex-slaves. He briefly attended LINCOLN UNIVERSITY in Pennsylvania, but graduated from Berea College in 1903, just a year before Kentucky would pass the infamous "Day Law," which prohibited interracial education. Woodson then briefly taught at Frederick Douglass High School. Because of his belief in the uplifting power of education, and because of the opportunity to travel to another country to observe and experience its culture firsthand, he decided to accept a teaching post in the Philippines, remaining there from 1903 to 1907.

Experiences as a college student and high school teacher expanded and influenced Woodson's worldview and shaped his ideas about the ways in which education could transform society, improve race relations, and benefit the lower classes. Determined to obtain additional education, he enrolled in correspondence courses at the University of Chicago. By 1907 he was enrolled there as a full-time student and earned both a bachelor's degree and a master's degree in European history. His thesis examined French diplomatic policy toward Germany in the eighteenth century. He then attended Harvard University, matriculating in 1909 and earning his Ph.D. in history in 1912. He studied with Edward Channing, Albert Bushnell Hart, and Frederick Jackson Turner, the latter of whom had moved from the University of Wisconsin to Harvard in 1910. Turner influenced the interpretation Woodson advanced in his dissertation, which was a study of the events leading to secession in West Virginia after the Civil War broke out. Unfortunately, Woodson never published the dissertation.

Carter G. Woodson. (Photographs and Prints Division, Schomburg Center for Research in Black Culture, The New York Public Library, Astor, Lenox and Tilden Foundations)

Woodson taught in the Washington, D.C., public schools, at HOWARD UNIVERSITY, and at the West Virginia Collegiate Institute. In 1915, in Chicago, he founded the Association for the Study of Negro Life and History, and began the work that sustained him for the rest of his career. Indeed, his life was given over to the pursuit of truth about the African and African-American pasts. He later founded the *Journal of Negro History,* the *Negro History Bulletin,* and the Associated Publishers; launched the annual celebration of Negro History Week in February 1926; and had a distinguished publishing career as a scholar of African-American history.

After the publication in 1915 of *The Education of the Negro Prior to 1861,* his first book, Woodson began a scholarly career that, even if judged by output alone, very few of his contemporaries or successors could match. By 1947, when the ninth edition of his textbook *The Negro in Our History* appeared, Woodson had published four monographs, five textbooks, five edited collections of source materials, and thirteen articles, as well as five sociological studies that were collaborative efforts. With his writings covering a wide array of subjects, Woodson's scholarly productivity and range were equally broad. He was among

the first scholars to study SLAVERY from the slaves' point of view, and to give attention to the comparative study of slavery as an institution in the United States and in Latin America. His work prefigured the interpretations of contemporary scholars of slavery by several decades. Woodson also noted in his work the African cultural influences on African-American culture.

One of the major objectives of his own research and the research program he sponsored through the Association for the Study of Negro Life and History was to correct the racism promoted in the work published by white scholars. Woodson and his assistants pioneered in writing the social history of black Americans, and used new sources and methods. They moved away from interpreting blacks solely as victims of white oppression and racism. Instead, blacks were viewed as major actors in American history. In recognition of his achievements, the NATIONAL ASSOCIATION FOR THE ADVANCEMENT OF COLORED PEOPLE (NAACP) in June 1926 presented Woodson with its highest honor, the prestigious SPINGARN MEDAL. In the award ceremony, John Haynes Holmes, minister and interracial activist, cited Woodson's tireless labors to promote the truth "about Negro life and history."

Woodson suffered a heart attack and died in his sleep on April 3, 1950, in his Washington, D.C., home. He had dedicated his life to the exploration and study of the African-American past. In view of the enormous difficulties he faced battling white racism and in convincing whites and blacks alike that his cause was credible and worthy of support, the achievement of so much seminal work in black history seems almost miraculous. Through his own scholarship and the programs he launched in the Association for the Study of Negro Life and History, Woodson made an immeasurable contribution to the advancement of black history.

REFERENCES

GOGGIN, JACQUELINE. *A Life in Black History.* Baton Rouge, La., 1993.
MEIER, AUGUST, and ELLIOTT RUDWICK. *Black History and the Historical Profession.* Urbana, Ill. 1986.

JACQUELINE GOGGIN

Woolridge, Anna Marie. *See* Lincoln, Abbey.

Work, John Wesley, III (June 15, 1901–May 17, 1967), composer.

John Wesley Work III was born in Tullahoma, Tenn., into a family of professional musicians. His father, John Work II, and an uncle Frederick Work, made significant contributions as folk music researchers and collectors; a brother, Julian C. Work, was a composer. The family had close ties to historic musical developments at FISK UNIVERSITY, notably to the FISK JUBILEE SINGERS. His mother, Agnes Hayes Work, a singer, helped Fisk train singing groups; his father directed the Jubilee Singers and arranged tours. John Wesley Work III studied music at Fisk and received a degree in history in 1923. He studied voice at the Institute of Musical Arts (now the Juilliard School of Music) in New York in 1923–1924, and received a teaching diploma from Columbia University in 1930; he studied composition at Yale University from 1931 to 1933. He spent his entire career, from 1927 to 1966, at Fisk University, where he taught theory and directed the Jubilee Singers, serving as chair of the music department from 1951 to 1957.

Although he is best known for his choral and solo arrangements of spirituals and African-American folk songs, for which he enjoyed a substantial success as a publisher, Work composed in a variety of styles and media throughout his career. His output includes music for full orchestra, chamber ensemble, violin, piano, and organ. While much of his writing draws upon folk song sources, many of his original compositions do not contain folk elements. His best known compositions are *Yenvalou,* for orchestra (1946); "Sassafras" (1946), "Scuppernon" (1951), and "Appalachia" (1954), for solo piano; an organ suite, *From the Deep South* (1936); and the cycle *Isaac Watts Contemplates the Cross* (1962). *The Singers,* a cantata, won first prize in the 1946 Fellowship of American Composers competition.

Work was highly respected as an authority on black American music. He did fieldwork and collecting throughout the South, and cofounded the Fort Valley College Folk Music Festivals with Willis Laurence JAMES in 1941, recording the 1942 festival with him for the Library of Congress; he also recorded for the library in other areas. He lectured widely and published articles on black American music in journals and music dictionaries. His major published books are *American Negro Songs and Spirituals* (1940) and *Jubilee* (1962).

REFERENCE

GARCIA, WILLIAM BURRES. The Life and Choral Music of John Wesley Work (1901–1967). Ph.D. diss., University of Iowa, 1973.

REBECCA T. CUREAU

Work, Monroe Nathan (August 15, 1866–May 2, 1945), sociologist.

Soon after Work's birth in 1866, in rural Tredell County, N.C., his parents joined

many other former slaves migrating westward and acquired a farm under the provisions of the Homestead Act. Remaining to help his aging parents, Work began secondary school when he was twenty-three. In 1903 he received his Master of Arts degree in sociology from the University of Chicago and accepted a teaching job at Georgia State Industrial College in Savannah, Ga., where he met and married Florence E. Henderson.

Appalled by the plight of the city's African Americans, in 1905 he took two actions to improve conditions. He attended the conference called by W. E. B. Du Bois that established the NIAGARA MOVEMENT and founded the Savannah Men's Sunday Club, which combined protest, lobbying, and petitioning with the functions of a lyceum and civic club. By means of a streetcar boycott, the group attempted, but finally failed, to prevent the enactment of the city's first segregation law in 1906.

In 1908 Booker T. WASHINGTON offered Work a position at Tuskegee Institute in Macon County, Ala. After his alliance with Du Bois, Work seemed an unlikely candidate to accept a job from Washington—the nemesis of the Niagara Movement. By 1908, however, Work was disillusioned with the power of protest and the Niagara Movement was floundering. Work reassessed his talents. Dignified instead of dynamic, he was a quiet scholar and researcher rather than a leader. Believing prejudice was rooted in ignorance, Work had long been compiling "exact knowledge concerning the Negro." The resources and audience available at Tuskegee for his research proved irresistible.

Work utilized his Department of Records and Research to compile a daily record of the African-American experience from newspaper clippings, pamphlets, reports, and replies to letters of inquiry. In 1912 he began publishing the *Negro Yearbook* and the yearly Tuskegee Lynching Report to enlighten black and white newspaper editors, educators, and leaders, especially in the South. In 1927 Work published *A Bibliography of the Negro in Africa and America,* the first extensive, classified bibliography of its kind. In addition, he was one of the participants invited to the conference held at Howard University on November 7, 1931, to plan the proposed (but never completed) *Encyclopedia of the Negro.*

Work also remained an activist after leaving the Niagara Movement for Tuskegee. He worked to improve black health conditions, to eradicate lynching, and to improve race relations. A pivotal figure in the establishment of National Negro Health Week in 1914, he subsequently organized it for seventeen years. He also participated in the southern antilynching movement of the Atlanta-based Commission on Interracial Cooperation and the Association of Southern Women for the Prevention of Lynching. From those contacts he became involved in other interracial groups.

By the time of his death in 1945, Work had published over seventy articles and pamphlets, including pioneering studies of Africa's contributions and its impact on African-American culture. In 1900 he was the first African American to publish an article in the *American Journal of Sociology,* and in 1929 he presented a paper at the annual meeting of the American Historical Association.

REFERENCES

GUZMAN, JESSIE P. "Monroe Nathan Work and His Contributions." *Journal of Negro History* 34 (1949): 428–461.

McMURRY, LINDA O. "A Black Intellectual in the New South: Monroe Nathan Work." *Phylon* 41 (1980): 333–344.

———. *Recorder of the Black Experience: A Biography of Monroe Nathan Work.* Baton Rouge, La., 1985.

LINDA O. McMURRY

Works Project Administration (WPA).

Originally the Works Progress Administration, later the Works Project Administration, began in 1935, when President Franklin D. Roosevelt established it to distribute the $4.88 billion appropriated by Congress for an emergency jobs program. Between 1935 and its ending on February 1, 1943, the WPA spent $11 billion and employed more than eight million people in a variety of construction, clerical, professional, and arts endeavors.

The WPA came at a time of critical need for African Americans. The depression, while imposing dire hardships on people of all races and ethnic backgrounds, struck blacks with particular impact. In 1934 and 1935, one out of every three New York City workers was jobless, but in Harlem one out of every two African Americans was unemployed. Pittsburgh's black laborers had an unemployment rate of 48 percent; its white workers, 31 percent. Between 1935 and 1943, the WPA employed over a million African Americans. WPA wages became the third largest source of income for blacks, exceeded only by income from agriculture and domestic service.

The WPA not only hired African Americans; its projects contributed to the well-being of blacks in many important ways. WPA construction crews built and renovated hospitals, housing projects, schools, parks, playgrounds, and swimming pools in African-American communities. Impoverished black children and adults received free medical and dental care at clinics staffed by black and white doctors and

Jim Walker, 100 years old, learns to write at a WPA Adult Education Center in Birmingham, Ala. (Photographs and Prints Division, Schomburg Center for Research in Black Culture, The New York Public Library, Astor, Lenox and Tilden Foundations)

dentists employed by the WPA. Over 5,000 African-American instructors and supervisors worked on the WPA's education programs. They taught a quarter of a million black adults to read and write, thus helping cut the rate of black illiteracy from 16.4 percent at the start of the 1930s to 11.5 percent at its end.

An editorial in OPPORTUNITY in 1939 credited the WPA in northern cities with giving qualified blacks their first chances for employment in white-collar positions, and Alain LOCKE, an early chronicler of the art movement known as the HARLEM RENAISSANCE, attributed its survival in the 1930s to the WPA. The WPA FEDERAL WRITERS' PROJECT employed thousands of black poets and novelists, among them Margaret WALKER, Richard WRIGHT, Sterling A. BROWN, Ralph ELLISON, Zora Neale HURSTON, and Claude MCKAY. Project employees researched and later wrote many studies of African American life, including *The Negro in Virginia* (1940); Benjamin Botkin's *Lay My Burden Down: A Folk History of Slavery* (1945); and Arna BONTEMPS's and Jack Conroy's *They Seek a City* (1945).

The WPA funded black acting troupes. For example, the Negro Theatre Project staged *Walk To-gether Chillun* by African-American playwright Frank Wilson at the Lafayette Theatre in Harlem and had its greatest hit with an all-black *Macbeth*. African-American musicians hired by the WPA gave concerts in schools and music halls, played for street dances, and gave free music lessons. In 1936, thirty-five hundred Harlemites were enrolled in WPA music classes. African-American artists such as Jacob LAWRENCE, Charles ALSTON, and Palmer HAYDEN painted and gave free art classes at the Harlem Community Art Center and thousands of other WPA centers across the nation. As Ralph Ellison remarked, black "writers and would-be writers, newspaper people, dancers, actors—they all got their chance" at the WPA.

Despite its substantial contributions to the welfare of African Americans, the WPA never fully met the needs of the unemployed, white or black. At no point did it hire more than one-third of the able-bodied jobless who wanted to work. Furthermore, despite orders from President Roosevelt and the national WPA directors, Harry Hopkins and Aubrey Williams, against discrimination "on any grounds, whatsoever, such as race, religion, or political affiliation," restrictive and unfair practices did occur. In the rural South, relief officials too often denied destitute African Americans certification for WPA jobs. The WPA adjusted its wage scales to prevailing rates of pay in the region. Thus, WPA laborers in the South, where about 75 percent of the black working population lived, received far lower compensation than WPA personnel in the North. Further, African Americans, even in the North, clustered in the least-skilled, poorest-paid WPA positions. In the New York City WPA in 1937, only 0.5 percent of its black employees were supervisors, while 75 percent were classified as unskilled laborers. This situation within the WPA resulted both from discriminatory practices and the generally limited educational and skill levels of African Americans on the relief rolls from which the WPA took its employees. While the WPA did try to educate and retrain its workers, especially after 1939, it never put enough resources into such efforts to upgrade substantially the skills of its common laborers.

REFERENCES

BLUMBERG, BARBARA. *The New Deal and the Unemployed: The View from New York City.* Lewisburg, Pa., 1979.

MANGIONE, JERRE. *The Dream and the Deal: The Federal Writers' Project, 1935–1943.* Boston, 1972.

MCELVAINE, ROBERT S. *The Great Depression.* New York, 1984.

SITKOFF, HARVARD. *A New Deal for Blacks.* New York, 1978.

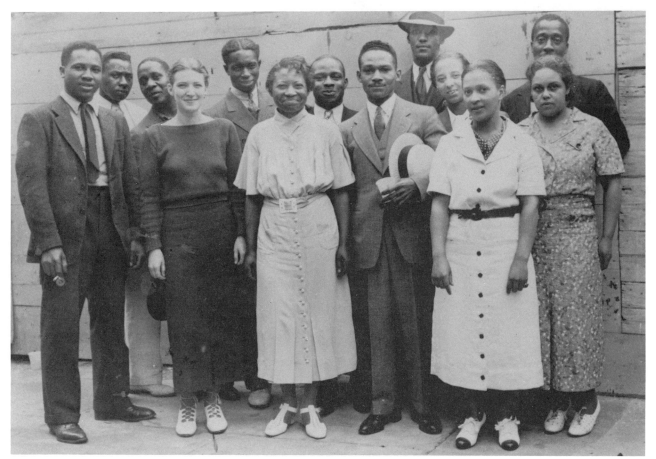

(Top) O. J. Thomas (standing center), president of the Negro State Teachers' Association, with an eighty-six-year-old woman, the oldest student in the district, who has been taught to read and write in a WPA education class. Behind her is an eighty-year-old student. (Bottom) Harlem Community Art Center instructors (front row, left to right) Zell Ingram, Pemberton West, Augusta Savage, Robert Pious, Sara West, Gwendolyn Bennett; (second row, left to right) Elton Fax, Rex Goreleigh, Fred Perry, William Artis, Francisco Lord, Louise Jefferson, Norman Lewis. (Photographs and Prints Division, Schomburg Center for Research in Black Culture, The New York Public Library, Astor, Lenox and Tilden Foundations)

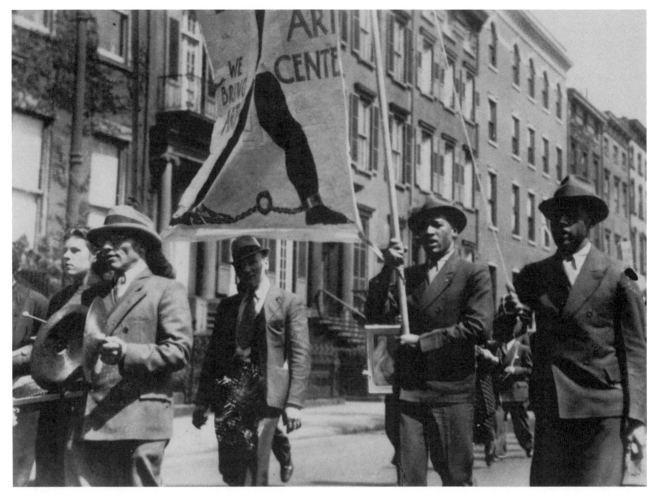

At a WPA Artists Union March in 1944, union members Morgan and Marvin Smith (at right) help to carry the WPA banner downtown, New York City. (Photographs and Prints Division, Schomburg Center for Research in Black Culture, The New York Public Library, Astor, Lenox and Tilden Foundations)

WOLTERS, RAYMOND. *Negroes and the Great Depression: The Problem of Economic Recovery.* Westport, Conn., 1970.

BARBARA BLUMBERG

World Saxophone Quartet, jazz ensemble. The World Saxophone Quartet, the most influential and popular ensemble working in the tradition of unaccompanied saxophone ensembles, was organized in 1976 when three former members of the St. Louis-based Black Artists Group (BAG)—baritone saxophonist Hamiett Bluiett (1940–), alto saxophonist Julius Hemphill (1940–), and alto saxophonist Oliver LAKE (1942–)—joined with the tenor saxophonist and bass clarinetist David Murray (1955–). At first they worked with a rhythm section of bass and drums, but in 1977 they began to play unaccompanied. Nonetheless, they created a strong rhythmic

drive and evoked the powerful yet nuanced sounds of the great saxophone sections of the big band era within an experimental context.

The World Saxophone Quartet's first album was *Point of No Return* (1977), followed by *Steppin'* (1978). Although most of the group's material was composed by Hemphill, they began to branch out into popular African-American idioms, particularly on *Revue* (1980), *Dances and Ballads* (1982), and *Rhythm and Blues* (1989). They have also recorded *World Saxophone Quartet Plays Duke Ellington* (1986), and *Metamorphosis* (1991), which included West African drum accompaniment. On the latter album, Arthur Blythe (1940–) appears in place of Hemphill, who left the ensemble in 1990.

REFERENCE

SANTORO, GENE. "Building on a New Tradition." *Downbeat* 56 (July 1989): 16–19.

TRAVIS JACKSON

World War I. African Americans saw World War I as an opportunity to demonstrate their patriotism and to convince whites that they should be granted full civil rights, but these efforts faced hostility and discrimination. Eventually over 400,000 blacks would serve in segregated organizations in the U.S. armed forces, mainly as laborers, though most of the attention would be focused on the two combat divisions. African-American women faced even more barriers in their attempts to join the crusade for democracy.

When the United States entered World War I in April 1917, most African Americans were eager to take part in the war. Many accepted the concept

War hero Needham Roberts of the 369th U.S. Infantry as he appeared in *The Crisis* in May 1919. He is wearing the Croix de Guerre, with palm, two service stripes, and two wound stripes. (Prints and Photographs Division, Library of Congress)

enunciated the following year by W. E. B. DU BOIS that they should forget their grievances for the duration of the war. But from the beginning there were clear indications that the problems of discrimination would not go away. Even before American participation in the war began, Lt. Col. Charles Young, the highest ranking African-American regular army officer, was found physically unfit for duty and placed on the retired list. Many African Americans thought that he was being removed because of the possibility that he might become a general and that white officers and enlisted men might have to serve under his command. Later, the reaction of the Army to the August 1917 riot in Houston (*see* HOUSTON, 1917) also demonstrated that African Americans would not be well treated in the armed forces. In an effort to placate the community, Secretary of War Newton Baker appointed Emmett J. Scott as his assistant for racial matters, but Scott had no real influence.

Despite the traditions established in the Spanish-American War and by the long service of the four Regular Army African-American regiments, the Army leadership believed that African Americans should not be asked to participate in combat. On the other hand, they believed that blacks made excellent laborers, especially if placed in organizations commanded by white commissioned and even noncommissioned officers. As a result, about 89 percent of all blacks who participated in World War I served in labor units both in the United States and in France. These organizations performed a variety of duties, including building training camps and loading supplies. Morale was quite low because the soldiers could see little relationship between their work and the war effort. Many of the officers did not want to be there; they saw little chance of promotion from being involved in the supply operations, and many did not like African Americans.

There was a great deal more controversy over the 11 percent of the black soldiers who were members of the combat arms. The arguments involved whether they should be allowed into combat, how the units should be organized, and who should command them. Some African Americans wanted the opportunity to fight the Germans but opposed the idea of a segregated combat division. The Army, however, was adamant that segregation must continue. Because African Americans wanted to take an active role in the war, most accepted segregation as the condition of their participation. The Army also at first refused to allow combat units to have black officers; in June 1917, it permitted the regiments to have lower-ranking African-American commissioned officers—lieutenants and captains—while keeping the control of the regiments and the divisional staff firmly in the hands of whites. The question of whether

African-American officers should be trained in integrated or segregated camps also engendered controversy. Again the Army won, and established Camp Des Moines, in Iowa, as a segregated camp where all African-American officers received their training.

Initially the Army planned to create only one black division, the 92nd, and used the draft to fill its ranks. Charles Ballou, a white officer with prior service with black Regular Army units and the commander of Camp Des Moines, was appointed its leader. He made it clear that African Americans under his command were not to protest any kind of discrimination. Ballou, like many other officers, also made it clear that he did not think African-American officers were very good or that his soldiers would ever be able to perform well in combat. Division morale and effectiveness were not helped when it was forced to train at seven different sites in the United States before being shipped to France in 1918. Once in Europe the 92nd received almost no training in the front lines and had little equipment to deal with the barbed wire and machine gun emplacements that they had to face. As a result, they did not perform very well when placed into combat.

As part of the September 1918 Meuse-Argonne Offensive, the 368th Infantry, part of the 92nd Division, was given the task of acting as a connecting link with the French army on its part of the front lines. After five days of battle, the regiment was relieved of duty. According to Army reports, the regiment had not met its objectives. Then the whole division was pulled out of the front lines and spent much of the remainder of the war as reserves or on patrol duty in relatively quiet sectors of the front. Ballou believed that the solution to the problems was to remove the black officers; he proposed to court-martial many of them. Though few of these trials were actually carried out, they destroyed what little morale remained in the division. For most white officers during the war and later, the performance of the 92nd Division reinforced their stereotypes of black soldiers: they were cowards who would not perform well under the leadership of African-American officers. For African Americans the whole experience demonstrated that whites would not let them succeed.

However, the experiences of the other African-American division were different. This provisional division, the 93rd, was composed of three National Guard regiments and one regiment of draftees, largely from the South. This division never had a staff or attached artillery regiments but was essentially four regiments grouped together as a way to absorb these African-American National Guard regiments. The 15th New York Infantry became the 369th Infantry, and its regimental band, under the leadership of James Reese EUROPE, became well

World War I hero Henry Johnson, a member of the 369th Infantry, fought off a German raiding party and rescued his comrades. (Photographs and Prints Division, Schomburg Center for Research in Black Culture, The New York Public Library, Astor, Lenox and Tilden Foundations)

known in the United States and in France. A number of the African-American National Guard officers were removed, including Franklin A. Dennison, commander of the 8th Illinois, and replaced by white officers. When the provisional division arrived in France, John J. Pershing willingly turned them over to the control of the French, a policy that he rarely pursued with white divisions. As a result, the four regiments encountered a different attitude from their commanders, as the French were much more willing to treat African-American soldiers and officers as equals and wanted them to perform well in combat.

The first two African-American war heroes, Needham Roberts and Henry Johnson, came from this division. In May 1918 they were on the front lines, involved in a training exercise. They were attacked by a German raiding party. First they fired their rifles at the raiders and then used every other weapon at their disposal, including hand grenades and a bolo knife. Despite being wounded, they were successful

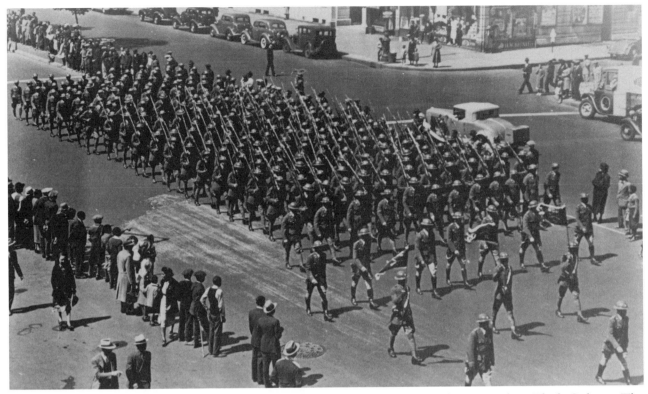

The 369th regiment. (Photographs and Prints Division, Schomburg Center for Research in Black Culture, The New York Public Library, Astor, Lenox and Tilden Foundations)

in beating off the Germans. Both received the French *Croix de Guerre* and became heroes in the black community. Despite their heroism, Pershing still wanted to bring them to the American Army and use them as laborers. The French refused and asked for more African-American troops; Pershing declined the request.

American officers tried to impose American racial standards on the French population. They instructed them that white Americans resented good treatment for African Americans; that the black soldiers had dangerous sexual proclivities; and that they should be segregated. When news of this secret order, which had been written on August 7, 1918, reached the United States in 1919, partly through the efforts of W. E. B. Du Bois, who published the directive in May 1919, anger mounted at the American government and the military.

African-American women also tried to enter the war effort. Adah Thoms, head of the Colored Nurses Association, volunteered her organization to become part of the Nursing Corps. For a long time the Army refused to accept this offer. Not until late in the war did this barrier break when the military allowed eighteen black nurses to serve at two camps in the United States; none was permitted to go to France.

Though most African Americans served in the United States Army, a few were allowed into the Navy. The attitude of that branch of the armed forces was that African Americans made excellent stewards. Only a few older sailors were able to break out of this occupational trap. The Marines continued to refuse to allow any African Americans to serve.

REFERENCES

BARBEAU, ARTHUR E., and HENRI FLORETTE. *The Unknown Soldiers: Black American Troops in World War I*. Philadelphia, 1974.

LITTLE, ARTHUR W. *From Harlem to the Rhine: The Story of New York's Colored Volunteers*. New York, 1936.

NALTY, BERNARD C. *Strength for the Fight: A History of Black Americans in the Military*. New York, 1986.

MARVIN E. FLETCHER

World War II. The Second World War and the emergency that preceded it enabled African Americans to enhance their status in both civilian life and military service. Circumstances worked to their advantage. An unprecedented threat required unprecedented mobilization, and the United States could not ignore its black citizens, who comprised roughly 10

percent of the populace. African-American men and women profited from the manpower crisis, whether in the armed forces or the civilian work force.

Better Treatment in the Segregated Armed Services

When World War II erupted in Europe in 1939, the neutral United States and its armed forces adhered to the principle of separate-but-equal, which had divided black from white since PLESSY V. FERGUSON gave it the force of law in 1896. The Navy, dependent upon black seamen until almost the end of the nineteenth century, accepted no African Americans from 1922 to 1932 and, when the ban ended, trained those it did enlist as cooks or messmen. The Army, in the 1930s, reduced its four black regiments, in existence as segregated units for some sixty years, to skeleton strength and reassigned many of the soldiers to housekeeping duties at scattered military posts. Operating within a congressionally authorized manpower ceiling, the War Department transferred some unfilled vacancies from the black regiments to the rapidly expanding Air Corps. Since Army aviation spurned African Americans, raiding the historic black regiments outraged civil rights organizations and inspired them to campaign for the admission of blacks to pilot training.

Although racial segregation permeated the military, faint signs of change appeared in 1939. Congress admitted African Americans to the Civilian Pilot Training Program administered by the Civil Aviation Administration and specified that the Air Corps cooperate in the endeavor, though not necessarily so fully as to accept the black graduates in its ranks. The Selective Service and Training Act of 1940 outlawed "discrimination against any person on account of race or color" in administering the draft, but it contained loopholes that perpetuated segregation despite the ban on discrimination. For example, black draftees could be told not to report because "suitable"—that is, segregated—quarters were not yet available. African-American leaders protested legislation that promised so much but delivered so little.

As the 1940 election approached, President Franklin D. Roosevelt, seeking an unprecedented third term, realized that he needed the support of those blacks, mainly in the large northern cities, who could exercise the right to vote. He and representatives of the War and Navy departments met with three African-American leaders: A. Philip RANDOLPH, head of the BROTHERHOOD OF SLEEPING CAR PORTERS; Walter WHITE, of the NATIONAL ASSOCIATION FOR THE ADVANCEMENT OF COLORED PEOPLE (NAACP); and T. Arnold HILL, an adviser to the federal National Youth Administration. This meet-

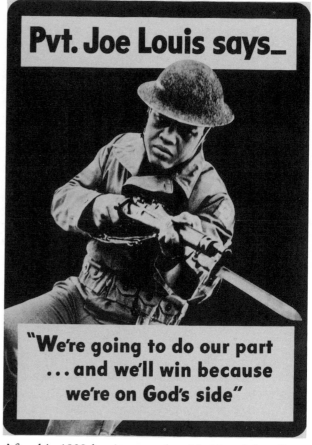

After his 1938 boxing match with Max Schmeling, Joe Louis became a symbol of the challenge to Nazism. Louis was a leading spokesman for the American effort in World War II, emblematic of strength and black support for the still-segregated armed forces. (Prints and Photographs Division, Library of Congress)

ing on September 27 produced a policy of giving black servicemen better treatment and greater opportunity within the confines of racial segregation.

Three appointments made in October 1940 symbolized the Roosevelt administration's new policy. Col. Benjamin O. DAVIS, Sr., received promotion to brigadier general, and became the first African American to attain that rank. When he reached retirement age a year later, he remained on active duty as a specialist on black troops in the office of inspector general. At the same time that Davis got his general's star, Col. Campbell C. Johnson, commander of the Reserve Officer Training Corps at Howard University, became an aide to the director of the Selective Service System, and another African American, Judge William H. HASTIE, former dean of the Howard University School of Law, was appointed a special adviser to the Secretary of War on matters pertaining to black soldiers.

Integration on the Assembly Line

"Demand the right to work and fight for our country," A. Philip Randolph urged in January 1941, three months after Roosevelt offered better treatment and broader opportunity to blacks serving in the armed forces and eleven months before Japan attacked Pearl Harbor and the United States went to war. Thus far, the President's policy had produced symbols rather than substance. Supported by other civil rights activists like Rayford LOGAN, of the National Urban League, and Walter White, Randolph threatened a March on Washington by 100,000 African Americans. The prospect of so massive a demonstration, scheduled for July 1, 1941, as Congress debated renewing the selective service legislation, persuaded Roosevelt to issue on June 25 Executive Order 8802, which specified that defense contracts bar discrimination and open training programs to minorities, established a Fair Employment Practice Committee to investigate violations, and resulted in cancellation of the march.

The Fair Employment Practice Committee lacked the power to subpoena witnesses or enforce compliance with the executive order and had no authority to investigate nondefense industries. Nevertheless, its deliberations publicized instances of discrimination, established the principle of federal protection of access to jobs by members of minorities, and inspired a number of northern states to establish similar agencies after the war. The committee survived bureaucratic struggles and political opposition until 1945, when segregationist opposition in Congress cut off its funding.

Despite the weakness and narrow scope of the Fair Employment Practice Committee, the African-American workforce underwent a marked change during World War II, especially in industrialized areas where labor was scarce. Overall, a million or more blacks found wartime employment, either replacing whites who entered the armed forces or occupying newly created jobs. Between January 1942 and November 1944, the percentage of African Americans in war industries increased from 3 percent to 8.3 percent.

The prospect of employment in the industrial cities of the North and West attracted both blacks and whites, as more than five million Americans exchanged a rural life for urban opportunity. In 1940, 51.4 percent of all African Americans lived in the country and 77.1 percent resided in the South, from Virginia to Texas. The next census, in 1950, revealed that only 37.6 percent still lived a rural life, with only 68.1 percent in the old Confederacy. The wartime migration intensified the competition for scarce housing and contributed to racial friction and violence in cities like Detroit, Chicago, and Los Angeles (*see* DE-TROIT RIOT OF 1943; URBAN RIOTS AND REBELLIONS).

Whereas Randolph in 1941 demanded the right to work and fight, the black press seized upon the symbol V for Victory and in 1942 launched the Double V Campaign, seeking victory over tyranny abroad and racial segregation at home. The two objectives proved closely linked; African Americans in the armed forces, as they battled foreign tyrants, won victories over domestic racism.

The Army Air Arm

The policy adopted in 1940, improved treatment and opportunity without racial integration, resulted in the admission of African Americans to pilot training in the Army air arm. During January 1941, as Roosevelt was about to begin his third term, Assistant Secretary of War Robert P. Patterson announced the organization of a black pursuit squadron, even though the Chief of the Air Corps, Maj. Gen. Henry H. Arnold, had insisted, as recently as the previous spring, that any mixing of the races within the organization would create an impossible social problem. Very little mingling occurred. African-American pilots began training in July 1941 at segregated facilities at Tuskegee Institute, in Alabama, and completed the course by the time Japan attacked Pearl Harbor on December 7 and plunged the United States into the war.

The Tuskegee experiment produced a trained fighter unit, the 99th Pursuit Squadron, manned by African-American pilots, mechanics, and even clerks—a racial exclusiveness that reflected official policy. The Army Air Forces, which had evolved from the old Army Air Corps, flinched at the prospect of integrating the races. When the air arm reneged on a promise to integrate its officer candidate school, which produced nonflying officers, Judge Hastie, an outspoken advocate of racial integration, resigned in protest. His departure jolted the Air Forces into integrating the school, but the black graduates nevertheless served in segregated units. Hastie's replacement, Truman K. GIBSON, a black attorney and civil rights advocate from Chicago, took up the fight for integration, though in a less confrontational manner.

The War Department initially planned to send the 99th Pursuit Squadron to Liberia, a thousand miles from the nearest battlefield, where it would sit out the war patrolling coastal waters for submarines. The unit, however, went to Northwest Africa, where the Allies landed in November 1942, arriving there in April of the next year. The change resulted in part from the War Department's desire to evaluate the Tuskegee experiment.

The 99th Pursuit (later Fighter) Squadron encountered unique obstacles after it entered combat over the Mediterranean island of Pantelleria on June 2, 1943. The squadron lacked a cadre of veterans to pass

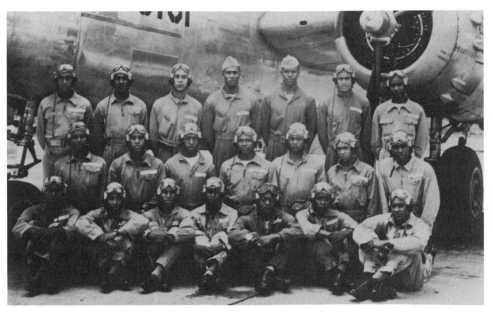

The 477th Bombardment Group, Army Air Force. (Photographs and Prints Division, Schomburg Center for Research in Black Culture, The New York Public Library, Astor, Lenox and Tilden Foundations)

along lessons learned in years of flying; all the pilots had learned to fly at the same time, even the commander, Maj. Benjamin O. DAVIS, Jr., the son of Brig. Gen. Davis and a 1936 graduate of West Point. The unit, moreover, had gaps in its training; because of racial segregation, few bases would provide overnight accommodations for black pilots, which eliminated the opportunity for long flights that honed navigating skills. Over Sicily and the Mediterranean, while the 99th Fighter Squadron operated as an appendage of the white 33rd Fighter Group, Maj. Davis and the others learned as they fought. They had scant hope of rest or refresher training, since Tuskegee concentrated in 1943 on producing new units—ultimately three more fighter squadrons and a medium bombardment group—rather than a steady flow of individual replacements.

Convinced that the understrength 99th could not keep pace, the commander of the 33rd Fighter Group recommended removing the squadron from combat. In October 1943, this recommendation, which could have ended the Tuskegee project, reached the War Department's Advisory Committee on Negro Troop Policy, headed by Assistant Secretary of War John J. McCloy. Maj. Davis, back from overseas, explained the circumstances that affected his unit's performance and convinced the committee, which included his father, that the 99th would improve.

Improve it did. By the time the war ended, the black 332nd Fighter Group of four squadrons—the 99th, 100th, 301st, and 302nd—was escorting bombers from airfields in Italy deep into Germany. The

number of African Americans in the wartime Air Forces peaked at 145,000, but fewer than a thousand were pilots or members of air crews.

In December 1942, the Selective Service System began providing manpower for all the services, and each one, including the Army Air Forces, received its share of African-American recruits. The air arm dumped those who did not qualify for technical training, or simply seemed excess to the needs of the service, into labor or housekeeping units. This practice created an explosive concentration of underutilized and dissatisfied individuals that needed only the spark of racism to ignite it. On June 24, 1943, at Bamber Bridge in the United Kingdom, white military police, angered by the sight of black airmen dancing with white English women, struck the spark. The ensuing riot wounded five Americans, three of them blacks.

The Army Ground and Service Forces

The problems of underutilization and dissatisfaction troubled the Army Ground Forces and Army Service Forces, as well as the Air Forces, since the entire Army had to absorb large numbers of blacks who scored poorly on the aptitude tests. The War Department, because it could not waste the time and resources necessary to segregate African Americans by both test scores and race, decided to create all-black divisions, some 15,000 strong, which would absorb black junior officers and make use of enlisted men with almost every skill and level of aptitude. During 1942 and 1943, the Army activated the 92nd and 93rd

The Reserve Officers' Training Corps at Tuskegee Institute, Ala., in 1942. The need to accept segregated training facilities for officers' training placed black leaders in a dilemma in both world wars. In 1941, the Army Air Force opened the Tuskegee Army Air Field, the primary training facility for black pilots in World War II. (Prints and Photographs Division, Library of Congress)

Infantry Divisions and designated the 2nd Cavalry Division a black unit. Other African-American soldiers served in nondivisional outfits: regimental combat teams; separate tank, antitank, artillery, and antiaircraft battalions that could be attached to white divisions without forfeiting their racial identity; and service units of various kinds. The number of African Americans in the Army exceeded 700,000 in the summer of 1944, most of them assigned to service organizations that, among other things, helped build the Ledo Road in Burma and the Alaskan highway, loaded ships in the United States and unloaded them overseas, and drove the trucks of the Red Ball Express, which delivered cargo from the French coast to the American troops advancing toward Germany.

By the end of 1943, the Army had sent two black combat units overseas—the 24th Infantry, a regimental combat team, in the South Pacific, and the 99th Fighter Squadron, in the Mediterranean Theater. The others continued to train, often under white officers whose attitude toward African Americans combined condescension with contempt, and in parts of the country where blacks faced rigid segregation and open hostility. Indifferent leadership and the hatred expressed by local inhabitants contributed to riots by black soldiers at nine military bases during 1943. Bad morale promised to grow even worse when the War Department decided to send the 2nd Cavalry Division overseas early in 1944, disband it, and reassign the black soldiers as military laborers. The planned break-up of the cavalry division and the failure to send either of the infantry divisions into combat caused another outcry, which prominent whites echoed, among them Eleanor Roosevelt, the wife of the President.

Political pressure and the need for troops overseas failed to save the 2nd Cavalry Division but did cause the War Department to send the 93rd Infantry Division to the Pacific in January and February 1944 and the 92nd Infantry Division to Italy between July and October of that year. The 93rd Infantry Division provided one regiment that fought on Bougainville in the Solomon Islands but never campaigned as a division. Functioning mainly in general reserve, it supplied working parties and garrison forces, some of which saw action against the Japanese.

The 92nd Infantry Division pooled its best trained troops in a single combat team, built around the 370th Infantry, which sailed for Italy in July 1944 and entered combat in August. As a result, the other two regiments that followed the 370th Infantry into action were still absorbing new officers and enlisted men as they did so. Moreover, the War Department failed to provide black replacements for the casualties the racially segregated division began suffering, causing combat effectiveness to decline. As the strength of the division ebbed, the army group commander in Italy shored it up with a black regiment already in the theater, plus white and Japanese-American units.

While the 92nd Infantry Division went to war in Italy, several of the African-American combat battalions, attached to white divisions, helped liberate France and invade Germany. The War Department had precisely calculated the number of divisions it would need for a world war, but in December 1944, after savage fighting in the Huertgen Forest, an unexpected German counterattack in the Ardennes resulted in the Battle of the Bulge and inflicted additional casualties. White divisions training in the United States and United Kingdom converged on the Continent, but swifter action seemed necessary. The answer to the demand for manpower lay in the African-American service troops already in Europe.

Lt. Gen. John C. H. Lee, in charge of logistics in the European Theater of Operations, persuaded Gen. Dwight D. Eisenhower, the Allied supreme com-

mander, to call for volunteers among the predominantly black service units to retrain as riflemen. Some 4,500 African Americans signed up, underwent training, and served in sixty-man platoons that were to join two-hundred-man white rifle companies. Except in the Seventh Army, where the platoons formed segregated companies instead of serving in white ones, this improvised racial policy integrated the fighting, though not the Army.

An attempt by the War Department to apportion officers' clubs, exchanges, and similar facilities by unit rather than race had only mixed success. As long as most units and cantonments remained racially segregated, the clubs followed suit, sometimes with the connivance of white commanders. At Freeman Field, in Indiana, the Air Forces commanding officer excluded blacks from the officers' club by reserving it for permanently assigned officers and categorizing all the African Americans as transients undergoing training. A demand by officers of the African-American 477th Bombardment Group for admission to the club triggered a confrontation that ended with the opening of the club to all officers, the transfer of the base commander, and a court-martial that imposed token punishment on one of the protesters.

The Navy

The Navy moved more slowly than the Army to provide broader opportunity and better treatment, while retaining racial segregation. The career of Doris Miller illustrated the Navy's reluctance to change. A male mess steward on the battleship USS *West Virginia,* he received the Navy Cross for shooting down two Japanese aircraft during the attack on Pearl Harbor, December 7, 1941. Instead of being reassigned to a specialty involving gunnery, he remained a mess attendant until his death in November 1943, when a Japanese submarine torpedoed the escort carrier *Liscome Bay.*

Secretary of the Navy Frank Knox believed in segregation and remained content to accept a few additional blacks as cooks and mess attendants in the rapidly expanding Navy. In January 1942, Roosevelt prodded the secretary to find better assignments for African Americans, but Knox and the General Board of the Navy, roughly the equivalent of the War Department General Staff, dragged their feet until April, when they established a quota. As a result, 277 black volunteers could enter the Navy each week and, beginning in June 1942, train at a segregated camp for recruits at the Great Lakes Naval Training Station, in Illinois. The Navy intended to assign the African American graduates of recruit training to advanced courses at the Hampton Institute, in Virginia, to learn specialties that would qualify them for general service. Even though fewer blacks volunteered than anticipated, the Navy could not easily place them in the general service and instead diverted many of them to duty as stevedores at naval ammunition depots. After December 1942, reliance on the draft dramatically increased the number of blacks in the Navy, which created new segregated units to accommodate them, including twenty-seven Naval Construction Battalions. Two navies functioned side by side, a white navy that manned the fleet, and a black one that performed heavy labor and menial work in support of the other.

Despite the growing proportion of blacks in the service, the Navy at the end of 1943 had yet to commission its first African-American officer. A dozen black college students, however, had enrolled in the V-12 officer training program and, upon graduation, would receive their commissions. To offer carefully selected black enlisted men a chance to become officers, the Navy on January 1, 1944, established a segregated officer candidate school and commissioned twelve of the sixteen graduates. The Golden Thirteen—the twelve newly minted ensigns plus another classmate who became a warrant officer—completed the course in March, and during the summer, ten other black officers, commissioned directly because of their civilian skill, reported for duty.

Since segregation confined to the galley those African Americans who served in the fleet, black morale suffered, as did the morale of white sailors who faced additional tours at sea because replacements were not available. Obviously, introducing black sailors into a greater range of seagoing specialties would improve the morale of both races. Early in 1944, the Navy tried to do this without disrupting segregation by assigning predominantly black crews to man a patrol craft, *PC 1264,* and the destroyer escort USS *Mason.* A few ships, however, could not absorb the surplus of African-American sailors.

When Knox died in April 1944, rigid segregation perished also. James V. Forrestal succeeded him as Secretary of the Navy and directed that the service integrate the crews of twenty-five fleet auxiliaries—oilers, ammunition ships, and the like—at the ratio of one black sailor in ten. Since the fleet of 75,000 ships and landing craft included 1,600 auxiliaries, the Forrestal program provided a commitment to change rather than full-fledged integration.

The Coast Guard

The Coast Guard, transferred from the Treasury Department to the Navy in November 1941, included a few African Americans who manned separate rescue stations or small craft or served in a segregated stewards' branch. Initially, the Coast Guard planned to cope with an increase in black volunteers by expanding the stewards' branch and designating additional

segregated vessels and stations. The use of the Selective Service System, which raised the total number of blacks to 5,000, overwhelmed this policy.

Moreover, segregated duty, especially as a steward, imposed limits on promotion and transfer, and by 1943 sixty percent of the black Coast Guardsmen were stewards. To broaden opportunities for African Americans, Rear Admiral Russell R. Waesche, the Commandant of the Coast Guard, endorsed an experiment with racially segregated crews. The weather ship *Sea Cloud* sailed the North Atlantic in November 1943 with some twenty blacks in the crew. During successive cruises, the proportion increased until African Americans formed almost a third of the crew, including fifty petty officers and four officers. The cutter *Hoquiam*, operating in Aleutian waters, also had a thoroughly integrated crew. Other Coast Guard ships and stations had at least a few blacks assigned, some of them in charge of whites.

The Marine Corps

The Marine Corps, which recruited blacks during the American Revolution, had accepted none since its reestablishment in 1798. As late as April 1941, the commandant, Maj. Gen. Thomas Holcomb, complained that those African Americans seeking to enlist as marines were "trying to break into a club that doesn't want them." He insisted that if he had to make a choice between "a Marine Corps of 5,000 whites or 250,000 Negroes," he would choose the whites. The pressures of war did not give Holcomb a choice, and on June 1, 1942, the Marine Corps began accepting African Americans. Plans called for organizing them into a segregated and self-contained defense battalion with artillery, infantry, and light tanks.

When the draft swelled the number of black marines, the Corps increased its segregated units—another defense battalion, fifty-one depot companies, and twelve ammunition companies, plus other miscellaneous detachments and a messman's branch. In all, some 20,000 African Americans served in the wartime Marine Corps. The first black entered officer training in April 1945 but did not receive his commission in the reserve until after the fighting ended.

The Merchant Marine

When the United States entered the war, the Merchant Marine comprised 131 operating companies and 22 unions that tended to restrict blacks to the galley and the engine room. After the United States War Shipping Administration took over the Merchant Marine in 1942, racial policy changed. Thanks in part to pressure from the Fair Employment Practice Committee, Hugh Mulzac became the first of three African Americans to serve as a wartime ship's captain when he took over the SS *Booker T. Washington*, a merchantman with a racially diverse crew. To meet the demands of war, the Merchant Marine found seagoing billets for some 24,000 blacks, across a broad spectrum of nautical specialties.

Women and the War Effort

World War II did not open employment opportunities for African-American males only. Some 600,000 black women joined the wartime work force. Previously, opportunities for these women existed mainly in domestic or service jobs, but possibilities expanded during the war in sales, clerical occupations, and especially light industry, where blacks of both sexes provided a ready source of unskilled labor.

All the services recruited women during the course of the conflict. On May 14, 1942, the Army established the Women's Auxiliary Army Corps, which became the Women's Army Corps on July 1, 1943. The Navy set up the Women Accepted for Volunteer Emergency Service, the WAVES, on July 30, 1942. The Coast Guard organized the SPARS, a contraction of the motto *semper paratus*, "always prepared," on May 23, 1942, and the Marine Corps created the Women's Reserve on February 13, 1943. Only the Marine Corps refused throughout the war to accept black women, and its women's component remained exclusively white.

Since comparatively few women underwent training, the efficient use of instructional facilities required some racial integration in that phase of service, but otherwise the same policy of racial segregation applied to females as to males. As a result, few of the Army's almost 4,000 African-American women volunteers performed duties commensurate with their skills. At Fort Devens, Mass., black women trained as medical technicians refused to perform menial labor. A court-martial convicted four of their number of disobeying a lawful order, but racial prejudice was so obvious in both the order and the trial that the Judge Advocate General reversed the court's decision. The Army sent overseas just one unit made up of black women, a postal battalion that served in the United Kingdom under an African-American officer, Maj. Charity Adams.

Although the Army accepted black volunteers from the beginning of its program for women, the WAVES and SPARS did not announce their decision to admit African Americans until October 1944. The change of policy reflected the determination of Capt. Mildred H. McAfee, the director of the WAVES, and the replacement of Secretary of the Navy Frank Knox by James V. Forrestal, who favored racial integration. Pressure from black organizations also

played an important role, since President Roosevelt would again need black votes when he sought a fourth term in November.

When the war began, the Army and the Navy accepted only whites as nurses. Judge William H. Hastie, before resigning as special assistant to the secretary of war, persuaded the War Department to accept black nurses, but the Army Nurse Corps commissioned only 476 African Americans during the war, roughly one percent of its strength, and tried to assign them where they would care exclusively for black troops. The wartime Navy, although acknowledging a shortage of 500 nurses in November 1943, admitted just four African-American women to that specialty.

Regression and Ultimate Integration

The wartime experience of African Americans afforded the promise of progress toward the exercise of full citizenship. The March on Washington, though it never took place, demonstrated the effectiveness of mass action, which in this instance had been planned exclusively by black leaders. The CONGRESS OF RACIAL EQUALITY (CORE), an important civil rights organization after the war, worked during the conflict for the integration of the armed forces, which, for reasons of their own, modified but did not abandon racial segregation. The war had a further impact on African-American life because military service qualified individuals for the G.I. Bill with its educational and other benefits.

As it reduced in size, the postwar Army attracted more African Americans than a segregated service could absorb. In Europe, which provided a generally benign racial climate, the number of black soldiers on duty in mid-1946 exceeded the authorization by 19,000, with another 5,000 seeking assignment there. Meanwhile, the Navy and Marine Corps attracted too few African Americans to make integration seem attractive, and, like the Army, they refused to break step with a racially segregated American society. The Air Force, established as an independent service in 1947, voluntarily undertook a measure of racial integration, but the other services avoided compliance with President Harry S. Truman's integration order of 1948 until the manpower demands of the KOREAN WAR forced them to obey.

REFERENCES

DALFIUME, RICHARD M. *Desegregation of the U.S. Armed Forces: Fighting on Two Fronts, 1939–1953.* Columbia, Mo., 1969.

DAVIS, BENJAMIN O., JR. *Benjamin O. Davis, Jr., American: An Autobiography.* Washington, D.C., 1991.

FINKLE, LEE. *Forum for Protest: The Black Press During World War II.* Cranbury, N.J., 1975.

FLETCHER, MARVIN E. *America's First Black General: Benjamin O. Davis, Sr., 1880–1970.* Lawrence, Kans., 1989.

JAKEMAN, ROBERT J. *The Divided Skies: Establishing Segregated Flight Training at Tuskegee, 1934–1942.* Tuscaloosa, Ala., 1992.

LEE, ULYSSES. *The United States Army in World War II; Special Studies: The Employment of Negro Troops.* Washington, D.C., 1966.

MacGREGOR, MORRIS J. *Defense Studies: The Integration of the Armed Forces, 1940–1965.* Washington, D.C., 1981.

McGUIRE, PHILLIP. *He, Too, Spoke for Democracy: Judge William Hastie, World War II, and the Black Soldier.* Westport, Conn., 1988.

NELSON, DENNIS D. *The Integration of the Negro into the United States Navy, 1776–1947, with a Brief Historical Introduction.* Washington, D.C., 1948.

OSUR, ALAN M. *Blacks in the Army Air Forces during World War II.* Washington, D.C., 1977.

SANDLER, STANLEY. *Segregated Skies: All-Black Combat Squadrons of World War II.* Washington, D.C., 1992.

SHAW, HENRY I., JR., and RALPH DONNELLY. *Blacks in the Marine Corps.* Washington, D.C., 1975.

STILLWELL, PAUL, ed. *The Golden Thirteen: Recollections of the First Black Naval Officers.* Annapolis, Md., 1993.

WYNNE, NEIL A. *Afro-Americans and the Second World War.* London, 1970.

BERNARD C. NALTY

WPA. *See* Works Project Administration.

Wrestling. Wrestling is one of the oldest and most widespread of sports. In traditional African society, wrestling served many social functions for individuals and groups, including determining male rank order, settling disputes, and establishing group solidarity (Paul, 1987). Wrestling remains important in Africa today; the main character in Nigerian writer Chinua Achebe's novel *Things Fall Apart* (1959), Okonkwo, achieved renown by defeating a reigning champion. African Americans brought traditions of wrestling to North America, where they were reinforced by its important role in English and Scottish popular culture.

Organized amateur wrestling dates to the middle of the nineteenth century. The first amateur black wrestler of note was Walter Gordon, who wrestled at Berkeley from 1916 to 1918. But wrestling at this time was not a sport that attracted a large number of African-American participants. The only black ath-

letic conference to sponsor wrestling, the CIAA (Colored Intercollegiate Athletic Association), did not begin until 1934.

By the 1950s, the powerful wrestling teams at major midwestern colleges were recruiting black students. In 1957, Simon Roberts of the University of Iowa became the first black to win a major NCAA title. Perhaps the most prominent black amateur wrestler has been Robert Douglas, Big Eight Champion at Oklahoma State in 1965, and Gold Medalist in the 138.5-pound freestyle at the 1968 Olympics. In 1970 Douglas was awarded the title of Outstanding Wrestler of the Year for the United States. He continued as a coach after he stopped wrestling. In accepting the position at Arizona State University, he became the first African American to coach wrestling at a major institution. Douglas also served as assistant coach of the 1984 Olympic wrestling team; in 1992, he was named head coach, and led the team to six medals. Other prominent amateur wrestlers include Kenny Monday (winner of a 1988 Olympic Gold Medal in freestyle), Chris Campbell and Nate Carr (Bronze Medalists in 1992 and 1988, respectively), Lee Hemp, Roy Washington, and Darryl Burley.

Professional wrestling began in sporting clubs and similar venues in the middle of the nineteenth century. The first well-known black professional wrestler was Viro "Black Sam" Small. Born a slave in Beaufort, S.C., in 1854, he made his way to New York City, where he made his professional debut in 1870.

In the twentieth century, professional wrestling has become more a spectacle than a sport. Nonetheless, like those in other, more legitimate sports, black wrestlers have faced problems of discrimination and stereotyping. After many decades in which most black professional wrestlers were forced to compete in segregated circumstances, wrestling was finally integrated after 1960. Edward "Bearcat" Wright, whose demand for integrated wrestling was supported by the NAACP, was the Jackie ROBINSON of professional wrestling. Others who participated include Buster "the Harlem Hangman" Lloyd, Bobo Brazil, and Jim "the Black Panther" Mitchell. Many former boxers, including Joe LOUIS, have tried their hand at wrestling. There have also been some black female wrestlers, notably Dinah Beamon and Sweet Georgia Brown.

Wrestling often involves stereotyped confrontations between heroes and villains, and blacks have played both roles. In the 1960s most blacks were cast as winners. In the 1980s, the stereotypes were more mixed. The leading wrestlers in the premier professional wrestling league, the World Wrestling Federation (WWF)—Junkyard Dog, Tony Atlas, and Special Delivery Jones—were often associated with negative stereotypes (Maguire and Wozniak, 1987). Junkyard Dog, for instance, wore a collar and chain that could be interpreted as vestiges of slavery. In their matches all three black wrestlers used the "head-butt" prominently. This tactic, particularly common among black wrestlers, suggests that there is nothing of importance inside the person's head.

Junkyard Dog and Tony Atlas frequently won their matches, while Special Delivery Jones typically lost; none of the three, however, ever had a championship bout. Rival wrestlers commonly used negative stereotypes in describing them. For example, one white rival said of Junkyard Dog: "Watch your wallet, don't turn your back on him, he grew up in the projects." Another white wrestler described Tony Atlas as a "monkey, a gorilla," and went on to compare Atlas to Willie Bee, a gorilla at the Atlanta Zoo. Even announcers use stereotypes in their commentary. On one occasion, as Junkyard Dog was being whipped (literally) by a white wrestler, a WWF announcer described the action as "*Roots* Two."

As a sport and/or recreational activity, wrestling has been relatively unimportant to African-American culture and history. Professional wrestling, however, is culturally relevant because of the negative STEREO-TYPES that are frequently highlighted. These stereotypes are not only offensive to African Americans but also reinforce offensive attitudes toward African Americans.

REFERENCES

ASHE, ARTHUR, JR. *A Hard Road to Glory*. New York, 1988.

MAGUIRE, BRENDAN, and JOHN F. WOZNIAK. "Racial and Ethnic Stereotypes in Professional Wrestling." *Social Science Journal* 24 (1987): 261–273.

PAUL, SIGRID. "The Wrestling Tradition and Its Social Functions." In William Baker and James Mangan, eds. *Sport in Africa: Essays in Social History*. New York, 1987.

BRENDAN MAGUIRE
JOHN F. WOZNIAK

Wright, Charles Stevenson (June 4, 1932–), writer. Charles Wright was born and raised in New Franklin, Mo. His parents were separated when he was very young. After his mother died when he was four, he was brought up by his maternal grandparents. He dropped out of high school during his sophomore year, hitchhiked to California, then returned to Missouri. He wrote for the *Kansas City Call,* and spent a few summers at Lowney Handy's Writers Colony in Marshall, Ill., before he was drafted into

the Army in 1952. He was stationed in Korea, but saw no fighting. Released from the Army in 1954, Wright lived for a while in St. Louis before moving to New York. In New York, he worked as a messenger while writing his first published novel, *The Messenger* (1963). The protagonist of the novel is named Charles Stevenson, and like Wright, works as a messenger in New York City, coming into contact with a whole range of fantastic characters. Described by the critic John O'Brien as a "surrealistic painting come to life in the streets of New York City," the novel is a satirical and sometimes depressing reflection of American society.

Wright's next novel, *The Wig: A Mirror Image* (1966), set in a future time, concerns Lester Jefferson, a black resident of New York who straightens his hair in the mistaken belief that in so doing he can assure himself success and riches. By the end of the novel he is so disillusioned that he has himself castrated. The experimental, episodic style of the novel served as a barrier to mainstream acceptance. Still, Wright's work shows a remarkable prescience, since in it he predicted such cultural phenomena as black militant groups and see-through plastic dresses. From 1967 to 1973, Wright wrote a column entitled "Wright's World" for the *Village Voice*. He collected these essays in *Absolutely Nothing to Get Alarmed About* (1973). In 1993, his three novels were reissued in a collection also called *Absolutely Nothing to Get Alarmed About*.

REFERENCES

DAVIS, THADIOUS M., and TRUDIER HARRIS, eds. *Dictionary of Literary Biography*. Vol. 3, *Afro-American Fiction Writers After 1955*. Detroit, Mich., 1984.

HARDY, GAYLE, ed. *American Women Civil Rights Activists*. Jefferson, N.C., 1993.

CHARLES M. DAVIDSON
LYDIA MCNEILL

Wright, Jane Cooke (November 17, 1919–), cancer researcher and medical school administrator. Born in New York City, Jane Cooke Wright's choice of a medical career was inspired by the accomplishments of her father, physician Louis T. Wright. After graduating from Smith College (B.A., 1938) and New York Medical College (M.D., 1945), she completed residencies in internal medicine at Bellevue Hospital and at Harlem Hospital in New York.

As a medical researcher, Wright worked on many types of cancer, from skin cancer and breast cancer to leukemia. In the 1950s she did pioneering research in the use of chemicals (chemotherapy) to treat the dis-

ease in humans. Her method of using human tissue cultures from cancer patients, rather than laboratory mice, to test the effects of drugs on cancer cells was a significant contribution to the field. She is credited with being the first to use the drug methotrexate to gain remissions in patients with mycosis fungoides (a skin cancer) and solid-tumor breast cancer. The Damon Runyon fund awarded her $25,000 in 1955 to continue her cancer research at Bellevue. In 1961 she was part of a medical group sponsored by the African Research Foundation that treated some 340 cancer patients in Kenya using a mobile medical unit.

Wright has been active in a number of national medical associations, including the American Association for Cancer Research and the New York Academy of Sciences. In 1964 she was one of the seven founding members of the American Society of Clinical Oncology, a preeminent organization in the field of cancer research. In 1967 Wright was appointed associate dean and professor of surgery at New York Medical College. That same year, President Lyndon Johnson appointed her to the National Cancer Advisory Council. In 1971 Wright became the first woman elected president of the New York Cancer Society. As she moved toward retirement in 1985, she led delegates to Ghana, China, Eastern Europe, and the Soviet Union, to learn the latest knowledge and techniques in cancer chemotherapy research and treatment.

REFERENCES

HABER, LOUIS. *Women Pioneers of Science*. New York, 1979.

HAYDEN, ROBERT C. *Eleven African American Doctors*. Frederick, Md., 1992.

OKON, MAY. "Why We Can't Solve the Cancer Problem. Dr. Jane C. Wright, Associate Dean of New York Medical College, Seeks Answers in the Research Lab." *New York Sunday News*. November 19, 1967, pp. 4, 34–35.

ROBERT C. HAYDEN

Wright, Jay (May 25, 1934–), poet. Jay Wright was born on May 25 in either 1934 or 1935 in Albuquerque, N.M., to Leona Dailey and George Murphy, a.k.a. Mercer Murphy Wright. He grew up in the care of a black Albuquerque, N.M., couple to whom his father left him at age three—Frankie Faucett, a cook, and his wife, Daisy. In his early teens Wright went to live with his father, a jitney driver and handyman, in Los Angeles and San Pedro, Calif., where he soon began to play both acoustic bass and minor-league baseball. From 1954 to 1957, he served in the Army. Being stationed in Germany

gave him the opportunity to travel throughout Europe. After Wright graduated from the University of California at Berkeley in 1961, he spent a semester at Union Theological Seminary in New York and subsequently attended Rutgers University, where he completed all the requirements for a doctoral degree in comparative literature except the dissertation. In 1964 Wright spent a year in Mexico; he returned in 1968 for another three years, this time in the company of his wife, Lois Silber. His poems consistently return to this stay in Guadalajara and Xalapa. In 1971, Wright went to Scotland where he accepted a position as creative writing fellow at Dundee University in Scotland. Since 1975, he has taught at Yale, the universities of Utah, Kentucky, and North Carolina at Chapel Hill, and Dartmouth College. He received a MacArthur Fellowship in 1986.

The fact that his personal origins are a composite of uncertain and contradictory stories may explain why Wright has a "passion for what is hidden," which takes the shape of a ceaseless spiritual quest. From *The Homecoming Singer* (1971) to *Elaine's Book* (1988) and *Boleros* (1991), his autobiographical person, traversing far-flung geographies, assimilates a vast and heterogeneous body of historical and mythological knowledge and uncovers forgotten links between Western Europe, Africa, the Caribbean, North and South America, and Asia. Wright's poetry insists on continuities across, not just within, cultures. Though his poetic vision is firmly grounded in both African-American historical experience and African—particularly Akan and Dogon—religion, it is cross-cultural in that it seeks to restore to African-American literature a sense of the breadth, the complexity, and the coherence of its cultural, historical, social, artistic, intellectual, and spiritual resources. In that respect, Wright's poetics and cultural politics have more in common with those of Robert HAYDEN and even Melvin TOLSON than with the black cultural nationalism many poets of his generation embraced in the late 1960s and early 1970s. The scope and depth of Wright's vision are due to extensive research in medieval and Renaissance literatures, music, anthropology, the history of religions, and the history of science. The texture of his poetry is as dense as his formal experiments are daring. A mixture of Italian, German, and Spanish often interspersed with Dogon, Bambara, and other ideograms, Wright's language is at times so unfamiliar that to call it "English" seems inadequate. The BLUES and JAZZ, as well as a host of Caribbean and Latin American song and dance forms, are as integral to his poetic endeavors as are splendid attempts at making English verse responsive to the "grammars" and metrics of other languages.

The book-length poems *Explications/Interpretations* (1984), *Dimensions of History* (1976), and *The Double*

Invention of Komo (1980)—which, together with *Soothsayers and Omens* (1976), make up Wright's first poetic cycle—include notes that acknowledge some of the author's principal scholarly debts. Yet Wright remains adamant in his refusal to make his poetry more "accessible." Behind this refusal lies neither arrogance nor obscurantism, as some have assumed, but an abiding respect for the complexity and difficulty of the social, historical, and creative processes his poetry tries to represent and enact.

REFERENCES

Callaloo 6 (Fall 1983). Special issue.
KUTZINSKI, VERA M. *Against the American Grain: Myth and History in William Carlos Williams, Jay Wright, and Nicolás Guillén*. Baltimore, 1987.
WRIGHT, JAY. "Desire's Design, Vision's Resonance." *Callaloo* 10 (1987): 13–28.

VERA M. KUTZINSKI

Wright, Louis Tompkins (July 23, 1891–October 8, 1952), physician and hospital administrator. Louis Tompkins Wright was born in LaGrange, Ga. Both his father, Ceah K. Wright, and his stepfather, William F. Penn, were physicians. Wright received a B.A. from Clark College in Atlanta in 1911. Four years later, he graduated from Harvard Medical School, finishing fourth in his class. During his Harvard obstetrics course he was told that he could not participate in the delivery of babies at Boston-Lying-In Hospital. Wright rallied his classmates to change this policy of racial discrimination. From 1915 to 1916, he completed his internship at Freedmen's Hospital in Washington, D.C. While there, he disproved the accepted medical belief that the Schick test for diphtheria was not useful on blacks because of their dark pigmentation. Wright devised new observational techniques that allowed physicians to detect the reddening of skin necessary to judge the test's results. Wright then returned to Atlanta and entered a medical practice with his stepfather, where he also worked as treasurer of a local branch of the NAACP.

During World War I, Wright entered the U.S. Army Medical Corp at Fort McPherson near Atlanta. Commissioned a first lieutenant, he served at the Colored Officers Training Camps in Iowa and New York. During his service years, Wright introduced the intradermal method of vaccination for smallpox that was adopted by the U.S. Army Medical Corps. Assigned to the 367th Infantry Regiment in France, he suffered permanent lung damage from a phosgene gas attack on the battlefield. The recipient of a Purple

Louis T. Wright. (Photographs and Prints Division, Schomburg Center for Research in Black Culture, The New York Public Library, Astor, Lenox and Tilden Foundations)

Heart, Wright rose to the rank of lieutenant colonel, but was forced to resign this commission because of his injuries. He moved to New York City in 1918, married Corrine Cooke and opened an office for the general practice of surgery.

In 1919 Wright was appointed clinical assistant visiting surgeon at New York's Harlem Hospital. The hospital, in a black community, was staffed and controlled by white physicians. Four doctors resigned in protest when Wright, the first black appointed to a municipal-hospital position in New York City, joined the staff. In 1928, he became the first African-American police surgeon in the city's history. Meanwhile, at Harlem Hospital he continued to succeed, becoming director of surgery in 1943 and president of the hospital's medical board in 1948.

Wright's interests went beyond his surgical specialty. He devised a splint for cervical fractures and a special plate for the repair of certain types of fractures of the femur bone. Using a mostly inert substance, the metal tantalum, he developed a procedure for repairing hernias. His chapter on "Head Injuries" in *The Treatment of Fractures* (1938), was one of the first contributions by an African American to a major medical text. Perhaps Wright's most significant contribution to clinical research involved the first tests on humans of the antibiotic Aureomycin. Aureomycin had been tested in laboratory mice but never on

humans. After it was first isolated in the Lederle Laboratories by a former Harvard classmate in 1945, a sample was sent to Wright at Harlem Hospital to adminster to patients who had infections for which other treatments had not worked. The results of this 1947 test were positive, and he experimented with another antibiotic, Terramycin. From 1948 to 1952, Wright published some thirty papers on his trials with antibiotics. His work helped pave the way for these drugs to be approved by the Food and Drug Administration for subsequent manufacturing and widespread use.

In 1948 Wright entered the field of cancer research. Grants from the National Cancer Institute and the Damon Runyon Fund allowed him to establish the Harlem Hospital Cancer Research Foundation. Wright and his researchers, including his daughter, Jane Cooke Wright, pioneered the use of chemotherapy to destroy cancerous cells. He published fifteen papers detailing his investigations with drugs and hormones in treating cancer.

Throughout his career, Wright attacked racial prejudice and discrimination in medicine. In 1932 he opposed the establishment of a separate veteran's hospital for African Americans in the North and protested the inadequate medical care being received by black veterans. As chairman of the board of directors of the NAACP from 1935 to 1952, he established the National Medical Committee to oppose racial discrimination in medicine. The NAACP under his leadership pressed a dozen investigations into discriminatory medical training and care. As chairman, Wright often served in an advisory role to Walter White, the secretary and dominant figure of the NAACP. With speeches and writings, Wright held the powerful American Medical Association accountable for inequalities in medical care for African Americans across the country. In 1940 Wright was awarded the NAACP's Spingarn Medal for his work as a scientist, public servant, and activist.

Wright suffered a fatal heart attack in 1952. Before his death, a new medical library at Harlem Hospital was named after him. At the library dedication ceremony, Wright said, "Harlem Hospital represents the finest example of democracy at work in the field of medicine. Its policy of complete integration throughout the institution has stood the test of time."

REFERENCES

COBB, W. MONTAGUE. "Louis Tompkins Wright." *Journal of the National Medical Association* (March 1953): 130–148.

HABER, LOUIS. "Louis Tompkins Wright." In *Black Pioneers in Science and Invention.* New York, 1970.

HAYDEN, ROBERT C. *Nine Black American Doctors.* Reading, Mass., 1976.

LOGAN, RAYFORD W., and MICHAEL R. WINSTON. "Louis Tompkins Wright." *Dictionary of American Negro Biography.* New York, 1982, pp. 670–671.

ROBERT C. HAYDEN

Wright, Richard (September 4, 1908–November 28, 1960), writer. Richard Wright was born near Roxie, Miss., the son of a sharecropper and a rural schoolteacher who supported the family when her husband deserted her. Wright's childhood, which he later described in his classic autobiography, *Black Boy* (1945), was horrific. His mother, Ella Wilson Wright, was never healthy, and she became completely paralyzed by the time her son was ten years old. Wright and his family were destitute, and their lives were sharply constricted by pervasive segregation and racism. Wright and his brother Leon moved several times to the homes of relatives in Natchez and in Memphis, Tenn., and then to their grandmother's house in Jackson. A staunch Seventh Day Adventist, Wright's grandmother discouraged his reading, destroyed a radio he had built, and unwittingly alienated him from religious practice. Wright had already had his first story published in a local newspaper, however, when he completed the ninth grade in 1925. He found employment in Memphis, where he discovered the work of H. L. Mencken. Mencken's essays spurred Wright's writing ambitions. Determined to escape the segregated South, which had plagued his childhood, Wright moved to Chicago in 1927.

Over the next several years, during the worst of the depression, Wright supported himself and his family, which had joined him, through menial labor and at the post office, and wrote when he could find the time. He became acquainted with contemporary literature through Mencken's essays and through friends at the post office, and in 1932 he began meeting writers and artists, mostly white, at the communist-run JOHN REED CLUB. Impressed by Marxist theory, Wright became a leader of the Chicago Club and published revolutionary verse in *New Masses* and in small magazines like *Anvil, Left Front* (whose editorial board he joined), and *Partisan Review.* Recruited by communists eager to showcase African Americans in their movement, Wright became active in the party as much for literary reasons as for political ones. He wished, he later explained, to describe the real feelings of the common people and serve as the bridge between them and party theorists. Wright participated in party literary conferences, wrote poetry and stories, and gave lectures. Wright's first novel, *Lawd Today,* written during this period, was published posthumously, in 1963. In 1935, the same year he started as a journalist for *New Masses,*

Richard Wright at the Venice Film Festival in 1951, in front of a poster for the Argentinean film *Sangre Negro,* an adaptation of his novel *Native Son.* Wright portrayed Bigger Thomas, the central character in the film. (AP/Wide World Photos)

Wright joined the Federal Writers Project of the Works Progress Administration (WPA), helping to write a guide to Illinois, and was transferred to the local Negro Theater unit of the Federal Theater Project the next year. By this time, Wright was having doubts about the Communist party, which he believed to be promoting him only because of his skin color. He insisted on freedom from the party line for his creative work, but he remained publicly committed to the party. In 1937, eager to find a publisher for his work, Wright moved to New York, where he worked as Harlem reporter for the Communist party newspaper *The Daily Worker,* and wrote the Harlem section of the WPA's *New York City Guide* (1939).

In the Autumn 1937 issue of the leftist magazine *Challenge,* Wright wrote his influential "Blueprint for Negro Writing," in which he tried to assert and encourage black nationalism among writers, within a larger Marxist perspective. Wright called on black writers to make use of folklore and oral tradition in their work, but also to pay attention to psychological and sociological data in framing their work. Wright's own short stories, whose unsparing treatment of racism and violence in the South was couched in poetic style, were winning competitions from *Story* magazine and others, and were collected under the title

Uncle Tom's Children (1938). Though the work was a success, Wright was dissatisfied. He thought that while he had generated sympathy for victims of racism, he had not shown its effects on all of society.

Native Son (1940), Wright's first published novel, became a Book-of-the-Month Club selection and called national attention to his compelling talent, although his unrelenting depiction of racism aroused controversy. In fact, editors had already toned down controversial material (it was not until 1992 that the unexpurgated version of the novel was published). *Native Son* is the story of a ghetto youngster, Bigger Thomas. Trapped by white racism and his own fear, Bigger accidentally murders a white woman. While he tries to cover up his deed, he is arrested, put on trial, and sentenced to death. Bigger's white communist lawyer argues that he is not responsible for his crimes, but Bigger feels that his murder and cover-up were his first creative acts, through which he has found a new freedom. The book's success won Wright the NAACP's prestigious SPINGARN MEDAL in 1941, and a dramatization by Wright and Paul Green was produced by Orson Welles. There were two film adaptations, one a Brazilian film, *Sangre Negra* (1950), in which Wright himself played the part of Bigger Thomas, and *Native Son* (1986), starring Victor Love, but both were commercially unsuccessful.

In 1941 Wright wrote a lyrical Marxist "folk history" of African Americans, *Twelve Million Black Voices*. The following year, he finally left the Communist party. Though still a Marxist, Wright felt that the communists were unrealistic, self-serving, and not truly interested in the liberation of African Americans. During the war years, Wright worked on *Black Boy* (1945), "a record of childhood and youth," which brought him money and international fame. In *Black Boy,* Wright gives a precise, unrelenting account of how he was scarred by the poisons of poverty and racism during his early years in Mississippi. *American Hunger* (1977), a version which included Wright's Chicago years, was published posthumously.

The same year *Black Boy* appeared, Wright wrote an introduction to *Black Metropolis,* the sociological study by St. Clair DRAKE and Horace CAYTON of African Americans in Chicago, in which he first expounded his major political theories. White American racism, Wright believed, was a symptom of a deeper general insecurity brought about by the dehumanizing forces of modernity and industrialization. He considered the condition of African Americans a model, and extreme example, of the alienation of the human individual by modern life.

Wright was invited to France by the French government in 1945, and during the trip he found himself lionized by French intellectuals as a spokesperson for his race. Wright had married a white woman, Ellen Poplar, in 1941, and the couple had had a daughter, Julia. They wished to escape America's racial discrimination. He was delighted by France's apparent freedom from racial prejudice and impressed by the central role that literature and thought enjoyed in French society. Wright decided to "choose exile," and moved to Paris permanently in 1947, although he kept his American passport.

While in France, Wright became friendly with the French existentialists, although he claimed his reading of Dostoyevsky had made him an existentialist long before he met Jean-Paul Sartre and the others. Wright's thesis novel, *The Outsider* (1953), explores the contemporary condition in existentialist terms while rejecting the ideologies of communism and fascism. A posthumously published novella Wright wrote during the period, *The Man Who Lived Underground* (1971), also makes use of existential ideas. Neither *The Outsider* nor Wright's next novel, *Savage Holiday* (1954), was well received.

Wright shared the French intellectuals' suspicion of America, and participated with Sartre and the existentialists in political meetings in 1948 with the idea of producing a "third way" to preserve European culture from the Cold War struggle between American industrial society and Soviet communism. Ironically, Wright was harassed for his leftist background in America, despite his repudiation of the communists. The hostility of the Communist party to Wright grew after he published his essay "I Tried to Be a Communist" in the important anticommunist anthology *The God That Failed* (1950).

Wright had been an original sponsor of the review *Présence Africaine* in 1946, and he turned his primary attention to anticolonial questions during the 1950s. After visiting the Gold Coast in 1954, he wrote *Black Power* (1954), "a record of reactions in a land of pathos," in which he approved Kwame Nkrumah's pan-Africanist policies but stressed his own estrangement from Africa. Wright's introduction to George Padmore's *Pan-Africanism or Communism?* (1956) further disclosed his pan-African ideas. In *The Color Curtain* (1956) he reported on the First Conference of Non-Aligned Countries held in Bandung, Indonesia, in 1955, and explored the importance of race and religion in the world of politics. The same year, he helped organize, under *Présence Africaine*'s auspices, the First Conference of Black Writers and Intellectuals. Papers from the conference, along with texts from the numerous lectures on decolonization Wright gave in Europe, were published as *White Man, Listen!* in 1959.

Wright's last works include *Pagan Spain* (1958), a report on Franco's Spain which included a discussion of the Catholic impact on European culture; *The Long*

Dream (1959), the first novel of an unfinished trilogy dealing with the lasting effects of racism; *Eight Men* (1960), a collection of short stories; and thousands of unpublished haiku on the Japanese model. Wright died unexpectedly, on November 28, 1960, in Paris, of a heart attack. He was under emotional and mental stress at the time, partly due to spying by U.S. intelligence agents on African Americans in Paris. His sudden death fostered lasting rumors that he had been poisoned by the CIA because of his persistent fight against racial oppression and colonialism.

Wright was the first African-American novelist of international stature, and his violent denunciation of American racism and the black deprivation and hatred it causes was uncompromising. Wright inspired both African-American novelists like Ralph ELLISON and Chester HIMES and foreign writers such as the novelists Peter Abrahams and George Lanning and the political theorist Frantz Fanon. Wright's legendary generosity to other writers was both moral and sometimes financial, through the grants and jobs he found them. Wright also created for himself a role as expatriate writer and international social critic. His strong intellectual interests and earnestness, through which he melded Freudian, Marxist, and pan-African perspectives, were matched by a deep spirituality—despite his rationalist suspicion of religion—and occasional humor and comedy in his works.

REFERENCES

CRUSE, HAROLD. *The Crisis of the Negro Intellectual.* New York, 1967.

FABRE, MICHEL. *From Harlem to Paris: Black American Writers in France, 1840–1980.* Champaign, Ill., 1991.

————. *The Unfinished Quest of Richard Wright.* Translated by Isabel Barzun. New York, 1973.

GAYLE, ADDISON. *Richard Wright: The Ordeal of a Native Son.* Gloucester, Mass., 1980.

WALKER, MARGARET. *Richard Wright, Daemonic Genius.* New York, 1987.

WEBB, CONSTANCE. *Richard Wright.* New York, 1968.

MICHEL FABRE

Wright, Richard Robert, Jr. (April 16, 1878–December 12, 1967), bishop, African Methodist Episcopal Church, educator. Richard R. Wright, Jr. was born in Cuthbert, Ga., and attended Augusta public schools. In 1898 he received an A.B. from the Georgia State Industrial College for Colored Youth (now Savannah State College), where his father Richard R. WRIGHT, Sr. was president. In 1901 he earned a B.D. From the University of Chicago Theological Seminary, and was ordained to the ministry in the AFRICAN METHODIST EPISCOPAL CHURCH. His first appointment in the church was as ministerial assistant to Reverdy C. Ransom at the Chicago Institutional Church and Social Settlement. Between 1901 and 1903 he served as a Hebrew instructor at Payne Theological Seminary. Wright studied in Berlin and Leipzig, Germany (1903–1904), and received his M.A. from Chicago in 1904. The Sociology Department at the University of Pennsylvania awarded him two fellowships, and in 1911 he became the first African American to earn a Ph.D. from the university. While writing his doctoral dissertation, "The Negro in Pennsylvania: A Study of Economic History," Wright also worked as the secretary of the People's Savings Bank of Philadelphia. After earning his degree, he prepared studies such as "Homeowning Among Negroes in Pennsylvania" (1911) and "Negroes in Industry in Philadelphia and Pittsburgh" (1913) for the U.S. Bureau of Labor and the Pennsylvania Bureau of Industrial Statistics, respectively.

Wright's primary vocation, however, was with the AME Church. He served short terms as pastor at churches in Illinois and later in Philadelphia. He declined an offer to chair the Departments of German and Sociology at HOWARD UNIVERSITY in order to become editor of the AME's *Christian Recorder,* a position he held in Philadelphia from 1909 to 1936. In 1916 he compiled and edited *The Encyclopedia of the African Methodist Episcopal Church.*

Wright was also active as a businessman. He founded the 8th Ward (Philadelphia) Building and Loan Association in 1906, and in 1908 he was one of the founders of the Armstrong Association, which later became affiliated with the NATIONAL URBAN LEAGUE. In 1921 he and his father began the Citizens and Southern Bank and Trust Company. At this time he also became a prominent middle-class supporter of Marcus GARVEY's UNIVERSAL NEGRO IMPROVEMENT ASSOCIATION, receiving the honorary title of Knight Commander, Order of the Nile, from Garvey in 1922.

In 1920 Wright received an LL.D. from WILBERFORCE UNIVERSITY; in 1932 the university elected him its president, a post he held for four years. In 1936 the AME Church elevated him to the rank of bishop and assigned him to South Africa, where he remained until 1940. He then returned to Wilberforce as acting president in 1941–1942. For the next twenty years, Wright served as bishop for various episcopal districts in the United States, as well as in the West Indies and South America. In 1960 he became the official historian of the AME Church.

Wright published his autobiography, *Eighty-Seven Years Behind the Black Curtain,* in 1965. He died two years later at the age of eighty-nine in a hospital in Philadelphia.

REFERENCES

BURKETT, RANDALL K. *Garveyism as a Religious Movement: The Institutionalization of a Black Civil Religion.* Metuchen, N.J., 1978.

MORRIS, CALVIN S. *Reverdy C. Ransom: Black Advocates of the Social Gospel.* Lanham, Md., 1990.

Obituary. *New York Times,* December 12, 1967, p. 47.

WILLIAMS, ETHEL L. *Biographical Directory of Negro Ministers.* 2nd ed. Metuchen, N.J., 1970, pp. 568–569.

PETER SCHILLING

Wright, Richard Robert, Sr.

(May 16, 1855?–July 2, 1947), educator, entrepreneur. Richard R. Wright, Sr., was born a slave on a plantation near Dalton, Ga., either in 1853 or 1855. Named Richard Robert Waddell at birth, his father escaped when Richard was still very young, and he and his mother Harriet were sent to another farm in Cuthbert, Ga., where Harriet married Alexander Wright. During the Civil War his stepfather escaped to join the Union Army.

At the end of the war, Harriet Wright learned of the opening of the Storrs School—operated in a boxcar by the AMERICAN MISSIONARY ASSOCIATION for blacks in Atlanta—and walked there from Cuthbert with her three children. Gen. O. O. Howard, head of the Freedmen's Bureau, visited the school in 1868 and asked the students what he should tell the children in the North about them. Wright's response, "Tell 'em we're rising," was later memorialized in a poem by John Greenleaf Whittier. In 1869 Atlanta University's preparatory division selected Wright as one of its students, and he went on to earn his B.A. and become, in 1876, the valedictorian of the university's first graduating class. (He became a trustee of the university in 1887 and remained on the board until 1929.)

While in college, Wright started teaching in rural schools during the summers as a way of helping to finance his education. After graduation, he took the job of principal of a Cuthbert elementary school. In Cuthbert, Wright also began his work as a community organizer, helping to found Georgia's first black county fair as well as starting a newspaper, the *Weekly Journal of Progress,* which later became the *Weekly Sentinel.* Wright also founded and became the first president of the black Georgia State Teachers' Association. In 1880 he was asked to head the state's first public high school for blacks, the Ware High School in Augusta. When the Ware School closed in 1891, Wright became the first president of the Georgia State Industrial College for Colored Youth in Savannah (now Savannah State College), a position he held until 1921. During his years as an educator Wright also served as president of both the National Association of Presidents of A & M Colleges (1906–1919) and the National Association of Teachers in Colored Schools (1908–1912).

Wright was active in Republican politics, and was a delegate to the National Republican Convention for presidential elections eight times between 1880 and 1916. In 1884 he was nominated to run for Congress. When William McKinley was elected president in 1896, he offered Wright several positions, including minister to Libera; Wright accepted the post of special paymaster and the rank of major in the U.S. Army during the Spanish-American War.

After several years of increasing conflict with the white board of trustees of the Georgia State College of Industry—many of whom opposed higher education for blacks—Wright left the college in 1921. That year he moved to Philadelphia, and opened, with several of his children, the Citizens and Southern Bank. Wright also founded and became the president of the National Negro Bankers' Association. Largely because of his prudent lending policies, the Citizens and Southern Bank and Trust Company remained open and solvent throughout the GREAT DEPRESSION. In 1935 Wright also organized the Haitian Coffee and Products Trading Company, and, five years later, after years of Wright's persistent lobbying, the post office issued a Booker T. WASHINGTON commemorative stamp, the first postage stamp to depict an African American.

Wright died on July 2, 1947 in Philadelphia.

REFERENCES

BUNI, ANDREW. "Richard Robert Wright." In John A. Garraty and Edward T. James, eds. *Dictionary of American Biography,* Supplement 4, *1946–1950.* New York, 1971.

HAYNES, ELIZABETH ROSS. *The Black Boy of Atlanta.* Boston, 1952.

PETER SCHILLING

Wright, Theodore Sedgwick

(1797–March 25, 1847), minister. Theodore Wright, a Presbyterian clergyman and abolitionist, was born in New Jersey, the son of Richard P. G. Wright, who was prominent in the early anticolonization protests and the antislavery movement. Theodore received instruction from Samuel E. CORNISH at New York City's African Free School. When he continued his studies at Princeton Seminary, he remained in contact with his mentor and served as an agent for Cornish's newspaper, *Freedom's Journal.* Wright shared his father's anticoloni-

zation sentiment, and coauthored with Cornish an anticolonization pamphlet, *The Colonization Scheme Considered* (1840).

Wright succeeded Cornish as pastor of the First Colored Presbyterian Church in New York City in 1828, and nurtured his church into the second largest African-American congregation in the city. The principles of moral reform informed his thought and activities. He created a temperance society as an auxiliary to his church. He founded the Phoenix Society, an organization dedicated to "morals, literature and the mechanical arts." He also promoted black education through his work with the Phoenix High School for Colored Youth.

Wright's commitment to abolitionism drew him to several black organizations. He participated in the New York Committee of Vigilance in the mid-1830s. A pioneer in the long, frustrating campaign to expand black suffrage in the state, he cofounded the New York Association for the Political Elevation and Improvement of the People of Color (1838) and attended the black state convention at Albany in 1840. Occasionally, Wright revealed a streak of militancy. At the 1843 national convention in Buffalo, New York, he surprised many delegates by supporting Henry Highland GARNET's call for slave violence.

Wright had a highly visible role in the organized antislavery movement. He was a founder of the AMERICAN ANTI-SLAVERY SOCIETY (AASS) and was one of the few blacks to hold a seat on the society's executive committee. He also participated in the New York State Anti-Slavery Society. Through his work in these organizations, he became aware of the subtle racism present among white reformers, and he chastised them publicly for their failure to "annihilate in their own bosom the cord of caste."

Like many black clergymen, Wright was never comfortable with the radical social doctrines of the Garrisonians. When these issues precipitated a schism in the AASS, Wright, along with several other black abolitionists, abandoned the old organization in favor of the new AMERICAN AND FOREIGN ANTI-SLAVERY SOCIETY. Wright served on the new society's executive committee, and embraced political abolitionism as an active supporter of the Liberty party in the early 1840s.

In his last years of public life, Wright devoted his efforts to African missions. He joined with several other black clergymen to found the Union Missionary Society in 1841 and later served as a vice president of the AMERICAN MISSIONARY SOCIETY. He died in 1847.

REFERENCE

SWIFT, DAVID E. "Black Presbyterian Attacks on Racism: Samuel Cornish, Theodore Wright and Their Contemporaries." *Journal of Presbyterian History* 51 (1973): 433–470.

MICHAEL F. HEMBREE

Wyoming. The first blacks in what would become Wyoming were the fur trappers and traders James E. Beckwourth and Edward Rose, in the early years of the nineteenth century. They were among the first after the Native Americans to traverse, in the early years of the nineteenth century, the area that in 1890 would become the forty-fourth state of the Union. After the Civil War, many black cowboys—among whom Thornton Biggs, Jim Simpson, and Isom Dart are some of the better known—rode herd on cattle drives through the region during the rise and throughout the heyday of the cattle industry. However, few of them ever became trail bosses or foremen because of white resistance to blacks in positions of authority. James Nathaniel Edwards and his wife, Lethal, eventually built one of the most successful black-owned cattle ranches in the West. During the late 1860s, many African Americans mi-

W. J. Hardin was the first African American elected to the Wyoming Territorial Legislative Assemblies, serving two terms from 1879 to 1882. (Wyoming State Museum)

grated temporarily to the future state of Wyoming to lay track for the Union Pacific Railroad, and put the town of Cheyenne on the map.

Almost immediately, fearful white settlers took proscriptive actions against the few black settlers, designed to preempt African Americans' desire to settle in Wyoming, and to ensure that they would remain isolated and separate from whites. In 1869, the First Territorial Legislature enfranchised white women, but refused to grant suffrage to blacks. The legislature also passed antimiscegenation laws, designed to prevent marriages between whites, blacks, and "asiatics." The laws, repealed in 1882, were reinstituted in 1913. In 1873, copying Colorado's law, Wyoming mandated segregated schools in any district containing more than fifteen black children.

Despite these restrictions, various individuals appeared, filling roles that in other times and places would be occupied by white people. Cheyenne Barney Ford, a prosperous barber and gold prospector who traveled back and forth between Colorado and Wyoming, built one of his Inter-Ocean Hotels in Cheyenne in 1875. It soon became a center of the city's social life. The same year, Lucy Phillips helped found Allen Chapel, the territory's first A.M.E. Church. William Jefferson Hardin, who had been politically active in Colorado in the 1870s, was forced to flee the state and settled in Wyoming. In 1880, he became the first African-American member of the Territorial Legislature, and was reelected in 1882.

There were two small waves of black migration. In January 1890, the same year Wyoming became a

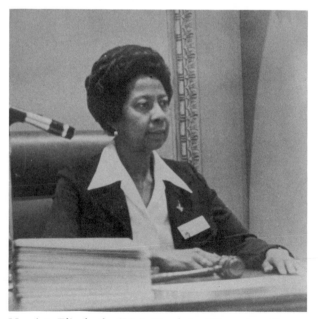

Harriet Elizabeth (Liz) Byrd in Wyoming Senate Chambers. (Wyoming State Museum)

state, a group of two hundred blacks from Harrison County, Ohio, were brought to Dana (near Hanna) to work as coal miners, provoking a mixed reaction among local whites. The work proved unremunerative, however, and most of the black miners left the state within a few years. Between 1885 and 1912, the Ninth and Tenth Cavalries, United States Colored Troops, two of the four black units formed at the end of the Civil War, were assigned to Wyoming Territory to guard against Native Americans. The two units saw service in many parts of the state, and they were particularly active in attempting to settle the Johnson County Cattle War between farmers and ranchers in 1892.

Unlike Colorado, its more populous neighbor to the south, Wyoming never gained a large African-American population. As part of the frontier, Wyoming had a predominantly male population, among blacks as well as whites. The black population in the late nineteenth century was on average 70 percent male. In 1900 the total number of African Americans in the state exceeded one thousand for the first time. It rose to two thousand by 1910, but returned to one thousand in 1920.

The state's black population has remained relatively constant over the last hundred years. Following the desegregation of the military in the years following World War II, black troops began to be stationed in the state, particularly at the F. E. Warren Air Force Base west of Cheyenne. The state's black population swelled to three thousand in 1950, after several retired military personnel settled permanently, but it returned to two thousand by 1960. In 1957, the state passed a civil rights law desegregating public accommodations, and in 1964 it repealed its antimiscegenation law and passed a law forbidding employment discrimination. In 1966 James Byrd, an African-American veteran, was named Police Chief of Cheyenne, a position he held until 1974. In 1978 his wife, Harriet Elizabeth Byrd, was elected to the Wyoming State Legislature for the first of four terms, the first black legislator since Hardin, a century earlier. Arthur Mercer, another former military man, was president of Wyoming's school board from 1985 to 1989.

By 1990 Wyoming's black population had reached four thousand. The bulk of Wyoming's black population remains retired military personnel. Black civilians are employed primarily in ranching, education, service jobs, and government service. Most Wyoming blacks live in Cheyenne. However, there is also a substantial black population at the University of Wyoming in Laramie, and others live in Casper and Rawlins. Although the University of Wyoming has been the site of chronic racial tension over the past years, many of the state's black residents claim they

feel less racism in Wyoming than in other parts of America.

REFERENCES

"Discrimination Against Negroes in Restaurants, Bars, Barbershops, and in Housing." *Crisis* (June–July 1956): 345–347.

LAMB, DAVID. "Home on the Range—Where Blacks Are Finding a Haven." *Los Angeles Times,* April 8, 1993, p. 3.

LAWSON, T. R. *History of Wyoming.* 2nd ed. Lincoln, Neb., 1978.

NEVIUS, C. W. "Wyoming's Racial Strife Remembered." *San Francisco Chronicle,* November 27, 1990, p. 3.

SAVAGE, WILLIAM SHERMAN. *Blacks in the West.* Westport, Conn., 1976.

WILLIAM KING

X, Malcolm. *See* Malcolm X.

Y

Yancey, James Edward "Jimmy" (c. February 20, 1894–September 17, 1951), pianist. Although the year of his birth is not certain, Jimmy Yancey was probably born in Chicago in 1894, and followed in the footsteps of his father, a vaudeville guitarist and singer, spending much of his youth as a vocalist and dancer, before eventually gaining fame as a boogie-woogie pianist. From 1903 to 1908 he sang and danced in a Chicago-based revue, and from 1908 to 1914 he toured the United States and Europe (participating in a command performance for the British royal family) with the troupes of Jeannette Adler, Cozy Smith, and Bert Earle.

In 1915 Yancey began to work full-time as a groundskeeper at Chicago's Comiskey Park, the home of the Chicago White Sox. Although he would keep that job for the rest of his life, in that year Yancey learned to play piano from his brother Alonzo, and began to play occasional gigs. He also began to record as a pianist in Chicago and New York, but did so only occasionally until the revival of interest in boogie-woogie in the late 1930s, when Yancey was hailed as one of the premier exponents of that style of playing.

Yancey lacked the virtuosity of fellow Chicagoans Meade "Lux" Lewis and Albert Ammons, but what distinguished him were his spare but sophisticated sense of rhythm and his subtle, instantly recognizable left-hand style, particularly on slow blues ("State Street Blues," 1925; "Yancey Special," 1936; "Slow and Easy Blues," 1936; "How Long," 1936; and "At The Window," 1943). Until his death in Chicago in 1951, Yancey remained active, both as a groundskeeper at Comiskey Park and as a soloist and accompanist for his wife, the singer Estella "Mama" Yancey, with whom he appeared at Carnegie Hall in 1948.

REFERENCES

KRISS, E. *Six Blues-Root Pianists*. New York, 1973.
RUSSELL, W. "Jimmy Yancey." In Martin Williams, ed., *The Art of Jazz*. New York, 1959.
SILVESTER, PETER. *A Left Hand Like God: A Study of Boogie-Woogie*. London, 1988.

JEFFREY TAYLOR

Yarborough, Sara (1950–), dancer. Born in New York City, raised in Haiti, groomed to be a performer by her dancer-mother, Lavinia Williams, Sara Yarborough began dancing when she was six years old at Williams's Academy of Dance in Haiti, studying folk, tap, jazz, modern dance, and ballet. Attracted to ballet, the gifted eleven-year-old came to New York City to study for two years at George Balanchine's School of American Ballet. In 1967 she became a protégée of Benjamin Harkarvy at the Harkness School, and soon joined the Harkness Ballet. Within two months, she was performing demanding roles in Brian MacDonald's *Firebird* and *Time Out of Mind*. She danced in John Butler's *Sebastian* and then took the lead role in Jerome Robbins's *New York Export: Opus Jazz*.

A delicate beauty and an extraordinarily elegant ballerina, she had effortless high extensions and a graceful lyrical style. Alvin AILEY saw her first when he was rehearsing *Feast of Ashes* in 1969 with the Harkness. When the Harkness Ballet collapsed in 1970, Ailey asked Yarborough to join him. She performed with the Ailey company from 1971 to 1975, then danced with the Joffrey Ballet from 1975 to 1976, but returned to the Ailey in 1977. She created roles in Ailey's *La Mooche* and danced feature roles in most of the repertory pieces, but she is known for her roles in *Hidden Rites* (1973) and especially, *The Lark Ascending* (1972). In tribute to Sara Yarborough, Ailey said her dancing was as close as humanly possible to flight.

REFERENCES

HASKINS, JAMES. *Black Dance in America: A History Through Its People.* New York, 1990.
LONG, RICHARD A. *The Black Tradition in American Dance.* New York, 1989.

KIMBERLY PITTMAN

Yerby, Frank Garvin (September 5, 1916–November 29, 1991), novelist. The son of a postal clerk, Frank Yerby was born in Augusta, Ga. He received a bachelor's degree in English from Paine College in Augusta in 1937 and a master's degree from Fisk University in Nashville, Tenn., in 1938. Yerby then studied education for a year at the University of Chicago while working on the Illinois Federal Writers' Project. He taught at Florida Agricultural and Mechanical College (1939), at Southern University in Baton Rouge, La. (1940–1941), and then briefly at the University of Chicago, before moving to Detroit, where he worked at the Ford Motor Company's Dearborn assembly plant (1942–1944). Yerby then moved to Jamaica, N.Y., where he worked as the chief inspector at Ranger Aircraft until 1945.

Yerby's prolific and commercially successful literary career was launched in 1944, when he received the O. Henry Memorial Award for "Health Card," a short story about racial injustice. Some of Yerby's early stories, including "The Homecoming" (1946), also dealt with social issues, but he soon began publishing "swashbuckling" historical romance novels that won popular if not critical acclaim. Over the course of his career, Yerby was attacked by reviewers and academics for his lack of attention to racial issues, his use of primarily Anglo-Saxon protagonists, and his reliance on pulp fiction formulas, but his thirty-two novels were immensely popular with the general reading public, particularly in the 1940s and 1950s.

His first novel, *The Foxes of Harrow* (1946), focused on the white owners of an antebellum southern plantation. The book became an immediate bestseller, sold over two million copies within a few years, was translated into numerous languages, and was made into a film by Twentieth Century-Fox in 1947. Yerby then began producing melodramatic adventure novels, set in various centuries and geographical locales, at the rate of one a year. His most popular titles were *The Vixens* (1947), *The Golden Hawk* (1948), *A Woman Called Fancy* (1951), and *The Saracen Blade* (1952).

Yerby moved to France in the early 1950s, then settled in Madrid in 1955. He lived there the rest of his life and wrote such novels as *Fairoaks* (1957), *An Odor of Sanctity* (1965), and *Goat Song* (1968). Considered by many to be Yerby's masterpiece, *The Dahomean* (1971) is his only work dealing primarily with blacks; set in the nineteenth century, the novel traces the life of an African protagonist who rises to a position of great authority in Dahomean tribal culture only to be sold into American slavery by his own kinsmen. Yerby was granted an honorary doctor of letters degree by Fisk University in 1976 and a doctor of humane letters by Paine College in 1977. His last published works were *Devilseed* (1984) and *McKenzie's Hundred* (1985). He died of heart failure in Madrid in 1991.

REFERENCES

GRIMES, WILLIAM. "Frank Yerby, Writer, 76, Is Dead; Novels of the South Sold Millions." *New York Times,* January 8, 1992, p. D-19.
VINSON, JAMES. "Frank Yerby." In *Twentieth Century Romance and Gothic Writers.* Detroit, 1982, pp. 731–733.

CAMERON BARDRICK

Yergan, Max (July 19, 1892–April 11, 1975), educator, civil rights leader. Born in Raleigh, N.C., Max Yergan attended Shaw University, and graduated in 1914. Shortly thereafter he received an M.A. degree from HOWARD UNIVERSITY. In 1915, he was hired as a traveling secretary with the student division of the YOUNG MEN'S CHRISTIAN ASSOCIATION (YMCA) in New York City. During World War I, he worked in India, then was sent to Kenya to organize YMCA units among Indian and African troops in the British Army. Though not an ordained minister, he was named a chaplain by the American army, and he briefly served with African-American troops in France.

In 1920, Yergan was appointed senior secretary of the International Committee of the YMCA and was stationed in South Africa, where he remained for sixteen years, working mainly with college students. He combined missionary work and improving educational facilities for black South Africans. For his efforts, Yergan received the Harmon Award in 1926, and the NAACP's SPINGARN MEDAL in 1933. He published two sociological reports, *Christian Students and Modern South Africa* (1932), and *Gold and Poverty in South Africa* (1938), in which he described the horrible living and working conditions faced by black African gold miners.

In 1936, claiming he had done all he could for Africans within the YMCA framework, Yergan returned to New York. City College hired him as a professor in history, one of the first African-American professors at an integrated college. Among the courses he taught was Negro History, the first such course taught outside black colleges. In 1937, with the support of Paul ROBESON and others, he founded the COUNCIL ON AFRICAN AFFAIRS (CAA)—then the International Committee on African Affairs—which promoted interest in Africa and lobbied against colonialism, and became its executive director. The CAA was largely dormant for several years.

While in New York, Yergan grew active in Harlem Communist political circles. Together with the Rev. Adam Clayton POWELL, JR., at the time an ally of the Communists, he published a newspaper, *The People's Voice.* He also became active in the Communist-dominated NATIONAL NEGRO CONGRESS (NNC). In 1940, after A. Philip RANDOLPH resigned as executive director, Yergan was named to lead the organization. He led the NNC in its opposition to military preparedness programs and its support of Powell's successful mass transit boycott in New York City during 1940–1941. In 1941, the COMMUNIST PARTY promoted Yergan as a candidate for the New York City Council, but Powell convinced him to drop out of the race.

After 1941, Yergan supported the war effort, but spoke out in favor of decolonization and African self-determination and against discrimination in the Army. During the war years, the CAA grew in size and power, and Yergan devoted more time to it. In 1946, at a CAA meeting in New York City, Yergan accused the Truman administration of opposing African freedom. In 1946, Yergan led a delegation of the NNC to the United Nations to present a petition against "political, economic and social discrimination against Negroes in the United States," and lobbied against poll taxes in southern states.

However, sometime in 1947, Yergan underwent a dramatic shift in his political views and turned away from his former associates. In October of that year, Yergan resigned from the NNC, by then largely inactive, claiming that "Communists sought to sabotage the decisions of the board." In December, after the U.S. government charged that the CAA was a subversive organization, Yergan affirmed its noncommunist character. In 1948, the CAA board, led by Robeson, opposed the statement. Yergan claimed that a Communist-led minority had seized control of the CAA in order to attack American foreign policy. Yergan attempted to seize the organization's property, and brought suit against Robeson's pro-Communist faction. He was expelled from the board and resigned in October.

In later years, Yergan became an increasingly strident anticommunist. In 1948, he testified on Communist involvement in civil rights efforts before a subcommittee of the House Committee on Un-American Activities. During the 1950s and 1960s, he lectured and wrote articles for conservative magazines and was a leading consultant on Africa to the U.S. State Department. He was also rumored to be an FBI informer. In 1962, Yergan organized and chaired the Free Katanga Committee, which worked against U.N. involvement in the former Belgian Congo and supported the Belgian-backed Katanga secessionist movement of Moise Tshombe. In 1964, while speaking in South Africa, Yergan praised the country's apartheid policy as a "realistic policy" in a "unique situation," which gave Africans "dignity and self-respect." During the 1970s, he spoke in support of Ian Smith's white minority government in Rhodesia. These actions prompted widespread criticism that Yergan had "sold out," and that his earlier activism had been self-serving and insecure. Yergan died near his home in Ossining, N.Y., in 1975.

REFERENCES

DUBERMAN, MARTIN B. *Paul Robeson.* New York, 1988.

LYNCH, HOLLIS R. *Black American Radicals and the Liberation of Africa: The Council on African Affairs, 1937–1955.* Ithaca, N.Y., 1978.

NAISON, MARK. *The Communists in Harlem During the Depression.* New York, 1983.

GREG ROBINSON

YMCA. *See* Young Men's Christian Association.

Young, Albert James "Al" (1939–), poet and educator. Al Young was raised in poverty in Ocean Springs, Miss., where his father was a professional musician and auto mechanic. Young moved with his

family to Detroit, in 1946, and attended the University of Michigan (1957–1961) and the University of California at Berkeley (1961). After traveling around the country, supporting himself by working as a disk jockey, janitor, and musician, he settled in the San Francisco area. Young was awarded a Wallace E. Stegner fellowship in creative writing at Stanford University for 1966–1967. He taught writing at Stanford while completing *Dancing* (1969), a collection of poetry, and his first novel, *Snakes* (1970).

Young's ear for language has been noted by reviewers, and his novels are known for their evocation of black vernacular speech. His fiction often concerns eccentric or unglamorous sectors of African-American life. In his novels—*Snakes, Who Is Angelina?* (1975), *Sitting Pretty* (1976), *Ask Me Now* (1980), and *Seduction by Light* (1988)—certain central themes reappear, such as the importance of love and the black family, the prominence of music in African-American life, the power of mystical spirituality, and the richness and variety of African-American speech patterns. Young is also the author of four books of "musical memoirs," collections of vignettes, emotional sketches, and critical responses to jazz and popular music: *Bodies and Soul* (1981), *Kinds of Blue* (1984), *Things Ain't What They Used To Be* (1987), and *Mingus/Mingus* (1989).

While Young is recognized mainly for his fiction and musical memoirs, he has published poetry as well: *Dancing, The Song Turning Back Into Itself* (1971), *Geography of the Near Past* (1976), *The Blues Don't Change* (1982), and *Heaven: Collected Poems, 1958–1988*. Much of his poetry is centered on the figures of dance and music, in a rhythmic free verse that celebrates the transcendence of the human spirit. He has also written a number of unproduced screenplays, and he writes regularly as a freelance journalist for such publications as the *New York Times Book Review* and *Rolling Stone*. Al Young has edited anthologies and journals, most notably the multicultural *Yardbird Lives!* (1978) and *Calafia: The California Poetry* (1979), both of which were co-edited with Ishmael REED.

REFERENCE

O'BRIEN, JOHN. *Interviews with Black Writers*. New York, 1973.

BRENT EDWARDS

Young, Andrew (October 23, 1932–) civil rights activist and politician. Andrew Young was born in New Orleans. His father was an affluent, prominent dentist, and Young was raised in a middle-class black family in a racially mixed neighborhood. He attended Howard University in Washington, D.C., and graduated in 1951. Young pursued his growing commitment to religion at Hartford Theological Seminary in Connecticut and was awarded a bachelor of divinity degree in 1955. He was ordained a Congregational minister, and from 1955 to 1959, he preached in churches in Georgia and Alabama. In the course of this work, Young experienced firsthand the wrenching poverty that shaped the lives of African Americans in the rural South. He became active in challenging racial inequality, joined the local CIVIL RIGHTS MOVEMENT and helped organize a voter-registration drive in Thomasville, Ga., one of the first of its kind in southern Georgia.

In 1959, Young went to New York to become an assistant director of the National Council of Churches and help channel New York City philanthropic money into southern civil rights activities. Two years later, he returned to Georgia and joined the SOUTHERN CHRISTIAN LEADERSHIP CONFERENCE (SCLC), a civil rights organization headed by the Rev. Dr. Martin Luther KING, Jr. Young became an active participant in the SCLC, building a reputation for coolness and rationality and often providing a moderating influence within the movement. From 1961 to 1964, he served as funding coordinator and administrator of the SCLC's Citizenship Education Program—a program aimed at increasing black voter registration among African Americans in the South.

Young grew to be one of King's most trusted aides. In 1964, he was named executive director of the SCLC and three years later took on additional responsibility as executive vice president. During his tenure, he focused on creating social and economic programs for African Americans to broaden the scope of SCLC's activism. In 1970, Young relinquished his executive positions. However, he continued his affiliation with SCLC—serving on the board of directors—until 1972.

In 1972, Young turned his energies to the political arena and launched a successful campaign to become the first African American elected to the House of Representatives from Georgia since 1870. In Congress, he served on the House Banking Committee and became familiar with the national and international business markets. In 1976, he vigorously supported the candidacy of fellow Georgian Jimmy Carter for president and vouched for Carter's commitment to black civil rights to many who were skeptical of supporting a white Democrat from the deep South. Upon Carter's election, Young resigned his congressional seat to accept an appointment as the United States Ambassador to the United Nations.

As ambassador, Young focused on strengthening the ties between the United States and the Third

Andrew Young addresses a crowd of civil rights marchers on June 12, 1966, with Fannie Lou Hamer to his right and Martin Luther King, Jr., to his left. (Charmian Reading)

World. In 1979, he was forced to resign his position when it was revealed that he had engaged in secret negotiations with representatives of the Palestine Liberation Organization (PLO) in violation of U.S. policy. Young's supporters argued that Young was merely doing the job of a diplomat by speaking to all interested parties in sensitive negotiations. Many Jews and other supporters of Israel, however, believed that Young's actions gave the PLO unwarranted legitimacy. The furor that surrounded his actions forced him to submit his resignation.

In 1982, Young mounted a successful campaign for mayor of Atlanta. During his administration, he faced the same urban problems that plagued other big-city mayors, including a shrinking tax base, rising unemployment, and rising costs—all of which required difficult decisions in fund allocation. Despite these constraints, he was able to increase business investment in Georgia. He successfully ran for reelection in 1986, despite growing criticism from some African-American critics who argued that black Atlantans had been hurt by his economic development programs. In 1990, after he ran unsuccessfully for the Democratic gubernatorial nomination, Young reentered private life. He served as chairman of Law International, Inc., until 1993, when he was appointed vice chairman of their parent company, Law Companies Group, an internationally respected engineering and environmental consulting company based in Atlanta.

During the course of his career, Young has received many awards, including the Presidential Medal of Freedom—America's highest civilian award—and more than thirty honorary degrees from universities such as Yale, Morehouse, and Emory. In 1994, his spiritual memoir, *A Way Out of No Way,* was published. Young lobbied successfully to bring the 1996 Summer Olympics to Atlanta and served as cochairman of the Atlanta Committee for the Olympic Games.

REFERENCES

CLEMENT, LEE, ed. *Andrew Young at the United Nations.* Salisbury, N.C., 1978.
GARDNER, CARL. *Andrew Young, A Biography.* New York, 1980.
POWLEDGE, FRED. *Free at Last? The Civil Rights Movement and the People Who Made It.* Boston, 1991.
YOUNG, ANDREW. *A Way Out of No Way.* Nashville, Tenn., 1994.

CHRISTINE A. LUNARDINI

Young, Charles (March 12, 1864–January 8, 1922), soldier. Born a slave in Macon County, Ky., Charles Young moved with his parents to Ripley, Ohio, in 1873. After graduating from Ripley's Colored High School in 1880, Young was appointed to

Maj. Charles Young, once the highest-ranking African-American officer in the U.S. Army, at the time he was awarded the NAACP's Spingarn Medal in 1916. (Prints and Photographs Division, Library of Congress)

the U.S. Military Academy at West Point, N.Y., in 1884, becoming only the ninth African-American cadet. When he graduated in 1889, he was only the third black graduate, and was the last for a half century. Following graduation, Young spent five years as a second lieutenant with the 9th Cavalry in Nebraska and in Utah. In 1894, he was assigned by the U.S. War Department to the military department at Wilberforce University in Ohio. Young was made professor of tactics and military science, and also taught French and mathematics. In 1896, Young was promoted to first lieutenant, and when the Spanish-American War broke out in 1898, he was made commander of the 9th Ohio Volunteer Infantry, and then was permitted to rejoin his old regiment. He saw no action, but in February 1901, he was promoted to captain and sent to the Philippines, where he commanded troops in the jungle during the American pacification of Philippine guerrilla independence fighters.

Upon returning to the United States in 1902, Young was named superintendent of two national parks in California, and then was assigned to the Presidio in San Francisco. In 1904, he became the first African-American military attaché. Assigned to Haiti, he spent three years making maps of the country and reporting on its society and government. Young returned to the United States in 1907 and served a year in Washington, D.C., and then two years in the Philippines. From 1909 to 1911, he commanded a squadron in Wyoming.

In 1911, at the request of Booker T. WASHINGTON, Young accepted the post of military attaché to Liberia. While in Liberia, Young was promoted to major. He engaged in exploring and mapmaking activities and reorganized the Liberian Frontier Force and police. The Army recalled him in 1915, over the protests of the Liberian government and the U.S. State Department. For his Liberian efforts, Young became the second recipient of the NAACP's SPINGARN MEDAL in 1916.

In February 1916, Young was assigned to Mexico to lead the 10th Cavalry Regiment in the punitive expedition against Pancho Villa. He served thirteen months in Mexico and distinguished himself by successful charges at Aguascalientes and Santa Cruz de Villegas. His commanding officers judged his work as "excellent in all categories" and U.S. Gen. John Pershing personally arranged his promotion to lieutenant colonel.

In 1917, Young established a school for black soldiers at Fort Huachuca, Ariz. When war broke out, Congress created a black division. Young was the obvious choice to lead it, and under such conditions could expect an eventual promotion to general. However, in June 1917, when he took his medical exam for promotion to full colonel, Young was certified as physically unfit. After further tests at San Francisco's Letterman General Hospital, doctors certified that he suffered from high blood pressure, and further service would be life-threatening. Young had in fact had high blood pressure for several years, as well as nephritis (Bright's Disease). Still, he protested that racist military officials were trying to deny him his command. Young maintained that he had never missed a day's service other than during an illness in Liberia, and rode a horse from Ohio to Washington to prove he was in good health.

Despite unceasing action by both white and African-American leaders across the political spectrum, notably W. E. B. DU BOIS, Young was retired and promoted to colonel on the inactive list. He was not reinstated to active duty until November 1918, five days before the armistice. He spent several months with the Ohio National Guard before being recalled to Liberia as a government adviser. He spent three years in Liberia, during which time his health began to fail. In 1922, while in Lagos, Nigeria, he died of nephritis. He was buried in state at Arlington

National Cemetery. In 1971, his house at Wilberforce, Ohio, was made a national landmark.

REFERENCES

HEINL, NANCY GORDON. "Colonel Charles Young." *Army Magazine* (March 1977).
NALTY, BERNARD. *Strength for the Fight: A History of Black Americans in the Military*. New York, 1986.

GREG ROBINSON

Young, Claude Henry "Buddy" (January 5, 1926–September 4, 1983), football player. Born in Chicago, Claude "Buddy" Young was a talented all-around athlete, the son of Claude Young, a Pullman porter, and Lillian Young. At Englewood and Wendell Phillips High Schools in Chicago, Young starred in track and football. In 1944, he attended the University of Illinois, where he played halfback on the football team, and in his first year he tied Red Grange's school record of 13 touchdowns in a season, five of them coming from runs of over sixty yards. Named an All-American for the season, that same year he ran a 60-yard dash in 6.1 seconds, tying the world indoor record, and won the National Collegiate Athletic Association's 100-yard and 200-yard dash championship. In 1945, Young served in the U.S. Merchant Marine. On his return to the University of Illinois in 1946, he led the team to a victory over UCLA in the Rose Bowl.

After his second season at Illinois, Young turned professional, joining the New York Yankees of the All-American Football Conference (AAFC), a rival of the National Football League. Young was only the second African-American player in the AAFC. When the Yankees joined the National Football League (NFL) in 1950, Young continued with them, becoming one of a handful of African Americans in the NFL. He played for the Dallas Texans in 1952 and the Baltimore Colts from 1953 to 1955.

After his retirement in 1955, Young scouted for the Baltimore Colts, and in 1964 he joined the NFL as director of player relations, a position he held for nineteen years. A member of the College Football Hall of Fame, Young was also honored by the Baltimore Colts, who retired his number. In 1983, Young was killed in an automobile accident.

REFERENCES

McCALLUM, JOHN D. *Big Ten Football Since 1895*. Radnor, Pa., 1976.
Obituary. *Chicago Tribune*, September 6, 1983.

GREG ROBINSON

Young, Coleman Alexander (May 18, 1919–), politician. Coleman Young was born in Tuscaloosa, Ala. He moved to Detroit at the age of five and grew up in an integrated east-side Detroit neighborhood called Black Bottom. After graduating from high school in 1936, he went to work for the Ford Motor Company. At the Ford plant Young became an organizer for the United Auto Workers, fighting in the auto industry's nascent labor movement. The draft interrupted his labor career. During World War II, he was given a commission in the army, and joined the Army Air Corps's elite all-black flying unit, the Tuskegee Airmen. After he returned from the service, he rose through the ranks to become the first paid African-American union staff officer in the city. Young, who had previously been the executive secretary of the National Negro Council's Detroit branch, was a founder and executive director of the NATIONAL NEGRO LABOR COUNCIL (NNCL).

In 1951, Young was called before the House Committee on Un-American Activities to answer charges that the NNCL was a subversive organization. He refused to provide the committee with the membership list of the organization and publicly rebuked committee members for questioning his patriotism. Rather than responding to its questions, Young chided the panel for its members' positions on racial issues. The exchange angered top labor leaders, who promptly blackballed him. During the 1950s Young found it difficult to find steady employment, and operated a short-lived cleaning business, among other occupations.

The next decade marked a change in Young's fortunes. He found steady work as a salesman, then reentered public life. In 1960 he was elected a delegate to the Michigan Constitutional Convention. In 1962 he lost a race for the state assembly, but in 1964 he was elected to the state senate and became a Democratic party floor leader. In 1968 he was the first African American elected to the Democratic National Committee.

Young wanted to run for the office of mayor of Detroit in 1969, but was stopped by a state law that prevented sitting state legislators from running for city office. The law was later changed, and in 1973 Young launched an improbable mayoral campaign. He promised to curb police brutality and made disbanding of the police special "decoy squad" his defining campaign issue. Blessed with rhetorical skills and the support of black trade unionists, he finished a strong second in the primaries. In the general election, he received few white votes, but he carried 92 percent of the black vote and narrowly defeated Detroit police chief John Nichols. In January 1974, he took office as Detroit's first black mayor.

Young has eased the formerly troubled relations between the city's residents and police, but the search

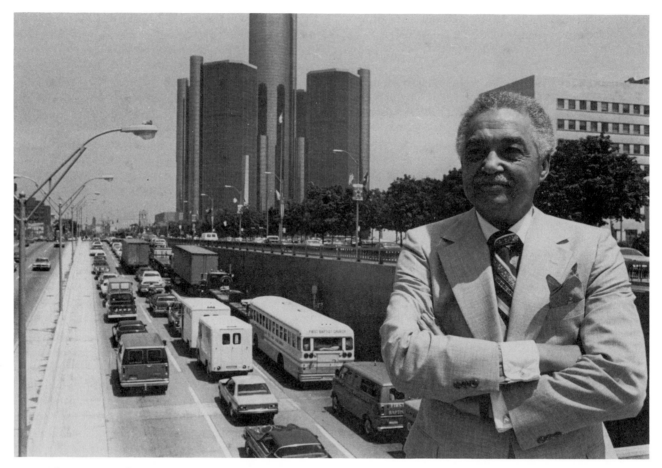

Detroit's mayor Coleman Young in 1978, in front of the newly opened Renaissance Center, one of the show-cases in his efforts to revitalize downtown Detroit. The city's first black mayor, Young served from 1974 through 1993. (AP/Wide World Photos)

for ways to revitalize the depressed local economy has occupied much of the mayor's time. Among the developments and projects associated with Young's administration are the Joe Louis Arena, the General Motors Poletown plant, the Renaissance Center (a hotel, office, and retail complex), and the Detroit People Mover (an elevated rail system around the central business district).

Though his aggressive style and personality have aroused opposition, Young's popularity among his core constituency of black working-class voters, plus the support of the Detroit business community, won him an unprecedented five terms as mayor. In 1993, however, he announced that he would not seek a sixth term.

REFERENCES

RICH, WILBUR C. "Coleman Young and Detroit Politics: 1973–1986." In *The New Black Power,* pp. 200–221. New York, 1987.
———. *Coleman Young and Detroit Politics: From Social Activist to Power Broker.* Detroit, 1989.

———. "Detroit: From Motor City to Service Hub." In *Big City Politics in Transition,* pp. 64–85. Newbury Park, Calif., 1991.

WILBUR C. RICH

Young, James Edward (January 18, 1926–), physicist and educator. James Young was born in Wheeling, W.Va., the son of James E. Young and Edna Thompson Young. He graduated with a B.S. (1946) and M.S. (1949) from Howard University before earning M.S. (1951) and Ph.D. (1953) degrees in physics from the Massachusetts Institute of Technology. He served as head of the physics department at Hampton Institute from 1946 to 1949.

Following postdoctoral fellowships at MIT (1954–1955) and the University of Southampton (1956), Young joined the staff of Los Alamos Scientific Laboratory in Los Alamos, N.M. There he worked on problems in particle physics. In 1961–1962, he was National Academy of Sciences–National Research

Council fellow at the Niels Bohr Institute in Copenhagen. In 1970, he became a professor of physics at MIT. His primary affiliation was with MIT's Institute of Theoretical Physics.

Young's doctoral thesis, "Propagation of Sound in Attenuating Ducts Containing Absorptive Strips," formed the foundation for his early work in acoustics. His first four scientific papers were published in the *Journal of the Acoustical Society of America.* Young's subsequent work in particle physics at Los Alamos was followed, at MIT, by a new interest in mathematical physics, specifically spin manifolds and cohomology of field theories. In the 1980s, he revived an earlier interest in biophysics (his master's at Howard had been in that general area), studied in the Division of Medical Sciences at Harvard University, and served as research associate in neurosciences at Tufts University. His research included an investigation of neural peptides with superfusion of brain tissues. A scientist of eclectic interests, Young patented a battery-controlled performance monitor and fuel gauge in 1986.

REFERENCES

YOUNG, J. E. "Inclusive Reactions: A Survey." *Rivista del nuovo cimento* 2, series 2, no. 1 (January–March 1972): 88–129.

"Young, James E." In *Who's Who Among Black Americans (1992–93)*. Detroit, 1992, p. 1585.

PHILIP N. ALEXANDER

Young, Lester (August 27, 1909–March 15, 1959), jazz tenor saxophonist. Born Willis Lester Young into a musical family headed by professor and band leader Willis Handy Young, in Woodville, Miss., he spent his childhood with his mother, sister, and brother in Algiers, La., a suburb of New Orleans, where he was introduced to jazz. At the age of ten, his father took three children, including Lester, throughout the South and Midwest with a carnival minstrel band.

Lester began playing on drums, but also played C-melody and alto saxophones before choosing the tenor saxophone as his main instrument. Although the band settled in Minneapolis in 1926, they also toured the northern plains region, playing primarily for dances. In the late 1920s, after a tour of the South, the family migrated to Los Angeles. In 1932, Young joined the original Blue Devils, based in Oklahoma City, which he left the following year to join Bennie MOTEN's band in Kansas City. Young also played briefly with King OLIVER and Count BASIE before he gained national attention in 1934 when he replaced Coleman HAWKINS in Fletcher HENDERSON's band.

Other members of the sax section did not welcome his unique sound, however, and Young left after a few months and returned to the Midwest. He played with Andy Kirk and with other ensembles before rejoining Count Basie in 1936, shortly before the band moved to New York City and achieved national fame.

Young remained with Basie until 1940, recording with both the full band and smaller ensembles. Many of his best known recordings were made at this time, including "Shoe Shine Boy," "Oh Lady Be Good," "Taxi War Dance," "Jive at Five," "Lester Leaps In," "Dickie's Dream," and "Way Down Yonder in New Orleans." He also recorded a number of sessions with small groups under the leadership of Teddy Wilson and Billie HOLIDAY. These records are exemplars of swing-era jazz.

After leaving Basie, Young led his own band in New York City and Los Angeles, before rejoining Count Basie from late 1943 until his induction into the Army in the fall of 1944. His military service—which led to a court-martial and a year in detention for barbituate and marijuana possession—was traumatic, and was in part responsible for his increasingly severe alcoholism. In 1946 Young joined Norman Granz's touring concert series Jazz at the Philharmonic, under whose auspices he toured extensively in the 1940s and '50s. In the 1950s he developed a new style, darker and less buoyant in tone. His playing remained at an extraordinarily high level until his death in New York on March 15, 1959, only a day after he returned from a sojourn in Paris.

Young's familiar nickname, "Pres," or "Prez," was allegedly given to him by singer Billie Holiday in the mid-1930s, but Oklahoma City Blue Devil band members remembered calling him "Pres" in 1932, before he met the famous singer. After the consummate innovator Coleman Hawkins, Young was the foremost tenor sax stylist with a unique sound and chief architect of a conception of playing alternative to that of Hawkins. Young's unique vibrato-less tone, flawless execution, rhythmic excitement, and daring new lines won him legions of admirers; while he was praised for his solos, counterpoised against the riffs of the big band, he also attracted considerable attention for his peerless backing of vocalists, and the numerous riffs that were the basis of his own compositions and many of the Basie band motifs. "Lester Leaps In," "D. B. Blues," and "Up and Adam" were among his own compositions, but he also excelled at providing definitive renditions of such ballads as "These Foolish Things," "Polka Dots and Moonbeams," and "Three Little Words." The juxtaposition of relaxation ("cool") and tension ("hot") characterized much of his playing, but his performances defied simple formulaic definition. His profound influence on saxophonists Al Cohn, John

COLTRANE, Stan Getz, Wardell Gray, Dexter GOR-DON, Charlie PARKER, and Zoot Sims was matched by his considerable impact on trumpeters Miles DAVIS and Art Farmer, as well as guitarists Charlie CHRISTIAN, John Collins, Barney Kessel, and B. B. KING. His contributions and influences placed him on a level with Louis ARMSTRONG and Charlie Parker.

Young's special genius extended beyond music to include his language and style of life. His life, words, and conception of music were a coherent whole. Young was complex, a man of gentle demeanor, introverted and nonviolent, but loved for his sense of humor, witty expressions, and storytelling abilities. He differed from many other band leaders in treating members of his combo as equals, staying with them in hotels on the road, and allowing ample time for them to solo on the bandstand. He also innovated in jazz slang, introducing such terms as "That's cool [all right; agreeable]," "How's the bread smell? [How much pay for the job?]," and "You dig? [Do you understand?]"; in fact, he preferred this argot, speaking standard English as little as possible. An archetypal hipster, he was famous for his adoption of the porkpie hat, a flat-crowned, wide-brimmed style popular in the 1940s. He was featured in Gjon Mili's film short "Jammin' the Blues" (1944) immortalized by Charles Mingus's tribute to him, "Goodbye Pork Pie Hat," and has been the subject of poems; a play, *The Resurrection of Lady Lester* (1980); and an opera, *Prez—A Jazz Opera* (1985). Among the numerous tributes to him are the "Pres Awards" on New York's 52nd Street; the Annual Lester Young Memorial Services in St. Peter's Lutheran Church (New York City) every March 15, which mark the day of his death; Prez Conference, a band which plays and harmonizes his solos; and numerous reissues of his recordings.

REFERENCES

BUCHMAN-MOLLER, FRANK. *You Just Fight for Your Life: The Story of Lester Young.* New York, 1990.
DANIELS, DOUGLAS HENRY. "Goodbye Pork Pie Hat: Lester Young as Spiritual Figure." *Annual Review of Jazz Studies* 4 (1988): 161–177.
PORTER, LEWIS. *Lester Young.* Boston, 1985.
PORTER, LEWIS, ed. *A Lester Young Reader.* Washington, 1991.

DOUGLAS HENRY DANIELS

Young, Moses Wharton (October 24, 1904–February 5, 1986), neuroanatomist. Moses Young was born and grew up in Spartanburg, S.C. He entered Howard University's College of Liberal Arts in 1924 as a third-year student, graduating with a B.S. in 1926. He led the academic honors list during his next four years at Howard's College of Medicine. After earning an M.D. in 1930, he entered the doctoral program in anatomy at the University of Michigan. For two years (1932–1934), his studies at Michigan were sponsored by a Rockefeller Foundation fellowship. He was awarded a Ph.D. in 1934.

Young's doctoral dissertation, "The Nuclear Pattern and Fiber Connections of the Non-Cortical Centers of the Telencephalon of the Rabbit (*Lepus cuniculus*)," opened up a lifelong interest in neuroanatomy. The problems of hypertensive deafness, phonoreception and photoreception, and anatomical similarities between the visual and auditory systems were among his favorite research topics. He developed a radio therapy of the ear—an electronic concept of hearing. During World War II, he was among the first to undertake a systematic investigation of neurological and other traumas connected to high explosives. In 1975, he was awarded a special citation by the Department of Defense for his "innovative medical research theories."

For most of his career, Young taught in the anatomy department at Howard University (1934–1973). He spent a year in Japan (1952–1953) as a Fulbright Professor at Chiba Medical College. Following his retirement from Howard, he taught at the University of Maryland until 1979. In 1975, he chaired the session on sensory organs (the ear) at the Tenth International Congress of Anatomists in Tokyo. He published over a hundred papers in the course of his career.

REFERENCES

Obituary. *Washington Post,* February 8, 1986, p. B6.
YOUNG, MOSES WHARTON. "Mechanics of Blast Injuries." *War Medicine* 8 (August 1945): 73–81.

PHILIP N. ALEXANDER

Young, Preston Bernard (1884–October 9, 1962), journalist. P. B. Young was born in Littleton, N.C. He learned the newspaper business by serving as an assistant to his father, who edited the *True Reformer,* a Littleton newspaper. From 1903 to 1905, he was a student and printing instructor at St. Augustine's College in Raleigh.

In 1907, Young moved to Norfolk, Va., to pursue a career as a journalist. In 1910, he purchased the *Lodge Journal and Guide,* a weekly newspaper published by the Knights of Gideon fraternal order, retitling the newspaper the *Norfolk Journal and Guide* and expanding its format from four pages to thirty-two

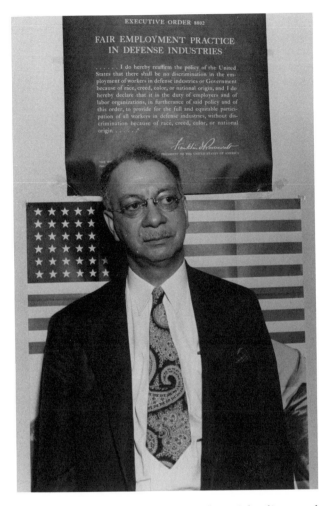

Preston Bernard Young, the influential editor and publisher of the *Norfolk Journal and Guide*, received his greatest national attention in 1943, when he was appointed by President Franklin Roosevelt to the Fair Employment Practices Commission, charged with investigating discrimination by defense contractors. (Prints and Photographs Division, Library of Congress)

pages. It soon became an influential black southern newspaper, and its circulation increased from 500 to 1910 to 28,500 by 1935. Young was sympathetic to the conservative self-help policies of Booker T. WASHINGTON, although he was an advocate of gradual reform and elimination of discriminatory racial statutes. In the 1930s, however, Young redirected the paper's editorial policy in favor of the New Deal and sharply denounced the disproportionate rate of black unemployment and poverty. During the years between the world wars, Young was generally considered the most powerful black political figure in Virginia.

Perhaps because of his reputation as a moderate on racial matters, in 1943, Young was appointed to the President's Commission on Fair Trade Practices, a

pioneering effort by the federal government to systematically investigate workplace discrimination. He continued to serve as editor and publisher of the *Journal and Guide* until 1946, when he handed over control of the newspaper to his two sons. After his retirement, he served as a trustee for several historically black colleges, including Hampton Institute, St. Paul's Polytechnic Institute, and Norfolk State College in Virginia, as well as Howard University in Washington, D.C. Young died in Norfolk in 1962.

REFERENCE

SUGGS, HENRY LEWIS. *P. B. Young, Newspaperman: Race, Politics, and Journalism in the New South, 1910–1962.* Charlottesville, Va., 1988.

THADDEUS RUSSELL

Young, Robert Alexander (1800s), nationalist. In 1829 Robert Alexander Young, a free African American from New York, published a pamphlet entitled *The Ethiopian Manifesto, Issued in Defence of the Black Man's Rights in the Scale of Universal Freedom,* the same year as David Walker issued his appeal in Boston for blacks to organize and act on their own behalf. Little is known about Young's background.

In *The Ethiopian Manifesto,* Young equated Ethiopia with Africa, and advocated a theocracy of Ethiopian people in America. In his view, the end of SLAVERY would come through the divine intervention of a mulatto messiah from Grenada in the West Indies. While Walker emphasized armed struggle instead of a messianic figure, both Young and Walker are recognized as two of the first African Americans to advocate PAN-AFRICANISM and black nationhood.

REFERENCES

HARDING, VINCENT. *There Is a River: The Black Struggle For Freedom in America.* New York, 1981.
STUCKEY, STERLING. *Ideological Origins of Black Nationalism.* Boston, 1972.

MARGARET D. JACOBS

Young, Roger Arliner (1899–November 9, 1964), zoologist. Roger Arliner Young was the first African-American woman to earn a doctoral degree in zoology, which she received from the University of Pennsylvania in 1940. In an era when few black scientists had the opportunity to conduct scientific research, Young published a number of papers on marine eggs based on experiments she had conducted

at the Marine Biological Laboratory in Woods Hole, Mass., the premier biological research institute in the country. She was the first black woman to do experimental biology at this institution.

Young was born in Clifton Forge, Va. She entered Howard University in 1916 and studied zoology under the eminent black scientist Ernest Everett JUST, one of the leading zoologists in the United States. When she completed her undergraduate work at Howard, she was hired as an assistant professor of zoology in 1924. During that same year she published the results of her observations on the morphology of the contractile vacuole and feeding canals in the microorganism in *Paramecium caudatum*.

Young received a master's degree in zoology in 1926 from the University of Chicago, where she was elected to Sigma Xi, the national science honors society. From 1927 until 1939, she taught at Howard, serving as acting head of the zoology department in Just's absence in 1929. She spent her summers doing research at Woods Hole.

Young's research, both alone and under Just, the leading biologist of his time in the study of normal marine eggs, was noteworthy. Her work on the paramecium challenged the prevailing theory on the role of the contractile vacuole and received favorable comments from scientists both in the United States and Europe. Burdened by a heavy teaching load and few financial resources, Young saw her career begin to flounder in the 1930s. After losing her position at Howard in 1936, she rallied to continue her research, publishing three papers between 1936 and 1938 and completing her doctoral work at the University of Pennsylvania under L. V. Heilbrunn in 1940.

Much of Young's research during this time continued the work she had begun with Just consisting of studies of the effects of ultraviolet radiation on sea-urchin eggs. From 1940 until her death she taught at a number of black colleges in the South, including the North Carolina College for Negroes, Shaw University (where she served as chair of the biology department), and Southern University in Louisiana.

REFERENCES

MANNING, KENNETH. *Black Apollo of Science: The Life of Ernest Everett Just.* New York, 1983.

————. "Roger Arliner Young: Scientist." *Sage: A Scholarly Journal on Black Women* 6, no. 2 (Fall 1989): 3–7.

EVELYNN M. HAMMONDS

Young, Whitney Moore, Jr. (July 31, 1921–March 11, 1971), civil rights leader. Whitney M.

Young, Jr., was born and raised in rural Lincoln Ridge, Ky., to Whitney, Sr., and Laura Ray Young. He grew up on the campus of Lincoln Institute, a vocational high school for black students where his father taught and later served as president. In this setting, Young, who attended the institute from 1933 to 1937, was relatively isolated from external racism. At the same time, he was surrounded by black people who held positions of authority and were treated with respect. In September 1937, Young enrolled at Kentucky State Industrial College in Frankfort; he graduated in June 1941. In college he met Margaret Buckner, whom he married in January 1944; the couple later had two daughters.

After serving in World War II, Young entered a master's program in social work at the University of Minnesota in the spring of 1946, which included a field placement with the Minneapolis chapter of the NATIONAL URBAN LEAGUE (NUL). He graduated in 1947 and, in September of that year, he became industrial relations secretary of the St. Paul Urban League, where he encouraged employers to hire black workers. Two years later he was appointed to serve as executive secretary with the NUL's affiliate in Omaha, Neb.

During his tenure in Omaha, Young dramatically increased both the chapter's membership base and its operating budget. He fared less well, however, in his attempts to gain increased employment opportunities for African Americans; victories in this area continued to be largely symbolic, resulting primarily from subtle behind-the-scenes pressure exerted by Young himself. Through his Urban League experience, Young became adept at cultivating relationships with powerful white corporate and political leaders.

In early 1954 Young became dean of the Atlanta University School of Social Work. He doubled the school's budget, raised teaching salaries and called for enhanced professional development. With the 1954 BROWN V. BOARD OF EDUCATION OF TOPEKA, KANSAS, Supreme Court decision and the unfolding of civil rights activism, his activities became increasingly political. He served on the board of the Atlanta NAACP, and he played a leadership role in several other organizations committed to challenging the racial status quo, including the Greater Atlanta Council on Human Relations and the Atlanta Committee for Cooperative Action. Unlike some other black community leaders, Young supported and even advised students who engaged in sit-in demonstrations in 1960. Yet Young personally opted for a low-key approach characterized by technical support for the CIVIL RIGHTS MOVEMENT rather than activism.

Young retained close ties with NUL, and in 1960 he emerged as a top candidate for executive director of the New York–based organization. Although by

far the youngest of the contenders for the position, and the least experienced in NUL work, Young was selected to fill the national post effective October 1961. Since its founding in 1910–1911, NUL had been more concerned with social services than social change; its successes had long depended on alliance with influential white corporate and political figures. However, by the early 1960s it was clear that unless it took on a more active and visible role in civil rights, the organization risked losing credibility with the black community. It was Whitney Young who, in more ways than one, would lead NUL into that turbulent decade.

For years, local Urban League activists had lobbied for a more aggressive posture on racial issues. At Young's urging, NUL's leadership reluctantly resolved to participate in the civil rights movement— but as a voice of "respectability" and restraint. In January 1962, Young declared that, while NUL would not engage actively in protests, it would not condemn others' efforts if they were carried out "under responsible leadership using legally acceptable methods." By helping to plan the 1963 March on Washington, Young simultaneously hoped to confirm NUL's new commitment and ensure that the march would pose no overt challenge to those in authority. Young also furthered NUL's moderate agenda by participating in the Council for United Civil Rights Leadership (CUCRL), a consortium founded in June 1963 to facilitate fundraising and information-sharing. (CUCRL was initiated by wealthy white philanthropists concerned with minimizing competition among civil rights organizations and tempering the movement's more militant elements.)

As "black power" gained currency within the movement, new tensions surfaced inside NUL itself. Students and other Urban League workers disrupted the organization's yearly conferences on several occasions, demanding the adoption of a more action-oriented strategy. Young continued to insist on the primacy of social service provision. But in June 1968, in an address at the CONGRESS OF RACIAL EQUALITY's (CORE) annual meeting, he spoke favorably of self-sufficiency and community control. The NUL initiated a "New Thrust" program intended to strengthen its base in black neighborhoods and to support community organizing.

During his ten-year tenure, Young made his mark on NUL in other significant ways. He guided the development of innovative new programs meant to facilitate job training and placement, and he vastly increased corporate and foundation support for the organization. In the early and mid-1960s, as corporations (especially government contractors) came under fire for failing to provide equal employment opportunities, business leaders turned to the NUL and its affiliates for help in hiring black workers. At the same time, by aiding NUL financially, they hoped to demonstrate convincingly a commitment to nondiscriminatory policies.

Of the three U.S. presidents in office during Young's tenure with the League, Lyndon B. Johnson proved to be the closest ally; he drew on Young's ideas and expertise in formulating antipoverty programs, tried to bring Young into the administration, and awarded him the Medal of Freedom in 1969. Although the relationship with Johnson was important for accomplishing NUL's goals, at times it constrained Young's own political positions. In mid-1966, Young clashed with the Rev. Dr. Martin Luther KING, Jr., and other civil rights leaders who opposed the Vietnam War; Young insisted that communism must be stopped in Southeast Asia; and he disagreed that the military effort would divert resources away from urgent problems facing African Americans at home. A year later, he was no longer so sure. Nonetheless, at Johnson's request, he traveled to South Vietnam with an official U.S. delegation. Young did not speak publicly against the war until late 1969, when Richard M. Nixon was president.

In addition to overseeing NUL's "entry" into civil rights, Young heightened the organization's visibility to a popular audience. He wrote a regular column, "To Be Equal," for the *Amsterdam News,* which was syndicated through newspapers and radio stations nationwide. He published several books, including *To Be Equal* (1964), and *Beyond Racism* (1969). At the same time, Young continued to maneuver in the highest echelons of the corporate world; among other activities, he served on the boards of the Federal Reserve Bank of New York, the Massachusetts Institute of Technology, and the Rockefeller Foundation. He also remained a prominent figure in the social work profession, serving as president of the National Conference on Social Welfare in 1967 and acting as president of the National Association of Social Workers from June 1969 until his death.

In March 1971, Young traveled to Lagos, Nigeria, with a delegation of African Americans, in order to participate in a dialogue with African leaders. He died there while swimming, either from drowning or from a brain hemorrhage.

REFERENCES

JOHNSON, THOMAS A. "Whitney Young Jr. Dies on Visit to Lagos." *New York Times,* March 12, 1971, p. 1.

NASW News 13, no. 4 (August 1968): 1.

PARRIS, GUICHARD, and LESTER BROOKS. *Blacks in the City: A History of the National Urban League.* Boston, 1971.

WEISS, NANCY J. *Whitney M. Young, Jr. and the Struggle for Civil Rights.* Princeton, N.J., 1989.

TAMI J. FRIEDMAN

Young Men's Christian Association. Although the image of a physical fitness facility dominates the current perception of the Young Men's Christian Association (YMCA), it has long been an avenue for building community spirit and a sense of social responsibility among black Christian men. When the YMCA movement in the United States began in 1852, African-American men were excluded from membership based on local practices of segregation. Two years later, when the YMCAs in the United States joined with those in Canada to form the Confederation of North American YMCAs, U.S. racial policies became a serious issue. This confederation eventually dissolved over slavery and the Civil War. Despite the conflict, the National YMCA held fast to its assertion that local associations were auton-

omous bodies which could choose to exclude black men from membership.

African-American men saw possibilities in YMCA work, despite the organization's failure to take a stand against discrimination. The first black YMCA was organized in 1853 in Washington, D.C., and lasted through the Civil War. Following the War, black associations were founded in Charleston, S.C., and New York City, as well as other cities. Student YMCAs among black college students were also founded in this period. The growing interest in YMCA work among black men and the question of how best to aid the newly freed slaves moved the national YMCA to begin to encourage the formation of black YMCA branches.

Although there was growth in this field during the late nineteenth century, it did not begin to thrive until the first black International Secretary for Colored Work was employed in 1891. William A. Hunton, who had worked in black YMCA branches in Ottawa, Canada, and Norfolk, Va., devoted his life to the expansion of YMCA work among black men. The staff later expanded to include Jesse E. Moorland, George Edmund Haynes, and Channing

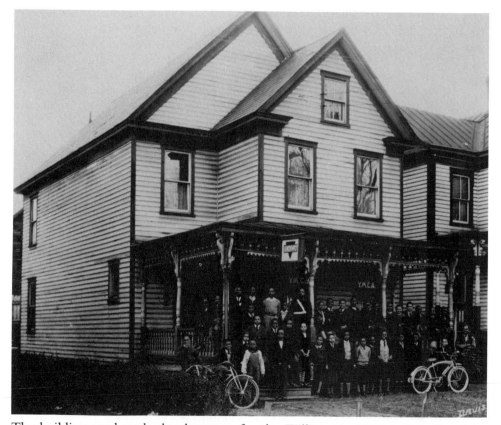

The building used as the headquarters for the William A. Hunton branch of the YMCA in Roanoke, Va. (Photographs and Prints Division, Schomburg Center for Research in Black Culture, The New York Public Library, Astor, Lenox and Tilden Foundations)

H. Tobias, among others. All these men opposed segregation in YMCA work but recognized the positive aspects of having the space to train young black men for leadership through volunteer and paid positions at the "Y." In addition, they felt that the problems facing young African-American men, particularly in urban areas, required knowledge of issues with which white YMCA workers had little experience dealing.

World War I proved to be a turning point for African-American men in the YMCA. During the war, the YMCA conducted successful work with black soldiers, focusing on health issues and on literacy training. Immediately following the war, the YMCA began to reevaluate its racial policies and encourage interracial dialogue. It was not until 1946, however, that the national YMCA urged local branches to desegregate, largely due to entreaties on the part of the World Alliance of YMCAs.

Although desegregation in YMCA work led to the closing of many of the all-black branches, the YMCA has remained a force in black communities. The work has expanded to include both women and men of all religious backgrounds. Local YMCAs sponsor summer camps, residence halls, adult education, job training, and a host of other activities and services. The YMCA continues to be relevant because of its longstanding commitment to creating workable communities and because of its willingness to modify its approach in changing times.

REFERENCE

MJAGKIJ, NINA. History of the Black YMCA in America, 1853–1946. Ph.D. diss., University of Cincinnati, 1990.

JUDITH WEISENFELD

Young Women's Christian Association. The Young Women's Christian Association (YWCA) has been an important avenue for black Christian women's activism since the late nineteenth century. African-American women, primarily in northern urban areas, began to develop such associations with a

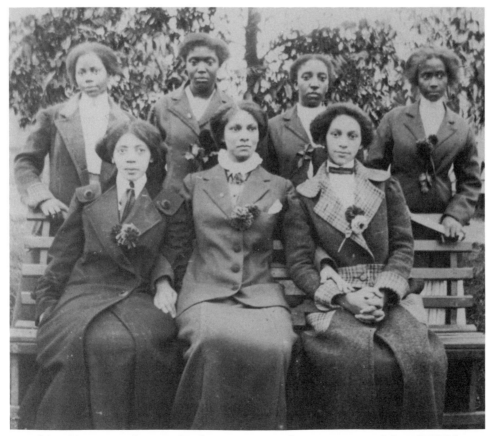

Josephine Pinyon Holmes, seated at center, student secretary of the YWCA's national board, 1917. (Photographs and Prints Division, Schomburg Center for Research in Black Culture, The New York Public Library, Astor, Lenox and Tilden Foundations)

desire to educate and train young black women and provide them with tools for survival in the city. A key component of this survival was a connection with the churches, so voting membership was restricted to young women who were members of Protestant evangelical churches. Services provided through these urban YWCA's included Bible study, lodging, trade classes, employment counseling and referrals, as well as a variety of social activities.

While the YWCA has had black members almost from the time of its founding in America in 1866, black women in the movement were segregated into a "Colored Branch" system. The YWCA operated as a biracial organization, then, rather than as an integrated one until the middle of the twentieth century. At the same time, however, a movement among students at both black colleges and at predominantly white colleges allowed for active participation in Student Christian Associations by African-American students. The student groups and the branches were brought under the jurisdiction of the National Board of the YWCA in 1906.

The segregated branch structure had both positive and negative aspects. On the one hand, these black YWCAs became important centers for educational and employment opportunities for young women and a training ground for leadership. On the other hand, colored branches were required to gain the approval of local white YWCAs in order to be recognized by the National Board. This policy clearly capitulated to the racism of many southern white women in the movement.

At the level of the National Board there were advances in representation and participation of black women in the operation of the national organization. Addie Waites HUNTON and Elizabeth Ross HAYNES were two of the early staff members at the national level. From World War I on, Eva BOWLES, the secretary for Colored Work for the National Board, expanded the staffing of her department and encouraged growth in local branches through financial assistance. In addition, in 1924, Elizabeth Ross Haynes became the first black elected member of the board. Black women in the YWCA, with the support of black women leaders in the South, continued to call for a clear break with the biracial policies operative in the movement.

At the 1946 annual convention the YWCA adopted an "Interracial Charter," which called for pioneering in a democratic and Christian "interracial experience" in the YWCA. From this point on, despite some opposition, the YWCA moved to reorganize its previously segregated system. Positions focusing on interracial education were created at the National Board level to assist in the transition. Dorothy HEIGHT was a key figure in this area.

By 1970, the YWCA had been fairly successful in achieving the goals of the Interracial Charter but recognized the continued presence of racism, both in the organization and in society at large. At the 1970 conference, the YWCA passed a declaration that pronounced its one imperative as exerting its "collective power to eliminate racism wherever it exists and by any means necessary." Helen Jackson Wilkins Claytor, the first black president of the National Board, was instrumental in achieving this declaration.

Black women have continued to work through the YWCA out of a commitment to activism from a Christian perspective and to the possibilities of such work with women of all backgrounds.

REFERENCES

LERNER, GERDA. *Black Women in White America*. New York, 1972.

SALEM, DOROTHY. *To Better Our World: Black Women in Organized Reform, 1890–1920*. Brooklyn, 1990.

JUDITH WEISENFELD

YWCA. *See* Young Women's Christian Association.

Z

Zollar, Jawole Willa Jo (1950–), choreographer and dancer. One of six children, Jawole Willa Jo Zollar was born in Kansas City, Mo. Steeped in sacred and secular aspects of African-American culture, she grew up doing musical revues. Her first dance teacher was Joseph Stevenson, a student of American dance pioneer Katherine DUNHAM. With a B.A. in dance from the University of Missouri (Kansas City) and an M.F.A. from Florida State University, she came to New York City in 1980 to study Diane MCINTYRE, artistic director of Sounds in Motion. After four years, she left McIntyre's studio to establish Urban Bush Women.

Through live music, a cappella vocalizations, and movement, Urban Bush Women explores the religious traditions and folklore of the African DIASPORA. In an article entitled "Urban Bush Women: Dances for the Homeless," writer Ntozake SHANGE describes Zollar's work: "The ensemble that Jawole Willa Jo Zollar has assembled and sustained takes women's bodies, racist myths, sexist stereotypes, postmodern conventions and the 'science' of hip-hop and catapults them over the rainbow, so they come tumbling out of the grin of the man in the moon" (Shange 1991).

Influenced by the writings of Toni MORRISON, Ishmael REED, and Alice WALKER, Zollar creates "a sense of community on stage," often in collaboration with other artists, such as folklorist and vocalist Tiye Giraud, choreographer Pat Hill-Smith, and percussionists David Pleasant and Edwina Lee Tyler. Some of her best-known works are *Song of Lawino* (1988), *I Don't Know, But I've Been Told, If You Keep on Dancin' You'll Never Grow Old* (1989), and *Praise House* (1990).

Jawole Willa Jo Zollar has received two Inter-Arts grants and three Choreographer's Fellowships from the National Endowment for the Arts. Her company has toured extensively throughout the United States and Europe.

REFERENCES

SHANGE, NTOZAKE. "Urban Bush Women: Dances for the Voiceless." *New York Times,* September 8, 1991, p. 20.

SIMS, LOWERY STOKES. "Heat and Other Climatic Manifestations: Urban Bush Women, Thought Music and Craig Harris with Dirty Tones Band." *High Performance* 45 (Spring 1989): 22–25.

JACQUI MALONE

Zydeco. Zydeco is a style of popular dance music played by African Americans of Francophone descent in the Gulf Coast region, particularly in the bayou country of southwestern Louisiana.

Despite its frenetic tempos, often led by a buoyant singer doubling on accordion, the term *zydeco* derives from the old Louisiana song "Les Haricots Sont Pas Salés," literally translated as "the green beans aren't salted," but commonly having the meaning "times aren't good."

The origins of zydeco go back to the popular dance tunes of French settlers, or Acadians, who were expelled from Nova Scotia by the British and arrived in Louisiana in the eighteenth century. They intermarried with African Americans and Native Americans of French and Spanish descent, and their European-derived string music absorbed Afro-Caribbean rhythmic elements. The first zydeco recordings, difficult to distinguish from other forms of Cajun music, are 1934 field recordings, including "Cajun Negro Fais Dos-Dos Tune," by Ellis Evans and Jimmy Lewis, and "Les Haricots Sont Pas Salés," by Austin Coleman and Joe Washington. Accordionist Amadé Ardoin was an important early zydeco musician whose "Les Blues de la Prison" (1934) shows a strong BLUES influence.

After World War II, RHYTHM AND BLUES began to influence zydeco, a development clearly heard on Clarence Garlow's "Bon Ton Roula" (1950), which translates as "Let the Good Times Roll." During this time accordionist Clifton Chenier, perhaps the greatest of all zydeco musicians, came to prominence. Born in Opelousas, La., in 1925, he made his first recordings in the 1950s, and pioneered the use of the piano accordion—an accordion with a keyboard—in zydeco music. Among the many popular and important records, noted for their heavy dance rhythms, that Chenier made before his death from diabetes in 1987 are "Black Gal" (1965), "Jambalaya" (1975), and *Country Boy Now* (1984).

In Louisiana, zydeco is invariably performed for dancers, often at nightclubs, dance halls, churches, picnics, and house parties known as "fais-do-do." Zydeco bands are typically led by a singer, with lead accompaniment by fiddle, button or piano accordion, or guitar, and backed by a rhythm section of bass, piano, and drums. Harmonica, washboard, "frottoir" (a metal rubbing board played with household implements), and the "bas trang" (triangle), were often used earlier in the century, but today are often replaced by electric instruments. Zydeco is sung in the patois of Creole Louisiana, with lyrics ranging from narrative tales, love songs, and laments to simple invocations to dancing and good times.

Although for a century zydeco has been, along with jazz and blues, a mainstay of the secular music scene among the Creole-descended population along the Gulf Coast from Louisiana to Texas, in recent years zydeco has achieved international popularity, and its greatest exponents have become celebrities with prolific touring and recording schedules. In addition to Chenier, other important zydeco musicians include accordionist Boozoo Chavis ("Paper In My Shoe," 1984), singer Queen Ida (*Cookin' With Queen Ida,* 1989), Rockin' Sidney ("My Toot Toot," 1984), and Lawrence "Black" Ardoin ("Bayou Two Step," 1984). Important ensembles include the Lawrence Ardoin Band, Terrence Semiens and the Mallet Playboys, and Buckwheat Zydeco's Ils Sont Partis Band.

Although zydeco and Cajun music share many musical elements and have common sociocultural origins in the late nineteenth-century contact between Creoles and Acadians, they are distinct forms, representing two aspects of the complex, multiracial culture that also produced jazz. Zydeco tends toward faster tempos, a syncopated rhythmic structure, and a deemphasis of the melodic line. Cajun's rhythms are often more rigid two-step dances or waltzes emphasizing melody. Zydeco has been documented in such films as *Zydeco: Creole Music and Culture in Rural Louisiana* (1984), and *J'ai Eté au Bal* (1991).

REFERENCES

ANCELET, BARRY JEAN, and E. MORGAN. *The Makers of Cajun Music.* Austin, Tex., 1984.

BROVEN, JOHN. *South to Louisiana: The Music of the Cajun Bayous.* New York, 1983.

SPITZER, NICHOLAS. Zydeco and Mardi Gras: Creole Identity and Performance Genres in Rural French Louisiana. Ph.D. diss., University of Texas at Austin, 1986.

JONATHAN GILL

APPENDIX

Tables, Charts, and Other Statistical Data

Contents

1. AGRICULTURE

TABLE 1.1 Farm Residents, 1920–1990*

Year	Population[1]	Black	Percent of farm residents who were black	Percent of blacks who were farm residents
1920				
Total U.S. Pop.	106,022	10,463	9.9	
Farm Pop.	31,974	5,100	16.0	48.7
1930				
Total U.S. Pop.	123,203	11,891	9.7	
Farm Pop.	30,529	4,681	15.3	39.4
1940				
Total U.S. Pop.	132,165	12,866	9.7	
Farm Pop.	30,547	4,502	14.7	35.0
1950				
Total U.S. Pop.	151,326	15,042	9.9	
Farm Pop.	23,048	3,167	13.7	21.1
1960				
Total U.S. Pop.	179,323	18,872	10.5	
Farm Pop.	13,445	1,482	11.0	7.9
1970				
Total U.S. Pop.	203,212	23,972	11.8	
Farm Pop.	9,712	849	8.7	3.5
1980[2]				
Total U.S. Pop.	217,520	25,502	11.7	
Farm Pop.	7,241	299	4.1	1.2
1980				
Total U.S. Pop.	217,520	25,502	11.7	
Farm Pop.	6,051	242	4.0	0.9
1990				
Total U.S. Pop.	246,081	30,369	12.3	
Farm Pop.	4,591	69	1.5	0.2

* In thousands.

[1] Total population figures were annual averages from the Current Population Survey for civilian non-institutional population. Until 1980, the farm population consisted of all persons living in rural territory on places of 10 or more acres if at least $50 worth of agricultural products were sold from the place during the preceding 12 months. Persons living on places of under 10 acres were included if agricultural sales totaled $250 or more. In 1980 the definition changed to include all persons living in rural territory on places from which $1,000 or more of agricultural products were sold in the preceding 12 months. Persons living in summer camps, motels, and tourist camps were classified as nonfarm.

[2] The 1980 estimate for the pre-1980 farm definition (see above).

Source: *Residents of Farms and Rural Areas* (Washington, D.C., 1972), p. 12.

2. AWARDS AND HONORS

TABLE 2.1 African-American Medal of Honor Recipients

The Medal of Honor is presented by Congress to members of the armed forces for valor "beyond the call of duty." In 1991 there were three medals of honor: the Navy Medal of Honor; the Army Medal of Honor; and the Air Force Medal of Honor. No African American had yet won the Air Force Medal of Honor. The table lists the date of action for which the medal was awarded. Often the medal was awarded at a much later date, sometimes years later.

The Civil War (1861–1865)

Aaron Anderson; Navy; Landsman, *U.S.S. Wyandank*; for action at Mattox Creek, March 17, 1865.

William H. Barnes; Army; Private, Company C, 38th U.S. Colored Troops; for action at Mattox Creek, March 17, 1865.

Powhattan Beaty; Army; First Sergeant, Company G, 5th U.S. Colored Troops; for action at Chapins Farm, Va., September 29, 1864.

Robert Blake; Navy; Powder Boy, *U.S.S. Marblehead*; for action at Stone's River, Tenn., December 25, 1863.

James H. Bronson; Army; First Sergeant, Company D, 5th U.S. Colored Troops; for action at Chapins Farms, Va., September 29, 1864.

William Brown; Navy; Landsman, *U.S.S. Brooklyn*; for action at Mobile Bay, Ala., August 5, 1864.

Wilson Brown; Navy; *U.S.S. Hartford*; for action at Mobile Bay, Ala., August 5, 1864.

William H. Carney; Army; Sergeant, Company C, 54th Massachusetts Colored Infantry; for action at Fort Wagner, S.C., July 18, 1863.

Decatur Dorsey; Army; Sergeant, Company B, 39th U.S. Colored Troops; for action at Petersburg, Va., July 30, 1864.

Christian A. Fleetwood; Army; Sergeant, 4th U.S. Colored Troops; for action at Chapins Farm, Va., September 29, 1864.

James Gardiner; Army; Private, Company I, 36th U.S. Colored Troops; for action at Chapins Farms, Va., September 29, 1864.

James H. Harris; Army; Sergeant, Company B, 38th U.S. Colored Troops; for action at Chapins Farms, Va., September 29, 1864.

Thomas R. Hawkins; Army; Sergeant-Major, 6th U.S. Colored Troops; for action at Deep Bottom, Va., July 21, 1864.

Alfred B. Hilton; Army; Sergeant, Company H, 4th U.S. Colored Troops; for action at Chapins Farm, Va., September 29, 1864.

Milton M. Holland; Army; Sergeant, 5th U.S. Colored Troops; for action at Chapins Farm, Va., September 29, 1864.

Alexander Kelly; Army; First Sergeant, Company F, 6th U.S. Colored Troops; for action at Chapins Farm, Va., September 29, 1864.

John Lawson; Navy; Landsman, *U.S.S. Hartford*; for action at Mobile Bay, Ala., August 5, 1864.

The Interim Period (1871–1898)

John Davis; Navy; Ordinary Seaman, *U.S.S. Trenton*; for action at Toulon, France, February, 1881.

Alphonse Girandy; Navy; Seaman, *U.S.S. Tetrel*; for action onboard ship, March 31, 1901.

John Johnson; Navy; Seaman, *U.S.S. Kansas*; for action near Greytown, Nicaragua, April 12, 1872.

William Johnson; Navy; Cooper, *U.S.S. Adams*; for action at Mare Island, Calif., November 14, 1879.

Joseph B. Noil; Navy; Seaman, *U.S.S. Powhattan*; for action at Norfolk, Va., December 26, 1872.

John Smith; Navy; Seaman, *U.S.S. Shenandoah*; for action at Rio de Janiero, Brazil, September 19, 1880.

Robert Sweeney; Navy; Ordinary Seaman; first award for action aboard the *U.S.S. Kearsage* at Hampton Roads, Va., October 26, 1881; second award for action aboard the *U.S.S. Jamestown*, December 20, 1863.

The Indian Campaigns in the West

Thomas Boyne; Army; Sergeant, Troop C, 9th U.S. Cavalry; for action at Chichillo Negro Mountains, N.M. in 1879.

Benjamin Brown; Army; Sergeant, Company C, 24th Infantry Regiment; for action at Cedar Springs and Fort Thomas, Ariz., May 11, 1889.

John Denny; Army; Sergeant, Troop C, 9th U.S. Cavalry; for action at Las Animas Canyon, N.M., September 18, 1879.

Pompey Factor; Army; Seminole Negro Indian Scouts; for action at Pecos River, Tex., April 25, 1875.

Clinton Greaves; Army; Troop C, 9th U.S. Cavalry; for action at Florida Mountains, N.M., June 26, 1879.

Henry Johnson; Army; Troop D, 9th U.S. Cavalry; for action at Milk River, Colo., October 2–5, 1879.

George Jordan; Army; Sergeant, Troop K, 9th U.S. Cavalry; for action at Carizzo Canyon, N.M., May 7, 1890.

William McBreyer; Army; Sergeant, Troop K, 10th U.S. Cavalry; for action at Elizabethtown, N.C., March 7, 1889.

Isaiah Mays; Army; Corporal, Company B, 24th Infantry Regiment; for action at Cedar Springs and Fort Thomas, Ariz., May 11, 1889.

Adam Paine; Army; Seminole Negro Indian Scouts; for action at Canyon Blanco, Statked Plains, Tex., September 26–27, 1874.

Isaac Payne; Army; Private (Trumpeter) Seminole Negro Indian Scouts; for action at Pecos River, Tex., April 22, 1875.

Thomas Shaw; Army; Sergeant, Troop K, 9th U.S. Cavalry; for action at Carizzo Canyon, N.M., August 12, 1881.

August Wally; Army; Private, Troop I, 9th U.S. Cavalry; for action at Chichillo Negro Mountains, N.M., August 16, 1881.

John Ward; Army; Sergeant; Seminole Negro Indian Scouts; for action at Pecos River, Tex., August 16, 1881.

Moses Williams; Army; First Sergeant, Troop I, 9th U.S. Cavalry; for action at Chichillo Negro Mountains, N.M., August 16, 1879.

William O. Wilson; Army; Corporal, Troop I, 9th U.S. Cavalry; for action during the Sioux Campaign, 1890.

Brent Woods; Army; Sergeant, Troop B, 9th U.S. Cavalry; for action near McEvers Ranch, N.M., August 19, 1881.

The Spanish-American War (1898)

Edward L. Baker, Jr.; Army; Sergeant-Major, 10th U.S. Cavalry; for action at Santiago, Cuba, July 1, 1898.

Dennis Bell; Army; Private, Troop H, 10th U.S. Cavalry; for action at Tayabacoa, Cuba, June 30, 1898.

Fitz Lee; Army; Private, Troop M, 10th U.S. Cavalry; for action at Tayabacoa, Cuba, June 30, 1898.

William H. Thompkins; Army; Private, Troop G, 10th U.S. Cavalry; for action at Tayabacoa, Cuba, June 30, 1898.

George H. Wanton; Army; Sergeant, Troop M, 10th U.S. Cavalry; for action at Tayabacoa, Cuba, June 30, 1898.

Robert Penn; Navy; Fireman First Class, *U.S.S. Iowa*; for action off Santiago, Cuba, July 20, 1898.

World War I (1917–1918)

Freddie Stowers; Army; Corporal, Company C, 371st Infantry Regiment, 93rd Infantry Division; for action at the Champagne Marne Sector of France, September 28, 1918.

Korean Conflict (1950–1953)

Cornelius H. Charlton; Army; Sergeant, Company C, 24th Infantry Regiment, 25th Division; for action near Chipo-Ri, Korea, June 2, 1951.

William Thompson; Army; Private First Class, Company M, 24th Infantry, 25th Division; for action near Haman, Korea, August 6, 1950.

Vietnam Conflict (1960–1975)

James A. Anderson; Marines; Private First Class, Company F, 2nd Battalion, 3rd Marine Division; for action at Cam Lo, Vietnam, February 28, 1967.

Webster Anderson; Army; Sergeant, Battery A, 2nd Battalion, 320th Artillery, 101st Airborne Division; for action at Tam Ky, Republic of Vietnam, October 15, 1967.

Eugene Ashley, Jr.; Army; Sergeant, Company C, 5th Special Forces Group (Airborne), 1st Special Forces; for action at Lang Vei, Republic of Vietnam, February 7, 1968.

Oscar P. Austin; Marines; Private First Class, Company E, 2nd Battalion, 1st Marine Division; for action at Da Nang, Republic of Vietnam, February 23, 1969.

William Maud Bryant; Army; Sergeant First Class; for action at Long Khanh Province, Republic of Vietnam, March 24, 1969.

Rodney M. Davis; Marines; Sergeant, Company B, 1st Battalion, 1st Marine Division; for action at Quang Nam Province, Republic of Vietnam, September 6, 1967.

Robert H. Jenkins; Marines; Private First Class, Company C, 3rd Reconnaissance Battalion, 3rd Marine Division; for action at Base Argonne, March 5, 1969.

Lawrence Joel; Army; Specialist Sixth Class, Headquarters and Headquarters Company, 1st Battalion, 173rd Airborne Brigade; for action in Vietnam on November 8, 1965.

Dwight Hal Johnson; Army; Specialist 5th Class, Company B, 1st Battalion, 69th Armor, 4th Infantry Division; for action at Dak To, Kontum Province, Republic of Vietnam, January 15, 1968.

Ralph H. Johnson; Marines; Private First Class, Company A, 1st Reconnaissance Battalion, 1st Marine Division; for action at Quan Duc Valley, Republic of Vietnam, March 5, 1968.

Garfield M. Langhorn; Army; Private, Troop C, 7th Squadron, 17th Cavalry, 1st Aviation Brigade; for action at Pleiku Province, Republic of Vietnam, January 15, 1969.

Matthew Leonard; Army; Platoon Sergeant, Company B, 1st Battalion, 16th Infantry, 1st Infantry Division; for action at Suoi Da, Republic of Vietnam, February 28, 1967.

Donald Russell Long; Army; Sergeant, Troop C, 1st Squadron, 4th Cavalry, 1st Infantry Division; for action in the Republic of Vietnam, June 30, 1966.

Milton L. Olive III; Army; Private First Class, Company B, 503rd Infantry, 173rd Airborne Brigade; for action at Phu Cuong, Republic of Vietnam, October 22, 1965.

Riley Leroy Pitts; Army; Captain, Company C, 2nd Battalion, 27th Infantry, 25th Infantry Division; for action at Ap Dong, Republic of Vietnam, October 31, 1967.

Charles Calvin Rogers; Army; Lieutenant Colonel, 1st Battalion, 5th Artillery, 1st Infantry Division; for action at Fishook, Republic of Vietnam, November 1, 1968.

Rupert L. Sargeant; Army; First Lieutenant, Company B, 4th Battalion, 9th Infantry, 25th Infantry Division; for action at Hau Nghia Province, Republic of Vietnam, March 15, 1967.

Clarence Eugene Sasser; Army; Specialist 5th Class, Headquarters Company, 3rd Battalion, 60th Infantry, 90th Infantry Division; for action at Ding Tuong Province, January 10, 1968.

Clifford Chester Sims; Army; Staff Sergeant, Company D, 2nd Battalion, 501st Infantry, 101st Airborne Division; for action at Hue, Republic of Vietnam, February 21, 1968.

John E. Warren, Jr.; Army; First Lieutenant, Company C, 2nd Battalion, 22nd Infantry, 25th Infantry Division; for action at Tay Ninh Province, Republic of Vietnam, January 14, 1969.

Sources: *Black Americans in Defense of Our Nation* (Washington, D.C., 1991); Robert Ewell Greene, *Black Defenders of America, 1775–1973* (Chicago, 1974).

TABLE 2.2 Nobel Prize Winners

1950	Ralph J. Bunche (8/7/04–12/9/71)	Peace
1964	Martin Luther King, Jr. (1/15/29–4/4/68)	Peace
1979	Arthur W. Lewis (1/23/15–)	Economic Sciences
1992	Derek Alton Walcott (1/23/30–)	Literature
1993	Toni Morrison (2/18/31–)	Literature

TABLE 2.3 Presidential Medal of Freedom Honorees

1963	Marian Anderson, singer
	Ralph J. Bunche, scholar, diplomat—with distinction
1964	Lena F. Edwards, physician, humanitarian
	Leontyne Price, singer
	Philip A. Randolph, trade unionist
1969	Ralph Ellison, writer
	Roy Wilkins, civil rights leader
	Whitney M. Young, social worker
	Edward Kennedy "Duke" Ellington, pianist, composer
1976	Jesse Owens, athlete, humanitarian

TABLE 2.3 **Presidential Medal of Freedom Honorees (*Continued*)**

1977	Martin Luther King, Jr., civil rights leader (posthumously)	
1980	Andrew Young, public servant	
	Clarence M. Mitchell, Jr., lawyer, civil rights activist	
1981	James H. "Eubie" Blake, ragtime pianist and composer	
1983	James Edward Cheek, educator, scholar	
	Mabel Mercer, singer	
1984	Jack Roosevelt Robinson, sportsman, baseball player (posthumously)	
1985	William "Count" Basie, jazz pianist	
	Jerome H. Holland, educator and ambassador, president of American Red Cross (posthumously)	
1988	Pearl Bailey, entertainer	
1992	Ella Fitzgerald, singer	
	Colin L. Powell, general, U.S. Army	
1993	Colin L. Powell, general, U.S. Army	

TABLE 2.4 **Pulitzer Prize Winners**

The Pulitzer Prizes were established by noted newspaper publisher Joseph Pulitzer to promote standards of excellence in American journalism and literature. Since 1917 they have been awarded annually to distinguished American journalists, authors, playwrights, and musicians. The following is a list, compiled by Bud Kliment, of individual African-American winners of the Pulitzer Prize, the categories in which they won, and the years of their awards.

Journalism

1969	Moneta Sleet, Jr.	Feature Photography
1975	Matthews Lewis	Feature Photography
1975	Ovie Carter	International Reporting
1977	Acel Moore	Investigative Reporting
1982	John H. White	Feature Photography
1984	Kenneth Cooper	Special Local Reporting
	Norman Lockman	Special Local Reporting
1985	Dennis Bell	International Reporting
	Ozier Muhammad	International Reporting
1986	Michel du Cille	Spot News Photography
1988	Dean Baquet	Investigative Reporting
1989	Clarence Page	Commentary
1991	Harold Jackson	Editorial Writing

Special Citations

1976	Scott Joplin (posthumous)	Music
1977	Alex Haley	

Literature

1950	Gwendolyn Brooks	Poetry
1970	Charles Gordone	Drama
1978	James Alan McPherson	Ficton
1982	Charles Fuller	Drama
1983	Alice Walker	Fiction
1987	August Wilson	Drama
1988	Toni Morrison	Fiction
1990	August Wilson	Drama

In addition to this list, numerous distinguished African-American journalists have contributed to staff efforts for which their newspapers were awarded Pulitzers, including Roger Wilkins of the *Washington Post,* which won the 1973 Public Service prize, Les Payne of *Newsday,* which won the 1974 Public Service prize, and many others.

TABLE 2.5 Other Honors and Awards Given by African-American Organizations, or Pertaining to African-American Issues

Sponsoring Organization	Award Name	Year Established	Frequency	Awarded For
A. Philip Randolph Institute	Achievement Award	1968	annual	Improvement in workers' lives by a ranking black trade unionist.
	Freedom Award	1968	annual	Outstanding contribution to the advancement of human and civil rights.
	Bayard Rustin Humanitarian Award	1989	annual	Achievement in human rights and social justice.
	Rosina Tucker Award	1989	annual	Significant contribution to the strengthening of the black labor alliance in the spirit of Randolph. Rosina Tucker was president of the Ladies' Auxiliary of the Brotherhood of Sleeping Car Porters.
Actors' Equity Association	Rosetta LeNoire Award	1989	annual	Exemplary work in the hiring of ethnic male and female actors on behalf of theaters and producing organizations under Equity contract.
African Studies Association	Herskovits Award	1986	annual	Original scholarly publication on Africa published in the previous year.
Afro-American Police League	National Law and Social Justice Leadership Award	1971	annual	Dedication to social justice.
American Alliance for Health, Physical Education, Recreation and Dance	Charles D. Henry Award	1984	annual	Service to AAHPERD in increasing involvement of ethnic minorities. Charles D. Henry made significant contributions to the alliance through his work in the finance and ethnic minorities committees.
American College Theatre Festival	Lorraine Hansberry Playwriting Award	1977	annual	Outstanding original play on the black experience by a student.
American Library Association–Social Responsibilities Roundtable	Coretta Scott King Book Award	1969	annual	Outstanding work by an author and illustrator which promotes an understanding of culture and the contribution of all peoples to the American Dream.

TABLE 2.5 Other Honors and Awards Given by African-American Organizations, or Pertaining to African-American Issues (*Continued*)

Sponsoring Organization	Award Name	Year Established	Frequency	Awarded For
American Physical Therapy Association	Minority Achievement Award	1984	annual	Achievement by an entry-level, accredited physical therapy program in the recruitment, admission, retention, and graduation of minority students.
American Political Science Association	Ralph J. Bunche Award	1978	annual	Scholarly work exploring ethnic and cultural pluralism published in the previous year.
Association of Black Nursing Faculty in Higher Education	Lifetime Achievement in Education or Research Award	1988	annual	Significant contribution by an individual to nursing and/or the health care of African-American patients.
Audience Development Committee (AUDELCO)	Audelco Recognition Award	1973	annual	Outstanding contributions to black theater, awarded in seventeen categories.
Berea College	Carter G. Woodson Award	1983	annual	Efforts to foster unity, culture, or research of black communities, or understanding in multicultural education. Carter G. Woodson (1875–1950) was a Berea alumnus and founder of Black History Month.
Black Academy of Arts and Letters	Hall of Fame	1970	annual	Cumulative impact on black arts and letters by a deceased black.
Black Filmmakers Hall of Fame	Oscar Micheaux Award	1974	annual	Significant contribution to improving the image of African Americans in film and the entertainment industry.
	Paul Robeson Medal for Outstanding Achievement in the Arts	1977	annual	Creativity and commitment to African-American humanism, espousing the ideals of Paul Robeson.
	Clarence Muse Youth Award	1978	annual	Young person in creative arts demonstrating dedication, discipline, daring, mastery of art form and concern with images. Clarence Muse (1889–1979) was an actor, writer, and composer noted for the dignity of his performances.

TABLE 2.5 Other Honors and Awards Given by African-American Organizations, or Pertaining to African-American Issues (*Continued*)

Sponsoring Organization	Award Name	Year Established	Frequency	Awarded For
B'nai B'rith International Don King Center for Black-Jewish Relations	Martin Luther King, Jr.–Abraham Joshua Heschel Award	1988	periodic	Individuals demonstrating a commitment to the advancement of equality, human rights, and a meaningful relationship between black and Jewish communities.
Catholic Interracial Council of New York	James J. and Jane Hoey Award for Interracial Justice	1942	annual	Outstanding contributions to the cause of human rights and social justice.
	John LaFarge Memorial Award for Interracial Justice	1965	annual	Outstanding contributions in furthering interracial justice. John LaFarge (1880–1963) was the founder of the Council.
Cleveland Foundation	Anisfield-Wolf Book Award in Race Relations	1934	annual	Outstanding literary contributions in the field of race relations. Edith Anisfield-Wolf (1889–1963), philanthropist, created the award in memory of her father and husband.
Columbia University Graduate School of Journalism	Paul Tobenkin Memorial Award	1960	annual	Reporting excellence in a U.S. newspaper in the fight against intolerance and bigotry. Paul Tobenkin (1913–1959) was a reporter for the *New York Herald Tribune* and a specialist in the labor field.
Congressional Black Caucus Foundation	George W. Collins Award	1973	annual	Exemplifying the dedication and work style of the late George Collins (1925–1973), an Illinois representative dedicated to helping the lives of the urban poor.
	William L. Dawson Award	1981	annual	Contributions to the development of legislation addressing the needs of minorities. William L. Dawson (1886–1970) was an Illinois representative and the first African-American chair of a House committee.
	Humanitarian Award	1990	annual	Exceptional work in the struggle for human rights and social justice.

TABLE 2.5 **Other Honors and Awards Given by African-American Organizations, or Pertaining to African-American Issues** (*Continued*)

Sponsoring Organization	Award Name	Year Established	Frequency	Awarded For
	Adam Clayton Powell Award	1972	annual	Contribution to black political awareness and empowerment by an African American in the political arena.
	Harold Washington Award	1988	annual	Excellence in coalition building. Harold Washington (1922–1987) was the first African-American mayor of Chicago (1983–87).
Congress of Racial Equality	Martin Luther King, Jr. Achievement Award	1985	annual	Individuals who have accomplished within their chosen field and maintained a commitment to civil and human rights.
Fellowship of Reconciliation	Martin Luther King, Jr. Award	1979	annual	Quiet but effective work for peace, justice and nonviolence.
Fiction Collective Two, University of Colorado	Charles H. and N. Mildren Nilon Excellence in Minority Fiction Award	1988	annual	Original, unpublished fiction by minority writers.
Group Theatre Company	Multicultural Playwrights' Festival	1984	annual	Previously unproduced scripts by Native American, Asian, African, Chicano, or Hispanic Americans.
International Black Writers	Alice C. Browning Award	1986	annual	Excellence in writing by a young black writer. Alice C. Browning was the founder of the International Black Writers Conference.
J. Morris Anderson Enterprises	Miss Black America	1968	annual	Outstanding pageant participants.
Jackie Robinson Foundation	Jackie Robinson Foundation Award for Achievement in Industry	1980	annual	Outstanding corporate leaders who have worked to improve the situation of minorities in economic development.
Johnson Publishing Company	American Black Achievement Awards	1978	annual	Accomplishment by African Americans in 10 categories.
	Gertrude Johnson Williams Writing Contest	1988	annual	Short stories by African Americans. Gertrude Johnson Williams was the mother of *Ebony* editor and publisher John H. Johnson (1918–).

TABLE 2.5 Other Honors and Awards Given by African-American Organizations, or Pertaining to African-American Issues (*Continued*)

Sponsoring Organization	Award Name	Year Established	Frequency	Awarded For
Leadership Conference on Civil Rights	Hubert H. Humphrey Civil Rights Award	1978	annual	Selfless devotion to equality. Hubert H. Humphrey (1911–1978) was a Minnesota senator and vice president of the United States.
Lincoln University of Missouri Department of Communications	Unity Awards in Media	1949	annual	Excellence in reporting on issues affecting minorities and the disadvantaged.
Martin Luther King, Jr., Center for Nonviolent Social Change, Inc.	Martin Luther King, Jr., Nonviolent Peace Prize	1973	annual	Outstanding contributions to nonviolent social change.
	Labor Social Responsibility Award	1976	annual	Outstanding contributions to the cause of economic justice, freedom and nonviolence.
National Action Council for Minorities in Engineering (NACME)	Reginald H. Jones Distinguished Service Award	1983	annual	Individuals whose efforts have resulted in increased minority participation in the nation's engineering workforce. Reginald H. Jones was the chairman and CEO of the General Electric Company.
National Association for the Advancement of Colored People (NAACP)	Kelly M. Alexander, Sr., NAACP State Conference President's Award	1987	annual	Outstanding achievement by a state conference president. Kelly M. Alexander, Sr., served as a state conference president for 27 years and chairman of the NAACP board of directors.
	W. E. B. Du Bois Medal	1985	annual	Contributions to the protection of human rights and furtherance of fundamental freedoms by individuals who are not U.S. citizens.
	Image Awards	1979	annual	Positive contributions to minority images by entertainers and sports figures.
	Thurgood Marshall Award	1993	annual	Lifetime commitment to civil and human rights issues.

TABLE 2.5 Other Honors and Awards Given by African-American Organizations, or Pertaining to African-American Issues (*Continued*)

Sponsoring Organization	Award Name	Year Established	Frequency	Awarded For
	Springarn Medal	1915	annual	Highest achievement by an African American in any honorable field of endeavor. Joel E. Spingarn (1875–1939) served as president of the NAACP 1930–1939.
National Association of Black Journalists	National Association of Black Journalists Salute to Excellence Awards	1975	annual	Outstanding contributions by black journalists in 20 categories.
National Association of Black Women Attorneys	Hall of Fame Award	1987	annual	Civic and community leadership.
National Bar Association	Gertrude E. Rush Award	1982	annual	Achievement in the law, public policy or social activism. Gertrude E. Rush was the association's only woman cofounder.
	C. Francis Stradford Award	—	annual	Outstanding service in the furtherance of the association's objectives. C. Francis Stradford was a cofounder of the association.
National Black Police Association	Renault Robinson Award	1978	annual	Member who has served the black community. Renault Robinson is honored for his courageous efforts for equal rights and justice.
National Black Programming Consortium	Prized Pieces Competition	1981	annual	Television programming which enriches understanding of the lives, culture, and concerns of African Americans in seven categories.
National Caucus and Center on Black Aged, Inc.	Living Legacy Award	1979	annual	Outstanding contributions to society and achievement in the arts, sciences, and humanities.
National Council for Black Studies	Bertha Maxwell Award	1978	annual	Best essays in the National Student Essay Contest. Bertha Maxwell was the first chairperson of the NCBS.
National Economic Association	Samuel Z. Westerfield Award	1974	usually biennial	Outstanding scholarly work by a black economist. Samuel Z. Westerfield (1919–1972) was an economist and U.S. ambassador to Liberia.

TABLE 2.5 Other Honors and Awards Given by African-American Organizations, or Pertaining to African-American Issues (*Continued*)

Sponsoring Organization	Award Name	Year Established	Frequency	Awarded For
National Newspaper Publishers Association	Distinguished Service Award		annual	Most significant contribution to black advancement during the previous year by a black leader.
	Russwurm Award		annual	Excellence in the black press. John B. Russwurm cofounded *Freedom's Journal* (1827), the first black-operated newspaper.
National Urban League	Equal Opportunity Day Award	1957	annual	Contributions to the National Urban League.
	Labor Affairs Award	1986	annual	Recognition of organized labor's commitment to strengthening bond between the trade union movement and the black community.
	Living Legends Award	1987	annual	Significant contributions by black Americans in their field of endeavor.
	Ann Tanneyhill Award	1970	annual	Excellence and extraordinary commitment to the Urban League Movement by an employee of the NUL. Anne Tanneyhill was an outstanding staff member of the NUL.
New York Urban League	Frederick Douglass Award	1966	annual	Leadership by New Yorkers in the fight for equal opportunity.
	Whitney M. Young, Jr., Memorial Football Classic Award	1978	annual	Leadership, character and sportsmanship.
Newark Black Film Festival	Paul Robeson Awards	1985	biennial	Excellence in independent filmmaking by black filmmakers in 4 categories.
Organization of American Historians	Elliot Rudwick Prize	1991	biennial	A book on the experience of racial and ethnic minorites in the United States. Elliott Rudwick was a professor of history and sociology at Kent State University.
Penumbra Theatre Company	Cornerstone: A National Black Playwriting Competition	1984	annual	Best play concerned with the African-American experience.

TABLE 2.5 Other Honors and Awards Given by African-American Organizations, or Pertaining to African-American Issues (*Continued*)

Sponsoring Organization	Award Name	Year Established	Frequency	Awarded For
Phelps-Stokes Fund	Aggrey Medal	1986	periodically	Significant contributions in the area of education for Africans, African Americans, and American Indians.
	Clarence L. Holte Literary Prize	1977	biennial	Significant contribution by a living writer to the cultural heritage of Africa and the African diaspora. Clarence L. Holte was a writer and editor who collected books about the African heritage and diaspora.
Society for the Psychological Study of Ethnic Minority Issues	Distinguished Contribution to Ethnic Minority Psychology Award	1990	annual	Contributions to ethnic minority psychology in research and service.
Unitarian Universalist Association	Holmes-Weatherly Award	1951	annual	Pursuit of social justice. John Haynes Holmes (1879–1964) was a founder of the NAACP and ACLU. Arthur R. Weatherly was an advocate of child welfare and labor reform.
Undergraduate Student Assembly	Salute to Black Women for Excellence in the Field	1981	annual	Commitment, dedication, achievement, and service to the community by black women.
Workers Defense League	David L. Clendenin Award	1941	annual	Distinguished service by prominent labor, religious, or political figures in the labor movement and civil rights. David L. Clendenin was a cofounder of the league and advocate of democratic trade unionism.

3. BUSINESS

TABLE 3.1 *Black Enterprise*'s **Top 10 Industrial/Service Companies, 1977, 1980, 1985, and 1990†**

1977	Company	Location	Chief Executive	Began	Staff	Type of Business	Sales*
1	MOTOWN INDUSTRIES	Los Angeles, Calif.	Berry Gordy, Jr.	1959	300	Entertainment	61.4
2	JOHNSON PUBLISHING CO., INC.	Chicago, Ill.	John H. Johnson	1942	395	Publishing	50.15
3	FEDCO FOODS CORPORATION	Bronx, N.Y.	J. Bruce Llewellyn	1969	525	Supermarkets	45.0
4	JOHNSON PRODUCTS CO., INC.	Chicago, Ill.	George E. Johnson	1954	437	Mfg. hair-care products and cosmetics	38.047
5	AFRO INTERNATIONAL CORP.	New York, N.Y.	Richard L. Trotman	1962	5	Exports	25.0
6	H. J. RUSSELL CONSTRUCTION CO., INC.	Atlanta, Ga.	Herman J. Russell	1958	150	Construction and development	25.0
7	WALLACE & WALLACE CHEMICAL & OIL CORP.	St. Albans, N.Y.	Charles Wallace	1972	78	Fuel oil import and distribution	17.57
8	DRUMMOND DISTRIBUTING CO., INC.	Compton, Calif.	Lancelot E. Drummond	1969	50	Liquor wholesaling	14.5
9	WALLACE & WALLACE FUEL OIL CO., INC.	St. Albans, N.Y.	Charles Wallace	1968	52	Retail fuel oil sales	12.739
10	S.T.R. CORPORATION	Cleveland, Ohio	Steve Rogers	1965	167	Supermarkets	10.72

† In order to be eligible, the firm must have been fully operational in the previous calendar year and be at least 51% black-owned. It must manufacturer or own the product it sells or provide industrial or consumer services. Brokerages, real estate firms, auto dealerships, and firms that provide professional services (accountants, lawyers, etc.) are not eligible.
* In millions of dollars. Ranked by sales as of December 1977. Prepared by B. E. Research.

1980	Company	Location	Chief Executive	Began	Staff	Type of Business	Sales*
1	MOTOWN INDUSTRIES	Los Angeles, Calif.	Berry Gordy, Jr.	1959	215	Entertainment	91.7
2	WALLACE & WALLACE ENTERPRISES, INC.	St. Albans, N.Y.	Charles Wallace	1969	36	Petroleum sales	81.935
3	JOHNSON PUBLISHING CO. INC.	Chicago, Ill.	John H. Johnson	1942	610	Publishing; cosmetics; broadcasting	72.974
4	FEDCO FOODS CORPORATION	New York, N.Y.	Samuel Berger	1969	475	Supermarkets	51.654
5	H. J. RUSSELL CONSTRUCTION CO., INC.	Atlanta, Ga.	Herman J. Russell	1958	275	Construction	51.0
6	VANGUARD OIL & SERVICE CO.	Brooklyn, N.Y.	Kenneth Butler	1970	40	Petroleum sales	50.5
7	SMITH PIPE & SUPPLY INC.	Houston, Tex.	George Smith, Sr.	1976	135	Oilfield pipe and supply sales	48.0
8	JOHNSON PRODUCTS CO., INC.	Chicago, Ill.	George E. Johnson	1954	575	Hair-care products and cosmetics	41.016
9	GRIMES OIL COMPANY	Dorchester, Mass.	Calvin M. Grimes, Jr.	1969	65	Petroleum sales	40.0
10	CHIOKE INTERNATIONAL CORPORATION	New York, N.Y.	Christopher E. Chioke	1970	14	Defense equipment and crude oil marketing	35.0

* In millions of dollars. Ranked by sales as of December 1980. Prepared by B. E. Research.

TABLE 3.1 *Black Enterprise*'s Top 10 Industrial/Service Companies, 1977, 1980, 1985, and 1990 (*Continued*)

1985	Company	Location	Chief Executive	Began	Staff	Type of Business	Sales*
1	JOHNSON PUBLISHING CO. INC.	Chicago, Ill.	John H. Johnson	1942	1,082	Publishing cosmetics; broadcasting; TV	154.86
2	MOTOWN INDUSTRIES	Los Angeles, Calif.	Berry Gordy	1958	246	Entertainment	149.029
3	H. J. RUSSELL CONSTRUCTION INC.	Atlanta, Ga.	Herman J. Russell	1958	600	Construction/ development; communications	118.0
4	PHILADELPHIA COCA-COLA BOTTLING CO. INC.	Philadelphia, Pa.	J. Bruce Llewellyn	1985	752	Soft-drink bottling	102.0
5	SOFT SHEEN PRODUCTS INC.	Chicago, Ill.	Edward G. Gardner	1964	850	Hair-care products manufacturer	85.0
6	G & M OIL COMPANY, INC.	Baltimore, Md.	Rudolph C. Gustus	1963	48	Petroleum products	61.853
7	INTERSTATE LANDSCAPING CO.	Harrisburg, Ill.	Raymond N. Johnson	1960	500	General contracting	61.0
8	TLC GROUP INC.	New York, N.Y.	Reginald F. Lewis	1983	605	Paper patterns for home sewing	60.0
9	SYSTEMS AND APPLIED SCIENCES CORPORATION	Vienna, Va.	Porter L. Bankhead	1973	960	Computer and electronic data systems	58.0
10	WARDOCO, INC.	New Haven, Conn.	Larry B. Wardlaw	1978	20	Commercial fuel oils	49.505

* In millions of dollars. Ranked by sales as of December 1985. Prepared by B. E. Research.

1990	Company	Location	Chief Executive	Began	Staff	Type of Business	Sales*
1	TLC BEATRICE INTERNATIONAL HOLDINGS INC.	New York, N.Y.	Reginald F. Lewis	1987	5,000	Processing and distribution of food products	1,496.0
2	JOHNSON PUBLISHING CO. INC.	Chicago, Ill.	John H. Johnson	1942	2,382	Publishing; broadcasting cosmetics; hair care	252.187
3	PHILADELPHIA COCA-COLA BOTTLING CO. INC.	Philadelphia, Pa.	J. Bruce Llewellyn	1985	1,000	Soft-drink bottling	251.3
4	H. J. RUSSELL & CO.	Atlanta, Ga.	Herman J. Russell	1958	668	Construction and development; food services	143.295
5	SOFT SHEEN PRODUCTS INC.	Chicago, Ill.	Edward G. Gardner	1964	532	Hair-care products manufacturer	92.1
6	BARDEN COMMUNICATIONS, INC.	Detroit, Mich.	Don H. Barden	1981	308	Communications and real estate development	86.0
7	TRANS JONES INC./ JONES TRANSFER CO.	Monroe, Mich.	Gary L. White	1986	1,189	Transportation services	75.0
8	GARDEN STATE CABLE TV	New York, N.Y.	J. Bruce Llewellyn	1989	300	Cable TV broadcasting	74.0
9	STOP SHOP AND SAVE	Baltimore, Md.	Henry T. Baines	1978	600	Supermarkets	65.0
10	THE BING GROUP	Detroit, Mich.	Dave Bing	1980	173	Steel processing & metal-stamping operations	61.0

* In millions of dollars. Ranked by sales as of December 1990. Prepared by B. E. Research.

TABLE **3.2** *Black Enterprise*'s **Top 100 Industrial/Service Companies, 1993**[†]

	Company	Location	Chief Executive	Began	Staff	Type of Business	Sales*
1	TLC BEATRICE INTERNATIONAL HOLDINGS INC.	New York, N.Y.	Loida N. Lewis Jean Fugett, Jr.	1987	4,500	International food processor and distributor	1,700.0
2	JOHNSON PUBLISHING CO. INC.	Chicago, Ill.	John H. Johnson	1942	2,600	Publishing; broadcasting; TV production; cosmetics; hair care	293.794
3	PHILADELPHIA COCA-COLA BOTTLING CO., INC.	Philadelphia, Pa.	J. Bruce Llewellyn	1985	1,000	Soft-drink bottling	290.0
4	H. J. RUSSELL & CO.	Atlanta, Ga.	Herman J. Russell	1952	984	Construction development and management; communications	152.4
5	RMS TECHNOLOGIES INC.	Marlton, N.J.	David W. Huggins	1977	1,178	Computer and technical services	115.2
6	THE ANDERSON-DUBOSE CO.	Solon, Ohio	Warren Anderson	1991	80	Food distributor	115.0
7	GOLD LINE REFINING LTD.	Houston, Tex.	Earl Thomas	1990	58	Oil refinery	108.119
8	THREADS 4 LIFE (d/b/a/ CROSS COLOURS)	Commerce, Calif.	Carl Jones	1990	250	Apparel manufacturer	97.0
9	SOFT SHEEN PRODUCTS INC.	Chicago, Ill.	Edward G. Gardner	1964	419	Hair-care products manufacturer	96.6
10	GARDEN STATE CABLE TV	Cherry Hill, N.J.	J. Bruce Llewellyn	1989	300	Cable TV operator	96.0
11	ENVIROTEST SYSTEMS CORP.	Tucson, Ariz.	Chester C. Davenport	1990	1,921	Vehicle emissions testing	90.0
12	THE BING GROUP	Detroit, Mich.	David Bing	1980	242	Steel processing; metal stamping distribution	83.324
13	BARDEN COMMUNICATIONS INC.	Detroit, Mich.	Don H. Barden	1981	350	Communications; real estate development	82.4
14	PULSAR DATA SYSTEMS INC.	New Castle, Del.	William W. Davis, Sr.	1982	79	Systems integration; office automation; computer reseller	79.1
15	DREW PEARSON COMPANIES	Addison, Tex.	Drew Pearson Kenneth Shead	1985	130	Sports licensing and sportswear manufacturing	77.525
16	UNIWORLD GROUP INC.	New York, N.Y.	Byron E. Lewis	1969	90	Advertising; public relations; event marketing; TV programming	77.091
17	BURRELL COMMUNICATIONS GROUP	Chicago, Ill.	Thomas J. Burrell	1971	120	Advertising; public relations; consumer promotions	74.7
18	BLACK ENTERTAINMENT TELEVISION HOLDINGS	Washington, D.C.	Robert Johnson	1980	350	Cable TV network; magazine publishing	74.218
19	ESSENCE COMMUNICATIONS INC.	New York, N.Y.	Edward Lewis	1969	94	Magazine publishing; TV production; direct mail	71.146
20	MAYS CHEMICAL COMPANY INC.	Indianapolis, Ind.	William G. Mays	1980	86	Industrial chemical distributors	65.0

[†] To be eligible for *Black Enterprise* business lists, a company must have been fully operational in the previous calendar year and be at least 51% black-owned. It must manufacture or own the product it sells or provide industrial or consumer services. Brokerages, real estate firms, auto dealerships, and firms that provide professional services (accountants, lawyers, etc.) are not eligible.
* In millions of dollars. Ranked by sales as of December 31, 1993. Prepared by B. E. Research. Reviewed by Mitchell/Titus & Co.

TABLE 3.2 *Black Enterprise*'s **Top 100 Industrial/Service Companies, 1993** (*Continued*)

	Company	Location	Chief Executive	Began	Staff	Type of Business	Sales*
21	STOP SHOP AND SAVE	Baltimore, Md.	Henry T. Baines Edward Hunt	1978	560	Supermarkets	64.02
22	AFRICAN DEVELOPMENT PUBLIC INVESTMENT CORP.	Hollywood, Calif.	Dick Griffey	1985	8	African commodities; air charter service and oil trading	57.818
23	WESLEY INDUSTRIES INC.	Flint, Mich.	Delbert W. Mullens	1983	395	Industrial coatings and grey iron foundry products	55.557
24	TRUMARK INC.	Lansing, Mich.	Carlton L. Guthrie	1985	390	Automotive metal stamping and exhaust products	52.1
25	THE MINGO GROUP	New York, N.Y.	Samuel Chisholm	1977	40	Advertising; public relations	50.047
26	PEPSI COLA OF WASHINGTON, D.C., L.P.	Washington, D.C.	Earl G. Graves	1990	143	Soft-drink distributor	49.283
27	SURFACE PROTECTION INDUSTRIES	Los Angeles, Calif.	Robert C. Davidson, Jr.	1978	200	Paint and specialty coatings manufacturer	48.5
28	COMMUNITY FOODS INC. T/A SUPER PRIDE MARKETS	Baltimore, Md.	Oscar A. Smith, Jr.	1970	400	Supermarkets	47.5
29	LUSTER PRODUCTS CO.	Chicago, Ill.	Jory Luster	1957	313	Hair-care products manufacturer & distributor	46.0
30	GRANITE BROADCASTING CORPORATION	New York, N.Y.	W. Don Cornwell	1988	450	Network TV affiliates	45.167
31	CAPSONIC GROUP INC. DIV. OF GABRIEL INC.	Elgin, Ill.	James Liautaud	1968	350	Composite components for auto and computer control systems	43.721
32	CREST COMPUTERS & SUPPLIES	Skokie, Ill.	Gayle Sayers	1984	60	Computer hardware/software supplier and systems integrator	43.0
33	THE MAXIMA CORPORATION	Lanham, Md.	Joshua I. Smith	1978	730	Systems engineering; computer facilities management	41.11
34	PRO-LINE CORPORATION	Dallas, Tex.	Comer J. Cottrell	1970	236	Hair-care products manufacturer and distributor	40.516
35	THACKER ENGINEERING INC.	Atlanta, Ga.	Floyd Thacker	1970	126	Construction; construction management; engineering	39.2
36	CALHOUN FOOD SUPERMARKET	Montgomery, Ala.	Greg Calhoun	1984	350	Supermarket	37.179
37	GRIMES OIL CO., INC.	Boston, Mass.	Calvin Grimes	1940	20	Petroleum products distributor	37.0
37	SYLVEST MANAGEMENT SYSTEMS CORPORATION	Lanham, Md.	Gary S. Murray	1987	54	Computer systems and engineering	37.0
39	THE GOURMET COMPANIES	Atlanta, Ga.	Nathaniel Goldston III	1975	1,000	Food service; golf facilities management	36.75
40	WESTWIDE DISTRIBUTORS	South Gate, Calif.	Edison R. Lara, Sr.	1974	115	Beer and snack foods distributor	35.0
41	METTERS INDUSTRIES INC.	McLean, Va.	Samuel Metters	1981	465	Systems engineering; configuration and data mgt.	34.861

TABLE 3.2 *Black Enterprise*'s Top 100 Industrial/Service Companies, 1993 (*Continued*)

	Company	Location	Chief Executive	Began	Staff	Type of Business	Sales*
42	INTEGRATED SYSTEMS ANALYSTS INC.	Arlington, Va.	C. Michael Gooden	1980	540	Systems engineering; computer systems services repair	34.6
43	BEAUCHAMP DISTRIBUTING CO.	Compton, Calif.	Patrick L. Beauchamp	1971	97	Beverage distributor	34.496
44	THOMPSON HOSPITALITY L.P.	Reston, Va.	Warren M. Thompson	1992	1,925	Restaurant and food service	34.25
45	ADVANTAGE ENTERPRISES INC.	Toledo, Ohio	Levi Cook, Jr.	1980	357	Project integrator for health care and construction	32.595
46	DUDLEY PRODUCTS INC.	Greensboro, N.C.	Joe Louis Dudley, Sr.	1967	505	Beauty products manufacturer	32.5
47	AM-PRO PROTECTIVE AGENCY INC.	Columbia, S.C.	John E. Brown	1982	1,200	Security guards services	31.565
48	BROOKS SAUSAGE CO., INC.	Kenosha, Wis.	Frank B. Brooks	1985	160	Sausage manufacturer	31.5
49	R.O.W. SCIENCES INC.	Rockville, Md.	Ralph Williams	1983	485	Biomedical and health services; research	31.0
49	RUSH COMMUNICATIONS	New York, N.Y.	Russell Simmons	1990	70	Music publishing; TV, film, radio production	31.0
51	EDGE SYSTEMS INC.	Aurora, Ill.	Sam Bishop	1985	60	Computer systems integration; turnkey computer systems for imaging	30.081
52	INNER CITY BROADCASTING CORPORATION	New York, N.Y.	Pierre Sutton	1972	205	Radio, TV, cable TV franchise	29.0
52	YANCY MINERALS	Woodbridge, Conn.	Earl J. Yancy	1977	12	Industrial metals, minerals and coal distributors	29.0
54	DIGITAL SYSTEMS RESEARCH INC.	Arlington, Va.	Willie Woods	1988	262	Defense systems; engineering; computer systems integration	28.978
55	AUTOMATED SCIENCES GROUP INC.	Silver Spring, Md.	Arthur Holmes, Jr.	1974	300	Information and sensor technologies manufacturer	28.0
56	QUEEN CITY BROADCASTING INC.	New York, N.Y.	J. Bruce Llewellyn	1985	130	Network TV affiliates	27.8
57	CIMARRON EXPRESS INC.	Genoa, Ohio	Glen G. Grady	1984	85	Contract carrier	26.5
57	DICK GRIFFEY PRODUCTIONS	Hollywood, Calif.	Dick Griffey	1975	102	Entertainment	26.5
59	INTEGRATED STEEL INC.	Detroit, Mich.	Geralda L. Dodd	1990	235	Automotive stamping and steel sales and processing	26.0
59	O. J. TRANSPORT CO.	Detroit, Mich.	John A. James	1971	225	Transportation service	26.0
59	PREMIUM DISTRIBUTORS INC. OF WASHINGTON, D.C.	Washington, D.C.	Henry Neloms	1984	75	Beverage distributor	26.0
62	SIMMONS ENTERPRISES INC.	Cincinnati, Ohio	Carvel Simmons	1970	80	Trucking; farm operations; day care	25.77

TABLE 3.2 *Black Enterprise*'s Top 100 Industrial/Service Companies, 1993 (*Continued*)

	Company	Location	Chief Executive	Began	Staff	Type of Business	Sales*
63	RESTORATION SUPERMARKET CORPORATION	Brooklyn, N.Y.	Roderick B. Mitchell	1977	169	Supermarket and drugstore	25.75
64	H. F. HENDERSON INDUSTRIES INC.	W. Caldwell, N.J.	Henry F. Henderson, Jr.	1954	126	Industrial process controls and defense electronics	25.659
65	ADVANCE INC.	Arlington, Va.	Dennis Brownlee	1980	270	Computer systems integration; telecommunications	25.4
66	NETWORK SOLUTIONS INC.	Herndon, Va.	Emmit C. McHenry	1979	314	Systems integration	24.5
67	NAVCOM SYSTEMS INC.	Manassas, Va.	Elijah "Zeke" Jackson	1986	150	Electronic engineering, design, integration, manufacturing/assembly	23.6
68	REGAL PLASTICS CO., INC.	Roseville, Mich.	William F. Pickard	1985	200	Custom plastic injection molding	23.5
69	LUNDY ENTERPRISES	New Orleans, La.	Larry Lundy	1992	1,000	Fast-food restaurants	23.3
70	V & J FOODS INC.	Milwaukee, Wis.	Valerie Daniels-Carter	1984	1,100	Fast-food restaurants	23.0
71	PARKS SAUSAGE CO.	Baltimore, Md.	Raymond Haysbert, Sr.	1951	230	Sausage manufacturer	22.886
72	EARL G. GRAVES LTD.	New York, N.Y.	Earl G. Graves	1970	65	Magazine publishing	22.434
73	D-ORUM HAIRCARE PRODUCTS	Gary, Ind.	Ernest Daurham	1979	130	Minority hair products manufacturer	22.0
74	SYSTEMS ENGINEERING & MANAGEMENT ASSOCIATES INC.	Alexandria, Va.	James C. Smith	1985	274	ADP technical support services	21.5
75	BRONNER BROTHERS	Atlanta, Ga.	Bernard Bronner	1947	250	Hair-care products manufacturer	21.0
75	DUAL INC.	Arlington, Va.	J. Fred Dual, Jr.	1983	300	Engineering and technical services	21.0
77	AMERICAN DEVELOPMENT CORPORATION	Charleston, S.C.	W. Melvin Brown, Jr.	1972	218	Manufacturing and sheet-metal fabrication	20.0
77	DYNAMIC CONCEPTS INC.	Washington, D.C.	Pedro Alfonso	1979	460	Telecommunication support; optical imaging and facilities management	20.0
77	LOCKHART & PETTUS INC.	New York, N.Y.	Keith E. Lockhart	1977	20	Advertising agency	20.0
77	STEPHENS ENGINEERING CO. INC.	Lanham, Md.	Wallace O. Stephens	1979	140	Systems integration; facility and computer maintenance	20.0
77	TERRY MANUFACTURING CO. INC.	Roanoke, Ala.	Roy Terry	1963	300	Apparel manufacturer	20.0
82	CONSOLIDATED BEVERAGE CORPORATION	New York, N.Y.	Albert N. Thompson	1978	24	Beverage exporter and importer	19.6
83	MID-DELTA HOME HEALTH INC.	Belzoni, Miss.	Clara Raylor Reed	1978	350	Home health care; medical equipment and supplies	19.5
84	TEXCOM INC.	Landover, Md.	Clemon H. Wesley	1982	261	Telecommunications; systems engineering, installation, maintenance	19.389

TABLE 3.2 *Black Enterprise*'s **Top 100 Industrial/Service Companies, 1993 (*Continued*)**

	Company	Location	Chief Executive	Began	Staff	Type of Business	Sales*
85	CROWN ENERGY INC.	Chicago, Ill.	Charles Harrison	1987	6	Petroleum products distributor	19.0
85	OZANNE CONSTRUCTION CO. INC.	Cleveland, Ohio	Leroy Ozanne	1956	125	General construction and construction management	19.0
87	URBAN ORGANIZATION INC.	Miami, Fla.	Jacque E. Thermilus	1988	140	General contracting and construction management	18.24
88	RESOURCE COMPUTER SYSTEMS ONE	Dublin, Ohio	Stampp W. Corbin	1992	15	Computer hardware and software	18.2
89	TRI-STATE DESIGN CONSTRUCTION CO. INC.	Fort Washington, Pa.	Ronald Davis	1981	75	Construction and construction management	17.735
90	SOLO CONSTRUCTION CORPORATION	N. Miami Beach, Fla.	Randy Pierson Derron Pierson	1978	78	General engineering construction	17.536
91	MYRIAD INDUSTRIES INC.	National City, Calif.	Jerome C. Crawford	1992	500	Shipbuilding and repair; electrical contracting	17.0
92	UBM INC.	Chicago, Ill.	Sandra D. Jiles P. King S. Dabadghao	1975	55	General construction and construction management	16.8
93	LA-VAN HAWKINS INNER CITY FOODS	Atlanta, Ga.	La-Van Hawkins	1991	2,500	Fast-food restaurant	16.547
94	CORPORATE OFFICE SYSTEMS INC.	Chicago, Ill.	Costello Johnson	1989	24	Office furniture dealership; interior design and space planning	16.5
95	SPECIALIZED PACKAGING INTERNATIONAL INC.	Hamden, Conn.	Carlton Highsmith	1983	7	Packaging design; engineering brokerage	16.314
96	AMERICAN URBAN RADIO NETWORKS	New York, N.Y.	Sydney Small Ronald Davenport	1973	65	Radio network; radio station; telemarketing	16.0
97	JOE MORGAN BEVERAGE CO.	Hayward, Calif.	Joe Morgan	1987	55	Wholesale beverage distributor	15.75
98	TRESP ASSOCIATES INC.	Alexandria, Va.	Lillian B. Handy	1981	285	Military logistics; systems engineering; computer integration	15.1
99	G & C EQUIPMENT CORPORATION	Gardena, Calif.	Gene Hale	1981	8	Sale, lease and rental of heavy construction equipment	15.0
99	PHOENIX OIL CO.	Chicago, Ill.	Mark Reddrick	1987	14	Gasoline, diesel and industrial lubricants	15.0

TABLE 3.3 *Black Enterprise*'s **Top 10 Financial Companies, 1977, 1980, 1985, and 1990**[†]

1977	Company Name	Location	Chief Executive	Began	Staff	Assets*	Deposit*	Loans*
1	CARVER FEDERAL SAVINGS & LOAN ASSN.	New York, N.Y.	Richard T. Greene	1948	55	76.306	67.050**	65.783
2	ILLINOIS/SERVICE FEDERAL S&L ASSN. OF CHICAGO	Chicago, Ill.	Louise Q. Lawson	1934	43	67.782	63.323**	58.143
3	INDEPENDENCE BANK OF CHICAGO	Chicago, Ill.	Alvin J. Boutte	1964	90	65.933	58.928	25.955
4	FAMILY SAVINGS & LOAN ASSN.	Los Angeles, Calif.	Robert E. Bowdoin	1948	66	63.914	43.331**	52.614
5	SEAWAY NATIONAL BANK	Chicago, Ill.	Richard K. Pearson	1964	104	61.629	57.590	28.566
6	FREEDOM NATIONAL BANK OF NEW YORK	New York, N.Y.	Sharina "Tab" Buford	1964	60	53.856	50.257	13.364
7	INDUSTRIAL BANK OF WASHINGTON	Washington, D.C.	B. Doyle Mitchell	1934	73	53.371	49.730	18.965
8	BROADWAY FEDERAL SAVINGS AND LOAN ASSOCIATION	Los Angeles, Calif.	Elbert T. Hudson	1946	48	53.031	42.578**	44.569
9	INDEPENDENCE FEDERAL SAVINGS & LOAN ASSN. OF WASHINGTON	Washington, D.C.	William B. Fitzgerald	1968	25	43.626	35.315**	39.542
10	MECHANICS AND FARMERS BANK	Durham, N.C.	John H. Wheeler	1907	69	42.468	38.177	20.504

[†] To be eligible, the firm must be fully operational in the previous calendar year and be at least 51% black-owned.
* In millions of dollars. Ranked by assets as of December 1977. Prepared by B. E. Research.
** Figures for savings and loan institutions are savings capital.

1980	Company Name	Location	Chief Executive	Began	Staff	Assets*	Deposit*	Loans*
1	FAMILY SAVINGS & LOAN ASSN.	Los Angeles, Calif.	Robert E. Bowdoin	1948	75	117.2	89.2	85.0
2	INDEPENDENCE BANK OF CHICAGO	Chicago, Ill.	Alvin J. Boutte	1964	124	101.891	83.656	23.94
3	ILLINOIS/SERVICE FEDERAL S&L ASSN. OF CHICAGO	Chicago, Ill.	Louise Q. Lawson	1935	45	89.6	81.0	72.983
4	CARVER FEDERAL SAVINGS & LOAN ASSN.	New York, N.Y.	Richard T. Greene	1949	54	86.599	72.496	71.044
5	FOUNDERS SAVINGS & LOAN ASSOCIATION	Los Angeles, Calif.	Peter W. Dauterive	1974	55	80.947	55.181	52.791
6	SEAWAY NATIONAL BANK OF CHICAGO	Chicago, Ill.	F. T. Collins	1965	125	72.5	58.0	36.5
7	BROADWAY FEDERAL SAVINGS & LOAN ASSN.	Los Angeles, Calif.	Elbert T. Hudson	1946	50	65.609	56.589	58.863
8	FREEDOM NATIONAL BANK OF NEW YORK	New York, N.Y.	Sharina "Tab" Buford	1964	72	63.83	42.639	21.383
9	UNITED NATIONAL BANK OF WASHINGTON	Washington, D.C.	Samuel L. Foggie	1964	90	62.733	58.454	27.852
10	INDUSTRIAL BANK OF WASHINGTON	Washington, D.C.	B. Doyle Mitchell	1934	80	58.971	52.496	26.701

* In millions of dollars. Ranked by assets as of December 1980. Prepared by B. E. Research.

TABLE **3.3** *Black Enterprise*'s **Top 10 Financial Companies, 1977, 1980, 1985, and 1990** (*Continued*)

1985	Company Name	Location	Chief Executive	Began	Staff	Assets*	Deposit*	Loans*
1	FOUNDERS SAVINGS & LOAN ASSOCIATION	Los Angeles, Calif.	Peter W. Dauterive	1974	79	193.6	174.1	131.6
2	INDEPENDENCE FEDERAL SAVINGS BANK	Washington, D. C.	William B. Fitzgerald	1968	70	157.905	107.724	131.101
3	FAMILY SAVINGS & LOAN ASSN.	Los Angeles, Calif.	Robert Bowdoin	1948	56	143.7	109.3	116.0
4	CARVER FEDERAL SAVINGS & LOAN ASSN.	New York, N.Y.	Richard T. Greene	1948	80	131.983	115.185	81.987
5	SEAWAY NATIONAL BANK OF CHICAGO	Chicago, Ill.	Walter E. Grady	1965	150	119.345	105.769	36.886
6	ILLINOIS/SERVICE FEDERAL S&L ASSN. OF CHICAGO	Chicago, Ill.	Thelma J. Smith	1934	48	103.754	100.087	74.057
7	CITIZENS TRUST BANK	Atlanta, Ga.	I. Owen Funderburg	1921	92	97.203	88.046	31.877
8	INDEPENDENCE BANK OF CHICAGO	Chicago, Ill.	Alvin J. Boutte	1964	137	95.829	83.219	40.238
9	FREEDOM NATIONAL BANK OF NEW YORK	New York, N.Y.	Sharina "Tab" Buford	1964	121	93.964	82.135	38.19
10	INDUSTRIAL BANK OF WASHINGTON	Washington, D. C.	B. Doyle Mitchell	1934	90	90.349	83.752	33.327

* In millions of dollars. Ranked by assets as of December 1985. Prepared by B. E. Research.

1990	Company Name	Location	Chief Executive	Began	Staff	Assets*	Deposit*	Loans*
1	CARVER FEDERAL SAVINGS BANK	New York, N.Y.	Richard T. Greene	1948	95	251.847	233.469	194.551
2	INDEPENDENCE FEDERAL SAVINGS BANK	Washington, D. C.	William B. Fitzgerald	1968	68	232.649	192.341	198.865
3	SEAWAY NATIONAL BANK OF CHICAGO	Chicago, Ill.	Walter E. Grady	1965	150	173.919	153.204	44.459
4	FAMILY SAVINGS BANK (FSB)	Los Angeles, Calif.	Wayne-Kent Bradshaw	1948	66	142.846	123.683	121.163
5	INDEPENDENCE BANK OF CHICAGO	Chicago, Ill.	Alvin J. Boutte	1964	111	133.064	121.181	48.919
6	INDUSTRIAL BANK OF WASHINGTON	Washington, D. C.	B. Doyle Mitchell	1934	95	132.997	122.109	64.82
7	CONSOLIDATED BANK AND TRUST CO.	Richmond, Va.	Varnard W. Henley	1903	82	121.492	114.727	60.012
8	CITIZENS TRUST BANK	Atlanta, Ga.	I. Owen Funderburg	1921	163	119.845	109.458	52.033
9	DREXEL NATIONAL BANK	Chicago, Ill.	Alvin J. Boutte	1989	76	110.708	103.723	41.686
10	ILLINOIS SERVICE/FEDERAL S&L ASSN. OF CHICAGO	Chicago, Ill.	Thelma J. Smith	1934	34	102.260	81.05	96.59

* In millions of dollars. Ranked by assets as of December 1990. Prepared by B. E. Research.

TABLE 3.4 *Black Enterprise*'s Top 25 Financial Companies, 1993[†]

	Company Name	Location	Chief Executive	Year Started	Staff	Assets*	Capital*	Deposit*	Loans*
1	CARVER FEDERAL SAVINGS BANK	New York, N.Y.	Richard T. Greene	1948	96	301.698	14.179	247.433	198.276
2	INDEPENDENCE FEDERAL SAVINGS BANK	Washington, D. C.	William B. Fitzgerald	1968	72	236.344	14.753	191.561	138.159
3	SEAWAY NATIONAL BANK OF CHICAGO	Chicago, Ill.	Walter E. Grady	1965	186	211.066	15.511	182.695	54.763
4	INDUSTRIAL BANK OF WASHINGTON	Washington, D. C.	B. Doyle Mitchell, Jr.	1934	109	191.645	13.055	177.69	69.062
5	FAMILY SAVINGS BANK (FSB)	Los Angeles, Calif.	Wayne-Kent Bradshaw	1948	54	181.0	9.1	169.0	136.0
6	INDEPENDENCE BANK OF CHICAGO	Chicago, Ill.	Alvin J. Boutte	1964	115	158.7	12.0	144.7	39.7
7	DREXEL NATIONAL BANK	Chicago, Ill.	Alvin J. Boutte	1989	86	134.61	9.734	124.379	31.783
8	FIRST TEXAS BANK	Dallas, Tex.	William E. Stahnke	1975	51	119.28	11.549	106.642	45.278
9	CITIZENS TRUST BANK	Atlanta, Ga.	William L. Gibbs	1921	149	118.304	8.091	108.71	50.404
10	MECHANICS AND FARMERS BANK	Durham, N.C.	Julia W. Taylor	1908	72	113.06	11.956	99.258	69.338
11	ILLINOIS SERVICE/FEDERAL S&L ASSN. OF CHICAGO	Chicago, Ill.	Thelma J. Smith	1934	45	102.781	6.862	94.633	61.9
12	BROADWAY FEDERAL SAVINGS & LOAN ASSN.	Los Angeles, Calif.	Paul C. Hudson	1946	42	98.569	4.681	92.117	78.147
13	LIBERTY BANK & TRUST	New Orleans, La.	Alden J. McDonald, Jr.	1972	96	96.51	7.025	88.601	54.706
14	FOUNDERS NATIONAL BANK OF LOS ANGELES	Los Angeles, Calif.	Carlton J. Jenkins	1991	79	92.972	9.5	77.764	55.514
15	CONSOLIDATED BANK & TRUST CO.	Richmond, Va.	Vernard W. Henley	1903	68	85.443	5.929	78.581	48.929
16	CITIZENS FEDERAL SAVINGS BANK	Birmingham, Ala.	Bunny Stokes, Jr.	1957	29	80.325	7.06	72.08	31.072
17	TRI-STATE BANK OF MEMPHIS	Memphis, Tenn.	Jesse H. Turner, Jr.	1946	68	79.478	8.293	70.433	30.657
18	UNITED BANK OF PHILADELPHIA	Philadelphia, Pa.	Emma C. Chappell	1992	50	75.3	6.1	67.3	48.9
19	CITY NATIONAL BANK OF NEW JERSEY	Newark, N.J.	Louis Prezeau	1973	39	74.286	4.562	64.435	23.687
20	FIRST INDEPENDENCE NATIONAL BANK OF DETROIT	Detroit, Mich.	Richard W. Shealey	1970	65	69.084	2.911	41.177	33.28
21	BOSTON BANK OF COMMERCE	Boston, Mass.	Ronald A. Homer	1982	53	68.168	3.803	60.573	53.412
22	THE HARBOR BANK OF MARYLAND	Baltimore, Md.	Joseph Haskins, Jr.	1982	40	61.741	4.479	56.868	36.08
23	MUTUAL COMMUNITY SAVINGS BANK, SSB	Durham, N.C.	Ferdinand V. Allison, Jr.	1921	24	49.169	7.04	38.901	33.278
24	FIRST TUSKEGEE BANK	Tuskegee, Ala.	James Wright	1894	36	44.025	4.083	33.492	27.872
25	MUTUAL FEDERAL SAVINGS & LOAN ASSN. OF ATLANTA	Atlanta, Ga.	Hamilton Glover	1925	17	38.127	2.679	33.21	19.572

[†] To be considered for the list, a firm must be at least 51% black-owned and have been in business at least one year.
* In millions of dollars. Ranked by assets as of December 31, 1993. Prepared by B. E. Research. Reviewed by Mitchell/Titus & Co.

TABLE 3.5 *Black Enterprise*'s Top 10 Insurance Companies, 1977, 1980, 1985, and 1990

1977	Company Name/Location	Chief Executive	Began	Staff	Assets*	Insurance in Force*
1	NORTH CAROLINA MUTUAL LIFE INSURANCE CO. Durham, N.C.	W. J. Kennedy III	1898	1,255	3,536.077	160.919
2	GOLDEN STATE MUTUAL LIFE INSURANCE CO. Los Angeles, Calif.	Ivan A. Houston	1925	691	2,232.462	69.174
3	SUPREME LIFE INSURANCE CO. OF AMERICA Chicago, Ill.	John H. Johnson	1919	500	2,013.515	49.003
4	CHICAGO METROPOLITAN MUTUAL ASSURANCE CO. Chicago, Ill.	Anderson M. Schweich	1927	279	905.832	34.948
5	ATLANTA LIFE INSURANCE CO. Atlanta, Ga.	Jesse Hill, Jr.	1905	1,100	819.539	99.422
6	UNIVERSAL LIFE INSURANCE CO. Memphis, Tenn.	A. M. Walker, Sr.	1923	778	414.245	52.415
7	BOOKER T. WASHINGTON INSURANCE CO. Birmingham, Ala.	A. G. Gaston	1923	250	231.355	16.58
8	THE PILGRIM HEALTH AND LIFE INSURANCE CO. Augusta, Ga.	W. S. Hornsby, Jr.	1898	258	151.284	14.606
9	MAMMOTH LIFE AND ACCIDENT INSURANCE CO. Louisville, Ky.	Julius E. Price	1915	300	148.535	25.026
10	AMERICAN WOODMEN'S LIFE INSURANCE CO. Denver, Colo.	James H. Browne	1966	48	98.489	9.707

* In millions of dollars. Ranked by assets as of December 1977.

1980	Company Name/Location	Chief Executive	Began	Staff	Assets*	Insurance in Force*
1	NORTH CAROLINA MUTUAL LIFE INSURANCE CO. Durham, N.C.	W. J. Kennedy III	1898	1,390	190.933	5,580.249
2	ATLANTA LIFE INSURANCE CO. Atlanta, Ga.	Jesse Hill, Jr.	1905	1,000	109.399	1,143.362
3	GOLDEN STATE MUTUAL LIFE INSURANCE CO. Los Angeles, Calif.	Ivan J. Houston	1925	700	84.961	2,904.733
4	UNIVERSAL LIFE INSURANCE CO. Memphis, Tenn.	A. Maceo Walker, Sr.	1923	885	61.173	518.383
5	SUPREME LIFE INSURANCE CO. OF AMERICA Chicago, Ill.	John H. Johnson	1919	400	50.48	1,506.933
6	CHICAGO METROPOLITAN MUTUAL ASSURANCE CO. Chicago, Ill.	Anderson M. Schweich	1927	233	41.462	1,341.67
7	MAMMOTH LIFE AND ACCIDENT INSURANCE CO. Louisville, Ky.	J. E. Price, Sr.	1915	275	27.444	185.0
8	BOOKER T. WASHINGTON INSURANCE CO. Birmingham, Ala.	A. G. Gaston	1932	250	21.241	465.0
9	THE PILGRIM HEALTH AND LIFE INSURANCE CO. Augusta, Ga.	S. W. Walker II	1897	268	15.484	148.09
10	UNITED MUTUAL LIFE INSURANCE CO. New York, N.Y.	James L. Howard	1933	30	10.562	53.429

* In millions of dollars. Ranked by assets as of December 1980.

TABLE 3.5 *Black Enterprise*'s Top 10 Insurance Companies, 1977, 1980, 1985, and 1990 (*Continued*)

1985	Company Name/Location	Chief Executive	Began	Staff	Assets*	Insurance in Force*
1	NORTH CAROLINA MUTUAL LIFE INSURANCE CO. Durham, N.C.	W. J. Kennedy III	1898	954	211.45	8,270.336
2	ATLANTA LIFE INSURANCE CO. Atlanta, Ga.	Jesse Hill, Jr.	1905	1,000	120.47	1,852.154
3	GOLDEN STATE MUTUAL LIFE INSURANCE CO. Los Angeles, Calif.	Ivan J. Houston	1925	800	111.826	4,803.25
4	UNIVERSAL LIFE INSURANCE CO. Memphis, Tenn.	A. Maceo Walker, Sr.	1923	750	63.510	620.155
5	SUPREME LIFE INSURANCE CO. OF AMERICA Chicago, Ill.	John H. Johnson	1921	400	53.482	1,845.682
6	CHICAGO METROPOLITAN MUTUAL ASSURANCE CO. Chicago, Ill.	Anderson M. Schweich	1927	200	52.56	2,304.985
7	CALIFORNIA LIFE CORPORATION Los Angeles, Calif.	Donald J. Bohana	1982	100	35.0	765.0
8	BOOKER T. WASHINGTON INSURANCE CO. Birmingham, Ala.	Arthur G. Gaston, Sr.	1932	150	29.997	659.889
9	MAMMOTH LIFE AND ACCIDENT INSURANCE CO. Louisville, Ky.	James P. King	1915	300	28.18	257.024
10	THE PILGRIM HEALTH AND LIFE INSURANCE CO. Augusta, Ga.	Solomon W. Walker III	1898	216	17.299	156.716

* In millions of dollars. Ranked by assets as of December 1985.

1990	Company Name/Location	Chief Executive	Began	Staff	Assets*	Insurance in Force*
1	NORTH CAROLINA MUTUAL LIFE INSURANCE CO. Durham, N.C.	Bert Collins	1898	615	211.446	8214.506
2	ATLANTA LIFE INSURANCE CO. Atlanta, Ga.	Jesse Hill, Jr.	1905	965	134.0	2062.0
3	GOLDEN STATE MUTUAL LIFE INSURANCE CO. Los Angeles, Calif.	Larkin Teasley	1925	324	117.724	5645.18
4	UNIVERSAL LIFE INSURANCE CO. Memphis, Tenn.	A. Maceo Walker, Sr.	1923	710	65.404	703.44
5	SUPREME LIFE INSURANCE CO. OF AMERICA Chicago, Ill.	John H. Johnson	1921	198	52.712	1454.947
6	CHICAGO METROPOLITAN MUTUAL ASSURANCE CO. Chicago, Ill.	Anderson M. Schweich	1927	176	51.225	2656.955
7	BOOKER T. WASHINGTON INSURANCE CO. Birmingham, Ala.	Louis J. Willie	1932	223	37.313	676.244
8	MAMMOTH LIFE AND ACCIDENT INSURANCE CO. Louisville, Ky.	Edwin Chestnut, Sr.	1915	200	29.028	258.171
9	THE PILGRIM HEALTH AND LIFE INSURANCE CO. Augusta, Ga.	Walter S. Hornsby III	1898	140	16.146	170.783
10	PROTECTIVE INDUSTRIAL INSURANCE OF ALABAMA INC. Birmingham, Ala.	Paul E. Harris	1923	112	13.684	67.614

* In millions of dollars. Ranked by assets as of December 1990.

TABLE **3.6** *Black Enterprise*'s **Top 15 Insurance Companies, 1993**[†]

	Company Name/Location	Chief Executive	Year Started	Staff	Assets*	Statutory Reserves*	Insurance in Force*	Premium Income*	Net Investment Income*
1	NORTH CAROLINA MUTUAL LIFE INSURANCE CO. Durham, N.C.	Bert Collins	1899	503	217.741	134.559	8,733.594	56.562	12.128
2	ATLANTA LIFE INSURANCE CO. Atlanta, Ga.	Don M. Royster, Sr.	1905	700	158.122	122.780	2,541.458	24.507	10.892
3	GOLDEN STATE MUTUAL LIFE INSURANCE CO. Los Angeles, Calif.	Larkin Teasley	1925	280	103.807	73.418	3,820.808	15.682	9.372
4	UNIVERSAL LIFE INSURANCE CO. Memphis, Tenn.	Gerald T. Howell	1923	700	64.242	55.921	929.327	20.976	5.621
5	CHICAGO METROPOLITAN ASSURANCE CO. Chicago, Ill.	Josephine King	1927	145	55.645	35.929	2,800.368	17.596	2.104
6	BOOKER T. WASHINGTON INSURANCE CO. Birmingham, Ala.	Louis J. Willie	1932	175	43.441	35.519	1,114.906	11.313	2.416
7	PROTECTIVE INDUSTRIAL INSURANCE CO. OF ALABAMA INC. Birmingham, Ala.	Paul E. Harris	1923	100	14.523	10.356	73.79	2.898	0.781
8	WINNFIELD LIFE INSURANCE CO. Natchitoches, La.	Ben D. Johnson	1936	17	7.797	6.942	50.643	1.661	0.032
9	WILLIAMS-PROGRESSIVE LIFE & ACCIDENT INSURANCE CO. Opelousas, La.	Borel C. Dauphin	1947	56	6.231	5.107	35.224	1.345	0.441
10	GOLDEN CIRCLE LIFE INSURANCE CO. Brownsville, Tenn.	William D. Rawls, Sr.	1958	73	6.157	4.198	24.901	1.536	0.622
11	RELIABLE LIFE INSURANCE CO. Monroe, La.	Joseph H. Miller, Jr.	1940	118	4.864	3.705	30.974	1.428	0.368
12	GERTRUDE GEDDES WILLIS LIFE INSURANCE CO. New Orleans, La.	Joseph O. Misshore, Jr.	1941	42	4.786	4.129	42.685	1.186	0.386
13	WRIGHT MUTUAL INSURANCE CO. Detroit, Mich.	Wardell C. Croft	1942	35	4.717	3.489	43.456	1.014	0.233
14	MAJESTIC LIFE INSURANCE CO. New Orleans, La.	Cecilia Roberts	1947	16	3.343	0.961	10.756	0.448	0.196
15	BENEVOLENT LIFE INSURANCE CO. INC. Shreveport, La.	Granville L. Smith	1934	83	2.991	2.105	16.075	0.646	0.113

[†] To be considered for the list, a firm must be at least 51% black-owned and have been in business at least one year.
* In millions of dollars. Ranked by assets as of December 31, 1993. Prepared by B. E. Research. Reviewed by Mitchell/Titus & Co.

TABLE 3.7 *Black Enterprise*'s Top 15 Investment Banks, 1993[†]

	Name of Company	Location	Chief Executive	Year Started	Senior-Managed Issues* (Millions of Dollars)	Co-Managed Issues* (Billions of Dollars)
1	Pryor, McClendon, Counts & Co. Inc.	Philadelphia, Penn.	Malcolm D. Pryor	1981	1,665.0	42.4
2	Grigsby, Branford & Co. Inc.	San Francisco, Calif.	Calvin B. Grigsby	1981	1,651.1	30.0
3	M. R. Beal & Co.	New York, N.Y.	Bernard B. Beal	1988	575.0	23.6
4	W. R. Lazard & Co.	New York, N.Y.	Wardell R. Lazard	1985	492.4	33.6
5	The Chapman Co.	Baltimore, Md.	Nathan A. Chapman	1986	33.1	5.0
6	Howard Gary & Co.	Miami, Fla.	Howard V. Gary	1980	15.5	3.9
7	Charles A. Bell Securities Corp.	San Francisco, Calif.	Charles A. Bell	1986	14.4	2.8
8	Weldon, Sullivan, Carmichael & Co.	Denver, Colo.	Ennis Hudson	1988	9.4	0.7
9	Apex Securities Inc.	Houston, Tex.	Richard M. Ramirez	1987	**	7.1
10	Utendahl Capital Partners LP.	New York, N.Y.	John O. Utendahl	1992	**	5.6
11	United Daniels Securities Inc.	New York, N.Y.	Willie L. Daniels	1984	**	3.9
12	Sturdivant & Co. Inc.	Clementon, N.J.	Ralph A. Sturdivant	1988	**	1.7
13	Ward & Associates Inc.	Atlanta, Ga.	Felker W. Ward Jr.	1988	**	0.9
14	Doley Securities Inc.	New Orleans, La.	Harold E. Doley	1976	**	0.8
15	Rideau, Lyons & Co. Inc.	Los Angeles, Calif.	Lamar Lyons	1985	**	0.7

* This is for all issues of municipal, agency, corporate, and mortgage-backed securities for the year ending Dec. 31, 1993.

** These investment banks did not participate as senior managers for municipal, agency, corporate and mortgage-backed securities for the year ending Dec. 31. 1993.

[†] Ranked by managed issues. To be considered for the list, a firm must be at least 51% black-owned and have been in business at least one year.

Source: Securities Data Co. Inc., Newark, N. J., 1994.

4. CRIME

TABLE 4.1 Homicide Victims, 1930–1990

Year	Total	Blacks
1930	10,331	4,490[1]
1940	8,329	4,556[1]
1950	7,942	4,340
1960	8,464	4,358
1970	16,848	8,834
1980	24,278	10,283
1990	24,932	12,144

[1] Includes blacks and other nonwhites.

Source: Statistical Abstract of the United States, 1993.

TABLE 4.2 Lynching Victims, 1868–1935

Year	Blacks	Year	Blacks
1868	291	1907	58
1869	31	1908	89
1870	34	1909	69
1871	53	1910	67
1882	49	1911	60
1883	53	1912	61
1884	51	1913	51
1885	74	1914	51
1886	74	1915	56
1887	70	1916	50
1888	69	1917	36
1889	94	1918	60
1890	85	1919	76
1891	113	1920	53
1892	161	1921	59
1893	118	1922	51
1894	134	1923	29
1895	113	1924	16
1896	78	1925	17
1897	123	1926	23
1898	101	1927	16
1899	85	1928	10
1900	106	1929	7
1901	105	1930	20
1902	85	1931	12
1903	84	1932	6
1904	76	1933	24
1905	57	1934	15
1906	62	1935	18

Figures not available for 1872–1879 and 1881. The number of blacks lynched annually was less than 10 during the period of 1936 to 1970. No lynching occurred in 1880, 1952 to 1954, 1956, 1958, 1960, 1962 and 1965–1970.
Source: *Historical Statistics, Colonial Times to 1970.*

TABLE 4.3 Prisoners Under State or Federal Jurisdiction, 1985 and 1991

Region and Jurisdiction	1985			1991		
	Prisoner Population 12/31/85	Black	Percent Black	Prisoner Population 12/31/91	Black	Percent Black
U.S. total	502,376	227,137	45.2	824,133	395,245	48.0
Federal	40,223	13,066	32.5	71,608	22,727	31.7
State	462,153	214,071	46.3	752,525	372,518	49.5
Northeast	75,706	38,036	50.2	131,866	66,442	50.4
Connecticut[a]	6,149	2,765	45.0	10,977	5,144	46.9
Maine	1,226	15	1.2	1,579	37	2.3
Massachusetts	5,390	1,849	34.3	9,155	3,036	33.2
New Hampshire	683	14	2.0	1,533	80	5.2
New Jersey	11,335	7,483	66.0	23,483	15,005	63.9
New York	34,712	17,497	50.4	57,862	29,151	50.4
Pennsylvania	14,227	8,035	56.5	23,388	13,090	56.0
Rhode Island[a]	1,307	378	28.9	2,771	899	32.4
Vermont[a,b]	677	0	0.0	1,118	—	—

TABLE **4.3** Prisoners Under State or Federal Jurisdiction, 1985 and 1991 (*Continued*)

Region and Jurisdiction	1985 Prisoner Population 12/31/85	Black	Percent Black	1991 Prisoner Population 12/31/91	Black	Percent Black
Midwest	95,585	43,543	45.6	155,917	79,217	50.8
Illinois	18,634	11,132	59.7	29,115	18,306	62.9
Indiana	9,904	3,464	35.0	13,008	4,971	38.2
Iowa	2,832	568	20.1	4,145	940	22.7
Kansas	4,732	1,678	35.5	5,903	2,145	36.3
Michigan	17,755	10,076	56.8	36,423	20,985	57.6
Minnesota	2,343	502	21.4	3,472	1,051	30.3
Missouri	9,796	3,918	40.0	15,897	7,317	46.0
Nebraska	1,814	553	30.5	2,495	830	33.3
North Dakota	422	5	1.2	492	4	0.8
Ohio[b]	20,864	9,553	45.8	35,744	19,311	54.0
South Dakota	1,047	22	2.1	1,374	32	2.3
Wisconsin	5,442	2,072	38.1	7,849	3,325	42.4
South	202,100	109,663	54.3	301,866	181,341	60.1
Alabama	11,015	6,560	59.6	16,760	10,793	64.4
Arkansas	4,611	2,264	49.1	7,766	4,437	57.1
Delaware[a]	2,553	1,443	56.5	3,717	2,449	65.9
District of Columbia[a, b]	6,404	6,232	97.3	10,455	10,237	97.9
Florida	28,600	14,142	49.4	46,533	27,185	58.4
Georgia	16,014	9,531	59.5	23,644	15,931	67.4
Kentucky	4,975	1,592	32.0	9,799	3,123	31.9
Louisiana	13,890	10,032	72.2	20,003	14,834	74.2
Maryland	13,005	9,370	72.0	19,291	14,638	75.9
Mississippi	6,392	4,324	67.6	8,904	6,410	72.0
North Carolina	17,344	9,341	53.9	18,903	11,522	61.0
Oklahoma	8,330	2,434	29.2	13,340	4,652	34.9
South Carolina	10,510	6,326	60.2	18,269	12,120	66.3
Tennessee	7,127	3,153	44.2	11,474	5,503	48.0
Texas[c]	37,532	15,548	41.4	51,677	24,520	47.4
Virginia	12,073	7,111	58.9	19,829	12,769	64.4
West Virginia	1,725	260	15.1	1,502	218	14.5
West	88,762	22,829	25.7	162,876	45,518	27.9
Alaska[a, b]	2,329	218	9.4	2,706	339	12.5
Arizona	8,531	1,362	16.0	15,415	2,633	17.1
California	50,111	16,954	33.8	101,808	35,205	34.6
Colorado[b]	3,369	705	20.9	8,392	1,937	23.1
Hawaii[a, b]	2,111	102	4.8	2,700	155	5.7
Idaho[b, d]	1,344	32	2.4	2,143	32	1.5
Montana	1,129	16	1.4	1,478	20	1.4
Nevada	3,771	1,240	32.9	5,503	1,719	31.2
New Mexico	2,313	239	10.3	3,119	316	10.1
Oregon	4,454	503	11.3	6,732	923	13.7
Utah	1,633	149	9.1	2,625	222	8.5
Washington	6,909	1,273	18.4	9,156	1,966	21.5
Wyoming	758	36	4.7	1,099	51	4.6

[a] Figures include both jail and prison inmates; jails and prisons are combined in one system.
[b] Race was estimated.
[c] Texas reported only two racial categories in 1985: white and nonwhite.
[d] Bureau of Justice Statistics has estimated all Idaho figures from monthly prison reports of the Idaho Department of Corrections in 1985.
— = Not reported.

TABLE 4.4 Prisoners Executed Under Civil Authority, 1930–1990

Period	All offenses		Murder		Rape		Other*	
	Total	Black	Total	Black	Total	Black	Total	Black
All years	4,002	2,122	3,477	1,686	455	405	70	31
1930 to 1939	1,667	816	1,514	687	125	115	28	14
1940 to 1949	1,284	781	1,064	595	200	179	20	7
1950 to 1959	717	376	601	280	102	89	14	7
1960 to 1967	191	93	155	68	28	22	8	3
1968 to 1976	—	—	—	—	—	—	—	—
1977 to 1980	3	—	3	—	—	—	—	—
1981 to 1990	140	56	140	56	—	—	—	—

* "Other" includes 25 armed robbery, 20 kidnapping, 11 burglary, 8 espionage (6 in 1942 and 2 in 1953), and 6 aggravated assault.
Source: *Statistical Abstract, 1992.*

TABLE 4.5 Persons Arrested, by Charge, 1972–1991*

Charge	1972		1980		1991	
	Total	Black	Total	Black	Total	Black
All Charges	6,707.0	1,847.6	9,684.0	2,375.2	10,516.0	3,049.0
Serious Crimes:	1,311.6	471.1	2,195.0	720.7	2,237.0	774.0
Murder & nonnegligent manslaughter	13.8	8.3	19.0	9.0	18.0	10.0
Forcible rape	17.8	8.8	29.0	14.0	30.0	13.0
Robbery	89.4	59.6	139.0	80.5	136.0	83.0
Aggravated assault	138.8	62.9	258.0	93.3	364.0	139.0
Burglary	296.2	95.9	479.0	139.4	324.0	95.0
Larceny/theft	642.3	196.9	1,123.0	342.6	1,190.0	368.0
Motor vehicle theft	110.3	37.9	130.0	38.1	160.0	63.0
Arson	n/a	n/a	18.0	3.8	15.0	3.0
All Other:						
Other assaults	290.9	111.8	456.0	145.1	772.0	257.0
Forgery & counterfeiting	40.1	12.9	72.0	23.9	75.0	25.0
Embezzlement, fraud	100.3	27.2	273.0	81.9	302.0	94.0
Stolen property	62.6	23.0	115.0	36.6	130.0	54.0
Weapons (carrying, etc.)	109.2	56.6	157.0	57.2	173.0	72.0
Prostitution & vice	40.9	25.1	83.0	45.6	79.0	30.0
Sex offenses	48.3	11.0	63.0	12.6	81.0	16.0
Drug abuse violations	402.3	84.4	532.0	125.6	763.0	313.0
Gambling	66.5	46.2	47.0	31.1	12.0	6.0
Offenses against family & children	51.9	15.2	50.0	18.0	71.0	21.0
Driving intoxicated	590.8	97.2	1,289.0	144.0	1,271.0	116.0
Liquor laws	203.5	22.6	428.0	27.5	449.0	44.0
Drunkenness	1,365.7	280.7	1,048.0	165.9	625.0	102.0
Disorderly conduct	565.1	190.1	724.0	219.4	559.0	182.0
Vagrancy	34.8	9.9	29.0	9.0	31.0	14.0
Other, except traffic	1,422.4	362.5	1,658.0	436.7	2,428.0	832.0

* In thousands.
Sources: *Statistical Abstract, 1980, 1972; Uniform Crime Reports: Crime in the United States, 1991.*

5. ECONOMICS

TABLE 5.1 Persons Living Below the Poverty Level, 1959–1990*

Year	Total (in Millions)	%	Blacks (in Millions)	%
1959	39.5	22.4	9.9	55.1
1970	25.4	12.6	7.5	33.5
1980	29.3	13.0	8.6	32.5
1990	33.6	13.5	9.8	31.9

* Persons are classified as being above or below the poverty level using the poverty index, based on the Department of Agriculture's 1961 Economy Food Plan. Poverty thresholds are updated every year. In 1990 the weighted average poverty threshold for a family of four was $13,359.
Source: *Statistical Abstract, 1992.*

TABLE 5.2 Children Living Below the Poverty Level, 1970–1990*

Year	Total (in Thousands)	%	Blacks (in Thousands)	%
1970	10,235	14.9	3,922	41.5
1980	11,114	17.9	3,906	42.1
1990	12,715	19.9	4,412	44.2

* Persons are classified as being above or below the poverty level using the poverty index, based on the Department of Agriculture's 1961 Economy Food Plan. Poverty thresholds are updated every year. In 1990 the weighted average poverty threshold for a family of four was $13,359. These statistics cover only children under 18 years old living in families.
Source: *Statistical Abstract, 1992.*

TABLE 5.3 Income Distribution, 1970–1990

		Percent Distribution						
Year	No. of Families	Under $10,000	$10,000– $14,999	$15,000– $24,999	$25,000– $34,999	$35,000– $49,999	$50,000– $74,999	$75,000 and over
	Total							
1970	52,227	8.7	7.5	17.6	20.3	23.1	16.2	6.5
1980	60,309	9.5	8.0	17.9	17.9	21.9	16.8	7.9
1990	66,322	9.4	7.5	16.4	16.2	20.1	18.2	12.3
	Black							
1970	4,928	20.9	13.6	23.9	17.6	13.9	8.3	1.6
1980	6,317	24.3	14.1	20.9	15.7	14.1	8.7	2.2
1990	7,471	25.6	11.3	19.5	14.0	15.0	9.8	4.7

Source: *Statistical Abstract, 1992.*

TABLE 5.4 Median Money Income of Families, 1960–1990

	1960[1]	1970[1]	1980[1]	1990[1]
Total				
All Families	5,620	9,867	21,023	35,353
Married-couple families	5,688	10,169	23,141	39,895
Female householder, no spouse	2,983	4,797	10,408	16,932
Black				
All Families	3,233	6,516	12,674	21,423
Married-couple families	n/a	7,816	18,593	33,784
Female householder, no spouse	n/a	3,576	7,425	12,125
	1960[2]	1970[2]	1980[2]	1990[2]
Total				
All Families	n/a	33,268	33,346	35,353
Married-couple families	n/a	34,286	36,706	39,895
Female householder	n/a	16,174	16,509	16,932
Black				
All Families	n/a	21,151	20,103	21,423
Married-couple families	n/a	25,371	29,491	33,784
Female householder, no spouse	n/a	11,608	11,777	12,125

[1] In current dollars
[2] In 1990 dollars
Sources: *Statistical Abstract, 1992, 1982–83; Historical Statistics of the United States; Current Population Reports,* p-60.

6. EDUCATION

TABLE 6.1 Annual High School Dropouts, 1967–1990*

Years	All Students			Black Students		
	Total	Dropouts	Dropout Rate (%)	Total	Dropouts	Dropout Rate (%)
All Persons, Grades 10–12						
1967	9,350	486	5.2	1,066	106	9.9
1968	9,814	506	5.2	1,123	113	10.1
1969	10,212	551	5.4	1,209	113	9.3
1970	10,281	588	5.7	1,192	133	11.2
1971	10,451	562	5.4	1,195	87	7.3
1972	10,664	659	6.2	1,373	133	9.7
1973	10,851	683	6.3	1,372	138	10.1
1974	11,026	742	6.7	1,441	167	11.6
1975	11,033	639	5.8	1,416	123	8.7
1976	10,996	644	5.9	1,449	105	7.2
1977	11,300	734	6.5	1,588	133	8.4
1978	11,116	743	6.7	1,542	160	10.4
1979	11,136	744	6.7	1,479	142	9.6
1980	10,891	658	6.0	1,496	124	8.3
1981	10,868	639	5.9	1,516	146	9.6
1982	10,611	577	5.4	1,553	121	7.8
1983	10,331	535	5.2	1,498	103	6.9
1984	10,041	507	5.0	1,524	88	5.8
1985	9,704	504	5.2	1,422	110	7.7
1986	9,969	468	4.7	1,495	81	5.4
1987	9,802	403	4.1	1,463	93	6.4
1988	9,590	461	4.8	1,468	93	6.3
1989	8,974	404	4.5	1,384	106	7.7
1990	8,679	347	4.0	1,303	66	5.1

* In thousands.

Source: *Current Population Reports, Population Characteristics*, p-20, no. 460: "School Enrollment—Social & Economic Status of Students: October 1990."

TABLE 6.2 Percentage of the Population Five to Twenty Years Old Enrolled in School, 1900–1970

Year	All races	Black
1900	50.5	31.0
1910	59.2	44.7
1920	64.3	53.5
1930	69.9	60.0
1940[1]	58.2	56.1
1950[2]	44.2	51.2
1960[2]	56.4	55.9
1970[2]	56.4	57.4

[1] 1940 figures are for persons aged 5 to 24.
[2] 1950–1970 figures reflect Americans 3 to 34 years old enrolled in school.

Source: U.S. Census, *Current Population Reports, Population Characteristics*, p-20-469 (February 1993: "Social and Economic Characteristics of Students, October 1991.")

TABLE 6.3 **Percentage of the Population Three to Thirty-four Years Old Enrolled in School, October 1975–October 1992**

	Total			Black		
Year and Ages	Both Sexes	Male	Female	Both Sexes	Male	Female
1975	53.7	56.1	51.5	57.7	60.4	55.3
Total, 3–34						
3–4	31.5	30.9	32.1	34.4	31.4	37.5
5–6	94.7	94.4	95.1	94.4	94.8	94.0
7–9	99.3	99.2	99.5	99.3	99.4	99.2
10–13	99.3	98.9	99.6	99.1	98.9	99.3
14–15	98.2	98.4	98.0	97.4	97.6	97.2
16–17	89.0	90.7	87.2	86.8	88.1	85.5
18–19	46.9	49.9	44.2	46.9	49.6	44.6
20–21	31.2	35.3	27.4	26.7	28.4	25.3
22–24	16.2	20.0	12.6	13.9	14.5	13.4
25–29	10.1	13.1	7.2	9.4	11.6	7.6
30–34	6.6	7.7	5.6	7.1	8.7	5.9
1980	49.7	50.9	48.5	54.0	56.2	52.1
Total, 3–34						
3–4	36.7	37.8	35.5	38.2	36.4	40.0
5–6	95.7	95.0	96.4	95.5	94.1	97.0
7–9	99.1	99.0	99.2	99.4	99.5	99.3
10–13	99.4	99.4	99.4	99.4	99.4	99.3
14–15	98.2	98.7	97.7	97.9	98.4	97.3
16–17	89.0	89.1	88.8	90.7	90.7	90.6
18–19	46.4	47.0	45.8	45.8	42.9	48.3
20–21	31.0	32.6	29.5	23.3	22.8	23.7
22–24	16.3	17.8	14.9	13.6	13.4	13.7
25–29	9.3	9.8	8.8	8.8	10.6	7.5
30–34	6.4	5.9	7.0	6.9	7.2	6.6
1985	48.3	49.2	47.4	50.8	52.6	49.2
Total, 3–34						
3–4	38.9	36.7	41.2	42.8	34.6	50.3
5–6	96.1	95.3	97.0	95.7	94.5	97.1
7–9	99.1	99.0	99.2	98.6	98.4	98.9
10–13	99.3	99.2	99.4	99.5	99.1	99.9
14–15	98.1	98.3	97.9	98.1	98.5	97.6
16–17	91.7	92.4	90.9	91.8	92.0	91.6
18–19	51.6	52.2	51.0	43.5	49.4	37.8
20–21	35.3	36.5	34.1	27.7	29.9	25.8
22–24	16.9	18.8	15.1	13.8	13.5	14.0
25–29	9.2	9.4	9.1	7.4	5.8	8.7
30–34	6.1	5.4	6.8	5.2	3.9	6.2
1990	50.2	50.9	49.5	52.2	54.3	50.3
Total, 3–34						
3–4	44.4	43.9	44.9	41.8	38.1	45.5
5–6	96.5	96.5	96.4	96.5	96.2	96.9
7–9	99.7	99.7	99.6	99.8	99.9	99.8
10–13	99.6	99.6	99.7	99.9	99.9	99.8
14–15	99.0	99.1	98.9	99.4	99.7	99.1
16–17	92.5	92.6	92.4	91.7	93.0	90.5
18–19	57.2	58.2	56.3	55.0	60.4	49.8
20–21	39.7	40.3	39.2	28.3	31.0	25.8
22–24	21.0	22.3	19.9	19.7	19.3	20.0
25–29	9.7	9.2	10.2	6.1	4.7	7.3
30–34	5.8	4.8	6.9	4.5	2.3	6.3

TABLE 6.3 Percentage of the Population Three to Thirty-four Years Old Enrolled in School, October 1975–October 1992 (*Continued*)

Year and Ages	Total			Black		
	Both Sexes	Male	Female	Both Sexes	Male	Female
1992 Total, 3–34	51.4	51.9	50.9	53.2	55.1	51.5
3–4	39.7	40.3	39.1	37.8	40.0	35.3
5–6	95.5	95.7	95.2	95.3	97.3	93.4
7–9	99.4	99.5	99.2	99.3	99.7	98.9
10–13	99.4	99.5	99.2	99.7	99.7	99.6
14–15	99.1	99.2	99.1	99.4	99.9	98.8
16–17	94.1	95.4	92.7	93.0	94.7	91.4
18–19	61.4	61.6	61.2	56.3	60.9	51.8
20–21	44.0	41.7	46.1	33.2	27.2	38.4
22–24	23.7	23.8	23.6	20.3	18.5	21.9
25–29	9.8	9.1	10.5	8.0	7.7	8.2
30–34	6.1	5.2	7.0	5.3	3.3	7.0

Source: U.S. Department of Education, National Center for Education Statistics, 1993.

TABLE 6.4 Years of School Completed by Persons Twenty-five and Over, 1940–1991

Date	Less than 5 yrs. of elementary school (%)		4 yrs. of high school or more (%)		4 yrs. of college or more (%)		Median school year completed	
	Total	Black	Total	Black	Total	Black	Total	Black
April 1940	13.7	41.8	24.5	7.7	4.6	1.3	8.6	5.7
April 1950	11.1	32.6	34.3	13.7	6.2	2.2	9.3	6.9
April 1960	8.3	23.5	41.1	21.7	7.7	3.5	10.5	8.2
March 1970	5.3	14.7	55.2	36.1	11.0	6.1	12.2	10.1
March 1975	4.2	11.7	62.5	46.4	13.9	9.2	12.3	11.4
March 1980	3.4	8.8	68.6	54.6	17.0	11.1	12.5	12.2
March 1985	2.7	6.0	73.9	63.2	19.4	15.4	12.6	12.4
March 1990	2.4	5.4	77.6	68.7	21.3	16.5	12.7	12.5
March 1991	2.4	5.0	78.4	69.6	21.4	16.7	12.7	12.5

TABLE 6.5 Master's Degrees Conferred, 1976–1977 to 1990–1991[†]

Year	All			Black			% Black		
	Total	Male	Female	Total	Male	Female	Total	Male	Female
1976–1977[1]	316,602	167,396	149,206	21,037	7,781	13,256	6.6	4.6	8.9
1978–1979[2]	300,255	152,637	147,618	19,418	7,070	12,348	6.5	4.6	8.4
1980–1981[3]	294,183	145,666	148,517	17,133	6,158	10,975	5.8	4.2	7.4
1984–1985[4]	280,421	139,417	140,004	13,939	5,200	8,739	5.0	3.7	6.2
1986–1987[5]	289,341	141,264	148,077	13,867	5,151	8,716	4.8	3.6	5.9
1988–1989[6]	309,770	148,872	160,898	14,096	5,175	8,921	4.6	3.5	5.5
1989–1990[7]	322,465	151,796	176,849	15,446	5,539	9,907	4.8	3.6	5.8
1990–1991[8]	328,645	151,796	176,849	16,136	5,707	10,429	4.9	3.8	5.9

[†] Areas of study included agriculture, architecture and environmental design, area and ethnic studies, business, communications, computer science, education, engineering, foreign languages, health, home economics, law, letters, liberal/general studies, library and archival sciences, life sciences, mathematics, multi/interdisciplinary studies, philosophy and religion, theology, physical sciences, psychology, protective services and public affairs, social sciences, visual and performing arts, other.

[1] Excludes 387 men and 175 women whose racial/ethnic group was not available.

[2] Excludes 733 men and 91 women whose racial/ethnic group was not available.

[3] Excludes 1,377 men and 179 women whose racial/ethnic group was not available.

[4] Excludes 3,973 men and 1,857 women whose racial/ethnic group was not available.

[5] Reported racial/ethnic distribution of students by level of degree, field of degree, and sex were used to estimate race/ethnicity for students whose race/ethnicity was not reported. Excludes 99 men and 117 women whose racial/ethnic group and field of study were not available.

[6] Reported racial/ethnic distribution of students by level of degree, field of degree, and sex were used to estimate race/ethnicity for students whose race/ethnicity was not reported. Excludes 482 men and 369 women whose racial/ethnic group and field of study were not available.

[7] Reported racial/ethnic distribution of students by level of degree, field of degree, and sex were used to estimate race/ethnicity for students whose race/ethnicity was not reported. Excludes 736 men and 1,116 women whose racial/ethnic group and field of study were not available.

[8] Reported racial/ethnic distributions of students by level of degree, field of degree and sex were used to estimate race/ethnicity for students whose race/ethnicity was not reported. Excludes 4,686 men and 3,837 women whose racial/ethnic group and field of study were not available. Preliminary data.

Source: U.S. Department of Education, National Center for Education Statistics, Digest of Educational Statistics, 1993.

TABLE 6.6 First Professional Degrees Conferred, 1976–1977 to 1990–1991[†]

Year	Total*			Black*			% Black		
	Total	Male	Female	Total	Male	Female	Total	Male	Female
1976–1977[1]	63,953	51,980	11,973	2,537	1,761	776	4.0	3.4	6.5
1978–1979[2]	68,611	52,425	16,186	2,836	1,783	1,053	4.1	3.4	6.5
1980–1981[3]	71,340	52,194	19,146	2,931	1,772	1,159	4.1	3.4	6.1
1984–1985[4]	71,057	47,501	23,556	3,029	1,623	1,406	4.3	3.4	6.0
1986–1987[5]	71,617	46,522	25,095	3,420	1,835	1,585	4.8	3.9	6.3
1988–1989	70,856	45,046	25,810	3,148	1,618	1,530	4.4	3.6	5.9
1989–1990[6]	70,744	43,778	26,966	3,410	1,672	1,738	4.8	3.8	6.4
1990–1991[7]	71,515	43,601	27,914	3,575	1,672	1,903	5.0	3.8	6.8

[†] Areas of study included dentistry, medicine, veterinary medicine, other health professions (optometry, osteopathy, podiatry, chiropractic), law, theology.
*Reported racial/ethnic distributions of students by level of degree, field of degree, and sex were used to estimate race/ethnicity for students whose race/ethnicity was not reported.
[1] Excludes 394 men and 12 women whose racial/ethnic group was not available.
[2] Excludes 227 men and 10 women whose racial/ethnic group was not available.
[3] Excludes 598 men and 18 women whose racial/ethnic group was not available.
[4] Racial/ethnic data were imputed for 4,279 men and 1,696 women. Excludes 2,954 men and 1,052 women whose racial/ethnic group was not available.
[5] Excludes 983 men and 195 women whose racial/ethnic group was not available.
[6] Excludes 183 men and 61 women whose racial/ethnic group was not available.
[7] Excludes 245 men and 188 women whose racial/ethnic group was not available.
 Preliminary data.
Source: U.S. Department of Education, National Center for Educational Statistics, Digest of Educational Statistics, 1992.

TABLE 6.7 Doctorates Conferred, 1976–1977 to 1990–1991[†]

Year	Total			Black			% Black		
	Both	Male	Female	Both	Male	Female	Both	Male	Female
1976–77[1]	33,126	25,036	8,090	1,253	766	487	3.8	3.1	6.0
1978–79[2]	32,675	23,488	9,187	1,268	734	534	3.9	3.1	5.8
1980–81[3]	32,839	22,595	10,244	1,265	694	571	3.9	3.1	5.6
1984–85[4]	32,307	21,296	11,011	1,154	561	593	3.6	2.6	5.4
1986–87[5]	34,033	22,059	11,974	1,060	488	572	3.1	2.2	4.8
1988–89[6]	35,659	22,597	13,062	1,065	490	575	3.0	2.2	4.4
1989–90[7]	38,113	24,248	13,865	1,152	533	619	3.0	2.2	4.5
1990–91[8]	38,547	24,333	14,214	1,212	582	630	3.1	2.4	4.4

[†] Includes Ph.D., Ed.D., and comparable degrees at the doctoral level. Excludes first professional degrees.
[1] Excludes 106 men whose racial/ethnic group was not available.
[2] Excludes 53 men and 2 women whose racial/ethnic group was not available.
[3] Excludes 116 men and 3 women whose racial/ethnic group was not available.
[4] Excludes 404 men and 232 women whose racial/ethnic group was not available.
[5] Reported racial/ethnic distributions of students by level of degree, field of degree, and sex were used to estimate race/ethnicity for students whose race/ethnicity was not reported. Excludes 40 men and 47 women whose racial/ethnic group and field of study were not available.
[6] Reported racial/ethnic distributions of students by level of degree, field of degree, and sex were used to estimate race/ethnicity for students whose race/ethnicity was not reported. Excludes 51 men and 10 women whose racial/ethnicity group and field of study were not available.
[7] Reported racial/ethnic distributions of students by level of degree, field of degree, and sex were used to estimate race/ethnicity for student whose race/ethnicity was not reported. Excludes 153 men and 105 women whose racial/ethnic group and field of study were not available.
[8] Reported racial/ethnic distributions of students by level of degree, field of degree, and sex were used to estimate race/ethnicity for students whose race/ethnicity was not reported. Excludes 423 men and 324 women whose racial/ethnic group and field of study were not available. Preliminary data.
Source: U.S. Department of Education, National Center for Educational Statistics, Digest of Educational Statistics, 1993.

TABLE **6.8 Bachelor's Degrees Conferred, by Major Field of Study, 1990–1991**

Major Field of Study	Total	Black	%
All fields, total	1,081,280	65,338	6.04
Agriculture and natural resources	13,124	341	2.60
Architecture and environmental design	9,781	329	3.36
Area and ethnic studies	4,623	362	7.83
Business and management	249,960	16,689	6.68
Communications	52,799	3,637	6.89
Computer and information sciences	25,083	2,063	8.22
Education	111,010	4,825	4.35
Engineering	61,632	2,279	3.70
Engineering technologies	17,232	1,203	6.98
Foreign language	12,095	344	2.84
Health sciences[1]	59,268	4,220	7.12
Home economics	15,474	932	6.02
Law	1,758	119	6.77
Letters[2]	52,880	2,325	4.40
Liberal/general studies	26,692	1,941	7.27
Library and archival sciences	93	6	6.45
Life sciences	39,530	2,154	5.45
Mathematics	14,661	825	5.63
Military sciences	418	14	3.35
Multi/interdisciplinary studies	21,653	1,465	6.77
Parks and recreation	4,062	209	5.15
Philosophy and religion	7,315	240	3.28
Physical sciences	16,344	772	4.72
Protective services	16,806	2,470	14.70
Psychology	58,451	3,786	6.48
Public affairs	16,976	2,086	12.29
Social Sciences[3]	124,893	8,099	6.48
Theology	4,813	134	2.78
Visual and performing arts	41,854	1,469	3.51

[1] The field of health sciences includes audiology/speech pathology, basic clinical health sciences, chiropractic, dentistry, epidemiology, health services administration, medical laboratory, medicine, nursing, optometry, osteopathic medicine, pharmacy, predentistry, premedicine, preveterinary, public health, veterinary medicine, and others.

[2] The field of letters includes general English, classics, comparative literature, composition, creative writing, linguistics, American literature, English literature, rhetoric, speech/debate/forensics, technical and business writing, and others.

[3] The field of social Sciences includes general social sciences, anthropology, archaeology, criminology, demography, economics, geography, history, international relations, political science and government, sociology, urban studies, and others.

Source: U.S. Department of Education, National Center for Education Statistics, Integrated Postsecondary Education Data System (IPEDS), "Completions" survey. Prepared April 1993.

TABLE 6.9 Master's Degrees Conferred, by Major Field of Study, 1990–1991

Major Field of Study	Total	Black	Percent
All fields, total	328,645	16,136	4.91
Agriculture and natural resources	3,295	71	2.15
Architecture and environmental design	3,490	110	3.15
Area and ethnic studies	1,250	57	4.56
Business and management	78,681	3,536	4.49
Communications	4,336	251	5.79
Computer and information sciences	9,324	303	3.25
Education	88,904	5,836	6.56
Engineering	23,984	421	1.76
Engineering technologies	975	46	4.72
Foreign language	2,073	25	1.21
Health sciences[1]	21,228	1,049	4.94
Home economics	2,021	102	5.05
Law	2,057	46	2.24
Letters[2]	7,810	171	2.19
Liberal/general studies	1,736	51	2.94
Library and archival sciences	4,805	174	3.62
Life sciences	4,765	144	3.02
Mathematics	3,615	105	2.90
Multi/interdisciplinary studies	2,548	92	3.61
Parks and recreation	393	12	3.05
Philosophy and religion	1,441	44	3.05
Physical sciences	5,309	80	1.51
Protective services	1,108	144	13.00
Psychology	9,731	477	4.90
Public affairs	18,534	1,805	9.74
Social sciences[3]	12,069	568	4.71
Theology	4,508	185	4.10
Visual and performing arts	8,655	231	2.67

[1] The field of health sciences includes audiology/speech pathology, basic clinical health sciences, chiropractic, dentistry, epidemiology, health services administration, medical laboratory, medicine, nursing, optometry, osteopathic medicine, pharmacy, predentistry, premedicine, preveterinary, public health, veterinary medicine, and others.

[2] The field of letters includes general English, classics, comparative literature, composition, creative writing, linguistics, American literature, English literature, rhetoric, speech/debate/forensics, technical and business writing, and others.

[3] The field of social sciences includes general social sciences, anthropology, archaeology, criminology, demography, economics, geography, history, international relations, political science and government, sociology, urban studies, and others.

Source: U.S. Department of Education, National Center for Education Statistics, Integrated Postsecondary Education Data System (IPEDS), "Completions" survey. Prepared April 1993.

TABLE **6.10** Doctoral Degrees Conferred, by Major Field of Study, 1990–1991

Major Field of Study	Total	Black	Percent
All fields, total	38,547	1,212	3.14
Agriculture and natural resources	1,185	17	1.43
Architecture and environmental design	135	2	1.48
Area and ethnic studies	167	13	7.78
Business and management	1,243	25	2.01
Communications	274	24	8.76
Computer and information sciences	676	4	0.59
Education	6,697	479	7.15
Engineering	5,262	47	0.89
Engineering technologies	10	0	0.00
Foreign language	526	5	0.95
Health sciences[1]	1,614	59	3.66
Home economics	255	11	4.31
Law	90	2	2.22
Letters[2]	1,416	39	2.75
Liberal/general studies	36	2	5.56
Library and archival sciences	56	5	8.93
Life sciences	4,093	46	1.12
Mathematics	978	10	1.02
Multi/interdisciplinary studies	258	10	3.88
Parks and recreation	27	2	7.41
Philosophy and religion	456	12	2.63
Physical sciences	4,290	38	0.89
Protective services	28	5	17.86
Psychology	3,422	132	3.86
Public affairs	430	36	8.37
Social sciences[3]	3,012	106	3.52
Theology	1,075	67	6.23
Visual and performing arts	836	14	1.67

[1] The field of health sciences includes audiology/speech pathology, basic clinical health sciences, chiropractic, dentistry, epidemiology, health services administration, medical laboratory, medicine, nursing, optometry, osteopathic medicine, pharmacy, predentistry, premedicine, preveterinary, public health, veterinary medicine, and others.

[2] The field of letters includes general English, classics, comparative literature, composition, creative writing, linguistics, American literature, English literature, rhetoric, speech/debate/forensics, technical and business writing, and others.

[3] The field of social sciences includes general social sciences, anthropology, archaeology, criminology, demography, economics, geography, history, international relations, political science and government, sociology, urban studies, and others.

Source: U.S. Department of Education, National Center for Education Statistics, Integrated Postsecondary Education Data System (IPEDS), "Completions" survey. Prepared April 1993.

TABLE **6.11** **First Professional Degrees, by Major Field of Study, 1990–1991**

Major Field of Study	Total	Black	Percent
All fields, total	71,515	3,575	5.00
Dentistry (D.D.S. or D.M.D.)	3,699	205	5.54
Medicine (M.D.)	15,043	882	5.86
Optometry (O.D.)	1,115	17	1.52
Osteopathic medicine (D.O.)	1,459	17	1.17
Pharmacy (Pharm.D.)	1,244	61	4.90
Podiatry (Pod.D. or D.P.) or podiatric medicine (D.P.M.)	589	52	8.83
Veterinary medicine (D.V.M.)	2,032	44	2.17
Chiropractic medicine (D.C. or D.C.M.)	2,640	30	1.14
Law (LL.B. or J.D.)	37,945	1,860	4.90
Theology (M.Div., M.H.L., B.D., or Ord.)	5,695	407	7.15
Medicine, other	54	0	0.00

Source: U.S. Department of Education, National Center for Education Statistics, Integrated Postsecondary Education Data System (IPEDS), "Completions" survey. Prepared April 1993.

TABLE **6.12** **College Enrollment, 1972–1991***

Year	Total		Black	
	Male	Female	Male	Female
1972	5,218	3,877	384	343
1975	5,911	4,969	523	577
1980	5,430	5,957	476	686
1983	6,038	6,329	537	690
1984	5,989	6,316	590	684
1985	5,906	6,618	518	689
1986	5,957	6,694	580	779
1987	6,030	6,689	587	764
1988	5,950	7,166	494	827
1989	5,950	7,231	480	807
1990	6,192	7,427	587	807
1991	6,439	7,618	629	848

*In thousands.
Source: *Statistical Abstract, 1993*.

TABLE 6.13 **Historically Black Colleges and Universities (HBCU)**

This listing presents a brief chronology of each HBCU's history. The current name of the college is followed by the school's official founding date. Name and location changes are listed after the date on which the change occurred. Colleges are designated as public (PU) or private (PR), as four-year (4) or four-year plus graduate school (4+G). The religious affiliations of private colleges are listed; all public colleges are nondenominational. Land-grant colleges are noted as such. Figures for total enrollment and the black percentage of total enrollment are from the Fall of 1992. Guidelines for designating colleges as Historically Black Colleges and Universities were provided by the National Association for Equal Opportunity in Higher Education (NAFEO).

Alabama

Alabama Agricultural and Mechanical University (1875)
 Normal, Ala.; PU-4+G; land-grant; 5,069; 78.8% black
 1875—Founded as Huntsville Normal School (Huntsville, Ala.)
 1885—State Normal and Industrial School at Huntsville
 1891—The State Agricultural and Mechanical College for Negroes (Normal, Ala.); land-grant status
 1919—The State Agricultural and Mechanical Institute for Negroes; began two-year college degree program
 1941—First baccalaureate degrees awarded
 1948—Alabama Agricultural and Mechanical College
 1958—Graduate program added
 1963—Accredited by the Southern Association of Colleges and Schools
 1969—Alabama Agricultural and Mechanical University

Alabama State University (1866)
 Montgomery, Ala.; PU-4+G; 5,488; 98% black
 1866—Founded as Lincoln Normal School (Marion, Ala.)
 1874—State Normal School
 1887—Alabama Colored People's University (Montgomery, Ala.)
 1888—State Normal School for Colored Students
 1928—Four-year teachers college
 1929—State Teachers College
 1943—First Master's degree granted
 1948—Alabama State College for Negroes
 1954—Alabama State College
 1966—Accredited by the Southern Association of Colleges and Schools
 1969—Alabama State University

Miles College (1905)
 Birmingham, Alabama; PR-4; Christian Methodist Episcopal; 751; 99.7% black
 1905—Founded by the Colored Methodist Episcopal Church in Booker City, Ala.
 1907—First college courses offered
 1908—Miles Memorial College (Birmingham, Ala.)
 1941—Miles College
 1971—Accredited by the Southern Association of Colleges and Schools

Oakwood College (1896)
 Huntsville, Ala.; PR-4; Seventh-Day Adventist; 1,334; 86.4% black
 1896—Founded as Oakwood Industrial School by the General Conference of Seventh-Day Adventists
 1904—Oakwood Manual Training School
 1917—Began two-year college degree program
 1938—Oakwood Junior College
 1943—Began four-year college degree program
 1944—Oakwood College
 1958—Accredited by the Southern Association of Colleges and Schools

Stillman College (1876)
 Tuscaloosa, Ala.; PR-4; Presbyterian; 890; 98.2% black
 1876—Founded as Tuscaloosa Institute for men by the Presbyterian Church
 1893—Stillman Institute
 1899—Women admitted
 1927—Began two-year college degree program
 1948—Stillman College
 1949—Began four-year college degree program
 1953—Accredited by the Southern Association of College and Schools

Talladega College (1867)
 Talladega, Ala.; PR-4; United Church of Christ; 917; 94.8% black
 1867—Founded as by the American Missionary Association (Congregational); elementary school
 1869—Normal school added
 1873—Theological department established
 1895—First baccalaureate degrees awarded
 1931—Accredited by the Southern Association of Colleges and Schools

Tuskegee University (1881)
 Tuskegee, Ala.; PR-4+G; Nondenominational; land-grand; 3,598; 92.7% black
 1881—Founded as the Normal School for Colored Teachers by the Alabama state legislature.
 1881—Tuskegee State Normal School
 1883—Became private
 1887—Tuskegee Normal School
 1891—Tuskegee Normal and Industrial Institute

1927—College department added
1933—Accredited by the Southern Association of Colleges and Schools
1937—Tuskegee Institute
1943—Graduate program added
1944—School of Veterinary Medicine established
1957—College of Arts and Sciences established
1972—Land-grant status
1985—Tuskegee University

Arkansas

Arkansas Baptist College (1884)
Little Rock, Ark.; PR-4; Arkansas Consolidated Baptist Convention; 311; 98.7% black
1884—Founded as Baptist Institute by the Colored Baptists of the State of Arkansas; located at Mount Zion Baptist Church
1887—Arkansas Baptist College; independent Board of Trustees
1888—First baccalaureate degrees awarded
1986—Accredited by the Southern Association of Colleges and Schools

Philander Smith College (1877)
Little Rock, Ark.; PR-4; United Methodist; 940; 86.6% black
1877—Founded as Walden Seminary by the Freedmen's Aid Society of the Methodist Episcopal Church
1883—Philander Smith College
1888—First baccalaureate degrees awarded
1949—Accredited by the North Central Association of Colleges and Secondary Schools

University of Arkansas at Pine Bluff (1873)
Pine Bluff, Ark.; PU-4; land-grant; 3,709; 80.9% black
1873—Founded as Branch Normal College at Pine Bluff by the Arkansas state legislature as a branch of Arkansas Industrial University (later University of Arkansas at Fayetteville); land-grant status
1875—School opened
1894—Began two-year college degree program
1927—Agricultural, Mechanical and Normal College; began four-year college degree program; Separated from University of Arkansas at Fayetteville
1929—Arkansas Agricultural, Mechanical and Normal College
1950—Accredited by the North Central Association of Colleges and Secondary Schools
1972—Became part of University of Arkansas System as the University of Arkansas at Pine Bluff

Delaware

Delaware State University (1891)
Dover, Del.; PU-4 + G; land-grant; 2,935; 62% black

1891—Founded as State College for Colored Students by the Delaware General Assembly; land-grant status
1892—School opened
1924—Began two-year college degree program
1927—Began four-year college degree program
1945—Accredited by the Middle States Association of Colleges and Secondary Schools
1947—Delaware State College
1993—Delaware State University

District of Columbia

Howard University (1867)
Washington, D.C.; PR-4 + G; nondenominational; 10,667; 86.1% black
1866—Howard Normal and Theological Institute planned by a group of Washington, D.C., Congregational Church members
1867—Founded as Howard University after Gen. Oliver Otis Howard, philanthropist and commissioner of the Freedmen's Bureau; funded by the Freedmen's Bureau; Normal and Preparatory Departments opened
1868—College Department opened, Medical Department opened
1869—Law Department opened
1870—Theological Department organized, funded by American Missionary Association of the Congregational Church
1872—First Bachelor's degrees awarded
1876—First Master's degrees awarded
1879—Granted annual subsidy by the federal government after demise of the Freedmen's Bureau in 1873
1881—College of Dentistry established
1901—Teachers College established
1907—Board of Trustees adopted new terminology: College Department became the College of Arts and Sciences; School of Medicine; School of Law; School of Theology; Normal College; Preparatory Department became Howard Academy
1914—School of Music established
1918—School of Theology became School of Religion (later the Divinity School, 1981; and School of Divinity, 1987)
1920—Howard Academy (high school) discontinued
1921 Accredited by the Middle States Association of Colleges and Secondary Schools
1934—Graduate School for arts and science established; School of Engineering and Architecture established
1945—School of Social Work established
1958—First Ph.D. awarded
1968—College of Nursing established

University of the District of Columbia (1851)
Washington, D.C.; PU-4 + G; land-grant; 11,577; 83% black
1851—Founded as Miss Miner's Colored Girls' School by Myrtilla Miner
1863—Institution for the Education of Colored Youth
1879—Miner Normal School; became part of the public school system as Washington Normal
1929—Miner Teachers College; four-year teachers college
1943—Accredited by the Middle States Association of Colleges and Secondary Schools
1955—District of Columbia Teachers College formed by merger of Miner Normal School and Wilson Normal School (formerly an all-white school)
1961—Accredited by the Middle States Association of Colleges and Secondary Schools
1977—University of the District of Columbia formed by merger of the District of Columbia Teachers College and Washington Technical Institute; land-grant status

Florida

Bethune-Cookman College (1904)
Daytona Beach, Fla.; PR-4; United Methodist; 2,301; 96.3% black
1904—Founded as the Daytona Educational and Industrial Training School (for girls) by Mary McLeod Bethune
1923—Became Bethune-Cookman Collegiate Institute after merger with the Darnell Cookman Institute, a boys' school, founded in Jacksonville, Fla., in 1872
1932—Bethune-Cookman College; high school curriculum dropped; began two-year degree program
1941—Began four-year college degree program
1947—Accredited by the Southern Association of Colleges and Schools

Edward Waters College (1866)
Jacksonville, Fla.; PR-4; African Methodist Episcopal Church; 612; 97.1% black
1866—Founded in Jacksonville by Rev. Charles H. Pearce under the auspices of the African Methodist Episcopal Church
1872—Brown Theological Institute
1874—Brown University; school closed
1883—East Florida Conference High School reopened in Jacksonville, Fla., by Rev. W. W. Sampson of the Mount Zion African Methodist Episcopal Church
1888—East Florida Scientific and Divinity High School
1892—Edward Waters College
1901—Campus destroyed by fire

1904—Acquired Kings Road site
1912—B. F. Lee Theological Seminary established
1955—Began two-year college degree program
1960—Began four-year college degree program
1979—Accredited by the Southern Association of Colleges and Schools

Florida Agricultural and Mechanical University (1887)
Tallahassee, Fla.; PU-4 + G; land-grant; 9,196; 87.4% black
1887—Founded as State Normal College for Colored Students
1891—Florida State Normal and Industrial School for Negro Youth; land-grant status
1904—School of Nursing established
1905—Began four-year college degree program
1909—Florida Agricultural and Mechanical College for Negroes
1935—Accredited by the Southern Association of Colleges and Schools
1951—Florida Agricultural and Mechanical College
1953—Florida Agricultural and Mechanical University
1971—Became part of the State University System of Florida
1975—School of Architecture established

Florida Memorial College (1879)
Miami, Fla.; PR-4; American Baptist; 1,488; 84.6% black
1879—Founded as Florida Baptist Institute by the American Baptist Home Mission Society (Live Oak, Fla.)
1931—Moved to Saint Augustine, Fla.; merged with Florida Normal and Industrial Institute (f. 1872 as Florida Baptist Academy, Jacksonville, Fla.; moved to St. Augustine, Fla., in 1918)
1944—Florida Normal and Industrial College; four-year college
1945—First baccalaureate degrees awarded
1950—Florida Normal and Industrial Memorial College
1951—Accredited by the Southern Association of Colleges and Schools
1963—Florida Memorial College
1968—Moved to Miami, Fla.

Georgia

Albany State College (1903)
Albany, Ga.; PU-4 + G; 3,102; 84.7% black
1903—Founded as Albany Bible and Training Institute
1917—Georgia Normal and Agricultural College; the state of Georgia assumed responsibility for the school; began two-year college degree program

1943—Albany State College; began four-year college degree program
1957—Accredited by the Southern Association of Colleges and Schools

Atlanta University Center (1957)

In 1929 the Atlanta University System was formed by affiliation of Atlanta University, Morehouse College, and Spelman College. In 1957 the Atlanta University System became the Atlanta University Center, adding Clark College, and Morris Brown College. In 1958, the Interdenominational Theological Center (ITC) was created as part of the Atlanta University Center through the affiliation of the Morehouse School of Religion, the Gammon Theological Center, the Turner Theological Seminary, and the Phillips School of Theology. The Johnson C. Smith Seminary and the Charles H. Mason Theological Seminary joined the ITC in 1970. Morehouse School of Medicine joined the Atlanta University Center in 1982. In 1988 Clark Atlanta University was founded by the merger of Atlanta University and Clark College—both members of the Atlanta University Center. The histories of individual colleges are listed below.

Clark Atlanta University (1988)
Atlanta, Ga.; 4,480; 85.9% black
1988—Founded by the merger of Atlanta University (1865) and Clark College (1869)

Atlanta University (1865)
Atlanta, Ga.; PR-G
1865—Classes held for ex-slaves in Jenkins Street Church and a railroad box-car
1866—Storr's School, opened by Edmund Asa Ware with money from the American Missionary Association and the Freedmen's Bureau
1867—Ware proposed an institution for higher learning; sponsored by the American Missionary Association
1869—Normal School established
1872—College departments added
1873—First normal class graduated
1876—Awarded first bachelor of arts degrees
1894—Elementary grades discontinued
1929—Atlanta University, Morehouse College, and Spelman College affiliated, forming the Atlanta University System; campus moved to present site
1930—Undergraduate courses discontinued; became graduate and professional school
1931—Began instruction in sculpturing and other fine arts
1932—Accredited by the Southern Association of Colleges and Schools
1933—Supported the Atlanta University Summer School
1941—People's College, a project in adult education, established; School of Library Science established
1944—School of Education established
1946—School of Business Administration established
1947—Atlanta School of Social Work merged into Atlanta University
1957—Atlanta University System became the Atlanta University Center, including Clark College, Morris Brown College, and Gammon Theological Seminary
1988—Merged with Clark College to found Clark Atlanta University

Clark College (1869)
Atlanta, Ga.; PR-4; United Methodist
1869—Founded as the Summer Hill school by Rev. J. W. Lee and wife under sponsorship of Freedmen's Aid Society of the Methodist Episcopal Church in Atlanta's Summerhill section
1870—Clark University in honor of Bishop Davis W. Clark, first president of Freemen's Aid Society of Methodist Episcopal Church.
1872—Relocated to new site on the Whitehall and McDaniel Streets property
1879—College department added
1883—Department of Theology added; first college degree awarded; relocated to South Atlanta
1886—Department of Theology separated from Clark University to form Gammon Theological Seminary
1933—Supported the Atlanta University Summer School
1940—Clark College
1941—Accredited by the Southern Association of Colleges and Schools; relocated to present site; joined the Atlanta University System
1957—Atlanta University System became the Atlanta University Center
1988—Merged with Atlanta University to found Clark Atlanta University

Interdenominational Theological Center (1958)
Atlanta, Ga.; 382; 93.5% black
1958—Founded as part of Atlanta University Center through the affiliation of Morehouse School of Religion, Gammon Theological Seminary, Turner Theological Seminary, and Phillips School of Theology.
Johnson C. Smith Theological Seminary and Charles H. Mason Theological Seminary added in 1970.

Morehouse School of Religion (1867)
1867—Founded as theological department of Augusta Institute by the American Baptist Home Mission Society; Augusta Institute became Atlanta Baptist in 1879

1904—Divinity School of Atlanta Baptist College; Atlanta Baptists became Morehouse College in 1913

1924—Morehouse School of Religion

1958—Merged into the Interdenominational Theological Center; affiliated with the Atlanta University Center

Gammon Theological Seminary (1883)

1883—Department of Theology established at Clark University

1888—Founded as Gammon Theological Seminary by the Methodist Episcopal Church

1958—Merged into the Interdenominational Theological Center, affiliated with the Atlanta University Center through the ITC

Turner Theological Seminary (1894)

1894—Founded by the African Methodist Episcopal Church as the Theology Department of Morris Brown College

1900—Turner Theological Seminary, independent of Morris Brown College

1958—Merged into the Interdenominational Theological Center; affiliated with the Atlanta University Center

Phillips School of Theology (1945)

1945—Founded by trustees of Lane College (Jackson, Tenn.) as a separate seminary operating at the college under auspices of Colored Methodist Episcopal Church

1958—Merged into the Interdenominational Theological Center; affiliated with the Atlanta University Center; relocated to Atlanta, Ga.

Johnson C. Smith Theological Seminary (1867)

1867—Founded by the Presbyterian Church (USA) as a part of the Freedmen's College of North Carolina, subsequently named Biddle Memorial Institute in Charlotte, N.C. (later Johnson C. Smith University)

1970—Joined the Interdenominational Theological Center; became affiliated with the Atlanta University Center

Charles H. Mason Theological Seminary (1970)

1970—Founded by Church of God in Christ under the leadership of Bishop J. O. Patterson; joined the Interdenominational Theological Seminary

Morehouse College (1867)

Atlanta, Ga.; PR-4; Nondenominational; 2,992 men; 98.8% black

1867—Founded as Augusta Institute for ex-slaves in Springfield Baptist Church under the sponsorship of the American Baptist Home Mission Society

1879—Atlanta Baptist Seminary

1881—Began four-year degree program

1897—Atlanta Baptist College; first baccalaureate degrees awarded

1913—Morehouse College

1928—Began joint operation of a summer school with Spelman College

1929—Joined with Atlanta University and Spelman College to form the Atlanta University System; Academy (high school) discontinued

1932—Accredited by the Southern Association of Colleges and Schools

1935—Control transferred from American Baptist Home Mission Society to Board of Trustees

1957—Atlanta University System became the Atlanta University Center

Morehouse School of Medicine (1974)

Atlanta, Ga.; PR-4; 157; 92% black

1974—Founded as medical program within Morehouse College

1981—Independent from Morehouse College

1982—Joined Atlanta University Center

Morris Brown College (1881)

Atlanta, Ga.; PR-4; African Methodist Episcopal; 2,140; 83.1% black

1881—Founded as Christian school for blacks by the African Methodist Episcopal Church

1882—College department opened

1885—Morris Brown College

1894—Theological department added

1900—Theological department became Turner Theological Seminary

1912—Commercial department added

1913—Morris Brown University established consisting of Morris Brown College and Turner Theological Seminary in Atlanta, Payne College in Cuthbert, Ga., and Central Park Normal and Industrial Institute in Savannah

1929—Morris Brown College; affiliation with Payne College and Central Park Normal and Industrial Institute discontinued

1931—High School and practice school closed; began four-year college degree program

1932—Moved to old Atlanta University campus; Preparatory School abolished; merged with Williams Business College

1941—Accredited by the Southern Association of Colleges and Schools; joined the Atlanta University System

1957—Atlanta University System became the Atlanta University Center

Spelman College (1881)

Atlanta, Ga.; PR-4; 1,938 women; 96.9% black

1881—Founded as Atlanta Baptist Female Seminary by Sophia B. Packard and Harriet E. Giles at Friendship Baptist Church (Atlanta, Ga.)

1883—Moved to present location; "Model School" to train student teachers opened; funded by the American Baptist Home Mission Society

1884—Spelman Seminary

1890—College department opened (only taught Latin and German)

1897—Full-fledged college department inaugurated

1901—First baccalaureate degrees awarded

1924—Spelman College

1928—Began joint operation of a summer school with Morehouse College; elementary school and nurse training department discontinued

1929—Affiliated with Atlanta University and Morehouse College to form the Atlanta University System

1930—Spelman High School discontinued; nursery school established

1932—Accredited by the Southern Association of Colleges and Schools

1957—Atlanta University System became the Atlanta University Center

Fort Valley State College (1895)

Fort Valley, Ga.; PU-4 + G; land-grant; 2,537; 92.8 black

1939—Fort Valley State College formed by merger of Fort Valley Normal and Industrial School and State Teachers and Agricultural College; four-year college in the University System of Georgia

1941—First baccalaureate degrees offered

1946—Began offering graduate courses

1947—Land-grant status

1951—Accredited by the Southern Association of Colleges and Schools

Fort Valley Normal and Industrial School (1895)

1895—Founded as Fort Valley High and Industrial School by black and white citizens of Fort Valley

1913—American Church Institute of the Episcopal Church became sponsor

1927—Began two-year college degree program

1932—Fort Valley Normal and Industrial School

1939—Sponsorship of Episcopal Church ended

State Teachers and Agricultural College (1902)

1902—Founded as Forsyth Normal and Industrial School for the Training of the Colored Youth (Forsyth, Ga.) by William Merida Hubbard; first classes held in Kynett Methodist Episcopal Church; some financial support from the American Missionary Association

1916—Became a senior high school

1922—Forsyth Agricultural and Mechanical School; partially supported by the state

1931—State Teachers and Agricultural College; came under university system of Georgia

1932—Began two-year college degree program

Paine College (1882)

Augusta, Ga.; PR-4; United Methodist and Christian Methodist Episcopal; 680; 97.4% black

1882—Founded as Paine Institute, organized by the General Conference of the Methodist Episcopal Church, South and the Colored Methodist Episcopal Church

1884—School opened

1888—Began four-year college degree program

1903—Paine College

1921—Theological School discontinued

1939—Control transferred to Board of Missions and Church Extension of the Methodist Church

1944—Accredited by the Southern Association of Colleges and Schools

Savannah State College (1890)

Savannah, Ga.; PU-4 + G; 90.9% black

1890—Founded as land-grant college; operated by Trustees of University of Georgia, with local Board of Commissioners in direct control; site selected near Thunderbolt, Ga., six miles from Savannah

1891—School opened, temporarily set up in the Baxter Street School (Athens, Ga.); all-male

1892—Georgia State Industrial College for Colored Youths (Savannah, Ga.)

1898—First student graduated from college department; coeducational

1926—Began four-year college degree program

1932—Georgia State College; integrated into reorganized University System of Georgia under control of Board of Regents;

1947—Lost land-grant status when Fort Valley State College assumed that function

1950—Savannah State College

1951—Accredited by Southern Association of Colleges and Schools

1968—Graduate program in elementary education added

1979—School of Business created when business teachers came from Armstrong State College under a desegregation order

Kentucky

Kentucky State University (1886)

Frankfort, Ky.; PU-4 + G; land-grant; 2,545; 49.7% black

1886—Founded as Kentucky State Normal School for Colored Persons

1887—School opened

1890—Land-grant status; agriculture, mechanics, and home economics courses added

1902—Kentucky Normal and Industrial Institute for Colored Persons

1926—Kentucky Industrial College for Colored Persons

1929—Began four-year college degree program

1938—Kentucky State College for Negroes

1939—Accredited by the Southern Association of Colleges and Schools

1952—Kentucky State College
1972—Kentucky State University

Berea College (1855)
Berea, Ky.; PR-4; Christian; 1,500; 10% black
1855—Founded by white abolitionists John Gregg Fee, Cassius M. Clay, and Dr. J. A. R. Rogers as a school for black and white students
1865—Berea Literary Institute
1867—Normal School established
1869—Berea College; college department added
1904—Kentucky state legislature passed Day Law prohibiting interracial education. Berea College Trustees raised funds to establish a school for black students (Lincoln Institute, near Louisville, Ky.)
1926—Accredited by the Southern Association of Colleges and Schools
1950—Day Law is amended, blacks again enrolled in Berea College
1968—Elementary and secondary schools discontinued

Louisiana

Dillard University (1869)
New Orleans, La.; PR-4; United Methodist Church and United Church of Christ; 1,511; 99.5% black
1930—Dillard University formed by the merger of Straight College with New Orleans University
1935—Began four-year college degree program
1937—Accredited by the Southern Association of Colleges and Schools

Straight College (1869)
1869—Founded by the American Missionary Association of the Congregational Church as Straight University
1915—Straight College

New Orleans University (1869)
1869—Founded as Union Normal School by the Freedmen's Aid Society of the Methodist Episcopal Church
1873—Merged with Thomson Biblical Institute and Thompson University as New Orleans University
1889—Flint Medical College established (discontinued in 1910); Thompson Theological School established
1903—Peck Home and School of Domestic Art & Science (discontinued in 1935)
1918—Gilbert Academy preparatory school established (discontinued in 1935)

Grambling State University (1901)
Grambling, La.; PU-4+G; 7,533; 93.8% black
1901—Founded as Colored Industrial and Agricultural School of Lincoln Parish (Ruston, La.) by Charles P. Adams for the Farmers Relief Association
1905—Became North Louisiana Agricultural and Industrial Institute (Grambling, La.)
1918—Lincoln Parish Training School
1928—Louisiana Negro Normal and Industrial Institute; state-supported two-year college
1940—Began four-year college degree program
1946—Grambling College of Louisiana
1949—Accredited by the Southern Association of Colleges and Schools
1974—Grambling State University
1975—First graduate degree awarded

Southern University System (1880)
1880—Charter for a school granted by the Louisiana legislature
1881—School opened
1890—Agricultural and mechanical department added
1893—Land-grant status
1914—Southern University and Agricultural and Mechanical College
1922—Began four-year college degree program
1937—Accredited by the Southern Association of Colleges and Schools
1947—School of law established
1959—Southern University, New Orleans, La., branch established
1967—Southern University, Shreveport, La., branch established as two-year college
1977—Southern University System founded, composed of Southern University Agricultural and Mechanical College (f. 1880, Baton Rouge, La.; PU-4+G; land-grant; 10,403; 93.9% black); Southern University, New Orleans (f. 1956, New Orleans, La.; PU-4; 4,591; 92.9% black); and Southern University, Shreveport (f. 1964, Shreveport, La.; PU-2; 932; 89.2% black)

Xavier University (1915)
New Orleans, La.; PR-4-G; Roman Catholic Church; 3,304; 90.4% black
1915—Founded as Xavier School (high school) by Mother M. Katherine Drexel (daughter of financier Francis Drexel), founder of the Sisters of the Blessed Sacrament; opened to black boys and girls from grades seven through eleven
1916—Grade twelve added
1917—Two-year normal school added
1918—Xavier University
1925—College of Arts and Sciences established; began four-year college degree program
1927—School of pharmacy established
1933—Graduate school established
1937—Accredited by the Southern Association of Colleges and Schools

Maryland

Bowie State College (1865)

Bowie, Md.; PU-4+G; 4,551; 67.1% black

1865—Founded as school to train elementary school teachers (Baltimore, Md.) by the Baltimore Association for the Moral and Educational Improvement of Colored People

1903—Baltimore Normal School

1908—Maryland Board of Education assumed control; Normal School No. 3

1911—Moved to Bowie, Md.

1914—Maryland Normal and Industrial School at Bowie

1935—Maryland State Teachers College at Bowie

1941—First Bachelor of Science degrees conferred

1961—Accredited by the Middle States Association of Colleges and Secondary Schools

1963—Liberal arts program begun; Bowie State College

Coppin State College (1900)

Baltimore, Md.; PU-4+G; 2,944; 91.5% black

1900—One-year course to train black elementary school teachers begun at Douglass High School (Baltimore, Md.)

1902—Two-year normal school program started

1909—Program separated from Douglass High School

1926—Fannie Jackson Coppin Normal School

1930—Four-year Bachelor of Science degree program begun; Coppin Teachers College

1950—Became a part of the Maryland education system; Coppin State Teachers College

1960—Coppin State College

1962—Accredited by the Middle States Association of Colleges and Secondary Schools

1967—First Bachelor of Arts degree conferred

Morgan State University (1867)

Baltimore, Md.; PU-4+G; 5,402; 92.5% black

1867—Founded as Centenary Biblical Institute by the Baltimore Conference of the Methodist Episcopal Church

1890—Morgan College; began four-year college degree program

1925—Accredited by the Middle States Association of Colleges and Secondary Schools

1939—Purchased by the state of Maryland from the Methodist Episcopal Church and renamed Morgan State College

1964—School of Graduate Studies established

1975—Morgan State University

University of Maryland, Eastern Shore (1886)

Princess Anne, Md.; PU-4+G; land-grant; 2,440; 68.9% black

1886—Founded as the Delaware Conference Academy (Princess Anne, Md.) by the Methodist Episcopal Church

1892—Land-grant status

1913—Princess Anne Academy

1919—Eastern Branch, Maryland Agricultural College

1921—Accredited by the Middle States Association of Colleges and Secondary Schools

1926—The state of Maryland assumes control; Princess Anne College

1936—Began four-year college degree program

1948—Maryland State College, a division of the University of Maryland

1970—University of Maryland, Eastern Shore

Mississippi

Alcorn State University (1871)

Lorman, Miss.; PU-4+G; land-grant; 2,919; 94.2% black

1871—Founded as Alcorn University by the state of Mississippi for the higher education of black youth

1878—Alcorn Agricultural and Mechanical College; land-grant status

1882—First graduating class

1888—First black woman graduates

1890—Land-grant status

1903—Officially coeducational

1948—Accredited by the Southern Association of Colleges and Schools

1974—Alcorn State University

1975—Graduate program added

Jackson State University (1877)

Jackson, Miss.; PU-4+G; 6,203; 94.0% black

1877—Founded as Natchez Seminary (Natchez, Miss.) by the American Baptist Home Missionary Society

1882—Jackson College (North Jackson, Miss.)

1883—First students graduated from theology and normal departments

1933—American Baptist Home Missionary Society decided to close the school in 1934, a new board is organized that kept the school open

1938—Control transferred to Jackson College, Inc.

1940—Becomes state-supported school

1941—Mississippi Negro Training School

1942—Four-year teacher education curriculum organized

1944—First Bachelor of Science degrees awarded; Jackson College for Negro Teachers

1953—Graduate studies and liberal arts programs added

1956—Jackson State College

1974—Jackson State University

Mississippi Valley State University (1946)

Itta Bena, Miss.; PU-4+G; 2,213; 99.4% black

1946—Mississippi legislature authorized the establishment of a public college for blacks in the Mississippi Delta area

1949—Site acquired in Le Flore County

1950—Mississippi Vocational College opened

1953—First Bachelor of Science degree awarded

1964—Mississippi Valley State College

1972—Accredited by the Southern Association of Colleges and Schools

1974—Mississippi Valley State University

1975—Graduate programs added

Rust College (1866)

Holly Springs, Miss.; PU-4; United Methodist Church; 1,129; 94.1% black

1866—Founded as Shaw School in Asbury Methodist Episcopal Church by the Freedman's Society of the Methodist Episcopal Church

1870—Shaw University; college courses added

1878—First two students graduated from the College department

1892—Rust University

1914—Came under the auspices of the Board of Education of the Methodist Episcopal Church

1915—Rust College

1930—Grade school discontinued

1952—High school discontinued

1970—Accredited by the Southern Association of Colleges and Schools

Tougaloo College (1869)

Tougaloo, Miss.; PU-4; United Church of Christ, Disciples of Christ; 1,132; 100% black

1869—School for blacks founded by the American Missionary Association

1871—Tougaloo University

1892—State funds discontinued

1901—First Bachelor of Arts degree awarded

1916—Tougaloo College

1920—Came under the control of the Congregational Christian Church

1953—Accredited by the Southern Association of Colleges and Schools

1954—Merged with the Southern Christain Institute as Tougaloo Southern Christian College

1963—Tougaloo College

Missouri

Harris-Stowe State College (1857)

Saint Louis, Mo.; PU-4; 1,979; 75.3% black

1877—School for black teachers founded in St. Louis by Oscar M. Waring

1890—Charles Henry Sumner Normal School

1924—Charles Henry Sumner Teachers College; four-year degree granting program instituted

1929—Harriet Beecher Stowe Teachers College

1954—Harriet Beecher Stowe Teachers College merged with Harris Teachers College (formerly an all-white school founded in 1857 as the Saint Louis Normal School)

1977—Harris-Stowe College

1979—Harris-Stowe State College; transferred to the Missouri state system

Lincoln University (1866)

Jefferson City, Mo., PU-4 + G; land-grant; 4,031; 25.7% black

1866—Founded as Lincoln Institute by Richard Baxter Foster, funded by men of the Sixty-fifth Colored Infantry stationed at Ft. McIntosh, Texas

1870—Funded by the state as a training school for black public school teachers

1877—College level courses added

1879—Deeded to the state of Missouri

1891—Agriculture and industrial arts program added to the curriculum; land-grant status

1921—Lincoln University; began four-year college degree program

1926—Accredited by the North Central Association of Colleges and Secondary Schools

1940—Graduate courses offered

North Carolina

Barber-Scotia College (1867)

Concord, N.C.; PR-4; United Presbyterian Church (U.S.A.); 704; 64.6% black

1867—Founded as Scotia Seminary by the Presbyterian Church (U.S.A.) for women

1916—Scotia Women's College

1930—Barber-Scotia formed by merger with Barber Memorial College (founded 1896 as a school for women in Anniston, Ala.)

1932—Affiliated with Johnson C. Smith University as a two-year college

1942—Began four-year college degree program

1949—Accredited by the Southern Association of Colleges and Schools

1954—Coeducational

Bennett College (1873)

Greensboro, N.C.; PR-4; United Methodist church; 635 women; 96.4% black

1873—W. J. Parker instructed a group of black students in the basement of St. Matthew's Methodist Episcopal Church in Greensboro

1874—The Freedmen's Aid Society and the Southern Educational Society of the Methodist Episcopal Church assumed control of the school; Bennett Seminary

1883—Bennett College

1926—Began four-year college degree program

1935—Accredited by the Southern Association of Colleges and Schools

Elizabeth City State University (1891)

Elizabeth City, N.C.; PU-4; 2,019; 73.7% black

1891—Bill introduced in the North Carolina legislature to establish a training school for black teachers

1892—State Colored Normal School; school opened

1937—Four-year normal college

1939—Elizabeth City State Teachers College

1947—Accredited by the Southern Association of Colleges and Schools

1963—Elizabeth City State College

1969—Elizabeth City State University

1972—Became part of the University of North Carolina system

Fayetteville State University (1867)

Fayetteville, N.C.; PU-4+G; 3,902; 62.6% black

1867—Founded as Howard School for the education of local black children

1877—North Carolina general assembly assumed control of the school; State Colored Normal School

1904—High School department added

1916—State Colored Normal and Industrial School

1921—State Normal School for the Negro Race

1926—State Normal School

1939—Fayetteville State Teachers College; course expanded to four years

1947—Accredited by the Southern Association of Colleges and Schools

1963—Fayetteville State College

1969—Fayetteville State University

1972—Became part of the University of North Carolina system

1980—Graduate program in elementary education teaching added

Johnson C. Smith University (1867)

Charlotte, N.C.; PR-4; United Presbyterian Church in the U.S.A.; 1,256; 100% black

1867—founded by the Charlotte Presbyterian Church; funded by the Freedmen's Bureau

1870—Biddle Memorial Institute

1876—Biddle University

1923—Johnson C. Smith University

1929—High school department discontinued

1932—Women admitted to the senior division

1941—Women admitted to the freshman class

Livingstone College (1879)

Salisbury, N.C.; PR-4; African Methodist Episcopal Zion; 677; 98.9% black

1879—Founded as Zion Wesley Institute (Concord, N.C.) by ministers of the African Methodist Episcopal Zion Church

1882—Moved to Salisbury, N.C.

1887—Livingstone College

North Carolina Agricultural and Technical State University (1891)

Greensboro, N.C.; PU-4+G; land-grant; 7,580; 85.9% black

1891—Founded as Agricultural and Mechanical College for the Colored Race at Shaw University (Raleigh, N.C.) by the North Carolina legislature; land-grant status

1893—Moved to Greensboro, N.C.; coeducational

1901—Became all-male

1925—Began four-year college degree program

1928—Coeducational

1915—Agricultural and Technical College of North Carolina

1936—Accredited by the Southern Association of Colleges and Schools

1939—Master of Science degree in education authorized

1941—First master's degree conferred

1953—School of Nursing established

1967—North Carolina Agricultural and Technical State University

1972—Became part of the University of North Carolina system

North Carolina Central University (1909)

Durham, N.C.; PU-4+G; 5,667; 83.8% black

1909—Founded as the National Religious Training School and Chautauqua by James Edward Shepard

1910—School opened

1915—Reorganized as the National Training School

1923—School purchased by the North Carolina legislature; Durham State Normal School

1925—North Carolina College for Negroes

1929—First four-year class graduated

1937—Accredited by the Southern Association of Colleges and Schools

1939—Graduate studies added

1947—North Carolina College at Durham

1969—North Carolina Central University

1972—Became a part of the University of North Carolina system

Saint Augustine's College (1867)

Raleigh, N.C.; PR-4; Protestant Episcopal Church; 1,918; 90.5% black

1867—Founded as Saint Augustine's Normal School and Collegiate Institute (Raleigh, N.C.) by the Freedmen's Commission of the Protestant Episcopal Church

1919—Began two-year college degree program

1928—Began four-year college degree program; Saint Augustine's College

1942—Accredited by the Southern Association of Colleges and Schools

Shaw University (1865)

Raleigh, N.C.; PR-4; General Baptist State Convention of North Carolina; 2,483; 92.9% black

1865—William Martin Tupper of Monson, Mass., conducted a class for black students in theology (Raleigh, N.C.)

1866—The Raleigh Institute; occupied a church that had been funded by the Freedmen's Aid Society of the Baptist Church

1870—Daniel Barringer estate purchased with major financial support from Elijah Shaw; renamed Shaw College Institute; supported by the American Baptist Home Mission Society

1874—College department instituted

1875—Shaw University

1881—Leonard Medical School established

1888—School of Law established

1891—Leonard School of Pharmacy established; Theological courses extended to four years

1912—Classical and scientific departments became the College of Arts and Sciences

1918—Schools of Medicine, Law, and Pharmacy closed

1933—School of Religion established (became Shaw Divinity School in 1960)

1943—Accredited by the Southern Association of Colleges and Schools

Winston-Salem State University (1892)

Winston-Salem, N.C.; PU-4; 2,665; 79.7% black

1892—Founded as Slater Industrial Academy by Simon Green Atkins as a school for blacks

1897—Slater Industrial and Normal School

1925—Began four-year college degree program

1947—Accredited by the Southern Association of Colleges and Schools

1953—School of Nursing established

1963—Winston-Salem State College

1969—Winston-Salem State University

Ohio

Central State University (1887)

Wilberforce, Ohio; PU-4; 3,236; 88.2% black

1887—Founded as a combined normal and industrial department at Wilberforce University by the Ohio legislature

1941—Expanded by the Ohio legislature to include four-year programs; College of Education and Industrial Arts

1947—Wilberforce State College, separated from Wilberforce University

1949—Accredited by the Southern Association of Colleges and Schools

1951—Central State College

1965—Central State University

Wilberforce University (1856)

Wilberforce, Ohio; PR-4; African Methodist Episcopal Church; 750; 97.9% black

1856—Founded as Wilberforce University for blacks by Cincinnati Conference of the Methodist Episcopal Church; African Methodist Episcopal Church and the Methodist Episcopal Church undertook cooperative maintenance

1863—Purchased by Bishop Daniel A. Payne for the African Methodist Episcopal Church

1866—Theological department added

1867—Classical and scientific departments added

1887—Normal and industrial department established by the state of Ohio under a separate board of trustees

1891—Theological department separated to become Payne Theological Seminary

1894—Military department added

1922—Began four-year college degree program

1939—Accredited by the North Central Association of Colleges and Secondary Schools

1947—The state-supported College of Education and Industrial Arts (later Central State University) separated from the University

Oklahoma

Langston University (1897)

Langston, Okla.; PU-4; land-grant; 3,710; 44.9% black

1897—Founded as the Colored Agricultural and Normal University of Oklahoma as a land-grant institution

1898—School opened

1914—College department added

1932—Two-year Normal School discontinued

1941—Became Langston University

1946—High School discontinued

1948—School of Law established; accredited by the North Central Association of Colleges and Secondary Schools

1950—School of Law discontinued when blacks admitted to the University of Oklahoma Law School

Pennsylvania

Cheyney University (1837)

Cheyney, Pa.; PU-4 + G; 1,548; 94.1% black

1837—Founded under a bequest of Richard Humphreys on a 133-acre farm at Old York Road near Philadelphia, Pa.; conducted as an agricultural school under Quaker control

1842—Became Institute for Colored Youth; moved to Philadelphia; began offering classical education

1903—Moved to George Cheyney's Farm, 24 miles west of Philadelphia

1913—Cheyney Training School of Teachers

1921—Purchased by the Commonwealth of Pennsylvania; State Normal School at Cheyney

1932—Authorized to grant the Bachelor of Science degree in home economics and education; first four-year degree awarded

1951—Cheyney State Teachers College; accredited by the Middle States Association of Colleges and Secondary Schools

1959—Cheyney State College

1968—Graduate program begun

1983—Cheyney University

Lincoln University (1853)

Lincoln, Pa.; PU-4 + G; 1,477; 92.1% black

1853—Founded as Ashman Institute by John Miller Dickey under the sponsorship of the Presbyterian Church

1857—Classes begun

1866—Lincoln University

1868—First baccalaureate class

1922—Accredited by the Middle States Association of Colleges and Secondary Schools

1953—Charter amended to grant degrees to women

1972—Acquired state-related status

1977—Graduate program instituted

South Carolina

Allen University (1870)

Columbia, S.C.; PR-4; African Methodist Episcopal Church; 171; 92.9% black

1870—Founded as Daniel A. Payne Institute (Cokesbury, S.C.) by the Columbia District Conference of the African Methodist Episcopal Church

1871—School opened

1880—Allen University (Columbia, S.C.); controlled by the state of South Carolina

1930—Department of science added

1933—High school discontinued

1936—Department of languages added

1945—Department of humanities, department of philosophy, and department of religion added

1992—Accredited by the Southern Association of Colleges and Schools

Benedict College (1870)

Columbia, S.C.; PR-4; American Baptist Church; 1,207; 95.7% black

1870—Founded as Benedict Institute by Mrs. Bathsheba A. Benedict of Pawtucket, R.I., with the assistance of the American Baptist Home Mission Society (headquartered in New York)

1894—Benedict College; first bachelor's degree awarded

1961—Accredited by the Southern Association of Colleges and Schools

Claflin College (1869)

Orangeburg, S.C.; PR-4; United Methodist; 940; 99.0% black

1869—Founded as Claflin University by the South Carolina Mission Conference; Boston philanthropist Lee Chaflin and his son, Massachusetts governor William Claflin, provided initial funding to purchase the Orangeburg Female Academy

1871—Claflin University merged with Baker Biblical Institute (Orangeburg, S.C.)

1872—Land-grant status approved, though funds not received

1879—First normal department graduated; land-grant endowment granted

1882—First college department diploma awarded

1896—Claflin's land-grant status transferred to the Agricultural and Mechanical College; Claflin University controlled by the Freedmen's Aid and Southern Education Society of the Methodist Episcopal Church

1915—Normal course changed to teacher training course (degree discontinued in 1931)

1927—Commercial and vocational departments discontinued

1941—Secondary department discontinued

1945—Elementary department discontinued

1979—Claflin College

Morris College (1908)

Sumter, S.C.; PR-4; Baptist Educational and Missionary Convention of South Carolina; 792; 99.7% black

1906—The establishment of a college for blacks authorized by the Baptist Educational and Missionary Convention of South Carolina; controlled by the Colored Baptist State Convention

1908—Founded as Morris College (Sumter, S.C.)

1915—First Bachelor of Arts degrees awarded

1929—Normal school discontinued

1930—Began two-year college degree program; elementary school discontinued

1932—Began four-year college degree program

1946—High school discontinued

1978—Accredited by the Southern Association of Colleges and Schools

South Carolina State University (1872)

Orangeburg, S.C.; PU-4 + G; land-grant; 5,071; 93.8% black

1872—South Carolina Agricultural and Mechanical Institute at Claflin University established with land-grant status

1896—State Agricultural and Mechanical College given land-grant status independent of Claflin

1924—Began four-year college degree program

1941—Accredited by the Southern Association of Colleges and Schools

1946—Graduate studies begun

1954—South Carolina State College
1992—South Carolina State University

Vorhees College (1897)
Denmark, S.C.; PR-4; Protestant Episcopal Church; 665; 98.9% black
1897—Founded as Denmark Industrial School (Denmark, S.C.) by Elizabeth Evelyn Wright and Jessie Dorsey as a school for blacks
1901—Vorhees Industrial School
1924—Relationship begun with the Protestant Episcopal Church and the American Church Institute
1929—Began two-year college degree program; Vorhees Normal and Industrial School
1946—Accredited by the Southern Association of Colleges and Schools
1947—Vorhees School and Junior College
1962—Vorhees College
1965—High school discontinued
1967—Began four-year college degree program
1968—First baccalaureate degrees awarded; accredited by the Southern Association of Colleges and Schools

Tennessee

Fisk University (1866)
Nashville, Tenn.; PR-4+G; nondenominational; 872; 98.2% black
1866—Founded as Fisk School (also known as Fisk Free Colored School) by John Ogden, Erastus M. Cravath, and Edward P. Smith; supported by the American Missionary Association, Western Freedman's Aid Commission, and the Freedmen's Bureau
1867—Fisk University; normal department organized, high school, model school, theology department, commercial department
1868—Faculty established the independent Union Church of Nashville, a nonsectarian church, to strengthen religious influence at Fisk
1869—College department organized (first students not accepted until 1871)
1870—Western Freedman's Aid Commission relinquished its interest in the land; Fisk property held by the American Missionary Association
1871—Began four-year college degree program
1875—First bachelor's degrees; control transferred from the American Missionary Association to university trustees
1902—Summer school for teachers inaugurated
1927—Department of social research established by Charles S. Johnson
1931—First graduate degrees awarded (in chemistry, English, and anthropology)
1930—Accredited by the Southern Association of Colleges and Schools
1944—Institute of Race Relations established
1953—First black institution to be granted a Phi Beta Kappa chapter

Knoxville College (1863)
Knoxville, Tenn.; PR-4; United Presbyterian Church in the U.S.A.; 914; 98.9% black
1863—Founded as McKee School (Nashville, Tenn.) by the United Presbyterian Church of North America
1875—Knoxville College
1890—Land-grant status
1913—Land-grant status transferred to the Agricultural and Industrial State Normal School for Negroes (Nashville, Tenn.)
1914—College of Arts and Sciences established
1948—Accredited by the Southern Association of Colleges and Schools

Lane College (1882)
Jackson, Tenn.; PR-4; Christian Methodist Episcopal church; 534; 99.6% black
1882—Founded as the Colored Methodist Episcopal High School
1883—Lane Institute
1896—Began four-year college degree program
1909—Lane College
1933—High school discontinued
1949—Accredited by the Southern Association of Colleges and Schools

LeMoyne-Owen College (1862)
Memphis, Tenn.; PR-4; United Church of Christ and Tennessee Baptist Missionary and Educational Convention; 1,065; 98.9% black
1968—LeMoyne-Owen College created by the merger of LeMoyne College and Owen College
1971—Accredited by the Southern Association of Colleges and Schools

LeMoyne College (1862)
1862—Founded as LeMoyne College (Camp Shiloh, Tenn.) by Lucinda Humphrey of the American Missionary Association
1863—Moved to Memphis, Tenn.
1866—Lincoln School
1871—LeMoyne Normal and Commercial School
1901—High school instituted
1924—Began two-year degree program; Lemoyne College
1932—First baccalaureate degrees awarded
1939—Accredited by the Southern Association of Colleges and Schools

Owen College (1954)
1946—The Tennessee Baptist Missionary and Educational Convention contracted to purchase property in Memphis, Tenn.
1954—S.A. Owen Junior College opened
1956—Owen College; first degrees conferred

1958—Accredited by the Southern Association of Colleges and Schools

Meharry Medical College (1876)
Nashville, Tenn.; PR-4 + G; United Methodist Church; 667; 82.8% black
1876—Founded as the department of medicine at Central Tennessee College under the Freedmen's Aid Society of the Methodist Episcopal Church
1900—Central Tennessee College became Walden University and the medical school became Meharry Medical College of Walden University
1915—Meharry Medical College granted a separate charter
1931—Division of Dental Hygiene established (discontinued in the 1960s)

Tennessee State University (1912)
Nashville, Tenn.; PU-4 + G; land-grant; 7,591; 62.9% black
1912—Founded as Agricultural and Industrial State Normal School for Negroes; land-grant status
1922—Four-year teacher-training institution
1924—First bachelor's degree awarded; Agricultural and Industrial State Normal College
1927—Agricultural and Industrial State College
1941—Graduate studies authorized
1944—First master's degree awarded
1951—The schools of Arts and Sciences, Education, Engineering, and Graduate Studies organized
1969—Tennessee State University

Texas

Huston-Tillotson College (1875)
Austin, Tex.; PR-4; United Church of Christ and the United Methodist Church; 537; 81.8% black
1953—Huston-Tillotson College created by the merger of Tillotson College with Samuel Huston College

Tillotson College (1875)
1875—Founded as Tillotson Collegiate and Normal Institute (Austin, Tex.) for blacks by George Jeffrey Tillotson, with support from the American Missionary Association
1881—School opened
1894—Tillotson College
1925—Recognized by the Texas State Department of Education as a two-year college
1926—Became a women's college
1931—Began four-year college degree program
1935—Coeducational

Samuel Huston College (1876)
1876—Founded as Andrews Normal by the West Texas Methodist Conference
1890—Moved to Austin, Tex.
1900—Samuel Huston College

1907—Funded by the Freedmen's Aid Society of the Methodist Episcopal Church
1926—Began four-year college degree program

Jarvis Christian College (1912)
Hawkins, Tex.; PR-4; Christian Church (Disciples of Christ); 597; 98.3% black
1912—Founded as Jarvis Christian Institute by the Christian Church (Disciples of Christ) as an elementary school for black children near Hawkins, Texas
1927—Two-year college by the Texas Department of Education; Jarvis Christian College
1937—Began four-year college degree program
1938—High school discontinued
1964—Became affiliated with Texas Christian University
1976—Accredited by the Southern Association of Colleges and Schools
1979—Affiliation with Texas Christian University discontinued

Paul Quinn College (1872)
Waco, Tex.; PR-4; African Methodist Episcopal; 783; 96.0% black
1872—Founded as Paul Quinn College (Austin, Tex.) by the African Methodist Episcopal Church
1881—Moved to Waco, Tex.
1972—Accredited by the Southern Association of Colleges and Schools

Prairie View Agricultural and Mechanical University (1876)
Prairie View, Tex.; PU-4 + G; 5,660; land-grant 86.5% black
1876—Founded as Agricultural and Mechanical College by the state of Texas as a land-grant college
1878—Control given to the Board of Directors of Texas A&M University; Alta Vista Agicultural College opened
1889—Prairie View State Normal and Industrial College
1891—Land-grant status
1901—Curriculum extended to four years
1919—Four-year senior college program started
1930—Academy (high school) discontinued
1934—Accredited by the Southern Association of Colleges and Schools
1937—Graduate program started; Master of Science degree granted; Prairie View Normal and Industrial College
1945—Prairie View University
1947—Prairie View Agricultural and Mechanical University

Texas College (1894)
Tyler, Tex.; PR-4; Christian Methodist Episcopal Church; 543; 95.6% black
1894—Founded as Texas College (Tyler, Tex.) or-

ganized by the Colored Methodist Episcopal Church
1909—Phillips University
1912—Texas College
1932—Began four-year college degree program
1980—Accredited by the Southern Association of Colleges and Schools

Texas Southern University (1927)
Houston, Tex.; PU-4 + G; 10,281; 79.2% black
1927—Founded as Houston College for Negroes, operated by city of Houston
1947—Texas State University, operated by state; Graduate program initiated
1951—Texas Southern University

Wiley College (1873)
Marshall, Tex.; PR-4; United Methodist Church; 438; 96.6% black
1873—Founded as Wiley University (near Marshall, Tex.) by the Freedmen's Aid Society of the Methodist Episcopal Church
1880—Moved to Marshall, Texas
1929—Wiley College
1933—Accredited by the Southern Association of Colleges and Schools

Virginia
Hampton University (1868)
Hampton, Va.; PU-4 + G; nondenominational; 4,852; 86.9% black
1868—Founded as Hampton Institute as a Normal School for former slaves by General Samuel Chapman Armstrong of the Freedmen's Bureau with the assistance of the American Missionary Association as a Normal School for former slaves
1872—Land-grant status
1920—Began four-year college degree program; land-grant status transferred to Virginia State College (Petersburg, Va.); Academic and Normal Courses discontinued
1924—Teachers College of Hampton Institute established
1928—Graduate course introduced; elementary and secondary school discontinued
1930—Hampton University
1932—Accredited by the Southern Association of Colleges and Schools
1933—Offered courses leading to the Master of Arts
1949—Graduate program discontinued
1956—Division of Graduate Studies reestablished

Norfolk State University (1935)
Norfolk, Va.; PU-4 + G; 8,625; 83.8% black
1935—Founded as a two-year college division of Virginia Union University
1942—Norfolk Polytechnic College

1944—Became Norfolk Division of Virginia State College
1958—First baccalaureate degrees awarded
1969—Norfolk State College; independent from Virginia State College
1972—Began Master's degree program
1979—Norfolk State University

Saint Paul's College (1883)
Lawrenceville, Va.; PR-4; Protestant Episcopal; 702; 90.0% black
1883—Founded as parish school for blacks by Deacon James Russell of Saint Paul's Church (Lawrenceville, Va.)
1888—A Normal School started by Russell
1890—Saint Paul Normal and Industrial School
1941—Saint Paul's Polytechnic Institute
1942—Began four-year college degree program
1950—Accredited by the Southern Association of Colleges and Schools
1951—Secondary school discontinued
1957—Became Saint Paul's College
1965—Elementary school discontinued

Virginia State University (1882)
Petersburg, Va.; PU-4 + G; land-grant; 4,203; 91.8% black
1882—Virginia Normal and Collegiate Institute (Ettrick, Va.)
1883—Classes begun
1891—Land-grant status
1902—Virginia Normal and Industrial Institute; collegiate program discontinued
1923—College program restored
1930—Virginia State College for Negroes
1933—Accredited by the Southern Association of Colleges and Schools
1946—Virginia State College
1979—Virginia State University

Virginia Union University (1865)
Richmond, Va.; PU-4 + G; American Baptist Convention; 1,511; 97.7% black
1899—Virginia Union University created by merger of Richmond Theological Seminary and Wayland Seminary
1905—First master's degrees conferred
1932—Hartshorn Memorial College (founded 1883 by Lyman B. Teft under the American Baptist Mission Society; Richmond, Va.) merged with Virginia Union University
1935—Accredited by the Southern Association of Colleges and Schools
1958—Established Norfolk State University as a two-year college division
1964—Storer College (founded 1865) merged with the Virginia Union University

Richmond Theological Seminary (1865)

1865—Founded as Richmond Theological Institute for Freedmen by the American Baptist Home Mission Society with the support of the Negro Baptist Church

1867—Reopened by Nathaniel Colver under the National Theological Institute of Washington, D.C.

1869—Colver Institute

1876—Richmond Institute

1886—Richmond Theological Seminary

Wayland Seminary (1865)

1865—Founded in Washington, D.C., as Wayland Seminary by the American Baptist Home Mission Society

1868—Run jointly with the National Theological Institute of Washington, D.C.

West Virginia

Bluefield State College (1895)

Bluefield, W. Va., PU-4; 2,931; 6.4% black

1895—Founded as Bluefield Colored Institute (Bluefield, W.Va.) by the West Virginia Legislature

1896—Classes begun

1926—Began four-year college degree program

1929—First baccalaureate degree awarded

1931—Bluefield State Teachers College; high school separated from the college

1943—Bluefield State College

1951—Accredited by the North Central Association of Colleges and Secondary Schools

1954—Desegregated

1979—Administrative control of the Greenbrier Center of West Virginia University (founded 1969) transferred to Bluefield State College

West Virginia State College (1891)

Institute, W. Va.; PU-4; land-grant; 4,896; 13.2% black

1891—West Virginia Colored Institute; land-grant institution

1892—Classes begun

1893—Teacher-training program added

1915—Degrees authorized; West Virginia Collegiate Institute

1927—Accredited by the North Central Association of Colleges and Secondary Schools

1929—West Virginia State College

1954—Desegregated

1954—Land-grant status transferred to West Virginia University

1957—High school discontinued

Sources:

American Council of Education, *Accredited Institutions of Higher Education* (Washington, D.C., 1965).

Addie Louise Joyner Butler, *The Distinctive Black College: Talladega, Tuskegee and Morehouse* (New Jersey and London, 1977).

Beverly Guy-Sheftall and Jo Moore Stewart, *Spelman: A Centennial Celebration* (Charlotte, N.C., 1981).

Dwight Oliver Wendell Holmes, *The Evolution of the Negro College* (New York, 1934).

Benjamin E. Mays, *Born to Rebel* (New York, 1971).

NAFEO Inroads: The Bi-Monthly Newsletter of the National Association for Equal Opportunity in Higher Education vol. 7, nos. 5 and 6 (February-March/April-May 1993).

J. F. Ohles and S. M Ohles, *The Greenwood Encyclopedia of American Institutions—Private Colleges and Universities* (New York, 1986).

Willard Range, *The Rise and Progress of Negro Colleges in Georgia 1865-1949* (Athens, Ga., 1951).

Florence Matilda Read, *The Story of Spelman College* (Princeton, N.J. 1961).

Julian B. Roebuck and Komandure S. Murty, *Historically Black Colleges and Universities; Their Place in American Higher Education* (Westport, Conn., 1993).

George A. Sewell and Cornelius V. Troupe, *Morris Brown College: The First Hundred Years, 1881–1981* (Atlanta, Ga., 1981)

Survey of Negro Colleges and Universities, GPO Bulletin (Washington, D.C., 1929).

7. ENTERTAINMENT

TABLE 7.1 Emmy Award Winners

Year	Performer	Category	Performance
1959	Harry Belafonte	Outstanding Performance in a Variety or Musical Program Series	"Tonight with Belafonte," *Revlon Revue*
1966	Bill Cosby	Outstanding Continued Performance by an Actor in a Leading Role in a Dramatic Series	*I Spy*
1967	Bill Cosby	Outstanding Continued Performance by an Actor in a Leading Role in a Dramatic Series	*I Spy*
1968	Bill Cosby	Outstanding Variety or Musical Program	*The Bill Cosby Special*
1970	Flip Wilson	Outstanding Writing Achievement in Variety or Music Series	*The Flip Wilson Show*
1973	Cicely Tyson	Best Lead Actress in a Drama—Special Program	*The Autobiography of Miss Jane Pittman*
1973	Cicely Tyson	Actress of the Year—Special Program	*The Autobiography of Miss Jane Pittman*
1976	Olivia Cole	Outstanding Single Performance by a Supporting Actress in a Drama or Comedy Series	*Roots, Part 8*
1976	Louis Gossett, Jr.	Outstanding Lead Actor for a Single Appearance in a Drama or Comedy Series	*Roots, Part 2*
1976	Quincy Jones	Outstanding Music Series Composition	*Roots, Part 1*
1978	Robert Guillaume	Outstanding Supporting Actor in a Comedy or Music Series	*Soap*
1978	Esther Rolle	Outstanding Supporting Actress in a Limited Series	*Summer of My German Soldier*
1980	Isabel Sanford	Outstanding Lead Actress in a Comedy Series	*The Jeffersons*
1981	Debbie Allen	Outstanding Choreography	"Come One, Come All," *Fame*
1981	Nell Carter	Outstanding Individual Achievement—Special Class	"*Ain't Misbehavin'* "
1982	Debbie Allen	Outstanding Choreography	"Class Act," *Fame*
1982	Leontyne Price	Outstanding Individual Performance in a Variety or Music Program	*From Lincoln Center*
1982	Leslie Uggams	Outstanding Host/Hostess in a Variety Series	*Fantasy*
1983	Suzanne de Passe	Outstanding Producing	*Motown 25: Yesterday, Today, Forever*
1984	Robert Guillaume	Outstanding Lead Actor in a Comedy Series	*Benson*
1985	Alfre Woodard	Outstanding Supporting Actress in a Drama Series	"Doris in Wonderland," *Hill Street Blues*
1985	George Stanford Brown	Outstanding Directing in a Drama Series	"Parting Shots," *Cagney & Lacey*
1985	Roscoe Lee Browne	Outstanding Guest Performer in a Comedy Series	*The Cosby Show*
1985	Suzanne de Passe	Outstanding Producing	*Motown at the Apollo*
1985	Whitney Houston	Outstanding Individual Performance in a Variety or Music Program	*The 28th Annual Grammy Awards*
1986	Alfre Woodard	Outstanding Guest Performer in a Drama Series	*L.A. Law*
1987	Jackée (Harry)	Outstanding Supporting Actress in a Comedy Series	*227*
1988	Beah Richards	Outstanding Guest Performer in a Comedy Series	*Frank's Place*
1991	Debbie Allen	Outstanding Choreography	*Motown 30: What's Goin' On!*
1989	Suzanne de Passe	Outstanding Producing	*Lonesome Dove*
1991	Ruby Dee	Outstanding Supporting Actress in a Miniseries or Special	"Decoration Day," *Hallmark Hall of Fame*
1991	James Earl Jones	Outstanding Lead Actor in a Drama Series	*Gabriel's Fire*
1991	James Earl Jones	Outstanding Supporting Actor in a Miniseries or Special	*Heat Wave*
1991	Madge Sinclair	Outstanding Supporting Actress in a Drama Series	*Gabriel's Fire*
1991	Lynn Whitfield	Outstanding Lead Actress in a Miniseries or Special	*The Josephine Baker Story*
1992	Eric Laneuville	Outstanding Individual Achievement in Directing in a Drama Series	"All God's Children," *I'll Fly Away*
1993	Mary Alice	Outstanding Supporting Actress in a Drama Series	*I'll Fly Away*
1993	Laurence Fishburne	Outstanding Guest Actor in a Drama Series	"The Box" *Tribeca*

TABLE **7.2 Grammy Award Winners**

Year	Category	Performance	Performer
1958	Best Vocal Performance, Female	*The Irving Berlin Song Book*	Ella Fitzgerald
	Best Performance by a Dance Band	*Basie*	Count Basie
	Best Jazz Performance, Individual	*The Duke Ellington Song Book*	Ella Fitzgerald
	Best Jazz Performance, Group	*Basie*	Count Basie
1959	Best Vocal Performance, Female	"But Not for Me"	Ella Fitzgerald
	Best Performance by a Dance Band	*Anatomy of a Murder*	Duke Ellington
	Best Jazz Performance, Soloist	*Ella Swings Lightly*	Ella Fitzgerald
	Best Jazz Performance, Group	"I Dig Chicks"	Jonah Jones
	Best Musical Composition	*Anatomy of a Murder*	Duke Ellington
	Best Performance by "Top 40" Artist	"Midnight Flyer"	Nat "King" Cole
	Best Rhythm & Blues Performance	"What a Diff'rence a Day Makes"	Dinah Washington
1960	Best Vocal Performance—Single, Female	"Mack the Knife"	Ella Fitzgerald
	Best Vocal Performance—Album, Female	*Mack the Knife—Ella in Berlin*	Ella Fitzgerald
	Best Vocal Performance—Single, Male	"Georgia on My Mind"	Ray Charles
	Best Vocal Performance—Album, Male	*Genius of Ray Charles*	Ray Charles
	Best Performance by a Band for Dancing	Dance with Basie	Count Basie
	Best Classical Performance Vocal Soloist	*A Program of Song*	Leontyne Price
	Best Performance by a Pop Artist	"Georgia On My Mind"	Ray Charles
	Best Rhythm & Blues Performance	"Let the Good Times Roll"	Ray Charles
	Best Performance—Folk	"Swing Dat Hammer"	Harry Belafonte
	Best Jazz Composition of More Than 5 Minutes	*Sketches of Spain*	Miles Davis & Gil Evans
1961	Best Rock and Roll Recording	"Let's Twist Again"	Chubby Checker
	Best Rhythm & Blues Recording	"Hit the Road Jack"	Ray Charles
	Best Gospel Recording	"Everytime I Feel the Spirit"	Mahalia Jackson
1962	Best Solo Vocal Performance—Female	*Ella Swings Brightly with Nelson Riddle*	Ella Fitzgerald
	Best Rhythm & Blues Recording	"I Can't Stop Loving You"	Ray Charles
	Best Gospel Recording	*Great Songs of Love and Faith*	Mahalia Jackson
1963	Best Performance by an Orchestra for Dancing	*This Time by Basie!*	Count Basie
	Best Instrumental Arrangement	"I Can't Stop Loving You"	Quincy Jones
	Best Classical Performance	*Scenes from "Porgy and Bess"*	Leontyne Price
	Most Promising New Classical Recording Artist	*André Watts*	André Watts
	Best Rhythm & Blues Recording	*Busted*	Ray Charles
	Best Comedy Performance	*Bill Cosby Is a Very Funny Fellow . . . Right!*	Bill Cosby
1964	Best Vocal Performance, Male	"Hello, Dolly!"	Louis Armstrong
	Best Comedy Performance	*I Started Out As a Child*	Bill Cosby
	Best Rhythm & Blues	*How Glad I Am*	Nancy Wilson
	Best Classical Vocal Soloist	*Berlioz: Nuits d'été*	Leontyne Price
1965	Best Comedy Performance	*Why Is There Air?*	Bill Cosby
	Best Instrumental Jazz Performance, Small Group	*The "In" Crowd*	Ramsey Lewis Trio
	Best Instrumental Jazz Performance, Large Group	*Ellington '66*	Duke Ellington
	Best Rhythm & Blues Recording	"Papa's Got a Brand New Bag"	James Brown
	Best Folk Recording	*An Evening with Belafonte*	Harry Belafonte
	Best Classical Vocal Performance	*Strauss: Salome*	Leontyne Price
1966	Best Comedy Performance	*Wonderfulness*	Bill Cosby
	Best Original Jazz Composition	*In the Beginning God*	Duke Ellington
	Best Rhythm & Blues Recording	*Crying Time*	Ray Charles
	Best Rhythm & Blues Solo Vocal Performance	"Crying Time"	Ray Charles
	Best Rhythm & Blues Group	"Hold It Right There"	Ramsey Lewis
	Best Classical Vocal Soloist	*Prima Donna*	Leontyne Price
1967	Record of the Year	*Up, Up and Away*	5th Dimension
	Best Performance by a Vocal Group	"Up, Up and Away"	5th Dimension
	Best Performance by a Chorus	"Up, Up and Away"	Johnny Mann Singers
	Best Comedy Recording	*Revenge*	Bill Cosby
	Best Instrumental Jazz Performance, Small Group	*Mercy, Mercy, Mercy*	Cannonball Adderly Quintet
	Best Instrumental Jazz Performance, Large Group	*Far East Suite*	Duke Ellington
	Best Contemporary Single	"Up, Up and Away"	5th Dimension

TABLE 7.2 **Grammy Award Winners** (*Continued*)

Year	Category	Performance	Performer
	Best Contemporary Group Performance	"Up, Up and Away"	5th Dimension
	Best Rhythm & Blues Recording	"Respect"	Aretha Franklin
	Best Rhythm & Blues Solo Vocal Performance, Female	"Respect"	Aretha Franklin
	Best Rhythm & Blues Solo Vocal Performance, Male	"Dead End Street"	Lou Rawls
	Best Rhythm & Blues Group Performance	"Soul Man"	Sam & Dave
	Best Classical Vocal Soloist Performance	*Prima Donna, Vol. 2*	Leontyne Price
1968	Best Contemporary—Pop Vocal Performance, Female	"Do You Know the Way to San José?"	Dionne Warwick
	Best Rhythm & Blues Vocal Performance, Female	Chain of Fools	Aretha Franklin
	Best Rhythm & Blues Vocal Performance, Male	"(Sittin' on) The Dock of the Bay"	Otis Redding
	Best Rhythm & Blues Performance by a Duo or Group	*Cloud Nine*	The Temptations
	Best Comedy Recording	*To Russell, My Brother, Whom I Slept With*	Bill Cosby
	Best Instrumental Jazz Performance, Large Group	*And His Mother Called Him Bill*	Duke Ellington
1969	Record of the Year	"Aquarius/Let the Sunshine In"	5th Dimension
	Best Contemporary Vocal Performance by a Group	"Aquarius/Let the Sunshine In"	5th Dimension
	Best Rhythm & Blues Vocal Performance, Female	"Share Your Love with Me"	Aretha Franklin
	Best Rhythm & Blues Vocal Performance, Male	"The Chokin' Kid"	Joe Simon
	Best Rhythm & Blues Vocal Performance by a Group	*It's Your Thing*	The Isley Brothers
	Best Rhythm & Blues Instrument Performance	*Games People Play*	King Curtis
	Best Soul Gospel	*Oh Happy Day*	Edwin Hawkins Singers
	Best Comedy Recording	*Bill Cosby*	Bill Cosby
	Best Instrumental Jazz Performance, Small Group	*Willow Weep for Me*	Web Montgomery
	Best Instrumental Jazz Performance, Large Group	*Walking in Space*	Quincy Jones
	Best Vocal Soloist Performance, Classical	*Barber: Two Scenes from "Antony & Cleopatra"*	Leontyne Price
1970	Best Contemporary Vocal Performance, Female	*I'll Never Fall in Love Again*	Dionne Warwick
	Best Rhythm & Blues Vocal Performance, Female	"Don't Play That Song"	Aretha Franklin
	Best Rhythm & Blues Vocal Performance, Male	"The Thrill Is Gone"	B.B. King
	Best Rhythm & Blues Vocal Performance, Group	"Didn't I (Blow Your Mind This Time)?"	The Delfonics
	Best Soul Gospel Performance	"Every Man Wants to Be Free"	Edward Hawkins Singers
	Best Ethnic or Traditional Recording	*Good Feelin'*	T-Bone Walker
	Best Comedy Recording	*The Devil Made Me Buy This Dress*	Flip Wilson
	Best Spoken Word Performance	*Why I Oppose the War in Vietnam*	Dr. Martin Luther King, Jr.
	Best Jazz Performance, Small Group	*Alone*	Bill Evans
	Best Jazz Performance, Large Group	*Bitches Brew*	Miles Davis
1971	Best Instrumental Arrangement	*Shaft*	Isaac Hayes, Johnny Allen
	Best Pop Instrumental Performance	*Smackwater Jack*	Quincy Jones
	Best Rhythm & Blues Vocal Performance, Female	"Bridge over Troubled Water"	Aretha Franklin
	Best Rhythm & Blues Vocal Performance, Male	"A Natural Man"	Lou Rawls
	Best Rhythm & Blues Vocal Performance, Group	"Proud Mary"	Ike & Tina Turner
	Best Soul Gospel Performance	*Put Your Hand in the Hand of the Man from Galilee*	Shirley Caesar
	Best Sacred Performance	*Did You Think to Pray?*	Charley Pride
	Best Gospel Performance	*Let Me Live*	Charley Pride
	Best Ethnic or Traditional Recording	*They Call Me Muddy Waters*	Muddy Waters
	Best Original Film Score	*Shaft*	Isaac Hayes

TABLE 7.2 Grammy Award Winners (*Continued*)

Year	Category	Performance	Performer
	Best Recording for Children	*Bill Cosby Talks to Kids About Drugs*	Bill Cosby
	Best Jazz Performance by a Big Band	*New Orleans Suite*	Duke Ellington
	Best Classical Vocal Soloist Performance	*Leontyne Price Sings Robert Schumann*	Leontyne Price
1972	Record of the Year	*The First Time Ever I Saw Your Face*	Roberta Flack
	Best Jazz Performance by a Group	*First Light*	Freddie Hubbard
	Best Jazz Performance by a Big Band	*Toga Brava Suite*	Duke Ellington
	Best Pop Vocal Performance by a Duo	"Where Is the Love?"	Roberta Flack, Donny Hathaway
	Best Pop Instrumental Performance by an Instrumental Performer	"Outa-Space"	Billy Preston
	Best Pop Instrumental Performance with Vocal Coloring	*Black Moses*	Isaac Hayes
	Best Rhythm & Blues Vocal Performance, Female	*Young, Gifted & Black*	Aretha Franklin
	Best Rhythm & Blues Vocal Performance, Male	"Me & Mrs Jones"	Billy Paul
	Best Rhythm & Blues Vocal Performance, Group	"Papa Was a Rolling Stone"	The Temptations
	Best Soul Gospel Performance	"Amazing Grace"	Aretha Franklin
	Best Coutry Vocal Performance, Male	*Charley Pride Sings Heart Songs*	Charley Pride
	Best Ethnic or Traditional Recording	*The London Muddy Waters Session*	Muddy Waters
1973	Record of the Year	*Killing Me Softly with His Song*	Roberta Flack
	Album of the Year	*Innervisions*	Stevie Wonder
	Best Instrumental Arrangement	"Summer in the City"	Quincy Jones
	Best Jazz Performance by a Soloist	*God Is in the House*	Art Tatum
	Beat Pop Vocal Performance, Female	"Killing Me Softly with His Song"	Roberta Flack
	Best Pop Vocal Performance, Male	"You Are the Sunshine of My Life"	Stevie Wonder
	Best Pop Vocal Performance, Group	"Neither One of Us"	Gladys Knight & The Pips
	Best Rhythm & Blues Vocal Performance, Female	"Master of Eyes"	Aretha Franklin
	Best Rhythm & Blues Vocal Performance, Male	"Superstition"	Stevie Wonder
	Best Rhythm & Blues Vocal Performance by a Group	"Midnight Train to Georgia"	Glayds Knight & The Pips
	Best Rhythm & Blues Instrumental Performance	"Hang On, Sloppy"	Ramsey Lewis
	Best Country Vocal Performance, Male	"Behind Closed Doors"	Charley Pride
	Best Classical Vocal Soloist Performance	*Puccini: Heroines*	Leontyne Price
1974	Album of the Year	*Fulfillingness' First Finale*	Stevie Wonder
	Best Jazz Performance by a Soloist	*First Recordings!*	Charlie Parker
	Best Jazz Performance by a Group	*The Trio*	Pass, Niels Pedersen
	Best Pop Vocal Performance, Male	*Fulfillingness' First Finale*	Stevie Wonder
	Best Rhythm & Blues Vocal Performance, Female	"Ain't Nothing like the Real Thing"	Aretha Franklin
	Best Rhythm & Blues Vocal Performance, Male	"Boogie On, Reggae Woman"	Stevie Wonder
	Best Rhythm & Blues Vocal Performance, Group	"Tell Me Something Good"	Rufus
	Best Rhythm & Blues Instrumental Performance	"TSOP (The Sound of Philadelphia)"	MFSB
	Best Comedy Recording	*The Nigger's Crazy*	Richard Pryor
	Best Score From the Original Cast Show	*Raisin*	Judd Woldin & Robert Britton
	Best Classical Vocal Soloist Performance	*Leontyne Price Sings Richard Strauss*	Leontyne Price
1975	Best New Artist of the Year		Natalie Cole
	Best Jazz Performance by a Soloist	*Oscar Peterson & Dizzy Gillespie*	Dizzy Gillespie
	Best Rhythm & Blues Vocal Performance, Female	"This Will Be"	Natalie Cole
	Best Rhythm & Blues Vocal Performance, Male	"Living for the City"	Ray Charles
	Best Rhythm & Blues Vocal Performance, Group	"Shining Star"	Earth, Wind & Fire
	Best Rhythm & Blues Instrumental Performance	"Fly, Robin, Fly"	Silver Convention
	Best Ethnic or Traditional Recording	*The Muddy Waters Woodstock Album*	
	Best Jazz Vocal Performance	*Fitzgerald & Pass Again*	Ella Fitzgerald
	Best Jazz Performance by a Soloist	*Basie & Zoot*	Count Basie
	Best Jazz Performance by a Big Band	*The Ellington Suites*	Duke Ellington

TABLE 7.2 **Grammy Award Winners** (*Continued*)

Year	Category	Performance	Performer
	Best Pop Vocal Performance, Male	*Songs in the Key of Life*	Stevie Wonder
	Best Pop Instrumental Performance	*Breezin'*	George Benson
	Best Rhythm & Blues Vocal Performance, Female	"Sophisticated Lady"	Natalie Cole
	Best Rhythm & Blues Vocal Performance, Male	"I Wish"	Stevie Wonder
	Best Rhythm & Blues Instrumental Performance	"Theme from Good King Bad"	George Benson
	Best Comedy Recording	*Bicentennial Nigger*	Richard Pryor
	Album of Best Original Score for Film or TV	*Car Wash*	Norman Whitfield
	Best Cast Show Album	*Bubbling Brown Sugar*	Prod: Hugo & Luigi
1977	Best Jazz Vocal Performance	*Look to the Rainbow*	Al Jarreau
	Best Jazz Performance by a Soloist	*The Giants*	Oscar Peterson
	Best Jazz Performance by a Big Band	*Prime Time*	Count Basie & Orch.
	Best Rhythm & Blues Vocal Performance, Female	"Don't Leave Me This Way"	Thelma Houston
	Best Rhythm & Blues Vocal Performance, Male	*Unmistakably Lou*	Lou Rawls
	Best Rhythm & Blues Vocal Performance by Group	"Best of My Love"	Emotions
	Best Rhythm & Blues Instrumental Performance	"Q"	Brothers Johnson
	Best Soul Gospel Performance Traditional	*James Cleveland Live at Carnegie Hall*	James Cleveland
	Best Ethnic or Traditional Recordings	*Hard Again*	
	Best Opera Recording	*Gershwin: Porgy & Bess*	John De Main conducting Houston Grand Opera Production
1978	Best Rhythm & Blues Vocal Performance, Female	"Last Dance"	Donna Summer
	Best Rhythm & Blues Vocal Performance, Male	"On Broadway"	George Benson
	Best Rhythm & Blues Vocal Performance by a Group	*All 'n All*	Earth, Wind & Fire
	Best Rhythm & Blues Instrumental Performance	"Runnin'"	Earth, Wind & Fire
	Best Soul Gospel Performance, Traditional	*Live and Direct*	Mighty Clouds of Joy
	Best Ethnic or Traditional Recording	*I'm Ready*	Muddy Waters
	Best Cast Show Album	*Ain't Misbehavin'*	Composed: Fats Waller; Produced: Thomas Z. Shepard
	Best Jazz Vocal Performance	*All Fly Home*	Al Jarreau
	Best Jazz Instrumental Performance, Soloist	*Montreux '77 Oscar Peterson Jam*	Oscar Peterson
	Best Instrumental Arrangement	*The Wiz (Original Soundtrack)*	Quincy Jones & Robert Freedman
1979	Best Pop Vocal Performance, Female	"I'll Never Love This Way Again"	Dionne Warwick
	Best Pop Instrumental Performance	"Rise"	Herb Alpert
	Best Rock Vocal Performance, Female	"Hot Stuff"	Donna Summer
	Best Rhythm & Blues Vocal Performance, Female	"Déjà Vu"	Dionne Warwick
	Best Rhythm & Blues Vocal Performance, Male	"Don't Stop 'Til You Get Enough"	Michael Jackson
	Best Rhythm & Blues Vocal Performance by a Group	"After the Love Has Gone"	Earth, Wind & Fire
	Best Rhythm & Blues Instrumental Performance	"Boogie Wonderland"	Earth, Wind & Fire
	Best Disco Recording	"I Will Survive"	Gloria Gaynor
	Best Gospel Performance, Contemporary	*Heed the Call*	Imperials
	Best Gospel Performance, Traditional	*Lift Up the Name of Jesus*	The Blackwood Brothers
	Best Soul Gospel Performance, Contemporary	*I'll Be Thinking of You*	Andrae Crouch
	Best Soul Gospel Performance, Traditional	*Changing Times*	Mighty Clouds of Joy
	Best Ethnic or Traditional Recording	*Muddy "Mississippi" Waters Live*	Muddy Waters
	Best Jazz Fusion Performance	*8:30*	Weather Report
	Best Jazz Vocal Performance	*Fine and Mellow*	Ella Fitzgerald
	Best Jazz Instrumental Performance, Soloist	*Jousts*	Oscar Peterson
	Best Jazz Instrumental Performance, Big Band	*At Fargo, 1940 Live*	Duke Ellington
	Best Historic Reissue	*Billie Holiday (Giants of Jazz)*	Billie Holiday; Produced by Michael Brooks

TABLE 7.2 **Grammy Award Winners** (*Continued*)

Year	Category	Performance	Performer
1980	Best Pop Instrumental Performance	*One on One*	Bob James & Earl Klugh
	Best Rhythm & Blues Vocal Performance, Female	"Never Knew Love like This Before"	Stephanie Mills
	Best Rhythm & Blues Vocal Performance, Male	*Give Me the Night*	George Benson
	Best Rhythm & Blues Performance by a Group	"Shining Star"	Manhattans
	Best Rhythm & Blues Instrumental Performance	"Off Broadway"	George Benson
	Best Soul Gospel Performance, Contemporary	*Rejoice*	Shirley Caesar
	Best Soul Gospel Performance, Traditional	*Lord, Let Me Be an Instrument*	James Cleveland & the Charles Fold Singers
	Best Ethnic or Traditional Recording	*Rare Blues*	Dr. Isaiah Ross & Others
	Best Recording for Children	*In Harmony/A Sesame Street Record*	Al Jarreau, George Benson & Others
	Best Jazz Vocal Performance, Female	*A Perfect Match/Ella & Basie*	Ella Fitzgerald
	Best Jazz Vocal Performance, Male	"Moody's Mood"	George Benson
	Best Jazz Instrumental Performance, Big Band	*On the Road*	Count Basie & Orchestra
	Best Instrumental Arrangement	"Dinorah, Dinorah"	Quincy Jones & Jerry Hey
	Best Classical Vocal Soloist Performance	*Prima Donna, Vol. 5*	Leontyne Price
1981	Best Pop Vocal Performance, Female	*Lena Horne: The Lady and Her Music Live on Broadway*	Lena Horne
	Best Pop Vocal Performance, Male	*Breakin' Away*	Al Jarreau
	Best Rhythm & Blues Performance, Female	"Hold On, I'm Coming"	Aretha Franklin
	Best Rhythm & Blues Performance, Male	"One Hundred Ways"	James Ingram
	Best Rhythm & Blues Performance by a Group	*The Dude*	Quincy Jones
	Best Jazz Fusion Performance, Vocal or Instrumental	*Winelight*	Grover Washington, Jr.
	Best Soul Gospel Performance, Contemporary	*Don't Give Up*	Andrae Crouch
	Best Soul Gospel Performance, Traditional	*The Lord Will Make a Way*	Al Green
	Best Ethnic or Traditional Recording	*There Must Be a Better World Somewhere*	B. B. King
	Best Comedy Recording	*Rev. Du Rite*	Richard Pryor
	Best Cast Show Album	*Lena Horne: The Lady and Her Music Live on Broadway*	Produced: Quincy Jones
	Best Jazz Vocal Performance, Female	*Digital III at Montreux*	Ella Fitzgerald
	Best Jazz Vocal Performance, Male	"Blue Rondo à la Turk"	Al Jarreau
	Best Jazz Instrumental Performance, Soloist	*Bye Bye Blackbird*	John Coltrane
	Best Arrangement on an Instrumental Recording	"Velas"	Quincy Jones
	Best Instrumental Arrangement— Accompanying Vocals	"Ai No Corrida"	Quincy Jones
	Producer of the Year		Quincy Jones
1982	Best Pop Vocal Performance, Male	"Truly"	Lionel Richie
	Best Rhythm & Blues Vocal Performance, Male	"Sexual Healing"	Marvin Gaye
	Best Rhythm & Blues Performance by a Group with Vocal	"Let It Whip"	Dazz Band
		"Wanna Be With You"	Earth, Wind & Fire
	Best Rhythm & Blues Performance	"Sexual Healing"	Marvin Gaye
	Best Soul Gospel Performance, Contemporary	*Higher Plane*	Al Green
	Best Soul Gospel Performance, Traditional	*Precious Lord*	Al Green
	Best Traditional Blues Recording	*Alright Again*	Clarence Gatemouth Brown
	Best Ethnic or Traditional Folk Recording	*Queen Ida and the Bon Temps Zydeco Band on Tour*	Queen Ida
	Best Comedy Recording	*Live on the Sunset Strip*	Richard Pryor
	Best Jazz Instrumental Performance, Soloist	*We Want Miles*	Miles Davis
	Best Jazz Instrumental Performance, Big Band	*Warm Breeze*	Count Basie & Orchestra
	Best Classical Vocal Soloist Performance	*Leontyne Price Sings Verdi*	Leontyne Price
1983	Record of the Year	"Beat It"	Michael Jackson
	Album of the Year	*Thriller*	Michael Jackson
	Best Pop Vocal Performance, Female	"Flashdance (What a Feeling)"	Irene Cara
	Best Pop Vocal Performance, Male	*Thriller*	Michael Jackson

TABLE 7.2 Grammy Award Winners (*Continued*)

Year	Category	Performance	Performer
	Best Pop Instrumental Performance	"Being with You"	George Benson
	Best Rock Vocal Performance, Male	"Beat It"	Michael Jackson
	Best Rhythm & Blues Performance, Female	*Chaka Khan*	Chaka Khan
	Best Rhythm & Blues Performance, Male	"Billie Jean"	Michael Jackson
	Best Rhythm & Blues Performance by a Group or Duo	"Ain't Nobody"	Rufus & Chaka Khan
	Best Rhythm & Blues Instrumental Performance	"Rockit"	Herbie Hancock
	Best Gospel Performance by Duo or Group	"More Than Wonderful"	Larnelle Harris
	Best Soul Gospel Performance, Female	*We Sing Praises*	Sandra Crouch
	Best Soul Gospel Performance, Male	*I'll Rise Again*	Al Green
	Best Inspirational Performance	"He's a Rebel"	Donna Summer
	Best Traditional Blues Recording	*Blues 'n' Jazz*	B. B. King
	Best Ethnic or Traditional Folk Recording	*I'm Here*	Clifton Chenier & His Red Hot Lousiana Band
	Best Recording for Children	*E. T. The Extra-Terrestrial*	Michael Jackson, Quincy Jones
	Best Comedy Recording	*Eddie Murphy, Comedian*	Eddie Murphy
	Best Spoken Word or Non-Musical Recording	*Copland: A Lincoln Portrait*	William Warfield
	Best Jazz Vocal Performance, Female	*The Best Is Yet to Come*	Ella Fitzgerald
	Best Jazz Instrumental Performance, Soloist	*Think of One*	Wynton Marsalis
	Best Vocal Arrangement for Two or More Voices	"Be Bop Medley"	Arif Hardin & Chaka Khan
	Producer of the Year		Quincy Jones & Michael Jackson
	Best Classical Vocal Soloist Performance	*Leontyne Price & Marilyn Horne in Concert*	Leontyne Price & Marilyn Horne
1984	Record of the Year	"What's Love Got to Do with It?"	Tina Turner
	Album of the Year	*Can't Slow Down*	Lionel Richie
	Best Pop Vocal Performance, Female	"What's Love Got to Do with It?"	Tina Turner
	Best Pop Performance by a Group	"Jump (for My Love)"	Pointer Sisters
	Best Pop Instrumental Performance	"Ghostbusters"	Ray Parker, Jr.
	Best Rock Vocal Performance, Female	"Better Be Good to Me"	Tina Turner
	Best Rock Performance by Duo or Group	*Purple Rain*	Prince & the Revolution
	Best Rhythm & Blues Performance, Female	"I Feel for You"	Chaka Khan
	Best Rhythm & Blues Performance, Male	"Caribbean Queen"	Billy Ocean
	Best Rhythm & Blues Performance, Group	"Yah Mo B There"	James Ingram
	Best Rhythm & Blues Instrumental Performance	*Sound-System*	Herbie Hancock
	Best Soul Gospel Performance, Female	*Sailin'*	Shirley Caesar
	Best Soul Gospel Performance, Male	"Always Remember"	Andrae Crouch
	Best Soul Gospel Performance by Duo or Group	"Sailin' on the Sea of Your Love"	Shirley Caesar & Al Green
	Best Inspirational Performance	"Forgive Me"	Donna Summer
	Best Ethnic or Traditional Folk Recording	*Elizabeth Cotton Live!*	Elizabeth Cotton
	Best Reggae Recording	*Anthem*	Black Uhuru
	Best Album of Original Score for Film or TV	*Purple Rain*	Prince
	Best Video Album	*Making Michael Jackson's Thriller*	Michael Jackson
	Best Jazz Instrumental Performance, Soloist	*Hot House Flowers*	Wynton Marsalis
	Best Jazz Instrumental Performance, Big Band	*88 Basie Street*	Count Basie & Orch.
	Best Arrangement on an Instrumental	"Grace (Gymnastics Theme)"	Quincy Jones
	Best Vocal Arrangement for Two or More Voices	"Automatic"	Pointer Sisters
	Producer of the Year		Lionel Richie
	Best Classical Performance	"Wynton Marsalis"	Wynton Marsalis
	Best Classical Vocal Soloist Performance	*Ravel: Songs of Maurice Ravel*	Jessye Norman
1985	Record of the Year	"We Are the World"	Produced: Quincy Jones
	Song of the Year	"We Are the World"	Michael Jackson & Lionel Richie
	Best New Artist		Sade
	Best Pop Vocal Performance, Female	"Saving All My Love for You"	Whitney Houston
	Best Rock Vocal Performance, Female	"One of the Living"	Tina Turner

TABLE 7.2 Grammy Award Winners (*Continued*)

Year	Category	Performance	Performer
	Best Rhythm & Blues Performance, Female	"Freeway of Love"	Aretha Franklin
	Best Rhythm & Blues Performance, Male	*In Square Circle*	Stevie Wonder
	Best Rhythm & Blues Performance, Group	"Nightshift"	Commodores
	Best Jazz Vocal Performance, Male	"Another Night in Tunisia"	Jon Hendricks & Bobby McFerrin
	Best Jazz Instrumental Performance, Soloist	*Black Codes from the Underground*	Wynton Marsalis
	Best Jazz Instrumental Performance, Group	*Black Codes from the Underground*	Wynton Marsalis Group
	Best Gospel Performance, Male	"How Excellent Is Thy Name"	Larnelle Harris
	Best Gospel Performance, Group	"I've Just Seen Jesus"	Larnelle Harris
	Best Soul Gospel Performance, Female	"Martin"	Shirley Caesar
	Best Soul Gospel Performance, Male	"Bring Back the Days of Yea and Nay"	Marvin Winans
	Best Soul Gospel Performance, Group	*Tomorrow*	The Winans
	Best Inspirational Performance	"Come Sunday"	Jennifer Holliday
	Best Traditional Blues Recording	"My Guitar Sings the Blues"	B. B. King
	Best Ethnic or Traditional Folk Recording	"My Toot Toot"	Rockin' Sidney
	Best Reggae Recording	*Cliff Hanger*	Jimmy Cliff
	Best Comedy Recording	*Whoopi Goldberg*	Whoopi Goldberg
	Best Music Video, Short Form	"We Are the World"	Produced: Quincy Jones
	Best Vocal Arrangement for Two or More Voices	"Another Night in Tunisia"	Bobby McFerrin
1986	Song of the Year	"That's What Friends Are For"	Dionne Warwick
			Gladys Knight & the Pips, Stevie Wonder
	Best Pop Performance by a Group	"That's What Friends Are For"	Warwick, etc.
	Best Rock Vocal Performance, Female	"Back Where You Started"	Tina Turner
	Best Rhythm & Blues Performance, Female	*Rapture*	Anita Baker
	Best Rhythm & Blues Performance, Male	"Living in America"	James Brown
	Best Rhythm & Blues Performance, Group	"Kiss"	Prince & the Revolution
	Best Jazz Vocal Performance, Male	" 'Round Midnight"	Bobby McFerrin
	Best Jazz Instrumental Performance, Soloist	*Tutu*	Miles Davis
	Best Jazz Instrumental Performance, Group	*J Mood*	Wynton Marsalis
	Best Gospel Performance, Male	*Triumph*	Philip Bailey
	Best Gospel Performance by a Duo or Group	"They Say"	Sandi Patti & Deniece Williams
	Best Soul Gospel Performance, Female	"I Surrender All"	Deniece Williams
	Best Soul Performance, Male	"Going Away"	Al Green
	Best Soul Gospel Performance by Duo or Group	*Let My People Go*	The Winans
	Best Traditional Blues Recording	*Showdown!*	Albert Collins, Robert Cray & Johnny Copeland
	Best Reggae Recording	*Babylon the Bandit*	Steel Pulse
	Best Comedy Recording	*Those of You with or Without Children, You'll Understand*	Bill Cosby
	Best Classical Vocal Soloist Performance	*Kathleen Battle Sings Mozart*	Kathleen Battle
1987	Song of the Year	"Somewhere Out There"	James Ingram & Linda Ronstadt
	Best New Artist		Jody Watley
	Best Pop Vocal Performance, Female	"I Wanna Dance with Somebody"	Whitney Houston
	Best New Age Performance	*Yusef Lateef's Little Symphony*	Yusef Lateef
	Best Rhythm & Blues Vocal Performance, Female	*Aretha*	Aretha Franklin
	Best Rhythm & Blues Vocal Performance, Male	"Just to See Her"	Smokey Robinson
	Best Rhythm & Blues Performance by a Duo or Group	"I Knew You Were Waiting"	Aretha Franklin & George Michael
	Best Jazz Vocal Performance, Male	"What Is This Thing Called Love?"	Bobby McFerrin
	Best Jazz Instrumental Performance, Group	*Marsalis Standard Time—Vol. 1*	Wynton Marsalis
	Best Jazz Instrumental Performance, Big Band	*Digital Duke*	Duke Ellington Orch.
	Best Gospel Performance, Female	"I Believe in You"	Deniece Williams
	Best Gospel Performance, Male	*The Father Hath Provided*	Larnell Harris
	Best Soul Gospel Performance, Female	"For Always"	CeCe Winans
	Best Soul Gospel Performance, Male	"Everything's Gonna Be Alright"	Al Green

TABLE **7.2 Grammy Award Winners** (*Continued*)

Year	Category	Performance	Performer
	Best Soul Gospel Performance by a Duo or Group	"Ain't No Need to Worry"	The Winans & Anita Baker
	Best Traditional Blues Recording	*Houseparty New Orleans Style*	Professor Longhair
	Best Contemporary Blues Recording	*Strong Persuader*	The Robert Cray Band
	Best Traditional Folk Recording	*Shaka Zulu*	Ladysmith Black Mambazo
	Best Reggae Recording	*No Nuclear War*	Peter Tosh
	Best Recording for Children	*The Elephant's Child*	Prod.: Bobby McFerrin
	Best Instrumental Composition	"Call Sheet Blues"	Herbie Hancock
	Best Historical Album	*Thelonious Monk—The Riverside Recording*	Thelonious Monk
	Best Classical Vocal Soloist Performance	*Kathleen Battle—Salzburg Recital*	Kathleen Battle
1988	Record of the Year	"Don't Worry, Be Happy"	Bobby McFerrin
	Song of the Year	"Don't Worry, Be Happy"	Bobby McFerrin
	Best New Artist		Tracy Chapman
	Best Pop Vocal Performance, Female	"Fast Car"	Tracy Chapman
	Best Pop Vocal Performance, Male	"Don't Worry, Be Happy"	Bobby McFerrin
	Best Rock Vocal Performance, Female	*Tina Live in Europe*	Tina Turner
	Best Rhythm & Blues Vocal Performance, Female	"Giving You the Best That I Got"	Anita Baker
	Best Rhythm & Blues Vocal Performance, Male	*Introducing the Hardline According to Terence Trent D'Arby*	Terence Trent D'Arby
	Best Rhythm & Blues Performance by a Duo or Group	"Love Overboard"	Gladys Knight & the Pips
	Best Rap Performance	"Parents Just Don't Understand"	D. J. Jazzy Jeff & the Fresh Prince
	Best Jazz Vocal Performance, Male	"Brothers"	Bobby McFerrin
	Best Jazz Vocal Performance, Duo or Group	"Spread Love"	Take 6
	Best Jazz Instrumental Performance, Group	*Blues for Coltrane*	McCoy Tyner, Pharoah Sanders, David Murray, Cecil McBee & Roy Haynes
	Best Gospel Performance, Male	*Christmas*	Larnelle Harris
	Best Soul Gospel Performance, Female	*One Lord, One Faith, One Baptism*	Aretha Franklin
	Best Soul Gospel Performance by a Duo or Group	*Take Six*	Take 6
	Best Traditional Blues Recording	*Hidden Charms*	Willie Dixon
	Best Contemporary Blues Recording	"Don't Be Afraid of the Dark"	The Robert Cray Band
	Best Contemporary Folk Recording	*Tracy Chapman*	Tracy Chapman
	Best Reggae Recording	*Conscious Party*	Ziggy Marley & the Melody Makers
	Best Spoken Word Recording	*Speech by Rev. Jesse Jackson*	Rev. Jesse Jackson
1989	Best Pop Instrumental	"Healing Chant"	Neville Brothers
	Best Rhythm & Blues Vocal Performance, Female	*Giving You the Best That I Got*	Anita Baker
	Best Rhythm & Blues Vocal Performance, Male	"Every Little Step"	Bobby Brown
	Best Rhythm & Blues Performance by a Duo or Group	"Back to Life"	Soul II Soul
	Best Rhythm & Blues Instrumental Performance	"African Dance"	Soul II Soul
	Best Rap Performance	"Bust a Move"	Young MC
	Best Jazz Instrumental Performance, Soloist	*Aura*	Miles Davis
	Best Jazz Instrumental Performance, Big Band	*Aura*	Miles Davis
	Best Gospel Vocal Performance, Female	"Don't Cry"	CeCe Winans
	Best Gospel Vocal Performance, Male	"Meantime"	BeBe Winans
	Best Gospel Vocal Performance by a Duo or Group	"The Savior Is Waiting"	Take 6
	Best Soul Gospel Vocal Performance	"As Long As We're Together"	Al Green
	Best Soul Gospel Vocal Performance by a Group	"Let Brotherly Love Continue"	Daniel Winans & Choir
	Best Traditional Blues Recording	"I'm in the Mood"	John Lee Hooker
	Best Reggae Recording	*One Bright Day*	Ziggy Marley & the Melody Makers
	Best Music Video—Short Form	*Leave Me Alone*	Michael Jackson

TABLE 7.2 Grammy Award Winners (*Continued*)

Year	Category	Performance	Performer
	Best Music Video—Long Form	*Rhythm Nation*	Janet Jackson
	Best Historical Album	*Chuck Berry—The Chess Set*	Chuck Berry
1990	Album of the Year	*Back on the Block*	Quincy Jones
	Best Rhythm & Blues Vocal Performance, Female	*Compositions*	Anita Baker
	Best Rhythm & Blues Vocal Performance, Male	"Here and Now"	Luther Vandross
	Best Rhythm & Blues Performance by a Duo or Group	"I'll Be Good To You"	Ray Charles & Chaka Khan
	Best Rap Solo Performance	"U Can't Touch This"	M. C. Hammer
	Best Rap Performance by a Duo or Group	"Back on the Block"	Ice-T, Melle Mel, Big Daddy Kane, Cool Moe Dee, Quincy Jones
	Best Jazz Fusion Performance	"Birdland"	Quincy Jones
	Best Jazz Vocal Performance, Female	*All That Jazz*	Ella Fitzgerald
	Best Jazz Instrumental Performance, Soloist	*The Legendary Oscar Peterson Trio Live at the Blue Note*	Oscar Peterson
	Best Jazz Instrumental Performance, Group	*The Legendary Oscar Peterson Trio Live at the Blue Note*	Oscar Peterson Trio
	Best Jazz Instrumental Performance, Big Band	"Basie's Bag"	Frank Foster
	Best Traditional Soul Gospel Album	*So Many 2 Say*	Take 6
	Best Traditional Blues Recording	*Live at San Quentin*	B. B. King
	Best Music Video—Short Form	*Opposites Attract*	Paula Abdul
	Best Music Video—Long Form	*Please Hammer, Don't Hurt Them*	M. C. Hammer
	Best Arrangement on an Instrumental	"Birdland"	Quincy Jones
	Best Instrumental Arrangement—Accompanying Vocals	"The Places You Find Love"	Quincy Jones
	Producer of the Year		Quincy Jones
	Best Historical Album	*Robert Johnson: The Complete Recordings*	Robert Johnson
1991	Record of the Year	"Unforgettable"	Natalie Cole
	Album of the Year	*Unforgettable*	Natalie Cole
	Best Traditional Pop Performance	"Unforgettable"	Natalie Cole
	Best Rhythm & Blues Vocal Performance, Female	*Burnin'*	Patti LaBelle
	Best Rhythm & Blues Vocal Performance, Male	*Power of Love*	Luther Vandross
	Best Rhythm & Blues Performance by a Duo or Group	*Cooley High Harmony*	Boyz II Men
	Best Rap Performance	"Mama Said Knock You Out"	L. L. Cool J.
	Best Rap Performance by a Duo or Group	"Summertime"	D. J. Jazzy Jeff & the Fresh Prince
	Best Jazz Vocal Performance	*He Is Christmas*	Take 6
	Best Jazz Instrumental Performance, Group	*Saturday Night at the Blue Note*	Oscar Peterson Trio
	Best Large Jazz Ensemble Performance	*Live at the Royal Festival Hall*	Dizzy Gillespie & the U.N. Orchestra
	Best Traditional Soul Gospel Album	*Pray for Me*	Mighty Clouds of Joy
	Best Contemporary Soul Gospel Album	*Different Lifestyles*	BeBe & CeCe Winans
	Best Gospel Album by a Choir	*The Evolution of Gospel*	Sounds of Blackness
	Best Traditional Blues Album	*Live at the Apollo*	B. B. King
	Best Contemporary Blues Album	*Damn Right, I've Got the Blues*	Buddy Guy
	Best Reggae Album	*As Raw As Ever*	Shabba Ranks
	Best Historical Album	*Billie Holiday: The Complete Decca Recordings*	Billie Holiday
1992	Best New Artist		Arrested Development
	Best Pop Performance by a Duo or Group	"Beauty and the Beast"	Celine Dion & Peabo Bryson
	Best Rhythm & Blues Vocal Performance, Female	*The Woman I Am*	Chaka Khan
	Best Rhythm & Blues Vocal Performance, Male	*Heaven and Earth*	Al Jarreau
	Best Rhythm & Blues Performance by a Duo or Group	"End of the Road"	Boyz II Men
	Best Rhythm & Blues Instrumental Performance	*Doo-Bop*	Miles Davis

TABLE **7.2 Grammy Award Winners (*Continued*)**

Year	Category	Performance	Performer
	Best Rap Solo Performance	"Baby Got Back"	Sir Mix-A-Lot
	Best Rap Performance by a Duo or Group	"Tennessee"	Arrested Development
	Best Jazz Instrumental Solo Performance	"Lush Life"	Joe Henderson
	Best Jazz Instrumental Performance, Individual or Group	*I Heard You Twice the First Time*	Branford Marsalis
	Best Large Jazz Ensemble Performance	*The Turning Point*	McCoy Tyner Big Band
	Best Traditional Soul Gospel Album	*He's Working It Out for You*	Shirley Caesar
	Best Gospel Album by a Choir	*Edwin Hawkins Music—Live in L.A.*	Edwin Hawkins
	Best Reggae Album	*X-Tra Naked*	Shabba Ranks
	Best Spoken Word Album	*What You Can Do to Avoid AIDS*	Earvin "Magic" Johnson
	Best Instrumental Composition	*Harlem Renaissance Suite*	Benny Carter
	Best Instrumental Arrangement	"Here's to Life"	Johnny Mandel
	Producer of the Year		L. A. Reid & Babyface
	Best Historical Album	*The Complete Capitol Recordings of the Nat "King" Cole Trio*	Nat "King" Cole
	Best Classical Vocal Performance	"Kathleen Battle at Carnegie Hall"	Kathleen Battle

TABLE **7.3 Academy Award/Oscar Winners**

Year	Performer	Category	Performance
1939	Hattie McDaniel	Best Supporting Actress	*Gone with the Wind*
1947	James Baskett	Special Award	*Song of the South*
1963	Sidney Poitier	Best Actor	*Lilies of the Field*
1971	Isaac Hayes	Best Song (from film)	"Theme from *Shaft*"—*Shaft*
1978	Paul Jabara	Best Song (from film)	"Last Dance"—*Thank God It's Friday*
1982	Louis Gossett, Jr.	Best Supporting Actor	*An Officer and a Gentleman*
1984	Stevie Wonder	Best Song (from film)	"I Just Called to Say I Love You"—*The Woman in Red*
1985	Lionel Richie	Best Song (from film)	"Say You, Say Me"—*White Nights*
1986	Herbie Hancock	Original Score	*'Round Midnight*
1989	Denzel Washington	Best Supporting Actor	*Glory*
1990	Whoopi Goldberg	Best Supporting Actress	*Ghost*

TABLE **7.4 Tony Award Winners**

Date	Performer	Category	Performance
1962	Diahann Carroll	Best Actress in a Musical	*No Strings*
1968	Leslie Uggams	Best Actress in a Musical	*Hallelujah, Baby!*
1968	Lillian Hayman	Best Supporting Actress in a Musical	*Hallelujah, Baby!*
1968	Pearl Bailey	Special Award	
1969	James Earl Jones	Best Actor in a Dramatic Play	*The Great White Hope*
1969	The Negro Ensemble Company	Special Award	
1970	Cleavon Little	Best Actor in a Musical	*Purlie*
1970	Melba Moore	Best Supporting Actress in a Musical	*Purlie*
1974	Virginia Capers	Best Actress in a Musical	*Raisin*
1974	Producer: The Negro Ensemble Company	Best Play	*The River Niger*
1974		Best Musical	*Raisin*
1975	John Kani & Winston Ntshona	Best Actor in a Dramatic Play	*Sizwe Banzi Is Dead & The Island*
1975	Dee Dee Bridgewater	Best Supporting Actress in a Musical	*The Wiz*
1975	Ted Ross	Best Supporting Actor in a Musical	*The Wiz*
1975		Best Musical	*The Wiz*
1977	Trazana Beverley	Best Actress in a Featured Role in a Dramatic Play	*For Colored Girls Who Have Considered Suicide . . .*
1977		Most Innovative Production of a Revival	*Porgy and Bess*

TABLE 7.4 Tony Award Winners (*Continued*)

Date	Performer	Category	Performance
1977	Diana Ross	Special Award	
1978		Best Musical	*Ain't Misbehavin'*
1978	Nell Carter	Outstanding Performance by an Actress in a Featured Role in a Musical	*Ain't Misbehavin'*
1982	Jennifer Holliday	Outstanding Performance by an Actress in a Musical	*Dreamgirls*
1982	Cleavant Derricks	Outstanding Performance by a Featured Actor in a Musical	*Dreamgirls*
1982	Ben Harney	Outstanding Performance by an Actor in a Musical	*Dreamgirls*
1983	Charles "Honi" Coles	Outstanding Performance by a Featured Actor in a Musical	*My One and Only*
1987	James Earl Jones	Best Actor in a Play	*Fences*
1989	Ruth Brown	Best Actress in a Musical	*Black and Blue*
1991	Hinton Battle	Outstanding Actor in a Featured Role in a Musical	*Miss Saigon*
1992	Gregory Hines	Best Actor in a Musical	*Jelly's Last Jam*
1992	Laurence Fishburne	Outstanding Featured Actor in a Play	*Two Trains Running*
1992	Tonya Pinkins	Outstanding Featured Actress in a Musical	*Jelly's Last Jam*

TABLE 7.5 Rock and Roll Hall of Fame Inductees

Year	Inductee	Category
1986	Robert Johnson	Early Influences
	Jimmy Yancey	Early Influences
	Chuck Berry	Artists
	James Brown	Artists
	Ray Charles	Artists
	Sam Cooke	Artists
	Fats Domino	Artists
	Little Richard	Artists
1987	Louis Jordan	Early Influences
	T-Bone Walker	Early Influences
	The Coasters	Artists
	Bo Diddley	Artists
	Aretha Franklin	Artists
	Marvin Gaye	Artists
	B. B. King	Artists
	Clyde McPhatter	Artists
	Smokey Robinson	Artists
	Big Joe Turner	Artists
	Muddy Waters	Artists
	Jackie Wilson	Artists
1988	Berry Gordy, Jr.	Nonperformers
	Leadbelly	Early Influences
	The Drifters	Artists
	The Supremes	Artists
1989	The Ink Spots	Early Influences
	Bessie Smith	Early Influences
	The Soul Stirrers	Early Influences
	Otis Redding	Artists
	The Temptations	Artists
	Stevie Wonder	Artists
1990	Lamont Dozier, Brian Holland & Eddie Holland	Nonperformers
	Hank Ballard	Early Influences
	The Platters	Artists

TABLE **7.5** **Rock and Roll Hall of Fame Inductees (*Continued*)**

Year	Inductee	Category
1991	Dave Bartholomew	Nonperformers
	Howlin' Wolf	Early Influences
	La Vern Baker	Artists
	John Lee Hooker	Artists
	The Impressions	Artists
	Wilson Pickett	Artists
	Jimmy Reed	Artists
	Ike and Tina Turner	Artists
1992	Elmore Leonard	Early Influences
	Professor Longhair	Early Influences
	Bobby "Blue" Bland	Artists
	Booker T. and the MG's	Artists
	The Jimi Hendrix Experience	Artists
	The Isley Brothers	Artists
	Sam and Dave	Artists
1993	Dinah Washington	Early Influences
	Ruth Brown	Artists
	Etta James	Artists
	Frankie Lymon & the Teenagers	Artists
	Sly & the Family Stone	Artists
1994	Willie Dixon	Early Influences
	Bob Marley	Artists

8. HEALTH

TABLE **8.1** **AIDS Deaths, 1982–1992**

Year	Total	Black	% Black
1982	431	147	34.11
1983	1,402	441	31.46
1984	3,266	895	27.40
1985	6,682	1,777	26.59
1986	11,537	3,044	26.38
1987	15,451	4,525	29.29
1988	19,657	6,015	30.60
1989	26,157	7,969	30.47
1990	28,060	8,584	30.59
1991	30,593	9,468	30.95
1992	22,675	7,092	31.28

Sources: *Black Americans: A Statistical Sourcebook* (for 1982 and 1983); *Statistical Abstract, 1992* (for 1984); *Statistical Abstract, 1993.*

TABLE **8.2** **Birthrate, 1917–1989***

Year	Total	Black[†]
1917	28.5	32.9
1920	27.7	35.0
1930	21.3	27.5
1940	19.4	26.7
1950	24.1	33.3
1960	23.7	32.1
1970	18.4	25.3
1980	15.9	22.1
1989	16.3	23.1

* Total live births per 1,000 population for specified group.
† Figures through 1960 are for total nonwhite births.
Sources: *Historical Statistics of the United States; Statistical Abstract, 1992.*

TABLE **8.3** **Births to Unmarried Women, 1940–1989**

	Total		Black	
Year	Total Live Births (in Thousands)	% Born to Unmarried Women	Total Live Births (in Thousands)	% Born to Unmarried Women
1940	2,559	3.5	360[1]	13.7
1950	3,632	3.9	524[1]	16.8
1960	4,258	5.3	602	23.5
1970	3,731	10.7	572	37.6
1980	3,612	18.4	590	55.2
1989	4,041	27.1	608	64.5

[1] Numbers for 1940 and 1950 include black and other nonwhite.
Sources: *Statistical Abstract, 1992; Historical Statistics of the United States.*

TABLE **8.4** **Death Rates by Selected Causes, 1960–1989***

Cause of Death	Total				Black			
	1960	1970	1980	1989	1960	1970	1980	1989
Total	760.9	714.3	585.8	523.0	1,073.3	1,044.0	842.5	783.1
Diseases of the heart	286.2	253.6	202.0	155.9	334.5	307.6	255.7	216.4
Malignant neoplasms (cancer)	125.8	129.9	132.8	133.0	142.3	156.7	172.1	172.7
Cerebrovascular diseases[1]	79.7	66.3	40.8	28.0	140.2	114.5	68.5	49.0
Accidents and adverse effects	49.9	53.7	42.3	33.8	66.4	74.4	51.2	42.7
Homicide and legal intervention	—	9.1	10.8	9.4	—	46.1	40.6	35.7
Diabetes	13.6	14.1	10.1	11.5	22.0	26.5	20.3	23.7
Pneumonia, flu[2]	28.0	22.1	12.9	13.7	56.4	40.4	19.2	19.8
Chronic obstructive pulmonary diseases[3]	—	—	15.9	19.4	—	—	12.5	16.6
Cirrhosis and chronic liver disease	10.5	14.7	12.2	8.9	11.7	24.8	21.6	13.9
Suicide	—	11.8	11.4	11.3	—	6.1	6.4	7.1

* Deaths classified according to the revision of the International Classification of Diseases in use at that time; rates are per 100,000 for residential, age-adjusted population.
[1] Primarily strokes.
[2] 1960s figures for pneumonia and influenza.
[3] Such as emphysema or asthma.
— = data not available on a comparable basis with later years.
Sources: *Statistical Abstract* (1984, 1992); U.S. National Center for Health Statistics, "Vital Statistics of the United States" (annual).

TABLE 8.5 **Legal Abortions, Women 15–44 Years of Age, 1975–1988**

	Total*	Black and Nonwhite*
1975		
Women, 15–44	47,606	6,749
Abortions	1,034.2	333.0
Rate	21.7	49.3
1980		
Women, 15–44	53,048	8,106
Abortions	1,553.9	460.3
Rate	29.3	56.5
1985		
Women, 15–44	56,754	9,242
Abortions	1,588.6	512.9
Rate	28.0	55.5
1988		
Women, 15–44	58,192	9,242
Abortions	1,590.8	565.1
Rate	27.3	57.3

* All data are in thousands or per 1,000.
Sources: *Statistical Abstract, 1992; Black Americans: A Statistical Sourcebook.*

TABLE 8.6 **Life Expectancy at Birth, 1900–1990**

Year	Total*	Black and Other Nonwhite* †
1900	47.3	33.0
1910	50.0	35.6
1920	54.1	45.3
1930	59.7	48.1
1940	62.9	53.1
1950	68.2	60.8
1960	69.7	63.6
1970	70.8	64.1
1980	73.7	68.1
1990	75.4	70.3

* In years.
† Figures through 1960 are for all nonwhites.
Sources: *Historical Statistics of the United States, Colonial Times to 1970,* part 1, p. 55; *Statistical Abstract, 1992.*

TABLE 8.7 **Infant, Maternal, Neonatal, and Fetal Mortality Rates, 1970–1989***

Year	Infant Deaths[1] Total	Black	Maternal Deaths[2] Total	Black	Fetal Deaths[3] Total	Black & Other	Neonatal Deaths[4] Total	Black
1970	20.0	32.6	21.5	59.8	14.2	22.6	15.1	22.8
1975	16.1	26.2	12.8	31.3	10.7	16.0	11.6	18.3
1979	13.1	21.8	9.6	25.1	9.4	13.8	8.9	14.3
1980	12.6	21.4	9.2	21.5	9.2	13.4	8.5	14.1
1981	11.9	20.0	8.5	20.4	9.0	12.8	8.0	13.4
1982	11.5	19.6	7.9	18.2	8.9	12.7	7.7	13.1
1983	11.2	19.2	8.0	18.3	8.5	12.4	7.3	12.4
1984	10.8	18.4	7.8	19.7	8.2	11.5	7.0	11.8
1985	10.6	18.2	7.8	20.4	7.9	11.3	7.0	12.1
1986	10.4	18.0	7.2	18.8	7.7	11.2	6.7	11.7
1987	10.1	17.9	6.6	14.2	7.7	11.5	6.5	11.7
1988	10.0	17.6	8.4	19.5	7.5	11.4	6.3	11.5
1989	9.8	17.7	7.9	18.4	7.5	11.4	6.2	11.3

* Deaths per 1,000 live births except as noted.
[1] Represents deaths of infants under 1 year old, exclusive of fetal deaths.
[2] Per 100,000 live births from deliveries and complications of pregnancy, childbirth, and the puerperium.
[3] Includes only those deaths with stated or presumed period of gestation of 20 weeks or more.
[4] Represents deaths of infants under 28 days old, exclusive of fetal deaths.
Source: *Statistical Abstract, 1990.*

9. IMMIGRATION

TABLE **9.1** **Immigrants Admitted by Region and Selected Country of Birth, 1981–1991***

	1981	1982	1983	1984	1985	1986	1987	1988	1989	1990	1991
Sub-Saharan Africa											
Cameroon	69	95	92	145	123	130	132	157	187	380	452
Cape Verde	849	852	594	591	627	760	657	921	1,118	907	973
Ethiopia	1,749	1,810	2,643	2,461	3,362	2,737	2,156	2,571	3,389	4,336	5,127.
Ghana	951	824	976	1,050	1,041	1,164	1,120	1,239	2,045	4,466	3,330
Ivory Coast	28	29	54	55	57	55	63	78	98	184	347
Kenya	657	601	710	753	735	719	698	773	910	1,297	1,185
Liberia	556	593	518	585	618	618	622	769	1,175	2,004	1,292
Nigeria	1,918	2,257	2,354	2,337	2,846	2,976	3,278	3,343	5,213	8,843	7,912
Senegal	65	74	71	59	91	91	92	130	141	537	869
Sierra Leone	277	283	319	368	371	323	453	571	939	1,290	951
Somalia	61	89	83	90	139	139	197	183	228	277	458
South Africa	1,559	1,434	1,261	1,246	1,210	2,566	2,741	1,832	1,899	1,990	1,854
Sudan	65	78	128	199	271	230	198	217	272	306	679
Tanzania	423	304	364	418	395	370	385	388	507	635	500
Uganda	410	304	332	369	301	401	357	343	393	674	538
Other Sub-Saharan Africa	1,067	957	993	1,166	1,021	1,050	1,088	1,141	1,386	1,654	1,651
Non-Hispanic Caribbean											
Antigua-Barbuda	929	3,234	2,008	953	957	812	874	837	979	1,319	944
Bahamas	546	577	505	499	533	570	556	1,283	861	1,378	1,062
Barbados	2,394	1,961	1,849	1,577	1,625	1,595	1,665	1,455	1,616	1,745	1,460
Dominica	721	569	546	442	540	564	740	611	748	963	982
Grenada	1,120	1,066	1,154	980	934	1,045	1,098	842	1,046	1,294	979
Haiti	6,683	8,779	8,424	9,839	10,165	12,666	14,819	34,806	13,658	20,324	47,527
Jamaica	23,569	18,711	19,535	19,822	18,923	19,595	23,148	20,966	24,523	25,013	23,828
St. Kitts & Nevis	867	1,039	2,773	1,648	769	573	589	660	795	896	830
St. Lucia	733	586	662	484	499	502	496	606	709	833	766
St. Vincent & Grenadines	799	719	767	695	693	635	746	634	892	973	808
Trinidad & Tobago	4,599	3,532	3,156	2,900	2,831	2,891	3,543	3,947	5,394	6,740	8,407
Other Non-Hispanic Caribbean	1,263	946	891	680	691	895	851	963	942	1,033	792
Non-Hispanic Central America											
Belize	1,289	2,031	1,585	1,492	1,353	1,385	1,354	1,497	2,217	3,867	2,377
Panama	4,613	3,320	2,546	2,276	2,611	2,194	2,084	2,486	3,482	3,433	4,204
Non-Hispanic South America											
Guyana	6,743	10,059	8,990	8,412	8,531	10,367	11,384	8,747	10,789	11,362	11,666

* Figures represent total immigration from countries, including nonblacks.
Source: U.S. Immigration and Naturalization Service, 1993.

TABLE **9.2** **Immigrants Admitted by Region and Selected Country of Birth, 1972–1980***

	1972	1973	1974	1975	1976	1977	1978	1979	1980
Sub-Saharan Africa									
Cameroon	7	11	13	14	16	21	39	29	65
Cape Verde	248	214	122	196	1,110	964	941	765	788
Ethiopia	192	149	276	206	332	354	539	726	977
Ghana	326	487	369	275	404	454	711	828	1,159
Ivory Coast	6	5	7	11	6	10	21	12	28
Kenya	295	300	386	446	528	493	516	618	592
Liberia	134	195	191	163	300	215	333	327	426
Nigeria	738	738	670	653	907	653	1,007	1,054	1,896
Senegal	40	40	42	26	70	80	75	63	106
Sierra Leone	48	65	61	66	137	157	212	217	267
Somalia	16	11	10	17	25	21	32	34	43
South Africa	521	503	525	586	1,098	1,988	1,689	2,214	1,960
Sudan	41	65	43	38	60	48	71	77	83
Tanzania	271	264	243	304	381	302	301	401	339
Uganda	159	339	320	859	425	241	303	284	343
Other Sub-Saharan Africa	355	306	393	565	1,172	1,193	1,120	1,121	1,181
Non-Hispanic Caribbean									
Antigua	344	404	461	435	646	835	908	770	972
Bahamas	255	365	529	256	406	400	585	651	547
Barbados	1,620	1,448	1,461	1,618	2,210	2,763	2,969	2,461	2,667
Dominica	198	258	236	274	377	572	595	1,009	846
Grenada	332	420	707	568	787	1,240	1,206	946	1,198
Haiti	5,809	4,786	3,946	5,145	6,691	5,441	6,470	6,433	6,540
Jamaica	13,427	9,963	12,408	11,076	11,100	11,501	19,265	19,714	18,970
St. Christopher-Nevis[1]	383	402	425	419	904	896	1,014	786	874
St. Lucia	238	264	283	278	379	545	572	953	1,193
St. Vincent & Grenadines	294	374	332	346	456	585	679	639	763
Trinidad & Tobago	6,615	7,035	6,516	5,982	6,040	6,106	5,973	5,225	5,154
Other Non-Hispanic Caribbean	896	859	890	850	1,042	1,570	1,664	1,097	1,078
Non-Hispanic Central America									
Belize	475	528	573	534	661	930	1,033	1,063	1,120
Panama	1,517	1,612	1,664	1,694	2,162	2,390	3,108	3,472	3,572
Non-Hispanic South America									
Guyana	2,826	2,969	3,241	3,169	4,497	5,718	7,614	7,001	8,381

* Figures represent total immigration from countries, including nonblacks.
[1] Prior to fiscal year 1977, historical data for Anguilla were included in St. Christopher-Nevis.
Source: U.S. Immigration and Naturalization Service, 1993.

TABLE **9.3** **Immigrants Admitted by Region and Selected Country of Birth, 1965–1971***

	1965	1966	1967	1968	1969	1970	1971
Africa							
Egypt	1,429	1,181	1,703	2,124	3,411	4,937	3,643
Other Africa	1,954	1,956	2,533	2,954	2,465	3,178	3,129
Non-Hispanic Caribbean							
Barbados	406	520	1,037	2,024	1,957	1,774	1,731
Haiti	3,609	3,801	3,567	6,806	6,542	6,932	7,444
Jamaica	1,837	2,743	10,483	17,470	16,947	15,033	14,571
Trinidad & Tobago	485	756	2,160	5,266	6,835	7,350	7,130
Non-Hispanic Central America							
Panama	1,933	1,594	1,676	1,976	1,585	1,630	1,457
Non-Hispanic South America							
Guyana	233	377	857	1,148	1,615	1,763	2,115

* Figures represent total immigration from countries, including nonblacks.
Source: U.S. Immigration and Naturalization Service, 1993.

TABLE 9.4 Immigration by Region and Selected Country of Last Residence, 1820–1990

	1820	1821–1830	1831–1840	1841–1850	1851–1860	1861–1870
Africa	1	16	54	55	210	312
Caribbean	164	3,834	12,301	13,528	10,660	9,046

	1871–1880	1881–1890	1891–1900	1901–1910	1911–1920	1921–1930
Africa	358	857	350	7,368	8,443	6,286
Caribbean	13,957	29,042	33,066	107,548	123,424	74,899

	1931–1940	1941–1950	1951–1960	1961–1970	1971–1980	1981–1990
Africa	1,750	7,367	14,092	28,954	80,779	176,893
Caribbean (Total)	15,502	49,725	123,091	470,213	741,126	872,051
Cuba[1]	9,571	26,313	78,948	208,536	264,863	144,578
Dominican Republic[2]	1,150	5,627	9,897	93,292	148,135	252,035
Haiti[2]	191	911	4,442	34,499	56,335	138,379
Jamaica[3]	—	—	8,869	74,906	137,577	208,148
Other Caribbean	4,590	16,874	20,935	58,980	134,216	128,911

[1] Data for Cuba not reported separately until 1925.
[2] Data for Dominican Republic and Haiti not reported separately until 1932.
[3] Data for Jamaica not collected separately until 1953.
Source: U.S. Immigration and Naturalization Service, 1993.

10. OCCUPATIONS

TABLE 10.1 Occupations, 1890–1990[†]

			Black		
Year	Occupations	Total	Both sexes	Male	Female
1890	All occupations	22,735,661	3,073,161	2,101,379	971,782
	Agriculture, fisheries & mining	9,013,336	1,757,403	1,329,594	427,809
	Professional services	944,333	33,991	25,170	8,821
	Domestic & personal services	4,360,577	963,080	457,091	505,989
	Trade & transportation	3,326,122	145,717	143,371	2,346
	Manufacturing & mech. industries	5,091,293	172,970	146,153	26,817
1900	All occupations	29,287,070	3,992,337	2,675,497	1,316,840
	Agriculture, fisheries & mining	10,438,219	2,143,154	1,561,153	582,001
	Professional services	1,264,536	47,219	31,625	15,594
	Domestic & personal services	5,693,778	1,317,859	635,933	681,926
	Trade & transportation	4,778,233	208,989	204,852	4,137
	Manufacturing & mech. industries	7,112,304	275,116	241,934	33,182
1910	All occupations	38,167,336	5,192,535	3,178,554	2,013,981
	Agriculture, forestry & husbandry	12,659,203	2,893,375	1,842,238	1,051,137
	Extraction of minerals	964,824	61,129	61,048	81
	Manufacturing & mech. industries	10,658,881	631,377	563,410	67,967
	Transportation	2,637,671	255,969	254,683	1,286
	Trade	3,614,670	119,491	112,464	7,027
	Public service (N.E.C.)*	459,291	22,382	22,033	349
	Professional service	1,663,569	67,245	37,600	29,645
	Domestic & personal service	3,772,174	1,122,231	268,874	853,357
	Clerical occupation	1,737,053	19,336	16,204	3,132
1920	All occupations	41,614,248	4,824,151	3,252,862	1,571,289
	Agriculture, forestry & husbandry	10,953,158	2,178,888	1,566,627	612,261
	Extraction of minerals	1,090,223	73,229	72,892	337
	Manufacturing & mech. industries	12,818,524	886,810	781,827	104,983
	Transportation	3,063,582	312,421	308,896	3,525
	Trade	4,242,979	140,467	129,309	11,158

TABLE 10.1 Occupations, 1890–1990[†] (*Continued*)

Year	Occupations	Total	Black Both sexes	Black Male	Black Female
	Public service (N.E.C.)*	770,460	50,552	49,586	966
	Professional service	2,143,889	80,183	41,056	39,127
	Domestic & personal service	3,404,892	1,064,590	273,959	790,631
	Clerical occupation	3,126,541	37,011	28,710	8,301
1930	All occupations	48,829,920	5,503,535	3,662,893	1,840,642
	Agriculture	10,471,998	1,987,839	1,492,555	495,284
	Forestry & fishing	250,469	31,732	31,652	80
	Extraction of minerals	984,323	74,972	74,919	53
	Manufacturing & mech. industries	14,110,652	1,024,656	923,586	101,070
	Transportation & communication	3,843,147	397,645	395,437	2,208
	Trade	6,081,467	183,809	169,241	14,568
	Public service (N.E.C.)*	856,205	50,203	49,273	930
	Professional service	3,253,884	135,925	72,898	63,027
	Domestic & personal service	4,952,451	1,576,205	423,645	1,152,560
	Clerical occupation	4,025,324	40,549	29,687	10,862
1940	All occupations**	44,000,963	4,479,068	2,936,795	1,542,273
	Professional & semi-pro workers	3,345,048	119,200	53,312	65,888
	Farmers & farm managers	5,143,614	666,695	620,479	46,216
	Proprietors, managers & officials, except farm	3,749,287	48,154	37,240	10,914
	Clerical, sales & kindred workers	7,517,630	79,322	58,557	20,765
	Craftsmen, foremen & kindred workers	5,055,722	132,110	129,736	2,374
	Operatives and kindred workers	8,252,277	464,195	368,005	96,190
	Domestic service workers	2,111,314	1,003,508	85,566	917,942
	Service workers, except domestic	3,458,334	522,229	362,424	159,805
	Farm laborers & foremen	1,924,890	780,312	581,763	198,549
	Laborers, except farm and mine	3,064,128	636,600	623,641	12,959
	Occupation not reported	378,719	26,743	16,072	10,671
1950	All occupations	56,225,340	5,832,450	3,787,560	2,044,890
	Prof., tech. & kindred workers	4,909,241	179,370	75,090	104,280
	Farmers and farm managers	4,306,253	503,970	471,180	32,790
	Managers, officials & proprietors, except farm	5,017,465	97,080	71,130	25,950
	Clerical & kindred workers	6,894,374	197,610	116,760	80,850
	Sales workers	3,926,510	68,460	42,030	26,430
	Craftsmen, foremen & kindred workers	7,772,560	310,830	297,540	13,290
	Operatives & kindred workers	11,146,220	1,092,750	792,060	300,690
	Private household workers (PHW)	1,407,466	571,950	38,700	533,250
	Service workers, except PHW	4,287,703	877,440	498,180	379,260
	Farm laborers and foremen	2,399,794	529,920	377,460	152,460
	Laborers, except farm and mine	3,417,232	936,120	904,230	31,890
	Occupations not reported	740,522	166,950	103,200	63,750
1960	All occupations***	64,646,563	6,622,658	4,004,770	2,617,888
	Prof., tech. & kindred workers	7,223,241	352,298	155,774	196,524
	Farmers & farm managers	2,508,172			
	Managers, officials & proprietors, including farm	5,407,890	315,152	267,855	47,297
	Clerical & kindred workers	9,303,231	433,090	206,269	226,821
	Sales workers	4,643,784	108,316	62,274	46,042
	Craftsmen, foremen & kindred workers	8,753,468	424,817	407,343	17,474
	Operatives & kindred workers	11,920,442	1,278,134	941,073	337,061
	Service workers, including PHW	7,171,837	2,015,683	580,090	1,435,593

TABLE 10.1 Occupations, 1890–1990† (*Continued*)

Year	Occupations	Total	Black		
			Both sexes	Male	Female
	Laborers, including farm	4,532,950	1,154,253	1,052,092	102,161
	Occupation not reported	3,181,548	540,915	332,000	208,915
1970	All occupations	76,805,171	7,403,056	4,069,397	3,333,659
	Prof., tech. & kindred workers	11,451,868	616,321	237,733	378,588
	Managers & administrators, except farm	6,386,977	166,187	119,562	46,625
	Sales workers	5,432,778	165,767	80,686	85,081
	Clerical & kindred workers	13,782,783	1,021,589	330,492	691,097
	Craftsmen & kindred workers	10,638,804	674,849	626,709	48,140
	Operatives, except transport	10,515,834	1,333,099	798,945	534,154
	Transport equipment operatives	2,954,932	416,146	403,209	12,937
	Laborers, except farm	3,430,637	688,212	639,840	48,372
	Farmers and farm managers	1,426,742	42,001	36,928	5,073
	Farm laborers & farm foremen	962,077	181,465	144,266	37,199
	Service workers, except PHW	8,653,987	1,483,993	633,538	850,455
	Private household workers (PHW)	1,167,752	613,427	17,489	595,938
1980	All occupations	97,639,355	9,334,048	4,674,871	4,659,177
	Managerial & prof. specialty occup.	22,151,648	1,317,080	546,271	770,809
	Tech. sales & admin. support occup.	29,593,506	2,352,079	712,342	1,639,737
	Service occupations	12,629,425	2,156,194	792,530	1,363,664
	Farming, forestry & fishing occup.	2,811,258	182,190	156,822	25,368
	Precision product, craft & repair occup.	12,594,175	834,947	726,192	108,755
	Operators, fabricators & laborers	17,859,343	2,491,558	1,740,714	750,844
1990	All occupations	127,041,599	12,775,917	6,102,232	6,673,685
	Managerial & prof. specialty occup.	31,266,845	2,156,676	821,977	1,334,699
	Tech. sales & admin. support occup.	38,525,740	3,723,838	1,130,062	2,593,776
	Service occupations	16,567,557	2,886,289	1,179,182	1,707,107
	Farming, forestry & fishing occup.	7,673,495	203,383	175,111	28,272
	Precision product, craft & repair occup.	14,031,300	1,051,714	889,906	161,808
	Operators, fabricators & laborers	18,976,662	2,754,017	1,905,994	848,023

† Methods of improving classification have been implemented by the Bureau of the Census over the years, making comparison of data difficult. A large-scale reworking of the classification system was put in place in 1940 (a partial key is included for that year). In some cases there were changes in title with no change in content. In others there were no changes in title but changes in content. Complete information on changes in occupational classification can be obtained from the Bureau of the Census and, for the 1940 census, from Alba M. Edwards, *Population: Comparative Occupation Statistics for the United States, 1870 to 1940* (Washington, D. C., 1943).

* N.E.C. = Not Elsewhere Classified.

** Key to 1940 Census:

"Operatives and kindred workers" includes apprentices, attendants, brakemen, chauffeurs, conductors, motormen, power-station operators, mechanical workers in manufacturing plants, etc.

"Laborers, except farm and mine" workers includes fishermen and oystermen, longshoremen, lumbermen, laborers (not specified) in manufacturing plants, etc.

"Proprietors, managers, and officials, except farm" workers includes proprietors and managers of transportation and communication utilities, eating and drinking establishments, wholesale companies, advertising and insurance agencies, etc., and postmasters and miscellaneous government officials.

"Clerical, sales, and kindred workers" includes baggagemen, bookkeepers, mail carriers, office-machine operators, telegraph operators, canvassers and solicitors, clerks in stores, and salesmen and saleswomen.

"Craftsmen, foremen, and kindred workers" includes bakers, blacksmiths, boilermakers, carpenters, electricians, and foremen in industry.

"Professional and semiprofessional" workers includes actors, architects, authors, chemists, clergymen, dentists, engineers, lawyers, musicians, pharmacists, teachers, trained nurses, surveyors, etc.

"Service workers, except domestic" workers includes barbers, beauticians, and manicurists, charwomen, janitors, cooks, waiters, etc.

*** Data for 1960 are based on a 5 percent sample.

Source: U.S. Census data, 1890–1990.

TABLE 10.2 **Professional Occupations, 1890–1990**

Year	Professions	Male	Female
1890	Architects	21	0
	Clergymen	12,110	49
	Dentists	118	2
	Lawyers	431	0
	Firemen & engineers (not locomotive)	6,326	0
	Physicians & surgeons	794	115
	Policemen, watchmen & detectives	2,015	4
	Professors in colleges & universities	81	11
	Teachers	7,155	7,853
	Nurses & midwives	323	4,890
1900	Architects	52	0
	Clergymen	15,366	164
	Teachers & professors in colleges, etc.[1]	7,743	13,525
	Dentists	205	7
	Lawyers	718	10
	Physicians & surgeons	1,574	160
	Nurses & midwives	759	18,676
	Watchmen, policemen, firemen, etc.	2,959	35
1910	Architects	56	0
	Clergymen	17,427	68
	Professors in colleges & universities	169	73
	Dentists	452	26
	Firemen (fire department)	321	0
	Lawyers	777	2
	Physicians & surgeons	2,744	333
	Policemen	576	0
	Teachers (school)	6,991	22,441
	Trained nurses	275	2,158
1920	Architects	50	0
	Clergymen	19,343	228
	College presidents & professors	567	496
	Dentists	1,074	35
	Firemen	109	0
	Lawyers, judges & justices	946	4
	Physicians & surgeons	3,430	65
	Policemen	992	7
	Teachers (school)	6,253	29,189
	Trained nurses	142	3,199
1930	Architects	63	0
	Clergymen	24,540	494
	College presidents & professors	1,126	1,020
	Dentists	1,746	27
	Firemen	520	0
	Lawyers, judges & justices	1,223	24
	Physicians & surgeons	3,713	92
	Policemen	1,264	33
	Teachers (school)	8,767	45,672
	Trained nurses	147	5,581
1940	Architects	80	0
	Clergymen	17,102	—
	College presidents, professors & instructors	1,408	931
	Dentists[2]	1,463	123
	Firemen, fire department	519	—
	Lawyers & judges	1,013	39
	Physicians & surgeons	3,395	129
	Policemen, sheriffs & marshalls	1,533	—

TABLE 10.2 Professional Occupations, 1890–1990 (*Continued*)

Year	Professions	Male	Female
	Teachers (N.E.C.) & including county agents[3]	13,585	50,112
	Trained nurses and student nurses	121	6,680
1950	Architects	180	0
	Clergymen	18,090	780
	College presidents, professors & instructors	2,490	1,410
	Dentists	1,620	60
	Firemen, fire protection	1,650	120
	Lawyers & judges	1,410	90
	Physicians & surgeons	3,360	300
	Policemen & detectives	3,720	120
	Teachers (N.E.C.)	18,420	67,500
	Nurses, professional	450	12,720
1960	Architects	142	0
	Clergymen	13,407	508
	College professors & instructors	3,286	2,238
	Dentists	2,261	80
	Firemen	—	—
	Lawyers, judges & justices	2,218	222
	Physicians & surgeons	4,551	487
	Policemen	—	—
	Teachers (school)	32,243	101,609
	Nurses, professional[4]	1,729	31,808
1970	Architects	1,120	195
	Clergymen & religious workers	12,840	1,031
	Dentists	2,218	145
	Firemen, fire protection	4,513	70
	Lawyers & judges	3,309	394
	Physicians, M.D. & osteopathic	5,216	786
	Policemen & detectives	22,716	1,740
	Registered nurses	3,318	59,007
	Teachers, colleges & universities	8,749	7,535
	Teachers, except colleges & universities[5]	49,908	173,502
1980	Architects	2,607	280
	Clergy & religious workers	15,956	2,127
	Dentists	2,707	474
	Firefighting & fire-prevention occupations	12,586	301
	Lawyers & judges	10,206	4,633
	Physicians	10,173	3,218
	Police & detectives	48,576	9,127
	Registered nurses	5,337	89,508
	Teachers, postsecondary	15,010	14,907
	Teachers, except postsecondary	74,409	279,767
1990	Architects	3,711	616
	Clergy & religious workers	21,776	5,029
	Dentists	3,549	1,218
	Firefighting & fire-prevention occupations	20,320	1,201
	Lawyers & judges	15,452	11,868
	Physicians	13,707	7,167
	Police & detectives	86,389	30,978
	Registered nurses	10,444	155,076
	Teachers, postsecondary	18,666	19,201
	Teachers, except postsecondary	89,757	345,801

[1] Includes teachers in schools below collegiate level
[2] Includes dentists, pharmacists, osteopaths, and veterinarians
[3] N.E.C.: Not elsewhere classified
[4] Excludes student professional nurses
[5] Includes adult education, elementary school, prekindergarten
Source: U.S. Bureau of the Census.

11. POLITICS

TABLE 11.1 African-American Ministers Resident and Consuls General to Haiti, 1869–1913

Ebenezer Don Carlos Basset, 1869–1877
John Mercer Langston, 1877–1885
John Edward West Thompson, 1885–1889
Frederick Augustus Washington Bailey Douglass, 1889–1891
John Stephens Durham, 1891–1893
William Frank Powell, 1897–1905
Henry Watson Furniss, 1905–1913*

* Envoy Extraordinary and Minister Plenipotentiary
Source: David Shavit, *The United States in Latin America: A Historical Dictionary*.

TABLE 11.2 African-American Ministers Resident and Consuls General to Liberia, 1871–1948

James Milton Turner, 1871–1878
Henry Highland Garnet, 1881–1882
John Henry Smyth, 1878–1881, 1882–1885
Moses Aaron Hopkins, 1885–1886
Ezekiel Ezra Smith, 1888–1890
Alexander Clark, 1890–1891
William Henry Heard, 1895–1898
Owen Lun West Smith, 1898–1902
Ernest Lyon, 1903–1910
William Demos Crum, 1910–1912
George Washington Buckner, 1913–1915
James L. Curtis, 1915–1917
Joseph Lowry Johnson, 1918–1922
Solomon Porter Hood, 1922–1926
William Treyanne Francis, 1927–1929
Lester Aglar Walton, 1935–1945*
Raphael O'Hara Lanier, 1946–1948*

* Envoy Extraordinary and Minister Plenipotentiary
Source: David Shavit, *The United States in Africa: A Historical Dictionary;* compiled by Erica Judge.

TABLE 11.3 African-American Ambassadors, by Year of Appointment, 1949–1992

Year	Name, Country	Year	Name, Country
1949	Edward R. Dudley, Liberia	1968	Samuel C. Adams, Niger
1953	Jessie D. Locker, Liberia	1969	Clinton E. Knox, Haiti
1955	Richard L. Jones, Liberia	1969	Terence A. Todman, Chad
1959	John Howard Morrow, Guinea	1969	Samuel Z. Westerfield, Liberia
1961	Mercer Cook, Niger	1970	Jerome Heartwell Holland, Sweden
1961	Clifton R. Wharton, Norway	1970	Clarence Clyde Ferguson, Jr., Uganda
1963	Carl T. Rowan, Finland	1971	Charles J. Nelson, Botswana, Lesotho, and Swaziland
1964	Mercer Cook, Senegal	1971	John E. Reinhardt, Nigeria
1964	Clinton E. Knox, Dahomey	1972	W. Beverly Carter, Tanzania
1965	Mercer Cook, Gambia	1972	Terence A. Todman, Guinea
1965	Patricia Roberts Harris, Luxembourg	1973	O. Rudolph Aggrey, Senegal and Gambia
1965	Hugh Smythe, Syrian Arab Republic	1974	David R. Bolen, Botswana, Lesotho, and Swaziland
1965	Franklin H. Williams, Ghana	1974	Theodore R. Britten, Jr., Barbados and Grenada
1966	Elliot P. Skinner, Upper Volta	1974	Terence A. Todman, Costa Rica
1967	Hugh Smythe, Malta	1976	W. Beverly Carter, Liberia

TABLE 11.3 African-American Ambassadors, by Year of Appointment, 1949–1992 (*Continued*)

1976	Ronald D. Palmer, Togo		1983	Terence A. Todman, Denmark
1976	Charles A. James, Niger		1985	Irvin Hicks, Seychelles
1977	O. Rudolph Aggrey, Romania		1985	Edward J. Perkins, Liberia
1977	Maurice D. Bean, Burma		1986	Ronald D. Palmer, Mauritius
1977	David B. Bolen, German Democratic Republic		1986	Edward J. Perkins, South Africa
1977	Richard K. Fox, Jr., Trinidad and Tobago		1986	Cynthia Shepard Perry, Sierra Leone
1977	Ulrich Haynes, Algeria		1988	John A. Burroughs, Jr., Uganda
1977	William B. Jones, Haiti		1988	George E. Moose, Senegal
1977	Wilbert LeMelle, Kenya		1988	Leonard O. Spearman, Sr., Rwanda
1977	Mabel M. Smythe, Cameroon		1989	Cynthia Shepard Perry, Burundi
1977	Andrew Young, United Nations		1989	Stephen Rhodes, Zimbabwe
1978	Terence A. Todman, Spain		1989	Terence A. Todman, Argentina
1979	Horace G. Dawson, Botswana		1989	Howard K. Walker, Madagascar
1979	Anne F. Holloway, Mali		1989	Ruth V. Washington, Gambia*
1979	Donald F. McHenry, United Nations		1989	Johnny Young, Sierra Leone
1980	Walter C. Carrington, Senegal		1990	Aurelia Erskine Brazeal, Micronesia
1980	Barbara Watson, Malaysia		1990	Arlene Render, Gambia
1981	John A. Burroughs, Jr., Malawi		1990	Leonard O. Spearman, Sr., Lesotho
1981	Melvin H. Evans, Trinidad and Tobago		1991	Charles R. Baquet III, Djibouti
1981	Ronald D. Palmer, Malaysia		1991	Johnnie Carson, Uganda
1981	Gerald E. Thomas, Guyana		1992	Ruth A. Davis, Benin
1982	Howard K. Walker, Togo		1992	Kenton Wesley Keith, Qatar
1983	Arthur W. Lewis, Sierra Leone		1992	Edward J. Perkins, United Nations
1983	George E. Moose, Benin		1992	Joseph Monroe Segars, Cape Verde
1983	Gerald E. Thomas, Guyana			

* Killed in car accident en route to post.
Source: Office of Equal Employment Opportunity and Civil Rights, U.S. Department of State.

TABLE 11.4 African Americans in the U.S. Congress, 1870–1993

U.S. Senate		John M. Langston (R-VA)	1890–91
Hiram R. Revel (R-MS)	1870–71	Thomas E. Miller (R-SC)	1890–91
Blanche K. Bruce (R-MS)	1875–81	George W. Murray (R-SC)	1893–95; 96–97
Edward W. Brooke (R-MA)	1967–79	George W. White (R-NC)	1897–1901
Carol Moseley-Braun (D-IL)	1993–	Oscar DePriest (R-IL)	1929–35
		Arthur W. Mitchell (D-IL)	1935–43
U.S. House of Representatives		William L. Dawson (D-IL)	1943–70
		Adam C. Powell, Jr. (D-NY)	1945–67; 69–71
Joseph H. Rainey (R-SC)	1870–79	Charles C. Diggs, Jr. (D-MI)	1955–80
Jefferson F. Long (R-GA)	1870–71	Robert N. C. Nix (D-PA)	1958–78
Robert B. Elliot (R-SC)	1871–74	Augustus F. Hawkins (D-CA)	1963–90
Robert C. DeLarge (R-SC)	1871–73	John Conyers, Jr. (D-MI)	1965–
Benjamin S. Turner (R-AL)	1871–73	William L. Clay (D-MO)	1969–
Josiah T. Walls (R-FL)	1871–73	Louis Stokes (D-OH)	1969–
Richard H. Crane (R-SC)	1873–75; 77–79	Shirley A. Chisholm (D-NY)	1969–82
John R. Lynch (R-MS)	1873–77; 82–83	George W. Collins (D-IL)	1970–72
James T. Rapier (R-AL)	1873–75	Ronald V. Dellums (D-CA)	1971–
Alonzo J. Ransier (R-SC)	1873–75	Ralph H. Metcalfe (D-IL)	1971–78
Jeremiah Haralson (R-AL)	1875–77	Parren H. Mitchell (D-MD)	1971–86
John A. Hyman (R-NC)	1875–77	Charles B. Rangel (D-NY)	1971–
Charles E. Nash (R-LA)	1875–77	Walter E. Fauntroy (D-DC)*	1971–90
Robert Smalls (R-SC)	1875–79	Yvonne B. Burke (D-CA)	1973–79
James E. O'Hara (R-NC)	1883–87	Cardiss Collins (D-IL)	1973–
Henry P. Cheatham (R-NC)	1889–93	Barbara C. Jordan (D-TX)	1973–78

TABLE 11.4 African Americans in the U.S. Congress, 1870–1993 (*Continued*)

Andrew J. Young (D-GA)	1973–77	Gary A. Franks (R-CT)	1991–
Harold E. Ford (D-TN)	1975–	William J. Jefferson (D-LA)	1991–
Bennett M. Steward (D-IL)	1979–80	Eleanor H. Norton (D-DC)*	1991–
Julian C. Dixon (D-CA)	1979–	Maxine Waters (D-CA)	1991–
William H. Gray (D-PA)	1979–91	Lucian E. Blackwell (D-PA)	1991–
Mickey Leland (D-TX)	1979–89	Sanford Bishop (D-GA)	1993–
Melvin Evans (R-V.I.)*	1979–80	Corrine Brown (D-FL)	1993–
George W. Crockett Jr. (D-MI)	1980–90	Eva M. Clayton (D-NC)	1993–
Mervyn M. Dymally (D-CA)	1981–92	James E. Clyburn (D-SC)	1993–
Gus Savage (D-IL)	1981–92	Cleo Fields (D-LA)	1993–
Harold Washington (D-IL)	1981–83	Alcee L. Hastings (D-FL)	1993–
Katie B. Hall (D-IN)	1982–84	Earl F. Hilliard (D-AL)	1993–
Major R. Owens (D-NY)	1983–	Eddie B. Johnson (D-TX)	1993–
Edolphus Towns (D-NY)	1983–	Cynthia McKinney (D-GA)	1993–
Alan Wheat (D-MO)	1983	Carrie Meek (D-FL)	1993–
Charles A. Hayes (D-IL)	1983–92	Mel Reynolds (D-IL)	1993–95
Alton R. Waldon, Jr. (D-NY)	1986–87	Bobby L. Rush (D-IL)	1993–
Mike Espy (D-MS)	1987–93	Robert C. Scott (D-VA)	1993–
Floyd H. Flake (D-NY)	1987–	Walter R. Tucker III (D-CA)	1993–
John Lewis (D-GA)	1987–	Melvin Watt (D-NC)	1993–
Kweisi Mfume (D-MD)	1987–	Albert R. Wynn (D-MD)	1993–
Donald M. Payne (D-NJ)	1989–	Bennie G. Thompson (D-MS)	1993–
Craig A. Washington (D-TX)	1989–		
Barbara R. Collins (D-MI)	1991–		

* Indicates members of Congress with restricted voting.

TABLE 11.5 African-American Federal Judges, by Appointing President, 1937–1994

Franklin D. Roosevelt (1933–1945)
 1937 William H. Hastie (1904–1976) District of Virgin Islands; see 1949
 1939 Herman E. Moore (1892–1980) District of Virgin Islands

Harry Truman (1945–1953)
 1945 Irwin C. Mollison (1898–1962) Customs Court
 1949 William H. Hastie (1904–1976) 3rd Circuit (PA)

Dwight D. Eisenhower (1953–1961)
 1957 Scovel Richardson (1912–1982) Customs Court
 1958 Walter A. Gordon (1895–1976) 3rd Circuit (V.I.)

John F. Kennedy (1961–1963)
 1961 Thurgood Marshall (1908–1993) 2nd Circuit (NY); see 1967
 Wade H. McCree (1920–1987) Eastern District of Michigan; see 1966
 James B. Parsons (1911–1993) Northern District of Illinois

Lyndon B. Johnson (1963–1969)
 1964 A. Leon Higginbotham (1928–) 3rd Circuit (PA); see 1977
 Spottswood W. Robinson (1916–) D.C. Circuit
 1965 William B. Bryant (1911–) D.C. Circuit
 1966 Wade H. McCree (1920–1987) 6th Circuit (MI)
 Constance B. Motley (1921–) Southern District of New York
 Aubrey E. Robinson, Jr. (1922–) District of Columbia
 James L. Watson (1922–) Customs Court
 1967 Damon Keith (1922–) 6th Circuit (MI)
 Thurgood Marshall (1908–1993) U.S. Supreme Court
 Joseph C. Waddy (1911–) District of Columbia

Richard Nixon (1969–1974)
 1969 Almeric L. Christian (1919–) 3rd Circuit (V.I.)
 Barrington Parker (1915–1993) District of Columbia
 David W. Williams (1910–) Southern District of California
 1971 Clifford Scott Green (1923–) Eastern District of Pennsylvania
 Lawrence W. Pierce (1924–) Southern District of New York; see 1981

TABLE 11.5 African-American Federal Judges, by Appointing President, 1937–1994 (*Continued*)

1972	Robert L. Carter (1917–)	Southern District of New York
	Robert M. Duncan (1927–)	Military Court of Appeals

Gerald Ford (1974–1977)

1974	Henry Bramwell (1919–)	Eastern District of New York
	Robert M. Duncan (1927–)	Southern District of Ohio
1976	Matthew Perry, Jr. (1921–)	Military Court of Appeals
	George N. Leighton (1912–)	Northern District of Illinois
	Cecil F. Poole (1914–)	Northern District of California; see 1979

James Carter (1977–1981)

1977	A. Leon Higginbotham (1928–)	3rd Circuit (PA)
	Damon Keith (1922–)	Eastern District of Michigan
1978	Robert F. Collins (1931–)	Eastern District of Louisiana
	Julian A. Cooke, Jr. (1930–)	Eastern District of Michigan
	Mary Johnson Lowe (1924–)	Southern District of New York
	Theodore McMillian (1919–)	8th Circuit (MO)
	David S. Nelson (1933–)	District of Massachusetts
	Paul A. Simmons (1921–)	Western District of Pennsylvania
	Jack E. Tanner (1919–)	Western District of Washington
1979	J. Jerome Farris (1930–)	9th Circuit (WA)
	Benjamin F. Gibson (1931–)	Western District of Michigan
	James T. Giles (1943–)	Eastern District of Pennsylvania
	Alcee L. Hastings (1936–)*	11th Circuit (FL)
	Joseph W. Hatchett (1932–)	11th Circuit (FL)
	Terry Hatter, Jr. (1933–)	Central District of California
	Joseph C. Howard (1922–)	D.C. Circuit
	Nathaniel R. Jones (1926–)	6th Circuit (OH)
	Amalya L. Kearse (1937–)	2nd Circuit (NY)
	Gabrielle Kirk McDonald (1942–)	Southern District of Texas
	John Garrett Penn (1932–)	District of Columbia
	Matthew Perry, Jr. (1921–)	District of South Carolina
	Cecil F. Poole (1914–)	9th Circuit (CA)
	Anna Diggs Taylor (1932–)	Eastern District of Michigan
	Anne E. Thompson (1934–)	District of New Jersey
	Horace T. Ward (1927–)	Northern District of Georgia
1980	Clyde S. Cahill, Jr. (1923–)	Eastern District of Missouri
	U. W. Clemon (1943–)	Northern District of Alabama
	Harry T. Edwards (1940–)	D.C. Circuit
	Richard C. Erwin (1923–)	Middle District of North Carolina
	Earl B. Gilliam (1931–)	Southern District of California
	Thelton E. Henderson (1933–)	Northern District of California
	Odell Horton (1929–)	Western District of Tennessee
	George Howard, Jr. (1924–)	Eastern District of Arkansas
	Norma H. Johnson (1932–)	District of Columbia
	Consuela B. Marshall (1936–)	Central District of California
	Myron H. Thompson (1947–)	Middle District of Alabama
	George White (1931–)	Northern District of Ohio

Ronald Reagan (1981–1989)

1981	Lawrence W. Pierce (1924–)	2nd Circuit (NY)
1982	Reginald Gibson (1927–)	U.S. Court of Claims
1984	John R. Hargrove (1923–)	District of Maryland
1985	Ann C. Williams (1949–)	Northern District of Illinois
	Henry T. Wingate (1947–)	Southern District of Mississippi
1986	James R. Spencer (1949–)	Eastern District of Virginia
1988	Kenneth M. Hoyt (1948–)	Southern District of Texas
	Herbert J. Hutton (1937–)	Eastern District of Pennsylvania

George Bush (1989–1993)

| 1990 | Clarence Thomas (1948–) | D.C. Circuit; see 1991 |

TABLE 11.5 African-American Federal Judges, by Appointing President, 1937–1994 (*Continued*)

	James Ware (1946–)	Northern District of California
1991	Saundra Brown Armstrong (1947–)	Northern District of California
	Fernando Gaitan (1948–)	Western District of Missouri
	Donald Graham (1948–)	Southern District of Florida
	Curtis Joyner (1948–)	Eastern District of Pennsylvania
	Joe McDade (1937–)	Central District of Illinois
	Clarence Thomas (1948–)	U.S. Supreme Court
1992	Garland Burrell (1947–)	Eastern District of California
	Carol E. Jackson (1952–)	Eastern District of Missouri
	Sterling Johnson (1934–)	Eastern District of New York
	Timothy Lewis (1954–)	3rd Circuit (PA)

William Clinton (1993–)

1993	Henry Lee Adams	Middle District of Florida
	Wilkie Ferguson	Southern District of Florida
	Raymond Jackson	Eastern District of Virginia
	Gary Lancaster	Western District of Pennsylvania
	Reginald Lindsay	District of Massachusetts
	Charles Shaw	Eastern District of Missouri
1994	Deborah Batts	Southern District of New York
	Franklin Burgess	Western District of Washington
	Audrey Collins	Central District of California
	Clarence Cooper	Northern District of Georgia
	Michael Davis	District of Minnesota
	Raymond Finch	District of Virgin Islands
	Vanessa Gilmore	Southern District of Texas
	Ancer Haggerty	District of Washington
	Theodore McKee	3rd Circuit
	Solomon Oliver, Jr.	Northern District of Ohio
	Judith Rogers	D.C. Circuit
	W. Louis Sands	Middle District of Georgia
	Emmet Sullivan	District of Columbia
	Carl E. Stewart	5th Circuit

* Impeached in 1988.
Sources: The Alliance for Justice, 1601 Connecticut Avenue, N.W. Suite 600, Washington, D.C. 20009; *Almanac of the Federal Judiciary: Profiles of All Active United States District Court Judges* (Chicago, Ill., 1993); Iris Cloyd, ed., *Who's Who Among Black Americans* (Detroit, Mich., 1990).

TABLE 11.6 African-American Mayors of Cities with Populations over 50,000, 1967–1993

Ann Arbor, Mich.	Albert Wheeler	1975–1978
Atlanta, Ga.	Maynard H. Jackson	1973–1982
	Andrew J. Young	1982–1990
	Maynard H. Jackson	1990–1993
	Keith Campbell	1994– [1]
Baltimore, Md.	Clarence H. "Du" Burns	1987
	Kurt L. Schmoke	1987–
Berkeley, Calif.	Warren H. Widener	1971–1979
	Eugene "Gus" Newport	1979–1986
Birmingham, Ala.	Richard Arrington, Jr.	1979–
Boulder, Colo.	Penfield W. Tate III	1974–1976
Cambridge, Mass.	Kenneth S. Reeves	1990–
Camden, N.J.	Melvin R. Primas, Jr.	1981–1990
	Aaron Thompson	1990–1993
	Arnold Webster	1993–
Carson, Calif.[2]	Clarence A. Bridgers	1975
	Thomas G. Mills	1982

TABLE 11.6 African-American Mayors of Cities with Populations over 50,000, 1967–1993 (Continued)

City	Mayor	Term
Chandler, Ariz.	Coy Payne	1990–
Charlotte, N.C.	Harvey B. Gantt	1983–1987
Chicago, Ill.	Harold Washington	1983–1987
	Eugene Sawyer	1987–1991
Cincinnati, Ohio	Theodore M. Berry	1972–1975
	John K. Blackwell	1979–1980
	Dwight Tillery	1991–1993
Cleveland, Ohio	Carl B. Stokes	1967–1971
	Michael R. White	1990–
Compton, Calif.	Douglas F. Dollarhide	1969–1973
	Doris A. Davis	1973–1977
	Lionel Cade	1977–1981
	Walter R. Tucker III	1981–1992
	Bernice Wood (interim appt.)	1992–1993
	Omar Bradley	1993–
Dayton, Ohio	James H. McGee	1970–1982
	Richard Clay Dixon	1989–1993
Denver, Colo.	Wellington E. Webb	1991–
Detroit, Mich.	Coleman A. Young	1974–1993
	Dennis Archer	1993–
East Orange, N.J.	William S. Hart, Sr.	1970–1978
	Thomas H. Cooke	1978–1985
	John Hatcher, Jr.	1985–1989
	Cardell Cooper	1990–
East St. Louis, Ill.	James E. Williams, Sr.	1971–1975
	William E. Mason	1975–1979
	Carl E. Officer	1979–1991
	Gordon D. Bush	1991–
Evanston, Ill.	Lorraine H. Morton	1993–
Flint, Mich.	James A. Sharp	1984–1987
	Stanley Woodrow	1991–
Gary, Ind.	Richard G. Hatcher	1967–1988
	Thomas Barnes	1988–
Grand Rapids, Mich.	Lyman S. Parks	1973–1975
Hartford, Conn.	Thirman L. Milner	1981–1987
	Carrie Perry	1987–1993
Inglewood, Calif.	Edward Vincent	1985–
Irvington, N.J.	Michael Steele	1990–1994
Kansas City, Mo.	Emanuel Cleaver II	1991–
Little Rock, Ark.	Charles Bussey	1981–1982
	Lottie Shakelford	1987–1988
Los Angeles, Calif.	Thomas Bradley	1973–1993
Memphis, Tenn.	Willie Herenton	1991–
Minneapolis, Minn.	Sharon Sayles Belton	1994–
Mt. Vernon, N.Y.	Ronald A. Blackwood	1985–
New Haven, Conn.	John C. Daniels, Jr.	1990–
New Orleans, La.	Ernest N. "Dutch" Morial	1978–1986
	Sidney Barthelemy	1986–
New York, N.Y.	David Dinkins	1990–1994
Newark, N.J.	Kenneth A. Gibson	1970–1986
	Sharpe James	1986–
Newport News, Va.	Jessie M. Rattley	1986–1990
Oakland, Calif.	Lionel J. Wilson	1977–1990
	Elihu M. Harris	1992–
Pasadena, Calif.	Loretta Thompson-Glickman	1982–1984
Philadelphia, Pa.	Wilson Goode	1983–1991
Pompano Beach, Fla.	Pat Larkins	1985–1989

TABLE **11.6** **African-American Mayors of Cities with Populations over 50,000, 1967–1993** (*Continued*)

Pontiac, Mich.	Wallace E. Holland	1974–1986
	Walter L. Moore	1986–1989
	Wallace E. Holland	1989–1993
	Charles Harrisson	1994–
Portsmouth, Va.	James W. Holley	1984–1987
Raleigh, N.C.	Clarence Lightner	1973–1975
Richmond, Calif.	Booker T. Anderson	1969–1975
	George Livingston	1985–
Richmond, Va.	Henry L. Marsh III	1977–1982
	Roy A. West	1982–1988
	Walter T. Kenney	1990–
Roanoke, Va.	Noel C. Taylor	1975–
Rochester, N.Y.	William Johnson	1994–
Rockford, Ill.	Charles E. Box	1989–
Saginaw, Mich.	S. Joe Stephens	1977–1979
	Lawrence D. Crawford	1983–1987
	Henry Nickelberry	1989–1993
	Gary Loster	1994–
Santa Monica, Calif.	Nathaniel Trives	1975–1979
Seattle, Wash.	Norman B. Rice	1990–
Spokane, Wash.	James Chase	1982–1985
St. Louis, Mo.	Freeman Bosley, Jr.	1993–
Tallahassee, Fla.[2]	James R. Ford	1972, 1976, 1982
	Jack McLean	1986
	Dorothy J. (Lee) Inman	1989, 1993
Trenton, N.J.	Douglas H. Palmer	1990–
Washington, D.C.[3]	Walter E. Washington	1974–1979
	Marion S. Barry, Jr.	1979–1990
	Sharon Pratt Kelly	1990–
West Palm Beach, Fla.	Eva W. Mack	1982–1984
	Samuel A. Thomas	1986–1987
	James Poole	1989–1991
Wichita, Kans.	Price Woodard	1970–1971
Wilmington, Del.	James H. Sills, Jr.	1993–

[1] As of December 31, 1993.
[2] City council members of these cities each serve mayoral terms of one year at a time.
[3] Washington, D.C., began holding mayoral elections in 1974.

TABLE **11.7** **Voting-Age Population, Percent Reporting Registered, 1976–1990**

			% Registered				% Voted			
	Population (in Millions)		Presidential Election Years		Congressional Election Years		Presidential Election Years		Congressional Election Years	
Year	Total	Black	Total	Black	Total	Black	Total	Black	Total	Black
1976	146.5	14.9	66.7	58.5	—	—	59.2	48.7	—	—
1978	151.6	15.6	—	—	62.6	57.1	—	—	45.9	37.2
1980	157.1	16.4	66.9	60.0	—	—	59.2	50.5	—	—
1982	165.5	17.6	—	—	64.1	59.1	—	—	48.8	43.0
1984	170.0	18.4	68.3	66.3	—	—	59.9	55.8	—	—
1986	173.9	19.0	—	—	64.3	64.0	—	—	46.0	43.2
1988	178.1	19.7	66.6	64.5	—	—	57.4	51.5	—	—
1990	182.1	20.4	—	—	62.2	58.8	—	—	45.0	39.2

Source: U.S. Bureau of the Census, *Current Population Reports,* Series P-20, no. 453, and earlier reports.

TABLE 11.8 African-American Suffrage, 1607–1860

Before the start of the Civil War and in particular before the adoption of the Fifteenth Amendment (1870), suffrage was regulated by state constitutions, statutes, and local ordinances. Suffrage in almost all states was limited to males in this period. Black suffrage extended only to free blacks; slaves were never allowed to vote. Unless otherwise indicated, changes in requirements were brought about by statute.

Virginia
1607 Colony established; male suffrage granted without racial qualification
1670 Property requirement imposed on suffrage
1705 Blacks and mulattoes forbidden to "bear any office" or "be in any place of public trust or power"
1723 Suffrage denied to blacks
1762 Black disfranchisement reaffirmed
1776 Statehood, black disfranchisement reaffirmed
1830 State constitution, black disfranchisement reaffirmed, vote limited to "every white male citizen"

Massachusetts
1630 Colony established; male suffrage granted without racial qualification
1776 Statehood; male suffrage without racial qualification reaffirmed

Rhode Island
1634 Colony established; male suffrage granted without racial qualification
1776 Statehood; male suffrage without racial qualification reaffirmed
1822 Suffrage restricted to existing free black voters
1836 Suffrage denied to blacks
1842 Male suffrage granted without racial qualification

Maryland
1634 Colony established; male suffrage granted without racial qualification
1776 Statehood; male suffrage without racial qualification reaffirmed
1783 Suffrage restricted to existing free black voters
1801 Suffrage denied to blacks
1809 Disfranchisement of blacks reaffirmed
1810 State constitution; disfranchisement of blacks reaffirmed

Connecticut
1636 Colony established; male suffrage granted without racial qualification
1776 Male suffrage without racial qualification reaffirmed
1818 Suffrage denied to blacks

North Carolina
1663 Colony established; male suffrage granted without racial qualification
1715 Suffrage denied to blacks
1776 Statehood; suffrage not explicitly denied to blacks
1835 State constitution; suffrage denied to blacks

South Carolina
1663 Colony established; male suffrage granted without racial qualification
1701 Some record of "aliens, strangers, servants and free Negroes" voting in elections for governor (also 1703)
1716 Suffrage denied to blacks in act granting vote to "every white man and no other" possessing requisite qualifications
1745 Black disfranchisement reaffirmed
1776 Statehood; black disfranchisement reaffirmed

New York
1664 Colony established as English take New Netherlands from the Dutch; male suffrage granted without racial qualification
1776 Statehood; male suffrage without racial qualification reaffirmed
1821 State constitution; property requirement eliminated for whites but retained for blacks

New Jersey
1665 Colony established; suffrage granted without racial qualification; female suffrage not explicitly denied
1776 Statehood; suffrage to "all inhabitants of this colony" with requisite property, age, and residence qualifications reaffirmed
1807 Suffrage denied to blacks
1834 Constitution, black disfranchisement reaffirmed

New Hampshire
1680 Colony established; male suffrage granted without racial qualification
1776 Statehood; male suffrage without racial qualification reaffirmed

Pennsylvania
1682 Colony established; male suffrage granted without racial qualification
1776 Statehood; male suffrage without racial qualification reaffirmed
1836 Judicial ruling, suffrage denied to blacks
1838 State constitution, black disfranchisement reaffirmed

Delaware
1682 Colony established (as part of Pennsylvania); male suffrage granted without racial qualification
1776 Statehood; male suffrage without racial qualification reaffirmed
1787 Suffrage reaffirmed for free-born blacks, denied to manumitted slaves
1792 Suffrage denied to blacks

Georgia
1733 Colony established; male suffrage granted without racial qualification
1761 Suffrage denied to blacks
1776 Statehood; black disfranchisement reaffirmed

Vermont
1791 Statehood; male suffrage granted without racial qualification

Kentucky
1792 Statehood; male suffrage granted without racial qualification
1799 Suffrage denied to blacks
1834 State constitution; black disfranchisement reaffirmed

Tennessee
1796 Statehood; male suffrage granted without racial qualification
1834 State constitution, suffrage denied to blacks

Ohio
1802 Statehood; male suffrage granted without racial qualification
1803 State constitution, suffrage denied to blacks

Washington, D.C.
1802 City incorporated; suffrage denied to blacks

Louisiana
1812 Statehood; suffrage denied to blacks

Indiana
1816 Statehood; suffrage denied to blacks

Mississippi
1817 Statehood; suffrage denied to blacks

Illinois
1818 Statehood; suffrage denied to blacks

Alabama
1819 Statehood; suffrage denied to blacks

Missouri
1820 Statehood; suffrage denied to blacks

Maine
1820 Statehood; male suffrage granted without racial qualification

Arkansas
1836 Statehood; suffrage denied to blacks

Michigan
1837 Statehood; suffrage denied to blacks

Florida
1845 Statehood; suffrage denied to blacks

Texas
1845 Statehood; suffrage denied to blacks

Iowa
1846 Statehood; suffrage denied to blacks

Wisconsin
1848 Statehood; suffrage denied to blacks
1849 Referendum; suffrage granted to blacks (not enforced until 1866)

California
1850 Statehood; suffrage denied to blacks

Minnesota
1858 Statehood; suffrage denied to blacks

Oregon
1859 Statehood; suffrage denied to blacks

TABLE 11.9 Chronology of African-American Voting Rights and Milestones, 1861–1993

1861 The Civil War begins. Thirty-four states are in the Union. Maine, New Hampshire, Vermont, Massachusetts, Rhode Island, and New York are the only states which permit free black males to vote.

1863 West Virginia, whose constitution bans black suffrage, is admitted to the Union.

1864 Nevada, whose constitution bans black suffrage, is admitted to the Union.

1865 The Civil War ends. The Thirteenth Amendment to the U.S. Constitution, which abolishes slavery, is ratified. The ex-Confederate states adopt new constitutions which abolish slavery, but they refuse to enfranchise blacks. Wisconsin, Kansas, Colorado Territory, Minnesota, and Connecticut voters defeat black suffrage propositions.

1866 Civil Rights Act passed by Congress fails to include suffrage.

Congress passes a bill enfranchising blacks in District of Columbia, but the act is defeated in a popular referendum by a vote of 6,591–35.

The proposed Fourteenth Amendment to the Constitution guaranteeing black citizenship is rejected by all southern states except Tennessee, which enfranchises blacks.

Wisconsin grants blacks suffrage.

1867 First Reconstruction Act is passed, dissolving ex-Confederate state governments and obligating them to grant black suffrage as a condition for rejoining the Union. Interim governments in eleven southern states enfranchise blacks.

Nebraska, whose constitution bans black suffrage, is admitted to statehood. Ohio rejects black suffrage. Iowa and the Dakota Territory enfranchise blacks. Congress rejects Colorado statehood petition because of black suffrage denial and enfranchises the territory's black residents.

1868 The Fourteenth Amendment to the U.S. Constitution, which guarantees blacks citizenship and reduces the congressional representation of any state which denies suffrage on racial grounds, is ratified.

Nevada, Illinois, and Minnesota grant black suffrage. Missouri and Michigan defeat suffrage proposals.

J. H. Rainey and J. F. Long become the first blacks elected to Congress.

1869 Ohio rejects a black suffrage proposition. California grants black suffrage.

Georgia expels its black state legislators, who are readmitted by Congress under constitutional guarantee of republican form of government.

1870 Ohio and Michigan grant black suffrage. The Fifteenth Amendment to the U.S. Constitution, which guarantees that "[t]he right of citizens of the United States to vote shall not be denied or abridged by the United States or by any state on account of race, color, or previous condition of servitude," is ratified.

As a result of the amendment, Wyoming Territory, which had granted women the vote one year previously, becomes the first polity to enfranchise black women.

Congress passes the First Enforcement Act (commonly called Force Act) to prevent infringement of the right to vote.

1871 The Second Force Act provides for federal supervision of voter registration and federal elections to prevent fraud and black exclusion.

1874 Virginia reapportions its electoral districts to dilute black voting power. It will do so four more times in the following seventeen years.

1875 In *United States* v. *Reese* the U.S. Supreme Court holds that the Force Acts do not cover voter registration, claiming the Fifteenth Amendment merely guarantees suffrage. The decision severely limits the amendment's scope.

1877 End of Reconstruction. Republican parties are removed from power in ex-Confederate states. Black voting is reduced through violence and fraud.

1878 Georgia establishes a poll tax. Though ostensibly nonracial, it is often applied discriminatorily and limits black voting.

1882 South Carolina passes the "eight box" law, requiring separate ballots and boxes for different elections, as well as a residency requirement and a clause requiring unregistered voters to register within thirty days or face permanent disfranchisement. The law disproportionately affects blacks.

1884 In *ex parte Yarborough* the U.S. Supreme Court upholds the convictions of whites who violently obstruct black men from voting.

1889 Florida establishes a poll tax.

1890 Mississippi and Tennessee establish poll taxes, which disfranchise almost all of the state's black population. Mississippi also establishes a literacy test and residency requirement for voting and disfranchisement for minor offenses. Officials enforce such laws selectively to eliminate black voting.

Henry Cabot Lodge, Massachusetts congressman, introduces a bill providing for federal supervision of national elections. It passes the House but is killed in the Senate without a vote.

1891 Arkansas passes "electoral reform" bill with a secret ballot and other measures designed to intimidate illiterates and discourage black voting.

1892 Arkansas establishes a poll tax.

1894 U.S. Congress repeals the section of 1871 Force Act providing for federal marshals in voter registration cases.

1895 South Carolina establishes a poll tax, residency requirement, and other measures which disfranchise most of its black population.

1896 South Carolina Democrats adopt a "white primary," excluding blacks from primary elections. Louisiana establishes a poll tax, property requirement, and literacy test for voting.

1898 In *Williams* v. *Mississippi* U.S. Supreme Court upholds the constitutionality of poll taxes.

Georgia Democrats adopt a white primary. Louisiana passes a "grandfather clause," temporarily exempting those eligible to vote in 1867 and their legal descendants from voting requirements, thus excluding blacks but enfranchising poor whites.

George White is elected to Congress from North Carolina, becoming the last southern black congressman for seventy years.

1900 North Carolina establishes a poll tax, literacy test, and property requirements with a grandfather clause.

1901 Alabama establishes a poll tax, literacy test, and property requirements with a grandfather clause. Florida and Tennessee Democrats adopt white primaries. Virginia establishes a poll tax.

1902 Alabama and Mississippi Democrats adopt white primaries. Virginia establishes property requirements and a literacy test with a grandfather clause.

1903 In *James* v. *Bowman* the U.S. Supreme Court rules the Fifteenth Amendment does not cover nonofficial action. Kentucky and Texas Democrats adopt white primaries. Texas establishes a poll tax.

1904 In *Giles* v. *Harris* and *Giles* v. *Teasley* (companion test cases both secretly funded by Booker T. Washington), U.S. Supreme Court refuses for technical reasons to address disfranchisement provisions of Alabama constitution.

1905 Texas allows districts the option of running white primaries.

1906 Oklahoma admitted to statehood, despite a white primary and franchise limits. Louisiana and Arkansas Democrats adopt white primaries.

1907 Georgia establishes a literacy test and other strict suffrage restrictions along with a grandfather clause.

1910 Oklahoma adds a permanent grandfather clause to the suffrage requirements in its constitution.

1913 Virginia Democrats adopt a white primary.

1915 In *Guinn* v. *United States* the U.S. Supreme Court rules that Oklahoma's permanent grandfather clause is unconstitutional. State officials respond by providing a one-time, twelve-day registration period for those previously excluded by the laws. This act bars most blacks from voting for a generation.

1920 The Nineteenth Amendment to the Constitution is ratified. It enfranchises black (as well as white) women.

1927 In *Nixon* v. *Herndon* the U.S. Supreme Court strikes down a Texas law forbidding blacks to vote in Democratic primary elections as a violation of Fourteenth Amendment.

1928 Chicago's Oscar DePriest becomes the first black congressman in twenty-eight years and the first from the North.

1932 In *Nixon* v. *Condon* U.S. Supreme Court rules that Texas state Democratic Party committee rules barring blacks from party primaries constitute unconstitutional state action. Texas responds by severing legal connections with the state Democratic party convention, which subsequently votes to exclude black voters.

1934 Chicago's Arthur Mitchell becomes the first black Democrat elected to Congress.

1935 In *Grovey* v. *Townsend* the U.S. Supreme Court approves the Texas white primary, ruling that the state Democratic party is a private organization and its exclusion of black voters is not impermissible state action.

1938 In *Lane* v. *Wilson* the U.S. Supreme Court invalidates Oklahoma's 1915 twelve-day voter registration limit, noting that the Fifteenth Amendment forbids "sophisticated as well as simpleminded modes of discrimination."

1944 In *Smith* v. *Allwright* the U.S. Supreme Court overrules *Grovey* and strikes down the white primary, ruling that party elections constitute state action.

1949 In *Davis* v. *Schnell* the U.S. Supreme Court invalidates Alabama's 1946 "Boswell Amendment," which requires voters to "understand and explain" sections of the U.S. Constitution to the registrar's satisfaction, ruling it an overly vague standard which grants registrars arbitrary power.

1953 In *Terry* v. *Adams* the U.S. Supreme Court strikes down a white primary by an "unofficial" Democratic faction in Texas.

1957 The Civil Rights Act of 1957 amends the U.S. Code to protect the right to vote in all elections and empowers the U.S. Justice Department to bring voter discrimination suits in federal court.

1960 The Civil Rights Act of 1960 allows judges to

appoint referees to register and protect voters in federal elections.

In Fayette County, Tenn., blacks attempting to register to vote are fired and evicted from their homes and sit in in the town square. With federal assistance they succeed in obtaining an injunction blocking further interference.

In *United States* v. *Raines* the U.S. Supreme Court rules that groups of white citizens in Louisiana may not challenge the registration of other voters. In *Gomillion* v. *Lightfoot* the Court annuls a Tuskegee, Ala., plan gerrymandering city boundaries to eliminate most black voting.

1961 Student Nonviolent Coordinating Committee (SNCC) sets up a voter education project to register voters in Mississippi and other Southern states.

The Twenty-third Amendment to the U.S. Constitution, granting residents of the heavily black District of Columbia the vote in presidential elections, is ratified.

1963 Blacks in Mississippi organize unofficial elections using "freedom ballots" to protest voting discrimination.

1964 Twenty-fourth Amendment to the U.S. Constitution, which outlaws poll taxes in federal elections, is ratified. Only four states still require poll taxes.

Mississippi Freedom Democratic party unsuccessfully challenges state Democratic party discrimination at national party convention.

1965 Southern Christian Leadership Conference (SCLC) and SNCC launch voting rights campaign in Selma, Ala. A march from Selma to Montgomery is violently turned back by police, but a second march, followed by a rally in Montgomery, proceeds with federal protection. The Voting Rights Act of 1965 authorizes federal officials to register voters. In those states which have voting qualifications and where less than half of the voting-age population is registered, qualifications for voting are suspended for five years, and new qualifications, practices, or procedures may only be enacted with the approval of the U.S. attorney general or a federal district court.

Mississippi Freedom Democratic party mounts an unsuccessful legal challenge to election of white representatives due to voting discrimination in five Mississippi districts where freedom balloting occurred.

1966 Edward Brooke of Massachusetts becomes the first black to be popularly elected to the U.S. Senate.

In *South Carolina* v. *Katzenbach* the U.S. Supreme Court upholds the constitutionality of the Voting Rights Act of 1965 and declares Virginia's poll tax unconstitutional.

Carl Stokes of Cleveland is elected as the first black mayor of a large city.

1868 New York City's Shirley Chisholm is elected the first black congresswoman.

1969 In *Allen* v. *Board of Elections* the U.S. Supreme Court rules the federal approval provisions of the Voting Rights Act of 1965 apply to redistricting, urban annexations of surrounding suburbs, institution of at-large elections, or other measures which have the effect of diluting minority votes.

1970 Voting Rights Act is extended for five years. Literacy tests and extended residency requirements are banned nationwide.

1971 The black-majority District of Columbia elects its first nonvoting delegate to Congress.

1972 Andrew Young of Georgia and Barbara Jordan of Texas become the first southern blacks elected to Congress in the twentieth century.

1975 The Voting Rights Act extended for seven years. Literacy tests are permanently banned.

In *Richmond* v. *United States* the U.S. Supreme Court rules that cities with at-large voting must adopt a ward system to maximize the number of black-majority districts.

1977 In *United Jewish Organizations* v. *Carey* the U.S. Supreme Court rules that, under the provisions of the Voting Rights Act, race-conscious apportionment using numerical quotas to increase minority voting strength is constitutional.

1978 Marion Barry becomes first elected mayor of Washington, D.C.

1980 In *Mobile* v. *Bolden* U.S. Supreme Court rules that electoral failure of black candidates is insufficient proof of voting discrimination. In *Rome* v. *United States* the Court rules the Voting Rights Act's preclearance strictures apply even to measures which unintentionally lead to discrimination.

1982 Voting Rights Act is extended twenty-five years. States are required to eliminate procedures with discriminatory effect and to draw electoral district lines to maximize minority voting strength. Numerous black-majority electoral districts will be created in succeeding years.

1985 A constitutional amendment to grant full voting privileges to residents of District of Columbia fails to achieve ratification by the required three-quarters of states.

1992 Carol Moseley-Braun of Illinois becomes the first black woman and black Democrat elected to the U.S. Senate.

1993 In *Shaw* v. *Reno* the U.S. Supreme Court rules that bizarre, highly elongated districts drawn to maximize minority voting may be unconstitutional and returns the cases to lower courts for further hearings.

Source: Compiled by Hanes Walton, Jr., and Mervyn Dymally.

TABLE **11.10** Southern African-American Voters, Potential and Eligible, 1940–1966*

State	1940 Registered	1940 % of voting age blacks registered	1947 Registered	1947 % of voting age blacks registered	1952 Registered	1952 % of voting age blacks registered	1956 Registered	1956 % of voting age blacks registered	1966 Registered	1966 % of voting age blacks registered
Ala.	1.5	0.30	6.0	1.2	50.0	9.68	53.366	11.0	246.396	51.2
Ark.	8.0	3.00	47.0	17.3	60.0	25.84	69.677	36.0	115.000	59.7
Fla.	10.0	3.20	49.0	15.4	150.0	40.89	148.703	32.0	286.446	60.9
Ga.	10.0	1.71	125.0	18.8	125.0	20.07	163.384	27.0	289.545	47.2
La.	2.0	0.42	10.0	2.6	130.0	27.01	161.410	31.0	242.130	47.1
Miss.	0.5	0.09	5.0	0.9	40.0	8.04	20.000	5.0	139.099	32.9
N.C.	50.0	10.14	75.0	15.2	97.5	17.73	135.000	24.0	281.134	51.0
S.C.	1.5	0.39	50.0	13.0	130.0	33.33	99.890	27.0	190.609	51.4
Tenn.	50.0	16.15	80.0	25.8	155.0	48.62	90.000	27.0	225.000	71.7
Tex.	50.0	9.24	100.0	18.5	200.0	34.31	214.000	37.0	400.000	61.6
Va.	20.0	5.29	48.0	13.2	70.0	16.56	82.603	19.0	205.000	46.9
Totals	203.5		595.0		1,207.5		1,238.033		2,620.359	

* In thousands of voters.
Sources: For 1940 and 1947: H. D. Bailey, *Negro Politics in America* (Columbus, Ohio, 1967); for 1952, 1956, and 1966: L. D. Jackson, "Race and Suffrage in the South Since 1940," *New South* (June-July 1948); Margaret Price, *The Negro Voter in the South* (Atlanta, 1957); P. Watters and R. Cleghorn, *Climbing Jacob's Ladder* (New York, 1960); U.S. Commission on Civil Rights, *Voting* (Washington, D.C., n.d.).

TABLE **11.11** Percentage of African Americans Voting Democratic in Presidential Elections, 1932–1992

1932[1]	Chicago	21.0
	Cincinnati	28.8
	Cleveland	17.3
	Detroit	31.0
	Knoxville	29.8
	New York	50.8
	Philadelphia	26.7
	Pittsburgh	41.3
1936[1]	Chicago	48.8
	Cincinnati	65.1
	Cleveland	60.5
	Detroit	66.2
	Knoxville	56.2
	New York	81.3
	Philadelphia	68.7
	Pittsburgh	74.7
1940[1]	Chicago	52.5
	Cincinnati	66.9
	Cleveland	64.7
	Detroit	74.8
	New York	81.0
	Philadelphia	68.4
	Pittsburgh	82.0

1944	—
1948[2]	70
1952[3]	83
1956[3]	68
1960[3]	72
1964[3]	99
1968[3]	92
1972[3]	86
1976[4]	94
1980[4]	93
1984[5]	89
1988[5]	87
1992[6]	83

[1] National election figures not available; Nancy J. Weiss, *Farewell to the Party of Lincoln: Black Politics in the Age of FDR* (Princeton, N.J., 1983).
[2] Donald R. McCoy, *Quest & Response* (Lawrence, Kans., 1973).
[3] Robert Axelrod, "Communication," *American Political Science Review* 68 (1974).
[4] American National Election Study Series, 1952–1980. Survey Research Center/Center for Political Studies, University of Michigan. *American Political Parties: Stability and Change* (New York, 1984).
[5] CBS-New York Times exit surveys, 1984 and 1988.
[6] USA Today (November 23, 1992).

12. POPULATION

TABLE 12.1 **African-American Population During Colonial Period, According to the U.S. Census**

Year	Total Population[1]	Black Population	%
	Connecticut		
1756	130,612	3,657	2.80
1774	197,842	6,529	3.30
	Georgia		
1753	2,261	1,600	70.77
1756	6,355	1,856	29.21
	Maryland		
1701	22,258	2,849	12.80
1704	34,912	4,475	12.82
1710	42,741	7,945	18.59
1712	46,151	8,408	18.22
1755	76,061	21,189	27.86
1762	164,007	49,694	30.30
	Massachusetts		
1764	245,698	6,880	2.80[2]
	New Hampshire		
1767	52,720	633	1.20
1773	73,097	674	0.92
1775	81,300	650	0.80
	New Jersey[3]		
1726	32,442	2,595	8.00
1737–38	46,676	3,981	8.53
1745	61,403	4,606	7.50
	New Orleans[4]		
1721	372	94	25.27
1771	3,190	1,387	43.48
	New York		
1698	18,067	2,168	12.00[5]
1703	20,665	2,258	10.93
1712–14	22,608	2,425	10.73
1723	40,564	6,171	15.21
1731	50,286	7,231	14.38
1737	60,437	8,941	14.79
1746	61,589	9,107	14.79
1749	73,348	10,592	14.44
1756	96,590	13,348	13.82
1771	168,007	19,825	11.80
	Rhode Island		
1708	7,181	424	5.90
1730	17,935	1,648	9.19
1699	32,773	3,077	9.39
1774	59,607	5,067	8.50
	South Carolina		
1708	9,580	5,499	57.40[6]
	Virginia		
1624	1,275	22	1.73

[1] The terms "black," "Negro," and "slave" were often used interchangeably by colonial census-takers, so accurate figures on free blacks and slaves are not available.
[2] Includes 0.7% Indians.
[3] West Jersey, 1726–1774.
[4] Not a British colony; no census data available for Louisiana.
[5] Includes 2.3% Indians.
[6] Includes 14.5% Indians.

TABLE 12.2 **African-American Population in Selected Cities, 1790**

City	Total Population	Black Population	%
Charleston S.C.	16,359	8,270	50.6
New York, N.Y.	33,131	3,470	10.5
New Orleans, La.[1]	4,516	2,451	54.3
Philadelphia, Pa.	28,522	2,078	7.3
Petersburg, Va.	3,761	1,744	46.4
Baltimore, Md.	13,503	1,578	11.7
Norfolk, Va.	2,959	1,355	45.8
Boston, Mass.	18,038	761	4.2
Newport, R.I.	6,716	640	9.5
Albany, N.Y.	3,498	598	17.1
Providence, R.I.	6,380	475	7.4
Brooklyn, N.Y.	1,603	419	26.1

[1] Figures for New Orleans, then owned by Spain, from 1791.
Source: U.S. Census, 1790; Randall M. Miller and John David Smith, eds., *Dictionary of Afro-American Slavery.*

TABLE 12.3 **African-American Population of the United States, 1790–1990**

Decade	Total Population	Total Black Population	Slave Population	Free Population	% Black
1790	3,929,214	757,208	697,624	59,557	19.27
1800	5,308,483	1,002,037	893,602	108,435	18.88
1810	7,239,881	1,377,808	1,191,362	186,446	19.03
1820	9,638,453	1,771,656	1,538,022	233,634	18.38
1830	12,866,020	2,328,612	2,009,043	319,599	18.10
1840	17,069,453	2,873,648	2,487,355	386,293	16.84
1850	23,191,876	3,638,808	3,204,313	434,495	15.69
1860	31,443,321	4,441,830	3,953,760	488,070	14.13
1870	38,558,371	4,880,009			12.66
1880	50,155,783	6,580,793			13.12
1890	62,947,714	7,488,676			11.90
1900	75,991,575	8,833,994			11.62
1910	91,972,266	9,827,763			10.69
1920	105,710,620	10,463,131			9.90
1930	122,775,046	11,891,143			9.69
1940	131,669,275	12,865,518			9.77
1950	150,697,361	15,042,286			9.98
1960	179,323,175	18,871,831			10.52
1970	203,211,920	22,580,289			11.11
1980	226,546,000	26,495,000			11.70
1990	248,710,000	29,986,000			12.06

TABLE 12.4 **Top Ten Cities in African-American Population, 1820–1990**

City	Total Population	Black Population	%
1820			
1. Baltimore	62,738	14,192	22.62
2. Charleston	24,780	14,127	57.01
3. District of Columbia	33,039	10,425	31.55
4. New York	123,706	10,086	8.15
5. Philadelphia	63,802	8,785	13.77
6. New Orleans	14,175	8,515	60.07
7. Richmond	12,067	5,622	46.59
8. Savannah	7,523	3,657	48.61
9. St. Louis	10,049	2,035	20.25
10. Boston	42,536	1,737	4.08
1860			
1. Baltimore	212,418	27,898	13.13
2. New Orleans	168,675	24,074	14.27
3. Philadelphia	562,529	22,185	3.94
4. Charleston	40,522	17,146	42.31
5. District of Columbia	75,080	14,316	19.07
6. Richmond	37,910	14,275	37.65
7. New York	805,658	12,472	1.55
8. Savannah	22,292	8,417	37.76
9. Mobile	29,258	8,404	28.72
10. Donaldsonville, La.	11,484	7,544	65.69
1900			
1. District of Columbia	278,718	86,702	31.11
2. Baltimore	508,957	79,258	15.57
3. New Orleans	287,104	77,714	27.07
4. Philadelphia	1,293,697	62,613	4.84

Table 12.4 Top Ten Cities in African-American Population, 1820–1990
(Continued)

City	Total Population	Black Population	%
5. New York	3,437,202	60,666	1.76
6. Memphis	102,320	49,910	48.78
7. Louisville	204,731	39,139	19.12
8. Atlanta	89,872	35,727	39.75
9. St. Louis	575,238	35,516	6.17
10. Richmond	85,050	32,230	37.90
1920			
1. New York	5,620,048	152,467	2.71
2. Philadelphia	1,823,799	134,229	7.30
3. District of Columbia	437,571	109,966	25.13
4. Chicago	2,701,705	109,458	4.05
5. Baltimore	733,826	103,322	14.08
6. New Orleans	387,219	100,930	26.07
7. Birmingham	178,806	70,230	39.28
8. St. Louis	772,897	69,854	9.04
9. Atlanta	200,616	62,796	31.30
10. Memphis	162,351	61,181	37.68
1940			
1. New York	7,454,995	458,444	6.15
2. Chicago	3,396,808	277,731	8.18
3. Philadelphia	1,931,334	251,880	13.04
4. District of Columbia	663,091	187,226	28.24
5. Baltimore	859,100	165,843	19.30
6. Detroit	1,623,452	149,119	9.19
7. New Orleans	494,537	149,034	30.14
8. Memphis	292,942	121,498	41.48
9. Birmingham	267,583	108,938	40.71
10. St. Louis	816,048	108,765	13.33
1960			
1. New York	7,781,984	1,087,931	13.98
2. Chicago	3,550,404	812,637	22.89
3. Philadelphia	2,002,512	529,240	26.43
4. Detroit	1,670,144	482,223	28.87
5. District of Columbia	763,956	411,737	53.90
6. Los Angeles	2,479,015	334,916	13.51
7. Baltimore	939,024	325,589	34.67
8. New Orleans	627,525	233,514	37.21
9. Houston	938,219	215,037	22.92
10. St. Louis	750,026	214,377	28.58
1990			
1. New York	7,322,564	2,102,512	28.71
2. Chicago	2,783,726	1,087,711	39.07
3. Detroit	1,027,974	777,916	75.67
4. Philadelphia	1,585,577	631,936	39.86
5. Los Angeles	3,485,398	487,674	13.99
6. Houston	1,630,553	457,990	28.09
7. Baltimore	736,014	435,768	59.21
8. District of Columbia	606,900	399,604	65.84
9. Memphis	610,337	334,737	54.84
10. New Orleans	496,938	307,728	61.92

TABLE 12.5 Families, Total Number, Average Size, Status of Head, 1940–1991

| | Families (in Thousands)* | | Average Size | | % husband-wife | | Single Parent | | | |
| | | | | | | | % male head | | % female head | |
Year	Total	Black	Total	Black	Total	Black	Total	Black	Total	Black
1940	32,166	2,699[1]	3.76	—	83.8	77.1	4.9	5.0	11.2	17.9
1950	39,303	3,432[2]	3.54	—	87.6	77.7	3.0	4.7	9.4	17.6
1960	45,111	3,950	3.67	—	87.2	74.1	2.8	4.1	10.0	21.7
1970	51,586	4,774	3.58	4.13	86.8	68.1	2.4	3.7	10.8	28.3
1980	59,550	6,184	3.29	3.67	82.5	55.5	2.9	4.1	14.6	40.3
1990	66,090	7,470	3.17	3.46	79.2	50.2	4.4	6.0	16.5	43.8
1991	66,322	7,471	3.18	3.51	78.6	47.8	4.4	6.3	17.0	45.9

* "Family" refers to a group of two or more persons related by blood, marriage, or adoption and residing together in a household.
[1] Data revised to exclude one-person families.
[2] Data include families of other nonwhite races.
Sources: *Statistical Abstract, 1992; Historical Statistics of the United States, Colonial Times to 1970; The Social and Economic Status of the Black Population in the United States: An Historical View, 1790–1978.*

TABLE 12.6 Households, Total Number, Average Size, 1890–1991

| | Households (in Thousands)* | | Average Size | |
Year	Total	Black	Total	Black
1890	12,960	1,411	4.93	5.32
1900	15,964	1,834	4.76	4.83
1910	20,256	2,173	4.54	4.54
1920	24,352	2,431	4.34	4.31
1930	29,905	2,804	4.11	4.27
1940	34,949	3,142	3.67	4.12
1950	43,554	3,822	3.37	4.12
1960	52,799	4,779	3.33	3.82
1970	63,401	6,180	3.14	3.54
1980	80,390	8,382	2.75	3.06
1991	94,312	10,671	2.63	2.87

* A household consists of all persons who occupy a housing unit, which is a house, apartment, or other group of rooms occupied or intended as separate living quarters.
Sources: *Statistical Abstract, 1992; Historical Statistics of the United States, Colonial Times to 1970; The Social and Economic Status of the Black Population in the United States: An Historical View, 1790–1978;* U.S. Census, 1980.

TABLE 12.7 African-American Net Intercensal Migration During Period of Great Migrations, 1870–1970*

State	1870–1880	1880–1890	1890–1900	1900–1910	1910–1920	1920–1930	1930–1940	1940–1950	1950–1960	1960–1970
Alabama	−36.1	−5.8	1.7	−22.1	−70.8	−80.7	−63.8	−204	−224	−231
Alaska	—	—	—	—	—	—	—	—	—²	—²
Arizona	—	—	—	0.2	5.8	1.9	3.5	6	4	−4
Arkansas	25.4	44.7	−7.9	22.5	−1.0	−46.3	−33.3	−158	−150	−112
California	—	—	—	9.8	16.1	36.4	41.2	289	255	272
Colorado	—	—	—	3.1	0.7	0.8	0.9	7	13	16
Connecticut	0.8	1.1	2.5	0.5	5.3	5.2	2.2	15	37	38
Delaware	−1.4	0.3	−0.7	−0.4	−0.6	0.5	2.4	4	6	4
District of Columbia	6.2	13.4	8.7	9.8	18.3	16.0	47.5	61	51	36
Florida	1.4	15.8	23.4	40.7	3.2	54.2	49.9	12	96	−32
Georgia	−20.3	12.3	−27.3	−16.2	−74.7	−260.0	−90.3	−243	−205	−154
Hawaii	—	—	—	—	—	—	—	—	—²	1
Idaho	—	—	—	0.3	0.3	−0.1	—¹	—²	—²	—²
Illinois	8.7	8.4	22.7	23.5	69.8	119.3	49.4	203	182	127
Indiana	6.6	3.9	8.1	4.1	20.3	23.2	8.6	39	42	32
Iowa	2.3	0.4	1.6	2.1	3.9	−1.9	−0.4	2	2	2
Kansas	14.7	2.7	−0.6	2.6	5.4	6.0	−0.1	4	2	−1
Kentucky	−13.1	−22.4	−12.2	−22.3	−16.6	−16.6	−9.1	−18	−16	1
Louisiana	−1.3	3.3	−21.6	16.1	−51.2	−25.5	−8.4	−147	−93	−163
Maine	−0.2	−0.1	0.3	0.2	0.1	−0.2	0.2	4	2	−2
Maryland	−7.5	−7.5	−6.5	−11.4	7.0	5.0	10.7	37	31	79
Massachusetts	3.0	4.4	9.9	5.9	6.9	2.9	2.7	12	20	33
Michigan	1.6	−1.2	0.4	1.9	38.7	86.1	28.0	186	122	124
Minesota	1.5	1.5	5.9	2.3	2.1	0.6	1.0	4	5	7
Mississippi	17.6	−13.2	−10.4	−30.9	−129.6	−68.8	−58.2	−326	−323	−279
Missouri	−4.3	−4.0	—¹	1.0	27.2	35.9	19.2	31	24	14
Montana	—	—	—	0.3	−0.1	−0.2	—¹	—²	—²	—²
Nebraska	1.2	7.3	−2.3	1.6	5.2	—¹	0.6	4	4	2
Nevada	—	—	—	0.4	−0.1	0.2	0.2	3	6	6
New Hampshire	0.1	—¹	0.1	—¹	—¹	0.2	−0.3	—²	1	—²
New Jersey	2.9	8.4	17.7	18.5	24.5	67.0	9.5	61	107	120
New Mexico	—	—	—	—	4.1	−2.9	1.5	2	4	−4
New York	7.6	9.9	33.8	35.8	63.1	172.8	135.9	266	255	396
North Carolina	−7.9	−38.4	−48.7	−28.4	−28.9	−15.7	−60.0	−164	−204	−175
North Dakota**	0.3	—¹	4.9	0.3	−0.1	−0.1	−0.1	—²	1	1
Ohio	2.6	5.2	5.2	15.6	69.4	90.7	20.7	131	129	45
Oklahoma	—	2.3	79.3	54.8	0.8	1.9	−13.0	−47	−21	−3
Oregon	—	—	—	0.5	0.7	0.2	0.5	8	3	4
Pennsylvania	8.7	20.8	39.2	32.9	82.5	101.7	20.3	107	75	25
Rhode Island	0.8	1.2	1.5	0.6	0.6	−0.7	0.6	1	1	2
South Carolina	15.7	−18.6	−65.5	−72.0	−74.5	−204.3	−94.4	−208	−218	−197
South Dakota	—	—	14.0	0.3	—¹	−0.2	−0.1	—²	—²	—²
Tennessee	−24.6	−18.7	−19.0	−34.3	−29.3	−14.0	8.6	−48	−59	−51
Texas	21.0	12.6	7.1	−10.2	5.2	9.7	4.9	−107	−33	−4
Utah	—	—	—	0.5	0.4	−0.3	0.2	1	1	1
Vermont	—¹	—¹	−0.1	0.8	−0.9	—¹	−0.2	—²	—¹	—²
Virginia	−37.6	−53.4	−70.8	−49.3	−27.2	−117.2	−36.9	−29	−74	−79
Washington	—	—	—	3.4	1.1	0.2	1.2	21	8	10
West Virginia	2.1	3.6	5.8	15.3	15.5	12.8	−4.1	−17	−41	−20
Wisconsin	1.3	0.1	3.0	0.5	2.2	4.4	1.0	14	29	27
Wyoming	1.2	—	—	1.2	−0.6	−0.1	−0.2	2	−1	—²

* In thousands; 1870–1940 computed using survival-rate method; 1940–1990 computed using components of change method (Bureau of Census); for 1870–1890 only white population in Mountain and Pacific states; no estimates made for blacks.
** Numbers for North Dakota 1870–1880 and 1880–1890 are for entire Dakota Territory.
¹ Less than 50.
² Less than 500.

TABLE 12.8 **African-American Population by Region, 1790–1990**

	Region	Total Population of Region	Black Population in Region	% of U.S. Black Population in Region	% of Regional Population Black
1790	Northeast	1,968,040	67,120	8.86	3.41
	Midwest	0	0	0.00	0.00
	Southeast	1,961,174	690,061	91.13	35.19
	South Central	0	0	—	—
	Mountain	0	0	—	—
	Pacific	0	0	—	—
1800	Northeast	2,635,576	83,066	8.29	3.15
	Midwest	51,006	635	0.06	1.24
	Southeast	2,621,901	918,336	91.65	35.03
	South Central	0	0	—	—
	Mountain	0	0	—	—
	Pacific	0	0	—	—
1810	Northeast	3,486,675	102,237	7.42	2.93
	Midwest	292,107	7,072	0.51	2.42
	Southeast	3,383,481	1,226,254	89.00	36.24
	South Central	77,618	42,245	3.07	54.43
	Mountain	0	0	—	—
	Pacific	0	0	—	—
1820	Northeast	4,359,916	110,724	6.25	2.54
	Midwest	859,305	18,260	1.03	2.12
	Southeast	4,251,552	1,515,784	85.56	35.65
	South Central	167,680	81,216	4.58	48.44
	Mountain	0	0	—	—
	Pacific	0	0	—	—
1830	Northeast	5,542,381	125,214	5.38	2.26
	Midwest	1,610,473	41,543	1.78	2.58
	Southeast	5,461,721	2,030,870	87.21	37.18
	South Central	246,127	131,015	5.63	53.23
	Mountain	0	0	—	—
	Pacific	0	0	—	—
1840	Northeast	6,761,082	142,324	4.95	2.11
	Midwest	3,351,542	89,347	3.11	2.67
	Southeast	6,500,744	2,427,623	84.48	37.34
	South Central	449,985	214,354	7.46	47.64
	Mountain	0	0	—	—
	Pacific	0	0	—	—
1850	Northeast	8,626,851	149,762	4.12	1.74
	Midwest	5,403,595	135,607	3.73	2.51
	Southeast	8,042,361	2,983,661	82.00	37.10
	South Central	940,251	368,537	10.13	39.20
	Mountain	72,927	72	0.00	0.10
	Pacific	105,891	1,169	0.03	1.10
1860	Northeast	10,594,268	156,001	3.51	1.47
	Midwest	9,096,716	184,239	4.15	2.03
	Southeast	9,385,694	3,452,558	77.73	36.79
	South Central	1,747,667	644,553	14.51	36.88
	Mountain	174,923	235	0.01	0.13
	Pacific	444,053	4,244	0.10	0.96
1870	Northeast	12,298,730	179,738	3.68	1.46
	Midwest	12,981,111	273,080	5.60	2.10
	Southeast	10,258,055	3,680,957	75.43	35.88
	South Central	2,029,965	739,854	15.16	36.45

TABLE 12.8 African-American Population by Region, 1790–1990 (*Continued*)

	Region	Total Population of Region	Black Population in Region	% of U.S. Black Population in Region	% of Regional Population Black
	Mountain	315,385	1,555	0.03	0.49
	Pacific	675,125	4,825	0.10	0.71
1880	Northeast	14,507,407	229,417	3.49	1.58
	Midwest	17,364,111	385,621	5.86	2.22
	Southeast	13,182,348	4,866,198	73.95	36.91
	South Central	3,334,220	1,087,705	16.53	32.62
	Mountain	653,119	5,022	0.08	0.77
	Pacific	1,147,578	6,830	0.10	0.60
1890	Northeast	17,406,969	269,906	3.60	1.55
	Midwest	22,410,417	431,112	5.76	1.92
	Southeast	15,287,076	5,382,487	71.88	35.21
	South Central	4,740,983	1,378,090	18.40	29.07
	Mountain	1,213,935	12,971	0.17	1.07
	Pacific	1,920,334	14,110	0.19	0.73
1900	Northeast	21,046,695	385,020	4.36	1.83
	Midwest	26,333,004	495,751	5.61	1.88
	Southeast	17,991,237	6,228,903	70.51	34.62
	South Central	6,532,290	1,694,066	19.18	25.93
	Mountain	1,674,607	15,590	0.18	0.93
	Pacific	2,634,692	14,664	0.17	0.56
1910	Northeast	25,868,573	484,176	4.93	1.87
	Midwest	29,888,542	543,498	5.53	1.82
	Southeast	20,604,796	6,765,001	68.84	32.83
	South Central	8,784,534	1,984,426	20.19	22.59
	Mountain	2,633,517	21,467	0.22	0.82
	Pacific	4,448,304	30,195	0.31	0.68
1920	Northeast	29,662,053	679,234	6.49	2.29
	Midwest	34,019,792	793,075	7.58	2.33
	Southeast	22,883,579	6,848,652	65.46	29.93
	South Central	10,242,224	2,063,579	19.72	20.15
	Mountain	3,336,101	30,801	0.29	0.92
	Pacific	5,877,819	47,790	0.46	0.81
1930	Northeast	34,427,091	1,146,985	9.65	3.33
	Midwest	38,594,100	1,262,234	10.62	3.27
	Southeast	25,680,803	7,079,626	59.54	27.57
	South Central	12,176,830	2,281,951	19.19	18.74
	Mountain	3,701,789	30,225	0.25	0.82
	Pacific	8,622,047	90,122	0.76	1.05
1940	Northeast	35,976,777	1,369,875	10.65	3.81
	Midwest	40,143,332	1,420,318	11.04	3.54
	Southeast	28,601,376	7,479,498	58.13	26.15
	South Central	13,064,525	2,425,121	18.85	18.56
	Mountain	4,150,003	36,411	0.28	0.88
	Pacific	10,229,116	134,691	1.05	1.32
1950	Northeast	39,477,986	2,018,182	13.42	5.11
	Midwest	44,460,762	2,227,876	14.81	5.01
	Southeast	32,659,516	7,793,379	51.81	23.86
	South Central	14,537,572	2,432,028	16.17	16.73
	Mountain	5,074,998	66,429	0.44	1.31
	Pacific	15,114,964	507,043	3.37	3.35
1960	Northeast	44,677,823	3,028,499	16.05	6.78
	Midwest	51,619,139	3,446,037	18.26	6.68

TABLE **12.8** **African-American Population by Region, 1790–1990 (*Continued*)**

	Region	Total Population of Region	Black Population in Region	% of U.S. Black Population in Region	% of Regional Population Black
	Southeast	38,021,858	8,543,404	45.27	22.47
	South Central	16,951,255	2,768,203	14.67	16.33
	Mountain	6,855,060	123,242	0.65	1.80
	Pacific*	21,198,044	962,446	5.10	4.54
1970	Northeast	49,040,703	4,344,153	19.24	8.86
	Midwest	56,571,633	4,571,550	20.25	8.08
	Southeast	43,474,807	8,959,787	39.68	20.61
	South Central	19,320,560	3,010,174	13.33	15.58
	Mountain	8,281,562	180,382	0.80	2.18
	Pacific	26,522,631	1,514,243	6.71	5.71
1980	Northeast	49,165,283	4,849,969	18.18	9.86
	Midwest	58,866,670	5,332,907	19.99	9.06
	Southeast	51,625,566	10,617,734	39.79	20.57
	South Central	23,746,816	3,521,048	13.20	14.83
	Mountain	11,372,785	267,538	1.00	2.35
	Pacific	31,799,705	1,993,153	7.47	6.27
1990	Northeast	50,809,229	5,613,222	18.72	11.05
	Midwest	59,668,632	5,715,940	19.06	9.58
	Southeast	58,725,137	11,900,363	39.69	20.26
	South Central	26,702,793	3,718,126	12.40	13.92
	Mountain	13,658,776	373,584	1.25	2.74
	Pacific	39,127,306	2,454,426	8.19	6.27

Northeast: Connecticut, Maine, Massachusetts, New Hampshire, New Jersey, New York, Pennsylvania, Rhode Island, Vermont
Midwest: Illinois, Indiana, Iowa, Kansas, Michigan, Minnesota, Missouri, Nebraska, North Dakota, Ohio, South Dakota, Wisconsin
Southeast: Alabama, Delaware, District of Columbia, Florida, Georgia, Maryland, Mississippi, North Carolina, South Carolina, Tennessee, Virginia, West Virginia
South Central: Arkansas, Louisiana, Oklahoma, Texas
Mountain: Arizona, Colorado, Idaho, Montana, Nevada, New Mexico, Utah, Wyoming
Pacific: Alaska, California, Hawaii, Oregon, Washington
* Includes Alaska and Hawaii for first time.
Sources: U.S. Bureau of the Census Release, 1991; and *Statistical Abstract, 1990.*

TABLE **12.9** **African-American Population by State, 1790–1990**

State	1790				1800				1810			
	Total Popu-lation	Slave Popu-lation	Free Black Popu-lation	% Black	Total Popu-lation	Slave Popu-lation	Free Black Popu-lation	% Black	Total Popu-lation	Slave Popu-lation	Free Black Popu-lation	% Black
Alabama	—	—	—	—	—	—	—	—	—	—	—	—
Alaska	—	—	—	—	—	—	—	—	—	—	—	—
Arizona	—	—	—	—	—	—	—	—	—	—	—	—
Arkansas	—	—	—	—	—	—	—	—	1,062	—	—	—
California	—	—	—	—	—	—	—	—	—	—	—	—
Colorado	—	—	—	—	—	—	—	—	—	—	—	—
Connecticut	237,946	2,648	2,771	2.28	251,002	951	5,330	2.50	261,942	310	6,453	2.58
Delaware	59,096	8,887	3,899	21.64	64,273	6,153	8,268	22.44	72,674	4,177	13,136	23.82
Florida	—	—	—	—	—	—	—	—	—	—	—	—
Georgia	82,548	29,264	398	35.93	162,686	59,406	1,019	37.14	252,433	105,218	1,801	42.40
Hawaii	—	—	—	—	—	—	—	—	—	—	—	—
Idaho	—	—	—	—	—	—	—	—	—	—	—	—
Illinois	—	—	—	—	—	—	—	—	12,282	168	613	6.36
Indiana	—	—	—	—	5,641	135	163	5.28	24,520	237	393	2.57
Iowa	—	—	—	—	—	—	—	—	—	—	—	—
Kansas	—	—	—	—	—	—	—	—	—	—	—	—
Kentucky	73,677	12,430	114	17.03	220,955	40,343	739	18.59	406,511	80,561	1,713	20.24
Louisiana	—	—	—	—	—	—	—	—	76,556	34,660	7,585	55.18
Maine	96,540	0	536	0.56	151,719	0	818	0.54	228,705	0	969	0.42
Maryland	319,728	103,036	8,043	34.74	341,548	105,635	19,587	36.66	380,546	111,502	33,927	38.22
Massachusetts	378,787	0	5,369	1.42	422,845	0	6,452	1.53	472,040	0	6,737	1.43
Michigan	—	—	—	—	—	—	—	—	4,762	24	120	3.02
Minnesota	—	—	—	—	—	—	—	—	—	—	—	—
Mississippi	—	—	—	—	8,850	3,489	182	41.48	40,352	17,088	240	42.94
Missouri	—	—	—	—	—	—	—	—	19,783	3,011	607	18.29
Montana	—	—	—	—	—	—	—	—	—	—	—	—
Nebraska	—	—	—	—	—	—	—	—	—	—	—	—
Nevada	—	—	—	—	—	—	—	—	—	—	—	—
New Hampshire	141,885	157	630	0.55	183,858	8	852	0.47	214,460	0	970	0.45
New Jersey	184,139	11,423	2,762	7.70	211,149	12,422	4,402	7.97	245,562	10,851	7,843	7.61
New Mexico	—	—	—	—	—	—	—	—	—	—	—	—
New York	340,120	21,193	4,682	7.61	589,051	20,903	10,417	5.32	959,049	15,017	25,333	4.21
North Carolina	393,751	100,783	5,041	26.88	478,103	133,296	7,043	29.35	555,500	168,824	10,266	32.24
North Dakota[1]	—	—	—	—	—	—	—	—	—	—	—	—
Ohio	—	—	—	—	45,365	0	337	0.74	230,760	0	1,899	0.82
Oklahoma	—	—	—	—	—	—	—	—	—	—	—	—
Oregon	—	—	—	—	—	—	—	—	—	—	—	—
Pennsylvania	434,373	3,707	6,531	2.36	602,365	1,706	14,564	2.70	810,091	795	22,492	2.87
Rhode Island	68,825	958	3,484	6.45	69,122	380	3,304	5.33	76,931	108	3,609	4.83
South Carolina	249,073	107,094	1,801	43.72	345,591	146,151	3,185	43.21	415,115	196,365	4,554	48.40
South Dakota[1]	—	—	—	—	—	—	—	—	—	—	—	—
Tennessee	35,691	3,417	361	10.59	105,602	13,584	309	13.16	261,727	44,535	1,317	17.52
Texas	—	—	—	—	—	—	—	—	—	—	—	—
Utah	—	—	—	—	—	—	—	—	—	—	—	—
Vermont	85,425	0	269	0.31	154,465	0	557	0.36	217,895	0	750	0.34
Virginia	747,610	292,627	12,866	40.86	880,200	345,796	20,124	41.57	974,600	392,516	30,570	43.41
Washington	—	—	—	—	—	—	—	—	—	—	—	—
Washington, D.C.	—	—	—	—	14,093	3,244	783	28.57	24,023	5,395	2,549	33.07
West Virginia[2]	—	—	—	—	—	—	—	—	—	—	—	—
Wisconsin	—	—	—	—	—	—	—	—	—	—	—	—
Wyoming	—	—	—	—	—	—	—	—	—	—	—	—

TABLE 12.9 African-American Population by State, 1790–1990 (*Continued*)

	1820				1830				1840			
State	Total Population	Slave Population	Free Black Population	% Black	Total Population	Slave Population	Free Black Population	% Black	Total Population	Slave Population	Free Black Population	% Black
Alabama	127,901	41,879	571	33.19	309,527	117,549	1,572	38.48	590,756	253,532	2,039	43.26
Alaska	—	—	—	—	—	—	—	—	—	—	—	—
Arizona	—	—	—	—	—	—	—	—	—	—	—	—
Arkansas	14,273	1,617	59	11.74	30,388	4,576	141	15.52	97,574	19,935	465	20.91
California	—	—	—	—	—	—	—	—	—	—	—	—
Colorado	—	—	—	—	—	—	—	—	—	—	—	—
Connecticut	275,248	97	7,870	2.89	297,675	25	8,047	2.71	309,978	17	8,105	2.62
Delaware	72,749	4,509	12,958	24.01	76,748	3,292	15,855	24.95	78,085	2,605	16,919	25.00
Florida	—	—	—	—	34,730	15,501	844	47.06	54,477	25,717	817	48.71
Georgia	340,989	149,656	1,763	44.41	516,823	217,531	2,486	42.57	691,392	280,944	2,753	41.03
Hawaii	—	—	—	—	—	—	—	—	—	—	—	—
Idaho	—	—	—	—	—	—	—	—	—	—	—	—
Illinois	55,211	917	457	2.49	157,445	747	1,637	1.51	476,183	331	3,598	0.83
Indiana	147,178	190	1,230	0.96	343,031	3	3,629	1.06	685,866	3	7,165	1.05
Iowa	—	—	—	—	—	—	—	—	43,112	16	172	0.44
Kansas	—	—	—	—	—	—	—	—	—	—	—	—
Kentucky	564,317	126,732	2,759	22.95	687,917	165,213	4,917	24.73	779,828	182,258	7,317	24.31
Louisiana	153,407	69,064	10,476	51.85	215,739	109,588	16,710	58.54	352,411	168,452	25,502	55.04
Maine	298,335	0	929	0.31	399,455	2	1,190	0.30	501,793	0	1,355	0.27
Maryland	407,350	107,397	39,730	36.12	447,040	102,994	52,938	34.88	470,019	89,737	62,078	32.30
Massachusetts	523,287	0	6,740	1.29	610,408	1	7,048	1.15	737,699	0	8,669	1.18
Michigan	8,896	0	174	1.96	31,639	32	261	0.93	212,267	0	707	0.33
Minnesota	—	—	—	—	—	—	—	—	—	—	—	—
Mississippi	75,448	32,814	458	44.10	136,621	65,659	519	48.44	375,651	195,211	1,366	52.33
Missouri	66,586	10,222	347	15.87	140,455	25,091	569	18.27	383,702	58,240	1,574	15.59
Montana	—	—	—	—	—	—	—	—	—	—	—	—
Nebraska	—	—	—	—	—	—	—	—	—	—	—	—
Nevada	—	—	—	—	—	—	—	—	—	—	—	—
New Hampshire	244,161	0	786	0.32	269,328	3	604	0.23	284,574	1	537	0.19
New Jersey	277,575	7,557	12,460	7.21	320,823	2,254	18,303	6.41	373,306	674	21,044	5.82
New Mexico	—	—	—	—	—	—	—	—	—	—	—	—
New York	1,372,812	10,088	29,279	2.87	1,918,608	75	44,870	2.34	2,428,921	4	50,027	2.06
North Carolina	638,829	204,917	14,712	34.38	737,987	245,601	19,543	35.93	753,419	245,817	22,732	35.64
North Dakota[1]	—	—	—	—	—	—	—	—	—	—	—	—
Ohio	581,434	0	4,723	0.81	937,903	6	9,568	1.02	1,519,467	3	17,342	1.14
Oklahoma	—	—	—	—	—	—	—	—	—	—	—	—
Oregon	—	—	—	—	—	—	—	—	—	—	—	—
Pennsylvania	1,049,458	211	30,202	2.90	1,348,233	403	37,930	2.84	1,724,033	64	47,854	2.78
Rhode Island	83,059	48	3,554	4.34	97,199	17	3,561	3.68	108,830	5	3,238	2.98
South Carolina	502,741	204,917	14,712	43.69	581,185	315,401	7,921	55.63	594,398	327,038	8,276	56.41
South Dakota[1]	—	—	—	—	—	—	—	—	—	—	—	—
Tennessee	422,823	80,107	2,737	19.59	681,904	141,603	4,555	21.43	829,210	183,059	5,524	22.74
Texas	—	—	—	—	—	—	—	—	—	—	—	—
Utah	—	—	—	—	—	—	—	—	—	—	—	—
Vermont	235,981	0	903	0.38	280,652	0	881	0.31	291,948	0	730	0.25
Virginia	1,065,366	425,148	36,883	43.37	1,211,405	469,757	47,348	42.69	1,239,797	448,987	49,842	40.23
Washington	—	—	—	—	—	—	—	—	—	—	—	—
Washington, D.C.	33,039	6,377	4,048	31.55	39,834	6,119	6,152	30.81	43,712	4,694	8,361	29.87
West Virginia[2]	—	—	—	—	—	—	—	—	—	—	—	—
Wisconsin	—	—	—	—	—	—	—	—	30,945	11	185	0.63
Wyoming	—	—	—	—	—	—	—	—	—	—	—	—

TABLE 12.9 African-American Population by State, 1790–1990 (*Continued*)

State	1850 Total Population	1850 Slave Population	1850 Free Black Population	1850 % Black	1860 Total Population	1860 Slave Population	1860 Free Black Population	1860 % Black	1870 Total Population	1870 Free Black Population	1870 % Black
Alabama	771,623	342,844	2,265	44.73	946,201	435,080	2,690	45.40	996,992	475,510	47.69
Alaska	—	—	—	—	—	—	—	—	—	—	—
Arizona	—	—	—	—	—	—	—	—	9,658	26	0.27
Arkansas	209,897	47,100	608	22.73	435,450	111,115	144	25.55	484,471	122,169	25.22
California	92,597	0	962	1.04	379,994	0	4,086	1.08	560,247	4,272	0.76
Colorado	—	—	—	—	34,277	0	46	0.13	39,864	456	1.14
Connecticut	370,792	0	7,693	2.07	460,147	0	8,627	1.87	537,454	9,668	1.80
Delaware	91,532	2,290	18,073	22.25	112,216	1,798	19,829	19.27	125,015	22,794	18.23
Florida	87,445	39,310	932	46.02	140,424	61,745	932	44.63	187,748	91,689	48.84
Georgia	906,185	381,682	2,931	42.44	1,057,286	462,198	3,500	44.05	1,184,109	545,142	46.04
Hawaii	—	—	—	—	—	—	—	—	—	—	—
Idaho	—	—	—	—	—	—	—	—	14,999	60	0.40
Illinois	851,470	0	5,436	0.64	1,711,951	0	7,628	0.45	2,539,891	28,762	1.13
Indiana	988,416	0	11,262	1.14	1,350,428	0	11,428	0.85	1,680,637	24,560	1.46
Iowa	192,214	0	333	0.17	674,913	0	1,069	0.16	1,194,020	5,762	0.48
Kansas	—	—	—	—	107,206	2	625	0.58	364,399	17,108	4.69
Kentucky	982,405	210,981	10,011	22.49	1,155,684	225,483	10,684	20.44	1,321,011	222,210	16.82
Louisiana	517,762	244,809	17,462	50.65	708,002	331,726	18,647	49.49	726,915	364,210	50.10
Maine	583,169	0	1,356	0.23	628,279	0	1,327	0.21	626,915	1,606	0.26
Maryland	583,034	90,368	74,723	28.32	687,049	87,189	83,942	24.91	780,894	175,391	22.46
Massachusetts	994,514	0	9,064	0.91	1,231,066	0	9,602	0.78	1,457,351	13,947	0.96
Michigan	397,654	0	2,583	0.65	749,113	—	6,799	0.91	1,184,059	11,849	1.00
Minnesota	6,077	0	39	—	172,023	0	259	0.15	439,706	759	0.17
Mississippi	606,526	309,878	930	51.24	791,305	436,631	773	55.28	827,922	444,201	53.65
Missouri	682,044	87,422	2,618	13.20	1,182,012	114,931	3,572	10.03	1,721,295	118,071	6.86
Montana	—	—	—	—	—	—	—	—	20,595	183	0.89
Nebraska	—	—	—	—	28,841	15	67	0.28	122,993	789	0.64
Nevada	—	—	—	—	6,857	0	45	0.66	42,491	357	0.84
New Hampshire	317,976	0	520	0.16	326,073	0	494	0.15	318,300	580	0.18
New Jersey	489,555	236	23,810	4.91	672,035	18	25,318	3.77	906,096	30,658	3.38
New Mexico	61,547	0	22	—	93,516	0	85	0.09	91,874	172	0.19
New York	3,097,394	0	49,069	1.58	3,880,735	0	49,005	1.26	4,382,759	52,081	1.19
North Carolina	869,039	288,548	27,463	36.36	992,622	331,059	30,463	36.42	1,071,361	391,650	36.56
North Dakota[1]	—	—	—	—	4,837	—	—	—	14,181	94	0.66
Ohio	1,980,329	0	25,279	1.28	2,339,511	0	36,673	1.57	2,665,260	63,213	2.37
Oklahoma	—	—	—	—	—	—	—	—	—	—	—
Oregon	13,294	0	207	—	52,465	0	128	0.24	90,923	346	0.38
Pennsylvania	2,311,786	0	53,626	2.32	2,906,215	0	56,949	1.96	3,521,951	65,294	1.85
Rhode Island	147,545	0	3,670	2.49	174,620	0	3,952	2.26	217,353	4,980	2.29
South Carolina	668,507	384,984	8,960	58.93	703,708	402,406	9,914	58.59	705,606	415,814	58.93
South Dakota[1]	—	—	—	—	—	—	—	—	—	—	—
Tennessee	1,002,717	239,459	6,422	24.52	1,109,801	275,719	7,300	25.50	1,258,520	322,331	25.61
Texas	212,592	58,161	397	27.54	604,215	182,566	355	30.27	818,579	253,475	30.97
Utah	11,380	26	24	0.44	40,273	29	30	0.15	86,786	118	0.14
Vermont	314,120	0	718	0.23	315,098	0	709	0.23	330,551	924	0.28
Virginia	1,421,661	472,528	54,333	37.06	1,596,318	490,865	58,042	34.39	1,225,163	512,841	41.86
Washington	—	—	—	—	11,594	0	30	0.26	23,955	207	0.86
Washington, D.C.	51,687	3,687	10,059	26.59	75,080	3,185	11,131	19.07	131,700	43,404	32.96
West Virginia[2]	—	—	—	—	—	—	—	—	442,014	17,980	4.07
Wisconsin	305,391	0	635	0.21	775,881	0	1,171	0.15	1,054,670	2,113	0.20
Wyoming	—	—	—	—	—	—	—	—	9,118	183	2.01

TABLE 12.9 African-American Population by State, 1790–1990 (*Continued*)

State	1880 Total Population	Black Population	% Black	1890 Total Population	Black Population	% Black	1900 Total Population	Black Population	% Black
Alabama	1,262,505	600,103	47.53	1,513,401	678,489	44.83	1,828,697	827,307	45.24
Alaska	33,000	—	—	32,000	—	—	64,000	—	—
Arizona	40,440	155	0.38	88,243	1,357	1.54	122,931	1,848	1.50
Arkansas	802,525	210,666	26.25	1,128,211	309,117	27.40	1,311,564	366,856	27.97
California	864,694	6,018	0.70	1,213,398	11,322	0.93	1,485,053	11,045	0.74
Colorado	194,327	2,435	1.25	413,249	6,215	1.50	539,700	8,570	1.59
Connecticut	622,700	11,547	1.85	746,258	12,302	1.65	908,420	15,226	1.68
Delaware	146,608	26,442	18.04	168,493	28,386	16.85	184,735	30,697	16.62
Florida	269,493	126,690	47.01	391,422	166,180	42.46	528,542	230,730	43.65
Georgia	1,542,180	725,133	47.02	1,837,353	858,815	46.74	2,216,331	1,034,813	46.69
Hawaii	—	—	—	—	—	—	154,000	—	—
Idaho	32,610	53	0.16	88,548	201	0.23	161,722	293	0.18
Illinois	3,077,871	46,368	1.51	3,826,352	57,028	1.49	4,821,550	85,078	1.76
Indiana	1,978,301	39,228	1.98	2,192,404	45,215	2.06	2,516,462	57,505	2.29
Iowa	1,624,615	9,516	0.59	1,912,297	10,685	0.56	2,231,853	12,693	0.57
Kansas	996,096	43,107	4.33	1,428,108	49,710	3.48	1,470,495	52,003	3.54
Kentucky	1,648,690	271,451	16.46	1,858,635	268,071	14.42	2,147,174	284,706	13.26
Louisiana	939,946	483,655	51.46	1,118,588	559,193	49.99	1,381,625	650,804	47.10
Maine	648,936	1,451	0.22	661,086	1,190	0.18	694,466	1,319	0.19
Maryland	934,943	210,230	22.49	1,042,390	215,657	20.69	1,188,044	235,064	19.79
Massachusetts	1,783,085	18,697	1.05	2,238,947	22,144	0.99	2,805,346	31,974	1.14
Michigan	1,636,937	15,100	0.92	2,093,890	15,223	0.73	2,420,982	15,816	0.65
Minnesota	780,773	1,564	0.20	1,310,283	3,683	0.28	1,751,394	4,959	0.28
Mississippi	1,131,597	650,291	57.47	1,289,600	742,559	57.58	1,551,270	907,630	58.51
Missouri	2,168,380	145,350	6.70	2,679,185	150,184	5.61	3,106,665	161,234	5.19
Montana	39,159	346	0.88	142,924	1,490	1.04	243,329	1,523	0.63
Nebraska	452,402	2,385	0.53	1,062,656	8,913	0.84	1,066,300	6,269	0.59
Nevada	62,266	488	0.78	47,355	242	0.51	42,335	134	0.32
New Hampshire	346,991	685	0.20	376,530	614	0.16	411,588	662	0.16
New Jersey	1,131,116	38,853	3.43	1,444,933	47,638	3.30	1,883,669	69,844	3.71
New Mexico	119,565	1,015	0.85	160,282	1,956	1.22	195,310	1,610	0.82
New York	5,082,871	65,104	1.28	6,003,174	70,092	1.17	7,268,894	99,232	1.37
North Carolina	1,399,750	531,277	37.96	1,617,949	561,018	34.67	1,893,810	624,469	32.97
North Dakota	135,177	401	0.30	190,983	373	0.20	319,146	286	0.09
Ohio	3,198,062	79,900	2.50	3,672,329	87,113	2.37	4,157,545	96,901	2.33
Oklahoma	—	—	—	258,657	21,609	8.35	790,391	55,684	7.05
Oregon	174,768	487	0.28	317,704	1,186	0.37	413,536	1,105	0.27
Pennsylvania	4,282,891	85,535	2.00	5,258,113	107,596	2.05	6,302,115	156,845	2.49
Rhode Island	276,531	6,488	2.35	345,506	7,393	2.14	428,556	9,092	2.12
South Carolina	995,577	604,332	60.70	1,151,149	688,934	59.85	1,340,316	782,321	58.37
South Dakota	—	—	—	348,600	541	0.16	401,570	465	0.12
Tennessee	1,542,359	403,151	26.14	1,767,518	430,678	24.37	2,020,616	480,243	23.77
Texas	1,591,749	393,384	24.71	2,235,527	488,171	21.84	3,048,710	620,722	20.36
Utah	143,963	232	0.16	210,779	588	0.28	276,749	672	0.24
Vermont	332,286	1,057	0.32	332,422	937	0.28	343,641	826	0.24
Virginia	1,512,565	631,616	41.76	1,655,980	635,438	38.37	1,854,184	660,722	35.63
Washington	75,116	325	0.43	357,232	1,602	0.45	518,103	2,514	0.49
Washington, D.C.	177,624	59,596	33.55	230,392	75,572	32.80	278,718	86,702	31.11
West Virginia	618,457	25,886	4.19	762,794	32,690	4.29	958,800	43,499	4.54
Wisconsin	1,315,497	2,702	0.21	1,693,330	2,444	0.14	2,069,042	2,542	0.12
Wyoming	20,789	298	1.43	62,555	922	1.47	92,531	940	1.02

TABLE 12.9 African-American Population by State, 1790–1990 (*Continued*)

State	1910 Total Population	1910 Black Population	1910 % Black	1920 Total Population	1920 Black Population	1920 % Black	1930 Total Population	1930 Black Population	1930 % Black
Alabama	2,138,093	908,282	42.48	2,348,174	900,652	38.36	2,646,248	944,834	35.70
Alaska	64,000	—	—	55,036	—	—	59,278	—	—
Arizona	204,354	2,009	0.98	334,162	8,005	2.40	435,573	10,749	2.47
Arkansas	1,574,449	442,891	28.13	1,752,204	472,220	26.95	1,854,482	478,463	25.80
California	2,377,549	21,645	0.91	3,426,861	38,763	1.13	5,677,251	81,048	1.43
Colorado	799,024	11,453	1.43	939,629	11,318	1.20	1,035,791	11,828	1.14
Connecticut	1,114,756	15,174	1.36	1,380,631	21,046	1.52	1,606,903	29,354	1.83
Delaware	202,322	31,181	15.41	223,003	30,335	13.60	238,380	32,602	13.68
Florida	752,619	308,669	41.01	968,470	329,487	34.02	1,468,211	431,828	29.41
Georgia	2,609,121	1,176,987	45.11	2,895,832	1,206,365	41.66	2,908,506	1,071,125	36.83
Hawaii	192,000	1,000	0.52	255,912	—	—	368,336	—	—
Idaho	325,594	651	0.20	431,866	920	0.21	445,032	668	0.15
Illinois	5,638,591	109,049	1.93	6,485,280	182,274	2.81	7,630,654	328,972	4.31
Indiana	2,700,876	60,320	2.23	2,930,390	80,810	2.76	3,238,503	111,982	3.46
Iowa	2,224,771	14,973	0.67	2,404,021	19,005	0.79	2,470,939	17,380	0.70
Kansas	1,690,949	54,030	3.20	1,769,257	57,925	3.27	1,880,999	66,344	3.53
Kentucky	2,289,905	261,656	11.43	2,416,630	235,938	9.76	2,614,589	226,040	8.65
Louisiana	1,656,388	713,874	43.10	1,798,509	700,257	38.94	2,101,593	776,326	36.94
Maine	742,371	1,363	0.18	768,014	1,310	0.17	797,423	1,096	0.14
Maryland	1,295,346	232,250	17.93	1,449,661	244,479	16.86	1,631,526	276,379	16.94
Massachusetts	3,366,416	38,055	1.13	3,852,356	45,466	1.18	4,249,614	52,365	1.23
Michigan	2,810,173	17,115	0.61	3,668,412	60,082	1.64	4,842,325	169,453	3.50
Minnesota	2,075,708	7,084	0.34	2,387,125	8,809	0.37	2,563,953	9,445	0.37
Mississippi	1,797,114	1,009,487	56.17	1,790,618	935,184	52.23	2,009,821	1,009,718	50.24
Missouri	3,293,335	157,452	4.78	3,404,055	178,241	5.24	3,629,367	223,840	6.17
Montana	376,053	1,834	0.49	548,889	1,658	0.30	537,606	1,256	0.23
Nebraska	1,192,214	7,689	0.64	1,296,372	13,242	1.02	1,377,963	13,752	1.00
Nevada	81,875	513	0.63	77,407	346	0.45	91,058	516	0.57
New Hampshire	430,572	564	0.13	443,083	621	0.14	465,293	790	0.17
New Jersey	2,537,167	89,760	3.54	3,155,900	117,132	3.71	4,041,334	208,828	5.17
New Mexico	327,301	1,628	0.50	360,350	5,733	1.59	423,317	2,850	0.67
New York	9,113,614	134,191	1.47	10,385,227	198,483	1.91	12,588,066	412,814	3.28
North Carolina	2,206,287	697,843	31.63	2,559,123	763,407	29.83	3,170,276	918,647	28.98
North Dakota	577,056	617	0.11	646,872	467	0.07	680,845	377	0.06
Ohio	4,767,121	111,452	2.34	5,759,394	186,187	3.23	6,646,697	309,304	4.65
Oklahoma	1,657,155	137,612	8.30	2,028,283	149,408	7.37	2,396,040	172,198	7.19
Oregon	672,765	1,492	0.22	783,389	2,144	0.27	953,786	2,234	0.23
Pennsylvania	7,665,111	193,919	2.53	8,720,017	284,568	3.26	9,631,350	431,257	4.48
Rhode Island	542,610	9,529	1.76	604,397	10,036	1.66	687,497	9,913	1.44
South Carolina	1,515,400	835,843	55.16	1,683,724	864,719	51.36	1,738,765	793,681	45.65
South Dakota	583,888	817	0.14	636,547	832	0.13	692,849	646	0.09
Tennessee	2,184,789	473,088	21.65	2,337,885	451,758	19.32	2,616,556	477,646	18.25
Texas	3,896,542	690,049	17.71	4,663,228	741,694	15.91	5,824,715	854,964	14.68
Utah	373,351	1,144	0.31	449,396	1,446	0.32	507,847	1,108	0.22
Vermont	355,956	1,621	0.46	352,428	572	0.16	359,611	568	0.16
Virginia	2,061,612	671,096	32.55	2,309,187	690,017	29.88	2,421,851	650,165	26.85
Washington	1,141,990	6,058	0.53	1,356,621	6,883	0.51	1,563,396	6,840	0.44
Washington, D.C.	331,069	94,446	28.53	437,571	109,966	25.13	486,869	132,068	27.13
West Virginia	1,221,119	64,173	5.26	1,463,701	86,345	5.90	1,729,205	114,893	6.64
Wisconsin	2,333,860	2,900	0.12	2,632,067	5,201	0.20	2,939,006	10,739	0.37
Wyoming	145,965	2,235	1.53	194,402	1,375	0.71	225,565	1,250	0.55

TABLE 12.9 African-American Population by State, 1790–1990 (*Continued*)

State	1940 Total Population	1940 Black Population	1940 % Black	1950 Total Population	1950 Black Population	1950 % Black	1960 Total Population	1960 Black Population	1960 % Black
Alabama	2,832,961	983,290	34.71	3,061,743	979,617	32.00	3,266,740	980,271	30.01
Alaska	72,524	141	0.19	128,643	—	—	226,167	6,771	2.99
Arizona	499,261	14,993	3.00	749,587	25,974	3.47	1,302,161	43,403	3.33
Arkansas	1,949,387	482,578	24.76	1,909,511	426,639	22.34	1,786,272	388,787	21.77
California	6,907,387	124,306	1.80	10,586,223	462,172	4.37	15,717,204	883,861	5.62
Colorado	1,123,296	12,176	1.08	1,325,089	20,177	1.52	1,753,947	39,992	2.28
Connecticut	1,709,242	32,992	1.93	2,007,280	53,472	2.66	2,535,234	107,449	4.24
Delaware	266,505	35,876	13.46	318,085	43,598	13.71	446,292	60,688	13.60
Florida	1,897,414	514,198	27.10	2,771,305	603,101	21.76	4,951,560	880,186	17.78
Georgia	3,123,723	1,084,927	34.73	3,444,578	1,062,762	30.85	3,943,116	1,122,596	28.47
Hawaii	423,330	255	0.06	499,794	2,651	0.53	632,772	4,943	0.78
Idaho	524,873	595	0.11	588,637	1,050	0.18	667,191	1,502	0.23
Illinois	7,897,241	387,446	4.91	8,712,176	645,980	7.41	10,081,158	1,037,470	10.29
Indiana	3,427,796	121,916	3.56	3,934,224	174,168	4.43	4,662,498	269,275	5.78
Iowa	2,538,268	16,694	0.66	2,621,073	19,692	0.75	2,757,537	25,354	0.92
Kansas	1,801,028	65,138	3.62	1,905,299	73,158	3.84	2,178,611	91,445	4.20
Kentucky	2,845,627	214,031	7.52	2,944,806	201,921	6.86	3,038,156	215,949	7.11
Louisiana	2,363,880	849,303	35.93	2,683,516	882,428	32.88	3,257,022	1,039,207	31.91
Maine	847,226	1,304	0.15	913,774	1,221	0.13	969,265	3,318	0.34
Maryland	1,821,244	301,931	16.58	2,343,001	385,972	16.47	3,100,689	518,410	16.72
Massachusetts	4,316,721	55,391	1.28	4,690,514	73,171	1.56	5,148,582	111,842	2.17
Michigan	5,256,106	208,345	3.96	6,371,766	442,296	6.94	7,823,194	717,581	9.17
Minnesota	2,792,300	9,928	0.36	2,982,483	14,022	0.47	3,413,864	22,263	0.65
Mississippi	2,183,796	1,074,578	49.21	2,178,914	986,494	45.27	2,178,141	915,743	42.04
Missouri	3,784,664	244,386	6.46	3,954,653	297,088	7.51	4,319,813	390,853	9.05
Montana	559,456	1,120	0.20	591,024	1,232	0.21	674,767	1,467	0.22
Nebraska	1,315,834	14,171	1.08	1,325,510	19,234	1.45	1,411,330	29,262	2.07
Nevada	110,247	664	0.60	160,083	4,302	2.69	285,278	13,484	4.73
New Hampshire	491,524	414	0.08	533,242	731	0.14	606,921	1,903	0.31
New Jersey	4,160,165	226,973	5.46	4,835,329	318,565	6.59	6,066,782	514,875	8.49
New Mexico	531,818	4,672	0.88	681,187	8,408	1.23	951,023	17,063	1.79
New York	13,479,142	571,221	4.24	14,830,192	918,191	6.19	16,782,304	1,417,511	8.45
North Carolina	3,571,623	981,298	27.47	4,061,929	1,047,353	25.78	4,556,155	1,116,021	24.49
North Dakota	641,935	201	0.03	619,636	257	0.04	632,446	777	0.12
Ohio	6,907,612	339,461	4.91	7,946,627	513,072	6.46	9,706,397	786,097	8.10
Oklahoma	2,336,434	168,849	7.23	2,233,351	145,503	6.52	2,328,284	153,084	6.57
Oregon	1,089,684	2,565	0.24	1,521,341	11,529	0.76	1,768,687	18,133	1.03
Pennsylvania	9,900,180	470,172	4.75	10,498,012	638,485	6.08	11,319,366	852,750	7.53
Rhode Island	713,346	11,024	1.55	791,896	13,903	1.76	859,488	18,332	2.13
South Carolina	1,899,804	814,164	42.86	2,117,027	822,077	38.83	2,382,594	829,291	34.81
South Dakota	642,961	474	0.07	652,740	727	0.11	680,514	1,114	0.16
Tennessee	2,915,841	508,736	17.45	3,291,718	530,603	16.12	3,567,089	586,876	16.45
Texas	6,414,824	924,391	14.41	7,711,194	977,458	12.68	9,579,677	1,187,125	12.39
Utah	550,310	1,235	0.22	688,862	2,729	0.40	890,627	4,148	0.47
Vermont	359,231	384	0.11	377,747	443	0.12	389,881	519	0.13
Virginia	2,677,773	661,449	24.70	3,318,680	734,211	22.12	3,966,949	816,258	20.58
Washington	1,736,191	7,424	0.43	2,378,963	30,691	1.29	2,853,214	48,738	1.71
Washington, D.C.	663,091	187,266	28.24	802,178	280,803	35.01	763,956	411,737	53.90
West Virginia	1,901,974	117,754	6.19	2,005,552	114,867	5.73	1,860,421	89,378	4.80
Wisconsin	3,137,587	12,158	0.39	3,434,575	28,182	0.82	3,951,777	74,546	1.89
Wyoming	250,742	956	0.38	290,529	2,557	0.88	330,066	2,183	0.66

TABLE 12.9 African-American Population by State, 1790–1990 (*Continued*)

State	1970 Total Population	1970 Black Population	1970 % Black	1980 Total Population	1980 Black Population	1980 % Black	1990 Total Population	1990 Black Population	1990 % Black
Alabama	3,444,165	903,467	26.23	3,893,888	996,283	25.59	4,040,587	1,020,705	25.26
Alaska	300,382	8,911	2.97	401,851	13,748	3.42	550,043	22,451	4.08
Arizona	1,770,900	53,344	3.01	2,718,215	74,159	2.73	3,665,228	110,524	3.02
Arkansas	1,923,295	352,445	18.33	2,286,435	373,025	16.31	2,350,725	373,912	15.91
California	19,953,134	1,400,143	7.02	23,667,902	1,818,660	7.68	29,760,021	2,208,801	7.42
Colorado	2,207,259	66,411	3.01	2,889,964	101,695	3.52	3,294,394	133,146	4.04
Connecticut	3,031,709	181,177	5.98	3,107,576	216,641	6.97	3,287,116	274,269	8.34
Delaware	548,104	78,276	14.28	594,338	96,157	16.18	666,168	112,460	16.88
Florida	6,789,443	1,041,651	15.34	9,746,324	1,343,134	13.78	12,937,926	1,759,534	13.60
Georgia	4,589,575	1,187,149	25.87	5,463,105	1,464,435	26.81	6,478,216	1,746,565	26.96
Hawaii	768,561	7,573	0.99	964,691	17,687	1.83	1,108,229	27,195	2.45
Idaho	712,567	2,130	0.30	943,935	2,711	0.29	1,006,749	3,370	0.33
Illinois	11,113,976	1,425,674	12.83	11,427,518	1,674,467	14.65	11,430,602	1,694,273	14.82
Indiana	5,193,669	357,464	6.88	5,490,224	414,489	7.55	5,544,159	432,092	7.79
Iowa	2,824,376	32,596	1.15	2,913,808	42,228	1.45	2,776,755	48,090	1.73
Kansas	2,246,578	106,977	4.76	2,363,679	126,356	5.35	2,477,574	143,076	5.77
Kentucky	3,218,706	230,793	7.17	3,660,777	359,289	9.81	3,685,296	262,907	7.13
Louisiana	3,641,306	1,086,832	29.85	4,205,900	1,238,472	29.45	4,219,973	1,299,281	30.79
Maine	992,048	2,800	0.28	1,124,660	3,381	0.30	1,227,928	5,138	0.42
Maryland	3,922,399	699,479	17.83	4,216,975	957,418	22.70	4,781,468	1,190,000	24.89
Massachusetts	5,689,170	175,817	3.09	5,737,037	221,029	3.85	6,016,425	300,130	4.99
Michigan	8,875,083	991,066	11.17	9,262,078	1,197,177	12.93	9,295,297	1,291,706	13.90
Minnesota	3,804,971	34,868	0.92	4,075,970	52,325	1.28	4,375,099	94,944	2.17
Mississippi	2,216,912	815,770	36.80	2,520,638	887,111	35.19	2,573,216	915,057	35.56
Missouri	4,676,501	480,172	10.27	4,916,686	513,385	10.44	5,117,073	548,208	10.71
Montana	694,409	1,995	0.29	786,690	1,738	0.22	799,065	2,381	0.30
Nebraska	1,483,493	39,911	2.69	1,569,825	47,946	3.05	1,578,385	57,404	3.64
Nevada	488,738	27,762	5.68	800,493	51,203	6.40	1,201,833	78,771	6.55
New Hampshire	737,681	2,505	0.34	920,610	4,324	0.47	1,109,252	7,198	0.65
New Jersey	7,168,164	770,292	10.75	7,364,823	924,909	12.56	7,730,188	1,036,825	13.41
New Mexico	1,016,000	19,555	1.92	1,302,894	23,071	1.77	1,515,069	30,210	1.99
New York	18,236,967	2,168,949	11.89	17,558,072	2,405,818	13.70	17,990,455	2,859,055	15.89
North Carolina	5,082,059	1,126,478	22.17	5,881,766	1,319,054	22.43	6,628,637	1,456,323	21.97
North Dakota	617,761	2,494	0.40	652,717	2,471	0.38	638,800	3,524	0.55
Ohio	10,651,987	970,477	9.11	10,797,630	1,076,742	9.97	10,847,115	1,154,826	10.65
Oklahoma	2,559,229	171,892	6.72	3,025,290	204,810	6.77	3,145,585	23,301	0.74
Oregon	2,091,385	26,308	1.26	2,633,105	37,454	1.42	2,842,321	46,178	1.62
Pennsylvania	11,793,909	1,016,514	8.62	11,893,895	1,045,318	8.79	11,881,643	1,089,795	9.17
Rhode Island	946,725	25,338	2.68	947,154	27,361	2.89	1,003,464	38,861	3.87
South Carolina	2,590,516	789,041	30.46	3,121,820	947,969	30.37	3,468,703	1,039,884	29.98
South Dakota	665,507	1,627	0.24	690,768	2,152	0.31	696,004	3,258	0.47
Tennessee	3,923,687	621,261	15.83	4,591,120	724,808	15.79	4,877,185	778,035	15.95
Texas	11,196,730	1,399,005	12.49	14,229,191	1,704,741	11.98	16,986,510	2,021,632	11.90
Utah	1,059,273	6,617	0.62	1,461,037	9,691	0.66	1,722,850	11,576	0.67
Vermont	444,330	761	0.17	511,456	1,188	0.23	562,758	1,951	0.35
Virginia	4,648,494	861,368	18.53	5,346,818	1,008,665	18.86	6,187,358	1,162,994	18.80
Washington	3,409,169	71,308	2.09	4,132,156	105,604	2.56	4,866,692	149,801	3.08
Washington, D.C.	756,510	537,712	71.08	638,333	448,370	70.24	606,900	399,604	65.84
West Virginia	1,744,237	67,342	3.86	1,949,664	65,041	3.34	1,793,477	56,295	3.14
Wisconsin	4,417,731	128,224	2.90	4,705,767	183,169	3.89	4,891,769	244,539	5.00
Wyoming	332,416	2,568	0.77	469,557	3,270	0.70	453,588	3,606	0.79

[1] Figures for North Dakota represent whole of Dakota Territory until 1890. North and South Dakota became states in 1889.
[2] West Virginia was originally part of Virginia. It became a separate state in 1863.

TABLE 12.10 City Populations, 1790–1990, for Selected Cities

Atlanta, Ga.

Year	Total Population	Free Black	Slave	% Black
1860	9,554	25	1,914	20.30
1870	21,789	9,929		45.57
1880	37,409	16,330		43.65
1890	65,533	28,098		42.88
1900	89,872	35,727		39.75
1910	154,839	51,902		33.52
1920	200,616	62,796		31.30
1930	270,366	90,075		33.32
1940	302,288	104,533		34.58
1950	331,314	121,285		36.61
1960	487,455	186,464		38.25
1970	496,973	255,051		51.32
1980	425,022	282,911		66.56
1990	394,017	264,262		67.07

Birmingham, Ala.

Year	Total Population	Black Population	% Black
1880	3,086		
1890	26,178	11,254	42.99
1900	38,415	16,575	43.15
1910	132,685	52,305	39.42
1920	178,806	70,230	39.28
1930	259,678	99,077	38.15
1940	267,583	108,938	40.71
1950	326,037	130,025	39.88
1960	340,887	135,113	39.64
1970	300,910	126,388	42.00
1980	284,413	158,224	55.63
1990	265,968	168,277	63.27

Baltimore, Md.

Year	Total Population	Free Black	Slave	% Black
1790	13,503	323	1,255	11.69
1800	26,514	2,771	2,843	21.17
1810	35,583	3,973	3,713	21.60
1820	62,738	10,234	3,958	22.62
1830	80,625	14,788	4,114	23.44
1840	102,313	17,967	3,199	20.69
1850	169,054	25,442	2,946	16.79
1860	212,418	25,680	2,218	13.13
1870	267,354	39,437		14.75
1880	332,313	53,716		16.16
1890	434,439	67,104		15.45
1900	508,957	79,258		15.57
1910	558,485	84,749		15.17
1920	733,826	103,322		14.08
1930	804,874	142,106		17.66
1940	859,100	165,843		19.30
1950	949,708	225,099		23.70
1960	939,024	325,589		34.67
1970	905,759	420,210		46.39
1980	786,775	345,113		43.86
1990	736,014	435,768		59.21

Boston, Mass.

Year	Total Population	Black Population	% Black
1790	18,038	761	4.22
1800	24,937	1,174	4.71
1810	33,250	1,464	4.40
1820	42,536	1,737	4.08
1830	61,392	1,875	3.05
1840	93,383	2,427	2.60
1850	136,881	1,999	1.46
1860	177,840	2,261	1.27
1870	250,526	3,112	1.24
1880	362,839	5,873	1.62
1890	448,477	8,125	1.81
1900	560,892	11,591	2.07
1910	670,585	13,564	2.02
1920	748,060	16,350	2.19
1930	781,188	20,574	2.63
1940	770,816	23,679	3.07
1950	801,444	40,057	5.00
1960	697,197	63,165	9.06
1970	641,071	104,707	16.33
1980	562,994	126,229	22.42
1990	574,283	149,945	26.11

Bronx County, N.Y.

Year	Total Population	Black Population	% Black
1910	430,980	4,117	0.96
1920	732,016	4,803	0.66
1930	1,265,258	12,930	1.02
1940	1,394,711	23,529	1.69
1950	1,451,277	97,752	6.74
1960	1,424,815	163,896	11.50
1970	1,471,701	357,681	24.30
1980	1,168,972	371,926	31.82
1990	1,203,789	449,399	37.33

Charleston, S.C.

Year	Total Population	Free Black	Slave	% Black
1790	16,359	586	7,684	50.55
1800	20,473	924	9,819	52.47
1810	24,711	1,472	11,671	53.19
1820	24,780	1,475	12,652	57.01
1830	30,289	2,106	15,297	57.46
1840	29,261	1,558	14,673	55.47
1850	42,985	3,441	19,532	53.44
1860	40,522	3,237	13,909	42.31
1870	48,956	26,173		53.46
1880	49,984	27,276		54.57
1890	54,955	30,970		56.36
1900	55,807	31,522		56.48
1910	58,833	31,056		52.79
1920	67,957	32,326		47.57
1930	62,265	28,062		45.07
1940	72,275	31,765		43.95
1950	70,174	30,854		43.97
1960	65,925	33,522		50.85
1970	66,945	30,251		45.19
1980	69,510	32,318		46.49
1990	80,414	33,439		41.58

Chicago, Ill.

Year	Total Population	Black Population	% Black
1840	4,470	53	1.19
1850	29,963	323	1.08
1860	109,260	955	0.87
1870	298,977	3,562	1.19
1880	503,185	6,480	1.29
1890	1,099,850	14,271	1.30
1900	1,698,575	30,150	1.78
1910	2,185,283	44,103	2.02
1920	2,701,705	109,458	4.05
1930	3,376,438	233,903	6.93
1940	3,396,808	277,731	8.18
1950	3,620,962	492,265	13.59
1960	3,550,404	812,637	22.89
1970	3,366,957	1,102,620	32.75
1980	3,005,072	1,197,174	39.84
1990	2,783,726	1,087,711	39.07

Cincinnati, Ohio

Year	Total Population	Black Population	% Black
1810	2,540	82	3.23
1820	9,642	433	4.49
1830	24,831	1,090	4.39
1840	46,338	2,240	4.83
1850	115,435	3,237	2.80
1860	161,044	3,731	2.32
1870	216,239	5,866	2.71
1880	255,139	8,179	3.21
1890	296,908	11,655	3.93
1900	325,902	14,482	4.44
1910	363,591	19,639	5.40
1920	401,247	30,079	7.50
1930	451,160	47,818	10.60
1940	455,610	55,593	12.20
1950	503,998	235,420	46.71
1960	502,550	108,754	21.64
1970	452,524	125,070	27.64
1980	385,457	130,467	33.85
1990	364,040	138,132	37.94

Cleveland, Ohio*

Year	Total Population	Black Population	% Black
1810[1]	547	10	1.83
1820	606	3	0.50
1830	1,076	10	0.93
1840[2]	6,071	60	0.99
1850	17,034	224	1.32
1860	43,417	799	1.84
1870	92,829	1,293	1.39
1880	160,416	2,038	1.27
1890	261,353	2,989	1.14
1900	381,768	5,988	1.57
1910	560,663	8,448	1.51
1920	796,841	34,451	4.32
1930	900,429	71,899	7.98
1940	878,336	84,504	9.62
1950	914,808	147,847	16.16
1960	876,050	250,818	28.63
1970	750,903	287,841	38.33
1980	573,822	251,347	43.80
1990	505,616	235,405	46.56

* The village of Cleveland was incorporated in 1814; the city of Cleveland was incorporated in 1836. Cleveland annexed Ohio City in 1854. It annexed the villages of South Brooklyn and Glenville in 1905 and Collinwood in 1910.
[1] "Black" includes all nonwhite.
[2] Includes Indians.

Detroit, Mich.

Year	Total Population	Free Black	Slave	% Black
1810	2,227	96	17	5.07
1820	1,422	67		4.71
1830	2,222	126		5.67
1840	9,102	193		2.12
1850	21,019	587		2.79
1860	45,619	1,403		3.08
1870	79,577	1,897		2.38
1880	116,340	2,821		2.42
1890	205,876	3,431		1.67
1900	285,704	4,111		1.44
1910	465,766	5,741		1.23
1920	993,678	40,838		4.11
1930	1,568,662	120,066		7.65
1940	1,623,452	149,119		9.19
1950	1,849,568	300,506		16.25
1960	1,670,144	482,223		28.87
1970	1,511,482	660,428		43.69
1980	1,203,339	758,939		63.07
1990	1,027,974	777,916		75.67

District of Columbia

Year	Total Population	Free Black	Slave	% Black
1800	14,093	3,244	783	28.57
1810	24,023	5,395	2,549	33.07
1820	33,039	6,377	4,048	31.55
1830	39,834	6,119	6,152	30.81
1840	43,712	4,694	8,361	29.87
1850	51,687	3,687	10,059	26.59
1860	75,080	3,185	11,131	19.07
1870	131,700	43,404		32.96
1880	177,624	59,596		33.55
1890	230,392	75,572		32.80
1900	278,718	86,702		31.11
1910	331,069	94,446		28.53
1920	437,571	109,966		25.13
1930	486,869	132,068		27.13
1940	663,091	187,226		28.24
1950	802,178	280,803		35.01
1960	763,956	411,737		53.90
1970	756,510	537,712		71.08
1980	638,333	448,370		70.24
1990	606,900	399,604		65.84

Durham, N.C.

Year	Total Population	Black Population	% Black
1870	2,323	698	30.05
1880	—	—	—
1890	5,485	1,859	33.89
1900	6,679	2,241	33.55
1910	18,241	6,869	37.66
1920	21,719	7,654	35.24
1930	52,037	18,717	35.97
1940	60,195	23,347	38.79
1950	71,311	26,095	36.59
1960	78,302	28,258	36.09
1970	95,438	37,018	38.79
1980	100,831	47,474	47.08
1990	136,611	62,449	45.71

Houston, Tex.

Year	Total Population	Free Black	Slave	% Black
1860	4,845	8	1,069	22.23
1870	9,382	3,691		39.34
1880	16,513	6,479		39.24
1890	27,557	10,370		37.63
1900	44,633	14,608		32.73
1910	78,800	23,929		30.37
1920	138,276	33,960		24.56
1930	292,352	63,337		21.66
1940	384,514	86,252		22.43
1950	596,163	124,766		20.93
1960	938,219	215,037		22.92
1970	1,232,802	316,551		25.68
1980	1,595,138	440,346		27.61
1990	1,630,553	457,990		28.09

Kansas City, Mo.

Year	Total Population	Free Black	Slave	% Black
1860	4,418	24	166	4.30
1870	32,260	3,770		11.69
1880	55,785	8,143		14.60
1890	132,716	13,700		10.32
1900	163,752	17,567		10.73
1910	248,381	23,566		9.49
1920	324,410	30,719		9.47
1930	399,746	38,574		9.65
1940	399,178	41,574		10.41
1950	456,622	55,682		12.19
1960	475,539	83,146		17.48
1970	507,087	112,005		22.09
1980	448,159	122,699		27.38
1990	435,146	128,768		29.59

Kings County, N.Y.

Year	Total Population	Free Black	Slave	% Black
1790	4,495	5	171	3.92
1800	5,820	332	1,479	31.12
1810	8,303	735	1,118	22.32
1820	11,187	1,782	879	23.79
1830	20,537	2,022	0	9.85
1840	47,613	2,843	3*	5.98
1850	138,882	4,065		2.93
1860	279,122	4,999		1.79
1870	419,921	5,653		1.35
1880	599,495	9,153		1.53
1890	838,547	11,307		1.35
1900	1,166,582	18,367		1.57
1910	1,634,351	22,708		1.39
1920	2,018,356	31,912		1.58
1930	2,560,401	68,921		2.69
1940	2,698,285	107,263		3.98
1950	2,378,175	208,478		8.77
1960	2,627,319	371,405		14.14
1970	2,602,012	656,194		25.22
1980	2,230,936	772,812		34.64
1990	2,300,664	872,305		37.92

* Despite the Manumission Act of 1827, slaves from other states were permitted temporary residence.

Little Rock, Ark.

Year	Total Population	Free Black	Slave	% Black
1850	2,167	21	525	25.20
1860	3,727	7	846	22.89
1870	12,380	5,274		42.60
1880	13,138	4,507		34.31
1890	25,874	9,739		37.64
1900	38,307	14,694		38.36
1910	45,941	14,539		31.65
1920	65,142	17,477		26.83
1930	81,679	19,698		24.12
1940	88,039	22,103		25.11
1950	102,213	23,517		23.01
1960	107,813	25,286		23.45
1970	132,483	33,074		24.96
1980	158,461	51,091		32.24
1990	175,795	59,742		33.98

Los Angeles, Calif.

Year	Total Population	Black Population	% Black
1850	3,539	12	0.34
1860	4,385	76	1.73
1870	5,728	93	1.62
1880	11,183	102	0.91
1890	50,395	1,258	2.50
1900	102,479	2,131	2.08
1910	319,198	7,599	2.38
1920	576,673	15,579	2.70
1930	1,238,048	38,894	3.14
1940	1,504,277	63,774	4.24
1950	1,970,358	171,209	8.69
1960	2,479,015	334,916	13.51
1970	2,816,061	503,606	17.88
1980	2,966,850	505,210	17.03
1990	3,485,398	487,674	13.99

Memphis, Tenn.

Year	Total Population	Free Black	Slave	% Black
1850	8,841	126	2,360	28.12
1860	22,623	198	3,684	17.16
1870	40,226	15,471		38.46
1880	33,592	14,896		44.34
1890	64,495	28,706		44.51
1900	102,320	49,910		48.78
1910	131,105	52,441		40.00
1920	162,351	61,181		37.68
1930	253,143	96,550		38.14
1940	292,942	121,498		41.48
1950	396,000	147,141		37.16
1960	497,524	184,320		37.05
1970	623,530	242,513		38.89
1980	646,356	307,702		47.61
1990	610,337	334,737		54.84

Louisville, Ky.

Year	Total Population	Free Black	Slave	% Black
1800	359	1	76	21.45
1810	1,357	11	484	36.48
1820	4,012	93	1,031	28.02
1830	10,352	236	2,414	25.60
1840	21,210	619	3,430	19.09
1850	43,194	1,538	5,432	16.14
1860	68,033	1,917	4,903	10.02
1870	100,753	14,956		14.84
1880	123,758	20,905		16.89
1890	161,129	28,651		17.78
1900	204,731	39,139		19.12
1910	223,928	40,522		18.10
1920	234,891	40,087		17.07
1930	307,745	47,345		15.38
1940	319,077	47,158		14.78
1950	369,129	57,657		15.62
1960	390,639	70,075		17.94
1970	361,472	86,040		23.80
1980	298,451	84,080		28.17
1990	269,063	79,783		29.65

Montgomery, Ala.

Year	Total Population	Free Black	Slave	% Black
1840	2,179	41	1,018	48.60
1850	8,728	98	2,119	25.40
1860	8,843	102	4,400	50.91
1870	10,588	5,183		48.95
1880	16,713	9,931		59.42
1890	21,883	12,987		59.35
1900	30,346	17,229		56.78
1910	38,136	19,322		50.67
1920	43,464	19,827		45.62
1930	66,079	29,970		45.35
1940	78,084	34,535		44.23
1950	106,525	42,538		39.93
1960	134,393	47,198		35.12
1970	133,386	44,523		33.38
1980	177,857	69,660		39.17
1990	187,106	79,217		42.34

New Orleans, La.

Year	Total Population	Free Black	Slave	% Black
1820	27,176	6,237	7,355	50.01
1830[1]	29,737	8,041	9,397	58.64
1840[2]	102,193	19,226	23,448	41.76
1850	116,375	9,084	16,845	22.28
1860	168,675	10,689	13,385	14.27
1870	191,418	50,456		26.36
1880	216,090	57,617		26.66
1890	242,039	64,491		26.64
1900	287,104	77,714		27.07
1910	339,075	89,262		26.33
1920	387,219	100,930		26.07
1930	458,762	129,632		28.26
1940	494,537	149,034		30.14
1950	570,445	181,775		31.87
1960	627,525	233,514		37.21
1970	593,471	267,308		45.04
1980	557,515	308,149		55.27
1990	496,938	307,728		61.92

[1] 1830 data for "Old Square of the City of New Orleans."
[2] 1840 data for "Orleans Parish and City of New Orleans."

New York County, N.Y.

Year	Total Population	Free Black	Slave	% Black
1790	33,131	1,101	2,369	10.47
1800	60,489	3,499	2,868	10.53
1810	96,373	8,137	1,686	10.19
1820	123,706	9,568	518	8.15
1830	203,007	14,083		6.94
1840	312,710	16,358		5.23
1850	515,547	13,815		2.68
1860	813,669	12,574		1.55
1870	942,292	13,072		1.39
1880	1,206,299	19,663		1.63
1890	1,515,301	23,601		1.56
1900	1,850,093	38,616		2.09
1910	2,331,542	60,534		2.60
1920	2,284,103	109,133		4.78
1930	1,867,312	224,670		12.03
1940	1,889,924	298,365		15.79
1950	1,960,101	384,482		19.62
1960	1,698,281	397,101		23.38
1970	1,539,233	380,442		24.72
1980	1,428,285	309,854		21.69
1990	1,487,536	326,967		21.98

New York, N.Y.*

Year	Total Population	Free Black	Slave	% Black
1790	33,131	1,101	2,369	10.47
1800	60,489	3,499	2,868	10.53
1810	96,373	8,137	1,686	10.19
1820	123,706	9,568	518	8.15
1830	203,007	14,083		6.94
1840	312,710	16,358		5.23
1850	515,547	13,815		2.68
1860	805,658	12,472		1.55
1870	942,292	13,072		1.39
1880	1,206,299	19,663		1.63
1890	1,515,301	23,601		1.56
1900	3,437,202	60,666		1.76
1910	1,766,883	91,709		1.92
1920	5,620,048	152,467		2.71
1930	6,930,446	327,706		4.73
1940	7,454,995	458,444		6.15
1950	7,891,957	747,608		9.47
1960	7,781,984	1,087,931		13.98
1970	7,894,862	1,668,115		21.13
1980	7,071,639	1,784,337		25.23
1990	7,322,564	2,102,512		28.71

* Figures for New York County (Manhattan) and New York City differ after 1880 as a result of New York City's annexation of a portion of the Bronx in 1874. In 1898 New York City incorporated the outlying counties of Kings, Richmond, Queens, and the Bronx to reach its present form.

Newark, N.J.

Year	Total Population	Free Black	Slave	% Black
1810	8,008	358	369	9.08
1820	6,507	504	98	9.25
1830	10,953	648	16	6.06
1840	17,290	853	2	4.95
1850	38,893	1,229		3.16
1860	71,941	1,287		1.79
1870	105,059	1,774		1.69
1880	136,508	3,311		2.43
1890	181,830	4,141		2.28
1900	246,070	6,694		2.72
1910	347,469	9,475		2.73
1920	414,524	16,977		4.10
1930	442,337	38,880		8.79
1940	429,760	45,760		10.65
1950	438,776	74,965		17.09
1960	405,220	138,035		34.06
1970	382,417	207,458		54.25
1980	329,248	191,745		58.24
1990	275,221	160,885		58.46

Oakland, Calif.

Year	Total Population	Black Population	% Black
1860	1,543	18	1.17
1870	11,104	55	0.50
1880	34,555	593	1.72
1890	48,682	644	1.32
1900	66,960	1,026	1.53
1910	150,174	3,055	2.03
1920	216,261	5,489	2.54
1930	284,063	7,503	2.64
1940	302,163	8,462	2.80
1950	384,575	47,562	12.37
1960	367,548	83,618	22.75
1970	361,561	124,710	34.49
1980	339,337	159,281	46.94
1990	372,242	163,335	43.88

Philadelphia, Pa. (City)*

Year	Total Population	Free Black	Slave	% Black
1790	28,522	1,420	210	5.71
1800	41,220	4,210	55	10.35
1810	53,722	6,352	2	11.83
1820	64,188	7,579	3	11.81
1830	80,458	9,795	12	12.19
1840	93,665	10,507		11.22
1850	121,376	10,736		8.85

* The City of Philadelphia united with outlying areas in 1843.

Philadelphia, Pa. (City and County)

Year	Total Population	Free Black	Slave	% Black
1790	54,336	2,101	384	9.63
1800	81,009	2,585	30	6.57
1810	111,210	4,162	6	7.25
1820	145,718	4,305	4	5.29
1830	217,555	11,884	7	8.67
1840	351,702	19,831		5.64
1850	408,762	19,761		4.83
1860	562,529	22,185		3.94
1870	674,022	22,147		3.29
1880	847,170	31,699		3.74
1890	1,046,964	39,371		3.76
1900	1,293,697	62,613		4.84
1910	1,549,008	84,459		5.45
1920	1,823,779	134,229		7.36
1930	1,950,961	219,599		11.26
1940	1,931,334	251,880		13.04
1950	2,071,605	376,041		18.15
1960	2,002,512	529,240		26.43
1970	1,948,609	653,791		33.55
1980	1,688,210	638,878		37.84
1990	1,585,577	631,936		39.86

Pittsburgh, Pa.

Year	Total Population	Free Black	Slave	% Black
1800	1,565	92	10	6.52
1810	4,768	185		3.88
1820	7,248	285		3.93
1830	12,542	453		3.61
1840	21,115	710		3.36
1850	46,601	1,959		4.20
1860	49,217	1,154		2.34
1870	86,076	1,991		2.31
1880	156,389	4,077		2.61
1890	238,617	7,850		3.29
1900	321,616	17,040		5.30
1910	553,905	25,623		4.63
1920	588,343	37,725		6.41
1930	669,817	54,983		8.21
1940	671,659	62,216		9.26
1950	676,806	82,453		12.18
1960	604,332	100,692		16.66
1970	520,117	104,904		20.17
1980	423,938	101,813		24.02
1990	369,879	95,362		25.78

Queens County, N.Y.

Year	Total Population	Free Black	Slave	% Black
1790	16,014	808	2,309	19.46
1800	16,893	1,431	1,528	17.52
1810	19,336	2,354	809	16.36
1820	21,519	2,648	490	14.58
1830	22,276	3,093		13.88
1840	30,324	3,509		11.57
1850	36,833	3,541		9.61
1860	57,391	3,387		5.90
1870	73,803	3,791		5.14
1880	90,574	3,801		4.20
1890	128,059	3,529		2.76
1900	152,999	2,611		1.71
1910	284,041	3,198		1.13
1920	469,042	5,120		1.09
1930	1,079,129	18,609		1.72
1940	1,297,634	25,890		2.00
1950	1,550,849	51,524		3.32
1960	1,809,578	145,855		8.06
1970	1,986,473	258,006		12.99
1980	1,891,325	354,129		18.72
1990	1,951,598	423,211		21.69

Richmond County, N.Y.

Year	Total Population	Free Black	Slave	% Black
1790	3,835	127	759	23.10
1800	4,563	83	675	16.61
1810	5,347	274	437	13.30
1820	6,135	120	682	13.07
1830	7,084	548		7.74
1840	10,965	483		4.40
1850	15,061	590		3.92
1860	25,492	659		2.59
1870	33,029	787		2.38
1880	38,991	932		2.39
1890	51,693	964		1.86
1900	67,021	1,072		1.60
1910	85,969	1,152		1.34
1920	116,531	1,499		1.29
1930	158,346	2,576		1.63
1940	174,441	3,397		1.95
1950	191,555	5,372		2.80
1960	221,991	9,674		4.36
1970	295,443	15,792		5.35
1980	352,121	25,616		7.27
1990	378,977	30,630		8.08

Richmond, Va.

Year	Total Population	Free Black	Slave	% Black
1800	5,737	607	2,293	50.55
1810	9,735	458	3,748	43.20
1820	12,067	1,235	4,387	46.59
1830	16,060	1,960	3,734	35.45
1840	20,153	1,926	7,509	46.82
1850	27,570	2,369	9,927	44.60
1860	37,910	2,576	11,699	37.65
1870	51,038	23,104		45.27
1880	63,600	27,832		43.76
1890	81,388	32,330		39.72
1900	85,050	32,230		37.90
1910	127,628	46,733		36.62
1920	171,667	54,041		31.48
1930	182,929	52,988		28.97
1940	193,042	61,251		31.73
1950	230,310	72,996		31.69
1960	219,958	91,972		41.81
1970	249,621	104,766		41.97
1980	219,214	112,357		51.25
1990	203,056	112,122		55.22

St. Louis, Mo.

Year	Total Population	Free Black	Slave	% Black
1840	16,469	531	1,531	12.52
1850	77,860	1,398	2,656	5.21
1860	160,773	1,755	1,542	2.05
1870	310,864	22,088		7.11
1880	350,518	22,256		6.35
1890	451,770	26,865		5.95
1900	575,238	35,516		6.17
1910	687,029	43,960		6.40
1920	772,897	69,854		9.04
1930	821,960	93,580		11.38
1940	816,048	108,765		13.33
1950	856,796	153,766		17.95
1960	750,026	214,377		28.58
1970	622,236	254,191		40.85
1980	453,085	206,386		45.55
1990	396,685	188,408		47.50

San Francisco, Calif.

Year	Total Population	Black Population	% Black
1850*	34,776	—	
1860	56,802	1,176	2.07
1870	149,473	1,132	0.76
1880	233,959	1,628	0.70
1890	298,997	1,847	0.62
1900	342,782	1,654	0.48
1910	416,912	1,642	0.39
1920	506,676	2,414	0.48
1930	634,394	3,803	0.60
1940	634,536	4,846	0.76
1950	775,357	43,502	5.61
1960	740,316	74,383	10.05
1970	715,674	96,078	13.42
1980	678,974	86,414	12.73
1990	723,959	79,039	10.92

* 1850 numbers from 1852 state census.

Seattle, Wash.

Year	Total Population	Black Population	% Black
1870	1,107	13	1.17
1880	3,533	—	—
1890	42,837	286	0.67
1900	80,671	406	0.50
1910	237,194	2,296	0.97
1920	315,312	2,894	0.92
1930	365,583	3,303	0.90
1940	368,302	3,780	1.03
1950	467,591	15,666	3.35
1960	557,087	26,901	4.83
1970	530,831	37,868	7.13
1980	493,846	46,755	9.47
1990	516,259	51,948	10.06

Source: U.S. Census, 1790–1990.

13. RELIGION

TABLE 13.1 **Membership of Predominantly Black Denominations, 1890, 1916 and 1936**

Denomination (Year of Founding)	1890 No. of Churches	1890 No. of Members	1916 No. of Churches	1916 No. of Members	1936 No. of Churches	1936 No. of Members
African Orthodox Church (1921)	—	—	—	—	13	1,952
Baptist Bodies						
National Convention (1895)	12,533	1,348,989	21,113	2,261,607	23,093	3,742,464
Colored Free Will (1901)	—	—	170	13,362	226	19,616
Colored Primitive (1907)	323	18,162	326	15,144	1,009	43,897
Black Hebrews						
Church of God and Saints of Christ (1896)	—	—	94	3,311	213	37,084
Churches of the Living God						
Church of the Living God (1903)	—	—	28	1,743	119	4,838
Church of the Living God, CWF (1889)	—	—	155	9,636	96	4,525
Kodesh Church of Immanuel (1929)	—	—	—	—	9	29
Methodist Bodies						
African Methodist Episcopal (1816)	2,481	452,725	6,636	548,355	4,578	493,357
African Methodist Episcopal Zion (1821)	1,704	349,788	2,716	257,169	2,252	414,244
Colored Methodist Protestant			26	1,967	1	216
Free Christian Zion Church of Christ (1905)	—	—	35	6,225	9	1,840
Union American Methodist Episcopal	42	2,279	67	3,624	71	9,369

TABLE **13.1** **Membership of Predominantly Black Denominations, 1890, 1916 and 1936 (*Continued*)**

Denomination (Year of Founding)	1890		1916		1936	
	No. of Churches	No. of Members	No. of Churches	No. of Members	No. of Churches	No. of Members
African Union Methodist Protestant (1866)	40	3,415	58	3,751	45	4,239
Colored Methodist Episcopal (1870)	1,759	129,383	2,621	245,749	2,063	269,915
Reformed Zion Union Apostolic (1869)	32	2,346	47	3,977	54	5,035
African-American Methodist Episcopal	—	—	28	1,310	29	1,064
Reformed Methodist Union Episcopal (1885)	—	—	27	2,196	29	1,836
National David Spiritual Temple of Christ Church Union	—	—	—	—	11	1,880
Pentecostal Bodies						
Apostolic Overcoming Holy Church of God (1920)	—	—	—	—	23	863
Christ's Sanctified Holy Church (Colored) (1904)	—	—	—	—	31	665
Church of Christ (Holiness), U.S.A. (1907)	—	—	—	—	106	7,379
Church of God in Christ (1906)	—	—	—	—	772	31,564
Church of God, Holiness (1914)	—	—	—	—	35	5,872
Fire-Baptized Holiness Church of God of the Americas (1908)	—	—	—	—	59	1,973
The House of God, the Holy Church of the Living God (1919)	—	—	—	—	4	200
Triumph the Church and Kingdom of God in Christ (1902)	—	—	—	—	2	69
United Holy Church of America, Inc. (1886)	—	—	—	—	162	7,535
Presbyterian Bodies						
Colored Cumberland Presbyterian (1874)	224	12,956	136	13,077	145	10,688

Sources: *Report on Statistics of Churches in the United States at the Eleventh Census: 1890* (Washington, D.C., 1894); *Religious Bodies: 1916* (Washington, D.C., 1919); *Religious Bodies: 1936* (Washington, D.C., 1941).

TABLE **13.2 Estimated Membership of Predominantly Black Denominations, 1947–1993**

Denomination (Year of Founding)	1950–1975			1976–1993		
	Year	Churches	Members	Year	Churches	Members
African Orthodox Churches						
African Orthodox Church (1921)	1957	24	6,000	1971*	—	10,000
African Orthodox Church of the West (1984)	—	—	—	1985	2	200
Baptist Bodies						
Black Primitive Baptists (1877)	1970	43	3,000	—	—	—
Fundamental Baptist Fellowship Association (1962)	1970	10	—	—	—	—
National Baptist Convention of America (1915)	1956	1,398	2,668,799	1987	2,500	3,500,000
National Baptist Convention of the United States of America, Inc. (1895)	1958	26,000	5,500,000	1991	30,000	7,800,000
National Baptist Evangelical Life and Soul Saving Assembly of the United States of America (1920)	1951	264	57,674	—	—	—
National Primitive Baptist Convention of the United States of America (1907)	1975	606	250,000	1991	—	250,000
Progressive National Baptist Convention, Inc. (1961)	—	—	—	1991	1,400	2,500,000
United Free-Will Baptist Church (1901)	—	—	—	1992	836	100,000
Black Hebrews						
Church of God and Saints of Christ (1896)	—	—	—	1991	217	38,127
House of Judah (1965)	—	—	—	1985	1	80
Original Hebrew Israelite Nation (1960)	—	—	—	1980	—	3,000
Yahweh's Temple (1947)	1973	—	10,000	—	—	—
Catholic Bodies						
American Catholic Church (Syro-Antiochean) (1930s)	1961	40	4,663	1979	3	501
Sacred Heart Catholic Church (1980)	—	—	—	1983	3	50
The Coptic Orthodox Church	—	—	—	1992	55	260,000
International Council of Community Churches (1946)	—	—	—	1988	300	250,000
Kodesh Church of Immanuel (1829)	—	—	—	1980	5	326
Methodist Bodies						
African Methodist Episcopal Church (1816)	1951	5,878	1,666,301	1991	8,000	3,500,000
African Methodist Episcopal Zion Church (1821)	1959	4,083	770,000	1991	3,000	1,200,000
African Union First Colored Methodist Protestant Church (1866)	—	—	—	1988	35	6,500
Christian Methodist Episcopal Church (1870)	1961	2,523	444,493	1988	—	788,922
Free Christian Zion Church of Christ (1905)	1956	742	22,260	—	—	—
Reformed Methodist Union Episcopal Church (1885)	1970	21	5,000	1980	33	3,800
Reformed Zion Union Apostolic Church (1869)	1960	50	16,000	—	—	—

TABLE 13.2 **Estimated Membership of Predominantly Black Denominations, 1947–1993** (*Continued*)

Denomination (Year of Founding)	1950–1975			1976–1993		
	Year	Churches	Members	Year	Churches	Members
Mount Hebron Apostolic Temple of Our Lord Jesus of the Apostolic Faith (1963)	—	—	—	1980	9	3,000
Muslim Bodies						
Muslims	—	—	—	1993	—	1,000,000
Nation of Islam (Farrakhan) (1978)	—	—	—	1989	—	20,000
Pentecostal Bodies						
Alpha and Omega Pentecostal Church of God of America, Inc. (1945)	1970	3	400	1990	—	800
Apostolic Assemblies of Christ, Inc. (1970)	—	—	—	1980	23	3,500
Apostolic Church of Christ (1969)	1980*	6	300	1990	10	600
Apostolic Church of Christ in God	—	—	—	1980	13	2,150
Apostolic Faith Mission Church of God (1906)	—	—	—	1989	18	6,200
Apostolic Overcoming Holy Church of God (1920)	1956	300	75,000	1988	200	12,000
The Bible Church of Christ	—	—	—	1991	6	6,812
Bible Way Church of Our Lord Jesus Christ World Wide (1957)	1970	350	30,000	1991	300	250,000
Christ's Sanctified Holy Church (Louisiana) (1904)	1957	30	600	—	—	—
Church of Christ (Holiness) U.S.A. (1907)	1965	159	9,289	1990	189	12,890
Church of God in Christ (1906)	1965	4,500	425,000	1991	15,300	5,477,875
Church of God in Christ, Congregational (1932)	1970	33	—	—	—	—
Church of God in Christ, International (1969)	1971	1,041	501,000	1982	300	200,000
Church of God (Sanctified Church) (1901)	1975	60	5,000	1991	69	6,000
Church of the Living God (Christian Workers for Fellowship) (1889)	—	—	—	1985	170	42,000
Church of Living God, the Pillar and Ground of Truth (1903)	—	—	—	1988	100	2,000
Church of the Lord Jesus Christ of the Apostolic Faith (1919)	1954	155	30,000	1993	457	81,000
Churches of God, Holiness (1914)	1967	42	165,000	—	—	—
Commandment Keepers Congregation of the Living God (1924)	1970	—	3,000	—	—	—
Fire-Baptized Holiness Church of God of the Americas (1908)	1958	53	998	1991	49	695
Highway Christian Church of Christ (1929)	1980*	13	3,000	1991	—	900
House of God, Which Is the Church of the Living God, the Pillar and Ground of Truth, Inc. (1919)	1956	107	2,350	1970*	103	25,800
Latter House of the Lord for All People and the Church of the Mountain, Apostolic Faith (1936)	1947	—	4,000	—	—	—
Mount Sinai Holy Church (1924)	1968	92	2,000	1991	125	10,000
Original Glorious Church of God in Christ Apostolic Faith (1921)	—	—	—	1980	55	25,000
Original United Holy Church International (1977)	—	—	—	1985	210	15,000

TABLE 13.2 Estimated Membership of Predominantly Black Denominations, 1947–1993 (*Continued*)

Denomination (Year of Founding)	1950–1975			1976–1993		
	Year	Churches	Members	Year	Churches	Members
Pentecostal Assemblies of the World (1906)	1960	550	4,500	1989	1,005	500,000
Pentecostal Churches of Apostolic Faith (1957)	—	—	—	1991	128	151,000
Shiloh Apostolic Temple (1953)	—	—	—	1985	33	7,500
Sought Out Church of God in Christ	1949	4	60	—	—	—
Triumph the Church and Kingdom of God in Christ (1902)	1972	475	54,307	—	—	—
United Church of Jesus Christ (Apostolic) (1945)	—	—	—	1985	75	100,000
United Holy Church of America (1886)	1960	470	28,890	1970*	470	50,000
United Way of the Cross Churches of Christ of the Apostolic Faith	1980*	14	1,100	1990	14	1,002
Universal Christian Spiritual Faith and Churches for All Nations (1952)	1965	60	40,816	—	—	—
Way of the Cross Church of Christ (1927)	1980	48	50,000	1987	68	60,000
Presbyterian Bodies						
Second Cumberland Presbyterian Church in the United States (1874)	1959	221	30,000	—	—	—

* Most recent data available.

Sources: "Black Americans and the Churches," in *Religions of America* (New York, 1975); *Black Americans Information Directory (1990–91)* (New York, 1990); *Directory of African American Religious Bodies: A Compendium by the Howard University School of Divinity* (Washington, D.C., 1991); "The Negro in American Religious Life," in *The American Negro Reference Book* (Englewood Cliffs, N.J., 1970); *Statistical Record of Black America* (Detroit, 1990); *Yearbook of American and Canadian Churches: 1993* (Nashville, Tenn., 1992); *Yearbook of American and Canadian Churches: 1992* (Nashville, Tenn., 1991); *Yearbook of American and Canadian Churches: 1973* (Nashville, Tenn., 1973). Membership figures provided by denominations themselves, which use different criteria to determine them.

TABLE 13.3 Membership of Racially Mixed Denominations, 1890, 1916, and 1936

Denomination	1890		1916		1936	
	Black Members	Total Members	Black Members	Total Members	Black Members	Total Members
Adventist Bodies						
Advent Christian	—	25,816	317	30,597	—	26,258
Seventh-day	—	28,991	2,553	79,355	6,367	133,254
Baptist Bodies						
Northern Convention	35,221	800,025	53,842	1,232,135	45,821	1,329,044
Congregational Church	6,908	512,771	13,209	791,274	20,437	976,388
Disciples of Christ	18,578	641,051	11,478	1,226,028	21,950	1,196,315
Lutheran Bodies						
Synodical Conference	211	357,153	1,525	777,701	8,985	1,463,482
Methodist Bodies						
Methodist Episcopal	246,249	2,240,354	320,025	3,717,785	193,761	3,509,763
Methodist Protestant	3,183	141,989	2,869	186,908	2,321	148,288
Moravian Bodies						
Moravian Church (Unitas Fratrum)	—	11,781	419	26,373	628	30,904

TABLE **13.3** **Membership of Racially Mixed Denominations, 1890, 1916, and 1936 (*Continued*)**

Denomination	1890 Black Members	1890 Total Members	1916 Black Members	1916 Total Members	1936 Black Members	1936 Total Members
Presbyterian Bodies						
Presbyterian Church in the United States of America	14,961	788,224	31,957	1,611,251	279	449,045
Presbyterian Church in the United States	1,568	179,721	1,429	357,769	2,971	1,797,927
Protestant Episcopal Church	2,977	532,054	23,775	1,092,821	29,738	1,735,335
Reformed Episcopal Church	1,723	8,455	3,017	11,050	2,434	7,656
Roman Catholic Church	17,079	6,231,417	51,688	15,721,815	137,684	19,914,937
Salvation Army	—	8,741	—	35,954	436	103,038

Sources: *Report on Statistics of Churches of the United States at the Eleventh Census: 1890* (Washington, D.C., 1894); *Religious Bodies: 1916* (Washington, D.C., 1919); *Religious Bodies: 1936* (Washington, D.C., 1941).

TABLE **13.4** **Membership of Racially Mixed Denominations, 1963–1992**

Denomination	Year	Black membership	Total membership
American Baptist Convention	1964	200,000	1,559,103
	1990	496,000	1,535,971
Christian Churches (Disciples of Christ)	1964	80,000	1,920,760
	1992	61,000	1,039,692
Congregational Christian Churches	1964	38,000	110,000
	1992	9,000	75,000
Lutheran Church–Missouri Synod	1991	15,147	2,609,025
Mennonite Church	1992	3,476	114,307
Protestant Episcopal Church	1963	73,867	3,340,759
	1990	250,000	2,446,050
Reformed Episcopal Church	1992	3,184	6,042
Roman Catholic Church	1964	722,609	45,640,619
	1990	2,000,000	58,568,015
Seventh-Day Adventists	1964	167,892	370,688
	1990	280,000	717,446
United Church of Christ	1964	21,859	2,056,696
	1989	62,048	1,662,568
United Methodist Church	1964	373,327	10,304,184
	1992	257,436	8,853,455
United Presbyterian Church in the United States of America	1964	6,000	3,302,839
	1990	65,000	3,788,009

14. SPORTS

TABLE **14.1** **African-American Olympic Medalists**

1904: St. Louis, Mo.
George C. Poage	bronze	400-m hurdles

1908: London, England
John Baxter Taylor	gold	4 × 400-m relay

1924: Paris, France
Edward Gourdin	silver	long jump
William DeHart Hubbard	gold	long jump
Earl Johnson	bronze	10,000-m run

1932: Los Angeles, Calif.
Edward Gordon	gold	long jump
Ralph Metcalfe	silver	100-m dash
	bronze	299-m dash
Eddie Tolan	gold	100-m dash
	gold	200-m dash

1936: Berlin, Germany
David Albritton	silver	high jump
Cornelius Johnson	gold	high jump
James Luvalle	bronze	400-m dash
Ralph Metcalfe	gold	4 × 100-m relay
	silver	100-m dash
Jesse Owens	gold	100-m dash
	gold	200-m dash
	gold	long jump
	gold	4 × 100-m relay
Fritz Pollard, Jr.	bronze	110-m hurdles
Mack Robinson	silver	200-m dash
Archie Williams	gold	400-m dash
Jackie Wilson	silver	boxing (bantamweight)
John Woodruff	gold	800-m run

1948: London, England
Women:
Alice Coachman	gold	high jump
Audrey Patterson	bronze	200-m dash

Men:
Don Barksdale	gold	basketball
John Davis	gold	weightlifting (heavyweight)
Harrison Dillard	gold	100-m dash
	gold	4 × 100-m relay
Norwood Ewell	gold	4 × 100-m relay
	silver	100-m dash
Horace Herring	silver	boxing (welterweight)
Willie Steele	gold	long jump
Mal Whitfield	gold	800-m run
	gold	4 × 400-m relay
Lorenzo Wright	gold	4 × 100-m relay

1952: Helsinki, Finland
Women:
Mae Faggs	gold	4 × 100-m relay
Catherine Hardy	gold	4 × 100-m relay
Barbara Jones	gold	4 × 100-m relay

Men:
Charles Adkins	gold	boxing (light welterweight)
Jerome Biffle	gold	long jump
James Bradford	silver	weightlifting (heavyweight)
Nathan Brooks	gold	boxing (flyweight)

TABLE **14.1** **African-American Olympic Medalists** (*Continued*)

Milton Campbell	silver	decathlon
John Davis	gold	weightlifting (heavyweight)
Harrison Dillard	gold	110-m hurdles
	gold	4 × 100-m relay
Meredith Gourdine	silver	long jump
Norvel Lee	gold	boxing (light heavyweight)
Ollie Matson	silver	4 × 400-m relay
	bronze	400-m dash
Floyd Patterson	gold	boxing (middleweight)
Edward Hayes Sanders	gold	boxing (heavyweight)
Andrew Stanfield	gold	200-m dash
	gold	4 × 100-m relay
Malvin Whitfield	gold	800-m run
	silver	4 × 400-m relay

1956: *Melbourne, Australia*

Women:

Isabelle Daniels	bronze	4 × 100-m relay
Mae Faggs	bronze	4 × 100-m relay
Margaret Matthews	bronze	4 × 100-m relay
Mildred McDaniel	gold	high jump
Wilma Rudolph	bronze	4 × 100-m relay

Men:

Greg Bell	gold	long jump
James Boyd	gold	boxing (light heavyweight)
Carl Cain	gold	basketball
Lee Calhoun	gold	110-m hurdles
Milton Campbell	gold	decathlon
Josh Culbreath	bronze	400-m hurdles
Charles Dumas	gold	high jump
Charles Jenkins	gold	4 × 400-m relay
	gold	400-m dash
Rafer Johnson	silver	decathlon
K. C. Jones	gold	basketball
Lou Jones	gold	4 × 400-m relay
Leamon King	gold	4 × 100-m relay
Ira Murchison	gold	4 × 100-m relay
Bill Russell	gold	basketball
Andrew Stanfield	silver	200-m dash
Jose Torres	silver	boxing (light middleweight)
Willye White	silver	long jump

1960: *Rome, Italy*

Women:

Earline Brown	bronze	shot put
Martha Hudson	gold	4 × 100-m relay
Barbara Jones	gold	4 × 100-m relay
Wilma Rudolph	gold	100-m dash
	gold	200-m dash
	gold	4 × 100-m relay
Lucinda Williams	gold	4 × 100-m relay

Men:

Cassius Clay (Muhammad Ali)	gold	boxing (light heavyweight)
Walt Bellamy	gold	basketball
Bob Boozer	gold	basketball
Ralph Boston	gold	long jump
James Bradford	silver	weightlifting (heavyweight)
Lee Calhoun	gold	110-m hurdles

TABLE 14.1 African-American Olympic Medalists (*Continued*)

Lester Carney	silver	200-m dash
Edward Crook	gold	boxing (middleweight)
Quincey Daniels	bronze	boxing (light welterweight)
Otis Davis	gold	400-m dash
	gold	4 × 400-m relay
Rafer Johnson	gold	decathlon
Hayes Jones	bronze	110-m hurdles
Willie May	silver	110-m hurdles
Wilbert McClure	gold	boxing (light middleweight)
Irvin Roberson	silver	long jump
Oscar Robertson	gold	basketball
John Thomas	bronze	high jump

1964: *Tokyo, Japan*

Women:

Edith McGuire	gold	200-m dash
	silver	4 × 100-m relay
	silver	100-m dash
Wyomia Tyus	gold	100-m dash
	silver	4 × 100-m relay
Marilyn White	silver	4 × 100-m relay

Men:

Jim Barnes	gold	basketball
Ralph Boston	silver	long jump
Charles Brown	bronze	boxing (featherweight)
Joe Caldwell	gold	basketball
Henry Carr	gold	200-m dash
	gold	4 × 400-m relay
Paul Drayton	gold	4 × 100-m relay
	silver	200-m dash
Joseph "Joe" Frazier	gold	boxing (heavyweight)
Ronald Harris	bronze	boxing (lightweight)
Bob Hayes	gold	100-m dash
	gold	4 × 100-m relay
Walt Hazzard	gold	basketball
Luke Jackson	gold	basketball
Hayes Jones	gold	110-m hurdles
John Rambo	bronze	high jump
Richard Stebbins	gold	4 × 100-m relay
John Thomas	silver	high jump
Willye White	silver	4 × 100-m relay
Ulis Williams	gold	4 × 400-m relay
George Wilson	gold	basketball

1968 *Mexico City, Mexico*

Women:

Margaret Bailes	gold	4 × 100-m relay
Barbara Ferrell	gold	4 × 100-m relay
	silver	100-m dash
Madeline Manning	gold	800-m run
Mildrette Netter	gold	4 × 100-m relay
Wyomia Tyus	gold	100-m dash
	gold	4 × 100-m relay

Men:

John Lee Baldwin	bronze	boxing (light middleweight)
Bob Beamon	gold	long jump
Ralph Boston	bronze	long jump
John Carlos	bronze	200-m dash
Edward Caruthers	silver	high jump

TABLE 14.1 **African–American Olympic Medalists (*Continued*)**

Willie Davenport	gold	110-m hurdles
Lee Evans	gold	400-m dash
	gold	4 × 400-m relay
George Foreman	gold	boxing (heavyweight)
Calvin Fowles	gold	basketball
Ron Freeman	gold	4 × 400-m relay
	bronze	400-m dash
Charles Greene	gold	4 × 100-m relay
	bronze	100-m dash
Ervin Hall	silver	110-m hurdles
Ronald Harris	gold	boxing (lightweight)
Spencer Haywood	gold	basketball
James Hines	gold	100-m dash
	gold	4 × 100-m relay
Larry James	gold	4 × 400-m relay
	silver	400-m dash
Alfred Jones	bronze	boxing (middleweight)
James King	gold	basketball
Harlan Marbley	bronze	boxing (light flyweight)
Vincent Mathews	gold	4 × 400-m relay
Melvin Pender	gold	4 × 100-m relay
Albert Robinson	silver	boxing (featherweight)
Charlie Scott	gold	basketball
Ronnie Smith	gold	4 × 100-m relay
Tommie Smith	gold	200-m dash
James Wallington	bronze	boxing (light welterweight)
Jo Jo White	gold	basketball

1972 *Munich, West Germany*

Women:

Mable Ferguson	silver	4 × 400-m relay
Madeline Manning	silver	4 × 400-m relay
Cheryl Toussaint	silver	4 × 400-m relay

Men:

Mike Bantom	silver	basketball
Larry Black	gold	4 × 100-m relay
	silver	200-m dash
Jim Brewer	silver	basketball
Ricardo Carreras	bronze	boxing (bantamweight)
Wayne Collett	silver	400-m dash
James Forbes	silver	basketball
Eddie Hart	gold	4 × 100-m relay
Tom Henderson	silver	basketball
Marvin L. Johnson	bronze	boxing (middleweight)
Dwight Jones	silver	basketball
Vincent Mathews	gold	400-m dash
Rod Milburn	gold	110-m hurdles
Ed Ratleff	silver	basketball
Arnie Robinson	bronze	long jump
Ray Seales	gold	boxing (light welterweight)
Robert Taylor	gold	4 × 100-m relay
	silver	100-m dash
Gerald Tinker	gold	4 × 100-m relay
Randy Williams	gold	long jump

1976: *Montreal, Canada*

Women:

Rosalyn Bryant	silver	4 × 400-m relay
Anita DeFrantz	bronze	rowing (eights with coxswain)

TABLE 14.1 African–American Olympic Medalists (*Continued*)

Lusia Harris	silver	basketball
Sheila Ingram	silver	4 × 400-m relay
Pamela Jiles	silver	4 × 400-m relay
Charlotte Lewis	silver	basketball
Gail Marquis	silver	basketball
Patricia Roberts	silver	basketball
Deborah Sapenter	silver	4 × 400-m relay
Men:		
David Lee Armstrong	silver	boxing (featherweight)
Benny Brown	gold	4 × 400-m relay
Quinn Buckner	gold	basketball
James Butts	silver	triple jump
Kenny Carr	gold	basketball
Allen Coage	bronze	judo
Adrian Dantley	gold	basketball
Willie Davenport	bronze	110-m hurdles
Howard Davis	gold	boxing (lightweight)
Walter Davis	gold	basketball
Dwayne Evans	bronze	200-m dash
Phil Ford	gold	basketball
Herman Frazier	gold	4 × 400-m relay
	bronze	400-m dash
Harvey Glance	gold	4 × 100-m relay
Millard Hampton	gold	4 × 100-m relay
	silver	200-m dash
Phil Hubbard	gold	basketball
John Jones	gold	4 × 100-m relay
Lloyd Keaser	silver	wrestling (freestyle)
"Sugar" Ray Leonard	gold	boxing (light welterweight)
Scott May	gold	basketball
Charles Michael Mooney	silver	boxing (bantamweight)
Edwin Moses	gold	400-m hurdles
Fred Newhouse	gold	4 × 400-m relay
	silver	400-m dash
Maxie Parks	gold	4 × 400-m relay
Leo Randolph	gold	boxing (flyweight)
Arnie Robinson	gold	long jump
Steve Riddick	gold	4 × 100-m relay
Steve Sheppard	gold	basketball
Leon Spinks	gold	boxing (light heavyweight)
Michael Spinks	gold	boxing (middleweight)
Johnny Tate	bronze	boxing (heavyweight)
Randy Williams	silver	long jump
1984: *Los Angeles, Calif.*		
Women:		
Evelyn Ashford	gold	100-m dash
	gold	4 × 100-m relay
Jeanette Bolden	gold	4 × 100-m relay
Cathy Boswell	gold	basketball
Valerie Brisco-Hooks	gold	200-m dash
	gold	400-m dash
	gold	4 × 400-m relay
Alice Brown	gold	4 × 100-m relay
	silver	100-m dash
Judi Brown	silver	400-m hurdles
Rita Crockett	silver	volleyball

TABLE 14.1 African-American Olympic Medalists (*Continued*)

Chandra Cheeseborough	gold	4 × 100-m relay
	gold	4 × 400-m relay
	silver	400-m dash
Teresa Edwards	gold	basketball
Benita Fitzgerald-Brown	gold	100-m hurdles
Florence Griffith	silver	200-m dash
Sherri Howard	gold	4 × 400-m relay
Flo Hyman	silver	volleyball
Jackie Joyner	silver	heptathlon
Janice Lawrence	gold	basketball
Lillie Leatherwood	gold	4 × 400-m relay
Rose Magers	silver	volleyball
Pam McGee	gold	basketball
Cheryl Miller	gold	basketball
Kim Turner	bronze	100-m hurdles
Lynette Woodard	gold	basketball
Men:		
Ray Armstead	gold	4 × 400-m relay
Alonzo Babers	gold	400-m dash
	gold	4 × 400-m relay
Kirk Baptiste	silver	200-m dash
Tyrell Biggs	gold	boxing (super heavyweight)
Mark Breland	gold	boxing (welterweight)
Ron Brown	gold	4 × 100-m relay
Mike Conley	silver	triple jump
Patrick Ewing	gold	basketball
Vern Fleming	gold	basketball
Greg Foster	silver	110-m hurdles
Greg Gibson	silver	wrestling (Greco-Roman)
Sam Graddy	gold	4 × 100-m relay
	silver	100-m dash
Danny Harris	silver	400-m hurdles
Virgil Eugene Hill	silver	boxing (middleweight)
Evander Holyfield	bronze	boxing (light heavyweight)
Earl Jones	bronze	800-m run
Michael Jordan	gold	basketball
Al Joyner	gold	triple jump
Roger Kingdom	gold	110-m hurdles
Carl Lewis	gold	100-m dash
	gold	200-m dash
	gold	long jump
	gold	4 × 100-m relay
Edward Liddie	bronze	judo
Steve McCroy	gold	boxing (flyweight)
Antonio McKay	gold	4 × 400-m relay
	bronze	400-m dash
Edwin Moses	gold	400-m hurdles
Sunder Nix	gold	4 × 400-m relay
Jerry Page	gold	boxing (light welterweight)
Sam Perkins	gold	basketball
Alvin Robertson	gold	basketball
Calvin Smith	gold	4 × 100-m relay
Frank Tate	gold	boxing (light middleweight)
Meldrick Taylor	gold	boxing (featherweight)
Henry Tillman	gold	boxing (heavyweight)
Waymon Tisdale	gold	basketball
Nelson Vails	silver	cycling

TABLE 14.1 African-American Olympic Medalists (*Continued*)

Peter Westbrook	bronze	fencing (saber)
Pernell Whitaker	gold	boxing (lightweight)
Leon Wood	gold	basketball

1988 *Seoul, Korea*

Women:

Evelyn Ashford	gold	4 × 100-m relay
Valerie Brisco	silver	4 × 400-m relay
Alice Brown	gold	4 × 100-m relay
Cynthia Brown	gold	basketball
Victoria Bullett	gold	basketball
Diane Dixon	silver	4 × 400-m relay
Sheila Echols	gold	4 × 100-m relay
Teresa Edwards	gold	basketball
Bridgette Gordon	gold	basketball
Florence Griffith-Joyner	gold	100-m dash
	gold	200-m dash
	gold	4 × 100-m relay
	silver	4 × 400-m relay
Denean Howard	silver	4 × 400-m relay
Jackie Joyner-Kersee	gold	heptathlon
	gold	long jump
Katrian McClain	gold	basketball
Teresa Weatherspoon	gold	basketball

Men:

Willie Anderson	silver	basketball
Stacey Augman	silver	basketball
Anthony Campbell	bronze	110-m hurdles
Vernell Coles	silver	basketball
Joe Deloach	gold	200-m dash
Romallis Ellis	bronze	boxing (lightweight)
Danny Everett	gold	4 × 400-m relay
Kenneth Gould	bronze	boxing (welterweight)
Hersey Hawkins	silver	basketball
Roy L. Jones II	silver	boxing (light middleweight)
Robert Kingdom	gold	110-m hurdles
Carl Lewis	gold	100-m dash
	gold	long jump
	silver	200-m dash
Steve Lewis	gold	400-m dash
	gold	4 × 400-m relay
Danny Manning	silver	basketball
Andrew Maynard	gold	boxing (light heavyweight)
Kennedy McKinney	gold	boxing (bantamweight)
Ray Mercer	gold	boxing (heavyweight)
Edwin Moses	bronze	400-m hurdles
Andre Phillips	gold	400-m hurdles
Mike Powell	silver	long jump
Herman "J. R." Reid	silver	basketball
Harold "Butch" Reynolds	gold	4 × 400-m relay
	silver	400-m dash
Mitchell Richmond	silver	basketball
David Robinson	silver	basketball
Charles D. Smith	silver	basketball
Charles E. Smith	silver	basketball

1988: *Calgary, Alberta*

Debi Thomas	bronze	ice skating

TABLE 14.1 African–American Olympic Medalists (*Continued*)

1992: *Barcelona, Spain*

Women:

Evelyn Ashford	gold	4 × 100-m relay
Victoria Bullett	bronze	basketball
Dedra Charles	bronze	basketball
Tara Cross–Battle	bronze	volleyball
Clarissa Davis	bronze	basketball
Gail Devers	gold	100-m dash
Medina Dixon	bronze	basketball
Sandra Farmer–Patrick	silver	400-m hurdles
Carlette Guidry	gold	4 × 100-m relay
Tammie Jackson	bronze	basketball
Carolyn Jones	bronze	basketball
Esther Jones	gold	4 × 100-m relay
Jackie Joyner-Kersee	gold	heptathlon
	bronze	long jump
Natasha Kaiser	silver	4 × 400-m relay
Ruth T. Lawanson	bronze	volleyball
Lavona Martin	silver	100-m hurdles
Katrina McClain	bronze	basketball
Jearl Miles	silver	4 × 400-m relay
Elaina Oden	bronze	volleyball
Kimberly Yvette Oden	bronze	volleyball
Vickie Orr	bronze	basketball
Tonya (Tee) Sanders	bronze	volleyball
Rochelle Stevens	silver	4 × 400-m relay
Gwen Torrence	gold	200-m dash
	gold	4 × 100-m relay
	silver	4 × 400-m relay
Janeene Vickers	silver	400-m hurdles
Teresa Weatherspoon	bronze	basketball

Men:

Tim Austin	bronze	boxing (flyweight)
Charles Barkley	gold	basketball
Mike Bates	bronze	200-m dash
Chris Byrd	silver	boxing (middleweight)
Leroy Burrell	gold	4 × 100-m relay
Chris Campbell	bronze	wrestling (freestyle)
Mike Conley	gold	triple jump
Tony Dees	silver	110-m hurdles
Clyde Drexler	gold	basketball
Patrick Ewing	gold	basketball
Johnny Gray	bronze	800-m run
Joe Greene	bronze	long jump
Kevin Jackson	gold	wrestling (freestyle)
Michael Johnson	gold	4 × 400-m relay
Earvin "Magic" Johnson	gold	basketball
Michael Johnson	gold	4 × 400-m relay
Michael Jordan	gold	basketball
Carl Lewis	gold	4 × 100-m relay
	gold	long jump
Steve Lewis	gold	4 × 400-m relay
	silver	400-m dash
Karl Malone	gold	basketball
Mike Marsh	gold	200-m dash
	gold	4 × 100-m relay
Dennis Mitchell	gold	4 × 100-m relay
	bronze	100-m dash

TABLE **14.1** **African-American Olympic Medalists** (*Continued*)

Kenny Monday	silver	wrestling (freestyle)
Scottie Pippen	gold	basketball
Mike Powell	silver	long jump
David Robinson	gold	basketball
Charles Simpkins	silver	triple jump
Rodney Smith	bronze	wrestling (Greco-Roman)
Quincy Watts	gold	400-m dash
	gold	4 × 400-m relay
Andrew Yalmon	gold	4 × 400-m relay
Kevin Young	gold	400-m hurdles

TABLE **14.2** **African-American Members of the National Baseball Hall of Fame, Cooperstown, N.Y.**

Year Inducted	Member	Born–Died
1962	Jack R. Robinson	1919–1972
1969	Roy Campanella	1921–1993
1971	Leroy R. "Satchel" Paige*	1906–1982
1972	Joshua Gibson*	1911–1947
	Walter F. "Buck" Leonard*	1907
1973	Roberto W. Clemente	1934–1972
	Monford "Monte" Irvin*	1919
1974	James T. "Cool Papa" Bell*	1903–1991
1975	William J. "Judy" Johnson*	1900–1989
1976	Oscar M. Charleston*	1896–1954
1977	Ernest Banks	1931
	Martin Dihigo*	1905–1971
1979	Willie H. Mays	1931
1981	Andrew "Rube" Foster*	1878–1930
	Robert Gibson	1935
1982	Henry L. Aaron	1934
	Frank Robinson	1935
1983	Juan A. Marichal	1937
1985	Louis C. Brock	1939
1986	Willie L. McCovey	1938
1987	Raymond E. Dandridge*	1913
	Billy L. Williams	1938
1988	Wilver D. Stargell	1940
1990	Joe L. Morgan	1943
1991	Rodney C. Carew	1945
	Ferguson A. Jenkins	1943
1993	Reginald M. Jackson	1946

* Members of the Negro League.

TABLE **14.3 African-American Members of the Naismith Memorial Basketball Hall of Fame, Springfield, Mass.**

Year Inducted	Member	Born–Died
1963	New York Renaissance (team)	
1971	Robert L. "Bobby" Douglas*	1884–1979
1974	William F. "Bill" Russell	1934
1976	Elgin Baylor	1934
	Charles T. "Chuck" Cooper	1907–1980
1978	Wilton N. "Wilt" Chamberlain	1936
	John B. McLendon, Jr.*	1915
1979	Oscar P. "Big O" Robertson	1938
1981	Clarence E. "Bighouse" Gaines*	1923
	Harold E. "Hal" Greer	1936
	Willis Reed, Jr.	1942
1983	Samuel "Sam" Jones	1933
1984	Nate Thurmond	1941
1986–87	Walter "Walt" Frazier, Jr.	1945
1987–88	Wesley S. "Wes" Unseld	1946
1988–89	William "Pops" Gates	1917
	K. C. Jones	1932
	Leonard R. "Lenny" Wilkens	1937
1989–90	Earl "The Pearl" Monroe	1944
	David "Dave" Bing	1943
	Elvin E. Hayes	1945
1990–91	Nathaniel "Nate" Archibald	1948
1991–92	Connie Hawkins	1942
	Robert J. "Bob" Lanier	1948
	Lusia Harris Stewart	1955
	Walt Bellamy	1939
	Julius W. "Dr. J" Erving II	1950
	Calvin J. Murphy	1948

*Coach

TABLE **14.4 African-American Members of the Pro Football Hall of Fame, Canton, Ohio**

Year Inducted	Member	Born–Died
1967	Emlen Tunnell	1925–1975
1968	Mario Motley	1920
1969	Fletcher Joseph "Joe" Perry	1927
1971	James N. Brown*	1936
	Gene Upshaw	1945
1972	Ollie Matson	1930
1973	James Thomas Parker	1934
1974	Richard "Night Train" Lane	1928
1975	Roosevelt Brown	1932
	Lenny Moore	1933
1976	Len Ford	1926–1972
1977	Gale Sayers	1943
	Bill Willis	1921
1980	Herb Adderley	1939
	David "Deacon" Jones	1938
1981	Willie Davis	1934

*James Brown was inducted into the Lacrosse Hall of Fame, Baltimore, Md., in 1957. As of 1994 he was the only African-American member of the Lacrosse Hall of Fame.

TABLE 14.4 African-American Members of the Pro Football Hall of Fame, Canton, Ohio (*Continued*)

Year Inducted	Member	Born–Died
1983	Bobby Bell	1940
	Bobby Mitchell	1935
	Paul Warfield	1942
1984	Willie Brown	1940
	Charles Robert "Charley" Taylor	1942
1985	Orenthal James "O. J." Simpson	1947
1986	Ken Houston	1944
	Willie Lanier	1945
1987	Charles Edward "Mean Joe" Greene	1946
	John Henry Johnson	1929
1988	Alan Page	1945
1989	Mel Blount	1948
	Art Shell	1946
	Willie Wood	1936
1990	Buck Buchanan	1940
	Franco Harris	1950
1991	Earl Campbell	1955
1992	Lem Barney	1945
	John Mackey	1941
1993	Larry Little	1945
	Walter Payton	1954

TABLE 14.5 African-American Members of the Horse Racing Hall of Fame, Saratoga Springs, N.Y.

Year Inducted	Member	Born–Died
1955	Isaac B. Murphy	1861–1896
1977	Willie Simms	1870–1927
1984	Edward D. Brown	1848–1906

TABLE 14.6 African-American Members of the International Tennis Hall of Fame, Newport, R.I.

Year Inducted	Member	Born–Died
1971	Althea Gibson Darben	1927
1985	Arthur Ashe	1943–1993

TABLE **14.7 African-American Members of the National Track & Field Hall of Fame, Indianapolis, Ind.**

Year Inducted	Member	Born–Died
1974	Ralph Boston	1939
	Lee Calhoun	1933
	Harrison Dillard	1923
	Rafer Johnson	1935
	Jesse Owens	1913–1980
	Wilma Rudolph	1940
	Mal Whitfield	1924
1975	Alice Coachman (Davis)	1932
	Edward Hurt	1900–1989
	Ralph Metcalfe	1910–1978
1976	Mae Faggs (Starrs)	1932
	Bob Hayes	1942
	Hayes Jones	1938
1977	Bob Beamon	1946
	Andy Stanfield	1927–1985
1978	Tommie Smith	1944
	John Woodruff	1915
1979	Jim Hines	1946
	Dehart Hubbard	1903–1976
	Edith McGuire (DuVall)	1944
1980	Dave Albritton	1913–1994
	Wyomia Tyus Tillman	1945
1981	Willye White	1939
1982	Willie Davenport	1943
	Eddie Tolan	1908–1967
1983	Lee Evans	1947
	Mildred McDaniel (Singleton)	1933
	Leroy Walker	1918
1984	Madeline Manning (Mims)	1948
	Joseph Yancey	1910–1991
1985	John Thomas	1941
1986	Barney Ewell	1918
1987	Eulace Peacock	1914
	Martha Watson	1946
1988	Greg Bell	1928
	Barbara Ferrell (Edmonson)	1947
1989	Milt Campbell	1933
	Nell Jackson	1929–1988
	Ed Temple	1927
1990	Charles Dumas	1937
1992	Charles Greene	1944
	Charlie Jenkins	1934
	Archie Williams	1915–1993

TABLE 14.8 Negro League Teams*

Negro National League I (1920–1931)
Birmingham Black Barons (1925, 1927–1930)
Chicago American Giants (1920–1931)
Chicago Giants (1920–1921)
Columbus Buckeyes (1921)
Cuban Stars (1920, 1922)
Cleveland Browns (1924)
Cleveland Cubs (1931)
Cleveland Elites (1926)
Cleveland Hornets (1927)
Cleveland Tate Stars (1922)
Dayton Marcos (1920, 1926)
Detroit Stars (1920–1931)
Indianapolis ABCs (1920–1926, 1931)
Kansas City Monarchs (1920–1931)
Louisville White Sox (1931)
Memphis Red Sox (1924–1925, 1927–1930)
Milwaukee Bears (1923)
Nashville Elite Giants (1930)
Pittsburgh Keystones (1922)
St. Louis Giants (1920–1921)
Toledo Tigers (1923)

Eastern Colored League (1923–1928)/
 American Negro League (1929)
Bacharach Giants [Atlantic City] (1923–1929)
Baltimore Black Sox (1923–1929)
Brooklyn Royal Giants (1923–1927)
Cuban Stars (East) (1923–1929)
Harrisburg [Pa.] Giants (1924–1927)
Hilldale [Philadelphia] (1923–1927, 1929)
Homestead Grays (1929)
Lincoln Giants [New York] (1923–1926, 1928–1929)
Newark Stars (1926)
Philadelphia Tigers (1928)
Washington Potomacs (1924)

Negro Southern League (1932)
Cole's American Giants (Chicago)
Columbus (Ohio) Turfs
Indianapolis ABCs
Louisville Black Caps
Memphis Red Sox
Monroe Monarchs
Montgomery Grey Sox
Nashville Elite Giants

East-West League (Spring 1932)
Baltimore Black Sox
Cleveland Stars
Cuban Stars

Hilldale [Philadelphia]
Homestead [Pa.] Grays
Newark Browns

Negro National League II (1933–1948)
Bacharach Giants [Atlantic City] 1934
Baltimore Black Sox (1933–1934)
Baltimore Elite Giants (1938–1948)
Brooklyn Eagles (1935)
Cleveland Giants (1933)
Cleveland Red Sox (1934)
Cole's American Giants [Chicago] (1933–1935)
Columbus Blue Birds (1933)
Columbus Elite Giants (1935)
Detroit Stars (1933)
Harrisburg–St. Louis Stars (1943)
Homestead Grays (1935–1948)[1]
Nashville Elite Giants (1933–1934)
Newark Dodgers (1934–1935)
Newark Eagles (1936–1948)
New York Black Yankees (1936–1948)
New York Cubans (1935–1936, 1939–1948)
Philadelphia Stars (1934–1948)
Pittsburgh Crawfords (1933–1938)
Washington Black Senators (1938)
Washington Elite Giants (1936–1937)

Negro-American League (1937–1950)
Atlanta Black Crackers (1938)
Baltimore Elite Giants (1949–1950)
Birmingham Black Barons (1937–1938, 1940–1950)
Chicago American Giants (1937–1950)
Cleveland Buckeyes (1943–1948, 1950)
Cincinnati Buckeyes (1942)
Cincinnati Tigers (1937)
Cleveland Bears (1939–1940)
Detroit Stars (1937)
Houston Eagles (1949–1950)
Indianapolis ABCs (1938–1939)
Indianapolis Athletics (1937)
Indianapolis Clowns (1943–1950)[2]
Indianapolis Crawfords (1940)
Jacksonville Red Caps (1938, 1941–1942)
Kansas City Monarchs (1937–1950)
Louisville Buckeyes (1949)
Memphis Red Sox (1937–1941, 1943–1950)
New York Cubans (1949–1950)
Philadelphia Stars (1949–1950)
St. Louis Stars (1937, 1939, 1941)
Toledo Crawfords (1939)

* Home cities have been identified where known.
[1] Sometimes referred to as Washington Homestead Grays
[2] Cincinnati Clowns (1943); Cincinnati-Indianapolis Clowns (1944)

TABLE 14.9 Negro League Batting Champions

Negro National League I

1920	Cris Torriente, CAG	.411
1921	Charles Blackwell, STL	.448
1922	Heavy Johnson, KC	.389
1923	Cris Torriente, CAG	.412
1924	Dobie Moore, KC	.453
1925	Edgar Wesley, DET	.416
1926	Mule Suttles, STL	.418
1927	Red Parnell, BIR	.426
1928	Pythian Russ, CAG	.406

Negro National League

1929	Mule Suttles, STL	.372
1930	Willie Wells, STL	.403
1931	Nat Rogers, MEM	.424

Negro National League II

1933	Oscar Charleston, PIT	.372
1934	Jud Wilson, HG	.361
1935	Turkey Stearnes, CAG	.430
1936	Lazaro Salazar, NYC	.367
1937	Bill Wright, HG	.410
1938	Ray Dandridge, NWK	.404
1939	Bill Wright, BAL	.402
1940	Buck Leonard, HG	.383
1941	Monte Irvin, NWK	.463
1942	Willie Wells, NWK	.344
	Josh Gibson, HG	.344
1943	Josh Gibson, HG	.474
1944	Frank Austin, PHI	.390
1945	Josh Gibson, HG	.393
1946	Monte Irvin, NWK	.389
1947	Luis Marquez, HG	.417
1948	Buck Leonard, HG	.395

Eastern Colored League

1923	Jud Wilson, BB	.373
1924	Pop Lloyd, BG	.433
1925	Oscar Charleston, BG	.445
1926	Robert Hudspeth, LG	.365
1927	Clarence Jenkins, BG	.398
1928	Pop Lloyd, LG	.564

Negro American League

1929	Chino Smith, LG	.454
1930	John Beckwith, NY/BB	.480
1931	George Scales, NY/HG	.393

East-West League

1932	Bill Perkins, CLE	.352

Negro American League

1937	Willard Brown, KC	.371
1938	Willard Brown, KC	.356
1939	Willard Brown, KC	.336
1940	Chester Williams, MEM	.473
1941	Lyman Bostock, CAG	.488
1942	Ducky Davenport, BBB	.381
1943	Lester Lockett, BBB	.408
1944	Sam Jethroe, CLE	.353
1945	Sam Jethroe, CLE	.393
1946	Buck O'Neil, KC	.350
1947	John Ritchie, CAG	.381
1948	Artie Wilson, BBB	.402

TABLE 14.10 First African-American Players on Major League Baseball Teams

Player	Date	Team
Jackie Robinson	4/47	Brooklyn Dodgers
Larry Doby	4/47	Cleveland Indians
Henry Thompson	7/47	St. Louis Browns
Henry Thompson	7/49	New York Giants
Sam Jethroe	4/50	Boston Braves
Sam Hairston	7/51	Chicago White Sox
Bob Trice	9/53	Philadelphia Athletics
Gene Baker	9/53	Chicago Cubs
Curt Roberts	4/54	Pittsburgh Pirates
Tom Alston	4/54	St. Louis Cardinals
Nino Escalera	4/54	Cincinnati Reds
Carlos Paula	9/54	Washington Senators
Elston Howard	4/55	New York Yankees
John Kennedy	4/57	Philadelphia Phillies
Ossie Virgil	6/58	Detroit Tigers
Pumpsie Green	7/59	Boston Red Sox

15. OTHER

TABLE 15.1 Fraternal Organizations*

Name	Founded (Flourished)	Description
African Blood Brotherhood	1919	Headquarters: New York City
Afro-American Sons and Daughters	1924	
American Protestant Association	1849	Founded Pennsylvania; African-American breakaway group from anti-Catholic parent
Ancient Accepted Scottish Rite Masons	1850	Prince Hall affiliate
Ancient Egyptian Arabic Order of Nobles of the Mystic Shrine	1893	Prince Hall affiliate; open to 32nd degree Masons and Knights Templar
Ancient Independent Order of Moses	(1920)	
Ancient Order of the Children of Israel of North America	(1930)	
Ancient Order of Gleaners	1894	Founded Caro, Mich.
Ancient United Knights and Daughters of Africa	(1920)	
Benevolent Protective Herd of Buffaloes of the World	(1930)	
Christian Knights and Heroines of Ethiopia of the East and West Hemispheres	1915	Founded Alabama
Colored Brotherhood and Sisterhood of Honor	1886	Founded Franklin, Ky.
Colored Consolidated Brotherhood	—	Founded Atlanta, Tex.
Colored Knights of Pythias	—	Benefit order: 1937: 10,834 members
Daughters of Calanthe	—	Women's affiliate, Knights of Pythias
Daughters of the Improved Benevolent and Protective Order of Elks	1902	Women's affiliate, Elks
Daughters of Isis	1910	Women's auxiliary of the Shriners; gives scholarships only to C students; 1979: 12,000 members
Foresters	(1902)	
Friends of Negro Freedom	1920	Headquarters: New York City
General Accepted Order of Brothers and Sisters of Love and Charity	(1920)	
Grand Council of Guardians	—	African-American police and correctional officers fraternity; 1993: 15,000 members
Grand United Order of Brothers and Sisters, Sons and Daughters of Moses	1868	
Grand United Order of Fishermen of Galilee of the East and West Hemispheres	1904	
Grand United Order of Galilean Fishermen	1856	Founded Washington, D.C.; 1897: 56,000 members
Grand United Order of Odd Fellows	1843	Founded New York City; 1922: 7,562 lodges and 304,557 members; 1992: 108,000 members
Grand United Order Sons and Daughters of Peace	1900	Founded Newport News, Va.
Grand United Order of Tents of the J. R. Giddings Joliffe Union	1866	Founded Norfolk, Va.; Christian women's society
Grand United Order of True Reformers	1881	Founded Richmond, Va.; 1900: 70,000 members; defunct by 1910
Grand United Order of Wise Men and Women	1901	
Heroines of Jericho	—	Women's auxiliary of Royal Arch Masonry
House of Ruth	—	Woman's auxiliary of Odd Fellows
Improved Benevolent Order of Reindeer	1922	
Improved Benevolent and Protective Order of Elks of the World	1897	Founded Cincinnati, Ohio; 1932: 400 lodges and more than 100,000 members; 1992: 450,000 members; headquarters: Winston, N.C.
Improved Benevolent Protective Order of the Moose of the World	(1930)	
Improved Order of King David	(1935)	

TABLE 15.1 Fraternal Organizations* (*Continued*)

Name	Founded (Flourished)	Description
Improved Order of Samaritans	(1920)	1922: 50,000 members
Independent Benevolent Order	(1920)	1915: 35,000 members
Independent Order of Good Samaritans and Daughters of Samaria	1847	Founded New York; headquarters: Washington, D.C.
Independent Order of Immaculates of the United States of America	—	
Independent Order of J. R. Giddings and Joliffe Union	1919	Founded Boston
Independent Order of St. Luke	1866	1915: 40,000 members; 1922: 82,687 members
International Order of Twelve of Knights and Daughters of Tabor	1871	Founded Independence, Mo.
Knights and Daughters of I Will Arise	—	
Knights of Gideon	(1935)	
Knights of Honor	(1902)	
Knights of the Invisible Colored Kingdom	1923	Founded Chattanooga, Tenn.; anti-KKK
Knights of Peter Claver	1909	Founded Mobile, Ala.; Catholic; 1992: 35,000 members; headquarters: New Orleans
Knights of Pythias of Europe, Asia, Africa, North and South America	(c. 1870 or 1880)	Founded Washington, D.C., or Richmond, Va.; 1915: 3,663 lodges and 107,000 members; 1917: more than 250,000 members; currently small
Mutual Link Protective Association of America	(1920)	
National Ideal Benefit Society	—	Founded Philadelphia; 1958: 10,000 members
National Order of Mosaic Templars of America	1882	Founded Little Rock, Ark.; 1915: 100,000 members; 1922: 87,069 members
Order of Eastern Star	—	Prince Hall women's affiliate; 1980: 175,000 members
Order of the Golden Circle	1886	Women's auxiliary to 32nd and 33rd degree Scottish Rite Masons
Order of Lone Star Race Pride, Friendship, Love and Help	—	
Nazarites	(1902)	
Prince Hall Masons	1787	Founded Boston; no national body; 1905: 1,700 lodges, 45,000 members; 1912: 150,000 members; 1915: 3,500 lodges, 183,000 members; 1992: about 350,000 members
Pullman Porter's Benevolent Association	1920	
Royal Arch Masons	1820	Founded Philadelphia; Prince Hall affiliate
Royal Circle of Friends of the World	1909	Founded Helena, Ark.; 1914–1915 in five states, 25,000 members; 1922: 50,000 members
Royal Knights of King David	1884	Founded Durham, N.C.
Royal Order of Menelik and the Princess of Abyssinia	1940	
Seven Wise Men	(1902)	
Sons and Daughters of Jacob	(1902)	
Supreme Camp of American Woodmen	1901	Founded Denver, Col.; 1969 merged with Crusader Life, became an insurance company
Supreme Circle of Benevolence	1920	
The St. Joseph's Aid Society	1896	1922: 100,000 members
United Brotherhood of America	1920	
United Brothers of Friendship and Sisters of the Mysterious Ten	1861	Founded Louisville, Ky.
United Friends of America	1920	
United Order of Good Shepherds	1906	
Woodmen of Union	1915	1919: 16,000 members; 1926: 20,000 members

*Information on fraternal organizations is often unavailable; founding dates and sites are often unreliable or unobtainable; quite often no information can be obtained on when the organizations terminated their activities. This list, compiled by Peter Schilling, is representative but includes only some of the major fraternal organizations.

TABLE 15.2 **Professional Associations**

Name	Year Founded	Members (1992)
African-American Museums Association	1978	430
African-American Publishers, Booksellers and Writers Association	1969	—
African Heritage Studies Association	1969	—
African Literature Association	1974	800
Afro-American Police League (formerly Afro-American Patrolmen's League, 1979)	1968	2,500
Alliance of Minority Women for Business and Political Development	1982	650
American Academy of Medical Directors	1975	3,500
American Association for Affirmative Action	1974	1,000
American Association of Blacks in Energy	1977	500
American Black Book Writers' Association	1980	—
Association for the Preservation and Presentation of the Arts	1964	500
Association for the Study of Afro-American Life and History (formerly Association for the Study of Negro Life and History, 1973)	1915	2,200
Association of African American People's Legal Council	1959	1,100
Association of African-American Women Business Owners (formerly American Association of Black Women Entrepreneurs, 1990)	1983	1,200
Association of Black Admissions and Financial Aid Officers of the Ivy League and Sister Schools	1970	77
Association of Black Cardiologists	1974	350
Association of Black Foundation Executives	1971	—
Association of Black Nursing Faculty in Higher Education	1987	127
Association of Black Psychologists	1968	1,250
Association of Black Sociologists (formerly Caucus of Black Sociologists, 1976)	1968	400
Association of Black Storytellers	1984	175
Association of Black Women in Higher Education	1979	350
Association of Concerned African Scholars	1977	175
Association of Haitian Physicians Abroad	1972	900
Black Business Alliance	1979	250
Black Caucus of the American Library Association	1970	600
Black Entertainment and Sports Lawyers Association	1979	400
Black Psychiatrists of America	1968	550
Black Rock Coalition	1985	50
Black Stuntmen's Association	1966	34
Black Women in Publishing	1979	—
Black Women's Educational Alliance	1976	300
Blacks in Government	1986	500
Blacks in Law Enforcement	1986	500
College Language Association	1937	350
Conference of Minority Public Administrators (section of the American Society for Public Administration)	1971	700
Council of 1890 College Presidents	1913	18
Ethnic Employees of the Library of Congress	1973	—
Gospel Music Association	1964	2,500
Gospel Music Workshop of America	1966	18,000

TABLE 15.2 Professional Associations (*Continued*)

Name	Year Founded	Members (1992)
International Association of African and American Black Business People	1965	84,000
International Association of Black Business Educators	1978	155
International Association of Black Professional Fire Fighters	1970	8,000
International Black Writers (formerly International Black Writers' Conference, 1982)	1970	500
International Black Writers and Artists	1974	500
International Rhythm and Blues Association	1966	500
Metropolitan Travel Agents	1969	35
Minorities in Media	1975	85
Minority Caucus of Family Service America (formerly Black Caucus of the Family Service Association of America, 1973; Minority Caucus of the Family Service Association of America, 1986)	1969	—
Music Educators' National Conference-National Black Music Caucus	1972	—
Mutual Musicians' Foundation	1917	125
National Action Council for Minorities in Engineering	1980	—
National Alliance of Black School Educators	1970	4,000
National Alliance of Third World Journalists	1981	330
National Association for Equal Opportunities	1975	60
National Association for the Advancement of Black Americans in Vocational Education	1977	900
National Association of African American Students of Law	1973	4,300
National Association of Black Accountants	1969	3,000
National Association of Black Catholic Administrators	1976	—
National Association of Black Consulting Engineers	1975	100
National Association of Black Geologists and Geophysicists	1981	120
National Association of Black Hospitality Professionals	1985	100
National Association of Black Journalists	1975	2,000
National Association of Black Owned Broadcasters	1976	150
National Association of Black Professors	1974	135
National Association of Black Real Estate Professionals	1984	—
National Association of Black Social Workers	1968	10,000
National Association of Black Women Attorneys	1972	500
National Association of Black Women Entrepreneurs	1979	3,000
National Association of Blacks in Criminal Justice	1972	5,000
National Association of Blacks Within Government	1982	—
National Association of College Deans, Registrars, and Admissions Officers (formerly National Association of Collegiate Deans and Registrars in Negro Schools, 1949; National Association of College Deans and Registrars, 1970)	1925	325

TABLE **15.2** **Professional Associations** (*Continued*)

Name	Year Founded	Members (1992)
National Association of Educational Office Personnel	1934	6,000
National Association of Extension Home Economists	1931	4,000
National Association of Fashion and Accessory Designers	1949	240
National Association of Health Service Executives	1968	500
National Association of Human Rights Workers	1947	350
National Association Management Consultants	1985	50
National Association of Market Developers	1953	700
National Association of Minority Automobile Dealers	1980	350
National Association of Minority Contractors	1969	3,500
National Association of Minority Women in Business	1972	5,000
National Association of Negro Musicians	1919	2,500
National Association of Securities Professionals	—	300
National Association of Urban Bankers	1975	1,500
National Bar Association	1925	12,500
National Beauty Culturists League	1919	10,500
National Black Bankers' Association	1927	160
National Black Catholic Clergy Caucus	1968	650
National Black Caucus of Local Elected Officials	1970	—
National Black Caucus of State Legislators	1977	415
National Black McDonalds Operators' Association	1972	169
National Black Nurses Association	1971	5,000
National Black Police Association	1972	35,000
National Black Public Relations Society	1981	100
National Black Sisters' Conference	1968	150
National Business League (formerly National Negro Business League)	1900	10,000
National Coalition of Black Meeting Planners	1983	400
National Conference of Black Lawyers	1968	1,000
National Conference of Black Mayors	1974	322
National Conference of Black Political Scientists	1969	400
National Conference of Editorial Workers	1947	560
National Council for Black Studies	1975	350
National Dental Assistants Association	1964	500
National Dental Association	1913	2,500
National Dental Hygienists' Association	1932	50
National Economic Association (formerly Caucus of Black Economists, 1975)	1969	—
National Florists' Association (formerly International Flower Association, 1963; International Florists' Association, 1988)	1953	500
National Forum for Black Public Administrators	1983	2,600
National Funeral Directors' and Morticians' Association	1938	2,000
National Hypertension Association	1977	1,700
National Insurance Association	1921	—
National Medical Association	1895	14,500
National Naval Officers' Association	1971	750
National Network of Minority Women in Science	1978	400
National Newspaper Publishers' Association	1940	178
National Optometric Association	1969	350

TABLE 15.2 Professional Associations (*Continued*)

Name	Year Founded	Members (1992)
National Organization for the Professional Advancement of Black Chemists and Chemical Engineers	1972	1,000
National Organization of Black County Officials	1982	1,400
National Organization of Black Law Enforcement Executives	1976	2,000
National Organization of Minority Architects (formerly National Organization of Black Architects, 1973)	1971	250
National Podiatric Medical Association	1971	200
National Society of Black Engineers	1975	168
National Society of Certified Public Accountants	—	200
National Technical Association	1926	1,500
National United Law Enforcement Association	1969	5,000
Negro Airmen International	1967	912
Organization of Black Airline Pilots	1976	650
Student National Dental Association	1972	9,000
Student National Medical Association	1964	2,500
Student National Podiatric Medical Association	1973	300
United Mortgage Bankers of America	1962	1,600

Source: Julia C. Furtaw, ed. *Black Americans Information Directory 1992–1993* (Detroit, 1992).

TABLE 15.3 African Americans on U.S. Postage Stamps

Name	Date Appeared	Name	Date Appeared
Booker T. Washington	1940; 1956	Patrick J. Healy	1989
George Washington Carver	1948	A. Philip Randolph	1989
Frederick Douglass	1967	Ida B. Wells	1990
Peter Salem	1968	Jesse Owens	1990
W. C. Handy	1969	Jan E. Matzeliger	1991
Henry O. Tanner	1973	W. E. B. Du Bois	1992
Paul Laurence Dunbar	1975	Percy Lavon Julian	1993
Salem Poor	1975	Joe Louis	1993
Harriet Tubman	1978	Otis Redding	1993
Martin Luther King, Jr.	1979	Clyde McPhatter	1993
Benjamin Banneker	1980	Dinah Washington	1993
Whitney M. Young, Jr.	1981	Allison Davis	1994
Charles Drew	1981	Bill Pickett	1994
Ralph J. Bunche	1982	Jim Beckwourth	1994
Jackie Robinson	1982	Bessie Smith	1994
Scott Joplin	1983	Billie Holiday	1994
Carter G. Woodson	1984	Buffalo Soldier	1994
Roberto Clemente	1984	Jimmy Rushing	1994
Mary McLeod Bethune	1985	Muddy Waters	1994
Sojourner Truth	1986	Robert Johnson	1994
Duke Ellington	1986	Ma Rainey	1994
Matthew A. Henson	1986	Howlin' Wolf	1994
Jean Baptiste Pointe DuSable	1987	Ethel Waters	1994
James Weldon Johnson	1988	Nat "King" Cole	1994

TABLE 15.4 Black Towns, Listed by State

Alabama
Cederlake
Greenwood Village
Hobson City
Plateau
Shepherdsville

Arkansas
Edmondson
Thomasville

California
Abila
Allensworth
Bowles
Victorville

Colorado
Dearfield

Florida
Eatonville
New Monrovia
Richmond Heights

Illinois
Brooklyn
Robbins

Iowa
Buxton

Kansas
Nicodemus

Kentucky
New Zion

Louisiana
Grambling
North Shreveport

Maryland
Fairmount Heights
Glenarden
Lincoln City

Michigan
Idlewind
Marlborough

Mississippi
Expose
Mound Bayou
Renova

Missouri
Kinloch

New Jersey
Gouldtown
Lawnside
Springtown
Whitesboro

New Mexico
Blackdom

North Carolina
Columbia Heights
Method
Oberlin

Ohio
Lincoln Heights
Urbancrest

Oklahoma
Arkansas Colored
Bailey
Boley
Booktee
Canadian Colored
Chase
Clearview
Ferguson
Forman
Gibson Station
Grayson
Langston City
Lewisville
Liberty
Lima
Lincoln City
Mantu
Marshalltown
North Fork Colored
Overton
Porter
Redbird

Rentiesville
Summit
Taft
Tatum
Tullahassee
Vernon
Wellston Colony
Wybark
Two unnamed towns
 in Seminole Nation

Tennessee
Hortense
New Bedford

Texas
Andy
Board House
Booker
Independence Heights
Kendleton
Mill City
Oldham
Roberts
Union City

Virginia
Ocean Grove
Titustown
Truxton

West Virginia
Institute

Sources: Adapted from Kenneth Marvin Hamilton, *Black Towns and Profit: Promotion and Development in the Trans-Appalachian West, 1877–1915* (Urbana, Ill., 1991); and Ben Wayne Wiley, *Ebonyville in the South and Southwest: Political Life in the All-Black Town,* Ph.D. diss., University of Texas at Arlington (1984).

BIOGRAPHICAL ENTRIES BY PROFESSION

This list organizes the Encyclopedia's biographical entries into the following categories. Readers should refer to the general Index for page numbers of each biography as well as additional references to these figures throughout the Encyclopedia.

Actors
Ambassadors and diplomats
Architects
Artisans
Artists
Athletes
Aviators and astronauts
Comedians
Composers
Conductors
Cowboys
Dancers and choreographers
Editors
Educators
Engineers
Entrepreneurs and business leaders
Explorers and pioneers
Filmmakers
Historians

Illustrators
Inventors
Journalists
Lawyers and jurists
Librarians
Mathematicians
Medical profession
Military
Musicians
Philosophers
Photographers
Politicians
Publishers
Religious leaders
Scientists
Singers
Social activists
Social scientists
Writers

Actors
Aldridge, Ira
Anderson, Eddie "Rochester"
Bailey, Pearl
Beavers, Louise
Belafonte, Harold George "Harry"
Brown, James Nathaniel "Jim"
Bryant, Hazel
Bush, Anita
Caesar, Adolph
Cambridge, Godfrey MacArthur
Carroll, Diahann
Carroll, Vinnette
Cooper, Ralph
Cosby, William Henry, Jr. "Bill"
Dandridge, Dorothy
Davis, Ossie
Davis, Sammy, Jr.
Dee, Ruby
Dixon, Ivan, III
Freeman, Morgan
Gilpin, Charles Sidney
Glover, Danny
Goldberg, Whoopi
Gossett, Louis, Jr.

Greaves, William
Gunn, Moses
Gunn, William Harrison "Bill"
Hall, Arsenio
Harrison, Richard Berry
Holder, Geoffrey
Horne, Lena
Johnson, Noble M.
Jones, James Earl
Jones, Robert Earl
King, Woodie, Jr.
Kitt, Eartha Mae
Lee, Canada
LeNoire, Rosetta Olive Burton
Lincoln, Abbey
Marshall, William Horace
Mayfield, Julian H.
McClendon, Rose
McDaniel, Hattie
McKinney, Nina Mae
McNeil, Claudia
McQueen, Thelma "Butterfly"
Mitchell, Abbie
Moore, Harry R. "Tim"
Murphy, Eddie

Norton, Kenneth Howard "Ken"
Poitier, Sidney
Robeson, Paul
Rolle, Esther
Ross, Diana
Stepin Fetchit
Teer, Barbara Ann
Tucker, Lorenzo
Tyson, Cicely
Ward, Douglas Turner
Washington, Denzel
Washington, Fredericka Carolyn "Fredi"
Waters, Ethel
Williams, Billy Dee
Williams, Samm-Art
Williams, Spencer, Jr.
Wilson, Arthur Eric "Dooley"
Winfrey, Oprah Gail
Ambassadors and diplomats
Bassett, Ebenezer Don Carlos
Bunche, Ralph Johnson
Carrington, Walter C.
Cook, Mercer
Crum, William D.
Greener, Richard Theodore

Powell, William Frank
Wharton, Clifton Reginald, Sr.
Williams, Franklin Hall
Architects
 Abele, Julian Francis
 Gantt, Harvey Bernard
 Lankford, John Anderson
 Pittman, William Sidney
 Tandy, Vertner Woodson
 Williams, Paul Revere
Armed forces. *See* Military
Artisans
 Day, Thomas
 Hill, Peter
Artists
 Alston, Charles Henry
 Andrews, Benny
 Artis, William Ellisworth
 Bannister, Edward Mitchell
 Barthé, Richmond
 Basquiat, Jean-Michel
 Bearden, Romare
 Biggers, John
 Brown, Samuel Joseph, Jr.
 Burke, Selma Hortense
 Burroughs, Margaret Taylor
 Campbell, Elmer Simms
 Catlett, Elizabeth
 Chase-Riboud, Barbara Dewayne
 Clark, Edward, Jr.
 Colescott, Robert H.
 Conwill, Houston
 Cortor, Eldzier
 Crichlow, Ernest
 Crite, Allan Rohan
 Cruz, Emilio
 Delaney, Beauford
 Delaney, Joseph
 Douglas, Aaron
 Driskell, David
 Duncanson, Robert S.
 Dwight, Edward Joseph, Jr.
 Edmondson, William
 Edwards, Melvin
 Evans, Minnie Jones
 Farrow, William McKnight
 Fax, Elton C.
 Fuller, Meta Vaux Warrick
 Gentry, Herbert
 Gilliam, Sam
 Goreleigh, Rex
 Hammons, David
 Hampton, James
 Hardrick, John Wesley
 Harleston, Edwin Augustus
 Harper, William A.
 Hayden, Palmer C.
 Hendricks, Barkley
 Hunt, Richard
 Hunter, Clementine
 Jackson, Oliver Lee
 Jennings, Wilmer Angier
 Joans, Ted
 Johnson, Joshua
 Johnson, Sargent
 Johnson, William Henry
 Jones, Lois Mailou

Joseph, Ronald
Knight, Gwendolyn
Lawrence, Jacob Armstead
Lee-Smith, Hughie
Lewis, Edmonia
Lindsey, Richard William
Loving, Alvin
Moorhead, Scipio
Morgan, Sister Gertrude
Motley, Archibald John, Jr.
Pierce, Elijah
Pindell, Howardena
Pippin, Horace
Porter, Charles Ethan C.
Porter, James Amos
Powell, Georgette Seabrooke
Primus, Nelson A.
Prophet, Nancy Elizabeth
Puryear, Martin
Ringgold, Faith
Saar, Betye Irene
Saunders, Raymond
Savage, Augusta Christine Fells
Scott, William Edouard
Sebree, Charles
Simpson, Merton Daniel
Simpson, William H.
Smith, Albert Alexander
Smith, Vincent
Stevens, Nelson
Tanner, Henry Ossawa
Thomas, Alma
Thompson, Robert Louis
Thrash, Dox
Waring, Laura Wheeler
Wells, James Lesesne
White, Charles
Whitten, Jack
Williams, Pat Ward
Williams, William Thomas
Wilson, Ellis
Wilson, John Woodrow
Woodruff, Hale Aspacio
Astronauts. *See* Aviators and astronauts
Athletes
 baseball
 Aaron, Henry Louis "Hank"
 Banks, Ernest "Ernie"
 Bell, James Thomas "Cool Papa"
 Brock, Louis Clark "Lou"
 Campanella, Roy
 Charleston, Oscar
 Clemente, Roberto
 Dismukes, William "Dizzy"
 Doby, Lawrence Eugene "Larry"
 Flood, Curtis Charles "Curt"
 Foster, Andrew "Rube"
 Gibson, Joshua "Josh"
 Gibson, Robert "Bob"
 Henderson, Rickey Henley
 Irvin, Monte
 Jackson, Reginald Martinez "Reggie"
 Jackson, Vincent Edward "Bo"
 Johnson, William Julius "Judy"
 Leonard, Walter Fenner "Buck"
 Mays, Willie Howard
 Paige, Leroy Robert "Satchel"

Robinson, Frank
Robinson, Jack Roosevelt "Jackie"
White, Bill
Wills, Maurice Morning "Maury"
 basketball
 Abdul-Jabbar, Kareem
 Baylor, Elgin Gay
 Bing, David "Dave"
 Chamberlain, Wilton Norman "Wilt"
 Cooper, Charles "Chuck"
 Embry, Wayne
 Erving, Julius Winfield, II
 Frazier, Walter, II
 Gaines, Clarence "Bighouse"
 Gregory, George, Jr.
 Johnson, Earvin, Jr., "Magic"
 Jones, K. C.
 Jordan, Michael Jeffrey
 Miller, Cheryl
 Reed, Willis
 Robertson, Oscar
 Russell, William Felton "Bill"
 Stringer, Charlene Vivian
 Thompson, John Robert, Jr.
 Washington, Ora Mae
 Wilkens, Leonard Randolph "Lenny"
 Woodard, Lynette
 boxing
 Ali, Muhammad
 Armstrong, Henry
 Bowe, Riddick
 Brown, Joe "Old Bones"
 Charles, Ezzard
 Foreman, George Edward
 Foster, Robert Wayne "Bob"
 Frazier, Joseph William
 Hagler, Marvelous Marvin
 Hearns, Thomas
 Holmes, Larry
 Holyfield, Evander
 Jack, Beau
 Jackson, Peter
 Johnson, John Arthur "Jack"
 Langford, Samuel E.
 Lee, Canada
 Leonard, Ray Charles "Sugar Ray"
 Liston, Charles "Sonny"
 Louis, Joe
 Molineaux, Tom
 Moore, Archibald Lee "Archie"
 Norton, Kenneth Howard "Ken"
 Patterson, Floyd
 Richmond, William "Bill"
 Robinson, Sugar Ray
 Spinks, Leon
 Spinks, Michael
 Tyson, Michael Gerald "Mike"
 Walcott, Jersey Joe
 Wills, Harry
 cycling
 Vails, Nelson "The Cheetah"
 figure skating
 Thomas, Debra J. "Debi"
 football
 Brown, James Nathaniel "Jim"
 Gaither, Alonzo Smith "Jake"
 Hayes, Robert Lee "Bob"

Jackson, Vincent Edward "Bo"
Lewis, William Henry
Mackey, John
Motley, Marion "Tank"
Page, Alan Cedric
Payton, Walter Jerry
Pollard, Frederick Douglass "Fritz"
Robinson, Edward Gay
Sayers, Gale Eugene
Shell, Arthur "Art"
Simpson, Orenthal James "O.J."
Upshaw, Eugene Thurman
 "Gene"
Williams, Douglas Lee
Young, Claude Henry "Buddy"
golf
Brown, Pete
Elder, Robert Lee
Gibson, Althea
Peete, Calvin
Rhodes, Theodore, Jr.
Sifford, Charles L.
horse racing
Lee, Canada
Murphy, Isaac
race car driving
Ribbs, William Theodore, Jr.
Scott, Wendell Oliver
rowing
DeFrantz, Anita
tennis
Ashe, Arthur Robert, Jr.
Eaton, Hubert Arthur
Garrison, Zina
Gibson, Althea
Washington, Ora Mae
Weir, Reginald
track and field
Ashford, Evelyn
Borican, John
Griffith-Joyner, Florence Delorez
Hayes, Robert Lee "Bob"
Hubbard, William DeHart
Jackson, Vincent Edward "Bo"
Joyner-Kersee, Jacqueline
Metcalfe, Ralph Horace
Moses, Edwin Corley
Owens, James Cleveland "Jesse"
Rudolph, Wilma Glodean
Tyus, Wyomia
volleyball
Hyman, Flora "Flo"
weight lifting
Davis, John Henry
Aviators and astronauts
Bluford, Guion Stewart, Jr., "Guy"
Coleman, Bessie
Davis, Benjamin Oliver, Jr.
Dwight, Edward Joseph, Jr.
Gregory, Frederick Drew
James, Daniel, Jr., "Chappie"
Jemison, Mae Carol
Julian, Hubert Fauntleroy
Lawrence, Robert Henry, Jr.
McNair, Ronald Erwin
Business leaders. *See* Entrepreneurs and
 business leaders

Civil rights activists. *See* Social
 activists
Comedians
Cosby, William Henry, Jr., "Bill"
Foxx, Redd
Goldberg, Whoopi
Gregory, Richard Claxton "Dick"
Mabley, Jackie "Moms"
Markham, Dewey "Pigmeat"
Murphy, Eddie
Pryor, Richard Franklin Lenox Thomas
Russell, Nipsey
Walker, George William
Williams, Egbert Austin "Bert"
Composers
Abrams, Muhal Richard
Ace, Johnny
Anderson, Thomas J.
Bethune, Thomas Greene Wiggins
 "Blind Tom"
Bigard, Leon Albany "Barney"
Blake, James Hubert "Eubie"
Bland, James A.
Bonds, Margaret Allison
Boone, "Blind" (John William)
Braxton, Anthony
Broonzy, William Lee Conley "Big Bill"
Brown, James Joe, Jr.
Burleigh, Henry Thacker "Harry"
Coleman, Ornette
Cook, Will Marion
Cooke, Samuel "Sam"
Dameron, Tadley Ewing Peake "Tadd"
Davis, Anthony
Davis, Miles Dewey, III
Dawson, William Levi
Dett, Robert Nathaniel
Dixon, Willie
Domino, Antoine, Jr., "Fats"
Dorsey, Thomas Andrew
Ellington, Edward Kennedy "Duke"
Europe, James Reese
Freeman, Harry Lawrence
Gaye, Marvin
Gillespie, John Birks "Dizzy"
Green, Frederick William "Freddie"
Hairston, Jestie "Jester"
Handy, William Christopher "W.C."
Henderson, Fletcher Hamilton, Jr.
Hendrix, James Marshall "Jimi"
Jackson, Michael
Jenkins, Edmund Thornton
Jenkins, Leroy
Jessye, Eva Alberta
Johnson, Francis Hall
Johnson, Frank
Johnson, James Louis "J.J."
Johnson, James Price
Johnson, James Weldon
Johnson, John Rosamond
Jones, Quincy Delight, Jr.
Joplin, Scott
Kay, Ulysses Simpson
Lake, Oliver
Lateef, Yusef
Marsalis, Wynton
Mayfield, Curtis

McLean, John Lenwood, Jr., "Jackie"
Monk, Thelonious Sphere
Moore, Undine Smith
Morton, Ferdinand Joseph "Jelly Roll"
Newton, James
Ory, Edward "Kid"
Peterson, Oscar Emmanuel
Pickett, Wilson
Postlewaite, Joseph William
Pozo, Chano
Price, Florence Beatrice Smith
Prince
Razaf, Andy
Redding, Otis
Rivers, Clarence Joseph
Robinson, William, Jr., "Smokey"
Rollins, Theodore Walter "Sonny"
Sanders, Farrell Pharoah
Santamaria, Mongo Ramon
Scott, James Sylvester
Scott-Heron, Gil
Shepp, Archibald Vernon "Archie"
Shorter, Wayne
Silver, Horace
Smith, Hale
Smith, "Willie the Lion"
Stewart, William, Jr., "Rex"
Still, William Grant
Strayhorn, William Thomas "Billy"
Swanson, Howard
Taylor, William, Jr., "Billy"
Threadgill, Henry Luther
Vodery, William Henry Bennett "Will"
Walker, George Theophilus
Waller, Thomas Wright "Fats"
White, Clarence Cameron
Williams, Anthony "Tony"
Wilson, Olly Woodrow
Wonder, Stevie
Work, John Wesley, III
Conductors
DePreist, James Anderson
Dixon, Dean Charles
Freeman, Paul Douglas
Hairston, Jestie "Jester"
Lee, Everett
Cowboys
Love, Nat "Deadwood Dick"
Pickett, Bill
Dancers and choreographers
Adams, Carolyn
Ailey, Alvin
Allen, Debbie
Atkins, Cholly
Bailey, Bill
Baker, Josephine
Bates, Clayton "Peg Leg"
Beatty, Talley
Benjamin, Fred
Berry Brothers
Bethel, Alfred "Pepsi"
Borde, Percival Sebastian
Bradley, Clarence "Buddy"
Briggs, Bunny
Bubbles, John
Coles, Charles "Honi"
Collins, Leon

Cook, Charles "Cookie"
Cooper, Ralph
Covan, Willie
Cummings, Blondell
Dafora, Asadata
Davis, Charles Rudolph "Chuck"
Davis, Sammy, Jr.
DeLavallade, Carmen
Destiné, Jean-Leon
Dove, Ulysses
Dunham, Katherine
Europe, James Reese
Fagan, Garth
Faison, George
Fort, Syvilla
Green, Chuck
Hill, Thelma
Hines, Gregory
Hinkson, Mary
Holder, Geoffrey
Jackson, Laurence Donald "Baby Laurence"
Jackson, Michael
James, Leon Edgehill
Jamison, Judith
Johnson, Louis
Johnson, Virginia Alma Fairfax
Jones, Bill T.
Lane, William Henry
LeTang, Henry
Manning, Frankie
McIntyre, Diane
McKayle, Donald
McKinney, Nina Mae
Miller, Bebe
Miller, Joan
Miller, Norma
Mills, Florence
Minns, Albert David
Mitchell, Arthur Adams, Jr.
Moore, Charles
Moore, Ella Thompson
Myers, Milton
Nicholas Brothers
Nugent, Pete
Pomare, Eleo
Primus, Pearl
Rector, Eddie
Robinson, Bill "Bojangles"
Robinson, LaVaughn
Rodgers, Rod Audrian
Sims, Howard "Sandman"
Slyde, Jimmy
Solomons, Gus, Jr.
Thompson, Clive
Tomlinson, Mel
Walker, Aida Overton
Walker, Diane
Waters, Sylvia
Williams, Dudley
Williams, Lavinia
Wilson, William Adolphus "Billy"
Wood, Donna
Yarborough, Sara
Zollar, Jawole Willa Jo
Diplomats. *See* Ambassadors and diplomats

Doctors. *See* Medical profession
Editors
Abbott, Robert Sengstacke
Bennett, Lerone, Jr.
Bibb, Henry Walton
Cornish, Samuel Eli
Davis, John P.
Domingo, Wilfred Adolphus
Du Bois, William Edward Burghardt
Harper, Michael Steven
Harrison, Hubert Henry
Johnson, Charles Spurgeon
Kaiser, Ernest Daniel
Sengstacke, Robert Abbott
Stewart, Pearl
Trotter, William Monroe
Williams, John Alfred
see also Publishers
Educators
Allen, William G.
Allensworth, Allen
Baldwin, Maria Louise
Bell, George
Bethune, Mary McLeod
Bond, Horace Mann
Bouchet, Edward Alexander
Brown, Charlotte Hawkins
Brown, Hallie Quinn
Brown, John Mifflin
Brown, Roscoe Conkling, Jr.
Bullock, Matthew Washington
Burroughs, Nannie Helen
Cardozo, Francis Louis
Carver, George Washington
Cary, Mary Ann Shadd
Cayton, Horace Roscoe, Jr.
Chavis, John
Clark, Peter Humphries
Clark, Septima Poinsette
Clement, Rufus Early
Cook, Mercer
Cooper, Anna Julia Haywood
Coppin, Frances "Fanny" Jackson
Councill, William Hooper
Davidson, Olivia America
Davis, John Warren
Davis, William Allison
Dawson, William Levi
Dodson, Owen
Douglass, Sarah Mapps
Granville, Evelyn Boyd
Hackley, Emma Azalia Smith
Herring, James Vernon
Hill, Leslie Pickney
Holland, Jerome Heartwell
Hope, John
Hunt, Henry Alexander
Hunton, William Alphaeus, Jr.
Jackson, Luther Porter
Johnson, Mordecai Wyatt
Laney, Lucy Craft
Lanusse, Armand
Lewis, Julian Herman
Mays, Benjamin Elijah
Moses, Robert Parris
Moton, Robert Russa
Nabrit, James Madison

Page, Inman Edward
Patterson, Frederick Douglass
Peake, Mary S.
Poussaint, Alvin Francis
Powell, William Frank
Price, Joseph Charles
Rayner, John B.
Riles, Wilson Camanza
Ross-Barnett, Marguerite
Sanderson, Jeremiah Burke
Saunders, Prince
Slowe, Lucy Diggs
Taylor, Susie Baker King
Taylor, William, Jr., "Billy"
Thurman, Howard
Washington, Booker Taliaferro
Washington, Margaret Murray
Wesley, Charles Harris
Wharton, Clifton Reginald, Jr.
Wilkerson, Doxey Alphonso
Williams, William Taylor Burwell
Wright, Richard Robert, Sr.
Engineers
Harris, Wesley Leroy
Lankford, John Anderson
Williams, James Henry, Jr.
Entrepreneurs and business leaders
Boyd, Henry Allen
Church, Robert Reed, Jr.
Church, Robert Reed, Sr.
De Passe, Suzanne
DePriest, Oscar Stanton
Fitzhugh, H. Naylor
Gibbs, Mifflin Wister
Gordy, Berry, Jr.
Graves, Earl Gilbert, Jr.
Gregory, Richard Claxton "Dick"
Johnson, John Harold
King, Don
Leidesdorff, William Alexander
Lewis, Reginald F.
Llewellyn, James Bruce
Malone, Annie Turnbo
Meachum, John Berry
Montgomery, Isaiah Thornton
O'Leary, Hazel Rollins
Overton, Anthony
Pace, Harry Herbert
Patterson, Charles R.
Payton, Philip A.
Pleasant, Mary Ellen "Mammy"
Simmons, Jake, Jr.
Spaulding, Charles Clinton
Sutton, Percy Ellis
Toussaint, Pierre
Walker, A'Lelia
Walker, Madam C. J.
Walker, Maggie Lena
Wharton, Clifton Reginald, Jr.
Wright, Richard Robert, Sr.
Explorers and pioneers
Beckwourth, James Pierson
Brown, Clara
Du Sable, Jean Baptiste Pointe
Henson, Matthew Alexander
Leidesdorff, William Alexander

Filmmakers
Bourne, St. Clair Cecil
Burnett, Charles
Dash, Julie
De Passe, Suzanne
Dickerson, Glenda
Greaves, William
Hudlin, Reginald
Hudlin, Warrington
Johnson, George Perry
Johnson, Noble M.
King, Woodie, Jr.
Lee, Shelton Jackson "Spike"
Micheaux, Oscar
Miles, William
Parks, Gordon, Jr.
Parks, Gordon, Sr.
Poitier, Sidney
Schultz, Michael
Van Peebles, Melvin
Williams, Spencer, Jr.
see also Actors

Historians
Beasley, Delilah Isontium
Brown, William Wells
Bruce, John Edward
Du Bois, William Edward
 Burghardt
Franklin, John Hope
Logan, Rayford Whittingham
Miller, Kelly
Nell, William Cooper
Quarles, Benjamin
Rogers, Joel Augustus
Wesley, Charles Harris
Williams, George Washington
Woodson, Carter Godwin

Illustrators
Biggers, John
Crite, Allan Rohan
Douglas, Aaron

Inventors
Barnes, William Harry
Beard, Andrew Jackson
Davidson, Shelby
Dickinson, Joseph Hunter
Harper, Solomon
Hawkins, Walter Lincoln
Hilyer Andrew Franklin
Latimer, Lewis Howard
Matzeliger, Jan Earnst
McCoy, Elijah J.
Morgan, Garrett Augustus
Rillieux, Norbert
Temple, Lewis
Thrash, Dox
Woods, Granville T.

Journalists
Barber, Jesse Max
Barnett, Claude
Bearden, Bessye Jean
Beasley, Delilah Isontium
Bell, Philip Alexander
Bennett, George Harold "Hal"
Bennett, Gwendolyn Bennetta
Bennett, Lerone, Jr.
Bradley, Edward R.

Brown, William Anthony
 "Tony"
Bruce, John Edward
Cary, Mary Ann Shadd
Douglass, Frederick
Dunnigan, Alice Allison
Fitzbutler, Henry
Fortune, Timothy Thomas
Garvey, Amy Jacques
Greaves, William
Gumbel, Bryant Charles
Haley, Alexander Palmer "Alex"
Hunter-Gault, Charlayne
Lacy, Sam
Lanusse, Armand
Matthews, Victoria Earle
Maynard, Robert Clyde
Mitchell, John R., Jr.
Moon, Henry Lee
Newby, William H.
Owen, Chandler
Ray, Charles Bennett
Robinson, Maxie Cleveland
Rogers, Joel Augustus
Rowan, Carl Thomas
Ruffin, Josephine St. Pierre
Ruggles, David
Salaam, Kalamu Ya
Schuyler, George S.
Smith, Wendell
Stewart, Pearl
Vann, Robert Lee
Waldron, John Milton
Washington, Valores J. "Val"
Wells-Barnett, Ida Bell
Withers, Ernest C.
Young, Preston Bernard

Lawyers and jurists
Alexander, Clifford L., Jr.
Alexander, Raymond Pace
Alexander, Sadie Tanner Mossell
Allen, Macon Bolling
Bolin, Jane Mathilda
Burke, Yvonne Brathwaite
Carey, Archibald J., Jr.
Coleman, William Thaddeus, Jr.
Davidson, Shelby James
Davis, Benjamin Jefferson, Jr.
DeFrantz, Anita
Dickerson, Earl Burris
Edelman, Marian Wright
Elliott, Robert Brown
Gibbs, Mifflin Wister
Greener, Richard Theodore
Harris, Patricia Roberts
Hastie, William Henry
Houston, Charles Hamilton
Jackson, Maynard Holbrook, Jr.
Kearse, Amalya Lyle
Keith, Damon Jerome
Lewis, Reginald F.
Lewis, William Henry
Lynch, John Roy
Marshall, Thurgood
Mitchell, Clarence Maurice, Jr.
Mitchell, Juanita Jackson
Motley, Constance Baker

Murray, Pauli
Nabrit, James Madison
Norton, Eleanor Holmes
O'Hara, James Edward
Page, Alan Cedric
Patterson, William
Pierce, Samuel Riley
Ray, Charlotte E.
Rock, John Sweat
Stewart, Thomas McCants
Stokes, Carl Burton
Thomas, Clarence
Thomas, Franklin Augustine
Thomas, William Hannibal
Wharton, Clifton Reginald, Sr.

Librarians
Hutson, Jean Blackwell
Marshall, Albert P.
Wesley, Dorothy Burnett Porter

Mathematicians
Blackwell, David Harold
Browne, Marjorie Lee
Claytor, William Waldron Schieffelin
Cox, Elbert Frank
Granville, Evelyn Boyd
Wilkins, J. Ernest, Jr.

Medical profession
anatomists
Lloyd, Ruth Smith
McKinney, Roscoe Lewis
Young, Moses Wharton
dentists
Bentley, Charles Edwin
Boyd, Robert Fulton
Freeman, Robert Tanner
dermatalogists
Lawless, Theodore K.
nurses
Franklin, Martha
Johnson-Brown, Hazel Winifred
Laurie, Eunice Verdell Rivers
Mahoney, Mary Eliza
Staupers, Mabel Keaton
Taylor, Susie Baker King
Thoms, Adah Belle Samuels
Tubman, Harriet Ross
nutritionists
Kittrell, Flemmie Pansy
otolaryngologists
Barnes, William Harry
pathologists
Quinland, William Samuel
pharmacists
Minton, Henry McKee
physicians
Abbott, Anderson Ruffin
Adams, Numa Pompilius Garfield
Augusta, Alexander Thomas
Bousfield, Midian Othello
Boyd, Robert Fulton
Bristow, Lonnie R.
Calloway, Nathaniel Oglesby
Cannon, George Dows
Cannon, George Epps
Chinn, May Edward
Cobb, William Montague
Cole, Rebecca J.

Comer, James Pierpont
Cornely, Paul Bertau
Creed, Courtlandt Van Rensselaer
De Grasse, John Van Surly
Dickens, Helen Octavia
Eaton, Hubert Arthur
Edelin, Kenneth C.
Edwards, Lena Frances
Elders, M. Joycelyn Jones
Ferguson, Angela Dorothea
Fitzbutler, Henry
Frederick, Rivers
Hall, George Cleveland
Hinton, William Augustus
Jefferson, Mildred Fay
Lawrence, Margaret Cornelia
 Morgan
Lee, Rebecca
Lewis, Julian Herman
Lynk, Miles Vandahurst
Majors, Monroe Alpheus
McCarroll, Ernest Mae
McKinney-Steward, Susan Maria
 Smith
Minton, Henry McKee
Mossell, Nathan Francis
Peck, David John
Perry, John Edward
Poindexter, Hildrus A.
Purvis, Charles Burleigh
Smith, James McCune
Stubbs, Frederick Douglass
Sullivan, Louis
Thompson, Solomon Henry
Wright, Louis Tompkins

psychiatrists
Bateman, Mildred Mitchell
Fuller, Solomon Carter
Poussaint, Alvin Francis
Spurlock, Jeanne

public health
Brown, Roscoe Conkling, Sr.

researchers
White, Augustus Aaron, III
Wright, Jane Cooke

surgeons
Abbott, Anderson Ruffin
Brown, Dorothy Lavania
Curtis, Austin Maurice
Dailey, Ulysses Grant
Drew, Charles Richard
Giles, Roscoe Conkling
Kenney, John Andrew
Logan, Arthur Courtney
Logan, Myra Adele
Maynard, Aubre de Lambert
Murray, Peter Marshall
White, Augustus Aaron, III
Williams, Daniel Hale

technicians
Thomas, Vivien Theodore

Military
Carney, William H.
Davis, Benjamin Oliver, Jr.
Davis, Benjamin O., Sr.
Delany, Martin Robison
Flipper, Henry Ossian

James, Daniel, Jr., "Chappie"
Johnson-Brown, Hazel Winifred
Petersen, Franklin E.
Poor, Salem
Powell, Colin Luther
Robinson, Roscoe, Jr.
Young, Charles

Movie industry. *See* Actors; Filmmakers
Musicians
Abrams, Muhal Richard
Ace, Johnny
Adderley, Julian Edwin "Cannonball"
Ammons, Albert
Ammons, Eugene "Gene"
Anderson, William Alonzo "Cat"
Armstrong, Lillian Hardin "Lil"
Armstrong, Louis "Satchmo"
Bailey, DeFord
Barron, William, Jr. "Bill"
Basie, William James "Count"
Bechet, Sidney Joseph
Benson, George
Berry, Leon Brown "Chu"
Bethune, Thomas Greene Wiggins
 "Blind Tom"
Bigard, Leon Albany "Barney"
Blackwell, Edward Joseph
Blake, James Hubert "Eubie"
Blakey, Art
Blanton, James "Jimmy"
Bolden, Charles Joseph "Buddy"
Bonds, Margaret Allison
Boone, "Blind" (John William)
Braxton, Anthony
Broonzy, William Lee Conley "Big Bill"
Brown, Clifford "Brownie"
Brown, Lawrence
Byas, Don
Carney, Harry Howell
Carter, Bennett Lester "Benny"
Catlett, Sidney "Big Sid"
Charles, Ray
Cherry, Donald Eugene "Don"
Christian, Charles "Charlie"
Clarke, Kenneth Spearman "Kenny"
Clinton, George
Cole, Nat "King"
Cole, William Randolph "Cozy"
Coleman, Ornette
Coltrane, John William
Cotten, Elizabeth
Dameron, Tadley Ewing Peake "Tadd"
Davis, Anthony
Davis, Miles Dewey, III
Dawson, Mary Cardwell
Dett, Robert Nathaniel
Diddley, Bo
Dodds, John "Johnny"
Dodds, Warren "Baby"
Dolphy, Eric Allan
Domino, Antoine, Jr., "Fats"
Eldridge, Roy David
Ellington, Edward Kennedy "Duke"
Foster, Frank Benjamin, II
Gillespie, John Birks "Dizzy"
Gordon, Dexter Keith
Green, Frederick William "Freddie"

Greer, William Alexander "Sonny"
Guillory, Ida Lewis "Queen Ida"
Hampton, Lionel Leo
Hancock, Herbert Jeffrey "Herbie"
Harrison, Hazel
Hawkins, Coleman Randolph
Hinderas, Natalie Leota Henderson
Hines, Earl Kenneth "Fatha"
Hinton, Milton John "Milt"
Hodges, Johnny
Hooker, John Lee
Hopkins, Lightnin'
House, Son
Jackson, Milton "Bags"
Jacobs, Marion Walter "Little Walter"
James, Elmore
Jefferson, "Blind" Lemon
Jenkins, Leroy
Joans, Ted
Johnson, Alonzo "Lonnie"
Johnson, "Blind" Willie
Johnson, James Louis "J.J."
Johnson, James Price
Johnson, Robert Leroy
Jones, Elvin Ray
Jones, Jonathan "Papa Jo"
Jones, Joseph Rudolph "Philly Joe"
Jordan, Clifford Laconia, Jr.
Jordan, Louis
Jordan, Stanley
King, Albert
King, Riley B. "B.B."
Lake, Oliver
Lateef, Yusef
Ledbetter, Hudson William "Leadbelly"
Lee, Sylvia Olden
Lewis, Meade "Lux"
Liston, Melba Doretta
Lunceford, James Melvin "Jimmie"
Marsalis, Wynton
McGhee, Walter Brown "Brownie"
McLean, John Lenwood, Jr., "Jackie"
Miley, James Wesley "Bubber"
Mingus, Charles, Jr.
Monk, Thelonious Sphere
Montgomery, John Leslie "Wes"
Morton, Ferdinand Joseph "Jelly Roll"
Moten, Benjamin "Bennie"
Muddy Waters
Nance, Ray Willis
Nanton, Joseph "Tricky Sam"
Navarro, Theodore "Fats"
Newton, James, Jr.
Nickerson, Camille Lucie
Noone, Jimmie
Oliver, Joseph "King"
Ory, Edward "Kid"
Parker, Charles Christopher "Charlie"
Patton, Charley
Peterson, Oscar Emmanuel
Pettiford, Oscar
Pittman, Portia Marshall Washington
Pozo, Chano
Price, Florence Beatrice Smith
Price, Samuel Blythe "Sammy"
Pride, Frank "Charley"
Roach, Maxwell Lemuel "Max"

Roberts, Charles Luckeyeth "Luckey"
Rollins, Theodore Walter "Sonny"
Ryder, Noah Francis
Santamaria, Mongo Ramon
Schuyler, Philippa Duke
Scott, Hazel
Shepp, Archibald Vernon "Archie"
Short, Robert Waltrip "Bobby"
Shorter, Wayne
Silver, Horace
Singleton, Arthur James "Zutty"
Sissle, Noble
Smith, Albert Alexander
Smith, Clara
Smith, Clarence "Pinetop"
Smith, James Oscar "Jimmy"
Smith, Stuff
Smith, "Willie the Lion"
South, Edward "Eddie"
Stewart, Leroy Elliott "Slam"
Stewart, William, Jr., "Rex"
Stone, Sly
Strayhorn, William Thomas "Billy"
Sun Ra
Tampa Red
Tatum, Arthur, Jr., "Art"
Taylor, Cecil Percival
Taylor, William, Jr., "Billy"
Terry, Sonny
Tharpe, "Sister" Rosetta
Threadgill, Henry Luther
Tindley, Charles Albert
Tizol, Juan
Walker, Aaron Thibeaux "T-Bone"
Walker, George Theophilus
Waller, Thomas Wright "Fats"
Watts, André
Webb, William Henry "Chick"
Webster, Benjamin Francis "Ben"
White, Clarence Cameron
White, Joshua Daniel "Josh"
Williams, Anthony "Tony"
Williams, Charles Melvin "Cootie"
Williams, Mary Lou
Williamson, John Lee "Sonny Boy"
Wilson, Arthur Eric "Dooley"
Yancey, James Edward "Jimmy"
Young, Lester
see also Composers; Conductors; Singers
Nurses. See Medical profession
Philosophers
Locke, Alain Leroy
Photographers
Ball, James Presley
Barboza, Anthony
Battey, Cornelius M.
Chong, Albert
DeCarava, Roy
Hansen, Austin
Hendricks, Barkley
Higgins, Chester
Lion, Jules
Newby, William H.
Parks, Gordon, Sr.
Polk, Prentice Herman
Roberts, Richard Samuel
Scales, Jeffrey Henson

Scurlock, Addison
Sengstacke, Robert Abbott
Simpson, Coreen
Simpson, Lorna
Sleet, Moneta J., Jr.
Sligh, Clarissa
Smith, Marvin Pentz, and Smith,
 Morgan Sparks
VanDerZee, James Augustus
Weems, Carrie Mae
Williams, Pat Ward
Withers, Ernest C.
Physicians. See Medical profession
Pioneers. See Explorers and pioneers
Politicians
Alexander, Raymond Pace
Allain, Théophile T.
Anderson, Charles
Antoine, Caesar Carpetier
Arnett, Benjamin William
Barry, Marion Shepilov, Jr.
Bradley, Thomas "Tom"
Brooke, Edward W., III
Brown, Ronald H.
Brown, Willie Lewis, Jr.
Bruce, Blanche Kelso
Burke, Yvonne Brathwaite
Cardozo, Francis Louis
Carey, Archibald J., Jr.
Cheatham, Henry Plummer
Chisholm, Shirley
Clay, William Lacy
Conyers, John, Jr.
Cuney, Norris Wright
Davis, Benjamin Jefferson, Jr.
Dawson, William Levi
DeLarge, Robert Carlos
Dellums, Ronald V. "Ron"
DePriest, Oscar Stanton
Dickerson, Earl Burris
Dickson, Moses
Diggs, Charles Coles, Jr.
Dinkins, David Norman
Elliott, Robert Brown
Fauset, Crystal Dreda Bird
Ford, Harold Eugene
Gantt, Harvey Bernard
Gray, William Herbert, III
Haralson, Jeremiah
Hatcher, Richard Gordon
Hawkins, Augustus Freeman
Hyman, John Adams
Jack, Hulan Edwin
Jackson, Maynard Holbrook, Jr.
Jones, John Raymond
Jordan, Barbara Charline
Langston, John Mercer
Lewis, John
Long, Jefferson Franklin
Lynch, John Roy
Metcalfe, Ralph Horace
Miller, Thomas Ezekial
Mitchell, Arthur Wergs
Mitchell, John R., Jr.
Montgomery, Isaiah Thornton
Murray, George Washington
Nash, William Beverly

Nix, Robert Nelson Cornelius
O'Hara, James Edward
Pierce, Samuel Riley
Pinchback, Pinckney Benton Stewart
Powell, Adam Clayton, Jr.
Powers, Georgia
Rainey, Joseph Hayne
Rangel, Charles Bernard
Ransier, Alonzo Jacob
Rapier, James Thomas
Revels, Hiram Rhoades
Smalls, Robert
Stokes, Carl Burton
Stokes, Louis
Sutton, Percy Ellis
Thompson, Holland
Trotter, James Monroe
Walls, Josiah Thomas
Washington, Harold
Washington, Valores J. "Val"
Waters, Maxine Moore
White, George Henry
Wilder, Lawrence Douglas
Williams, Hosea Lorenzo
Young, Andrew
Young, Coleman Alexander
Publishers
Abbott, Robert Sengstacke
Antoine, Caesar Carpetier
Murphy, Carl
Pace, Harry Herbert
Sengstacke, Robert Abbott
Religious leaders (eighteenth century)
Allen, Richard
George, David
Haynes, Lemuel
Hosier, Harry "Black Harry"
Jones, Absalom
Liele, George
Paul, Thomas
Varick, James
Williams, Peter, Sr.
Religious leaders (nineteenth century)
Allen, Richard
Anderson, Matthew
Arnett, Benjamin William
Beman, Amos Gerry
Boyd, Richard Henry
Brawley, Edward McKnight
Brown, John Mifflin
Brown, Morris
Butts, Calvin O., III
Cain, Richard Harvey
Carey, Lott
Chavis, John
Coker, Daniel
Coppin, Levi Jenkins
Crowdy, William Saunders
Crummell, Alexander
DeBerry, William Nelson
Derrick, William Benjamin
Early, Jordan Winston
Elaw, Zilpha
Ferrill, London
Foote, Julia
Gardner, Charles W.
Garnet, Henry Highland

Gloucester, John
Grimes, Leonard Andrew
Grimké, Francis James
Haynes, Lemuel
Henson, Josiah
Holsey, Lucius Henry
Hood, James Walker
Jackson, Rebecca Cox
Jasper, John
Jones, Absalom
Jones, Charles Price
Jones, Edward
Jordan, Lewis Garnet
Lane, Isaac
Lee, Jarena
Loguen, Jermain Wesley
Love, Emanuel King
Marshall, Andrew Cox
Martin, John Sella
Meachum, John Berry
Miller, George Frazier
Moorland, Jesse Edward
Morris, Elias Camp
Paul, Thomas
Payne, Daniel Alexander
Perry, Rufus Lewis
Poindexter, James Preston
Price, Joseph Charles
Quinn, William Paul
Ray, Charles Bennett
Rogers, Elymas Payson
Rudd, Daniel A.
Simmons, William J.
Smith, Amanda Berry
Spencer, Peter
Steward, William Henry
Tanner, Benjamin Tucker
Tolton, Augustus
Toussaint, Pierre
Turner, Henry McNeal
Varick, James
Williams, George Washington
Williams, Peter, Jr.
Wright, Theodore Sedgwick

Religious leaders (twentieth century)
Borders, William Holmes
Carey, Archibald J., Jr.
Cherry, Frank S.
Cone, James Hal
Coppin, Levi Jenkins
DeBerry, William Nelson
Fard, Wallace D.
Farrakhan, Louis Abdul
Father Divine
Franklin, Clarence LaVaughn
Grace, Charles Emmanuel "Sweet Daddy"
Harris, Barbara Clementine
Hawkins, Edler Garnett
Holsey, Lucius Henry
Hood, James Walker
Horn, Rosa Artimus
Jackson, Jesse Louis
Jackson, Joseph Harrison
Jernagin, William Henry
Johns, Vernon

Johnson, Mordecai Wyatt
Jones, Charles Price
Jordan, Lewis Garnet
Kelly, Leontine Turpeau Current
Lawson, James Morris
Mason, Charles Harrison
Mays, Benjamin Elijah
McGuire, George Alexander
Michaux, Elder Lightfoot Solomon
Miller, George Frazier
Morris, Elias Camp
Muhammad, Elijah
Murray, Pauli
Noble Drew Ali
Powell, Adam Clayton, Jr.
Powell, Adam Clayton, Sr.
Proctor, Henry Hugh
Ransom, Reverdy Cassius
Reverend Ike
Riddick, George
Rivers, Clarence Joseph
Robinson, Ida Bell
Seymour, William Joseph
Steward, William Henry
Taylor, Gardner Calvin
Thurman, Howard
Walker, Wyatt Tee
Walters, Alexander
Williams, Lacey Kirk
Wright, Richard Robert, Jr.

Scientists
astronomy
 Banneker, Benjamin
biochemistry
 Daly, Marie M.
 West, Harold Dadforth
biology
 Anderson, Everett
 Anderson, Winston A.
botany
 Carver, George Washington
 Parker, Charles Stewart
 Turner, Thomas Wyatt
chemistry
 Barnes, Robert Percy
 Brady, St. Elmo
 Calloway, Nathaniel Oglesby
 Cooke, Lloyd M.
 Hall, Lloyd Augustus
 Hill, Henry Aaron
 Julian, Percy Lavon
 Massie, Samuel Proctor, Jr.
 McBay, Henry Cecil Ransom
microbiology
 Amos, Harold
 Buggs, Charles Wesley
physics
 Bouchet, Edward Alexander
 Branson, Herman Russell
 Imes, Elmer Samuel
 Jackson, Shirley Ann
 Massey, Walter E.
 McNair, Ronald Erwin
 Young, James Edward
zoology
 Chase, Hyman Yates
 Just, Ernest Everett

Turner, Charles Henry
Young, Roger Arliner
see also Medical profession
Singers
Anderson, Ivie Marie
Anderson, Marian
Armstrong, Louis "Satchmo"
Arroyo, Martina
Bailey, Pearl
Barnett, Etta Moten
Battle, Kathleen
Belafonte, Harold George "Harry"
Benson, George
Berry, Charles Edward Anderson "Chuck"
Bledsoe, Julius C. "Jules"
Broonzy, William Lee Conley "Big Bill"
Brown, Anne Wiggins
Brown, James Joe, Jr.
Brown, Ruth
Bryant, Hazel
Bumbry, Grace Ann Melzia
Burleigh, Henry Thacker "Harry"
Caesar, Shirley
Calloway, Cabell "Cab"
Campbell, Delois Barrett
Carr, Wynona
Carroll, Diahann
Carter, Betty
Charles, Ray
Checker, Chubby
Cleveland, James Edward
Cole, Nat "King"
Cole, Robert Allen "Bob"
Cooke, Samuel "Sam"
Cox, Ida Prather
Crouch, Andrae Edward
Dandridge, Dorothy
Davis, Sammy, Jr.
Dobbs, Mattiwilda
Dranes, Arizona Juanita
Duncan, Robert Todd
Eckstine, William Clarence "Billy"
Estes, Simon Lamont
Fisk Jubilee Singers
Fitzgerald, Ella
Flack, Roberta
Franklin, Aretha Louise
Gaye, Marvin
George, Zelma Watson
Gilpin, Charles Sidney
Green, Al
Green, Cora
Greenfield, Elizabeth Taylor
Guillory, Ida Lewis "Queen Ida"
Hackley, Emma Azalia Smith
Harris, Hilda
Havens, Richard Pierce "Richie"
Hawkins, Edwin R.
Hayes, Roland Willsie
Hendricks, John Carl "Jon"
Hendrix, James Marshall "Jimi"
Holiday, Billie
Hooker, John Lee
Hopkins, Lightnin'
Horne, Lena

House, Son
Howlin' Wolf
Humes, Helen
Hunter, Alberta
Hyers Sisters
Jackson, Mahalia
Jackson, Michael, and the Jackson
 Family
James, Elmore
James, Etta
James, Rick
Jarreau, Alwyn Lopez "Al"
Johnson, Alonzo "Lonnie"
Johnson, "Blind" Willie
Johnson, Robert Leroy
Jones, M. Sissieretta "Black Patti"
King, Albert
King, Riley B. "B.B."
Kitt, Eartha Mae
Knight, Gladys
LaBelle, Patti
Ledbetter, Hudson William
 "Leadbelly"
Lincoln, Abbey
Little Richard
Luca Family Singers
Makeba, Miriam Zenzi
Martin, Roberta Winston
Martin, Sallie
Mathis, Johnny
Mayfield, Curtis
Maynor, Dorothy Leigh
McDaniel, Hattie
McFerrin, Robert, Jr., "Bobby"
McFerrin, Robert, Sr.
McKinney, Nina Mae
McPhatter, Clyde Lensley
McRae, Carmen
Mercer, Mabel Alice Wadham
Mills, Florence
Mills Brothers
Mitchell, Abbie
Muddy Waters
Norman, Jessye
Odetta
Patton, Charley
Pickett, Wilson
Pointer Sisters, The
Price, Mary Violet Leontyne
Prince
Rainey, Gertrude Pridgett "Ma"
Rawls, Louis Allen "Lou"
Redding, Otis
Robeson, Paul
Robinson, William, Jr., "Smokey"
Ross, Diana
Rushing, James Andrew "Jimmy"
Sam and Dave
Scott, Hazel
Shepp, Archibald Vernon "Archie"
Shirley, George Irving
Short, Robert Waltrip "Bobby"
Simone, Nina
Smith, Ada Beatrice Queen Victoria
 Louise Virginia "Bricktop"
Smith, Bessie
Smith, Clara

Smith, Mamie
Smith, Willie Mae Ford
Supremes, The
Temptations, The
Tharpe, "Sister" Rosetta
Thornton, Willie Mae "Big Mama"
Turner, Joseph Vernon "Big Joe"
Turner, Tina
Vaughan, Sarah
Verrett, Shirley
Walker, Aaron Thibeaux "T-Bone"
Walker, Aida Overton
Wallace, Sippie
Warwick, Dionne
Washington, Dinah
Waters, Ethel
Wells, Mary Esther
White, Joshua Daniel "Josh"
Williams, Joseph Goreed "Joe"
Williams, Marion
Williamson, John Lee "Sonny Boy"
Wilson, Jackie
Wilson, Nancy Sue
Wonder, Stevie

**Social activists (eighteenth
 century)**
Cuffe, Paul
Hall, Prince
Jones, Absalom

**Social activists (nineteenth
 century)**
Anderson, Osborne Perry
Barbadoes, James G.
Barrett, Janie Porter
Bell, James Madison
Beman, Jehiel C.
Bragg, George Freeman, Jr.
Brown, Henry "Box"
Butts, Calvin O., III
Cuffe, Paul
Delany, Martin Robison
Douglass, Anna Murray
Douglass, Frederick
Forten, James
Forten, Robert Bridges
Fortune, Timothy Thomas
Gardner, Charles W.
Garnet, Henry Highland
Gibbs, Mifflin Wister
Grimes, Leonard Andrew
Grimké, Archibald Henry
Grimké, Charlotte L. Forten
Hamilton, William
Harper, Frances Ellen Watkins
Harris, Andrew
Henson, Josiah
Hilyer, Andrew Franklin
Hodges, Willis Augustus
Jacobs, Harriet Ann
Jones, Absalom
Langston, Charles Henry
Langston, John Mercer
Loguen, Jermain Wesley
Matthews, Victoria Earle
McCrummill, James
Nell, William Cooper
O'Hara, James Edward

Parsons, Lucy
Pennington, James William Charles
Poindexter, James Preston
Purvis, Harriet Forten
Purvis, Robert
Remond, Charles Lenox
Remond, Sarah Parker
Rock, John Sweat
Ruffin, Josephine St. Pierre
Ruggles, David
Russwurm, John Brown
Shadd, Abraham Doras
Smith, James McCune
Steward, William Henry
Stewart, Thomas McCants
Still, William
Terrell, Mary Eliza Church
Trotter, William Monroe
Truth, Sojourner
Tubman, Harriet Ross
Varick, James
Walker, David
Ward, Samuel Ringgold
Wells-Barnett, Ida Bell
Whipper, William
Williams, Peter, Jr.
Young, Robert Alexander

**Social activists (twentieth
 century)**
Abernathy, Ralph David
Alexander, Sadie Tanner Mossell
Ashe, Arthur Robert, Jr.
Bagnall, Robert Wellington, Jr.
Baker, Ella J.
Barry, Marion Shepilov, Jr.
Bates, Daisy Gaston
Belafonte, Harold George "Harry"
Bethune, Mary McLeod
Bevel, James
Blackwell, Unita
Bond, Julian
Borders, William Holmes
Bragg, George Freeman, Jr.
Briggs, Cyril Valentine
Brown, Hubert G. "H. Rap"
Carmichael, Stokely
Chaney, James Earl
Chavis, Benjamin Franklin, Jr.
Clark, Septima Poinsette
Cleaver, Eldridge
Crosswaith, Frank Rudolph
Davis, Angela Yvonne
Davis, John Preston
Davis, Ossie
Dee, Ruby
Domingo, Wilfred Adolphus
Du Bois, Shirley Graham
Eaton, Hubert Arthur
Evers, James Charles
Evers, Medgar Wylie
Farmer, James
Forman, James
Fortune, Timothy Thomas
Franklin, Clarence LaVaughn
Frazier, Edward Franklin
Garvey, Amy Ashwood
Garvey, Amy Jacques

Garvey, Marcus Mosiah
Giles, Roscoe Conkling
Granger, Lester Blackwell
Gregory, Richard Claxton
 "Dick"
Grimké, Archibald Henry
Hale, Clara McBride "Mother"
Hamer, Fannie Lou
Hancock, Gordon Blaine
Harrison, Hubert Henry
Haynes, Elizabeth Ross
Haywood, Harry
Hedgeman, Anna Arnold
Height, Dorothy
Herndon, Angelo Braxton
Hill, T. Arnold
Hilyer, Andrew Franklin
Holman, Moses Carl
Hooks, Benjamin Lawrence
Hope, John
Hope, Lugenia Burns
Hudson, Hosea
Hunter, Jane Edna
Hunton, Addie Waites
Hunton, William Alphaeus, Jr.
Hurley, Ruby
Innis, Roy
Jackson, George Lester
Jackson, Jesse Louis
Jackson, Jimmy Lee
Jackson, Lillie Mae Carroll
James, Cyril Lionel Richard
Jenkins, Esau
Jernagin, William Henry
Johns, Vernon
Johnson, James Weldon
Johnson, Mordecai Wyatt
Jones, Claudia
Jordan, Vernon Eulion, Jr.
Julian, Percy Lavon
Karenga, Maulana
King, Coretta Scott
King, Martin Luther, Jr.
Lampkin, Daisy Elizabeth Adams
Lawson, James Morris
Lewis, John
Logan, Arthur Courtney
Logan, Rayford Whittingham
Lowery, Joseph Echols
Lucy Foster, Autherine
Malcolm X
Mayfield, Julian H.
McKissick, Floyd B.
Meredith, James H.
Mitchell, Clarence Maurice, Jr.
Mitchell, Juanita Jackson
Moody, Anne
Moore, Audley "Queen Mother"
Moore, Harry Tyson
Moore, Richard Benjamin
Moses, Robert Parris
Nash, Diane Bevel
Newton, Huey P.
Nixon, Edgar Daniel
Norton, Eleanor Holmes
Parks, Rosa Louise McCauley
Parsons, Lucy

Patterson, William
Powell, Adam Clayton, Jr.
Proctor, Henry Hugh
Randolph, Asa Philip
Richardson, Gloria St. Clair Hayes
Riddick, George
Robeson, Paul
Robinson, Jo Ann Gibson
Robinson, Randall
Robinson, Ruby Doris
Rustin, Bayard
Seale, Robert George "Bobby"
Shakur, Assata
Sharpton, Alfred, Jr.
Sherrod, Charles
Shuttlesworth, Fred L.
Simkins, Mary Modjeska Monteith
Simmons, Jake, Jr.
Staupers, Mabel Keaton
Steward, William Henry
Stewart, Thomas McCants
Sullivan, Leon Howard
Talbert, Mary Morris Burnett
Taylor, Gardner Calvin
Terrell, Mary Eliza Church
Thompson, Louise
Trotter, William Monroe
Waldron, John Milton
Walker, Wyatt Tee
Walters, Alexander
Wattleton, Faye
Wells-Barnett, Ida Bell
White, Walter Francis
Wilkerson, Doxey Alphonso
Wilkins, Roy Ottoway
Williams, Franklin Hall
Williams, Hosea Lorenzo
Williams, Robert Franklin
Yergan, Max
Young, Andrew
Young, Whitney Moore, Jr.

Social scientists
 anthropology
 Davis, William Allison
 Fauset, Arthur Huff
 Hurston, Zora Neale
 Robeson, Eslanda Cardozo Goode
 economics
 Brimmer, Andrew Felton
 Harris, Abram Lincoln, Jr.
 Weaver, Robert Clifton
 psychology
 Clark, Kenneth Bancroft
 sociology
 Cayton, Horace Roscoe, Jr.
 Cox, Oliver Cromwell
 Dill, Augustus
 Drake, St. Clair
 Du Bois, William Edward
 Burghardt
 Frazier, Edward Franklin
 Hancock, Gordon Blaine
 Haynes, George Edmund
 Johnson, Charles Spurgeon
 Work, Monroe Nathan
Sports. *See* Athletes
Theater. *See* Actors; Writers, drama

Writers
 autobiography
 Angelou, Maya
 Bibb, Henry Walton
 Equiano, Olaudah
 Hammon, Briton
 Jacobs, Harriet Ann
 Lee, Jarena
 Moody, Anne
 Northrup, Solomon
 Prince, Nancy Gardner
 Smith, Venture
 drama
 Baraka, Amiri
 Bontemps, Arna
 Branch, William Blackwell
 Bullins, Ed
 Carroll, Vinnette
 Childress, Alice
 Conwell, Kathleen
 Cullen, Countee
 Davis, Ossie
 Dent, Thomas
 Deveaux, Alexis
 Dickerson, Glenda
 Elder, Lonne, III
 Fisher, Rudolph John Chauncey
 Fuller, Charles H., Jr.
 Grimké, Angelina Weld
 Gunn, William Harrison "Bill"
 Guy, Rosa Cuthbert
 Hansberry, Lorraine
 Harrison, Paul Carter
 Hughes, Langston
 Jackson, Angela
 Johnson, Georgia Douglas
 Kennedy, Adrienne
 Mackey, William Wellington
 Marvin X
 Milner, Ronald
 Mitchell, Loften
 Parks, Suzan-Lori
 Salaam, Kalamu Ya
 Sebree, Charles
 Shange, Ntozake
 Shine, Ted
 Walcott, Derek
 Walker, Joseph A.
 Ward, Douglas Turner
 Ward, Theodore
 White, Edgar Nkose
 Williams, Samm-Art
 Wilson, August
 Wolfe, George C.
 essays
 Baldwin, James
 Braithwaite, William Stanley
 Beaumont
 Cleaver, Eldridge Leroy
 Cooper, Anna Julia Haywood
 Dunbar-Nelson, Alice
 Ellison, Ralph
 Fauset, Arthur Huff
 Fisher, Rudolph John Chauncey
 Frazier, Edward Franklin
 Johnson, Fenton
 Jordan, June

Madhubuti, Haki R.
Matheus, John Frederick
Meriwether, Louise
Neal, Larry
Stewart, Maria Miller
Toomer, Jean
Walcott, Derek Alton
Walker, Margaret

nonfiction
Bennett, Lerone, Jr.
Bragg, George Freeman, Jr.
Brawley, Benjamin Griffith
Brown, Claude
Brown, Hubert G. "H. Rap"
Brown, Sterling Allen
Cooper, Anna Julia Haywood
Cruse, Harold Wright
Delany, Martin Robison
Desdunes, Rodolphe Lucien
Driskell, David
Du Bois, Shirley Graham
Grimké, Archibald Henry
Lester, Julius
Lynk, Miles Vandahurst
Majors, Monroe Alpheus
Marrant, John
Morrison, Toni
Redding, Jay Saunders
Simmons, William J.
Steward, Theophilus Gould
Thomas, William Hannibal
Thurman, Wallace

novels
Attaway, William Alexander
Baldwin, James
Bennett, George Harold "Hal"
Boles, Robert
Bontemps, Arna
Bradley, David Henry, Jr.
Brooks, Gwendolyn Elizabeth
Brown, Cecil Morris
Brown, William Wells
Butler, Octavia Estelle
Chase-Riboud, Barbara Dewayne
Chesnutt, Charles Waddell
Colter, Cyrus
Conwell, Kathleen
Cullen, Countee
Demby, William E., Jr.
Deveaux, Alexis
Dixon, Melvin
Dodson, Owen Vincent
Du Bois, William Edward Burghardt
Dunbar, Paul Laurence
Ellison, Ralph
Fauset, Jessie Redmon
Fisher, Rudolph John Chauncey
Forrest, Leon
Gaines, Ernest J.
Griggs, Sutton Elbert
Gunn, William Harrison "Bill"
Guy, Rosa Cuthbert
Haley, Alexander Palmer "Alex"
Hamilton, Virginia
Harper, Frances Ellen Watkins
Himes, Chester
Hopkins, Pauline Elizabeth

Hurston, Zora Neale
Jackson, Angela
James, Cyril Lionel Richard
Johnson, Charles Richard
Johnson, James Weldon
Jones, Gayl
Kelley, William Melvin
Killens, John Oliver
Kincaid, Jamaica
Larsen, Nella
Lorde, Audre Geraldine
Major, Clarence
Marshall, Paule
Mayfield, Julian H.
McKay, Claude
McMillan, Terry
Meriwether, Louise
Micheaux, Oscar
Morrison, Toni
Mosley, Walter
Motley, Willard Francis
Murray, Albert L.
Naylor, Gloria
Petry, Ann Lane
Polite, Carlene Hatcher
Reed, Ishmael
Scott-Heron, Gil
Shange, Ntozake
Smith, William Gardner
Steward, Theophilus Gould
Thurman, Wallace
Toomer, Jean
Van Peebles, Melvin
Walker, Alice
Walker, Margaret
Webb, Frank J.
Wesley, Richard
West, Dorothy
White, Edgar Nkose
Wideman, John Edgar
Williams, John Alfred
Williams, Sherley Anne
Wilson, Harriet E. Adams
Wright, Charles Stevenson
Wright, Richard
Yerby, Frank Garvin
Young, Albert James "Al"

poetry
Ai
Angelou, Maya
Baraka, Amiri
Bell, James Madison
Bennett, Gwendolyn Bennetta
Bontemps, Arna
Braithwaite, William Stanley
 Beaumont
Brathwaite, Edward Kamau
Brooks, Gwendolyn Elizabeth
Brown, Sterling Allen
Chase-Riboud, Barbara Dewayne
Clifton, Thelma Lucille
Cortez, Jayne
Cortor, Eldzier
Cullen, Countee
Danner, Margaret Essie
Dee, Ruby
Dixon, Melvin

Dodson, Owen Vincent
Dove, Rita
Dumas, Henry Lee
Dunbar, Paul Laurence
Dunbar-Nelson, Alice
Evans, Mari E.
Giovanni, Yolanda Cornelia "Nikki"
Grimké, Angelina Weld
Grimké, Charlotte L. Forten
Hammon, Jupiter
Harper, Frances Ellen Watkins
Harper, Michael Steven
Hayden, Robert Earl
Holman, Moses Carl
Horne, Frank Smith
Horton, George Moses
Hughes, Langston
Jackson, Angela
Johnson, Fenton
Johnson, Georgia Douglas
Johnson, Helen V. "Helene"
Jones, Gayl
Jordan, June
Kaufman, Bob
Knight, Etheridge
Komunyakaa, Yusef
Lanusse, Armand
Lorde, Audre Geraldine
Madhubuti, Haki R.
Major, Clarence
Marvin X
McClane, Kenneth
McElroy, Colleen J.
McKay, Claude
Murray, Pauli
Plato, Ann
Prince, Lucy Terry
Randall, Dudley Felker
Ray, Henrietta Cordelia
Rodgers, Carolyn
Rogers, Elymas Payson
Sanchez, Sonia
Scott-Heron, Gil
Shange, Ntozake
Tolson, Melvin Beaunorus
Toomer, Jean
Walcott, Derek Alton
Walker, Margaret
Wheatley, Phillis
Whitfield, James Monroe
Wright, Jay
Young, Albert James "Al"

science fiction
Delany, Samuel R.

short stories
Bambara, Toni Cade
Bennett, Gwendolyn Bennetta
Boles, Robert
Bonner, Marita
Butler, Octavia Estelle
Chesnutt, Charles Waddell
Dee, Ruby
Demby, William E., Jr.
Dumas, Henry Lee
Dunbar-Nelson, Alice
Fisher, Rudolph John Chauncey
Fuller, Charles Henry, Jr.

Himes, Chester
Hopkins, Pauline Elizabeth
Kincaid, Jamaica
Matheus, John Frederick
Matthews, Victoria Earle

McElroy, Colleen J.
McMillan, Terry
McPherson, James Alan
Meriwether, Louise
Petry, Ann Lane

Walrond, Eric Derwent
West, Dorothy
Wideman, John Edgar
Williams, Sherley Anne
see also Journalists

INDEX

Numbers in **boldface** refer to the main entry on the subject. Numbers in *italic* refer to illustrations.

Banks, William H., Jr., 1220
Bannarn, Henry, 1582
Banneker, Benjamin, **251–253**, 1370,
 2062, 2148, 2401
 almanac, 399, 1715
 education, 847
 Jefferson (Thomas) correspondence,
 252, 731, 1627, 2201
 Washington, D.C., planning, 2786
Bannerman, Helen, 535
Banning, James Herman, 29
Bannister, Christiana Carteaux, 254
Bannister, Edward Mitchell, **253–254**,
 2080–2081, 2221
Bantu language family, 44, 160
Baptisms, 2299, *2303*
Baptiste, Eugene, 898
Baptists, **255–261**
 Abernathy, Ralph David, 5–6
 Allensworth, Allen, 102
 antebellum period, 255–256, 2301–
 2302
 Borders, William Holmes, 404–405
 Boyd, Henry Allen, 420
 Boyd, Richard Henry, 420–421
 Brawley, Edward McKnight, 428–429
 Bryan, Andrew, 465
 Carey, Lott, 498
 Civil rights movement, 2306
 Civil War era, 256
 Ferrill, London, 950
 Grimes, Leonard Andrew, 1149–1150
 Holiness movement, 1291
 Jackson, Joseph Harrison, 1408
 Jasper, John, 1429
 Jernagin, William Henry, 1443
 Johns, Vernon, 1450
 Jordan, Lewis Garnet, 1489
 Liele, George, 1617
 literature, 420, 421
 Love, Emanuel King, 1661–1662
 Marshall, Andrew Cox, 1699–1700
 Meachum, John Berry, 1746–1747
 membership, 912, 2300, 2305, 2306,
 2307
 missionary activities, 1816, 1817
 Morris, Elias Camp, 1855–1856
 North Dakota, 2029
 Paul, Thomas, 2114
 Perry, Rufus Lewis, 2128
 Poindexter, James Preston, 2164–2165
 postbellum period, 2304, 2306, 2308
 Powell, Adam Clayton, Jr., 2193
 religious instruction, 2311
 schism, 2220, 2304
 Simmons, William J., 2434–2435
 social gospel, 2514
 Taylor, Gardner Calvin, 2611–2612
 theological education, 2642
 Virginia, 2746
 Waldron, John Milton, 2757–2758
 Williams, Lacey Kirk, 2846
 women, 2303
 see also Abyssinian Baptist Church;
 National Baptist Convention,
 U.S.A.; Primitive Baptists; Six-
 teenth Street Baptist Church

Baptist Standard Hymnal, 1122
Baptist World Alliance, 1855
Baraka, Amiri (Jones, LeRoi), **261–262**
 Black Arts Movement, 262, 325, 327,
 329, 795
 black culture, 1386, 2717
 dramas, 794–795
 Gary, Ind., convention, 1093
 homosexuality, views on, 1095
 Kawaida ideology, 1527–1528, 1985
 literary magazines, 1625
 political writings, 1634
Baranco, June, 1158
Barbadoes, James G., **263**
Barbadoes, Robert, 263
Barbados
 immigrants, 1352–1354
 slave trade, 2475
Barbecue, 1008–1009
Barbee, Lloyd, 2868
Barber, Jesse Max, **263–264**, 412, 1623
Barbering. *See under* Hair and beauty
 culture
Barboza, Anthony, **264–265**, *2147*
Barefoot in the Park (television program),
 2620
"Bargain of 1877," 2285
Barker, Danny, 1699
Barkley, Charles, 2051
Barksdale, Don, 2051
Barksdale, Richard, 694
Barnes, Albert C., 1203, 2153, 2154
Barnes, Frank, 1943
Barnes, Robert Percy, **265**
Barnes, Steven, 2403, 2404
Barnes, Thomas V., 1234
Barnes, William Harry, **265–266**, 1253,
 1617, 2596
Barnes Foundation, 781
Barnet, Charlie, 2130
Barnett, Claude Albert, **266**
Barnett, Etta Moten, **266**
Barnett, Ferdinand Lee, 1343
Barnett, Marguerite Ross, 1829
Barnett, Richard "Dick," 285
Barnett, Ross, 1758, 1948
Barnett-Aden Gallery (Washington,
 D.C.), 200, 1273, 1887, 2188, 2647
Barnstorming, 272, 273, 274, 282
Barnum, P. T., 2698
Barnum & Bailey Circus, 1688, 1689,
 1690
Barrett, Janie Porter, **267**, 2747
Barrett Campbell, Delois. *See* Campbell,
 Delois Barrett
Barrett Sisters, 490
Barron, William, Jr. "Bill," **267**
Barron v. *Baltimore* (1833), 553
Barrow, Bennett H., 1655
Barrow, Willie T., 2060
Barry, Marion Shepilov, Jr., **268**, 1508,
 2368, 2584, 2629, 2791
"Bars Fight, August 28, 1746" (Prince),
 2223–2224
Barthé, Richmond, **269**, 1327, 1880,
 2083
Barthelemy, Sidney, 1725, 1998

Bartholomew, Dave, 778
Barthwell, Sydney, 903
Bartleman, Frank, 2124
Baryshnikov, Mikhail, 1427
Baseball, **270–279**, 2554
 Birmingham, Ala., 321
 black exclusion, 271
 black vs. white, 273
 boycott, 279
 Canada, 495
 contemporary, 277–279
 executives, 2, 2819
 farm team integration, 1
 first black manager, 2350
 first black umpire, 206
 integration, 275–277, 627, 1501, 2160,
 2352, 3061
 Kansas City Monarchs, 1523
 management, 279, 2350, 2559–2560,
 2857
 Pittsburgh, Pa., 2158
 reserve clause, 981
 White (Bill) presidency, 2818–2819
 see also Negro Leagues; *specific players
 and teams*
Baseball Hall of Fame
 inductees, 3056
 Negro League Committee, 274
 writers' wing, 2500
Baseball Writers' Association, 1570
Basie, William James "Count," **280–
 281**, 1144, 1523, 2632, 2911
 autobiography, 1884
 Byas, Don, 481
 Humes, Helen, 1326
 influence, 1434
 Jones, Jonathan "Papa Jo," 1480
 orchestra origins, 1865
 popularity, 1436
 recordings, 2287
 Williams, Joseph Goreed "Joe," 2846
Basilio, Carmen, 2356
Basketball, **281–287**, 2555, 2556
 integration, 2556–2557, 2558
 management, 286, 294, 2559, 2560
 Olympic Games, 2051
 see also Harlem Globetrotters; Renais-
 sance Big Five; *specific players and
 other teams*
Basketball Hall of Fame inductees, 3057
Basketry, 61, 986–987, 997
Basquiat, Jean-Michel, **287–289**, 2091,
 2654
Bass, Harriston Lee, Jr., 1982
Bass, Harry W., 1619, 2122
Bass, Kingsley B. *See* Bullins, Ed
Bassett, Ebenezer Don Carlos, *104*, **289**,
 2206
Basso, Hamilton, 2107
Batchelor, Joseph, 2141
Bateman, Mildred Mitchell, **289**
Bates, Clayton "Peg Leg," **289–290**
Bates, Daisy Gaston, 191, 192, 193,
 290–291
Bates, L. C., 191, *192*, 290
Bates, Ruby, 2410, 2411
Batiste, Rodney, 1704

Chew, William H., 2260
Cheyenne Valley (settlement), 2866
Chez Honey (Paris), 1099
Chicago, Illinois, **530–532**
 AfriCobra, 78
 Alpha Suffrage Club, 103
 anthropologic study, 147
 artists, 533, 2086
 Black Arts Movement, 328, 329
 black voter power increase, 2168
 caste-class model, 2251
 DePriest, Oscar Stanton, 751
 dissimilarity index, 1784
 Du Sable, Jean Baptiste Pointe, 819–
 820
 Federal Art Projects, 941, 942
 housing, 1310, *2715*, 2801
 jazz, 1433–1434
 migration impact, 1783
 Mitchell, Arthur Wergs, 1832
 Moseley-Braun, Carol, 1861
 numbers games, 2033
 population, 1781, 3034
 public schools, 866
 racial violence, 338, 532, 534–535,
 1343, 2723
 radio stations, 2254–2255
 Roman Catholicism, 2663–2664
 settlement houses, 2517–2518
 Southern Christian Leadership Con-
 ference campaign, 2536
 Spiritual movement, 2547
 Wall of Respect mural, 78
 Washington, Harold, 2781–2782
 World's Columbian Exposition, 2801,
 2842
Chicago Art League, **533**
Chicago Bee (newspaper), 2071
Chicago blues, 774
Chicago Commission on Race Relations,
 3, 535, 1453, 2716
Chicago Defender, **533–534**, 710, 902,
 1343, 1498–1499, 2784
 Abbott, Robert Sengstacke, 3
 aviation support, 29
 Bearden (Bessye Jean) column, 295
 black baseball news, 273
 circulation, 534, 1503
 comic strips, 624
 Harlem Renaissance, 1210
 Hughes (Langston) column, 1325
 as intellectual forum, 1500
 as Longview riot catalyst, 1646
 western migration support, 2804
Chicago Defender Youth Band, 1180
Chicago Peace and Protection Associa-
 tion, 2846
Chicago Public Library, 402
Chicago riot of 1919, 338, 532, **534–535,**
"Chicago school" of sociology, 365
Chicago Symphony Orchestra, 2749
Chicago Tribune, 1507, 1670
Chicago Urban League, 1275–1276
Chicago White Stockings (baseball), 271
Chickasaw Indians, 1654, 2044
Chickasaw war, 1060
Chicken, as staple food, 1008

Chick Webb Orchestra, 1287
Child, Lydia Maria, 1422, 1607, 2371
Childers, Lulu V., 1953–1954
Children of Bondage, The (Davis and
 Dollard), 726
Children of Ham (Brown), 444
Children's Defense Fund, 845, 2067
Children's literature, **535–537**
 Bontemps, Arna, 398
 Clifton, Thelma Lucille, 599
 comic books, 622–623
 comic strips, 624
 Crichlow (Ernest) illustrations, 674–
 675
 Cullen, Countee, 706
 Deveaux, Alexis, 761
 Giovanni, Yolanda Cornelia "Nikki,"
 1111
 Hamilton, Virginia, 1177–1178
 Harlem Writers Guild, 1220
 Jordan, June, 1488
 Moody, Anne, 1844
 Petry, Ann Lane, 2130
 Ringgold, Faith, 2342
Childress, Alice, 120, **537–538**
Childress, Alvin, 128
Childs, Frank, 1461
Childs, John Brown, 1379
Childs, Samuel R., 733
Chilembwe, John, 1354, 2096
Chiles, James A., 1534
Chiles, Lawton, 1848
Chinaberry Tree, The (Fauset), 939
Chinn, Chester W., 1617, 2596
Chinn, May Edward, **538**, 1254, 2842
Chisholm, Sam, 26
Chisholm, Shirley, **538–539**, 747, 934,
 1093
"Chitlin Circuit." *See* Theater Owners
 Booking Association
Chitterlings (food), 1008
C. H. James & Company, 902
Chlistowa, Xenia, 787
Chocolate Dandies, 1239
Chocolate Soldier, A (Colter), 615
Choctaw Indians, 2044
Choice of Weapons, A (Parks), 2102
Chong, Albert, **539–540**
Chopin, Kate, 170
Chosen Place, The Timeless People, The
 (Marshall), 1701
Chow, Raymond, 968
Chrisman, Robert, 363
Christian, Barbara T., 684, 687
Christian, Charles "Charlie," **540**, 2047,
 2130, 2912
Christian, William, 1121
Christiana revolt of 1851, **541**, 2120
Christian Church. *See* Disciples of
 Christ
Christian Civic League. *See* White Citi-
 zens' Councils
Christian Commission, 2041
Christian Endeavor Movement, 2312
Christian Identity Movement, 1559
Christianity. *See* Bible and African-
 American culture; Missionary

movements; Religion; Religious
 education; Slave religion; *specific
 denominations and sects*
Christianity, Islam and the Negro Race
 (Blyden), 1398
Christian Methodist Episcopal Church,
 71, **541–543**, 1572, 2304, 2306; *see
 also* Colored Methodist Episcopal
 Church
Christian Recorder, **543**
Christian Students and Modern South Africa
 (Yergan), 2905
Christian Women's Board of Missions.
 See National Christian Missionary
 Convention
Christie Comedies, 2854
Christmas, Walter, and June Jackson,
 201, 1219
Christmas festivals, 955
"Christmas Song, The" (recording), 604
Christophe, Henri, 122
Christ's Association of Mississippi of
 Baptized Believers, 1475
Christy and Wood's Minstrels, 2698
Chu Berry and His Stompy Stevedores,
 309
Chuck and Chuckles (dance team), 1143
Chuck Davis Dance Company, 719
Chudoff, Earl, 2020
Church, Robert Reed, Jr., **543–544,**
 2168
Church, Robert Reed, Sr., 249, **544,**
 900, 902, 1754
Church of Christ. *See* United Church of
 Christ
Church of Christ (Holiness) U.S.A.,
 544, 1292, 1476, 2304
Church of England. *See* Episcopalians
Church of God and Saints of Christ. *See*
 Temple Beth El congregations
Church of God in Christ, **544–545,**
 1291, 1292, 2124, 2304
 Hawkins, Edwin R., 1240
 Jones, Charles Price, 1475
 Lexington, Miss., 1121
 Mason, Charles Harrison, 1711
 role of women, 2304
Church of Jesus Christ of Latter-day
 Saints. *See* Mormons
Church of Our Lord Jesus Church of
 the Apostolic Faith, Inc., 167
Church of the Living God (Wrightsville,
 Ark.), 1121
Church of the Lord Jesus Christ Apos-
 tolic, 167
Churty, George, 2606
CIAA. *See* Colored Intercollegiate Ath-
 letic Association
CIC. *See* Commission on Interracial
 Cooperation
Cincinnati, Ohio, **545–547**
 Clark, Peter Humphries, 578
 convention movement, 139
 population, 3035
 racial violence, 547, 2720
Cinema. *See* Film
Cinqué, Joseph, 126

Colored Intercollegiate Athletic Association, 281–282, 1011, 1012
"Colored Man" folktales, 999
Colored Methodist Episcopal Church, 1763
 development, 2302
 Holsey, Lucius Henry, 1295
 membership, 2305
 name change, 2306
 role of women, 2304
 see also Christian Methodist Episcopal Church
Colored Museum, The (play), 797, 2869
Colored National Labor Union, 830, 1705
Colored Patriots of the American Revolution (Nell), 1980
Colored People's Convention, 738
Colored Pioneers Association, 187
Colored Players, 962
Colored Regulars, The (Steward), 2570
Colored Republican Club (N.Y.C.), 130–131, 1459–1460
Colored Socialist Club, 1230
Colored Union Club (baseball), 270
Colored Vigilance Committee, 755
Colored World Series, 273
Color Purple, The (film), 458, 621, 1112, 1113, 1296, 1949
Color Purple, The (Walker), 685, 686, 1635, 2761
Color of Solomon, What?, The (Tanner), 65
Coloured American Temperance Society, 139
Colter, Cyrus, **615**
Coltrane, Alice, 616
Coltrane, John William, 77, **615–616**, 722, 1436, 2363, 2911–2912
 Jones (Elvin Ray) band membership, 1477
 Parker (Charlie) influence, 2100
 Sanders (Farrell Pharoah) association, 2384, 2385
Columbia, South Carolina, 2433
Columbia Broadcasting System, 128, 1508, 2254, 2615
Columbia Gramophone Company, 2493
Columbian Exposition (1893). See World's Columbian Exposition
Columbia-Presbyterian Hospital (N.Y.C.), 803
Columbia Records, 1070, 2286, 2291
Columbia University, 402, 1503
Colvard, D. W., 2558
Colvin, Claudette, 1841–1842, 2353
Comachee River Collective, 681
Comedians, **617–621**
 minstrel, 1812
 Pryor (Richard) standards, 2231
 radio, 2253–2254
 television, 2615–2616, 2617, 2618–2619, 2619–2620, 2622, 2623
 Williams and Walker, 2763–2764
 see also Amos 'n' Andy
Comedy: American Style (Fauset), 939, 1216

Comer, James Pierpont, **621–622**, 873
Comer, William H. W., 2029
Comer Process, 622
Comic books, **622–623**
"Comic Relief" (benefit), 1113
Comic strips, **623–625**
 Bearden, Romare, 296
 Campbell, Elmer Simms, 490
 Fax, Elton C., 940
 Feelings, Thomas, 948–949
 Harrington, Oliver Wendell "Ollie," 1225
 Herriman, George, 1272
Coming of Age in Mississippi (Moody), 1634, 1844
Coming Up Black (Schulz), 148
Comiskey, Charles, 1033
Comité des Citoyens, 165, 754, 1997
Comly, James M., 1236
Commager, Henry Steele, 1378
Commerce clause, 374
Commercial banks. See Banking
Commercial broadcasting. See Radio; Television
Commission for Racial Justice, 2707
Commission on Civil Rights. See United States Commission on Civil Rights
Commission on Interracial Cooperation, 213, 217, 506, 819, 1672, 1709, 1869, 2139, 2537
Commission on Religion and Race, 2200
Committee Against Racial Discrimination, 111
Committee Against Racism in the Arts, 2153
Committee for a Unified Newark, 1985
Committee for West Indian Missions, 116
Committee of Forty on Permanent Organization. See National Negro Committee
Committee of Government Contract Compliance, 1556
Committee of Thirteen, 2495
Committee of Twelve for the Advancement of the Interests of the Negro Race, 217, 425, 2017
Committee on Appeal for Human Rights, 395
Committee on Interracial Cooperation, 1708, 2571
Committee on Negro Troop Policies, 719
Committee to Present the Truth About the Name Negro, 1849
Committee to Retain Our Segregated Schools, 193
Commodore, Chester, 624
Commodores (vocal group), 750
Common Destiny, A: Blacks in American Society (National Research Council), 868–869
Common School and the Negro American, The (Du Bois), 854–855
Commonwealth v. Jennison (1783), 1128

Communist Party of the United States, **625–628**
 African Blood Brotherhood alliance, 58
 Birmingham, Ala., 321
 black conservative opposition, 649
 black homeland argument, 2316
 black support, 1383, 2177
 Briggs, Cyril Valentine, 431–432
 Civil Rights Congress affiliation, 551, 552
 CORE relationship, 639–640
 Council on African Affairs affiliation, 666
 Davis, Angela Yvonne, 715, 716
 Davis, Benjamin Jefferson, Jr., 716–717, 1588
 Du Bois, W. E. B., 809, 1502
 FBI investigation, 942–943
 Ford, James W., 1022
 Harlem activism, 1192, 1196
 Harlem Renaissance, 1215–1216
 Haywood, Harry, 1246
 Herndon, Angelo Braxton, 1271–1272
 Hudson, Hosea, 1323–1324
 Hughes, Langston, 1325
 John Reed clubs, 1450
 Jones, Claudia, 1476
 literary patronage, 1216, 1631
 Moore (Audley "Queen Mother"), 1845–1846
 Moore (Richard Benjamin), 1848, 1849
 NAACP rivalry, 1939, 1943
 National Negro Congress, 1961
 National Negro Labor Council, 1962–1963
 New York City, 2006
 Parsons, Lucy, 2105
 Patterson, William, 2112–2113
 Robeson, Paul, 2348
 Rustin, Bayard, 2374, 2375
 Thompson, Louise, 2653
 Wilkerson, Doxey Alphonso, 2834
 Wright (Richard), 2895, 2896
 Yergan, Max, 2905
 see also Blacklisting; House Committee on Un-American Activities
Community Design Centers, 178
Community Development Corporations, 1313
Community Organization for Urban Politics, 1998
Community Reinvestment Act (1977), 1312
Competitor, The (magazine), 2733
Complementarity (African social organization), 47
Compound (extended family housing), 930
Comprehensive Anti-Apartheid Act of 1986, 153, 2355
Compromise of 1850, **628**, 1071, 1767, 2204, 2696
Compromise of 1877, **629**, 2206
Compton, Arthur Holly, 2402

neoconservative movement, 1386, 1388–1389
 Republican identification, 1388
 Thomas, Clarence, 2648–2649
Consolidated American Baptist Convention, 256
Consolidated Edison Electric Company, 1196
Consolidated Lasting Machine Company, 1719
Consolidated National Equal Rights League and Race Congress, 1443
Constable, John, 2080
Constant, Jean-Joseph Benjamin, 2604
Constellation, USS (ship), 2744
Constitution, U.S.
 commerce clause, 557
 secession issue, 2416
 slavery issue, 2469–2471
 see also Supreme Court, U.S.; *specific amendments*
Constitutional Convention of 1787, 1071, 2462–2463, 2469, 2484
Constitution Hall (Washington, D.C.), 133, 1244
Constitution League, 461
Consumer Product Safety Commission, 2048
Consumers, black. *See under* Economics
"Consumptive, The" (Hughes), 910
Contagious diseases. *See* Diseases and epidemics; *specific diseases*
Content of Our Character, The (Steele), 1388, 1929
Continental Feature Syndicate, 624
Contraband camps, *573*, 2277
 emancipation celebrations, 887
 Jacobs, Harriet Ann, 1422
 life in, 891, 892
 recruitment, 572
 schools, 849
Contraband Relief Association, 1529
Contraception. *See* Birth control
Contribution of the Negro to American Democracy (mural), 2820
Convention movement. *See* Antebellum convention movement
Convention of the Negroes of Indian Territory, 2044
Convention of the People of Color, 263
Converse, Frederick, 2215
Convict labor. *See* Prison labor
Conway, H. J., 2698
Conwell, Kathleen, **651–652**
Conwill, Houston, **652–653**, 1882, 2092
Conyers, John, F. Jr., **653–654**, 758, 1777, 2103, *2177*, 2320
Cook, Charles Chaveau, 124, 2629
Cook, Charles "Cookie," **654**, 659
Cook, Glen, 166
Cook, John F., 2787
Cook, Mercer, **654–655**, 1320, 1830
Cook, Ralph, 124
Cook, Samuel Du Bois, 2181–2182
Cook, Thomas, 68
Cook, Walter, 270

Cook, Will Marion, 630, **655–656**, 811, 1830, 1917, 2257, 2259, 2638
Cooke, Henry and Jay, 1063
Cooke, Janet, 1508
Cooke, Lloyd M., **656**
Cooke, Samuel "Sam," **656**, 1123, 1125, 2328
Cooking. *See* Food
Cooley High (film), 2398
Coolidge, Calvin, 2712
 Garvey (Marcus) pardon, 943
 immigration policies, 917
 presidency, 2208
 racial policies, 2318
Cool jazz, 1435, 1836, 1896
"Coonering," 955
Cooney, Gerry, 2031, 2546
"Coon songs," 196, 1288, 1894, 2286;
 see also Ragtime
Cooper, Anna Julia Haywood, **656–658**, 681, 2253, 2788–2789
Cooper, Bert, 1295
Cooper, Charles (Arizona settler), 186
Cooper, Charles "Chuck," 283, **658**
Cooper, Chauncey Ira
Cooper, Emmett E., 1790, 2191
Cooper, George C., 2740
Cooper, George W., 2348
Cooper, Jack L., 2254
Cooper, Lulu, 83
Cooper, Marjorie, 165
Cooper, Ralph, 165, 166, *658*, *2608*
Cooper, William, 406
Cooperative College Development Program, 2112, 2132, 2138
Coopers and Lybrand, 2048
Cooper v. Aaron (1958), 558, 860, 1924
Coordinating Council for Negro Performers, 1600
Copasetics, The, 610, 654, **659–660**, 2349
Copeland, John A., Jr., 1449
Copperheads, 744, 1342, 2013, 2041
Coppin, Frances "Fanny" Jackson, **660**
Coppin, Levi Jenkins, 65, **660–661**
Corbett, James J. "Jim," 413, 414, 415, 1417–1418
Corbin, Joseph, 190
Corcoran Gallery of Art (Washington, D.C.), 992
Corder, Frederick, 1441
Cordero, Roque, 632
CORE. *See* Congress of Racial Equality
Corea, Chick, 723
CORE-lator (publication), 639, 640
Coretta Scott King Book Award, 536
Corey, Robert B., 426
Corley, Simeon, 2396
Cornbread, 62, 1009
Cornell, Joseph, 2377
Cornell University, 399
Cornely, Paul Bertau, **661**, 1258–1259, 1749
Cornish, James, 2839
Cornish, Samuel Eli, **661–662**, 1112, 1494, 2001, 2002, 2371, 2797
 convention movement, 138–139

Freedom's Journal, 1065–1066
Cornrows (hairstyle), 1167
Cornwallis, Charles, 1665
Cornwell, Anita, 1604
Coromantees (Gold Coast slaves), 56
Corps D'Afrique, 164, 1996, 2150
Correll, Charles, 128, 2253, 2616
Corrigan v. *Buckley* (1926), 556, 1309
Corrin, Malcolm L., 1391
Corrothers, James D., 761, 1629
Cortés, Hernando, 115
Cortez, Jayne, *326*, 607, 608, **662–663**
Cortor, Eldzier, **663**
Corwin (U.S. Revenue Cutter), 1261
Cosby, Camille, 665
Cosby, William Henry, Jr., "Bill," 619–620, **663–665**, 906, 1639
 commercial endorsements, 24
 philanthropy, 619, 2140, 2543
 publicist, 2239
 Ribbs (William Theodore, Jr.) sponsorship, 2331
 television work, 2619–2620, 2622
Cosby Show, The (television program), 99, 620, 664, 2193, 2622, 2846
Cosmetics. *See* Hair and beauty culture
Cosmograms, 652, *653*
Cosmopolitan Life Insurance Company, 165
Costin, Louise Parke, 2787
Cotten, Elizabeth, **665**
Cotter, Joseph, 1210
Cottingham, Robert, 949
Cotton, 45, 84, 191, 1873, 2463, 2529
Cotton Bowl, 1012
Cotton Club, **665–666**, 712, 883, 1301, 1434, 2636, 2640
 Calloway ("Cab") orchestra, 487, 488
 Four Step Brothers, 1034
 Mabley, Jackie "Moms," 1675
 Nicholas Brothers, 2018
 tap dancers, 2608
 Tizol, Juan, 2661
Cotton Club Boys, 210
Cotton Comes to Harlem (film), 724, 1036
Cotton States League, 277
Cottrell, Charles, 1236
Cottrell, Louis, Sr., 776
Coubertin, Pierre de, 2050
Coughlin, Father, 756
Council, Julian, 30
Council Against Poverty, 1643
Council for Racial/Ethnic Minorities, 2707
Council for United Civil Rights Leadership, 2915
Councill, William Hooper, 86, 647, **667–668**, 744
Council of Federated Organizations, **667**, 2585
 Chaney, James Earl, 513, 515
 Freedom Summer, 1066–1068
 Moses, Robert Parris, 1862–1863
Council on African Affairs, **666–667**, 809, 1023, 1331, 2097, 2905
Council on Minority Planning and Strategy, 934

Cumbaya (newsletter), 2037
Cumbo, Marion, 1979, 1980
Cummings, Blondell, **707**
cummings, e. e., 1204, 1205, 1272
Cummings, Harry Smythe, 243, 1708, 2168
Cumming v. School Board of Richmond County, Ga. (1899), 555, 855
Cunard, Nancy, 1216
Cuney, Norris Wright, **707–708**, 2635
Cuney-Hare, Maude, 1385
Cunningham, Arthur P., 632
Cunningham, George, 1323
Cunningham, Merce, 787
Cunningham, Randall, 1019
Curley, James, 110
Curley, Michael, 1713
Current, Goster B., 1532, 1945
Currin, Green, 2045
Curry, Jerry R., 30
Curry, John W., 2190
Curtin, Philip, 2472, 2477
Curtis, Austin Maurice, **708**, 1064
Curtis, Benjamin Robbins, 801
Curtis, David, 1235
Curtis (comic strip), 625
Curtis Knight and the Squires, 1268
Curtiss-Wright Aeronautical School, 28
Cushing, Richard, 2172
Cushing, William, 1128, 1712
Cushman, Charlotte, 1608
Custer Expedition (1874), 2533
Custom Craft Studios, 2412, 2413
Cuthbert, Eccles, 2766
Cuties (comic strip), 624
Cuvier, Georges, 2400
Cycling, 2554

D

D & G Bakery, 1282
Dabh, Halim El-, 632
Dabney, Abner, 122
Dabney, Virginius, 1264
Dabney, Wendell Phillips, 547
Daddy Grace. *See* Grace, Charles Emmanuel "Sweet Daddy"
Daddy Was a Numbers Runner (Meriwether), 1220, 1759
Dafora, Asadata, 330, **709**, 1846, 2362
Dago, Leroy R., 2163
Daguerre, Louis Jacques Mandé, 2142
Daguerreotypes, 235, 2080
Dahomean, The (Yerby), 2904
Dahomey, 56
Dailey, Ulysses Grant, **709–710**, 2594
Dailey Hospital and Sanitarium (Chicago), 710
Daimler-Benz, 2317
Dakar, Senegal, 702, 773, 816, 1109, 1142, 1328, 1618
Dakota Territory, 2533
Dalby, David, 61
Daley, Phillis, 2036
Daley, Richard J., 727, 1545, 1762, 2536
Dalh-Wolfe, Louise, 845
Daly, E. L., 2387

Daly, Marie M., 524, **710**, 2406
Daly, Mary, 1614
Damas, Leon-Gontran, *326*
D'Amato, Cus, 2692, 2693
Dameron, Tadley Ewing "Tadd," **710–711**, 722
Dana, Charles A., 2554–2555
Dana, Richard Henry, 476–477
Dana Reed Literary Prize, 1531
Dance. *See* Ballet; Breakdancing; Social dance; Tap dance; Theatrical dance; *specific dance companies, dancers, and dance names*
DanceAfrica (festival), 719
Dancemobile, 304, 2185
Dance Players, 1799
Dancer, Earl, 1144
Dances and Drums of Africa (N.Y.C.), 1846, 1847
Dance Theater of Harlem, 236, *240*, **711–712**
 Black Arts Movement link, 330
 founding, 1831
 Johnson, Virginia Alma Fairfax, 1469
 legacy, 239, 241
 Tomlinson, Mel, 2664
Dandridge, Dorothy, **712–713**, 966
Dandridge, Ray, 277
Dandridge, Ruby, 712
Dandridge, Vivian, 712
Danforth, John, 2648
Daniel, P. V., 1075
Daniels, H. B., 187
Daniels, Jerry, 1364
Daniels, John, 910
Daniels, Josephus, 2791
Daniels, Ron, 2179
Daniels, Walter T., 895
Daniels, Willie L., 1394
Danner, Margaret Essie, **713**
Dante, Madame, 2770
DAR. *See* Daughters of the American Revolution
Darby, Dorothy, 29
Darden, Christine, 31, 896
Darden, Colgate W., Jr., 2038, 2039
Dark Laughter (Anderson), 1204–1205
Dark Princess (Du Bois), 1212
Dark Tower (Walker salon), 1211, 2760
Darktown Follies (musical), 2343, 2607, 2638
Darktown Follies, The (film), 2292
Darrow, Clarence, 756, 1939
Dart, Isom, 186, 2359, 2899
Darul Islam movement, 1400
Darwin, Charles, 43, 916, 2252, 2400
Dash, Julie, **713–714**, 969, 1157
Dash, Sarah, 1563
Daughaday, George, 2311
Daugherty, Harry, 227
Daugherty, Romeo, 962
Daughter of the Congo (film), 1774
Daughters (Marshall), 1701
Daughters of Bilitis, 1603
Daughters of the American Revolution, 133, 2193–2194

Daughters of the Dust (film), 713–714, 1157
Daughtry, Herbert, 2125
Davenport, Charles B., 916, 2252–2253
Davenport, Charles "Cow-Cow," 800, 2494
Davenport-Richards, Scott, *798*
Dave (slave potter), 989
David (slave leader), 1971
David, Hal, 2777
Davidoff, Paul, 178
Davidson, Olivia America, **714**, 2688, 2778
Davidson, Shelby James, **714–715**
David Walker's Appeal, in Four Articles (Walker), 1627
Davies, Samuel, 847, 2199, 2311, 2551
Davies-Hinton test, 1283
Davis, Algenita Scott, 1590
Davis, Allison, 141, 146–147, 456
Davis, Angela Yvonne, 628, **715–716**, 724, 1925
 feminist criticism, 683
 political hairstyle, 1167
 Republic of New Africa support, 2320
 Soledad brothers, 1405
 supporters, *486*, 2653
Davis, Anthony, **716**, 2057–2058, 2405
Davis, Arthur P., 436, 457, 972, 2096–2097, 2292
Davis, Benjamin Jefferson, Jr., *626*, 627, **716–717**, 1022, 1271, 1588, 1961, 2006
Davis, Benjamin Oliver, Jr., 29, 30, **717–718**, 1791, 2886
Davis, Benjamin O., Sr., 717, **718–719**, 1789, 1791, *1792*, 2141, 2728, 2824, 2884
Davis, Bill, *1490*
Davis, Blind Gary, 387
Davis, Bruce, 949
Davis, Charles Rudolph "Chuck," **719**, 2639
Davis, Charles T., 694, 716
Davis, Christopher, 716
Davis, C. P., 1646
Davis, Daniel Webster, 761, 811
Davis, David Brion, 645, 2564
Davis, Dominique, 1161
Davis, Dorothy, 2748
Davis, Eddie "Lockjaw," 281
Davis, Edmund J., 707
Davis, Ellabelle, 2056
Davis, Ernie, 1014, 2557
Davis, Frank Marshall, 1237
Davis, Jeff (Arkansas governor), 191
Davis, Jefferson, 1188, 1620, 2320
Davis, John (Virginia slave), 1071
Davis, John (weightlifter), 2051
Davis, John Henry, **720**
Davis, John Preston, **720**, 1136, 1505, 1940, 1960–1961
Davis, John Warren (educator), 207, **721**
Davis, Joseph E., 900, 1393, 1840, 2109
Davis, Leon, 1640, 1641

transracial acceptance of, 68, 1199–2300
women evangelists, 2303
Evangelical United Brethren Church, 1764
Evans, Bill, 722
Evans, Clay, 1406, 2059
Evans, Dwight, 2123
Evans, Ellis, 2920
Evans, Fred "Ahmad" (black militant), 598
Evans, Fred (swimmer), 2599
Evans, Gil, 722, 1435
Evans, Henry, 1815–1816
Evans, Herschel, 280
Evans, Hiram Wesley, 1557
Evans, Joseph H. B., 2366
Evans, Lee, 2668
Evans, Mari E., **917–918**
Evans, Minnie Jones, **919**, 2088
Evans, Walker, 1267
Evans, Walter O., 202
Evans, Wilson Bruce, 2041
Evans-Pritchard, E. E., 146
Evanti, Lillian, 727
Evening Light Saints, 2124
Evers, James Charles, **919–920**, *2178*
Evers, Medgar Wylie, 919, **920**, 1332, 1821, 1947, 1948
Evers, Myrlie, 1949, 1950
Evers, O. Z., 1755
Evert, Chris, 1089
Everything and Nothing (Dandridge), 713
Ewing, Patrick, 286, 2051
Exile, The (film), 1774
Exile's Return (Cowley), 1204
Existentialism, 2896
Exodusters, 769, **920–922**
black towns settlement, 370
Colorado settlement, 613
Kansas City, Mo., 1522
Kansas migration, 1520
legislation, 464
Louisiana migration, 1657
migration size, 1781
Missouri impact, 1826, 2380
Nebraska, 1973
Singleton (Benjamin "Pap") leadership, 2440–2441, 2805
Expatriates, **922–924**
artists, 2089
Baldwin, James, 233
Canada, 494
Clarke, Kenneth Spearman "Kenny," 582
Harrington, Oliver Wendell "Ollie," 1225
Himes, Chester, 1279
Lewis, Edmonia, 1608
Logan, Rayford Whittingham, 1644
Slyde, Jimmy, 2489
Smith, Ada Beatrice Queen Victoria Louise Virginia, 2491
Wright, Richard, 2896
Experimental Band, 14
Exploration (Lawrence), 1882
Explorers Club, 1271

Extended family, 929–930, 931
Extinguisher, Extinguished...or David M. Reese, M.D. "Used Up" (Ruggles), 2371
Eyes on the Prize (television documentary), 396
EzalDeen, Muhammad, 1399
Ezana, king of Aksum, 161
Ezion Methodist Episcopal Church, 77

F

Fabricius, Jacob, 1667
Factors (slave agents), 2472
Faduma, Orishatukeh, 1354, 2096
Fagan, Garth, **925**
Fagen, David, 2141–2142
Fahy, Charles T., 1553
Fair Employment Practices Committee (FEPC), 745, 763, 839, **926–927**, 1524, 1591, 1648, 2913
Alabama cases, 87
California, 486
creation, 441, 2885
Houston, Charles Hamilton, 1314
Maryland, 1708
Minnesota, 1807, 1808
Mitchell, Clarence Maurice, Jr., 1832
National Council of Negro Women role, 1958
scientific job opportunities, 524
Fairfax, Alfred, 1520
Fairfax, Frank, 1108
Fairfield Four, 1122
Fair Housing Act of 1968, 1311–1312
Fair Labor Standards Act of 1938, 1139–1140
Fair Play for Cuba, 1219
Fair Play League, 324
Fais-do-do, 2920
Faison, George, 99, **927–928**
Fakir, Abdul "Duke," 1036
Falana, Lola, 24
Falk, Leslie A., 1749
Fall, Albert B., 980
Falls, Mildred, 1412
Fame (film and television program), 99
Family
African roots. *See* Family: African roots *below*
average size, 3021
centrality of, 2335
female-headed, 584–585
Frazier, Edward Franklin, 1052–1053
income surveys, 585
median net worth, 345
Moynihan Report, 1875–1876, 2519, 2717, 2798
post-Emancipation community, 2278
poverty victims, 582
slave, 2419–2420, 2458–2460
stereotypes, 2233
unmarried births, table of, 2996
urbanization effects, 2717
Family: African roots, 47–48, **928–931**
historiography, 1285
Family of Man (exhibition), 730

Family Pictures (Weems), 2798
Family planning. *See* Birth control
Famous Blue Jay Singers, 1125
Famous Flames, 448, 449
Fannie Mae. *See* Federal National Mortgage Association
Fanon, Frantz, 794–795, 1384, 2234, 2717, 2719, 2897
Fantasy. *See* Science fiction
FAP. *See* Federal Art Projects
Fard, Wallace D., **932**, 935, 1400, 2306
Muhammad (Elijah) relationship, 1876–1877
Nation of Islam, 1966
Farley, Reynolds, 584
Farmer, Art, 2912
Farmer, James, **933–934**, 1365, 2263
CORE directorship, 566, 638–639, 640, 641, 642, 1658, 1947
Freedom Rides, 640, 641
Harlem riots, 1219
Farmers' Alliance, 86
Farmers' Improvement Society, 2273
Farming. *See* Agriculture
Farm Security Administration, 2101, 2145
Farrakhan, Louis Abdul, **934–935**, 1401
Jackson (Jesse) relationship, 935, 1406–1407
NAACP policies toward, 1950
Nation of Islam, 1967, 1969
Farris, Milton, 1413
Farrow, Lucy, 2422
Farrow, William McKnight, **936**
Fat Albert and the Cosby Kids (television program), 664
Fate (Ai), 81
Father Divine, **936–937**, 938, 1191–1192, 2139, 2305, 2547
entrepreneurship encouragement, 340, *341*
followers, 415, 2716
Faubus, Orval, 192, 193, 291, 859, 1946
Faulkner, William (author), 2566
Faulkner, William (Detroit suspect), 755
Faulks, Joe, 1570
Fauntroy, Walter, 2791
Fauset, Arthur Huff, 526, **937–938**, 1377, 1513, 2716
anthropology studies, 142
Harlem Renaissance, 1216
Fauset, Crystal Dreda Bird, 937, **938–939**, 2136
Fauset, Jessie Redmon, 937, **939–940**, *1200*, 1203, 1623, 1630–1631
on experience of passing, 2107
Harlem Renaissance, 1206, 1210, 1211, 1212, 1213, 1216
Favorite Magazine, 1455–1456
Favors, Malachi, 202, 207, 208
Fax, Elton C., 624, **940**, 2087–2088, *2879*
Fax, Mark, 777
FBI. *See* Federal Bureau of Investigation
Featherstone, Ralph, *363*
FEDCO Foods Corporation, 906, 1639

abolition movement, 10–11, 11–12, 1088
 American Anti-Slavery Society, 108, 113, 2311
 attack on, 151
 convention movement support, 139
 Douglass (Frederick) *Narrative* introduction, 2451
 on emancipation, 2281
 Liberator, The, 1615–1616
 supporters, 1178
 on U.S. Constitution, 2469–2470
 Walker (David) *Appeal,* 2762
Garrison, Zina, **1089,** *2631*
Garrison Literary and Benevolent Association, 2371
Garvey, Amy Ashwood, **1089–1090**
Garvey, Amy Euphemia Jacques, 1089, **1090,** 1092
Garvey, Marcus Mosiah, 778, **1090–1092**
 birth control condemnation, 322
 black entrepreneurship development, 338
 Du Bois (W. E. B.) criticism of, 808
 FBI investigation, 943
 Garvey, Amy Ashwood, 1089, 1090
 Harlem influence, 1191, 2262
 influence, 1353–1354
 influence on Rastafarians, 2270
 McGuire (George Alexander) relationship, 1736
 NAACP criticism, 1937–1938
 opposition, 227, 432, 1760
 oratory, 2065
 popularization of African independence, 2096
 religious appeal of, 2305
 skin color issue, 2448
 social conservatism, 648
 support for, 1206–1207
 VanDerZee, James Augustus, 2732
 Walrond (Eric Derwent) friendship, 2772
 Washington (Booker T.) admiration for, 16
Garvey and Garveyism (Garvey), 1090
Garvey movement. *See* Universal Negro Improvement Association
Garvin, Charles, 2042
Gary, Indiana, 1234, 1358, 1359, 1723
Gary convention (1972), 653, 767, **1093,** 1359, 2426
 Congressional Black Caucus sponsorship, 636
Gaskell, Sonia, 2863
Gaston, Arthur George, 321, 903
Gaston, Cito, 279, 495
Gates, Daryl, 1650
Gates, George A., 974
Gates, Henry Louis, Jr., 390, 1626, 1637, 1976, 2860
 feminist criticism, 685
 literary criticism, 695–696
Gates, Lee A., 1982
Gathering of Old Men, A (Gaines), 1079, 1084, 1085

Gather Together in My Name (Angelou), 137
Gathings, Joseph G., 752
Gaudin, Juliette, 2364, 2442
Gaul, Willia, 2865
Gault, Prentiss, 1014, 2558
Gay, Frederick P., 971
Gay, Marvin, Sr., 1093
Gaye, Marvin, **1093–1094,** 1871, 1872, 2511
Gayle, William A., 1842
Gayle v. *Browder* (1956), 1925, 1947
Gay Liberation Front, 1096
Gay men, **1094–1098**
 Baldwin (James) writings, 233, 234, 1632
 Cullen, Countee, 705
 Dill, Augustus Granville, 767
 Dixon, Melvin, 773
 drama, 798
 Jones, Bill T., 1475
 liberation movement, 1603
 literary magazines, 1624
 Riggs, Marlon Troy, 2340
 Rustin, Bayard, 2375
 San Francisco community, 2389
 Walker (A'Lelia) salon, 2760
Gay women. *See* Lesbians
GEB. *See* General Education Board
Geiss, Imanuel, 2093
Gellert, Lawrence, 1005
Gender studies. *See* Criticism, feminist
Genealogy studies, 1173
General Education Board
 black hospitals, 1306
 fellowships, 524, 1516
 medical school funding, 1751
 philanthropy, 218, 855, 1184, 2036, 2138, 2709
General Electric, 839, 1580, 1853
General Federation of Women's Clubs, 1986, 2370
General Motors, 1776, 2591
Generations (television program), 2621
Genetics. *See* Eugenics
Geneva Disarmament Conference, 1540
Genitalia, male, 2421
Genius of Universal Emancipation (newspaper), 400, **1098**
Gennaro, Peter, 1606
Genovese, Eugene D., 1073, 1077, 1285, 2455
Genthe, Arnold, 2221
Gentle Ben (television program), 2620
Gentry, Herbert, **1098–1099,** 2089
George, Claybourne, 597
George, David, 255, **1099–1100,** 1617, 2746
George, Henry, 1030
George, Nelson, 2287, 2290, 2291
George, Zelma Watson, **1100**
Georgetown University, 286
 basketball program, 2229
 Healy, Patrick, 1260
 Thompson, John Robert, Jr., 2652–2653

George Washington Carver Foundation, 506
George Washington Williams (Franklin), 1040
Georgia, **1101–1103**
 agriculture, 828
 Albany Movement, 314, 1544, 2428, 2536, 2584
 American Revolution, 1665
 antiliteracy laws, 846
 black codes, 348
 Bond, Julian, 396
 education, 593
 Federal Art Projects, 942
 Gullah, 148, 1154
 housing discrimination, 1309
 Jackson, Maynard Holbrook, Jr., 1413–1414
 Ku Klux Klan, 2283
 maroonage, 1697
 migration distribution points, 1782
 NAACP, 1946
 prison labor, 2225
 Reconstruction, 2278, 2279–2280
 secession, 2204, 2416
 slave quarters, 184
 slavery, 1101, 2456, 2462
 suffrage, 2589
 urban black population, 2715
 White Citizens' Councils, 2826
 Young, Andrew, 2906
 see also Atlanta *headings*
Georgia Equal Rights League, 1542, 2681
"Georgia on My Mind" (song), 516, 517
Georgia Pacific Railroad, 211
Gerard, Gil, 1098
Gergen, David, 2214
Gerima, Haile, 968
Gershwin, George, 1444, 1618, 2566, 2750
Gesell, Gerhard A., 1795, 2740
Gesell Committee, 2740, 2741, 2743
Gethsemane Baptist Church (Cleveland), 2864
Getting Religion (Motley), *1866*
Gettysburg Address, 732
Getz, Stan, 2432, 2912
Ghana
 ancient, 52
 court traditions, 49–50
 Feelings, Thomas, 948
 Hunton, William Alphaeus, Jr., 1331
 Hutson, Jean Blackwell, 1335
 immigrants, 1347
 Mayfield, Julian H., 1721
 oil industry, 2434
 Williams, Franklin Hall, 2842
Ghent, Henri, 136, 349
Ghetto. *See* Urbanization; Urban riots and rebellions
Ghost (film), 621
Gibbons, James, 2698
Gibbs, Ernest, Jr., 623
Gibbs, James L., 142
Gibbs, Jonathan C., 983

Jackson, Mahalia, 1411–1412
Johnson, "Blind" Willie, 1451–1452
Martin, Roberta Winston, 1705
Martin, Sallie, 1705–1706
Pentecostal, 2127
popularity, 2305, 2308
quartets, 1125
Smith, Willie Mae Ford, 2501–2502
Tharpe, "Sister" Rosetta, 2636–2637
Tindley, Charles Albert, 2660–2661
Walker (Wyatt Tee) expertise, 2769
Williams, Marion, 2847–2848
Wings Over Jordan, 2864–2865
Gospel Music Workshop of America, 595
Gospel Pearls, 1122, 2661
Gospel quartets, 1122, **1125**, 1143, 1899
Brown, James Joe, Jr., 448
Smith, Willie Mae Ford, 2501
Gossett, Louis, Jr., **1126**
Go Tell It on the Mountain (Baldwin), 233–234, 356, 1632
Gottlieb, Jay, 870
Gould, Stephen Jay, 130
Go Up for Glory (Russell), 2372–2373
Government National Mortgage Association, 1312
Govern, S. K., 270
Grace, Charles Emmanuel "Sweet Daddy," 938, **1126–1128**, 1352, 2305
Grace, princess of Monaco, 232
"Grace is Sufficient" (gospel song), 594
Graceland (album) tour, 1682
Gradual emancipation statutes, **1128**
abolition vs., 7
Connecticut, 643
manumission societies' support, 1686
New England, 1057
New York, 2012
northern states, 2171, 2172
Pennsylvania, 2119, 2462
Washington (George) support, 2201
Graetz, Robert, 1843, 1844
Graf, Steffi, 1089
Gragg, Rosa L., *2209*
Graham, Billy (comic book artist), 623
Graham, Billy (evangelist), 2793
Graham, George, 212
Graham, Henry, 124, 2630
Graham, Martha, 1282, 1738
Grambling State University, 1015, 1658, 2350
Grammy Awards
disco music, 2290
gospel music, 1123, 1124
winners, 2984–2993
Grand Canyon (film), 970
Grandfather clause, **1129**, 2589
Arkansas, 191
Guinn v. *United States,* 1588, 1938
Louisiana, 1657
NAACP challenge, 1588, 2590
Oklahoma, 2046
Supreme Court decision, 555, 563
Grandmaster Flash, 1904, 2267, 2268, 2291

Grandmaster Flowers, 2267
Grand National, 2409
Grand Ole Opry, 228, 2219
Grand Parade, The (Mayfield), 1721
Grand United Order of Galilean Fishermen, 1044, 1045
Grand United Order of Odd Fellows, 1044
Grand United Order of True Reformers, 1045
Grand Wizard Theodore, 2267
Grange, Red, 2909
Granger, Gideon, 2190
Granger, Lester Blackwell, **1130–1131**, 1478, 1960, 1964
Grant, Annie Lee, 1602
Grant, Carolyn, 2022
Grant, Charlie, 271
Grant, Frank, 271
Grant, Henry L., 1953
Grant, Jacquelyn, 67, 1614, 2645
Grant, Milton Earl, 903
Grant, Ulysses S.
appointees, 289, 1588
Davis Bend directive, 2278
Mexican War, 1766
presidency, 2205–2206
presidential campaigns, 2152
Reconstruction, 2281, 2283–2284
response to Ku Klux Klan, 1556
Grant Memorial Association, 1145
Granville, Evelyn Boyd, **1131**
Granz, Norman, 882, 977, 1239, 1480, 2911
Graphic arts, **1131–1133**
Blackburn, Robert Hamilton, 332
Catlett, Elizabeth, 507–508
Crite, Allan Rohan, 681
Farrow, William McKnight, 936
Federal Art Projects, 941
Jennings, Wilmer Angier, 1442–1443
Lindsey, Richard William, 1620
Lion, Jules, 1620
Loving, Alvin, 1663
Thrash, Dox, 2656–2657
Wells, James Lesesne, 2084–2085, 2799–2800
Wilson, John Woodrow, 2861
Woodruff, Hale Aspacio, 2873
Gravely, Samuel L., Jr., 1237
Graves, Earl Gilbert, Jr., 905–906, **1133–1134**, 1506, *2181*
Graves, Junius C., 900
Gray, Conny, 2540
Gray, Edward B., 1010, 1011
Gray, Ellis, 102
Gray, Fred D., 1842, 1844
Gray, Pete, 276
Gray, Robert, 2068
Gray, Thomas Ruffin, 1970
Gray, Victoria, *1823*
Gray, Wardell, 1117, 2912
Gray, William Herbert, III, **1134**, 2020, 2123, *2709*, 2710
Gray Areas project, 2140
Greased Lightning (film), 2409

Great Awakenings, 847, 912, 1370, 1667, 1762
Congregationalism, 2704
evangelicalism, 67–68
missionary movement development, 1815
New York State, 2013
slave embrace of Christianity, 2299–2300, 2452
Great Blacks in Wax Museum, 244, 1920
Great Britain
American Revolution, 120–123
antislavery campaigns, 7–8
boxing, 413–414
Canadian territory, 491
colonial-era free blacks, 1060
as emancipation symbol, 953
Florida, 981–982
Haitian Revolution, 1170, 1171
Hawaii, 1236
slave abolition, 2480–2481
slavery views, 2455–2456
slave trade, 2472, 2474–2475, 2479, 2484
slave trade abolition, 2483, 2484, 2485
use of American Indians to hunt escaped slaves, 115
War of 1812, 2773–2774
Great Cities School Improvement project, 2140
Great Depression and the New Deal, **1134–1141**
arts patronage, 940–942, 1119, 1139, 1582, 1880, 2085–2088
Birmingham, Ala., 321
black baseball impact, 273
black business impact, 339–340
Black Cabinet, 312, 2365–2366
black economic impact, 832–835, 1285
black education milestone, 857
black employment as postal workers, 2191
California, 2387–2388
Cleveland, Ohio, 597–598
Davis, John Preston, 720
Democratic party coalition. *See under* Democratic party
Detroit, Mich., 756–757
drama, 791–793
electoral coalition, 757
entrepreneurs, 902–903
Harlem, 1192
health legislation, 1256
Indiana, 1358
insurance company losses, 1367–1368
Kansas City, Mo., 1524
Kentucky, 1535
labor unions, 1564
Maryland, 1708
Missouri, 1827
NAACP during, 1939–1941
National Urban League role, 1963
newspaper support for, 2913
New York City, 2006
North Carolina, 2025
Ohio, 2042

slavery, 1818–1819, 2463, 2470
Student Nonviolent Coordinating
 Committee campaign, 2584–2585
suffrage, 569, 2589
Thirteenth Amendment, 2646
Till, Emmett (Louis), 2660
urban black population, 2715
White Citizens' Councils, 2825, 2826,
 2827
see also Mound Bayou, Mississippi
Mississippi Delta
 agriculture, 1820
 blues style, 387
 Mound Bayou, Miss., 1873
Mississippi Flood Control project, 1940
Mississippi Freedom Democratic party,
 746, 1821, **1822–1824**, 2169, 2180,
 2585
 Baker, Ella J., 230
 founding, 375
 Freedom Summer, 1066
 Hamer, Fannie Lou, 1177
 Moses, Robert Parris, 1863
Mississippi Plan (white rule), 1820
Mississippi University for Women v. *Hogan*
 (1982), 37–38
Mississippi Valley Historical Review, 2245
Missouri, **1824–1829**
 Clay, William Lacy, 591
 Exodusters, 370
 secession issue, 2416
 statehood compromise, 1829–1830
 see also Kansas City, Missouri; St.
 Louis, Missouri
Missourians (big band), 487, 666
Missouri Compromise, **1829–1830,**
 2202, 2471
 Dred Scott v. *Sandford,* 800, 801
Missouri Equal Rights League, 1825–
 1826
Missouri ex rel Gaines v. *Canada* (1938),
 556, 1314, 1524, 1923, 1942
Mitchell, Abbie, 655, **1830**
Mitchell, Abner, 1077–1078
Mitchell, Arthur Adams, Jr., 239, 711,
 745, 751, 1469, **1830–1831**
Mitchell, Arthur Wergs, 1586–1587,
 1831–1832
Mitchell, Carl, 711
Mitchell, Charlene, 628
Mitchell, Charles (Boston politician),
 2168
Mitchell, Charles Lewis, 407
Mitchell, Clarence Maurice, Jr., **1832–**
 1834, 2194
 Leadership Conference on Civil
 Rights, 1591, 1592
 NAACP, 1942, 1943, 1945
Mitchell, George S., 509
Mitchell, Henry, 2549, 2550
Mitchell, H. L., 2538
Mitchell, Jim "the black panther," 2891
Mitchell, John (boycott organizer), 2337
Mitchell, John (Richmond politician),
 2168
Mitchell, John R., Jr., **1834,** 2179, 2748
Mitchell, Juanita Jackson, 243, **1835**

Mitchell, Loften, 120, **1835**
Mitchell, Mitch, 1269
Mitchell, Nellie Brown, 2056
Mitchell, Parren, 244, 1709
Mitchell, Roscoe, 202, 207, 208
Mitchell, William, 2766
Mitchell, Willie, 1143
Mitchell v. *United States* (1941), 1832
Mixed-raced ancestry. *See* Passing; Skin
 color
Mixon, Winfield Henri, 64
Mizelle, Ralph E., 394, 2191
Mo' Better Blues (film), 1597
Mobile, Alabama, 84–85, 87, 1841
Mobile Bay, Battle of (1864), 1788
Mobile v. *Bolden* (1980), 2753–2754
Mobilization for Youth, 1548
Mobilization to End the War in Viet-
 nam, 1540
Mobley, Eugenia L., 749
Modal jazz, 722
Modern jazz. *See* Free jazz
Modern Jazz Quartet, 582, 1417, **1836**
Modern Language Association, 693,
 1637
Modern Negro Art (Porter), 198
Modern records, 2287
Mod Squad (television program), 967
Mohammed (African Muslim slave), 76
Mohammed (prophet), 1514
Mohammed Ahmed Ibn Adulla, 1514
Molineaux, Algernon, 1836
Molineaux, Tom, 413, **1836,** 2339, 2554
Moments Without Proper Names (Parks),
 2102
Moms (one-woman show), 1113
Monaco, 232
Mondale, Walter, 747, 1406
Monday, Kenny, 2891
Monitors (baseball), 270
Monk, Thelonious Sphere, 722, **1837,**
 2838
Monogenists, 2252
Monplaisir, Sharon, 949
Monroe, Bill, 2556
Monroe, C. C., 1534
Monroe, Earl "the Pearl," 284, 1084
Monroe, George A "Alfred," **1837**
Monroe, James, 112, 2202, 2462
Monroe, Mary, *827*
Monroe, William, 755
Monroe, Winnie, *827*
Monroe, North Carolina, 2851–2852
Montana, **1838–1840**
 Ball (James Presley) photographs,
 235–236
 black migration, 2805
Monte, Irvin, **1397**
Monterey Pop Festival, 1269, 2293
Montes, Pedro, 125, 126
Montgomery, Benjamin, 900, 1393,
 2029
Montgomery, Bob, 1403
Montgomery, Isaiah Thornton, 372,
 373, 646, 900, 1820, **1840,** 1872,
 1873
Montgomery, John Weslie "Wes," **1841**

Montgomery, Joshua P. T., 1840
Montgomery, Louis, 1012
Montgomery, Olen, 2410
Montgomery, Richard B., 2867
Montgomery, William Thornton, 2029
Montgomery, Alabama
 civil rights movement, 565
 population, 3037
Montgomery, Ala., bus boycott, 565,
 1841–1843, 2716
 CORE role, 640
 King, Martin Luther, Jr., 1543
 Montgomery Improvement Associa-
 tion founding, 1843–1844
 newspaper coverage, 2368
 Parks, Rosa, 2103
 Robinson, Jo Ann Gibson, 2353
 Rustin, Bayard, 2375
 Southern Christian Leadership Con-
 ference role, 2535
*Montgomery Bus Boycott and the Women
 Who Started It, The* (Robinson),
 2354
Montgomery Improvement Association,
 1543, **1843–1844,** 2353
 Abernathy, Ralph David, 6
 bus boycott, 1841, 1842
 King, Coretta Scott, 1540
 Nixon, Edgar Daniel, 2021
 Parks, Rosa, 2103
 relationship with NAACP, 1947
Montgomery Ward, marketing study,
 19
Moody, Anne, 1634, **1844**
Moody, Robert, 1949–1950
Moon, Henry Lee, **1844–1845,** 1945,
 1949
Moon, Warren, 1019
Moon Illustrated Weekly, The (publica-
 tion), 808, 2075
Moons and Low Times (McClane), 1730
Moon walk (dance step), 430, 2349
Moore, Aaron, 2541
Moore, Archibald Lee "Archie," 415,
 1845
Moore, Audley "Queen Mother," **1845–**
 1846, 2316
Moore, Charles, 1276, **1846,** 1847
Moore, Dorothy Rudd, 632
Moore, Ella Thompson, 1846, **1847**
Moore, Fred R., 1031
Moore, George E., 68
Moore, Harry R. "Tim," 128, **1847**
Moore, Harry Tyson, 984, **1847–1848,**
 1945
Moore, J. L., 983
Moore, John Jamison, 2386
Moore, Lake, 371
Moore, Lenny, 1016
Moore, Richard Benjamin, 402, **1848–**
 1849, 1928
Moore, Samuel. *See* Sam and Dave
Moore, Undine Smith, 632, **1849–1850**
Moore, Walthall, 1827, 2381
Moore-Forrest, Marie, 1642
Moorehead, Guy, 1984
Moorer, Michael, 1295–1296

Nevada, 1981
New Deal legislation, 1136, 1137, 1138, 1139, 1140, 1141
New Mexico, 1992
New Orleans chapter, 1998
as Niagara Movement successor, 2018
North Carolina, 2851–2852
Oklahoma, 2046
opposition to Poor People's Campaign, 2187
protest against U.S. invasion of Haiti, 1023
Rachel controversy, 790
San Francisco chapter, 2387
South Carolina, 579, 2433
South Dakota chapters, 2533, 2534
Spingarn Medal, 1935, 2545–2546
sports discrimination campaign, 124
television depiction of blacks, 2617
Trotter (William Monroe) disdain for, 1498, 2673
Utah, 1855, 2729
Virginia, 1411, 2748
Waldron, John Milton, 2758
Washington, D.C., riot, 2791, 2792
Wells-Barnett (Ida Bell) view of, 2802
White, Walter Francis, 2823–2825
white leadership, 1934–1935
Wilkins, Roy Ottoway, 2835–2836
Wisconsin chapters, 2867
youth program, 1835
National Association for the Advancement of Colored People v. *Alabama ex rel. Patterson,* 1946
National Association for the Advancement of Colored People v. *Blossom* (1962), 2748
National Association for the Advancement of Colored People v. *Button,* 1946
National Association of Base Ball Players, 270
National Association of Black Journalists, 1158, 1509, 1571
National Association of Black Media Producers, 457
National Association of Black Owners of Broadcasting, 27, 2256
National Association of Broadcasters, 27, 2287
National Association of Chiropodists, 2163
National Association of College Women, 2489
National Association of Colored Graduate Nurses, 1040, 1678, 2035–2036, 2070, 2227, 2656
National Association of Colored Women, **1951–1953**, 1957, 2370, 2631, 2677
Bethune, Mary McLeon, 311
Brown, Hallie Quinn, 445
Burroughs, Nannie Helen, 479
formation, 376, 1986
Hunter, Jane Edna, 1329
skin color controversy, 2446
Walker, Maggie Lena, 2767
Washington, Margaret Murray, 2783

National Association of Colored Women's Clubs, 1953, 2601
National Association of Evangelicals, 1955–1956
National Association of Investment Companies, 1395
National Association of Kawiada Organizations, 1528
National Association of Market Developers, 2237
National Association of Negro Musicians, 726, 760, **1953–1954**
National Association of Professional Baseball Players, 270
National Association of Real Estate Boards, 1309–1310
National Association of Securities Professionals, 1395
National Association of Social Workers, 2519
National Association of Stock Car Automobile Racing, 1870, 2409
National Bankers Association, **1954**
National Baptist Convention, U.S.A., 256, 257, 258, 913, 1121–1122, **1954–1955**, 2304, 2305, 2612, 2846
Boyd, Henry Allen, 420
Boyd, Richard Henry, 421
Burroughs, Nannie Helen, 478
Jackson, Joseph Harrison, 1408–1409
Love, Emanuel King, 1661
Morris, Elias Camp, 1855, 1856
size, 2306
Women's Convention, 2303
National Bar Association, 94, 95, 763, 1396
National Basketball Association, 283, 893, 906, 915, 2373, 2730
National Basketball League, 1198, 2315
National Beauty Culturalists League, 1167
National Black Catholic Clergy Caucus, 2365
National Black Development Conference, 1026
National Black Economic Development Conference, 360
National Black Evangelical Association, 843, **1955–1957**
National Black Independent Political Party, 818
National Black Institute of Communication Through Theatre Arts, 2614
National Black Network, 22, 2256
National Black Nurses Association, 2036
National Black Pastors Conference, 844
National Black Political Assembly, 2179
National Black Political Convention of 1972. *See* Gary convention
National Black Presbyterian Caucus, 2200
National Black Republican Council, 2711
National Black Seminarians Association, 2365
National Black Sisters' Conference, 2365
National Black Theater, 2614

National Black Touring Circuit, 1548
National Black United Fund, 2140
National Board for Professional Teaching Standards, 871
National Board of Medical Examiners, 1616
National Bowling Association, 413
National Broadcasting Company, 1508, 2254, 2615, 2632
Amos 'n' Andy, 128
Cosby (Bill) purchase attempt, 664
National Center for Afro-American Artists, 200
National Christian Missionary Convention, 770
National Civil Liberties Bureau, 110
National Coalition of Black Lesbians and Gays, 1097
National Coalition of Blacks for Reparations in America, 2317
National Collegiate Athletic Association
basketball, 284, 285, 286, 287
Propositions 48 and 42, 1015, 1407, 2652–2653
National Colored Democratic Association, 744
National Commission on Excellence in Education, 868
National Committee for the Advancement of the Negro. *See* National Negro Committee
National Committee for the Employment of the Physically Handicapped, 817
National Committee of Black Churchmen, 2312–2313
National Committee to Defend Negro Leadership, 1022
National Conference of African-American Catholics, 2369
National Conference of Artists, 327–328
National Conference of Black Christians, 843, 844, 1613, 1614
National Conference of Black Churchmen, 2309, 2644
National Conference of Colored Men, 2627
National Conference on Black Power. *See* Black Power Conference of Newark
National Conference on Social Welfare, 2518
National Convention Movement, 118
National Convention of Churches of Christ, 769
National Convention of Colored Citizens, 2013
National Convention of Congregational Workers Among Colored People, 2226
National Convention of Gospel Choirs and Choruses, 261, 780, 1123, 1706, 2501
National Convention of the Disciples of Christ
National Council for a Permanent FEPC, 1591, 1833

Notes on the State of Virginia (Jefferson), 688, 2201
Nothing but a Man (film), 381, 773, 967, 1618
Nott, Josiah C., 2252
Not without Laughter (Hughes), 1214, 1324, 1631
No Way Out (film), 966
Noyes, William, 2515
NPA. *See* National People's Action; National Pharmaceutical Association
NRA. *See* National Recovery Administration
Nuba (African people), 48
Nubia, 155, 156, 157, 160
Nubian Islamic Hebrew Mission, 1512, 1513–1514
Nubin, Katie Bell, 2636
NUC. *See* National Urban Coalition
Nuer (African people), 49
Nugent, Bruce, 2081
Nugent, Pete, **2032**
Nugent, Richard Bruce, 1096, 1210, 1211, 1213, 1216
Nullification doctrine, 2203, 2531
Numbers games, **2032–2033**
 black entrepreneurial success, 340
 fictional account, 1721
 Greenlee, Gus, 273
Nunn, Bobby, 600
Nunn, William G., 1500, 1501, 2160
Nuns, first African-American, 242, 1279, 2038, 2364
Nuriddin, Jalaludin Mansur, 1578
Nursing, **2034–2036**
 discriminatory school policies, 1306
 education and affirmative action, 37–38
 graduates, *1258*
 Provident Hospital training, 2230
 schools, 1250
 World War I, 2883
 World War II, 2890
Nutter, Donald, 1839
Nutter, T. G., 2811
NWA (rappers), 2291
NWRO. *See* National Welfare Rights Organization
NYA. *See* National Youth Administration

O

Oakland, California. *See* San Francisco and Oakland, California
Oakland Tribune (newspaper), 1507, 1722, 2573–2574
OAU. *See* Organization of African Unity
OBAC Writers' Workshop, 328, **2037–2038**
 Jackson, Angela, 1404
 Rodgers, Carolyn, 2360
 Visual Arts Workshop, 78
Obadele, Gaidi, 2316, 2319
Obadele, Imari Abubakari, 2316, 2319, 2320

Oberlin College, 493, 759, 2040, 2705
 anti-slavrey collection, 399–400
Oberlin-Wellington rescue of 1858, 1073
Obie Awards, 1069
Oblate Sisters of Providence, 242, 1279, **2038**, 2364
O'Brien, George, 767
O'Brien, Jack, 1574
O'Brien, W. J., 1516
O'Bryant, John, 409
Occom, Samson, 2815, 2816
Occupations, statistical tables, 3000–3004
Ocean Hill-Brownsville School Board (N.Y.C.), 866
O'Connor, James A., 91
O'Connor, John, 2666
O'Connor, Sandra Day, 36, 37, 39
Octoroons, 1655
O'Day, Anita, 882
Odds Against Tomorrow (film), 301, 381
Odell Waller case, **2038–2039**
Odetta, **2039**
Ododo (Walker), 2764
Odontographic Society, 308
Odum, Howard, 1045
Oduyoye, Mercy Amba, 1614
O'Dwyer, William, 1481
Odyssey (Homer), 159
Office of Civilian Defense, 938
Office of Economic Opportunity, 1197, 2212
Office of Minority Business Enterprise. *See* Minority Business Development Agency
Office of Strategic Services, 470
Of Love and Dust (Gaines), 1084, 1085
Of National Characters (Hume), 2252
Ogawa, Florence Ai. *See* Ai
Ogden, John, 973
Ogden, Peter, 1044
Oglethorpe, James, 2528
O'Hara, James Edward, 1586, **2039–2040**
O. Henry Memorial Award, 2904
"Oh, Happy Day" (song), 1124, 1900
Ohio, **2040–2043**
 abolitionism, 1574, 1575
 antislavery societies, 11
 black codes, 139, 347, 493, 596
 Civil War, 596
 convention movement, 139, 140
 education, 858
 politics, 2178
 Stokes, Louis, 2579
 Underground Railroad, 2699
 see also Cincinnati, Ohio; Cleveland, Ohio
Ohio Falls Express (publication), 976
Ohio Ladies Education Society, 1371
Ohio State Anti-Slavery Society, 1574
Oh, She Got a Head Fulla Hair (Williams), 2850
Ojibwa Indians, 1805
O'Keeffe, Georgia, 976
Okeh Records, 800, 2286, 2493, 2497, 2770

O'Kelly Christians, 769
Okino, Betty, 1161
Oklahoma, **2043–2048**
 black migration, 2805
 black towns, 371, 371–372
 Chandler, Charles, 2434
 prison labor, 2225
 Seminoles, 1157, 1698
 slavery, 2043, 2044, 2646
 suffrage, 2515
Oklahoma City, Oklahoma, 1309
Oklahoma State Baptist Convention, 2045
Okra (Georgia slave), 182
Okra (food), 1009
Olatunji, Babatundi, 719, 1579
Oldfield, Berna Eli "Barney," 1870
Old North State Medical Society, 1250
O'Leary, Hazel Rollins, **2048–2049**
O'Leary, John F., 2048
Oliver, Joseph "King," 194, 195, *673*, 776, 1422, 1431, 1528, **2049–2050**, 2070, 2286, 2866, 2911
Oliver, Perry, 313
Oliver, Sy, 1667
Oliver, Willis "Kid," 1197, *1198*
Olivia, Sergio, 392
Olmsted, Frederick Law, 1890
Olson, Bobo, 2356
Olugebefola, Ademola, 1133
Olusegun, Kalonji, 2317
Olympia Disc Record Company, 369
Olympic Hall of Fame, 720
Olympic movement, 247, 1761, 1797, 1862, **2050–2054**, 2072, 2111, 2369, *2370*, 2372, 2545, 2649, 2693–2694, 2872
 basketball, 284, 285–287
 black representation, 2555
 boycott, 2559
 fencing, 949
 Georgia, 2907
 gymnastics, 1160–1161
 medalists, 3047–3056
 Nazis, 2051, 2072, 2668
 rowing, 2051
 swimming and aquatic sports, 2599
 track and field, 2667–2669
 U.S. Olympic Committee, 733, 2054, 2764–2765
 volleyball, 2750
 winter sports, 2865
 wrestling, 2891
Omaha, Nebraska, 1974, 1975
Omar (African Muslim slave), 76, 77
OMBE. *See* Minority Business Development Agency
Omega Phi, 352
Omega Psi Phi, 1517
Once (Walker), 2760
Once on This Island (musical), 1160
Onchocerciasis, 44
Onderdonk, Benjamin T., 2851
O'Neal, Frederick, 119–120, 2618
O'Neal, Ron, 383
O'Neal, Shaquille, 287

Refuge Churches of Our Lord, 167
Refugee Home Society, 493, 494
Regents of the University of California v.
 Bakke (1978), 37, 561–562, 568,
 1925, 1950
Reggae, 2271, **2297–2298**
Reggie's World of Soul (film), 1322
Rehnquist, William, 38, 39, 568
Reid, Herbert Ordré, Sr., 1589
Reid, Ira, 107, 1346, 1376, 1940, 2158
Reid, Lonnie, 31
Reid, Mel, 1014
Reiss, Fritz Winold, 781, 2081
Religion, **2298–2310**
 African, 50–51, 55, 56, 2390
 African musical conceptions, 72–73,
 1889–1890
 Alabama, 84, 85
 Arkansas, 190
 Atlanta, Ga., 211
 Baltimore, Md., 242
 Bible and African-American culture,
 315–316
 biblical color symbolism, 162
 Birmingham, Ala., 320
 black church homophobia, 1094–1095
 black church as philanthropy source,
 2139
 black church study, 1727
 black entrepreneurship support, 337
 black evangelism. *See* Evangelicalism
 black gay churches, 1097
 as black intellectual life influence,
 1372–1373, 1386–1387
 black theology, 2643–2645
 Canada, 494
 Christian and Muslim interaction,
 1398
 Cincinnati, Ohio, 546
 Cleveland, Ohio, 595
 Congress of National Black Churches,
 Inc., 637–638
 denomination membership, table of,
 3041–3046
 dissemination of, 847–848
 ecumenism, 842–844, 2644
 education. *See subheads* religious edu-
 cation; theological education *below*
 folk, 1006–1007
 as folk art influence, 992
 free blacks, 2302–2303
 Georgia, 1101
 Gullah, 1156–1157
 Harlem, 1191–1192
 Hawaii, 1237
 Holiness movement, 1291–1292
 liberation theology, 1613–1615
 messianism, 1760–1761
 missionary movements, 1815–1818
 Montana, 1839
 music 1120–1124, 1889–217, 2551–
 2553; *see also* Gospel music; Spir-
 ituals
 National Black Evangelical Associa-
 tion, 1955–1957
 Nevada, 1982
 New Hampshire, 1988

New York City, 2002–2003
New York State, 2012
North Carolina, 2025
Ohio, 2040
Pennsylvania, 2120–2121
Philadelphia, Pa., 2133–2134
post-Emancipation community, 2278–
 2279
religious dances, 2503–2504
religious education, 2310–2313
Rhode Island, 2325
Richmond, Va., 2335
St. Louis, Mo., 2379
Santeria, 2390–2391
slave. *See* Slave religion
social gospel, 2513–2514
South Carolina, 518–519
Spiritual Church movement, 2547–173
spirituality, 2549–2550
storefront churches, 1007, 1191–1192,
 2304, 2581–2582
theological education, 1390–1391,
 2642–2643
urban, 1784, 2716
Utah, 1854–1855
voodoo, 2301, 2750–2752
Washington, D.C., 2787
"womanist" theology, 67, 1614, 2645
*see also specific church congregations,
 denominations, and sects*
Religion and Trade in New Netherlands
 (Smith), 2296
Religious education, **2310–2313**
Religious Instruction of the Negroes, The
 (Jones), 2311
*Reminiscences of My Life in Camp with the
 33rd United States Colored Troops*
 (Taylor), 2613
Remond, Charles Lenox, 1029, 1679,
 2313–2314
Remond, Cornelius Lenox, 122
Remond, Sarah Parker, **2314–2315**
Renaissance Big Five (Harlem Rens),
 282, 1197, **2315**, 2556
Renault, Francis, 1341–1432
Renfroe, Earl W., 29
Reno, Janet, 1771
Renouard, Auguste, 2701
Reol Studio, 962
Reparations, **2315–2317**
 Black Manifesto, 360, 1026, 2200
 forty acres and a mule, 1033, 2315
 Moore (Audley "Queen Mother")
 campaign, 1846
 New York City draft riot of 1863,
 2010
 Republic of New Africa, 2319–2320
Reparations Committee for the Descen-
 dants of American Slaves, 2316
Report on Negro Housing (1931), 1215
Republican party, **2318–2319**
 Alabama, 85–86, 1188–1189
 Amsterdam News endorsements, 129
 antilynching legislation, 1937
 black and tan factions, 2179
 black support for, 743, 2168
 Carey (Archibald J., Jr.) speech, 498

carpetbaggers, 500–501
Compromise of 1877, 629
Delaware, 741
Detroit, Mich., 756
Douglass (Frederick) support for, 785
1884 convention, 1669
Florida, 2771–2772
Georgia, 1646
Gibbs, Mifflin Wister, 1104
Harlem, 1192
Illinois, 751
Kentucky, 1535
Louisiana, 2152
Maryland, 1708
Mississippi, 1820, 1822
Missouri, 1826
New York City politics, 130–131
Ohio, 2164
Reconstruction, 850, 2274, 2275,
 2276, 2280, 2281–2283, 2283, 2284
scalawags, 2396
slavery issue, 2471
South Carolina, 738–739
Tennessee, 543
Texas, 707–708, 2634
Thirteenth Amendment, 2646
Union League, 2702
Washington, 2785
Washington (Booker T.) support for,
 2779
Washington, Valores J. "Val," 2784
Republic of New Africa, 2316, **2319–
 2320**
Resolute Beneficial Society, 301
"Respect" (song), 1038
Restrictive covenants
 housing discrimination, 1309, 1310,
 1314
 Supreme Court decisions, 556, 557
Resurrection City (Washington, D.C.),
 2186
Retail Drug Employees Union, 1640
Retail, Wholesale, Department Store
 Union, 1640
Retzius, Anders, 2252
Reuter, Edward Byron, 2108
Reuther, Walter, 413, *565*, 758, 1823,
 1962
Revels, Hiram Rhoades, 1586, *2175*,
 2282, **2320–2321**, 2379, 2785
Reverend Ike (Eikerenkoetter, Frederick
 J.), **2321–2322**
Reverse discrimination. *See* Affirmative
 action
Review of Black Political Economy (jour-
 nal), 2317
Revlon, 24
Revolutionary Action Movement, **2322–
 2323**, 2413, 2696, 2852
Revolutionary Ensemble (music group),
 1442
Revolutionary Union Movement, 1592
Revolutionary War, American. *See*
 American Revolution
Reyburn, Robert, 1063
Reyneau, Betsy, 2776–2777
Reynolds, Barbara, 1507

Steward, William Henry, 646, 1534, 1535, 1660, **2570–2571**
Stewart, Alex, 1295
Stewart, Billy, 309
Stewart, Chuck, 2147
Stewart, Donald Mitchell, 2543
Stewart, Ellen, **2571–2572**
Stewart, Ernie, 2502
Stewart, Frank, 2599
Stewart, George, 2799
Stewart, James, 2712–2713
Stewart, John, 1816, **2572**
Stewart, Leroy Elliot "Sam," **2572**
Stewart, Maria Miller, 10–11, 681, 1371, 2094, 2173, **2573**
Stewart, Mary Watson, 66
Stewart, Pearl, 2389, **2573–2574**
Stewart, Peter, 1342
Stewart, Sherwood, 1089
Stewart, Slam, 2610
Stewart, Thomas McCants, 924, 1236, 1587, **2574–2575**
Stewart, William, Jr., "Rex," **2575**
Stewart Four (music group), 2579
Stewart-Lai, Carlotta, 1236, *1237*
STFU. *See* Southern Tenant Farmers' Union
Stienburg, Martha Jean "the Queen," 2255
Still, James, 1248, **2575–2576**
Still, William, 270, **2576–2577**, 2676, 2699–2700
Still, William Grant, 630, 2057, 2058, **2577–2578**
 Black Swan Records, 369
 New Negro movement goals, 1893
 Pace & Handy Publishing Company, 2075
Still, William and Peter, 1248
Stillwell, William, 69
Stith, James, 2148
Stitt, Sonny, 711
Stock, Frederick, 2749
Stockbrokers. *See* Investment banking
Stockholm Peace Appeal, 809
Stockton, Betsey, 1235
Stockton, J. W. B., 1788
Stokes, Anson Phelps, 893, *894*, 2132
Stokes, Carl Burton, 598, 718, 1723, *1724*, 1725, 2043, 2140, **2578–2579**
Stokes, Caroline Phelps, 2132
Stokes, Charles, 2414
Stokes, Isaac Newton Phelps, 2132
Stokes, Louis, 598, 636, 2043, **2579**
Stokes, Pembert E., 2832
Stokowski, Leopold, 630, 633, 727
Stoller, Mike, 601
Stone, Barton W., 769
Stone, Chuck, 1507
Stone, Robert, 2200
Stone, Sly, 2256, 2331, **2579–2580**
Stone, Toni, 274
Stonequist, Everett V., 2446
Stonewall riot (N.Y.C.), 1096
Stono rebellion, 846, 1786–1787, **2580–2581**
 aftermath, 2456

Angolan origins, 57
 use of drums, 988, 1004
"Stop the Killing" campaign, 1664
Stop This Outrageous Purge (pro-integration group), 193
Stop the Violence Movement, 2291
Storefront churches, 1007, 1191–1192, 2304, **2581–2582**
Store Front Lawyers, The (television program), 967
Storey, Moorfield, 879, 1934, 1938
Stories from Africa (Dolch), 2499
Stork Club (N.Y.C.), 232, 942
Stormy Weather (film), 2019
Story, Joseph, 1071, 2470, 2471
Story of a Three-Day Pass, The (film), 381, 2734
Story of My Struggles, The (Griggs), 1149
Story of the Negro (Bontemps), 398
Story quilts, 2342
Storyville (New Orleans), 1431, 1433, 1860, 1997
Stoughton, John, 2704
Stovall, Charles, 185, 186
Stovall, Lou, 1133
Stovey, George, 271
Stowe, Calvin, 2696
Stowe, Harriet Beecher, 1270, 1422, 1534, 1627, 1679
 Baldwin (James) criticism of, 233, 234
 Uncle Tom's Cabin, 2696–2698
"Straight-ahead" jazz, 379
Straight Out of Brooklyn (film), 969
Straker, David Augustus, 756, 2574
Strandberg, Julie Adams, 18
Stratford, John, 551
Strayhorn, William Thomas "Billy," 659, **2582–2583**
Streator, George, 1502
Street, The (Petry), 2130
Street Corner Stories (film), 1323
Street cries (communication form), 1891
Street in Bronzeville, A (Brooks), 1631
Street Scene (musical), 1325
Streisand, Barbra, 2166
Stribling, T. S., 1204
Stride pianists, 1458–1459
Stride Toward Freedom: The Montgomery Story (King), 1544
Strikes, labor. *See* Labor and labor unions
Stringer, Charlene Vivian, 285–286, 957, **2583**
Strip quilts, 991
Strode, Woodrow "Woody," 1012, 1013, 1015, 2556
Strong, Barrett, 1872
Strong, Nat, 273
Stryker, Roy, 2101–2102
Stuart, Charles, 1714
Stuart, Gilbert, 2078
Stuart, J. E. B., 1449
Stubbs, Frederick Douglass, **2583–2584**, 2594
Stubbs, Joe, 2149
Stubbs, Levi, 1036

Student Nonviolent Coordinating Committee, **2584–2585**
Alabama, 88
anti-apartheid demonstrations, 152
Baker, Ella J., 230
Barry, Marion Shepilov, Jr., 268
Black Panthers relationship, 361–362, 1026, 2585
Bond, Julian, 395–396
Brown, Hubert G. "H. Rap," 447
Carmichael, Stokely, 498–499
civil rights activism, 566, 567, 640–641, 1066, 1068
Council of Federated Organizations founding, 667
Deacons for Defense and Justice, 729
factionalism, 1863
Forman, James, 1025–1026
founding, 566
Hamer, Fannie Lou, 1176, 1177
King, Martin Luther, Jr., 1544
Lewis, John, 1609
Mississippi Freedom Democratic Party formation, 1822–1824
Moses, Robert Parris, 1862–1863
Nash, Diane Bevel, 1930
Sherrod, Charles, 2427–2428
Third World Women's Alliance, 2646
Students for Education and Economic Development, 314
Studin, Charles H., 1938
Studio Museum of Harlem, 200, 1887
Stull, Donald L., 180
Sturdy Black Bridges: Visions of Black Women in Literature (anthology), 683
Sturgis, Stokely, 63
Stuyvesant, Peter, 2296
Stuyvesant Town (N.Y.C. housing), 1217, 2006
Stylus magazine, 1623, 1624
Styron, William, 307, 1969–1970
Suburbanization, **2585–2587**
 affluent black suburbs, 588
 effects on schools, 560–561
 Maryland, 1709
 white flight, 1723
Succeeding Against the Odds (Johnson), 1463
Sudarkasa, Niara, 1619
Suffrage, tables of African-American historical rights and voting patterns, 3012–3017
Suffrage, eighteenth-century, 2170–2171
 Pennsylvania, 2119, 2135
 table, 3012–3013
Suffrage, nineteenth-century, 1825–1826, **2587–2589**
 Alabama, 86
 Arkansas, 191
 black male enfranchisement. *See* Fifteenth Amendment
 California, 485, 2386
 Colorado, 613
 Connecticut, 643
 conservative ideology, 645
 convention movement, 140

Swimming and aquatic sports, **2599**
Swinton, David, 2317
Switzer, Lou, 178
Sydenham Hospital (N.Y.C.), 1218
Sykes, Roosevelt, 800
Symbol of the Unconquered (film), 1774
Symington, Stuart, 1553
Symons, Arthur, 354
Symphonic music. *See* Concert music
Symphony in Black, The (film), 964
Symphony of the New World, **2600**
Synan, Vinson, 2123
Syphax, Maria, 2787
Syphax, Theophilius John Minton, 2108
Syphilis, 1581, 1729
 epidemiology, 910, 1215
 Hinton test, 1253, 1283
 inaccurate stereotype as "Negro" dis-
 ease, 771
 see also Tuskegee syphilis experiment
Syphilis and Its Treatment (Hinton),
 1283
Syracuse, New York, 953, 2013
Syria, ancient, 156, 158
Szwed, John F., 147

T

Tablighi Jamaat, 1400
Tae kwon do. *See* Martial arts
Taft, Seth C., 2578
Taft, William Howard, 744–745, 2536
 appointees, 700, 1236, 1612, 2191
 civil rights policies, 943, 2318
 presidency, 436, 2207
 reelection campaign, 131
Taggard, Blind Joe, 1122
Ta-Har, 1514
Take Five: Collected Poems (McClane),
 1730
Take 6 (gospel group), 1124
Taking of Miss Janie, The (play), 468
Talbert, Bill, 2799
Talbert, Henry, 2631
Talbert, Mary Morris Burnett, 1498,
 1952, **2601**
Talented Tenth (black educated elite)
 anti-Garveyism, 1207
 dramatic aesthetic, 790
 embracement of arts, 1205
 Harlem Renaissance role, 1201, 1202,
 1209
 literary aesthetic, 791, 1623
 mission of, 583, 853, 1202
 Morehouse College students, 1851
 radical socialist criticism of, 16
Talented Tenth, The (Wesley), 2804
Taliaferro, George, 1019
Talkin and Testifyin (Smitherman), 148
Talladega College, 1880
Tallahassee, Florida, bus boycott, 984
Talley, Charles W., 2200
Talley, Thomas, 1377
Talley's Corner (Liebow), 147
Talmadge, Herman, 1413
Tamez, Elsa, 1614
Tamla Records, 1118, 1870, 1871

Tammany Hall (N.Y.C.), 2003, 2707,
 2708
Tam O'Shanter All American tourna-
 ment, 1115
Tampa Red (Whittaker, Hudson), 779,
 2602
Tan Confessions (publication), 1505
Tandem Productions, 2622
Tandy, Vertner Woodson, 172, 175,
 2602
Taney, Roger B., 126, 570, 801, 2471
Tango (dance), 2506
Tanner, Benjamin Tucker, 65, 95, **2602–
 2603**
Tanner, Henry Ossawa, 95, 1132, *1633*,
 2080, **2603–2605**, 2872
Tanner, Obour, 2815
Tap dance, **2605–2610**, 2638, 2639, 2640
 acts, 2641
 Atkins, Cholly, 210
 Bailey, Bill, 228
 Bates, Clayton, "Peg Leg," 289–290
 Briggs, Bunny, 431
 Bubbles, John, 466–467
 Coles, Charles "Honi," 609–610
 Collins, Leon, 611–612
 Cook, Charles "Cookie," 654
 Copasetics, 659–660
 Covan, William McKinley "Willie,"
 668–669
 Four Step Brothers, 1034–1035
 Harlem, 1191
 Hines, Gregory, 1281
 Jackson, Laurence Donald "Baby Lau-
 rence," 1409–1410
 Nicholas Brothers, 2018–2019
 Nugent, Pete, 2032
 Rector, Eddie, 2292
 Robinson, Bill "Bojangles," 2348–
 2349
 Robinson, LaVaughn, 2354
 Sims, Howard "Sandman," 2439
 Slyde, Jimmy, 2489
 Walker, Dianne, 2762–2763
Tapley, Mel, 624
Tappan, Arthur, 11, 108, 114, 139
Tappan, Lewis, 11, 108, 114, 126, 400,
 2705
Tappan School. *See* Avery Normal
 Institute
Tappes, Sheldon, 757
Taras, John, 711
Tar Baby (Morrison), 1857
Tar Beach (Ringgold), 536, 2342
Tate, Allen, 2665
Tate, Carolyn, 787
Tate, Emory, 528
Tate, Greg, 1442
Tate, James, 211
Tate, Magdalena, 2125
Tatum, Arthur, Jr., "Art," *223*, 1409,
 1434, **2610–2611**
Tatum, Reece "Goose," 1198
Tatum, Wilbert, 129
Taussig, Helen, 2650
Tawes, J. Millard, 1709, 2333
Tawney, R. H., 586

Taylor, Barbara, 2239
Taylor, Cecil Percival, 1436, **2611**
Taylor, Creed, 1268
Taylor, C. W., 2697
Taylor, Edward, 349
Taylor, Gardner Calvin, 258, 1409,
 1955, **2611–2612**
Taylor, George Baxter, 2050
Taylor, George Edwin, 2178
Taylor, Hobart, 903, 2238
Taylor, John B., 2667, 2739–2740
Taylor, Julius F., 2029
Taylor, Lawrence, 1020
Taylor, Marshall "Major," 2554
Taylor, Mildred, 536
Taylor, Moddie D., 2406
Taylor, Preston, 769, 770
Taylor, Robert R., 170, 172, 1380–1381
Taylor, Ruth Carol, 30
Taylor, Susie Baker King, **2612–2613**
Taylor, William F., 2547
Taylor, William, Jr., "Billy," **2613–
 2614**
Taylor, Zachary, 1766, 2203
Taylor, Zora, 2161
TCA. *See* Tuskegee Civic Association
Teachers Insurance Annuity Association
 and College Retirement Fund, 2814
*Teaching for the Lost-Found Nation of
 Islam in a Mathematical Way* (Fard),
 1966
Teague, Collin, 498, 1817
Teer, Barbara Ann, 795, **2614**
Telegraph
 Underground Railroad use, 2700
 Woods (Granville T.) patents, 894,
 2110, 2874
Telephone, patents, 2874
Television, **2615–2624**
 advertising, 22, 23–24
 Allen (Debbie) directing, 99
 Amos 'n' Andy, 128
 black journalists, 1502–1503, 1507,
 1508
 celebrity commercial endorsements,
 24
 Cole (Nat "King") program, 20, 604
 comedians, 618–621
 comedies, 2615–2616, 2617, 2618–
 2619, 2619–2620, 2622, 2623
 documentaries, 410, 2618
 Emmy Awards winners, 2983
 entrepreneurs, 905, 906, 907
 first black-produced program, 301
 first woman program host, 2408
 impact on film industry, 967–968
 Mammy and Sambo stereotypes,
 2566, 2567
 Motown Productions, 1872
 musical scoring, 504
 NAACP campaign against stereo-
 types, 1949
 Roots popularity, 137, 2621
 Terry, Clark, 2632
 Van Peebles, Melvin, 2734–2735
 vernacular dance, 2641
 White Citizens' Councils use of, 2826

Thompson, Holland, 85, 2167, **2651–2652**

Thompson, John, 286, 2229

Thompson, John Robert, Jr., **2652–2653**

Thompson, Louise, 666, 1215, **2653**

Thompson, Marie, 1114

Thompson, Robert Louis, **2654–2655**

Thompson, Solomon Henry, **2655**

Thompson, Stith, 1377

Thompson, Theophilus, 528

Thompson, Ulysses "Slow Kid," 2607

Thompson, Vincent L., 1982

Thompson, Wiley, 2418

Thompson, William Hale "Big Bill," 751, 2033

Thoms, Adah Belle Samuels, 1040, 2035, **2655–2656**, 2883

Thorne, George D., 1617

Thornton, Lee, 1507

Thornton, Willie Mae "Big Mama," **2656**

Thorpe, Earl E., 1285

Thoughts on African Colonization (Garrison), 11

Thrash, Dox, 1132, **2656–2657**
 Federal Art Projects, 942

Threadgill, Henry Luther, 207, 208, 1437, **2657**

Threads 4 Life Corporation, 907

Three Bosses (jazz group), 582

Three-fifths clause (U.S. Constitution), 2469, 2470

Three-Fifths of a Man (McKissick), 1741

306 studio (Harlem), 1610, 2086

Thriller (album), 1415, 1485, 2290

Throne of the Third Heaven of the Nations' Millennium General Assembly, The (Hampton), 200, 1180, 2088

Thrower, Willie, 1019

Thurman, Howard, 1386, 2388, **2657–2658**

Thurman, Lillian, 66

Thurman, Wallace, 1624, 2653, **2658–2660**, 2808
 Harlem Renaissance, 1211, 1212, 1213, 1216
 Messenger magazine, 1760

Thurmond, Strom, 746, 2532

Thurston, Lorrin A., 1236

Thurston, Neptune, 2078

Thye, Edward, 1807

TIAA-CREF. *See* Teachers Insurance Annuity Association and College Retirement Fund

Tiant, Luis, Sr., 274

Tibbett, Lawrence, 2056

Tides of Lust, The (Delany), 2404

Tifineh alphabet, 158

Tiger, Dick, 1034

Tilden, Samuel J., 2206, 2284–2285
 Compromise of 1877, 629

Till, Emmett Louis, 920, 1332, 1672, 1821, **2660**, 2827

Tillery, Dwight, 2043

Tilley, Madison, 596

Tillman, O. T., 2548

Tillman, "Pitchfork" Ben, 2177, 2490, 2531

Tillmon, Johnnie, 1965

Tilman, Julliann Jane, *66*

Time (magazine), 1504

Time for Laughter, A (television program), 1675

Time to Speak, a Time to Act, A (Bond), 396

Tindley, Charles Albert, **2660–2661**
 gospel compositions, 1899, 2305, 2306

Tio, Lorenzo, Jr., 317, 776

Tituba of Salem Village (Petry), 535

Tives, Thomas W., 2163

Tizol, Juan, 132, **2661**

Tjader, Cal, 2390

TLC Group, 906, 1611

"Toasting" (reggae style), 2297

TOBA. *See* Theater Owners Booking Association

To BE or Not to BOP (Gillespie), 1109

To Be Young, Gifted and Black (Hansberry), 1187–1188

Tobias, Channing Heggie, 1944, 2132, **2661–2662**, 2916–2917
 Council on African Affairs affiliation, 666, 667

Tobin, Pat, 2239

Tocqueville, Alexis de, 2482

Today (television program), 1158

Todd, David, 2041

Todman, Terence, 105

Toggle harpoon, 2624–2625

"To His Excellency General Washington" (Wheatley), 2816

Tolan, Eddie, 2668

Toll, Robert C., 1812, 2638

Tolson, Melvin Beaunorus, *1629, 1632,* **2662–2663**

Tolton, Augustus, 2365, **2663–2664**

To Make a Poet Black (Redding), 692, 2292

Tomlin, Elaine, 2147

Tomlinson, Mel, **2664**

Tommy Traveler in the World of Negro History (comic strip), 624, 948

Tonga (people), 48

Tongues, speaking in. *See* Glossolalia

Tongues Untied (film), 2340

Tonight Show (television program), 2632

Tony Atlas (wrestler), 2891

Tony Awards
 musical theater, 1919
 winners, 2993–2994

Tony Brown Productions, 2239

Tony Brown's Journal (television program), 457, 458

Tools, early African, 51

Toomer, Jean, 1630, **2664–2666**
 grandfather, 2152
 Harlem Renaissance, 1203, 1204–1205, 1207

Toote, Fred A., 2712

"To Our Old Masters" (Bibb), 7

Topology, 591, 592

Torchy Brown (comic strip), 624

Tories, black. *See* Loyalists in the American Revolution

Toronto, Canada
 black emigrés, 493, 495
 carnivals, 954, 956

Torrance School of Race Relations, 1185

Torrence, Ridgely, 1204, *1633*

Torrey, Charles T., 2700

To Secure These Rights (President's Commission on Civil Rights), 96, 564, 858–859, 1942–1943, 2209, 2824

Tosh, Peter, 2271

To Sleep with Anger (film), 475, 476

Totten, Ashley, 439

Toucoutou (Laroque-Tinker), 674

Toure, Askia Muhammad, 2294

Toure, Kwame. *See* Carmichael, Stokely

Tourgée, Albion W., 501, 2162

Toussaint, Pierre, 898, **2666**

"Towards a Black Feminist Criticism" (Smith), 681

Townsend, Fannie Lou. *See* Hamer, Fannie Lou

Townsend, James, 1813

Townsend, Jonas H., 1986

Townsend, Robert, 969

Townsend, Willa A., 1122

Track and field, **2666–2670**
 Hall of Fame inductees, 3058–3059
 Olympic Games, 2051, 2053–2054

Tracking system, 2403

Trade unions. *See* Labor and labor unions

Traditional Jazz Dance Company, 310

Traffic light, invention, 1853

Tragedy of Lynching, The (Raper), 1670–1671

Trail of Tears, 84, 115, 2044

Trainor, Mike, 1600

Train Whistle Guitar (Murray), 1884

TransAfrica, 1134, 2093, **2670–2671**
 Artists and Athletes Against Apartheid, 204
 Congressional Black Caucus, 636
 formation, 152
 Robinson, Randall, 2355

Trans Alaska Oil Pipeline, 92

Trans-Atlantic Society, 2441

Transportation, U.S. Department of, 718

Travis, Dempsey, 903–904

Travis, Geraldine, 1839

Travis, Jack, 178, 181

Traylor, Fasha, 871

Treadwell, George, 2736

Treaty of Versailles, 2673

Tredegar Iron Works, 1363, 2335, 2714, 2746

Treemonisha (Joplin), 135, 632, 1465, 1486, 1618, 1953

Trent, Alphonso, 2498

Trent, William, 2709

Trenton Six Trial, 94

Trévigne, Paul, 1996

Trevor-Roper, H. R., 2564

Trice, Jack, 1012

Wilmington, N.C., 2722, 2857
Urquhart, Brian, 471
US (nationalist organization), 362, 944–945, 1526
USA for Africa, 1485
USA Today (publication), 1507
U.S. Civil Rights Commission. *See* United States Commission on Civil Rights
U.S. Congress. *See* Congress, U.S.
USGA. *See* United States Golf Association
USIA. *See* United States Information Agency
U.S. Military Academy. *See* United States Military Academy
U.S. Naval Academy. *See* United States Naval Academy
USOC. *See* United States Olympic Committee
U.S. Open (golf), 1113–1114
U.S. Open (tennis), 1089
U.S. Public Health Service. *See* Public health
USSR. *See* Russia
Utah, **2727–2730**
 black Mormons, 1854–1855
 slavery, 628
Ute Indians, 2728
Utopia House, 1582
UUA. *See* Unitarian Univeralist Association

V

Vaccination, 1247, 1255, 2893
Vails, Nelson "The Cheetah," 2051, **2731**
Vallandigham, Clement, 2041
Van Buren, Martin, 126, 743, 2203
Vandenberg, Hoyt S., 1553
Vanderhorst, Richard H., 542
VanDerZee, James Augustus, 1188, 2142, 2144, **2731–2732**
 photograph of "Sweet Daddy" Grace, *1127*
VanDerZee, Walter, 2731
Van Doren, Carl, 1203
Van Dyke, Earl, 1871
Vandyke, Peter, 246
Vanguard (artist group), 2393, 2653
Van Guinee, Aree and Jora, 1667
"Vanishing Mulatto" (Johnson), 2107–2108
Van Lew, Elizabeth, 2766
Vann, Jesse L., 1501
Vann, Robert Lee, 1141, 1571, 2254, **2733**
 Pittsburgh Courier, 1499–1501, 2157–2158, 2159–2160
 social conservatism, 648
Van Peebles, Mario, 2735
Van Peebles, Melvin, 380, 381, 968, 969, **2733–2735**
Van Renssalaer, Thomas, 1288, 2261
Van Vechten, Carl, 1096, 1201, 1209
 Harlem Renaissance, 1211–1212, 1215

research collection, 401
Van Wagenen, Isaac, 2674
Van Wagenen, Isabella. *See* Truth, Sojourner
Vanzetti, Bartolomeo, 2112
Vardaman, James K., 1820
Varick, James, 69, 2001, **2735**
Varna, Henri, 231
Vashon, George Boyer, 1318, 1378, 2272
Vashon, John, 736, 2157
Vassa, Gustavus. *See* Equiano, Olaudah
Vaudeville
 Apollo Theater, 165
 Atkins, Cholly, 210
 Bethune, Thomas Greene Wiggins "Blind Tom," 312
 blackface dialect, 1812
 Blake, James Hubert "Eubie," 377–378
 blues style, 386, 1895
 Bubbles, John, 466–467
 circus inclusion, 1688–1689
 Cook, Charles "Cookie," 654
 dancers, 2640
 Four Covans, 669
 growth of black, 1916–1918
 Harlem, 1191
 Mabley, Jackie "Moms," 1675
 Mills, Florence, 1801
 Nugent, Pete, 2032
 Rector, Eddie, 2292
 Rice, Linda Johnson, 1464
 Robinson, Bill "Bojangles," 2348–2349
 Sissle, Noble, 2441
 Stepin Fetchit, 2563
 tap dancers, 2607
 Theater Owners Booking Association, 2637–2638, 2640
 Whitman Sisters, 2828–2829
 Williams, Egbert Austin "Bert," 2841
 Wilson, Arthur Eric "Dooley," 2857–2858
 see also Minstrels/minstrelsy
Vaughan, Sarah, 165, **2736–2737**
Veblen, Thorstein, 588
Vedas, 162
Veeck, Bill, 275, 277
Vee Jay Records, 1551
Vehanen, Kosti, 93, 133
Vélez de Escalante, Silvestre, 612
Venable, Charlie, 413, *2558*
VEP. *See* Voter Education Project
Vermont, **2737–2738**
 politics, 2172
 slavery, 123, 1057
 suffrage, 2171
 Twilight, Alexander Lucius, 2691
Vernacular architecture. *See* Architecture, vernacular
Vernacular jazz dance, 2507–2508
Vernacular language. *See* Black English Vernacular
Verrett, Shirley, **2738–2739**
Versailles Peace Conference, 2670
Verve records, 977

Vesey, Denmark. *See* Denmark Vesey Conspiracy
Vesey, Joseph, 747
Vest, Hilda and Donald, 434
Veterinary medicine, **2739–2740**
Vicato (jazz technique), 1442
Victoria, queen of England, 973, 1270
Victory Life Insurance Company, 2071
Videos, music, 2290
Vietnam War, 1023–1024, **2740–2744**
 Ali (Muhammad) case, 97
 blacks during, 1795
 Brown, Jesse, 451
 Congressional Medal of Honor recipients, 2929–2930
 economic impact, 840
 Howard University protests, 1320
 Jackson State incident, 1420–1421
 Johnson (Lyndon) administration, 2212
 Komunyakaa (Yusef) poems, 1552–1553
 opposition, 97, 268, 314, 396, 419, 1147, 1540, 1545, 1547, 1549, 2194, 2413, 2915
 Petersen, Franklin E., 2128
 Powell, Colin Luther, 2195
 Robinson, Roscoe, Jr., 2355
View From Pompey's Head, The (Basso), 2107
Vilatte, Joseph René, 1736
Villa, Pancho, 1765, 1991, 2908
Villa Lewaro (Irvington, N.Y.), 175, 2759–2760, 2765
Villard, Oswald Garrison, 1208, 1933, 1934, 1935, 2536
Vincennes Convention (1803), 1356
Vincent, Marjorie Judith, 1343
Violence. *See* Crime; Lynching; Rape; Urban riots and rebellions
Virginia, **2745–2749**
 antiliteracy laws, 846
 black codes, 348
 black seamen laws, 1693
 colonial-era politics, 2170
 education, 2488
 free blacks' military service, 122
 fugitive slaves, 1073–1078
 Gabriel Prosser conspiracy, 1083–1084
 Hampton Institute, 1181–1184
 housing discrimination, 1309
 John Brown's raid, 1447–1448
 maroonage, 1697
 migrants, 756
 NAACP, 1946
 Nat Turner's rebellion, 1970–1971
 Odell Waller case, 2038–2039
 politics, 2179
 prison labor, 2224
 Reconstruction, 2283
 secession, 2204, 2416
 slavery, 2333–2335, 2455–2456, 2462, 2745–2747
 slave trade, 2484
 suffrage, 1411, 2589
 Underground Railroad, 2699
 Wilder, Lawrence Douglas, 2832–2833
 see also Richmond *headings*

Walton, Lester, 962, 1502, 1827
Walton, Tom, 2177
Waltz clog, 2292
Wanamaker Music Competition
 Contest, 2216
Wanderer (slave ship), 2485
Warbourg, Armand, 1995
Ward, Charlie, 2561
Ward, Clara, 1037, 1122, 1412
Ward, Douglas Turner, 331, 1978,
 2774–2775
Ward, Mary Frances, 2386
Ward, Samuel Ringgold, 494, 1372,
 2775
Ward, Theodore, 791–792, 793, **2775–
 2776**
Wards Cove Packing Co. v. *Atonio* (1989),
 568
Ward Singers, 2847–2848
Ware, Charles, 1755
Ware, Edmund, 580
Ware, Elvira Dozier, 2768
Warfield, William, 633, 1064, 2056
Waring, Everett J., 1586
Waring, Laura Wheeler, 2081, **2776–
 2777**
Waring, William, 253
Warley, William, 1535, 1660
Warmoth, Henry C., 1657, 1996
Warner, W. Lloyd, 141, 147, 670, 726,
 788, 2249, 2251
Warner Brothers, 2238
Warner Records, 2291
War of 1812, **2773–2774**
 Alabama, 84
 black emigration to Canada, 491
 black sailors, 1787
 black troops, 1655, 2120, 2774
War of Jenkins' Ear, 2580
War on Poverty, 1197
 Moynihan Report, 1875–1876
War Relocation Authority, 1649
Warren, Earl, 564
 Brown v. *Board of Education* decision,
 463
 Fourteenth Amendment decisions,
 1035
 Powell (Adam Clayton, Jr.) ruling,
 2194
Warren, Earle (jazz musician), 280
Warren, Nathan, 189
Warren, Sadie, 129
War Resisters League, 2375
Warwick, Dionne, **2777**
Washburn, Henry, 1838
Washington, Andy, 1197
Washington, Augustus, 2143
Washington, Booker Taliaferro, 119,
 462, 1568, **2777–2779**
 accommodationist philosophy. *See*
 Accommodationism
 anti-colonialism views, 2095
 Atlanta Compromise, 215–216
 belief in importance of artisans, 170
 on black church, 2302
 black entrepreneurship support, 335,
 337

black movies support, 961
black towns development, 372,
 1873
conservative ideology, 644, 646, 647–
 648
daughter. *See* Pittman, Portia Mar-
 shall Washington
Davidson, Olivia America, 714
death, 1935
Du Bois (W. E. B.) criticism of, 808,
 1630
educational philosophy, 850, 853, 854,
 1184, 1362, 1373, 1496, 1993, 2402,
 2517, 2688, 2690
fading appeal of, 1202
Fortune (Timothy Thomas) relation-
 ship, 1031, 1032
fraternal orders, 1045, 1046
Hawaii visit, 1236
health movement, 1251, 1256, 2236
Howard University trusteeship, 1318
National Afro-American Council,
 1932
opponents, 263, 407, 1151, 1153,
 1278, 1298, 1932–1933, 2672–2673,
 2758, 2773
opposition to Niagara Movement,
 2017, 2018
oratory, 2064
personal secretary, 2407
political network, 2779
postage stamp honoring, 2191
presidential advisory role, 2318
press influence, 263–264, 1496, 1497,
 1622–1623, 2157–2158
quotations, 1717–1718
Republican patronage power, 2168
Roosevelt (Theodore) relationship,
 2206–2207
secret societies, approval of, 2691
slave narrative, 2451
stepfather, 2810
supporters, 131, 1612, 1868, 1869,
 2733, 2913
Tuskegee Institute, 86, 736, 1533,
 2688, 2690
Washington, Bushrod, 112
Washington, Chester "Ches," 1500,
 2160
Washington, Craig, 1316
Washington, Denzel, *796*, **2780**
Washington, Desiree, 2693
Washington, Dinah, 1124, 1706, *2327*,
 2329, **2780–2781**
Washington, Earl, 31
Washington, Edith, 408
Washington, Ford Lee "Buck," 466,
 2608
Washington, Forrester, 1141
Washington, Fredericka Carolyn
 "Fredi," **2781**
Washington, George
 presidency, 2201
 use of black troops, 121, 122, 1787,
 2185, 2383
Washington, George (Idaho miner),
 1340

Washington, Harold, 532, 1725, **2781–
 2782**
Washington, Joe, 2920
Washington, Kenny, 1012, 1013, 1015,
 2556
Washington, Madame Ernestine, 800
Washington, Margaret Murray, 1952,
 2778, **2783–2784**
Washington, Mary Helen, 682, 2107,
 2809
Washington, Ora Mae, 124, *125*, **2784**
Washington, Paul, 2136
Washington, Portia Marshall. *See* Pitt-
 man, Portia Marshall Washington
Washington, Ray, 207
Washington, Roberta, 179
Washington, Roy, 2891
Washington, Valores J. "Val," **2784**
Washington, Walter, 94, 268, *1724*, 2187
Washington, 2068, **2784–2786**
 black migration, 2805, 2807
 see also Seattle, Washington
Washington, D.C., **2786–2791**
 Banneker, Benjamin, 252
 Barry, Marion Shepilov, Jr., 268
 black women's club movement, 376
 color line, 464
 congressional rule, 1064, 2168, 2791
 mayoralty, 1725
 Norton, Eleanor Holmes, 2031
 photographic documentation, 2412
 Poor People's Campaign, 2185–2187
 population, 3035
 protests. *See* March on Washington
 headings
 schools, 301, 2788, 2790
 slavery, 2203, 2204, 2786, 2787
 statehood, 1592
 Underground Railroad, 2700
 see also Freedman's Hospital; Howard
 University
Washington, D.C., riot of 1919, 2789,
 2791–2792
Washington Generals (basketball), 1198
Washingtonians (jazz band), 1786
Washington Post (newspaper), 1508, 1722
 black reporters, 1507
 Washington, D.C., riot coverage,
 2791
Washington Redskins (football), 1013,
 1016
Washington, U.S.S. (ship), 126
Washington Alerts (baseball), 270
Washtub bass, 1914
Watchtower, The (publication), 1440
Watchtower Bible and Tract Society of
 New York and Pennsylvania, 1439
Waterhouse, Benjamin, 1255
Watermelon, 62, 1009
Watermelon Man (film), 2734
Waters, Elmer "Youngblood," 659
Waters, Emily, 892
Waters, Enoch, 788
Waters, Ethel, 369, 735, 902, 1266,
 1602, 2566, 2616, **2792–2793**
Waters, Mary, *827*, 2105
Waters, Maxine Moore, **2793**